BURIAL AND MEMORIAL IN LATE ANTIQUITY

BURIAL AND MEMORIAL IN LATE ANTIQUITY

VOL. 1: THEMATIC PERSPECTIVES

EDITED BY

LUKE LAVAN

BRILL

LEIDEN | BOSTON

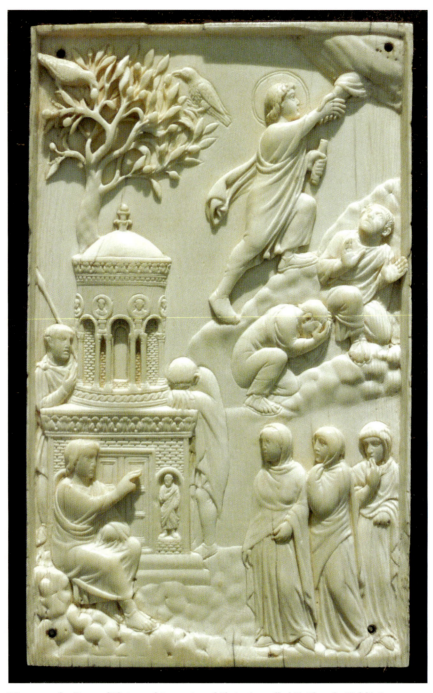

Women at the Grave of Christ and Ascension of Christ (so-called 'Reidersche Tafel'); Ivory; Milan or Rome, c. 400 AD.
BAYERISCHES NATIONALMUSEUM MÜNCHEN, INV. MA 157, ERWORBEN 1860 MIT DER SAMMLUNG MARTIN VON REIDER
PHOTO: ANDREAS PRAEFCKE (FEBRUARY 2008; PUBLIC DOMAIN)

Library of Congress Cataloging-in-Publication Data

Names: Lavan, Luke, editor.
Title: Burial and memorial in late antiquity set / managing editor, Luke Lavan.
Description: Leiden ; Boston : Brill, 2024. | Series: Late antique archaeology, 1570-6893 ; vol. 13 | Includes bibliographical references and index. | Contents: v. 1. Thematic perspectives—v. 2. Regional perspectives. | Summary: "Burial and Memorial explores funerary and commemorative archaeology, A.D. 284-650, across the late antique world, from Catalonia to Cappadocia. The first volume includes an overview of research, and papers exploring bioarchaeology, mortuary rituals, mausolea, and funerary landscapes. It considers the sacralisation of tombs, movements of relics, and the political significance of cemeteries. The fate of statue monuments is explored, as memorials for individuals. Authors also compare the spoliation or preservation of tombs to other buildings, and, finally, how the city itself, with its monuments, served as a place of collective memory, where meanings were long maintained. The second volume includes papers exploring all aspects of funerary archaeology, from scientific samples in graves, to grave goods and tomb robbing and a bibliographic essay. It brings into focus neglected regions not usually considered by funerary archaeologists in NW Europe, such as the Levant, where burial archaeology is rich in grave good, to Sicily and Sardinia, where post-mortem offerings and burial manipulations are well-attested. We also hear from excavations in Britain, from Canterbury and London, and see astonishing fruits from the application of science to graves recently excavated in Trier"—Provided by publisher.
Identifiers: LCCN 2023059384 (print) | LCCN 2023059385 (ebook) | ISBN 9789004687950 (v. 1 ; cloth) | ISBN 9789004687967 (v. 2 ; hardback) | ISBN 9789004688162 (hardback) | ISBN 9789004687981 (v. 1 ; ebook) | ISBN 9789004687974 (v. 2 ; ebook)
Subjects: LCSH: Funeral rites and ceremonies, Ancient. | Burial. | Excavations (Archaeology)
Classification: LCC GT3170 .B86 2024 (print) | LCC GT3170 (ebook) | DDC 393/.930936—dc23/eng/20240202
LC record available at https://lccn.loc.gov/2023059384
LC ebook record available at https://lccn.loc.gov/2023059385

Typeface for the Latin, Greek, and Cyrillic scripts: "Brill". See and download: brill.com/brill-typeface.

ISSN 1570-6893
ISBN 978-90-04-68795-0 (hardback, volume 1)
ISBN 978-90-04-68796-7 (hardback, volume 2)
ISBN 978-90-04-68816-2 (hardback, set)
ISBN 978-90-04-68798-1 (e-book, volume 1)
ISBN 978-90-04-68797-4 (e-book, volume 2)
DOI 10.1163/9789004687981

Copyright 2024 by Koninklijke Brill BV, Leiden, The Netherlands.
Koninklijke Brill BV incorporates the imprints Brill, Brill Nijhoff, Brill Schöningh, Brill Fink, Brill mentis, Brill Wageningen Academic, Vandenhoeck & Ruprecht, Böhlau and V&R unipress.
All rights reserved. No part of this publication may be reproduced, translated, stored in a retrieval system, or transmitted in any form or by any means, electronic, mechanical, photocopying, recording or otherwise, without prior written permission from the publisher. Requests for re-use and/or translations must be addressed to Koninklijke Brill BV via brill.com or copyright.com.

This book is printed on acid-free paper and produced in a sustainable manner.

Contents

VOLUME 1

Acknowledgements XI
List of Contributors XII

Burial and Memorial in Late Antiquity: Perspectives and Opportunities 1
 Luke Lavan

Bioarchaeology

Recent Bioarchaeological Research on Early Medieval Cemeteries in Italy 23
 Alexandra Chavarría Arnau, Leonardo Lamanna and Maurizio Marinato

Treatment of the Body

"To Make the Unseen Seen": Organic Residue Analysis of Late Roman Grave Deposits 43
 Rhea C. Brettell, Eline M. J. Schotsmans, William H. C. Martin, Ben Stern and Carl P. Heron

The Colour of Death: Colour Symbolism and Burial in Roman Britain 67
 Chloe Clark

Funeral Processions in Late Antiquity 84
 Luke Lavan

Mausolea

Late Roman 'Mausolea' in Hispania 97
 José Miguel Noguera Celdrán and Javier Arce

Mausolea in North-West Europe: the Transition from the Roman to Late Antique Periods 119
 Christopher J. Sparey-Green

Late Roman Mausolea in Pannonia 146
 Zsolt Magyar

Mausolea in Late Antique Italy 169
 Mark J. Johnson

Changing Funerary Landscapes in Late Antiquity: Mausolea in North Africa 183
 Julia Nikolaus

Funerary Landscapes

Funerary Landscapes in Catalonia (3rd–6th c. AD) 203
 Judit Ciurana Prast

The Late Antique Funerary Landscape of Rome: 3rd to 4th c. AD 222
 Barbara E. Borg

Burying the Saints Next to the Common Dead: the Burial Habits of the Christian Elite in the 4th c. and the First Translations of Relics 248
 Efthymios Rizos

Topography and Ideology: Contested Episcopal Elections and Suburban Cemeteries in Late Antique Rome 265
 Samuel Cohen

Other Memorials: Statue Monuments

The Archaeology of Late Antique Statue Monuments 287
 Luke Lavan

The Many Lives of the Statue Bases of Lepcis Magna 325
 Francesca Bigi and Ignazio Tantillo

Tombs and Spolia in City Walls

Memorial and Oblivion in Late Antiquity: the Testimony of *Spolia* in City Walls 383
 Luke Lavan

The Destruction, Preservation, and Adaptive Reuse of Funerary Monuments within Urban Fortifications in Late Antiquity: the West 394
 Douglas Underwood

The Destruction, Preservation, and Adaptive Reuse of Funerary Monuments in Urban Fortifications in Late Antiquity: the East 411
 Nick Mishkovsky

Spolia in Late Antique City Walls: Catalogue 1: Africa and the East 427
 Luke Lavan

Spolia in Late Antique City Walls: Catalogue 2: The West 459
 Douglas Underwood and Luke Lavan

Spolia and Civic Memory

Urban Landscapes from Architectural Reuse: Spolia, Chronology and Civic Memory in Late Antique Ephesus 485
 Luke Lavan

Abstracts in French 534

VOLUME 2

Acknowledgements XI
Contributors XII

Burial in Late Antiquity: a Bibliographic Essay
Part 1: Thematic and Regional Studies 539
 Solinda Kamani and Luke Lavan

Burial in Late Antiquity: A Bibliographic Essay
Part 2: Key Sites 564
 Solinda Kamani

Regional Perspectives

Aspects of Late Roman Burial Practice in Southern Britain 597
 Paul Booth

Burial in Late Antiquity: Evidence from Londinium 630
 Victoria Ridgeway and Sadie Watson

New Cemetery Evidence from Late Roman Canterbury:
the Former Hallet's Garage Site in Context 647
 Elizabeth Duffy, Adrian Gollop and Jake Weekes

Levis aesto terra – Early Christian Elite Burials from St. Maximin, Trier (Germany) 667
 Nicole Reifarth, Hiltrud Merten, Wolf-Rüdiger Teegen, Jens Amendt,
 Ina Vanden Berghe, Carl Heron, Julian Wiethold, Ursula Drewello,
 Rainer Drewello and Lukas Clemens

Funerary Patterns in Late Roman Cities (3rd to 7th c.):
Reviewing Archaeological Data in Northern Italy 692
 Alexandra Chavarría Arnau

Funerary Practices in Late Antique Sardinia: Overview and Potential 705
 Mauro Puddu

Burial Rites in Byzantine Sicily – New Approaches and Discoveries 727
 Valentina Caminneci, Maria-Serena Rizzo and Martin Carver

Late Roman Burials in Slovenia 752
 Kaja Stemberger

Death at the Edge of Empire: Burial Practices in the Province of Scythia
(4th–7th c. AD) 764
 Ciprian Crețu and Andrei D. Soficaru

Burial and Society in the Greek World during Late Antiquity 779
 Joseph L. Rife

From Necropoleis to Koimētēria: Burial Practices in Late Antique (late 3rd–7th c. AD) Sagalassos, South-West Turkey 811
 Sam Cleymans and Peter Talloen

The Archaeology of Late Antique Mortuary Practices in the Near East 832
 Ádám Bollók

The Archaeology of Death, Burial and Commemoration in Late Antique Egypt 856
 Elisabeth R. O'Connell

Abstracts in French 891
Indices 894

Acknowledgements

The conference which inspired this volume met at Birkbeck College, London in March 2018, under the title "Burial and Memorial in Late Antiquity". The conference was convened by Luke Lavan, Rebecca Darley, and Tim Penn, assisted by Michael Mulryan. It would not have been possible without the collaboration at Birkbeck provided by Rebecca Darley. Financial support came from the School of European Culture and Languages (University of Kent), the Virtual Centre for Late Antiquity, Birkbeck, and Museum Selection. Our thanks also go out to the many people with whom we have discussed different aspects of this project for their advice and encouragement, and to the referees who read the articles contained here and offered many helpful comments. Finally, we are grateful to Dirk Bakker and Marcella Mulder at Brill for their help in overseeing the submission and page-setting of this book. We must apologise to all involved in the book, for delays in the editing, which Peter Crawford did much to minimise, caused by COVID and changes in editing personnel. This has been a frustrating experience for our authors. However, we believe the quality of papers in the volume to be high and range to be good, for what is the first overview of burial and memorial in Late Antiquity to cover a wide range of regions across the Mediterranean. It is to be hoped that the book will not only serve specialists but also bring a rich area of archaeology to the attention of mainstream late antique historians, who might better appreciate phenomena such as the cult of relics from studying mid to late antique funerary practices more widely.

Luke Lavan

List of Contributors

Javier Arce
is an Emeritus Professor of Roman Archaeology at the University of Lille (France). He is currently working on a book on Constantius II.

Francesca Bigi
Ph.D. (2008), works for the Sovrintendenza Capitolina ai Beni Culturali. She is currently responsible for the architectural decoration of the former Antiquarium del Celio collection and of the Mausoleum of Augustus.

Barbara Borg
holds the Chair in Classical Archaeology at the Scuola Normale Superiore in Pisa. She has published widely on Roman funerary culture and is PI of the ERC-funded project The INscribed City: Urban Structures and Interaction in Imperial ROME (101054143 IN-ROME)

Rhea Brettell
has a Ph.D. (2016) in Archaeological Sciences. Her specialism is the use of instrumental methods, primarily organic residue analysis, to enhance our understanding of past mortuary practices.

Alexandra Chavarría Arnau
is Full Professor of Medieval Archaeology at the University of Padua (Italy) has developed research and published in different subjects related to the period between the end of the Roman World and the Late Middle Ages such as rural settlement, cemeteries and churches.

Judit Ciurana Prast
Ph.D. (2011), works as a professional archaeologist in southern Catalonia. She has been involved in various projects conducting field surveys and post-excavation analysis.

Chloe Clark
is a Ph.D. student at King's College London. Her research focuses on the role and experience of colour in ancient death and burial.

Sam Cohen
is an Associate Professor at Sonoma State University, with research interests in the evolution of the concept of heresy, the bishops of Rome, sacred topography, polemic and rhetoric, migration, as well as the place of minority and non-conforming peoples in late antique Christian society.

Carl Heron
is Director of Scientific Research at the British Museum. Prior to this he was Professor of Archaeological Sciences at the University of Bradford with interests in molecular and isotopic investigation of archaeological materials.

Mark Johnson
Ph.D. (1986), is Professor Emeritus at Brigham Young University in Provo, Utah. His most recent books are *San Vitale in Ravenna and Octagonal Churches in Late Antiquity* and a study connected with his late wife's ancestors, *The Patriots of Penne in the Nineteenth Century*.

Leonardo Lamanna
Ph.D. (2018), is an archaeologist specialized in the study of ancient human remains. He is currently employed as an Archaeological officer at the Soprintendenza of Mantua (Ministry of Culture – Italy).

Luke Lavan
Ph.D. (2001), is a Lecturer in Archaeology at the University of Kent. He is the series editor of *Late Antique Archaeology*, has directed excavation and survey at Ostia, and author of *Public Space in the Late Antique City* (2020).

Zsolt Magyar
is an independent researcher. He has published papers on late antique mausolea, imperial cult, Roman Sopianae (Pécs, Hungary), and the archaeology of Hungary.

Maurizio Marinato
is a Postdoctoral Fellow at the University of Padua, where he obtained his Ph.D. (Doctor Europaeus). His scientific interests include medieval archaeology and bioarchaeology, in particular the study of cemetery contexts.

William Martin
Ph.D. (2005), is an Associate Professor in Organic Chemistry at the University of Bradford. His interests are in the synthesis and mass spectrometry of small molecules of archaeological significance.

Nick Mishkovsky
is a professional collections manager in New York City, with research interests in late antique archaeology, and specifically on ancient *spolia*.

Julia Nikolaus
Ph.D. (2017), is a Senior Research Fellow at the Maritime Endangered Archaeology Project (MarEA) at Ulster University. Her research focuses on heritage management and protection in the MENA region, as well as funerary landscapes of North Africa.

José Miguel Noguera Celdrán
Ph.D. (1993), is a Professor in Archaeology at the University of Murcia. He is the series editor of Corpus Signorum Imperii Romani-Spain, director of Archivo Español de Arqueología, scientific director of the archaeological project of Molinete (Cartegena) and author of some books and papers on Late Antique funerary architecture in Hispania.

Efthymios Rizos
Ph.D. (2011) has been a Research Fellow at Koç University, the Netherlands Institute in Turkey and the *Cult of Saints* research project at the University of Oxford, with research interests focusing on the late antique urbanism and cultural history of the Balkans, Greece and Anatolia.

Eline M. J. Schotsmans
Ph.D., is a Research Fellow at the University of Wollongong (Australia). Her research lies at the interface between archaeology, anthropology and forensic science with a focus on taphonomy, funerary treatment and preservation practices to provide insights in past social organisation. Eline edited *The Routledge Handbook of Archaeothanatology* (2022).

Christopher Sparey-Green
(BA, MCIfA) is an archaeologist and Honorary Research Fellow at University of Kent, excavator of the Late Antique Cemetery at Poundbury, Dorchester, Dorset.

Ben Stern
Ph.D. (1996), is a Lecturer in Archaeological Science at the University of Bradford. Research interests include organic residue analysis.

Ignazio Tantillo
is Professor of Roman History at the University of Naples "L'Orientale". He is the author of several studies on the late antique period, ranging from municipal to imperial court history.

Douglas Underwood
Ph.D. (2015), is an independent scholar. He researches the cities of the late antique west, focusing especially on public monuments and memory.

Burial and Memorial in Late Antiquity

Perspectives and Opportunities

Luke Lavan

Abstract

This article provides an overview of the archaeology of funerary and memorial customs in Late Antiquity, setting the work presented in this volume in a wider context. It points out the significance of the period's funerary archaeology beyond mortuary behaviour, considering its contribution to studies of social structure, cultural identity, demography, health, and dress. Of direct pertinence to the funerary process, are the composition of cemetery populations, in which the treatment of the newborn, or sometimes the unborn, is especially significant. There are also trends relating to 'deviant burial' practices. The changing nature of memorial structures, from stellae to mausolea is considered. Grave goods reveal a decline but with some special consideration of children and young adults, with meaningful gifts rather than status markers. Science now says much about burial ritual, from embalming to the flowers placed in graces. However, texts give us non-material aspects of funerary and memorial rites, from processions to charitable meals. The treatment of graves over time reveals some instances of protection, some of desacralisation, sometimes earlier or later than thought. Memorial as a burial priority seems to have been on the decline. Even so, monumental tombs were not always targeted in building works, sometimes preserved longer than one might expect. Late antique society also had other outlets for memorial than burial, some of which were collective, as well as individual.

Introduction

An overview of funerary practice in Late Antiquity has been a long time coming. There are now great numbers of cemetery reports, especially from North-West Europe. Nonetheless, a lack of synthesis, above a regional level, has made burial archaeology for the late antique period difficult to access for research or teaching. There are syntheses of what may be called Palaeochristian funerary archaeology (focusing on the East Mediterranean) or Early Medieval funerary archaeology (focusing on the 5th to 9th c. West), but nothing covers the cultural mainstream of the late antique world in a holistic manner. In this book, we try to address this by providing an overview, by region and theme, to put a reference tool into the hands of aspiring students of funerary practice. We have not entirely succeeded in making this work comprehensive, notably from the loss of some articles that were presented at the conference in the great disruption of the past few years under COVID 19. However, what we have is still a strong set of papers, by some 50 authors, which represents a step forward in orienting those seeking to access the discipline or those wishing to provide context for their finds. The book provides more than a collection of regional perspectives, though it does represent the work of scholars based in Western Europe, where, as Brettell's figures for graves with molecular data show, the weight of scholarly attention on burial archaeology has been focused.[1]

The papers also spread beyond the study of burial, strictly speaking, to encompass the related, if more abstract, topic of memorial. This might seem odd to those working on cemeteries without standing monuments, where, so often, ploughing or machine-stripping has removed cemetery occupation levels above graves. But in many parts of the Mediterranean, Roman cemetery architecture is highly prominent and focused on the perpetuation and celebration of memory. My wish to understand this role of cemeteries, within wider schemes of memorial, has led to the latter topic's inclusion within the volume. In book 4 of his *Meditations*, Marcus Aurelius thought it essential to underline the vanity of wishing to be remembered for family status or great deeds, an aim treasured by so many of his contemporaries: not only would they soon be forgotten on death but those who could have remembered them would fast be forgotten too. Now, 1,800 years later, we have for the Roman world a story of funerary rites and monuments based on material traces. It is a story that Marcus might have used to illustrate his argument. This might have worked, if its description of loss, parting, commemoration, and oblivion were not so engaging to one, like he was, with a sense for human feelings. Today, we can offer an increasingly detailed account not only of how Roman funerary customs were practiced but also of how memorials fared in the centuries that followed, across the 3rd to 7th c.

1 Burial excavation focused on western Europe: Brettell *et al.* in this volume.

The decision to include the theme of memorial in this volume also comes from another impulse: that we should, as archaeologists, always consider the full 'life' of a burial, a funerary stele, a statue monument (a good number of which are funerary), or a memorial building. A burial obviously took place at a single point in time, a moment of great significance for those involved. Yet, it cannot be denied that funerary remains, markers, and monuments were often intended to have an impact long after this. To study burials as single events is also to neglect the compelling archaeology of commemoration, now coming to light in the cemeteries of Roman cities, just as we can now trace the kinds of disuse and abandonment familiar to us in 19th-c. cemeteries of London and elsewhere. All of these considerations can be true of other monuments, by which individuals and communities were commemorated, notably honorific statues. These too had a history beyond the point of commemoration, before they finished up incorporated into late fortification walls or reused to honour someone else. It is reasonable that we study the later history of statues or civic monuments, to contribute to such themes and so provide a source of comparative arguments with which to gauge our judgements when we assess the memorial lives of tombs.

Significance: Funerary Studies and Beyond

Whilst this volume will be of interest primarily to scholars of the mortuary process, its significance extends far beyond the domain of funerary studies, informing us on a host of other, quite different, themes. This is not surprising, as funerary archaeology commonly represents a deliberately buried assemblage of high quality that occurs in great quantity. It gives us a refreshing change from excavating Roman fill layers from buildings that were so often swept in antiquity, removing surface finds. It will not take any scholar long, when flicking through the pages of this book, to see that there is much that informs one about dress, diet, and health in Late Antiquity. There are also a wide variety of insights into social life becoming available, especially from recently dug western graves. The latter topic has long been an unfulfilled ambition for scholars of funerary archaeology, who have argued over the significance of alignments, spatial associations, or similarities and differences between grave goods. But new information is coming out from both bioarchaeology and environmental sampling, as well as simply from better understanding cemeteries in their wider local context, thanks to careful excavation. Perhaps the most impressive social insights come from London, where varied levels of fish consumption can be studied from analysis of nitrogen isotopes, down to the poorest parts of the population, as noted by Watson.[2]

Understanding the relationship between funerary display and social structure is another by-product of investigating burial evidence. It has been complicated by recent cemetery excavations: in Italy, Borg observes that members of the senatorial class were buried under church floors and in catacombs from the 4th c., not only in mausolea, suggesting there was not always a direct relationship between status and burial.[3] Chavarría and her colleagues note that isotopic analyses and dental traits suggest different population groups in Italy with matrilocal or patrilocal marriage customs, the latter involving women brought over great distances, perhaps by raiding, by a cohesive group of males.[4] The same paper notes that at San Giusto in Apulia clear differences in diet and health are visible in skeletons found in different parts of the same church, whereas at Brescia people in very poor health, who have been interpreted as servants, were buried in buildings reused for craft purposes.[5] Thus, it does seem possible to track the social status of different people according to diet variations suggested by osteology of bone found in graves. Chavarría points to more men than women and children in some Italian cemeteries, especially around certain churches. Notably taller men are linked to incoming groups.[6] Questions of cultural identity have long interested scholars of Germanic and 'Slavic' burials, but today we are able to understand social as well as cultural differences from within late antique populations in the Mediterranean.[7]

It is now possible to envisage the study of aspects of demography from the analysis of burial evidence, thanks to the recovery and scientific analysis of DNA, trace elements, and osteological data. Such a demographic reading of funerary data is not straightforward in many periods due to selection in burial: children may not end up in cemeteries, for a variety of reasons. However, in Late Antiquity, perhaps under the influence of Christianity, we see an increasing presence of children and neonates, suggesting that this bias is perhaps fading or no longer

2 Diet and burials, England: Ridgeway and Watson in this volume, 639–39.
3 Social status and burials, Italy: Borg in this volume, 242.
4 Ethnic group and burials, Italy: Chavarría *et al.* in this volume, 33–36.
5 Social structure and burials, Italy: Chavarría *et al.* in this volume, 28–29.
6 Gender status in burials around churches, Italy: Chavarría *et al.* in this volume, 29.
7 Cultural identity and burials: Swift (2006) 97–112; Rife this volume.

such a distorting factor when reading off demographic information. The rise of inhumation over cremation also undoubtedly makes this an easier task. Perhaps the most celebrated results of the application of scientific techniques concern the study of origins – the connection of individuals believed to be non-native to the regions in which they were buried – which has become possible from combining osteology and the study of isotopes. British evidence shows incomers from elsewhere within the empire, not simply Germanic immigration, as noted by Booth. Studies of mDNA plus the above techniques give African and Asian origins to some Londoners, detailed by Ridgeway and Watson. This can be complemented by inscriptions from Trier which reveal origins in North Africa and Free Germany, for individuals buried there, as noted by Reifarth and her colleagues. In Italy, the identification of textually attested Avar and Slavic groups has been made, in the first case, at Campobasso, from cranial features and on the second case, at Udine, from burial practices (use of fire), the latter also showing a more meat rich diet for the same group, in comparison to others in the cemetery.

Health is an obvious subject to explore from osteology, with Chavarría pointing to a decline for the period in Italy, highlighted by comparative studies between three cemeteries, marked by excessive intake of carbohydrates, poor nutrition, and poor hygiene.[8] Booth documents a potential reduction in stature in Dorset, although it is difficult to be sure if this relates to stunting of the earlier population or to some population replacement. It will of course be interesting to see if improvements in health can be attested in more prosperous parts of the late empire. In South-East Europe during Late Antiquity, the published evidence points to a stable health profile as a general pattern, with signs of physical resilience, an active lifestyle, and a nutritious diet particularly among rural residents, in contrast to their urban counterparts.[9] Britain has also produced good data for children's health between city and country, with distinctive diseases for both areas.[10] At Canterbury, Duffy *et al.* have been able to document the use of crutches and also weapon injuries.[11] Osteology and isotopes reveal a more varied diet in cities than in rural settings in Britain (Booth), with greater consumption of fish in urban locations. Such studies are perhaps most advanced due to the very great number of cemeteries that have been dug,

in comparison to other regions, of which only Germany and France come close.[12] Other non-funerary subjects which funerary data can contribute to include dress, as demonstrated so richly for Egypt by O'Connell, whilst hairstyles are particularly well-documented in Trier.[13] Then, funerary inscriptions from graves in Greece, as well as from Cilicia, give us quantitative data on the range of professions one might find in the period, far more varied than those suggested by urban excavations.[14] Finally, Chavarría and co-authors point to the use of human bone as a source for studies of warfare: the cemetery in Campobasso shows injuries characteristic of specifically Byzantine or Avar weapons.[15]

Absences: Intentional and Unintentional

In the planning of the conferences that led to this book, a decision was taken to exclude 'Germanic burials' and to focus on those from the late 3rd to early 7th c. which can be considered to be of Roman Mediterranean tradition. Yet, this is now a controversial distinction to make in the UK. Although there is a clear regional distinction between burials, with those showing grave goods primarily found in the south and east of Britain and those without found primarily in the West, their interpretation is controversial. Few scholars would now directly link cemetery practice to biologically distinct groups or categoric religious differences, but rather to cultural practices, some of which had their origins within Roman Britain or were developed here rather than in Germany.[16] Nonetheless, the differences between West and East do lend themselves to hypotheses which link the nature of cemeteries to changes in population or political hegemony relating to Germanic incomers, revealed for example by placenames also found on the German coasts.[17] The recovery of aDNA from such cemeteries looks to be capable of resolving at least some of these questions, with a substantial genetic input from the continent now being supported, if with degrees

8 Health and burials, Italy: Chavarría *et al.* in this volume, 26–28.
9 Britain: Booth this vol. 613. SE Europe: Rife 2012.
10 Child health between country and city: Booth in this volume, 614.
11 Assistive technology, Britain: Duffy *et al.* in this volume, 357.
12 Differences in diet between rural and urban areas, Britain: Booth in this volume, 614.
13 Dress and burials, Egypt: O'Connell in this volume; Hairstyle, Trier: Reifarth *et al.* in this volume, 679.
14 Professions indicated on tombstones, Greece: Rife in this volume, 787, 799. Cilicia: Trombley (1987).
15 Osteological evidence of warfare, Italy: Chavarría *et al.* in this volume, 36.
16 Debate on distinctive burials in Britain and Germanisation, a selection of works: Petts (2004); Quensel-von Kalbern (2000); Lucy and Reynolds (2002); Williams (2004).
17 Placenames as markers of incomers: Hines (1994).

of mixing with the British population.[18] It should be noted that the well-furnished burials of South-East England often attracted the attention of museums and other archaeological organisations, in part for their well-preserved artefacts. They are well-studied and support a scholarly community that has little to do with the late antique Mediterranean and is mainly focused on North-West/Northern Europe. Thus, they are not included here.

Admittedly, the exclusion of 'Germanic' burials is less reasonable away from northern frontier regions, where the incoming Germanic population was only a small minority, and where the cultural traits of the host population were more speedily adopted by them. This was perhaps in part because the economic and social collapse experienced in Britain in the 5th c. was not seen to the same extent elsewhere. Thus, in Gaul, Italy, or Spain, it is not unreasonable to include Germanic graves mixed within a wider late antique landscape, and we have not prevented this as a rule. For this volume, we can at least note that Frankish graves at Trier also yield much richer grave goods than their late antique counterparts, with precious dress ornaments being recovered.[19] Other lacunae include extended study of funerary inscriptions, on which a paper was commissioned, or sarcophagi, devotions to relics, or stories of the undead, though Rife in this volume briefly addresses epitaphs, sarcophagi, and relics in Late Antique Greece. Nonetheless, the pertinence of burial traditions described in this book to the cult of saints and their relics is very strong.

Unintentional absences are perhaps more significant. There is no paper describing the traumas of mass graves or of no grave, although mass graves have been identified at Scupi and Ibida in the Balkans (the result of occupants experiencing violent deaths, in the later 3rd and 4th c.).[20] There are a few sites included within this book which might represent such events: at Corinth, it has been argued that the cemetery at Lerna Hollow represents a plague pit. There was worse of course: we can remember the decapitated bodies thrown down a well in a signal station at Huntcliffe, in North-East England, or the body folded into a hole amid garbage at Isthmia, in Greece, or the dog-gnawed skeletons of Dichin, in Bulgaria.[21] Such awful interments are important to burial archaeology as they mark the absence of ritual and care, sometimes testifying to attitudes to the body in instances of mutilation, either before or after death. A paper drawing together mass grave evidence has been written by McCormick recently, but it is not a subject covered within this volume.[22]

Similarly, we have no discussion of the 6th c. deposit in Ascalon, of the remains of 97 infants of less than three days old, in a sewer under a bath building. These were the result of infanticide, which here claimed three times as many boys as it did girls, perhaps because the latter were kept to be raised as prostitutes, in what may have been a brothel on the site. This discovery, so far unparalleled for the period, suggests that the disposal of unwanted children remained part of a continuing sex trade, at least in some places. It provides a counterpoint to the late antique cemeteries for neonates in Egypt, or for stillborn babies in Genoa, which seem easiest to relate to Christianisation, seen from the Roman tradition, although a neonate and stillborn cemetery of 2nd–3rd c. date is known from Auxerre.[23] However, the absence of skeletal and artefactual analysis from identifiably Jewish cemeteries blurs the distinctiveness of Christian practices relative to Jewish traditions. As in architecture, it is likely that both groups influenced each other.

Further unintentional gaps include the study of sarcophagi, on which we could not commission a paper, although traces of lead or wooden coffins are included in discussions of the north-west provinces. This perhaps comes from the book giving limited space to high status burial habits in Rome or some eastern cities. Such sarcophagi are often the one bit of burial archaeology to feature in the illustrations of general works on Late Antiquity, but here we rest the topic. For some regions, we have little knowledge of rural cemeteries, which though considered in this volume for Catalonia and Britain are not documented in all parts. We also have quite uneven sources on some elements of funeral ritual, meaning that some regions are mute on aspects that almost certainly existed, but which the evidence does not yet support. The papers in this book show us that the full process of preparing, mourning, and burying the deceased went through many more processes than can be restructured by most cemetery excavations in Britain or North-West Europe. What survives to be excavated also does not necessarily represent the elements of most importance to the late antique population, which might

18 aDNA and British cemetery evidence, e.g.: Gretzinger, Sayer, Justeau *et al.* (2022).
19 Trier, Frankish graves: Reifarth *et al.* this volume, 686–87.
20 Mass grave, Scupi: https://haemus.org.mk/exhibition-mass-grave-burial-from-scupi-the-dark-side-of-archaeology/ (last accessed March 2023). Ibida: Cretu *et al.* this volume 772.
21 Plague pit?, Corinth (Lerna Hollow): Rife, this volume 796. Battle skeletons, Huntcliffe, well: Craster, Hill, MacDonald, Keith, and Marshall (1912); Isthmia: Rife (2012); Dichin: Johnstone (2019).
22 Mass graves: McCormick (2016).
23 Infanticide deposit, Ascalon: Smith and Kahlia (1991) with Rose (1997). Neonate cemetery, Egypt: n. 29 below. Stillborns cemetery, Genoa: n. 43 below. Auxerre: Inrap (2024).

have expressed itself in other ways: in the funeral procession, the customary distribution of food to the poor, and perhaps in cemetery visits and meals. Some regions do provide us with a great number of insights into funerary processes outside the grave, but others are more restricted at present. The excavations at St. Maximin in Trier perhaps represent the most advanced results seen in this book, with high quality data permitting many elements of funerary customs to be reconstructed, suggesting paths to the future of research for superficially poorer sites.

A final theme that has not generated the slightest comment in a footnote in this collection is the ethical treatment of human remains. Whilst this is a very hot topic in much of archaeology, and the excavation of Islamic or Jewish graves garners controversy, these debates have not penetrated into the printed concerns of those excavating and studying them in late antique archaeology. Yet, I doubt they are very far away from their minds, considering the prominence of such issues in other cultural settings studied in archaeology. We are now familiar with neo-pagans in the UK taking an interest in prehistoric burial sites. I have myself been on a dig where rare Iron Age burials were stolen mid-excavation, perhaps by someone ethically opposed to their removal. Archaeologists analysing DNA from late antique sites have also been known to interest site workers from surrounding communities by claiming that the bones of the people they excavate are indeed their genetic forebears.[24] Finally, it does happen that intelligent lay visitors to digs, from outside of our profession, voice reservations about the disturbing of the dead, whilst also appreciating our rationales, say of adding to anthropological knowledge of disease. Should we not be able to set their concerns into the mix of attitudes that govern a research project? Can we prepare, within our replanning, for potential reburial?

Given the experience that archaeologists increasingly have in handling these issues, should we not begin to address them in late antique contexts? It is commonly held that the desacralizing of the dead is an inevitable part of the objectivity of the scientific process. Taken to extremes some might view the undertaking of a cemetery excavation as the advance of progress, chasing away the obscurantist ideas of an ignorant past. This position tends to involve forgetting that the investigators themselves have feelings about the treatment of their own dead. Alternatively, it can be argued that we should only be concerned with respect for human graves when there are living relatives or communities with a historic affiliation with a site. One might be encouraged in these views by the later medieval treatment of human bones, stored in charnel houses or displayed in decorative arrangements within churches. After the First World War, which produced remains not unlike those of the 40 martyrs of Sebaste, even Christians began to accept attitudes to human bones that their theologians had developed for some time, in which the Resurrection was possible no matter what the fate of a human body. So, what is the problem? Why might we need to consider the ethical treatment of human remains within late antique studies?

It is worth remembering that, for most late antique people, of whatever confession, the disruption and disinterment of mortal remains was something shocking, dishonourable, and dangerous, threatening the passage of a soul after death. This was, of course, not new. Even the cremated remains of earlier centuries of Antiquity had to be properly interred and the rite of burning the body was no obstacle to the construction of a tomb. The refusal of proper burial was something that was reserved for declared public enemies or very serious criminals. Even some 3rd c. emperors, killed by their own troops, got a tomb, as in the case of Severus Alexander.[25] Solidarity with the wishes of the dead was visible in respect for cemetery monuments, in legislation and in practice, even when monuments were to be incorporated into fortifications, an attitude being maintained in Italy as late as the 8th c.[26] This was not universal, although variations in cemetery preservation do not easily correspond with changes in belief, in terms of their date. The wholesale despoiling of the older dead by tomb robbery, in the few cases where we can date it, looks likely to be the result of regulatory change, the end of the boule at Sagalassos, as much as Christianisation.[27] Even some 7th c. Christian texts suggest that pagan remains should rather be left well alone.[28]

24 Sagalassos, claiming DNA from bones excavated by site workers match their genetic forebears: https://www.hurriyet.com.tr/gundem/kaza-kaza-3-bin-yillik-akrabalarini-buldular-39088700 (last accessed March 2023).

25 Severus Alexander, Cenotaph in Gaul and Tomb in Rome, after killed by soldiers: SHA *Sev. Alex.* 63. Gordian III, Tomb at Circesium in Mesopotamia: Amm. Marc. 23.5.7; Cenotaph only, with ashes returned to Rome, for Eutr. 9.2.3.

26 Legislation protecting cemetery monuments: Underwood in this volume 399–400 (section on legal texts) and with 394 (on a poem on the destruction of Aquileia). Tombs visitable at Palmyra after incorporation into city wall: Juchniewicz, As'ad and al Hariri (2010) 56–58.

27 Tomb robbery as result of regulatory change, perhaps at Sagalassos, where looting of end of 5th c. to end of 6th c., corresponds with the replacement of the boule by the notables: Cleymans and Talloen, in this volume, 823.

28 Christian texts of early 7th c. on non-violation of pagan remains: *V. Theod. Syc.* 116.

Whilst we do not have to share either background cultural habits nor foreground ethical beliefs with people from Late Antiquity, it is true to say that the level of detail now coming out of funerary archaeology, from Britain, to Trier, to Egypt, is sometimes so large that a great degree of sympathy can be experienced by the scholar investigating the remains and the story of a person deceased. We have gone beyond calculating statistics on ages at death or constructing typologies of belt buckles, to learning of the flowers placed in graves, the care taken to wrap children, and the sentimental rather than status-driven objects deposited with the deceased. Archaeologists now record the traces of those left behind as they held meals around a grave and passed a moment together to remember a departed family member or friend. All this constitutes a personal story, one which is centred around the wishes of the deceased or their family to be laid in the earth in a particular manner. Whilst science helps tell this story, does it need more than a brief window, before bones are returned to or near the place where they were laid? Perhaps an infant laid amongst their family, awaiting the Resurrection, buried by a favoured church, ultimately belongs back there, rather than in a museum store. We can have time to look at them, and we might retain a laser scan of bones, but do we need to take ownership? For this most personal of objects, the human body, we can surely afford a place for subjectivity, the very quality which makes a story in the first place, for lives so richly read from graves.

Methods

One might expect a volume like this to provide something of a showcase of contemporary method, especially given that it includes some of the finest and best-funded practitioners in the field. This is true up to a point but it is not a full or consciously planned collection of technical papers. We have lost some science: as a stimulating paper on the application of scientific techniques and osteology at Rome by Flavio de Angelis and Andrea Battistini was sadly not submitted, and an exceptional contribution by Thibaut Devièse on colourants and dyes had to be published elsewhere. Nonetheless, we have an exposition on evidential traces for burial's different practices presented by Duffy, Gollop, and Weekes from Canterbury, and an inspiring account of the application of science in recording from St. Maximin in Trier by Reifarth and her team.[29] What is especially fruitful is the comparison of the results there to what is found in Egypt, where better preserved evidence serves to confirm and extend impressions from Germany, reminding us that the late antique world was a cultural commonwealth, as much as it was a collection of localities. This confrontation of different regions, on a methodological level, is perhaps one of the most engaging aspects of the book. Britain has a highly developed burial archaeology for Late Antiquity, from which is possible to produce statistics, whereas Bollók in the Near East has produced a statistical method for dealing with graves that have been robbed.[30] From Britain, we can see variations in diet and health that are well-studied, with a fine understanding of the nature of grave goods and the presence of coffins. These interests extend to other parts of the late antique world, but it is rarely true that one regional paper does not suggest research to be done in another region.

Sometimes, we see common problems expressed but with few solutions. The incomplete or absent publication of discovered remains is a challenge that is patent but hard to assess, perhaps more so in the East than in other regions of the Late Antique world. Struggles over the dating of unfurnished or little furnished burials represent an obstacle to our chronologies across many regions, from Britain to Slovenia. Radiocarbon dates are few and far between, even in North-West Europe. We sometimes see judgments on ethnicity from material culture made in one region that remind us of older academic practice from another, though the circumstances suggest hypotheses that cannot easily be discarded until DNA and osteology provide further clues. On other occasions, scholars are hesitant to recognise Christianisation based on fewer grave goods or alignment, as in Britain, whereas in Spain, Italy, and Greece, they are not: here, the coincidence of several factors in cemetery topography, in association with epigraphic evidence makes the identification of confessional cemeteries, of Christians and others, incontrovertible. In Mediterranean regions, variation in interpretation is not trans-regional but rather a disagreement between those working on texts and those working on inscriptions. The archaeologists in this volume are not able to share the views of Rebillard, which he has so fully argued, that burial was not a concern of the Church nor carried out with church involvement in an organised manner in the 4th to 5th c. The physical evidence does not seem to exclude this, despite the value evident in Rebillard's nuanced critique of funerary inscriptions and certain literary sources.[31]

29 Recording method for excavating burials, Canterbury: Duffy *et al.* in this volume, table 4; Application of science in recording, Trier: Reifarth *et al.* in this volume.

30 Statistical method for robbed graves, Near East: Bollók in this volume.

31 Involvement of church in burial: Rebillard (2003).

Themes

Burial Populations

The rise in visibility in cemeteries of children and of neonates, is a common theme recognised across many regions, reflecting either positive Christianisation of attitudes to children or a decline in a culturally particular Roman practice of disposing living neonates or infant corpses via rubbish tips or via non-conventional burial locations. This is seen in Britain at Poundbury, where neonates and stillbirths were being buried. Here, even an unborn child removed via embryotomy was buried in regular coffin in a proper grave in one infant/child group.[32] A high number of children have also been recognised in recently dug Canterbury cemeteries (Duffy, Gollop, and Weekes). At Trier, St. Maximin, newborns and children are well-represented in terms of the wider cemetery population. However, neonates and infants under 12 months were still somewhat under-represented in graves and inscriptions. In Africa, at Sufetula an infant of only a few months old was commemorated by a grave slab within a church, and older children were commemorated in church graves, on the same level as adults, in their inscriptions.[33] In Italy, a stillborn cemetery of Genova, is a testimony to changes in habits, though burials beneath and around houses also increase in Late Antiquity.[34] In Asia Minor, the graves of Sagalassos show us children reappearing in the Late Roman period after a mid-Roman absence. This dignified funerary treatment of children is picked up in Egypt, for example in a cemetery where 93% of burials are of children and newborns. There is even a hypogeum devoted to children at Alexandria.[35] These are important changes which we can easily take for granted, to the extent that scholars of later periods seek to study the marginality of unbaptised infants in Christian interments, rather than their burial at all.

Yet, this development was not universal: in Greece, there are still some rare examples of unwanted newborns found in irregular non-grave contexts. Furthermore, in this region, whether on Crete or at Corinth, Isthmia, and Athens, there are some bodies thrown into wells or bogs, bodies with mutilated limbs, and bodies stuffed into pits next to animal carcasses.[36] These examples of the denial of funerary rite should not be mixed up with deviant burials, notably decapitation burials, which, though odd, represent a specific rite, in many cases involving the removal of the head after death rather than at death. In Sardinia, some skulls were removed from the spine after less than a year, to be laid over other bodies.[37] In Britain, decapitation burials are increasingly common, mentioned in this volume at Lincoln, Ilchester, Godmanchester, Winchester, Horcott, and Canterbury, though their incidence does not seem to correlate with any difference in grave goods. In this region, decapitation burials tend to be Late Roman and occur within cemeteries. Prone burial, where the body is buried face down, is another exceptional rite, which perhaps might be associated with some kind of conscious *damnatio*. It is found outside of cemeteries, but is known from earlier periods too.[38] Nonetheless, there may be other groups brought into cemeteries or brought into specific types of cemeteries which archaeology cannot trace: legal and epigraphic sources tell us the provision of free funerals for the poor during the 6th c. in Ephesus and Constantinople, probably also practiced elsewhere.[39] One might also ask how successful this initiative was, given that funerary rites continued to be an occasion for social display, in which church acolytes, even when provided free, expected to be tipped, as I explore in my paper on funerary processions.[40] Quite how archaeologists track the social status of people with no possessions is a difficult question, though we can identify hospital cemeteries in Italy and Palestine, with the latter

32 Visible occurrence of neonates and stillbirths in cemeteries, England: Booth in this volume, 610–11. Further detail on Poundbury: C. Sparey-Green pers. comm. 2023.

33 Neonates under-represented in burials and inscriptions, Trier: Reifarth *et al.* in this volume, 679–60. Sufetula, infant commemorated in grave slabs within a church: Duval (1971) 436–37; inscribed slabs for children in another church: Duval (1956) 277–81 (nos. 1–5).

34 The 4th c. cemetery for stillborn, Genoa, Italy (via San Vincenzo), 1 newborn and 3 full-term foetuses: Maetzke (2003). Burials around and under houses: Vitale (2015) 198.

35 Children reappearing in late antique cemeteries, Sagalassos, Asia Minor: Cleymans and Talloen in this volume, 821. Hypogeum for children, Alexandria, Egypt: O'Connell in this volume, 876.

36 Unwanted newborns in non-grave contexts or bodies thrown into wells, Greece: Rife in this volume, 797.

37 Cranial detachment, laid over other bodies, Sardinia: Puddu in this volume, 720.

38 Decapitation burials, Britain: Booth in this volume, 600, 601; Duffy *et al.* in this volume, 650, 657. Decapitation and prone burials, Britain: see for example the chapter on "Death in the countryside: rural burial practices", in Smith, Allen, Brindle, Fulford, and Lodwick (2018). N. Italy: see for example, Quercia and Cazzulo (Oxford 2016) 28–42.

39 Free funerals: at Constantinople: *Just. Nov.* 59.5–6 (AD 537); at Ephesus, bishop Hypatius (PCBE 3.457–69 Hypatios 4 (AD 519–540/541)): IvE 7.4135 (funerals must be free) (Feissel (1999) 132 no. 28, found in the atrium of the church of St. Mary, dated by Foss to *ca.* 530–40).

40 Funerary rites as occasions for social display: see Lavan, this volume, on processions, with payments to acolytes on p. 8.

showing attempts to care for people with TB, leprosy, and facial disfigurements.[41]

Funerary Landscapes

Funerary landscapes are well-represented in this book. We see in many places a move to being buried close to the remains of saints, from ordinary to high status graves, or, conversely, the movement of saints to the places where high-status individuals were being buried, starting at the top of the secular social hierarchy. Regarding the movement of burials towards holy places, we hear, from Italy, that mausolea were increasingly built near churches, sometimes attached to them, as were those of Christian emperors, so losing their façades. By the 6th c., burial in this region was inside or around churches, with family and individual tombs previously attached to churches largely disappearing. Conversely, new intramural burial is not always linked to churches.[42] In Africa, there is a shift to burial in or near churches which seems to be already underway by the 4th c., though with spaces close to saints reserved for clergy until the mid-5th c. In Greece, the gravitational pull of monumental churches on elite urban burial is a well-documented phenomenon at Thessalian Thebes, Athens, and Corinth. A wider social range of burials crowded church floors at Philippi and Tigani.[43] On the movement of relics, this book contains a key paper by Rizos, presenting important evidence, especially from Asia Minor and Constantinople, of the transfer of relics to adorn the tombs of secular magnates, perhaps following the example of Constantine. For the West, Sparey-Green recalls a bishop of Lyon, who died in Egypt as a monk near the end of the 4th c., but whose body was brought back home to be buried in the Gallic city.[44]

Of the types of funerary marker or building known, we have a good description of Early Imperial types by Sparey-Green for the West (stelae, altars, barrows, temple-tombs, towers, hypogea, and apsidal structures) but not for the East, which saw the use of stelae, cippi, altars, arcosolia, temple tombs, columns, and statues.[45]

Tombstones are rare in Slovenia, as they are in lowland Britain, for Late Antiquity.[46] In Italy, the hey-day of the mausoleum seems to be the 4th c. From the 5th c. onwards, they are, however, rare. Mausolea are already becoming rare in Africa in the 4th c., and above-ground visible tomb monuments cease from the 2nd c. AD in Asia Minor.[47] In other regions, such as Pannonia, mausolea appear especially from the 4th c., to the extent that they are associated with Christianisation. The association *ad sanctos* (i.e. close to the burials of saints) at Cibalae, and probably Savaria and Iovia, suggests this, as does their art, as in the Biblical themes on the walls of the hypogeum of the so-called 'Early Christian Mausoleum' and in burial chamber I in Sopianae. Furthermore, Sparey-Green notes that in North-West Europe no late style mausoleum is provably non-Christian. By this he does not reference those which existed prior to the mid-3rd c. In Italy, two examples of mausolea, out of only three known for the 6th c., are built for the burial of bishops: a small octagonal tomb on the north side of the church of San Lorenzo in Milan and a circular chamber on the south side of the sanctuary of the church of San Vitale in Ravenna.[48] In North-Central Algeria, mausolea have Chi-Rho monograms. Tripolitania provides the exception: temple mausolea at Ghirza bear visibly pagan images of sacrifice as well as martial and lordly images.[49]

The design of mausolea is worth remarking upon as representing a key part of the architectural endeavour of the first half of the late antique period, alongside palaces and *domus*, churches, and secular public monuments. In Italy, mausolea changed from two-storied to one-storied structures and from being dimly lit to having interiors flooded with light.[50] The line of Roman domed tomb structures finishes with the Mausoleum of Theoderic in Ravenna. Here, at least, we can see a royal statement that goes beyond any religious identity, from the 'Gothic' decoration of the rotunda, its monolithic capping, and the porphyry bath reused as a sarcophagus. This was a

41 Hospital cemetery, Italy: Chavarría Arnau, Lamanna, and Marinato, in this volume, 32. Hospital cemetery, 8th–9th c., working in late antique tradition, by River Jordan: Shamir (2005).

42 Mausolea built near or attached to churches, Italy: Borg in this volume. Intramural burial that is not linked to churches: Borg in this vol. 238; Chavarría Arnau in this volume, 698–99.

43 Shift to burial in or near churches, Africa: Nikolaus in this volume, 195–97. Greece: Rife in this volume, 793–94.

44 Movement of relics, the East (Asia Minor and Constantinople): Rizos in this volume. The West: Sparey-Green in this volume, 127.

45 Early Imperial funerary markers, the West: Sparey-Green in this volume, 121–26. The East: Balty (1993) introduction.

46 Scarcity of late antique tombstones, Slovenia: Stemberger in this volume, 756. S. Britain (all earlier than LA): Booth 612.

47 Decline of mausolea: from the 5th c., Italy: Johnson in this volume, 179; from the 4th c. in Africa: Nikolaus in this volume, 195–97. Cessation of above ground funerary structures from the 2nd c., Asia Minor: Cleymans and Talloen in this volume, 821.

48 Mausolea associated with Christianisation from the 4th c., Britain: Sparey-Green in this volume, 137, plus pers. comm. 2023; Pannonia: Magyar in this volume, 164. 6th c. bishops' mausolea, Italy: Johnson in this volume, 177, 179.

49 Mausolea with Christian symbols, north-central Algeria: Nikolaus 193. Mausolea with pagan iconography, Ghirza: Brogan and Smith (1984).

50 Shift to one-storied mausolea, Italy: Johnson in this volume, 180.

building that would have been compared by contemporaries to the imperial mausolea in the region, such as those of Maximian or Diocletian, not to a Christian fashion.[51] Some Italian mausolea undoubtedly looked back to the architectural excellence of the Pantheon, as a model, from the 2nd c. AD onwards, a century or two before it was adopted by Maxentius for his son. Tolentino even has a Christian domed rotunda mausoleum which was modelled explicitly on the Pantheon in Rome, as detailed in an inscription found here, noted by Johnson.[52] In this instance, the boundaries of taste drew on a widely shared culture which appreciated architectural exemplars and had its own tradition of form, with 'temple tombs' being a 4th c. favourite, from Pannonia to Ghirza.

The confessional nature of cemeteries has sometimes been a source of controversy. In Britain, archaeologists find it hard to identify a burial or a cemetery as Christian, based on its orientation, a situation paralleled in Slovenia, if one attempts to read Christian burials from artefacts. One can argue that this is due to the nature of the evidence: at Emona in Slovenia a cemetery surrounding a new *intra muros* church, produced only one distinctively Christian artefact: a round silver-alloy mirror depicting four crosses.[53] In Italy and Africa, Rebillard has insisted on the complex use of Christian identity in inscribed monuments within the funerary landscape, where burial was private, not a church matter. The art of the catacombs has also been shown to be overlapping in confessional terms, with Christians using older 'pagan' motifs and some symbols being shared.[54] However, archaeologists take a different view, at least outside of Britain, the late antique graves of which are largely anepigraphic (except in the far West). Chavarría emphasises the existence of confessional cemeteries at Rome, from the early 3rd c.; Borg notes the epigraphy of the capital in the late 3rd to 4th c., of both Christians and Jews, which suggests a parting of ways, as distinctive confessional epigraphy develops. More widely in Italy, some distinctively Christian and Jewish cemeteries can be identified from the 2nd and 3rd c. AD. At Tarraco, in Spain, distinctive and well-planned Christian cemeteries developed in 4th and 5th c., at some distance outside of city walls on a main road, forming a different habit to earlier cemeteries. In particular, the Francolí cemetery grew up around a martyr's burial, with Christianity attested in 22 funerary inscriptions of the mid-4th c. AD. In Sardinia, Puddu notes at Sulci a recognisably Jewish group of graves with menorahs and Hebrew names in the 5th–6th c., whereas in the East, the confident presence of Jewish groups in cemeteries has been articulated by Stern.[55]

Perhaps it is significant to note the difference between Mediterranean communities, in which Christianity was dominant but survived alongside other institutions, and parts of the West where there was no significant survival of any other Roman institution or identity. In the latter regions, the Church often became the community, rather than continuing to compete with social or ethnic identities. We might expect more homogenous and church-focused burials. But in such areas, the arrival of incoming Germanic groups represents a visibly new factor in organising cemeteries, even if usually less stark than the divisions seen in Britain in the 5th–6th c. Scholars of Slovenia assert a distinction between German and Roman cemeteries, based on grave goods.[56] Social status groups might assert an alternative type of distinction: elite cemeteries are known in Sardinia and at Trier. Britain has bounded cemetery plots sometimes, for associated groups within Late Roman cemeteries, whereas in Greece, there is a clustering of ordered groups of graves that often share walls or coverings. These forms in the latter two regions perhaps suggest family groups of different status.[57] Finally, we can also, in a few cases, identify groups of people brought together in death by Christian charitable institutions: at San Pietro in Canosa, the osteology suggests a high number of very ill people – some with operations – perhaps because of a *xenodocheion* nearby or because the church was a pilgrimage

51 On the architecture of Theodoric's mausoleum, see esp. Gotsmich (1958) and Johnson (1988) 73–96.

52 Pantheon as model for Italian mausolea: Johnson in this volume, 174–76; Borg in this volume 230, 237–38.

53 Identification of Christian burials: based on orientation, Britain: Booth in this volume, 604–605, 621; based on artefacts, Slovenia: Stemberger in this volume, 757. More subtle arguments may be based on the frequency of different burial practices in relation to grave groups and boundaries, according to C. Sparey-Green pers. comm 2023.

54 Complexity of Christian identity based on funerary inscriptions, Africa and Italy: Rebillard (2003) and (2012). See also Johnson (1997). Catacomb art and confessional identity: see bibliography in Mulryan (2013) 70f., esp. 73–75.

55 The West: Confessional cemeteries from early 3rd c., Rome, Italy: Chavarría Arnau in this volume, 693–97. Distinctive confessional funerary epigraphy from the 3rd–4th c., Rome, Italy: Borg in this volume, 228. Distinctive Christian cemetery from mid-4th c., Tarraco, Spain: Prast in this volume, 216. Presence of group of Jewish graves, Sulci, Sardinia, 5th–6th c.: Puddu in this volume, 714. The East: presence of Jews in cemeteries: Stern (2018).

56 Distinction of ethnicity based on grave goods, Slovenia: Stenberg in this volume, 4. Trier and Britain: see n. 18 and 19.

57 Social status distinction in cemeteries: Elite burials, Sardinia: Puddu in this volume, 712; Trier: Reifarth *et al.* in this volume. Bounded cemetery plots for associated groups, Britain: Booth in this volume, 600. Ordered groups of graves, Greece: Rife in this volume, 792.

site.[58] Osteology, DNA, and the many rapid advances of scientific techniques are likely to give us ever more arguments to associate burials, that go beyond grave goods or grave morphology in the future.

Funerary Rites

Perhaps the most vivid insights available from new scientific work relates to the treatment of the body at death, which is particularly rich when joined to wider excavation data. Brettell's analysis of graves studied for their molecular data provides a panorama of insights into the topic. Her choice of well-preserved examples focuses our minds on what has been lost elsewhere: many bodies in her sample had been dressed in elaborate clothes then wrapped in shrouds or textile bandages. In Trier, at St. Maximin, a sarcophagus entombed a young woman with two infants. The woman had been wrapped in strips of silk damask with another silk cloth on her face. Her body was subsequently covered with additional, resin-soaked burial shrouds. The children were also dressed or wrapped in silk, having first been treated with umbra pigments.[59] Brettell notes that some bodies had been encased with plaster or packed with wood shavings of fir. Myrtle twigs seem to have commonly been used, as found at Trier, even for a girl of 3–6 years. This was an evergreen plant either imported from the Mediterranean or grown carefully in Trier, perhaps as a potted plant.[60] But it is in the reconstruction of the embalming process that science gives us greatest insights. Brettell provides such a clear logic for each stage that it conjures a vivid image of the items and process used in a Late Roman embalmer's visit. When combined with papyri from Egypt, documenting a family of funerary workers, we can imagine the dynamics of a funerary 'workshop', as if it were possible to observe a group at work.[61] Brettell points out the use of frankincense, storax, pine resins, and especially mastic, attested from traces found in graves.[62] We know that some anointing could take place after the body had been placed in the tomb: in the Near East, it is suggested by certain glass vessels found in tombs. From Egypt, the preservation of the body took on a different aspect, with desiccation, encouraged by the sprinkling of salt over bundles of wrappings, traces of which remain.[63]

One might think the main element of late antique funerary rite is both homogenous and of little interest: the movement from cremation to inhumation, which is almost empire-wide. There were of course some regions, such as Judaea or Egypt, where cremation was never especially popular. Yet, for the central and western Mediterranean, there is a major shift in practice. At Trier, it has been noted that this coincides chronologically with Christianisation, but elsewhere the change can seem too widespread and too early to be directly associated: in Slovenia it may be earlier, 3rd c., as elsewhere.[64] In terms of the form of inhumation, in Greece, the layout of the body was now uniform, consistently placing the head and limbs of the corpse in the same manner, with mourners using a fixed range of ritual tools. In the Near East, this might include a belt to tie the legs.[65] Nonetheless, in many regions the ubiquity of late antique cemeteries is striking, with single-occupancy inhumation being the preferred model, often arranged in rows, approximately East-West. How many other parts of the funerary ritual would have been recognised across the late antique world is unclear, but parallels between regions suggest that we should be cautious in asserting regional variation when what really distinguishes this is the level of preservation.

It seems reasonable to assert that funeral processions, for which the evidence is so far uniquely textual, would have been understood across the entire Mediterranean world, given commonalities between Merovingian Paris and Justinianic Constantinople in the 6th c. The carrying of a bier through the streets, the freeing of slaves, the presence of mourning women, dress codes, and the progressive involvement of the Church via psalms or clerical pall-bearers, are all features found widely in the 4th to 6th c., with many overlaps between pagan and Christian funerary behaviours. It is a mistake to think that funeral processions did not permeate down the social hierarchy to those of modest means: anecdotes suggest they did, just as did wedding marches. It is simply that traces of such important rites do not easily enter

58 Group of people brought together in death by Christian charitable institutions, Italy: Chavarría *et al.* in this volume 32.

59 Dress in burials, Britain: Brettell *et al.* in this volume, 46–47; Trier: Reifarth *et al.* in this volume, 674–78.

60 Bodies encased with plaster or packed with wood shavings, Britain: Brettell *et al.* in this volume, 59. Wood shaving and myrtle twigs, Trier: Reifarth *et al.* in this volume, 673–74.

61 Embalming process: tools and process, Britain: Brettell *et al.* in this volume, 46–47. Papyri documenting funerary workers, Egypt: O'Connell in this volume, 863–65.

62 Embalming resins: Brettel *et al.* in this volume, whole article.

63 Anointing after the body placed in tomb, Near East: indicated by presence of glass vessels & incense burners, Bollók in this volume, 847. Desiccation, Egypt: O'Connell in this volume, 878.

64 Shift from cremation to inhumation: Trier, associated with Christianisation: Reifarth *et al.* in this volume, 670. In Slovenia appears earlier, in the 3rd c.: Stemberger in this volume, 757.

65 Form of inhumation, Greece: consistent model for the placement of the body and the use of fixed ritual tools: Rife in this volume, 803. Use of belt as a ritual tool, Near East: Bollók in this volume, 845.

the archaeological record.[66] We can at least get a glimpse of a specific funerary dress that would be displayed in funeral processions, with the insightful paper of Clark on beads, suggesting that blue and black were appropriate colours displayed on such occasions.[67] Another missing part of funeral ritual that might never make it into a purely archaeological discussion is the existence of a charitable distribution of food to the poor – as a standard rite of passage on death, just like funeral processions – seen as appropriate "for every Christian woman" in a will from Egypt.[68] This Christian transformation of funeral generosity into a largess aimed beyond dependents and clients, should not be confused with funerary feasting for those who knew the deceased, which, as we will see, continued.

Grave Goods
One area of funerary rite where archaeology can act as the main source is the provision of grave goods, which one might have supposed Christianisation to have eliminated. We are not looking at a change equivalent to the swing towards unfurnished graves, as seen in 7th to 8th c. Gaul, Germany and Britain, which one might want to directly associate with Christian teaching.[69] Rather, changes are more subtle, showing considerable continuity with the past. Science can now tell us of the botanical offerings made at funerals, from flower garlands to bay leaves, as Brettell informs us. But it is the traces of ordinary objects, increasingly from the eastern and southern shores of the Mediterranean, that provide us with the richest evidence, of new patterns in grave good deposition rather than elimination, a series of changes that may indeed have something to do with Christianisation. These changes take place on a regional basis. In Slovenia, there is swing away from grave goods that are not personal adornments. This pattern seems repeated in Greece, where items found in graves commonly include buckles, buttons, and hobnails from clothes, belts, and sometimes shoes. Simple articles manufactured from bronze, iron, glass, stone, and shell are found in modest numbers: hairpins, earrings, necklaces, bracelets, finger rings, and fibulae, all part of dress.[70]

Nonetheless, the quantity and quality of grave goods does change in some regions. At Trier, Christian graves are generally without grave goods. In Asia Minor, at Sagalassos, the grave goods were now of lesser quality, in contrast to the continued prosperity of the city. In the Near East, there is reduction in the number of containers in graves from the 5th c., when compared to the 3rd to 4th c. In Greece, we hear that earlier graves and chamber tombs produce a broad range of personal possessions, such as cosmetic items, coffers, mirrors, toys, and pets, with a variety of storage and serving vessels in terracotta and glass, and unguentaria. In contrast, late antique funerary assemblages, which are entirely absent from plenty of burials, habitually include a few plain pouring and drinking vessels and occasional accessories, particularly crosses.[71]

Sometimes differences in the goods deposited give us an idea of the meanings invested in them. At Lankhills, near Winchester, adolescents, rather than family leaders, have the highest number of grave goods, suggesting that affection or grief over lost adulthood was the motivation behind the deposition of objects here, though this pattern is not replicated more widely in Britain.[72] In the Near East, grave goods are commoner for women and children than for men. They are usually simple rather than status-oriented items, including domestic objects such as spindle whorls. In Egypt, kitchen implements, along with weaving items and jewellery, can be taken as signifying gender in graves of women.[73] Other items can more easily be related to Christian belief. The presence of a single glass beaker per grave in Slovenia has been interpreted as a reference to the Eucharist, whereas a single jar of oil comes to replace food containers in the Near East. In Greece, coins are also found in graves in different positions, whilst lamps with Christian symbols are found inside and next to graves. These are commonly of terracotta, very frequently decorated with a cross.

66 On funeral procession see, Lavan in this volume, with extensive literature.

67 Colour as an element of funerary ritual, Britain: Clark in this volume, 17–19.

68 Charitable distribution of food to the poor, Egypt: O'Connell in this volume, 857–58.

69 Swing towards unfurnished graves, as seen in 7th to 8th c. Germany and Britain: e.g. Halsall (1995) 9, 13, 15, 17.

70 Grave goods, nature: botanical offerings, Britain: Brettell *et al.* in this volume, 57; Jewellery and elements of clothing, Slovenia: Stemberger in this volume, 756; Dress accessories, Greece: Rife in this volume, 790.

71 Variation in grave goods: almost none in Christian graves, Trier: Reifarth *et al.* in this volume, 678; lesser quality, Asia Minor, Sagalassos: Cleymans and Talloen in this volume, 824. Reduction in quantity (of containers) from the 5th c., Near East: Bollók in this volume, 847. Reduction of funerary assemblages to pouring and drinking vessels, and occasional accessories, Greece: Rife in this volume, 803.

72 Grave goods and age: adolescent with very high number of grave goods, Lankhills, Britain: Booth, 641; Older adults with distinctive grave goods, Britain: Booth in this volume, 641.

73 Grave goods and gender: domestic objects in women's burials, Near East: Bollók in this volume, 843. Kitchen implements, alongside weaving tools and jewellery, Egypt: O'Connell in this volume, 879.

Miniature crosses are also found in tombs, worn as pendants, sewn onto clothes, or laid on a corpse.[74]

A rather different form of grave good is found in Egypt: curses seem to have been placed in some graves, even in the 6th c., testifying to continuing belief in the power of the dead between death and their passage to the other world. In such an environment, we can envisage that the above-mentioned crosses had an apotropaic value, as indeed they are noted as having in texts.[75] For Greece, Rife points to the discovery, at Olympia, Kenchreai, Delion, Thessalonica, and Edessa, of small metal bells (κωδωνίσκοι), known also across Asia Minor and the Near East. These are present disproportionately in the graves of infants and children. These bells were designed to scare away demons around tombs, an anxiety Bollók sees reflected in the Armenian liturgy. The apotropaic devices used might vary. Pendants of coins of Justinian might have served such a function, whilst the presence of extra non-structural iron nails in graves in the Near East, Trier, and Britain have been interpreted as apotropaic in each context.[76]

Memorial Meals

There is evidence of memorial meals from all parts of the late antique world, a custom clearly unaffected by Christianisation. Some of this comes from an exclusively pagan context: at Ghirza, in Tripolitania, offering tables set by mausolea are very similar to those found inside the adjacent temple, which continued to be repaired to the 6th c. In this place, an inscription survives recording *parentalia*, at which 51 bulls and 38 goats were killed, as Nikolaus describes. This suggests, that, like the temples here, the community was largely or completely pagan.[77]
At Sabratha, cemeteries exhibit funerary couches and a painted feasting chamber is known above a hypogeum, of early 4th c. date. The room was furnished with four large sigma couches, tables, and a well, providing a space for the family to gather and hold feasts in honour of the dead. Funerary couches are also known in a cemetery at Tipasa, in Mauretania, whilst the habit of leaving food offerings for the saints was part of the life of Monica, mother of Augustine, from Thagaste in Numidia, if not for Ambrose of Milan.[78] In Sardinia, where African cultural trends are sometimes followed, Puddu notes *mensae* to recline on, which surround some graves. Surface assemblages of ceramics, glass vessels, and animal bones from meals are known from Cornus, continuing earlier pre-Christian practices. In Hungary, Magyar suggests that apsidal halls could have been used for funerary/memorial banquets, whilst in Italy mausolea have apses, likely housing *stibadia* for commemorative meals. In Greece, flat surfaces and platforms are known, sometimes in the shape of a bed, or there are low surfaces like trays by graves, or raised like altars, which would have been used for offerings: vessels with food, unguents, incense, or lamps.[79]

A feature of some stone-lined cists was a hole through the cover fitted with a channel or pipe. This kind of aperture, which is well known in North Africa, is found at the burials of officials or grandees in churches at Knossos, Heraklion, Eleftherna, Corinth, and Athens. It allowed visitors to pour libations or oil down to the dead. At Agrigento, in Sicily, libations are suggested via an amphora neck next to the burial or grafted vertically onto the container that made up the tomb. Similar devices for the introduction of offerings have been described for *necropoleis* in Milan, Ostia, Aquileia, and Turris Libisonis (Sardinia), where necks of amphorae were affixed to tile-capped graves. These installations at least prove that there was post-funerary activity, rather than simply a meal at the time of the funeral.[80]

The archaeological trace of memorial meals is especially strong in Greece. Amphorae and serving wares have been recovered around cists and tombs at Argos and Thessalonica, whilst animal bones, shells, seeds, and burned materials have been found in a cemetery in the latter city, testifying to cooking, eating, and rubbish disposal here. Elsewhere, jugs found by graves could suggest either banquets or libations.[81] But there is also another tradition attested, in which domestic cooking or serving vessels were smashed over graves, reported at

74 Grave goods related to Christian belief: single glass beaker, Slovenia: Stemberger in this volume, 757. Single jar of oil, Near East: Bollók in this volume, 847. Miniature crosses, lamps with Christian symbols, Greece: Rife in this volume, 791–92.

75 Deposition of curses in graves, Egypt: O'Connell in this volume, 868. For the use of crosses as apotropaic devices see, Lavan (2020) 254–58 and Crow (2008).

76 Small metal bells as apotropaic devices, Greece: Rife in this volume, 790; Near East: Bollók in this volume, 841–43, with reference to Armenian liturgy. Pendants of coins of Justinian as amulets: O'Connell in this volume, 872; Iron nails as apotropaic items, Near East: Bollók in this volume, 846 with n. 130; Trier: Reifarth *et al.* in this volume, 678; Britain: Booth in this volume, 609.

77 Offering tables from pagan context, Ghirza, Tripolitania: Nikolaus in this volume, 186–88.

78 Food for saints, left by Numidian Monica: August. *Conf.* 6.2 (cakes, bread, wine).

79 Funerary couches: *mensae*, Sardinia: Puddu in this volume, 713; *sigma* couches, Italy: Johnson, 170. 175; Africa: Nikolaus 189. Apsidal halls likely for funerary banquets, Hungary: Magyar, 148, 150, 156. Greece, fixtures for offerings: Rife, 785.

80 Libations: Greece: Rife in this volume, 785; Near East: Bollók in this volume, 847; Italy (amphora necks etc fixed over graves): Caminneci, Rizzo, and Carver in this volume, 734.

81 Memorial meals, Greece: Rife in this volume, 790.

Isthmia, Corinth, and Thessalonica. This ritual is so far undetected in texts, leaving archaeologists to speculate on its function. It provides an important corollary to the comments on funeral processions made above: this is a part of the funerary process known only in material evidence.[82] Memorial events are of course best attested for saints, in the form of liturgies or lively festivals around the graves of martyrs or other holy personalities. I do not wish to discuss evidence from major pilgrimage sites, which is well-studied.[83] Here, I will only mention the evidence from Xanten, in Germany, where a grave containing a decapitated body without the head was visited heavily, as seen from trampling around it, suggesting funerary meals or public gatherings. The same phenomenon was also observed in the interior floors of mausolea at Poundbury, as described by Sparey-Green.[84] Both sites suggest that memorial events, whether for saints or not, extended to regions where the textual or artefactual evidence does not reach, making cemeteries busier places than one might expect.

Monument Memory

At a more general level, we have archaeological testimony for the frequenting of tombs. In Africa, some were visited and cared for a long time, such as a mausoleum of the Trajanic period in Puppet, which was frequented up until the 5th c., as seen in burial remains and pottery sherds.[85] What we are missing so far is an archaeology of tomb repair, on which this volume is silent. Some mausolea in Africa were reused, such as the 2nd c. example re-employed in the 5th c., in Yasmina cemetery in Carthage. The reuse of heroa and other tombs is also known in Greece.[86] However, here, we also have a well-structured phenomenon of extended family use of the same tomb, with the retention of older burials within, by the careful concentration of earlier bones into a pile with the cranium on top. This was done according to a well-ordered and selective method, whether the bones were moved within or removed from tombs when a new body was laid inside. Puddu suggests that in Sardinia there was a removal of older dead to new tombs.[87] The phenomenon of cemetery disuse can be earlier than one might imagine. At Pompeii, Porta Nocera, some tombs were seeing stellae removed or surface deposits obscuring burials prior to AD 79. At Sagalassos, a cemetery was covered by the Potter's Quarter from the 2nd c. AD.[88] However, respect for older graves ends in late 5th to 6th c. at Sagalassos, with dumping of refuse, moving of tombs, their opening and looting, as can be seen from the presence of intrusive artefacts.[89] It is tempting to see this as Christianisation, but it fits better chronologically with a change in the form of civic government, from the boule to the council of notables. At Ostia, the spoliation of cemetery material (epitaphs, sarcophagi, and statues) dates from as early as the turn of the 3rd and 4th c. with the reuse of sarcophagi more frequent from the last third of the 3rd c. onwards.[90] Elsewhere in Italy, the conversion of mausolea in the later 6th c. might be seen as reflecting Christianisation, though the reasons for it may have been varied: to honour a Christian martyr or to reuse a solid structure, more than any desire to confront the undead or demons. The lateness of the conversions provides an interesting parallel to that of temples.[91]

The reuse/spoliation of tombs within city walls, from the 3rd c. onwards, is striking. It might tempt one to associate it with desacralisation of cemeteries, especially when little else is spoliated for the work, as, for example, at Gorsium (72% of material) and Aquincum (where only gravestones and grave altars have been reported). However, the studies of Mishkovsky for Rome, and for Hierapolis and Aphrodisias in Asia Minor, demonstrate that this was a highly selective process, drawing on stelae and funerary buildings only. An attempt was made to preserve sarcophagi from such structures, so respecting the bones of the dead, in the latter city.[92] It is thus not enough to assume that cemeteries have been desacralized when one sees a wall full of funerary *spolia*. Careful study is needed of the nature of the material reused in each phase and of the condition of *necropoleis*

82 Ritual of smashed domestic vessels in graves: Rife in this volume, 790.
83 Festivals of martyrs: e.g. Macmullen (2009) 104–109. Pilgrimage sites: see review of Bangert (2010).
84 Memorial meals for saints, Gaul and Britain: Sparey-Green in this volume, 132.
85 Tomb visiting, Africa: Nikolaus in this volume, 187 and 184, 187, 195–97.
86 Reuse of mausolea, Carthage, Africa: Nikolaus in this volume, 197. Reuse of *heroa* and other tombs, Greece: Rife in this volume, 796.
87 Removal of older dead to new tombs, Sardinia: Puddu in this volume, 717–21.
88 Earlier disuse/decay of cemeteries, Pompeii: Duday and Van Andringa (2017). Sagalassos: Cleymans and Talloen in this volume, 820.
89 Respect for older graves ending in late 5th c. at Sagalassos: Cleymans and Talloen in this volume, 823.
90 At Ostia, spoliation of cemetery material from end of 3rd to 4th c.: Borg in this volume 224.
91 For late examples of temple conversion see, Hanson (1978); Bayliss (2004); Lavan (2020) 330–331 and Lavan (2020) vol. 2, appendix T4, 850–51.
92 Reuse/spoliation of tombs within city walls, almost exclusively, as at Gorsium and Aquincum: see the catalogue by Lavan for the East, in this volume, 430–32. Reuse/spoliation of tombs, Rome, Italy: Mishkovsky in this volume, 422–25; Hierapolis, and Aphrodisias, Asia Minor: Mishkovsky in this volume, 416–18.

themselves. Tombs are sometimes incorporated into fortifications but usually as towers. The city wall of Palmyra in late 3rd c. provides an interesting case study, as here the incorporation was accomplished without preventing people from accessing the tombs for traditional visits.

Here, we can see a quite sophisticated attitude towards the monumental heritage of a city, observed also in the treatment of other non-funerary structures at the time when these massive circuits were built. Mishkovsky and Underwood demonstrate a pragmatic approach on the part of builders, removing and reusing monuments on the route of their new walls, with entertainment buildings serving as quarries, in preference to individual decorative monuments where more complex memories might be preserved.[93] This might point not only to the persistence of memories of what monuments represented but also to a more general prejudice in favour of the retention of old civic buildings, especially in the Aegean region. Even here, however, we must except cases of walls erected in response to the troubles of the 3rd c., which appear more like a free-for all.

The spoliation of statues provides some well-dated comparanda to tombs, for the treatment of personal memorials. I argue, based on the plazas of Cuicul, Thamugadi, Sabratha, Sarmizegetusa, and Sagalassos, that, up to the end of the 3rd c. and in Africa to the 5th c., many cities simply allowed statues to passively accumulate in their main squares, rather than follow any active policy of statue editing. Large-scale statue clearances, attested by archaeology or texts, seem to have occurred after traumatic destructions, or perhaps, in the capital, due to imperial replanning. However, the absence of Early Imperial statues from many agorai in Greece or Asia Minor, when compared to a city like Sagalassos, suggests that clearances did take place, likely occurring under the Tetrarchs, whom it benefitted. At Sagalassos or Aphrodisias, or earlier at Pompeii, the concentration of statues of particular date in certain settings further suggests an ability to replan statuary landscapes according to contemporary priorities or building strategies, something that could not be done as easily with tombs.[94]

We do, however, have epigraphic and statue base evidence for selective recutting of monuments to serve new dedications, well-studied by Tantillo and Bigi at Lepcis Magna, in this volume. They back their argument up with textual sources that show this process at work in earlier centuries, even when the honorand was still alive, with all the dishonour that entailed. At Rhodes, older statues were wasted because nobody knew who the honorands were any longer, as Dio Chrysostom records. This is an outrage he connects to and contrasts with the protection given to tombs.[95] Indeed, despite an exceptional number of dedications to late governors and post-Severan emperors, curial honorands seem to be almost absent from the Severan Forum. However, it may be that the topographic data from Lepcis is incomplete. Curial statues could rather have been concentrated in the Old Forum, where a fire is attested prior to 324–326, and disturbed later by church building, accounting for this plaza being low in recovered statue monuments.[96] The epigraphic record of Sarmizegetusa confirms that such spatial zoning had been established for statues by the 2nd to early 3rd c., with imperial monuments in the main square, being given priority over civic statues which were sent elsewhere. Two destruction deposits relating to the forum of Sabratha suggests the same. This is a process we see already underway in the Forum of Pompeii.[97] Thus, it is possible that curial statues persisted where their setting was considered most appropriate to their status, and that reinscription was not always common.

Rather, the evidence we have for statue wastage often involves large-scale collective processes, relating to the management of a specific architectural setting after a crisis, instead of being a direct testimony to the archaeology of forgetting individuals. Understanding the dynamics of more selective preservation, away from single destructive events, is not straightforward: as late as the 6th c. we see older statues being re-erected and repaired, as on the Upper Agora of Sagalassos or the Embolos of Ephesus, whilst an adjacent square (the Tetragonal Agora of Ephesus) is cleared of its statue monuments: some are stored in tabernae, others are used to rebuild an adjacent street portico.[98] One might evoke pragmatism, in that some statues were damaged, or more space was needed for a market stall in one spot but not another, but at Sagalassos a more deliberate process seems to be at work: some monuments were simply

93 Incorporation of tombs into fortifications, the East: Mishkovsky in this volume; the West: Underwood in this volume.

94 Statue movement/editing, Pompeii forum: Zanker (1998) 102–103. For statue movement/editing in agorai, see Lavan (2020) 293–308 and 350–51.

95 Rededications, Leptis Magna, Africa: see paper by Tantillo and Bigi (2010), republished in this volume. Texts on statue rededication and removal, including Dio Chrys. Or. 31, esp. 9, 94, and 71: Bigi and Tantillo, this volume 370–71.

96 Old forum fire in earlier 4th c., Leptis: Tantillo/Bigi no. 71 = IRT 467 = LSA 2213. Dated to AD 324–326.

97 Sarmizegetusa forum: see overview in Étienne, Piso and Diaconescu (1990). Civic buildings repaired before temples at Pompeii: Zanker (1998) 124–31.

98 Re-erection or repair of older statues, Sagalassos, Upper Agora: Lavan (2020) appendix K9; Ephesus, Embolos: Lavan (2020) appendix H7. Clearance of statues, Ephesus, Tetragonal Agora: see Lavan (2020) remarks in appendix K9 on Ephesus.

displaced a few metres whilst others are recycled as construction material in adjacent new buildings.[99]

Thus, if we wish to grasp an archaeology of memory, we must consider the broadest scale of ancient attitudes, not simply attitudes to one tomb or statue. At Ephesus, the later 6th c. fortification and the contemporary rebuilding of the city's porticoes both reveal a complex situation: monuments left outside the new wall were not only preserved but their forms were imitated by new building using *spolia*. Here, we have a very conservative attitude to secular public monuments in ethnically Greek regions, which can be compared or contrasted to attitudes to tombs.[100] My case study of *spolia* in the metropolis of Asia shows that to analyse these phenomena accurately we need to consider the whole cityscape and start from the bottom up, at looking how *spolia* were used in new building, balanced against when they were not used. We must avoid knee-jerk reactions when confronted by distinctive *spolia* set in new uses. Eye-catching statements about forgetting the past, despoiling of the dead, or of a major change in *mores*, may turn out to be misleading on more balanced inspection.

Memory in Comparative Perspective

So how can this wider evidence for memorial be used to shed light on funerary intentions and commemorative practices? Perhaps the most obvious thing to note is that the preoccupations against which Marcus Aurelius reacted – of attaining immortality in his life – may have been on the wane. Whilst we are used to the idea of Early Roman tomb monuments jostling for position and prominence on main streets leaving a city – as at the *Via dei Sepolchri* at Pompeii – the late antique evidence shows the presence of other concerns, even amongst the elite. There is certainly a continuity of memorial customs for the 4th to early 5th c. in many regions – mausolea appear for the first time in some areas precisely in this first half of the late antique period. We also hear of continued use of funerary processions for forms of social display that are familiar from the Late Republic, as late as the 6th c. But balancing this we have elite burials that occur within churches without surface monuments, and a cessation of mausolea construction in many regions by the later 5th c. These changes coincide with a new type of funerary epigraphy, in which simpler statements about years lived and invocations to God, not the *cursus honorum*, fill the grave slab, a more anonymous form of epitaph, which coincides with the decline of the *trianomina*.[101] Was this a world without the concerns of Marcus Aurelius' contemporaries, happy to renounce memory, or was something else at work?

Part of the answer may lie in changes affecting the secular elites of cities, and the way they made their presence felt in the world. It is probably no accident that honorific statuary dedications also collapse in the early 5th c. and numbers of new *domus* decline, which are very few in the 6th c. and stop by *ca.* 550. Nonetheless, statues do not stop being repaired nor do these peristyle houses stop being lived in, until the early 7th c., for the East. Civic building work also drastically declines outside the capitals, forever in the West, and until the later 5th c. in the East. Daily processions of the well-to-do seem to converge on churches at around the same time, rather than going to the forum/agora, at least outside of Constantinople.[102] Donations to church building from all levels of society, from the rich to those capable of only donating fractions of *solidi*, also increase greatly in this century. By the 6th c., new *domus* are constructed only for bishops, who are now the sole occupants of mausolea in Italy, with the exception of king Theoderic.[103] Admittedly, in a few places, in the East, there are hints of a survival of earlier patterns of civic elite display: Aphrodisias has new statues of notables, even in the 6th c., alongside epigraphic celebrations of civic euergetism, something which is reflected more elsewhere

99 Monuments displaced or recycled, Sagalassos: Lavan (2020) appendix S11 pp. 842–43; Lavan (2013).
100 Lavan, in this volume, on Ephesus.
101 Funerary epigraphy, simplified, with decline of *trianomina*, e.g. at Corinth and across southern Greece: Ivison (1996) 107; Sironen (2018).
102 Collapse of honorific statuary dedications in early 5th c.: Smith (2016) 6–10. Domus new construction decline: Ellis (1988). Continued occupation, e.g. Thasos, last repairs (incomplete) in 560s then degradation of domus *ca.* 570 then destruction in late 6th to 7th c.: Muller (2015) and (2017); Aphrodisias, 'bishops's palace': with wall-painted dated (basis unknown) to 6th–7th c. plus lead seals of bishop: Campbell (1996) 192; Xanthos: house with several post-5th c. wealthy phases: Manière-Lévêque (2007). Civic building declines outside of capitals, based on texts, inscr. and archaeology: Lavan (2020) vol. 1 419–20, with 505 graph 60, based on all of vol. 2. Note also this decline in the epigraphic patterns in collections of Lepelley (1979 and 1981), Ward-Perkins (1984). Recovery in East later, inscriptions: Roueché (1979) plus Di Segni (1999). Daily processions of the well-to-do to churches: Lavan (2020) vol. 1 191–92. On reconfiguring elite display around churches see also Rife, in this volume 803. See also Nikolaus, 196.
103 Donations to church building, epigraphically attested as rising in 5th c., in Italy, Greece and Palestine/Arabia respectively: e.g. Ward-Perkins (1984) 51–61, Caillet (1993), Caraher (2003) esp. catalogue, and Di Segni (1999) esp. with 160–61 with tables 2B and 3B (showing 6th c. to be the peak). New *domus* constructed only for bishops in the 6th c., Italy: Marano (2006); Asia Minor: Ceylan (2006), with Baldini Lippolis (2005) on the phenomenon more generally. Bishops the sole occupants of mausolea, in 6th c. Italy: Johnson in this volume, 177–79.

in texts and inscriptions in Asia Minor. But outside this region, and a few cities of the Levant, it is far harder to find secular elites engaged in such civic gestures.[104] Could we be witnessing in funerary display a rupture in elite traditions that matched such political trends, a phenomenon only indirectly related to Christianisation, if at all? Whatever the nature of the 5th c. change to 'memorialisation', it was not total, straightforward, nor without regional nuances, just as with the change from cremation to inhumation or the desacralisation of cemeteries.

Whilst the memorial of secular power might have dimmed, the commemoration of the holy dead provided ample compensation for those visiting cemeteries. Much can be said about the patronage of saints over communities and the desire to maintain proximity to them in the Last Judgement, just as one might have sought a position close to a patron in a street procession in life. Yet, it is at least as interesting to consider the ample evidence of relationships between family mourners and individual tombs, via the tradition of funerary meals, which show no signs of abating with the rise of Christianity. However, to reduce funerary customs to an analysis of change and continuity is perhaps to miss the point. The ample evidence of grave goods, or of assemblages associated with graves, attests to types of commemoration that are noteworthy. One can note the increased presence of neonates and children, or stillborn babies, as reflective of Christian belief. The level of care shown to infant corpses, their commemoration in epitaphs, and the increased number of grave goods given to children and adolescents also indicates greater attention to the young in burial rites. It suggests that sentiment and memories of past shared experiences, were strongly present at the graveside, memories of past events lived out, rather than of achievements, status, or hopes for honour amongst those who remained: an echo of Augustine's comforting memory of Monica's life, returning to him as a consolation during grief.[105] Taken with the increased presence of the young in formal cemeteries, can we see here a Christian memorial to the personal impact of a life lived, at the moment of burial, eclipsing concerns for posthumous reputation?

Clearly, an earlier concern with worldly memorial in tomb construction was evaporating, except for emperors and the highest members of the elite, after an Indian summer in the 4th c. Other values were asserting themselves in burial customs, if not entirely eliminating those related to social status. This does seem to coincide with other trends in the wider world. Yet, we could go too far to imagine that there were no new alternatives for perpetuating one's memory in late antique society. The dedication of churches with mosaic inscriptions involved an element of memorial. Occasionally, the mosaic depiction of major donors is known, as from Ephesus, and Constantinople, where the custom may have begun, a habit reminiscent of the display of statues and busts on the exterior of late antique mausolea, known from the Munich Ivory.[106] In another domain, the great houses at Constantinople were named after members of the court of Theodosius I and managed to retain these names for centuries afterwards.[107] We know that inscribed acclamations might now honour civic benefactors just as they honoured emperors, whilst painted boards honoured actors, pantomimes, and charioteers.[108] Nonetheless, it is undoubtedly true that tomb monuments and mausolea had lost their power to hold memory from the later 5th c., as had statues, to a lesser degree, the identities of which were now sometimes remembered accurately, but often misidentified, as we see at Rome, Constantinople, and Antioch at the end of the period.[109] Popular memory depended rather on being part of a story: either as an emperor/king, a saint, or a civic founder, which might get one's name on a civic calendar or on a public building that was preserved. The most reliable alternative, confined to those attending school, was to achieve

104 Survival of earlier patterns of civic elite display in the East: Honorific statues at Aphrodisias, local notables on South Agora or adjacent Hadrianic Baths: see n. 27. ALA 85 is dedicated by the city. For later 6th c. examples, see Lenaghan (2019) on an example from Aphrodisias. Wider civic activity of notables in Asia Minor: Roueché (1979).

105 Memory of Monica's life: August. *Conf.* 9.33.

106 Auferstehung und Himmelfahrt Christi, Inv.-Nr. MA 157, Foto Nr. D27841, Bayerisches Nationalmuseum.

107 Church donor inscriptions: see above, n. 103. Church donor mosaic depictions: Ephesus: *Anth. Graec.* 1.36 for Theodore Illustris, twice Proconsul of Asia, receiving *insignia* of office from an archangel; Constantinople: Suda (Anonymous articles from Suda) 1 (A 783) Acacius patriarch of Cple under Zeno, with Zach. Myt. *Chron.* 8.1 on mosaic images of Justin I in public baths of the city. Names of grand houses at Constantinople, explored by Magdalino (2001) 53–72. Theophanes AM 6021 AD 528/529 (date from edn. of Mango and Scott (1997)). Discussed in Lavan (2020b) vol. 2 appendix E1 391.

108 Inscribed acclamations honouring civic benefactor Albinus at Aphrodisias: Albinus: see Roueché (1984) 190–99, plus ALA 82; acclamations honouring emperors: Roueché (1994a) and (1994b) and Miranda (2002). Pictures (*pictura*) of actors of pantomimes, charioteers, actor in public porticoes: *Cod. Theod.* 15.7.12pr. (AD 394, Heraclea).

109 Statue epitaphs copied in 6th c.: *Anth. Graec.* Book 16. Statues misidentified, 6th c. Rome: Zach. Myt. *Chron.* 10.6; Constantinople: *Parastaseis* 74, *Patria* 2.40 (Constantinople). 6th c. Antioch (from Malalas): Saliou (2006).

literary memory, in the form of a much-copied work. Thus, the second half of the late antique period might be seen as representing a reduction in memorial activity, but it was far from being a complete rupture. The memory of saints, of major cultural figures, and of civic legacy in East Mediterranean cities remained intact; only memorial practices of burial changed.

Conclusions

The above overview has, of course, been created from insights made available by contributions to this volume on points of topical interest. There are plenty more insights to be gleaned from other readings of what are a strong set of scholarly contributions that should bring the study both of burial and memorial to a point where research students and perhaps students find the subject somewhat easier to access. There are also undoubtedly further thematic essays and regional syntheses to be written. Some of these were commissioned for this volume but lost due to the stress of writing and editing during COVID. However, it would be wrong to pass over the feelings that emerged from the conference meetings themselves, especially in the thematic meeting, towards the scientific papers of Brettell and others, of which a standout paper by Devièse on colorants and dyes was not available for publication here. These papers, due to their ability to produce traces of materials attested in literary sources, but from areas far beyond their usual reach, elicited both excitement and hopes for the future as to what molecular sampling and other techniques could give to research in the next decades. Also, the presence of Egypt in the heart of discussions dominated by scholars based in North-West Europe was greatly illuminating. Very often scientific papers were finding traces of material in the West matched by evidence from well-preserved cemeteries in this region. The application of a full battery of scientific methods to Egypt will likely give us the best of both worlds. Finally, future studies of memory might well take a more tangential relationship to funerary archaeology than we have in this volume: tomb destruction by city walls was not ideological, systematic, nor especially new, whilst late antique funerary practices were rather less concerned with the perpetuation of reputations than they were earlier. But the subject of memory was so significant for a civilisation highly conscious of its past, that some comparisons to commemorative acts of burial should always be maintained. If not, we may be tricked into thinking that cultural attitudes can easily be read from one source type, when many strands are, in fact, needed.

Acknowledgements

I wish to thank Joseph Rife and Christopher Sparey-Green for their comments on my paper, of which errors and views expressed within remain my own.

Bibliography

Primary Sources

Amm. Marc. = J. C. Rolfe, *Ammianus Marcellinus* (Loeb Classical Library) (Cambridge Mass. 1939–1950).

Anth. Graec. = W.R. Patton ed. and transl., *The Greek Anthology*, 5 vols. (London 1916–25) (with Greek text).

August. *Conf.* = W. Yates ed. and transl., *St. Augustine's Confessions in Two Volumes* (London and Cambridge, Mass. 1946) (with Latin text).

Dio Chrys. *Or.* 31 = J. W. Cohoon and H. Lamar Crosby transl. *Dio Chrysostom* vol. 3. *Discourses 31–36* (Cambridge, MA and London 1940) with Greek text.

Eutr. = H. W. Bird transl. *Eutropius, Breviarium ab urbe condita* (Translated Texts for Historians) (Liverpool 1993).

Iust. *Nov* = R. Schoell and W. Kroll edd., *Justinian. Novellae* (Berlin 1895); E. Bloom transl., *Justinian's Novels* 2nd edn. http://www.uwyo.edu/lawlib/blume-justinian/ajc-edition-2/books/ (last accessed March 2014); http://www.uwyo.edu/lawlib/blume-justinian/ajc-edition-2/novels/index.html.

M. Aur. *Med.* = Marcus Aurelius. ed. and transl. C. R. Haines (Cambridge, MA 1916).

Parastaseis = Av. Cameron and J. Herrin edd., transl. and comm., *Constantinople in the Early Eighth Century: the Parastaseis Syntomoi Chronikai* (Columbia Studies in the Classical Tradition 10) (Leiden 1984).

Patria = T. Preger ed., *Scriptores originum Constantinopolitanarum*, vol. 2 (Leipzig 1907) 135–283.

V. Theod. Syc. = E. Davies transl. *Three Byzantine Saints: Contemporary Biographies of St. Daniel the Stylite, St. Theodore of Sykeon and St. John the Almsgiver* (London 1948).

SHA *Sev. Alex.* = D. Magie transl. *Scriptores Historiae Augustae* (Loeb Classical Library) (Cambridge Mass. 1921–1932).

Suda = *Suda On Line: Byzantine Lexicography*: www.stoa.org/sol/.

Tantillo/Bigi = I. Tantillo and F. Bigi edd., *Leptis Magna. Una città e le sue iscrizioni in epoca tardoromana* (Cassino 2010).

Zach. Myt. *Chron.* = E. W. Brooks ed., *Historia ecclesiastica Zachariae rhetori vulgo adscripta; Accedit fragmentum Historiae ecclesiasticae Dionysii Telmahrensis* (CSCO 83–84/38–39) 2 vols. (Paris 1919–24); F. Hamilton and E. Brooks transl., *The Syriac Chronicle Known as that of Zachariah of Mitylene* (London 1899). Now recently edited and translated (but not used by me here) as G. Greatrex, R. Phenix, and C. Horn

edd. and transl., *The Chronicle of Pseudo-Zachariah Rhetor: Church and War in Late Antiquity* (Liverpool 2011).

Secondary Sources

Baldini Lippolis I. (2005) *L'architettura residenziale nelle città tardoantiche* (Rome 2005).

Balty J. C. and Van Rengen W. (1993) *Apamée de Syrie: quartiers d'hiver de la IIe légion parthique. Monuments funéraires de la nécropole militaire* (Brussels 1993).

Bangert S. (2010) "The archaeology of pilgrimage: Abu Mina and beyond", in *Religious Diversity in Late Antiquity*, edd. D. M. Gwynn and S. Bangert (Leiden 2010) 293–327.

Bayliss R. (2004) *Provincial Cilicia and the Archaeology of Temple Conversion* (BAR-IS 1281) (Oxford 2004).

Brogan O. and Smith D. J. (1984) *Ghirza. A Libyan Settlement in the Roman Period* (Libyan Antiquities Series 1) (Tripoli 1984).

Caillet J-P. (1993) *L'évergétisme monumental chrétien en Italie et à ses marges, d'après l'épigraphie des pavements de mosaïque (IVe–VIIe siècle)* (Publications de l'École Française de Rome 175) (Rome 1993).

Campbell S. (1996) "Signs of prosperity in the decoration of some 4th–5th c. buildings at Aphrodisias", in *Aphrodisias Papers* 3, edd. C. Roueché and R.R.R. Smith (JRA Supplementary Series 20) (Ann Arbor 1996) 188–99.

Caraher W. (2003) *Church, Society, and the Sacred in Earthly Christian Greece* (PhD diss. Ohio State University, Columbus 2003).

Ceylan B. (2006) "Episcopeia in Asia Minor", in *The Archaeology of Late Antique Paganism* (Late Antique Archaeology 7), edd. L. Lavan and M. Mulryan (Leiden 2006) 347–87.

Crow J. (2008) "Chapter 7. The Christian symbols and iconography of the aqueducts of Thrace", in *The Water Supply of Byzantine Constantinople* (JRS Monograph 11), J. Crow, J. Bardill, and R. Bayliss (London 2008) 157–80.

Di Segni L. (1999) "Epigraphic evidence for building in Palaestina and Arabia (fourth–seventh c.)", in *The Roman and Byzantine Near East: Some Recent Archaeological Research*, vol. 2, ed. J. Humphrey (Portsmouth RI 1999) 149–78.

Duday H. and Van Andringa W. (2017) "Archaeology of memory: about the forms and the time of memory in a necropolis of Pompeii", in *Ritual Matters and Ancient Religion* (Supplements to the Memoirs of the American Academy in Rome) edd. C. Moser and J. Knust (Michigan 2017) 73–85.

Duval N. (1956) "Nouvelles recherches d'archéologie et d'épigraphie chrétiennes à Sufetula (Byzacène)", *MEFRA* 68 (1956) 247–98.

Duval N. (1971) "Inscriptions byzantines de Sbeitla (Tunisie), III", *MEFRA* 83.2 (1971) 423–43.

Ellis S. P. (1988) "The end of the Roman house", *AJA* 92.4 (1988) 565–76.

Étienne R., Piso I., and Diaconescu A. (1990) "Les deux forums de la colonia Ulpia Traiana Augusta Dacica Sarmizegetusa", *RÉA* 92 (1990) 273–96.

Feissel D. (1999) "Épigraphie administrative et topographie urbaine: l'emplacement des actes inscrits dans l'Éphèse protobyzantine (IVe–VIe S.)", in *Efeso Paleocristiana e Bizantina = Frühchristliches und byzantinisches Ephesos* (DenkschrWien 282. AF 3), edd. R. Pillinger et al. (Vienna 1999) 121–32.

Gotsmich A. (1958) "Il Mausoleo di Teodorico", *Felix Ravenna* 3.25 (1958) 56–71.

Green C. Sparey, Paterson M. and Biek L. (1981) "A Roman coffin burial from the Crown Buildings site, Dorchester, with particular reference to the head of well-preserved hair", *Proceedings of the Dorset Natural History and Archaeological Society* 103 (1981) 67–100.

Gretzinger J., Sayer D., Justeau P. et al. (2022) "The Anglo-Saxon migration and the formation of the early English gene pool", *Nature* 610 (2022) 112–19.

Halsall G. (1995) *Early Medieval Cemeteries: An Introduction to Burial Archaeology in the Post-Roman West* (New Light on the Dark Ages 1) (Skelmorlie 1995).

Hanson R. P. C. (1978) "The transformation of pagan temples into churches in the early Christian centuries", *Journal of Semitic Studies* 23 (1978) 257–67.

Hines J. (1994) "The becoming of the English: identity, material culture and Language in early Anglo-Saxon England", *Anglo Saxon Studies in Archaeology and History* 7 (1994) 49–59.

Hornsby W., Stanton R., Craster H. H. E., Hill G. F., Newbold P., MacDonald G., Keith A., and Marshall G. S. (1912) "The Roman fort at Huntcliff, near Saltburn", *JRS* 2 (1912) 215–32.

Inrap (2024) https://www.inrap.fr/une-necropole-antique-de-tres-jeunes-enfants-et-mort-nes-auxerre-yonne-18073 (last accessed June 2024).

Ivison E. (1996) "Burials and urbanism in late antique and Byzantine Corinth", in *Towns in Transition. Urban Evolution in Late Antiquity and the Early Middle Ages*, edd. N. Christie and S. Loseby (Aldershot 1996) 99–125.

Johnson M. J. (1988) "Toward a history of Theoderic's building program", *DOP* 42 (1988) 73–96. http://doi.org/10.2307/1291590.

Johnson M. J. (1997) "Pagan-Christian burial practices of the fourth century: shared tombs?", *Journal of Early Christian Studies* 5.1 (1997) 37–59.

Johnstone C. (2019) "Human remains", in *The Transition to Late Antiquity on the Lower Danube: Excavations and Survey at Dichin, a Late Roman to Early Byzantine Fort and a Roman Aqueduct*, Poulter, A. (Oxford 2019) 663–66.

Juchniewicz K., As'ad K. and al Hariri K. (2010) "The defense wall in Palmyra after recent Syrian excavations", *Studia Palmyreńskie* 9 (2010) 55–73) 56–58.

Lavan L. (2013) "The agorai of Sagalassos in Late Antiquity. An interpretive study", in *Field Methods and Post-Excavation Techniques in Late Antique Archaeology*, edd. L. Lavan and M. Mulryan (Late Antique Archaeology 9) (Leiden 2013) 289–353.

Lavan L. (2020) *Public Space in the Late Antique City*, 2 vols. (Late Antique Archaeology Supplementary Series 5) (Leiden 2020).

Lenaghan J. (2019) "Another statue in context: Rhodopaios at Aphrodisias", in *Visual Histories of the Classical World: Essays in Honour of R.R.R. Smith*, ed. R. Raja (Turnhout 2019) 502–518.

Lepelley C. (1979) *Les cités de l'Afrique romaine au bas-empire, vol. 1: La permanence d'une civilisation municipale* (Paris 1979).

Lepelley C. (1981) *Les cités de l'Afrique romaine au bas-empire, vol. 2: Notices d'histoire municipale* (Paris 1981).

Lucy S. and Reynolds A. (2002) "Burial in Early Medieval England and Wales: past, present and future", in *Burial in Early Medieval England and Wales*, edd. S. Lucy and A. Reynolds (London 2002) 1–23.

MacMullen R. (2009) *The Second Church. Popular Christianity A.D. 200–400* (Writings from the Greco-Roman World Supplements 1) (Atlanta 2009).

Maetzke G. (2003) "Elementi della città altomedievale", in S. Lusuardi Siena ed., *Fonti archeologiche e iconografiche per la storia e la cultura degli insediamenti nell'altomedioevo. Atti delle Giornate di Studio* (Milano – Vercelli, 21–22 marzo 2002). (Contributi di archeologia 3) (Milan 2003) 91–95.

Magdalino P. (2001) "Aristocratic oikoi in the tenth and eleventh regions of Constantinople", in *Byzantine Constantinople: Monuments, Topography and Everyday Life* (The Medieval Mediterranean 33), ed. N. Necipoğlu (Leiden–Boston–Cologne 2001) 53–72.

Manière-Lévêque A.-M. (2007) "The House of the Lycian Acropolis at Xanthos", in *Housing in Late Antiquity* (Late Antique Archaeology 3.2), edd. L. Lavan, L. Özgenel, and A. Sarantis (Leiden 2007) 475–94.

Marano Y. (2007) "*Domus in qua manebat episcopus*: episcopal residences in northern Italy during Late Antiquity (4th to 6th Centuries AD)", in *Housing in Late Antiquity: from Palaces to Shops* (Late Antique Archaeology 3.2), edd. L. Lavan, L. Özgenel, and A. Sarantis (Leiden 2007) 97–129.

Miranda E. (2002) "Acclamazioni a Giustiniano I da Hierapolis di Frigia", in *Saggi in onore di Paolo Verzone* (Hierapolis. Scavi e Ricerche 4) (Rome 2002) 109–18.

McCormick M. (2016) "Tracking mass death during the fall of Rome's empire (II): a first inventory of mass graves", *JRA* 29 (2016) 1004–1046.

Muller A. (2005) "Thasos: domus protobyzantine. Rapport d'activités aux abords nord de l'Artémision (Thanar) – DOM5 en 2011", *BCH* (2012): http://chronique.efa.gr/index.php/fiches/to_pdf/2650/ (last accessed May 2015).

Muller A. (2017) "Thasos: domus protobyzantine. Rapport d'activités aux abords nord de l'Artémision (Thanar) (2017)", submission for *Grand Prix d'Archéologie de la Fondation Simone et Cino Del Duca* at l'Institut de France / Académie des Inscriptions et Belles-Lettres, available at https://www.academia.edu/36179175/Un_site_exceptionnel_%C3%A0_Thasos_Treize_si%C3%A8cles_dhistoire_au_prisme_de_larch%C3%A9ologie_2017 (last accessed April 2023).

Mulryan M. (2011) "'Paganism' in Late Antiquity: regional studies and material culture", in *The Archaeology of Late Antique 'Paganism'* (Late Antique Archaeology 7) edd. L. Lavan and M. Mulryan (Leiden 2011) 41–88.

Petts D. (2004) "Burial in Western Britain AD 400–800: Late Antique or Early Medieval?", in *Debating Late Antiquity in Britain AD 300–700*, edd. R. Collins and J. Gerrard (Oxford 2004) 77–87.

Quensel-von Kalbern (2000) "Putting Late Roman burial practice (from Britain) in context", in *Burial, Society and Context in the Roman World*, edd. J. Pearce, M. Millett, and M. Struck (Oxford 2000) 217–30.

Quercia A. and Cazzulo M. (2016) "Fear of the dead? 'Deviant' burials in Roman Northern Italy", in *TRAC 2015: Proceedings of the Twenty-fifth Annual Theoretical Roman Archaeology Conference, The University of Leicester, 27–29 March 2015* (Oxford and Philadelphia 2016) 28–42.

Rebillard É. (2003) *Religion et Sépulture: L'église, les vivants et les morts dans l'antiquité tardive* (Paris 2003).

Rebillard E. (2012) *Christians and their Many Identities in Late Antiquity. North Africa, 200–450 CE* (Ithaca and London 2012).

Rife J. (2012) *Isthmia IX: The Roman and Byzantine Graves and Human Remains* (Princeton 2012).

Rose M. (1997) "Ashkelon's dead babies", *Archaeology* 50.2 (1997) https://archive.archaeology.org/9703/newsbriefs/ashkelon.html (last accessed March 2023).

Roueché C. (1979) "A new inscription from Aphrodisias and the title pater tes poleos", *GRBS* 20 (1979) 173–85.

Roueché C. (1984) "Acclamations in the later Roman empire: new evidence from Aphrodisias", *JRS* 74 (1984) 181–99.

Roueché C. (1999a) "Enter your city! A new acclamation from Ephesos", in *Steine und Wege. Festschrift für Dieter Knibbe*, edd. P. Scherrer *et al.* (Vienna 1999) 131–36.

Roueché C. (1999b) "Looking for late antique ceremonial: Ephesos and Aphrodisias", in *100 Jahre österreichische Forschungen in Ephesos. Akten des Symposions Wien 1995* (DenkschrWien 260 = AF 1), edd. H. Friesinger and F. Krinzinger (Vienna 1999) 161–68.

Saliou C. (2006) "Statues d'Antioche de Syrie dans la Chronographie de Malalas", in *Recherches sur la Chronique de Jean Malalas II* (Actes du colloque 'Malalas et l'Histoire', Aix-en-Provence, 21–22 octobre 2005), edd. S. Agusta-Boularot, J. Beaucamp, A.-M. Bernardi, and E. Caire (Paris 2006) 69–95.

Smith A., Allen M., Brindle T., Fulford M., and Lodwick, L. (2018) *New Visions of the Countryside of Roman Britain, Volume 3: Life and Death in the Countryside of Roman Britain* (Britannia monograph series 31) (London 2018).

Smith P. and Kahila G. (1991) "Bones of a hundred infants found in Ashkelon sewer", *Biblical Archaeology Review* 16.4 (1991) 5.

Smith R. R. R. (2016) "Statue practice in the late Roman Empire: numbers, costumes, and styles", in *The Last Statues of Antiquity*, edd. Smith R. R. R. and Ward-Perkins B. (Oxford 2016) 1–27.

Stern K. (2018) *Writing on the Wall: Graffiti and the Forgotten Jews of Antiquity* (Princeton 2018).

Swift E. (2006) "Constructing Roman identities in Late Antiquity? Material culture on the western frontier", in *Social and Political Life in Late Antiquity* (Late Antique Archaeology 3.1), edd. W. Bowden, C. Machado, and A. Gutteridge (Leiden 2006) 95–111.

Tantillo I. and Bigi F. edd. (2010) *Leptis Magna. Una città e le sue iscrizioni in epoca tardoromana* (Cassino 2010).

Trombley F. R. (1987) "Korykos in Cilicia Trachis: the economy of a small coastal city in late antiquity (saec. V–VI)," *Ancient History Bulletin* 1 (1987) 16–23.

Vitale L. (2015) "Lo spazio degli infanti nei cimiteri tardoantichi: organizzazione e distribuzione spaziale fra ritualità e consuetudini sociali", in *Isole e terraferma nel primo cristianesimo: identità locale ed interscambi culturali, religiosi e produttivi: atti XI Congresso nazionale di archeologia cristiana, Cagliari, Dipartimento di storia, beni culturali e territorio – sede della Cittadella dei Musei, Cagliari, Pontificia Facoltà teologica della Sardegna, Sant'Antioco, Sala consiliare del Comune, 23–27 settembre 2014* edd. Martorelli R., Piras A., and Spanu P. G. (Cagliari 2015) vol. 1 197–202.

Ward-Perkins B. (1984) *From Classical Antiquity to the Early Middle Ages. Urban Public Building in Northern and Central Italy AD 300–850* (Oxford 1984).

Williams H. (2004) "Artefacts in early medieval graves", in *Debating Late Antiquity in Britain AD 300–700*, edd. R. Collins and J. Gerrard (Oxford 2004) 89–101.

Zanker P. (1988) *Pompeji: Stadtbilder als Spiegel von Gesellschaft und Herrschaftsform* (Mainz 1988) translated as Zanker P. (1998) *Pompeii: Public and Private Life* (Revealing Antiquity 11) (Cambridge Mass and London 1998).

Bioarchaeology

Recent Bioarchaeological Research on Early Medieval Cemeteries in Italy

Alexandra Chavarría Arnau, Leonardo Lamanna and Maurizio Marinato

Abstract

This paper discusses the state of research involving bioarchaeological analyses which are available for some Italian cemeteries dated between the 4th and the 8th c. It focuses on considerations as to how this kind of specialist analysis can contribute to answering current historical questions – the end of villas, burial uses of churches, Lombard settlement. It also underlines the need to consider the social and economic meaning and context of cemeteries, an aspect which is of great importance for the interpretation of the results and their contextualization into the wider framework of the period.

Introduction

Early Medieval funerary archaeology has enjoyed an important development in the last decades,[1] with a particular focus, as we will see, on the period in which the Lombard population settled in Italy, from the second half of the 6th c. and throughout the 7th c. This specific interest continues a historiographical tradition of investigation into the 'Lombard question', which dates from at least the 18th c., when intellectuals such as Ludovico Antonio Muratori (1672–1750) and Alessandro Manzoni (1785–1873) debated the impact of the Lombard conquests in Italy, as well as the positive or negative result of the Church alliance with the Carolingian Empire and the destruction at least for the northern duchies of the Lombard kingdom. The 'Lombard question' is still debated today. There are those who evaluate Lombard presence as weak and consider it improbable that archaeologists could identify any 'real' Lombard population. The opposing point of view highlights the radical economic and cultural transformations that this small but politically dominant warrior group (identifiable in cemeteries with specific grave goods and particular kinds of settlements)[2] caused to the already damaged Late Roman structures after the Gothic War which devastated large parts of Italy (535–553).

Much less attention has been paid to the study of cemeteries dating to the earlier period between the 4th and 6th c. This problem is due to the lack of a systematic record of burial evidence for these centuries, the difficulties for dating them and also because bioarchaeological studies of the previous rural anthropological material from the Roman period have only recently begun to develop.[3] The same can be said about later cemeteries, dating from the 8th until the 12th c.: they are rarely studied and yet they are essential to complete the picture of historical evolutions.

In this paper, we will discuss firstly the state of research on 4th–mid-6th c. cemeteries, particularly the few bioarchaeological analyses which are available for some sites, and secondly some of the most important research which is being developed for the later mid-6th and 7th c. (Fig. 1). Our focus will be to consider how this kind of specialist analysis can contribute to answering current historical questions.

What Can Bioarchaeological Research Tell Us about People in Late Antiquity?

The study of human bones is the most tangible source for understanding the lives and deaths of all past populations: élites in some cases, but also the vast majority of people who generally receive little attention in the written sources and are poorly represented in the material remains of late antique churches, domus, villas, castles etc. and general archaeology. Macroscopic and biomolecular analysis of skeletons can provide us with fundamental information on many different aspects, such as origins and migration, demography, physical activity, diet and health, and consequently occupation and social status, as well as the environment and climate changes and, sometimes, causes of death. This information should be analysed in relation to data on the topography and structure of the cemetery, as well as the personal objects and grave goods found in the tombs in order to understand, for example, the social status of the deceased.

1 Main Italian research groups developing bioarchaeological research on Early Medieval cemeteries are in Lombardy: C. Cattaneo and A. Mazzucchi; in Tuscany: V. Giuffra; in Emilia: M. G. Belcastro; in Piedmont: E. Bedini; in Venice: E. Bertoldi; in Rome: M. Rubini; in Puglia: S. Sublimi Saponetti.

2 Cemeteries: Possenti (2014), houses: Fresidential structures: Fronza (2011).

3 An on-going project leaded by Alexandra Chavarría Arnau has been working on a database of Late Roman/Early Medieval cemeteries to cope with this problem. An online catalogue (CAMIS geodatabase) has recently been made available on line: http://arc-med.lettere.unipd.it/CAMIS_home.html.

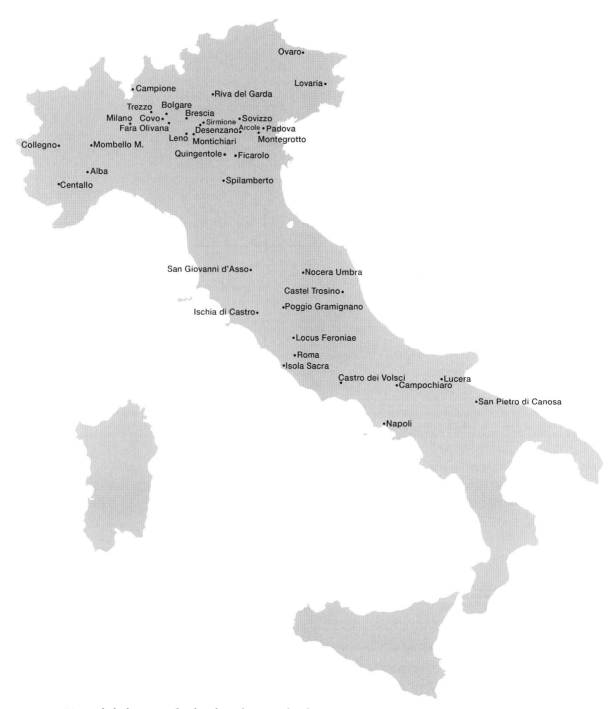

FIGURE 1 Map with the locations of archaeological sites cited in the text.
BY THE AUTHORS

Demography

A major problem in some cemeteries is the poor conservation of the bone remains, resulting in a lack of clear evidence (sexual dimorphism) for defining sex. Therefore, in many cases, there is an extraordinarily high number of skeletons of indeterminate sex.[4] For the 7th c., much demographic analysis has been based on cemeteries of the Lombard population and on burial areas linked to churches, sometimes taking into account only a part of the cemetery. In both cases, it is important to emphasize that we are only dealing with 'special' burial contexts, where the recovered skeletons represent only a small subset of the total Early Medieval population.[5]

4 See for example St. Quirico in Bolgare with 171 undetermined, 135 males and 188 females or San Pietro in Mavinas with 85 undetermined, 44 males and 20 females; Ovaro 5 males, 5 females, 4 infants and 17 undetermined; Quingentole, church of San Lorenzo 26 males, 18 females and 46 undetermined, among many other examples.

5 Giovannini (2001); Barbiera and Dalla Zuanna (2009) for example.

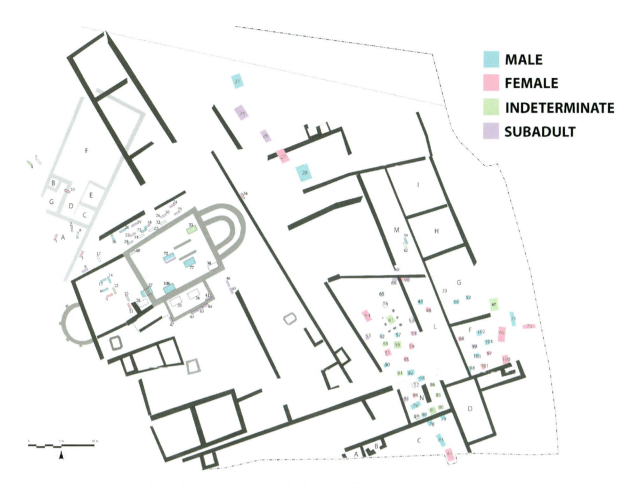

FIGURE 2 San Cassiano (Riva del Garda, Trento), Late Roman/Early Medieval church.
AMORETTI (2011), MODIFIED BY THE AUTHORS

Thus, they cannot, in our opinion, be considered a valid basis for accurately reconstructing burial rituality or demographic patterns in Early Medieval Italy.

One interesting and much-debated aspect that has emerged in recent years in northern Italy concerns the difference between the high number of males in relation to female individuals, detected in various Early Medieval Italian *necropoleis*.[6] Cultural considerations have been advanced to explain this peculiarity, such as infanticide of girls that could have led to a smaller number of adult women in Early Medieval society, or the fact that some cemeteries belong to nomadic populations in which the number of females was less. It has also been underlined that the number of deaths at birth among females could be quite high in this period.[7] In many cases, however, we must take into consideration the fact that again these are very selective contexts, such as cemeteries in churches, which could represent places reserved for a small group in the community, mainly males. Some funerary contexts in fact contain a larger number of females and subadults, such as outside the church of San Cassiano at Riva del Garda (Fig. 2)[8] or at the harbour of Classe.[9] Furthermore, it can be seen that in many cases the biological data can be misleading, taking into consideration the high number of individuals of indeterminable sex within the sample. While not suggesting a defect in the most widespread methods of sex determination, we must carefully evaluate the state of preservation of the particular skeletal remains. This can provide a better understanding of the reliability of the attributions of sex and, in particular, precisely which skeletal diagnostics were used in the determination in each case.

Valuable efforts have been made to understand the demographic composition and evolution of some Lombard cemeteries following the research developed by Jørgensen in 1992 for Nocera Umbra and Castel Trosino.[10] The majority of graveyards – e.g. Collegno, Povegliano or Spilamberto – seem to endure for two-three generations,

6 At Collegno, or Centallo, in Cuneo; cf. Bedini and Bertoldi (2004); Bedini *et al.* (1997).
7 Barbiera (2008).
8 In the northern area outside the church; Amoretti (2011).
9 Inside building 9, for example: 13 burials from which 7 are females, 4 infants and 2 males, Ferrari (2011) 67–68.
10 Jørgensen (1992); Giostra (2017a) 23.

calculated at 40 years each, and were occupied by an average of 30–40 individuals organised in extended family groups of 10–12 individuals (possibly the *farae* mentioned in written sources).[11] Other cemeteries, such as Leno (Brescia), are composed of larger groups: 70–80 individuals for each of the three generations identified in the cemetery. The largest Lombard cemetery identified in northern Italy is Sant'Albano Stura in north-western Italy where 750 graves have been unearthed.[12] After that period, these cemeteries and possibly the settlements were abandoned, a pattern which shows the nomadic and unstable character of these settlements during the first decades after the Lombard arrival in Italy.

Late Roman Diet and Environment
Multidisciplinary research combining anthropological, archaeobotanical, archaeozoological and even pottery studies, including gas-chromatography analysis, now enables the accurate reconstruction of dietary patterns and the potential to link them to transformations in environmental conditions and agricultural strategies during this period.[13] While it is clear that the extraordinary variety evident in the diet of the Roman élite was curtailed by the end of the *annona* system of state-directed food distribution and the reduction of commercial exchanges and some products, such as pigs, tended to be consumed most frequently in élite contexts – e.g. *castra* and monasteries, isotopic analysis of Roman and post-classical contexts reveal a less polarized and more regionalized picture of what the normal population ate. The study of carbon (C) and nitrogen (N) in the low status Late Roman population of the suburbs of Rome shows a wider consumption of low-quality cereals – e.g. panicum and millet – than that described in the written sources. Therefore, the picture of a wide diffusion of this type of cereals during the whole Early Medieval period was perhaps more nuanced.[14] People in general probably were poorer and ate fewer high-quality cereals (also because panicum and millet were more resistant to harvest failure, reflecting climatic deterioration),[15] but this was not specific to the period as the practice did not disappear in some regions until recent times.[16]

The comparison of diet in two similar Late Roman cemeteries, probably belonging to dependent farmers, in two different geographic but close areas, like Spilamberto, via Macchioni in Modena and Covo in Bergamo,[17] indicates that while the nitrogen levels of both cemeteries show an average consumption of meat and derivatives such as milk and cheese, there are differences in the kind of cereals consumed: C_3 plants – e.g. wheat or barley among others – were eaten in Spilamberto and C_4 – e.g. millet or panicum – in Covo. This information could reveal how the cultivation of certain cereals, and hence the diet, at the end of the Roman Empire depended also on the different climatic and environmental evolution of each microregion. Furthermore, the presence of C_3 plants in some of these predominantly C_4-consuming contexts could also indicate different social and economic status and, therefore, the élite's ability to obtain quality food.

Regarding the consumption of meat, although stable isotopes indicate animal protein in the diet, we cannot be sure if these results reflect the consumption of actual animal meat or rather a diet that included milk and cheese, which would produce a similar amount of animal protein.[18] A comparison with the archaeozoological material from the settlements to which these cemeteries belong is needed to deepen our analysis on this subject.[19] The increased stature of some skeletons in certain cemeteries cannot be considered as evidence of a general improvement in diet,[20] but, taking into account archaeological evidence such as grave goods or grave typologies, could attest to the presence of an immigrant population from central Europe and/or the privileged status of the individuals. This is suggested by specific analysis and comparisons among Lombard and autochthonous cemeteries.[21]

Late Roman Health and Diseases
From the point of view of health in individuals with similar social status, it seems evident that the living conditions deteriorated considerably in Italy after the end of the Roman Empire.[22] From a comparative study of

11 Jarnut (2002).
12 Micheletto *et al.* (2014).
13 See various papers in Chavarría Arnau (2017) for the multidisciplinary studies carried out at the site next to the cathedral of Padua. Tafuri, Goude and Manzi (2018) for research in central Italy. For the identification of millet consumption, see also Ganzarolli *et al.* (2018).
14 Killgrove (2018).
15 Castiglioni and Rottoli (2013).
16 Castiglioni and Rottoli (2013) and Bosi *et al.* (2020).

17 As a part of the Ph.D. of Maurizio Marinato, now published in Marinato (2019).
18 O'Connel and Hedges (1999).
19 A good synthesis on the development of animal consumption between Late Antiquity and the Early Middle Ages in Italy in Salvadori (2011).
20 As proposed by Barbiera and Dalla Zuanna (2009).
21 Mazzuchi, Gaudio, and Sguazza (2014) 529. These authors detect significant differences between Roman and Lombard population, for example in life expectancy (25–32 years). Lombard women also seem to be significantly taller than Roman ones (up to 7 cm).
22 In general Mazzuchi, Gaudio, and Sguazza (2014) 531.

FIGURE 3 7th c. cemetery at Bolgare (Bergamo).
BY THE AUTHOR

the Roman cemeteries of Isola Sacra near Porto, the city of Lucus Feroniae (both Roman, dated between the 1st and 3rd c. AD) and the cemetery implanted in the late antique villa of Selvicciola in Ischia di Castro (Viterbo, 7th c.), there is a marked increase in dental cavities and, more generally, a worsening of health caused by a greater consumption of carbohydrates, malnutrition and poor hygienic-sanitary conditions.[23] Other interesting examples of comparison are the late antique and Early Medieval cemeteries located in the Roman villa of Spilamberto: the 5th–6th c. population shows strong occupational stress due to very demanding physical work and a precarious state of health, while the 7th c. skeletons have a moderate state of health.[24] Here too, the difference lies not so much in the chronology, but in the social distinctions: the late antique skeletons belong to a dependent rural population, while the others, judging by the grave goods, grave typologies, and some particular rituals, belong rather to a Lombard *fara* or familiar group, recently settled in Italian territory.

Most scholars agree in linking, at least for the post-classical period, adverse climatic conditions to the development of some illnesses and the spread of pestilences mediated by malnutrition caused by food shortages. In some areas, such as the territory of Bergamo, arthritis/osteoarthritis was the most common pathology: in the cemetery of Bolgare (Fig. 3) for example, 143 individuals (33% of the entire sample) of 439 show signs related to this pathology.[25] Enthesopathies are evenly distributed between males (92 individuals) and females (88 individuals). In both cases, these illnesses are linked to cold and humid weather as well as precarious houses, both characteristics of this period. The Justinianic plague is connected, at least chronologically, to the environmental cooling of the 6th c. – the 'Late Antique Little Ice Age' – which, with successive waves, affected large areas of the Mediterranean from 541 to 700 with serious socio-economic consequences, that are still now the subject of discussion among scholars.[26] In Italy, this plague is attested by infant burials found in Naples[27] and

23 Salvadei, Ricci, and Manzi (2001); Tafuri, Goude, and Manzi (2018).
24 Marinato (2019).
25 Sguazza *et al.* (2015) 143. Both males (73 individuals) and females (57 individuals) are affected; there are also 13 individuals of undetermined sex, of these 2 are subadults (grave 139 and grave 184). Among the adults, arthritis is present in all age groups and it is equally distributed between the groups with different cranial morphologies. Upper limb is most frequently affected by arthritis (85 individuals). In addition to arthritis, signs that can be related to other pathological conditions of articular surfaces, such as rheumatoid arthritis (23 individuals), juvenile rheumatoid arthritis (10 individuals) and diffuse idiopathic skeletal hyperostosis (DISH) that probably affected 4 adults, have been observed.
26 Keller *et al.* (2019).
27 Carminiello ai Mannesi, in contexts dating back to the 6th c., where skeletal remains of *rattus rattus* were also found: Arthur (2017) 139.

those of hundreds of individuals of the 6th c. in Castro dei Volsci, 100 km south-east of Rome.[28]

In addition to the plagues, other 'seasonal' diseases could affect the population of some areas annually. Malaria, for example, appeared periodically in the areas around Rome between the end of August and the beginning of autumn.[29] It has been recognized in a child cemetery dated to the 5th c. at the villa of Poggio Gramignano at Lugnano di Teverina (Umbria). DNA analysis in one of the individuals (B36) confirmed the presence of the unicellular protozoan (*Plasmodium Falciparum*) that causes malaria, a diagnosis that could be confirmed also by the bone characteristics of children with a honeycomb structure showing clear signs of anaemia.[30] The historical connection with the withdrawal of Attila's troops in 452, fleeing from the illness, is less easy to confirm, but is certainly a fascinating question.[31] Infectious diseases are represented mainly by tuberculosis: signs of this disease have been found in the cemetery of Bolgare, at least in grave 185 (an adult female aged 23–39 years old), as well as perhaps in another three individuals (graves 93, 207, and 228).[32]

Research has also been conducted to understand if migrations could have been the cause of the spread of particular illnesses in Italy. The arrival of the Lombards in 568/569 and their brief forays into France immediately thereafter correlate well with the 569–570 human-bovine pestilence reported to have spread through much of *Italiam Galliamque*.[33] It has also been suggested that leprosy in central Italy could have re-emerged during this period, maybe linked to the presence of Avar groups.[34] Analysis on diet and disease inferred from ancient DNA in dental calculus has not yet been applied to or published on Later Roman/Early Medieval skeletons, but this is a field where considerable growth is possible.[35]

Bioarchaeological Data and Some Specific Historical Problems

The End of the Villas

Bioarchaeological analysis can provide further data on social status – mainly through the state of health, diet and physical stresses – and, therefore, aid the interpretation of the large variety of locations in which burials could be placed in Late Antiquity and the Early Middle Ages,[36] as well as provide some clues to answering still unsolved questions relating to the period. For example, what happened after the end of the villas and to whom do the burial clusters which frequently occupy some areas of these complexes belong: impoverished owners, barbarians, dependents or poorer farmers? In some of the cases which have been analyzed – e.g. Desenzano in Brescia, Montegrotto Terme in Padua, Arcole in Verona (Fig. 4), the composition of the clusters (5–10 burials comprising a more or less balanced number of men, women and children) seem to support their interpretation as low-status family units, generally practicing hard physical activity (probably agriculture) with a very low level of hygiene and personal care.[37] In other cases, the typology of the burials or the presence of particular grave-goods can point to a higher social level of the deceased, sometimes also identifiable as a non-local population with different burial traditions: Ficarolo (Rovigo),[38] Lovaria (Pradamano, Udine)[39] or Sovizzo (Vicenza)[40] among others.

A different situation is the one of Sirmione (Brescia) and its famous Roman villa known as the Grotte di Catullo (Fig. 5). In this case, the approximately 50 graves which have been discovered in the southern area of this large building belong mostly to men, a few women and a large number of infants, indicating a high level of infant mortality.[41] The identification of these people as soldiers, perhaps living in the ruins of the nearby villa of Via Antiche Mura, relies on some of the grave-goods, including bronze crossbow fibulae,[42] as well as the historical context of the peninsula where the villa was located, which was fortified and became a Late Roman castrum.[43] The élite occupants of the castrum lived in a monumental stone building identified in the area of

28 Rubini (2008) and Arthur (2017) 139.
29 Shaw (1996) and more generally for southern Italy for the Roman period, Marciniak (2016).
30 See Montagnetti *et al.* (2020).
31 Soren (2003); Harper (2017) 85–88.
32 Sguazza, Mazzucchi, Fortunati *et al.* (2015) 143.
33 Marius of Avenches, *Chronica* 238 quoted in Newfield (2013) 98–99, 111.
34 Donoghue *et al.* (2015); Rubini and Zaio (2009) on the basis of the cemetery in Campochiaro, Molise.
35 For previous periods, see Weyrich *et al.* (2017).

36 Burials in churches, burials in open air cemeteries, dispersed burials or small clusters in private or public abandoned buildings among the most common ones, see Chavarría Arnau (2018a and 2018b).
37 Marinato (2007).
38 Busing Kolbe (1997); Uggeri (2002).
39 Buora (1993); Buora (1996).
40 Rigoni, Hudson, and La Rocca (1988).
41 Bolla (1996); Bolla (2018) 312.
42 Bolla (2018) 313.
43 Brogiolo (2018).

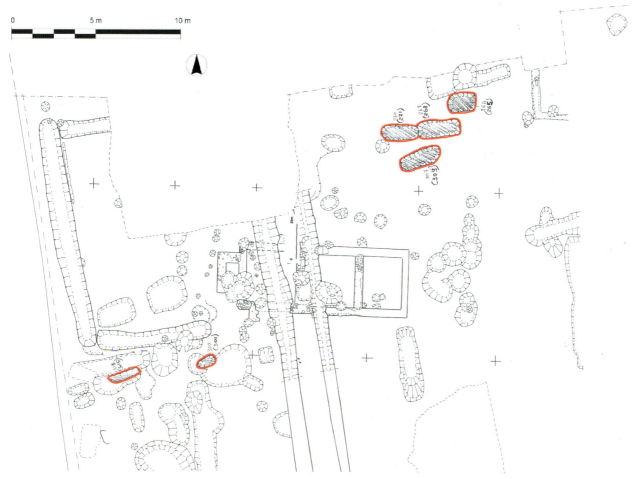

FIGURE 4 Specific area of the villa at Arcore (Verona) where a cluster of early medieval burials was documented (from Marinato (2007) with modifications). 50 graves were unhearthened from the ruins of the villa (in the northern area of the Peninsula).
BY THE AUTHOR

Cortine, and were buried in the nearby church of San Pietro in Mavinas, a building that began to be used for privileged burials in the 6th c. and continued to be used by Lombard aristocracies in the 7th c.[44]

Churches and Burials in Late Antiquity

Many Late Roman and Early Medieval churches were occupied at one point or another by burials, although it is not clear whether all churches were conceived initially as burial places and who had access to a church grave. In the urban context, this question is explored in another paper published in this volume.[45] A clear hierarchical distinction in the use of church spaces for burials can be identified thanks to bioarchaeology, with a higher proportion of male adults occupying privileged spaces, such as the presbytery (generally occupying the eastern part of the building) and nearby areas,[46] but also within the inner space of the churches more generally.[47] Significant differences in their health status depending on their location can also be seen.

Particularly interesting is the study of the different contemporary burial areas at the site of San Giusto (Lucera, Foggia) in south-eastern Italy. There, a large ecclesiastical complex linked to productive activities has been carefully analysed,[48] demonstrating a connection between better health, higher social status and increasing prominence of burial area (Fig. 6). In the funerary basilica and in the narthex (room preceding the entrance), the tombs belong mainly to adult male burials with a reasonable state of health possibly belonging to the ecclesiastical hierarchy. Those buried in the north aisle show low degrees of intensity of the

44 For the interpretation of this site, see Brogiolo (2018). For the church of San Pietro in Mavinas, see Breda *et al.* (2011), including the analysis of grave goods by E. Possenti. Some reflections on the use of the church as burial space, Chavarría Arnau (2012).

45 See Chavarría Arnau in this volume.

46 For example, behind the apse in San Lorenzo di Quingentole (Mantova), see Dal Poz *et al.* (2001).

47 See Chavarría Arnau (2018b).

48 Sublimi Saponetti, Emanuel, and Scatarella (2005) for the study of the cemeteries. Volpe identifies this site as a rural bishopric established in an imperial property and developing mostly during the 5th and 6th c. (Volpe (1998); (2011)).

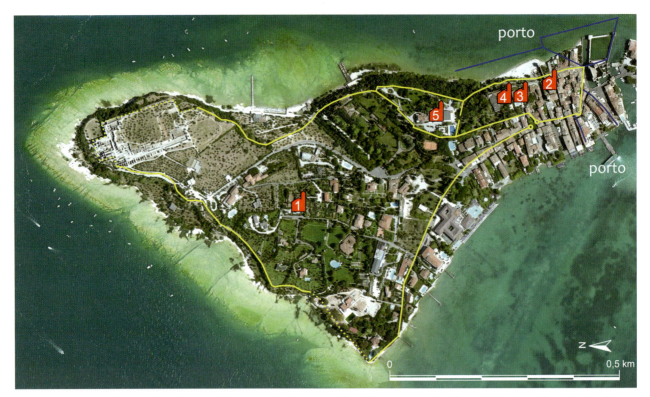

FIGURE 5 Sirmione (Brescia) aerial photo of the site with indication of the different areas: 1 San Pietro in Mavinas; 2 Santa Maria; 3 San Martino; 4. San Salvatore; 5 San Vito.

bone enthesis, together with a high percentage of bone biomass that would depict a sedentary condition and good nutritional diet from childhood. The individuals buried in the south aisle, on the other hand, are characterized by harder physical work, with poorer nutritional intake. Less wealthy individuals, buried outside the church between the baptistery and the baths, reveal a greater incidence of cavities, dental loss in their lifetime, and a high percentage of severe dental wear. These are all parameters that indicate a lack of hygienic-sanitary conditions in a socially disadvantaged nucleus that consumed mainly raw cereals and, to a lesser extent, tubers, roots and more raw foods. Among the particular diseases identified in this sector, there is a case of brucellosis, a disease contracted through the consumption of milk and derivatives of infected animals that was very common in the agricultural-pastoral world. Chronic pathologies include porotic hyperostosis, present in 53% of observable burials, particularly among individuals buried in the church and within production environments at the site. The causes can be found in a lack of iron in the diet through a low intake of meat and legumes, some parasites contracted through close contact with domestic animals and also in malaria, perhaps linked to congenital hemopathies, such as thalassemia, very frequent among groups settled near marshy areas with high malaria incidence.

With respect to the 8 Late Roman men buried inside the church of San Cassiano at Riva del Garda (Trentino) at the end of the 5th or the first half of the 6th c. (Fig. 2), anthropological study of stress markers show signs of horse-riding, making it less likely that the inhumed were the priests of the church, as might have been expected.[49] In fact, the dimensions of the church and the complexity of its liturgical arrangements, which include a synthronon or priest's throne and a monumental *loculus* for relics, point rather to some kind of public enterprise, with the interred men probably belonging to the highest, perhaps military, local élite of this community.[50] Women were buried in the outside cemetery: they were located first in the northern area, while later they occupy the space in front of the church. The limited number of burials and the building dimensions could indicate also a private character for the oratory of St. Quirico in Bolgare (Bergamo) (Fig. 3), measuring 4.5 × 12 m, and containing 7 graves, including one infant aged about 1 year, a 12-year-old child, 2 men and 2 women aged about 30 to

49 Amoretti (2011).
50 Chavarría Arnau (2012).

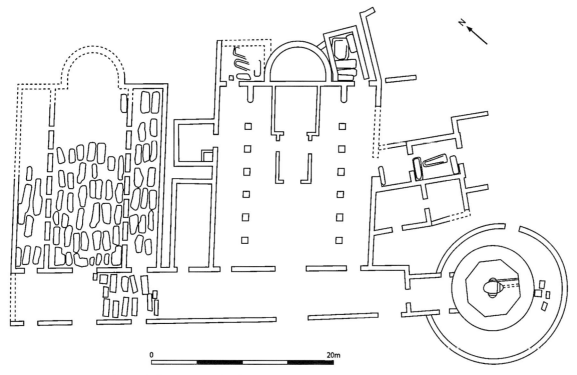

FIGURE 6 San Giusto (Foggia) Christian complex during the 6th c. (Volpe (1988) 204).

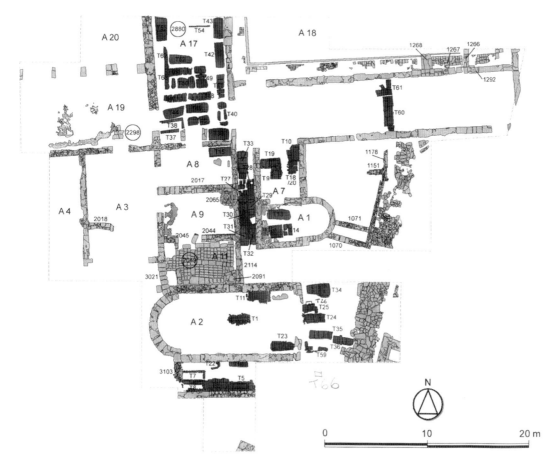

FIGURE 7 Suburban church of San Pietro di Canosa (Barletta) (Volpe *et al.* (2007) 1159 fig. 2).

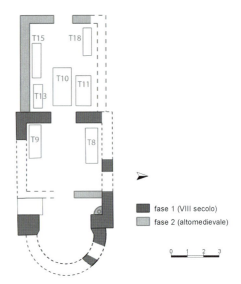

FIGURE 8
San Zeno di Campione (Como) (from Blockley, Caimi, Caporusso *et al.* (2005)).

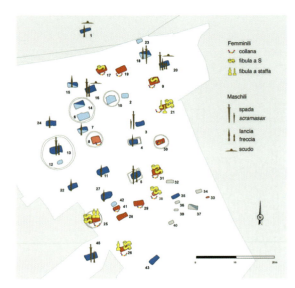

FIGURE 9A
Lombard cemeteries of Szólád (Hungary).

40 years.[51] A frequently quoted example is that of the church of San Zeno di Campione (Como), with at least 15 burials belonging to three generations of the same family, starting with that of the founder, a Lombard slave merchant called Gunduald at the end of the 7th c., up to the last – a certain Totone – who was still alive in 807 when he gave the building to the church of St. Ambrose in Milan (Fig. 8).[52]

The different functions of churches must always be considered because these parish churches, pilgrimage centres, private family chapels, or churches linked to fortifications among other possibilities could lead to different dynamics in their burial usage. A particular case of this is the cemetery at the late antique church of San Pietro in Canosa (Barletta-Andria-Trani, Fig. 7), where the palaeopathological analysis of 49 subjects of 60 recovered highlighted an abnormal palaeopathological situation. Both the frequency and severity of the pathologies could support the hypothesis that the site, due to the presence of Bishop Sabino and then his mortal remains, constituted "a sort of medieval Lourdes, where incurable patients flocked to seek healing".[53] The presence of an individual subjected to a surgical operation to the skull has been linked to the presence of some sort of hospital structure or *xenodochium*, which was not infrequent in suburban martyrial complexes. Another problem related to Late Roman churches, to which bio-archaeological analysis can make an important contribution, is the interpretation of multiple burials. The reuse of a grave linked to a church is obviously related to the prestige of being buried close to or inside a religious building because of the presence of relics (*ad sanctos*) or the intrinsic value of the masses performed in the building for the afterlife. But do shared tombs belong to family groups which were buried in the same grave, or were graves being used in relation to different strategies?

Scattered Urban Burials

As has already been discussed in another paper published in this volume, scattered burials were placed inside the original limits of the majority of the ancient cities, particularly from the 6th c. onwards, often related to abandoned private and public buildings.[54] Palaeopathological studies regarding isolated Early Medieval burials in urban contexts linked to public buildings reused for production activities, such as metallurgy or pottery manufacturing, seem to confirm Brogiolo's identification of this population as servants or at least individuals with a very poor state of health.[55] At Brescia, the people buried in the area of the Capitolium temple, a public building transformed into the craft district in the Early Middle Ages, died young and had signs of malnutrition.[56] In Verona, 18 inhumations dated to between the 6th and the 8th c. found in the ruins of the Capitolium again showed signs (*criba orbitalia* and *criba cranii*) of possible protracted nutrition deficiency, as well as signs of precarious life conditions showed by lines of hypoplasia of the enamel found in some individuals.

51 Mazzucchi *et al.* (2009); Sguazza *et al.* (2015).
52 Blockley *et al.* (2005).
53 Sublimi Saponetti, De Nicola, and Scattarella (2010) 173.

54 See Chavarría Arnau in this volume.
55 Brogiolo (1994) 560. On these problems see also Chavarría (2020) with further examples.
56 Mazzuchi *et al.* (2014) and also see Brogiolo (1997) for the context and interpretation.

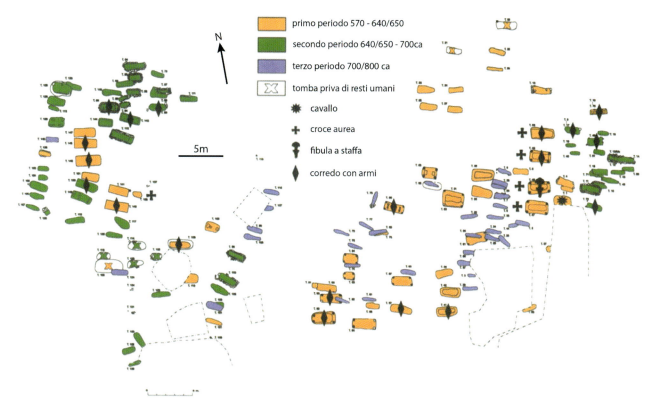

FIGURE 9B Lombard cemeteries Collegno (Torino) (from Amorim *et al.* (2018); Giostra (2019)).

In rural contexts, the difference in status between free men and servants, as reported by the written sources, can be identified not only on the basis of tomb types and grave-goods, the distribution and centrality of the graves in the cemetery[57] or particular physical stresses such as by horse riding, but now also by DNA analysis which has identified marginal graves in large Lombard cemeteries as those of Mediterranean people (possibly Romans) in contrast to the central European (Lombard) graves.[58]

New Biomolecular Research on Lombard Migrations
As noted at the start of this paper, scholarly attention in northern Italy has focused above all on Lombard burials and their material culture and recent publications include notable syntheses, monographs on Early Medieval Lombard contexts[59] and their cemeteries and bioarchaeological research, including investigation of DNA and stable isotopes.[60] DNA analysis carried out by a large international research group directed by Patrick Geary in the cemetery of Collegno (Torino) and Szólád in Hungary (see fig. 9) has identified two different genetic groups, one coming from central Europe and the other with Mediterranean origins. This divide also appeared in burial practices: central Europeans were in general buried with weapons and rich grave-goods and occupy the central areas of both cemeteries, while Mediterranean people seem to correspond to the poorer graves located at the margins of the burial area. Furthermore, strontium isotopic data show clear mobility of individuals belonging to the central European area (Figs. 10–11).[61] While waiting for a wider number of cemeteries to be published, these results seem to support the most 'traditional' hypothesis of ethnic identification of individuals through their material culture and confirm a connection between social and biological identity,[62] although first reactions to these interpretations have already been published.[63]

At Povegliano (Verona), a cemetery with 224 individuals, preliminary strontium analysis (24 teeth, 2 bones and 4 soil samples) has established that at least 8 individuals buried with grave-goods dated to the first

57 Giostra (2017b) 62.
58 Amorim *et al.* (2018).
59 General volume with synthesis and papers on particular cemeteries: Possenti (2014). Monographs on Lombard specific cemeteries: Collegno: Pejrani (2004) and Pejrani (2007); Mombello: Micheletto (2007); Spilamberto: Breda (2010); Trezzo sull'Adda: Lusuardi Siena and Giostra (2012); Cividale S. Mauro: Ahumada Silva (2010); Sant'Albano Stura: Micheletto *et al.* (2014), among others.
60 For DNA see now the papers published by Giostra (2019), as well as Vai *et al.* (2019). For stable isotopes Marinato (2018); (2019).
61 Bedini *et al.* (2012); Alt *et al.* (2015); Amorim *et al.* (2018); Geary and Veerahmar (2016); Geary (2019).
62 See Giostra (2011) for the whole historiographical discussion with a complete bibliography.
63 Brather (2016).

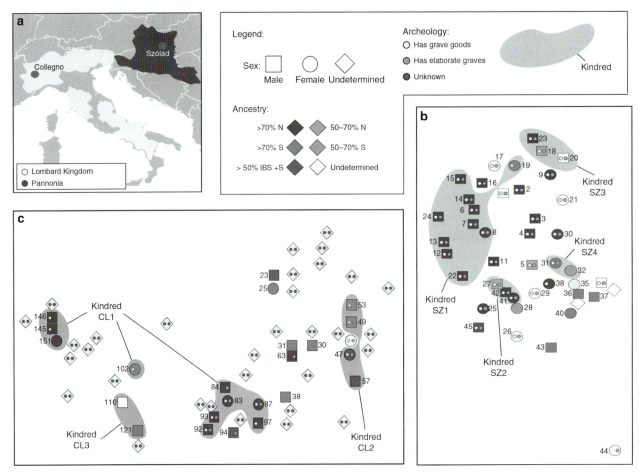

FIGURE 10 Isotopic data comparison between the cemeteries of Szólad and Collegno (from Amorim *et al.* (2018)).

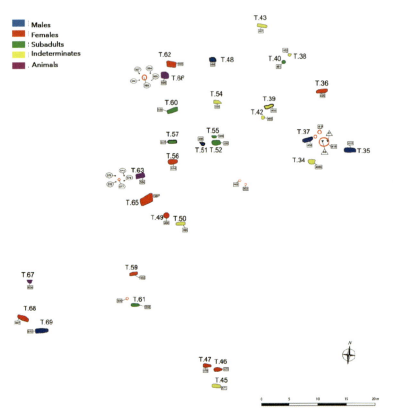

FIGURE 11 Plan of the early medieval cemetery from Spilamberto (Marinato (2019)).

FIGURE 12 Non-metrical dental traits study at Fara Olivana and Montichiari.
LAMANNA (2018)

phase of the cemetery were of non-local provenance and, therefore, have been tentatively identified as migrants of the first generation of Lombards entering Italy.[64] Tracing the origins of individuals through strontium values is, however, still very problematic because it depends on the geological characterization of soils which are widespread in different areas of Europe. No mapping of the distribution of the relationship between 87Sr/86Sr for Italian soils is available. Therefore, it is very difficult to compare results on human values in different areas in order to verify mobility both over long-distances (European areas) and short (other areas in northern Italy).[65] The analysis of carbon and nitrogen isotopes in different cemeteries shows, on the other hand, that generally, the Lombard population presents a diet based on C3 plants/high-quality cereals.[66]

At the Lombard cemetery of Spilamberto (Fig. 11) strontium analysis has also shown value differences in three female individuals, revealing how these women probably came from a different area with respect to the group. This seems to confirm what written sources already document about an intense mobility of women through different regions during this period due to political alliances or abduction in raids.[67] A similar interpretation has been proposed for one female individual at Povegliano whose isotopic signature shows that her geochemical region is a great distance from all the other individuals analysed in the cemetery i.e. locals and supposed Lombard immigrants. She is, therefore, interpreted in terms of individual female mobility, probably in connection with exogamy. The position of the grave in the central area of the cemetery and close to two immigrant males and an infant with rich grave goods could possibly connect this female with the leading family that founded the cemetery.[68]

This data, as well as information about the genetic origins of Early Medieval Italian populations, can also be obtained from the study of non-metrical dental traits and, therefore, from phenotype analysis. This method has found important applications in other contexts but has been rarely applied to human skeletons from this period.[69] Specific frequencies of non-metrical dental traits[70] can be compared to available data from other European and non-European skeletal samples. In relation to the grade of genetic affinity among these populations, it is possible to estimate their relative

64 Francisci *et al.* (2020).
65 On these problems, see Marinato (2019).
66 Marinato (2019); Chavarría and Marinato (2021).
67 Amorim *et al.* (2018); Hakenbeck (2011); La Rocca (2011).
68 Francisci *et al.* (2020).
69 Coppa *et al.* (2007); Hanihara (2008).
70 Turner, Nichol, and Scott (1991); Scott and Irish (2017).

biological distance, obtaining information about the geographic origin, provenance, migration dynamics and genetic ties between ancient communities. This method has been applied to some Early Medieval cemeteries (Montichiari – Monte San Zeno, Brescia and Fara Olivana, Bergamo) in order to evaluate genetic variability within male and female groups in each cemetery. It can also confirm if females, being more 'mobile', are also more genetically variable and if this variability can be observed and measured on the basis of the observation of the phenotype.[71] Results suggest the existence of two different – yet coeval – post-marital residence models: the first, represented by the warrior group of Fara Olivana, is patrilocal; the other, represented by the group of Montichiari (Fig. 12), is matrilocal. It is noteworthy that the duality of post-marital dynamics seems to be related to differences in material culture, as reflected by grave goods in each cemetery.

In southern Italy, interesting studies have also identified an Avar population, a nomadic group appearing in Europe from central Asia in the 6th c., possibly entering Italy with Lombard troops and settling in areas bordering on Byzantine territory, as documented by written sources.[72] Of particular interest are the cemeteries of Vicenne and Morrione (Campobasso), which seem to belong to a homogeneous Avar group, but other individuals with characteristic cranial features – both natural and artificial – have also been detected at sites such as San Giusto.[73] The military lifestyle of this Early Medieval nomadic population is evident from the violent lesions on some individuals: two skeletons show injuries to the skull probably produced by weapons characteristic of the Byzantine army, the spiked bat and the battle axe. The advanced scarring of these wounds shows that these individuals survived the injuries for a long time. Another man, however, although the wound does not appear to have been fatal, died shortly after, perhaps because he was also ill with leprosy, evident in the nasal cavities and acro-osteolysis in the bones of the hands and feet.[74] In the cemetery of San Giusto, the skeleton buried in grave 53 died from a fatal injury perhaps caused by the characteristic 'three wing arrow' linked to Avar soldiers.

Finally, at the church of San Martino di Ovaro (Udine), the presence of a Slavic population, whose settlement in this area during the end of the 6th c. is described by Paul the Deacon, has been identified from particular burial practices involving the use of fire. Interestingly, it seems that immigrants shared the funerary area with the local population, but anthropological analysis and particularly ergonomic deformations show different uses of the body to carry loads and a dissimilar diet (identified by trace element analysis), with slightly higher consumption of animal protein by Slavic individuals.[75]

Problems and Perspectives

As in other countries, bioarchaeological analysis has flourished in Italy during recent years and many regions can rely on specialist groups developing many kinds of sophisticated studies relating to health and disease of Early Medieval populations. An important development has been a close collaboration between anthropologists and archaeologists and a growing number of archaeo-anthropologists, who have become an essential component in any archaeological team working in cemeteries in order to prevent the loss of important information during the excavation phases. Both have helped the moving on from the publication of particular 'anecdotal' pathological cases (which was the norm until the 2000s) to studies which link health and disease to the broader environmental, economic and political picture. However, recording and publication of cemeteries is still frequently inadequate and the data and vocabulary used are too heterogenous to compare information from different cemeteries. Single graves or small *necropoleis* are rarely published. Online databases cataloguing cemeteries in all their aspects and complexity using standard vocabularies are urgently needed.[76]

There are still several important practical problems concerning the study of ancient populations: the state of conservation of the material is not always ideal due to the acidity of many soils, causing difficulties in not only obtaining enough collagen from bones (necessary for DNA and isotopes analysis), but also in identifying general paleopathologies due to the fragmentary condition of the bones. Many analyses have to rely, therefore, on teeth, with a loss of information. Bad conservation also prevents clear identification of sex and age data which make demographic analysis difficult. Dating is – as in many other aspects of medieval archaeology – still an unsolved question as no systematic radiocarbon analysis is generally performed on the material, so the results

71 Non-metrical traits of the teeth, cf. Lamanna (2018) for first results, a synthesis of the author's Ph.D. discussed in March 2019.
72 Paul the Deacon, *HL* 5.29.
73 Rubini (2011); Rubini and Zaio (2011); Sublimi Saponetti *et al.* (2008).
74 Rubini and Zaio (2009).
75 For this church and its cemetery see Cagnana (2011).
76 An attempt has been developed by our team in the CAMIS geodatabase (see footnote number 3) which, however, relies on published information that frequently is very incomplete.

tend to be very vague for Late Roman and Early Medieval periods, causing great difficulty in understanding the evolution of burial practices. Grave goods, at least for the 4th–5th c., are generally lacking and multiple depositions tend to complicate the identification of the sequence of burial in the absence of accurate excavation of the remains. Fundamentally, future research must take into account the social and economic meaning and context of the cemetery or cemeteries under study, an aspect which is of great importance for the interpretation of the results and their contextualization into the wider framework of the period.

Acknowledgements

Research on this paper was funded by the University of Padua (Progetto di Ateneo 2012 – Bird: 2019–2021 PI: Alexandra Chavarría Arnau and STARS Fellowship Project PI: M. Marinato). Sections 1, 3.1–3.2.3.3 and 4 were written by Alexandra Chavarría, sections 2 and 3.4 by Maurizio Marinato. The paragraph on non-metrical dental traits was written by Leonardo Lamana.

Bibliography

Primary Sources

Paul the Deacon, *HL* = W. D. Foulke transl., *Paul the Deacon, Historia Langobardorum* (Philadelphia 1906).

Secondary Sources

Ahumada Silva, I. (2010) *La collina di San Mauro a Cividale del Friuli. Dalla necropoli longobarda alla chiesetta basso medievale* (Florence 2010).

Alt K. W. *et al.* (2014) "Lombards on the move: an integrative study of the migration period cemetery at Szólád, Hungary", *PLoS ONE* 9.11 (2014) https://doi.org/10.1371/journal.pone.0110793.

Amoretti V. (2011) "San Cassiano nel popolamento della piana di Riva: analisi antropologiche", in *Nuove ricerche sulle chiese altomedievali del Garda*, ed. G. P. Brogiolo (Mantua 2011) 125–31.

Amorim C. E. G. *et al.* (2018) "Understanding 6th-century barbarian social organization and migration through paleogenomics", *Nature Communications* 9 (2018) https://doi.org/10.1101/268250.

Arthur A. (2017) "Environmental archaeology and Byzantine Southern Italy", in *A Most Pleasant Scene and an Inexhaustible Resource. Steps Towards a Byzantine Environmental History*, edd. H. Baron and F. Daim (Mainz 2017) 137–47.

Barbiera I. (2008) "Il mistero delle donne scomparse. Sex-ratio e società nel medioevo italiano", *Archeologia Medievale* 35 (2008) 491–501.

Barbiera I. and Dalla Zuanna G. (2009) "Population dynamics in Italy in the Middle Ages: new insights from archaeological findings", *Population and Development Review* 35.2 (2009) 367–89.

Bedini E. *et al.* (1997) "Paleobiologia del gruppo umano altomedievale della chiesa cimiteriale di Centallo (Cuneo)", in *L'Italia centro-settentrionale in età longobarda*, ed. L. Paroli (Florence 1997) 345–64.

Bedini E. and Bertoldi F. (2004) "Aspetto fisico, stile di vita e stato di salute del gruppo umano", in *Presenza longobarda a Collegno nell'altomedioevo*, ed. L. Pejrani Baricco (Turin 2004) 217–34.

Bedini E. *et al.* (2012) "Per una conoscenza dei Longobardi in Italia: primi risultati delle analisi genetiche su individui provenienti di necropoli del Piemonte", in *VI Congresso Nazionale di Archeologia Medievale (L'Aquila 2012)* (Florence 2012) 448–51.

Blockley P. *et al.* (2005) "Campione d'Italia. Scavi archeologici nella ex chiesa di San Zeno", in *Carte di Famiglia – Strategie, rappresentazione e memoria del gruppo familiare di Totone di Campione (721–877)*, edd. S. Gasparri and C. La Rocca (Rome 2005) 29–80.

Bolla M. (1996) "Le necropoli delle ville romane di Desenzano e Sirmione", in *La fine delle ville romane: trasformazioni nelle campagne tra tarda antichità e alto medioevo. I Convegno Archeologico del Garda*, ed. G. P. Brogiolo (Mantua 1996) 51–70.

Bolla M. (2018) "Le necropoli", in *Sirmione in età tardoantica. Il territorio del comune della preistoria al medioevo*, ed. E. Roffia (Milan 2018) 310–33.

Bosi G. *et al.* (2020) "Archaeobotanical evidence of food plants in Northern Italy during the Roman period", *Vegetation History and Archaeobotany* https://doi.org/10.1007/s00334-020-00772-4.

Brather S. (2016) "New questions instead of old answers: archaeological expectations of DNA analysis", *Medieval Worlds* 4 (2016) 22–41.

Breda A. (2010) *Il tesoro di Spilamberto. Signori Longobardi alla frontiera* (Modena 2010).

Breda A. *et al.* (2011) "San Pietro in Mavinas a Sirmione", in *Nuove ricerche sulle chiese altomedievali del Garda*, ed. G. P. Brogiolo (Mantua 2011) 33–66.

Brogiolo G. P. (1994) "La città longobarda nel periodo della conquista (569-in VII sec.)", in *La storia dell'alto medioevo italiano alla luce dell'archeologia*, edd. R. Francovich and G. Noyé (Florence 1994) 555–66.

Brogiolo G. P. (1997) "Le sepolture a Brescia tra tarda antichità e prima età longobarda (ex IV–VII secolo)" in

L'Italia centro-settentrionale in età longobarda, ed. L. Paroli (Florence 1997) 413–24.

Brogiolo G. P. (2018) "Nuove storie da Sirmione raccontate dall'archeologia", in *Sirmione in età tardoantica. Il territorio del comune della preistoria al medioevo*, ed. E. Roffia (Mailand 2018) 9–12.

Buora M. (1993) "Lovaria (Comune di Pradamano) Scavo di un edificio romano a destinazione agricola e di una necropoli altomedievale", *Quaderni Friulani di Archeologia* 3 (1993) 162–63.

Buora M. (1996) "(UD, Pradamano) Lovaria. 1995–1996", in *Schede 1995–1996*, ed. Nepoti S. *Archeologia Medievale* 23 (1996) 556–58.

Busing Kolbe, A. (1997) "Sei anni di ricerche archeologiche a Gaiba Ficarolo", *Padusa* 31 (1997) 7–10.

Cagnana A. (2011) *Lo scavo di San Martino di Ovaro (sec. V–XII). Archeologia della cristianizzazione rurale nel territorio di Aquileia* (Mantua 2011).

Castiglioni E. and Rottoli M. (2013) "Broomcorn millet, foxtail millet and sorghum in north Italian Early Medieval sites", *European Journal of Post-Classical Archaeologies* 3 (2013) 131–44.

Chavarría Arnau A. (2012) "Cimiteri altomedievali: alcune riflessioni in merito a due scavi recenti di chiese gardesane", *Hortus Artium Medievalium* 18 (2012) 189–200.

Chavarría Arnau A. (2017) *Ricerche sul centro episcopale di Padova (scavi 2011–2012)* (Mantua 2017).

Chavarría Arnau A. (2018a) "People and landscapes in Northern Italy: interrogating the burial archaeology of the Early Middle Ages", in *Interpreting Transformations of Landscapes and People in Late Antiquity*, edd. P. Diarte-Blasco and N. Christie (Oxford 2018) 163–78.

Chavarría Arnau A. (2018b) *Archeologia delle Chiese. Dalle origini all'anno Mille*, Nuova edizione (Rome 2018b).

Chavarría A. (2020) 'Il contributo delle analisi bioarcheologiche allo studio della stratificazione sociale in Italia tra Tardoantico e alto Medioevo', *Archeologia Medievale* 47 (2020) 321–32.

Chavarría Arnau A. and Marinato M. (2021) 'Dieta e Privilegio: Riflessioni sulla diversità alimentare nel consumo di cereal in Italia settentrionale tra tardoantico e alto medioevo', in *Sepolture di prestigio nel bacino Mediterraneo*, edd. P. de Vingo *et al.* (Firenze 2021) 51–62.

Coppa A. *et al.* (2007) "Origins and spread of agriculture in Italy: a nonmetric dental analysis", *American Journal of Physical Anthropology* 133 (2007) 918–30.

Dal Poz M. *et al.* (2001) "Paleobiologia della Popolazione altomedievale di San Lorenzo di Quingentole, Mantova", in *S. Lorenzo di Quingentole. Archeologia, Storia e Antropologia*, ed. Manicardi A. (Mantua 2001) 151–98.

de Vingo P. (2014) 'Longobard Lords in Central Emilia: the cemetery of Spilamberto (Modena – Northern Italy)', in *Necropoli longobarde in Italia. Indirizzi della ricerca e nuovi dati*, ed. E. Possenti (Trento 2014) 163–87.

Donoghue H. D. *et al.* (2015) "A migration-driven model for the historical spread of leprosy in medieval Eastern and Central Europe, infection, genetics and evolution", *Journal of Molecular Epidemiology and Evolutionary Genetics in Infectious Diseases* 31 (2015) 250–56.

Ferrari D. (2011) "Spazi cimiteriali, prattiche funerarie e identità nella città di Classe", *Archeologia Medievale* 38 (2011) 59–74.

Francisci G. *et al.* (2020) "Strontium and oxygen isotopes as indicators of Longobards mobility in Italy: an investigation at Povegliano Veronese", *Scientific Reports* 10 (2020) 116–78.

Fronza V. (2011) "Edilizia in materiali deperibili nell'alto medioevo italiano: metodologie e casi di studio per un'agenda della ricerca", *European Journal of Post-Classical Archaeologies* 1 (2011) 95–138.

Ganzarolli G. *et al.* (2018) "Direct evidence from lipid residue analysis for the routine consumption of millet in Early Medieval Italy", *JAS* 96 (2018) 124–30.

Geary P. (2019) "The use of ancient DNA to analyse population movements between Pannonia and Italy in the sixth century", in *Le migrazioni nell'Alto Medioevo, Atti della LXVI Settimana del Centro di Studi sull'Alto Medioevo (Spoleto 2018)* (Spoleto 2019) 45–62 (Italian version published as: "Tracciare la migrazione longobarda attraverso il DNA nucleare", in *Migrazioni, Clan, Culture. Archeologia, Genetica, Isotopi Stabili* (Archeologia Barbarica 3), ed. Giostra C. (Mantua 2019) 35–49.

Geary P. and Veerahmar K. (2016) "Mapping European population movement through genomic research", *Medieval Worlds* 4 (2016) 65–78.

Giostra C. (2011) "Goths and Lombards in Italy: the potential of archaeology with respect to ethnocultural identification", *European Journal of Post-Classical Archaeologies* 1 (2011) 7–36.

Giostra C. (2017a) "Temi e metodi dell'archeologia funeraria longobarda in Italia", in *Archeologia dei Longobardi. Dati e metodi per nuovi percorsi di analisi,* ed. C. Giostra (Mantua 2017) 16–41.

Giostra C. (2017b) "Verso l'aldilà: i riti funerari e la cultura materiali", in *I Longobardi. Un popolo che cambia la storia*, edd. G. P. Brogiolo, F. Marazzi, and C. Giostra (Mailand 2017) 61–67.

Giostra C. (2019) *Migrazioni, Clan, Culture. Archeologia, Genetica, Isotopi Stabili* (Archeologia Barbarica 3) (Mantua 2019).

Giovannini F. (2001) *Natalità, mortalità e demografia dell'Italia medievale sulla base dei dati archeologici* (Oxford 2001).

Hakenbeck S. (2011) *Regional and Ethnic Identities in Early Medieval Cemeteries in Bavaria* (Florence 2011).

Hanihara T. (2008) "Morphological variation of major human populations based on nonmetric dental traits", *American Journal of Physical Anthropology* 136 (2008) 169–82.

Harper K. (2017) *The Fate of Rome. Climate, Disease and the End of an Empire* (Princeton 2017).

Jarnut J. (2002) *Storia dei Longobardi* (Turin 2002).

Jørgensen L. (1992) "Castel Trosino and Nocera Umbra. A chronological and social analysis of family burial practices in Lombard Italy (6th–8th cent A.D.)", *Acta Archaeologica* 62 (1992) 1–58.

Keller M. et al. (2019) "Ancient *Yersinia pestis* genomes from across Western Europe reveal early diversification during the First Pandemic (541–750)", *PNAS* 116 (2019) 12363–72.

Killgrove C. (2018) "Using skeletal remains as a proxy for Roman lifestyles. The potential and problems with osteological reconstructions of health, diet and stature in Imperial Rome", in *Diet and Nutrition in the Roman World*, edd. C. Holleran and P. Erdkamp (London 2018) 245–58.

Lamanna L. (2018) "Il canino mandibolare con doppia radice come indicatore di parentela nei cimiteri antichi. Il caso studio della necropoli altomedievale di Montichiari, Monte San Zeno (BS)", *European Journal of Post-Classical Archaeologies* 8 (2018) 243–51.

La Rocca C. (2011) "La migrazione delle donne nell'alto medioevo tra testi scritti e fonti materiali primi spunti di ricerca", in *Archeologia e storia delle migrazioni. Europa, Italia, Mediterraneo fra tarda età romana e alto medioevo*, edd. C. Ebanista and M. Rotili (Cimitile 2011) 65–83.

Lusuardi Siena S. and Giostra C. (2012) *Archeologia medievale a Trezzo sull'Adda. Il sepolcreto longobardo e l'oratorio di san Martino. Le chiese di Santo Stefano e San Michele in Sallianense* (Mailand 2012).

Marinack S. et al. (2016) "Plasmodium falciparum malaria in 1st–2nd century CE southern Italy", *Current Biology* 26.23 (2016) R1220–R1222.

Marinato M. (2007) *Studio antropologico e paleontologico del sito altomedievale di Arcole (Vr)* (Thesis triennale, Univ. of Padua 2007).

Marinato M. (2018) "Potenzialità di un approccio multidisciplinare per lo studio del popolamento antico: il territorio di Bergamo tra tarda antichità e altomedioevo", in *Città e campagna: culture, insediamenti, economia (secc. VI–IX)* (Archeologia barbarica 2), ed. C. Giostra (Mantua 2018) 75–96.

Marinato M. (2019) *Mobilità, alimentazione e salute nelle popolazioni dell'Italia settentrionale tra tardoantico e altomedioevo. L'approccio bioarcheologico* (Mantua 2019).

Mazzucchi A., et al. (2009) "La necropoli di S. Chierico a Bolgare. Studi antropologici e paleopatologici", *Notizie archeologiche bergomensi* 17 (2009) 87–156.

Mazzuchi A., Sguazza E., and Steffenini D. (2014) "Le indagini antropologiche: alta mortalità infantile e popolazione disagiata", in *Un luogo per gli Dei. L'area del Capitolium a Brescia*, ed. F. Rossi (Brescia 2014) 487–95.

Mazzuchi A., Gaudio D., and Sguazza E. (2014) "Aspetti antropologici, paleopatologici e musealizzabili dei Longobardi in Lombardia", in *Necropoli longobarde in Italia. Indirizzi della ricerca e nuovi dati. Atti del convegno internazionale, 26–28 settembre 2011 (Castello del Buonconsiglio, Trento)*, ed. Possenti E. (Trento 2014) 528–35.

Micheletto E. (2007) *Longobardi in Monferrato. Archeologia della 'Iudiciaria Torrensis'* (Chivasso 2007).

Micheletto E. et al. (2014) "Due nuove grandi necropoli in Piemonte", in *Necropoli longobarde in Italia. Indirizzi della ricerca e nuovi dati. Atti del convegno internazionale, 26–28 settembre 2011 (Castello del Buonconsiglio, Trento)*, ed. E. Possenti (Trento 2014) 96–117.

Montagnetti R. et al. (2020) "New research in the Roman villa and late Roman infant and child cemetery at Poggio Gramignano (Lugnano in Teverina, Umbria, Italy)", *European Journal of Post-Classical Archaeologies* 10 (2020) 279–302.

Newfield T. P. (2013) "Early medieval epizootics and landscapes of disease: the origins and triggers of European livestock pestilences, 400–1000 CE", in *Landscapes and Societies in Medieval Europe: Interactions between Environmental Settings and Cultural Transformations (Papers in Medieval Studies)*, edd. S. Kleingartner, T. P. Newfield, S. Rossignol et al. (Toronto 2013) 73–113.

O'Connell T. C. and Hedges R. E. M. (1999) "Investigations into the effect of diet on modern human hair isotopic values", *American Journal of Physical Anthropology* 108 (1999) 409–425.

Pejrani Baricco L. (2004) *Presenze longobarde. Collegno nell'Alto Medioevo* (Turin 2004).

Pejrani Baricco L. (2007) "Il Piemonte tra Ostrogoti e Longobardi", in *I Longobardi. Dalla caduta all'impero all'alba dell'Italia, Catalogo della Mostra (Torino-Novalesa, 2007–2008)*, edd. G.P. Brogiolo and A. Chavarría Arnau (Turin 2007) 255–67.

Possenti E. (2014) *Necropoli longobarde in Italia. Indirizzi della ricerca e nuovi dati. Atti del convegno internazionale, 26–28 settembre 2011 (Castello del Buonconsiglio, Trento)* (Trento 2014).

Rigoni M., Hudson P., and La Rocca C. (1988) "Indagini archeologiche a Sovizzo. Scavo di una villa rustica romana e di una necropoli longobarda", in *La Venetia dall'Antichità all'alto medioevo* (Rome 1988) 229–41.

Rubini M. (2011) "Gli Àvari europei. Quei guerrieri venuti dall'est", *Archeologia Viva* 148 (2011) 72–75.

Rubini M. (2018) "La terribile peste di Giustiniano", *Archeologia Viva* 28 (2018) 50–55.

Rubini M. and Zaio P. (2009) "Lepromatous leprosy in an early medieval cemetery in Central Italy (Morrione, Campochiaro, Molise, 6th–8th century AD)", *JAS* 36 (2009) 2771–79.

Rubini M. and Zaio P. (2011) "Warriors from the East. Skeletal evidence of warfare from a Lombard-Avar cemetery in Central Italy (Campochiaro, Molise, 6th–8th Century AD)", *JAS* 38 (2011) 1551–59.

Salvadei L., Ricci F., and Manzi G. (2001) "Porotic hyperostosis as a marker of health and nutritional conditions during childhood: Studies at the transition between Imperial Rome and the Early Middle Ages", *American Journal of Human Biology* 13 (2001) 709–17.

Salvadori F. (2011) "Zooarcheologia e controllo delle risorse economiche locali nel medioevo", *European Journal of Post-Classical Archaeologies* 1 (2011) 195–244.

Scott G. R. and Irish J. D. (2017) *Human Tooth Crown and Root Morphology: The Arizona State University Dental Anthropology System* (Cambridge 2017).

Sguazza E. et al. (2015) "The necropolis of Bolgare (Lombardy, Italy). Anthropological and paleopathological features of a Lombard population", *HOMO* 66 (2015) 139–48.

Shaw B. D. (1996) "Seasons of death: aspects of mortality in Imperial Rome", *JRS* 86 (1996) 100–138.

Soren D. (2003) "Can archaeologists excavate evidence of malaria?", *World Archaeology* 35.2 (2003) 193–209.

Sublimi Saponetti S., Emanuel P., and Scatarella V. (2005) "Paleobiologia di un campione scheletrico proveniente del complesso paleocristiano di San Giusto (Lucera, V–VI secolo)", in *Paesaggi e insediamenti rurali in Italia meridionale fra Tardoantico e Altomedioevo*, ed. G. Volpe (Bari 2005) 315–28.

Sublimi Saponetti S., Scattarella V., and Cassano R. (2008) "Paleobiologia di una sepoltura terragna della seconda metà del V sec. d.C. rinvenuta nel battistero del piano di San Giovanni a Canosa, Bari", *International Journal of Anthropology Numero Speciale, Atti XVII Congresso AAI* (2008) 256–68.

Sublimi Saponetti S., De Nicola L., and Scattarella V. (2010) "Relazione tra morte e aree sacre: paleopatologia di un campione scheletrico dal sito tardoantico di San Pietro a Canosa (Bari)", in *Paessaggi e insediamenti urbani in Italia meridionale*, ed. G. Volpe (Bari 2010) 167–74.

Tafuri M. A., Goude G. and Manzi G. (2018) "Isotopic evidence of diet variation at the transition between classical and post-classical times in Central Italy", *JAS* 21 (2018) 496–503.

Turner C. G., Nichol C. R., and Scott G. R. (1991) "Scoring procedures for key morphological traits of the permanent dentition: the Arizona State University dental anthropology system", in *Advances in Dental Anthropology*, edd. M. A. Kelley and C. S. Larsen (New York 1991) 13–31.

Uggeri G. (2002) *Carta archeologica del Territorio Ferrarese (F.° 76)*, Journal of Ancient Topography – Rivista di Topografia Antica Supplemento I (Galatina 2002).

Vai S. et al. (2019) "A genetic perspective on Lombard era migrations", *European Journal of Human Genetics* 27 (2019) 647–56.

Volpe G. ed. (1998) *San Giusto. La villa, le ecclesiae. Primi risultati dagli scavi nel sito rurale di San Giusto (Lucera): 1995–1997* (Bari 1998).

Volpe G. (2011) "Vagnari nel contesto dei paesaggi rurali dell'Apulia romana e tardoantica", in *Vagnari. Il villaggio, l'artigianato, la proprietà imperiale*, ed. A. M. Small (Bari 2011) 345–68.

Weyrich L. S. et al. (2017) "Neanderthal behaviour, diet, and disease inferred from ancient DNA in dental calculus", *Nature* 544 (2017) 357–61.

Treatment of the Body

∴

"To Make the Unseen Seen": Organic Residue Analysis of Late Roman Grave Deposits

Rhea C. Brettell, Eline M. J. Schotsmans, William H. C. Martin, Ben Stern and Carl P. Heron

Abstract

The concept that invisible molecular traces may remain in grave deposits, the often discarded 'dirt' from substantial mortuary containers, is not widely appreciated. Organic residue analysis of samples from Late Roman (2nd–4th c. AD) burials in Britain has revealed their potential to retain diagnostic biomarkers. Alongside the analysis of visible residues from similar continental burials, these results confirm that resinous substances were employed in the treatment of the dead throughout the Roman Empire. Deposited in close proximity to the body, they masked the reality of decay, signified the status of the deceased and promoted memorialisation. These findings, in conjunction with the sampling approach and methodology detailed here, have important implications for future mortuary research in the late antique period and beyond.

Introduction

For the majority of archaeologists, sight is the most important of the senses.[1] The ability to distinguish slight colour variations, observe fine textural differences, and recognise key shapes and regularities are vital attributes in the recovery of traces of human activity in the archaeological record. But what if those traces are of biological origin and can no longer be perceived with the naked eye or even differentiated from soil organic matter by microscopy? How can we discover what, of significance, remains? This is the realm of the organic residue analyst, a branch of archaeological science based around knowledge of organic chemistry, natural products, taphonomic processes, and the use of instrumental techniques, principally gas chromatography-mass spectrometry (GC-MS). Here, invisible evidence retained at the molecular scale within the fabric of ceramic vessels or in matrices such as soils and sediments can be extracted and analysed.[2] Identification of the class, range, and relative abundance of the compounds present (e.g., alkanes, alkanols, carboxylic acids, wax esters, sterols, stanols, hopanes, and/or terpenoids) can provide valuable insights into input source(s): plant oil, animal fat, natural wax, faecal material, petroleum product or resinous exudate (Fig. 1).[3] Moreover, when suites of biomarkers (compounds of limited biological origin) are recovered, a more precise determination of taxonomic and/or geographic provenance can be achieved.[4]

The nature of visible residues adhering to stone tools, cooking pots or storage containers, fragmentary materials recovered from floor levels or substances deposited in mortuary contexts can, of course, also be illuminated.[5] This holds true even when complex mixtures such as Egyptian mummy balms or perfumed unguents are being evaluated.[6] In such cases, the collection of the necessary samples does not, generally, present a problem. It is when time and diagenetic processes have acted to comminute or otherwise transform organic materials, rendering them invisible, that difficulties arise. How can excavators be expected to recognise the importance of what, simply put, appears to be dirt? When should they consider the possibility that molecular evidence of diagnostic value may survive? Clearly, it would be ridiculous to suggest that soil/sediment samples from every mortuary context should be collected for analysis. This would be impossible in terms of logistics (i.e., time, transportation, storage), prohibitively expensive with respect to analysis (i.e., chemicals, instrument use, interpretation of results) and, most importantly, pointless. In the vast majority of cases, all that tends to remain in the molecular record are generic traces of plant and animal input sources.[7] Thus, it is the responsibility of those who are familiar with this field of research to supply guidance for the benefit of all concerned.[8]

This paper, which details recent research regarding the treatment of the dead in Late Roman Britain, serves as an example of the potential and limitations of applying organic residue analysis to grave deposits. The findings have significant implications for the investigation of late antique burial practices, while the methodology

1 The quotation in the title is from Lewis (1965).
2 Evershed (2008); Historic England (2016).
3 Colombini and Modugno (2009); Evershed (1993).
4 E.g. bitumen from a specific seep, resin from a certain botanical genus; Connan (2012); Mills and White (1977).
5 Evershed (2008); Regert *et al.* (2008); Stern *et al.* (2003).
6 Buckley and Evershed (2001); Colombini *et al.* (2009); Mathe *et al.* (2004); Stacey (2011).
7 Brettell (2016) 135–279.
8 Cf., Modugno and Ribechini (2009); Evershed (1993); Historic England (2016).

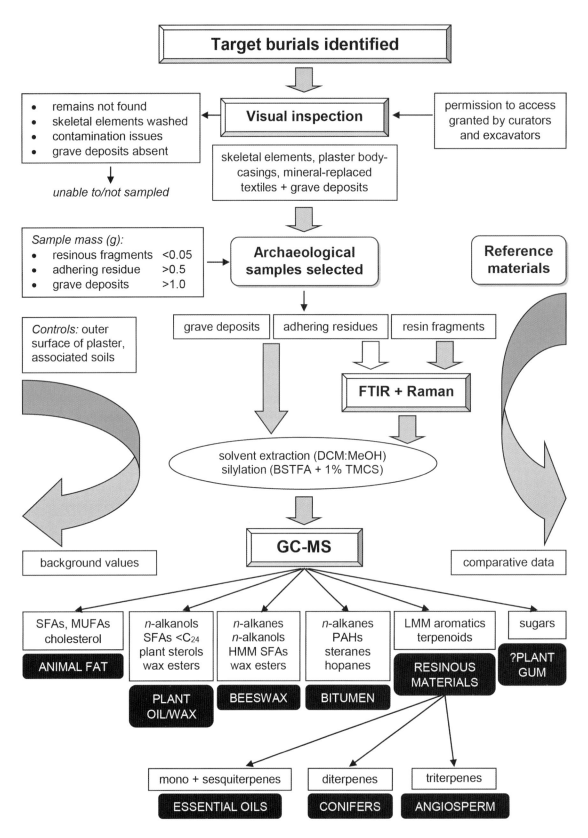

FIGURE 1 Sample protocol developed and employed during research into the recovery of molecular evidence from Roman mortuary contexts in Britain.

has broader relevance within the archaeological mortuary sphere.

Research Background

Literary Evidence

> Who could give true account of the rites and gifts of the funeral procession? There, crowded together in a long train, flow the spring produce of Arabia and Cilicia, Sabaean flowers and the flame-feeding Indian harvests, incense carried from Palestinian shrines, and Hebrew essences, Corycian saffron, and myrrh; her body lies on a high bier, veiled by silk, and Tyrian purple.[9]

Insights into the treatment of the dead in the Roman world can be gleaned from surviving primary sources. Piecing together this information, it appears that, soon after death was established, perfumed oils were applied to the body: 'the corpse is next washed, anointed with the choicest unguents … crowned with fresh flowers and laid out in sumptuous raiment'.[10] Resinous woods and exudates were burnt as torches and incense around the funerary couch, on which the deceased might be displayed for up to seven days. Aromatic substances were piled on the bier and even fashioned into effigies: 'a large image of Sulla, himself … was moulded out of costly frankincense and cinnamon'.[11] If the individual was cremated, these fragrant natural products seem to have been burnt with the body in a display of conspicuous consumption: 'a costly pyre heaped with incense to give off a rich smoke of eastern perfumes'.[12] In addition, resinous materials (and other votive offerings) might be deposited in the tomb so that the cremated remains should not be consigned 'unscented to the urn'.[13] The treatment of the body with balms and lading of the bier with scented substances also appears to have been deemed appropriate when the individual was inhumed. This is supported by descriptions of the treatment of Poppaea (AD 65, Rome), the wife of Nero, who was 'stuffed with spices and embalmed in the manner of foreign potentates',[14] the funeral procession of Priscilla (late 1st c. AD, Rome) with its long list of exotic 'gifts' (cited above), which seemingly ended with her inhumation[15] and the assertion that the remains of the young man anointed with unguents were destined to 'presently decay, or, if such is your … pleasure, be consumed with fire'.[16] The ultimate fate of any accompanying aromatics remains unclear, however, as they could have been burnt at the graveside rather than being interred with the deceased.

These tantalising glimpses suggest that plant products, in particular resinous exudates, played a significant role in the Roman mortuary sphere. Nonetheless, there are a number of problems with these passages. The majority come from works of poetry, date around the turn of the first millennium and were penned by elite males working within the milieu of Rome. The accuracy of the details provided and relevance of these descriptions to mortuary practices elsewhere in the Roman world, both geographically (beyond the confines of the city itself) and chronologically (once inhumation became the dominant method of disposal) remain, therefore, a matter of considerable debate. That such questions are worth pursuing is indicated by comments in later sources, which imply that this body treatment was more widespread and continued into the Late Roman period and beyond, at least within the Eastern Roman Empire. They include the account of the embalming of the Emperor Justinian I (565 AD) 'with honey, balsams, unguents, and incense' in Constantinople,[17] passages from the New Testament regarding the anointing of Jesus,[18] and complaints voiced by the Christian Fathers about the persistence of pagan symbols as part of burial practices. The latter illustrated by St. Augustine's scathing comment (4th c. AD): 'If a rich man is buried with perfumes, he may delay bodily corruption but will he not still decay?'[19]

Archaeological Traces

The possibility that traces of this mortuary practice might remain in the archaeological record is found in reports of exceptional body preservation in Roman period inhumation burials (outside of Egypt). Many of these accounts, regarding examples from continental Europe, have been catalogued by Chioffi with further instances identified by Reifarth.[20] As with the literary evidence, the majority derive from Rome and its environs (including the funerals of Poppaea and Priscilla, mentioned above). Moreover, only 11 of the archaeological finds specifically mention the presence of aromatic substances with three, additional, references to 'embalmed' remains and one to a box containing various ointments (Table 1). All of these individuals had

9 Stat., *Silv.* 5.1.208–15.
10 Lucian *Luct.* 11.
11 Plut. *Sull.* 38.2.
12 Luc. 8.729.
13 Pers. 6.34.
14 Tac., *Ann.* 16.6.
15 Stat. *Silv.* 5.1.228–31.
16 Lucian *Luct.* 18.
17 Chioffi (1998) 23.
18 ESV (2009) Matt. 26.6–12; Mark 14.3–8, 16.1; Luke 23.56–24.1; John 19.39–40.
19 August. *Serm.* 177. 7.
20 Chioffi (1998); Reifarth (2013).

been interred in sarcophagi and placed within mausolea or vaulted tombs. The majority had been dressed in elaborate garments, wrapped in shrouds or textile bandages and/or provided with high quality grave goods. The presence of plaster was noted in 5 instances, while many of the descriptions imply that the resinous substances were closely associated with the body and textiles. In one case, the well-preserved remains of a sub-adult female discovered in 1485 near the *Via Appia Antica*, Rome, an attempt was made to identify the materials employed. Evaluation of the thick casing of transparent substances applied to the body indicated the use of a gum-resin mixed with plant oils.[21]

TABLE 1 Reported examples of embalming or mummification from continental Europe, compiled from data collected by Chioffi (1998).

Catalogue number	*Find date/* Location	Date (c. AD)	Sex/Age	Container	Description of body treatment
2	*1507*. Rome, Vatican. Presbytery of Constantine.	?2nd–3rd	Sub-adult.	Marble sarcophagus with sealed lid. Inscription.	Embalmed body sprinkled with a liquid mixture. Thick layer of 'hardening' substances around the limbs. Dressed in a robe woven with gold.
3	*1544*. Rome, Vatican. Mausoleum of Honorius.	Late 4th–early 5th	Young adult (Mary, wife of Honorius).	Red porphyry sarcophagus with lid.	Wrapped in robes of gold tissue. High quality grave goods including a box containing various ointments and amulets.
9	*1731*. Rome, Via Cassia. Vaulted tomb near roadside.	?1st	Adult female (Attia) ?2 children.	Marble sarcophagus with lid.	"Fragrant unguents and perfumes had scented the body". Jewellery, amulet?, gold hair net. Hair preserved.
10 Analysed	*1964*. Rome, Via Cassia. [*Ascenzi et al. 1996*]	2nd	c. 8 year old girl ('Grottarossa girl').	Marble sarcophagus with lid. Decorated.	Artificial mummification including embalming. Extensive soft tissue preservation. Jewellery, make-up items, ivory 'doll'.
11–12	*16th c. AD*. Rome, Via Cassia.	Late 1st–2nd	11: adult female 12: sub-adult.	11: marble sarcophagus with lid. Gilded interior.	Partially gilded (face and hands), embalmed 'Egyptian style', possibly with painted portrait mask (Toynbee 1996: 42). 12: was also a gilded mummy but embalming not mentioned.
13	*1967*. Rome, Via Labicana-Casilina. Under mound.	'Augustan age'	Adult male.	Marble sarcophagus with lid. False window.	Wrapped in leather and encased in preservatives. Resinous substances and plaster reported. Body poorly preserved.
15–29 x1 analysed	*1914–1939*. Rome, via Appia Antica. Catacomb of *San Sebastiano*. 10 sarcophagi and other containers. [*Mitschke & gen. Schieck 2012*]	2nd–5th	16: adult male. 17: young female. 21: ? 25: female.	Marble sarcophagus. Decorated. Marble sarcophagus. Decorated. Slab-lined. Some sections re-used. Divided sarcophagus. Paired plaster burial.	16: plaster and aromatic resinous substances, areas still semi-fluid and others solidified to create a casing. 17: thin layer of plaster, sprinkled with hydrocarbon-based substances and wrapped in textiles with gold threads. 21: thin layer of plaster, sprinkled with balsamic substances and wrapped in bandages/shroud. Traces of gold threads. 25: 'embalmed', layer of plaster over abdomen, wrapped in linen shroud/bandages. Strewn with herbs. Hair present.

21 Myrrh, frankincense and aloes are suggested with, possibly, cedar and olive oil, Chioffi (1998) 66–67.

TABLE 1 Reported examples of embalming or mummification from continental Europe, compiled from data collected by Chioffi (*cont.*)

Catalogue number	*Find date/* Location	Date (c. AD)	Sex/Age	Container	Description of body treatment
30 **Analysed in 1400s**	*1485*. Rome, via Appia Antica. Above ground monument. Reburied on Pope's orders.	2nd–3rd	Sub-adult female.	Marble sarcophagus with sealed lid.	Coated with thick casing of transparent substances. Soft tissue/appearance preserved but quickly deteriorated. Analysis indicated gum-resins mixed with cedar and olive oil.
31	*16th c. AD*. Ferento, Etruria.	7th c. BC	Adult female.	Sarcophagus.	Referred to as 'embalmed'. Bronze utensils, copper, terracotta and glass vessels. Next to male with iron weapons.
33	*1756*. Lugdunum, Gaul (Puy-de-Dôme, France).	?3rd	Male. 10–12 years old.	Granite sarcophagus with inner lead-liner.	'Perfectly' preserved, soft tissue and organs present. 'Balsamic' substances over the body, shroud, linen bandages.
34–36	*1912–1962*. Carnuntum (Petronell, Austria) and Aquincum, Pannonia (Budapest, Hungary).	3rd–4th	1 undetermined. 3 females.	Sarcophagus. Slab-lined graves. Probably plaster burials.	Originally described as artificially desiccated with saline. Textiles soaked in resin mentioned. One with a painted portrait mask. High quality textiles, footwear and grave goods. Plant remains.
38	*1970* Callatis, Moesia (Mangalia, Romania). Monument under a circular mound in Greco-Roman necropolis.	2nd–3rd	Female c. 50 years old. Pyxis holding ×2 teeth of the deceased.	Marble sarcophagus with mortar-sealed gabled lid and inner wooden coffin.	Described as preserved by resin. Hair and soft tissue present. Laid on mattress/foliage (twigs, charred debris and resin fragments). Dressed in a decorated tunic. Wrapped in a shroud. Veil over face/chest. Footwear (×6 pairs). High quality grave goods. Plant remains.

Unusual residues in Roman period mortuary contexts are, likewise, noted in a small number of accounts from Britain. The antiquarian Gage reported that aqueous liquids, some mixed with what appeared to be organic matter, were recovered from various cremation urns.[22] Chemical examination, during the 1800s, of white residues from two such cremation burials (Bartlow Hills, Cambridgeshire; Weston Turville, Buckinghamshire) indicated that both materials were gum-resins.[23] In addition, observations that "a coating of gum … which retained an aromatic and pleasant smell"[24] was present in a plaster burial from Dartford, Kent and that the remains of a child interred in a sarcophagus near Glaston, Leicestershire "exuded a pleasant odour like scented disinfectant,"[25] suggested that some form of body treatment involving plant exudates might also have been introduced into the province. It was not until 1993, however, that more reliable evidence for this practice was obtained when a lead-lined coffin was discovered near Arrington, Cambridgeshire. Excavated under laboratory conditions, traces of plaster, and "numerous pieces of aromatic resin, still smelling distinctly of incense"[26] were recovered. Analysis confirmed that these were, indeed, resinous in nature, although their botanical source was not identified. This find sparked fresh interest in Ramm's ideas, as subsequently developed by Sparey Green, concerning the role of plaster and presence of resinous substances in Roman mortuary contexts in northern Europe.[27]

22 Described as "oleaginous" at Litlington, Hertfordshire, Gage (1836) 19 and as "unctuous" at Withersfield, Cambridgeshire, Gage (1836) 314.
23 Gage (1834); Waugh (1962).
24 Dunkin (1844) 93.
25 Webster (1950) 72.
26 Taylor (1993) 194.
27 Ramm (1971); Sparey Green (1977).

TABLE 2 Details of Roman period inhumations from continental Europe containing resinous substances with results of the chemical analysis of visible organic residues.

Find location	Publications	Date c. AD	Brief details	Results of chemical analysis
Rome. Italy. Via Appia Antica.	Cited in Chioffi 1998	2nd–3rd	12–15 year old female in sarcophagus with marble lid.	Gum-resins (e.g. frankincense or myrrh). Aloes also suggested. Cedar oil and olive oil.
Rome. Italy. Via Latina, Grottaferrata.	Ghini et al. 2005	2nd	18 year old, *Carvilius Gemellus*, in a marble sarcophagus accompanied by well-preserved floral offerings.	Traces of myrrh pollen and pine products reported (residue analysis mentioned but precise method unclear).
Rome. Italy. Via Appia Antica. Hypogeum of *San Sebastiano*.	Mitschke & gen. Schieck 2012	2nd–3rd	Adult ?male in marble sarcophagus.	Cinnamic acid and *p*-hydroxy cinnamic acid. Balsamic resin suggested (although no terpenic compounds are mentioned).
Rome. Italy. Via Cassia, Grottarossa.	Ascenzi et al. 1993	2nd	c. 8 year old girl possibly interred in decorated marble sarcophagus.	Sesquiterpenes and abietic acid derivatives indicative of the presence of a conifer resin. Egyptian-style mummification?
Rome. Italy. Catacombs of *Santi Marcellino e Pietro*.	Devièse 2008 Devièse et al. 2010, 2017	2nd–3rd	Multiple burials within pits, wrapped in shrouds, gypsum present. Amber.	Diterpenoids indicative of *Tetraclinis articulata* (sandarac). Triterpenoids characteristic of *Boswellia* spp. gum-resins.
Milan. Italy. Necropolis of the *Università Cattolica*.	Bruni & Guglielmi 2005 Bruni & Guglielmi 2014	3rd–4th	'Lady of the sarcophagus', young adult female in gneiss sarcophagus.	Triterpenoids characteristic of *Pistacia* spp. resin.
Milan. Italy. Basilica of *St. Ambrogio*.	Bruni & Guglielmi 2014	4th	Remains of *ss. Ambrogio, Gervasio e Protasio* in porphyry sarcophagus.	Triterpenoids characteristic of *Pistacia* spp. resin.
Thessaloniki, Greece. Eastern cemetery.	Papageorgopoulou et al. 2009	3rd	Mature adult female in marble sarcophagus with inner lead coffin.	Range of fatty acids with sesqui-, di- and triterpenoids indicative of scented unguent or oil.
Naintré, Gaul (Poitou-Charentes, France).	Devièse 2008 Devièse et al. 2011	3rd	Adult female and 12 year old child in sarcophagi within 2 vaulted tombs.	*Boswellia* spp. (frankincense) and *Pistacia* spp. (mastic) on and around both bodies. Black substance interpreted as *Boswellia* spp. bark located above the remains.
Anché, Gaul (Indre-et-Loire, France).	Devièse 2008	2nd–4th	Adult female and 12 year old child in stone sarcophagi.	Pinaceae and frankincense with the adult. *Pistacia* spp. resin with the child.
Trier, Rhineland (Germany). Crypt of St. Maximin's.	Reifarth 2013	4th	Individuals of all ages and both sexes in stone sarcophagi in crypt.	Pinaceae, *Pistacia* spp., balsamic resin (GC-MS); gums and gum-resins? (FTIR)
Iovia, Pannonia (Heténypuszta, Hungary).	Reifarth 2013	2nd–4th	Sarcophagus from the Roman period south-eastern cemetery.	'Thermoanalysis' indicated pine and frankincense. GC-MS of a double burial confirmed Pinaceae and *Pistacia* spp. resins.
Palmyra, Syria. Tomb of Atenatan.	Reifarth 2013	1st–3rd	Sarcophagus burial from the tomb of Atenatan.	Mixture of gum and a balsam? due to presence of cinnamic acid and related compounds.

Analytical Proof

Since the 1990s, visible residues recovered from 2nd–4th c. AD inhumation burials in continental Europe have been subject to modern methods of analysis (Table 2). The first of these finds to be assessed were the remains of a sub-adult female discovered at Grottarossa, Rome in 1964. Probably interred in a marble sarcophagus during the 2nd c. AD, she had been wrapped in textiles and equipped with high quality (gold, ivory, and amber) artefacts.[28] Evaluation of the plant remains present revealed pollen from a range of species including conifers and an African *Commiphora* spp. (myrrh). Chemical analysis of the substances applied to the skin, silk cloth, and linen bandages indicated that a conifer (Pinaceae) resin had formed part of the mixture.[29] Similar evidence for *Commiphora* spp. pollen and conifer products was obtained from the tomb of 18 year old Carvilius Gemellus, who had been placed in a decorated marble sarcophagus within a subterranean chamber at Grottaferrata, just outside Rome.[30] Residues from the catacombs have, likewise, been analysed. A marble sarcophagus from the Christian hypogeum of San Sebastiano was found to contain skeletal remains on a "bed of powdery ... material ... [and]... covered with a hard, smooth substance of reddish or black colour".[31] GC-MS analysis of a single fragment indicated that an unguent containing cinnamates (from an essential oil or balsamic exudate) may have been applied to the body. Most recently, definitive data for the presence of resinous substances has been obtained from the catacomb of Santi Marcellino e Pietro.[32] Here, certain chambers had been filled with individually shrouded inhumations that had been stacked in rows and encased in gypsum. Human hair, textile fragments, gold thread, and a pair of gold earrings were recovered alongside crystalline materials. Analysis of the latter demonstrated that sandarac (from *Tetraclinis articulata*), frankincense (*Boswellia* spp. gum-resin), and fragments of amber (a fossil diterpenoid resin) were present.

Beyond the confines of Rome, an intact burial from the necropolis of the Università Cattolica, Milan, termed the Lady of the Sarcophagus, revealed "masses of a spongy material having a deep yellow colour"[33] around her cranium and between the femora. Originally assumed to be frankincense, detailed investigation using Fourier Transform Infrared Spectroscopy (FTIR) and GC-MS demonstrated that this was, in fact, *Pistacia* spp. (mastic/terebinth) resin. Likewise, a large lump of 'frankincense' found in 1864 in a sarcophagus containing the remains of three saints and archived in the basilica of St. Ambrogio, Milan was, upon analysis, shown to derive from the genus *Pistacia*.[34] Elaborate burials and body treatments have also been observed in Greece and France. In 1962, the partially mummified remains of a mature adult female interred in a sarcophagus were recovered from the eastern cemetery, Thessalonica, Greece. Subsequent analysis of loose particles and residues adhering to the hair revealed compounds characteristic of plant exudates. Although the botanical sources were not established, these appear to represent the application of an embalming unguent.[35] More recent discoveries in France of a vaulted double tomb at Naintré, near Poitiers and of two stone sarcophagi with inner lead coffins near Anché in the Loire Valley have permitted multi-analytical examination of their contents. Organic residue analysis revealed that both individuals, an adult female and a child, at Naintré, had been interred with frankincense (*Boswellia* spp.) and mastic (*Pistacia* spp.) while, at Anché, *Pistacia* spp. resin was present with the child and a combination of *Pistacia* spp., conifer (Pinaceae), and *Boswellia* spp. exudates with the adult female.[36]

Finally, Late Roman mortuary practices in Trier, Germany were subject to a similar comprehensive investigation.[37] Organic residues adhering to the remarkably well-preserved textiles (Fig. 2) were collected from 21 sarcophagi from the 'coemeterialbasilika' of St. Maximin, a glass vessel and the sarcophagus of a child from the abbey of St. Matthias, and from the tomb of St. Paulinus. Interred in the 4th c. AD, many of these individuals were members of the senatorial elite and/or officers at the court of the Emperor Constantine I, while some, at least, were Christians according to their epitaphs.[38] These samples, alongside materials from a sarcophagus burial, Heténypuszta (Iovia), Hungary, the tower tomb of Atenatan, Palmyra, Syria and Burial 530, Poundbury, Dorchester, UK were analysed using multiple techniques. The chemical data from Trier indicated the presence of complex mixtures of oils/fats accompanied, in many cases, by plant exudates. Those confirmed by GC-MS consisted of conifer and *Pistacia* spp. resins

28 Ascenzi *et al.* (1996); Toynbee (1996) 42.
29 Pollen analysis, Ciuffarella *et al.* (1998); residue analysis, Ascenzi *et al.* (1996).
30 Ghini *et al.* (2005).
31 Mitschke and gen. Schieck (2012) 126–27.
32 Details of excavation and human remains, Blanchard *et al.* (2007) and Kachi *et al.* (2014); analysis of white inorganic matter Devièse *et al.* (2010); residue analysis, Devièse *et al.* (2017).
33 Bruni and Guglielmi (2014) 615.
34 Bruni and Guglielmi (2005); Bruni and Guglielmi (2014).
35 Papageorgopoulou *et al.* (2009).
36 Devièse (2008); Devièse *et al.* (2011).
37 Reifarth (2013).
38 Reifarth (2009).

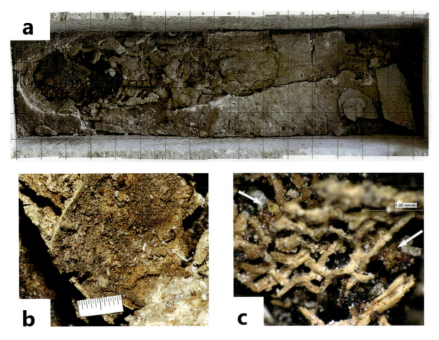

FIGURE 2 Late Roman sarcophagus burial, Grave 107, St. Maximin, Trier, Germany. a. the skeletal remains encased in gypsum; b. associated textiles embedded with resin (macroscale); c. embedded resin fragments (microscale, 100 mm/div).
IMAGES COURTESY OF NICOLE REIFARTH

with indications of a possible balsamic resin. Likewise, evidence of Pinaceae and *Pistacia* spp. resins was found in the double burial from Hungary, while aromatic substances, which have yet to be securely identified, impregnated the textiles from Palmyra and Poundbury.[39]

Roman Britain

Project Rationale

The evidence from continental Europe demonstrated that resinous substances were, indeed, deposited in Late Roman inhumation burials and that this practice extended into the provinces. These finds also indicated the type of mortuary context (i.e., more substantial containers) in which visible organic residues may have survived. Nonetheless, only a small number of sites were represented with most of the 'resin burials' associated with cities which had acted as Imperial capitals (Rome, Milan, and Trier) or formed part of the eastern empire (Thessalonica and Palmyra), with its long-standing traditions for the ritual use of plant exudates.[40] Thus, a number of key questions remained. Could the deposition of resinous substances with the dead have been more widespread in the Roman world? How embedded were these actions in the cultural fabric of the north-western provinces? Might molecular traces survive in the absence of visible residues to help address these issues? Late Roman mortuary practices in Britain provided an appropriate context for such research since they were sufficiently defined (in space and time) to enable a systematic study of extant sarcophagus and lead-lined coffin burials to be undertaken. Moreover, molecular evidence for plant exudates in such contexts could be attributed, with some confidence, to archaeological sources as only one native species, *Pinus sylvestris* (Scots pine), readily produces a resin and then not in any significant abundance.[41] Problems with the recovery of visible residues could, likewise, be predicted due to inclement environmental conditions (e.g., high levels of precipitation) and the absence of upstanding mortuary structures. In addition, the extent to which Roman culture permeated society in the remote province of *Britannia* has long been a matter for debate with its impact on the minutiae of daily living (and dying) considered by many to have been more superficial than elsewhere in the Roman Empire.[42] Proof of the deposition of exotic resinous exudates in mortuary contexts across the province would, therefore, have important implications for the significance of these substances

39 Reifarth (2013) molecular evidence from Trier 91–114, Hungary, Syria and Poundbury 460–504.
40 Cf. Groom (1981); Plin. *HN* 13.1–2.
41 Howes (1949) 109.
42 Mattingly (2006) 3–22.

Sample Selection

195 samples and controls (#1 fragments of resinous appearance; #2 residues from cremation urns; #1 solvent wash of preserved hair; #40 residues adhering to skeletal elements; #46 residues associated with plaster or mineral-replaced textiles; #78 grave deposits; #27 soil/sediment samples) were collected from two multi-container cremation burials and 70 inhumation burials in Britain dated between the 2nd–4th c. AD. Of the latter, 39 represented individuals accorded more elaborate rites than the norm (stone sarcophagi, lead-lined coffins and/or plaster body casings) while the remainder (#31) had been interred in a more normative manner (wood coffin and/or shroud), although some contained plaster. A further 28 soil/sediment samples collected from the mid-torso region of normative inhumations from a single site (West Smithfield, London) were analysed as part of an associated project.[43] The materials chosen derived from both urban and rural burial grounds and were associated with individuals of both biological sexes and all ages. Sample selection was constrained by the materials curated. Thus, discrete deposits (i.e. the resin from Arrington and organic matter from both cremations) and residues adhering to skeletal elements, and plaster body casings (e.g. Alington Avenue, Poundbury and York) were sampled, where visible. Sub-samples of grave deposits, from the interior of stone and/or lead-lined burial containers, were also collected, when extant. Such grave deposits comprise a variable mixture of inorganic and organic matter derived from the *in situ* degradation and/or diagenetic transformation of materials originally placed within the mortuary context (e.g. human remains, substances applied to the corpse, textiles, floral tributes, grave goods, plaster, the container itself etc.) and any ingress from the burial environment. Where possible, controls were analysed to establish background values. Comparative, botanically and geographically certified, reference materials were obtained from Bristol Botanicals Ltd.[44]

Analytical Method

Organic residue analyses and interpretations were conducted using established protocols (Fig. 1).[45] Briefly, ~0.5–2.0 g of the archaeological materials and ~0.05 g of the modern reference resins were solvent extracted in dichloromethane:methanol (DCM:MeOH, 2:1 *v*/*v*, 3 × 2 ml) aided by ultrasonication. The solvent-soluble fractions were combined and excess solvent evaporated under a stream of nitrogen. To produce trimethylsilyl derivatives, a portion of each dry residue was treated with ~0.5 ml of *N,O*-bis(trimethylsilyl)trifluoroacetamide (BSTFA) with 1% trimethylchlorosilane (TMCS) (40 °C, 15 min; 25 °C, overnight). The derivatised samples were re-diluted in DCM for analysis by GC-MS. All solvents were high performance liquid chromatography (HPLC) grade.

Instrumental analysis was carried out by combined gas chromatography-mass spectrometry using an Agilent 7890A GC system, fitted with a 30 m × 0.25 mm, 0.25 μm HP-5MS 5% phenyl methyl siloxane phase fused silica column (Agilent), connected to a 5975C inert XL triple axis mass selective detector. The splitless injector and interface were maintained at 300 °C and 280 °C respectively and the carrier gas, helium, at constant flow. The temperature of the oven was programmed to rise from 50 °C (isothermal for 2 min) to 350 °C (isothermal for 10 min) at a gradient of 10 °C per min. The column was directly inserted into the ion source where electron ionisation (EI) spectra were obtained at 70 eV with full scan from *m/z* 50 to 800 amu.

Resin Chemistry

Many plants produce natural exudates, although far fewer species secrete scented substances in any abundance. Consideration of the archaeological context can narrow the field further by determining which were accessible in terms of time and place. With regards to Roman Britain, botanical sources native to the Mediterranean region, obtained via ancient trade networks and/or detailed in contemporary literary sources are of relevance.[46] Such products can be grouped into gums (water-soluble polysaccharides i.e., sugars), resins (predominantly, water-insoluble terpenoids), and gum-resins, which contain variable amounts of both fractions.[47] Since gum sugars are rarely diagnostic and susceptible to leaching, archaeological research has largely focused on the compounds present in the resin fraction. These complex lipids are known as terpenes and terpenoids and are classified according to the number of C_5 isoprene ($CH_2=C(CH_3)CH=CH_2$) units from which they are formed.[48] Of these, the lower molecular mass (LMM) mono- and sesquiterpenes tend to be

43 Harrison (2014).
44 Full details are given in Brettell (2016).
45 Brettell *et al.* (2014); Stern *et al.* (2008).
46 *Peripl. M. Rubr.*; Howes (1950); Regert *et al.* (2008); those accessible in the Roman world and their chemical composition have been reviewed in the thesis of Serpico (1996) and Brettell (2016).
47 Howes (1949) 87–89; Langenheim (2003) 51–105.
48 Pollard and Heron (2008) 241–42.

readily lost due to their volatility. They are also of relatively common occurrence and can vary widely in expression, even within a single species. Fortunately, the higher molecular mass (HMM) di- and triterpenic compounds are both more degradation resistant and more limited in their botanical origins so can act as biomarkers in the archaeological record.[49]

Resins from conifer species are characterised by diterpenoids and their derivatives, with the main skeletal type dependant on family. In contrast, resins produced by angiosperms tend to contain triterpenoids, although balsamic resins mostly consist of LMM terpenic and phenolic compounds.[50] Gum-resins are highly variable. Myrrh (*Commiphora* spp.), is composed mainly of sugars and LMM furanosesquiterpenes, while frankincense (*Boswellia* spp.) may contain a mixture of cembrene-based diterpenes, tetra- and pentacyclic triterpenoids, and/or the unique isomers, α- and β-boswellic acid, and their derivatives.[51] In addition, essential oils extracted from various plant tissues (i.e. flowers, leaves, stems) can include volatile LMM terpenic and phenolic compounds. These features permit the characterisation of resinous exudates, usually to the level of genus, since commonality of components and the homogenising impact of degradation pathways tends to limit more precise identification, even in modern exudates.[52] In archaeological materials, this complexity is further complicated by natural aging processes (e.g., oxidation, polymerisation) and anthropogenic activities (e.g., heating, mixing), which can significantly alter the structures of key compounds and/or their relative abundance.[53] Thus, diagenetic factors that will have modified the 'fingerprint' of the resin have to be considered and suites of biomarkers used to securely characterise ancient resinous exudates.[54]

Residue Results

Suites of terpenic compounds were recovered from 16 of the stone sarcophagus sarcophagi and/or lead-lined coffin burials and both cremation burials. In most cases, only HMM di- and triterpenoids had survived, but LMM terpenes and/or phenolics were also observed in some circumstances (Table 3). Chromatograms and selected images are shown in Fig. 3. The peak identifiers for these chromatograms are, as follows: a. **1** pimaric acid, **2** sandaracopimaric acid, **3** isopimaric acid, **4** didehydroabietic acid, **5** dehydroabietic acid, **6** abietic acid; b. **7** moronic acid, **8** oleanonic acid, **9** oleanonic aldehyde, **10** isomasticadienonic acid, **11** masticadienonic acid; c. **12** 24-norolean-3,12-diene, **13** 24-norursa-3,12-diene, **14** 3-epi-β-amyrin, **15** 3-epi-α-amyrin, **16** 24-norursa-3,12-dien-11-one, **17** β-amyrin, **18** α-amyrin, **19** α-boswellic acid, **20** β-boswellic acid, **21** 3-O-acetyl-α-boswellic acid; **22** 3-O-acetyl-β-boswellic acid; d. **23** β-amyrin, **24** α-amyrin, **25** 3α-epioleanolic acid, **26** 3α-epiursolic acid, **27** oleanonic acid, **28** oleanolic acid, **29** ursonic acid, **30** ursolic acid.

The visible orange fragments recovered from a lead-lined coffin burial at Arrington, Cambridgeshire were the first samples analysed. Found around the cranium of a year-old infant and previously identified as resinous in nature, GC-MS results revealed triterpenoids characteristic of mastic/terebinth resins obtained from members of the genus *Pistacia*.[55] Plaster body coatings and mineral-replaced textiles from Poundbury, Dorchester, where unusual residues had been noted during excavation,[56] were then examined. Dark patches on the inner surface of a number of body casings and darker layers within the mineral-replaced textiles were observed. In 7 cases, samples were found to contain resin acids with abietane and pimarane skeletons and/or their derivatives indicative of a diterpenoid Pinaceae resin. The opportunity to determine whether invisible evidence might survive came with the discovery of well-protected grave deposits from the rural burial ground at Alington Avenue, Dorchester. These mixed materials had been recovered from the base of an intact lead-lined coffin of a 4–6 year old child who had been provided with high quality grave goods and clothed in textiles with murex purple-dyed decoration, probably a traditional male tunic, with *clavi* on the shoulders.[57] As these grave deposits had been stored, untreated (i.e., not wet sieved or otherwise sorted), this find not only provided a chance to recover organic traces but minimised the potential for contamination. Samples of the comminuted debris associated with the unwashed skeletal remains of an adult female who had been interred in a wood coffin covered with a substantial stone slab were, likewise, analysed. The residue results from both burials provided evidence of a matching array of triterpenic compounds characteristic of the degradation products of *Boswellia* spp. gum-resins with the traces of the

49 Colombini and Modugno (2009).
50 Colombini and Modugno (2009); Langenheim (2003) 23–50.
51 Hamm *et al.* (2004); Mathe *et al.* (2004).
52 Mills and White (1977).
53 Cf., Colombini *et al.* (2000); Serpico (2000); Stacey (2011).
54 Charrié-Duhaut *et al.* (2009); Evershed (2008).
55 Brettell *et al.* (2014); Taylor (1993).
56 Details of excavation and finds, Farwell and Molleson (1993); plaster burials, Sparey-Green (1977); residue analysis, Brettell *et al.* (2015a).
57 Details of excavation, Davies *et al.* (2002); dyed textiles, Walton (2002); residue analysis, Brettell *et al.* (2015a).

TABLE 3 Burials from Roman Britain found to contain resinous substances. Skeletal condition: visual assessment (author); unknown (not accessed); cremation condition (McKinley (1994) 2014). Age determination: infant < 12 months; child 1 < 11 years; sub-adult 12–20 years; young adult 20–35 years; middle adult 36–50 years; old adult 50+ years. Plaster: *analysed by E. Schotsmans; LSC = lead substituted carbonate. For site details: see in text references.

Location	Date c. AD	Age	Sex	Body position/ *skeletal condition*	Container(s) + *fill*	Associated finds	Nature of sample	Resinous exudate(s) present
Wraggs Farm, Arrington, Cambridgeshire.	2nd–3rd	Infant	–	extended, supine *poor/ fragmentary*	wood with lead-liner **traces of plaster (LSC)*	Pipeclay figurines, dyed-wool fragments; hair.	Brittle orange fragments of resinous appearance	*Pistacia* spp.
280 Bishopsgate, London, E1. 'Spitalfields Lady' SK15903.	4th	YA	F	extended, supine *excellent*	limestone sarcophagus inner lead coffin	Wool; silk; gold thread; murex dye; bay leaves; jet artefacts; glasswares.	Deposit adhering to hyoid; grave deposits	*Pistacia* spp. Pinaceae
Eagle Hotel site, Andover Road, Winchester. G336.	4th	MA	M	extended, supine *poor-moderate*	wood with lead-liner	Mineralised textiles; coin of Constantine.	Grave deposits from base of lead-liner	*Liquidambar orientalis* Pinaceae
Northview Hospital, Purton, Wiltshire. Grave 1.	4th	YA	F	extended, supine *poor*	stone sarcophagus undecorated lead-liner *traces of plaster?*	Wool with dyed-border; shale bracelet; glasswares; ceramics; animal bones.	Deposits associated with skeletal elements and lead fragments	*Pistacia* spp. Pinaceae
Northview Hospital, Purton, Wiltshire. Grave 2.	?	MA	?F	NA *incomplete combustion*	limestone ossuary, lead urn, blue-green glass vessel	Charcoal; bird and animal bones; ceramic fragments.	Grey-white residue (in cremation vessel)	*Boswellia* spp. ?*Pistacia* spp.
Poundbury, Dorchester, Dorset. R2 mausoleum, G8.	4th			extended, supine *unknown*	limestone sarcophagus **gypsum body-casing*	Textile impressions; fragments of bone comb.	Residues, inner surface of body-casing	Pinaceae
Poundbury, Dorchester, Dorset. Site E, G127.	4th	SA	F	extended, supine *unknown*	wood with lead-liner **traces of plaster (LSC)*	Textile impressions.	Residues adhering to mineralised textiles	Pinaceae
Poundbury, Dorchester, Dorset. R10 mausoleum, G517.	4th	MA	F	extended, supine *unknown*	limestone sarcophagus **gypsum body-casing*	Textile impressions; bone comb; copper alloy ring.	Residues, inner surface of body-casing	Pinaceae
Poundbury, Dorchester, Dorset. R9 mausoleum, G529.	4th	MA	F	extended, supine *unknown*	wood with lead-liner *plaster body-casing*	Textile impressions; hair.	Residues, inner surface of body-casing	Pinaceae

TABLE 3 Burials from Roman Britain found to contain resinous substances (cont.)

Location	Date c. AD	Age	Sex	Body position/ skeletal condition	Container(s) + fill	Associated finds	Nature of sample	Resinous exudate(s) present
Poundbury, Dorchester, Dorset. R9 mausoleum, G530.	4th	MA	M	extended, supine *unknown*	wood with lead-liner **gypsum body-casing*	Textile impressions; hair. [Residue on wool band, Reifarth 2013]	Residues, inner surface of body-casing	Pinaceae [*L. orientalis?*]
Poundbury, Dorchester, Dorset. Site E, Grave 892.	4th	MA	M	extended, supine *unknown*	wood with lead-liner *traces of plaster*	Textile impressions.	Residues adhering to mineralised textiles	Pinaceae
Poundbury, Dorchester, Dorset. Site E, Grave 1040.	4th	MA	M	extended, supine *unknown*	wood with lead-liner **plaster (LSC) body-casing*	Textile impressions.	Residue adhering to mineralised textiles	Pinaceae
Alington Avenue, Dorchester, Dorset. Burial 3664, SF 1075.	3rd	OA	F	extended, supine *moderate-good*	wood, lid of sandstone **chalk rubble packing*	Hobnailed shoes; glass vessels; food offerings?	Grave deposits associated with cranium	*Boswellia* spp.
Alington Avenue, Dorchester, Dorset. Burial 4378, SF 1169.	3rd	Child	?	extended, supine *good*	wood with lead-liner **chalk ingress*	Wool with murex dyed *clavi*; jar; coin; iron rod.	Grave deposits and adhering residues	*Boswellia* spp.
Railway excavations, York. YORYM: 2007.6206/11931.	–	–	–	– *unknown*	stone cist/cedar-wood coffin *plaster body casing*	Fragments of coarse textile.	Residue, inner surface of body-casing	?*Boswellia* spp.
Mill Mount, York. YORYM: 2007.6205i/11928.	–	–	–	– *unknown*	– *plaster body casing*	Textile impressions.	Residue, inner surface of body-casing	?*Boswellia* spp.
Railway excavations, York. YORYM: 2010.1219.	–	A	–	– *excellent*	stone sarcophagus *plaster body casing*	–	Grave deposits from base of sarcophagus	*Pistacia* spp.
Mersea Island barrow (Mersea Mount), Mersea Island, Essex.	2nd C	MA	M	NA *variable oxidation*	tile-built chamber, lead ossuary, green glass vessel	–	Yellow-white residues with orange fragments	*Boswellia* spp. Pinaceae

ORGANIC RESIDUE ANALYSIS OF LATE ROMAN GRAVE DEPOSITS 55

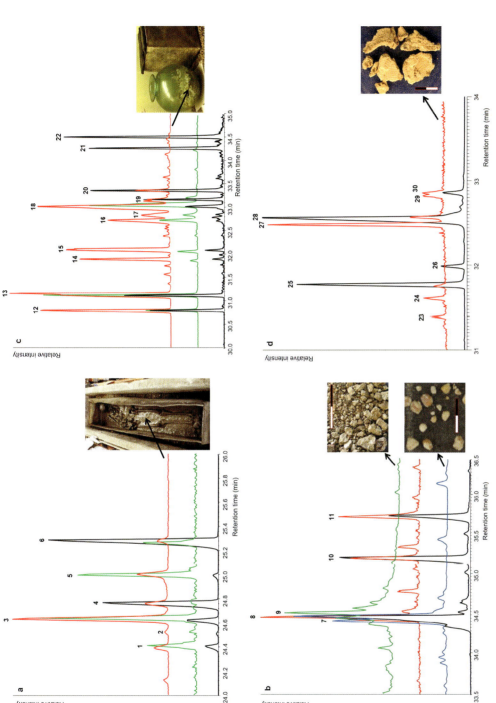

FIGURE 3 Partial extracted ion current (XIC) chromatograms of the trimethylsilylated lipid extracts of the archaeological and comparative modern reference materials. a. XIC (m/z 241) of modern Pinus spp. Resin (BLACK); residue from inner surface of plaster, Burial 8 Poundbury Camp, Dorchester (GREEN); debris from the pelvic region, base of lead coffin, Spitalfields Lady, London (RED), with material sampled indicated in inset (©MOL). b. XIC (m/z 511) of modern Pistacia spp. resin (BLACK); resinous orange fragments, cranial region, infant burial in lead-lined coffin, Arrington, Cambridgeshire (BLUE), shown in lower inset; debris from the upper torso region, base of lead coffin, Spitalfields Lady, London (RED); solvent extract from grave deposits associated with the adult female interred in a lead-lined sarcophagus, Grave 1, Purton, Wiltshire (GREEN), shown in upper inset. c. XIC (m/z 218) of modern Boswellia carterii gum-resin (BLACK); solvent extract of grave deposits from base of lead coffin of child, Burial 4378, Alington Avenue, Dorchester (GREEN); organic matter coating cremated remains in glass cremation vessel, Mersea Island barrow (RED), shown in inset alongside lead ossuary with wood cover (©Mersea Island Museum). d. XIC (m/z 205) modern Liquidambar orientalis exudate (BLACK); solvent extract from mineralised textiles; focal burial, B336, Eagle Hotel site, Winchester (RED), shown in inset.

boswellic acids, themselves, present in the deposits from lead-lined coffin.

These positive results facilitated access to grave deposits from other sites. Their analysis revealed that a combination of Pinaceae and *Pistacia* spp. resins had been deposited with two young adult females interred in substantial lead-lined sarcophagi in the 4th c. AD, one in a rural burial ground at Purton, Wiltshire and the other in the northern cemetery of London.[58] The latter, known as the Spitalfields Lady, had been clothed in silk damask and purple-dyed wool tabby with interwoven gold threads and was accompanied by bay leaves and high quality artefacts.[59] The intact, undisturbed nature of this find and gridded excavation strategy employed enabled numerous fully contextualised samples to be analysed. Spatial patterning indicated that diterpenic and triterpenic compounds were present from head to toe, although Pinaceae markers were more prevalent in the pelvic region and *Pistacia* spp. markers in the area of the cranium/upper torso. In addition, samples lateral to the lower arm bones contained only traces of persistent neutral triterpenic derivatives (nor/oleanones and oleanonic aldehyde). These findings suggested that the resins were intimately associated with the corpse and/or textile wrappings and that differential treatment of discrete areas of the body may have occurred although a single example is insufficient in this regard. Unfortunately, analysis of multiple grave deposits collected from a sarcophagus containing the remains of an adult and child from Boscombe Down, Wiltshire, in which animal skin footwear survived, provided no evidence of resinous substances.[60]

Solvent extracts of mineral-replaced textiles and fragments of redeposited lead from the base of the lead-lined oak coffin of a mature adult male, the focal burial at the Eagle Hotel site, Winchester, again, revealed biomarkers for Pinaceae resins.[61] These were accompanied by LMM phenolics including benzoic, cinnamic and vanillic acid alongside triterpenic compounds comprising traces of the pentacyclic alcohols, α- and β-amyrin, and resin acids with olean-12-ene and urs-12-ene skeletons. This combination and the sequence of triterpenoids resembled that reportedly found in the balsamic resin of *Liquidambar orientalis* (storax), although inconsistencies were noted regarding which triterpenic epimers were recorded. These issues were resolved through the purchase, synthesis and analysis of standards and precise characterisation of the compounds in modern reference materials. The results of this research showed that, although the same basic components were present in resinous extracts from *L. orientalis*, their epimers differed in dominance between the modern (3α) and archaeological samples (3β). Such αβ-epimerisation, when observed in related compounds (e.g. steroids and hopanoids), has provided insights into past human activities and improved our understanding of depositional environments since the position of equilibrium is dependent on the relative stabilities of the different epimers, temperature and, possibly, hydrology.[62] Thus, the most parsimonious explanation for the combination of compounds recovered from this lead-lined coffin is that the occupant was accompanied by a mixture of Pinaceae and *Liquidambar orientalis* exudates, with the latter modified by interactions within the burial environment.[63]

Extant materials from the plaster burials in York, North Yorkshire which had given rise to the ideas formulated by Ramm were also examined.[64] Analysis of grave deposits, still *in situ* alongside skeletal remains in the base of a stone sarcophagus (found in 1877 during work on the railway), indicated the inclusion of a *Pistacia* spp. resin. Compounds with a base peak at m/z 218 and key fragments ions at m/z 203 and 189 in residues adhering to plaster body casings from two other burials (found near the current railway station and Mill Mount, York) suggested the presence of *Boswellia* spp. gum-resins. A further three burials (location unspecified) contained non-diagnostic triterpenic traces. Despite the extended and somewhat checkered post-excavation history of these finds, this rather more degraded molecular evidence indicated that the use of resinous substances in mortuary contexts extended into northern Britain. To complete the picture, compounds characteristic of degraded *Boswellia* spp. gum-resins[65] and, perhaps, traces of a *Pistacia* spp. resin were recovered from grey-white residues (predominately comprising a fat or an oil), from a glass cremation vessel placed within a decorated lead urn in a limestone ossuary at Purton, Wiltshire.[66] Re-examination of a similarly elaborate

58 Details of excavation and finds, Purton Chandler (1994); Spitalfields, Thomas (1999).
59 Details of excavation and finds, Museum of London (1999); textiles and dyes, Wild (2012); residue analysis, Brettell et al. (2015a).
60 Residue analysis, Brettell (2016) 197–204; discussion and image, Pearce (2013) text and Fig. 4.
61 Details of excavation and finds, Richards (1999) 84–107; Teague (2012); residue analysis, Brettell (2016) 170–97.
62 Cf. Connan (2012); Evershed (1993); Inglis *et al.* (2018); Townley *et al.* (2015).
63 Brettell (2016) 183–97.
64 Details of burials, RCHME (1962); plaster burials, Ramm (1971); residue analysis, Brettell (2016) 245–64.
65 Cf., Baetan *et al.* (2014).
66 Chandler (1994).

cremation burial from a tile vault at the centre of the Mersea Island barrow, Essex revealed an abundance of a yellow-white substance (ca. 93 g).[67] The array of LMM mono-, sesquiterpenes together with HMM di- and triterpenes including cembrenes, incensol, boswellic acids and their derivatives present demonstrated that this residue comprised an substantial quantity of an unheated *Boswellia* spp. gum-resin accompanied by a Pinaceae resin in lower abundance.

Discussion

To date, molecular evidence for the deposition of resinous substances in Roman period mortuary contexts (outside of Egypt) has been obtained from inhumation burials in Italy (#3), Greece (#1), Syria (#1), France (#4), Germany (#17), Hungary (#1) and Britain (#16) alongside two cremation burials (Purton, Wiltshire and Mersea Island, Essex, UK). The natural plant exudates identified, in both the British and continental European finds, comprise diterpenoid Pinaceae resins and triterpenoid-containing *Pistacia* spp. (mastic/terebinth) resins, *Boswellia* spp. (frankincense/olibanum) gum-resins and, probably, *Liquidambar orientalis* (storax) balsamic resins. In addition, *Tetraclinis articulata* (sandarac) fragments were recovered from the unusual multiple burials in the catacomb of Santi Marcellino e Pietro, Rome.[68] Plant oils or animal fats were observed in a number of cases, most notably in the cremation burial from Purton, while FTIR results from Trier indicate that gums or gum-resins such as myrrh may also have been employed.[69] The majority of these results relate to individuals whose remains had been interred in substantial containers such as stone sarcophagi and/or lead-lined coffins and often placed in crypts, vaults or mausolea. Many had been dressed in elaborate garments and wrapped in shrouds or textile bandages. A few had been encased in plaster or surrounded by fir (*Abies* spp.) wood shavings. Some had been provided with high quality grave goods and/or botanical offerings (e.g. flower garlands, bay leaves, myrtle twigs). All ages (infant to mature adult) and both biological sexes were represented, with a slight preponderance of young females. In the UK, where a systematic study was undertaken, these better-protected burials were found to represent a tiny proportion (<5%) of total population interred in the sites assessed, while a significant percentage (>40%) of those analysed were found to contain resinous substances. Indeed, the evidence compiled here indicates that, over a broad chronological period, certain individuals were provided with a very similar material 'package' with minor modifications to suit the dominant method of disposal.

Samples and Strategies

What do these findings tell us about where to focus our resources? The decay of organic matter is an essential part of nature. Seeking to access such evidence in the archaeological record is a battle against the odds. Vast losses as a result of diagenetic processes are to be expected. Nonetheless, a surprising amount of information may be retained even in the most unprepossessing of samples.[70] The key to success has been shown to lie in determination of what might initially have been deposited, in this instance in Roman period mortuary contexts, and what, in terms of diagnostic molecular evidence might survive over archaeological time. Resinous plant exudates fall into both of these categories. Roman literary sources indicate that scented substances played a significant role in the funerary sphere, while chemical analysis of visible residues from continental Europe has successfully identified a number of resins/gum-resins.[71] The varied, often ill-defined, form of these natural exudates and their tendency to become increasingly friable over time may, however, mean that they are overlooked during excavation, missed by conventional analytical techniques or, indeed, have been rendered invisible.[72] That soils and sediments retain chemical markers which can be used to ascertain input sources has been demonstrated across a range of disciplines.[73] Grave deposits of archaeological interest can, now, be added to this list. Planning for the recovery of samples with the potential to contain molecular information relating to the treatment of the dead is, therefore, a matter that requires careful consideration. Where remarkable preservation conditions are encountered, as in the crypt and vault burials from continental Europe, numerous samples associated with different areas of the body or types/layers of textiles may be available for analysis and incredible images can be obtained (Fig. 2).[74] In the absence of such visible evidence, research in Britain has shown that the inner surface of plaster body casings, mineralised textiles and the degraded materials from the base

67 Details of cremation burial and discovery of residue, McKinley (2014); residue analysis, Brettell *et al.* (2015b).
68 Devièse *et al.* (2017).
69 Brettell (2016) 204–221; Reifarth (2013) 96–99.
70 Cf., Colombini and Modugno (2009); Evershed (2008).
71 Brettell *et al.* (2018).
72 Evershed *et al.* (1997).
73 Cf., Forbes *et al.* (2003); Goesman *et al.* (2017); Killops and Killops (2005); Kögel-Knabner (2002).
74 Devièse (2008); Reifarth (2013).

of stone sarcophagi and/or lead-lined coffins may retain chemical traces. If the latter are all that remains, it is recommended that at least 10 to 20 <5 g (approximately a glass scintillation vial full) samples of such grave deposits, spatially distributed within a grid system, should be collected. A minimum of one control, but preferably more, should be selected from inside and outside the grave cut to enable the surrounding soil profile to be characterised.[75]

When dealing with soil cut graves, this sampling strategy may only be advisable when these more substantial containers remain, largely, intact. This is because analysis of samples from damaged sarcophagi and/or lead-lined coffins has, so far, proved unproductive, even when excavation took place in a laboratory setting. Likewise, materials associated with individuals interred solely in wood coffins or shrouds have, rarely, provided evidence related to the treatment of the body. All that appears to remain in such contexts are degradation products characteristic of soil organic matter due to diagenetic factors, including extensive soil ingress, bioturbation and hydrology, at least in the inclement climate of the UK.[76] Thus, the sampling of badly damaged, more elaborate burials or of normative inhumations is probably only worthwhile when exceptional circumstances prevail (e.g., formation of adipocere, presence of adhering residues, extensive plaster body casings). It should also be noted that, in the burials found to contain resinous substances, the condition of the skeletal remains varied from poor (Trier) to excellent (Spitalfields Lady, London), plaster was present in abundance (York and Poundbury), minimal amounts (Arrington) or absent (Lady of the Sarcophagus, Milan) while textile preservation ranged from exceptional (Trier), to small fragments (Alington Avenue, Dorchester), mineralised (Eagle Hotel, Winchester) or no longer extant (impressions on plaster, Poundbury; cf. Table 2.3). So, beyond the fact that the more substantial and intact the container, the better protected its contents, there does not seem to be a proxy for determining when chemical evidence denoting the treatment of the body with aromatic exudates may survive.

As newly discovered, Roman sarcophagus/lead-lined coffin burials are rare, the potential of finds retained in museum collections should not be overlooked. Attitudes at the time of discovery may, however, have impacted on the survival of appropriate materials. Prior to the 1950s, these included the rapid re-burial of human remains, a focus on inorganic finds and the open-air display of sarcophagi. Nonetheless, molecular evidence may remain, even after an extended post-excavation history, as illustrated by the burials from York, many of which were excavated in the 1800s.[77] In the case of the *Pistacia* spp. resin identified, information provided by the museum staff supported the validity of the determination. Although the sarcophagus had been on public display, the skeletal remains and associated debris had remained largely undisturbed under a sealed glass cover. In more recent times, financial constraints have led to the reburial of sarcophagi without investigation, restrictions on the extent of post-excavation analysis and difficulties with long-term storage. Standard practices such as the cleaning of skeletal remains and the sieving or flotation of grave deposits will, almost certainly, have led to the discard of potentially valuable organic matter. For example, if the multiple samples (collected with environmental analysis in mind) that allowed two resins to be identified from the grave of the Spitalfields Lady had not been retained, the residual traces on the unwashed hyoid bone would have been insufficient to confirm the presence of even one resin. Thus, through consultation with curators and conservators and careful evaluation of any remaining materials, valuable evidence can still be recovered.

Taphonomy and Terminology
Which other factors need to be considered prior to interpretation of the data? This analytical focus on the more elaborate burials does not, necessarily, mean that the use of aromatic exudates was confined to such mortuary contexts. As with all archaeological finds, the old adage holds true: absence of evidence cannot automatically be taken as evidence of absence. Simpler versions of this body treatment may have formed part of a range of funerary practices with, perhaps, only a 'few grains of incense' deposited in the grave[78] or individuals interred with resinous substances may have been provided with less substantial containers. In such cases, as indicated by the British research, taphonomic factors tend to inhibit the recovery of molecular traces. The limitations of organic residue analysis must also be considered. Even in well-protected burials, a lack of diagnostic compounds in the species selected[79] or the use of gums and gum-resins like myrrh, with their highly soluble and volatile components, would make chemical confirmation elusive. These issues might account for the limited number of exudates identified in these Late Roman

75 Brettell (2016) 424–26.
76 Brettell (2016) 135–279.
77 RCHME (1962).
78 Plin. *HN* 12.41.83.
79 E.g., *P. khinjuk* and *B. frereana* which do not contain the biomarkers characteristic of their genus; Brettell (2016) 438; Proietti *et al.* (1981).

mortuary contexts and the minimal overlap with those, similarly hard to securely characterise spices/essential oils (e.g., cassia, cinnamon, saffron), named in earlier literary sources.[80] This mismatch could, however, be an artefact of the poetic language employed by the Roman authors. Generic terms such as 'produce of the East' and 'Palestinian incense' could include *Pistacia* spp. resins, while both of these categories, as well as 'balsam' and 'Cilician harvests', could incorporate extracts from *L. orientalis*.[81] Alternatively, it is possible that changing fashions, external influences (e.g., from Egypt) and access to new markets between the 1st and 4th c. AD may have modified the range of aromatics deemed appropriate for use in the mortuary sphere.[82]

Just as the impact of taphonomy must be considered before residue results are interpreted, it is important to use the correct terminology in relation to the material evidence recovered. Thus, the resinous plant exudates identified are not perfumes, although they may have provided the stable fraction of perfumed unguents (solid state ointments or creams).[83] Perfumes, by definition, are liquids infused with highly volatile compounds derived from essential oils and are designed to evaporate rapidly. So, although the literature implies that ephemeral fragrances (e.g., Hebrew liquids) were employed as part of Roman funerary practices, traces will, almost certainly, not survive in these mortuary contexts. Likewise, the treatment accorded these individuals should be referred to as embalming and clearly distinguished from artificial (e.g. Egyptian) mummification (aimed at long-term preservation of the body through intentional desiccation and the application of complex mixtures including resins) or natural mummification (soft tissue preservation as the result of favourable conditions within the burial/depositional environment).[84] Assumptions based on visual assessment alone should also be avoided. For example, the presence of various materials (e.g., bandages, gilding, garlands) has, previously, been misidentified as evidence for embalming or mummification.[85] When dealing with resinous exudates, even those from the same source may display disparities in colour (creamy-white to dark red-brown), texture (rough to smooth) and consistency (solid to viscous) as a result of natural variability, extraction methods and/or circumstances of storage. Moreover, in archaeological contexts, anthropogenic actions (e.g., mixing, heating) and interactions with the body, any textile wrappings or plaster body coatings and the burial environment add to this complexity.[86] That appearance is no guide to the identity of materials recovered from the archaeological record has been clearly demonstrated with respect to white residues.[87] Only when chemical analysis has been undertaken can there be any surety about the form of body treatment or the nature and source(s) of any substances, resinous or otherwise, employed.

Materiality and Memorialisation

Now that definitive evidence for the use of resinous exudates in Roman mortuary contexts has been provided, what can be said about this practice? As part of a range of materials employed in the mortuary sphere, aromatic substances played an important role in the transformation of the dead. On a practical level, in response to the biological reality of the decomposing corpse, it appears that these 'choicest unguents [were indeed used] to arrest the progress of decay'.[88] Placed in close association with the body, the steady release of their more volatile compounds would have masked the odour of putrefaction and slowed the progress of external (although not internal) decomposer organisms.[89] Similarly, the anti-microbial properties of the substances selected would have served, in the short term, to retard soft-tissue decay. Wrapping the body in textiles would have aided this process and absorbed purgative fluids. In addition, the application of pigments to exposed areas of skin would have masked progressive discolouration.[90] These practices signify attempts to disguise the visual and olfactory impact of corporeal decay during the *funus* (the period between death and burial) and would have been particularly pressing during the extended funerary rites accorded the social elite.[91] The deposition of plaster or wood shavings within the sarcophagus or coffin would, likewise, have prevented the egress of gases and liquids and temporarily slowed the rate of decomposition.[92] In the longer term, the provision of plaster body casings, lead-liners and/or stone sarcophagi would have afforded additional protection to the remains as would interment in vaults, crypts or mausolea. Such actions appear to be tangible manifestations of a desire to maintain the integrity of the body and

80 Brettell *et al.* (2018).
81 Cf., Auson. *Ep.* 6.31; Stat. *Silv.* 3.3.42–48; 5.1.281–87.
82 Cf., Plin. *HN* 13.1–2.
83 Cf., Plin. *HN* 13.2.7.
84 For an example of reinterpretation as a result of modern analysis, see Thillaud (2004).
85 Examples are provided in Chioffi (1998); Reifarth (2013).
86 Brettell (2016) 125–29; Colombini *et al.* (2000); Evershed (1993); Stern *et al.* (2003).
87 Schotsmans *et al.* (2014a); Schotsmans *et al.* (2019).
88 Lucian, *Luct.* 11–12.
89 Scotsmans *et al.* (2014b).
90 Devièse *et al.* (2011); Reifarth (2013) 112–13.
91 Hope (2009) 71–74.
92 Schotsmans *et al.* (2012).

contain the essence of the individual within a defined space, so that those treated in this way could avoid the fate of the poor man whose 'corpse disappears just like his soul'.[93]

Thus, although resinous substances may have been deposited in less elaborate burial contexts, as discussed above, the material aspects of this lavish 'package' suggest the conspicuous consumption of costly items as a mark of social status. The sourcing and shaping of stone and lead for the containers, dressing of the dead in gender and status appropriate garments made from raw materials including silk (imported from China) decorated with gold thread and murex purple (from the Mediterranean) and manufactured in Constantinople or the Levant indicate a considerable financial investment.[94] Likewise, the aromatic exudates obtained from as far afield as southern Arabia/eastern Africa (frankincense), the Mediterranean/Levant (mastic/terebinth and storax) and, probably, southern France (Pinaceae resins) were highly valued in the ancient world.[95] The view that this combination of materials reflected the social standing of the deceased is supported by the limited number of individuals interred in this manner, the epigraphs from Trier and the remarkable correspondence with literary descriptions of the treatment of the Roman elite.[96] It would also appear that, although adult males of importance to their communities received such honours (e.g., focal burial, Eagle Hotel site, Winchester), the most lavish materialised manifestations of grief were often those accorded young adult females and children.[97] In Roman culture, where emphasis on the family was manifested through delineation of female identity centred around an idealised life course of childhood, marriage and motherhood, such deaths represented a severe blow to "familial and social continuity":[98] This is illustrated in one of Pliny's letters: 'No words can express my grief ... the money [her father] had intended for clothing ... and jewels [for her wedding was now] to be spent on incense, ointment and spices'.[99]

Nonetheless, with regards to the use of resinous substances, it must surely have been their ritual significance that warranted their transportation throughout the Empire although many questions about the nature and extent of this trade remain.[100] Employed at every stage of the *funus*, they performed a key role in mediating the journey from this life to the next. Following the tripartite structure of mortuary rites,[101] the initial period of separation was marked by the application of oils/unguents, which were used to cleanse and purify the corpse. During the liminal stage, when the deceased was dressed for display, aromatic extracts and exudates were incorporated within the textile wrappings or deposited around the body. Then, as part of the final transformation, offerings, which included scented substances deemed 'an appropriate tribute to the dead', were made at the tomb.[102] In the Roman world, the success of this rite of passage focused on establishing and maintaining an individual's *fama* (reputation) through correct, witnessed and materialised, action.[103] Thus, the odour of sanctity provided by these aromatic exudates, viewed both as gifts from the gods and gifts acceptable to the gods, served as a testament to the good name of the deceased and signified the high regard in which they were held by the living. Prior to death, individuals may have requested certain rituals, including specific perfumed products,[104] but it was the survivors who chose to follow this path in order to honour their dead. Driven by social mores, these culturally situated strategies were designed to ensure a successful transition of the spirit to the afterlife and their own return to the world of the living.

Finally, the desire to ensure immortality through remembrance seems to have been of considerable importance in Roman society.[105] The sequence of bodily display, conspicuous funeral procession and final interment was designed to create a highly visible spectacle, whose cathartic effect would translate socially disruptive emotions into lasting counter-memories.[106] Through the agency of materials, the unpleasant reality of earthly decay would be replaced by an idealised image of the beautiful (and fragrant) dead. Fundamental to this riot of sights, sounds and smells was the desire that the final appearance in this world would be rendered individually memorable and would be collectively situated through associations with ancestral traditions. The materiality of each new *funus* was, therefore, intended to trigger recollections of those who had gone before with the greater the sensory impact, the more lasting the embedded memory. Subsequently, the survivors were encouraged

93 Juv. 3. 260–61.
94 Gleba (2008); Reifarth (2013) 47–90; Walton Rogers (2002); Wild (2013).
95 Brettell (2016) 288–96; Brettell *et al*. (2018).
96 Reifarth (2009); Brettell *et al*. (2018).
97 Ascenzi *et al*. (1996); Brettell (2016) 143–70 ; Bruni and Guglielmi (2005); Chioffi (1998) 31; Hope (2009) 137–44.
98 Moore (2009) 209.
99 Plin. *Ep*. 54.16.
100 Brettell *et al*. (2018).
101 van Gennep (1960).
102 Plin. *HN* 13.1.3.
103 Graham (2011); Noy (2011).
104 Cf., Petron. *Sat*. 77–78.
105 Cf., Graham (2011); Hope (2007) 71–79.
106 Cf., Hallam and Hockey (2001).

to undertake commemorate acts on a regular basis with feasting at the graveside (e.g., on birthdays) and attendance at public festivals in honour of the departed where iteration of aspects of the funeral served as a *refrigerium* (a refreshment, in literal and metaphorical terms) of the relationship between the living and the dead.[107] Thus, as part of the powerful, symbol-laden, performance surrounding death in the Roman world, resinous exudates would have helped imprint an enduring impression on the minds of the living and have harnessed the power of smell to elicit recall: 'Sprinkle my ashes with pure wine and fragrant oil of spikenard; bring balsam too … I have not lost a single joy of my old life, whether you think that I remember all or none.'[108]

Conclusion and Future Research

The corpus of research reviewed here has shown that resinous plant exudates had a significant role to play in Roman mortuary practices. Applied as part of perfumed oils/unguents to purify the corpse, incorporated within the textile wrappings to mask odours and delay decomposition, loaded upon the bier as a mark of status and respect and/or deposited within the tomb as votive offerings, they acted on both a practical and symbolic level. Their powerful aromas, alongside the visual impact provided by elaborate textiles and floral tributes, served to establish the credentials of the deceased in this world in order to negotiate entrance to the next and create an idealised image to be maintained in the minds of the survivors.[109] Mentioned, on occasion, in Roman literary sources, definitive archaeological evidence for their presence in burial contexts had only, previously, been obtained when visible residues survived due to favourable preservation conditions. The majority of these finds relate to sarcophagus burials in continental Europe, many of which were additionally protected in crypts, vaults or mausolea. The current British study has, now, demonstrated that invisible traces may also remain in grave deposits, the unprepossessing comminuted materials found in the base of sarcophagus and lead-lined coffin burials. This largely untapped reservoir of chemical evidence can retain biomarkers, diagnostic of resins and gum-resins employed in the treatment of the dead, long after the decomposition of macro-scale organic materials. These findings resolve years of speculation concerning the presence of resinous substances in Roman mortuary contexts and confirm that this practice had spread across the Empire, even as far as northern Britain. Thus, often invisible, molecular traces have thrown new light on the extent to which imported customs had influenced ritual action and become embedded in this remote province.

To date, the botanical sources identified comprise Pinaceae and *Pistacia* spp. resins, *Boswellia* spp. gum-resins, balsamic extracts from *Liquidambar orientalis* and *Tetraclinis articulata* fragments from the catacombs. This limited palette may indicate that, by the Late Roman period, only a few resins/gum-resins were considered appropriate for use in the mortuary sphere. Losses as a result of the natural volatility or solubility of the compounds present in other scented substances may, however, have masked the true extent of the species employed. This will have been compounded by the lack of diagnostic biomarkers in many exudates and the limitations of conventional organic residue analysis. The use of enhanced GC-MS techniques (e.g., selected ion monitoring, py-GC-MS, GC-MS/MS) and multi-analytical approaches (i.e., GC-MS combined with FTIR, Raman and NMR) applied to multiple samples collected from new finds might extend the range of species identified.[110] Systematic studies of sarcophagus burials or the investigation of different body treatments within a single burial ground in regions of the empire where more arid conditions prevail and upstanding mortuary structures persist should serve to further illuminate the nature and spread of this rite.[111] Evaluation of materials from Jewish tombs and additional analysis of mummy balms from Egypt could help explore external influences, trade links and chronological change, while application of this approach in Greek and Etruscan mortuary contexts might prove useful in identifying the precursors of these burial traditions.[112] Moreover, tracing subsequent developments could be rewarding. A well-attested resurgence in embalming occurred in the 13th c., focused on members of the secular social elite and those of high status in religious communities.[113] There is, however, a considerable hiatus during post-Roman Late Antiquity (*ca.* 5th–8th c. AD), where the tradition of plaster burial is known to have persisted, but molecular evidence of embalming is non-existent.[114] The possibility that the 'uncorrupted' bodies of saints and the production of relics resulted from continued application of this

107 Gee (2008).
108 Auson. *Ep.* 6.31.
109 Cf., Pearce (2013).
110 Cf., Bruni and Guglielmi (2014); Colombini *et al.* (2011); Modugno and Ribechini (2009).
111 Cf., Pearce (2013).
112 Cf., Colombini *et al.* (2009).
113 Corbineau *et al.* (2018); Duch (2016) passim; Knüsel *et al.* (2010).
114 Kachi and Capron (2017).

knowledge in continental Europe and its re-introduction, alongside Christianity, into Britain should, therefore, repay examination.

Finally, the ability "to make the unseen seen"[115] by recovering invisible molecular traces from 'dirt' may seem like technical wizardry, but, as in Lewis' novel, it is more a question of perceived value and the importance placed on being able to see 'evidence'. For many years, organic residue analysis using GC-MS has played a valuable role in revealing traces of anthropogenic activities in the archaeological record. Even relatively small molecules may survive if trapped within an appropriate matrix, while larger compounds, such as the terpenes and terpenoids present in resinous plant exudates, are more degradation resistant and so can be recovered from less well-protected contexts, including soils and sediments. Nonetheless, although many people are familiar with the recovery of evidence for food residues from ceramics, few are aware of full potential of organic residue analysis. We have, therefore, not yet been able to follow through on the 'archaeological biomarker revolution'.[116] Those working in this field need to find ways to clarify what is required in terms of sample collection, demonstrate the wide range of contexts and substances that can be analysed, engage with a wider audience and enhance the profile of the technique in the face of more direct methods of addressing human lifeways (e.g., isotopes, DNA, proteomics). If we do not, valuable data will continue to be lost and the true scope of archaeological residue analysis will remain unseen.

Acknowledgements

We thank Dorset County Museum (DCM), Mersea Island Museum (MIM), Museum of Anthropology and Archaeology (MAA), Cambridge, Museum of London (MoL), Swindon Museum and Art Gallery (SMA), Wessex Archaeology (WA), Winchester Museums (WM), York Museums (YM) for access to their archives and collections; R. Breward (DCM), S. Cummings (SMA), J. Godfrey (MIM), I. Gunn (MAA), S. Howlett (MIM), R. Johnson (MoL), J. McKinley (WA), A. Parker (YM), R. Redfern (MoL) and H. Rees (WM) for facilitating such access; C. Hynam at Bristol Botanicals Ltd., Royal Botanical Gardens, Kew and Soma Luna LLC for the modern reference materials; N. Reifarth for permission to use her images; R. C. B. was supported by a Ph.D. studentship from the Art and Humanities Research Council (43019R00209).

115 Lewis (1965).
116 Evershed (2008).

Bibliography

Primary Sources

Auson. *Ep.* = *Ausonius Epitaphs* H. G. Evelyn White transl., *Ausonius in two volumes, volume 1* (London and New York 1919).

ESV = *English Standard Version: Bible with Apocrypha* (New York 2009).

Juven. Sat. = *Juvenal Satires* G. G. Ramsey transl., *Juvenal and Persius* (London and New York 1918).

Lucan = *Lucan Pharsalia* J. D. Duff transl., *The Civil War (Pharsalia)* (Cambridge, Massachusetts 1928).

Lucian Luct. = *Lucian De Luctu* H. W. Fowler and F. G. Fowler transl., *The works of Lucian of Samosata* (reprint) (Charleston, South Carolina, 2007).

Perip. M. Rubr. = *Periplus Maris Erythraei* G. W. B. Huntingford transl., *The Periplus of the Erythraean Sea* (London 1980).

Pers. Sat. = *Persius Satires* G. G. Ramsey transl., *Juvenal and Persius* (London and New York 1918).

Petron. Sat. = *Petronius Satyricon* J. P. Sullivan transl., *Petronius: the Satyricon / Seneca / the Apocolocyntosis* (Harmondsworth, Middlesex 1977).

Plin. HN = *Pliny the Elder Naturalis Historia* H. Rackham transl., *Pliny: Natural History* (revised edition) (Cambridge, Massachusetts 1968).

Plin. Epist. = *Pliny the Younger Epistulae* B. Radice transl., *The Letters of Pliny the Younger* (reprint edition) (Cambridge, Massachusetts 1969).

Plut. Sull. = *Plutarch Sulla* B. Perrin transl., *Plutarch's Lives* (London 1916).

August. Serm. = *Augustine Sermones* E. Hill transl., *The works of Saint Augustine (a translation for the 21st century): Sermons III/5 (148–183) on the New Testament* (New York 1992).

Stat. Silv. = Statius *Silvae* B. R. Nagle transl., *The Silvae of Statius* (Bloomington, Indianapolis 2004).

Tac. Ann. = *Tacitus Annales* M. Grant transl., *Tacitus: the annals of Imperial Rome* (London 1971).

Secondary Sources

Ascenzi A., Bianco P., Nicoletti R., Ceccarini G., Fornaseri M., Graziani G., Giuliani M. R., Rosicarello R., Ciuffarella L., and Granger-Taylor H. (1996) "The Roman mummy of Grottarossa", in *Human Mummies: A Global Study of their Status and the Techniques of Conservation* (Man in the Ice 3), edd. K. Spindler, H. Wilfing, E. Rastbichler-Zissernig, D. zur Nedden, and H. Nothdurfter (Vienna 1996) 205–217.

Baeten J., Deforce K., Challe S., de Vos D., and Degryse P. (2014) "Holy smoke in medieval funerary rites: chemical fingerprints of frankincense in Southern Belgian incense burners", *PLOS One* (2014) http://journals.plos.org/plosone/article?id=10.1371/journal.pone.0113142.

Blanchard P., Castex D., Coquerelle M., Giuliani R., and Ricciardi M. (2007) "A mass grave from the catacomb of

Saints Peter and Marcellinus in Rome, second-third century AD", *Antiquity* 81 (2007) 989–99.

Brettell R. (2016) *The Final Masquerade: a Molecular-Based Approach to the Identification of Resinous Plant Exudates in Roman Mortuary Contexts in Britain and Evaluation of their Significance* (Ph.D thesis, Univ. of Bradford 2016).

Brettell R., Stern B., Reifarth N., and Heron C. (2014) "The 'semblance of immortality'? Resinous materials and mortuary rites in Roman Britain", *Archaeometry* 56 (2014) 444–59.

Brettell R., Schotsmans E. M. J., Walton Rogers P., Reifarth N., Redfern R. C., Stern B., and Heron C. P. (2015a) "'Choicest unguents': molecular evidence for the use of resinous plant exudates in late Roman mortuary rites in Britain", *JAS* 53 (2015) 639–48.

Brettell R., Stern B., and Heron C. P. (2015b) "Mersea Island barrow: molecular evidence for frankincense", *Essex Society for Archaeology and History* 4 (2015) 81–87.

Brettell R., Schotsmans E., Martin W., Stern B., and Heron C. (2018) "The final masquerade: resinous substances and Roman mortuary rites", in *The Bioarchaeology of Ritual and Religion*, edd. A. Livarda, R. Madgwick, and S. R. Mora (Oxford 2018) 44–57.

Bruni S. and Guglielmi V. (2005) "Le analisi chimiche", in *La signora del sarcofago: una sepoltura di rango nella necropoli dell'Università Cattolica*, edd. M. P. Rossignani, M. Sannazaro, and G. Legrottaglie (Milan 2005) 131–36.

Bruni S. and Guglielmi V. (2014) "Identification of archaeological triterpenic resins by the non-separative techniques FTIR and 13C NMR: the case of *Pistacia* (mastic) in comparison with frankincense", *Spectrochimica Acta Part A: Molecular and Bimolecular Spectroscopy* 121 (2014) 613–22.

Buckley S. A. and Evershed R. P. (2001) "Organic chemistry of embalming agents in Pharaonic and Græco-Roman mummies", *Nature* 413 (2001) 837–41.

Chandler C. J. (1994) *Excavations at the Romano-British Walled Cemetery, Northview Hospital, Purton* (Site monograph, second draft, WILT MC890036, Purton 806, Swindon Museum and Art Gallery 1994).

Charrié-Duhaut A., Burger P., Maurer J., Connan J., and Albrecht P. (2009) "Molecular and isotopic archaeology: top grade tools to investigate organic archaeological materials", *Comptes Rendus Chimie* 12 (2009) 1140–53.

Chioffi L. (1998) *Mummificazione e imbalsamazione a Roma ed in altri luoghi del mondo Romano* (Rome 1998).

Ciuffarella L. (1998) "Palynological analyses of resinous materials from the Roman mummy of Grottarosa, second century AD: a new hypothesis about the site of mummification", *Review of Palaeobotany and Palynology* 103 (1998) 201–208.

Colombini M. P. and Modugno F. (2009) "Organic materials in art and archaeology", in *Organic Mass Spectrometry in Art and Archaeology*, edd. M. P. Colombini and F. Modugno (Chichester 2009) 1–36.

Colombini M. P., Modugno F., Silvano F., and Onor M. (2000) "Characterization of the balm of an Egyptian mummy from the seventh century B.C.", *Studies in Conservation* 45 (2000) 19–29.

Colombini M. P., Giachi G., Iozzo M., and Ribechini E. (2009) "An Etruscan ointment from Chiusi (Tuscany, Italy): its chemical characterization", *JAS* 36 (2009) 1488–95.

Colombini M. P., Modugno F., Gamberini M. C., Rocchi M., Baraldi C., Devièse T., Stacey R. J., Orlandi M., Saliu F., Riedo C., Chiantore O., Sciutto G., Catelli E., Brambilla L., Toniolo L., Miliani C., Rocchi P., Bleton J., Baumer U., Dietemann P., Pojana G., and Marras S. (2011) "A round robin exercise in archaeometry: analysis of a blind sample reproducing a seventeenth century pharmaceutical ointment", *Analytical and Bioanalytical Chemistry* 401 (2011) 1847–60.

Connan J. (2012) *Le bitumen dans l'antiquité* (Arles 2012).

Corbineau R., Ruas M. P., Barbier-Pain D., Fornaciari G., Dupont H., and Colleter R. (2018) "Plants and aromatics for embalming in Late Middle Ages and modern period: a synthesis of written sources and archaeobotanical data (France, Italy)", *Vegetation History and Archaeobotany* 27 (2018) 151–64.

Davies S. M., Bellamy P. A., Heaton M. J., and Woodward P. J. (2002) *Excavations at Alington Avenue, Fordington, Dorchester, Dorset, 1984–87* (Dorchester 2002).

Devièse T. (2008) *Elucidating Funeral Rituals in Burials from the End of the Roman Empire: Development of a Multi-Analytical Approach* (Ph.D. thesis, Univ. of Pisa 2008).

Devièse T., Vanhove C., Blanchard P., Colombini M. P., Regert M., and Castex D. (2010) "Détermination et function des substances organiques et des matières minérals exploitées dans les rites funéraires de la catacombe des Saints Pierre-et-Marcellin à Rome (1er–IIIe siècle)", in *De corps en corps: traitement et devenir du cadaver*, edd. I. Cartron, D. Castex, P. Georges, M. Vivas, and M. Charageat (Pessac, Aquitaine 2010) 115–39.

Devièse T., Ribechini E., Baraldi P., Farago-Szekeres B., Duday H., Regert M., and Colombini M. P. (2011) "First chemical evidence of royal purple as a material used for funeral treatment discovered in a Gallo-Roman burial (Naintré, France, third century AD)", *Analytical and Bioanalytical Chemistry* 401 (2011) 1739–48.

Devièse T., Ribechini E., Castex D., Stuart B., Regert M., and Colombini M. P. (2017) "A multi-analytical approach using FTIR, GC/MS and Py-GC/MS revealed early evidence of embalming practices in Roman catacombs", *Microchemical Journal* 133 (2017) 49–59.

Dunkin J. (1844) *The History and Antiquities of Dartford* (London 1844).

Evershed R. P. (1993) "Biomolecular archaeology and lipids", *World Archaeology* 25 (1993) 74–93.

Evershed R. P. (2008) "Organic residue analysis in archaeology: the archaeological biomarker revolution", *Archaeometry* 50 (2008) 895–924.

Evershed R. P., van Bergen P. F., Peakman T. M., Leigh-Firbank E. C., Horton M. C., Edwards D., Biddle M., Kjølbye-Biddle B., and Rowley-Conwy P. A. (1997) "Archaeological frankincense", *Nature* 390 (1997) 667–68.

Farwell D. E. and Molleson T. I. (1993) *Excavations at Poundbury 1966–80. Volume 2: the Cemeteries* (Dorchester 1993).

Ficoroni F. (1732) *La bolla d'oro de' fanciulli nobili romani e quella de' libertine ed altre singolarità spettanti a' mausolea nuovamente scopertisi* (Rome 1732), cited in L. Chioffi (1998) *Mummificazione e imbalsamazione a Roma ed in altri luoghi del mondo Romano* (Rome 1998) 46.

Forbes S. L., Keegan J., Stuart B. H., and Dent B. B. (2003) "A gas chromatography-mass spectrometry method for the detection of adipocere in grave soils", *European Journal of Lipid Science and Technology* 105 (2003) 761–68.

Gage J. (1834) "A plan of barrows called the Bartlow Hills in the parish of Ashdown in Essex with an account of Roman sepulchral relics recently discovered in the lesser barrows", *Archaeologia* 25 (1834) 1–23.

Gage J. (1836) "The recent discovery of Roman sepulchral relics in one of the greater barrows at Bartlow, in the parish of Ashdon, in Essex", *Archaeologia* 26 (1836) 300–317.

Gee R. (2008) "From corpse to ancestor: the role of tombside dining in the transformation of the body in Ancient Rome", in *The Materiality of Death: Bodies, Burials, Beliefs* (BAR-IS 1768), edd. F. Fahlander and T. Oestigaard (Oxford 2008) 59–68.

Ghini G., Cecere M. G. G., Rubini M., and Arietti F. (2005) "L'ipogeo delle Ghirlande a Grottaferrata (Roma): una storia vissuta 2000 anni fa", in *Communities and Settlements from the Neolithic to the Early Medieval Period, Papers in Italian Archaeology VI* (BAR-IS 1452), edd. P. Attema, A. Nijboer, A. Zifferero, O. Satijn, L. Alessandri, M. Bierma, and E. Bolhuis (Oxford 2005) 246–57.

Gleba M. (2008) "*Auratae vestes*: gold textiles in the ancient Mediterranean", in *Vestidos, textiles y tintes: studios sobre la producción de bienes de donsume en la Antigüedad* (Purpureae Vestes II: Textiles and Dyes in Antiquity), edd. C. Alfaro and K. Karali (Valencia 2008) 61–77.

Goesmann F., Brinckerhoff W. B., Raulin F., Goetz W., Danell R. M., 20 others, and the MOMA Science Team (2017) "The Mars organic molecule analyzer (MOMA) instrument: characterization of organic material in Martian sediments", *Astrobiology* 17 (2017) https://www.liebertpub.com/doi/pdfplus/10.1089/ast.2016.1551.

Graham E.-J. (2011) "Memory and materiality: re-embodying the Roman funeral", in *Memory and Mourning: Studies on Roman Death*, edd. V. M. Hope and J. Huskinson (Oxford 2011) 21–39.

Groom N. (1981) *Frankincense and Myrrh: A Study of the Arabian Incense Trade* (Harlow 1981).

Hallam E. and Hockey J. (2001) *Death, Memory and Material Culture* (Oxford 2001).

Hamm S., Bleton J., and Tchapla A. (2004) "Headspace solid phase microextraction for screening for the presence of resins in Egyptian archaeological samples", *Journal of Separation Science* 27 (2004) 235–43.

Harrison W. (2014) *A Multi-Technique Analysis of Roman Era Grave Soil Deposits* (B.Sc. diss., Univ. of Bradford 2014).

Hope V. M. (2007) *Death in Ancient Rome: A Sourcebook* (London and New York 2007).

Hope V. M. (2009) *Roman Death: The Dying and the Dead in Ancient Rome* (London 2009).

Howes F. N. (1949) *Vegetable Gums and Resins* (Waltham Mass. 1949).

Howes F. N. (1950) "Age-old resins of the Mediterranean region and their uses", *Economic Botany* 4 (1950) 307–316.

Inglis G. N., Naafs B. D. A., Zheng Y., McClymont E. L., Evershed R. P., Pancost R. D., and the 'T-GRES Peat Database collaborators' (2018) "Distributions of geohopanoids in peat: implications for the use of hopanoids-based proxies in natural archives", *Geochimica et Cosmochimica Acta* 224 (2018) 249–61.

Kachi S., Réveillas H., Sachau-Carcel G., and Castex D. (2014) "Réévaluation des arguments de simultanéité des depots de cadavers: l'exemple des sépultures plurielles de la catacomb des Saints Pierre-et-Marcillin (Rome)", *Bulletins et Memoires de la Societe d'Anthropologie de Paris* 26 (2014) 88–97.

Killops S. D. and Killops V. J. (2005) *An Introduction to Organic Geochemistry*, 2nd edition (Malden 2005).

Kögel-Knabner I. (2002) "The macromolecular organic composition of plant and microbial residues as inputs to soil organic matter", *Organic Geochemistry* 34 (2002) 139–62.

Langenheim J. H. (2003) *Plant Resins: Chemistry, Evolution, Ecology and Ethnobotany* (Portland 2003).

Lewis C. S. (1965) *Voyage of the Dawn Treader* (Harmondsworth 1965).

Mathe C., Culioli G., Archier P., and Veillescazes C. (2004) "Characterization of archaeological frankincense by gas chromatography-mass spectrometry", *Journal of Chromatography A* 1023 (2004) 277–85.

Mattingly D. (2006) *An Imperial Possession: Britain in the Roman Empire, 54 BC–AD 409* (London 2006).

McKinley J. I. (1994) "The skeletal material", in *Excavations at the Romano-British Walled Cemetery, Northview Hospital, Purton*, ed. Chandler, C. J. (Site monograph, second draft,

WILT MC890036, Purton 806, Swindon Museum and Art Gallery 1994).

McKinley J. I. (2014) "Mersea Island barrow: the cremated bone and aspects of the mortuary rite", *Essex Society for Archaeology and History* 4 (2014) 74–80.

Mills J. S. and White R. (1977) "Natural resins of art and archaeology: their sources, chemistry, and identification", *Studies in Conservation* 22 (1977) 12–31.

Mitschke S. and Paetz A. P. (2012) "Dressing the dead in the city of Rome: burial customs according to textiles", in *Dressing the Dead in Classical Antiquity*, edd. M. Carroll and J. P. Wild (Stroud 2012) 115–33.

Modugno F. and Ribechini E. (2009) "GC/MS in the characterisation of resinous materials", in *Organic Mass Spectrometry in Art and Archaeology*, edd. M. P. Colombini and F. Modugno (Chichester 2009) 215–35.

Montgomery J., Evans J., Chenery S., Pashley V., and Killgrove K. (2010) "'Gleaming, white and deadly': using lead to track human exposure and geographic origins in the Roman period in Britain", in *Roman Diasporas: Archaeological Approaches to Mobility and Diversity in the Roman Empire* (JRA Supplementary Series 78), ed. H. Eckardt (Portsmouth RI 2010) 199–226.

Moore A. J. (2009) *Young and Old in Roman Britain: Aspects of Age Identity and Life-course Transitions in Regional Burial Practice* (Ph.D thesis, Univ. of Southampton 2009).

Museum of London (1999) *The Spitalfields Roman* (London 1999).

Noy D. (2011) "'Goodbye Livia': dying in the Roman home", in *Memory and Mourning: Studies on Roman Death*, edd. V. M. Hope and J. Huskinson (Oxford 2011) 1–20.

Papageorgopoulou C., Xirotiris N. I., Iten P. X., Baumgartner M. R., Schmid M., and Rühli F. (2009) "Indications of embalming in Roman Greece by physical, chemical and histological analysis", *JAS* 36 (2009) 35–42.

Pearce J. (2013) "Beyond the grave: excavating the dead in the late Roman provinces", *Late Antique Archaeology* 9 (2013) 441–82.

Pollard M. A. and Heron C. (2008) *Archaeological Chemistry*, 2nd edition (Cambridge 2008).

Proietti G., Strappaghetti G., and Corsano S. (1981) "Triterpenes of *Boswellia frereana*", *Planta Medica* 41 (1981) 417–18.

Ramm H. G. (1971) "The end of Roman York", in *Soldier and Civilian in Roman Yorkshire*, ed. R. M. Butler (Leicester 1971) 179–99.

Regert M., Devièse T., Le Hô A. S., and Rougeulle A. (2008) "Reconstructing ancient Yemeni commercial routes during the Middle Ages using structural characterization of terpenoid resins", *Archaeometry* 50 (2008) 668–95.

Reifarth N. (2009) "Textile in their scientific context: interdisciplinary cooperation during the evaluation of burial textiles", in *Textiles y tintes en la ciudad Antigua* (Purpureae Vestes 3: actas del symposium internacional sobre textiles y tintes del Mediterráneo en el mundo antiguo), edd. C. Alfaro, J.-P. Brun, P. Borgard, and R. Pierobon Benoit (Valencia 2009) 101–107.

Reifarth N. (2013) *Zur Ausstattung spätantiker Elitegräber aus St. Maximin in Trier: Purpur, Seide, Gold und Harze*, *Internationale Archäologie* 124 (Rahden 2013).

Richards J. (1999) *Meet the Ancestors: Unearthing the Evidence that Brings us Face to Face with the Past* (London 1999).

Royal Commission on the Historic Monuments of England (RCHME) (1962) *Roman York (Eburacum)* (Leicester 1962).

Schotsmans E. M. J., Denton J., Dekeirsschieter J., Ivaneanu T., Leentjes S., Janaway R. C., and Wilson A. S. (2012) "Effects of hydrated lime and quicklime on the decay of buried human remains using pig cadavers as human body analogues", *Forensic Science International* 217 (2012) 50–59.

Schotsmans E. M. J., Wilson A. S., Brettell R., Munshi T., and Edwards H. G. M. (2014a) "Raman spectroscopy as a non-destructive screening technique for studying white substances from archaeological and forensic burial contexts", *Journal of Raman Spectroscopy* 45 (2014) 1301–1308.

Schotsmans E. M. J., Denton J., Fletcher J. N., Janaway R. C., and Wilson A. S. (2014b) "Short-term effects of hydrated lime and quicklime on the decay of human remains using pig cadavers as human body analogues: laboratory experiments", *Forensic Science International* 238 (2014) 142.e1–142.e10.

Schotsmans E. M. J., Toksay-Köksal F., Brettell R. C., Bessou M., Corbineau R., Lingle A. M., Bouquin D., Blanchard P., Becker K., Castex D., Knüsel C. J., Wilson A. S., and Chapoulie, R. (2019) "'Not all that is white is lime' – white substances from archaeological burial contexts: analyses and interpretations", *Archaeometry* 12453 (2019) https://doi.org/10.1111/arcm.12453.

Serpico M. T. (1996) *Mediterranean Resins in New Kingdom Egypt: a Multidisciplinary Approach to Grade and Usage* (Ph.D. thesis, Univ. College London 1996).

Serpico M. (2000) "Resins, amber and bitumen", in *Ancient Egyptian Materials and Technology*, edd. P. T. Nicholson and I. Shaw (Cambridge 2000) 430–74.

Sparey Green C. J. (1977) "The significance of plaster burials for the recognition of Christian cemeteries", in *Burial in the Roman World* (CBA Report 22), ed. R. Reece (London 1977) 46–53.

Stacey R. J. (2011) "The composition of some Roman medicines: evidence for Pliny's Punic wax?", *Analytical and Bioanalytical Chemistry* 401 (2011) 1749–59.

Stern B., Heron C., Corr L., Serpico M., and Bourriau J. (2003) "Compositional variations in aged and heated *Pistacia* resin found in Late Bronze Age Canaanite amphorae and bowls from Amarna, Egypt", *Archaeometry* 45 (2003) 457–69.

Stern B., Heron C., Tellefsen T., and Serpico M. (2008) "New investigations into the Uluburun resin cargo", *JAS* 35 (2008) 2188–2203.

Taylor A. (1993) "A Roman lead coffin with pipeclay figurines from Arrington, Cambridgeshire", *Britannia* 24 (1993) 191–225.

Teague S. C. (2012) "Eagle Hotel, Andover Road", in *The Roman Cemeteries and Suburbs of Winchester: Excavations 1971–86*, P. J. Ottaway, K. E. Qualmann, H. Rees, and G. D. Scobie (Winchester 2012) 120–26.

Thillaud P. L. (2004) "Les secrets de la momie de Bourges", *La Revue du Praticien* 54 (2004) 691–93.

Thomas C. (1999) "Laid to rest on pillow of bay leaves", *British Archaeology* 50 (1999) http://www.archaeologyuk.org.

Townley C., Brettell R. C., Bowen R. D., Gallagher R. T., and Martin W. H. C. (2015) "The application of positive mode atmospheric chemical ionisation to distinguish epimeric oleanolic and ursolic acids", *European Journal of Mass Spectrometry* 21 (2015) 433–42.

Toynbee J. M. C. (1971) *Death and Burial in the Roman World* (London 1971).

van Gennep A. (1909) *The Rites of Passage*, transl. M. B. Vizedom and G. L. Caffee (Chicago 1960).

Walton Rogers P. (2002) "Dye tests on textile fragments from the lead coffin", in *Excavations at Alington Avenue, Fordington, Dorchester, Dorset, 1984–87* (Dorset Natural History and Archaeological Society Monograph 15), S. M. Davies, P. A. Bellamy, M. J. Heaton, and P. J. Woodward (Dorchester 2002) 159.

Waugh H. (1962) "The Romano-British burial at Weston Turville", *Records of Buckinghamshire* 17 (1962) 107–114.

Webster G. (1947) "A Romano-British burial at Glaston, Rutlandshire", *AntJ* 30 (1947) 72–73.

Wild J. P. (2012) "The textile archaeology of Roman burials: eyes wide shut", in *Dressing the Dead in Classical Antiquity*, edd. M. Carroll and J. P. Wild (Stroud 2012) 17–25.

Wild J. P. (2013) "Luxury? The north-west end of the silk -purple-and-gold horizon", in *Luxury and Dress: Political Power and Appearance in the Roman Empire and its Provinces*, edd. C. A. Giner, J. O. García, and J. J. M. García (Valencia 2013) 169–80.

The Colour of Death: Colour Symbolism and Burial in Roman Britain

Chloe Clark

Abstract

The aim of this paper is to investigate colour as an understudied aspect of death and burial in Late Roman Britain. Colour is explored both as an essential element of display in the lived experience of funeral ritual and also as an interpretative tool. These inter-related strands will be explored first, with a survey of colour displayed in the treatments performed on and for the dead. Following this, a case study of burial beads from Roman London's Eastern Cemetery and the Lankhills Cemetery explores the potential for a symbolic colour approach in further understanding the burial choices of mourners.

Introduction

We live in a world which is codified and understood via colour. Colour is ingrained in socio-cultural lexicons, and so facilitates the symbolic communication of ideas and meaning.[1] In much of the western world, we accept that we must stop at a red traffic light or that, to show respect at a funeral we should wear black. Colour is also a proxy for broader concepts, such as identity and gender; a popular contemporary rise in the trend of 'gender reveal' parties, where an activity is performed resulting in the display of either pink or blue to onlookers, signifying the gender of an unborn child, being one of many examples. Colour is also a highly potent and easily exploited symbol within ideological beliefs. The Colour Revolutions of the early 21st c. and more recently the *Mouvement des gilets jaunes* in France being examples of how colour, without the need for literacy or translation, can be rapidly understood and emulated by a wide audience. So symbolically powerful is colour that in the early 2000s the state of California introduced injunctions allowing the arrest of those wearing gang affiliated colours with the aim to reduce street violence,[2] exemplifying the threat colour holds by its ability to act as an emblem of a collective ideology. What colour means within a given society is a route into a greater understanding of that society. The concept of colour symbolism within archaeological research is not a new one. It first emerged through anthropological and linguistic traditions,[3] before making its way into the field and often utilised to understand pre-literate societies. Chapman highlights this potential when applying the method to the Neolithic and Copper Age Eastern Balkan cemetery sites of Durankulak and Varna.[4] More recently, Hoechler illustrates the wide-ranging possibilities of a methodology focused on colour symbolism when applied to an Iron Age context.[5] While utilised to good effect in prehistoric research, a colour-focused interpretive approach is applied less often within later Roman contexts. Outside of important recent work in pigment detection[6] and poly-chrome reconstructions of sculptures, there are a comparably small number of studies exploring colour symbolism from the Roman world.[7] Here, an analytical opportunity has been missed.

This paper aims to highlight the importance of colour in death and burial in Roman Britain in two ways: firstly, as a significant but easily lost element of display within the lived experience of burial ritual; secondly, as an interpretative tool to further understand the objects chosen to rest with the dead. A two-strand approach explores both of these objectives. Initially, a survey of treatments enacted upon the dead, as documented archaeologically in examples from the province, will investigate the significance of colour in funeral display. This survey will, also, serve as context for colour symbolism to work as an interpretive tool, demonstrated in a case study of beads from both the Eastern Cemetery of Roman London and Lankhills cemetery. We start by outlining what is meant by colour and colour symbolism before moving on to detail the visual impact of the burial process.

What Is Colour?

The retinas of the human eye contain roughly 120 million rods and 6 million cones. Rods are more abundant and allow us to process differences in light and dark, while cones detect colour.[8] The colours we see are light waves not absorbed by the surface of an object, reflected back into the eye. St. Clair observes that because of this,

1 Turner (1966); Berlin and Kay (1969); Wierzbicka (1996); Bradley (2009).
2 Cal. Pen. Code 182.5. See also https://www.nationalgangcenter.gov/Legislation/Penalties#state-CA Accessed January 2019.
3 Turner (1966); Berlin and Kay (1969); Bolton (1978); Murton (1980); Wierzbicka (1996); Casson (1997).
4 Chapman (2002).
5 Hoecherl (2015).
6 Campbell (2020).
7 See Bradley (2009).
8 St. Clair (2016) 13.

in fact, "the way we perceive a colour to be is precisely the colour it *isn't*".[9] The eye responds to differences in wavelengths and these wavelengths create what we recognise as different colours. The longer the wavelength, the warmer the hue. The human eye can process wavelengths between roughly 400 nanometers (nm) and 700 nm, with blues in the lower range and reds in the upper. This limited range is why at 10 nm, the human eye cannot process ultraviolet light or in the opposite direction at 0.01 cm, infra-red light.[10] Colour itself is formed in two ways, either by additive or subtractive mixing. Additive colour mixing is the mixing of light waves. This phenomena, first discovered by Newton in 1666,[11] will eventually create white light due to the increasing number of light waves visible.[12] Subtractive mixing, i.e. paint, increasingly diminishes the light waves reflected into the eye and so will become darker with increased mixing.[13] All of the colours discussed in this chapter relate to those created by pigments, dyes, and chemical processes and are all subtractive mixed colour types. For this discussion, this is relevant to note because it illustrates the complexities in creating coloured dress ornaments, specifically glass beads, relative to their opacity, luminosity, and tone.

Colour in Antiquity[14]

Greek writers give us our earliest understanding of ancient perspectives on colour. In the 5th c. BC, Alcmaeon of Croton[15] wrote about the duality of black and white and later Empedocles associated black and white as well as primary colours with the Earth's elements.[16] By the 4th c. BC, Plato[17] was writing that the eye would dilate to coloured stimuli. While incorrect, it shows that there was a will to understand sensory stimuli to colour at this time. From the Roman world, Pliny's extensive treatise on the natural world provides multiple examples of discussions of colour.[18] Colour is a constant refrain and oft-remarked upon characteristic used by Pliny to explain the world around him. To Pliny, the origin, quality, or effectiveness of anything from precious stones to medicines is revealed in the colour it presents. Colour acted as an integral element of the visual world for ancient Romans. The richness of colour language as used by Pliny and others has been explored by Bradley to show, for example, how orators used reference to colour to organise, classify, and evaluate their world.[19] Bradley notes that "color, and all the categories that made it up, contributed to a Roman moral discourse crucially concerned with the ability to distinguish true from fake, whether in the context of philosophical epistemology, natural history, love elegy, drama or rhetoric".[20] From literary evidence we can then trace a long-established colour symbolism within the ancient world. How this symbolism has been treated and understood in archaeology is now discussed.

What Is Colour Symbolism and What Is Its Role in Archaeology?

In the simplest of terms, colour symbolism as discussed here, is the acknowledgement that colours can trigger resonances within the human brain. What these resonances are is not fixed and can be influenced by multiple socio-cultural factors. For example, in many 21st c. western countries, the colour red is used to symbolise danger, as evidenced in traffic lights and warning signs. However, in China, the colour is also associated with good luck rather than risk. It is by understanding the colour cues of a particular group that we may more fully understand the artefacts produced and in the context of this discussion, buried by them.

Much work on colour symbolism emerged from the fields of anthropology and linguistics, specifically, understanding the emergence of colour terminology relative to social practices. Fundamental to this is Berlin and Kay's 1969 anthropological study exploring the evolutionary development of basic colour terms within heterogeneous cultural groups.[21] It concluded that what were designated 'primitive' societies had fewer significant colours within their lexicon; the number of colours would increase in observable stages relative to social complexity. This process identified 11 basic colour terms: black, white, red, blue, green, brown, grey, purple, orange, pink, and yellow. Black and white formed the first developmental stage, with red added at the second and so forth until, at the most developed stage, all colour terms were evident. Whilst the significance of the Berlin and Kay hypothesis for the study of colour symbolism cannot be underemphasised, problems with its methodology and approach are manifest, specifically the Anglo-centric perspective of the research.[22] Wierzbicka later sought to

9 St. Clair (2016) 13.
10 St. Clair (2016) 15.
11 Newton (1672); St. Clair (2016) 15.
12 St. Clair (2016) 17; see also Hoecherl (2015) 10.
13 St. Clair (2016) 17.
14 For a fuller discussion of colour theory from the ancient world, see Hoecherl (2015) 10.
15 Hoecherl (2015) 10.
16 Hoecherl (2015) 10.
17 Hoecherl (2015) 10.
18 Plin. *HN* 33.19; 33.57; 34.3; 34.32; 34.40; Books 35–37.
19 Bradley (2009).
20 Bradley (2009) 228.
21 Berlin and Kay (1969).
22 Chapman (2002).

apply a more rounded approach by identifying linguistic associations across multiple language groups.[23] With this method, they determined that many colour terms are structured within an environmental context, i.e. related to the natural environment and that these connections are universal to the human experience.[24] While work continues in this area to align the complexities of basic colour terms, in Jones and McGregor's significant 2002 publication *Colouring the Past*,[25] Chapman combined the previously mentioned strands of colour theory into a workable model by incorporating Hacking's principle of "dynamic nominalism"[26] (the idea that categories emerge at the same time as individuals do to fit them in an ever-evolving process of 'refinement'),[27] with the theory of cultural biographies. By combining these approaches, Chapman explored both environmental colours and cultural colour resonances of manufactured and raw materials within artefacts from Neolithic Balkan burials. While some have criticised this approach as lacking recognition of potential overlap between universal and culturally determined resonances,[28] Chapman's approach nevertheless presents a working method to understand the artefacts of burial, beyond form and manufacture, and as significant colour symbols.

The wider significance of colour symbolism in prehistoric Britain has been explored in a range of thematic areas. Aldhouse-Green discusses the presence of quartz in Neolithic bog burials, while also highlighting the use of white birch tree branches in Iron Age burials, which created a strong visual contrast against the peaty soil of the bog.[29] Additionally, Giles recognises the importance of coloured textiles as symbolic indicators of gender, age and status in Iron Age societies.[30] They also note the extensive use of red 'enamelling' in martial decoration from Iron Age Britain and the presence of red coral in burials.[31] Hoecherl's in-depth study of colour symbolism in Iron Age Britain further illustrates the scope of this methodology, exploring as it does, colour meaning in metalwork and manufacture, identity, cosmology, and mortuary practices of this period.[32] Despite colour symbolism providing a fruitful method to investigate prehistoric societies, beyond Bradley's important work in this area, it is an interpretive tool seldom applied to contexts after the Roman invasion of Britain. This is curious, not least because one of the most widely recognised culturally determined colour symbols in the ancient world originated from Rome itself, that of imperial purple.[33] While colour continues to be assessed for its symbolic potential both in prehistoric archaeology and classics, it remains underutilised in the archaeology of Roman Britain.

Colour in the Treatment of Death and Burial

This paper explores the significance of colour in death and burial in two ways. The symbolic interpretation of colour in one specific artefact type, namely beads, is explored in part 3. However, first a survey of burial treatments is presented which notes probable dominant colours at each stage. This will not only illustrate the visual impact of colour within burial but also form a contextual background for the case studies explored in parts 4 and 5.[34]

Physical Death and the Colour of the Body
The initial stage of the burial process is death itself. Death probably frequently occurred in the family home and was witnessed by family members.[35] The dying person was the focal point of this environment. Their body, breathing, sounds, and other physical conditions were continually viewed and interpreted by onlookers. The colours the body produced in its final moments, predominantly skin colour, but also blood, bile, and other bodily fluids were the colours of sickness and death itself. Once deceased, the *conclamatio* (closing the corpses' eyes and calling their name) may have been performed by family members.[36] Upon death, the inevitable processes of decay would begin. Hoecherl argues that the biological stages of death and decomposition (as determined from a controlled study on a pig carcass) align themselves with a colour triad of white, black, and red.[37] Red relates to blood, black to decay and white to bone in the final 'dry' phase. Hoecherl uses this framework in reference to Iron Age excarnation practices, where the visceral aspects of bodily decay were visible to all over an extended period of time. How far these

23 Wierzbicka (1996).
24 Chapman (2002) 50.
25 Jones and McGregor (2002).
26 Chapman (2002) 52.
27 Chapman (2002) 52.
28 Hoecherl (2015) 7.
29 Aldhouse-Green (2012) 101.
30 Giles (2012) 127.
31 Giles (2008) 163.
32 Hoecherl (2015).

33 Plin. *HN* 9.63.
34 While cremation is recognised as a frequent disposal method of the dead, in the interests of space and thoroughness, inhumation practices alone are discussed here.
35 Noy (2011).
36 Toynbee (1971).
37 Hoecherl (2015) 70.

colours were experienced by people of Roman Britain is more difficult to assess. The practice of *collocare*[38] (laying out the body after death in the family home) suggests that post-mortem skin would have been a common symbol of death to Roman eyes. However, it is unlikely that the later stages of decomposition occurred in sight of mourners. Decomposition, when a body is exposed to the elements, can take between three and 50 days to occur and up to one year for carrion insects to remove all flesh. Roman funerals took place within days of death,[39] meaning the later stages of decomposition occurred within the confines of the coffin, unseen by mourners. There were, of course, specific circumstances when a body was not buried in a timely and traditional way, such as in war. Alternatively, if the deceased was destitute and unable to pay for membership of a *collegium*[40] their body may have been discarded in a communal pit. In these environments, further stages of decomposition may have been visible. However, these are specific circumstances, viewed by a limited number of people in unique professions such as soldiers or undertakers, rather than a majority experience.

Dressing and Display

After death, in a traditional Roman funeral, the deceased was washed and anointed with unguents and perfumes, while incense was burned.[41] Dressing the body also occurred at this time. It is possible that professionals performed this act: undertakers, *libitinari*[42] and *pollinctores* (so named for the powder used to conceal the pallor of dead skin)[43] were specialists in preparing bodies. Here, it is important to quantify that much of what we know of Roman funerals comes from writers within Rome itself. A less formal structure of funeral professionals may have existed across the wider western provinces than those described for the capital. It is plausible that while the processes of the funeral ritual remained similar, the action within was conducted by family members of the deceased, including dressing the dead. For men of rank, clothing may have consisted of a toga. Assessing how universal this practice was is problematic. Lindsey notes that Livy describes senators dressing in their finery while awaiting the Gauls in 390 BC.[44] However, this evocative retelling of a city on the eve of occupation is an exceptional occurrence and the clothes worn were not wholly representative of the usual dress of death. Many people were probably dressed for death in the clothes they wore in life, due to practical and economic considerations. The ubiquitous dressing of the dead in hobnailed footwear across the provinces further supports this.[45]

Due to the fragility of textiles, what we know of dress in Roman Britain is understood primarily from funeral reliefs and written records. Funerary portraits offer valuable evidence for the style of personal dress existing in Roman Britain at this time. As Rothe notes,[46] "portraits on gravestones may not always reflect exactly what was worn in everyday life, but their symbolic value more than makes up for this". Stone funerary sculpture, such as that of the tombstone of Philus from Cirencester, illustrates the likely primary garment for men in Roman Britain: the Gallic coat. This was a large tunic falling to just below the knee,[47] likely made of wool but possibly also flax or hemp.[48] Funerary sculptures of women's clothing in Britain are relatively few, with surviving examples, such as that at Murrell Hill, Carlisle generally dating to the 2nd–3rd c. AD.[49] A combination of Gallic coat and cloak appears the dominant clothing style for women, mirroring that of men, although generally of a longer length.

If undyed, flax fabric has a muted off-white to beige hue. Wool however, can range from white to dark brown and black depending on the fleece of the animal. While animal fibres absorb dyestuffs well, plant fibres are less effective at doing so and may have largely remained their natural colour. Some notable examples of purple-dyed textiles exist from Roman Britain, such as the burial of a juvenile (approx. 4–6 years old) from Arlington Avenue, Dorchester dating to AD 150/175–250.[50] With the child was a woollen tunic with purple *clavi* or striped borders appearing worn at the point of burial.[51] This was the first known find of a Tyrian purple-dyed textile in Britain. Similar garment types exist from the wider Roman world, including at Palmyra, also in a 3rd c. context.[52] One of the most significant finds from Britain in terms of textile evidence in recent years is the so-called 'Spitalfields Woman'. Excavations in 1999, unearthed a lead-lined sarcophagus containing the skeleton of a woman in her early 20s dating to *ca.* AD

38 Toynbee (1971) 44.
39 Toynbee (1971).
40 Bond (2016); see also Morris (1992).
41 Plin. *HN* 12.41.83.
42 Toynbee (1971) 45.
43 Bodel (2000) 137.
44 Lindsay (2000) 162.
45 Philpott (1991) 168.
46 Rothe (2009) 78.
47 Wild (2004) 301.
48 Wild (2004) 299.
49 Wild (2004) 303–304.
50 Davies *et al.* (2002).
51 Davies *et al.* (2002) 158.
52 Davies *et al.* (2002) 158.

350.[53] Silt within the sarcophagus enabled the preservation of jet beads and bay leaves, the latter thought to have been worn or placed under the head of the deceased to form a pillow. Small fibres of gold thread and silk were also found, as were traces of Tyrian purple dye, probably forming part of an item of clothing or shroud covering. These finds suggest a burial well provisioned with expensive and carefully selected artefacts, prompting a potent reimagining of the deceased and her treatment. Silk, particularly combined with delicate gold decoration and purple dye, would have stood out, both literally and metaphorically against a backdrop of more widely used natural and undyed materials. Whether this silk material was worn by the deceased in life as some form of ceremonial dress or appropriated from an opulent household item, it is impossible to say. However, this visual display spoke unequivocally of high status. Additionally, at a burial at Stanway, Colchester, dated to around the time of the Roman invasion in AD 43, a purple cloak of good quality made from wool with a relatively high thread count and decorative purple diamond twill pattern was discovered.[54] It lay half beneath an array of other grave goods, including a gaming board and counters at the end of the grave, with a portion of the textile folded on top.[55]

While burials such as these reveal tantalising glimpses of ornately coloured textiles in burials, many people in antiquity were unable to afford such dyes, particularly purple which was one of the most costly and remained associated with luxury and wealth throughout the period.[56] It is probable that most people were not buried in the colourful way described above, but instead in garments in the naturally occurring colours of wool and plant fibre textiles. We should note, however, that while an unremarkable woollen cloak, undyed and lacking a pattern may not seem a particularly luxurious article of clothing to be buried in or with, the labour value of such an item may have been considerable. The family could have retained the clothing, either for wear by another family member or repurposed for household textiles. At Vindolanda, recycled clothes became sleeping mats, bandages, and shoe insoles, showing that cloth had a practical value regardless of condition.[57] The decision to bury a person with any article of clothing shows care and also economic consideration to that person. In a pre-Industrial era, when all textiles were produced by hand, often by family members themselves,[58] the choice to 'discard' such items in the ritual of burial is significant.

Shrouds

If not dressed, a shroud may have wrapped the deceased. Often depicted as white,[59] these textiles may have been created specifically for the purpose of burial. Alternatively, shrouds could have also been repurposed from household textiles. At Poundbury, textiles attributed to shrouds were found in 9 graves, the weave indicating a household style linen was re-used for the purpose.[60] A further 18 graves produced textile impressions in gypsum, which again match impressions of household textiles repurposed as shrouds. Impressions of cloth of different wefts from burials at York indicate that a range of textile scraps were used in conjunction with gypsum to wrap and cover the dead. In addition to these domestic items, a length of gold thread was also found at Poundbury, highlighting a mixture of widely available and rarer cloths in use here.[61] From the above examples, we can see the varying function and appearance of cloth in burial. Whether opulent and visually striking or utilised from repurposed household scraps, all textiles deposited with the dead represent not only an economic investment to the deceased but a traceable action of care too. Contrasting the care bestowed on the deceased, mourners were expected to wear muted colours in black or brown and appear unkempt,[62] creating a juxtaposition between the light cloth of the shroud, wrapping or possibly dress of the dead and the dark hues worn by those surrounding them. Even after the burial act was complete, in the days and weeks following a funeral, family members avoided wearing white or purple, and women were discouraged from wearing jewellery.[63]

Pompa

Once the *collocatio* was complete, the deceased was transported from the home to a place of burial outside the settlement boundary.[64] The procession (*pompa*) was a highly visible occasion, witnessed by the community. Bodel has calculated that with a population between 750,000–1 million, death rates in Rome were approximately 30,000 per year, roughly 1:25.[65] Accepting that the population of London was significantly smaller than

53 Swain and Roberts (1999).
54 Crummy *et al.* (2007) 349.
55 Crummy *et al.* (2007) 348.
56 Pennick Morgan (2018) 51.
57 Birley (2005) 35.
58 Birley (2005) 35.
59 Hope (2017) 93.
60 Farwell and Molleson (1993) 111.
61 Farwell and Molleson (1993) 111.
62 Hope (2017) 93.
63 Hope (2017) 93.
64 Toynbee (1971).
65 Bodel (2000) 128; Bond (2016) 66.

that of Rome, this estimate still produces a substantial number of deaths and resulting funerals per year. The colours of textiles, notably black, grey-brown fleece, white and potentially purple in exceptional cases, were seen by crowds regularly and formed an established colour language for viewers. If the deceased was a person of note, the funeral would be a quasi-public event with mourners in formal dress and expanded colour display. Burial containers, commonly wooden coffins but occasionally lead-lined or stone[66] would further impact the burial scene both in how and when the body was placed inside and sealed and how it was transported. These considerations would also impact the visibility of the deceased and accompanying grave goods. If, as has been suggested, Roman funerals took place at night,[67] the impact of burial colours would create an entirely different visual experience. In dark, torch-lit conditions, the lighter colours of the deceased's clothing would be illuminated, while the dark cloth of mourners increasingly muted by shadows. These conditions would also cause metal or glass dress ornaments to glisten and refract torchlight against the less reflective textiles on which they rested.

The Graveside
Beyond the settlement environment, we might expect an array of colours in the British landscape. In daylight during spring and summer months, green grass and foliage would have been the most visible colours on display. Evidence of flowers in burials from Britain and France[68] suggest that seasonal flowers may have been displayed with the dead, providing a significant contribution to the colour profile of burials. Seasonal changes could alter this dramatically. Winter funerals would be characterised by black-brown bare branches, dark mud, white snow and frost and grey skies. Depending on the locale, the sides of the grave pit could range in colour from light chalk to brown-red clay or dark peat. If the funeral occurred at night, depending on levels of moonlight, the surrounding landscape may have been very dark, making an environment previously familiar to mourners, unknown. With little light pollution beyond the moon and torchlight, visibility of stars on a clear night would be exceptional.

While there exist many variables to consider when surveying colour in the Roman funeral and accepting that any attempt to do so will always be schematic and to a degree conjectural, it is possible to advance some arguments regarding notable colour tendencies from the evidence discussed. Firstly, the physical presence of the deceased, specifically their pallor, would be an unavoidable reality for viewers. The complexion of the dead exemplifies the transformation of a familiar, living individual to a corpse. Secondly, the lighter and adorned dress of the dead contrasted with the dark, dishevelled appearance of mourners. Finally, the environmental conditions of the funeral served to characterise the experience for mourners. The above survey aims to demonstrate the significant role colour had in the Roman funeral. Colour characterised much of what viewers saw during this time, codifying the tasks required and facilitating a visual language for the action taking place. With this visual background and the significance of colour within it established, I now wish to explore further the potential for colour to act as a symbol within a society, and one which may allow an interpretive understanding of the artefacts mourners chose to bury with their dead.

A Study of Colour Symbolism in Burial Beads from Two Cemeteries in Roman Britain

Methodological Approach
Beads are entirely unnecessary in the dress of death. Bead necklaces, bracelets and anklets serve no practical function as could be argued of brooches or belts. They are designed primarily for visual display, and so their colours may be significant. Indeed, an indigenous tradition of burying beads with the dead existed in Iron Age Britain. These are hypothesised to have held visually symbolic resonances, especially for adult women and may have represented status, rites of passage, or the number of children borne.[69] These associations would not disappear entirely with the Roman conquest of AD 43 and may have become merged with Roman aesthetic considerations, creating an integration of ideology and appearance. In addition, glass beads and those of other naturally occurring materials retain their colour well in comparison to other ornament types, making them well-suited to a colour-centric study of burial goods.

The approach here will analyse the frequency and position on the body of coloured beads in inhumations at two sites, The Eastern Cemetery of Roman London and Lankhills cemetery, as well as a control sample of beads from non-burial sites. Findings will be interpreted within a framework of colour symbolism, established by the work of Chapman from Wierzbicka, explored above.

66 Philpott (1991) 53–68.
67 Toynbee (1971) 46. Aen. VI, 244.
68 Swain and Roberts (1999). Devièse, Ribechini, Baraldi, Farago-Szekeres and Duday (2011).

69 Giles (2012) 149.

Using this approach, two categories of colour symbolism were created; those of universal resonance based on associations to the natural environment (Table 1) and those from culturally-specific evidence (literary sources, visual and archaeological remains). What follows is a brief outline of these cultural symbols. While in no way exhaustive, and recognising the potential for divergence in colour meaning between Rome and Britain, they nevertheless represent some of the most well-established and often repeated associations within Roman culture.

Black: Black is frequently present in objects associated with death, evidenced by Roman mourners wearing black clothes.[70] In a culture-specific setting, colour may also evoke the presence of a particular material either when that material is truly present or when represented by one visually similar. For example, black glass jewellery could trigger associations with jet without the presence of jet itself. Jet contained electrostatic properties that made it mysterious to ancient people. Jet was also strongly associated with women, medicine, and was thought to have apotropaic effects.[71] Thus, black jewellery made of shale or glass, may have held similar connotations regardless of physical material. In this way, colour provides a proxy for material and serves as a cultural symbol to onlookers.

White: In the Roman world, particularly in personal dress, whiteness was revered for its association with purity.[72] The dead were traditionally dressed in white or light clothing, an inverse to the dark dress of mourners.[73]

Purple: Culturally representative in Roman antiquity of royal or elite status as determined by multiple examples in literary sources.[74]

Yellow and Orange: One of the most culturally significant yellow-orange objects is amber. In both Iron Age and Roman contexts, amber held multiple inter-related resonances. It contains light and was often used in parallel with jet, a pairing possibly symbolising life and death.[75] Amber also resonates with the sun, honey, and glowing embers, the Greek word for amber being *Helektron* taken from *helektor* meaning 'beaming sun'.[76] Pliny, when describing amber, uses the words 'fiery' and 'honey'.[77] Here, the colour and reflectance of the material recall the sun and its qualities. As with jet, when a non-amber, orange material is present, it may contain some of the same resonance due to this affinity with amber.

Red: In an art historical context, Gage terms red the 'colour of light', noting that it often appeared as decoration in Roman religious buildings.[78] Red is also synonymous with blood, an association made in many cultural contexts[79] and strong in the Roman world too, with blood sacrifice a notable feature of Roman religious practices.[80] In addition, red clothing was associated with high rank and military service.[81] Within Iron Age British culture, red is associated with enamelling in jewellery, and this tradition may have continued and melded with Roman jewellery styles,[82] potentially evoking more prestigious gemstones such as garnets or rubies.

Blue: Derived from Lapis Lazuli, blue was difficult and expensive to acquire in antiquity.[83] As such, blue in personal dress may have held associations with luxury and wealth, but this distinction is less clear than other colours discussed.

Green: Green produces few culturally determined colour associations. However, in the context of glass beads, green glass was sometimes used as a substitute for emeralds,[84] again demonstrating the symbolic power colour has to represent a material which is not there.

Gold: Gold is synonymous with wealth in many societies and was recognised as a valuable commodity in Rome.[85]

Silver: Similar to gold, silver symbolises wealth and opulence.

From this survey, it is clear that some colour associations might relate to cultural concepts (purity or luxury), whereas others evoke materials (jet, emeralds, and amber). Both categories can overlap or be viewed in isolation. The strength of the association is difficult to determine, but a logic of cultural resonance can be identified. On this premise, Table 1 below shows these identifiable cultural colour associations with the environmental colour resonances, identified by Wierzbicka as universal to the lived human experience.[86] To this, multi-coloured, transparent, gold, and silver were also added, totalling 15 colour categories (Table 1). Some

70 Croom (2000) 28; Jones (1990) 813.
71 Allason-Jones (1996).
72 Croom (2000) 28.
73 Hope (2017) 93.
74 Vitr. *De arch*. 7.13; Bradley (2009) 189–211; Pennick Morgan (2018) 51.
75 Giles (2012) 122.
76 Causey and Shepherd (2004) 75.
77 Plin. *HN* 37.12.47–48; Causey and Shepherd (2004) 75.
78 Gage (1999) 25.
79 Turner (1966).
80 Weddle (2013).
81 Croom (2000) 28.
82 Giles (2008) 163.
83 Gage 1999, 13.
84 Swift (1999) 23.
85 Plin. *HN* 33.19.
86 Wierzbicka (1996).

TABLE 1 Framework of universal and cultural colour symbolism. Grey, pink, transparent and multi-coloured colours provided no strong symbolic associations within the textual evidence. Numbers of beads in the sample from these categories were small. While grey and pink could be considered tones of black/white and red/white, they are included here because they are independent categories within the Berlin and Kay/Wierzbicka linguistic model.

Colour	Environmental resonance	Cultural concepts	Cultural objects
White	– Day – Bone	– Purity	– Shrouds – Bone inlaid objects – Ivory Objects
Black	– Night	– Death – Magic/Healing	– Jet – Shale
Blue	– Sky – Water	– Luxury	– Unknown
Green	– Vegetation	– Unknown	– Emeralds
Red	– Fire – Blood	– Religion – Sacrifice – Military Rank	– Blood – Garnets
Brown	– Earth	– Unknown	– Unknown
Purple	– N/A	– Imperial – Senatorial Rank	– Unknown
Orange and Yellow	– The Sun	– Unknown	– Amber – Honey
Gold	– The Sun	– Wealth	– Jewellery
Silver	– The Moon	– Wealth	– Jewellery
Grey	– N/A	– Unknown	– Unknown
Multi-coloured	– N/A	– Unknown	– Unknown
Transparent	– N/A	– Unknown	– Unknown
Pink	– Unknown	– Unknown	– Unknown

colours produce a distinct cultural-specific link, i.e. black and its clear association to the concept of death and the object jet. Other colours prove less well-defined (e.g. green). Additionally, individual life experience means that not all colours would resonate with Roman mourners equally. However, as an overarching framework, it provides a flexible guide to interpret the bead colours selected for display and burial with the dead.

Assigning beads to the 15 colour groups required a degree of individual judgement. Beads were documented from published reports, and I rely on the expertise of finds specialists in their recording. Where possible, additional visual analysis was also conducted. Beads from settlements were inspected and recorded by the author. Some materials required standardisation to fit within the developed framework, i.e. glass containing the impurity iron-oxide produces a green-blue hue, known as natural green-blue or NGB. This hue can vary, but it was necessary to catalogue beads from it in one colour group (green, Table 2). Other materials in the sample with similar variability were catalogued as follows:

TABLE 2 Table showing variable materials and colour category assigned.
Carbonised beads from the settlement sample proved particularly challenging to categorise. Originally wooden, they were possibly also painted in now, undetectable colours. However, with no evidence to the contrary, carbonised beads were placed within the brown category, as the most obvious colour type for wood.

Material	Colour category assigned
Natural Green Blue Glass	Green
Carnelian	Red
Gold-in-Glass	Gold
Amber	Orange
Coral	Orange
Opalescent	Multi-coloured
Decorative Pattern	Multi-coloured
Carbonised Wood	Brown

While acknowledging that original colours may have been altered due to depositional processes, materials were catalogued as if new, or at least as their intended colour. At this time, the effects of wear and tarnish on artefacts before deposition have not been accounted for in this quantification.

Results

The Settlement Sample

A control sample of 274 beads of non-funerary contexts were recorded from 13 residential sites in London excavated by Museum of London Archaeology (Table 3). This was done to demonstrate which bead colours were available to mourners in Roman London and facilitate comparison to those from burial contexts (Figs. 1 and 3).

Typological categories were defined as per Birley.[87] Beads were dated by site context, and if this data was not available or deemed unreliable, relative spot dating was used. Most beads date to AD 50–100 (48.17%). For subsequent periods, the sample distributed as follows:

AD 101–150	13.61%
AD 151–200	4.85%
AD 201–350	2.59%
AD 351–401	3.11%
Post-AD 401	10.21%
unknown	17.51%

The most frequent colour in the assemblage was blue (60.94%), followed by green (13.86%) and brown, largely comprising carbonised wooden beads (12.77%). Other colours were less frequent: black (4.01%); white (1.09%); colourless glass, orange, and multi-coloured (each 0.72%); yellow, purple, grey and gold (each 0.36%, i.e. a single bead per colour). Pink and red were not present in the assemblage and 3.64% were of unknown colour due to degradation. One amber annular bead (categorised orange) was found in a ditch containing two adult human skeletons and canine remains. While not characterised as a cemetery space, the presence of skeletal remains implies that this bead cannot be isolated from mortuary action entirely.

TABLE 3 Quantities of bead colours from non-burial data sample.

Colours	Number of beads
Blue	167
Green	38
Brown	35
Black	11
Unknown	10
White	3
Orange	2
Colourless	2
Multi	2
Purple	1
Yellow	1
Gold	1
Grey	1
Total	274

Eastern Cemetery of Roman London

The Eastern Cemetery of Roman London[88] comprises 12 burial sites covering roughly 12 hectares situated to the east of the city, excavated 1983–1990 by the Museum of London. It represents a well-recorded site with good demographic detail from 550 inhumations. Of these, 14 burials contained at total of 1,473 beads (Fig. 1). To retain the format of the control sample, beads were recorded individually rather than by string. The sites span a broad chronology (AD 40–410); however, the inhumations under discussion are weighted towards the later period of Roman occupation: AD 251–300 (29.36%), AD 301–350 (22.39%), AD 351–400 (21.91%). Beads were compared with demographic burial data as well as their worn and unworn position (Fig. 2).

Fig. 1 shows colours of beads per individual burial from the Eastern Cemetery sample. As in the settlement data (Table 3), blue is the most numerous colour (47.25%), followed by black (41.61%), white (5.97%), green (3.19%), gold (1.83%), colourless and unknown colour (0.06%) respectively. Colour combinations of beads per burial are limited, the most complex combination (three), occurring twice. White is only present in combination with other colours, while in half of burials black is the only bead colour.

A comparison of worn and unworn bead positions was included to highlight differences in colour visibility and potential mourner interaction. Fig. 2 shows a similar division of beads in worn and unworn positions with the most numerous colours in the sample, black and blue, in both positions. A notable feature of the unworn group are 27 gold-in-glass beads from burial 652 and 42 green from burial 461, a colour pattern not replicated by worn beads.

The Lankhills Cemetery

Lankhills is a key Late Roman cemetery in Winchester (AD 310–410) with extensive grave furnishings, first excavated by Clarke (1967–1972)[89] and subsequently Oxford Archaeology.[90] From a combined inhumation total of 789, 314 burials contained items of personal adornment or dress. Of these burials, 20 contained beads, totalling 1,578.[91] The majority (79.08%) dated to AD 350–400. Other periods were as follows: AD 300–350 (15.96%) and post-AD 401 (4.94%).

87 Birley (2005).

88 Barber and Bowsher (2000).
89 Clarke (1979).
90 Booth (2010).
91 For continuity, beads were again recorded individually.

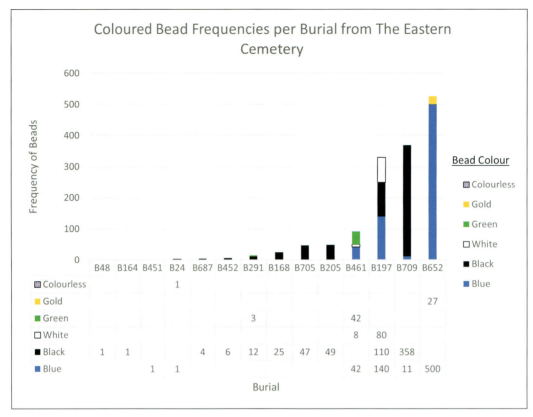

FIGURE 1 Graph showing the frequency of coloured beads by burial from the Eastern Cemetery.

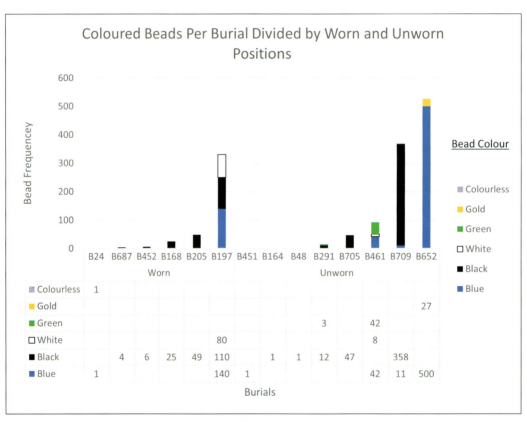

FIGURE 2 Graph showing the frequency of coloured beads per burial from the Eastern Cemetery by worn and unworn positions.

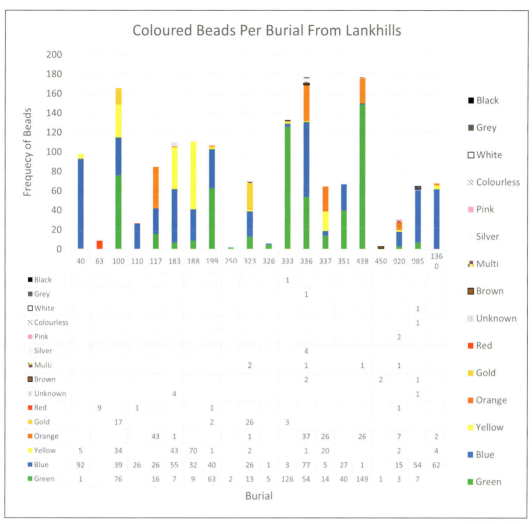

FIGURE 3 Graph displaying the frequency of coloured beads per burial from Lankhills.

Fig. 3 shows coloured beads per burial from Lankhills. Green (37.13%) was the most frequent colour, closely followed by blue (36.88%). Following this: yellow (11.53%), orange (9.06%), gold (3.04%), red (0.76%), multi-coloured and brown (0.31%), silver (0.25%), pink (0.12%), colourless, white, grey, and black (0.06%). Unknown colour types through colour degradation (0.31%). There is a high degree of colour complexity in the sample, with the majority of burials showing multiple colour combinations.

Figs. 4 and 5 show the worn and unworn position of beads per burial from Lankhills. In the worn sample (Fig. 4), green was most numerous (15.08%), with blue (12.99%), orange (2.34%), and yellow (0.44%) following. In the unworn sample (Fig. 5), blue beads (23.89%) were more frequent, followed by green (22.05%), yellow (11.08%), and orange (6.7%). While there are some differences in less well-represented bead colours across worn and unworn groups, the dominant colour patterns (green, blue, orange, and yellow) appear throughout both. Overall, there are more unworn than worn beads in the Lankhills group, a feature which will be discussed further below.

Discussion

Beads from Settlement Contexts

The high volume of blue and green beads in the settlement sample (Table 3) may result from numerous factors. While NGB beads were present in the sample, they only totalled 5. The majority of blue beads were dark cobalt blue and similarly, a high proportion of green beads were dark green. In Roman Britain, recycled green and blue bottle glass was frequently used to manufacture new vessels and decorative items, including glass beads. This is probably the primary cause of high numbers of dark-toned green and blue in the sample. A further contributing factor to the ratio of blue and green in this group, is the presence of turquoise gadroon or melon beads. This style is often found in turquoise faience but are also recorded in dark blue and black

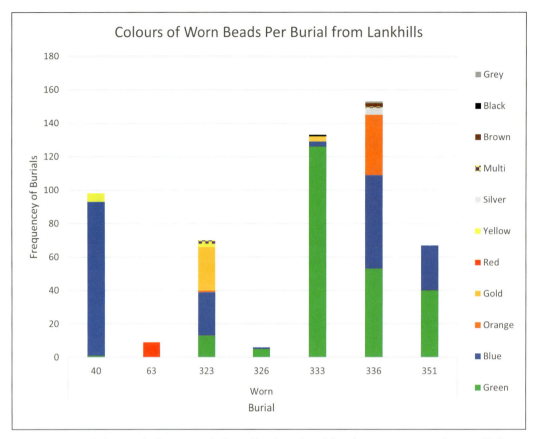

FIGURE 4 Graph showing the frequency of coloured beads per burial found in a worn position from Lankhills.

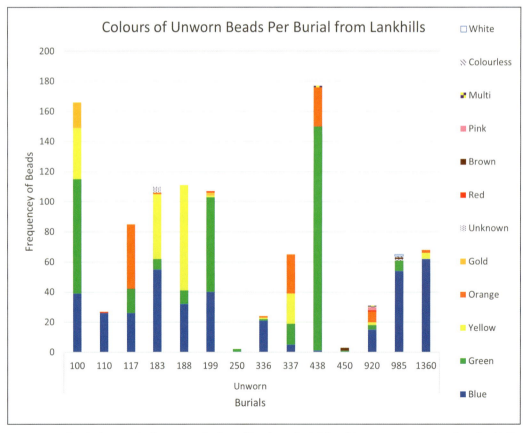

FIGURE 5 Graph showing the frequency of coloured beads per burial found in an unworn position from Lankhills.

glass. This bead style is overwhelmingly the most frequent within the settlement sample. Melon beads are thought to have decorated horse harnesses and are present at military sites, but their function is complicated by their discovery in both burial and civilian settlements.[92] Exemplifying this, the glass working centre of Basinghall Street revealed melon beads of different sizes indicating use by both humans and equines.[93] While the question of function remains debateable, within this discussion, this style of bead was categorised blue and contributes significantly to the colour ratios discussed here.

This sample suggests that blue and green beads were frequently displayed and witnessed by the people of Roman London. As items of display with a universal resonance, these colours evoke the sky and vegetation. Turquoise and NGB are light and bright colours, easily noticeable against the skin and natural textiles. Culturally, if made from recycled blue and green vessel glass, as evidence of Early Roman bead manufacturing at 10 Gresham Street suggests,[94] these beads may have been widely available and relatively affordable. Additionally, 11 black beads in the settlement sample were in a chronological distribution indicating that they were in circulation throughout the 1st–5th c. There are very few warm-toned colours present in this sample. Yellow appears only once, orange three times, and red not at all. Recognising that the sample size of this group is relatively small and while effective in its purpose of demonstrating which bead colours were available to Roman Britons, attempting to isolate defined assertions regarding wider patterns should be avoided. In addition, the Early Roman date of many beads in the settlement sample means that changes in colour preference over time must be considered when comparing this data to that from later burial contexts.

Colour Trends of Beads from the Eastern Cemetery

The limited range of colours at the Eastern Cemetery is perhaps the most notable characteristic of this sample. When compared to the settlement data, the lack of colour diversity becomes even more striking. Only 7 colours are present at the Eastern Cemetery, rather than 12 in settlements. Black, the highest frequency colour appears in 10 of 14 burials containing beads and in 7 is the only colour present. Most beads (1,298) were buried with adult women in both worn and unworn positions. No male skeletal remains were found with beads. 175 beads were with unknown skeletal remains and 32 with non-adults,[95] meaning that when addressing bead colour from this site, we are largely discussing the treatment of adult women.

The majority of black beads from the Eastern Cemetery (503) were jet. Jet and shale items became widely used bead materials in 3rd–4th c. Britain.[96] Due to its electrostatic properties, jet was attributed with perceived apotropaic qualities and further to this, was associated with the treatment of toothache and scrofulous.[97] Jet was also closely associated with women,[98] bleeding,[99] and as a test of female virginity.[100] In Iron Age traditions, amber and jet have been identified as symbolic of life and death. The warm, light-infused colour of amber represented life with jet emblematic of death.[101] This characterisation may have continued in later periods with black glass, shale or jet contrasted with other colours to form a strong visual symbol. In addition to jet, 110 black glass beads were also found at the Eastern Cemetery. In B197, these formed part of a worn anklet with white and dark blue glass beads. The similar contrasting symbolism of light and dark in this sequence is a tantalising echo of the interplay between jet and amber, but is here displayed in dark and white glass. While we should not draw too much from a single occurrence, if we momentarily allow for the comparison to run a little further, it could illustrate how colour (here, black) acts as proxy for a material with which it is culturally associated in the mind of viewers (jet). This poses the question: which is more significant, the material itself, or the idea of the material that colour might evoke? This is perhaps not possible to fully answer, but it illustrates the potential flexibility of colour as a symbol. Further to this, black's universal association with night, sleep, and death may also have prompted the preference of mourners at the Eastern Cemetery, who left it with their dead in relatively high numbers, while excluding many other colours.

Visibility and Contact with Beads from the Eastern Cemetery

The worn and unworn position of beads at the Eastern Cemetery provides additional insight into the potential role of colour in the Roman funeral. While there is little

92 Wardle (2015).
93 Wardle (2015).
94 Casson, Drummond-Murray, and Francis (2015).
95 I am grateful to Rebecca Redfern, Museum of London Centre for Human Bioarchaeology (pers. comm.), for giving me access to recently reworked sex and age determinations for several key burials from this site which differ from the published site report.
96 Allason-Jones (1996).
97 Plin. *HN* 36.34; Parker (2016) 99, 107.
98 Allason-Jones (1996).
99 Parker (2016) 99.
100 Plin. *HN* 36.34.
101 Giles (2012) 122.

difference in worn and unworn colours (Fig. 2), with black, blue, and a moderate amount of white appearing in both groups, the visibility of colours worn by the dead remains noteworthy. Overwhelmingly, mourners from the Eastern Cemetery would have seen black beads, which are present in all but one burial containing worn beads. Continuing the theme of contrasting dark and light colour display, worn black beads would draw the viewer's eye to particular areas on the body. A necklace or bracelet focuses attention towards the head or wrist, particularly if hands are folded on the chest, serving as a visual point of contact. Caressing, holding or talking to these areas of the body in grief, it is possible that noticeable coloured objects located nearby would help to humanise and lessen the corporeal realities of the body for mourners. A funeral at night might further emphasise the glistening qualities of specific materials. Jet is incredibly reflective, as is most coloured glass. Beads made of these materials in black and blue, the most frequent colours at the Eastern Cemetery, would catch the light of torches, effectively making areas of the deceased shimmer and shine. When contrasted with the appearance of surrounding mourners, dressed darkly, and without ornament or jewellery of their own, the deceased might appear increasingly separate from the assembled onlookers.

One exception to the dark colours which dominate the Eastern Cemetery sample is a string of 27 gold-in-glass beads placed by the feet in B652 with a longer string of blue glass beads. As explored with the example of jet, the colour in this case may be a direct referent of the material gold, an opulent gift. There has been discussion that gold-in-glass and other rarer bead types have a possible external origin,[102] specifically in reference to the Lankhills bead sample. However, isotope analysis and wider distribution of gold-in-glass beads in Roman Britain suggest otherwise,[103] and it is possible that aesthetic considerations motivated the inclusion of these beads here. The single occurrence of gold in the group may indicate that darker coloured beads were more often intentionally selected by mourners in the community for a range of socio-cultural and symbolic associations.

Colour Trends at the Lankhills Cemetery
In contrast to both of the London datasets, a greater variety of bead colours was documented at Lankhills. Blue and green were the most common; however, high levels of yellow-orange and gold were also evident. Of the three sample groups, Lankhills alone shows evidence of all 15 colours. As at the Eastern Cemetery, no men were positively identified with beads at Lankhills. Many more beads (1,193) were found with burials of unknown sex (16 burials), while 384 were with women (4 burials). An overwhelming number of the total sample were found in graves of individuals under 18 years old (18 burials, 1,504 beads), while 79 were with adults (two). Dominant colours at Lankhills are those universally classified as 'living' symbols, i.e. associated with sun, vegetation, and sky. The high percentage of orange in this sample is in part the result of 10 amber and 133 coral beads. Coral is a living organism and while this may have been unknown to mourners, its association with the sea further emphasises representations of the living world in the Lankhills data. Amber, as discussed, also has associations with the sun and life in Iron Age symbolism. Further examples of naturally occurring materials in this sample are tooth, carnelian, emerald, pearl, and bone beads. While these materials evoke aspects of the living world, they also highlight the range of colour in the Lankhills sample, which compares starkly to the previous two groups.

Vibrancy and Visibility of Worn and Unworn Beads at the Lankhills Cemetery
Seven burials contained worn beads (Fig. 4), but within this relatively small group, 11 colours were present in varied combinations. Only one worn burial contained a single bead colour, B63 which had 9 red carnelian. The main feature of these burials for viewers would be a vivid array of worn colours in the ornamentation of the dead, a notable contrast to the muted tones seen from the Eastern Cemetery.

Burials with unworn beads (Fig. 5) are double those with worn. Green and blue are the dominant colours in this group, with yellow and orange also being well represented. In Clarke's original excavation, he hypothesised that the position of dress ornaments may relate to ethnicity. Isotope analysis[104] would later show the individuals under discussion to be local, leading Cool to argue that an individual's age at death was more significant to grave good placement at Lankhills.[105] If so, the high number of children found with beads in this sample may explain the larger number of unworn beads. There is little difference in bead material from either group; amber, bone, coral, and glass feature in both. The only exceptions are isolated instances of pearl and stone in the unworn and carnelian in the worn. The presence of similar bead materials in both groups shows that some mourners had access to a variety of bead types, while also making a range of personal choices in how they used them, either

102 Boon and Dekówna (1977) 200.
103 Booth (2010) 295.
104 Eckardt *et al.* (2009).
105 Booth (2010) 296.

to adorn their dead or as grave goods. As a visual spectacle, many of the considerations explored at the Eastern Cemetery remain relevant to Lankhills. However here, instead of the contrastingly dark tones evident in the London burial group, it is vibrant hues which characterise Lankhills beads. These too would guide the eye to focal points on the body, potentially facilitating areas of physical contact between mourner and deceased. In addition, bright beads would contrast notably against the surrounding colours of the burial ritual, discussed above. In the darker space of the grave, mourners may still have observed brighter burial goods while performing other tasks at the graveside, making colour and the dress of the dead a continuing element of the burial process until the grave was filled. While burials with beads were less frequent at Lankhills than those without, this indicates that when colourful burials occurred, they were highly visible in the community and (the data suggests) often reserved for women or children. Dressing or giving colourful beads was just one element in a range of treatments enacted on and for the dead within the burial process of Lankhills. Colours within these burials could broadly be defined as environmentally or materially focused, the complexities of which, had the potential to create oblique or direct social-cultural cues. Furthermore, colour also symbolised the unique choices of mourners within a complex sensory environment and the wider burial landscape.

Comparing Colours Displayed at the Eastern and Lankhills Cemeteries

At the Eastern Cemetery, the colour palette was muted with black and blue the most frequently occurring colours and limited instances of gold and white. The colours well-represented at Lankhills are different to those from London and can be said potentially to draw on a different range of symbolic associations. While this difference could be conditioned by accessibility of beads in both communities, the London settlement sample contained 13 colours, with the Eastern Cemetery displaying only 6 of these, suggesting that intentional choices regarding which colours to deposit with the dead may have been made. If this is true, those same choices were not being made by mourners depositing beads at Lankhills. Colour choices may have been informed by different aesthetic considerations within different communities. Recent isotope analysis in both Winchester[106] and London[107] suggest that burial communities in both locales were mixed groups of people living together. However, as noted above, analysis from Lankhills cautions us against drawing direct parallels between dress ornaments and ethnic identity. What it is possible to suggest is that colour is indicative of a range of different burial choices, possibly informed by different symbolism or beliefs. Black, in some cases potentially mimicking jet, is a dominant colour at the Eastern Cemetery, possibly motivated by the socio-cultural association of jet with medicine and magic and black for its association with death. In contrast, Lankhills saw beads in a more extensive range of both bead colour and material, signifying that within the wider burial landscape there existed a more noticeable section of burials which emphasised colour in the dress of the dead, treatment, and display.

Conclusion

Presented here is a working framework for the analysis of colour symbolism in artefacts from burials in Roman Britain. While provisional and in part schematic, it nevertheless highlights burial trends from different sites from a previously underutilised perspective. Using this approach, colour is hypothesised as a key component of funerary experience. Walking through what is known of the 'standard' Roman funeral we can highlight coloured elements of the burial process, including skin complexion, clothing, wrappings, and container which although now lost in the archaeological record, would have been central components of the funeral experience for mourners. Colour symbolism can also be accessed by documentation of artefact colour. From the case studies of London and Lankhills, we see that different communities make quite different choices in bead colour. Availability of beads could be a contributing factor to this difference, although that the range of colours from London settlements are not reflected more in the burial pattern of the Eastern Cemetery goes some way to suggest that other choices were being made by mourners. It is possible that the difference in colours between the two sites is also reflective of different symbolic values related to colour. These could be drawn from culturally determined resonances or less clearly-defined universal stimuli.

The framework outlined here is provisional. With further research, it could be expanded to include a more comprehensive catalogue of colour resonances from the Roman world, as well as a broader range of burial artefacts, and work in this area is on-going. Further integration into a wider sensory framework incorporating sounds, taste, and smell would also benefit this study.

106 Eckardt *et al.* (2009).
107 Shaw *et al.* (2016).

Acknowledgements

I would like to thank John Pearce for his continued support, ideas, and discussion, which contributed significantly to this paper. I would also like to thank Michael Marshall for his help and advice during the early stages of this study and MOLA for allowing me to access their archive. Finally, I wish to thank Rebecca Redfern for her help and assistance with the skeletal remains from the Eastern Cemetery.

Bibliography

Primary Sources

Plin. *HN* = H. Rackham, W. H. S. Jones, and D. E. Eichholz ed. and transl., *Pliny. Natural History*, 10 volumes (Loeb Classical Library) (Cambridge Mass. 1938–1962; revised edition 1989).

Vitr. *De arch.* = F. Granger ed. and transl., *Vitruvius. On Architecture*, 2 volumes (Loeb Classical Library 251, 280) (Cambridge Mass. 1931–1934).

Secondary Sources

Aldhouse-Green M. J. (2012) "Singing stones, contextualising body language in Romano-British iconography", *Britannia* 43 (2012) 115–34.

Allason-Jones L. (1996) *Roman Jet in the Yorkshire Museum* (York 1996).

Barber B. and Bowsher D. (2000) *The Eastern Cemetery of Roman London* (London 2000).

Berlin B. and Kay P. (1969) *Basic Colour Terms, their Universality and Evolution* (California 1969).

Birley R. (2005) *Vindolanda, Extraordinary Records of Daily Life on the Northern Frontier* (London 2005).

Bodel J. (2000) "Dealing with the dead, undertakers, executioners and potter's fields in ancient Rome", in *Death and Disease in the Ancient City*, ed. V. Hope (London 2000) 128–51.

Bolton R. (1978) "Black, white and red all over, the riddle of colour term salience", *Ethnology* 17 (1978) 287–311.

Bond S. (2016) *Trade and Taboo: Disreputable Professions in the Roman Mediterranean* (Michigan 2016).

Boon C. and Dekówna M. (1977) "Gold-in-glass Beads from the Ancient World", *Britannia* 8 (1977) 193–207.

Booth P. (2010) *The Late Roman Cemetery at Lankhills, Winchester, Excavations 2000–2005* (Oxford 2010).

Bradley M. (2009) *Colour and Meaning in Ancient Rome* (Cambridge 2009).

Campbell L. (2020) "Polychromy on the Antonine Wall distance sculptures, non-destructive identification of pigments on Roman reliefs", *Britannia* 51 (2020) 1–27.

Casson L., Drummond-Muray J., and Francis A. (2015) *Romano-British Round Houses to Medieval Parish, Excavations at 10 Gresham Street, City of London, 1999–2002* (London 2015).

Casson R. (1997) "Colour shift, evolution of English color terms from brightness to hue", in *Color Categories in Thought and Language*, edd. C. Hardin and L. Maffi (Cambridge 1997) 224–39.

Causey F. and Shepherd J. (2004) "Amber", in *Colour in the Ancient Mediterranean World*, edd. K. Stears and L. Cleland (Oxford 2004).

Chapman J. (2002) "Colourful prehistories, the problem with the Berlin and Kay colour paradigm", in *Coloring the Past: The Significance of Colour in Archaeological Research*, edd. A. Jones and G. MacGregor (Oxford 2002) 45–72.

Clarke G. (1979) *Pre-Roman and Roman Winchester – Part II. The Roman Cemetery at Lankhills* (New York 1979).

Croom A. (2000) *Roman Clothing and Fashion* (London 2000).

Crummy P. et al. (2007) *Stanway: An Elite Burial at Camulodunum* (London 2017).

Davies S. et al. (2002) *Excavations at Alington Avenue, Fordington, Dorchester, Dorset, 1984–87* (Dorset 2002).

Devièse T., Ribechini P., Baraldi B., Farago-Szekeres H., and Duday M. (2011) "First chemical evidence of royal purple as a material used for funeral treatment discovered in a Gallo Roman Burial, Naintré, France, third century AD", *Analytical and Bioanalytical Chemistry* (2011) 1739–48.

Eckardt H. et al. (2009) "Oxygen and strontium isotope evidence for mobility in Roman Winchester", *JAS* 36 (2009) 2816–25.

Farwell D. and Molleson T. (1993) *Excavations at Poundbury 1966–80 Volume II: The Cemeteries* (1993 Dorset).

Gage J. (1999) *Colour and Meaning: Art, Science and Symbolism* (1999 London).

Giles M. (2008) "Seeing red, the aesthetics of martial objects in British and Irish Iron Age", in *Rethinking Celtic Art*, edd. D. Garrow, C. Gosden, and J. Hill (Oxford 2008) 59–77.

Giles M. (2012) *A Forged Glamour: Landscape, Identity and Material Culture in the Iron Age* (2012 London).

Hoecherl M. (2015) *Controlling Colours: Function and Meaning in the British Iron Age* (2015 Oxford).

Hope V. (2017) "A sense of grief, the role of the senses in the performance of Roman mourning", in *Senses of the Empire*, ed. E. Betts (London 2017) 86–103.

Hope V. and Marshall E. edd. (2000) *Death and Disease in the Ancient City* (London 2000).

Jones A. and MacGregor G. (2002) *Colouring the Past: The Significance of Colour in Archaeological Research* (Oxford 2002).

Lindsay H. (2000) "Death-pollution and funerals in the city of Rome", in *Death and Disease in the Ancient City*, edd. V. Hope and E. Marshall (London 2000).

Morris I. (1992) *Death-ritual and Social Structure in Classical Antiquity* (Cambridge 1992).

Murton D. (1980) "There's no such beast: cattle and colour naming among the Mursi", *Man N.S.* 15 (1980) 320–38.

Newton I. (1704) *Opticks, or, a Treatise of the Reflections, Refractions, Inflections & Colours of Light* (London 1704).

Noy D. (2011) "Goodbye Livia: dying in the Roman home", in *Memory and Mourning, Studies on Roman Death* edd. V. Hope and J. Huskinson (Oxford 2011) 1–20.

Parker A. (2016) "Staring at death, the jet gorgoneia of Roman Britain" in *Small Finds and Ancient Social Practices in the Northwest Provinces of the Roman Empire*, edd. S. Hoss and A. Whitmaore (Oxford 2016).

Pearce J. and Weekes J. edd. (2017) *Death as a Process: The Archaeology of the Roman Funeral* (Oxford 2017).

Pennick Morgan F. (2018) *Dress and Personal Appearance in Late Antiquity: The Clothing of the Middle and Lower Classes* (Boston 2018).

Philpott R. (1991) *Burial Practices in Roman Britain: A Survey of Grave Treatment and Furnishing AD 43–410* (BAR-BS 219) (Oxford 1991).

Rothe U. (2009) *Dress in the Rhine-Moselle Region of the Roman Empire* (Oxford 2009).

Shaw H. *et al.* (2016) "Identifying migrants in Roman London using lead and strontium stable isotopes", *JAS* 66 (2016) 57–68.

St Clair K. (2016) *The Secret Lives of Colours* (London 2016).

Swain H. and Roberts M. (1999) *The Spitalfields Roman* (London 1999).

Swift E. (1999) *Rationality in the Late Roman West through the Study of Crossbow Brooches, Bracelets, Beads and Belt Sets* (Ph.D. diss., Univ. of London 1999).

Toynbee J. (1971) *Death and Burial in the Roman World* (London 1985).

Turner V. (1966) "Colour symbolism of Ndembu ritual", in *Anthropological Approaches to the Study of Religion* ed. P. Banton (London 1966) 47–84.

Wardle A. (2015) *Glass Working on the Margins of Roman London: Excavations at 35 Basinghall Street, City of London, 2005* (London 2015).

Weddle C. (2013) "The sensory experience of blood sacrifice in Roman Imperial cult", in *Making Senses of the Past: Towards a Sensory Archaeology,* ed. J. Day (Illinois 2013) 137–59.

Wierzbicka A. (1996) *Semantics, Primes and Universals* (Oxford 1996).

Wild J.-P. (2004) "Textiles and dress", in *A Companion to Roman Britain*, ed. M. Todd (2004) 299–308.

Funeral Processions in Late Antiquity

Luke Lavan

Abstract

The article presents a synthesis of evidence for late antique funeral processions, which come exclusively from textual sources, many of which are hagiographic, but also include secular histories, letters, and some laws. This is done to build up a material evocation of funeral processions, especially expressed in the visualisation of a procession contemporary with that of Monica, mother of Augustine, in AD 387. Common patterns emerge across the late antique world, reflecting some Roman customs, such as the freeing of slaves/captives, expecting in both 6th c. Constantinople and Merovingian Gaul, where a 'consular' inauguration procession survived for bishops in a raised chair, beyond the period. Although the evidence for funeral processions is largely confined to the elite a few snippets of evidence suggest that these forms also influenced more modest funeral processions for more modest individuals.

As Roman death rates were high, funeral processions were likely to have been a regular occurrence.[1] These were perhaps confined to adults, as none are recorded for children, with the exception of a grand cortège for two Merovingian princes.[2] Poor people likely had no more than a bier carried by family and neighbours, although it is wrong to assume they had no ceremony at all. When the penniless Symeon the Fool died in his hut at Emesa, where he had prepared his own rough resting place, two neighbours carried him out to burial: there were no human psalms, although a third heard heavenly voices singing them for him. Elsewhere, ecclesiastical attempts to provide free funerals (discussed below) must have extended to people like Symeon.[3] Although the Early Roman funeral procession has been studied, it is important not simply to assume continuity. Rather, we must try to establish, from late antique sources, exactly how similar or different late antique customs were. This was a collective ritual that involved not only family and friends but potentially entire neighbourhoods, as the obligation to follow a funeral cortège was widely felt: at Edessa, in 500/501, those returning from a collective funeral procession for famine victims then 'accompanied the funeral of those who had died in his own neighbourhood'.[4] Occasionally, a whole city might be involved, as on the deaths of bishops and emperors. It should also be noted that almost all funeral processions described from the period were for Christians, although the appearance of the cortège remained geared as much to social display as to religious values, even in the eastern capital in the 6th c.[5]

The route of the procession was essentially the same as it had been earlier: from the house, through the streets of the city, to inhumation in a burial ground beyond the city limits. There was a growing tendency to focus on a church: for example, prominent lay Christians were buried at St. Peter's in Rome from the 4th c. onwards. However, extramural burials were still the norm in Justinian's Constantinople, though archaeology confirms intramural burial in many places during the Early Medieval transition of the 6th–8th c.[6] Biers would naturally pass along the main colonnaded streets, and would have had little choice of exit in any walled city with gates. The desire of some to pass through the agora suggests that the route of the procession might be designed to increase visibility, in order to allow a show of the wealth of the deceased and the strength of his or

1 Funeral processions, in Republican and Early Imperial Rome: Toynbee (1971) 46–48; Bodel (1999) and Arce (2000). I hereby reproduce a section of my monograph Lavan (2020) vol. 1 196–201, with kind permission of Brill.
2 For children: Gregory of Tours *Hist*. 3.18 (on a bier with psalms at Paris, AD 524), PLRE 3.526 Guntharius, and 3.1113 Theudobald.
3 Funeral 'procession' of a pauper, Emesa: *v. Sym*. part 4 (p. 168).
4 As collective rituals: at Antioch, Libanius obliged to follow corteges: *Or*. 34.22–23 (when school master, so after 354 but before 387 when written); at Edessa: Josh. Styl. 43 (AD 500/501).
5 Studies of late antique funerals: see especially Rebillard (2009) of which 131–34 deals with processions, with Burman (2004), Cameron (2002), and Matthews (2009). See also the edition of Greg. Nyss. *V. Macr*. by Maraval (1971).
6 Route, ending with burials in churches: Cantino Wataghin (1999) 159–63, who also discusses intra-mural burial. For Justinianic Cple, see Just. *Nov*. 59.6 (AD 537). Burials of urban prefect Junius Bassus and praetorian prefect Petronius Probus at St. Peter's, Rome: (for Probus, d. AD 388) see PLRE 1.736–40 Sex. Claudius Petronius Probus 5; Matthews (2009) 133–36 with *AE* (1953) 239 and Cameron (2002); (for Bassus, d. AD 331) PLRE 1.154–55 Iunius Bassus 14 and ILCV 63 = CIL 6.1756b (pp. 855, 4752) = CIL 6.31922b = CLE 1347 = ILCV 63 = ICUR 2.4219 = AE (1999) 198 = AE (2004) 192 = AE (2008) 91 (for Probus); Macrina (Pontus, d. 379, shortly after Synod of Antioch) from monastery (where resident) to a church: Greg. Nyss. *V. Macr*. 34, with Lumpe (1993); Monica (Ostia, d. 387 in Bezzenberger (1993)) from house to tomb: August. *Conf*. 9.12 (epitaph was discovered at St. Aurea, outside the city: *Anth. Lat*. 1.670, commented by Boin (2010)).

her following, as well as of the identity of the heir.[7] This habit was reinforced by a new tendency to undertake such processions during the daytime: whether this was the influence of Christianity is uncertain, as Libanius joined such processions regularly and St. Martin of Tours encountered one during sunlit hours in the countryside.[8] Julian thought the habit was an unfortunate innovation, and that the streets should not be the scene of such mourning in daylight: he banned them during his stay in Antioch. This is not to say that burials by night ceased, even for Christians. At Constantinople, the funerals of both Constantius II and bishop Meletius, a few years before Julian enacted his measure at Antioch, seem to have been at night: descriptions mention nocturnal chants and the spectacular impression created by torches/lamps. Gregory of Nazianzus also expected a typical Christian funeral to take place during the hours of darkness. At Milan, we have a different pattern: for the funeral of Ambrose, the procession began at dawn, after the Eucharist had been celebrated, from a church where the body had lain, to the Ambrosian Basilica. Quite what happened in other western cities is uncertain.[9]

The funeral cortège was set around the bier of the deceased, which was carried on the shoulders of eight men at Constantinople, in Justinian's day. The bier might be decorated: Justinian refers to two precious biers of Studius (*gloriosus*) and Stephen (*magnificentissimus*), and a gilded bier – all of which were available for hire for funerals conducted by the clergy of Constantinople – for fees of 10 and 24 *solidi* respectively. A golden coffin was used to carry Constantine through Constantinople, but this was of course exceptional.[10] In most cases, even for the wealthy, the bier seems to have been open, with layers of cloth draped over the body. We might expect a coffin only to have been used if the deceased needed to be moved some distance. A simple linen shroud seems to be the most usual covering: the inhabitants of Edessa thought it fit for a martyr in the early 4th c.; Gallic peasants used it in the early 5th c. At Alexandria, in the early 7th c., linen was the under-sheet over which finer coverings were laid. In Pontus, Gregory of Nyssa gave his sister a shroud of the same material, again covered by other garments.[11] We have a fine description of the pall of Justinian, which was embroidered with purple, gold, and jewels, depicting his conquests and defeated enemies. That of Blæsilla, a wealthy friend of Jerome, was a cloth of gold.[12] Gregory of Nyssa implies that fine textiles were used for eminent people, who might acquire such items years earlier and store them for their funeral.[13] Silk is also known. Ammianus mentions the wearing of this material in processions as being most appropriate for one's funeral, perhaps reflecting the tastes of the elite in larger cities.[14] On the deaths of holy men, members of the public might try to touch the textiles covering the body. In the case of Meletius, bishop of Antioch, mourners went so far as to take napkins binding the face to use as amulets, suggesting that the face was exposed. Attempts by the crowds to touch the robes of Basil during his funeral procession resulted in a number of fatalities. The crowds mourning Ambrose sought to touch the body with their own items of clothing, for some benefit.[15]

Those accompanying the bier took different positions according to their status. The crowds came behind the cortege. In the Near East, Eusebius mentions the noise of flutes, likely played by professional mourners, and the sound of blows (to the body?), as part of funeral processions under Maximinus Daia. Into the 5th c.,

7 Route, passing through agora: at Antioch: Lib. *Or.* 2.36 (generic, but given in AD 380/81); in Near East: Euseb. *Hist. eccl.* 9.8.11: lamentation 'in every lane and market place'; Joh. Chrys. *Hom. in 2 Thessal.* 1.2 (PG 62.471) (between edict of toleration (AD 311) and death of Maxminus Daia in 313); at Caesarea in Cappadocia (Basil, d. AD 379, Bautz (1990)), which Gregory described but did not witness, see Greg. Naz. *Or.* 43.80.

8 Daytime funeral processions, at Antioch: Libanius joined them during school time (*Or.* 34.22–23), which was in the morning (*Or.* 58.8–9 and *Ep.* 25.7); another took place at dawn: *Or.* 1.174; in Gaul: pagan rural funeral procession, in daylight, Sulp. Sev. *V. Mart.* 12; at Vercelli: burial before sunset, even if no actual procession is recorded: Jer. *Ep.* 1.12; at Nicomedia during the earthquake of AD 358, Ephr. *Hymn* 7.109, 7.125–40 (PO 37.101–102), has the funeral processions taking place at the 3rd hour of the day.

9 Night-time funeral processions: at Antioch, Julian bans daytime funerals: Julian *Ep.* 56; at Cple, nocturnal chants for Constantius: Greg. Naz. *Or.* 5.16, taken as typical of a Christian funeral by Gregory; Greg. Nyssa *Melet.* (PG 46.861), noting that lamps make rivers of fire. Dawn funeral procession: at Milan: Paul. *V. Amb.* 48.1 (along with pagans, for Ambrose) from CSA 894 (from which I saw the text).

10 Biers: carried by eight men: implication of Just. *Nov.* 59.3(1); for hire: Just. *Nov.* 59.6 (AD 537); Constantine's golden coffin (λάρνακα = urn): Euseb. *Vit. Const.* 4.66, 4.70.

11 Linen cloths: at Edessa: *Martyrdom of Habbib the Deacon* 38 (AD 308/309 on Macedonian year); in Gaul: Sulp. Sev. *V. Mart.* 12 (bishop 371–397) PCBE 4.2.1267–79 Martinvs 1 (bishop AD 371/372–397); at Alexandria: Joh. Moschus 77; in Pontus: Greg. Nyss. *V. Macr.* 32 (linen, covered by a dark robe).

12 Pall, at Cple (Justinian): Corippus *Laud. Just.* 1.275–92; at Rome (Blæsilla): Jer. *Ep.* 39.1; in Pontus (Macrina) and at Alexandria: see previous note.

13 Storing clothes for a funeral: Greg. Nyss. *V. Macr.* 28.

14 Silk appropriate for funeral: Amm. Marc. 28.4.8.

15 Public touching clothing of deceased: Greg. Naz. *Or.* 43.80 (Basil of Caesarea d. 379) see n. 7; taking napkins (σουδάρια) from face in procession at Cple: Greg. Nyss. *Melet.* (PG 46.861) (Meletius of Antioch d. 381, during council of Constantinople); touching body with own clothes: Paul. *V. Amb.* 48.1 (Ambrose d. 397) from CSA 894 (from which I saw the text).

female mourners were hired to announce the arrival of the cortège by weeping, lamenting, and chanting. Their desolate presentation of death was hated by bishops, though these mourners were sometimes invited to join Christian funeral processions, a habit which John Chrysostom tried to ban. Yet, at Edessa in 500/501, women still took part, 'with mournful lamentation and emotional cries'. They are attested at Gaza, in the reign of Justinian, again the subject of an episcopal ban. Here they were definitely professional mourners: one of their number 'knowing her art well, causes louder cries and requests an abundance of tears from [the other] pitiful women'. Even in 6th c. Hispania and Gaul, at funerals of major public figures, crowds of sympathetic women might adopt mourning dress, as if for their own relatives. Clearly, ecclesiastical attempts to remove female mourners outside of the family from funerals had not entirely succeeded. The payment of female hermits and nuns to attend processions (probably to sing psalms), in 6th c. Constantinople, suggests practices were Christianised by slow change or substitution. Pagan songs may have disappeared, but grief was still displayed in a theatrical manner, encouraged and perhaps led by women who were not close relatives.[16]

Preceding the bier was the heir, as described for funerals in the 4th c. and 6th c. The heir was now arranged in a similar position to the steward who stood at the front of daily processions of the wealthy, in Rome and elsewhere.[17] Around the bier was usually an escort of domestic servants, slave or free, who might wail or carry candles. These groups participated in Christian funerals, from late 4th/early 5th c. Africa, Antioch and Pontus, to 6th c. Constantinople.[18] In the latter city, slaves who had been freed in the will of the deceased, or by the heir, would wear the 'liberty cap' (*pileus*) and parade in front of the cortege. The custom survived also in the West: the freeing of slaves who participated in the funeral service was a practice recognised by the Council of Paris in 566–573. Gregory of Tours' account of a miracle during the funeral procession of bishop Germanus in the same city, in 576, is also instructive: the body became heavy when prisoners called out to it, as the cortège passed by; when the prisoners were released, the body became light again, and the funeral party could proceed. Sometimes, slaves were dressed up as freedmen, though they had not in fact been granted their liberty. Rather, they were being used to convince onlookers of the liberality of the deceased. Justinian legislated against this abuse, which was also addressed by the Parisian council.[19] In the laws of Justinian, we also hear of candle-bearing acolytes, normally three in number, who surrounded the bier. For the emperor's own funeral, we hear that the candle holders were of silver.[20]

Of the identity of those carrying the corpse, we have a few details. Libanius says that his teachers carried biers in funeral processions at Antioch, in the later 4th c., whilst the epitaph of the Christian urban prefect Junius Bassus signo Theotecnius boasts that the crowds competed to carry his bier in 359: they prevented his servants/slaves (*famulis domini*, presumably here *liberti*) from doing so.[21] For all later Christian funerals, we hear of clergy undertaking this service, as in the funeral of Macrina in Pontus (four are mentioned) and for that of Paula, the friend of Jerome, at Jerusalem. Synesius suggests clergy had some role in funerals, *ca.* 400; he asked his fellow bishops not to escort the funerals of the governor Andronicus and his associates, who had been excommunicated, in the event of their death. Jerome also records after an execution at Vercelli, in Italy during the mid-4th c., after which the clergy both covered the body and buried it in the grave they had dug, as was their duty; it is thus likely they also carried it. At Constantinople, in the 6th c., the carrying of the

16 Women (mourners): <u>Near East</u>: Euseb. *Hist. eccl.* 9.8.11; <u>Antioch/Cple</u>: Joh. *Chrys. Hom in Mt.* 31.4 (PG 57.374) disapproves of bringing in 'heathen women' who 'kindle ... feelings and stir up the furnace' (presumably by singing dirges), which he bans at *Hom. in Heb.* 4.6 (PG 63.44); commented by Rebillard (2009) 131–33; at <u>Edessa</u> (AD 500/501) in Josh. Styl. 43; at <u>Gaza</u> (during reign of Justinian): Choricius *Or.* 8.53–54 (banned by bishop). Mourning dress in 6th c. at <u>Soissons</u>: Gregory of Tours *Hist.* 5.34 (*lucubribus vestimentis*), for funeral of Chilperic's son Chlodobert (d. 580, PLRE 3.297 Chlodobertus), also suggested at <u>Zaragoza</u> (AD 542) by 3.29. For female hermits or nuns attending funerary processions in 6th c. at Cple see Just. *Nov.* 59.5 (AD 537).

17 Heirs walking before the bier: <u>Julian</u>: Lib. *Or.* 18.120–21 (for Constantius, Cple AD 361/62); <u>Egyptian bishop</u> (6th c.): Anastasius of Sinai *Tales of the Sinai Fathers* 1.16 (Greek not seen).

18 Servants escort the bier: in <u>Africa</u> (August. *Serm.* 102.3 (PL 38.612)); at <u>Antioch</u>, both male and female (Joh. Chrys. *Hom. ad pop. Ant.* 3.4 (PG 49.52); in <u>Pontus</u> (Greg. Nyss. *V. Macr.* 34), when the servants (ὑπηρετῶν – which Maraval would like to be 'clercs inférieurs' rather than servants) and deacons surrounding the bier carried wax tapers (κηροῦ λαμπάδας); in <u>Cple</u>: see next footnote.

19 Freedmen, freed in the deceased's will wear the liberty cap and march in front of the funeral procession of their former master at <u>Cple</u>: *Cod. Iust.* 7.6.1.5 (AD 531); at <u>Paris</u>: *C. Paris III* Canon 9; at <u>Paris</u> (AD 576), at funeral of bishop Germanus: Gregory of Tours *Hist.* 5.8 PCBE 4.1.884–94 Germanvs 3 (d. AD 576).

20 Acolytes bearing candles: *Cod. Iust.* 7.6.1.5 (AD 531); Just. *Nov.* 59.5 (AD 537); Corippus, *Laud. Just.* 3.8–9, 3.39 (Justinian's funeral (AD 565), Cple).

21 Bier carriers, non-clergy: <u>teachers</u> (διδάσκαλοι) in late 4th c. Antioch: Lib. *Or.* 34.23; <u>crowds</u> (rather than *famulis domini*) in Rome (AD 359): see Junius Bassus epitaph, above n. 6.

bier was undertaken by eight clergy, either priests or monks (the *assisterium*), a service which Anastasius and Justinian sought to ensure was provided for free. This concern was echoed at Ephesus around the same time in an inscribed public letter of bishop Hypatius, who insisted that the Church offer funerals free of charge. According to Justinian's law, when not being used, an *assisterium* processed behind the body. The text records that some might wish to hire supplementary *assisteria* in order to make a show. Such evidence for ostentation perhaps explains why one creditor, recalled in the same legislation, refused to allow a bier to appear in the street until the debts of the deceased man had been paid, an act which thoroughly annoyed the reforming emperor.[22]

By accompanying the corpse itself, the clergy and their acolytes were making some impact, in adding Christian layers to the rite. Their handling of the body was perhaps encouraged by the late antique conception of holiness, as something quite physical in its qualities. This act allowed them to constitute the core of the funeral cortege, and thus (in theory) impose halts, determine the route, or keep mourners away from the corpse itself. Even if the clergy were not involved in all 4th to early 5th c. funeral processions, they seem to have become important by the 6th c., if the funerals alluded to in Justinian's legislation are representative: nuns were present and are thus likely to have added a further Christian element, through their singing. A change in atmosphere would have surely accompanied the involvement of so many members of the clergy, and the exclusion of traditional wailers where this was achieved.

Grief was most acceptable when coming from close family members. According to Choricius of Gaza, one could expect fathers, children, and mothers to pull their hair, lament, and wail. Gregory of Tours remarked that the sight of women 'weeping and wailing … with their hair flowing free and with ashes on their heads' was more appropriate for the funerals of their own husbands, than to a supplicatory ritual which it was part of.[23] This exhibition and acceptance of the grief of the family was a long-standing part of funeral processions. Chrysostom remarks that his congregation often saw 'a dead body carried through the market-place, orphan children following it, a widow beating her breast, servants bewailing, friends looking dejected …' Here, he appears to reveal to us the relative position of family members within the cortege, slightly ahead of the servants/slaves, who were themselves part of the *familia*, but not among those privileged to carry or walk before the bier, as could those who were being freed under the terms of the will. The presence of servants was no doubt of practical use, in case anyone was overcome by grief, as was the mother of Jerome's friend Blæsilla, who fainted. But Chrysostom imagined an ideal Christian funeral at which all family members, down to great-grandchildren, might attend.[24]

Some of the 'friends' who followed the family group were undoubtedly clients, reflecting the order of daily processions of (living) wealthy patrons in 4th c. Rome. Augustine is explicit, describing clients following after servants, though he does not list as many types of participant as Chrysostom.[25] Other 'friends' were either peers or individuals of high status. Libanius followed daytime funerals as a habit, suspending school to do so. The parents of his pupils complained. In his defence, Libanius stated that this was common practice for governors, or at least ex-governors. At Edessa in 500, a governor and all the free-born attended a procession led by the bishop, for a public funeral of plague victims. For the latter occasion, the city authorities clearly wanted to make a public statement, though only the bishop is described as being 'in their head/top/beginning'. A forward position in the cortège is also known for distinguished lay friends in other funerals. Jerome notes that, at Rome in 384 or 385, 'people of rank headed the procession', for his rich friend Blæsilla. Valens, at Antioch, honoured his favourite astrologer by obliging *honorati*, including two former consuls, to parade in front of the body, a gesture which Ammianus found intolerable. The same honour was given by Theodosius I himself to the Gothic king Athanaric at Constantinople in 381. In the last two cases, we can be sure that distinguished friends definitely walked at the head of cortège rather than behind the family. Quite what message they sought to convey by doing so is difficult to decipher: did they intend to show support for an heir or suggest dependent status like one of the patron's freedmen, or like retainers walking before

22 Bier carriers, clergy: in Pontus: Greg. Nyss. *V. Macr.* 32 with Lumpe (1993) (AD 379, Gregory, a bishop and two priests carry the bier); in Cyrenaica: Syn. *Ep.* 42 (συμπροπέμψουσιν, AD 411); at Jerusalem: Jer. *Ep.* 108.30 (AD 404, bishops carry bier) PCBE 2.1617–26 Paula 1; in Cyrenaica: Syn. *Ep.* 3 (*ca.* AD 400); at Vercelli?: Jer. *Ep.* 1.12 (mid-4th c.); at Cple: Just. *Nov.* 59.5–6 (AD 537) (mentioning Anastasius and regulation of expenses, with story of creditor); at Ephesus, bishop Hypatius (PCBE 3.457–69 Hypatios 4 (AD 519–540/41)): IvE 7.4135 (funerals must be free); (Feissel (1999) 132 no. 28, found in the atrium of the church of St. Mary, dated by F. to *ca.* 530–540).

23 Professional mourners excluded: see n. 16 above. Family mourning at Gaza: Choricius *Or.* 8.27, 8.53. Mourning women at Zaragoza: Gregory of Tours *Hist.* 3.29.

24 Family, servants, friends following body: Joh. Chrys. *Hom. in 2 Thessal.* 1.2 (PG 62.471). Mother overcome: Jer. *Ep.* 39.6. Children, grandchildren, great-grandchildren: Joh. Chrys. *Hom. in Heb.* 4.6 (PG 63.44).

25 Clients: August. *Serm.* 102.3 (PL 38.612); Amm. Marc. 14.6.16–17.

a magistrate? On other occasions we do not know the position of *honorati* but their presence was significant: at Gaza, in the reign of Justinian, the funeral of the mother of the bishop *ca.* 518 was attended by men of illustrious rank, including the authorities of the neighbouring cities, who seem to have participated in a procession which 'emptied' the city, according to Choricius.[26]

Unlike in earlier centuries, the dress code for funerals seems to have excluded white, which had once been worn, at least by women. For Sidonius Apollinaris of Clermont/Arvernis 474/75, wearing white at a funeral was a *faux pas* of the *nouveau riche*. A century or so earlier, the only white clothing visible in a funeral procession in the Gallic countryside was the linen covering the body of the deceased.[27] Failure to wear mourning dress within the family could be seen as shocking, as it was for Synesius, when a niece refused to change out of her pre-nuptial costume on the death of her uncle, out of fear of creating a bad omen. At Rome, senators took off their (normally white) togas to mourn the urban prefect Junius Bassus in 359, perhaps replacing them with *saga* (traditional mourning garments), as Al. Cameron suggests. At Constantinople, the *Book of Ceremonies* also describes senators changing out of their white *chlamydes* (appropriate for imperial ceremony) into coloured ones, inside the Great Church, to attend the funeral of bishop Sergius in 638. This ritual was a protocol which supposedly followed the form of funerals of earlier patriarchs, in 606 and 610. More often, funerary dress seems to have been far simpler. In the same city in 381, Gregory of Nyssa talks of people wearing sackcloth and black garments for the funeral of bishop Meletius.

This is what people wore in the 'funereal' supplicatory procession at Zaragoza in 542, the men in hair shirts and the women in black. At Antioch, John Chrysostom noted that both the servants and the horses of rich men were dressed in sackcloth, leading their funeral processions.[28]

Modifications of personal appearance were common in funeral processions. At Constantinople, Julian walked before the bier of Constantius not only clothed in mourning dress, but also without a diadem. At Antioch, the *honorati*, mourning for Valens' astrologer, were obliged to walk with uncovered heads and bare feet. Chrysostom, Corripus, and Gregory of Tours observe that women might tear their clothes, loosen their hair in grief, and even cover themselves in ashes.[29] It is important to note that we have no indication of status display in the dress of those following the bier: this was apparently inappropriate. The carrying of torches/lamps and especially candles is widely mentioned, as is the burning of incense, and in one case perfumes, which were sprinkled on the coffin and on the crowds watching the burial of St. Simeon the Elder at Antioch in 459, according to his biographer.[30] The singing of religious melodies seems to have become important, especially of psalms, which are widely attested, but other 'hymns and spiritual songs' are mentioned at Edessa in 500/501.[31] We hear of designated choirs singing in the funeral processions of

26 Honorati: at Antioch: Libanius and ex-governors following funerals: Lib. *Or.* 34.22 (governors follow funerals up to the day of their death), given after AD 387/388, but before 392/93; at Edessa: Josh. Styl. 43 (AD 500/501), on which I am grateful to J. Watt for a revised translation, noting that the published translation suggests the governor and company are with the bishop 'with him'; the revised 'with them' suggests they were in the procession, not leading it, which only the bishop is recorded doing; at Rome: Blæsilla's procession headed by people of rank (*nobilium ordine praeeunte*): Jer. *Ep.* 39.1, with PLRE 1.162 Blæsilla 2, PCBE 2.310–11 Blæsilla (died AD 384 or 385); at Antioch (or so the narrative implies) for Heliodorus the astrologer: Amm. Marc. 29.2.15 (d. after treason trials of 371–372 and before King Pap's death in 374); at Cple: (Theodosius for Athanaric): Jordanes *Get.* 28 (144), PLRE 1.120–21 Athanaricus (d. AD 381, Cple); at Gaza (after AD 518): Choricius *Or.* 7.13.

27 Dress at funerals: white (καθαραῖς) for participants in procession: e.g. Plut. *Aem.* 3.24 (d. 160 BC), but otherwise dark mourning clothes, except for women who wore white/light (λευκάς) clothing in the Early Empire: Herodian 4.2 (with senators wearing black μελαίναις); see Smith (1875) for a still useful collection of sources, including the non-white dress of family male members; not white: Sid. Apoll. *Ep.* 5.7.4 (AD 474–475); white linen on corpse only: Sulp. Sev. *V. Mart.* 12.

28 Dress, at funerals: family in mourning dress: Greg. Naz. *Or.* 5.17; Syn. *Ep.* 3 (implied); senators changing clothes: Junius Bassus epitaph, as above n. 6 (out of togas); *Cer.* 2.30 (coloured *chlamydes*); sackcloth: Greg. Nyss. *Melet.* (PG 46.853) (σάκκος); hairshirts: Gregory of Tours *Hist.* 3.29 (*induti ciliciis*, also using ashes); Joh. Chrys. *Hom. ad pop. Ant.* 3.4 (PG 49.52) (σάκκῳ) for servants (male and female), mules and horses; black robe (for preacher): Greg. Nyss. *Melet.* (PG 46.853) (μελανειμονοῦντες).

29 Dress modification: without diadem: Greg. Naz. *Or.* 5.17; bare heads and feet: Amm. Marc. 29.2.15; women, tearing clothes/loosening hair: Joh. Chrys. *Hom. in Jo.* 62.4 (PG 59.316); Corippus *Laud. Just.* 3.46 (funeral of Justinian); Gregory of Tours *Hist.* 3.29 (also using ashes).

30 Lamps, candles, and torches: Greg. Nyss. *Melet.* (PG 46.861) mentions torches/lights (λαμπάδων); Jer. *Ep.* 108.29 mentions torches/lights and candles (*lampadas cereosque*); Just. *Nov.* 59.5 (AD 537) (*cereos*); Corippus, *Laud. Just.* 3.10. 3.38 (*ceras/ceris*); Greg. Naz. *Or.* 5.16 (PG 35.686) mentions torch-bearing (δᾳδουχίαις). Incense (as sign of respect rather than against smells): *Syriac Life of St Simeon the Elder* p. 641 (with perfumes also, though I was not able to check the Syriac); Corippus *Laud. Just.* 3.54.

31 Psalms: at Cple (for Constantius II, but presented as typical of Christian practice): Greg Naz. *Or.* 5.16; at Rome (for Fabiola, d. 399 or 400): Jer. *Ep.* 77.11, PCBE 2.734–35 Fabiola 1; at Alexandria (early 7th c.): Joh. Moschus 77; at Edessa (AD 500/501): 'Psalms and hymns and spiritual songs that were full of the hope of the resurrection' *Josh. Styl.* 43; at Antioch (AD 549): *Syriac Life of St. Simeon the Elder* p. 641, a text which I am not able to read in its original.

Paula in Jerusalem and Justinian in the eastern capital. For Paula, singing was in Latin, Greek, and Syriac.[32]

A number of authors represent the ideal that Christian funerals should not only be modest but ought to be sober, positive affairs, in which no tears were shed and in which psalms were sung, reflecting hope in the Resurrection.[33] Yet even for the pious, weeping was not far away. Augustine describes how he painfully repressed his own feelings for his mother, in order to return without tears from her burial. Yet the funeral processions of Macrina, Basil, and Blæsilla degenerated, as psalms gave way to unchecked lamentation, often coming from those external to the core group. In 565, Corippus reports universal tears around the emperor Justinian's cortège, as if they were entirely appropriate.[34] It seems that the presence of the clergy was a key factor in maintaining order, which could effectively be done through leading the singing of psalms. This could at least cut out theatricality and leave uncontrollable grief to the genuinely distressed. The introduction of liturgical elements seems to date from the later 4th c.: Monica's funeral included a Eucharist at her graveside in 387. Yet, the processions of prominent Christian lay people were not effectively Christianised until the 5th c.: under Anastasius and Justinian we can see that status was strongly expressed by enhancing the liturgical ornaments of the procession, though it still contained some traditional elements.[35]

As the cortège passed through the city, the public had the chance to interact with it. Women, children, and old men might be present, making this a universally accessible public event.[36] Some came out to stand by their doors, as a sign of respect. During the funerals of famous people, spectators looked out of upper storey windows or stood on roofs, as they might during the *adventus*, because streets and porticoes were full.[37] The sentiments of onlookers could be mixed: Augustine tried to remind Christians depressed by the funeral parades of wicked men to keep their nerve, whilst the *Pratum Spirituale* of *ca.* 600, recalls how a rich cortège at Alexandria attracted a thief, who followed the group to a tomb before attempting to strip the corpse. The same text describes a similar incident at Antioch, whereby just the news of a rich funeral was enough to make a robber set off to look for the grave. In each case, the violated corpses came back to life to attack their despoilers, although at Alexandria this only occurred when the last linen sheet (and not the rich garments over it) was removed. The thief had hesitated to take it, revealing that even grave-robbers understood that the outer garments were for show, whilst the linen shroud was a mark of basic dignity.[38]

The mourning crowds who surrounded the cortège of Basil of Caesarea had more complex intentions: Gregory reports that different groups, including Jews, sought to outdo each other in their public displays of mourning: 'Our own people vied with strangers, Jews, Greeks, and foreigners, and they with us, for a greater share in the benefit, by means of a more abundant lamentation'. Perhaps they, along with the servants who guarded the bier, had something to gain from competitive mourning, when a new generation was about to take over a prominent family, in the form of a grateful heir, although in this case the heir was likely the Church, making the dynamics of their petitions far more complex. The histrionic gestures of senators, recorded above for the funeral of Junius Bassus, may also have had a political object. The writer of Bassus' funerary inscription seemed to revel in the spectacle, and in the crowds of mothers, children, and old men who grieved on that occasion, as if it was an obvious mark of status for the deceased.[39] Libanius, as the leading Greek orator of his city, perhaps sometimes gained something from regularly following funeral processions. It is possible that families asked him for an impromptu funeral eulogy, such as that with which he had honoured Zenobius, his predecessor in the civic school at Antioch. He would thus have been provided with an opportunity to acquire grateful clients. More overt advancements of personal interest were

32 Choirs: at Cple (Justinian): Corippus, *Laud. Just.* 3.41 (Justinian's funeral procession, AD 565); at Jerusalem (Paula, PLRE 1.674–75 Pavla (St.) 1, d. 404): Jer. *Ep.* 108.29 (singing in Greek, Latin and Syriac).

33 Psalms not tears: August. *Conf.* 9.12; Greg. Nyss. *V. Macr.* 26–27, 33–34 (the edition of Maraval (1971) contains commentary on contemporary Christian funerals). See discussion in Rebillard (2009) 131–34.

34 Mourning and lamentation at Christian funerals: in Pontus (Macrina): Greg. Nyss. *V. Macr.* 34; at Caesarea (Basil): Greg. Naz. *Or.* 43.80; at Rome (Blæsilla): Jer. *Ep.* 39.6; at Cple (Justinian) tears during funeral procession: Corippus *Laud. Just.* 3.43–44.

35 Introduction of liturgical elements: Eucharist at graveside for Monica: August. *Conf.* 9.12; see Rebillard (2009) 134–38 on this topic. For processions where wealth was exhibited in both liturgical and traditional elements, 6th c. see Just. *Nov.* 59 (AD 537), 60 (AD 537), *Cod. Iust.* 7.6.1.5 (AD 531).

36 Women, children, and old men present: at Rome: (Junius Bassus) epitaph discussed by Cameron (2002); at Cple (Constantine) Euseb. *Vit. Const.* 4.67 (women and children).

37 Spectators: standing by doors: Corippus, *Laud. Just.* 3.47. This as a sign of respect: *V. Dan* 78, 80; in upper storey windows: Corippus, *Laud. Just.* 3.48; streets (plateae), porticoes, roofs: full, of the multitude who attend the funeral of Fabiola at Rome in Jer. *Ep.* 77.11.

38 Feelings of onlookers: August. *Serm.* 102(52).2 (PL 38.611); thieves: Joh. Moschus 77–78 (Alexandria and Antioch).

39 Competitive lamentation: Greg. Naz. *Or.* 43.80; Junius Bassus epitaph, as above n. 36.

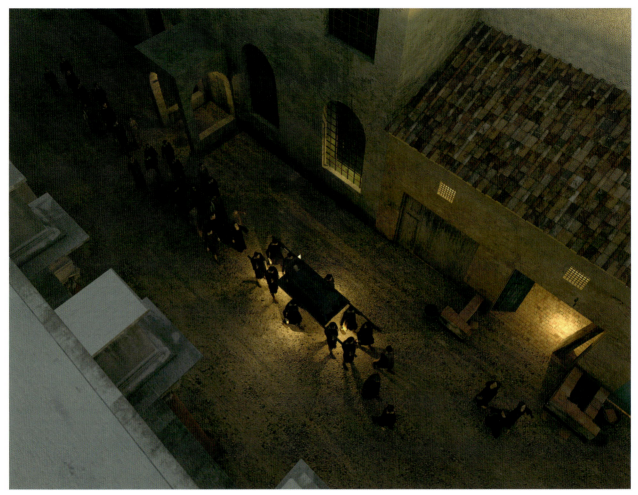

FIGURE 1 Visualisation of a late antique funeral, Decumanus of Ostia AD 387. Note the professional mourners, the heir walking in front, the freedmen carrying the bier (with their liberty cap), the distraught family, then clients and friends following them, as they make their way out to the extra mural cemetery.

possible: in 6th c. Constantinople, Christian acolytes and pall-bearers charged for wax tapers and the carrying of the bier, much to Justinian's discomfort.[40]

Thus, the dynamics of public funerals were as complex as those of any other public ceremony, despite the distinctively mournful nature of the occasion. The motives of the crowds could extend beyond veniality, however. The presence of Jews, Samaritans, and sometimes of pagans, in funeral processions of prominent Christians is notable. Such mixed crowds are recorded at Edessa in 308/309 (for Habbib the Deacon), at Caesarea in Cappadocia in 379 (for Basil), at Milan in 397 (for Ambrose, within the procession, after the baptised), at Edessa in 434/36 (for Rabbula, outside the church), near Gaza in 489 (for Peter the Iberian), and at Clermont/Arvernis in 551 (for bishop Gallus), suggesting that major funerals could count as public events for the whole city. These were times when demonstrations of solidarity were welcomed and remembered, as metaphorical stitches in the fabric of the civic community.[41] As such, they deserve to be considered fully within a volume on burial, as to those attending the funeral ceremony the way the bier was carried and received by onlookers in the street and leading out to the grave,

40 Motivations of participants: rhetors: Lib. *Or.* 1.105 (PLRE 1.991 Zenobius), had not wanted to vacate his seat to Libanius, making Libanius' elaborate mourning for him an important if empty part of his succession, as this text reveals); bier-bearers and acolytes: Just. *Nov.* 59.5 (AD 537).

41 Jews in funeral processions of Christian figures: *Martyrdom of Habbib the Deacon* 38a (along with pagans (AD 308/309 on Macedonian year); Paul. *V. Amb.* 48.1 (along with pagans, for Ambrose) from CSA 894 (from which I saw the text); Greg. Naz. *Or.* 43.80 (with pagans, for Basil); *Life of Rabbula* 55 (AD 435/36) (not seen); Gregory of Tours *V. Patrum* 6.7 (for dating to 551 see James transl. (1985) p. 40, n. 23, plus PCBE 4.1.849–51 Gallvs 3, bishop (AD 525/26–551)). The latter is remarkable as it was a time of tension between Christians and Jews in Gaul: in AD 576, a later bishop of the same city, Avitus, offered the Jews of the city conversion or expulsion: Gregory of Tours, *Hist.* 5.11; PCBE 4.1.265–68 Avitvs 5. Samaritans for Peter the Iberian: *Life of Peter the Iberian* (AD 489) (not seen).

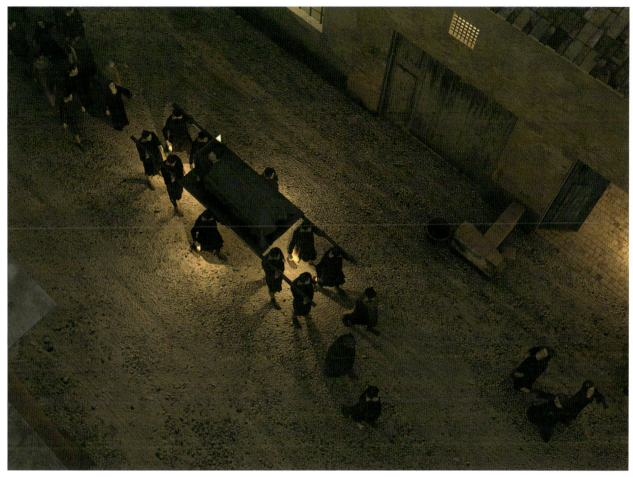

FIGURE 2 A zoomed-in version of Figure 1 to show detail.

potentially had as great an impact as what happened at the graveside, a moment on which our textual sources tells us far less, even if the placing of the body into the earth would inevitably have been charged with feeling for those attending, no matter what the status of the person concerned.

The goal of this text, as with all syntheses of processions found in the *Public Space* monograph which it is taken, is to permit visualisation, which is not simply an illustrative exercise but can be considered, when undertaken seriously as VR reconstruction or experimental archaeology to represent a disciplined form of data analysis, in which hypotheses can be tested and materiality explored. Therefore, I think it is useful to here present a reconstruction of a funeral procession from our public engagement material for the Kent Late Antique Ostia Project, showing a cortège that might have been witnessed by Augustine in Ostia, at daybreak, when returning from burying his own mother. This has been visualised by Will Foster based on information supplied by myself and members of the Leverhulme funded Visualisation of the Late Antique City Project (Ellen Swift, Faith Morgan, Joe Williams, Jo Stoner) and is included as Fig. 1.

Bibliography

Abbreviations

AE	*L'Année épigraphique*.
CIL	*Corpus Inscriptionum Latinarum*.
CLE	Bücheler F. and Lommatzsch E. edd. (1930) *Carmina Latina Epigraphica* (Leipzig 1930).
Cple	Constantinople
ICUR	*Inscriptiones Christianae urbis Romae* ed. G.B. de Rossi (Rome 1857–1888).
ILCV	Diehl E. (1961–1967) *Inscriptiones Latinae Christianae veteres*, 4 vols. (Berlin 1961–1967).
IvE	AA.VV., *Die Inschriften von Ephesos*, 8 vols. (Bonn 1979–1984).
PCBE	AA. VV. *Prosopographie chrétienne du Bas-Empire* (Paris 1982–)
PG	Migne J.-P. (1860–1894) ed., *Patrologiae cursus completus. Series Graeca*, 17 vols. (1860–1894).

PL Migne J.-P. ed. (1844–1904) *Patrologiae cursus completus. Series Latina*, 221 vols. (1844–1904).

PLRE Jones A. H. M. (1971–1992) *The Prosopography of the Later Roman Empire*, 3 vols. (Cambridge 1971–92).

PO *Patrologia Orientalis*, 43 vols. (Paris and Turnhout 1907–1986).

Primary Sources

Amm. Marc. = J. C. Rolfe transl., *Ammianus Marcellinus*, 3 vols. (Loeb Classical Library) (London-Cambridge, Mass. 1935–1939) (with Latin text).

Anastasius of Sinai, *Tales of the Sinai Fathers* = D. F. Caner et al. transl., *History and Hagiography from the Late Antique Sinai* (Translated Texts for Historians 53) (Liverpool 2010) 172–202. Based on text edited by A. Binggeli, *Anastase le Sinaïte. Récits sur le Sinaï et récits utiles à l'âme. Edition, traduction, commentaire* (Ph.D. diss. Paris IV 2001) 2 vols. (the latter text I have not seen).

Anth. Lat. = F. Bücheler and A. Reise edd., *Anthologia Latina* 2 vols. (Leipzig 1894); D. R. Shackleton Bailey ed. *Anthologia Latina I: Carmina in codicibus scripta, Fasc. 1: Libri Salmasiani aliorumque carmina* (Stuttgart 1982), of which I have not been able to obtain Shackleton Bailey. Some of the poems are in English in N. M. Kay transl., *Epigrams from the Anthologia Latina. Text, Translation and Commentary* (London 2006).

August. *Conf.* = W. Yates ed. and transl., *St. Augustine's Confessions in Two Volumes* (London and Cambridge Mass. 1946) (with Latin text).

August. *Serm.* = PL 38–39.

C. Paris III (A.D. 566–73) = J. Gaudemet and B. Basdevant transl., *Les canons des conciles mérovingiens (Vie–Viie siècles)* vol. 2 (Paris 1989) (Sources Chrétiennes 354) 410–25, reproducing Latin text of C. de Clercq ed. *Concilia Galliae A. 511 – A. 695* (CCSL 148a) (Turnhout 1963).

Cer. = J. J. Reiske ed., *Constantine VII Porphyrogenitus. De Ceremoniis Aulae Byzantinae*, 2 vols. (Corpus Scriptorum Historiae Byzantinae) (Bonn 1829–30); French. transl. by A. Vogt, *Constantin VII Porphyrogénète, le Livre des Cérémonies*, 4 vols. (Paris 1935–40); A. Moffatt and M. Tall transl., *Constantine Porphyrogennetos, The Book of Ceremonies with the Greek Edition of CSHB* (1829), vol. 1 (Byzantina Australiensia 18) (Canberra 2012).

Choricius *Or.* = R. Foerster and E. Richtsteig edd., *Choricius Gazaeus* (Leipzig 1929). English translations of some other these works in F. K. Litsas, *Choricius of Gaza: An Approach to his Work. Introduction, Translation and Commentary* (UMI Dissertation Services of a Ph.D. diss. Univ. of Chicago 1980) (Ann Arbor 1999).

Cod. Iust. = P. Krüger ed., *Corpus Iuris Civilis*, vol. 2: *Codex Iustinianus* (Berlin 1887). E. Bloom transl., *Annotated Justinian Code*, 2nd edn. http://www.uwyo.edu/lawlib/blume-justinian/ajc-edition-2/books/ (last accessed March 2014).

Corippus *Laud. Just.* = A. Cameron ed. and transl., *Flavius Cresconius Corippus: in laudem Iustini Augusti Minoris (In Praise of Justin II)* (London 1976).

Ephr. *Hymn on Nicomedia* = C. Renoux ed., *Éphrem de Nisibe. Mêmrê sur Nicomédie* (PO 37.2–3 172–73) (Turnhout 1975).

Euseb. *Hist. eccl.* = E. Schwartz ed., *Eusebius Kirchengeschichte* (GCS 9.1) (Leipzig 1902).

Euseb. *Vit. Const.* = F. Winkelmann ed., *Eusebius Werke. Über das Leben des Kaisers Konstantin*, vol. 1.1 (GCS 7) (2nd edn. Berlin 1991); A. Cameron and S. G. Hall transl., *Life of Constantine* (Oxford 1999).

Greg. Naz. *Or.* 4–5 = J. Bernardi ed. and transl., *Grégoire de Nazianze. Discours 4–5 contre Julien* (Sources Chrétiennes 309) (Paris 1983).

Greg. Naz. *Or.* 43 = J. Bernardi ed. and transl., *Grégoire de Nazianze. Discours 42–43* (Sources Chrétiennes 384) (Paris 1992).

Greg. Nyss. *Melet.* = A. Spira ed. and transl., *Gregorii Nysseni: Sermones*, vol. 9.1 (Leiden 1967) 441–57.

Greg. Nyss. *V. Macr.* = P. Maraval ed. and transl., *Grégoire de Nysse. Vie de Sainte Macrine* (Sources Chrétiennes 178) (Paris 1971).

Gregory of Tours *Hist.* = B. Krusch and W. Levison edd., *Gregorii episcopi Turonensis. Libri Historiarum X* (MGH SRM 1.1) revised edn. (Hanover 1951).

Gregory of Tours *V. Patrum* = B. Krusch ed., *Gregorii episcopi Turonensis. Miracula et opera minora* (MGH SRM 1.2) (Hanover 1885) 211–94; E. James transl., *Life of the Fathers* (Translated Texts for Historians 1) (Liverpool 1985).

Herodian = C. R. Whittaker transl., *Herodian: History of the Empire* 2 vols. (Cambridge, Mass. and London 1969 and 1970) (with Latin text).

Jer. *Ep.* = I. Hilberg ed., *Hieronymus, Epistulae* (CSEL 54–55) 2 vols (Vienna and Leipzig 1912, which I had access to) (see Vienna 1996 for the revised edn.). For a translation of selected letters see F. A. Wright transl., *Select Letters of Jerome* (Cambridge, Mass. 1933). Letters 1, 22, 38, 54, 60, 66, and 77 are in Hilberg and Wright. Lettters 23, 39, 52, and 108 are in Hilberg only.

Joh. Chrys. *Hom. ad pop. Ant.* = PG 49.15–222 (on the statues).

Joh. Chrys. *Hom. in Heb.* = PG 63.8–238.

Joh. Chrys. *Hom. in Jo.* = PG 59.23–482.

Joh. Chrys. *Hom in Mt* = PG 57–58.

Joh. Chrys. *Hom. in 2 Thessal.* = PG 62.467–500.

Joh. Moschus = *John Moschus. Pratum Spirituale*, in PG 87.2851–3116; M.-J. Rouët de Journel transl., *Jean Moschus, Le pré spirituel* (Sources Chrétiennes 12) (Paris 1946). See also also T. Nissen, "Unbekannte Erzählungen aus dem Pratum Spirituale", *Byzantinische Zeitschrift* 38 (1938) 354–76.

Josh. Styl. = W. Wright ed. and transl., *The Chronicle of Joshua the Stylite* (Cambridge 1882); A. Luther transl., *Die syrische Chronik des Josua Stylites* (Berlin 1997) (with Syriac text).

Jordanes *Get.* = Th. Mommsen ed., *Iordanis Romana et Gethica* (MGH AA 5.1) (Berlin 1882) 53–138; C. C. Mierow transl. *The Gothic History of Jordanes* (Princeton 1915).

Julian *Ep.* = W. C. Wright transl., *The Works of the Emperor Julian*, vol. 3 (London and New York 1923) (with Greek text).

Just. *Nov* = R. Schoell and W. Kroll edd., *Justinian. Novellae* (Berlin 1895). E. Bloom transl., *Justinian's Novels* 2nd edn. http://www.uwyo.edu/lawlib/blume-justinian/ajc-edition-2/books/ (last accessed March 2014). http://www.uwyo.edu/lawlib/blume-justinian/ajc-edition-2/novels/index.html.

Lib. *Ep.* = R. Foerster ed., *Libanii Opera*, vols 10–11 (Leipzig 1903–1927). A. F. Norman transl., *Libanius. Autobiography and Selected Letters*, 2 vols. (London 1987–1992); S. Bradbury, *Selected Letters of Libanius from the Age of Constantius and Julian* (Translated Texts for Historians 41) (Liverpool 2004).

Lib. *Or.* = R. Foerster ed., *Libanii Opera*, 12 vols. (Leipzig 1903–27). A. F. Norman transl. *Libanius. Selected Works*, 2 vols (London 1969–77); A. F. Norman transl., *Libanius. Autobiography and Selected Letters* (London 1992). A. F. Norman transl., *Antioch as a Centre of Hellenic Culture as Observed by Libanius* (Translated Texts for Historians 34) (Liverpool 2000). J. Martin ed. and transl., *Libanios, Discours II–X* (Paris 1988). See also M. J. B. Wright, "Appendix: Libanios, Oration IX: On the Kalends", *Archiv für Religionsgeschichte* 13.1 (2012) 205–12. For a full concordance list see https://www.academia.edu/3612083/Libanius_Discourses_translations (last accessed March 2014).

Life of Peter the Iberian = *John Rufus: The Lives of Peter the Iberian, Theodosius of Jerusalem, and the Monk Romanus* (Writings from the Greco-Roman World 24) ed and transl. C. B. Horn (Atlanta 2008) (not seen).

Life of Rabbula = R. R. Phenix Jr. and C. B. Horn, *The Rabbula Corpus Comprising the Life of Rabbula, his Correspondence, a Homily Delivered in Constantinople, Canons, and Hymns with Texts in Syriac and Latin, English Translations, Notes, and Introduction* (Atlanta 2017).

Martyrdom of Habbib the Deacon = E. von Dobschütz ed., *Die Akten der edessenischen Bekenner Gurjas, Samonas und Abibos* (Text und Untersuchungen zur Geschichte der altchristlichen Literatur 3.7.2) (Leipzig 1911); E. Doran transl., "The martyrdom of Habib the Deacon", in *Religions of Late Antiquity in Practice*, ed. R. Valantasis (Princeton 2000) 413–23; F. C. Burkitt ed. and transl., *Euphemia and the Goth, with the Acts of Martyrdom of the Confessors of Edessa* (London-Oxford 1913) 112–28, with Syriac text at end of book. See discussion of dating problems in this work and in F. Millar, *The Roman Near East, 31 B.C.–A.D. 337* (Cambridge, Mass.-London 1993) 486–87.

Paul. *V. Amb.* (Paulinus of Milan) = A. A. R. Bastiaensen, *Vita di Ambrogio* (with translation of L. Canali), *Vite dei santi*, vol. 3 (Milan 1975). English translation: J. A. Lacy, in *Early Christian Biographies* ed. J. R. Deferrari (Washington D.C. 1952) 25–66.

Plut. *Aem.* = B. Perrin transl., *Parallel Lives: Dion and Brutus Timoleon and Aemilius Paulus* vol. 6 (London 1918).

Sid. Apoll. *Ep.* = W. B. Anderson ed. and transl., *Sidonius. Poems and Letters* (London and Cambridge, Mass. 1936–1965) 1–327.

Sulp. Sev. *V. Mart.* = J. Fontaine ed. and transl., *Sulpice Sévère. Vie de saint Martin*, vol.1 (Sources Chrétiennes 133) (Paris 1967).

Syn. *Ep.* = A. Garzya ed. and transl. (Italian), *Opere di Sinesio di Cirene. Epistole Operetti Inni* (Turin 1989). A. Fitzgerald transl. *The Letters of Synesius* (New York 1926). The letter numbers do not correspond between Garzya and Fitzgerald. Fitzgerald follows the numbers of PG 56.1321–1560.

Syriac Life of Simeon Stylites the Elder = F. Lent transl., "The life of Simeon Stylites: a translation of the Syriac text in Bedjan's *Acta Martyrum et Sanctorum*, vol. IV", *JAOS* 35 (1915) 111–98. I have not located or consulted an original edition of this.

V. Dan. = H. Delahaye ed., *Les saints stylites* (Brussels 1923) 1–147 (Life of Daniel the Stylite). E. Dawes and N. H. Baynes comm. and transl., *Three Byzantine Saints: Contemporary Biographies of St. Daniel the Stylite, St. Theodore of Sykeon and St. John the Almsgiver* (London 1948).

V. Sym. Jun. = P. van den Ven ed. and transl., *La vie ancienne de s. Syméon le Jeune*, 2 vols. (Brussels 1962–1970).

Secondary Sources

Arce J. (2000) *Memoria de los antepasados: puesta en escena y desarrollo del elogio funebre Romano* (Madrid 2000).

Bautz F. W. (1990b) "Basilius der Große, Bischof von Cäsarea und Metropolit von Kappadozien, hervorragender Kirchenpolitiker, Kirchenlehrer, 'Patriarch der griechischen Mönche', Heiliger", *BBKL* 1 (1990) 406–409.

Bezzenberger G. E. Th. (1993) "Monika (Monnica) hl., Mutter des Kirchenvaters Augustinus", *BBKL* 6 (1993) 61–62.

Bodel J. (1999) "Death on display: looking at Roman funerals", in *The Art of Ancient Spectacle*, edd. B. A. Bergmann and C. Kondoleon (Washington D.C. 1999) 259–80.

Boin D. (2010) "Late antique Ostia and a campaign for pious tourism: epitaphs for Bishop Cyriacus and Monica, mother of Augustine", *JRS* 100 (2010) 1–15.

Burman J. (2004) "Christianising the celebrations of death in Late Antiquity. Funerals and society", in *Games and Festivals in Classical Antiquity. Proceedings of the Conference Held in Edinburgh 10–12 July 2000*, edd. S. Bell and G. Davies (Oxford 2004) 137–42.

Cameron Al. (2002) "The funeral of Junius Bassus", *ZPE* 139 (2002) 288–92.

Cantino Wataghin G. (1999) "The ideology of urban burials", in *The Idea and Ideal of the Town between Late Antiquity*

and the Early Middle Ages (The Transformation of the Roman World 4), edd. G. P. Brogiolo and B. Ward-Perkins (Leiden 1999) 147–80.

Feissel D. (1999) "Épigraphie administrative et topographie urbaine: l'emplacement des actes inscrits dans l'Éphèse protobyzantine (IVe–VIe S.)", in *Efeso Paleocristiana e Bizantina = Frühchristliches und byzantinisches Ephesos* (DenkschrWien 282. AF 3), edd. R. Pillinger *et al.* (Vienna 1999) 121–32.

Lavan L. (2020) *Public Space in the Late Antique City. Vol.1: Streets, Processions, Fora, Agorai, Macella, Shops* (LAA Supplement 5.1) (Leiden 2020).

Lumpe A. (1993) "Macrina der Jüngere (Makrina) Asketin, Heiliger", *BBKL* 5 (1993) 542–44.

Matthews J. (2009) "Four funerals and a wedding: this world and the next in fourth-century Rome", in *Transformations of Late Antiquity: Essays for Peter Brown* (Farnham 2009) 129–46.

Rebillard E. (2009) *The Care of the Dead in Late Antiquity* (Ithaca and London 2009).

Smith W. (1875) "Funus 2. Roman", in *A Dictionary of Greek and Roman Antiquities* (London 1875) 558–62.

Toynbee J. M. C. (1971) *Death and Burial in the Roman World* (London 1971).

Mausolea

∴

Late Roman 'Mausolea' in Hispania

José Miguel Noguera Celdrán and Javier Arce

Abstract

This paper contains a study of the different types of funerary monuments (*monumenta*, but currently called *mausolea*) used in the Iberian Peninsula during Late Antiquity (4th–5th c.). It will establish their individual typologies, meanings and functions, while highlighting that few of them can be identified as Christian tombs. Instead, most are to be associated with Roman villas.

Introduction

In the Late Roman period, Hispania had a rich and varied tradition of funerary architecture.[1] This study aims to provide a general overview of the tombs that characterised the period between the end of the 3rd and the opening decades of the 5th c. in the *Dioceses Hispaniarum*. In the first place, the question of whether 'mausoleum' is the appropriate term to identify these funerary structures is discussed. Although we here adopt the term *mausolea*, strictly speaking these buildings ought to be called *monimenta* (or *monumenta*). For this reason, '*mausolea*' is always placed in single quotations marks as it is considered to be the name that is normally applied by researchers, and which has been adopted in this volume.

It is almost impossible to identify the owners of these monuments as there is no literary or epigraphic evidence in this respect. The only exception is the case of the building at Foixà (Girona), which can be attributed to a certain Sidilianus. The hypothesis that the building at Centcelles belonged to or was the 'mausoleum' of Constans (son of Constantine) should be discarded, because, among other reasons, there is no grounds whatsoever to claim that it is a 'mausoleum'. However, as is pointed out in this study, in the rural context, the landowners who ordered these monuments to be built undoubtedly belonged to the category of wealthy owners (*possessores*) of the large number of villas, many of which were magnificently and luxuriously decorated, that could be found across much of the Iberian Peninsula in this period. Only a few of these 'mausolea' can be considered to have been 'Christian' in view of the lack of specific evidence to support such an idea.

This study emphasises the architectural and typological features of these funerary buildings and their possible connections with others in different areas of the Eastern Mediterranean and central Europe. Both the 'mausolea' in urban contexts and, above all, those in rural settings associated with villas are considered, as well as other questions related to burial typology and funerary practices. The overall aim is thus to offer the reader who might be interested an up-to-date synthesis of our knowledge of the aspects covered here.

Terminology Issues

The terms used by writers in antiquity to refer to tombs are both manifold and, at times, ambiguous. Strictly speaking, the word to indicate a tomb is *monimentum*.[2] Augustus' tomb on the *Campus Martius* is frequently called the *tumulus Iuliorum*, *tumulus Caesarum* or *tumulus Augusti*.[3] The text of the *Tabula Hebana*, which alludes to Germanicus' funeral, enables us to state that Augustus' tomb was the *tumulus*, without any further specifications, the *tumulus* par excellence.[4] The word indicates and suggests a circular construction derived from a mound of earth. Strabo says that this *tumulus* was also called the 'Mausoleum'.[5] And he was not the only one. Suetonius calls it the 'Mausoleum' on several occasions, as do the *Fasti Cuprenses*.[6] A final term for Augustus' tomb is also that of *sepulchrum*, which, for example, is found in Suetonius.[7] From Augustus onwards, the term *mausoleum* became synonymous with an imperial tomb, but very generically, since in the later history of imperial tombs and in descriptions of them the term is not used to designate them.[8] *Sepulchrum* is the term to refer to

1 This work has been undertaken within the framework of project PID2019-105376GB-C41, MINECO/FEDER UE. We thank Dr. Philip Banks for his translation and remarks.
2 Festus 139, 115 (Lindsay (1997) 123): *Monimentum est, quod et mortui causa aedificatum est. Monimentum* is derived from *monere*, 'to inform', 'to warn', 'to announce'.
3 *Tumulus Iuliorum*: Tac. *Ann.* 16.6.2; *tumulus Caesarum*: Tac. *Ann.* 3.9.2; *tumulus Augusti*: Tac. *Ann.* 3.4.1.
4 *Tabula Hebana*, PP, 5 (1950) 106.
5 Strabo 5.3.8, naturally using the Greek word.
6 Suet. *Aug.* 100.8; 101.6. *Fasti*: CIL I, 5290. On this subject see: Richard (1970) 370–88.
7 Suet. *Aug.* 101.5.
8 Richard (1970) 383 citing Suet. *Otho* 10.6, and above all Florus, 2.21.10: *in mausoleum se (sepulcra regum sic vocant) recipit*

many imperial tombs, and it is the specific word that is used for that of Hadrian: *Sepulchrum Antoninorum* or, in Greek, 'Antonineion'. It is never called a mausoleum: this term was reserved for that of Augustus. The tomb of the Flavians was known as the *Templum Gentis Flaviae*, which might apparently suggest a specific architectural form: but not necessarily so if it is considered that a *templum* is a sacred space. In fact, it seems to have contained a temple, a temenos and a circular, domed tomb.

Therefore, it is strictly incorrect to refer to 'mausolea' when it is a question of studying the tombs of private individuals in a provincial context. *Monumenta* would be more appropriate.[9] In antiquity, 'mausoleum' involves certain specific connotations that are not reflected in the type of tombs that will be studied in this article. The buildings to which reference will be made are tombs associated with an owner or a family (unfortunately of unknown identity in almost all cases) that exhibit certain architectural features that are, generally speaking, common: buildings of square or central plan that were roofed by vaults, domes and apses. Be that as it may, the study of the *monumenta* or 'mausolea' in the Iberian Peninsula is a vast subject that cannot be fully covered in an article of the length of this one.[10] For this reason, and since the aim of this study is to provide a synthesis of the current state of knowledge of this field, only a certain number of tombs will be examined: the main examples, whose dates range, in general, from the late 3rd c. until the first decades of the 5th c., although they are particularly abundant from the mid-4th c. onwards.

In practice, in the late 3rd c. and, in particular, in the 4th c., a process of architectural 'globalisation' took place; this was defined by the diffusion and generalisation of specific and well-defined types and forms that were initially indistinctly used by pagans and Christians alike. For instance, the case of triapsidal halls (*trichorum*), which were used at the same time in the architecture of residential buildings as well as in funerary 'mausolea' is particularly significant.[11] Inter-regional contacts and influences meant that this phenomenon reached the different parts of Hispania, leading to the development of an architecture different from that of the early empire and known from a wide repertory of remains of civil and religious buildings, as well as tombs, recorded both in the new Christianised spaces in the topography of late antique cities and in connection with great agricultural estates and their villas scattered throughout the landscape of Hispania;[12] in fact, these two situations constituted a single, coherent *urbs-suburbium-territorium* whole.

Late Roman funerary architecture in the Iberian Peninsula is represented by a small, although interesting assemblage of burial buildings distributed in urban and, above all, rural cemeteries recorded all over the peninsula, with a particularly noticeable presence in the Mediterranean coastal area and certain inland points, especially in the Ebro valley, western Andalusia, Extremadura and the central peninsula (Fig. 1). These funerary buildings are located in urban cemeteries, such as those of Tarraco, Carthago Nova, Italica, Hispalis and Mazarrón, and many others were designed as family 'mausolea' in the vicinity of the villas belonging to wealthy *possessores* and *potentiores*, a phenomenon that can be applied to almost all of the provinces of the empire. Some can be interpreted as having been Christian on the basis of archaeological and iconographic evidence, whereas others lack the necessary information for such an attribution to be made.

As in other provinces of the empire, Late Roman funerary architecture in Hispania can be defined by a certain diversity in both form and typology; as a result, the above mentioned influences resulted in a range of adaptations, which were to a greater or lesser degree simplified, with complex 'mausolea', such as those found in the urban Christian cemetery of Tarragona or associated with villas such as those of Centcelles, La Cocosa, La Alberca and Las Vegas de Pueblanueva, and others of simpler design, such as the similarly rural ones of Sádaba, Las Vegas de Pedraza and Jumilla. On the whole, whether Christian or not, 'mausolea' of square and central plan are frequently recorded in the Late Roman funerary architecture of this area, although there are a large number of variations, inspired by Roman and oriental models.[13]

(referring to Cleopatra's suicide, a text that seems to demonstrate that the term *Mausoleum* was used in Egypt for royal tombs).

9 See ILS 8341: *haec est domus aeterna, hic est fundus, heis sunt horti, hoc est monumentum nostrum*. See, for example, Valenti (2010). However, there are some cases in which *mausoleum* is used: *cf*. Faure and Tran (2013) 114–16, no. 12. The reconstruction of the text is not definite.

10 The bibliography is extensive, although there is no study of the subject as a whole. See, for example, Bowes and Kulikowski (2005) 189–258; Chavarría (2007) *passim*; Graen (2008).

11 Noguera (2004); Hidalgo (2011–2012) 655–70.

12 On Late Roman villas in Hispania: Ripoll and Arce (2000); Ripoll and Arce (2001); Chavarría (2007); Fernández Ochoa, García-Entero and Gil Sendino (2008); Ripoll (2018) 426–52 (with the earlier bibliography).

13 Palol (1967b) 211.

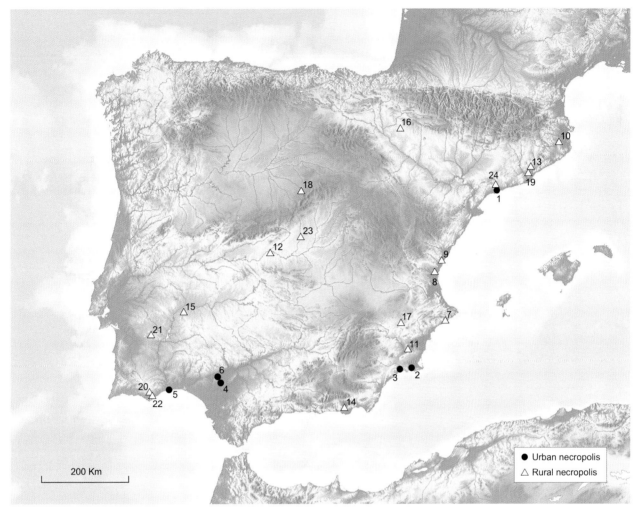

FIGURE 1 Map of the Iberian Peninsula with distribution of late-Roman mausoleums from the 4th c. (urban and rural). 1. Tarragona. 2. Cartagena. 3. La Molineta (Puerto de Mazarrón, Mazarrón). 4. Hispalis (Sevilla). 5. Isla Canela (Ayamonte, Huelva). 6. Itálica (Santiponce, Sevilla). 7. El Albir (Alfaz del Pi, Alicante). 8. Camí del Molí dels Frares (Orriols, Valencia). 9. Muntanyeta dels Estanys (Almenara, Castellón). 10. Foixà (Girona). 11. La Alberca (Murcia). 12. Las Vegas de Pueblanueva (Talavera de la Reina, Toledo). 13. Sentmenat (Barcelona). 14. Cerrillo de Ciavieja (El Ejido, Almería). 15. La Cocosa (Mérida, Badajoz). 16. Sádaba (Zaragoza). 17. Jumilla (Murcia). 18. Santiuste de Pedraza (Segovia). 19. Barcelona. 20. Milreu (Faro, Algarve). 21. São Cucufate (Frades, Alentejo). 22. Quinta de Marim (Olhão, Algarve). 23. Carranque (Toledo). 24. Centcelles (Constantí, Tarragona) (J. G. Gómez).

Urban Cemeteries

Both the square and central-plan 'mausolea' types developed in certain relatively well-known urban cemeteries that formed part of the new urban topography of the Late Roman city. *Monumenta* with a square chamber and of central plan have been recorded in the cemeteries in Tarragona, while examples that can be assigned to the first category are known from the cemeteries of La Molineta (Puerto Mazarrón, Mazarrón, Murcia) and San Antón (Cartagena, Murcia).

Among the 4 types of 'mausolea' defined by M. D. Del Amo in her study of the Christian cemetery of the Fábrica de Tabacos in Tarraco (Tarragona; capital of the ancient province of Tarraconensis[14]) (Figs. 1.1 and 2), those of square or rectangular plan occupy an important place in numerical terms (with a total of 16).[15] They can be dated between the mid-4th c. and the mid-5th c.[16] The burials in them are of a wide range of types (in sarcophagi and in graves under the floor). Of modest dimensions, almost all of them were constructed with similar materials and had vaulted ceilings covered by gable or pyramid

14 On Tarraco in Late Antiquity, its Christianisation and ecclesiastical topography: Pérez (2012); (2019) 49–56.

15 Del Amo (1979) 173–218, particularly 173 and 268–70. Also Macias *et al.* (2007) 156–60, no. 564, figs. 57–59 (with previous bibliography); Pérez (2019) 49–56. For other late funerary finds in the city, see Macias *et al.* (2007); López and Muñoz (2019) 35–48.

16 Del Amo (1979), in particular the table on 218.

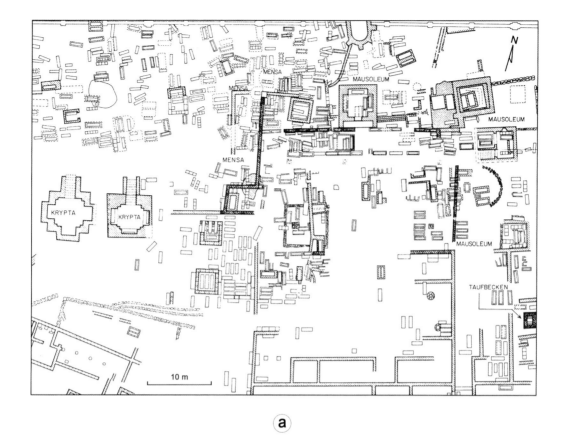

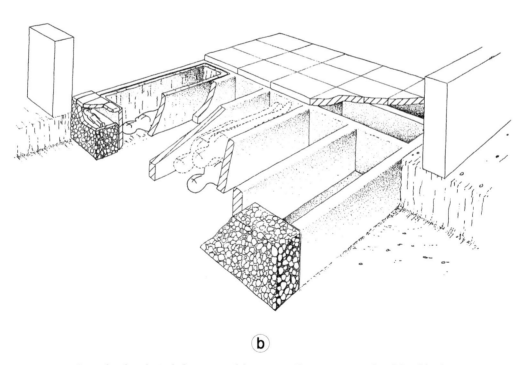

FIGURE 2 a. General archaeological planimetry of the ancient Christian necropolis of the old Tobacco Factory, superimposed on the current city of Tarragona (Schlunk and Hauschild (1978) fig. 84). b. Rectangular chamber tomb of the necropolis of the Parc de la Ciutat of Tarragona (TED'A (1987) fig. 97) (J. G. Gómez).

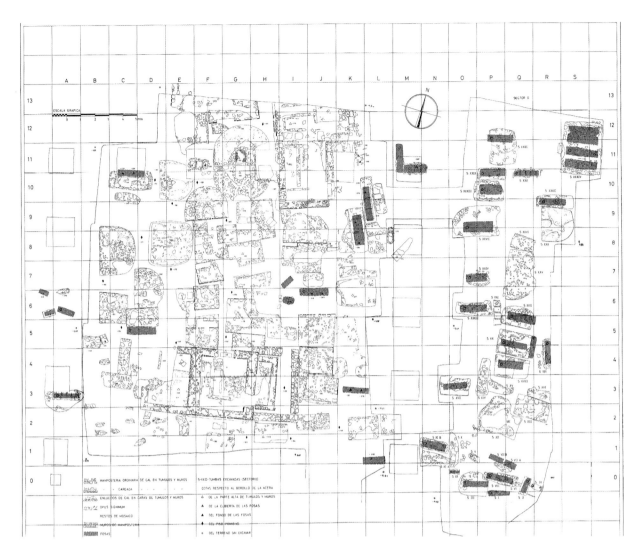

FIGURE 3 General archaeological planimetry of the Christian necropolis of San Antón (Cartagena) (San Martín (1985) fig. 5).

hip roofs. They have a single chamber – enclosures number 3b, 16, 17 and perhaps 11 and 12 of the Del Amo classification – or a two-storey *cella* with a *cubiculum inferius* with access to both chambers, or only to the upper one. The ones with a crypt to which access was gained from the upper chamber recall the *monumenta* of Centcelles and Las Vegas de Pueblanueva. These buildings can be dated from the mid-4th c. onwards, and they were reused until the middle of the following century.[17] A further three 'mausolea' (one of which had almost totally disappeared) excavated on the Parc de la Ciutat site were similar to the single *cella monumenta* with burials sealed beneath the floor levels; they tend to be square in plan, oriented north-east/south-west, and to have rectangular graves beneath the chamber floor.[18] Their typology and the scant material found in the burials and the associated contexts suggest a Late Roman date.[19]

In addition, two further 'mausolea' of rectangular plan were recorded in the Christian cemetery located in the district of San Antón in Carthago Nova (Cartagena, Murcia) (Figs. 2.2 and 3), the capital of the Diocletianic province of Carthaginiensis.[20] Datable to the late 4th or early 5th c., these consisted of separate family 'pantheons' that may have been covered by barrel vaults, with several burials inside them and various additions that reflected subsequent extensions. Similar to the square, single-*cella* 'mausolea' in Tarragona with burials in *loculi* sealed beneath the floor are the ones of the earliest phase in which the cemetery of La Molineta (Puerto de Mazarrón, Mazarrón, Murcia; province of Carthaginiensis) (figs. 1.3 and 4) was in use; they can be dated between the mid-4th c. and the mid-5th c. and

17 Del Amo (1979) 177–207, table on 218; 268–70.
18 TED'A (1987) 98–101, figs. 82–83; 138–40, fig. 97 (no. I); 101–102, fig. 84; 140–41, fig. 99 (no. II); Macias *et al.* (2007) 136–37, no. 549 (with previous bibliography).
19 Macias *et al.* (2007) 134.
20 San Martín and Palol (1972) 447–59; Berrocal and Láiz (1995) 173–82.

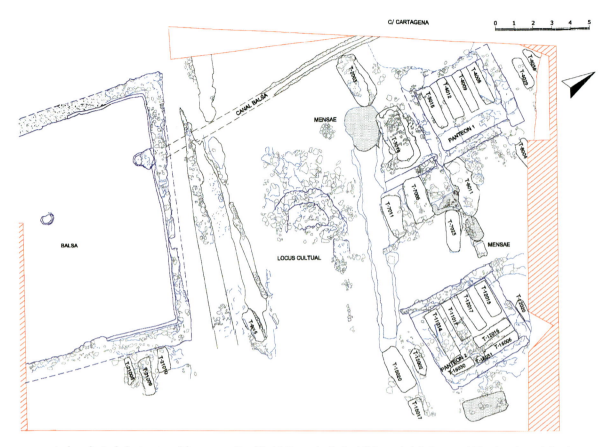

FIGURE 4 Archaeological planimetry of the necropolis of La Molineta (calle Era) (Mazarrón) (Iniesta and Martínez (2000) fig. 3).

belong to an urban site of unknown juridical status that acquired a certain economic and social standing in the 4th and 5th c. as a consequence of fisheries and the fish-salting industry.[21] Three square family pantheons[22] were found in the well-laid out and 'managed' cemetery;[23] in them, the chamber floor was placed at a lower level than that of the burials themselves. The *formae* must have been covered with limestone slabs and perhaps large, 1.5 ft bricks, almost certainly coated in mortar, which would have enabled several inhumations to be undertaken.[24] They are datable to the second half of the 4th c. and the first half of the following century, the peak period of activity in the port and its fisheries.[25]

A particularly interesting case is that of the late antique cemetery in the north-western sector of Hispalis (current Seville; ancient province of Baetica) (Figs. 1.4 and 5), the plan of which includes *monumenta* of different types lining a funerary road. Two simple 'mausolea' of square or rectangular plan and another complex one of the same layout similar to the ones recorded in Mazarrón and the Fábrica Tabacos de Tarragona site have been found. The chronology of the cemetery can be determined as having lasted from the late 4th c. until the 6th–7th c.[26]

A further example comes from the beaches of Isla Canela (Ayamonte, Huelva; province of Baetica) (Fig. 1.5), where the presence of a small 'mausoleum' of square plan, whose burial chamber contained 4 simple inhumation tombs, has been recorded. As in the case of Mazarrón, it was associated with a settlement of fisherfolk involved in the production of salted products and can be dated to the 4th c.[27]

In addition, three of the four categories of 'mausolea' defined by Del Amo in the Christian cemetery of the Fábrica Tabacos de Tarragona can be classified as

21 For the evidence on single-family dwellings indicating a permanent population, which fell out of use around the middle of the 5th c.: Ruiz (1991) 47; for the fishing industries: Pérez (1993a) 225–36; (1993b) 237–44; Martínez and Iniesta (2007).
22 Iniesta and Martínez (2000) 215–16.
23 López (1999) 604–605 n. 4; Martínez and Iniesta (2007) 160–69.
24 García and Amante (1993) 259, type 4.1; Iniesta and Martínez (2000) 215–16.
25 A funerary building found at calle Alcalá Galiano, nos. 4–6 in Mazarrón, perhaps with a rectangular chamber with one or, maybe, two apses should be added to this group of pantheons (Amante and López (1991) 475–81, figs. 2–3).

26 Barragán (2009) 230–48 and 251–52; (2010).
27 Teba (1987) 317–22; Del Amo, Muñoz and Arroyo (2003).

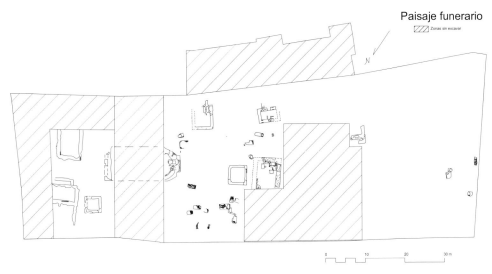

FIGURE 5 Archaeological planimetry of the Hispalis necropolis (Barragán (2006) fig. 17).

being of central plan (Figs. 1.1 and 2): 1) of externally rectangular plan, with a tendency to being square, and internally circular with niches disposed around the circumference; 2) of cruciform plan enclosed within a rectangular construction; 3) and of freestanding cruciform plan.[28] These buildings can be dated, in general terms, between the mid-4th c. and the mid-5th c.[29] These centrally planned buildings became popular as from the 3rd c. and, above all, in the 4th c. in the context of funerary architecture (although there is no lack of examples from earlier periods)[30] and can be in the shape of a freestanding cross or enclosed inside a built space that tends to be square in plan.[31] Centrally planned buildings whose internal structure is reflected in their external design are characteristic of the organic architecture of the Constantinian period, and from this period onwards they acquired a noticeable symbolic value.[32]

A layout of this type, which, however, has now disappeared, might also have existed in a 'mausoleum' of Greek-cross plan in the Christian cemetery of Italica (Santiponce, Seville) (Fig. 1.6), in Baetica, the form of which has been associated with buildings of triconch and tetraconch plan in North Africa, although in fact they also exist in the East and in Hispania itself (Centcelles). Interpreted as a *martyrium*, this building has been dated to the early 4th c.[33] Central-plan structures have also been identified in the late antique cemetery in the north-western sector of Hispalis; these include a simple horseshoe-plan monument, similar to that at the villa of La Cocosa, a *monumentum* of pentagonal plan, of the type found at Las Vegas de Pueblanueva, and another of basilican plan, the use of which for religious or martyrial purposes can be ruled out, which recalls buildings such as that found in the plaça Antoni Maura in Barcelona. In general terms, their chronology can be placed between the end of the 4th c. and the 6th–7th c.[34]

Rural Contexts

Alongside these examples erected in urban cemeteries, a substantial number of 'mausolea' were built in rural contexts. Although they may now appear isolated and decontextualised, these buildings were located on and belonged to a rural estate, more specifically to a villa.[35] The custom of constructing funerary buildings on this type of property dates back to the Republican period,[36] and many examples are known. A law of Marcus Aurelius, to which the *Historia Augusta* (written at the end of the 4th c.) refers, seems to prohibit this custom, at least provisionally, as a consequence of a plague epidemic.[37]

28 Del Amo (1979) 173–218, particularly 173 and 268–70; cf. Macias *et al.* (2007) 156–60, no. 564, figs. 57–59 (with previous bibliography).
29 Del Amo (1979), particularly the table on 218.
30 Sanmartí (1984) 137–38 and 147.
31 Sanmartí (1984) 148.
32 Del Amo (1979) 213.
33 Ruiz (2013) 93–95.
34 Barragán (2009) 230–48 and 251–52; (2010).
35 Cioffi (2005).
36 Livy 6, 36, 11. On this subject see: Graen (2008).
37 SHA, *Marc.* 13, 4: 'tunc autem Antonini leges sepeliendi sepulchrorumque asperrimas sanxerunt, quando quidem caverunt, ne quis ubi vellet fabricaretur sepulchrum. Quod hodieque servartur' – 'About this time (that is, because of the plague), also, the two emperors ratified certain very stringent laws on burial and tombs, in which they even forbade any one to build a tomb at his country-place, a law still in force'. The reference is not very exact, but it might be supposed that it could have affected the placing of tombs at villas, ensuring that they were kept as far away as possible from points of settlement. If the expression 'a law still in force' refers to the time when the SHA

Such rural tombs are usually located away from the main residence or *pars urbana* of the villa,[38] and in many cases even act as a property boundary. John Bodel has studied their meaning within the context of self-representation and of Roman family values.[39] The first to set an example for this trend were the emperors themselves; not all of them, but many did.[40]

This custom, for which the imperial model must have been a stimulus, was followed by the owners of rural *fundi* of greater or lesser importance distributed throughout the empire, including Hispania, both in the Early Imperial period and in the later Roman period. Significant examples include the 'mausolea' of the Atilii in Sádaba,[41] Fabia Severa in Chiprana[42] and Fabara[43] (province of Zaragoza) and that of the Sergii in Sagunto (Valencia) (all 4 in province of Tarraconensis).[44] At these points, the tomb recorded the memory of the deceased and at the same time, insofar as it was a *monumentum*, it was a memorial to their presence, not far from the home of the living, so that visitors or passers-by might remember them.[45] Although it has occasionally been suggested that such 'mausolea' proved that landowners permanently resided in the countryside, some textual evidence[46] and the examples put forward above for the emperors might well contradict the likelihood of this having been the case.

'Mausolea' Associated with a Villa

For the Late Roman period, a number of noteworthy examples of such *monumenta* (or 'mausolea') associated with a villa are known in Hispania.[47] They are usually located at varying distances from the residential and agricultural buildings. For instance, the *monumentum* of the villa of La Dehesa de La Cocosa is some 250 m from the villa, that of Jumilla some 60 m away, and that of Santiuste de Pedraza some 500 m.[48] They tend to stand in isolation, although they occasionally form part of villa burial grounds, as in the case of La Alberca.[49]

Archaeologically speaking, these buildings can also be classified according to their plans, which obviously conditions their elevations. There are many 'mausolea' with a burial *cella* that are square in plan, and several key examples might be mentioned. In certain rural contexts in Carthaginiensis, surely villas, reference might be made to those in necropolis II of El Albir (Alfaz del Pi, Alicante) (Figs. 1.7 and 6a), where a large building of rectangular plan was erected, with 6 external buttresses and two chambers inside, one of which had *formae* for inhumation burials covered with stone slabs sealed with lime mortar. The grave goods, in terms of both pottery and coin finds, establish a date in the third quarter of the 4th c.[50] Further north, at the Camí del Molí dels Frares (in the district of Els Orriols, Valencia) (Figs. 1.9 and 6b), the alignment of which must reflect the route taken by the *Via Augusta*, there stood a small family *monumentum* of rectangular plan that formed part of a rural cemetery

was written, it must be understood that the regulation continued to be valid until the end of the 4th c., which does not seem to have been the case.

38 See Siculus Flaccus, *De condic. agrorum*: *sepulchra in extremis finibus facere soliti sunt et cippos ponere … nam in locis saxuosis et in sterilibus etiam in mediis posessionibus sepulchra faciant*. *Corpus agr. romanorum* 104 Thulin.

39 Bodel (1997) 5–35.

40 Some of the emperors who met their deaths away from Rome were buried, in the first instance, in a tomb on their estates, at their villa. Hadrian died in Baiae (Campania) in 138 (SHA, *Hadr*. 25.6; *Ant. Pius* 5.1) and was initially buried there on land that had belonged to Cicero (*sepultus est in villa ciceroniana Puteoli*); it was the *pietas* of his successor, Antoninus Pius, that made it possible not only to complete his *sepulchrum* in Rome, but also to transfer his ashes to the tomb that Hadrian himself had commissioned (death in Baiae and burial at Cicero's villa: SHA, *Hadr*. 25.7: Eutr. 8.7.3 only states that *obiit in Campania* and Aur. Vic., *Caes*. 14.12 *apud Baias tabe interiit*. SHA, *Ant. Pius*, 8.2 [completion of the *sepulchrum Hadriani*]; SHA, *Ant. Pius*, 5.1: transfer and burial in the gardens of Domitia [*in hortis Domitiae*], which was the space where the *sepulchrum antoninorum* was built). Neither did Antoninus Pius die in Rome, but at a villa owned by him, in Lorium, near the *Via Aurelia*, very close to the city (Eutr. 8.4. Aur. Vic., *Caes*. 16.3. *Epit. de Caes*. 15.7). From there, his remains were transferred to the same tomb in Rome (CIL 6.986; statue in the 'Antonineion': Coarelli (1975) 323). In the case of Galba, he was also buried *in hortis suis* (Suet. *Galb*. 20.2; Plut. *Galb*. 27.1), although in this case the precise location remains unknown. The case of Domitian is similar: in the first instance buried at a villa on the *Via Latina*, he was subsequently transferred to the *Templum Gentis Flaviae* (on this detail, see Arce (1988) 78–80). Finally, without seeking to provide an exhaustive list of cases, that of Nerva can be added; after being buried in the *horti Sallustiani*, his remains were ultimately transferred to the Mausoleum of Augustus (For a complete list, *cf*. Arce (1988)).

41 Cancela and Martín-Bueno (1993) 406, fig. 10; Ortiz and Paz (2004).

42 Cancela and Martín-Bueno (1993) 405–406, fig. 8.

43 Cancela (1993) 242–43, figs. 2–5; Cancela and Martín-Bueno (1993) 403–404, fig. 6; Beltrán (2000) 253–64.

44 Jiménez (1989) 207–220.

45 Varro, *Ling*. VI, 49: *sic monimenta quae in sepulchris, et ideo secundum viam, quo praetereuntis admoneant et se fuisse et illos esse mortalis*.

46 Chavarría (2007) 120.

47 On this subject, see Noguera (2004) 231–72; Bowes and Kulikowski (2005) 189–258; Chavarría (2007) 120–24; Graen (2008).

48 See Chavarría (2007) 120–24 for the references.

49 Noguera (2019) 148–51, no. 8. For villa cemeteries in Hispania: Chavarría (2007) 117–20.

50 González (2001) 360–65, fig. 113; Martínez (2015) 115–16, fig. 13.

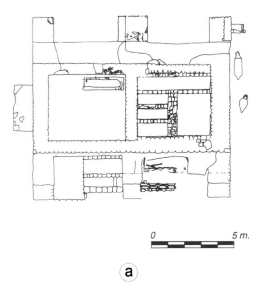

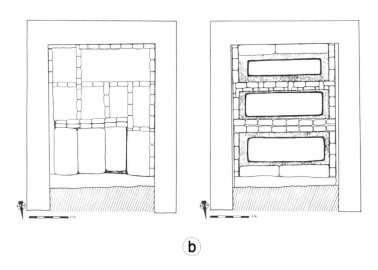

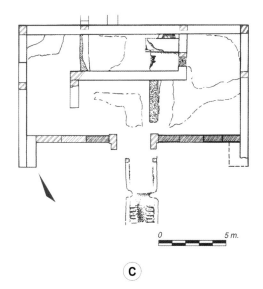

FIGURE 6 A. Mausoleum of El Albir (Alfaz del Pi, Alicante) (González (2001) fig. 113). B. Mausoleum of Camí del Molí (Orriols, Valencia) (Ribera and Soriano (1987) fig. 15). C. Mausoleum of Muntanyeta dels Estanys (Almenara, Castellón) (González (2001) fig. 32) (J. G. Gómez).

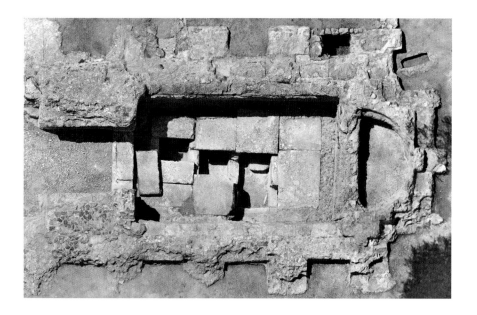

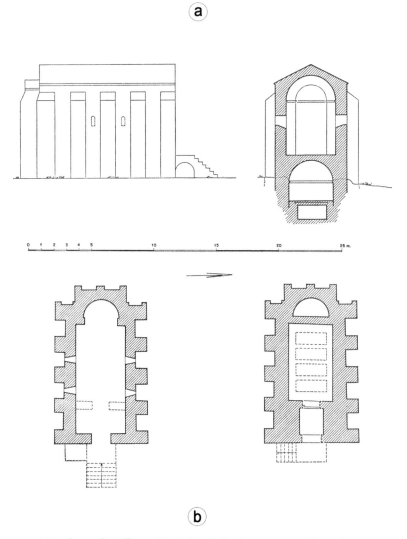

FIGURE 7 Mausoleum of La Alberca (Murcia). a. Orthophotogrammetry (according to J. J. Martínez). b. Hypothetical restitution of the south elevation (top left), hypothetical restitution of the south-north section (top right), plan of *cubiculus inferius* (down left), and plan of *cubiculus superius* (down right) (Hauschild (1971) fig. 6) (J. G. Gómez).

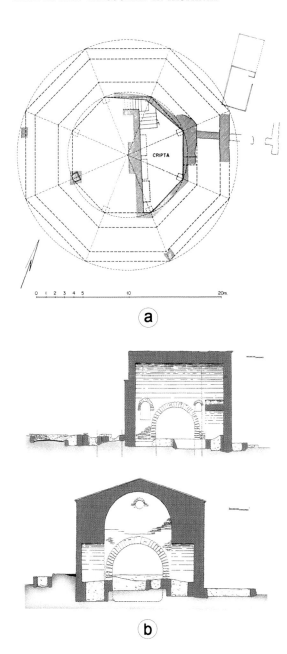
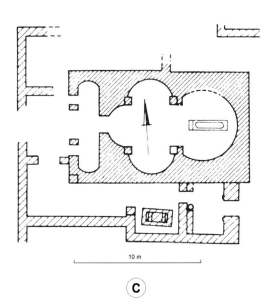

FIGURE 8
a. Mausoleum of Las Vegas de Pueblanueva (Talavera de la Reina, Toledo) (Hauschild (1971) fig. 6). b. Mausoleum of El Daymun (El Ejido, Almería) (García and Cara (1987) fig. 5). c. Mausoleum of Dehesa de la Cocosa (Mérida, Badajoz) (Gorges (1979) fig. 45) (J. G. Gómez).

belonging to a Roman villa.[51] The chamber, which may have been roofed or open to the elements, had an underground section with three stucco-plastered *formae* covered by stone slabs of different size that were coated in mortar; in each grave there was an undecorated lead coffin. The grave goods and the typology of the building itself support the idea that it should be considered to have been of Late Roman date (4th c.).[52] Comparable to the El Albir 'mausoleum' is that of the Muntanyeta dels Estanys (Almenara, Plana Baixa, Castellón) (Figs. 1.9 and 6c), which belonged to a villa near Saguntum.[53] This is a rectangular building with a vestibule and an internal chamber with an adjoining rectangular burial *cella* with three *formae* for inhumation burials covered with irregular slabs coated with mortar. The building techniques, the poverty of the decoration and the use of inhumation would suggest a date that lies in the 4th or 5th c.[54]

Recently, Sant Sebastià's tower at the site of Sant Romà de Sidillà (Foixà, Girona; province of Tarraconensis) (Fig. 1.10) has been interpreted as a rectangular (8.43 × 6.50 m) Late Roman 'mausoleum' dated to the 4th c., used for the burial of a villa owner, named Sidilianus (or Sicilianus), and his family.[55]

Within the category of 'mausolea' of square plan, the one at La Alberca (Murcia; province of Carthaginiensis) (Figs. 1.11 and 7), which can be found near Carthago Nova at the foot of the north-western slopes of the Costera Sur mountains that run down to the floodplain of the River Segura, stands out because of its typology and monumental features.[56] It was initially described as a *martyrium* due to the similarities with the *martyrium*-'mausoleum' of St. Anastasius of Salona, in Dalmatia, but this interpretation must be ruled out as there are no documentary sources or archaeological evidence to support it; it should therefore be understood as a Late Roman family 'mausoleum' of a private nature. It formed part of an important 4th c. *possessor*'s rural estate, of which only a large tank, perhaps associated with irrigation, and part of a cemetery adjoining the 'mausoleum' are known. The building is rectangular in plan and oriented east/west; it had a semi-circular apse in its rear part and comprised two floors, one on top of the other: a *cubiculum inferius* with a surbased barrel vault, under the floor of which there were 4 inhumation graves (*formae*) covered with stone slabs coated in mortar; and a *cella superius* with a floor with funerary mosaics, which have now disappeared. A date in the first half of the 4th c. can be proposed on the basis of the building techniques and its typological parallels.

Several noteworthy examples of central-plan funerary structures associated with villas can also be associated with Late Imperial *possessores* in Hispania. In the ancient province of Carthaginiensis, the burial building at Las Vegas de Pueblanueva (Talavera de la Reina, Toledo) (Figs. 1.12 and 8a), which is made up by an equilateral octagonal structure inside which there could have been either an enclosed octagonal room with pillars at its angles or, alternatively, a spacious circular peristasis with pillars or columns from which wide arches stretching from one support to the next must have sprung, so that the central space would have been directly connected with the ambulatory. The central octagon must have been roofed with a dome. Beneath the floor, there was an underground burial crypt (as in the case of Centcelles, considered below) of octagonal plan, that would have been able to house up to three sarcophagi.[57] Only one sarcophagus has been found; it is decorated with depictions of Christ and the Twelve Apostles in columns and can be dated to the Theodosian period (*c*.400).[58] The building forms part of a series of large central-plan funerary structures existing in all regions of the empire in the Late Roman period; on the basis of the Theodosian date of the above mentioned sarcophagus and the building techniques of eastern tradition used, it should be dated to the second half of the 4th c., a time when the conversion of the members of Hispano-Roman aristocratic society to Christianity was being consolidated and strengthened.[59]

The *pars rustica* of a villa at Can Palau (Sentmenat, Barcelona; province of Tarraconensis) (Fig. 1.13), has been identified in association with a 4th c. 'mausoleum', circular in plan on the exterior and 8-sided in the interior, which includes two individual *formae* decorated with polychromatic mosaics. In the 4th–5th c., a necropolis formed around the 'mausoleum'.[60]

51 Albiach and Soriano (1996) 123–45; González (2001) 239–40; Martínez (2015) 115, fig. 12.
52 Ribera and Soriano (1987) 139–46, fig. 15, pl. I, 1; Martínez (2016) 186–87.
53 Alcina (1950) 92–128; Mesado (1966) 177–96.
54 Arasa (1999) 338–42, figs. 7, 1–2, 8, 10, 1, 11, 12, 2, and 14; González (2001) 180–86, figs. 32–33; Martínez (2015) 114–15, fig. 11.
55 Ripoll *et al.* (2019) 46–49.
56 Mergelina (1948) 283–93; Schlunk (1948) 335–79, pl. CVII–CVIII; Hauschild (1971) 170–94; Schlunk and Hauschild (1978) 10–11; 112–15, pl. 3, figs. 76 a–b; Chavarría (2007) 123 and 210, no. 39, figs. 24D and 64; Noguera (2019) 148–51, no. 8.

57 Hauschild (1969) 293–316; (1978) 307–339; *cf.* also Schlunk and Hauschild (1978) 129–31, fig. 83, pl. 21b and 22b; Chavarría (2007) 124 and 294–95, no. 123, figs. 24E and 133; De la Llave and Escobar (2017) 26–45.
58 Schlunk (1966) 210–31; subsequently on the sarcophagus, *cf.* Schlunk and Hauschild (1978) 129, pl. 21a; Vidal (2016) 195–210.
59 Schlunk and Hauschild (1978) 17–18, fig. 10 (building); 21–22 (sarcophagus).
60 Coll and Roig (2011) 163–64.

In Baetica, on the Cerrillo de Ciavieja (El Ejido, Almería) (Figs. 1.14 and 8b), near the ancient Murgi, stands another 'mausoleum' known as El Daymún.[61] Externally square in plan and covered by a barrel vault, in the interior there is a square semi-subterranean chamber flanked to the north, east and west by rectangular arcosolia. It was used as a private family *monumentum*, probably on a suburban *fundus*. In the course of its excavation, no evidence that might support an affiliation with Christianity was found. Its date can be placed at the very end of the 3rd c. or, perhaps better, in the 4th c.;[62] it forms part of a group of 'mausolea' with cruciform central plans inside externally square buildings, including those recorded in the Christian cemetery of Tarragona dated between the mid-4th c. and the first half of the 5th c.

In Lusitania, at the already mentioned villa of La Cocosa (Mérida, Badajoz; ancient province of Lusitania) (Figs. 1.15 and 8c), where elements of Christian tradition of Theodosian date are recorded, together with two *monumenta* that were probably built once the residential buildings had fallen out of use,[63] a central-plan 'mausoleum' with a distyle porch flanked by side apses, and a central square space limited by two further apses and a spacious horseshoe-shaped *exedra* at the far end was constructed. In the course of the 4th c., a hall for worship and a baptistery were added to the complex. This lies within the tradition of Roman funerary buildings with an internally central plan inside in a structure of externally rectangular plan, as is also the case at Centcelles.[64] The use of porticoes with two apses in front of 'mausolea' (and other categories of building for the purposes of worship) is recorded from the Constantinian period onwards.[65]

A number of buildings with a greater or lesser degree of architectural sophistication stand out within the category of central-plan 'mausolea' associated with villas; they are characterised by including a square burial chamber flanked on its long sides by semi-circular apses. Among them are the 'mausolea' of Sádaba, Jumilla, Santiuste de Pedraza and Barcelona. The example at Sádaba (Zaragoza; province of Tarraconensis) (Figs. 1.16 and 9a) is the northernmost example of Late Roman funerary architecture in a rural context in the upper Ebro valley; it belongs to the category of *cellae dichorae*. It consists of a square central block flanked by apses on two sides, while the north arm has a rectilinear rear façade; in front of it there is a small rectangular distyle *in antis* vestibule, with columns adjoining the walls.[66] Because of its central plan and the building techniques employed, it falls within the tradition of Roman funerary buildings of Constantinian date, although it might be datable as late as the mid-4th c.[67] There is no evidence to support a hypothetical relationship with Christianity.[68] As regards the *monumentum* in Jumilla, it is a building of small size that consists of a rectangular *cella* flanked by two small apses, which gave rise to a simple cruciform central plan that can be defined as a *cella dichora* (or *trichora*). Datable to the late 3rd or 4th c., it lacks any feature that might support a Christian interpretation.[69] Such *cellae dichorae* were occasionally simply for burial purposes, but they also acted as *martyria* or reliquaries. In the case of Jumilla (Murcia; province of Carthaginiensis) (Figs. 1.17 and 9b), there were three tombs of almost identical dimensions located under the floor levels, and there are no arguments to suggest that there was any difference in status between them. As a consequence, the buildings at Sádaba and Jumilla should be understood as family 'mausolea', which means that the presence of a third apse would have been superfluous.

The funerary chapel at Santiuste de Pedraza (Segovia; province of Carthaginiensis) (Figs. 1.18 and 9c), found under the portico of the Romanesque church of Nuestra Señora de Las Vegas, forms part of the same tradition. In this case, the levelled remains of the *caldarium* of the bath-building attached to an Early Imperial villa on the same site were reused; even though only the foundations and the first course of ashlars are preserved, it can be interpreted as a central-plan building of trefoil design. Within the externally rectangular structure, the interior contains a central space flanked by two arms, externally rectilinear but internally with *exedrae* of semi-circular shape; a third rectangular arm housed a mosaic-covered tomb.[70] It must be related to a villa located nearby. Even though it has been dated to the 5th c., the building techniques used suggest a Tetrarchic date. Finally, a 'mausoleum' found in Barcelona (province of Tarraconensis) (Figs. 1.19 and 9d) belonged to a suburban villa; it consists of a burial chamber whose southern shorter side ends in an apse although the existence of a second apse

61 Cara (1986) 67–79, particularly fig. 35; García and Cara (1987) 29–36.
62 García and Cara (1987) 36.
63 Chavarría (2007) 121.
64 Serra (1949) 105–116; (1952); Schlunk and Hauschild (1978) 11–12, fig. 6; Chavarría (2007) 121 and 262–64, no. 93, figs. 23 and 100.
65 Tolotti (1986) 485–88.
66 García y Bellido (1963); *cf.* also Schlunk and Hauschild (1978) 12; Chavarría (2007) 122 and 196–98, no. 26, figs. 24A and 55; Valle *et al.* (2016) 4–19.
67 García y Bellido (1963); Palol (1983) 60.
68 García y Bellido (1963); Schlunk and Hauschild (1978) 12.
69 Noguera (2004).
70 Izquierdo (1977a) 213–21; (1977b) 303–307, figs. 1–2, pl. I–II; Chavarría (2007) 124 and 294, no. 122, figs. 24B and 132.

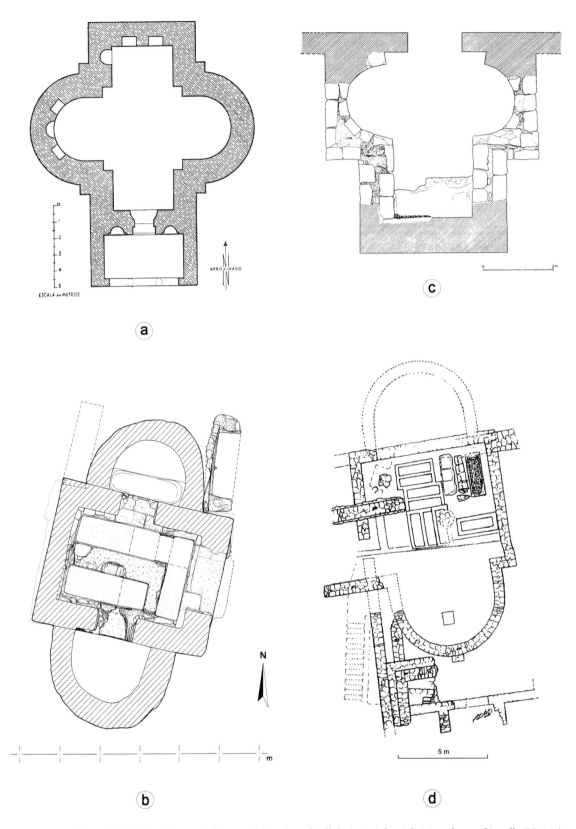

FIGURE 9 a. Mausoleum of Sádaba (La Sinagoga) (Zaragoza) (García and Bellido (1963a) fig. 3). b. Mausoleum of Jumilla (Murcia) (Noguera (2004) 130, fig. 1). c. Mausoleum of Nuestra Señora de las Vegas (Santiuste de Pedraza, Segovia) (Izquierdo (1977a) fig. 1). d. Mausoleum of Barcelona (Travesset (1993) fig. 6) (J. G. Gómez).

on the northern shorter side has also been conjectured; if this were the case, it would have been of simple, symmetrical, cruciform central plan, similar in style to that of Ságvár. It can be dated to the final years of the 4th c. or, perhaps, the opening years of the 5th c.[71]

Apart from questions concerning their plan and architectural type, generally speaking, the burials in these Late Roman 'mausolea' tended to take the form of multiple inhumations in *loculi* laid out under the floor levels or inside the burial chamber, in line with the changes that occurred in funerary ideology from the 3rd c. onwards.[72] The use of rectangular graves (*formae*) under the floor, which might be covered with plain mortar, is recorded in the 'mausolea' in the Parc de la Ciutat cemetery in Tarragona, and also in those at La Molineta, where they might also be covered with limestone slabs and, possibly, large 1.5 ft bricks almost certainly coated in mortar, which would have enabled several burials to have been carried out. *Formae* covered with stone stabs and sealed with lime mortar have also been recorded at El Albir, the Camí del Molí dels Frares, La Alberca and Jumilla. As regards the floor of the *cella superius* at La Alberca, it was decorated with funerary mosaics, which have now disappeared, as seems to have been the case in the Italica 'mausoleum', although it cannot be ruled out that this technique was frequently used in such buildings, as is demonstrated by the exceptional case of Centcelles.

Deposition of Bodies

As regards the way in which the body might be deposited inside the *formae*, in some cases, such as that of the Parc de la Ciutat in Tarragona, it could be placed in the grave wrapped in a simple shroud. However, the dimensions of the graves in certain buildings, such as those at La Alberca and Jumilla (to which that in Italica should be added[73]), suggest the use of sarcophagi, perhaps of wood or lead, inside which the shrouded corpse would have been deposited. In fact, each of the three graves in the building on the Camí del Molí dels Frares contained an undecorated lead coffin.

Pantheons containing chambers with underground *loculi* and stone-built cists (*formae*) for inhumation burials in urban cemeteries such as those found in Tarragona and Puerto de Mazarrón, and the marked contrast between them and the large number of individual burials that surrounded them – of a wide range of types and lacking any built features – are evidence for the clear social stratification of the urban population, which was made up by different socio-economic segments, some of whom had the economic resources necessary to afford funerary buildings of a certain size and quality in terms of building materials. Simple inhumations are associated with groups probably made up by socially disadvantaged free individuals. The owners of tombs with chambers inside in Tarragona must have been middle- or upper middle-class family groups, while in Puerto de Mazarrón they are likely to have belonged to those who were responsible for producing and commercialising the output of local fishing activity. In the case of 'mausolea' nos. I and II at the Parc de la Ciutat in Tarragona, it has been proposed that they belonged to middle-class families or to burial *collegia*. As far as Cartagena is concerned, the cemetery is defined by its wide variety of burial types; the above mentioned pantheons may have belonged to prominent family groups, which would demonstrate that the Christian community and the population of the Late Roman city as a whole were hierarchically organised, a fact that is similarly emphasised by the large 5th c. cemetery discovered in the area of the modern university district. The same conclusion can be reached for the suburban or rural 'mausolea', some of large size and extremely high cost, which should be related to rural landholders.

Relations with the Eastern Mediterranean

Funerary architecture in 4th c. Hispania points to there having been connections with Eastern Mediterranean circles. A significant case is that of the *monumentum* of La Alberca, typological parallels for which can be found in the 'mausoleum'-*martyrium* of Marusinac (Solin, Croatia)[74] and in the 'mausolea' of Pécs (Baranya, Hungary)[75] and St. Stephan (Chur, Switzerland).[76] These 'mausolea' were inspired by Hellenistic and Roman *hérôa* in Asia Minor and attained considerable diffusion throughout the empire from the 2nd c. onwards,[77] particularly in the East. They stood on a small podium and had two storeys, the lower one with a burial chamber and the upper one with a *cella* for the funerary cult.[78]

71 Travesset (1993) 99–104, fig. 6; Beltrán (2010) 382–83.
72 Baldassarri (1984) 148–49.
73 González (2002) 415.

74 Dyggve (1951) 77–78, figs. IV, 5, 17–19, 22–25 and 35; and 109–110, figs. V, 35–36; Schmidt (2000) 303–305, figs. 54–56.
75 Fülep (1977) 246–57 (for the excavations carried out in 1975–1976); Fülep (1984) 36–41, figs. 7–10; Schmidt (2000) 291–92, fig. 38.
76 Schneider-Schnekenburger (1979) 184 *et seq.*; Schmidt (2000) 278–80, figs. 20–21.
77 Noguera (2004) 260–62.
78 Grabar (1943) I, 75–193, particularly 96–97.

The Christian world adopted this type, particularly in the Eastern Mediterranean, although it also spread throughout central and western Europe.[79] The square 'mausolea' in the Christian cemetery of Tarragona with superimposed *cellae* and two entrances recall 'mausolea' such as those of Pécs, Marusinac, St. Stephan and La Alberca.

The *monumentum* at Jumilla and that at Sádaba also have parallels as regards their shape in 'mausolea' built at different points in both the Eastern and Western Mediterranean, such as those at Ságvár[80] and Alsóhetény[81] (both in Somogy, Hungary), Kővágószőlős (Baranya, Hungary)[82] and Aguntum (Austria).[83] These are Late Roman burial buildings of a type that developed from the 3rd c. and, above all, in the 4th c., some of a Christian nature, although in general they were used for pagan burials or they simply lack any precise cultural affiliations.[84] The link between the 'mausolea' of La Alberca, Jumilla and Sádaba and those in the Christian regions of the Adriatic and Dalmatia is proof of the breadth of the social and economic connections of the individuals who built them, who surely belonged to the Roman rural aristocracy of the 4th c.[85] In addition, the 'mausoleum' at Las Vegas de Pueblanueva also confirms the strong eastern influence to which 4th c. Hispano-Roman architecture was subject, a fact that was manifest from the Constantinian period onwards in major landmarks such as Centcelles, La Alberca and Jumilla.

In this period the individuals commissioning these buildings seem to have been able to hire skilled craftsmen of a certain level. Behind such projects there appears to have been a network of social relationships that could be borne out in the search for skilled craftsmen able to undertake building projects or complex figurative decoration inspired by the norms of the time. The sarcophagus found at Las Vegas de Pueblanueva, made of marble quarried in Estremoz (Évora, Portugal) and almost certainly imported from Rome, points in the same direction.[86] This is significant because it is not a matter of the straightforward construction of buildings that were to a greater or lesser degree either sumptuous or singular, but rather adhesion to global models endowed with a clear and precise meaning.

Pagan or Christian *Monumenta*?

This last point is directly related to the cultural meaning of these buildings and particularly whether they were Christian or not.[87] The tombs with chambers in the cemeteries in Tarragona and Cartagena offer no doubts as regards their ties with Christianity.[88] In contrast, there is no archaeological evidence that supports such an interpretation in the case of the Parc de la Ciutat buildings in Tarragona or those in Mazarrón. In this case, the funerary customs and ritual practices recorded, such as the scarcity of grave goods, the association of coins with the corpses and the use of animal amulets are characteristic of a population of Hispano-Roman origin, either pagan or Christian.[89] Some of the *possessores* who commissioned rural 'mausolea' must have been among the first members of the aristocracy to be converted to Christianity in Hispania. Theodor Hauschild came to the conclusion that the clear connections between the 'mausoleum' of La Alberca and others in the Christian areas on the Adriatic and in Dalmatia was evidence for, as has already been mentioned, the breadth of the personal contacts of the individual who ordered it to be built as a family 'mausoleum', who was surely a member of the 4th c. Christian Roman rural aristocracy. He also pointed out that the building at Las Vegas de Pueblanueva could have belonged to a wealthy individual of eastern origin who had most probably arrived in Hispania with a specific mission related to the administration of the province of Carthaginiensis, bringing with him Christian ideas, clearly manifested in the iconography of the sarcophagus in which he must have been buried.[90] Comparable conclusions might also be drawn in the case of many of the other 'mausolea' referred to in this study, such as that of La Cocosa, which, on the grounds of its orientation, may have been Christian.[91] For this reason, the evidence of the 'mausolea' is a further argument that

79 Some time ago, Palol (1967a) 106–116, identified certain similarities between the 'mausoleum' at La Alberca and the funerary chapel of Asterius in Carthage (of 5th or 6th c. date) (Duval and Lézine (1959) 339–57), which enabled him to defend the African connections of the south-east of the Iberian Peninsula from a comparatively early date. However, the morphological and typological similarities between the two types of burial chamber are almost non-existent and, furthermore, they belong to widely differing periods of time (Sotomayor (1979) 143, n. 62).
80 Schmidt (2000) 357–420, particularly 288–90, fig. 32.
81 Tóth (1987–1988) 22–62; Schmidt (2000) 290–91, fig. 36.
82 Schmidt (2000) 300–301, figs. 49–50.
83 Swoboda (1935) 81–83; Pleyel (1987) 295–97.
84 On this question, see Schmidt (2000) 213–441.
85 Hauschild (1971) 170–94.
86 Vidal (2016) 195–210.
87 Chavarría (2007) 124.
88 Tarragona: Del Amo (1979) *passim*; Macias *et al.* (2007) 156–60, no. 564, figs. 57–59. Cartagena: San Martín and Palol (1972) 447–59; Berrocal and Láiz (1995) 173–82.
89 Iniesta and Martínez (2000) 215–16.
90 Vidal (2016) 195–210.
91 Bowes (2008) 138.

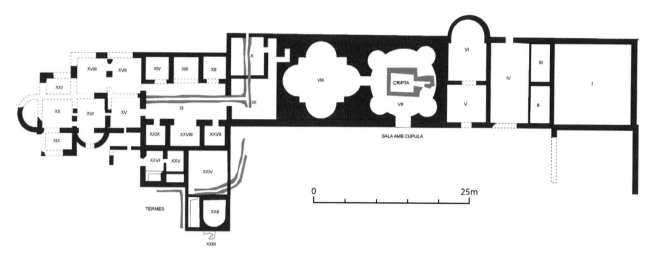

FIGURE 10 Mausoleum of Centcelles (Constantí, Tarragona) (Hauschild and Arbeiter (1993) 33).

should be added to the debate on the conversion of society in Hispania to Christianity, together with the process that it involved, as well as, in particular, that concerning the villas and their owners, a subject to which we are unable to dwell on here for reasons of space.[92] Only in a few cases were these 'mausolea' converted into places of worship, as occurred at La Cocosa or, perhaps, at La Alberca, but not before the 6th or 7th c.[93]

Some rectangular buildings with an apse in southern Portugal (province of Lusitania) – e.g. the villas of Milreu (Faro, Algarve), São Cucufate (Frades, Alentejo) and Quinta de Marim (Olhão, Algarve) (Fig. 1.20–22), which have been interpreted as Early Imperial temples, have also been interpreted as 'mausolea' dated to the late 3rd and the 4th c.[94] These buildings are rectangular in plan, and present a complex architecture and decoration, the expression of the increasing need of their builders to display their social position, and define a regional style for late antique 'mausolea'.[95] However, their similarities with the *martyrium* of St. Eulalia (Mérida), has led to their interpretation as rural *martyria* or *memoriae*, around which Christian cemeteries and basilicas sprang up.[96] A similar building exists in the villa of Carranque (Toledo; province of Carthaginiensis) (Fig. 1.23), which has been interpreted as a 'mausoleum'.[97]

As can be seen, unfortunately it is barely possible to even speculate as regards the origins or condition of the owners of these 'mausolea', who also owned the *fundi* that were associated with them. Perhaps the only 'mausoleum' that lends itself to making a contribution to the debate as regards who might have commissioned it, and also its real function, is that of Centcelles (Constantí, Tarragona) (Figs. 1.24 and 10), constructed at a villa some 5 km from Tarraco. The building is a *unicum*,[98] both as concerns its state of preservation and the cycle of mosaics in its dome and since it is the richest and most eloquent example of the Christianisation of the Roman aristocracy in Hispania or of imperial origins.[99] It consists of a still standing block of rectangular plan, inside which there are two intercommunicating, central-plan spaces. The eastern one is circular and is flanked by 4 small *exedrae*. Its dome, 13.6 m in height, was decorated with polychrome mosaics distributed in a total of three bands: the lowest one contains a hunting scene; the middle one Old and New Testament motifs; and the uppermost one 4 enthroned figures that alternate with figurative representations of the seasons of the year.[100] Under the floor, there is a chamber covered with a barrel vault, which has sometimes been interpreted as having been for burial purposes.[101] The western hall, only partially preserved to a height of some 6 m, is a *cella tetrachora*, with a central area perhaps originally covered by a dome and 4 side *exedrae* perhaps covered by quarter-sphere semi-domes. Its architectural typology,

92 Recent works on this subject: Ripoll (2018) 426–52; Bowes (2018) 453–66.
93 Ripoll and Velázquez (1999) 139; Chavarría (2007) 124.
94 Graen (2005) 257–78; Martínez (2006).
95 Graen (2004) 65–74.
96 Pereira (2015a); (2015b); Sastre (2016) 227–41.
97 García-Entero and Castelo (2008) 345–68.
98 For the villa to which the 'mausoleum' was attached: Hauschild and Schlunk (1986); Hauschild and Arbeiter (1993).
99 Schlunk (1959) 344–65; Schlunk and Hauschild (1961) 119–82; Hauschild and Schlunk (1962); Rüger (1969) 251–75; Hauschild (2002) 51–57; Arce (2002); Chavarría (2007) 108–111, 124 and 186–89, no. 17, fig. 48.
100 For the dome and its mosaics: Schlunk (1972) 459–76; (1988); Arbeiter and Korol (1988–1989) 193–244; Engemann (1989) 127–38.
101 Palol (1961) 235–46; (1967b) 212–14; Schlunk and Hauschild (1978) 15–17, fig. 9; 25–28 and 109–110, pl. colour III–IV; 119–27, figs. 79–82, pl. 8–19; Hauschild and Schlunk (1986); Johnson (2009).

building techniques and the style of the mosaics suggest a late Constantinian date (second quarter of the 4th c.), according to what has been proposed or, as has been shown by the recent study of the ceramics, carried out by P. A. Remolà, a late 4th c. or early 5th c. one.[102]

The dome-covered space at Centcelles could have been a reception hall or a 'mausoleum'. The possibility of it having been imperial can be ruled out as a result of the study of the iconography and because of the chronology of the building. The iconographic programme found at Centcelles, whether it is accepted that it represents a civil figure (Warland) or a bishop (Arce), is sufficiently ambiguous or ambivalent (or even, one might say, polyvalent), so as not to reject outright that its function was definitely not funerary.

From an architectural point of view, this is not impossible if two facts are taken into account: firstly, central-plan *monumenta*, which, as has been seen, belong to a type that acquired a special significance among the great Roman estate-owners, above all from the time of the Tetrarchy, are frequent, and the sarcophagus (or sarcophagi) need not have been placed in a crypt; and secondly, because the 'mausoleum' and the villa tend to be located together, not just in the 4th c., but also beforehand. If the central hall of Centcelles had been reused at a given moment as a 'mausoleum', the sarcophagus would have been placed either in the centre or in one of its side niches. The iconography of the Centcelles mosaics is consistent with a funerary context (even the figures seated in their chairs in the dome who are receiving their vestments: the tomb of Silistra in Bulgaria would be a parallel example). The self-representation of the owner accompanied by servants or in iconic scenes depicting his activity may have been of a funerary nature or have had no special significance because it simply could have been a polyvalent scene.

The ownership of the Centcelles 'mausoleum' has been the subject of different interpretations, ranging from the imperial hypothesis, which linked it to a member of the Constantinian imperial house,[103] perhaps Constans, one of Constantine I's three sons,[104] to the possibility of relating the monument to a high-ranking figure in the ecclesiastical hierarchy of Tarragona, perhaps the bishop of the city.[105] Neither should the idea that it belonged to a wealthy *possessor*, who belonged to the provincial aristocracy of Tarraconensis or circles close to imperial power,[106] who converted to Christianity in the first half or around the middle of the 4th c.,[107] be discarded.

Bibliography

Primary Sources

Aur. Vic., *Caes.* = F. Pichlmayr ed., *Liber de Caesaribus* (Teubner) (Stuttgart 1970).

Epit. de Caes. = F. Pichlmayr ed., *Epitome de Caesaribus* (Teubner) (Stuttgart 1970).

Eutr. = C. Santini ed., *Breviarium ab urbe condita* (Stuttgart 1979).

Festus = W. M. Lindsay ed., *Festus de verborum significatu* (Teubner) (Stuttgart 1997).

Florus = P. Jal ed. *Florus, Ouevres* I, *Les Belles Lettres* (Paris 2002).

Livy = J. Bayet and G. Baillet ed. *Tite-Live, Histoire Romaine* (*Les Belles Lettres*) (Paris 1954).

Plut. *Galb.* = B. Perrin transl. *Plutarch, Parallel Lives* (Loeb Classical Library 11) (London and Cambridge Mass. 1926).

HA, *Ant. Pius* = A. Chastagnol transl., *Historia Augusta* (Paris 1994).

HA, *Hadr.* = A. Chastagnol transl., *Historia Augusta* (Paris 1994).

HA, *Marc.* = A. Chastagnol transl. *Historia Augusta* (Paris 1994).

Siculus Flaccus, *De condic. Agrorum* = M. Clavel-Lévêque, D. D. Conso, F. Favory, J. F. Guillaumin, and P. Robin transl., *Siculus Flaccus. Les conditions des terres* (Naples 1993).

Strabo = H. L. Jones transl., *Strabo. Geography*, 8 vols. (Loeb Classical Library) (London and Cambraidge Mass. 1917–1932).

Suet. *Aug.* = H. Allond ed., *Suetone. Vies des Douze Césars* (*Les Belles Lettres*) (Paris 1931–1932)

Suet. *Galb.* = H. Allond ed., *Suetone. Vies des Douze Césars* (*Les Belles Lettres*) (Paris 1931–1932)

Suet. *Otho* = H. Allond ed., *Suetone. Vies des Douze Césars* (*Les Belles Lettres*) (Paris 1931–1932)

Tabula Hebana = F. de Visscher, F. della Corte, C. Gatti, and M. A. Levi ed. *Tabula Hebana, Revista Parola del Pasato* 4 (1950) 99–107.

Tac. *Ann.* = E. Koestermann ed., *Cornelii Taciti libri qui supersunt* (Teubner) (Leipzig 1971).

Varro, *Ling.* = R. G. Kent transl. *Varro. On the Latin Language* (Loeb Classical Library 333) (London and Cambridge Mass. 1938).

102 Arce (2002) 97 *et seq.*
103 Hauschild and Schlunk (1961) 66–77; (1962).
104 Arbeiter and Korol (1988–1989) 193–244; Arbeiter (2002) 1–9. It has also been proposed that the 4 enthroned figures preserved in the dome are an allegory of the 4 powers of the reigning emperor (Recio (1998) 709–737).
105 Arce (1994) 147–65; Isla (2002) 37–50.
106 Warland (1994) 192–202; (2002) 21–35.
107 Palol (1983) 58.

Secondary Sources

Albiach R. and Soriano R. (1996) "El cementerio romano de Orriols", *Saitabi* 46 (1996) 123–45.

Alcina J. (1950) "Las ruinas romanas de Almenara (Castellón)", *Boletín de la Sociedad Castellonense de Cultura* 26 (1950) 92–128.

Amante M. and López M. "La necrópolis de La Molineta: aproximación a la historia social y económica en el Puerto de Mazarrón (Murcia) durante la Antigüedad Tardía", in *Arte, sociedad, economía y religión durante el Bajo Imperio y la Antigüedad Tardía* (Antigüedad y Cristianismo 8) (Murcia 1991) 475–81.

Arasa F. (1999) "Noves propostes d'interpretació sobre el conjunt monumental de La Muntanyeta dels Estanys d'Almenara (La Plana Baixa, Castelló)", *Archivo de prehistoria levantina* 23 (1999) 301–358.

Arbeiter A. (2002) "Centcelles. Puntualizaciones relativas al estado actual del debate", in *Centcelles. El monumento tardorromano. Iconografía y arquitectura*, ed. J. Arce (Rome 2002) 1–9.

Arbeiter A. and Korol D. (1988–1989) "El mosaico de la cúpula de Centcelles y el derrocamiento de Constante por Magnencio", *Butlletí arqueològic. Reial societat arqueològica tarraconense. Boletín arqueológico. Real sociedad arqueológica tarragonese* 11–12 (1988–1989) 193–244.

Arce J. (1988) *Funus imperatorum. Los funerales de los emperadores romanos* (Madrid 1988).

Arce J. (1994) "Constantinopla, Tarraco y Centcelles", *Butlletí arqueològic. Reial societat arqueològica tarraconense. Boletín arqueológico. Real sociedad arqueológica tarragonese* 16 (1994) 147–65.

Arce J. ed. (2002) *Centcelles. El monumento tardorromano. Iconografía y arquitectura* (Rome 2002).

Baldassarri I. (1984) "Una necropoli imperiale romana: proposte di lettura", in *Aspetti dell'ideologia funeraria nel mondo romano* (Annali. Sezione di archeologia e storia antica. Istituto universitario orientale di Napoli. Dipartimento di studi del mondo classico e del Mediterraneo antico 6) (Naples 1984) 141–49.

Barragán M. (2009) "La necrópolis tardoantigua de Carretera de Carmona, Hispalis", *Rómula* 8 (2009) 227–56.

Barragán M. (2010) *La necrópolis tardoantigua de Carretera de Carmona (Hispalis), Sevilla* (Scripta 2) (Seville 2010).

Beltrán F. (2000) "Las inscripciones del Mausoleo de Fabara (Zaragoza)", *Caesaraugusta* 74 (2000) 253–64.

Beltrán J. (2010) "La cristianización del suburbio de Barcino", in *Las áreas suburbanas en la ciudad histórica. Topografía, usos, función* (Monografías de Arqueología Cordubesa 18), ed. D. Vaquerizo (Cordoba 2010) 363–96.

Berrocal M. and Laiz M. D. (1995) "Tipología de enterramientos en la necrópolis de San Antón en cartagena", in *IV Reunió d'Arqueologia cristiana hispànica (Lisboa, 28 sept.– 2 oct. 1992)* (Barcelona 1995) 173–85.

Bodel J. P. (1997) "Monumental Villas and Villa Monuments", *JRA* 10 (1997) 5–35.

Bowes K. D. (2008) *Private Worship, Public Values, and Religious Change in Late Antiquity* (Cambridge 2008).

Bowes K. D. "Christianization of villas", in *The Roman Villa in the Mediterranean Basin. Late Republic to Late Antiquity*, edd. A. Marzano and G. P. R. Metraux (New York 2018) 453–66.

Bowes K. D. and Kulikowski M. (2005) *Hispania in Late Antiquity. Current Perspectives* (Boston 2005).

Cancela M. L. (1993) "Elementos decorativos de la arquitectura funeraria de la Tarraconense oriental", in *Actas de la I Reunión sobre Escultura Romana en Hispania (Mérida, 1992)* (Madrid 1993) 239–61.

Cancela M. L. and Martín-Bueno M. (1993) "Hispanie romaine: architecture funérarire monumental dans le monde rural", in *Monde des morts, monde des vivants en Gaule rural (1er s. av. J.-C. – Ve s. ap. J.-C.), Actes du Colloque ARCHEA/ AGER (Orléans, 1992)* (Tours 1993) 399–409.

Cara L. (1986) "El mausoleo tardorromano de El Daymun (El Ejido, Almería)", in *Historia de la Baja Alpujarra* (Almería 1986) 67–79.

Chavarría A. (2007) *El final de las* villae *en Hispania (siglos IV–VIII)* (Bibliothèque de l'antiquité tardive 7) (Turnhout 2007).

Cioffi L. "Sepultura in extremis finibus ... etiam in modiis possess onibus sepulchre faciunt", in *Roman Villas around the Urbs. Interaction with Landscape and Environment (Proceedings of a Conference held at the Swedish Institut in Rome. Sett. 17–18, 2004)*, edd. B. Santillo and A. Klyme (Rome 2005) 1–9.

Coarelli F. (1975) *Guida Archeologica di Roma* (Rome 1975).

Coll J.-M. and Roig J. (2011) "La fi de les vil·les romanes baix-imperials a la depressió prelitoral (segles IV–V): contextos estratigràfics i registre material per datar-los", in *Actes del IV Congrés d'arqueologia medieval i moderna a Catalunya (Tarragona, del 10 al 13 de juny de 2010)* (Tarragona 2011) 161–72.

De la Llave S. and Escobar A. (2017) "Redescubriendo el mausoleo tardorromano de Las Vegas (La Pueblanueva, Toledo)", *Urbs Regia* 2 (2017) 26–45.

Del Amo M. D. *Estudio crítico de la necrópolis paleocristiana de Tarragona* (Tarragona 1979).

Del Amo M. D., Muñoz F., and Arroyo E. A. (2003) *Panteón familiar Romano en Isla Canela (Ayamonte, Huelva)* (Ayamonte 2003).

Duval N. and Lézine A. (1959) "La chapelle funéraire souterraine dite d'Astérius à Carthage", *MEFRA* 71 (1959) 339–57.

Dyggve E. (1951) *History of Salonitan Christianity* (Oslo 1951).

Engemann J. (1989) "Die Mosaikdarstellungen des Kuppelsaals in Centcelles. Anlässlich der Publikation von Helmut Schlunk", *Jahrbuch für Antike und Christentum* 32 (1989) 127–38.

Faure P., Tran N., and Rémy B. (2013) *Inscriptions Latines de Narbonnaise. VIII. Valence* (Gallia, XLIVe Supplément-ILN) (Paris 2013).

Fernández Ochoa C., García-Entero V., and Gil F. (2008) *Las "villae" tardorromanas en el Occidente del Imperio. Arquitectura y función* (IV Coloquio Internacional de Arqueología en Gijón) (Gijón 2008).

Fülep F. (1977) "A Pécsi ókeresztény mauzóleum ásatása" [Excavations of the Early Christian mausoleum of Pécs], *Archaeologiai értesítő* 104 (1977) 246–57.

Fülep F. (1984) *Sopianae. The History of Pécs during the Roman Era, and the Problem of the Continuity of the Late Roman Population* (Budapest 1984).

García L. A. and Amante M. (1993) "La necrópolis de La Molineta. Puerto de Mazarrón, Murcia", *Memorias de Arqueología de la Región de Murcia* 4 (1993) 245–60.

García J. L. and Cara L. (1987) "Excavación arqueológica efectuada en el mausoleo tardorromano de El Daimuz (El Ejido-Almería)", *Anuario Arqueológico de Andalucía* 3 (1987) 29–36.

García y Bellido A. (1963) *La Villa y el Mausoleo Romanos de Sádaba* (Archivo Español de Arqueología 19) (Madrid 1963).

García-Entero V. and Castel R. (2008) "Carranque, El Saucedo y las villae tardorromanas del valle medio del Tajo", in *Las "villae" tardorromanas en el Occidente del Imperio. Arquitectura y función* (IV Coloquio Internacional de Arqueología en Gijón), edd. C. Fernández Ochoa, V. García-Entero, and F. Gil (Gijón 2008) 345–68.

González R. (2001) *El mundo funerario romano en el País Valenciano. Monumentos funerarios y sepulturas entre los siglos I a. de C. – VII d. de C.* (Madrid and Alicante 2001).

González J. M. (2002) "Un aspecto del cristianismo en Itálica y su plasmación en el registro funerario: Las excavaciones de 1903", *SPAL Revista de Prehistoria y Arqueología de la Universidad de Sevilla* 11 (2002) 409–417.

Grabar A. (1943) *Martyrium. Recherches sur le culte des reliquies et l'art chrétien antique* (Paris 1943).

Graen D. (2004) "'Sepultus in villa'. Bestattet in der Villa. Drei Zentralbauten in Portugal zeugen vom Grabprunk der Spätantike", *AntW* 35.3 (2004) 65–74.

Graen D. (2005) "Two Roman mausoleums at Quinta de Marim (Olhão). Preliminary results of the excavations in 2002 and 2003", *Revista portuguesa de arqueologia* 8.1 (2005) 257–78.

Graen D. (2008) *Sepultus in villa – die Grabbauten römischer Villenbesitzer. Studien zu Ursprung und Entwicklung von den Anfängen bis zum Ende des 4. Jahrhunderts nach Christus* (Schriftenreihe Antiquitates 46) (Hamburg 2008).

Hauschild T. (1969) "Das Mausoluem bei Las Vegas de Puebla Nueva", *MM* 10 (1969) 293–316.

Hauschild T. (1970) "Ein römischer Zentralbau bei Tarragona", *MM* 11 (1970) 139–60.

Hauschild T. (1971) "Das Martyrium von La Alberca (prov. Murcia)", *MM* 12 (1971) 170–94.

Hauschild T. (1978) "Das Mausoluem bei Las Vegas de Puebla Nueva (Toledo)", *MM* 19 (1978) 307–39.

Hauschild T. (2002) "Centcelles: exploraciones en la sala de la cúpula", in *Centcelles. El monumento tardorromano. Iconografía y arquitectura*, ed. J. Arce (Rome 2002) 51–57.

Hauschild T. and Arbeiter A. (1993) *La villa romana de Centcelles* (Barcelona 1993).

Hauschild T. and Schlunk H. (1961) "Vorbericht über die Untersuchungen in Centcelles", *MM* 2 (1961) 66–77.

Hauschild T. and Schlunk H. (1962) *Informe preliminar sobre los trabajos realizados en Centcelles* (Archivo Español de Arqueología 18) (Madrid 1962).

Hauschild T. and Schlunk H. (1986) *La villa romana i el mausoleu constantinià de Centcelles* (Tarragona 1986).

Hidalgo R. (2011–2012) "En torno a la interpretación de la sala triabsidada del Palatium de Corduba", *Cuadernos de Prehistoria y Arqueología de la Universidad Autónoma de Madrid* 37–38 (2011–2012) 655–70.

Iniesta Á. and Martínez M. (2000) "Nuevas excavaciones en la necrópolis tardorromana de la La Molineta (Puerto de Mazarrón, Murcia)", *Anales de Prehistoria y Arqueología* 16 (2000) 199–224.

Isla A. (2002) "La epifanía episcopal en los mosaicos de la *villa* de Centcelles", in *Centcelles. El monumento tardorromano. Iconografía y arquitectura*, ed. J. Arce (Rome 2002) 37–50.

Izquierdo J. M. (1977) "Mausoleo de época paleocristiana en Las Vegas de Pedraza (Segovia)", *Segovia. Symposium de arqueología romana* (Barcelona 1977) 213–21.

Izquierdo J. M. (1977) "Excavaciones en Las Vegas de Pedraza, Santiuste de Pedraza (Segovia), 1972–73", *Noticiario arqueológico hispánico. Arqueología* 5 (1977) 303–307.

Jiménez J. L. (1989) "El monumento funerario de los Sergii en Sagunto", in *Homenatge A. Chabret 1888–1988* (Valencia 1989) 207–220.

Johnson M. J. (2008) "The porphyry alveus of Santes Creus and the mausoleum at Centcelles", *MM* 49 (2008) 388–94.

Johnson M. J. (2009) *The Roman Imperial Mausoleum in Late Antiquity* (Cambridge 2009).

Lindsay W. M. ed. (1997) *Festus de verborum significatu* (Bibliotheca Teubneriana) (Stuttgart 1997).

López A. (1999) "Orientaciones de tumbas y sol naciente. Astronomía cultural en la Antigüedad Tardía", in *XXIV Congreso Nacional de Arqueología (Cartagena, 1997)* (Murcia 1999) 593–610.

López J. and Muñoz A. (2019) "L'arqueologia cristiana de Tarragona. Balanç dels darrers 25 anys (1993–2018)", in *Actes. 4t*

Congrés Internacional d'Arqueologia i Món Antic. VII Reunió d'Arqueologia Cristiana Hispànica. El cristianisme en l'antiguitat tardana, noves perspectives (Tarragona, 21–24 de novembre de 2018), ed. J. López (Tarragona 2019) 35–48.

Macias J. M., Fiz I., Piñol L., Miró M. T. and Guitart J. (2007) Planimetria arqeològica de Tàrraco (Documenta 5) (Tarragona 2007).

Martínez A. M. (2006) "Arquitectura cristiana en Hispania durante la Antigüedad Tardía (siglos IV–VIII) (I)", in Gallia e Hispania en el contexto de la presencia 'germánica' (ss. V–VII): balance y perspectivas. Actas de la mesa redonda hispano-francesa celebrada en la Universidad Autónoma de Madrid (UAM) y Museo Arqueológico Regional de la Comunidad de Madrid (MAR), 19/20 diciembre 2005, edd. J. López, M. A. Martínez, and J. Marín (Oxford 2006) 109–187.

Martínez M. A. (2015) "Monumentos funerarios romanos en la Comunidad Valenciana. Tipos y ejemplos más destacados", ArqueoWeb 16 (2015) 102–123.

Martínez M. A. (2016) "La necrópolis de Orriols (Valencia): ejemplos de ritual funerario en época romana (siglos II–IV d.C.)", Lucentum 35 (2016) 171–91.

Martínez M. A. and Iniesta Á. (2007) Factoría romana de salazones. Guía del Museo Arqueológico Municipal de Mazarrón (Mazarrón, 2007).

Mateos P. (1999) La basílica de Santa Eulalia de Mérida. Arqueología y urbanismo (Anejos de AEspA 19) (Madrid 1999).

Mergelina C. (1948) "El sepúlcro de La Alberca", in Crónica del III Congreso Arqueológico del Sudeste Español (Murcia, 1947) (Murcia 1948) 283–93.

Mesado N. (1966) "Breves notas sobre las ruinas romanas de 'Els Estanys' (Almenara)", Archivo de prehistoria levantina 11 (1966) 177–96.

Noguera J. M. (2004) El Casón de Jumilla. Arqueología de un mausoleo tardorromano (Murcia 2004).

Noguera J. M. (2019) Villae. Vida y producción rural en el sureste de Hispania (Murcia 2019).

Ortiz M. E. and Paz J. Á. (2004) Los Bañales, Uncastillo. Los Atilios, la Sinagoga, Sadaba (Zaragoza 2004).

Palol P. (1961) "El mausoleo constantiniano de Centcelles, Tarragona", in Corsi di cultura sull'arte ravennate e bizantina (Ravenna 1961) 235–46.

Palol P. (1967) Arqueología cristiana de la España romana, siglos IV al VI (Madrid and Valladolid 1967).

Palol P. (1967) "Arqueología cristiana hispánica de tiempos romanos y visigodos", RACrist 43 (1967) 177–232.

Palol P. (1983) "La conversion de l'aristocracie de la péninsule Ibérique au IVe siècle", in Les transformations dans la société chrétienne au IVe siècle (Crongrès de Varsovie, 25 juin–1 juliet 1978) (Miscellanea Historiae Ecclesiasticae, VI. Section 1) (Brussels 1983) 47–69.

Pereira C. (2015) About the Oldest Known Christian Buildings in the Extreme South of Lusitania: The Case of Quinta De Marim (Olhão, Algarve, Portugal) (Oxford 2015).

Pereira C. (2015) The Roman Necropolis of Algarve (Portugal). About the Spaces of Death in the South of Lusitania (Oxford 2015).

Pérez M. (1993) "La excavación de urgencia de C/. Pedreño (Puerto de Mazarrón). Informe preliminar", Memorias de Arqueología de la Región de Murcia 4 (1993) 225–36.

Pérez, M. (1993) "Calle Fábrica (Puerto de Mazarrón)", Memorias de Arqueología de la Región de Murcia 4 (1993) 237–44.

Pérez M. (2012) Tarraco en la antigüedad tardíacristianización y organización eclesiástica (III a VIII siglos) (Tarragona 2012).

Pérez M. (2019) "Loca sanctorum Tarraconis. Els escenaris de culte als sants en la Tarraco de l'antiguitat tardada (ss. IV al VIII)", in Actes. 4[t] Congrés Internacional d'Arqueologia i Món Antic. VII Reunió d'Arqueologia Cristiana Hispànica. El cristianisme en l'antiguitat tardana, noves perspectives (Tarragona, 21–24 de novembre de 2018), ed. J. López (Tarragona 2019) 49–56.

Pleyel P. (1987) Das römische Österreich. Kulturgeschichte und Führer zu Fundstätten und Museen (Vienna 1987).

Recio A. (1998) "Il mausoleo di Centcelles (Tarragona) del 350–355 ca. Lettura ed interpretazione iconografica di alcune scene musive del registro B della cupola", in Domum tuam dilexi. Miscellanea in onore di Aldo Nestori (Rome 1998) 709–737.

Ribera A. and Soriano R. (1987) "Enterramientos de la Antigüedad Tardía en Valentia", Lucentum 6 (1987) 139–64.

Richard J. Cl. (1970) "'Mausoleum': d'Halicarnasse à Rome, puis à Alexandrie", Latomus 29 (1970) 370–88.

Ripoll G. (2018) "Aristocratic residences in late antique Hispania", in The Roman Villa in the Mediterranean Basin. Late Republic to Late Antiquity, edd. A. Marzano and G. P. R. Metraux (New York 2018) 426–52.

Ripoll G. and Arce J. (2000) "The transformation and end of Roman villae in the West (fourth-seventh centuries): problems and perspectives", in Towns and their Territories between Late Antiquity and the Early Middle Ages, edd. G. P. Brogiolo, N. Gauthier, and N. Christie (Leiden 2000) 63–114.

Ripoll G. and Arce J. (2001) "Transformación y final de las villae en occidente (siglos IV–VIII): problemas y perspectivas", Arqueología y Territorio Medieval 8 (2001) 21–54.

Ripoll G. and Velázquez I. (2000) "Origen y desarrollo de las parrochiae en la Hispania de la antigüedad tardía", in Alle origini della parrocchia rurale (IV–VII sec.) Atti della giornata tematica dei Seminari di Archeologia Cristiana, École française de Rome-19 marzo 1998 (Sussidi allo Studio delle antichità cristiane pubblicati a cura del Pontificio Istituto di Archeologia Cristiana 12), ed. Ph. Pergola (Vatican City 2000) 101–165.

Ripoll G., Tuset F., Benseny J., and Mesas I. (2019) "Sidillà, de vil·la romana a aglomeració medieval", *Revista de Girona* 312 (2019) 46–49.

Rüger C. B. (1969) "Vorbericht über die Arbeiten in Centcelles, 4", *MM* 10 (1969) 251–75.

Ruiz E. (1991) "Núcleo urbano y necrópolis de la calle Era, en el Puerto de Mazarrón", *Verdolay* 3 (1991) 45–58.

Ruiz E. (2013) "Itálica tardoantigua: reflexiones y asignaturas pendientes", *Ligustinus* 1 (2013) 81–118.

San Martín P. A. and Palol P. de (1972) "Necrópolis Paleocristiana de Cartagena", in *VII Congreso Internacional de Arqueología Cristiana* (Barcelona 1972) 447–58.

Sanmartí J. (1984) "Edificis sepulcrals del Països Catalans, Aragó i Múrcia", *Fonaments* 4 (1984) 87–160.

Sastre I. (2016) "El exemplum de Eulalia en la cristianización de la aristocracia romana hispana. Arqueología, Hagiografía y Epigrafía", in *A Baete ad fluvium Anam. Cultura epigráfica en la Bética Occidental y territorios fronterizos*, edd. J. Carbonell and H. Gimeno (Alcalá 2016) 227–41.

Schlunk H. (1948) "El arte de la época paleocristiana en el Sudeste español. La sinagoga de Elche y el 'Martyrium' de La Alberca", in *Crónica del III Congreso Arqueológico del Sudeste Español (Murcia 1947)* (Murcia 1948) 335–79.

Schlunk H. (1959) "Untersuchungen im frühchristlichen Mausoleum von Centcelles", in *Neue deutsche Ausgrabungen im Mittelmeergebiet und im Vorderen Orient* (Berlin 1959) 344–65.

Schlunk H. (1966) "Der Sarkophag von Puebla Nueva (Prov. Toledo)", *MM* 7 (1966) 210–31.

Schlunk H. (1972) "Bericht über die Arbeiten in der Mosaikkuppel von Centcelles", *Actas del VIII Congreso Internacional de Arqueología Cristiana (Barcelona 1969)* (Rome 1972) 459–76.

Schlunk H. (1988) *Die Mosaikkuppel von Centcelles* (Madrider Beiträge 13) (Mainz 1988).

Schlunk H. and Hauschild T. (1961) "Vorbericht über die Arbeiten in Centcelles", *MM* 2 (1961) 119–82.

Schlunk H. and Hauschild T. (1978) *Hispania Antiqua. Die Denkmäler der frühchristlichen und westgotischen Zeit* (Mainz 1978).

Schmidt W. (2000) "Spätantike Gräberfelder in den Nordprovinzen des römischen Reiches und das Aufkommen christlichen Bestattungsbrauchtums", *Saalburg-Jahrbuch. Bericht des Saalburg-Museums* 50 (2000) 213–441.

Schneider-Schnekenburger G. (1979) "Raetia I vom 4. bis 8. Jahrhundert auf Grund der Grabfunde", in *Von der Spätantike zum frühen Mittelalter. Aktuelle Probleme in historisches und archäologischer Sicht* (Vorträge und Forschungen 25), edd. J. Werner and E. Ewig (Sigmaringen 1979) 179–91.

Serra, J. de C. (1949) "La capilla funeraria de la dehesa de La Cocosa", *Revista de Estudios Extremeños* 1–2 (1949) 105–116.

Serra J. de C. (1952) *La villa romana de la dehesa de la Cocosa* (Revista de Estudios Extremeños Anejos 2) (Badajoz 1952).

Sotomayor M. (1979) "La Iglesia en la España romana", in *Historia de la Iglesia en España, I. La Iglesia en la España romana y visigoda (dirigida por García-Villoslada, R.)* (Madrid 1979) 7–400.

Swoboda E. (1935) "Aguntum", *ÖJh* 29 (1935) 5–102.

Teba J. A. (1989) "Mausoleo de la Punta del Moral (Ayamonte, Huelva)", in *Anuario Arqueológico de Andalucía, III, Actividades de Urgencia. 1987* (Seville 1989) 317–22.

TED'A (1987) *Els enterraments del Parc de la Ciutat i la problemàtica funerària de Tàrraco* (Tarragona 1987).

Tolotti F. (1986) "Il S. Sepolcro di Gerusalemme e le coeve basiliche di Roma", *RM* 93 (1986) 485–88.

Tóth E. (1987–1988) "Vorbericht über die Ausgrabung der Festung und des Gräberfeldes von Alsóhetény 1981–1986. Ergebnisse und umstrittere Fragen", *Archaeologiai értesitő* 114–115 (1987–1988) 22–62.

Travesset M. (1993) "Una necròpolis paleocristiana a la Barcelona de l'època del bisbe Sant Pacià (segle IV d.C.)", *Finestrelles* 5 (1993) 71–140.

Valenti M. ed. (2010) *Monumenta. Mausolei romani, tra commemorazione funebre e propaganda celebrativa* (Tuscolana 3) (Rome 2010).

Valle J. M., Pérez P., Rodríguez Á., D'Anna C. M., Uceda S., Sánchez J., and Akizu O. (2016) "El modelo 3D como base para la documentación y difusión de los elementos patrimoniales. Aplicación al mausoleo romano denominado 'la Sinagoga' de Sádaba (Zaragoza, España)", *Restauro archeologico* 24 (2016) 4–19.

Vidal S. (2016) "Análisis arqueométricos del sarcófago de Pueblanueva (Toledo) y estudio de cinco fragmentos de sarcófago procedentes de Pueblanueva en las colecciones del Museo Arqueológico Nacional", *Boletín del Museo Arqueológico Nacional* 34 (2016) 195–210.

Warland R. (1994) "Status und Formular in der Repräsentation der spätantiken Führungsschicht", *RM* 101 (1994) 175–202.

Warland R. (2002) "Die Kuppelmosaiken von Centcelles. Als Bildprogramm spätantiker Privatrepräsentation", in *Centcelles. El monumento tardorromano. Iconografía y arquitectura*, ed. J. Arce (Rome 2002) 21–35.

Mausolea in North-West Europe: the Transition from the Roman to Late Antique Periods

Christopher J. Sparey-Green

Abstract

This paper summarises knowledge of major funerary monument types of the late antique period in the north-western provinces. Starting with a definition of the term 'mausoleum', structures in the classical tradition are briefly outlined using examples from Gaul, Britain, and the German frontier in the period up to the crisis of the later 3rd c. Thereafter, developments in the late antique funerary tradition are considered against the backdrop of religious developments, identifying particular building types associated with the earliest Christian places of burial and worship and the honouring of major figures in the Early Church.

Introduction

Discussion of processes for handling the dead and the range of burial rites in the north-western provinces has proliferated in recent decades.[1] The following outlines evidence for funerary structures within the north-western provinces without describing in detail either the form of burial or their context within cemeteries of the Roman period. While the majority of monuments detailed are late antique, their origins in the Late Roman period are first outlined. The range of burial monuments includes funerary gardens and the rare cases of structures set within the grounds of villas or, indeed, the earliest Christian churches. The selection of sites includes Britain, France, Germany, the Low Countries and Switzerland, with the British evidence including an updated summary of the structures within the cemetery at Poundbury Camp, Dorchester.

The finest Early Imperial monuments were ostentatious with room for ceremonies and additional burials in a surrounding court, others marked private burial plots with limited access for further interments within the structure. Interments were normally of adults and juveniles, but neonate burials could be interred within the richer mausolea while the mass of the population were interred in flat cemeteries of cremations or inhumations with only the simplest marker. Although early cemeteries were set beyond formal settlement boundaries, frequently on roadsides or in prominent positions visible to passers-by or relatives, later burial places might be focused on Christian sites, lying beneath churches or within their precincts, the church building effectively a mausoleum. In Late Antiquity, the separation of the living and the dead ended, church and cemetery moving within the settlement or providing a focus beyond.

Mausolea within the Mediterranean world lie beyond the scope of this paper, but the term derives from the name of Mausolus, the satrap of Caria whose tomb, the *Mausolleion,* lay in the western necropolis of the early 4th c. BC city of Halicarnassus. Although robbed to bedrock, structural fragments and written sources allow its recognition as one of the Seven Wonders of the Ancient World on account of its scale and the quality of its decoration.[2] It may have passed through phases of construction, the initial monument to Mausolus enlarged to house Artemisia in a joint tomb, one of a group set by a road approaching the city from the west.[3] From the Hellenistic period onward, the *Mausolleion* has been the pattern and the eponym for a funerary monument, some examples outlined here, either as exceptional monuments or from textual references. In Italy, the description of the bizarre monument erected to Lars Porsenna seems unparalleled with the use of both metal and stone to create a multiple pyramid with suspended metal elements.[4] Augustus' burial monument between the *Via Flaminia* and the Tiber north of Rome was described as

1 This paper derives from research, starting with Green (1977) and continued as Sparey-Green (1993a); (2003) and (2004), with particular regard to the Poundbury Camp cemetery, summarised below, and developing research undertaken at Darwin College, Cambridge in 1993–1994. Surveys of funerary sites and burial customs in the western provinces, while including some monuments, have emphasised burial customs and grave furniture: Struck (1993); Pearce, Millett and Struck (2000). Recent surveys of Britain, Gerrard (2013) and Millett, Revell and Moore (2016), have said little of monuments, although Pearce (2016) describes some types. Toynbee (1971) remains a valuable account of the range of burial rites and monuments across the empire.

2 Hoepfner (2013).
3 If my proposition is correct, the term 'Artemisium' would be more accurate for a burial monument, but might be too radical a change in terminology after 1,400 years.
4 For this monument, see Myres (1951). The monument of the Orazi and Curiazi at Albano displays some features of the described structure, see Ghini (2010).

a mausoleum by Vitruvius, although this was effectively a barrow containing a burial chamber, its mass retained by masonry.[5] Monuments for later emperors and their families at Rome, in Italy, Spain and the Balkans continued the tradition, ending with the masonry mausoleum of Theoderic of the early 6th c. with its massive cap-stone.[6]

Cicero's letters reference a planned memorial for a much-loved daughter, Tullia, his account only recording the intention of obtaining a plot on land in the *Ager Vaticanus* west of the Tiber.[7] The same area, a century later, saw the first recorded interment of an apostle, St. Peter, buried on the western side of an open area and uphill of a series of chamber tombs. The presumed inhumation of the apostle was later marked by an aedicule of uncertain form.[8] Petronius, *Satyricon* 71, characterizes the lavish rituals and monuments of the Early Imperial period with Trimalchio specifying the dimensions of a plot set end on to a road, the form of the monument, its garden setting and the public banquet overseen by the goddess Fortuna.

More directly relevant to the present study is the 'Testament du Lingon', a copy of a legal document from the late 2nd c. recording the wishes of a wealthy Gallic aristocrat for a monument in the form of an altar tomb in front of a funerary chapel and *exedra*, set within a garden with pond, the whole enclosed and approached by a road. Directions for its maintenance and even the use of produce from the site are given, the description correlating with some of the finds outlined below.[9]

Earlier Roman Burial Monuments

As a background to the funerary structures of Late Antiquity in the north-western provinces a simplified typology is offered here, covering the major monument types of the Early Imperial period.[10] Of the numerous mausolea known in the study area some have their origin in pre-Roman custom, others follow Classical models. While some burial places were devoid of built monuments, elsewhere mausolea were integral to the development of burial grounds, whether public or private, acting as memorials and ceremonial foci. Some occupied suburban plots overlooking roadways or rivers, others lay on private estates or were, rarely, set in the gardens of rural dwellings. Derelict structures reused for burial are not covered in detail, but there are instances of structures, perhaps purpose-built for funerary use, having burials inserted when they were in a state of decay. The use of caves, as at Wookey Hole in Britain, with no evidence for any formal monument, are also excluded, even though the site had received burials by analogy to the entrance to the underworld and the river Styx.[11]

The following monument types or burial places can be proposed: the major distinction between massive structures marking an interment and those giving access for ceremonies or additional burials. The evidence for Types 1 and 2 in the earlier Roman period is summarized, while Type 3 is given more prominence in the late antique period since this is the apparent pattern for structures marking the burial of early martyrs and ecclesiastics.

Dating of monuments is often uncertain, but for the Treveran territory a sequence has been proposed starting from a native tradition of earthen barrow burials in the late 1st c. BC to early 1st c. AD, these succeeded by masonry-revetted barrows in the later 1st c. AD.[12] The elaborate triple-tiered and columnated monuments, populated by figured sculptures, are dated to the mid-1st to mid-2nd c. and seen as honouring military families, as suggested by the decoration of battle scenes on the Mausolée de Bertrange. The less elaborate towered aedicule extend from the earlier 2nd until the mid-3rd c. The Germanic invasions are seen as disrupting any further development, but the spread of Christian belief may

5 Vitr., *de arch.* II.11; Johnson (2009); Barraco (2014). Strabo V.3, 8 refers to it as *mausolleion*, while Mart., *Epigr.* II.59, calls it a *tholum*. Tac., *Ann.* III.4, terms it more correctly as a *tumulus*, but Suet., *Aug.* 100 uses *mausoleum*.
6 As a monument to a Germanic king, the latter is omitted by Johnson (2009), but included in the wider survey of Toynbee (1971) 163, pl. 53.
7 Cic., *Att.* XII.18; Lavagne (1987) 160–62.
8 Toynbee and Ward Perkins (1956); Kirschbaum (1959); Prandi (1957); (1963). The St. Peter's aedicule hardly qualifies as a mausoleum, but was set against the 'Red Wall' boundary of the area, the monument later identified with the *Tropaeum Gaii*, Liverani *et al.* (2010) 47–55 and 136–39.
9 Le Bohec (1993); Rodríguez (1995). Marble cemetery plans survive from Italy, Toynbee (1971) 98–99, figs. 7–8.
10 While Struck (1993) included some examples of funerary architecture, more recent works, such as Moretti and Tardy (2006), Castorio and Maligorne (2016) and Clauss-Balty *et al.* (2016), have concentrated on monuments in Gaul, the Low Countries and the Rhine frontier; Schindler (1980) and Binsfeld *et al.* (2020) have covered north-east Gaul and the Rhineland. A typology and reconstructions of the earliest timber monuments in the Champagne area is included in Castorio and Maligorne (2016) fig. 4, the burials from this native tradition omitted here.
11 Hawkes *et al.* (1978).
12 For the chronology, see Kremer (2016) 91–92, fig. 12.

have already been influencing burial customs, as suggested below.[13]

Type 1. Tombstones and Inscription Slabs

A stone bearing an inscription or acting simply as a marker, set either upright or laid as a plaque over a flat grave containing the inhumed or cremated remains; in Late Antiquity, they are the slabs laid flat over dug graves. As not a built monument these will not be described here, although it should be noted that the inscription tablets formed an important element in the marking of some interred burials in Late Antiquity.

Type 2. Barrows

A wide-spread monument type, they range from the late prehistoric barrows or tumuli to the Etruscan barrows with decorated burial chambers and the Roman stone monuments of the *Via Appia*. Burials might occupy a built inner chamber, perhaps with access corridor and with reinforcing structures and surmounted by decorative features or statuary. The monument type was adopted by the imperial family, the most famous example was that of Augustus. In north-west Europe, barrow monuments of Type 2 are mostly 'earth-mass' structures, their origin in the early prehistoric period as the simplest form of monument formed from soil removed during the interment or from a surrounding ditch. The custom continued into Late Antiquity amongst Germanic peoples. Many smaller examples have now been lost through agriculture, only the larger surviving, with a marked concentration of earlier Roman date in north-eastern Gaul and southern Britain.[14] Such monuments are also concentrated in central Belgium and Luxembourg and are a feature of the area between Tongres and Trier, with three distinctively conical mounds adjoining the Tongres road at Tirlemont.[15] Elsewhere, rural sites at Siesbach in Germany and Gravenknapp in Luxembourg have produced mounds with an apical finial and bounded by a stone kerb interrupted by an altar monument of Type 3a.[16] In southern Gaul an early Masonry tumulus occurs at St. Paul-Trois-Chateaux, Augusta Tricastinorum, in the lower Rhone Valley, a fragmentary curving wall within a road-side cremation cemetery retaining a barrow mound.[17] A drum-shaped structure at Larcay in the Cher valley, east of Tours, was probably a reinforced barrow of Type 2 set above the river, the monument later incorporated into the gateway of a Late Roman *castellum*.[18]

The long tradition of such monuments in Britain extended into the 1st c. AD with monuments such as the Lexden Tumulus at Colchester which overlay a richly furnished burial accompanied by a medallion of Augustus, a diplomatic gift to a significant leader of the Trinovantes.[19] Of a later date, 'The Six Hills' at Stevenage adjoin a road while two parallel rows of 5 and 4 mounds at the Bartlow Hills, Cambridgeshire may adjoin a rural estate.[20] A more elaborate structure at West Mersea, dateable to the early 2nd c., had a mound, 20 m in diameter, reinforced with radiating walls and external buttresses and a central circular chamber. On higher ground near the centre of Mersea Island another earthen barrow approximately 33 m in diameter and 6.8 m high overlay a masonry core within which was a glass cremation urn within a lead box.[21]

In Kent, the Keston villa was overlooked by a smaller family cemetery which included a buttressed and masonry-revetted barrow and a rectangular tomb, dated to the 2nd or 3rd c.[22] The barrow was approximately 9 m in diameter, the rectangular tomb 4 × 3 m with an attached foundation on the downhill side, its chamber originally containing a single stone coffin with ansate panel.

Type 3. Masonry Monuments

Within this category are structures containing the dead or overlying interments, the interior sometimes accessible. The superstructure may have incorporated inscriptional slabs and architectural decoration, often

13 Kremer (2016) 82–85, fig. 6. For the Mausolée de Bertrange, see Martin-Kilcher (1993) 164. At Newel and other villa sites, the latest burials of status are contained in stone coffins without obvious monuments.
14 Dunning and Jessup (1936) and Jessup (1959) remain useful for the British evidence, Becker (1993) and Wigg (1993) survey, respectively, the wider European evidence and that for north-east Gaul.
15 Massart (2016) 95–97, figs. 1 and 2.
16 Castorio and Maligorne (2016) 15, fig. 2.
17 Bel and Tranoy (1993) 104–107, figs. 10–11.
18 Bromwich (2014) 226–27 only references the *castellum*; for the monument, see Wood (1989).
19 Laver (1927); Foster (1986); Henig and Nash Briggs (2020) 13.
20 For the original investigation of the Bartlow Hills, see Gage (1834); (1836). The wide range of grave goods from the largest mounds were destroyed in a fire at Audley End.
21 Benton (1924); Howlett (2013). The glass urn produced evidence for the use of aromatics applied to the cremated bones: Brettall (2016) 264–79.
22 Philp *et al.* (1999) 192–230.

reconstructed from the excavated ground plans of the monuments and structural elements re-used in Late Roman defences or post-Roman buildings.

Type 3a. Altar Monuments

Monuments in the form of a classical altar, although sometimes on a larger scale could carry an inscription to the deceased in place of the dedication to the deity, the cremated remains placed below or within the monument. Monuments of this type have already been cited as features set in the retaining walls of barrows, but others were free standing monuments, sometimes within Type 3f enclosures. Finely decorated altar tombs are exemplified by fragments from two from Neumagen, one with memorial inscription.[23]

Lyon has produced a finely-decorated ash cist in the form of an altar, dedicated to Aufidia Antiochis, figured on the lid.[24] The eastern cemetery of Roman London has produced a more substantial but austere example dedicated to the known procurator of Britain, Gaius Julius Alpinus Classicianus, who died in the mid-60s AD. Reconstructed from fragments reused in a Late Roman bastion at Tower Hill, the large inscription was suited to a monument set up to be visible from the nearby Colchester road or the Thames.[25]

Type 3b. Temple Tombs

This category includes both structures in the form of small classical temples with a burial chamber in the foundations and mausolea of a double-square plan similar to Romano-Celtic temples. While the former derived from temples of the Mediterranean world, the latter originated from Late Iron Age timber monuments, the burials contained above ground level or interred beneath.

The legionary base at Cologne has produced an early example of the classical temple-tomb, raised to Lucius Poblicius of the Fifth Legion Alaudae in the 1st c. AD.[26] It was set on rising ground south of the fortress, overlooking the Rhine and has been reconstructed as set on a high square base decorated with garlands in low relief between pilasters. The second storey was columnated and held statuary in the round, the roof decorated with a central finial and figures at the corners.[27] The high ground of Choulans west of the Rhone at Lyon has produced groups of 5 and 4 monuments on the rue de Trion, facing downhill onto the road to Aquitania. The most substantial, to the *sevir* C. Calvius Turpio, was a square structure with Ionic corner pilasters, the decorated cornice suggesting a temple-like superstructure. On the road crossing the Presqu'ile between the Saone and Rhone, fragments of superstructure and a decorated coffin derived from the tomb of the Acceptii, a curial family of the 3rd c. This has been reconstructed as a classical prostyle temple on a podium which presumably carried the inscription, the burials housed in the base.[28]

Of similar date, the building at Lanuéjoles (Lozère) was set on a low podium with a *pronaos* of 4 columns with two *in antis* (now lost) and steps up from the adjacent road. The exterior was decorated with pilasters supporting an architrave of classical form, the *cella* furnished with three rectangular niches, 2.2 m wide internally, perhaps large enough to have originally housed coffins.[29] Close to the Rhine frontier the recently reconstructed 'Grutenhäuschen' near Igel is a rural example facing south on a steep hillside above the Moselle. The ground plan, 5.7 × 9.1 m, contained within the podium a chamber reinforced with external pilasters and with arched entrance downslope, a niche in the back wall presumably for burials. The upper storey is reconstructed as a small temple building with columnated frontage, the '*cella*', accessible from the hillside as a room for funerary ceremonies. The building is assigned to the late 3rd or 4th c. so belongs to the period of major change outlined below.[30]

The Romano-Celtic temple mausoleum is possibly exemplified as early as the Augustan period at En Chaplix in Switzerland where two double-square structures within enclosures were situated at an angle to a roadway, as if preceding it. A later example lay adjacent to a group of small circular monuments set in an enclosure close to the villa at Newel.[31]

In Britain, this type is represented by the tomb at Bancroft, Buckinghamshire, set on rising ground near a villa, the Celtic temple plan enclosing a semi-subterranean chamber with supports for a pair of

23 Schindler (1980) 104–105, figs. 329–31; Krier (2020) fig. 9.
24 Le Mer and Chomer (2007) 635–36, fig. 622.
25 Grasby and Tomlin (2002).
26 Schutz (1985) 97–99, fig. 104.
27 Cüppers (1990) 170, 462–63, Abb. 41. The structure is reconstructed as having a base 14.6 × 14.6 m, the superstructure 10.6 m in diameter and 10.3 m high.
28 Le Mer and Chomer (2007) 603–607, figs. 580–82 and 426–27, figs. 357–58.
29 An inscription dedicates it to Lucius Pomponius Bassulus and Lucius Pomponius Balbinus (CIL 13.1567). Architectural fragments suggest other monuments existed within a burial ground continuing into Early Christian times.
30 Faust (2001). A similar monument in the Trèves-Westfriedhof held two inhumations in the vaulted base, the upper building reconstructed with peripteral colonnade approached by steps: Cüppers (1993) 87, fig. 1.
31 En Chaplix: Castella (2016) 107–109, with figs. 7–8 illustrating the cemetery at the Newel villa.

coffins.³² The shallow basement recalls the Folly Lane structure at St. Albans, but was more substantial and furnished with a porch giving access to the interior. The temple mausoleum at Lullingstone is described below as a Late Roman monument later incorporated in a Saxon church.

Type 3c. Tower Tombs

These were massive masonry buildings overlying or containing burial chambers, rare surviving examples showing that these could be carried up as towers of some height. In the most elaborate examples, the base supported two or three tiers, these circular, polygonal or square with an elaborate cupola supported on columns. This superstructure could house memorial statuary or the cremated remains within a decorated vessel, unless these were incorporated in the base.³³ Others, designed to be viewed from a roadside have a second stage aedicule with a false doorway or bas-reliefs of a family group within an architectural framework. The roof might be conical or pedimented, the former gracefully tapered and imbricated, terminating in a pine cone and with corner finials, the latter with classical pediment and stylized tiles above a columnated *pronaos*. On a smaller scale are the pillared monuments, hardly mausolea, constructed from blocks decorated in the round, the base carrying an inscription, the block above with funerary bas-reliefs beneath a pedimented roof. Small-scale representations of the 'mausolées à acrotères' were also carved from single stone blocks.³⁴

Although much-degraded, the monument to the elder Drusus who died at Mainz on the Rhine frontier in 9 BC may be an early and exceptional example, more a cenotaph since his remains were carried to Rome for burial.³⁵ As a two-stage masonry monument, possibly 30 m high, it consisted of a square base with cylindrical upper storey with a low conical capping and was similar to imperial barrow monuments only taller. A famous example of the more lavishly decorated monument is that to the Julii at St. Rémy-de-Provence (Glanum), the three stages on a stepped foundation. The base is decorated with pictorial reliefs including weaponry and battle scenes with Amazons. Above this a *quadrifrons* with attached Corinthian columns supports an open circular canopy sheltering statuary topped by a conical roof.³⁶ A monument at Beaucaire (L'Ile-du-Comte) was of two stages with a square podium and an upper storey with a *pronaos* containing statues portraying the family set in front of a false door to the *cella*. The conical roof was decorated with scale ornament and floral corner finials, the central terminal carrying an urn.³⁷ Villas could incorporate monuments of various forms within their grounds and at Bierbach, in the Sarre region, a columnated aedicule has been reconstructed as protecting a statue set on a base within a garden facing the villa's main entrance.³⁸

A wide range of tower monuments are known from north-east Gaul and the German frontier, including that from Bartringen which consisted of a square base supporting a columnated aedicule surmounted by a cylindrical third stage. The base bears scenes of warfare with portrait statuary set in the aedicule, the top stage possibly containing a cremation urn and sculptures of maenads or Amazons.³⁹ Fragments of a structure from Arlon suggest an upper storey in the form of an alcove fronted by free-standing pillars, the back decorated with engaged fluted columns and figures of Amazons in bas-relief.⁴⁰ Later monuments from the area illustrate daily life and the business activities of the deceased families, the Igel monument a riverside structure bearing scenes from the life of a wool-trading family, fragments from Neumagen depicting river craft loaded with barrels and amphorae, commemorating families involved in the wine trade.⁴¹

Massively-built tower tombs form a distinct variation on the Type 3c. They are concentrated in south-west

32 Frere (1983).
33 Clauss-Balty (2016) figs. 272–75; Kremer *et al.* (2020) figs. 2 and 6 illustrate relative scale and complexity of the monuments in comparison with St. Remy-en-Provence. The relative footprints of the masonry structures is illustrated by Achard-Corompt *et al.* (2016) 56, fig. 9, the problem of reconstructing the superstructure by fig. 10.
34 A monument from a single block is illustrated in a catalogue of the Musée de Picardie, Amiens (2006) 194–95, cat 271.
35 Cüppers (1990) 55, Abb. 41; 462–63, Abb. 378.
36 Termed a base-and-'canopy' monument by Toynbee (1971) 126, pl. 31. The range of 'Mausolées à acrotères' is illustrated by those from Sens/Agedincum: Ribolet (2020) fig. 5. Of Italian origin, the type is also found in the Balkans and North Africa: Clauss-Balty and Soukiassian (2016) figs. 238, 245a–c; Clauss-Balty (2016) figs. 272–93.
37 Roth-Congès (1993) 393, fig. 3.
38 Martin-Kilcher (1993) Fig. 6 illustrates the relationship of some villas to funerary monuments. For the plan of Biberist, see Castella (2016) fig. 9. A reconstruction of the Bierbach monument is shown in Castorio and Maligorne (2016) 25, fig. 9.
39 Kremer *et al.* (2020) 30–34, figs. 2–6.
40 Ruppert and Binsfeld (2020). The significance of the Amazon figures, as found on other monuments, is discussed on 112–14.
41 Fragments exist from three ships under oars, loaded with barrels, as well as blocks showing stacked globular amphorae with basket-work protection. One reconstruction has the latter adjoining a ship set atop a base decorated with genre scenes: Schindler (1980) 43, fig. 125; 107, fig. 342. The suggested reconstructions have been examined in detail by Schwinden (2019) and Mahler (2019), but the form of the monuments still uncertain. The depiction of barrels recalls the inscribed stone half-barrels used as grave markers at Lyon.

France and consisted of a base supporting an aedicule for statuary set high up below a conical or pedimented roof.[42] The exterior may have received architectural decoration, the base an inscription, the burial contained within or set in a basement. An example at Pirelongue, Saint-Romain (Charante-Inférieure) was 6 × 6 m in plan and at least 24 m high; another at Saziré à Prahecq (Deux-Sèvres), survived as a burial chamber approached by a short corridor linked to foundations for a concentric boundary wall, while at Bethèze à Mirande (Gers) the monument was set at the rear of a more spacious enclosure.[43] A well-preserved example on the north bank of the Loire at Cinq-Mars La Pile, west of Tours, adjoined a road, but was undoubtedly also visible to river traffic. This monument has a base 6 × 6 m, with its three stages rising to 29 m, the upper part decorated with patterned brickwork of a style seen in the patterned *petit appareil* of north-east Gaul.[44] The tower is capped by three surviving corner finials around a conical capping. Excavation in 2005 identified a sunken chamber, possibly for burial, and an enclosing wall on the higher ground behind.

In Britain, such structures may have been identified from their foundations, but little is known of their superstructures. At Shadwell, in London's eastern cemetery, a square buttressed structure set on rising ground overlooking the Thames may have been the foundation of a tower within a roadside cremation cemetery of the late 1st to 2nd c.[45] No features survived within the interior, but the plan and location recalled the Cinq-Mars La Pile monument. The solidly built foundations defined an area of 5 × 5 m, traces of buttresses on the river-facing corners perhaps part of a decorated façade. South of the river, a group of monuments on the approach to London Bridge faced onto Watling Street, the main road to Dover.[46] Two Type 3f enclosures contained square foundations, one fronted by a small base, perhaps for statuary or an altar. These flanked a building with lateral buttresses suggesting a structure carried to height, while another smaller building had a façade decorated with pilasters and was fronted by a rectangular foundation towards the road. Primary burials did not survive, but cremations and inhumations of the 2nd or 3rd c. had been interred within the enclosures.

A similar roadside cemetery at Colchester contained a hexagonal foundation within an enclosure 9 × 9 m, facing onto the London Road at a junction with another leading to the *colonia*.[47] A pyre site had preceded the monument, a cremation burial occupying the centre of the monument, 6 cremations set within the enclosure. At the cantonal capital of Wroxeter, a multi-generational inscription (RIB 295) divided into three panels on a convex face, may have derived from a cylindrical monument erected over cremations. The inscriptional panel with space for additional dedications implies a monument accessible for further interments.

Near St. Albans, Hertfordshire, heavily robbed structures of this general type can be recognized at Wood Lane End, Hemel Hempstead, Harpenden and Welwyn.[48] At the first site two masonry structures had lain off-centre within an enclosure approximately 90 × 90 m with service buildings set on the perimeter. The larger monument was 12 × 12 m, its substantial buttressed footings suggesting a tower-like structure, set over a tile-built vault, the whole within a concentric 17 m wide walled enclosure. A smaller buttressed structure set axially in front contained a small oval footing, perhaps for a monument above eye level. At the second site fragments of life-size sculpture associated with a massive circular foundation within a walled enclosure were possibly for a tower with an eastern façade and internal foundation. The third monument at Welwyn adjoined a river crossing and settlement and lay opposite the site of prestigious pre-conquest burials accompanied by Mediterranean silver ware. Associated with the heavily robbed structure were remains of a decorated marble coffin of the early 3rd c., a rare find in Britain.

Monuments on this scale are paralleled in Kent, where a structure at Southfleet was set within a buttressed enclosure of 14 × 14 m, itself within an enclosure 100 m wide. The monument, 10 × 10 m, contained within its solid foundation a rich inhumation of the 2nd c., a rectangular structure, 2 × 1.3 m, set to its east conceivably, from its size, the base of an equestrian statue.[49] On the margin of the northern military zone, at Little Chester, Derby, 5 monuments adjoined the road to London, while a walled cemetery of Type 3f contained a

42 Sillières and Soukiassian (1993); Clauss-Balty and Soukiassian (2016).
43 Grenier (1934) 215–20; Clauss-Balty and Soukiassian (2016); Vidal (2016).
44 Bromwich (2014) 201–203. A statue of a bearded man in a Phrygian cap has been identified with the cult of Jupiter-Sabazios, but was this a portrait fallen from the monument?
45 Lakin *et al.* (2002) 10–11. Bird (2008) sees the structure as a signal tower adjacent to a 3rd c. harbour settlement, but this may be the re-use of an existing burial monument.
46 Mackinder (2000).
47 Hull (1958) 6 and 296; Booth (2008).
48 Neal (1983); (1984); Roman Britain in 1937, 1, Sites explored, *JRS* 28 (1938) 186; Rook *et al.* (1984).
49 Rashleigh (1808); Davies (2001). Watling Street lay 200 m to the north and a settlement accompanied by high-status Iron Age burials was to the east, Allen (2007); Booth *et al.* (2011) 257, fig. 5.8; 267–69.

dense cluster of cremations and inhumations respecting a central zone, 3 × 3 m, occupied by three cremations, probably the site of a now lost monument.[50] The grave goods indicated burials of military personnel and of other family members, civilian traders or artisans of the adjacent kilnfield. Settlements in the northern military zone have produced monuments such as Shorden Brae, west of the major base of Corbridge behind Hadrian's Wall, where a single burial was marked by a 10 × 10 m foundation within an enclosure 45 m wide. Constructed soon after Hadrian's Wall itself, but demolished in the 4th c., the footings suggest a monument as large as any in Britain, overlooking the crossing of the Tyne and on the sightline of the approach road from the south.[51] The external enclosure wall had been of ashlar and decorated with corner finials, a surviving example of a lion attacking a stag recalling a lion sculpture from nearby.

Type 3d. Hypogea or Underground Burial Chambers

In the Mediterranean such below-ground burial chambers are ubiquitous, carved from the living rock with an external building façade giving access to chambers for further burial, but in the study area few such structures are known. A burial chamber at Neuvy-Pailloux (Indre) represents a monument of this type set into a low hill, without evidence for above ground monument.[52] An underground timber-reinforced chamber 4.9 × 4.9 × 3 m deep was accessed by a ramped entrance, the rubble and plaster walls of the chamber decorated with panel paintings of animals, birds and small cultic structures within classical landscapes. The chamber contained an array of amphorae and metal vessels, kitchen equipment, tools, a lantern, hunting spears and a wheeled vehicle. Animal remains included boar carcasses but may have included traction animals. While the metal vessels were of Mediterranean origin and dateable to the 1st c. AD, the form of the tomb and the range of grave goods followed a Celtic tradition.

Of simpler form is the later 'Heidenkeller' at Nehren below Trier, this overlooking the site of a villa close to a bend in the river.[53] Here two burial chambers on a south-facing slope were each of two rooms, the main one 4.2 × 4.2 m internally, the outer approximately 4.2 × 3.5 m with a doorway on the downhill side. The more westerly had a wide inter-connecting doorway, the vaulted roof and walls decorated with wall paintings, in the other the dividing wall was furnished with a small semi-circular apse, the chamber containing a single coffin. In both cases, angled vents in the walls of the lower chamber may have been for illumination. A similar feature is recorded in a subterranean chamber from Saint-Martin de Rheims, its description given below on account of its decoration suggesting an Early Christian context of Late Roman date.

In Britain at Folly Lane, St. Albans, Hertfordshire, a richly furnished cremation burial of the mid-1st c. AD, set within a rectangular enclosure overlooking the city of Verulamium, appears to combine features of Types 2, 3b and 3d. A primary subterranean timber chamber may have been carried above ground as a double-square building, this replaced by a turf mound following its destruction and the insertion of cremated grave goods and human remains. A yet later Romano-Celtic temple adjoined, but did not contain any burial.[54] Of later date are vaulted masonry chambers in cemeteries west and south of the legionary base and *colonia* at York.[55] That from the Mount on the road south to London consisted of a barrel-vaulted chamber 3.4 × 2.4 m externally, set at right angles to the road and containing an inhumation in a stone coffin interred prior to the construction of the chamber.[56] A similar road side structure has been recorded in Bishopsgate, north of London.[57]

Type 3e. Surface Buildings

Within this category are included rectangular buildings with solid walls and a single access, the burials inhumed below floor level, in coffins set on the floor or in *loculi* within the walls. The interior wall surfaces and ceiling might be decorated with paintings or stucco work. Alternatively, the structure was open-sided, the roof supported by pillars, in the form of a *baldachino*. Such buildings are difficult to identify in the earlier Roman period north of the Alps, their ground plans easily erased or robbed, their remains easily conflated with those of surface structures described above.

Simple rectangular structures recorded on lower-status rural settlements in the area of Jülich and Niederzier, between Aachen and Cologne, have been recognized as mortuary buildings, one, 5.5 × 4.5 m, containing 4 adult cremations and two infant burials of the 1st c. AD. Another of the middle Roman period was

50 Dool (1985); Dool and Wheeler (1985).
51 Gillam and Daniels (1961).
52 Ferdière and Villard (1993) 156–203.
53 Cüppers (1990) 489–91, Abb. 405–406.
54 Niblett (1999). The grave goods had here been cremated and included items of silver and other metals, the only recognisable item a chain-mail corselet. As a below ground chamber, it would be comparable to structures in north-east France: Lambot (1994) 136; Castorio and Maligorne (2016) fig. 4; Foster (1986) 188–91.
55 RCHM(E) (1962) 95, fig. 72, IV Region (l), i.
56 RCHM(E) (1962) 79.
57 Hall (1996) 66 'an arched vault'.

slightly smaller and contained three burials.[58] Those dateable to later Roman or late antique date are covered below.

Type 3f. Funerary Enclosures or Apsidal Structures

These have figured already as defining the area of discrete monuments, surface dug graves and formal gardens, the site accessed by a formal entrance from an adjacent road. Included within this are the small walled areas containing individual graves, a monument set within or at the entrance. Where simply a walled enclosure to an open area, it is debatable whether this should be classed as a mausoleum.[59]

Early examples are perhaps the two 1st or 2nd c. enclosures at St. Paul-Trois-Chateaux, Augusta Tricastinorum, in the lower Rhone Valley, which contained cremation burials and *busta*, the roadside frontage carrying honorific inscriptions.[60] Perhaps related are the 'alcove' monuments at En Chaplix, Avenches, Switzerland, where two were set within enclosures facing onto a road. The superstructure has been reconstructed as being of 4 stages, the curved façade of the base supporting a decorated architrave of two levels above which was a decorated pediment fronting the base of a canopy holding statuary, the conical roof topped by a pinecone, in one case, and a statue in the other.[61] Numerous cremations and inhumations adjoined the northern enclosure, the complex dependent on a nearby villa.

Other rural monuments within central Gaul include three with attached enclosures set back from a road on the boundary of a villa estate at Nod-sur – Seine, Châtillonais. The largest centrally placed structure, Edifice 1, was an enclosure approximately 9 × 9 m internally with a rectangular alcove in the rear wall, this 3 m wide internally, wide enough to have taken a free-standing monument. A group of 6 cremation pits lay offset on the approach to the enclosure. Edifice 2 was similar in size with a 1 m recess in the back wall, the interior devoid of features other than a single pit set in front towards the road. The smallest, Edifice 3, was a solid structure with a rear projection and a cremation pit in front. Numerous fragments of inscriptions and at least 4 over-life-size statues, one perhaps on horseback, demonstrate an elaborate superstructure.[62]

Small yards surrounded by low walls capped with moulded stones contained monuments or, as at Strasbourg-Koenigshoffen, were set behind inscribed tombstones.[63] Elsewhere, such enclosures have been reconstructed as incorporating reliefs on the interior back walls, these including scenes, as at Til-Chatel and Dijon, which recreate shop fronts. In these the owners are shown serving customers, genre scenes giving a rare insight into the livelihood of the deceased and recalling Dutch paintings of a millennium later.[64]

Late Antique Monuments

To draw a division between the foregoing and Late Antiquity is somewhat arbitrary and subjective. As already stated, a major change in the form of monuments has been noted, at least in north-east Gaul, in the later 3rd c. Thereafter, few ostensibly secular or pagan burial monuments can be recognised within the study area, with funerary structures increasingly a component of cemeteries associated with the Christian church. Numerous churches contained burials of church figures, *memoriae* held relics of saints and martyrs, the most revered of whom, as well as members of the imperial family, were honoured by major *basilicae*.[65] Other than the latter, the structures follow the general form of the Type 3d and 3e structures, these then incorporated into the fabric of later churches.[66] Early in their development some of the latter have apsidal extensions or annexes and accessible underground chambers. The apse might be set at the eastern end or be set midway along the longer side.

Although not directly associated with a recorded figure or early church building, a barrel-vaulted funerary chamber discovered in the 18th c. on the site of the bell-tower of Saint-Martin de Rheims in north-west France is exceptional for its Christian iconography. This was approximately 5 × 2.5 m with stepped access at one

58 Gaitzsch (1993) 25, fig. 8, Sites HA 303 and 415.
59 Examples of enclosures for rural monuments are given in Achard-Corompt *et al.* (2016) fig. 2.
60 Bel and Tranoy (1993) 104–107, figs. 10–11. Open burial enclosures could enclose burial markers or altars of Type 1 or 2.
61 Flutsch (1993); Castella (2016) figs. 3–4. The façade was founded on a massive curving foundation, the upper tower supported on a base projecting from the back wall, the whole one of the most 'Baroque' monuments north of the Alps.

62 Renard (1993); Gaulandi (2016) fig. 2. Pottery and glass of 2nd or 3rd c. date may have derived from funeral feasts, the complex likened to that described in the *Testament du Lingon*.
63 Blin and Flotté (2020) 168, fig. 6.
64 For the shop-front monuments, see Langner (2020) 25, fig. 6. The criss-cross framework on the Dijon slab may be the protective screen on a banker's counter.
65 Johnson (2009), updating Ward-Perkins (1966) at least for the imperial mausolea.
66 See Colardelle (2008) fig. IV.57 and Bonnet (1977) Plates XI and XVIII for examples of *martyria*, *memoria* and *mausolea*, some of which are included here.

end and with a deeper cavity at the opposite end. The latter was of a size suitable for 3 or 4 inhumations laid side by side. The recorded decoration appears to show painted scenes from the New Testament on one long side, including the curing of the paralytic, and possibly Abraham preparing to sacrifice Isaac from the Old Testament. The opposite wall may have depicted Christ flanked by two apostles and two peacocks atop urns. The vault was decorated with a geometric pattern. It should be noted that a roof-light above the first wall might have allowed daylight to fall onto the latter, illuminating the Christ-figure. Niches would also have allowed illumination by lamp.[67] The existence at Rheims of such a chamber with New Testament decoration would be consistent with the existence of a Christian community here from the mid-3rd c., perhaps led by St. Sixtus, the monument later subsumed into St. Martin's church.

Records of the Christian community at Lyon imply that a dedicated cemetery may have existed at the time of the infamous persecution of 177 occasioned by the community's status as perhaps the only provincial Christian church in the west with links to Asia Minor at this early date. The disposal of the martyrs' bodies in the Rhone indicates the pagan fear of a grave-site cult. St. Irenaeus, the second bishop of Lyon, suffered soon after, but his body was retrieved and, with the Peace of the Church, a focus of burial and veneration existed south of the city, close to the important road to Clermont-Ferrand. Of the three known churches, Saint-Irénée and Saint-Just lay on the hillside and Saint-Laurent closer to the river. Excavated burial areas comprise Cemeteries I and II, located between the first two, while a further scatter of mausolea and burials was encountered on the line of the rue des Macchabécs close to Saint-Irénée.[68] The basilica of Saint-Irénée, possibly originally dedicated to St. John the Baptist, honoured the bishop's memory, his remains interred within the existing church.[69] Three rectangular structures set side by side and facing on to a roadway north of the basilica have been claimed as mausolea associated with the numerous oriented stone coffin burials in the area. The northern-most and most substantial was 6.3 × at least 4 m internally, the foundations 1.5 m wide with provision for corner pilasters, the southern building 3.8 m² facing onto the road. The narrow space between was occupied by a chamber 2.5 × 1.8 m with internal recess towards the road, possibly for an entrance. Bases on the opposite side of the road suggest smaller monuments of a pagan form.[70]

The Basilica of Saint-Just, Macchabees, nearer the city, honoured Iustus the 4th c. bishop of Lyon who, ending his life as a hermit in Egypt, was brought back for burial in the basilica built by Bishop Patiens in his honour.[71] The first phase of the basilica was adjoined on the north-east by a separate structure which consisted of an almost square chamber approximately 5 m wide with a broad apse on the east set into the hillside, this enclosed on the south and west by foundations of a forebuilding or *porticus* (Fig. 1.1). Devoid of burials, this had perhaps served as a *martyrium*. Of the two burial areas, Cemetery I contained a range of oriented coffined and un-coffined burials dated to the 4th and 5th c. and remains of two rectangular chambers, one 4 × 5 m, containing two inhumations, another 3 × 4 m containing a single burial. Cemetery II beyond has revealed further oriented inhumations of the 4th and 5th c. and two overlapping structures. The larger was a rectangular structure 3 m wide internally and extending at least 1 m downhill, the lower end truncated by the smaller structure. The latter was 2.5 m wide and extended for at least 3 m, a single burial set in a stone-lined grave occupying the interior. Late Roman lead-lined coffins from the site of the 6th c. basilica of St. Laurent – de-Choulans may indicate another area of Early Christian burial downhill close to the river.[72]

The simple architecture of the earliest structures is shown elsewhere, as at La Madeleine outside the walls of Late Roman Geneva. A semi-subterranean square chamber 2.8 × 3.2 m internally with a wide south-eastern doorway was offset from the later church development, the structure re-using a derelict extra-mural building (Fig. 1.2). In the 6th c., this slight construction was rebuilt as a chapel incorporated in the south-eastern corner of a new church with a nave 10 × 10 m, an

67 Barbet (1993) 169–70. The scene of the paralytic carrying his bed over his shoulder is remarkably similar to that in the sacrament chapel A3 in the Catacomb of Calixtus, Rome.
68 Reynaud (1986) 39–76; Le Mer and Chomer (2007) 647–52.
69 Three lead-lined coffin burials found in the 15th c. have been claimed as those of three bishops including Irenaeus. The site has produced an important series of palaeo-Christian inscriptions.
70 Le Mer and Chomer (2007) 659–61. Bonnet (1977) 57–58, pl. XI, saw the southern-most structure as a *memoria*, but the ground plans and position suggest earlier road-side monuments, re-used and contemporary with the late burials associated and church.
71 Reynaud (1986) 59, fig. 23–24. Sidonius Apollinaris' description of the church's orientation appears to conflict with that of the excavated remains, *Ep.* 2.10.2–4. Another letter (3.12) describes a cemetery administered by the church, and the marking of an existing simple interment with an inscriptional slab, presumably similar to those recovered from the area: CIL 13.2353, 2354, 2365, 2367, 2374.
72 Reynaud (1986) 77–87 figs. 33–40; Le Mer and Chomer (2007) 506–512.

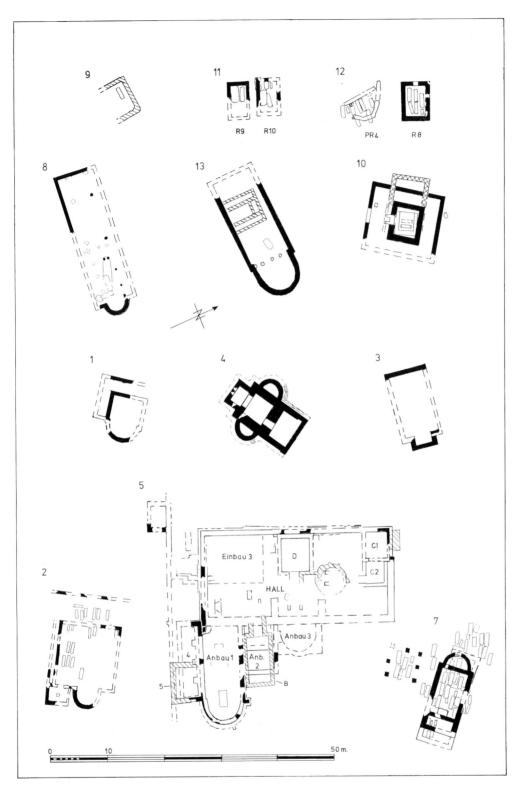

FIGURE 1

1. Martyrium at church of St. Just, Lyon (after Reynaud (1986) fig. 23); 2. Martyrium at church of La Madelaine, Geneva (after Bonnet (1977) pl. XVIII,1); 3. Plan of cemetery church of St. Pierre, Vienne (after Jannet-Vallet *et al.* (1986) fig. 38); 4. Plan of funerary chapel at St. Martial, Limoges (after Lhermite (2017) fig. 2); 5. Plan of funerary chapel complex and hall or basilica at St. Mathias, Trier. The hatched wall lines indicate later additions (after Siedow (2020) Plan 7a); 7. St. Maximin's, Trier. Plan of mausoleum and adjacent burial group surrounded by stone bases, presumably supports for a columnated structure overlying a group of stone coffins (after Cüppers (1984c) fig. 125); 8. Plan of basilical building at Colchester, identified as either a *mithraeum* or funerary church (after Crummy *et al.* (1993) fig. 3.24 and Walsh (2018) fig. 7); 9. Plan of mausoleum at Gloucester, the hatched outline indicating the robbed walls of the chamber (after Hurst *et al.* (1975) fig. 4); 10. Plan of temple/mausoleum adjacent to the villa at Lullingstone, Kent. Solid lines indicate the Roman period structure, cross-hatched outline indicates the medieval church re-using this structure (after Meates (1979) fig. 31, with addition of burials); 11. Plan of mausolea R9 and R10 in the late Roman cemetery at Poundbury Camp, Dorchester, Dorset; 12. Poundbury Camp cemetery. Plan of mausolea R8 and possible early post-Roman apsidal structure PR4, the latter identified by trenches for a timber structure; 13. Plan of funerary church at St. Paul in the Bail, Lincoln. The hatched outlined structure represents an earlier timber structure, the oval outline of the presumed grave-pit is shown near the cord of the later building's apse (after Gilmour (2007) figs. 3a–b).

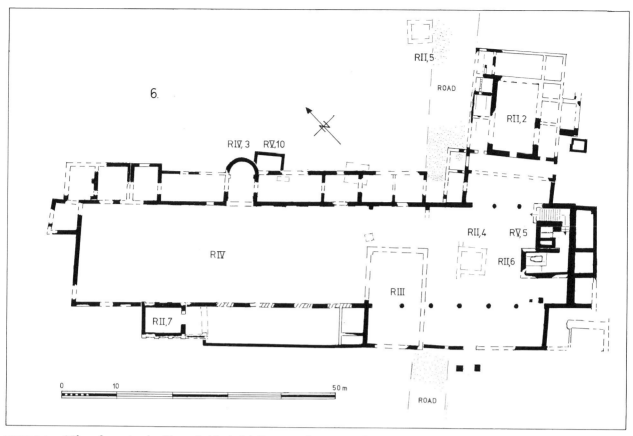

FIGURE 2 6 Plan of cemetery basilica at St. Maximin's, Trier in its later stages, dating to late fourth or early fifth century. With the complexity of the site plan, grave outlines are omitted (after Neyses (1999) bailage VIII).

eastern apse and a *porticus* or *narthex* on the west.[73] In the same region, at Grenoble across the L'Isere from the city of Gratianopolis, the church of Saint-Laurent went through a complex development during the 4th to 6th c.[74] In the 4th c. (phase 3), three structures, A, C and H, can be identified. Chamber A, east of the church, survived as footings around a tiled floor, 4 × 3 m in area, C, to the south was of similar size, but approached by steps from the east. H survived only as a footing from a heavily truncated structure at the eastern focus of the later church. In the early 5th c. (phase 4) a larger building B, with a total internal floor surface of approximately 10 × 12 m, was constructed to the west close to an adjacent road, from which its 4 rooms could be accessed at ground level. The principal eastern room overlay two rectangular graves of the early 5th c., its interior occupied by at least 12 later oriented cists and stone coffins. Of three chambers within the western interior, the central one gave onto the road and overlay a vaulted basement accessed by stairs. This presumed hypogeum was decorated with square and rectangular polychrome painted panels on the walls, the vault octagonal panels. In the late 5th c. (phase 5), two additional chambers, D and E, were added on the south. The major development (phase 6) took place in the 6th to 7th c., when a larger church was erected linked to building B on its eastern side, this of cross plan, each arm with elaborate tri-lobed apses. The eastern apse and the crypt of St. Oyand was on the site of structure H, presumably the remains of a primary mausoleum or *martyium*.[75]

Of the 12 funerary churches outside Late Roman Vienne, that of Saint-Pierre had origins in a much simpler rectangular building, its main room of 60 m², with a shallow rectangular eastern apse (Fig. 1.3).[76] This structure overlaid the levelled remains of a 4th c. house and was surrounded by oriented inhumations in stone cists, but did not itself contain burials. Its incorporation into the eastern apse of a much-expanded 5th c. church, however, demonstrates its significance. While similar in floor area and plan the church of Saint-Just

73 In the absence of associated burials this chamber is interpreted as a *memoria* or chapel with a central feature: Bonnet (1977) 57–58, pls. VII–XI. The latter illustrates comparable buildings, while Bonnet (1986) 44–47 summarises the structural sequence at St. Madeleine. The chapel of the second phase, in its scale and location flanking the eastern apse, resembles the early phase of St. Iustus.

74 Colardelle (2008) 102–135, figs. IV.6, 26, 45 and V.1.

75 Colardelle (2008) fig. V.30 provides a typology of burials in phase 6.

76 Jannet-Vallat, Lauxerois and Reynaud (1986) 48–57, fig. 38.

at St. Bertrand-de-Comminges was set on a north/south axis. Set within a Late Roman cemetery 1 km east of the city-centre of Lugdunum, it consisted of a two-cell structure, the main room, 5.5 × 8 m internally with a rectangular apse, 2.7 × 4 m, on the east.[77] Succeeding medieval structures on a different plan focused on a spot to its east. At Alba (Ardèche), the Basilica of St. Pierre, beyond the western limits of settlement, is adjoined by remains of two earlier structures.[78] Of the larger building only the south side and part of a rectangular eastern apse has been exposed, the interior densely packed with oriented inhumations of the 5th or 6th c. To the south, and separated by a paved path, was a separate rectangular building 11 × 15 m internally, its axis north/south, an apse 5.5 × 5.5 m, again set in the centre of the longer eastern side. Internal structures suggest not only a formal division of the eastern part of the interior, but footings dividing the remainder into a broad nave and aisles.

A funerary chapel or mausoleum at Limoges, incorporated into the foundations of the church of Saint-Martial, beyond the Late Roman settlement, may be similar in plan and scale (Fig. 1.4).[79] The original structure was rectangular, 5.5 × 9.5 m internally, aligned north-east to south-west, with apses on either side towards the west end, each 3 m across the chord. Between these a substantial 4 × 4 m sunken chamber was accessed by steps from the eastern interior. A rectangular barrel-vaulted extension on the west, 2 × 2.75 m and lit by three splayed windows, possibly replaced an original ground-level apse linked to the sunken chamber. Alteration as a church in Merovingian times by the addition of an eastern apse almost doubled the building's footprint. The interior later served as an ossuary, but inhumations in stone cists survive in the vicinity, suggesting its use as a mausoleum in its original state.

Structures within the countryside often occupy abandoned or reduced settlements, as at the villa of Séviac a Montréal (Gers) which was adjoined by a two-cell building comprising a rectangular basilical room with a rectangular apse at the eastern end. The adjacent partially-ruined bath wing was occupied by inhumation burials, one of the 7th c.[80]

Some important Early Christian centres such as Tours have produced less clear-cut structures. Prior to St. Martin, Bishop Gatianus, was described as holding services in 'crypts' and having been buried in the cemetery in the 'Christian quarter' in 301 AD[81] 36 years later, Bishop Litorius set up a church in a townhouse, this subsequently his burial place in 370, by which time the inhabited area had shrunk eastwards within the *castrum*. St. Martin, as the third bishop, translated St. Gatianus' remains to the basilica of St. Lidoire in the extra-mural area, his own burial site a nearby church erected by his successor St. Bricius. Although this burial place is inaccessible, an adjacent slightly-built timber structure has been suggested as a temporary wooden chapel to house his body prior to interment.[82] The building enclosed an area 6 × at least 6 m defined by traces of slight timber foundations, the roof supported by a central 4-post structure centred on a sunken area 4.2 × 3.8 m. Trampling around this central feature was interpreted as the result of the circulation of the faithful around the bier supporting St. Martin's translated coffin.

Major centres in southern Gaul have produced extensive structures, chiefly at Marseille at the church of St. Victor on the south side of the harbour. This complex site dedicated to the martyr Victor and mostly dated to the 5th c. has partially revealed the southern end of an apparently aisled cemetery church aligned north/south, with a corridor-like extension to the north and other structures to the east. The presumed nave was 17 m wide and at least 30 m long, the 500 m² of accessible floor housing stone coffined burials aligned both on and at right angles to its axis. Other coffins clustered round the building were mostly oriented, some set in rock-cut *loculi*.[83]

The imperial city of Arles is notable for the funerary complex of the Alyscamp and Trinquetaille, but also for a major funerary structure in a cemetery adjoining

77 Esmonde Cleary (2008) 136–38, fig. 5.4. A 4th c. cemetery at Aosta, adjacent to the road from the Little St. Bernard pass, contains an example of the same ground-plan and an apsidal-ended building of Early Christian character, Bonnet and Perinetti (1986) 50–53.

78 Fevrier and Leyge (1986) 88, site 163.

79 Lhermite (2013); (2017).

80 This site is similar to the latest phase of the Romano-British villa at Eccles in Kent, where the south-eastern bath suite was adjoined by an early Saxon cemetery, the oriented rectangular rooms perhaps adapted as a church: Bell (2005) 167. See Stoodley and Cosh (2021) for a summary account of the villa structure and the cemetery.

81 Greg. Tur., *HF* X.31.

82 Late Roman burials occur close to the site of the Basilica of St. Martin, now inaccessible: Galinié (2007) 94–98, figs. 11a–d. Could St. Gatianus have originally been buried in the same area? The church erected by St. Bricius for St. Martin is referenced in Gregory, the excavated structure interpreted as temporary, anticipating construction of a church by the succeeding Bishop Perpetuus in 470/471.

83 The excavations are summarized in D'Archimbaud (1971). The reliquary and inhumations containing clothing impregnated with aromatics and floral offerings are described by Boyer (1987), these similar to those described below from Early Christian contexts at Trier and Milan, Reifarth (2013); Rossignani *et al.* (2005).

the earlier circus.[84] Measuring 40 × 43 m overall, this unfinished complex would have housed a row of 5 rectangular buildings linked on the north-east to a larger square structure, probably accessed on the north-east side, towards the city. This block, 20 × 20 m externally, contained a circular room 17.6 m in diameter and presumably domed, with apses set within each corner. The 5 linked buildings on the south-west were in two pairs either side of a narrower structure of similar plan, 12 m long × 5 m wide. Each of the outer buildings comprised a hall approximately 8 × 10 m internally ending in alternate square or rounded apses on the south-west. Doorways were not identified, but each was presumably intended to be accessed by attached chambers 5 × 5 m at the opposite end. The unfinished nature of the structure has hindered interpretation as a funerary complex, but the location in a cemetery close to a circus recalls the situation of the imperial monuments at the Vatican, Rome. While the apsidal chambers are comparable in scale and plan to structures described above, the larger rotunda is possibly unique within the province, its ground plan comparable to the smaller imperial mausolea. Closest geographically is the circular room within the Centcelles building complex in Spain, this identified as a mausoleum for Constans, constructed in the mid-4th c., the rotunda only 11 m in diameter.[85]

Beyond the Gallic provinces, on the Rhine frontier and at the imperial capital at Trier, Late Roman cemeteries contain structures associated with the origins of Christianity in the region. At the legionary base at Bonn, one of the most important was on the south-west perimeter of the civilian settlement at the site of the church dedicated to Cassius and Florentius. These saints and a certain Malosius were buried here, reputedly by Helena, mother of Constantine, all three claimed as members of the 'Theban legion'.[86] A structure identified here in 1930 as a *cella memoriae* was surrounded by Late Roman burials, some in stone sarcophagi, all on a north-east to south-west alignment, at variance to the later, oriented medieval church. This unusual structure consisted of low benches defining a sunken floor within which were set two masonry bases, one with two vessels set in its upper surface. A dry-stone wall at the north-east end survived from a surrounding structure, any primary burial inaccessible. The structure recalls the smaller open yards of Type 3f, its location and the re-use of a pagan altar in the structure supporting identification as a Christian monument. A larger rectangular building with mortared floor and an interior area of 160 m², built by the newly-converted Frankish population, enclosed this primary structure before passing through at least three re-buildings over the following 4 centuries. Numerous burials were inserted both within the interior and in the surrounding area. The later structure had been roofed partly in lead and decorated with wall paintings; the building seen as the *basilicam sanctorum Casii et Florentii sociorum* serving Early Medieval Bonn.

An early memorial from Cologne, noted above, is representative of the pagan funerary landscape extending along roads south-west and west of that military base. Important Christian foci developed later, at least 5 early churches known within the suburban zone, the most important those of Saint-Ursula and Saint-Gereon to the north and north-west, with Saint-Severin to the south.[87] The church of Saint-Gereon, with its complex multi-apsidal plan dating from the mid- to late 4th c., appears to not only occupy an early cemetery, but also overlay an altar of Isis, claimed as in use until shortly before construction. Although one late 4th c. burial lay south of the entrance hall a funerary use is unproven, the altar is a remnant of a preceding temple. Saint-Ursula on the road north to Neuss is more directly associated with burial. Here, an inscription records the building of the basilica by the senator Clematius to the honour of women who had dedicated their lives to Christ, a link to the legend of the 11,000 martyred virgins. Excavation has revealed two phases of a Late Roman basilica with apsidal east end, oriented burials within its interior.

Saint-Severin occupied a major early cremation cemetery on the road south to Bonn. Here, a hexagonal monument beneath the west end of the church adjoined an early cremation cemetery set back from the road line, the intervening space occupied by oriented inhumations of the 3rd and 4th c. A rectangular funerary church, 10 × 8 m internally, with a western apse and eastern entrance towards the road, occupied this space, the foundations including re-used funerary sculptures. This building contained inhumations aligned with it, others on the exterior either following its axis or more strictly oriented. The disturbed interior of the apse overlay two earlier burials in wooden coffins. Later association of

84 Euzennat (1972); Heijmans (2007) 216. The former provides important parallels for the ground-plan, figs. 8–10.

85 Johnson (2009) 129–39. The Arles structure has been claimed as an abandoned project of Constantine III, the complex designed for himself and family when he was based in Arles. Although decoration of the Centcelles building was complete and a porphyry coffin has been found in the area, the connection with Constans is uncertain, and the villa remained unfinished.

86 Keller (2003). The location on the margins of the extra-mural zone suggests deliberate isolation.

87 La Baume (1958); Von Gerkan (1951).

the site with the martyrs Cornelius and Cyprianus conflict with references in the *Martyrium Hieronymianum* to Asclinius and Pamphilius, this building possibly a Constantinian *memoria*. A larger tripartite building with an apse on its longer western side succeeded this, its forehall or atrium containing a decorated burial chamber. This has been identified as that of St. Severin who died in 400. Square chambers to west, north and east may represent burial chambers, the smallest, immediately north of the atrium and with an eastern entrance, containing 4 oriented burials. A slab with Christian text of the 5th c., while out of context, perhaps illustrates the nature of burials. The aisled building was extended west in the Frankish period, more than doubling its floor area, prior to a re-alignment to focus on the presumed tomb of St. Severin.

Lower down the Rhine, Xanten is notable for the derivation of the place name from Latin *Ad Sanctos*, the Early Christian focus lying between the earlier fort and *colonia*.[88] As elsewhere, this was an early cemetery area, the succeeding Late Roman complex beneath the cathedral including at least 8 rectangular buildings, the most significant the focus of its development. Numerous Late Roman and Frankish oriented inhumations are known and at least one Early Christian grave inscription. The earliest structure was a rectangular timber structure 3 × 4.5 m, aligned north-west to south-east and divided into two, each compartment containing an adult male inhumation. These were dated to the 4th c., one individual decapitated, the head absent from the grave. A trampled area on the south-west suggests public gatherings and funerary meals at a *cella memoriae*, the decapitation suggesting the burial of a martyr. The first timber building was burnt in the early 5th c., its timber replacement marking the double burial within its eastern interior. A child grave beneath an offering table and family tomb 2.5 × 3.3 m internally lay to the east. In the 5th c., a rectangular masonry building, 8 × 5.5 m internally, was erected over the double burial. A northern chamber and rectangular eastern apse or chancel were then added in the 8th c., this subsumed within the subsequent cathedral development.

Of the 8 Early Christian foci at Trier, Saint-Matthias on the road south to Metz, and Saint-Maximin on the road to Mainz are the most researched, the development of each site linked to the burial sites of important figures in the early church.[89] Saint-Matthias may be the earlier and was originally dedicated to St. John the Evangelist, the name marking the introduction of relics of the apostle Matthew. The east end is presumably focused on the burials of the earliest bishops Eucharius and Valerius, the more accessible west end overlying three simple rectangular mausolea aligned at right angles to the Metz road, 80 m distant.[90] The best-preserved was 3.5 × 4.5 m with an eastern doorway, this marking the site of at least 4 pre-existing stone coffins of Roman date. In the Frankish period, two further burials defined by stone slabs were set within the interior immediately below the floor level, two more 'cist' graves lying close to the south side.[91] A further 5 burials were then inserted from a higher level cutting the footings, these in reused stone coffins interred in the Middle Ages. Under the south aisle another much damaged rectangular foundation, 1.5 × 2 m internally and lined with lead may have been a tomb set approximately 2 m below the Roman ground level.[92] Two stone coffins overlaid this, above which was a cist grave with an inscribed memorial to Victura.

Two groups of structures to the north-east and north-west comprise chapels dedicated to early bishops, the former dedicated to St. Quirinus and St. Quintinus, the latter to St. Maternus, the third recorded bishop.[93] Only the outline of this cruciform-plan church and its eastern apse is known, but it was adjoined on the south by a chamber 6 × 4 m with a smaller chamber to the west, burials lying both within and without these structures. Another larger apsidal structure lay nearer the main church, two square buildings at varying angles placed towards the road.

The north-east complex, although fragmented, can now be recognized as of 7 phases with an initial vaulted chamber C1 used as a water-source accessed from room C2 on its east (Fig. 1.5). Phase 2 saw these incorporated within the north-west corner of a large rectangular hall 31.5 × 13.5 m aligned north/south. Two further structures

88 Borger (1958). The structural sequence beneath the cathedral is here only outlined.
89 Wightman (1970) 227–36, map 8, the Early Christian cemeteries described on 247–49. For Saint-Matthias, Cüppers (1965); (1984) 203–212; for Saint-Maximin, Eiden (1958) 359–65 and Cüppers (1984) 232–37. Heinen (1996) provides a more recent survey. I am indebted to Nicole Reifarth for recent information.
90 Reusch (1965) plans A767–9. These structures were on an alignment of 290° at right angles to the nearby road, the chapels more truly oriented. For a recent general plan, see Siedow (2020). Plan 3a, without full reading of the data at the time of writing.
91 The coffin alignments and stratigraphy suggest burials III, IV, VII and VIII–XI were interred prior to the building of the mausoleum, VIII notable for its cover being a re-used pilaster with floral decoration. Coffins I and II were then inserted within it, II set north/south to respect the orientation of I. Coffins V and VI were aligned with the exterior face of the south wall. Later Frankish cist burials respected the building.
92 Reusch (1965) plan A770.
93 For St. Quirinus and Quintinus, see Siedow (2020). The building sequence is described on pages 414–58, plan 7a.

were inserted during Phase 3: one, Einbau 3, at ground level in the south-west corner of uncertain plan; the other, D, a vaulted chamber 5 × 5 m, set below ground level in the middle of the southern interior. Phase 4 saw 4 buildings added on the east at the south-eastern corner. The largest of these, Anbau 1, was the chapel dedicated to St. Quirinus and consisted of a hall 6 m wide × 10 m, the apsidal east end extending a further 6 m and overlying chamber Q, a vaulted crypt containing the presumably re-used decorated coffin of Albana. This building had been extended on the south successively by Anbau 4 and 5, while a two-roomed Anbau 2 was added on the north. Adjacent, and central to the northern side, Anbau 3 was an apse 6 m wide and 4.7 m deep, set, significantly, opposite the subterranean chamber D.[94] In Phase 6–7, Anbau 2 was truncated by the chapel of St. Quintinus, the vaulted chamber B with an entrance on the west. The recent study suggests the main hall did not house interred burials unlike the larger basilica at Saint-Maximin.

Saint-Maximin, north of the city, displays a similarly complex history culminating in a vast cemetery basilica (Fig. 2.6).[95] In phases R I and R II, the east end of the site was crossed by a road adjoined on the south-east by a richly decorated building RII, 2, its construction dated to the late 3rd c. This consisted of a hall 8 × 12 m internally surrounded by ranges of rooms with a colonnaded entrance towards the city. This building has been suggested as having housed the ashes of Constantius Chlorus who died in York in 306.[96] Another hall, building RIII, 9 × 17 m internally, but lacking side chambers, lay to the south on the opposite side of the street.[97] While this was replaced by the cemetery basilica, RIV, the first was retained and later linked to it with a formal entrance.

At least 4 small chambers or rectangular mausolea either side of the road are assigned to the same period. Structures RII, 4–6, and a burial vault, RII, 7, set back to the north-west, were similar to those already described, varying from 3 × 2.5 m to 4 × 6.5 m in floor area. Structure RII, 4, on the south-east roadside enclosed 4 inhumations, three oriented with one occupying the remaining space. In line and to the south-east, a vaulted structure, RII, 6, 3.5 × ca. 8 m, held a single burial and was flanked by a later mausoleum, RV, 5, containing three more. This burial group was the focus of the late 4th c. extended basilica and its successor church, this spot traditionally the burial place of St. Maximin, who died in 346.

In the mid-4th c., the RIII Hall was extended west of the road to form a basilica over 60 m long and 17 m wide with an apsidal extension on the middle of the north-east side. A series of rooms adjoined either side of the apse, while the existing burial vault II, 7 was incorporated into the opposite side. In the late 4th c., the building was extended in the opposite direction across the road, the basilica now approximately 88 m long, with colonnades to either side and incorporating burial group RII, 6 and RV, 5, already mentioned. Hall RII, 2, was linked with a formal entrance to become a north-east wing, a porch on the opposite side of the basilica giving access from the road to the south-west. In the early 5th c., a long room with a hypocaust at one end was added on the south-west side of the original structure. A truncated vaulted chamber, 0.8 × at least 1.8 m long on the north side of the nave had presumably housed a single inhumation, the painted decoration of the south and west walls including the image of a vase containing palm branches on the western wall, this stylistically dated to the same period. As the reconstruction paintings show, the floor of the hall was covered in inscribed markers over the individual burials, several of these the subject of recent study.[98] A yet later phase saw the insertion within the basilica of a pulpit and an apsidal south-east end.

South of the main church is a large cemetery of the early 4th c., within which was a burial chapel overlying an earlier mausoleum, set at right angles to the early road line (Fig. 1.7).[99] This building is a clear example of the progressive enlargement through 4 phases from a simple chamber 3.5 × 5 m internally containing two graves to the final apsidal-ended rectangular building with atrium towards the road, the main room 4.9 × 7.8 m and containing perhaps 12 graves of adults and children. Adjoining this on the south, 7 stone bases surrounding a further group of 6 stone coffins may have supported a

94 A plan of 1931, reproduced as Siedow (2020) fig. 3b, reconstructs Chamber D as lying within the western end of a rectangular building 7 × 15 m, the apsidal Anbau 3 its eastern end extending beyond the Phase 2 hall.
95 For a detailed phase plan, see Neyses (2003) beilage VIII. Heinen (1996) summarises the site, Abb. 24 showing the density of coffins within the interior. Burials from the site have been intensively studied, the quality of clothing suggesting those interred were members of senatorial families: Reifarth (2013) 133–48.
96 This possibility is discussed in Binsfeld (2003), but the building is dated to about 275 by Neyses (1999) beilage VIII.
97 The road alignment of 50° is similar to that of the Mainz road, rather than the city street grid to the south.
98 The scale of the Trier hall can be judged by comparison with St. Peter's and the cemetery basilicas in Rome: Weber-Dellacroce and Weber (2007) 249, fig. 4. A reconstruction painting of the interior of the cemetery basilica, listed in Cüppers (1984) 122, is reproduced in Reifarth (2013) fig. 3; other views are in Neyses (2003), which includes recent studies of the inscriptions.
99 Eiden (1958) 360, Abb. 12; Cüppers (1984) Site 125, 238–39.

timber building or a series of free-standing pillars supporting a *baldachino* or open-sided funerary building.

As the phased plans of the main church show, smaller family mausolea of the late 3rd c. preceded the funerary basilica, these approximately 10 to 30 m² in area, in contrast with the communal basilica of the early 4th c. The first of these, RIII, covered 160 m²; the larger basilica, RIV, of the mid-4th c. covered approximately 1,300 m². At its full extent in the early 5th c., the basilica covered nearly 2,000 m², sufficient to take 500 to 600 inhumations, if neatly oriented within the floor area. Saint-Maximin shows the increase in covered space provided for burial in the 4th and early 5th c., but how this compares with Saint-Matthias, or the 6 other Christian churches is unknown and it would be too simplistic to see the floor area as a measure of the size of the Christian community and its anticipated growth.

To conclude with the limited evidence from the Late to sub-Roman period in Britain is somewhat of an anti-climax, no comparable site having been recognized. At Colchester, the Butt Road building has been variously interpreted as a cemetery church, funerary banqueting hall or a *mithraeum* (Fig. 1.8).[100] This substantial, partially-aisled building with eastern apse, was 22 × 6.3 m internally, a floor area of 138 m². It was adjoined on at least two sides by an extensive, ordered, inhumation cemetery, the rectangular building containing only three inhumations within the aisled interior close to the cord of the apsidal east end.[101] Such a relationship with a cemetery militates against the mithraic interpretation; yet, equally, the building hardly served as a mausoleum and is best seen as a funerary church.

Type 3e rectangular structures can be identified at various sites as at Richborough in Kent where one adjoined the road from the 3rd c. fort, the monument then levelled for the construction of the western wall of the Saxon Shore fort. This consisted of an above-ground masonry chamber, approximately 4.6 m², set over a pit containing a single coffined inhumation.[102] The above ground structure was surrounded by rubble either from its demolition or as the foundation of a Type 2 barrow raised over it. Other examples containing inhumed burials have been identified at Arbury Road, Cambridge and at Icklingham, Suffolk, where a rectangular building 6 × 4 m internally adjoined an apsidal masonry tank, possibly of baptismal use, and the findspot of at least three lead tanks, one bearing Chi-Rho symbols.[103] No burials occurred within the building, but it adjoined an inhumation cemetery, suggesting use as a funerary church rather than as a mausoleum. In western Britain, north of the Gloucester *colonia*, a Type 3e mausoleum occurred within an Anglo-Saxon cemetery (Fig. 1.9).[104] This rectangular building, 5 × at least 3.5 m internally, had originally been furnished with a stone floor set below ground level, perhaps to receive coffined burials, but instead had had an oriented coffined inhumation cut into the mortar bedding. The male skeleton was accompanied by buckles and a knife, the former of Frankish type and dateable to the early 5th c., a rare instance in Britain of a late antique funerary structure and a burial with grave goods similar to those from Saint-Just at Lyon. Of the few mausolea incorporated into early churches, the most significant is perhaps that adjoining the river-side villa at Lullingstone, the dwelling incorporating a Christian chapel. Separate from this, a Type 3b structure of Romano-Celtic temple plan, decorated with figured wall-paintings, overlay two interments, one robbed at an unknown date, the surviving interment in the form of a lead-lined coffin with gypsum packing and possible traces of resin impregnated clothing (Fig. 1.10).[105] The mausoleum was incorporated in the medieval church of St. John the Baptist, as if some reverence was accorded the burials in the early post-Roman period although no tradition as a *martyrium* is recorded. Also in Kent, the medieval chapel at Stone-by-Faversham incorporated in its chancel a heavily buttressed building 3.5 × 4.5 m internally with a western doorway, the structure adjoined by inhumation burials. The plan and use of patterned masonry, as at Cinq-Mars La Pile, suggest this may have been a Type 3c tower.[106]

The largest group of Type 3e mausolea occurs in the Late Roman cemetery at Poundbury Camp, outside the Roman town of Durnovaria (Dorchester, Dorset) (Figs. 1.11–12).[107] At least 7 mausolea had been erected within the excavated area of cemetery 3 at regular intervals, the surrounding burial ground defined by pre-existing field boundaries and containing rows of

100 Crummy *et al.* (1993); Millett (1995); Walsh (2018) 349–51.
101 Although within a cemetery the presence of a pit containing chicken bones and cooking vessels might support identification as a Mithraeum, following Walsh (2018).
102 Bushe-Fox (1932) 25–29, Pl. III and XLV.
103 West and Plouviez (1976).
104 Hurst *et al.* (1975) 272–74, 290–94.
105 Meates (1979) 122–24, figs. 31–33; Meates (1987) 9. The burial pit was skewed to the central chamber foundations, suggesting the burials had preceded construction.
106 Fletcher and Meates (1969); Bell (2005) 240–41.
107 Green (1982); Sparey-Green (1993a); Farwell and Molleson (1993). The site lies in the extra-mural area between the Roman town and the earlier Poundbury Camp hillfort. Often referred to as 'Poundbury', it should not be confused with the nearby new town of that name where further burials have been excavated.

oriented inhumations, mostly in plain wooden coffins, occasionally lead-lined and plaster-packed and containing rare grave goods.[108] The densest grave rows surrounded a large group of lead-lined and stone coffins near the centre of the site. These had possibly been enclosed by a columnated structure or *ciborium*, the outline of which was recognisable from the burial pattern which suggested the one-time location of roof supports.[109] The rectangular masonry mausolea each outlined an area of approximately 5 × 3.5 m, the buildings aligned approximately east-west against the east-facing hillslope with a door at the west end. The walls were constructed of rubble masonry, the roofs of stone-tiles. In most cases the structures were secondary to at least some interments, others having been inserted within the structure and, in rare cases, had even post-dated their dereliction. The interments were in stone or wooden coffins, some lead-lined, most containing a body with mineral packing and occasional grave goods in the form of items of personal adornment.[110] The latest burials, perhaps of 5th c. date, were in cists of re-used stone-work or contained no evidence of a coffin. The number of burials within the mausolea varied from 2 to 13, the latter figure identified in R3, which may have been of extended plan. Two mausolea, R8 and R9, were notable for the painted decoration, the former with scenes of robed human figures ranged along at least one wall, the ceiling also decorated with portraits set in hexagonal panels surrounded by floral ornament.[111] Constructed in the late 4th or early 5th c., its western entrance had given access to the worn internal floor surface, suggesting continued use as a funerary church after interment was complete. The masonry mausolea are comparable to the smaller examples on the continent described above, and comparable to the earliest Saxon churches in the area, as at Stockwood in north Dorset.[112] The scale of burial and the cross-section of the population represented here indicates an urban origin, use of the site extending from the late 3rd into the early 5th c. Later in the development of the site during the 5th to 7th c., an apsidal building, PR4, was erected beside mausoleum R8, this of massive timber construction, its eastern side polygonal and 5 m wide.[113] Discussion of the site over recent decades has left its nature and any religious affiliation unresolved.[114]

The existence of a martyrium at St. Albans is referenced in the literary sources, the evidence masked by the later abbey, although Late Roman burials have been identified close to the abbey building.[115] These finds complement St. Germanus' reference to honouring the martyr in 429[116] and Bede's later record of a 'beautiful church worthy of his martyrdom, built when the 'Peace of Christian times was restored',[117] both suggesting a 4th c. origin. In the 6th c., Gildas referenced not only St. Alban, but Aaron and Julius at Caerleon, while noting others unknown and the existence elsewhere of martyrial burials and places of veneration, these sites inaccessible within areas of Saxon domination.[118] As noted above, there are rare instances where post-Roman churches incorporated existing Late Roman mausolea. At St. Augustine's Canterbury, the church of St. Martin's, certainly associated with Queen Bertha and pre-dating the Augustinian mission, lay on rising ground east of the later monastic complex and incorporated a small chancel containing a re-used coffin of early post-Roman type, but whether this building had originally been of funerary use or was merely a reused structure, such as a *castellum divisorum* for the water supply to the Roman

108 A graffito on a lead coffin lid from one mausoleum, read as INDNE, although dismissed by Tomlin (1993), is paralleled as an abbreviation of *in Nomine (tuo)Domine* in the Balkans.

109 This may have been a structure similar to that close to the burial chapel south of St. Maximin, Trier: Cüppers (1984c) site 125.

110 The white mineral is largely locally available gypsum, the few analyses suggesting use in its anhydrous form, see specialist reports in Green, Paterson and Biek (1981). The burial rite, as used at York and Trier, was brought to my attention in 1969 through the good offices of Raymond Farrar and Hermann Ramm of the *Royal Commission on Historical Monuments* (England). These 'special burials' are catalogued in Reifarth (2013) Anhänge, 458–62, I 1–37.

111 Davey and Ling (1982); Sparey-Green (1993b). The ceiling design also included floral elements, while representations of a naked figure from the east wall recalls scenes of Adam and Eve from similar funerary contexts. Depictions of buildings in semi-aerial perspective from the west wall may derive from a representation of the Holy City, a rare but appropriate decoration for a Christian mausoleum or chapel.

112 RCHM (1952) 224.

113 This may have stood in isolation or been the apsidal end of a building extending off site: Sparey-Green (1987) 77–79, fig. 56; Sparey-Green (1997) 129, fig. 3. The two phases of settlement may be the precursor of the monastic foundation at Charminster across the Frome valley: Sparey-Green (2004). Identification of an Early Christian community in the Dorchester area is supported by the iconography of local villa mosaics and artefacts from the town. Records of early ecclesiastics or church dedications are lacking, but a nearby *eccles-* place name and later ecclesiastical landholdings should be noted.

114 Philpott (1991) 418 described the burial rites without analysis of the monuments or cemetery development. Petts (2003) 156, while recognizing Butts Road, Colchester and Icklingham Suffolk as funerary churches, was unwilling to accept this site without more explicit documentary or archaeological evidence.

115 Biddle and Kjølbye-Biddle (2001).

116 Constantius of Lyon, *Vie de Saint Germain D'Auxerre*, III, 16, 3.

117 Bede. *Hist. Eccl.* 1, 7.

118 Gildas, *de exc. Brit.* 10.2: '*corporum sepulturae et passionum loca*'. Gildas, *de exc. Brit.* 24, 4 references the use of derelict buildings for burial, something attested archaeologically.

city, is uncertain. The aligned churches to the west date to the Augustinian mission and were used for burial in the 7th and 8th c.[119] Glastonbury in Somerset has a similarly early origin, its earliest phase a rectangular timber church, the '*vetusta ecclesia*' dedicated to St. Mary, and a '*hypogeum*' 4 × 2 m internally set to its east.[120] The developed alignment incorporated the latter in the chancel of the church of St. Peter and Paul. In the same county, St. Mary's Chapel at Wells Cathedral originated in a rectangular masonry and timber chamber 2.3 × 1.5 m, set 0.75 m below the existing ground surface, this originally containing burials and adjoined by a later cemetery. This was replaced by a similar rectangular burial chamber later incorporated into the chancel of the Anglo-Saxon chapel.[121] One of the more significant excavated sites lies within the upper *colonia* of the Roman city of Lincoln, not in one of the extra-mural cemeteries.[122] In the courtyard of the forum, a 5-phase building was traced, the sequence commencing in the late 4th or 5th c., with a rectangular building adjoined by two oriented inhumation burials (Fig. 1.13). This building was approximately 5 × 6 m with a central room flanked by narrow aisles and a small lateral chamber at its northern end. This was replaced by a timber building of rectangular plan, 14 × 7 m internally with the pit for a cist-burial close to the cord of its eastern apse. The major skeletal elements had been removed, suggesting a formal translation, but a hanging bowl of the early 7th c., presumably laid as a grave good, remained *in situ*. The succeeding three phases were represented by smaller two-cell rectangular churches surrounded by inhumation burials, extending from 8th to 12th c. and dedicated as St. Paul-in-the-Bail.

Finally, it should be noted that within Anglo-Saxon south-east England, cemeteries were furnished with mortuary houses containing the cremated remains of the dead both above and below ground, but any relationship to late antique mausolea is unlikely, these presumably representing a Germanic custom.[123]

Discussion

This outline of monument types from the Roman period to Late Antiquity suggests major changes in funerary customs. At least within north-west Europe, these changes provide the basis for the development of a new architecture reflecting new beliefs about death and the afterlife. Burial monuments were increasingly linked to cult sites and incorporated in places of worship. During the Roman period, three variants in location can be recognized for funerary monuments. Firstly, the long-recognised road-side location needs little comment other than to add that high status monuments might preferentially be placed as close to the gateway as possible on the most significant routes entering a town from the direction of the provincial capital or Rome, with the idea that the decoration and inscriptions could be read and pondered on by travellers on their arrival or by urban dwellers and relatives. Secondly, waterways were important whether the viewer was travelling on riverside roads or on a vessel. Indeed, the mausolea of the Flavians and of Hadrian and his successors, either side of the Tiber, were placed at a point where visible from both the *Via Flamina* and the Tiber.[124] Thirdly, private family burial grounds could have been placed within an estate, their monuments visible to the landowners or visitors and to travellers on nearby routes.

Within these early burial grounds the monuments acted as foci for burial within reserved compounds or, rarely, within the grounds of the residence. Where monuments were set in dedicated enclosures these could also be accompanied by gardens, orchards and even fishponds. As the '*Testament du Lingon*' records, these facilities were not just decorative, but also supported the upkeep of the monument. While an inscription from Milan refers to gardens and orchards as well as churches in suburbs, later reference to gardens and vine trellises at Saint-Justus church, Lyon and at Trier suggests their continued association with cemeteries.[125]

Throughout north-west Europe, there was no existing native tradition of built monuments other than earthen barrows, although simple timber structures appear in the immediate pre-conquest period. The barrows of south-eastern Britain mirror their occurrence in north-eastern Gaul, overlying richly-furnished graves at least in the 1st and 2nd c., as at Folly Lane, St. Albans. In Gaul, the Classical idiom was introduced early in the imperial period, possibly inspired by the architecture of monuments such as that at La Turbie on the border of the new provinces, although the tiered monuments on rectangular podia, not surprisingly, recall the original *Mausolleion*, while other forms are based on classical temples. Superficially, the more elaborate monuments are similar to architectural features or decorative details of Gothic churches a millennium later. Where

119 Cambridge (1999); Sparey-Green (2015) 32.
120 Rahtz (1993).
121 Bell (2005) 243–44.
122 Gilmour (2007). For the possible dedication of the second phase church to a figure contemporary with the mission of St. Paulinus, see 253.
123 Emery and Williams (2018).

124 Barraco (2014).
125 Sid. Apoll., *Ep.* v.17.4–5. There may be similar evidence from Trier: Aug., *Conf.* 8.6.

the pyramidal or conical tops of monuments decorated with floral and faunal elements had survived into the post-Roman period, their design begs the question of their possible influence as a model for later church architecture, an area of enquiry beyond consideration here. These monuments date early in the history of Gaul and the German frontier and have rarely been recognised in Britain other than at early cities such as London and Colchester and then only from their ground plan, with the notable exception of the Classicianus tomb. The structures at Shadwell and Welwyn may be rare examples of tower tombs of the continental type, set in prominent positions over rivers and adjacent roadways. Mausolea on a Celtic-temple plan beg the question as to whether pagan religious rites had been carried out within them, with the dead as intermediaries, those interred even holding some priestly status.

In Late Antiquity, there is a shift from these Roman customs to one where burials recognised as of religious significance, becoming foci of communal burial and eventually of Christian worship. The chronology proposed by Kremer for north-east Gaul gives a sequence from the native barrow tradition, the Classical built monuments dating from the 1st and 2nd c., their construction ceasing in the mid-3rd c. At this time many were demolished to provide material for the construction of new urban defences, their demise associated with the Germanic incursions. This may be a local reaction, but at least at London similar pressures caused some monuments, nearly three centuries old, to be re-used in the creation of the later 4th c. bastions.

Ostensibly pagan mausolea cannot be identified in Late Antiquity, new monuments reflecting different priorities and economic conditions in the western empire, but the impact of Christianity may also have changed attitudes to funerary ritual. Whether pagan or Christian believer, of provincial or immigrant origin, the great number of the dead were interred in open cemeteries with minimal structural markers. The only distinction was for those who were significant figures of reverence amongst the Christian community, deserving of a physical monument to house their remains and the relics of the holy. I here leave aside the question of whether these were confined to specific areas reserved for followers of the new religion, still a matter of much debate.

Late antique urban communities had different priorities, the Christian reverence of their dead providing a catalyst to the change in attitude, bodies once seen as polluting now revered as holy relics to be conserved and worshipped. Timber structures at Tours and Xanten, although slight and possibly temporary, were associated with trampled areas indicating the regular gathering of people and at the former site, their circulation around the monument. This may even be visible in the Poundbury Camp mausolea where trampled interior floors show continued activity even as the buildings decayed. All burial monuments imply reverence of the dead, but individuals were only occasionally honoured by the erection of a cenotaph, as with Drusus the Elder at Mainz, or the monument in the garden facing the entrance of the villa at Bierbach. The memory of the emperor might be revered, but only later in Christian contexts were deceased clerics or their associated relics worshipped as a means to intercede with the deity.

The relationship of funerary building to earlier structures and to their burials can be complex. The re-use of architectural elements from earlier monuments served the practical needs of construction, architectural elements being placed as grave covers at Saint-Just, Lyon and Saint-Matthias, Trier, in one case at the latter site, set perhaps symbolically with the pagan decoration placed face downwards. Elsewhere the use of pagan altars or reliefs in church foundations appears symbolic of the 'defeat' of earlier cults. Both on the continent and in Britain burials could demonstrably pre-date construction, be contemporaneous or to have been interred after dereliction. This was the case at St. Matthias, Trier, where burials pre-dated some mausolea or were inserted within them, the same sequence noted at Poundbury Camp where, in some cases, burials were also even inserted through the roof fall into the ruined building. The extramural burial chamber at Gloucester had had a 5th c. burial cut into its floor, while in the heart of the Roman city of Lincoln a prestigious burial of the 7th c. was set within a forum courtyard. This site exemplifies the process by which burial structures might be founded within the urban core and become sites of veneration, the mausolea incorporated into early churches, as with the sites dedicated to known ecclesiastics elsewhere.

Within the north-western provinces, funerary structures at the core of urban Christian cemeteries were mostly of the simplest form, even for important persons in the church. While early mausolea were decorated with architectural features, and, rarely, painted scenes from pagan mythology, the surviving late antique structures seem to have been decorated with painted interior surfaces, the scenes alluding to an afterlife and Christian iconography or floral and faunal imagery of an ambiguous nature. While little can be reconstructed of the superstructures, other than in the case of the vaulted hypogea, some recurring building-plans can be recognized.

Orientation varied, with no axis in the case of subterranean chambers. The main structures were square or rectangular, some embellished with apses and opposed entrances or atria, the larger room perhaps of 6–17 m²,

space for perhaps 2 to 4 extended inhumations and for small gatherings and ceremonies.[126] The Poundbury Camp mausolea are of this simple form, the most complete ground plan approximately 15 m², within the range of continental surface buildings, although comparisons between structures of such simplicity requires analysis of other features of decoration, burial type and the cemetery type. Larger examples include the first phase of St. Pierre, Vienne where a rectangular main room of 60 m² had a shallow rectangular apse on the east. By contrast, Saint-Just at St. Bertrand-de-Comminges was set on a north/south axis, the 44 m² interior furnished with a rectangular apse, 2.7 × 4 m, on its eastern side, a feature also at St. Pierre d'Alba (Ardèche). The church of St. Martial, Limoges, represents a more elaborate layout where a rectangular structure of smaller floor plan was focussed on a substantial vaulted chamber with ground level apses on three sides. This contrasts with St. Just, Lyon where the 5th c. basilica adjoined an earlier almost square chamber of 10 m², with a wide eastern apse, surrounded by traces of a covered walkway. Hypogea were served by stepped entrances and could be lit and ventilated by vents or roof lights, the interior decorated with painted panels containing a simple floral design; in this respect, the chamber at St. Martin de Rheims is exceptional, recalling decorative themes from the Roman catacombs.

As with many of the recorded structures, evidence for burial is lacking, possibly through the translation of the burial and the reuse of the coffins. A rectangular room, with or without an atrium and apse could have served as a family funerary chapel and a space for private commemoration of those interred, in contrast with the communal funerary basilicae. One distinctive ground-plan already noted is the rectangular hall aligned with an apse set in the middle of one long side. This feature may also be recognisable in the larger halls at St. Matthias and at St. Maximin, Trier, where both sites have lateral apses and ranges of rooms or chapels flanking the main hall.

The Arles mausoleum stands out for its unusual plan as a row of two chamber buildings, the main room of each ending in an apse and accessed from an atrium, the whole intended to form a single structure with the rotunda. This massive, unfinished structure may have been intended as the monument to someone of imperial status. Although its plan is only partially visible, St. Victor, Marseille, was seemingly of basilican plan, but with extensions to north and east, the numerous stone coffined burials leaving no doubt as to the sepulchral use. In its scale and the density of burial, this is comparable to the Trier basilicas, marking these cities as of equivalent status to Rome and Milan. The basilica of St. Maximin at Trier was effectively a hall reserved for a flat cemetery with grave markers, the use of the smaller hall identified at Saint-Matthias less clear-cut. Both were of complex design with additional halls or mausolea attached.[127]

By contrast, most of the dead through-out these north-western provinces, whatever their religious persuasion, were placed in open cemeteries of dug graves without obvious built monuments; the only distinguishing factors were the form of interment, the range of grave goods, grave orientation and the grouping within a defined burial area. The significance of such factors is contested, but the existence of funerary buildings of any size may, however, be indicative of the dedication of a burial ground to Christian usage rather than to other native or foreign cults and the *prisca religio*.[128] With the economic and social disruption of the Late Antiquity, resources were limited, priorities had changed and while old monuments were demolished or symbolically incorporated into the foundations of the new, adherents to the religion constructed new structures honouring the memory of figures in the church and providing accommodation for ceremonies. Such monuments also acted as a focus for those identifying with the leaders of the faith or with those who had suffered for their beliefs, adherents desiring to be buried *ad sanctos*, close to revered figures. This feature distinguished Christian communities from others, the location of simple oriented, unfurnished inhumations around a central mausoleum or building complex perhaps a means of identifying such sites even where documentary evidence is lacking.

Acknowledgements

This paper is dedicated to the memories of Raymond Farrar and Herman Ramm who introduced me to the evidence from Trier and encouraged my research. I would also like to thank the Institute of Classical Studies Library at the University of London and Dr. Peter Crawford at *Late Antique Archaeology* for all their help in preparing this piece for publication.

126 As summarized in Colardelle (2008) fig. IV.57 and Bonnet (1977) pl. XI and XVIII.
127 Other sites in this category should undoubtedly include the Alyscamps at Arles, St. Seurin de Bordeaux.
128 As the inscription on the Cirencester Jupiter column with its reference to the restoration of the cult, possibly in the time of Julian: RIB 103.

Bibliography

Primary Sources

Aug., *Conf.* = L. Verheizen ed., *Augustine, Confessiones*, CCSL 27 (Turnhout 1981).

Bede = C. Plummer ed., *Venerabilis Baedae Historia Ecclesiastica Gentis Anglorum, Historia Abbatum, Epistolam* (Oxford 1956).

Cicero, *Att.* = D.R. Shackleton Bailey ed. and transl., *Cicero's Letters to Atticus*, 6 vols. (Cambridge, England 1966).

Constantius of Lyon = R. Borius ed. and transl., *Constance de Lyon, Vie de Saint Germain d'Auxerre,* Sources Chrétiennes 112 (Paris 1965).

Gildas, *de exc. Brit.* = M. Winterbottom ed. and transl., *Gildas, The Ruin of Britain and Other Documents* (Chichester 1978).

Greg. Tur., *HF* = L. Thorpe transl. and intro. *Gregory of Tours, The History of the Franks* (London 1974).

Mart. *Epigr.* = D.R. Shackleton Bailey ed. and transl., *Martial, Epigrams*, 4 vols. (Cambridge, Mass. and London 1993).

Petron., *Sat.* = J. P. Sullivan transl. *Petronius, The Satyricon* (London 2011).

Sid. Apoll. *Ep.* = O. M. Dalton transl., *The Letters of Sidonius*, 2 vols. (Oxford 1915).

Strabo = H.L. Jones ed. and transl., *The Geography of Strabo*, 8 vols. (Cambridge, Mass.and London 1964).

Suet., *Aug.* = J.C. Rolfe ed. and transl., *Suetonius, the Lives of the Caesars*, 2 vols. (Cambridge, Mass. and London 1979).

Tac., *Ann.*= C. H. Moore ed. and transl., *Tacitus, The Histories* and J. Jackson ed. and transl., *Tacitus, Annals*, 5 vols. (Cambridge, Mass. and London 1979).

Vitr., *de arch.* = F. Granger transl., *Vitruvius: On Architecture*, vol. 2 (London 1931).

Secondary Sources

Achard-Corompt N., Kasprzyk M., Durost R., Bontrond R., Gestreau R., Jemin R., Gérard M., Izri S., Nouvel P., and Riquier V. (2016) "Présence des élites en milieu rural en territoires rème et tricasse durant le Haut-Empire: l'apport dans les monuments funéraires", in *Mausolées et grands domaines ruraux à l'époque romaine dans le nord-est de la Gaule* (Scripta Antiqua 90), edd. J-N. Castorio and Y. Maligorne (Bordeaux 2016) 35–64.

Allen T. (2007) "Archaeological discoveries on the A2 Pepperhill to Cobham widening scheme", *Kent Archaeological Society Newsletter* 73 (2007) 2–4.

Barbet A. (1993) "Les peintures murals du tombeau de Neuvy-Pailloux et la question des tombes peintes gallo-romaines", in *La tombe augustéenne de Fléré-La-Rivière (Indre) et les sépultures aristocratiques de la cité des Bituriges (Supplément à la Revue archéologique du centre de la France 7)*, edd. A. Ferdière and A. Villard (Tours 1993) 162–68.

Barraco M. E. G. (2014) *Il Mausoleo di Augusto, XIV–MMXIV Bimillenario della Morte di Augusto* (Rome 2014).

Becker M. (1993) "Einführung von neun Begräbnissitten: Neue Bevölkerungsströmung oder eine autochthone, romanisierte Bevölkerung? Problemdarstellung am Beispiel der Tumulussitte", in *Römerzeitliche Gräber als Quellen zu Religion, Bevölkerungsstruktur und Sozialgeschichte*, ed. M. Struck (Mainz 1993) 361–70.

Bel V. and Tranoy L. (1993) "Note sur les busta dans le sud-est de la Gaule", in *Römerzeitliche Gräber als Quellen zu Religion, Bevölkerungsstruktur und Sozialgeschichte*, ed. M. Struck (Mainz 1993) 95–110.

Bell T. (2005) *The Religious Reuse of Roman Structures in Early Medieval England* (BAR-BS 390) (Oxford 2005).

Benton G.M. (1924) "Roman burial group discovered at West Mersea", *Transactions of the Essex Archaeological Society* 17 (1924) 128–30.

Biddle M. and Kjølbye-Biddle B. (2001) "The origins of St. Albans Abbey: Romano-British cemetery and Anglo-Saxon monastery in Alban and St. Albans, Roman and Medieval architecture, art and archaeology", *British Archaeological Association Conference Transactions* 24 (2001) 45–77.

Binsfeld W. (2001) "Wo ist der römische Kaiser Constantius Chlorus beigesetzt?", *TrZ* 64 (2001) 60–61.

Binsfeld A., Klöckner A., Kremer G., Reuter M., and Scholz M. (2020) *Grabdenkmäler der Treverer in lokaler und uüberregionaler Perspektive, Akten der Internationalen Konferenz vom 25–27 Oktober 2018 in Neumagen und Trier, Beiheft zur Trierer Zeitschrift* 37 (Wiesbaden 2020).

Bird D. (2008) "'The rest to some faint meaning make pretence, but Shadwell never deviates into sense' (further speculation about the Shadwell 'tower')", in *Londinium and Beyond, Essays on Roman London and its Hinterland for Harvey Sheldon* (CBA Research Report 156), edd. J. Clark, J. Cotton, J. Hall, R. Sherris, and H. Swain (York 2008) 96–101.

Blin S. and Flotté P. (2020) "La nécropole de Strasbourg-Koenigshoffen, Decouverte d'une allée des tombeaux du 1er siècle apr. J.C.", in *Grabdenkmäler der Treverer in lokaler und uberregionaler Perspeektive, Akten der Internationalen Konferenz vom 25–27 Oktober 2018 in Neumagen und Trier, Beiheft zur Trierer Zeitschrift* 37, edd. A. Binsfeld, A. Klöckner, G. Kremer, M. Reuter, and M. Scholz (Wiesbaden 2020) 163–74.

Bonnet C. (1977) *Les premiers édifices chrétiens de la Madeleine a Genève, étude archéologique et rcherches sur les fonctions des constructions funéraires* (Geneva 1977).

Bonnet C. (1986) *Genève aux premiers temps chrétiens* (Geneva 1986).

Bonnet C. and Perinetti R. (1986) *Aoste aux premiers temps Chrétiens* (Aoste 1986).

Booth P. (2008) "East Anglia", *Britannia* 39 (2008) 310–14.

Booth P., Champion T., Foreman S., Garwood P., Glass H., Munby J., and Reynolds A. (2011) *On Track, The Archaeology of High Speed 1 Section 1 in Kent* (Oxford and Salisbury 2011).

Borger H. (1958) "Die ausgrabungen im bereich des Xantener Domes" in *Neue Ausgrabungen in Deutschland* (Berlin 1958) 380–90.

Boulanger K. (2016) "Mausolée, cénotaphe ou temple? Évolution des pôles funéraires et cultuels au sein du domaine bâti de la villa de Damblain (Vosges)", in *Mausolées et grands domaines ruraux à l'époque romaine dans le nord-est de la Gaule* (Scripta Antiqua 90), edd. J-N. Castorio and Y. Maligorne (Bordeaux 2016) 123–44.

Boyer R. (1987) *Vie et mort à Marseille à la fin de l'Antiquité, Inhumations habillées des Ve et VIe siècles et sarcophage reliquaire trouvés à l'abbaye de Saint-Victor* (Marseille 1987).

Bretall R. (2016) *The Final Masquerade: A Molecular-Based Approach to the Identification of Resinous Plant Exudates in Roman Mortuary Contexts in Britain and Evaluation of their Significance* (Ph.D. diss., Univ. of Bradford 2016).

Bromwich J. (2014) *The Roman Remains of Brittany, Normandy and the Loire Valley, A Guide Book* (Peterborough 2014).

Bushe-Fox J.P. (1932) *Third Report on the Excavations of the Roman Fort at Richborough, Kent* (Reports of the Research Committee of the Society of Antiquaries of London 10) (Oxford 1932).

Cambridge E. (1999) "The architecture of the Augustinian mission", in *St Augustine and the Conversion of England*, ed. R. Gameson (Stroud 1999) 202–236.

Carver M. ed. (2003) *The Cross goes North, Processes of Conversion in Northern Europe, AD 300–1300* (York 2003).

Castella D. (2016) "Monuments funéraires et lieux de culte privés en pays helvète", in *Mausolées et grands domaines ruraux à l'époque romaine dans le nord-est de la Gaule* (Scripta Antiqua 90), edd. J-N. Castorio and Y. Maligorne (Bordeaux 2016) 105–122.

Castorio J-N. and Maligorne Y. (2016) "Introduction: état de la question, problématiques de la recherché", in *Mausolées et grands domaines ruraux à l'époque romaine dans le nord-est de la Gaule* (Scripta Antiqua 90), edd. J-N. Castorio and Y. Maligorne (Bordeaux 2016) 9–34.

Castorio J-N. and Maligorne Y. edd. (2016) *Mausolées et grands domaines ruraux à l'époque romaine dans le nord-est de la Gaule* (Scripta Antiqua 90) (Bordeaux 2016).

Clark J., Cotton J., Hall J., Sherris R., and Swain H. edd. (2008) *Londinium and Beyond, Essays on Roman London and its hinterland for Harvey Sheldon* (CBA Research Report 156) (York 2008).

Clauss-Balty P. (2016) "Piles funéraires gallo-romaines et autres mausolées-tours", in *Les piles funéraires gallo-romaines du Sud-Ouest de la France*, ed. P. Clauss-Balty (Pau 2016) 201–216.

Clauss-Balty P. and Soukiassian G. (2016) "Étude typologique des piles funéraires du Sud-Ouest", in *Les piles funéraires gallo-romaines du Sud-Ouest de la France*, ed. P. Clauss-Balty (Pau 2016) 179–200.

Colardelle R. (2008) *La ville et la mort, Saint-Laurent de Grenoble, 2000 ans de tradition funéraire* (Bibliothèque de l'Antiquité Tardive 11) (Turnhout 2008).

Crummy N., Crummy P. and Crossan C. (1993) *Excavations of Roman and Later Cemeteries, Churches and Monastic Sites in Colchester, 1971–88* (Colchester Archaeological Report 9) (Colchester 1993).

Crummy P., Benfield S., Crummy N., Rigby V., and Shimmin D. (2007) *Stanway: An Elite Burial Site at Camulodunum* (Britannia Monograph 24) (London 2007).

Cüppers H. (1965) "Das Gräberfeld von St. Matthias", in *Frühchristliche Zeugnisse im Einzugsgebiet von Rhein und Mosel*, ed. W. Reusch (Trier 1965) 165–74.

Cüppers H. (1984a) "Das frühchristliche Gräberfeld von St. Matthias", in *Trier, Kaiserresidenz und Bischofssitz, Die Stadt in spätantiker und frühchristlicher Zeit* (Mainz 1984) 204–208.

Cüppers H. (1984b) "St. Maximin, Grabungsareal und ausgewählte Neufunde", in *Trier, Kaiserresidenz und Bischofssitz, Die Stadt in spätantiker und frühchristlicher Zeit* (Mainz 1984) 232–35.

Cüppers H. (1984c) "Grabanlage und Friedhofsbereich bei St. Maximin", in *Trier, Kaiserresidenz und Bischofssitz, Die Stadt in spätantiker und frühchristlicher Zeit* (Mainz 1984) 238–39.

Cüppers H. (1990) *Die Römer in Rheinland-Pfalz* (Trier 1990).

Cüppers H. (1993) "Sépultures et cimetières ruraux en pays trévire", in *Monde des Morts, Monde des Vivants en Gaule Rurale, Actes du Colloque ARCHÉA/AGER* (Orleans, Conseil Régional, 7–9 février 1992) (Supplément à la Revue archéologique du centre de la France 6), ed. A. Ferdière (Tours 1992) 81–88.

Dark K. R. ed. (1997) *External Contacts and the Economy of Late Roman and Post-Roman Britain* (Woodbridge 1997).

Davey N. and Ling R. (1982) *Wall-Painting in Roman Britain* (Britannia Monograph 3) (London 1982).

Davies M. (2001) "Death and social division at Roman Springhead", *Archaeologia Cantiana* 121 (2001) 157–69.

Dellacroce B. and Weber W. (2007) "'Dort, wo sich gottes volk versammelt' – Die Kirchenbauten Konstantinischen zeit" in *Konstantin der Grosse, Geschichte – Archäologie – Rezeption, Internationales Kolloquium 2005*, edd. A. Demandt and J. Engemann (Trier 2007) 245–55.

D'Archimbaud G. D. (1971) "Les Fouilles de St Victor de Marseille", *CRAI* (1971) 87–117.

De Visscher F. (1963) *Le droit des tombeaux romains* (Milan 1963).

Dool J. (1985) "Derby Racecourse: excavations on the Roman industrial settlement, 1970", in *Roman Derby: Excavations 1968–1983*, edd. J. Dool, H. Wheeler *et al.*, *Derbyshire Archaeological Journal* 105 (1985) 155–221.

Dool J., Wheeler H. *et al.* (1985) *Roman Derby: Excavations 1968–1983*, *Derbyshire Archaeological Journal* 105 (1985).

Dunning G. C. and Jessup R. F. (1936) "Roman barrows", *Antiquity* 10 (1936) 37–53.

Eiden H. (1958) "Ausgrabungen im spätantiken Trier", in *Neue Ausgrabungen in Deutschland* (Berlin 1958) 340–67.

Emery K. M. and Williams H. (2018) "A place to rest your (burnt) bones? Mortuary houses in Early Anglo-Saxon England", *ArchJ* 175 (2018) 55–86.

Esmonde Cleary A.S. (2008) *Rome in the Pyrenees, Lugdunum and the Convenae from the first century B.C. to the seventh century A.D.* (London and New York 2008).

Euzennat M. M. (1972) "Le monument a rotonde de la necropole du cirque a Arles", *CRAI* (1971) 404–423.

Farwell D. E. and Molleson T. L. (1993) *Excavations at Poundbury 1966–80, Vol. II, The Cemeteries* (Dorset Natural History and Archaeological Society Monograph 11) (Dorchester 1993).

Fasold P. (1992) *Römischer Grabbrauch in Süddeutschland* (Stuttgart 1992).

Faust S. (2001) "Das 'Grutenhäuschen' bei Igel (Kreis Trier-Saarburg), Ein Rekonstruktionsversuch des römischen Grabtempels als Schutzbau", *Funde und Ausgrabungen im Bezirk Trier* 33 (2001) 41–46.

Ferdière A. (1993) *Monde des morts, monde des vivants en Gaule rurale. Actes du colloque ARCHÉA/AGER (Orleans, Conseil Régional, 7–9 février 1992)* (Supplément à la Revue archéologique du centre de la France 6) (Tours 1992).

Ferdière A. and Villard A. edd. (1993) *La tombe augustéenne de Fléré-La-Rivière (Indre) et les sépultures aristocratiques de la cité des Bituriges* (Supplément à la Revue archéologique du centre de la France 7) (Tours 1993).

Fevrier P-A. and Leyge F. (1986) *Premiers temps Chretiens en Gaule méridionale, Antiquite tardive et haut moyen age IIIeme–VIIIeme siècles* (Lyon 1986).

Fletcher E. and Meates G.W. (1969) "The ruined church of Stone-by-Faversham", *AntJ* 49 (1969) 273–94.

Flutsch L. (1993) "Deux monuments funéraires récemment mis au jour à Avenches (Suisse)", in *Römerzeitliche Gräber als Quellen zu Religion, Bevölkerungsstruktur und Sozialgeschichte*, ed. M. Struck (Mainz 1993) 213–28.

Foster J. (1986) *The Lexden Tumulus: A Reappraisal of an Iron Age Burial from Colchester, Essex* (BAR International Series 156) (Oxford 1986).

Frere S. S. (1983) "Roman Britain in 1983, Buckinghamshire: Bancroft mausoleum and shrine", *Britannia* 15 (1983) 302–304.

Gage J. (1834) "A plan of barrows called the Bartlow Hills in the parish of Ashdown in Essex with an account of Roman sepulchral relics recently discovered in the lesser barrows", *Archaeologia* 25 (1834) 1–23.

Gage J. (1836) "The recent discovery of Roman sepulchral relics in one of the greater barrows at Bartlow, in the parish of Ashdown, in Essex", *Archaeologia* 26 (1836) 300–317.

Galinie H. ed. (2007) *Tours antique et médiéval. Lieux de vie, temps de la ville, 40 ans d'archeologie urbaine* (Tours 2007).

Gaitzsch W. (1993) "Brand- und Körpergräber in römischen Landseidlungen der Jülicher Lössbörde", in *Römerzeitliche Gräber als Quellen zu Religion, Bevölkerungsstruktur und Sozialgeschichte*, ed. M. Struck (Mainz 1993) 17–40.

Gameson R. ed. (1999) *St Augustine and the Conversion of England* (Stroud 1999).

Gerrard J. (2013) *The Ruin of Roman Britain, An Archaeological Perspective* (Cambridge 2013).

Ghini G. (2010) "Il sepolcro ditto degli Orazi e Curiazi ad Albano: monumento funerario o memoria gentilizia?", in *Monumenta. I mausolei romani tra commemorazione funebre e propaganda celebrativa. Atti del Convegno di studi, Monte Porzio Catone, 25 ottobre 2008*, ed. M. Valenti (Milan 2010) 79–88.

Gillam J. P. and Daniels C. M. (1961) "The Roman Mausoleum on Shorden Brae, Beaufront, Corbridge, Northumberland", *Archaeologia Aeliana* 39 (1961) 37–61.

Gilmour B. (2007) "Sub-Roman or Saxon, pagan or Christian: who was buried in the early cemetery at St Paul in the Bail, Lincoln?", in *Pagans and Christians: From Antiquity to the Middle Ages, Papers in honour of Martin Henig, presented on the occasion of his 65th birthday* (BAR-IS 1610), ed. L. Gilmour (Oxford 2007) 229–56.

Grasby R. D. and Tomlin R. S. O. (2002) "The sepulchral monument of the procurator C. Julius Classicianus", *Britannia* 33 (2002) 43–75.

Green C. J. S., see also under Sparey-Green C. J.

Green C. J. S. (1977) "The significance of plaster burials for the recognition of Christian cemeteries", in *Burial in the Roman World* (CBA Research Report 22), ed. R. Reece (London 1977) 46–53.

Green C. J. S. (1982) "The cemetery of a Romano-British Christian community at Poundbury, Dorchester, Dorset", in *The Early Church in Western Britain and Ireland* (BAR-BS 102), ed. S. M. Pearce (Oxford 1982) 61–76.

Green C. Sparey, Paterson M. and Biek L. (1981) "A Roman coffin burial from the Crown Buildings site, Dorchester, with particular reference to the head of well-preserved hair", *Proceedings of the Dorset Natural History and Archaeological Society* 103 (1981) 67–100.

Grenier A. (1934) *Manuel d-Archéologie Gallo-Romaine, 2me. Partie, L'Archéologie du sol, Les Routes* (Paris 1934).

Gualandi S. (2016) "Périurbains ou ruraux: critères d'implantation de quelques mausolées lingons", in *Mausolées et grands domaines ruraux à l'époque romaine dans le nord-est de la Gaule* (Scripta Antiqua 90), edd. J-N. Castorio and Y. Maligorne (Bordeaux 2016) 65–74.

Haalebos J. K. (1993) "Das Gräberfeld von Nijmegen-Hatart", in *Römerzeitliche Gräber als Quellen zu Religion, Bevölkerungsstruktur und Sozialgeschichte*, ed. M. Struck (Mainz 1993) 397–402.

Hall J. (1996) "The cemeteries of Roman London: A review", in *Interpreting Roman London, Papers in memory of Hugh Chapman*, edd. J. Bird, M. Hassall, and H. Sheldon (Oxford 1996) 57–84.

Hawkes C. J., Rogers J. M., and Tratman E.K. (1978) "Wookey Hole Cave, the Romano-British cemetery in the fourth chamber", *University of Bristol Spelaeological Society* 15 (1978) 23–54.

Hazzledine Warren S. (1913) "The opening of the Romano-British barrow on Mersea Island, Essex", *Transactions of the Essex Archaeological Society* 13 (1913) 114–41.

Heinen H. (1996) *Früchristliche Trier, von den Anfängen bis zur Völkerwanderung* (Trier 1996).

Heijmans M. (2007) "Constantina urbs. Arles durant le IVe siecle: une autre residence imperiale?", in *Konstantin der Grosse, Geschichte – Archäologie – Rezeption, Internationales Kolloquium 2005*, edd. A. Demandt and J. Engemann (Trier 2007) 209–220.

Henig M. and Nash Briggs D. (2020) "Caratacus", *ARA News, Association for Roman Archaeology* 44 (2020) 6–17.

Hinard F. ed. (1987) *La Mort, les mortes et l'au-delà dans le monde romaine* (Caen 1987).

Hoepfner W. (2013) *Halikarnassos und das Maussolleion: die modernste Stadtanlage der späten Klassik und der als Weltwunder gefeierte Grabtempel des karischen Königs Maussollos* (Darmstadt 2013).

Howlett S. (2013) *The Secrets of the Mound: Mersea Barrow, 1912–2012*, revised edition (West Mersea 2013).

Hull M. R. (1958) *Roman Colchester* (Oxford 1958).

Hurst H., Garrod P., Russell Robinson H., Toynbee J., and Brown D. (1975) "Excavations at Gloucester, third interim Report: Kingsholm 1966–75", *AntJ* 55 (1975) 267–94.

Jannet-Vallat M., Lauxerois R., and Reynaud J-F. (1986) *Vienne (Isere) aux premiers temps chrétiens* (Paris 1986).

Jessup R. F. (1959) "Barrows and walled cemeteries in Roman Britain", *Journal of the British Archaeological Association* 22 (1959) 1–32.

Johnson M. J. (2009) *The Roman Imperial Mausoleum in Late Antiquity* (Cambridge 2009).

Keller C. (2003) "From a Late Roman cemetery to the *Basilica Sanctorum Cassii et Florentii* in Bonn, Germany", in *The Cross goes North, Processes of Conversion in Northern Europe, AD 300–1300*, ed. M. Carver (York 2003) 415–27.

Koster A. (1993) "Ein reich ausgestattetes Waffengrab des 1. Jahrhunderts n. Chr. aus Nijmegen", in *Römerzeitliche Gräber als Quellen zu Religion, Bevölkerungsstruktur und Sozialgeschichte*, ed. M. Struck (Mainz 1993) 293–96.

Kirschbaum E. (1959) *The Tombs of St. Peter and St. Paul* (London 1959).

Kremer G. (2016) "Monuments funéraires de la cité des Trévires occidentale: réflexions sur les commanditaires", in *Mausolées et grands domaines ruraux à l'époque romaine dans le nord-est de la Gaule* (Scripta Antiqua 90), edd. J-N. Castorio and Y. Maligorne (Bordeaux 2016) 75–92.

Kremer G., von Insulander S., Krier J. and Muhling S. (2020) "Grabbauten des westlichen Trevererebiets", in *Grabdenkmäler der Treverer in lokaler und überregionaler Perspektive, Akten der Internationalen Konferenz vom 25–27 Oktober 2018 in Neumagen und Trier* (Beiheft zur Trierer Zeitschrift 37), edd. A. Binsfeld, A. Klöckner, G. Kremer, M. Reuter, and M. Scholz (Wiesbaden 2020) 27–36.

Krier J. (2020) "Die einheimische Führungsschicht in den Grabdenkmälern und Grabinschriften des Treveregebiets: Das 1. Jh. n. Chr. – und danach?", in *Grabdenkmäler der Treverer in lokaler und überregionaler Perspektive, Akten der Internationalen Konferenz vom 25–27 Oktober 2018 in Neumagen und Trier* (Beiheft zur Trierer Zeitschrift 37), A. Binsfeld, A. Klöckner, G. Kremer, M. Reuter, and M. Scholz (Wiesbaden 2020) 37–48.

Lakin D., Seeley F., Bird J., and Rielly K. (2002) *The Roman Tower at Shadwell, London: A Reappraisal* (MoLAS Archaeology Studies Series 8) (London 2002).

Lambot B. (1992) "Habitats, nécropolis et organisation du territoire à La Tène finale en Champagne septentrionale", in *Monde des Morts, Monde des Vivants en Gaule Rurale, Actes du Colloque ARCHÉA/AGER (Orleans, Conseil Régional, 7–9 février 1992)* (Supplément à la Revue archéologique du centre de la France 6), ed. A. Ferdière (Tours 1992) 121–51.

Langner M. (2020) "Die Konstruktion einer gallo-römischen Identität", in *Grabdenkmäler der Treverer in lokaler und überregionaler Perspektive, Akten der Internationalen Konferenz vom 25–27 Oktober 2018 in Neumagen und Trier* (Beiheft zur Trierer Zeitschrift 37), A. Binsfeld, A. Klöckner, G. Kremer, M. Reuter, and M. Scholz (Wiesbaden 2020) 13–26.

Laver P. G. (1927) "The excavation of a tumulus at Lexden, Colchester", *Archaeologia* 76 (1927) 241–54.

Lavagne H. (1987) "Le tombeau, mémoire du mort", in *La Mort, les mortes et l'au-delà dans le monde romaine*, ed. F. Hinard (Caen 1987) 159–65.

La Baume P. (1958) *Köln, Colonia Agrippinensis* (Cologne 1958).

Le Bohec Y. (1993) "Sepulture et monde rural dans le *Testament du Lingon*", in *La tombe augustéenne de Fléré-La-Rivière (Indre) et les sépultures aristocratiques de la cité des Bituriges* (Supplément à la Revue archéologique du centre

de la France 7), edd. A. Ferdière and A. Villard (Tours 1993) 29–35.

Le Mer A-C. and Chomer C. (2007) *Carte Archéologique de la Gaule, Lyon*, 69/2 (Paris 2007).

Lhermite X. (2013) "Limoges. Découvert d'un mausolée de l'Antiquité tardive au seins de la necropole de Saint-Martial, 1, rue de la Courtine", *Bulletine Monumental* 171 (2013) 160–62; https://www.persee.fr/docAsPDF/bulmo_0007-473x_2013_num_171_2_9594.pdf; pdf 19/07/2018.

Lhermite X. (2017) "La mausolée du 1, rue de la Courtine á Limoges", *Association pour L'Antiquité Tardive Bulletin* 26 (2017) 80–87.

Liverani P., Spinola G., and Zander P. (2010) *The Vatican Necropoleis: Rome's City of the Dead* (Turnhout 2010).

Mackinder A. (2000) *A Romano-British Cemetery on Watling Street, Excavations at 165 Great Dover Street, Southwark, London* (MoLAS Archaeology Studies Series 4) (London 2000).

Mahler K-U. (2019) "Wo sass der 'ernst Steuermann' des Neumagener Weinschiffs tatsächlich?", *Funde und Ausgrabungen im Bezirk Trier* 51 (2019) 46–53.

Maligorne Y. and Fevrier S. (2020) "Des membra disiecta a l'esquisse d'une typologie", in *Grabdenkmäler der Treverer in lokaler und überregionaler Perspektive, Akten der Internationalen Konferenz vom 25–27 Oktober 2018 in Neumagen und Trier* (Beiheft zur Trierer Zeitschrift 37), edd. A. Binsfeld, A. Klöckner, G. Kremer, M. Reuter, and M. Scholz (Wiesbaden 2020) 137–50.

Martin-Kilcher S. (1993) "Situation des cimetières et tombes rurales en *Germania Superior* et dans les régions voisines", in *La tombe augustéenne de Fléré-La-Rivière (Indre) et les sépultures aristocratiques de la cité des Bituriges* (Supplément à la Revue archéologique du centre de la France 7), edd. A. Ferdière and A. Villard (Tours 1993) 153–64.

Massart C. (2016) "Les tumulus dans la cité des Tongres. Caractéristiques et diversités regionals", in *Mausolées et grands domaines ruraux à l'époque romaine dans le nord-est de la Gaule* (Scripta Antiqua 90), edd. J-N. Castorio and Y. Maligorne (Bordeaux 2016) 93–104.

Meates G. W. (1979) *The Roman Villa at Lullingstone, Kent, Volume I: The Site* (Maidstone 1979).

Meates G. W. (1987) *The Roman Villa at Lullingstone, Kent, Volume II: The Wall Paintings and Finds* (Maidstone 1987).

Millett M. (1995) "An Early Christian community at Colchester?", *ArchJ* 152 (1995) 451–54.

Millett M., Revell L., and Moore A. edd. (2016) *The Oxford Handbook of Roman Britain* (Oxford 2016).

Moretti J-C. and Tardy D. edd. (2006) *L'architecture funéraire monumentale: la Gaule dans l'empire romain, Actes du colloque organisé par l'IRAA du CNRS et le muse archéologique Henri-Prades, 11–13 octobre 2001, Lattes* (Paris 2006).

Musee de Picardie, Amiens (2006) *La marquee de Rome, Samarobriva (Amiens) et les villes du nord de la Gaule* (Amiens 2006).

Myres J. L. (1951) "The tomb of Porsena at Clusium", *BSA* 46 (1951) 117–21.

Neal D. S. (1983) "Unusual buildings at Wood Lane End, Hemel Hempstead, Herts", *Britannia* 14 (1983) 73–86.

Neal D. S. (1984) "A sanctuary at Wood Lane End, Hemel Hempstead", *Britannia* 15 (1984) 193–215.

Neyses A. (1999) "Lage und Gestaltung von Grabinschriften im Spätantiken Coemeterial-Grossbau von St. Maximin", in *Trier, Jahrebuch des Römische-Germanischen Zentralmuseums, Mainz* 46 (Mainz 1999) 413–46.

Niblett R. (1999) *The Excavation of a Ceremonial Site at Folly Lane, Verulamium* (Britannia Monograph 14) (London 1999).

Pearce J. (2016) "Status and burial", in *The Oxford Handbook of Roman Britain*, Millett M., Revell L., and Moore A. (Oxford 2016) 341–62.

Pearce J., Millett M., and Struck M. edd. (2000) *Burial, Society and Context in the Roman World* (Oxford 2000).

Pearce S. M. ed. (1982) *The Early Church in Western Britain and Ireland* (BAR-BS 102) (Oxford 1982).

Petts D. (2003) *Christianity in Roman Britain* (Stroud 2003).

Philp B., Parfitt K., Willson J., and Williams W. (1999) *The Roman Villa site at Keston, Kent, Second Report (Excavations 1967 and 1978–1990)* (Kent monograph series 8) (Maidstone 1999).

Philpott R. (1991) *Burial Practices in Roman Britain, A Survey of Grave Treatment and Furnishing AD 43–410* (BAR-BS 219) (Oxford 1991).

Prandi A. (1957) *La Zona Archeologica della Confessio Vaticana* (Vatican City 1957).

Prandi A. (1963) "La tomba di S. Pietro nei pelligrinaggi dell'eta medievali (11ed)", in *Pellegrinaggi e culto dei santi in Europa fino alla la Crociata, Proceedings of the IV conference, Todi 8–11 October 1961* (Todi 1963) 283–447.

Rahtz P. (1993) *English Heritage Book of Glastonbury* (London 1993).

Rashleigh P. A. (1808) "Account of antiquities at Southfleet and account of a further discovery of antiquities at Southfleet", *Archaeologia* 14 (1808) 37–38, 221–23.

Reifarth N. (2013) *Zur Ausstattung spätantiker Elitegräber aus St. Maximin in Trier, Purpur, Seide, Gold und Harze* (Internationale Archäologie Band 124) (Rahden 2013).

Renard E. (1993) "Les monuments funéraires de Nod-sur-Seine (Cote-d'Or)", in *Monde des morts, monde des vivants en Gaule rurale. Actes du colloque ARCHÉA/AGER (Orleans, Conseil Régional, 7–9 février 1992)* (Supplément à la Revue archéologique du centre de la France 6), ed. A. Ferdière (Tours 1992) 247–51.

Reusch W. ed. (1965) *Frühchristliche Zeugnisse im Einzugsgebiet von Rhein und Mosel* (Trier 1965).

Reynaud J. F. (1986) *Lyon aux premiers temps chrétiens: basiliques et necropolis* (Paris 1986).

Ribolet M. (2020) "Les monuments funéraires d'*Agedincum* (Sens, France)", in *Grabdenkmäler der Treverer in lokaler und überregionaler Perspektive, Akten der Internationalen Konferenz vom 25–27 Oktober 2018 in Neumagen und Trier* (Beiheft zur Trierer Zeitschrift 37), edd. A. Binsfeld, A. Klöckner, G. Kremer, M. Reuter, and M. Scholz (Wiesbaden 2020) 151–62.

Rodriguez J. R. (1995) "'*In perpetuum dicitur*'. Un modelo de fundacion en el Imperio Romano. "Sex. Iulius Frontinus, Iulius Sabinus" y el Testamento del Lingon (CIL XIII 5708)", *Gerion* 13 (1995) 99–126.

Rook T., Walker S. and Denston C.B. (1984) "A Roman mausoleum and associated marble sarcophagus and burials from Welwyn, Hertfordshire", *Britannia* 15 (1984) 143–62.

Rossignani M. P., Sannazaro M., and Legrottaglie G. (2005) *Ricerche Archeologiche nei Cortili dell'Universita Cattolica, La Signora del Sarcofago, una sepoltura di rango nella necropolis dell'Universita Cattolica* (Milan 2005).

Roth-Congès A. (1993) "Les mausolees du sud-est de la Gaule", in *Monde des Morts, Monde des Vivants en Gaule Rurale, Actes du Colloque ARCHÉA/AGER (Orleans, Conseil Régional, 7–9 février 1992)* (Supplément à la Revue archéologique du centre de la France 6), ed. A. Ferdière (Tours 1992) 389–96.

RCHM(E) (1952) *Royal Commission on Historical Monuments (England), An Inventory of the Historical Monuments in the County of Dorset, Vol. I, West* (London 1952).

RCHM(E) (1962) *Royal Commission on Historical Monuments (England), An Inventory of the Historical Monuments in the City of York Vol I Eburacum, Roman York* (London 1962).

Ruppert C. and Binsfield A. (2020) "Das Amazonenmonument", in *Grabdenkmäler der Treverer in lokaler und überregionaler Perspektive, Akten der Internationalen Konferenz vom 25–27 Oktober 2018 in Neumagen und Trier* (Beiheft zur Trierer Zeitschrift 37), A. Binsfeld, A. Klöckner, G. Kremer, M. Reuter, and M. Scholz (Wiesbaden 2020) 105–116.

Schindler R. (1980) *Führer durch das Landesmuseum Trier* (Trier 1980).

Schutz H. (1985) *The Romans in Central Europe* (New Haven and London 1985).

Schwinden L. (2019) "Die Weinschiffe der romischen Grabmaler von Neumagen", *Funde und Ausgrabungen im Bezirk Trier* 51 (2019) 27–45.

Siedow M. (2020) *Der spätantike Baukomplex bei St. Matthias in Trier. Ein Großbau auf dem südlichen Gräberfeld der Kaiserresidenz Trier* (Ph.D. diss. Universität Trier 2020) https://doi.org/10.25353/ubtr-xxxx-8028-ca79.

Sillières P. and Soukiassian G. (1993) "Les Piles funéraires gallo-romaines du sud-ouest de la France: état des recherches", in *Monde des morts, monde des vivants en Gaule rurale, Actes du Colloque ARCHÉA/AGER (Orleans, Conseil Régional, 7–9 février 1992)* (Supplément à la Revue archéologique du centre de la France 6), ed. A. Ferdière (Tours 1992) 298–306.

Sparey-Green C. J. (1987) *Excavations at Poundbury Volume I: The Settlements* (Dorset Natural History and Archaeological Society Monograph 7) (Dorchester 1987).

Sparey-Green C. J. (1993a) "The rite of plaster burial in the context of the Romano-British cemetery at Poundbury, Dorset, England", in *Römerzeitliche Gräber als Quellen zu Religion, Bevölkerungsstruktur und Sozialgeschichte*, ed. M. Struck (Mainz 1993) 421–32.

Sparey-Green C. J. (1993b) "The mausolea painted plaster", in *Excavations at Poundbury 1966–80, Vol. II, The Cemeteries* (Dorset Natural History and Archaeological Society Monograph 11), edd. D. E. Farwell and T. I. Molleson (Dorchester 1993) 135–40.

Sparey-Green C. J. (1997) "Poundbury, Dorset: settlement and economy in Late and post-Roman Dorchester", in *External Contacts and the Economy of Late Roman and Post-Roman Britain*, ed. K. R. Dark (Woodbridge 1997) 121–52.

Sparey-Green C. J. (2003) "Where are the Christians? Late Roman cemeteries in Britain", in *The Cross goes North, Processes of Conversion in Northern Europe, AD 300–1300*, ed. M. Carver (York 2003) 93–107.

Sparey-Green C. L. (2004) "Living amongst the dead – from Roman cemetery to post-Roman monastic settlement at Poundbury", in *Debating Late Antiquity in Britain AD 300–700* (BAR-BS 365), edd. R. Collins and J. Gerrard (Oxford 2004) 103–11.

Sparey-Green C. J. (2015) "Excavations at St. Martin's House: archaeological investigations in the vicinity of St Martin's Church, Canterbury", *Archaeologia Cantiana* 136 (2015) 17–36.

Steer K. A. (1976) "More light on Arthur's O'on", *Glasgow Archaeological Journal, Studies in Roman Archaeology for Anne S. Robertson* 4 (1976) 90–92.

Stoodley N. and Cosh S. R. (2021) *The Romano-British Villa and Anglo-Saxon Cemetery at Eccles, Kent, A Summary of the Excavations by Alec Detsicas with a Consideration of the Archaeological, Historical and Linguistic Context* (Oxford 2021).

Struck M. ed. (1993) *Römerzeitliche Gräber als Quellen zu Religion, Bevölkerungsstruktur und Sozialgeschichte* (Mainz 1993).

Thomas C. (1981) *Christianity in Roman Britain to AD 500* (London 1981).

Tomlin R. S. O. (1993) "An inscription from the lead-lining in grave 530", in *Excavations at Poundbury 1966–80, Vol. II, The Cemeteries* (Dorset Natural History and Archaeological Society Monograph 11), edd. D. E. Farwell and T. I. Molleson (Dorchester 1993) 132–33.

Toynbee J. M. C. (1971) *Death and Burial in the Roman World* (London 1971).

Toynbee J. M. C. and Ward-Perkins J. B. (1956) *The Shrine of St. Peter and the Vatican Excavations* (London 1956).

Trier, Jahrebuch des Römisch-Germanischen Zentralmuseums, Mainz 46 (Mainz 1999).

Trier, Kaiserresidenz und Bischofssitz, Die Stadt in spätantiker und frühchristlicher Zeit (Mainz 1984).

Valenti M. (2010) *Monumenta. I mausolei romani tra commemorazione funebre e propaganda celebrativa. Atti del Convegno di studi, Monte Porzio Catone, 25 ottobre 2008* (Milan 2010).

Vidal M. (2016) "Fouilles des piles funéraires de Betbèze à Mirande (Gers). Essai de synthèse", in *Les piles funéraires gallo-romaines du Sud-Ouest de la France*, ed. P. Clauss-Balty (Pau 2016) 129–56.

Von Gerkan A. (1951) "St Gereon in Koln", *Germania, Anzeiger der Römische-Germanische Commission* 29 (1951) 215–18.

Von Ossel P. (1993) "L'occupation des campagnes dans le nord de la Gaule durant l'Antiquité tardive: l'apport des cimetières", in *Monde des morts, monde des vivants en Gaule rurale, Actes du Colloque ARCHÉA/AGER (Orleans, Conseil Régional, 7–9 février 1992)* (*Supplément à la Revue archéologique du centre de la France* 6), ed. A. Ferdière (Tours 1992) 209–239.

Walsh D. (2018) "Reconsidering the Butt Road 'Church,' Colchester: another *mithraeum*?", *JLA* 11 (2018) 339–74.

Ward-Perkins J. B. (1966) "Memoria, martyr's tomb and martyr's church, memoirs", *JThS* 17 (1966) 20–37.

Weekes J. (2016) "Cemeteries and funerary practice", in *The Oxford Handbook of Roman Britain*, edd. M. Millett, L. Revell, and A. Moore (Oxford 2016) 425–47.

West S. E. and Plouviez J. (1976) "The Romano-British site at Icklingham", *East Anglian Archaeology* 3 (1976) 63–125.

Wheeler H. (1985) "The Racecourse cemetery", in *Roman Derby: Excavations 1968–1983*, edd. J. Dool, H. Wheeler *et al.*, *Derbyshire Archaeological Journal* 105 (1985) 222–80.

Wigg A. (1993) "Barrows in northeastern Gallia Belgica: cultural and social aspects", in *Römerzeitliche Gräber als Quellen zu Religion, Bevölkerungsstruktur und Sozialgeschichte*, ed. M. Struck (Mainz 1993) 371–79.

Wightman E. M. (1970) *Roman Trier and the Treveri* (London 1970).

Witteyer M. (1993) "Die Ustrinen und Busta von Mainz-Weisenau", in *Römerzeitliche Gräber als Quellen zu Religion, Bevölkerungsstruktur und Sozialgeschichte*, ed. M. Struck (Mainz 1993) 69–80.

Wood J. (1989) "Etudes *archéologiques* à Larçay, 1986–1987, rapport préliminaire", *Bulletin de la Societe Archaeologique de Touraine* 42 (1989) 53–75.

Late Roman Mausolea in Pannonia

Zsolt Magyar

Abstract

The purpose of this paper is to show the chronology, typology and topography of Late Roman mausolea in Pannonia from a new point of view. It contains terminological clarification and new mausolea types including local variants. It also deals with the problem of the builders of the mausolea, who paid for the erection of such funerary structures.

Introduction

The Roman conquest of Pannonia began with the occupation of Siscia (Sisak) in 35 BC, with complete conquest following in the succeeding decades.[1] The first Pannonian Roman colonies were established for veterans of the four legions stationed in the *limes Pannoniae*.[2] The significance of Pannonia was primarily based on Italy's defence.[3] Native Pannonians and Celts – unless fully Romanised – did not play an important role in the history of the province; however, many Celtic villages still existed in the 3rd c.[4] Despite being at the centre of the Marcomannic Wars (168–180),[5] it was the 'Third Century Crisis' and its attendant barbarian invasions that brought the more significant damage to the province.[6] While relatively quiet during the initial stages of the Tetrarchy (Diocletian did subdivide the region into 4 provinces),[7] Pannonia increased in importance as Constantine I used Sirmium (Sremska Mitrovica) as a base from 317, a year which also saw the birth of Constantius II in the city; as was Gratian in 359. Increasing barbarian pressures in the 4th c. saw Pannonia continue to receive imperial attention, with Valentinian I campaigning and then dying there in 375. Despite imperial efforts, barbarian infiltration began to alter the character of Pannonia by the 5th c. and in the 430s the province was given up to the Huns.[8]

The indigenous people of the province mainly lived in villages, while the more significant landowners were frequently extra-province arrivals. With the emergence of towns after the Roman conquest, within a couple of decades new inhabitants – tradesmen, merchants, soldierly dependents – settled down together, independently of the army, whose veterans founded colonies.[9] Pannonian natives were organised into civitates, with their *praefecti* offered the opportunity of making it into higher society, which furthered their Romanisation and the dilution of their native character.[10] Such Romanisation was also aided by the arrival of considerable numbers of Italians into the region.[11] The 4th c. saw a mixing of Romanised inhabitants with various barbarian peoples who came to settle in Pannonia;[12] however, landowners control of the cities reached their peak in the 4th c., as well.[13] Among them we can find the great villa owners[14] and the builders of the bigger mausolea. However, the decline of imperial authority in the western provinces saw Pannonia lose its military and political significance.[15]

Before the Late Roman period, there is very little data about funerary buildings in Pannonia, unless *tumuli* are to be considered buildings.[16] While *aediculae* were built structures, they are not buildings and hence cannot be considered mausolea. Excavated rectangular walls belonged to funerary gardens, not mausolea.[17] The few archaeological remains were built tombs in Aquincum, a 25 × 3 m wall in the cemetery of Keszthely-Újmajor, with attached buildings or gardens and a *templum in antis* type *sanctuarium* (?) in Carnuntum.[18] Subterranean, often painted, funerary chambers could also be mentioned, but they do not follow the definition of mausolea used herein.[19] However, even with the high cost of tombs and sculptures and the absence of remains to be considered mausolea, one could still presume the presence of funerary buildings in Pannonia before the late 3rd c. But until these structures are found, high-status Pannonian tombs pre-4th c. are represented by *aediculae*, *tumuli*,

1 Mócsy and Fitz (1990) 31–34.
2 Mócsy and Fitz (1990) 35; Mócsy (1962) cols. 612–53.
3 Fitz (2003) 207.
4 Gabler (1991); Gabler (2003a); Magyar (2015).
5 Mócsy and Fitz (1990) 36–41.
6 Mócsy and Fitz (1990) 44–45.
7 Mócsy and Fitz (1990) 46.
8 Mócsy and Fitz (1990) 46–51; for the history of Pannonia see also: Barkóczi (1980) and Alföldy (1994).
9 Fitz (1980) 142; Mócsy (1990a) 240–42.
10 Fitz (1980) 143–45.
11 Fitz (1980) 144.
12 Fitz (1980) 155.
13 Fitz (1980) 156.
14 Thomas (1980); Gabler (2003b).
15 Fitz (2003) 208.
16 Palágyi and Nagy (2000); Palágyi (2003); Leleković (2012) 324–26.
17 Mócsy (1962) cols. 726.; Mócsy (1990b) 251–52.
18 Mócsy (1990b) 252–53 with further literature.
19 See for example: Mócsy (1990b) 251 (Neviodunum).

funerary gardens and richly decorated above-ground sarcophagi. They disappear by the 4th c., replaced by a different type of high-status tomb: mausolea.[20]

Late antique mausolea were places of rituals, memory, and representation. To understand their varied functions, it is necessary to examine the everyday and extraordinary ceremonies which took place within them, like funerals, annual family celebrations and, in special cases, feasts of the saints, buried or transferred to such cemetery structures. In Late Antiquity, they took the place of some other forms of funerary representation, like above ground sarcophagi, open aediculae, built tombs and tumuli as expensive, hence representative cemetery buildings. As the period progressed, more and more members of the Roman elite became Christian. This socio-religious transformation was mirrored by both active and causal phenomenon in the landscape of cemeteries, which became new centres of power; places where displays of power and influence were re-enacted every time mausolea were viewed by the local population or visitors.

The name *mausoleum* comes from the splendid Hellenistic funerary monument of a 4th c. BC Carian ruler, Mausolus.[21] Later, the term was applied generally to any grand tomb in the Roman world[22] through to the end of Antiquity and even beyond. While the term, mausoleum, is clear and simple, several other terms are used for such grand tombs in different time periods and contexts. On Roman funerary inscriptions, the general term *sepulcrum* was used, which meant a tomb, grave or burial place, and they did not differentiate between mausolea and other tombs. Scholarly typology, however, used 'mausoleum tomb' as a type in itself, with several sub groups of mausolea providing important categorisation. Toynbee used the term of mausoleum, and differentiated house-tombs, tower-tombs, temple tombs and large circular or polygonal tombs based on architectural characteristics.[23] He mainly dealt with Early and Middle Imperial monuments. As for some Late Roman[24] mausolea often the terms funerary chapel, memorial chapel or *martyrium* were used mainly by the scholarship belongs to Early Christian Archaeology.[25] German scholarship used the term *Grabkapell* as a translation of funerary chapel, or *Grabbau*,[26] stressing that they are buildings, not just tombs. Italian scholarship for smaller mausolea often used the simple term *tomba*,[27] which only means tombs. Some English scholars, like Sparey-Green used the term mausoleum independently of the size and religious affiliation of these monuments.[28] The phrase *cella memoriae* were also used for small mausolea, not always consequently. The *Oxford Companion to Christian Art and Architecture* defined *cella memoriae* as a "small building in a cemetery, over a grave, in which Christians, and also some pagans, met for feasts on anniversaries. In the case of martyrs such chapels, whether above or below ground, are usually called martyria (or *confessiones*)". The *Oxford Dictionary of Architecture* defines mausolea as a "roofed building used as a tomb, detached or joined to another building (e.g., a church), containing coffins, sarcophagi, or urns, often on shelves".[29] In this paper I use the term mausoleum (plural: mausolea) according to this meaning.

A Brief History of Burial Finds in Pannonia

The archaeological research of late antique mausolea in the Pannonian region started at the very beginnings of Hungarian archaeology. In 1782, when burial chamber I in Sopianae (Pécs) was discovered, it was a great attraction of the times.[30] During the 19th c., several other mausolea came to the light in Sopianae,[31] while in 1922, a *cella trichora* was also found in Sopianae and later published by Szőnyi.[32] By the first decades of the 20th c., the cemetery buildings of Sopianae became widely known in the international scholarship.[33] In other parts of the province, like in Sirmium (Sremska Mitrovica), the probable martyrium of St. Demetrios was found in 1878, together with three other mausolea.[34] Between 1909 and 1913, the so-called cemetery basilica in the 'Gas Factory' cemetery of Aquincum (Budapest) was discovered (although

20 Mócsy (1990b) 252.
21 On Mausolus, see Hornblower (1982).
22 Just to name the most famous ones: the mausolea of Augustus and Hadrian (today's Castel San Angelo) in Rome.
23 Mausoleum: Toynbee (1971) 105, 109, 129–30, 161, 163; house-tombs: Toynbee (1971) 110–12, 133–47; tower-tombs: Toynbee (1971) 164–72; temple tombs: Toynbee (1971) 130–32, 144–63.
24 For the purposes of this paper and its Pannonian context, 'Late Roman' is taken to indicate the period between the accession of Diocletian in 284 and the loss of a significant part of Pannonia to the Huns in the 430s.

25 For example: Testini (1958) 178, 217, 223, 280, 314. Funerary or memorial chapels were originally developed in connection with the cult of the saints, commemorating both their grave sites and their places of martyrdom.
26 Gabelmann (1979); Von Hesberg (1992); Eisner (1996).
27 Calza (1940).
28 Sparey-Green (1977).
29 Curl and Wilson (2015) 472.
30 Koller (1804) 33; Lengvári (2003) 55.
31 Haas (1845) 226; Henszlmann (1873).
32 Szőnyi (1923–1926).
33 Rossi (1874); Zeiller (1918) 191–92; Dyggve (1935).
34 Hytrek (1894).

not published) by Kuzsinszky.[35] In 1910, several mausolea were also found along Bécsi Street in Budapest.[36] L. Nagy, successor of Kuzsinszky at the Aquincum Museum, tried to interpret the ruins of the so-called 'Gas Factory' cemetery basilica and published the plan, based on Kuzsinszky's excavation archive.[37] In 1930, L. Nagy also discovered a *cella trichora* in the area of the former *canabae* of the fortress of Aquincum.[38] He also discovered a 'cemetery basilica' on Vihar Street, close to the above mentioned triconch mausoleum, together with smaller mausolea in 1933.[39] This led to the first works written in Hungary, discussing and collecting the Pannonian material found by L. Nagy and Gosztonyi, an architect from Pécs, who had an interest in mausolea.[40]

During the Second World War, archaeological research continued, with new buildings excavated; however, some of these excavations could not be finished or where only published decades later.[41] Real progress in the research has come after the war, mainly by Fülep and Mócsy under the heading of Christian cemetery buildings.[42] By the 21st c., the question of whether these buildings were Christian or not was being asked. Only in a few cases, mostly based on decoration, has it been possible to make such a determination. The majority of Late Roman cemeteries in Pannonia were actually established for pagans and Christians with little difference in the form of burials.[43] The monographs of Hudák and Nagy and of Gábor are currently the most up-to-date discussions of the Sopianae cemetery and its buildings.[44] With their extensive use of international scholarship, these monographs provide a good basis for the understanding the role of Pannonian mausolea in funerary architecture.

The Location of Late Antique Mausolea in Pannonia

From the available data, a picture can be drawn about the settlement types in which mausolea appeared (Figs. 1–2). The example of the legionary fortress of Aquincum shows that some such sites were still had an active 'mausoleum habit', while new town-like settlements in inner fortresses produced a similar amount of evidence. Provincial capitals in the hinterland, like Sopianae and Sirmium were important sites for Late Roman mausolea, and one can expect more evidence from Savaria (Szombathely) and Siscia (Sisak) as well.

In late antique Pannonia, cemeteries around towns were situated very close to the walls. In some cases even formerly inhabited areas were used for burials, the graves being dug into earlier rubbish layers.[45] The re-use of earlier funerary space or the transformation of the inhabited areas into cemeteries was a general practice; only those places were exempted from that, which still had extensive empty areas close to the city, like in Sopianae.[46] The cemeteries of Pannonia were all surface or horizontal cemeteries, as opposed to underground or vertical cemeteries outside the province.[47] The presence of mausolea was mainly limited to the cemeteries of the bigger cities or next to rural villas, while mausolea were atypical in the cemeteries of auxiliary fortresses. There are some exceptions, such as at Castra Constantia (Szentendre) or Intercisa (Dunaújváros), but in both cases only one or two mausolea were found and were far from each other.

Rural Estates

In rural estates, usually one or two mausolea could be found, belonging to the owners of such estates. Erecting a lavish tomb next to a suburban Roman villa is a well-known phenomenon and was already widely practised from the 2nd c. BC.[48] In late antique Pannonia, five villa sites were found with mausolea; these buildings usually had a floor space of 20–50 m², big enough to hold funerary banquets with several attendees. Different ground plans were applied, with size seemingly more important than a specific layout. The applied ground plans were not necessarily late antique in origin, with the octagonal mausoleum of Livada, near Sirmium following an earlier tradition.[49]

The cemeteries of the villa in Nagykanizsa-Palin revealed the complexity of burials in such settlements, since not one but two Late Roman cemeteries of similar date were found around the villa. While in cemetery II,

35 Kuzsinszky (1932).
36 Foerk (1923).
37 Nagy (1940) 253–55.
38 Nagy (1931).
39 Nagy (1937) 272; Nagy (1938) 63–64.
40 Nagy (1938); Gosztonyi (1943).
41 Radnóti (1939) 151–53; Gosztonyi (1940); Schmidt (2000).
42 Fülep (1959a); (1962); (1969); (1977a); (1984); Fülep and Bachman (1990); Mócsy (1962) col. 727–28; Mócsy (1990) 263–64.
43 Schmidt (2000); Nagy (2002); Visy (2003); Visy (2007); Hudák (2009a); Hudák (2009b); Magyar (2012a); Nagy (2013), Gábor (2016).
44 Hudák and Nagy (2005); (2009); Gábor (2016).

45 Póczy (1964) 70.
46 Lányi and Mócsy (1990) 248.
47 Gosztonyi (1943) 124.
48 Plin. *Ep.* 8.17.5; Toynbee (1971) 49, 101–244; Waurick (1973) 126–40; Prieur (1986) 79–100; Bodel (1997) 20–26; Marzano (2007) 222, 477, 487, 521; In the 'testament of the Lingon', a mausoleum near a rural estate was also ordered as a proper burial place for an aristocrat.
49 Cf. De Rossi (1980) 154–57.

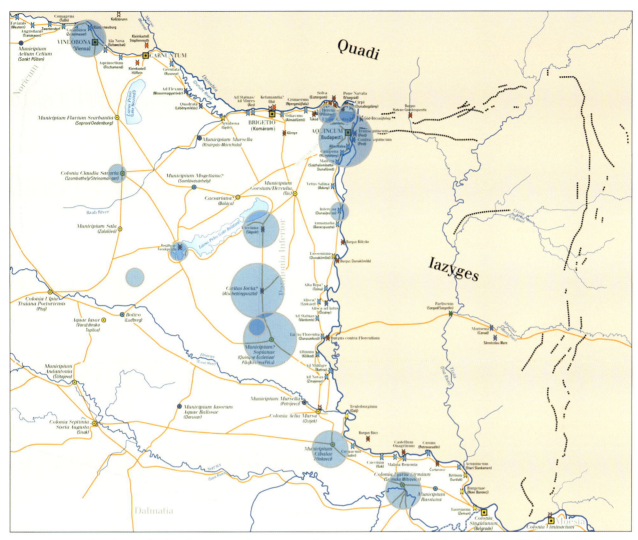

FIGURE 1 Number of mausolea found in Pannonia by site. Big circle: more than 10, middle-sized circle: 2–10, small circle: 1.
MAP: ©MEDIATUS AND ZIEGELBRENNER (2009), PROJEKT RÖMISCHER LIMES, WIKIPEDIA.DE

two mausolea were found, the cemetery 1 contained none, but did have a centrally placed grave with a clearly distinguishable ditch around it. This shows one of the many possibilities of distinguishing burials.[50] It is still an open question as to why this villa settlement had two cemeteries at the same time. The situation of the villa buildings in relation to the mausoleum in Sárisáp is not known, but the entrance of the mausoleum on the hillside might intentionally point at the villa in the valley.[51]

Auxiliary Forts

Auxiliary forts should be treated as exceptional cases in the erection of mausolea, simply due to the lack of economic resources for such expensive tombs. Generally, these mausolea were smaller in terms of inner floor space than at rural estates, also pointing to the difference in socio-economic means of those who could pay for such structures.

Inner Fortresses

By the second half of the 4th c., the inner fortresses in Pannonia in a way was functioned as urban settlements and people moved there to seek protection in the turmoil of Barbarian raids. In Fenékpuszta one, in Ságvár three mausolea was found. The reason behind the higher number of mausolea in the inner fortress of Alsóhetény was perhaps the transferring of the whole population to the fortress of from a nearby important, but unexcavated city in Pannonia Valeria at Alsóhetény (Iovia in Valeria?) (Fig. 4).[52] This is mirrored in the relatively greater interior space of the mausolea in the cemeteries of inner fortresses, like the huge structure in Alsóhetény, with interior floor space of 185 m^2 (mausoleum no. 1).

50 Eke and Horváth (2006) 74–76.
51 B. Major *pers. comm.*
52 Tóth (2001b) 130.

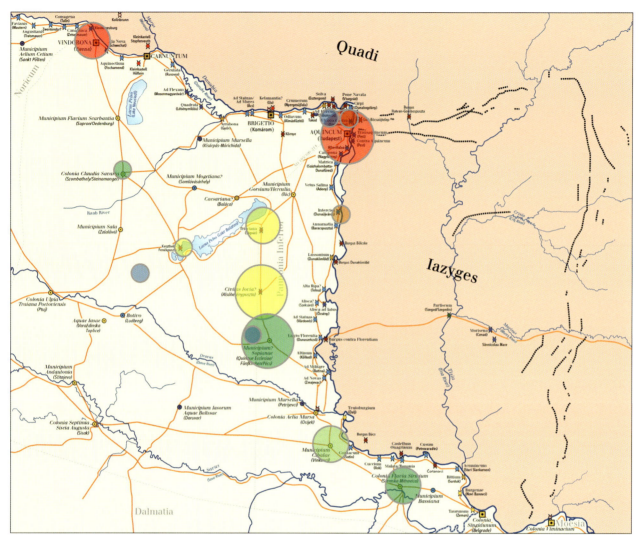

FIGURE 2 Number of mausolea found in Pannonia by settlement type. Red circle: legionary fortress, yellow circle: inner fortress, pink circle: auxiliary fort, green circle: provincial capital, light green circle: other town, blue circle: villa.
MAP: ©MEDIATUS AND ZIEGELBRENNER (2009), PROJEKT RÖMISCHER LIMES, WIKIPEDIA.DE

Legionary Fortresses

The legionary fortresses in the province, except for Aquincum, lost their importance in the 4th c. Therefore, only one mausoleum is known from Vindobona (Vienna), none from Brigetio (Komárom-Szőny) and, although numerous high-status tombs are known from the earlier centuries in Carnuntum (Bad Deutsch-Altenburg), Late Roman mausolea have not yet been found in the city. It seems that Aquincum retained its importance through being a provincial capital. Apart of Sirmium, which was an imperial city, Aquincum is the only Pannonian settlement where mausolea have been found in more than one cemetery, and more mausolea or their ruins might be still underground in modern Budapest.

The different Late Roman cemeteries of Aquincum also showed distinguishable features. The cemetery along Bécsi Street preserved its linear nature and continued the heritage of the earlier centuries. In some places, the cemetery can stray quite far from the road. In these wider areas, the orientation of mausolea did not follow the surrounding roads, but rather the assigned cemetery plots. In other cemeteries, like the eastern cemetery of the civil town of Aquincum or the former areas of the *canabae legionis*, scholarship has suggested that mausolea stood in central positions. However, either only small areas were excavated, with the position of the mausolea within the cemeteries being indeterminate, or it is questionable if the mausolea were contemporary with the surrounding graves.[53]

53 Nagy (1940) 254; Parragi (1976) 179; Tóth (1994) 250; Schmidt (2000) 285–86.

Towns

The urban centres in the hinterland, mainly in the centres of civil administration were the favoured living places of the wealthy classes, especially with public service in the provincial administration being a very good source of income. In Sirmium, which was the administrative centre of Pannonia Secunda and a temporary residence for emperors, it is very hard to describe the topography of the late antique cemeteries before the 5th c. as excavations were mainly focused on the great 5th and 6th c. *martyria* and did not reveal much information about 4th c. mausolea. Some examples were published, mainly because they were thought to be *martyria*.

The northern cemetery of Sopianae provides the best evidence for the morphology of a particular cemetery, since the whole extent of the necropolis is known, and a considerable part has been excavated. The earliest mausoleum was probably a larger rectangular monument, cemetery building XXVIII, built at the end of the 3rd c., but the variation of small apsidal mausolea also appeared quite early. By the second half of the 4th c., the typical mausoleum in the cemetery was the simple rectangular mausoleum with interior floor space of 8.7 m² (100 Roman ft²), which was just enough to hold a small family banquet or other memorial service. The bigger structures (over 30 m²) first followed the regular apsidal plan, but was replaced by a new local layout development – the "Sopianae-Marusinac type". This design was subsequently used for more complex architectural plans. As for the chronological development of the cemetery of Sopianae in general, the use of the necropolis started at the turn of the 2nd and 3rd c. at the north-eastern corner of the city along a main road leading through the hills.[54] From our point of view, the later development is more important, with the first mausolea appearing at the turn of the 3rd and 4th c. The area, which became part of the cemetery in this same period, was further away from the road but probably built along smaller diagonal roads.[55] In the second half of the 4th c., new areas were drawn into the cemetery, which by this time was closer to the western road than to the eastern one. Here, the division of the cemetery into rows of smaller lots has been suggested.[56] The regulation of the brooks and water sources with ditches in the area was also important phenomenon of the local topography; however, the courses of the ditches and brooks were altered during the 230 years of the usage of the cemetery, with new buildings constructed over the backfilled ditches to obtain new lots.[57] It is generally accepted that the cemetery had reached its natural limits by the second half of the 4th c., and from then the system of graves became denser, with every possible spot re-considered as funerary space.[58] The usage of the cemetery ended towards the 430s, when regulation of the area declined, with tombs and mausolea falling into disrepair.[59]

The case of Sopianae is quite special compared to other Pannonian cemeteries, where a high density of mausolea does not prevail; however, it does not mean that the situation in other cities like Savaria, Aquincum or Sirmium could not be similar. The lack of excavations or the fact that the late antique cemeteries were overlain and destroyed by later layers well could be responsible for the disappearance of such cemeteries. As for the location of mausolea within the cemetery in Sopianae or in other cemeteries the practicalities had to play an important role. In Sopianae, because of the high water table and the temporary running water from the hillside, building mausolea right next to each other was avoided. This could explain why solid external floors were built around the mausolea.[60]

Regional Distribution

It is tempting to analyse the distribution of mausolea within the province; however, considering the low levels of data, and the problems with documentations, it is better to avoid any far-reaching conclusions as different parts of the province show significant differences in Late Roman cemeteries. While several extensive cemeteries are known from the north-eastern areas, i.e., the Late Roman province of Pannonia Valeria (Sopianae, Aquincum, Alsóhetény, Solva [Esztergom], Intercisa, Castra Constantia etc.), there is considerably less evidence available from the north-western areas, i.e., Pannonia Prima (Savaria, Vindobona, Nagykanizsa-Palin, Keszthely-Fenékpuszta, Ságvár) (see Fig. 1). Southern Pannonia is even less well researched, with only a few late antique cemeteries known from the region (Sirmium, Cibalae [Vinkovci], and Tekić). While there are some recent excavations, the situation have changed little in the last 30 years.[61] Tóth argued that mausolea were more popular around Sirmium and the south-eastern areas of the Transdanubia.[62] However, there are only four mausolea known from the Sirmium area, with several other sites in Pannonia having similar

54 Kraft (2006) 48–53; Gábor (2016) 163.
55 Kraft (2006) 53–68; Magyar (2007) 45; Gábor (2016) 158.
56 Hudák and Nagy (2009) 35; Gábor (2016) 158.
57 Kraft (2006) 27, 78–79; Gábor (2016) 154–58.
58 Gábor (2016) 164.
59 Kraft (2006) 19–20.
60 Gábor (2016) 162.
61 Lányi and Mócsy (1990) 248.
62 Tóth (2001b) 126.

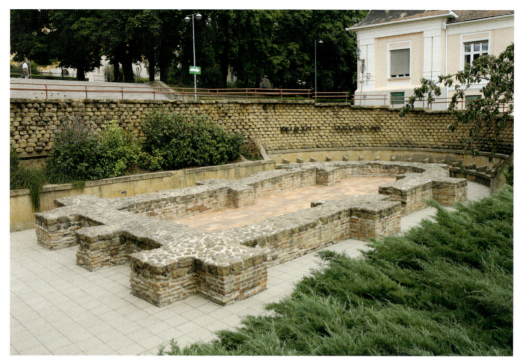

FIGURE 3 The remains of the so-called "Early Christian Mausoleum" in Sopianae (Pécs).
AUTHOR'S PHOTOGRAPH

numbers or more mausolea (e.g. Aquincum and Ságvár). Tóth's argument rests on the presumption that, while Aquincum was a big city, it only had one mausoleum like Constantia; however, Aquincum had much more than one mausoleum. The presence of a single mausoleum in Constantia is rather the consequence of the settlement being an auxiliary fort, rather than its geographical location. Intercisa was also an auxiliary fort in south-eastern Pannonia and has only two excavated mausolea, but the inner fortress of Ságvár, north from Intercisa had three. Tóth has also argued that the popularity of mausolea in south-eastern Transdanubia goes together with the presence of painted *hypogeia* under the mausolea; for this he refers to Sirmium and Sopianae, where the presence of painted *hypogeia* might be the result of influences from the Balkans. While I agree that the painted graves and burial chambers was most likely show Balkan influence, Sirmium is not a good example for mausolea, since only painted graves were found there, not *hypogeia* nor *hypogeia* with mausolea.[63] On the other hand, there is a painted grave, decorated with a Chi-Rho, at Aquincum,[64] which is in north-eastern Transdanubia. In the case of Sopianae, there are three painted *hypogeia* and a couple of painted graves: burial chambers I and II and the so-called "Early Christian Mausoleum"[65] (Fig. 3, Fig. 12).

63 Popović (2011).
64 Topál (2003) 33.
65 Fülep (1984) 76–87; Hudák and Nagy (2009) 14–15, 66–67.

I would argue that they could be the result of a local fashion, especially the painted *hypogeia*, but clearly had origins in southern Pannonia and outside of the province.

Statistics

Within the province, only three sites produced more than 10 mausolea in the archaeological records: Aquincum, Alsóhetény and Sopianae. Aquincum could have even more mausolea, but as modern Budapest overlays the cemeteries, the excavated area remains limited, unlike Sopianae, where the area of the main, northern cemetery was uninhabited for a long time and even now is covered by a park, or Alsóhetény, which is now uninhabited, with its abundant structures recognisable on aerial photographs (Fig. 4). The bigger towns in the province, like Cibalae, Sirmium or Vindobona, have less than 10, but more than two excavated mausolea. And yet, a city like Savaria has only one excavated mausoleum, the same as a small villa settlement or an auxiliary camp. While Sopianae or Alsóhetény could be special cases, un-excavated parts of bigger towns could still hide un-excavated mausolea. The numbers of excavated mausolea – higher in Aquincum, lower in the likes of Savaria or Cibalae – may simply reflect the amount of excavation carried out (over 200 years in the case of Aquincum) and/or the scale of destruction of ancient cemeteries, rather than an actual lack of cemeteries created in parts of late antique Pannonia.

FIGURE 4 Aerial photograph of the cemetery near Alsóhetény.
BY M. SZABÓ, PÉCSI LÉGIRÉGÉSZETI TÉKA, USED WITH PERMISSION

Distribution of Mausolea within the Cemeteries

As for the positioning of mausolea within the cemeteries, a huge mausoleum close to the villa, or small mausolea in a row of an urban cemetery plot is quite typical. In Sopianae, smaller mausolea were built next to each other in rows, while huge mausolea were outside of this system in empty plots. On the other hand, in huge cemeteries, mausolea can be found in no particular order amongst smaller graves. It is hard to investigate the placement of mausolea in connection of the settlement but surely that was an important point too. The placement of villa mausolea close to the villa building (e.g. Kővágószőlős) or to a hill looking over to the villa (e.g. Sárisáp) showed the importance of the noble ancestors and a respect. A hill overlooking the town, the provincial capital was a great spot for representative mausolea in Sopianae. While a probable martyr-burial in Alsóhetény was a good reference point for other mausolea.

The Types of Late Antique Mausolea in Pannonia

Several typologies exist for cemetery buildings: some treat mausolea as an individual type, others put different kinds of mausolea into different groups.[66] Those works, which discuss late antique mausolea in more detail, usually treat them as special Christian features, sometimes drawing a straight line between mausolea and martyria.[67] Testini, one of the main figures of Christian archaeology in the 20th c., described mausolea types as follows: rectangular, polygonal and circular, which can be modified by the number of apses the building has (*unicora, dicora, tricora, tetracora* and *hexacora*).[68] He treats the mausoleum with *hypogeum* as a special type, similarly to Gosztonyi, who was an architect in Pécs before and during the Second World War.[69] There are some shorter publications available, which deal specifically with late antique mausolea in Pannonia; however, none of them used the full scope of evidence.[70] L. Nagy was the first to establish a typology of late antique mausolea in Pannonia. His main groups were the *cella trichorae*, 'chapels' with one apse and rectangular buildings.[71] Gosztonyi placed the buildings from Pannonia into the context of the whole Roman Empire; his main groups were apsidal, single-naved, cross-naved mausolea and mausolea with *hypogea*, all within the framework of Christian buildings.[72] He included structures of other usages, like churches, basilicas and underground

66 Toynbee (1971); Van Hesberg (1992); Gros (2001).
67 Nagy, Lajos (1938) 115–19; Gosztonyi (1943) 76–128; Grabar (1946); Testini (1958) 89–92; Tóth (1994).
68 Testini (1958) 90.
69 Gosztonyi (1943) 120–24; Testini (1958) 90.
70 Nagy (1938) 115–19; Gosztonyi (1943) 76–128; Mócsy (1962) cols. 727–28; Fülep (1984); Mócsy (1990) 262–64; Tóth (1994); Nagy (2002); Gábor (2016).
71 Nagy (1938) 115–19.
72 Gosztonyi (1943) 76–124.

cemetery buildings. Another typology by Radnóti distinguished *hypogeia* with structures above ground (*cella memoriae* or as Radnóti calls them, *Kultraum*) and without.[73] Tóth, still within the group of Christian structures, classified late antique mausolea as rectangular, room with one apse, building with one or two apses, *cellae trichorae*, buildings with five and seven apses, and those with complex ground plans.[74] He also made a typological distinction on the basis of the presence or absence of a *hypogeum*.[75] M. Nagy did not offer a full overview of the evidence; however he suggested two groups based on ideological background, one with Neoplatonist-Christian ideological background and one without it.[76] Gábor followed the typology of Tóth, adding only the octagonal mausolea.[77]

The typology, which I apply within here, is based on the architectural ground plan of the buildings, following the line of thought of the most recent studies.[78] However, I do not accept the division of mausolea into two-storey and one-storey buildings, in which some scholars mean buildings with and without underground sepulchral chambers/*hypogeia*, since mausolea with exactly the same ground plan can be found with and without *hypogeia*, showing that they were additional features.[79] It also could be confusing in such a typology that there were two-storey mausolea, with both stories above ground.[80] There is another factor in the typology of Tóth, which I did not apply, and this is the division of painted and not painted sepulchral chambers, because I think it was an even more minor factor in architecture, than the existence of the *hypogeia*, as *hypogeia* with exactly the same structure are found in both painted and unpainted versions. The division into painted and not painted burial chambers could well be applied to the typology of *hypogeia*, but they are not very useful for the typology of mausolea. They could, however, cause differences in the price of the monuments for the builders.[81]

The typology presented here is based on architectural typology. The division of the material is based mainly on the surviving ground plan. While my typology could well be too simplistic and monolithic, ground plan is the only data that could be collected about nearly every structure under discussion. Obviously, structures with unknown ground plans do not fit into my typology. Information about decoration – apart from the *hypogeia* and the *cella trichora* in Pécs – is very rare, mainly consists of a couple of fragments from wall paintings or small fragments from architectural elements, like consoles from the roof. This data is usually not enough to reconstruct the decoration of the mausolea with any certainty; hence I could not use them as a basis for my typology. Using ground plans can allow differentiation between rectangular, apsidal and central plan mausolea.

Rectangular Structures

Rectangular mausolea (Fig. 5) can be just a bigger or smaller rectangular room. In special circumstances they could be strengthened with buttresses, which did not have other purpose just to support the structure of the buildings. Bigger rectangular mausolea could have more rooms. Examples are:

In Aquincum, the Bécsi Street cemetery housed a rectangular mausoleum, the interior space of which was divided into two rooms, with a door separating them. A coin of Constantius II (337–361) may date the mausoleum to the middle of the 4th c. That same cemetery also housed four other small rectangular mausolea. A built grave from stone slabs, probably from *spolia*, suggests a Late Roman date for one of the mausolea, which could also be applied to the remaining three as well.[82] In Vindobona, a mausoleum or *Grabbau* was found (numbered as H8) in the area of the former *canabae legionis* east of the Late Roman fortress. It was a simple, rectangular building. In Sopianae, several rectangular mausolea were found, such as the mausoleum of burial chamber VIII (in Pécs confusingly mausolea and *hypogea* were numbered consecutively, and all of them called burial chamber), which broadly dated to the second half of the 4th c. (Fig. 5, no. 1).[83] The mausoleum of burial chamber IX was similar to that of chamber VIII and was also dated to the second half of the 4th c. (Fig. 5, no. 2).[84] Not much is known about burial chamber XIV apart of the rectangular ground plan, since none of the walls survived to their full extent,[85] although this area of the cemetery is datable to the 3rd and 4th c. The mausoleum of burial chamber II (Fig. 5, no. 3) in Sopianae was roughly in line with the mausoleum of chamber VIII, yet was quite a distance from it.[86] The date of the

73 Radnóti (1939) 155.
74 Tóth (1994).
75 Tóth (1994) 252.
76 Nagy (2002) 25.
77 Gábor (2016) 27, cf. Tóth (1994).
78 Tóth (1994); Gábor (2016) 59–60.
79 Gosztonyi (1943) 115–24; Tóth (1994) 252.
80 Nagy (1943) 374.
81 Rendić-Miočević (1954); Tóth (1994) 253; Rakocija (2011).

82 Foerk (1923) 76–77.
83 Török (1942) 214; Fülep (1984) 61; Gábor (2016) 59–60.
84 Török (1942) 214; Fülep (1984) 61; Gábor (2016) 59–60.
85 Fülep (1984) 92.
86 Gosztonyi (1942); Gosztonyi (1943) 22–26; Gerke (1952); Fülep and Fetter (1971); Fülep (1984) 42–46; Fülep et al. (1988) 27–31; Schmidt (2000) 293–94; Gáspár (2002) 74–76; Tóth (2006); Magyar (2007) 51; Visy (2007) 139–40; Hudák and Nagy (2009) 30–37; Magyar (2009) 113–14; Magyar (2012b).

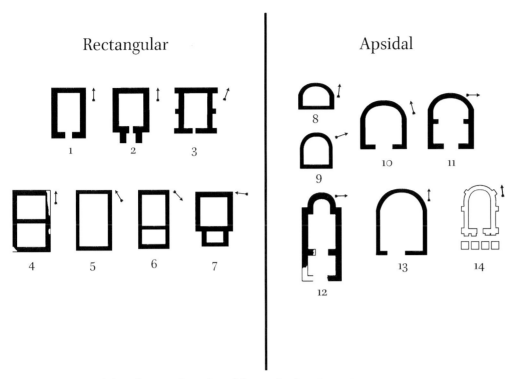

FIGURE 5 Ground plan of rectangular and apsidal mausolea from Pannonia.

mausoleum is usually put to the second half/end of the 4th c. or beginning of the 5th c., based on a coin minted between 367 and 375 found at the entrance of the *hypogeum*.[87] Recently, another rectangular mausoleum was found, under the present day cathedral, datable between 380 and 420.[88] In Sirmium, the excavations of Hytrek in 1882–1883 revealed 8 buildings, surrounded by several graves in a late antique necropolis, east of the city. Buildings marked with III and IV were also rectangular mausolea.[89] The use of the cemetery probably started in the 3rd c., and new excavations have revealed graves from the first half and middle of the 4th c.[90] Thus, the date of building III should be between the 3rd and mid-4th c. Building IV is very similar to building III in terms of ground plan, orientation and dimensions. In Cibalae, in 1968, two rectangular mausolea were found in a Christian cemetery, 1.5 km east of the city along the road to Sirmium, around the supposed cemetery basilica of Pollio the martyr.[91] The cemetery was dated to the 4th–5th c. by Migotti.[92] In Nagykanizsa-Palin, two mausolea was found in 2004 and 2005.[93] One of them had a simple rectangular ground plan and was divided into two rooms.[94] In Castra Constantia, a rectangular mausoleum was also found. The mausoleum was dated to the second half of the 4th c.,[95] simply because of the general dating of the cemetery. In Alsóhetény, mausoleum no. 3 was attached to the wall of the *atrium* of the probable cemetery basilica, developed from mausoleum no. 1, sometime towards the end of the 4th c.

Apsidal Structures (Fig. 5)

The simplest apsidal ground plan for a mausoleum was basically only an apse or a semi-circle. These small mausolea, of which only two were found in the province, both in the northern cemetery of Sopianae, did not even have entrances; they probably only had windows with which to view the inner space (Fig. 5, nos. 8–9). Another type had a rectangular room (*cella*), with one side ending in an apse (Fig. 5, nos. 10, 11, 13). One group of these apsidal mausolea were relatively wide, the length of the buildings was hardly bigger than the diameter of the apse. However, there were narrower buildings, which were more elongated; the length was double or more that of the diameter of the apse (elongated apses). A perfect example is the earliest found Late

87 Fülep and Fetter (1971) 100–103; Fülep (1984) 160; Fülep *et al.* (1988) 31; Hudák and Nagy (2009) 35; Gábor (2016) 51.
88 Tóth *et al.* (2020).
89 Hytrek (1894); Brunšmid (1895) 161–67; Hoffiller (1940) 523; Milošević (1971) 7; Milošević (1976) 26–27, 153–54; Milošević (2001) 172; Jeremić (2005) 125–28.
90 Milošević (1976) 122, 154.
91 Šaranović-Svetek (1967); Dimitrijević (1979) 247–50; Migotti (1994) 193–94.
92 Migotti (1994) 194.
93 Eke and Horváth (2006); Horváth and Frankovics (2008) 53–55.
94 Eke and Horváth (2006) 77.
95 Nagy (1938) 131; Nagy (1942) 772–73.

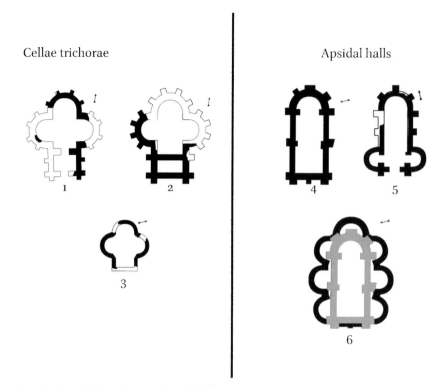

FIGURE 6 Ground plan of *cella trichorae* and apsidal halls (Sopianae-Marusinac type) and variations from Pannonia.

Roman mausoleum in Pannonia: the mausoleum of burial chamber I in Sopianae (Fig. 5, no. 14).[96] Some bigger apsidal mausolea were basilica-like structures, although as they were much smaller than Early Christian basilicas, I call them *apsidal halls*. It is characteristic that the diameter of the apse was smaller than the length of the shorter side. These structures were mostly found in or around Aquincum. The origin of this ground plan goes back to the simple basilica plan. This was in use already in the 2nd c. and mausolea, in the form of these apsidal halls, were used for funerary banquets. In Sárisáp, about 25 miles from Aquincum next to a Roman settlement, most likely a villa, an apsidal hall mausoleum was discovered on the southern side of a hill, overlooking the settlement (Fig. 5, no. 12).[97]

As local variation of these apsidal halls was developed in Sopianae and its vicinity. I call it the "*Sopianae – Marusinac type*", since it resembles a mausoleum found in Marusinac, a cemetery of Salona dated to the early 4th c.[98] It is generally formed by a rectangular hall and an apse, but the hall is even longer than in case of the elongated apses. It is also a characteristic of this type that it has buttresses. The so-called 'Early Christian Mausoleum' was a bigger version of the mausoleum of burial chamber I, but built earlier (Fig. 6, no. 4). As for the dating of the 'Early Christian Mausoleum', Fülep coin-dated the mausoleum to the middle of the 4th c.[99] Hudák and Nagy have dated the first painting of the *hypogeum* under the mausoleum also to the middle of the 4th c.[100] It is likely that the building was erected for an important local family or individual and was in use for several decades. The 'Early Christian Mausoleum' clearly provided a sample for a similarly sized mausoleum near a villa at Kővágószőlős, only 6 miles from Sopianae (Fig. 6, no. 5).[101] The ground plan followed the 'Early Christian Mausoleum' of Sopianae with the addition of two side apses at the southern end of the building. The construction of the mausoleum was dated to the 350s by the excavator,[102] but she did not take into consideration that three coins of Valentinian I, dated to AD 367, were found in the *hypogeum*, one inside the walls, which suggests that the *terminus post quem* for the building of the mausoleum is rather AD 367.[103] The latest development of this ground plan can be seen on the so-called *cella septichora* from Sopianae, which can

96 Koller (1804).
97 Balogh (1927) 201; Nagy (1931) 31; Balogh (1934) 50–51; Horváth et al. (1979) 308–309; Gáspár (2002) 98–99.
98 Dyggve and Egger (1939); Grabar (1946) 94–95; Deichmann (1970) 163–64; Brenk (1995) 88–89; Schmidt (2000) 303–305; Dukić (2009) 71–73.
99 Fülep (1977b) 254–55; Fülep (1987) 38; Fülep et al. (1988) 20–22.
100 Hudák and Nagy (2009) 26.
101 Burger (1987) 165–79.
102 Burger (1987) 178–79.
103 Burger (1987) 179.

be interpreted as a structure where seven apses were attached to the plan of the 'Early Christian Mausoleum' (Fig. 6, no. 6). The *cella septichora* is the biggest mausoleum in Sopianae.[104] Fülep suggested a date for the *septichora* at the very end of the 4th c. or the first two decades of the 5th c.,[105] while Tóth dated it to the 430s because of its unfinished state, since the abandonment of the province was around that time.[106]

Other apsidal type is an apsidal building with two apses. At the edge of cemetery I in Sárvár, a mausoleum was found with a rectangular ground plan and two side apses (Fig. 10, no. 6).[107] It can be interpreted either as a triconch mausoleum, where in place of the third apse there is a rectangular room, or a rectangular mausoleum with two side apses. It also resembles the ground plan of the antechambers at Alsóhetény and Kővágószőlős (Fig. 6, no. 5; Fig. 9, no. 11). Due to these differences, I list this form as an independent type. Radnóti dated the structure to the 4th c. on the basis of the general date of the cemetery.[108] Schmidt suggested a date at end of the 4th c., since the building was on the eastern edge of the cemetery, in an area likely to brought in use towards the end of the lifespan of the cemetery.[109]

Triconch mausolea or *cella trichorae* (Fig. 6) were also found in Pannonia. In Aquincum, a *cella trichora* was found in the Vihar Street cemetery[110] with a *terminus post quem* of the reign of Valentinian I (Fig. 6, no. 3).[111] In Sopianae, it seems that the local architects re-used the ground plan of the 'Early Christian Mausoleum' not just for the mausoleum in Kővágószőlős, but for *cellae trichorae*, as well. They only had to attach two side apses with the same diameter as the main apse to adapt the plan. The first *cella trichora* was discovered in 1922 and was re-excavated in 1955 by Radnóti and Fülep (Fig. 6, no. 1).[112] The date of the construction of the mausoleum could be put around the end of the 4th or the beginning of the 5th c. considering its topographical position within the cemetery.[113] Schmidt argued that the mausoleum housed the remains of an important individual, judging from its extensive dimensions and cost of its construction.[114] Gábor argues in favour of the Christian character of the building.[115] *Cella trichora* II of Sopianae was excavated in 2010 and 2011 by Tóth and a relatively detailed excavation report was published in 2011 (Fig. 6, no. 2).[116] The excavator dated the building between 380 and 420 but did not provide the basis for his dating.[117]

Central Plan Structures
A mausoleum with a ground plan of a slightly elongated Greek cross, found in Fenékpuszta, 3 km south of the inner fortress, at a site called Halászrét (Fig. 9, no. 9). The mausoleum was at the edge of a Late Roman cemetery, together with some other graves.[118] One could interpret it as a structure with rectangular ground plan, with two smaller rooms attached to the rectangular 'main nave'. The foundation of a *mensa* were found at the eastern end of the mausoleum.[119] The mausoleum was dated to the 5th c. based on stratigraphic observations.[120]

Central plan rotundas (Fig. 7) in Late Roman funerary contexts were mainly hexagonal and octagonal buildings in Pannonia. A hexagonal mausoleum with five apses was found in the southern area of the former *canabae legionis* of the legionary fortress of Aquincum (Fig. 7, no. 2).[121] The building was dated to the end of the 3rd c. by the excavator on the basis of art historical parallels from Aquincum; however, she dates the first burials to the second half of the 4th c.[122] In this way she fails to explain what the building was used for between the end of the 3rd and the middle of the 4th c. As only two apses were excavated, it is possible that the earlier graves were in the other apses, but I would also consider that the building has built in the second half of the 4th c. While some art historical parallels may point to the end of the 3rd c., the ground plan of the building has its parallel in the mausolea of Iovia (mausoleum no. 1), which is dated to the second half of the 4th c. It can be presumed that some painting styles, which were introduced at the end of the 3rd c. in an Aquincum villa, were still applicable in a funerary context in the second half of the 4th c.

104 Visy (2006).
105 Fülep (1984) 285; cf. Fülep and Burger (1979) 250.
106 Tóth (2001a) 1133.
107 Radnóti (1939) 152–53; Burger (1966) 107; Schmidt (2000) 365, 367.
108 Radnóti (1939) 154.
109 Schmidt (2000) 289.
110 Nagy (1931) 9–17.
111 Lőrinc (1980) 50–52.
112 Szőnyi (1927); Nagy (1931) 18; Nagy (1938) 34; Gosztonyi (1939) 97; Gosztonyi (1943) 14–16; Fülep (1959a); Fülep (1959b); Fülep (1969a) 152; Fülep and Duma (1972); Fülep (1984) 51–53, 296–301; Fülep et al. (1988) 31–35; Schmidt (2000) 294–95; Tóth (2006) 83; Hudák and Nagy (2009) 73–76; Magyar (2012a) 131; Gábor (2016) 74–76.
113 Fülep (1984) 297; Schmidt (2000) 294.
114 Schmidt (2000) 295.
115 Gábor (2016) 76.
116 Tóth (2011).
117 Tóth (2011) 11.
118 Sági (1960) 188–96.
119 Sági (1960) 196.
120 Sági (1960) 195–96.
121 Parragi (1976); Soproni (1985) 70–71 and fig. 41; Tóth (1990) 21, fig. 9; Tóth (1994) 249, Abb. 9; Madarassy (2000) 34–35; Schmidt (2000) 286; Gáspár (2002) 17–20; Nagy (2002) 24–25.
122 Parragi (1976) 179.

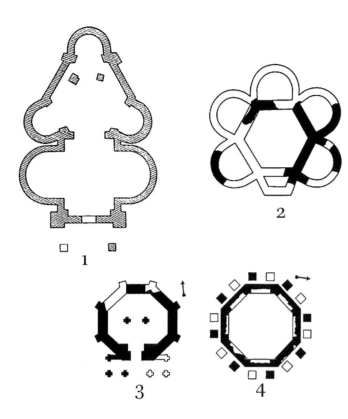

FIGURE 7
Ground plan of hexagonal and octagonal mausolea from Pannonia.

As I mentioned above, mausoleum no. 1 in Alsóhetény was a hexagonal building, with apses attached on every other side (Fig. 7, no. 1). An apsidal antechamber, similar to the antechamber of the mausoleum in Kővágószőlős, was attached to the building. The floor of the main building was probably covered with marble veneer and mosaics, but since it was only at the depth of the modern, ploughed surface, it did not survive; only some marble and mosaic fragments were found, along with some gold and glass mosaic pieces, probably from the walls.[123] White marble column fragments and plates, and a lattice fragment, were found, together with green porphyry fragments.[124] I would argue that the mausoleum in Alsóhetény was clearly built for someone of high rank. The later restructuring of the building would suggest the burial of a bishop, a *confessor* or even a martyr.[125] The ground plan of the mausoleum copies the similar high status mausolea in Thessalonica and Milan; however, the mausoleum in Alsóhetény is a smaller version, which seems sensible in a relatively remote setting with no links to the imperial family.[126] Mausoleum no. 1. could not be built before the end of the 350s or in the 360s as dated by coins.[127]

Mausolea with octagonal ground plans largely follow the most famous mausoleum *topos* in Late Antiquity: the mausoleum of Diocletian in Split (Fig. 8); however, an octagonal ground plan was used for mausolea earlier.[128] These buildings usually had a circular portico around them (*peripteros*), similar to the mausoleum of Diocletian, or a portico in front of their façade. A Late Roman octagonal mausoleum was found in Livada close to Sirmium (Fig. 7, no. 4), most probably belonging to a villa.[129] The mausoleum was dated to the late 3rd c.; however, no basis for such a dating has been put forward, apart of some architectural parallels.[130] Another octagonal mausoleum, burial chamber V in Sopianae, was discovered right next to the mausoleum of burial chamber I and excavated between 1999 and 2001 (Fig. 7, no. 3).[131] Three phases of construction were identified during the excavations between the middle of the 4th c. and the beginning of the 5th c.[132] As the mausoleum likely only

123 Tóth (1988) 41; Tóth (2009) 54–57.
124 Tóth (1988) 41.
125 About martyrs in Iovia, see Nagy (2012); cf. Schmidt (2000) 291.
126 Cf. Calderini (1950); Vickers (1973); Tóth (1988) 46–51; Johnson (2009) 70–74.
127 Tóth (1988) 51–52; Tóth (1994) 250; Tóth (2009) 55–56.
128 Testini (1958) 620–28; De Rossi (1980) 154–57.
129 Brukner (1987); Brukner (1995a); Brukner (1995b); Milošević (1995); Petrovič (1995); Milošević (2001) 175; Đorđević (2007) 29; Magyar (2012a) 130.
130 Milošević (2001) 75.
131 Gosztonyi (1939) 117; Gosztonyi (1943) 30–31; Fülep (1984) 50; Kárpáti (2002); Gábor (2007) 367; Hudák and Nagy (2009) 62–63; Magyar (2012a) 131–35; Gábor (2016) 53–58.
132 Gábor (2016) 56.

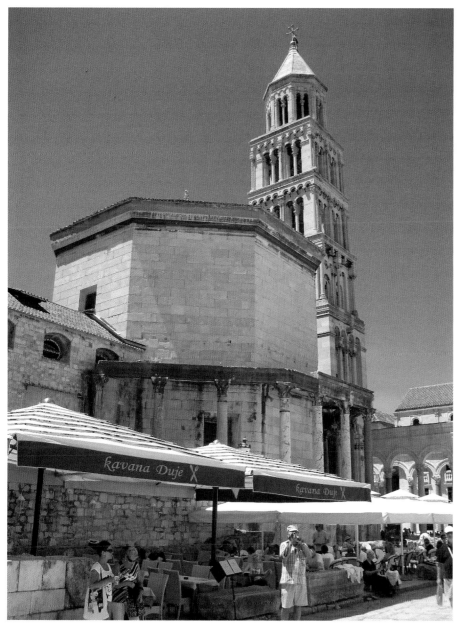

FIGURE 8 The mausoleum of Diocletian in Split.
AUTHOR'S PHOTOGRAPH

contained only one grave originally,[133] it could be that this marks the burial of someone who had given great service to the community and received the mausoleum as a reward.

Grouping by Size

The division of mausolea into 'small' and 'grand' was suggested by French scholarship and also, independently of their research, by myself.[134] My typology was based mainly on ground space: mausolea with an area less than 50 m² were classed as 'small', those between 50 and 100 m² were called 'middle-sized' and over 100 m² were called 'large' mausolea.[135] It is probably not correct to use the word 'typology' for the division of structures based on size, but there is a clear phenomenon here. However, reconsidering my work, I would rather divide the mausolea into two groups. Some huge mausolea with several graves (or places for graves in case of the unfinished *cella septichora* in Sopianae) had covered a much larger area (with greater body mass) than other smaller structures with one to three graves. I call the first group 'grand' mausolea, where 2 or 3 generations of a family are buried and the second group 'small' mausolea

133 Gábor (2016) 55.
134 The papers in vol. 18 of *Hortus Artium Medievalium*; Magyar (2012a).
135 Magyar (2012a) 126.

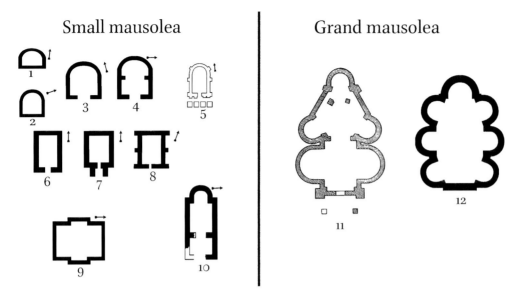

FIGURE 9 Small and grand mausolea from Pannonia.

(Fig. 9), which were built for only one individual and occasionally another burial took place. 'Grand' mausolea and 'small' mausolea will have involved a significant difference in building cost. The 'small' mausolea could also be built by families, but they could only afford a place for a nuclear family. 'Grand' mausolea on the other hand served the family for generations and had an outstanding mass of body in the cemetery, showing the importance of the family.

The Chronology of Late Antique Mausolea in Pannonia

Based on the dating of individual structures, one can set up an approximate typo-chronology (Fig. 10). There are the long-used forms like mausolea with simple rectangular ground plan or *trichorae* (Fig. 10, nos. 1–2), which can be found all over the funerary architecture even before the imperial period. Rectangular, house-like mausolea were already found in the Isola Sacra cemetery of Portus, just like as in the Vatican cemetery under St. Peter's. The *trichora* was known in Italy from the 2nd c. These forms remained in use, not just in the Late Roman period, but beyond as well.

However, some local development can be observed. In the first half of the 4th c., apart from the abundant rectangular mausolea, an apsidal ground plan appeared in Sopianae and Intercisa, where the shorter side opposite the entrance was curved (a 'church-like' ground plan) (Fig. 10, no. 3). This form appeared in the first half of the century and remained in use throughout the Late Roman period. However, based on that new form (new in funerary context in Pannonia) and the earlier mentioned general forms, more complex planned structures appeared by the second half of the 4th c., like elongated apsidal halls, rectangular mausolea with two side apses, central planned mausolea with three or five apses, and some with an attached apsidal entrance room (Fig. 10, nos. 4–6). This shows a tendency to build more complex structures. There is a connection between the size and a more complex ground plan. Small mausolea were mainly simple planned rectangular or apsidal structures, even at the end of the 4th and the beginning of the 5th c. Grand mausolea usually had more complex ground plans and became even more so by the end of the 4th c. The elongated apsidal halls got two side apses, so in a way they became *trichorae* (Fig. 10, nos. 10–11), while even small apsidal halls got porticoes (Fig. 10, no. 7). By the early 5th c., a complex form appeared when the elongated apsidal hall got six more apses ('*cella septichora*') (Fig. 10, no. 12). This is also the time when a Greek cross-like ground plan appeared in Pannonian funerary contexts (Fig. 10, no. 13). While it can be due to the state of research, it seems that in Pannonia the habit of building mausolea was the strongest in the second half of the 4th c. (Fig. 11).

Who Were the Builders?

Funerary monuments may have "kept the dead among the living,"[136] but it is a sad fact that very few Late Roman funerary inscriptions survived from mausolea from Pannonia.[137] This leaves drawing parallels from earlier high-status burials as the only way to investigate mausoleum builders in Late Roman Pannonia. Early Imperial funerary monuments acted as a long term visual indicator of the status of an individual and of the individual's family, providing a permanent record of the

136 Hope (2003) 122.
137 CIL 3.3576.

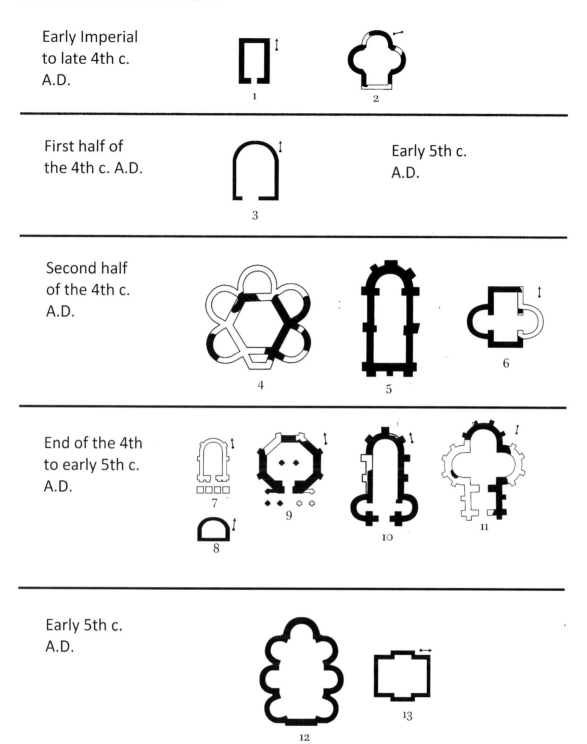

FIGURE 10 The chronological sequence of mausolea from Pannonia.

achievements of the deceased and proof of the family's success.[138] The mausolea themselves were part of the self-representation of the individual or the family, with a whole range of visual effects applied, such as frescos, sculpture, architectural details or inscriptions in or on the mausoleum itself or in any *hypogeum* (Fig. 12).[139] The size, decoration and placement of the monuments all played a role in that representation.[140] This was of course dependent on the financial capabilities of the builders and their needs.[141] In Roman society, children, who were just as today the usual heirs, inherited not just material possessions of their parents, but also their social *persona*.[142] Hence it was in their interest to

138 Carroll (2006) 30, 87; Pearce (2015) 1211.
139 Hesberg (1992) 12–13, 243.
140 Hesberg (1992) 235.
141 Hesberg (1992) 235.
142 Hopkins (1983) 236.

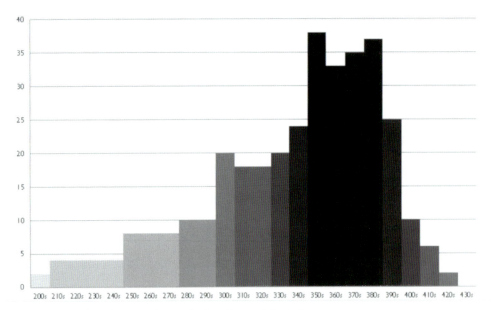

FIGURE 11 Number of excavated mausolea from Pannonia by dating.

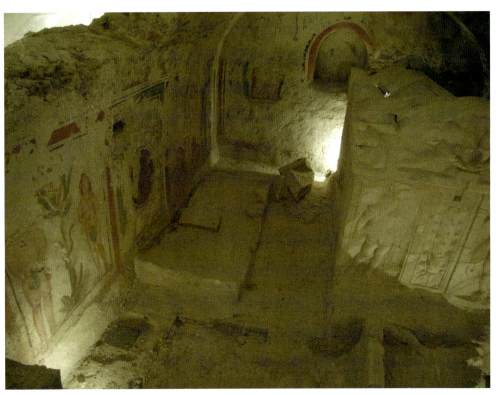

FIGURE 12 The interior of the *hypogeum* under the so-called "Early Christian Mausoleum" in Sopianae (Pécs).
AUTHOR'S PHOTOGRAPH

show the best side and highest possible social status of their parents. Some wealthy and powerful people left a huge amount of money for the erection of their funerary monuments to ensure that their memory would last.[143] Funerary monuments could also be built by heirs, other than children (mainly following the orders of the will) and communities out of respect.

There are very few details about the potential costs involved in building a mausoleum in Late Antiquity, but there is some data from Early Imperial times. This shows a great range of cost from 6,000 sesterces for a 20 m² floor space, 5 m height in the 2nd c. to a million sesterces for the impressive monument of Caecillia Metella

143 Hopkins (1983) 247.

on the *Via Appia*.[144] The closest to late antique mausolea in terms of status were the burials in free-standing, decorated sarcophagi, about which some information survives. After an analysis of decorated sarcophagi from Rome, Birk drew the conclusion that mainly members of the rich, upper class chose this burial form; however, most of them were not part of the nobility.[145] We have also some data about the cost of sarcophagi in Late Antiquity, which shows that a considerable amount of money was needed for a decorated sarcophagus burial.[146] The costs were clearly prohibitive, limiting who could afford to build a mausoleum and what size it might be. Inheriting a family mausoleum was close to inheriting a house. It is interesting to compare the price of modern mausolea in the United States, which ranges from $150,000 into the millions.[147] Only a very few could afford it, a situation almost certainly similar to Late Antiquity.

Mausolea were not only a sign of wealth. They also represented the beliefs and tastes of the individual who built them. While no standing mausolea survives from Late Roman Pannonia, the *hypogeum* of a huge underground family mausoleum survived in Sopianae, the so-called 'Early Christian Mausoleum', which shows the wealth, status, and belief of the family members. Expensive material was applied (marble sarcophagus), the building was in the best spot and the *hypogeum* were decorated by Biblical scenes. Since the *hypogeum* was only accessible during funerals, I would argue that burial representation was not only static in terms of standing monuments, but the funeral itself was part of the representation. The annual remembrance rituals were also in or at the mausolea, so everybody could identify the living members of the society with their ancestors represented by the mausolea.

In short, late antique mausolea in Pannonia (and probably in other provinces) were set up by individuals or families, who had high status or wanted to be represented like that, had enough money, or wanted to be represented as Romans, instead of their other identities. They could be well off members of the provincial administration, high status officers or soldiers (Roman or barbarian), members of important families or prominent members of the local community. Town authorities or local Christian communities could also build a mausoleum for honoured individuals. Villa owners often built a family mausoleum on their estate. They had the financial means and like the splendid villa buildings itself, mausolea also showed their status to visitors and passers-by.

Conclusions

The goal of this paper was to provide critical overview of late antique mausolea in Pannonia, analyse the dataset and examine some of the problems and research directions connected with them. I drew attention to the fact that the forms of late antique mausolea partly originated in Early Imperial tomb design; hence treating them only as Christian *memoriae* would be problematic. I cannot agree with the statement of Mócsy,[148] which had a strong impact on Hungarian scholarship, that late antique mausolea were mainly cult buildings and provided space for Early Christian cults, as opposed to pagan burials. Pagan mausolea in the Early Imperial period were also places of funerary cult; closed *cellae* were just as popular in the Early Imperial period as open monuments. My corpus could be also a useful tool for further research in late antique funerary studies in other provinces as well, as the basic types of mausolea, identified in Pannonia occur in other provinces.

Several conclusions can be drawn from the analysis presented in this paper. It seems clear that simple rectangular mausolea were the most popular form; other types were relatively few and could be treated as extraordinary. As for the ground plan of the buildings, I would argue that the very small mausolea, into which it was impossible to enter, were just tombs (*sepulchri*) rather than monuments (*monumenti*), more for the placement of the body than for preserving and presenting the memory of the deceased and providing markers for where the funerary rituals could be held. This distinction between the function of a tomb/grave and that of funerary monuments was an important one in Antiquity. Larger mausolea also provided interior space for cults of the dead, while 'grand' mausolea represented wealth and status and were focal points of the late antique cemeteries in the province.

The topography of the mausolea shows that they were most popular in towns and pseudo-towns (inner forts), although high status mausolea built next to rural villas also continued to be popular in Late Antiquity, just like in the earlier periods. Villages and auxiliary *vici*, apart from some exceptions, did not have mausolea, most likely because of the lack of inhabitants who could afford such a building. The inner topographies of the

144 Hesberg (1992) 10.
145 Birk (2013).
146 Birk (2013).
147 https://www.mausoleums.com/what-to-look-for-when-investing-in-a-private-mausoleum/ [Accessed on 21st of July 2022].
148 Mócsy (1990) 264.

cemeteries could be studied only in exceptional cases, since there are very few late antique Pannonian cemeteries with mausolea that have been excavated extensively with modern field methods. However, the cemetery of Sopianae was amongst these exceptional sites and provided very useful information for the inner topography for a late antique urban cemetery in the province, demonstrating the factors that played a role in the process of its development: roads, natural waterways, other geographical features and the topographical relation of the cemetery and the settlement. In Sopianae, even the chronological development of the cemetery topography could be studied, which captured the change in high status funerary representation in the province, with 2nd–3rd c. funerary enclosures in the earliest part of the cemetery giving way to mausolea at the end of the 3rd c. By the second half of the 4th c., mausolea had become very popular in that cemetery. This might or might not be connected to the spread of Christianity, but some of the buildings were undoubtedly connected with the new religion. Christianity was clearly represented in the Biblical themes on the walls of the *hypogeum* of the so-called 'Early Christian Mausoleum' and in burial chamber I in Sopianae. Other sites, such as the *ad sanctos* mausolea in Cibalae and their probable occurrence in Savaria and Iovia, shows that our knowledge about the role of Christianity in funerary representation and the erection of mausolea is still very limited. New research remains to be done, which should shine new light on the *ad sanctos* burial north of the river Drave and the nature of church organisation in this area.

Religious, political, cultural, and ethnological changes could be responsible for the variations in funerary architecture during Late Antiquity. Mausolea were high status buildings built for people who were important in local society. These people (or their family) expressed their self-identity or desire for social recognition by the kinds of monuments they built for themselves and by the placement of those monuments. Consideration of the socio-economic and religious context seems to be very important for the contemporary commissioners of these buildings. They were not just for display but stood in place of the deceased members of the family, confirming the standing of the family in the future through the memories they evoked. The spread and growing popularity of Christianity is clearly represented in the Biblical themes on the walls of the crypt of the so called 'Early Christian Mausoleum' or in the St. Peter and Paul Burial Chamber in Pécs.[149]

The best sources of information about the dead commemorated in mausolea are usually inscriptions; however, very few inscriptions survived in Pannonia that can be related to mausolea with certainty. A number of inscriptions from late antique mausolea were recovered in Salona, which confirmed the previous suggestions that mausolea were used by privileged groups: in this case, senators and governors could be identified together with villa owners.[150]

Late antique Pannonian mausolea were special funerary buildings found in significant enough numbers to stand out in comparison with other provinces. Their role in social representation, similar to other high-status burials, was very important as it was a general requirement in late antique provincial society to represent one's high social standing. Families diligently kept up the memory of their deceased members, demonstrating their wealth and status, not just for pious reasons, but also to justify the standing of the family within local society. This function was probably even more important – at least in case of the grand mausolea – than the providing of places for burial and settings for funerary cult. The monuments stood in place of the social self of those individuals, who were once the leaders and important functionaries of their community, as a reminder of their importance and a memento of their achievements.

Bibliography

Primary Sources

Plin. *Ep.* = B. Radice ed. and transl., *Pliny the Younger. Letters, Volume I: Books 1–7* (Loeb Classical Library 55) (Cambridge Mass. 1969).

Secondary Sources

Balogh A. (1927) "A római Pannonia kereszténységéről" [About the Christianity of Roman Pannonia], *Katholikus Szemle* 41 (1927) 193–204.

Balogh A. (1934) "Néhány adat Esztergom városának és vármegyének római koráról" [Some details of the Roman times of the city and county of Esztergom], *Esztergom Évlapjai* 7 (1934) 41–52.

Birk S. (2013) *Depicting the Dead. Self-representation and Commemoration on Roman Sarcophagi with Portraits* (Aarhus 2013).

Bodel J. (1997) "Monumental villas and villa monuments", *JRA* 10 (1997) 5–35.

149 Hudák and Nagy (2009) 18–26, 39–61.

150 Dyggve and Egger (1939) 1–13; Gauthier *et al.* (2010) 13, see also nos. 106, 137, 154, 155, 159, 177, 221, 223, 236, 355, 361, 434, 436, 442, 460, 564, 612, 655, 667, 794 and 796.

Burger A. Sz. (1966) "The Late Roman cemetery at Ságvár", *ActaArchHung* 18 (1966) 99–234.

Burger A. Sz. (1987) "The Roman villa and mausoleum at Kővágószőlős, near Pécs (Sopianae). Excavations 1977–1982", *A Janus Pannonius Múzeum Évkönyve* 30–31 (1985–1986) 65–228.

Brenk B. (1995) "Der Kultort, seine Zugänglichkeit und seine Besucher", in *Akten des XII. Internationalen Kongresses für christliche Archäologie, Bonn 22. 28. September 1991*, edd. E. Dassman and J. Engemann (Münster 1995) 69–122.

Brukner O. (1987) "Sremska Mitrovica/Livade. villa rustica", *Arheološki Pregled* 28 (1987) 113–18.

Brukner O. (1995a) "Rimska naselja i vile rustike" [Roman settlements and a villae rusticae], in *Arheološka istraživanja duž autoputa kroz Srem,* ed. Z. Vapa (Novi Sad 1995) 137–74.

Brukner O. (1995b) "Mauzolej – oktogonalna građevina" [Mausoleum – an octagonal tomb], in *Arheološka istraživanja duž autoputa kroz Srem,* ed. Z. Vapa (Novi Sad 1995) 175–80.

Brunšmid J. (1895) "Arheološke bilješke iz Dalmacije i Panonije" [Archaeological notes on Dalmatia and Pannonia], *Vjesnik Hrvatskoga Arheološkog Društva* n.s. 1 (1895) 148–83.

Calderini A. (1950) "I mausolei imperiali di Milano", in *Arte del primo millenio: atti del II°convegno per studio dell'arte alto medio evo* (Turin 1950) 42–55.

Calza G. (1940) *La necropoli del porto di Rome nell'Isola Sacra* (Rome 1940).

Carroll M. (2006) *Spirits of the Dead. Roman Funerary Commemoration in Western Europe* (Oxford 2006).

Curl J. S. and Wilson S. (2015) *The Oxford Dictionary of Architecture* (Oxford 2015).

Deichmann F. (1970) "Märtyrerbasilika, Martyrion, Memoria und Altargrab", *RömMitt* 77 (1970) 144–69.

Dimitrijević S. (1979) "Archäologische Topographie und Auswahl archäologischer Funde vom Vinkovcer Boden", in *Corolla Memoriae Iosepho Brunšmid dicata*, ed. Ž. Rapanić (Vinkovci 1979) 201–82.

Đorđević M. (2007) *Arheološka nalazišta rimskog perioda u Vojvodini* [Archaeological Sites from the Roman Period in Vojvodina] (Belgrade 2007).

Dukić J. (2009) *Vita e fede dei cristiani di Salona secondo le iscrizioni* (Rome and Split 2009).

Dyggve E. (1935) "Das Mausoleum in Pécs (Ein christliches Heroon aus Pannonia Inferior)", *Pannonia* 1 (1935) 62–77.

Dyggve E. and Egger R. (1939) *Der altchristliche Friedhof Marusinac* (Vienna 1939).

Eisner J. (1996) *Art and Text in Roman Culture* (Cambridge 1996).

Eke I. and Horváth L. (2006) "Late Roman cemeteries at Nagykanizsa", *Régészeti Kutatások Magyarországon* (2005) 73–86.

Foerk E. (1923) "Ujabb leletek a Viktoria telkén [New finds from the Victoria estate]", *Budapest Régiségei* 10 (1923) 74–80.

Fülep F. (1959a) "Neuere Ausgrabungen in der Cella Trichora von Pécs (Fünfkirchen)", *ActaArchHung* 11 (1959) 399–417.

Fülep F. (1959b) "Újabb ásatások a pécsi cella trichorában" [Recent excavations in the cella trichora of Pécs] *A Janus Pannonius Múzeum Évkönyve* 4 (1959) 75–91.

Fülep F. (1962) "Újabb kutatások a pécsi későrómai temetőben [New investigations in the Late Roman cemetery of Pécs]", *ArchErt* 89 (1962) 23–46.

Fülep F. (1969) "Scavi archeologici a Sopianae", *Corso di Cultura sull'Arte Ravennate e Bizantina* 16 (1969) 151–63.

Fülep F. and Duma Gy. (1972) "Examinations of the wall paintings in the cella trichora of Pécs", *FolArch* 23 (1972) 195–213.

Fülep F. (1977a) *Roman Cemeteries on the Territory of Pécs (Sopianae)* (Budapest 1977).

Fülep F. (1977b) "A pécsi ókeresztény mauzóleum ásatása" [Excavations of the Early Christian mausoleum of Pécs], *ArchErt* 104 (1977) 246–57.

Fülep F. (1984) *Sopianae. The History of Pécs During the Roman Era and the Problem of Continuity of the Late Roman Population* (Budapest 1984).

Fülep F. (1987) "A pécsi későrómai-ókeresztény mauzóleum feltárásáról" [The excavation of the Late Roman-Early Christian mausoleum in Pécs], *A Janus Pannonius Múzeum Évkönyve* 32 (1987) 31–44.

Fülep F. and Fetter A. (1971) "Neuere Forschungen in der ausgemalten, frühchristlichen Grabkammer Nr. II von Pécs", *A Janus Pannonius Múzeum Évkönyve* 16 (1971) 91–103.

Fülep F. and Burger A. (1979) "Baranya megye a római korban" [County Baranya in Roman times], in *Baranya megye története az őskortól a honfoglalásig*, ed. G. Bándi (Pécs 1979) 223–328.

Fülep F., Bachman Z. and Pintér A. (1988) *Sopianae-Pécs ókeresztény emlékei* [The Early Christian remains of Sopianae-Pécs] (Budapest 1988).

Fülep F. and Bachman Z. (1990) *Pécs frühchristliches Mausoleum* (Budapest).

Gábor O. (2007) "Ókeresztény jellegek a pécsi késő antik temetőben" [Early Christian characteristics in the Late Antique cemetery of Pécs], in *FiRKáK I. Fiatal római koros kutatók I. konferenciakötete. Xantus János Múzeum, Győr 2006. március 8–10.*, ed. Sz. Bíró (Győr 2007) 367–77.

Gábor O. (2013) "Sopianae ókeresztény temetőjének épületei" [The buildings of the Early Christian cemetery of Sopianae], in *Pécs története I.*, ed. Zs. Visy (Pécs 2013) 195–222.

Gábor O. (2016) *Sopianae késő antik temetői épületei* [The Late Antique Cemetery Buildings of Sopianae] (Kaposvár – Pécs 2016).

Gáspár D (2002) *Christianity in Roman Pannonia. An Evaluation of Early Christian Finds and Sites in Hungary* (BAR International Series 1010) (Oxford 2002).

Gauthier N., Marin E. and Prévot D. (2010) eds. *Salona IV: inscriptions de Salone chrétienne, IV*e*–VII*e *siècles.* (Rome – Split 2010).

Gerke F. (1952) "Die Wandmalereien der neugefundenen Grabkammer in Pécs (Sopianae). Ihre Stellung in der spätrömischen Kunstgeschichte", in *Neue Beiträge zur Kunstgeschichte des 1. Jahrtausends, 1. Halbband: Spätantike und Byzanz* (Forschungen zur Kunstgeschichte und christliche Archäologie 1) (Baden-Baden 1952) 115–37.

Gosztonyi Gy. (1939) *A pécsi Szt. Péter székesegyház eredete* [The origin of the St Peter Cathedral of Pécs]. (Pécs 1939).

Gosztonyi Gy. (1940) "A pécsi hétkaréjos ókeresztény temetői épület" [The Early Christian cemetery building with seven apses from Pécs], *ArchErt* 67 (1940) 56–61.

Gosztonyi Gy. (1942) "A pécsi II. számú ókeresztény festett sírkamra és sírkápolna" [The Early Christian painted burial chamber no. 2. and chapel from Pécs], *ArchErt* 69 (1942) 196–206.

Gosztonyi Gy. (1943) *A pécsi ókeresztény temető* [The Early Christian cemetery of Pécs] (Pécs 1943).

Grabar A. (1946) *Martyrium. Recherches sur le culte des reliques et l'art chrétien antique* (Paris 1946).

Gros P. (2001) *L'architecture romaine: du début du III*e *siècle av. J.-C. à la fin du Haut-Empire*, vol. 2 (Paris 2001).

Haas M. ed. (1845) *Baranya* (Pécs 1845).

Henszlmann I. (1873) "Die altchristliche Grabkammer in Fünfkirchen", *Mitteilungen der K. u. K. Central-Commission zur Erforschung und Erhaltung der Baudenkmale* 18 (1873) 57–83.

Hesberg von H. (1992) *Römische Grabbauten* (Darmstadt 1992).

Hoffiller V. (1940) "Prolegomena zu Ausgrabungen in Sirmium", in *Bericht über den VI. Internationalen Kongress für Archäologie, Berlin 21–26. August 1939* (Berlin 1940) 517–26.

Hope V. (2003) "Remembering Rome: memory, funerary moments and the Roman soldier", in *Archaeologies of Remembrance: Death and Memory in Past Societies*, ed. H. Williams (New York 2003) 113–40.

Hopkins M. K. (1983) *Death and Renewal. Sociological Studies in Roman History* (Cambridge 1983).

Hornblower S. (1982) *Mausolus* (Oxford 1982).

Horváth I., Kelemen M. H. and Torma I. (1979) *Komárom megye régészeti topográfiája: Esztergom és a dorogi járás* [The archaeological topography of county Komárom: Esztergom and the district of Dorog]. (Budapest 1979).

Horváth L. and Frankovics T. edd. (2008) *Régészeti feltárások az M7–M70 autópálya Zala megyei nyomvonalán* [Archaeological excavations on the track of the M7–M70 motorway in county Zala]. (Zalaegerszeg 2008).

Hudák K. (2009a) "The chronology of the paintings in the Saint Peter and Paul burial chamber of Sopianae", in *Ex officina ... Studia in honorem Dénes Gabler*, ed. Sz. Bíró (Győr 2009) 225–38.

Hudák K. (2009b) "The iconographical program of the wall-paintings in the Saint Peter and Paul burial chamber of Sopianae (Pécs)", *Mitteilungen zur Christlichen Archäologie* 15 (2009) 47–76.

Hudák K. and Nagy L. (2005) *A Fine and Private Place: Discovering the Early Christian Cemetery of Sopianae/Pécs* (Pécs 2005).

Hudák K. and Nagy L. (2009) *A Fine and Private Place: Discovering the Early Christian Cemetery of Sopianae/Pécs*, 2nd edition (Pécs 2009).

Hytrek A. (1894) "Starikršćansko grobište sv. Sinerota u Sremu" [The Early Christian cemetery of St Syneros in Srem], in *Ephemeris Salonitana* (Zadar 1894) 5–10.

Jeremić, M. (2005) "Adolf Hytrek et les premieres fouilles archeologiques a Sirmium", *Starinar* 55 (2005) 115–30.

Johnson M. J. (2009) *The Roman Imperial Mausoleum in Late Antiquity* (Cambridge 2009).

Kárpáti G. (2002) "A pécsi v. számú sírkamra" [Burial Chamber number 5 of Pécs]. *Műemlékvédelem* 44 (2002) 142–44.

Koller J. (1804) *Prolegomena in historiam Episcopatus Quinqueecclesiarum* (Bratislava 1804).

Kraft J. (2006) *A pécsi ókeresztény temető geológiája és felszínének fejlődése* [*The Geology and Surface Development of the Early Christian Cemetery of Pécs*] (Örökségi Füzetek 5) (Pécs 2006).

Kuzsinszky B. (1932) "A gázgyári római fazekastelep Aquincumban" [The Roman potters quartier at the Gas Factory in Aquincum], *Budapest Régiségei* 11 (1932) 3–423.

Lányi V. and Mócsy A. (1990) "Temetkezés és halottkultusz" [Burials and the cult of the dead], in *Pannonia régészeti kézikönyve*, edd. A. Mócsy and J. Fitz (Budapest 1990) 243–53.

Lengvári I. (2003) "Sopianae kutatásának története" [History of the research of Sopianae], in *A pécsi világörökség* (Örökségi Füzetek 2) (Pécs 2003) 55–62.

Lőrinc B. (1980) *Pannonische Ziegelstempel, vol. 3. Limes-Strecke Ad Flexum – Ad Mures* (Dissertationes Archaeologicae ex Instituto Archaeologico de Rolando Eötvös nominatae II.9.) (Budapest 1980).

Magyar Zs. (2007) "Sopianae: a study of cultural influences in fourth century southern Pannonia" *Buletinul Cercurilor Științifice Studențești: Arheologie-Istorie-Muzeologie* 13 (2007) 41–58.

Magyar Zs. (2009) "The world of late antique Sopianae: artistic connections and scholarly problems", in *Niš and Byzantium VII: The collection of the scientific works*, ed. M. Rakocija (Niš 2009) 107–118.

Magyar Zs. (2012a) "Késő császárkori sírépületek Pannoniában" [Late Roman mausolea in Pannonia]. *ArchErt* 137 (2012) 125–44.

Magyar Zs. (2012b) "Jelen volt-e Sopianaeban az arianizmus?" [Was the Arianism present in Sopianae?], in *Az ókori*

keresztény világ (Patmosz Könyvtár 1), edd. I. Peres and P. Jenei (Debrecen 2012) 67–79.

Madarassy O. (2000) "Régészeti kutatások az aquincumi katonaváros területén" [Archaeological investigations in the military town of Aquincum], *Aqincumi Füzetek* 6 (2000) 46–55.

Marzano A. (2007) *Roman Villas in Central Italy. A Social and Economic History* (Leiden 2007).

Migotti B. (1994) "The archaeological material of the Early Christian period in continental Croatia", in *From the Invincible Sun to the Sun of Justice: Early Christianity in Continental Croatia*, ed. Ž. Demo (Zagreb 1994) 187–209.

Milošević P. (1971) "Earlier archeological activity in Sirmium", *Sirmium* 2 (1971) 3–11.

Milošević P. (1976) *Kompleks rimskih nekropola u Sirmijumu (nastanak, geneza i kraj)* [*The Roman Cemetery Complexes of Sirmium: Origin, Genesis and their End*)] (Ph.D. diss., Univ. of Belgrade 1976).

Milošević P. (1995) "Rimska nekropola na izlaznici mitrovačke petlje" [Roman necropolis at Mitrovica at the exit of the motorway], in *Arheološka istraživanja duž autoputa kroz Srem*, ed. Z. Vapa (Novi Sad 1995) 195–218.

Milošević P. (2001) *Arheoloija i istorija Sirmijuma* [The archeology and history of Sirmium] (Novi Sad 2001).

Mócsy A. (1962) "Pannonia", in *Paulys Realenzyklopädie der klassischen Altertumswissenschaft beg. von G. Wissowa Suppl. IX*. (Stuttgart 1962) cols. 515–775.

Mócsy A. (1990) "Vallás" [Religion], in *Pannonia régészeti kézikönyve*, edd. A. Mócsy and J. Fitz (Budapest 1990) 255–64.

Nagy L. (1931) *Az óbudai ókeresztény cella trichora a Raktár-utcában (Az Aquincumi Múzeum 1930. évi ásatása* [*The Early Christian Cella Trichora in Óbuda in the Raktár Street (The Excavation of the Aquincum Museum in 1930)*] (Budapest 1931).

Nagy L. (1937) "Az Aquincumi Múzeum kutatásai és gyarapodása az 1923–1935. években" [New acquisitions in the Aquincum Museum in the year of 1923–1935], *Budapest Régiségei* 12 (1937) 261–75.

Nagy L. (1938) "Pannonia Sacra", in *Szent István Emlékkönyv*, ed. J. Serédi (Budapest 1938) 29–148.

Nagy L. (1940) "Az aquincumi ókereszténység újabb emlékei" [New monuments of the Early Christianity from Aquincum], *ArchErt* 67 (1940) 246–56.

Nagy L. (1942) "Kereszténység – kontinuitás" [Christianity – Continuity], in *Budapest története vol. 1*, ed. K. Szendy (Budapest 1942) 765–78.

Nagy L. (2012) *Pannóniai városok, mártírok, ereklyék: négy szenvedéstörténet helyszínei nyomában* [*Cities, Martyrs and Relics in Pannonia: Discovering the Topography of Four Pannonian Passion Stories*] (Thesaurus Historiae et Ecclesiasticae in Universitate Quinqueecclesiensis 1) Pécs (2012).

Nagy L. (2013) "Túlvilági elképzelések és értelmezési problémák a pécsi késő római-ókeresztény temetőben" [Beliefs of the afterlife and the problems of interpretation on the Late Roman-Early Christian cemetery of Pécs], *Műemlékvédelem* 57 (2013) 1–12.

Nagy M. (2002) "Typological considerations on Christian funerary buildings in Pannonia", *Zalai Múzeum* 11 (2002) 21–30.

Nagy T. (1943) "A Fővárosi Régészeti és Ásatási Intézet jelentése az 1938–1942 évek között végzett kutatásairól" [Report on the research of the archaeological and excavating institution of Budapest between 1938 and 1942], *Budapest Régiségei* 13 (1943) 361–39.

Parragi Gy. (1976) "Karéjos épület a Kiscelli utcában" [Apsidial building in the Kiscelli Street], *Budapest Régiségei* 24 (1976) 177–83.

Pearce J. (2015) "Commemorating the dead in Roman Britain: monuments and their setting", in *Proceedings of the 18th International Congress of Classical Archaeology, Centro y periferia en el mundo clásico/Centre and Periphery in the Ancient World, Merida, May 2013 (Vol. 2)*, edd. J. Álvarez, T. Nogales, and I. Rodà (Merida 2015) 1209–1212.

Petrović M. (1995) "Mauzolej – arhitektonska analiza i rekonstrukcija" [The mausoleum – architectonic analysis and reconstruction], in *Arheološka istraživanja duž autoputa kroz Srem*, ed. Z. Vapa (Novi Sad 1995) 181–84.

Prieur J. (1986) *La mort dans l'antiquité romaine* (La Guerche-de-Bretagne 1986).

Póczy K. Sz. (1964) "Aquincum a IV. században" [Aquincum in the fourth century], *Budapest Régiségei* 21 (1964) 55–77.

Popović I. (2011) "Wall painting of late antique tombs in Sirmium and its vicinity" *Starinar* 61 (2011) 223–49.

Radnóti A. (1939) "Római kutatások Ságváron" [Roman research in Ságvár], *ArchErt* 52 (1939) 148–64.

Rakocija M. (2011) "Das frühe Christentum in Naissus/Niš (Serbien)", *Mitteilungen zur Christlichen Archäologie* 17 (2011) 9–50.

Rendić-Miočević D. (1954) "Neue Funde in der altchristlichen Nekropole Manastirine in Salona", *Archaeologia Iugoslavica* 1 (1954) 53–70.

Rossi de G. B. (1874) "Fünfkirchen in Ungheria camera sepolcrale sotterranea dipinta", *Bulletiono di Archeologia Cristiana Ser.* II. 5 (1874) 150–52.

Rossi de G. M. (1980) *Lazio meridionale* (Itinerari Archeologici 5) (Rome 1980).

Sági K. (1960) "Die spätrömische Bevölkerung der Umgebung von Keszthely" *ActaArchHung* 12 (1960) 187–256.

Šaranović-Svetek V. (1967) "Vinkovci, Kamenica – antičko nalazište" [Vinkovci, Kamenica – ancient sites]. *Arheološki Pregled* 9 (1967) 105–108.

Schmidt W. (2000) "Spätantike Gräberfelder in den Nordprovinzen des römischen Reiches und das Aufkommen

christlichen Bestattungsbrauchtums. Tricciana (Ságvár) in der Provinz Valeria", *Saalburg-Jahrbuch* 50 (2000) 213–441.

Soproni S. (1985) *Die letzten Jahrzehnte des pannonischen Limes* (Munich 1985).

Sparey-Green Chr. (1977) "The significance of plaster burials for the recognition of Christian cemeteries", in *Burial in the Roman World* (CBA Research Reports 22), ed. R. Reece (London 1977) 46–53.

Szőnyi O. (1927) "Ásatások a pécsi székesegyház környékén 1922-ben" [Excavations at the area of the cathedral of Pécs], *Az Országos Magyar Régészeti Társulat Évkönyve* 2 (1923–1926) 172–95.

Testini P. (1958) *Archeologia Cristiana* (Rome 1958).

Topál J. (2003) *Roman Cemeteries of Aquincum. The Western Cemetery (Bécsi Road) vol. 2.* (Aquincum Nostrum I. 2) Budapest (2003).

Tóth E. (1990) "A 4.-8. századi pannóniai kereszténység forrásairól és a leletek forrásértékéről" [About the sources of Pannonian Christianity in the 4th–8th centuries and about the source value of the finds], *Magyar Egyháztörténeti Vázlatok* 2:2 (1990) 17–33.

Tóth E. (1988) "Az alsóhetényi 4. századi erőd és temető kutatása, 1981–1986: eredmények és vitás kérdések" [The research of the 4th century fortress and cemetery in Alsóhetény, 1981–1986: results and questions for discussion], *ArchErt* 114–15 (1987–1988) 22–61.

Tóth E. (1994) "Das Christentum in Pannonien bis zum 7. Jahrhundert nach den archäologischen Zeugnissen", in *Das Christentum im bairischen Raum*, edd. E. Boshof and H. Wolff (Cologne 1994) 241–72.

Tóth E. (2001a) "Sopianae a késő császárkorban" [Sopianae in Late Imperial period], *Jelenkor* 44 (2001) 1129–36.

Tóth E. (2001b) "Adatok Valeria tartomány kereszténységének történetéhez" [Data for the history of the Christianity of the province of Valeria], in *Szent István és Európa*, ed. G. Hamza (Budapest 2001) 119–39.

Tóth E. (2006) "A pogány és keresztény Sopianae: a császárkultusz-központ Pannonia Inferiorban, valamint a pogány és keresztény temetkezések elkülönítésének lehetőségéről, a II. sírkamra" [The pagan and Christian Sopianae: the center of the imperial cult in Pannonia Inferior and the possibility to separate the Christian and pagan burials, Burial Chamber II], *Specimina Nova* 20 (2006) 49–102.

Tóth E. (2009) *Studia Valeriana: az alsóhetényi és ságvári késő római erődök kutatásának eredményei* [*Studia Valeriana: Results of the Research of the Fortresses of Alsóhetény and Ságvár*] (Dombóvár 2009).

Tóth Zs. (2011) "Régészeti kutatások a Rózsakertben" [Archaeological investigations in the Rózsakert], *Pécsi Szemle* 14:4 (2011) 2–13.

Tóth Zs., Buzás G., and Neményi R. (2020) "Előzetes beszámoló a pécsi székesegyház altemplomában végzett 2019. évi régészeti kutatásról (Preliminary report on the archaeological excavation in the crypt of the cathedral of Pécs in 2019)", in *Pécsi Tudományegyetem Bölcsész Akadémia 4.*, edd. G. Bőhm, D. Czeferner, and T. Fedeles (Pécs 2020).

Török Gy. (1942) "Grabkammern aus der Römerzeit an der oberen Promenade von Pécs", *ArchErt* 69 (1942) 211–15.

Toynbee J. (1971) *Death and Burial in the Roman World* (London 1971).

Vickers M. (1973) "Observations on the octagon at Thessaloniki", *JRS* 63 (1973) 111–20.

Visy Zs. (2003) "Adatok Sopianae ókeresztény leletegyüttesének értékeléséhez" [Data for the interpretation for the Early Christian finds o1f Sopianae], in *A pécsi világörökség* (Örökségi Füzetek 2) (Pécs 2003) 117–23.

Visy Zs. (2006) "Cella Septichora. Előzetes beszámoló a Szent István téren az ókeresztény temető területén folytatott régészeti kutatásokról" [Cella septichora: preliminary report on the archaeological investigations on the area of the Early Christian cemetery in the Szent István Square], *Pécsi Szemle* 9:2 (2006) 3–13.

Visy Zs. (2007) "Recent data on the structure of the Early Christian burial buildings in Pécs", *Acta Classica Debrecensiensis* 43 (2007) 137–55.

Waurick G. (1973) "Untersuchungen zur Lage der römischen Kaisergräber in der Zeit von Augustus bis Constantin", *JRGZM* 20 (1973) 107–46.

Williams H. ed. (2003) *Archaeologies of Remembrance: Death and Memory in Past Societies* (New York 2003).

Zeiller J. (1918) *Les origins chrétiennes dans les provinces danubiennes de l'Empire romain* (Paris 1918).

Mausolea in Late Antique Italy

Mark J. Johnson

Abstract

Mausolea in late antique Italy continued many of the practices of traditional Roman funerary architecture in their placement and architectural forms. A new practice was introduced in conjunction with the growth of Christianity – some mausolea were built attached to churches. The domed rotunda type saw an increased use and varied modifications during the period and was employed for most imperial burials. Late antique mausolea were at times built as two-storied monuments, incorporating both a burial crypt and a funerary chapel.

Introduction

Rich evidence of Roman funerary architecture remains to this day in Italy. This includes evidence of the tradition of using mausolea for the burials of individuals and families, a practice that continued throughout Late Antiquity in Italy, which is home to some of the most important mausolea of the period. Though studied as individual monuments or as small defined groups, such as imperial mausolea, there is no comprehensive study to date of late antique mausolea in Italy. The present study will identify important examples of these monuments and consider a number of issues connected with them. As is true for Roman funerary architecture in general, various types of buildings were employed, but the period is particularly notable for the maturation of the domed rotunda as a funerary architectural type. Though at first continuing the Roman practice of extra-urban settings for tombs and mausolea, some significant changes in funerary practice did occur in Late Antiquity. Perhaps the most important, as regards the design and placement of mausolea during the period, occurred in conjunction with the growth of Christianity among the upper classes of Roman society as Christians sought burial near the tombs of saints.

Setting

Under Roman law, burials, with few exceptions, were to take place outside the boundaries of cities and towns.[1] This resulted in the placement of family and individual mausolea along the roads leading out from the inhabited urban centres into the suburbs and countryside, as is still evident in the ruins of numerous tombs and mausolea along the *Via Appia* for a distance of more than 20 miles outside Rome's walls. Such monuments were constructed by individuals and families with the means to build these structures, a practice that continued among the Romans into the 5th c. in Italy. More humble structures and simple excavated graves were often built in extra-urban necropolises, packed together along narrow alleys. Part of the motivation of building tombs next to the roadways was that it allowed inscriptions naming the occupants, their portraits, and other sculptural decoration reflecting their accomplishments or place in society, to be displayed to the passersby. This was a device to attract attention, for someone seeing the portrait or reading the inscription would help keep the memory of the dead alive.

A variation on burial outside cities was to build funerary monuments on the grounds of a suburban or country family villa.[2] At times, such mausolea could still be near one of the major Roman roads. These monuments were normally built as individual structures away from the villa itself, creating distinct and separate areas for the living and the dead. This practice would continue into the late 5th c., at which time the mausolea built by Christians would function as funerary chapels as well as tombs.

The rise of Christianity brought a significant change to the choice of the affluent as to where to build the family mausoleum. For many Christians, there was a desire to be buried near the 'Holy Dead', the martyrs and other saints whose exemplary lives had earned their souls a place in paradise.[3] Such burials '*ad sanctos*' were taking place as early as the early 3rd c. Under Constantine I (306–337), a number of funerary basilicas were built as covered cemeteries near the tombs of important saints, such as St. Lawrence, in the suburbs of Rome.[4] While many Christians were content with a tomb under the floor of such a structure, wealthier families and even emperors constructed their own family mausolea attached to the walls of these buildings. As seen in the

1 The law was first recorded in a compilation of Roman laws dating to the 5th c. BC and reiterated in AD 381. See Johnson *et al.* (1961) 12; *Cod. Theod.* 9.17.6.

2 Griesbach (2005); Griesbach (2007); Brenk (1996); Chavarría Arnau (2007).

3 Duval (1988).

4 Lehmann (2003).

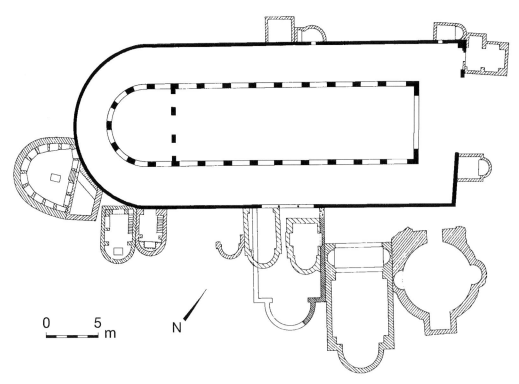

FIGURE 1 San Sebastiano, Rome, *ca.* 320, plan (author, redrawn after Lehmann (2003) fig. 8).

plan of the church of San Sebastiano on the *Via Appia* outside Rome, such family mausolea line the south wall of the church (Fig. 1).[5]

Mausolea Types

Rectangular/Square

Roman funerary architecture employed a wide variety of building types, from tumuli to temple forms to domed rotundas. For Late Antiquity in Italy, simple rectangular mausolea were the most common, based on a basic house structure, or with an added porch and columns, a temple. Cruciform plans also appear, with the cross arms acting as niches for the placement of sarcophagi. The most distinctive mausoleum type for Late Antiquity was the domed rotunda, a form that makes its earliest appearance in Roman funerary architecture during the Severan period and used into the 5th c.[6] It was also adopted by both pagan and Christian emperors and employed in several imperial mausolea in Late Antiquity.

Most of the mausolea attached to the church of San Sebastiano are rectangular structures with apses. Entered through doors cut out of the exterior walls of the church, several have vestibules that connect with their main rooms through a doorway. In a few cases the main rooms have small niches along the walls; one monument, placed next to the entrance of the church, has rectangular niches designed to contain sarcophagi. Those without niches would have had sarcophagi placed along their walls. All terminate with semicircular apses, making them similar to small churches. The function of these semicircular spaces was most likely to hold sigma- or C-shaped banqueting tables for commemorative funerary meals. They might have also held altars as they were set up in tombs during this period for commemorative services.

This simple type was employed throughout the Roman world in Late Antiquity, either as a free-standing mausoleum built in conjunction with a villa or attached churches. A number of small, simple square or rectangular tomb structures have been identified in Northern Italy. Dating to the 5th or 6th c. and built for individuals or small numbers of people, perhaps families, many were converted into funerary oratories or chapels during the 7th–9th c., as shown by Brogiolo.[7] It may be surmised that the same type with a similar history were found throughout Italy but have not yet been identified or studied to the same degree.

A similar but notable example is the tiny square structure known as 'Mausoleum M' in the Vatican necropolis

5 Krauthemier, Corbett, and Frankl (1970) 136–39.
6 Coarelli (2016) makes the interesting argument that the destroyed Templum Gentis Flaviae, the Flavian dynastic mausoleum in Rome from the late 1st c. AD, was the first mausoleum of the type.

7 Brogiolo (2002).

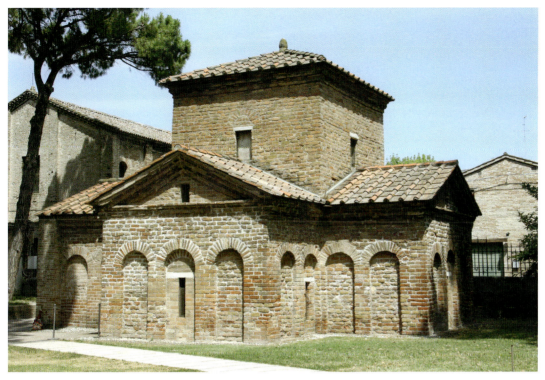

FIGURE 2 So-called "Mausoleum of Galla Placidia", Ravenna, *ca*. 430, exterior from south-west.
PHOTO: AUTHOR

under St. Peter's.[8] Squeezed in between other tombs, its vaulted interior was built in the middle of the 3rd c. as one of the few recognizably Christian mausolea in the necropolis. It would not be very significant except for its mosaic decoration which includes the famous 'Christus-Sol' adorning its vault and biblical scenes on its walls. A more elaborate version of the rectangular mausoleum type rose nearby in the 4th c. Members of the aristocratic Anicii constructed a family tomb attached to the apse of the Constantinian church of Old St. Peter's, sharing its axis with the church.[9] If the plans and sections published in the 17th c. can be trusted, it took the form of a small basilica, with a nave, side aisles and 5 columns supporting arcades on each side of the nave, and ending in a small apse at its west end.

An important example of the small, square plan type of private mausoleum attached to a church is that known as the chapel of Santa Matrona in the village of San Prisco near Santa Maria Capua Vetere in Campania.[10] A legendary account written much later claims that Matrona was a Lusitanian princess who was healed in this spot after locating the relics of St. Priscus and then built a church on the site to honor the saint, probably late in the 5th c. After she died, she was buried in a square mausoleum next to the church. The original church was replaced in the 17th c. but the mausoleum remains. Though architecturally very simple, a square with rectangular niches on the east and west, covered with a cross vault, the vault and two of the lunettes retain their colorful mosaic decoration with images of a bearded Christ and Evangelist symbols. Though designated now as a chapel of the sainted Matrona, it is likely that it was built as a mausoleum for the benefactress of the church, who only later was given her saintly status.

Cruciform

Notwithstanding an obvious link to Christian symbolism, the cruciform plan mausoleum was rare. Most famous is the so-called 'Mausoleum of Galla Placidia' in Ravenna, usually dated to the second quarter of the 5th c. (Fig. 2).[11] Though likely not having anything to do with the empress, the building is deservedly famous for its sumptuous interior decoration of alabaster and mosaics. Now free-standing, it was originally attached and entered through a door at one end of the narthex of the church of Santa Croce. The entry arm, slightly longer than the other three, leads to the crossing from which extend the other three arms, each mostly filled with a large marble sarcophagus, whose occupants and thus the patronage of the building, are unknown. Barrel vaults cover the arms and a short tower rises to support

8 Liverani, Spinola and Zander (2010) 114–19.
9 Bartolazzi Casti (2010).
10 Mackie (2003) 129–43.

11 Rizzardi (1996); Deliyannis (2010b).

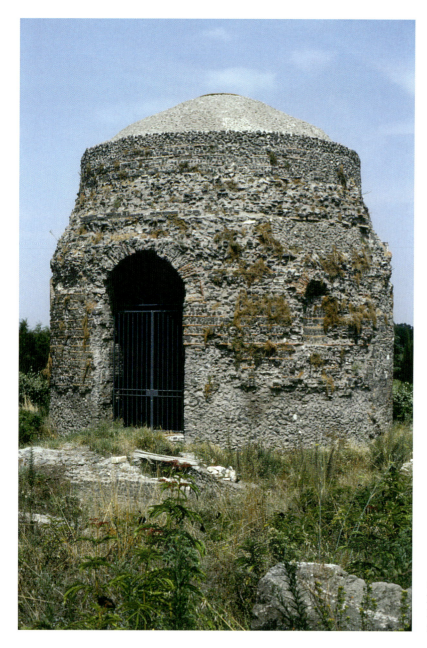

FIGURE 3
Mausoleum known as the "Berreta di Prete", Rome, 4th c., exterior from south.
PHOTO: AUTHOR

and cover a dome on pendentives, constructed in the locally preferred technique of hollow tubes. The vaults, the lunettes at their ends, and the dome are covered with mosaics. The dome has a gold cross at its apex, surrounded by 99 gold stars and the 4 Evangelist symbols. Unidentified men dressed in white appear on the walls of the tower and decorative patterns fill the undersides of the vaults. An image of a saint, usually identified as St. Lawrence, is in the lunette opposite the entrance, facing the image of Christ as good shepherd in the lunette above the door.

Domed Rotunda

Variations of the domed rotunda type appeared in the 4th c. in the suburbs of Rome. A small mausoleum from the early part of the century known as 'Le Cappellette' on the *Via Praenestina* has a domed circular room, measuring about 6.6 m in diameter, set within a square structure that measures about 8.2 m per side.[12] A small porch with piers supporting arches marked its entrance. Standing midway between the 8th and 9th milestones of the *Via Appia* is a domed circular building known as the 'Berretta del Prete' (Fig. 3). Constructed of *opus listatum*, with a dark leucite alternating with courses of red brick, the exterior of the rotunda is 12.7 m in diameter to which was added an exterior corridor 3.52 m wide that probably supported an exterior colonnade whose remains lay scattered on the site. Inside the rotunda has a diameter of 7.82 m with three semicircular niches placed on its main axes. The arrangement of the niches within the

12 Luschi (1984).

rotunda is typical for most circular structures in Roman architecture, no matter what their particular function. The niches could be used to hold burials, whether in sarcophagi or under the floor.

The date of the building is indicated by its masonry. *Opus listatum*, with brick and a dark stone, was used in and near Rome during the 4th and 5th c. More telling is the use of *bipedales*, which would indicate a 4th c. date for the building.[13] It is unclear based on its architecture whether or not this was built by pagans or Christians. The first mention of the building, in a 10th c. document, notes that a church dedicated to Santa Maria already then deserted, was on the site and linked to this 'monument', which suggests Christian origins and a memorial function for the rotunda.[14]

Octagonal

There are also examples of free-standing domed mausolea with octagonal plans in Italy. A small, crudely executed building is found at Torrenova on the north coast of Sicily.[15] Known as the 'Coventazzo', its irregular plan measures from 9.7–10 m diagonally with a few irregularly placed small niches on the interior. Constructed in the 4th c. of fieldstone, it was near a villa and intended for its owners. Later, a church was constructed next to the building, with a new doorway cut so that it could only be entered through the church. The other simple domed octagon mausoleum, also datable to the 4th c., was built in Lavinium, modern Pratica di Mare, south-west of Rome, not far from the remains of a villa.[16] Facing north, it is entered through a double-apsed rectangular vestibule leading to an octagon with a diameter of about 9 m measured diagonally. Its walls and dome are constructed of brick-faced concrete. At some point, it was converted into a church, dedicated to Mary, although exactly when this occurred is uncertain.

Domed Rotunda Variants

A more elaborate variation on the domed rotunda architectural type is found just off the *Via Appia* closer to the city in the area of the cemetery and catacomb of Praetextatus (Fig. 4). Here, a circular room, 9.42 m in diameter, is enveloped by 6 conches that are expressed externally. One contains the door linking the interior with a rectangular vestibule; that opposite the entrance

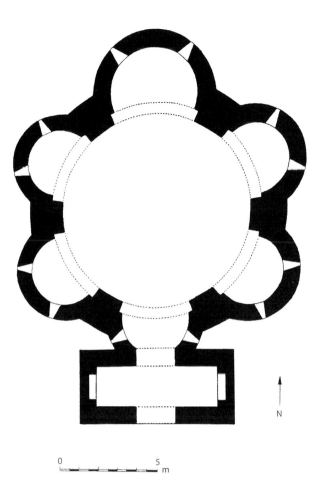

FIGURE 4 Mausoleum at Praetextatus Cemetery, Rome, late 4th–early 5th c. plan.
DRAWING: AUTHOR

is noticeably larger than the others. The piers between the openings rise to support a drum with small windows and a dome above. The building is constructed of reused brick, with no *bipedales* in the rising wall, although a few were randomly employed in the arches that cover the opening into the conches. This style of masonry indicates a date in the latter half of the 4th c. or beginning of the 5th. The building's placement in a cemetery above a catacomb leaves no doubt as to its funerary function and its Christian origins.

Another Christian free-standing rotunda mausoleum was that of Flavius Iulius Catervius at Tolentino, datable to *ca*. 390–410 (Fig. 5).[17] Though only parts of the structure survive, enough remains to clarify its plan: a domed rotunda, an exterior diameter of 10.65 m, a circular interior 8.9 m in diameter, with three arms extending outward to the north, west, and south, can be ascertained; a 4th arm or porch may have existed in the area of the entry on the east but this is very uncertain. The interior was domed and reached to a height of about 10.65 m. The

13 Windfeld-Hansen (2003) 719, notes the use of bipedales in all Constantinian era buildings as well as the fact that they are not found in buildings in and near Rome built after the sack of the city in 410.
14 Gai (1986) 369, n. 5.
15 Johnson (2018) 24–25.
16 Johnson (2018) 23–24.

17 Nestori (1996) 23, for the date.

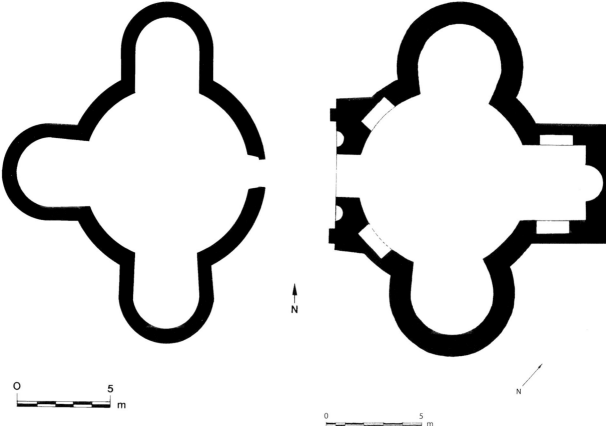

FIGURE 5 Mausoleum of Catervius, Tolentino, reconstructed plan.
DRAWING: AUTHOR

FIGURE 6 Mausoleum, San Cesareo, Rome, 4th c., plan.
DRAWING: AUTHOR

sarcophagus of Catervius and his wife, Severa, remains in the church and has a famous inscription in which it is stated that to house the sarcophagus, the structure was built as a 'Pantheum cum tricoro.'[18] The reference to the Pantheon in Rome is a clear indication that the domed rotunda at Tolentino was indeed the structure Severa had built and that is was similar, in design if not in scale, because of its circular plan, its niches and domed covering, to the famous temple in Rome. One of the niches could have been the original setting for the sarcophagus; the other two niches could have been used to set up tables for the funerary meals held in honor of the deceased.

Ruins of a circular building with an unusual plan lie near the *Via Ardeatina* outside Rome in the area known as San Cesareo (Fig. 6). Poorly studied, never excavated, and now in dire need of restoration, the building faced the road to the south-west and was entered through a flattened façade, its portal flanked by two small niches. It is a rotunda, with an interior diameter of 9.3 m and an exterior diameter of 11.7 m. Opposite the entry is a notable rectangular apse, its interior walls marked by a semicircular niche on the central axis, and two shallow but tall rectangular niches on its side walls. On the north and south, large horseshoe-shaped niches open from the rotunda. Their curved walls are expressed externally as well. A shallow rectangular niche is placed on the wall of the rotunda between each of these and the portal. In its ruined state, parts of the walls are missing down to the foundations; other sections remain standing to a height of as much as 4 m. The thickness of the walls allows the possibility that the interior was vaulted, with a dome covering the central rotunda.

Given the lack of scientific investigation, numerous questions remain about this building. The scholars who have written about it are in general agreement that it is datable to the 4th c., based on its masonry of reused brick.[19] Most refer to it as a mausoleum, but others express some uncertainty as to its original function. It does appear to have been used as a church at some point in its history, but determining when that conversion may have happened is not possible at this time. Other archaeological finds in the area include several sarcophagi from the second through the 4th c., showing that a

18 CIL 9.5566 = ILCV 98a and in Nestori (1996) 3 and 17–31 for the use of the word 'panteum'.

19 De Rossi (1967) 33.

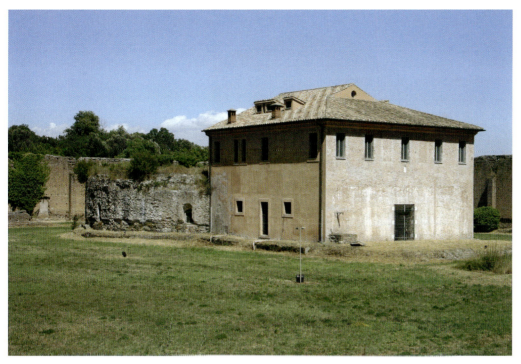

FIGURE 7 Mausoleum of Maxentius, Rome, *ca.* 307–312, exterior from north-west.
DRAWING: AUTHOR

funerary function for the building is likely.[20] The plan suggests that the rectangular apse on the north-east could have held a sarcophagus, probably that of the primary patron, while the lateral horseshoe-shaped niches could have been intended to hold banqueting couches or additional sarcophagi.

A similar domed rotunda with externally extended niches is found at Silligo in Sardinia. Used as a church at least as early as the 11th c., it is known as Santa Maria Mesumundu.[21] Located in a necropolis in use from the 4th c., it was built in the 5th c., using *opus listatum* with red brick and black basalt. Three arms, actually large interior niches, extend out from the rotunda on the south, west, and north. An apse was added to the east side when it became a church.

Two-storeyed Rotunda
Two-storied rotunda mausolea appeared in Italy during the 3rd c., the lower level used for burials, the upper floor as some sort of funerary chapel.[22] It was this type built with a dome that was adopted as the standard imperial mausoleum type in the second half of the 3rd c., seen first in the Mausoleum of Gallienus, who died in 268.[23]

Here, a lower level with 4 deep niches was encircled by an ambulatory. On the upper floor, the room was circular with 5 shallow niches and a door, with a free-standing colonnade surrounding the exterior. Though a smaller building, only about 18 m in diameter, its typology would be echoed in the imperial mausolea to follow.

'Tetrarchic'
Burial at Rome was not an imperative for members of the Tetrarchy and so their mausolea were scattered across the empire. Maximian, who had ruled Italy before stepping down in 305, built his intended mausoleum in what had been one of his capital cities, Milan, probably sometime near the beginning of the 4th c.[24] Later converted into a Christian chapel dedicated to St. Gregory, the building was razed in the 16th c. A small portion of its remains was excavated in the 1970s, revealing that, like Diocletian's mausoleum in Split, Croatia, it was an octagonal building with interior niches, constructed in brick. Several pieces of the building's interior marble decoration were recovered. It was also determined that the free-standing structure stood in the middle of a temenos enclosure, with walls laid out in a very irregular octagon with turrets at the corners, giving the temenos the appearance of a small fortress.

Maximian's son Maxentius started building his family mausoleum early in his reign, perhaps following the

20 Venturi (1992).
21 Johnson (2015).
22 For the development of the Roman imperial mausoleum in this period, see Johnson (2009); Coarelli (2014); Lo Tennero (2000).
23 Johnson (2009) 42–47.

24 Johnson (2009) 70–74.

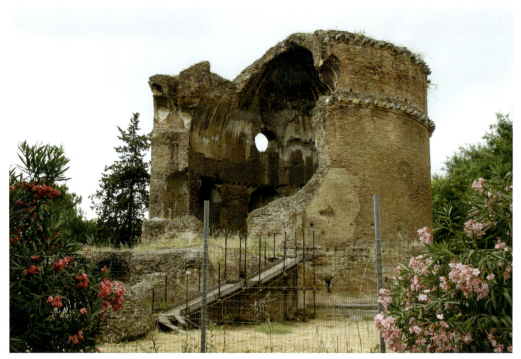

FIGURE 8 Mausoleum known as the Tor de' Schiavi, Rome, *ca.* 310–320, exterior from south-east.
DRAWING: AUTHOR

death of his son Romulus in 307 (Fig. 7).[25] Located at Maxentius' suburban villa complex on the *Via Appia* outside Rome, the building and its quadriporticus temenos enclosure faced the road, rather than the villa proper. What stands on the site today is the building's crypt and pronaos, the latter covered with a 17th c. farm house. It is uncertain that the upper level was ever constructed or finished, but it would have had a rotunda form with a pronaos consisting of a hexastyle porch and pediment and the rotunda covered by a dome. The exterior wall was dressed in ashlar blocks of travertine and the whole would have appeared to be a smaller version of the Pantheon, giving the mausoleum a decidedly temple-like appearance. The crypt is large with a central pier with niches to accommodate sarcophagi and an annular barrel vault supporting the floor of the upper room.

Closely related to the Mausoleum of Maxentius is the so-called Tor de'Schiavi, located on the *Via Praenestina* (Fig. 8).[26] Although the porch and front part of the building have collapsed, most of the rotunda with its underlying crypt and a large part of its dome remain standing. The crypt has a circular pier supporting the annular barrel vault covering the space and supporting the floor of the upper room. The upper chamber has alternating rectangular and semicircular niches and was illuminated by 4 round windows. Remnants, greatly deteriorated, of frescoes decorate the dome.[27] Though datable to the early 4th c., scholars debate whether it was built before or after the Mausoleum of Maxentius and whether or not it was intended for a member of the imperial family, which, given its form, seems likely. Though near a Christian funerary basilica, it is free-standing and nothing about its architecture or its frescoes would suggest the patron was Christian.

Imperial Christian

The first Christian imperial mausoleum was that of Constantine's mother, Helena (died *ca.* 327) outside Rome (Fig. 9).[28] Like other imperial mausolea, it was designed as a domed rotunda, but with significant differences. Rather than being free-standing, it was attached to the east end of a cemetery basilica, that of ss Petrus and Marcellinus. In addition, it has no crypt, so the sarcophagus of the empress was placed in a niche on the single storied space, a significant room illuminated by large windows placed above each of the niches. Constructed of brick faced concrete, the exterior walls were stuccoed, drafted to look like ashlar masonry. The interior was a tall, domed space illuminated by large windows, creating a notable contrast with earlier, sparsely lit mausolea. Furthermore, it was lavishly decorated with marble revetment on the walls and mosaics in the vaults of the

25 Johnson (2009) 86–93.
26 Johnson (2009) 93–103; Blanco *et al.* (2013).

27 For this decoration and that of the other mausolea mentioned here, see Tortorella (2008) and Branconi (2016) and (2018).
28 Johnson (2009) 110–18; Oosten (2016); Vendittelli (2012).

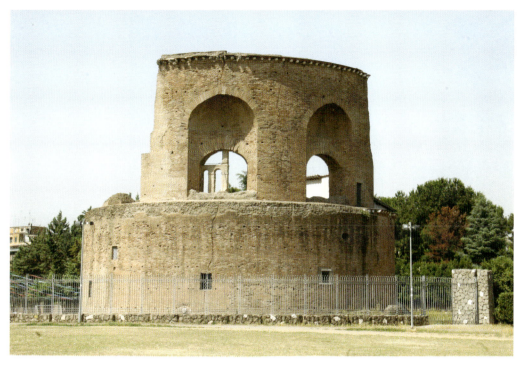

FIGURE 9 Mausoleum of Helena, Rome, *ca.* 320–328, exterior from north-east.
PHOTO: AUTHOR

niches and dome, although only a few isolated tesserae remain.

Constantine's daughter, Constantina, owned a villa on the *Via Nomentana* outside Rome, near the catacomb of St. Agnes. At some point towards the middle of the century, a funerary basilica was built nearby and, attached to it, her mausoleum (Fig. 10).[29] Constantina died in 354 and the complex may have been completed by her brother, Constantius II. Today, the basilica stands in ruins and the mausoleum, converted into a church in the 7th c. and named Santa Costanza, appears as a free-standing building, although originally it was entered through the basilica. Perhaps inspired by their father Constantine's burial church called the Apostoleion in Constantinople, it is a remarkable structure, circular and domed like other imperial mausolea, but introducing the 'double-shell' concept in which the taller, domed inner circular space, 11.5 m in diameter, is encircled by a vaulted ambulatory, separated by 12 pairs of columns.[30] The dome sits on a tall drum, which permits large clerestory windows to illuminate the central space with bright light in contrast to the darkened ambulatory. Niches line the ambulatory with the largest one, opposite the entrance, possibly being the original location of Constantina's porphyry sarcophagus now in the Vatican Museum.

On the outside, the lower level was originally surrounded by a free-standing colonnade, but otherwise the exterior walls were unadorned. From Renaissance drawings and descriptions, it is known that the interior was decorated with marble revetment and opus sectile on the walls and biblical scenes in mosaic covered the dome. As Mackie has pointed out, the scenes depicted in these mosaics correspond to those mentioned in an early prayer for the salvation of the dead.[31]

Attached to the church of San Lorenzo in Milan are three octagonal structures (Fig. 11). The original function of the one on the east is debated, with suggested functions being to house relics or, recently, as the planned mausoleum of Stilicho.[32] It was used as a burial chapel by Milanese bishops in the latter part of the 5th c. The smallest of the three, that on the north side of the church, dedicated to St. Sixtus, was built as a mausoleum for Bishop Lawrence in the early part of the 6th c. and used by other bishops thereafter.[33] The third, known as Sant'Aquilino, with its vestibule attached to the south flank of the church, is the largest of the three and evidence suggests that it was built as an imperial mausoleum.[34] It has the exact form of Milan's earlier imperial mausoleum and Giuliano da Sangallo noted

29 Johnson (2009) 139–56.
30 Johnson (2020).
31 Mackie (2003) 145–53.
32 Löx (2008).
33 Mackie (2003) 34–35; Fieni (2006).
34 Johnson (2009) 156–67; Rinaldi (2021) 39–94.

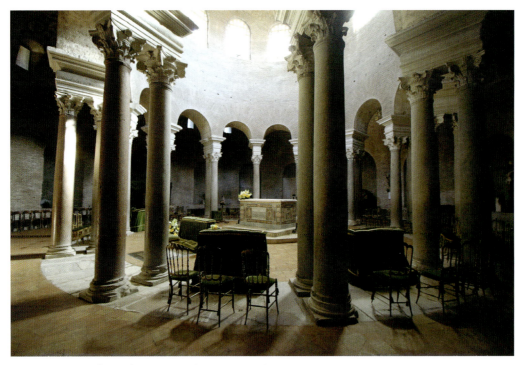

FIGURE 10 Mausoleum of Constantina (Santa Costanza), Rome, *ca*. 350, interior.
PHOTO: AUTHOR

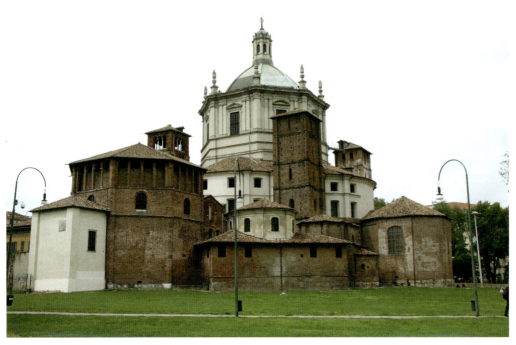

FIGURE 11 Church of San Lorenzo, Milan, *ca*. 380 exterior from south-east with chapel of S. Aquilino on left and chapel of S. Ippolito on right.
PHOTO: AUTHOR

that it was decorated "all in porphyry" at the time he visited and drew a plan of the building in the later 15th c.

The vestibule is rectangular with apsed ends and small sections of fragmentary mosaics on its walls. These depict some of the 12 sons of Jacob, representing the 12 tribes. The mausoleum has niches on each of its sides, rectangular ones on the main axes alternating with semicircular ones on the diagonals. Above the vaults of the niches are windows on each side to illuminate the interior. The vaults of two of the niches contain mosaics, suggesting they were all similarly decorated. A 16th c. drawing of the building shows mosaic in the cloister vault that covers the interior, which included an image of Christ.

The interpretation of Sant'Aquilino as an imperial mausoleum hinges in part on the date of the San Lorenzo complex, with suggested dates from as early as the mid-4th to the early 5th c. being proposed. A dating of the mortar would favor the later date, but still allow a date two decades earlier. Historically, the period that fits best would be the 380s, with Sant'Aquilino being built as the mausoleum of the Valentinian dynasty, housing the burials of Valentinian II (d. 392), his brother Gratian (d. 383) and perhaps their sister, Galla (d. 394), as well.

The last Roman imperial mausoleum to be constructed in Italy was that of Honorius, attached to the south transept of the church of Old St. Peter's in Rome and perhaps begun around 404–407 at the death of his first wife, Maria, who was buried therein.[35] Destroyed in the early 16th c. as the new church of St. Peter was being built, there is a single plan done before its destruction that shows the form of the building. It was a rotunda, with thick circular exterior walls possessing rectangular niches on the interior. The 7 niches were arranged on the principal axes and diagonals of the building, with an entrance on the north leading to a vestibule set between the rotunda and the transept of the church. It was under the floor of one of the niches that the sarcophagus of Maria was discovered during the razing of the building. Honorius' second wife, Thermantia, Honorius, and probably Constantius III, Galla Placidia, her son Theodosius II were among those buried here. It may be supposed that there were large windows about the niches in the manner of the Mausoleum of Helena and that the building was domed. It is likely that remains of its lower walls and foundations lie under the south transept of the present church.

For the most part, the family and individual tombs attached to churches disappeared by the 6th c. in favour of burials within churches or church cemeteries.

Noticeable exceptions are found in two examples of mausolea built for the burial of bishops. The small octagonal tomb on the north side of the church of San Lorenzo in Milan has been mentioned. The other is the circular chamber on the south side of the sanctuary of the church of San Vitale in Ravenna, dedicated in 547, which was used as the mausoleum of the church's founder, Ecclesius and at least two of his successors.[36]

The Roman tradition of domed tomb structures concludes with the Mausoleum of Theoderic in Ravenna, an extraordinary building that is unique in 6th c. architecture and reveals much about Theoderic's perception of his own place in history (Fig. 12).[37] Eschewing a church burial or even a mausoleum attached to a church, he built a free-standing monument like those of earlier Roman emperors, choosing a site north-east of the city walls, near a lighthouse, and in the area of a cemetery. A bronze fence with carved stone pillars encircled the mausoleum, giving it a measure of protection and setting it off from the rest of the cemetery. The building has two levels: the lower one, set at ground level, is decagonal in plan, with exterior niches on each of its sides, except for that on the west containing an entrance. Inside, the plan is cruciform creating rectangular niches on the north, east, and south. The second level is set back from the lower one, creating a ledge. Its plan is dodecagonal externally and internally circular with a door directly above that of the lower level on the west and a small niche that protrudes on the east.

The Ravenna monument is close in design, construction, and scale to the tombs of Galerius and his mother Romula at Gamzigrad in Serbia.[38] Each has a two-storey design, with a burial chamber in the podium. Mausoleum I, probably of Romula, has a square base and an octagonal upper structure with a circular interior room, but no exterior colonnade. Mausoleum II, likely that of Galerius, is dodecagonal on the lower level, which provides the floor for the upper level, but its upper structure is circular both externally and internally and was encircled by a free-standing portico. Both were probably domed. They represent the type of mausoleum Theoderic had in mind in the design of his own and demonstrate that his models were Roman and his intent was to associate himself with the Roman imperial tradition and an expression of his desire to make himself 'equal to the ancients.' The choice of a decagonal structure to surround the burial chamber is unique and may be related to the symbolism of the number ten, which

35 Johnson (2009) 167–74; Paolucci (2008) 225–52.
36 Johnson (2018) 139–40.
37 Johnson (2016) 378–84; Deliyannis (2010a).
38 Johnson (2009) 74–82.

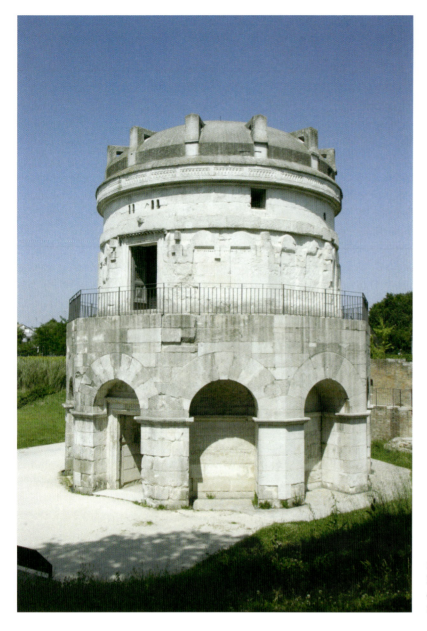

FIGURE 12
Mausoleum of Theoderic, Ravenna, *ca.* 520–526, exterior from south-west.
PHOTO: AUTHOR

was perfection, an idea found in both the writings of Boethius and Cassiodorus.[39]

As in the pre-Christian imperial mausolea with burial chambers in their lower level, the original location of the sarcophagus of Theoderic within his mausoleum was probably in its lower level. The cruciform arrangement of the interior space in the Mausoleum of Theoderic has many parallels in Roman funerary architecture and in all cases, the arms are used for holding sarcophagi, or earlier, urns. In the two-storied funerary monuments the lower level is always the burial chamber, the upper level functions as a memorial temple or chapel. During the latter part of the 6th c., numerous private mausolea from earlier periods were converted or incorporated into churches.[40] Burials were done in cemeteries or in churches, including urban ones as the practice of larger mausolea, free-standing or attached to churches came to an end. Family burial chapels and even attached mausolea would make a reappearance in the Later Medieval period and continue to be used thereafter.

While the practices associated with Roman funerary architecture such as site selection and multiple architectural types continued in the building of mausolea in late antique Italy, significant changes did occur. Italy took the lead in the development and use of the domed rotunda mausoleum type with the majority of those examples being built near one of Italy's large cites. The other major change from Roman practice was due to the rise of Christianity, which led to many mausolea being sited near or even attached to churches. The design of the mausolea also changed from two-storied to one-storied structures and from mausolea being dimly lit to having interiors flooded with light. It is fitting that Italy is also

39 Johnson (2016) 383.
40 Brogiolo (2002); Chavarría Arnau (2007).

home to one of the last free-standing domed rotundas of Late Antiquity – that of Theoderic, its builder paying homage to the great mausolea of the past.

Bibliography

Primary Sources

Cod. Theod. = C. Pharr ed. and transl., *The Theodosian Code and Novels, and the Sirmondian Constitutions* (New York 1952–1969; rev. 2001).

Secondary Sources

Bartolazzi Casti G. (2010) "Gli Anici e il mausoleo di famiglia presso la basilica vaticana", *Palladio* 23/45 (2010) 15–30.

Blanco A. et al. (2013) "Il mausoleo e la basilica circiforme della cd. Villa dei Gordiani sulla Presnestina", *BullCom* 114 (2013) 285–94.

Braconi M. (2016) "I mausolei, le cupole, le decorazioni: tra committenza imperiali ed emulazione privata", *Acta XVI Congressus internationalis archaeologiae christianae (Roma 22–28.9.2013)* (Vatican City 2016) 987–1008.

Braconi M. (2018) "'Il cielo in una stanza'. I sistemi decorativi delle cupole dei mausolei imperiali e le formule emulative della committenza privata nei monumenti funerari tardoantichi", in *Entre terre et ciel. Les édifices à coupole et leur décor entre l'Antiquité tardive et le haut Moyen Âge* (Études de Lettres 307), edd. C. Croci and V. Ivanovici (2018) 17–41.

Brenk B. (1996) "Innovation im Residenzbau der Spätantike", in *Innovation in der Spätantike. Kolloquium Basel 6. und 7. Mai 1991*, ed. B. Brenk (Wiesbaden 1996) 67–114.

Brogiolo G. (2002) "Oratori funerari tra VII e VIII secolo nelle campane transpadane," *Hortus Artium Medievalium* 8 (2002) 9–31.

Chavarría Arnau A. (2007) "*Splendida sepulcra ut posteri audiant*. Aristocrazie, mausolei e chiese funerarie nelle campagne tardoantiche", in *Archeologia e società tra tardo antico e alto medioevo* (Documenti di Archeologia 44), edd. G. P. Brogiolo and A. Chavarría Arnau (Mantova 2007) 127–46.

Coarelli F. (2016) "Mausolei imperiali tardoantichi: le origini di un tipo architettonico", *Acta XVI Congressus internationalis archaeologiae christianae (Roma 22–28.9.2013)* (Vatican City 2016) 493–508.

Deliyannis D. M. (2010a) "The Mausoleum of Theoderic and the Seven Wonders of the World," *JLA* 3 (2010) 365–85.

Deliyannis D. M. (2010b) *Ravenna in Late Antiquity* (Cambridge 2010).

De Rossi G. M. (1967) *Tellenae* (Forma Italiae, Regio I, vol. 4) (Rome 1967).

Duvall Y. (1988) *Auprès des saints-corps et âme. L'inhumation 'ad sanctos' dans la chrétieneté d'Orient et d'Occidente du IIIe au VIIe siècle* (Paris 1988).

Fieni L. (2006) "The art of building in Milan during late antiquity: San Lorenzo Maggiore", in *Technology in Transition, A.D. 300–650*, edd. L. Lavan, E. Zanini, and A. Sarantis, *Late Antique Archaeology* 4 (Boston 2006) 407–433.

Gai S. (1986) "La 'Berretta del Prete' sulla via Appia antica: Indagini preliminari sull'insediamento medievale, 1984", *Archeologia medievale* 13 (1986) 365–402.

Griesbach J. (2005) "Villa e mausoleo: trasformazioni nel concetto della memoria nel suburbio romano", in *Roman Villas around the Urbs. Interaction with Landscape and Environment. Proceedings of a Conference held at the Swedish Institute in Rome, September 17–18, 2004*, edd. A. Klynne and B. Santillo Frizell (Rome 2005) 1–11.

Griesbach J. (2007) *Villen und Gräber. Siedlungs- und Bestattungsplätze der römischen Kaiserzeit im Suburbium von Rom* (Rahden 2007).

Johnson A. et al. (1961) *Ancient Roman Statutes* (Austin 1961).

Johnson M. J. (2009) *The Roman Imperial Mausoleum in Late Antiquity* (Cambridge 2009).

Johnson M. J. (2015) "La chiesa di Santa Maria de Mesumundu a Siligo e gli edifici rotondi nei cimiteri cristiani della tarda antichità: datazione e funzione", in *Itinerando. Senza confini dalla preistoria ad oggi. Studi in ricordo di Roberto Coroneo*, ed. R. Martorelli (Perugia 2015) 425–40.

Johnson M. J. (2016) "Art and architecture", in *A Companion to Ostrogothic Italy*, edd. J. J. Arnold, M. S. Bjornlie, and K. Sessa (Leiden 2016) 350–89.

Johnson M. J. (2018) *San Vitale in Ravenna and Octagonal Churches in Late Antiquity* (Wiesbaden 2018).

Johnson M. J. (2020) "Constantine's Apostoleion: a reappraisal", in *The Holy Apostles, A Lost Monument, and the Presentness of the Past*, edd. M. Mullett and R. G. Ousterhout (Washington D.C. 2020) 79–98.

Lehmann T. (2003) "'Circus Basilicas', 'coemeteria subteglata' and church buildings in the suburbium of Rome", *ActaAArtHist* 17 (2003) 57–77.

Liverani P., Spinola G., and Zander P. (2010) *The Vatican Necropoles. Rome's City of the Dead* (Turnhout 2010)

Lo Tennero G. (2000) "Tradizioni e innovazioni nell'architettura degli edifici funerari a pianta centrica tra III e IV secolo", *Quaderni di storia dell'architettura* (Florence 2000) 7–26.

Krautheimer R., Corbett S., and Frankl W. (1970) *Corpus Basilicarum Christianorum Romae. The Early Christian Basilicas of Rome, IV–IX Cent.*, IV (Vatican City 1970).

Löx M. (2008) "Die Kirche San Lorenzo in Mailand: Eine Stiftung des Stilicho?", *RömMitt* 114 (2008) 407–438.

Luschi L. (1984) "Un edificio funerario della via Prenestina nei disegni degli Uffizi", *Prospettive* 39 (1984) 30–37.

Mackie G. (2003) *Early Christian Chapels in the West: Decoration, Function, and Patronage* (Toronto 2003).

Nestori A. (1996) *Il mausoleo e il sarcofago di Flavius Iulius Catervius a Tolentino* (Vatican City 1996).

Oosten D. (2016) "The Mausoleum of Helena and the adjoining Basilica Ad Duas Lauros: construction, evolution and reception", in *Monuments & Memory Christian Cult Buildings and Constructions of the Past. Essays in Honour of Sible de Blaauw*, edd. M. Verhoeven, L. Bosman, and H. van Asperen (Turnhout 2016) 131–43.

Paolucci L. (2008) "La tomba dell'imperatrice Maria e altre sepulture di rango di età tardoantica a San Pietro", *Temporis signa. Archeologia della tarda antichità e del medioevo* 3 (2008) 225–52.

Pharr C. (1952) *The Theodosian Code and Novels and the Sirmondian Constitutions* (Princeton 1952).

Rinaldi A. (2021) *La Cappella di Sant'Aquilino in San Lorenzo Maggiore a Milano. Storia e restauro* (Milan 2021).

Rizzardi C. (1996) "Il mausoleo di Galla Placidia", in *Il mausoleo di Galla Placidia a Ravenna*, ed. C. Rizzardi (Modena 1996) 105–128.

Tortorella S. (2010) "Mausolei imperiali tardo-antichi: le decorazioni pittoriche e musive delle cupole", in *Monumenta. I mausolei romani, tra commemorazione funebre e propaganda celebrativa*, ed. M. Valenti (Rome 2010) 131–46.

Vendittelli L. (2011) *Il mausoleo di Sant'Elena. Gli scavi* (Milan 2011).

Venturi L. (1992) "Gruppo di materiali archeologici conservati nella tenuta di San Cesareo sulla via Ardeatina", *BullCom* 94 (1991–1992) 428–36.

Windfeld-Hansen H. (2003) "Le cimetière de Prétextat. Hexaconque funéraire de l'area sub divo", in *Suburbium. Il suburbio di Roma dalla crisi del sistema delle ville a Gregorio Magno*, edd. P. Pergola *et al.* (Rome 2003) 712–25.

Changing Funerary Landscapes in Late Antiquity: Mausolea in North Africa

Julia Nikolaus

Abstract

This paper considers the changes in elite burial monuments during Late Antiquity in North Africa using archaeological evidence, inscriptions, and literary sources where relevant. It highlights the complex nature of funerary behaviour by primarily focusing on late antique mausolea in Tripolitania (Libya) to explore how these prestigious funerary monuments were used by the local elite to proclaim power and status during a time when power shifted from the centralised Roman authority to local rulers in the 4th and 5th c. The paper also pays attention to mausolea in Tunisia and Algeria, particularly in the light of the rise of Christianity, and how changes in religious beliefs may have influenced the mausolea culture in this region.

Introduction

Mausolea were an integral part of the funerary landscape in late antique North Africa, built by the prosperous elite to serve as the final resting place for themselves and their families. They were significant social markers that commemorated the deceased and their families while also conveying subtle religious and political ideas that were deeply engrained in local society and culture. Tower and temple mausolea,[1] larger drum mausolea,[2] and large tumuli[3] were already a familiar mode of burial in the pre-Roman period. Notably, one of the major differences between the pre-Roman and Roman period monuments is the dramatic rise in their numbers. In Tripolitania only three pre-Roman tower mausolea are known,[4] but by the end of the 3rd c., over 230 mausolea were constructed.[5] In neighbouring Tunisia, we know of at least 7 pre-Roman mausolea, but their number rose to over 340 in the same time span.[6] This picture appears to change again from the late 3rd c. onwards, when the overall number of newly constructed mausolea began to dwindle. In some areas of North Africa, however, new and lavish forms of monumental tombs were constructed. By focusing on the mausolea of Tripolitania (modern-day Libya), this article will examine how the changing economic, social, and political circumstances in Late Antiquity shaped the way in which the elite chose to commemorate themselves and their family through their funerary monuments. Furthermore, the influence of Christianity on mausolea construction in Tunisia and Algeria during Late Antiquity will be considered in the latter part of this paper (Fig. 1).

It is important to point out from the outset that the nature of the evidence for late antique mausolea is problematic. We still know comparatively little about the mausolea of the 4th to 6th c.[7] Mausolea frequently lie on the periphery of ancient cities and settlements, outside the protected areas and are, as a result, more vulnerable to destruction through development and looting. Especially in densely settled areas the evidence for mausolea may have long disappeared. A further problem arises in that many excavations focus on the Punic and the Early to mid-Imperial Roman period, and it is only recently that the interest in the late antique period has increased. New excavations are beginning to shed some light on the existence of mausolea in Late Antiquity. For instance, at Bulla Regia the foundations of at least one mausoleum dated to the 6th c. were recently discovered.[8] Another major problem is the lack of comprehensive dating materials through excavation and thorough architectural studies. Consequently, many mausolea have only vague dates attached to them, and the lack of excavation gives us little idea of the ritual that may have been conducted there, how long the monument may have been in use, or if it was reused later. For this reason, rather broad date ranges are given for many mausolea discussed in this piece. A further difficulty lies in the fact that it is often impossible to distinguish between Christian or pagan monuments, particularly if

1 Pre-Roman temple and tower mausolea can be found in Cyrenaican, Tripolitanian, and Numidian territories. See for instance Bentivogli (2007–2008); Di Vita (1976); Ferchiou (2009); Gsell (1901); Moore (2007); Poinssot and Salomonson (1959); Quinn (2013); Rakob (1979); Stucchi (1987).
2 Large drum mausolea include, for instance, Medracen see Camps (1973) or the 'Royal Mausoleum' see Coarelli and Thébert (1988), both in Algeria.
3 For examples in Tunisia, see Ferchiou (1987). For Algeria or Cyrenaica, see Stucchi (1987) or Colvin (1991) 26–27.
4 See Di Vita (2010) for the two mausolea at Sabratha (Mausoleum A and Mausoleum B), see Ferchiou (2009) for Henchir Būrgū on Jerba.
5 For mausolea in Tripolitania see, for instance, Brogan and Smith (1984); Fontana (1997); Nikolaus (2017).
6 Moore (2007) 75; see also Bentivogli (2007–2008) and Ferchiou (1995) for a detailed study of mausolea in Tunisia.
7 Ferchiou (1995) 135–136, for instance, lamented the lack of knowledge about 4th to 5th c. mausolea in Tunisia.
8 Chaouali, Fenwick and Booms (2018) 194–195.

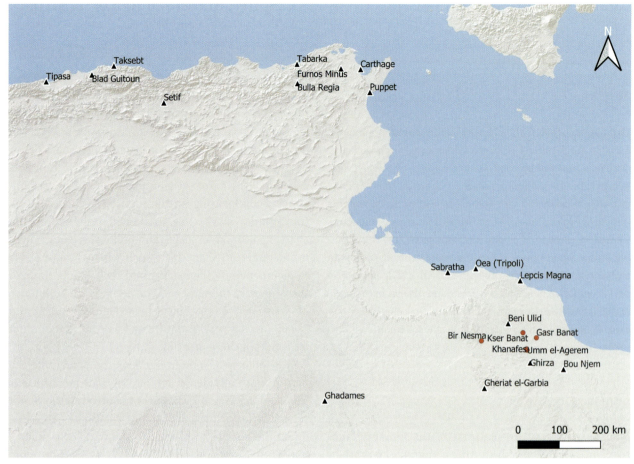

FIGURE 1 Map showing places and mausolea mentioned in the article.

inscriptions or iconography are absent. Despite these limitations we can start to make some observations about the continuity and change of mausolea in the different regions of North Africa during the late antique period.

Late Antique Mausolea at the Periphery – Ghirza and Beyond

> Marchius Fydel and Flavia Thesylgum,
> father and mother of Marchius Metusan
> who had this memorial made for them,
> and have reckoned that there was spent on this,
> in coin [·· ? ··] thousand folles,
> and in addition the food for the workmen.
> May my sons and grandsons read (this)
> in good fortune and build others like it.[9]

At some point in the early 4th c., Marchius Fydel and Flavia Thesylgum commissioned their arcaded temple mausoleum as their final resting place in the northern cemetery of Ghirza in the Tripolitanian pre-desert.[10] The inscription expressed the hope for their sons and grandsons to 'build others like this', a wish that came true as the nomenclature and style of inscription on the neighbouring mausoleum (North C) suggest.[11] Over the next 100 years, an additional 4 arcaded temple mausolea were constructed in the northern necropolis and by the 5th c., there were at least 14 monumental tombs in the cemeteries of Ghirza, 7 in the North Cemetery, and 7 in the South Cemetery.[12] Together, they represent the largest concentration of mausolea in the pre-desert.

Ghirza is located a considerable distance away from the big coastal cities of Lepcis Magna, Sabratha, and

9 IRT2009, 900, for Latin and translation see http://inslib.kcl.ac.uk/irt2009/IRT900.html.

10 Ghirza North B. Throughout this article, I follow the labelling established by Brogan and Smith (1984).

11 IRT2009, 898: "Marchius Chullam and Varnychsin, father and mother of the Marchii Nimmira and [?M]accurasan, who had this memorial built for them. We paid out in reckoning for these things, in coin on salaries a total of 45,600 folles, in addition to the food for the workmen. May their sons and grandsons visit it happily". For Latin and translation see http://inslib.kcl.ac.uk/irt2009/IRT898.html.

12 The southern cemetery is located approximately 2 km to the south of Ghirza and the northern cemetery is only a short distance to the south of Ghirza.

Oea, deep in the pre-desert of Tripolitania on the west bank of the Wadi Zemzem, ca. 250 km south-east of Oea (modern-day Tripoli). The settlement consisted of about 40 buildings, including several substantial fortified structures and a temple. Archaeological evidence shows that Ghirza reached its hey-day in the late 3rd and 4th c., which corresponds to the construction of the majority of mausolea.[13] The size of the settlement and the presence of a substantial temple and the two monumental cemeteries suggests that Ghirza was probably an important centre for trade and security for the region.[14] The pre-desert region, in which Ghriza is situated, is defined by a large limestone and basalt plateau intersected by wadi channels (ancient riverbeds). Vegetation is sparse due to hot summers, cold winters, and little rainfall. From the later 1st c. AD onwards settlement increased dramatically, including farmsteads and larger courtyard farms,[15] with fortified farms (gsur) starting to appear in the 3rd c.[16] Farms and settlements were established along certain wadis with some of them becoming very densely settled.[17] Intense water management techniques, including irrigation walls and cisterns, were employed to make agriculture a possible and fruitful venture.[18] Notably, by far the largest number of mausolea in Tripolitania were located in the pre-desert, amounting to at least 103 in total, which can be linked to large farms and gsur situated nearby. The pattern of settlement suggests that the region was divided into independent farms and estates that held a considerable amount of land, which was owned by the local elite.[19]

By the time Marchius Fydel and Flavia Thesylgum commissioned their final resting place, mausolea were not an unusual sight in the pre-desert and, indeed, across Tripolitania. What was new was the architectural form they had chosen: the temple mausoleum. Before the mid-3rd c. tower mausolea were favoured, an architectural type that developed out of wider North African ancestral traditions of Punic tower tombs. During the Roman period, the tower mausoleum developed into the tall obelisk mausoleum, so-called because it was crowned by a long and slender pyramidal roof. This architectural type is unique to Tripolitania, and typically consisted of two or three superimposed storeys that could reach up to a height of 18 m above the subterranean burial chamber. Pilasters, engaged columns, and mouldings served as architectural decoration, while friezes displayed animals, human figures, rosettes, vegetal scrolls, and portrait busts in relief and in some cases, portrait statues.[20]

Thus, in the mid-3rd c. the temple mausoleum constituted a completely new trend in the pre-desert. This type of monument increased in popularity across North Africa at some point during the late 2nd and 3rd c., although the architectural forms that developed differ across the region.[21] Two types of temple mausoleum were popular in the Tripolitania pre-desert: the peripteral and the arcaded temple tomb. The peripteral temple tomb reassembles the classical Doric temple, featuring free-standing columns that run along the sides of the central chamber. The burial chamber is located below the central chamber. A flight of stairs leads up to the podium and the false door that decorates the central chamber. The roof is flat without a pediment. This tomb-type can be found at Gasr Banat in the Wadi Nfed (Fig. 2C),[22] at Ghirza (North A) (Fig. 2A),[23] and possibly in the Wadi Sofeggin, called Kser Banat.[24] North A at Ghirza was the first monumental tomb in the northern cemetery and the names on the inscription highlight the Libyan heritage of the family.[25] The mausoleum is

13 Brogan and Smith (1984) 40–92; Mattingly (2011) 248.
14 Barker *et al.* (1996) 144–149; Mattingly (1995) 162–167; Mattingly (2011) 249.
15 Barker *et al.* (1996), Sheldrick (2021).
16 Mattingly with Flower (1996) 168.
17 Sheldrick (2021).
18 Barker *et al.* (1996) 5–13.
19 Barker *et al.* (1996) 178; Nikolaus (2017).

20 Brogan and Smith (1984); Mattingly (1995); Nikolaus (2016) 205–206.
21 They became popular across the Roman Empire from the 1st c. AD onwards, especially in the western provinces. In Palmyra, the number of temple mausolea rose dramatically from the 2nd c., where they were chosen over the traditional tower mausolea; see von Hesberg (1992) 187–188; Toynbee (1971) 130–132. Moore has noted that while in the eastern provinces temple mausolea eventually replaced tower mausolea, in Africa Proconsularis, tower and temple mausolea existed contemporaneously, and they survive in approximately equal numbers; Moore (2007) 84.
22 Banat: Bauer (1935) 72–73; Brogan and Smith (1984) 264–272; Mattingly (1996) 263; Di Vita (1964) 89. Gasr Banat is dated to the mid-3rd c., based on its architectural decoration and the lettering of the inscription Brogan and Smith (1984) 264–265. For the inscription, see *IRT2009*, 891: To Aurellius Nazmur their father and [·· ? ··· their] mother, the Aurellii Maior and Magnus and Arcadius, sons, [·· ? ··] had this made for their most dutiful [parents]. See http://inslib.kcl.ac.uk/irt2009/IRT891.html for Latin and translation.
23 The dating of North A is difficult, but the architectural decoration and the lettering of the inscription suggest that it was built no earlier than the mid-3rd c. Ghirza North A: Brogan and Smith (1984) 121–133; Mattingly (1996) 120; Smith (1985); Kenrick (2009) 190; Nikolaus (2017).
24 Kasr Banat: Al-Khadduri (1997) 220–223; Mattingly (1996) 280. This very large structure (8.66 m × 4.74 m) was, most likely, also surrounded by columns, very similarly to Gasr Banat or Ghirza North A.
25 IRT2009, 899: Of M(archius) Nasif and M(archia) Mathlich, mother; the Marchii Nimira and Fydel, their sons, had this built for their dear parents. See http://inslib.kcl.ac.uk/irt2009/IRT899.html for Latin and translation.

decorated with relief sculpture displaying the portrait of two females, a lion hunting a herbivore, two men sacrificing a bull, a cauldron, two birds drinking out of a beaker, and a mask. Roof ornaments such as palmettes and scrolls topped the monument.

The most innovative architectural type of mausoleum that developed in Late Antiquity in the pre-desert is the arcaded temple mausoleum, which is unique to North Africa.[26] These structures consist of a central pier that is frequently decorated with a false door in relief. The pier is placed on top of a podium and is surrounded by a colonnade that supports monolithic arch heads. The arches were, in fact, arcuate lintels, with the cut-out arch reducing their weight. They were excellent supports for the above frieze, and could, themselves, be decorated. In an aesthetic sense, the cut-out arches gave the structure a much lighter and higher appearance. This type of arch head alone was not an innovation, for it was already known from windows or tower mausolea. Thus, this type of arch may have simply been the easiest and most economical way for the builders to construct the tombs.[27] The arch heads (decorated with figurative, floral, and geometric reliefs) are directly on top of the columns on which the highly decorated friezes are placed. Like in the case of the peripteral temple tomb, the roof is flat and crowned with roof ornaments. The burial chamber is located underneath the podium. This type of mausoleum was particularly popular at Ghirza, where 8 out of 12 were of this type (Fig. 1A). Other examples can be found at Bir Nesma in the Wadi Sofeggin (Fig. 2B), in the Wadi Khanafes (Fig. 2D), in the Wadi Umm el-Agerem, and in the oasis settlement of Ghadames in the true desert. Although the mausolea in the pre-desert area are poorly dated, the evidence suggests that temple mausolea replaced tower mausolea by the 4th c. It is, therefore, the more striking that no examples of peripteral and arcaded temple mausolea are known beyond the borders of Tripolitania. Instead, in neighbouring Africa Proconsularis, the tetrastyle mausoleum was favoured. They were commissioned contemporally at approximately equal numbers to tower mausolea but, interestingly, do not appear to date beyond the 3rd c.[28]

The design of the temple mausoleum was ideal to facilitate the worship of the ancestors buried within.[29]

The cult of the dead and the veneration of ancestors were a deeply engrained aspect of North African culture and are invariably linked to the developments in mausolea architecture and decoration.[30] The ancestral cult was already a long-standing tradition by the time North Africa was integrated into the Roman Empire, as tomb furniture such as offering tables or libation bowls found at pre-Roman burials show.[31] The importance of the ancestors did not cease during the Roman period but developed even more clearly into a cult where the deceased reached near-divine status.[32] The use of offering tables continued, and it is not unusual to find them deliberately placed next to a mausoleum.[33] Many mausolea show evidence of libation channels that lead into the tombs.[34] Ritual practices are displayed on figural reliefs that decorate the mausolea at Ghirza, such as figures holding offering bowls, or the depiction of animal sacrifice.[35] Further evidence comes from an inscription found near Ghirza North A which mentions a large feast that took place to honour the dead. It refers to the festival of the *parentalia*, for which 51 bulls and 38 goats were killed.[36] It is doubtful that the *parentalia* was the same festival that was held on the Italian peninsula, particularly because these were usually conducted by close family members in smaller groups.[37] However, if we believe the inscription from Ghirza, an enormous amount of meat would have been processed, amounting up to 8,670 kg of bull meat, and 950 kg of goat meat.[38] Such a vast amount suggests that several thousand people could have taken part in commemorating the dead at a certain time in the year; certainly far more than the whole community normally living at Ghirza.[39]

26 Similar examples of this type are located in Turkey, such as the tomb of Mylasa or the mausoleum at Kimar and Brad in Syria, though they lack the decorated monolithic arch heads; see von Hesberg (1992) 150–151.
27 Brogan and Smith (1984) 209.
28 Moore (2007) 85.
29 Moore notes that in Tunisia in at least 13 cases there remains uncertainty if the structure is a temple or a mausoleum: Moore (2007) 92.
30 Mattingly (1996); (2003); (2007a); Stone and Stirling (2007) 22–23.
31 See, for instance, Camps (1961); Hitchner (1995); Mattingly (2003); (2007a); (2007b).
32 Two insightful poems were inscribed on the tower mausoleum of the Flavii family at Kasserine, in modern day Tunisia, built around AD 150. The mausoleum is referred to as a 'temple', and the poems highlight the importance of the structure as a sacred monument in which the ancestors were housed permanently. For the poems and their interpretation see Thomas (2007) and Pillinger (2013).
33 Nikolaus (2017).
34 Some mausolea at Ghirza have steps leading up to the central pillar and false door. A libation channel is located below the false door, indicating some ritual that was associated with the cult of the dead, see Brogan and Smith (1984).
35 Scenes of bull sacrifice come from Ghirza North A and the Wadi al-Binaya while a relief from Ghirza South F may depict the impending sacrifice of a goat.
36 Brogan and Smith (1984) 262.
37 Mattingly (2011) 265.
38 Fontana (1997) 185.
39 Mattingly (2011) 265.

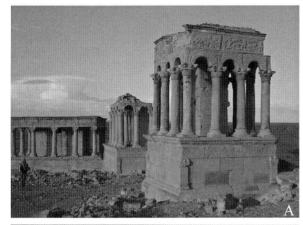 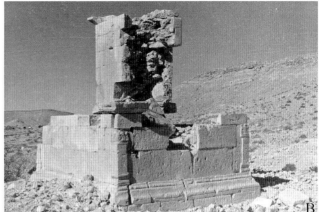
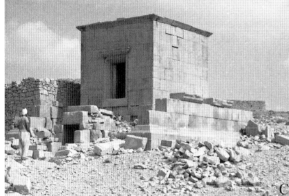 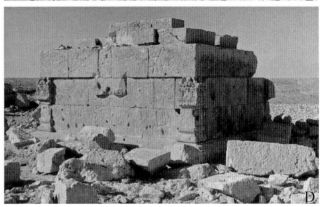

FIGURE 2 A. Temple mausolea in the northern cemetery of Ghirza, North A, B, and C from left to right (Image: Philip Kenrick);
B. Bir Nesma arcaded temple mausoleum (Image: ULVS Collection, British Institute for Libyan and North African Studies Archive); C. temple mausoleum Gasr Banat (Image: ULVS Collection, British Institute for Libyan and North African Studies Archive); D. Wadi Khanafes arcaded temple mausoleum.
IMAGE: ULVS COLLECTION, BRITISH INSTITUTE FOR LIBYAN AND NORTH AFRICAN STUDIES ARCHIVE

Even if the numbers of slaughtered animals were inflated to enhance the importance and wealth of the family, it still marks the *parentalia* out as one of the major events of the region, perhaps bringing together the immediate and more extended clans, who may have lived further away. As Mattingly points out, "the scale of the sacrifice matches the impressive funerary architecture and iconography produced to honour and appease those ancestors".[40] Unfortunately, we have little archaeological evidence about the ritual that may have accompanied the feasts and where they were held at Ghirza in Late Antiquity. There is no evidence of *mensa* or dedicated banqueting spaces where funerary feasts may have been held. Such funerary couches are evident in late antique cemeteries across North Africa as, for instance, at Tipasa or at Sabratha.[41] However, two semi-submerged structures in the cemeteries of Ghirza, one in the South and one in the North, are very different from the mausolea. They consist of two small, interconnected chambers. The back room was a funerary chamber, while the room at the front featured a bench along the back wall. They do not bear any figural or architectural decorations. Mattingly suggests that they may be linked to the ancestral cult, where visitors of the tombs could spend time in these 'funerary chapels' in close proximity to the dead.[42]

A further clue that rituals were performed at the pre-desert mausolea comes from the iconography on the mausolea and from the temple at Ghirza. The temple was the largest in the pre-desert and was in use from the 2nd c. onwards. It was continuously enlarged and altered up to the 6th c., when it was eventually destroyed by a fire. It is unknown to whom this temple was dedicated.[43]

40 Mattingly (2011) 265–267; see also Diggle and Goodyear (1970); Mattingly (1983).
41 Duval (1995). For Tipasa, see Ardeleanu (2018); for Sabratha, see Di Vita (1980–81); (1990); Rizzo (2015).
42 Mattingly (2011) 263–265. Rooms associated with large burials are known from across North Africa, see for instance Camps (1986).
43 It has been previously suggested that the temple was dedicated to the god Gurzil. Bull heads and masks on the mausolea of Ghirza may refer to Gurzil, who was the son of the desert god Ammon and a cow. However, Gurzil is only mentioned in Corippus (*Ioh* 5.22 26), and it is not clear how widespread

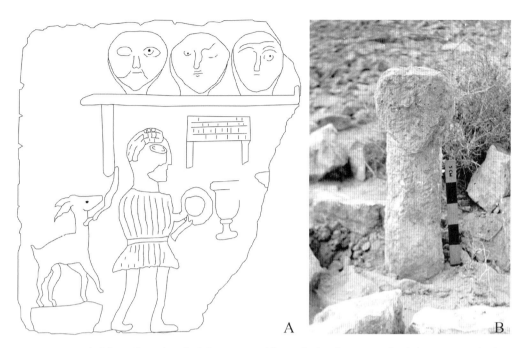

FIGURE 3 A. Relief from Ghirza (South F) showing possible ritual related to ancestral cult (Drawing: Author);
B. Headstone from Ghirza cemeteries associated with minor tombs.
IMAGE: BROGAN COLLECTION BRITISH INSTITUTE FOR LIBYAN AND NORTH AFRICAN STUDIES

Offering tables very similar in style to those in the cemeteries of Ghirza were found inside the temple, together with 26 altars of which some resemble buildings that recall the architecture of the mausolea.[44] Interestingly, a relief sculpture from the mausoleum South F depicts a row of heads lined up on a shelf. A person is holding a bowl in one hand, and a goat is tied up behind him. This scene may depict offerings being held in the temple, but may also refer to offerings being made to the ancestors who were represented by the heads on the shelf above (Fig. 3A). Sculpted stone heads reminiscent of the ones on the relief were discovered at both the temple and the cemeteries, where they functioned as headstones (Fig. 3B). Although we cannot yet reconstruct the rituals that surrounded the cult of the dead at the mausolea at Ghirza in Late Antiquity, it appears that there was a close connection between the ritual that was celebrated in the temple and the ritual that was held at the mausolea, further suggesting that the latter had a religious function as well as serving as memorials and markers of status at least up until the 5th c., when the last of the arcaded mausolea were built.

Changing Power Relations and Changing Burial Monuments in Late Roman Africa

During the economic prosperity of the Antonine and Severan ages, one of the main drivers for the 'mausoleum culture' in North Africa was that more people were able to accumulate the necessary wealth that enabled them to spend large sums of surplus money on building their own elaborate burial monuments.[45] Although North Africa in general fared better during the Third Century Crisis than much of the empire, by the 4th c. this situation had changed.[46] Wealth (and power) was restricted to fewer people than before, and considerably less money was poured into public buildings. Instead, the remaining prosperous families poured their wealth into private houses elaborated with rich mosaics that decorated large representative rooms.[47] The 4th c. saw a series of tribal upheavals across North Africa, including raids and full-scale wars that, together with a series of earthquakes, affected the political, social, and economic stability of the region. This instability and decline in the numbers of wealthy elite with considerable disposable income inevitably influenced the number of mausolea that were constructed in Late Antiquity.

this cult was. Bulls may refer to the ram-horned Ammon himself, who was very popular in Tripolitania and who shared many attributes with Baal-Hammon; see Brouquier-Reddé (1992) 255–265; Le Glay (1966) 107–152; Mattingly (1995) 168; Riedlberger (2010) 301.

44 Brogan and Smith 1984; Mattingly and Sterry (2010).

45 Moore (2007) 102.
46 Dossey (2010) 16–17.
47 Brett and Fentress (1996) 70–71; Dossey (2010) 18.

Shifting Power Relations: Lepcis Magna and Ghirza

In Tripolitania it is remarkable that, at the same time as building activities on temple mausolea in the pre-desert of Tripolitania flourished in Late Antiquity, the construction of mausolea at the prosperous coastal city of Lepcis Magna started to dwindle rapidly. At least 19 mausolea built during the Early and mid-Imperial period once stood in the vicinity of the city and its hinterlands, but archaeological evidence suggest that they ceased to be constructed by the mid- to late 3rd c.[48] A survey conducted in the hinterlands of Lepcis Magna (between Ras el Mergheb and Ras el Hammam) recorded 11 mausolea in total, which were dated between the 1st and 3rd c. AD.[49] The decline of mausolea corresponds to the slow reduction of agricultural settlement during the late 3rd c., followed by a period of 'declining stability' in the 4th c.[50] Production, export, and import continued to exist, showing that the agricultural and productive systems were still in place, although not as prosperous as in the periods before.[51] A more pronounced decline is presented around the area of Silin west of Lepcis Magna, where settlements reduce by approximately 50% from the mid-3rd c. However, a new villa and some new fortified farms were constructed in that area despite many other farms and villas being abandoned.[52]

In Lepcis Magna itself, there was a major decline in urban investment after the reign of Septimius Severus. The epigraphy of the 1st and 2nd c. attests a flurry of constructions or restorations of buildings. However, for the period from Caracalla to Diocletian, there is not a single dated inscription mentioning building activities;[53] this does not mean that building activities completely stopped as the lack of inscriptions may also indicate a change in the epigraphic habit. Also, there is evidence that buildings were still maintained or extended.[54] Nevertheless, the number of sculpture workshops dwindled to the extent that 1st and 2nd c. portrait sculptures were frequently re-worked to create new portraits.[55] The once rich and powerful city of Lepcis Magna never fully recovered from the struggles of the late 3rd c. The 4th c. was defined by further political, economic, and natural upheaval which led to Lepcis Magna, and Tripolitania as a whole, dropping sharply in importance within the Roman imperial administration. By the late 4th c., the reduced military resources were no longer under the control of the governor of the province but rather other local officials. The raids of the Austuriani in the second half of the 4th c., together with the earthquakes that struck the city and the dwindling influence of the local elites in the imperial administration, contributed to the fact that Tripolitania was slowly reduced to a provincial backwater.[56]

The decline of mausolea at the coast corresponds to the decrease of settlement and wealth in that region. The financial outlay of building a mausoleum perhaps became too costly for some of the elite families, as income started to dwindle. As the population of Lepcis Magna declined, the elite may have chosen to retreat to their country estates. That some of the already existing monumental tombs may have been used up until the 6th c. is exemplified by a tower mausoleum in the Wadi al-Farni in the hinterlands of Lepcis Magna. The monumental structure marked an underground hypogeum, which was used up until the 6th c.[57] Little is known about the earliest churches of Lepcis Magna, but evidence from the 5th c. Byzantine church suggests that burials took place here.[58] Further evidence that funerary customs changed at the coastal cities in Late Antiquity comes from a painted feasting chamber above a hypogeum at Sabratha. The early 4th c. hypogeum at Sidret el-Balik at the outskirts of Sabratha had a funerary chapel built on top of the burial chamber. The chapel was furnished with 4 large sigma couches, tables and a well, providing a space for the family to gather and hold feasts in honour of the dead. The walls were decorated with frescos that depicted hunting on horseback, birds amongst vegetation, several houses, probably representing a town, wild animals amongst scrolls and vegetation, and small, winged figures cutting grapes amongst birds.[59] This is an indication that funerary rituals may have become more private at the coastal cities, and were reserved for the immediate members of the family.

Why is it that the pre-desert region thrived during the 3rd and 4th c. and continued to build elaborate mausolea, while funerary monuments at the coastal cities of Tripolitania ceased to be built? Merrills has pointed out that studies of Early Medieval Europe show

48 Fontana (2001) noted that, on the basis of the little dating evidence we have for the mausolea at the coast, the majority seem to have been built in the 1st to the mid-3rd c. Nikolaus (2017) 46–47; Munzi *et al.* (2016).
49 Munzi *et al.* (2016) 84–93.
50 Munzi *et al.* (2016); see also Dossey (2010).
51 Munzi *et al.* (2016).
52 Munzi *et al.* (2004) 21–26.
53 Tantillo (2010) 13–14.
54 See, for instance, Goodchild (1965) on the 'unfinished' baths at Lepcis Magna.
55 Bianchi (2005); Caputo and Traversari (1976) 14–16.
56 Kenrick (2009) 6; Mattingly (1983); Mattingly (1995) 176–177; Sears (2007) 70–78; Sears (2011) 130.
57 Matoug (1998); Musso *et al.* (1998); for cemeteries at Lepcis Magna, see Fontana (1996).
58 Ward-Perkins and Goodchild (1953); Kenrick (2009) 101.
59 Di Vita (1980–81); (1990) 352–355; Rizzo (2015).

that "elaborate funerary practices appear especially frequently in periods of social and political upheaval, when new elites sought to establish their authority through material, liturgical, ritual and metaphysical channels".[60] This appears to be the case in the Tripolitanian pre-desert. The diminishing Roman authority in Tripolitania rewarded the pre-desert elite with growing authority over their territory. The withdrawal of the troops from the forts of Bu Njem and Gheriat in the second half of the 3rd c. left this region more exposed to threats from the south. As a result, some of the regional power was handed back to the local leaders who, at least until the end of the 3rd c., maintained a close relationship with Rome via treaty.[61] The growing instabilities of the 4th and 5th c. led prominent families to grow increasingly more loyal to the new federations of the interior and thus slowly turn away from the Roman Empire. Ghirza was probably one of the major centres for trade and administration and a key location for the safekeeping of the region. Consequently, the elite's power progressively strengthened, fuelled by Rome's loss of imperial authority over the Libyan pre-desert.[62]

This power shift is vividly reflected in the iconography of the late antique mausolea of the pre-desert. Displays of martial scenes, men garbed in military dress and ceremonial scenes appear on mausolea at Ghirza, at Nesma in the Wadi Sofeggin, and in the Wadi al-Binya, reflecting the increasing power of the elite in the region. Such iconography is rare elsewhere on North African mausolea in general and did not appear before the late 3rd/early 4th c. on the pre-desert mausolea. The imagery indicates that the local elite executed judicial power over the region, controlled the main centres of trade, and safeguarded the Roman former frontier zone.[63] Scenes of combat and gift-giving underline their new status, and draws attention to the responsibility of the elite family to keep their communities safe. The mausoleum of Marchius Fydel and Flavia Thesylgum (North B) is particularly striking of its display of power and prosperity. Amongst scenes in relief depicting agricultural imagery and hunting, showcasing the prosperity of the region (and the elite status of the family no less), are scenes that are clearly linked to the authority of the elite. Marchius Fydel is depicted seated on the cross-legged chair holding a cup or small staff. The seated figure is disproportionally large, indicating that this is indeed a portrait of the owner of the tomb. In front of him are a group of people wearing a variety of costumes and headdresses, perhaps indicating the different regions or tribes from which they came. In their hands, they are holding a variety of objects, presumably gifts that are being presented to the deceased. To the right of this scene, a person is being punished or executed by two figures. Another combat scene shows an armed man with carefully curled hair holding a spear. He is overpowering a nude figure with much longer, straight hair, most likely showing the distinction between the civilised people of Ghirza, and the uncivilised 'other'. This emerging iconography of military and judicial power vividly sets the family apart from the iconography that was displayed on earlier mausolea from the region, which primarily focused on portrait sculptures of the deceased and the family as well as symbolic sculpture.[64]

The imagery of North C is remarkably similar to North B including agricultural scenes, hunting, execution or punishment, the presentation of gifts to the deceased, and the arrival of a caravan. The deceased is depicted seated on a cross-legged chair surrounded by figures that are presenting vessels, a long staff, and a quiver to him (Fig. 4A). A second scene shows the deceased standing up and facing outwards. His distinct curly hair and beard are still just about visible. To the right and left of him are two smaller figures raising their arms above their heads in the pose of prayer, adoration, or mourning. To the right stands another tall figure with a long tunic wearing a conical cap. To the left of this scene, a group of horsemen are approaching in full gallop. On another relief a captured man has his arms bound behind his back and is held by two men. The man to the left is holding the victim's head with one hand while swinging a weapon with the other. The person to the right holds on to the victim's head and right upper arm (Fig. 4B).[65]

The symbolism chosen on these scenes is particularly interesting in the context of the changing power relations between the Roman Empire and the local groupings of the interior of North Africa. The execution scenes suggest that they had the status of magistrates which gave them judicial power. This is further underlined by the folding chair the deceased was portrayed sitting on, perhaps a *sella*, an insigne that embodied magisterial power.[66] In this context, what had previously been identified as a quiver could indeed be interpreted as *fasces*, an insigne which consisted of bundles of reeds tied together to demonstrate magisterial or religious power.[67]

60 Merrills (2018a) 385.
61 Mattingly (1995) 176, 186.
62 Mattingly (1995) 205ff; Fontana (1997) 150; Merrills (2004) 3.
63 Nikolaus (2017).
64 Nikolaus (2017).
65 A very similar scene has also been found in the Wadi al-Binaya, now in the museum at Bani Ualid.
66 Fontana (1997) 156; Schäfer (1989) 19.
67 Schäfer (1989) 196.

FIGURE 4 A. Power related iconography from Ghirza (North C), a bearded figure seated on a chair receiving gifts (Drawing: Author); B. Ghirza North C, two men holding a third person between them, the left is about to strike the person in the middle with a long object.
IMAGE: BROGAN COLLECTION BRITISH INSTITUTE FOR LIBYAN AND NORTH AFRICAN STUDIES

The sceptre, which both seated figures on North B and C held, are a further symbol of the Roman magistrate.[68] These symbols were depicted on coins, and were probably well known in the hinterlands of Tripolitania. The continued existence of mausolea in the pre-desert of Tripolitania was closely bound to regional, social, economic, and political circumstances. They were integral to the religious beliefs of the populations and the iconography, and inscriptions show that the veneration of the dead was an important part of ritual life. However, the mausolea also had another purpose, they were the ideal canvas to express the growing prosperity and power of the elite, visual evidence of their control over the region at a time when the Roman empire was in decline.

Monuments of Power at the Periphery: the Late Antique Mausolea of Ghadames

At least 7 arcaded temple mausolea can be found at the very periphery of the Roman Empire at the Asnam cemetery of Ghadames in Tripolitania, an oasis situated approximately 450 km south of Oea in the Saharan Desert.[69] Pliny refers to the Oasis town as Cydamus,[70] and its importance (most likely in the caravan trade) is highlighted during the triumph of Balbus in Rome in 19 BC when Cydamus was displayed amongst the most valuable achievements of his military campaign.[71] The elites of Ghadames probably entered a client relationship with Rome from this point onwards.[72] In the early 3rd c., a garrison was installed that remained until at least AD 235.[73] The oasis probably returned to its autonomous status after the withdrawal of the garrison at some point in the mid-3rd c., but it maintained close trade links with Rome and later the Byzantine Empire.[74]

The architectural style of the Ghadames mausolea is very similar to the ones at Ghirza, which allows the tentative dating of the monuments to the 3rd–5th c.[75] An obelisk mausoleum may have also been present at Ghadames, suggested by a curious stelae that depicts a tomb with a tree growing out of the top of the roof. Today, all mausolea are completely stripped of their stone facings, and consequently many of the decorative elements are now lost (Fig. 5). Numerous structural elements, such as columns and arch heads, were reused in the Islamic town and bear testimony to the once richly decorated monuments. Furthermore, various figural stone reliefs and funerary inscriptions have been recorded. The funerary inscriptions were written in Latin or Latino-Punic and bore Latin and Libyan names such as Rosauarugarage and Macarcum Varivara (from the Latin inscriptions), and Julianus (from a neo-Punic inscription).[76]

68 Salmonson (1956) 96; Schäfer (1989) 184–190.
69 Brogan and Smith (1984) 212; Largeau (1881); Mattingly and Sterry (2010) 76; Rebuffat (1975) 498–99; Richardson (1848).
70 Pliny, *NH* 5.26–5.37.
71 Merrills (2016).
72 Mattingly and Sterry (2010) 18.
73 Legio III Augusta is mentioned on inscriptions found at Ghadames: IRT2009, 907, 908; Mattingly (1995).
74 Mattingly and Sterry (2010) 18.
75 Mattingly and Sterry (2010) 76. One of the major differences between the Ghirza and Ghadames mausolea is that the Ghadames mausolea were built with a rubble core and were faced with ashlar, masonry, or plaster, while the Ghriza monuments were solid ashlar constructions.
76 IRT2009, 912; IRT2009, 911; Mattingly and Sterry (2010) 111.

FIGURE 5 The Asnam cemetery of Ghadames with the remains of the arcaded temple tombs.
IMAGE: AUTHOR

In total, 14 stone reliefs are known from Ghadames.[77] Stylistically, these sculptures are very similar to the funerary art of the Tripolitanian pre-desert, which suggests that they were part of the decoration that adorned the arcaded temple tombs. The overall themes include agricultural activities, hunting on horseback, hunting with dogs, and ceremonial scenes reminiscent of the iconography at Ghirza; however, many of the figures wear local costume and the hair is arranged in thick braids gathered high on the head, with the ends hanging down to the shoulder in a long, thick ponytail. Some of the reliefs that survive draw attention to the elevated status of the deceased. For instance, a figure is displayed holding a palm leaf above an arch decorated with a zig-zag pattern, in which a seated person is holding a staff.[78] The person sitting in the centre, most likely the deceased, clearly had some social significance. Another relief shows the procession of three people holding small objects such as cups and flasks. A cup is offered to a fourth person who appears to be facing outwards and is slightly larger than the rest of the group (Fig. 6). Unfortunately, the stone is broken off here and only part of this larger figure is showing. It is striking, however, that some of the overall composition recalls the ceremonial scene on the Ghirza reliefs, where cups, vessels, and gifts were presented to the deceased.

Although the evidence from Ghadames is not as rich as that from Ghirza, it is clear that the late antique mausolea at the Asnam cemetery were more than just markers of wealth of the local elite. The difference of dress and hairstyle at Ghadames and Ghirza show that the imagery was not randomly chosen out of a pattern book, but was designed to send clear, customised messages to the local community. Ghadames, like Ghirza, was an important centre of trade, and was probably one of the main centres of power in the region. These large and impressive mausolea functioned as powerful markers at the very periphery of the Roman Empire not only to the local people, but also to the transhumant population that was involved in the caravan trade. In Late Antiquity, they sent a clear message of the power held by the local elite who now ruled over the region after the retreat of the Roman army.

Within the wider context of North Africa, Tripolitania is somewhat an exception in that its social and political upheaval had already begun in the late 3rd and 4th c., while other areas of North Africa were still prosperous. Christianity did not take hold in the remote pre-desert and desert regions until the Byzantine era, while elsewhere the new religion gradually had a much larger impact. The rich figural relief decorations are distinctly Tripolitanian, while in the rest of North Africa mausolea were less vividly decorated. Although fewer in number, mausolea were still built at the coast and in the countryside including mausolea near the 4th c. fortified farm of Kasr el-Kaoua in Algeria and the large tower mausoleum 'La Ghorfa' in Wadi Selama in Algeria, which was built in the 4th or 5th c.[79]

77 Nikolaus (2017).
78 A drawing of this relief by Duveyrier (1864) survives but the original stone is now lost.

79 Laporte (2009a) 503; La Ghorfa: Laporte (1980); (2009b).

FIGURE 6 Relief from Ghadames, a group of people proceeding towards a tall figure on the right.
IMAGE: AUTHOR

The Emergence of a New Elite in Late Antiquity: the Djedar Mausolea

In north-central Algeria on the western edge of the Sersou Plateau are the Djedar mausolea, comprising 13 monuments divided into two groups. These large, high-status funerary structures date from the 5th to the 7th c.[80] The three earliest structures from the 5th c. are grouped together on the Djebel Lakhdar, while the later mausolea are located a few km to the south of the first group. These monuments are located near the old Roman frontier at a point that connected the High Plateau in the south to the Tell and the Ouarsenis mountains in the north.[81] As in the pre-desert of Tripolitania, the number of settlements in this region was high, although perhaps the major difference was that Christianity was well established in the area.[82] Chi-Rho monograms, floral rosettes, and paired birds in relief are found on the mausolea.[83] Other decorations include well-established elite iconography, such as the hunting on horseback of lions and ostriches, similar to those on the mausolea of Ghirza, underlining the high status of the elite family buried here.[84] Partial inscriptions that survive on the three earliest mausolea are in Latin, and the words *duc(i)* and *ecrecius(s)* may refer to Roman military rank.[85] The phrase *dis minibus sacrum* suggests some connection to Roman imperial culture under the local rulers.[86]

The architecture of the mausolea represents a striking mix of past traditions stretching back to the Mauritanian and Numidian kingdoms of the 3rd to 1st c. BC, Saharan traditions (including bazinas with flanking chapels), as well as local mausolea structures.[87] For instance, the base of Djedar A is formed of a large rectangular masonry plinth (about 35 m wide and approximately 2 m high) topped by a tumulus, which may have reached a total height of 17 m (Fig. 7). Small rooms, or 'chapels' were added to the eastern side of the monuments, indicating that ancestral worship still played an important part in this region. Merrills rightly points out that the architecture of the Djedar may be "a part of a continuum of different types of funerary constructions that stretch from the desert to the heart of the old Roman province, and which seems to have become particularly prominent in Late Antiquity".[88] We do not know who built the Djedar, or what exactly the cultural impulses behind those mausolea were, but they

80 Laporte (2005) 360; Merrills (2018a) 382.
81 Kadra (1983); Laporte (2005); Rushworth (1999); (2004); Merrills (2018a).
82 Cadenat (1957); Février (1996).
83 Kadra (1983) 198–207; Laporte (2005) 349.
84 Brett and Fentress (1996) 77–79.
85 Laporte (2005) 352–354.
86 Merrills (2018a) 383.
87 Rushworth (1999) 93; on pre-Roman burial monuments, see Camps (1986); Fentress (1979); Rakob (1979). See Fentress and Wilson (2016) for connections to the Royal Cemetery in Germa in Fezzan and Kadra (1983) for parallels in Algeria; on Saharan burials in general, see Gatto *et al.* (2019).
88 Merrills (2018a) 385. A similar 'merging' of longstanding burial traditions and contemporary features can be observed at the mausoleum at Blad Guitoun. This octagonal structure was over 9 m high and stood on a hill dominating the surrounding landscape, Gsell (1898); Laporte (2013).

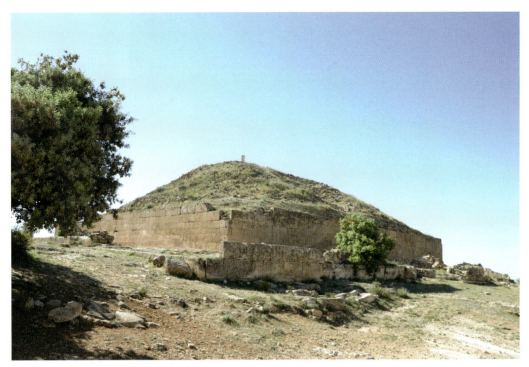

FIGURE 7 Djeddar A in the djebal Lakthar.
IMAGE: MUS52, CREATIVE COMMONS LICENCE

represent the emergence of a new elite in the hinterlands of Algeria that used large mausolea structures to help establish and express their power over the region.[89] The collapse of Roman authority in the region in the 5th c. brought with it the formation of sub-Roman successor states, apparently ruled by new elites bearing Berber names.[90] Similar to Ghirza, this region was previously at the periphery of the Roman Empire and the decreasing authority of Roman rule caused a considerable increase in power and wealth of local rulers. The size of the mausolea reflects the power and status of the ruling family, and the iconography of the stone reliefs together with the inscriptions echoes the complex identity of the society and the local rulers. They represent a fascinating mix of local customs and ritual traditions married with past architectural traditions. The community held Christian beliefs, but the existence of 'chapels' indicates that the 'cult of the dead' was still very much alive when the Djedars were constructed.

The continued relevance to the community of these structures and the interred is further underlined by the relief decorations that appear to have been added after the construction of the monument had been completed. Some parts of the monument, however, appear to have been prepared for decoration but were never worked.

These funerary monuments, similar to the examples at Ghirza, were much more than the resting place of the local elite; they represented a place for ritual and ancestral worship for the local community, a tradition that outlasted the end of the Roman Empire. What both Ghirza and the Djedars represent is a sense of continuity in a time when the political and social world was changing drastically. Both cemeteries represent 'dynasties' of local rulers who wanted to enforce and emphasise their power over the region. Not only did they have the means and manpower available to build these monuments, but their rule also lasted over several generations as the mausolea very vividly demonstrate. In Late Antiquity, mausolea were increasingly becoming monuments of power, used by local rulers and their families to enforce, and emphasise, their legitimate rule over the region.

It is important to keep in mind that the Ghirza and Ghadames mausolea were built earlier than the Djedars and, indeed, historical events are very different in both regions. While the pre-desert and desert region of Tripolitania did not seem to be affected by the Vandal conquest, Algeria was under Vandal rule during the mid-5th c. until 546, when King Gelimer surrendered to Byzantine forces. Furthermore, the uprising of Moorish tribes caused continuous fighting even after the Byzantine conquest. However, the mausolea from Djedar, Ghadames, and Ghirza are remarkable because they are all located in marginal locations and represent family groups, perhaps even dynasties, of local ruler elites who established and continued their rule over

89 See also Merrills (2018b), Fentress and Wilson (2016), and Rushworth (1999); (2004) on the emergence and identity of these new Moorish leaders.
90 Merrills (2018a) 356.

their territories for generations. It is significant that they were located at the fringes of the Roman Empire, in areas that were losing, or had lost, their foothold in these marginal zones. They were placed at strategic positions near important centres of trade and transhumant activity and were seen by a wide variety of people, who would have interpreted them in different ways. The architecture of the Djedar monuments, for example, reflects the fluidity of these transitional zones, drawing on both Saharan and local traditions.

The Impact of Christianity on the Monumental Funerary Landscape of North Africa

Power relations, power shifts, and changes in economic circumstances represent part of the reason why the mausolea landscape has changed in Late Antiquity. Another factor that has influenced a change in burial practice across North Africa is the rise of Christianity. In the last section of this paper, I will briefly explore what impact this change in religious beliefs and practices had on mausolea in particular. I will focus on what is now modern-day Tunisia and Algeria, as Christianity had very little impact in the pre-desert region of Tripolitania.[91] In fact, it is notable that Christian symbols are completely lacking on the mausolea at Ghirza as well as on other mausolea of Tripolitania. Only two churches are known in the pre-desert: Souk el Oti in the Wadi Burza, dating to the 5th c., and Chafagi Amer in the Wadi Sofeggin. Christian symbols are also known from a gasr in the Sofeggin basin, near Chafagi Amer.[92] These communities appear to have remained rather small and isolated with paganism continuing until at least the 6th c.[93] However, in other regions of North Africa, the slow emergence of Christianity had a substantial impact on burial traditions from about the 4th c. onwards.

Already by the beginning of the 3rd c. Tertullian, a member of the clergy of the Christian church at Carthage, voices his reservations towards Christians participating in funerary rites, offerings, or banquets held at tombs.[94]

So on that account, since both kinds of idol stand on the same footing (dead men and gods are one and the same thing) we abstain from both kinds of idolatry. Temples or tombs, we abominate both equally, we know neither sort of altar; we adore sort of image, we pay no sacrifice, we pay no funeral rite. No, we do not eat of what is offered in sacrificial or funeral rite, because, 'we cannot eat of the Lords supper and the supper of demons'.[95]

The fact that Tertullian mentions temples and tombs in one sentence is rather telling within the North African context, particularly in relation to the emerging trend of the temple mausoleum. He rejects Roman gods together with dead men and the worship of cult images as 'false religion'.[96] He does not imply that this custom is one that Christians no longer followed; rather, he indicates that this is a custom that should be abandoned.[97] Despite reservations of the clergy, the practice of honouring the dead by visiting the tombs, providing offerings, and holding banquets at the gravesite remained very much alive up until the time of Augustine in the 4th c. In the *Confessions*, Augustine refers to his mother Monica, who wanted to take offerings of food and wine to the shrine of a martyr at Milan, 'as had been her custom in Africa'. She was forbidden to enter the shrine under Bishop Ambrose's new law, and Augustine himself seems surprised at how readily his mother gave up this custom.[98] Monica probably not only visited the tombs of martyrs, but also of family members,[99] and while Augustine seems to be rather opposed to the tradition of holding banquets for martyrs, he did tolerate meals at the tombs of ordinary people. The cult of the martyrs and the already existing cult of the dead were closely related, and martyrdom was an essential aspect of Christian identity in North Africa, but differing in the fact that the martyr's cult was practiced by the whole church community, and not only by the family.[100]

Amongst Christians in the 4th c., burial in or around cemetery churches and basilicas became more and more popular. Inhumations in and around churches signal a cultural shift from the focus on individual or family memorials, such as mausolea, to Christian communal burials.[101] Burials were organized according to membership within the local church, rather than

91 Conant (2012) 267–268; Mattingly (1995) 212–213; for ancient authors, see Cor. *Ioh.* 2.109–11; 3.81–85; 5.494–502; 6.145–90; 8.300–17; The temple at Ghirza went up in flames around AD 550, which marks the end of the pagan cult, Brogan and Smith (1984) 85, 232.
92 A possible Christian building inscription comes from Gasr Gasia *IRT2009*, 894a: Lauratianus[and·· ? ··] established the foundations with his sons and grandsons [·· ? ··] ?fortune (case unknown) [·· ? ··] increases with God favouring (?us).
93 Mattingly (1995) 214.
94 Rebillard (2009) 143; Rebillard (2012) 9–10.

95 Tertullian, *De Spectaculis* 13.3–4.
96 Sroumsa (2008) 176; see also Tertullian, *De idolatria*.
97 Rebillard (2009) 143.
98 August. *Conf.* 6.2.2.
99 Rebillard (2009) 147.
100 Decret (2009) 95.
101 Yasin (2005).

around the family unit.[102] As a result, collective identity as part of the church community became more (or as) important as individual ties based on kinship, rank, or office. Members of the community were interred below the surface of the church pavement. Above ground burial markers included stone slabs or mosaic pavements decorated with inscriptions and Christian symbols. Interestingly, the mosaics and markers in many churches such as at Kelibia in Tunisia and Setif in Algeria are fairly homogeneous.

At the cemetery church of Bir el Knissia at Carthage, the individuals chose from the standard repertoire of iconography, formulae, and nomenclature.[103] This ensured that the identity of the individual was preserved while, at the same time, he or she fitted in with the existing community.[104] Hierarchical arrangements within the burials still existed and could be determined by the material in which the covering, such as mosaics, were constructed.[105] Most important was the location of the burial: burial spaces in privileged positions in close proximity to saints secured salvation and proclaimed a personal relation with the saint which could signify status; up until the mid-5th c., these spaces were often reserved for the clergy.[106] Furthermore, as Yasin points out, "while the grave of a martyr may have been the place where heaven and earth met, it was also the place where people met", creating a relationship between the living audience and the interred.[107] Over time, for some elite families of Christian faith, annexed funerary chapels may have been preferred to the mausoleum, such as at Tabarka or at Damous el Krita where whole family groups are buried.[108]

Despite the change in burial customs, some mausolea were clearly built by people of Christian faith. St. Salsa at Tipasa in Algeria was first interred in a mausoleum in the early 4th c. The mausoleum stood in a dominant position, visible from the sea.[109] At some point after AD 371/372, she was moved into a small basilica, inevitably shifting the main ritual focus to the church.[110] A second Christian mausoleum may have stood in the same cemetery bearing the inscription *ichthys*.[111] In Tunisia, at Furnos Minus, approximately 40 km south-west of Carthage, the mausoleum of Blossius was built in the 4th or 5th c. The entire floor of the mausoleum was decorated with a mosaic depicting Daniel and the lion showcasing Blossius' Christian beliefs. The burial chamber had room for 6 adult and 2 child burials, and perhaps a ninth burial under the 'Daniel' mosaic.[112] There is no clear evidence that this tomb was a *memoria* for martyrs.[113] Other members of the Blossii family were buried nearby in mosaic-covered tombs, which were probably part of a basilica.[114] An octagonal mausoleum was constructed in the 5th c. at Blad Guitoun in Algeria, 3.5 km east of Thénia.[115] Intricate decorations reminiscent of wood carvings adorned the monument, including a false door.[116] Fragments of the decorated sarcophagus found inside, as well as decorations on the outside of the tomb, including a chalice flanked by two fish, indicate that the commissioner of the tomb was of Christian faith. That the 'cult of the dead' was still active is suggested by the large platform that was constructed at the eastern side of the monument. Gsell mentions the archaeological remains of a large church that stood near the monument, probably built in the 5th or 6th c., but we know nothing about the relationship between the church and the mausoleum. At Bulla Regia, a recently excavated mausoleum, which was perhaps a converted cistern, was probably constructed in the 6th c. This mausoleum held 4 burials.[117]

The above indicates that one reason for the drop in numbers of mausolea across North Africa is a change in attitude towards death and commemoration among the elite, motivated by Christian religion and liturgy.[118] The focus shifted from demonstrating the status and importance of the individual family by building a large funerary monument, to displaying their position within the existing church community. Despite this shift, the longevity of a number of mausolea across North Africa is remarkable. Mausolea were still cared for, repaired and visited, and some were re-used in Late Antiquity. The large cemetery at Puppet in Tunisia was in use up until the 5th c.[119] Overall, 29 mausolea were recorded at this site and the majority were surrounded by an enclosure wall. The long life of some of these monuments is well

102 Yasin (2005) 433, 442.
103 Stevens (2008).
104 Yasin (2005) 444.
105 Yasin (2005).
106 See Brown (1981) and Duval (1988) on the eschatological advantage of burials near saints; Stevens (2009) for Bir el Knissia. At Tipasa, in the church of St. Salsa burials near the apse were staggered on top of each other. This location became so desirable that earlier Christian burials were disturbed to create new ones, see Ardeleanu (2018) for further references.
107 Yasin (2005) 433; see also Ardeleanu (2018).
108 Duval (1986); Frevier (1996).
109 Fevrier (1996) 923.
110 Ardeleanu (2018) 489–490; Gsell (1893) 18–19.
111 Ardeleanu (2018) 493; Albertini and Leschi (1932).
112 Kalinowski (2017) 117.
113 Duval and Cintas (1978); on the mosaic, see Kalinowski (2017).
114 Duval and Cintas (1978).
115 Laporte (2013) 101. See Gsell (1898) for a 4th c. date.
116 Gsell (1898).
117 Chaouali, Fenwick, Booms (2018) 194–196.
118 Ferchiou (1995) 135–137.
119 Ben Abed and Grisheimer (2001) 562.

demonstrated by mausoleum 19, built after the reign of Trajan and continuously used and visited up until the 5th c., as evident through burial remains and pottery sherds.[120] The anonymous mausoleum at Blad Guitoun equally appears to have a long chronology from the 1st c. up to the 5th c. Repairs took place on the building at the end of the 4th or early 5th c. Some of the pits containing mid- to late 5th c. pottery could also indicate that the tomb was robbed, perhaps at the end of its use.[121] At Taksebt, an elaborate circular mausoleum was built at some point in the 3rd or 4th c. The structure integrated a much earlier mausoleum that may have been destroyed by an earthquake.[122] A slightly different story is being told at the Yasmina cemetery at Carthage, where a 2nd c. mausoleum and the elaborate three-storey stucco monument of M. Bibius Tertullus were reused in the 5th c. Here, the individuals were of apparently lower status than the original owners. Burial activity at this cemetery ceased by the early 4th c., but new inhumation burials appeared a century later. The graves were cut into the still-standing mausolea, which likely served as collective markers for this community.[123]

Conclusions

It is difficult to assess the processes that caused the decline of mausolea, not least because of the small amount of systematic work that has been undertaken on late antique mausolea and the subsequent lack of precise dating. It is important to stress that regional differences and preferences are prevalent in North Africa, and changes are closely bound to local traditions, religious beliefs, as well as political and economic circumstances. However, the evidence we have suggests that the monumental funerary landscape across North Africa changed noticeably during Late Antiquity, and the popularity of the mausoleum as the family memorial and final resting place appears to decrease. Some mausolea were still built in the 4th c. but the rise of Christianity and the associated communal burial churches and cemeteries may eventually have replaced the need to build such an expensive memorial amongst many of the Christian communities. The difficult economic circumstances of some regions in late antique North Africa were also likely to have contributed to the decline in mausolea numbers, because building one simply could no longer

be afforded. Yet, particularly at the fringes of the Roman Empire, they still provided the ideal canvas for the ruling elite to demonstrate and re-enforce authority over their regions during the complex shift in power relations that took place. New and innovative architectural styles were chosen that included elements of Roman and pre-Roman forms, resulting in a funerary monument that clearly reflected local circumstances as well as wider social and political dynamics of the region.

Acknowledgements

I would like to thank Dr. Luke Lavan for the invitation to write this paper for this volume. I also would like to thank Dr. Corisande Fenwick for her advice on late antique mausolea of North Africa. Furthermore, I would like to thank Dr. Nick Ray for reading and commenting on this paper. I would also like to thank Prof. David Mattingly and Dr. David Edwards who both thoroughly commented on my Ph.D. out of which this chapter has partly evolved; and other colleagues at the University of Leicester for their advice and comments. Finally, I would like to thank Philip Kenrick for, yet again, letting me use photos from his photographic collection, and the British Institute for Libyan and North African Studies for giving me access to their archive and permission to publish relevant photographs.

Abbreviations

IRT2009 = Bodard, G. and Roueché, C. (2009) *Enhanced electronic reissue of: Reynolds J. M. and Ward-Perkins, J. B. 1952. Inscriptions of Roman Tripolitania*. Available at: http://inslib.kcl.ac.uk/irt2009/ [Last accessed: 14/10/20].

Bibliography

Albertini E. and Leschi L. (1932) "Le cimetière de Sainte-Salsa, à Tipasa", *CRAI* (1932) 77–88.

Al Khadduri A. E. (1997) "Wadi Sofeggin: Gasr al-Merkazant", *Libya Antiqua* n.s. 3 (1997) 220–23.

Ardeleanu S. (2018) "Directing the faithful, structuring the sacred space: funerary epigraphy in its archaeological context in late-antique Tipasa", *JRA* 31 (2018) 475–500.

Barker G. ed. (1996) *Farming the Desert. The UNESCO Libyan Valleys Archaeological Survey. Volume 1: Synthesis* (London 1996).

Bauer G. (1935) "Notizie sulla regione di Orfella, Le due necropoli di Ghirza", *Africa Italiana* 6 (1935) 61–78.

120 Ben Abed and Grisheimer (2001).
121 Ferchiou (1986).
122 Euzennat and Hallier (1992) 241.
123 Stevens (2008) 99–100; see also Norman and Haeckl (1993).

Ben Abed A. and Griesheimer M. (2001) "Fouilles de la nécropole romaine de Pupput (Tunisie)", *Comptes rendus des séances de l'Académie des Inscriptions et Belles-Lettres, 145e année* 1 (2001) 553–92.

Bentivogli V. (2007–2008) *Per un Corpus delle forme architettoniche funerarie di epoca Romana in Tunisia: gli altari, i columbaria, i monumenti a daldacchino, a tamburo, a tempio e a torre* (Ph.D. diss., Univ. degli Studi di Pisa 2007–2008).

Bianchi L. (2005) "Ritratti di Leptis Magna fra III e IV secolo", *Archeologia Classica* 56 (2005) 269–302.

Brett M. and Fentress E. W. B. (1996) *The Berbers* (Oxford 1996).

Brogan O. and Smith D. J. (1984) *Ghirza. A Libyan Settlement in the Roman Period* (Libyan Antiquities Series, 1) (Tripoli 1984).

Brouquier-Reddé V. (1992) *Temples et cultes de Tripolitaine* (Paris 1992).

Brown P. (1981) *The Cult of the Saints: Its Rise and Function in Latin Christianity* (Chicago 1981).

Cadenat P (1957) "Vestiges paléochrétiens dans la région de Tiaret", *Libyca* 5 (1957) 77–103.

Camps G. (1961) *Aux origines de la Berbèrie: Rites et monuments funéraires* (Paris 1961).

Camps G. (1973) "Nouvelles observations sur l'architecture et l'âge du Medracen, mausolée royal de Numidie", *Comptes rendus des séances de l'Académie des Inscriptions et Belles-Lettres* 117 (1973) 470–517.

Camps G. (1986) "Funerary monuments with attached chapels from the northern Sahara", *The African Archaeological Review* 4 (1986) 151–64.

Caputo G. and Traversari G. (1976) *Le sculture del teatro di Leptis Magna* (Rome 1976).

Chaouali M., Fenwick C., and Booms D. (2018) "Bulla Regia I: A new church and Christian cemetery", *Libyan Studies* 49 (2018) 187–97.

Coarelli F. and Thébert Y. (1988) "Architecture funéraire et pouvoir: réflexions sur l'hellénisme numide", *MÉFRA* 100 (1988) 761–818.

Colvin H. (1991) *Architecture of the After-life* (Yale 1991).

Conant J. (2012) *Staying Roman. Conquest and Identity in Africa and the Mediterranean, 439–700* (Cambridge 2012).

Decret F. (2009) *Early Christianity in North Africa* (Eugene 2009).

Diggle I. and Goodyear, F. R. D. (1970) *Flavii Cresconii Corippi Iohannidos seu de bellis Libycis libri VIII* (Cambridge 1970).

Di Vita A. (1964) "Il 'limes' romano di Tripolitania", *Libya Antiqua* 1 (1964) 65–98.

Di Vita A. (1976) "Il mausoleo punico-ellenistico B di Sabratha", *RM* 83 (1976) 273–85.

Di Vita A. (1980–1981) "L'area sacro-funeraria di Sidret el-Balik a Sabratha", *RendPontAcc* 53–54 (1980–1981) 273–82.

Di Vita A. (1990) "Antico e tardo-antico in Tripolitania. Sopravvivenze e metodologia", in *L'Africa romana. Atti del VII Convegno di Studio, Sassari 15–17 dicembre 1989*, ed. A. Mastino (Sassari 1990) 347–56.

Di Vita A. (2010) "I mausolei punici di Sabratha e l'impianto urbano della città ellenistica: prodotti di un sincretismo culturale", *Bollettino di Archeologia Online, Special Volume*. Available at: http://bollettinodiarcheologiaonline.beniculturali.it/wp-content/uploads/2019/01/1_DiVITA.pdf [Last accessed: 04/06/2019].

Dossey L. (2010) *Peasant and Empire in Christian North Africa* (London 2008).

Duval N. (1986) "L'inhumation privilegiee en Tunisie et en Triplitaine", in *L'inhumation privilégiée du IVe au VIIIe siècle en Occident. Actes du colloque tenu à Créteil les 16–18 mars 1984*, edd. Y. Duval and J.- C. Picard (Paris 1986) 25–34.

Duval N. (1995) "Les Nécropoles chrétiennes d'Afrique du Nord", in *L'Afrique du nord antique et médiévale: Monuments funéraires : institutions autochtones : VIe colloque international sur l'histoire et larchéologie de lAfrique du Nord*, edd. P. Trousset (Paris 1995) 187–206.

Duval Y. (1988) *Auprès des saints corps et âme: L'inhumation 'ad sanctos' dans la chrétienté d'Orient et d'Occident du IIIe au VIIe siècle* (Paris 1988).

Duval N. and Cintas M. (1978) "VI. Basiliques et mosaïques funéraires de Furnos Minus", *MEFRA* 90 (1978) 871–950

Duveyrier H. (1864) *Les Touareg du nord. Exploration du Sahara* (Paris 1984).

Euzennat M. and Hallier G. (1992) "Le mausolea de Taksebt (Algérie)", *CRAI* 136.1 (1992) 235–48.

Fentress E. (1979) *Numidia and the Roman Army: Social, Military and Economic Aspects of the Frontier Zone* (Oxford 1979).

Fentress E. and Wilson A. (2016) "The Saharan Berber diaspora and the southern frontiers of Byzantine North Africa", in *North Africa under Byzantium and Early Islam, 500–800*, edd. S. T. Stevens and J. P. Conant (Washington D.C. 2016) 41–63.

Ferchiou N. (1986) "The anonymous mausoleum of Thuburnica", *MEFRA* 98 (1986) 665–705.

Ferchiou N. (1987) "Le paysage funéraire pré-romain dans deux régions céréalières de Tunisie antique (Fahs-bou Arada et Tebourba-Mateur): Les tombeaux monumentaux", *Antiquités Africaines* 13 (1987) 13–69.

Ferchiou, N. (1995) "Architecture funéraire de Tunisie à l'époque romaine", in *L'Afrique du nord antique et médiévale: monuments funéraires, institutions autochtones Author Colloque international sur l'histoire et l'archéologie de l'Afrique du Nord (6th: 1993: Pau, France)*, ed. P. Trousset (Paris 1995) 111–37.

Ferchiou N. (2009) "Recherches sur le mausolée hellénistique d'Hinshīr Būrgū", in *An Island through Time: Jerba Studies, 1. The Punic and Roman Periods* (JRA Suppl. 71),

edd. E. Fentress, A. Drine, and R. Holod (Ann Arbor 2009) 107–128.

Février P-A. (1996) "Tombes privilégiées en Maurétanie et Numidie" in *La Méditerranée*, ed. P-A. Février (Rome 1996) 923–33.

Fontana S. (1996) "Le necropoli di Leptis Magna. Introduzione", *Libya Antiqua* n.s. 2 (1996) 79–84.

Fontana S. (1997) "Il predeserto tripolitano: mausolei e rappresentazione del potere", *Libya Antiqua* n.s. 3 (1997) 149–63.

Fontana S. (2001) "Leptis Magna. The Romanization of a major African city through burial evidence" in *Italy and the West: Comparative Issues in Romanization*, edd. S. Keay and N. Terrenato (Oxford 2001) 161–72.

Gatto M. C., Mattingly D. J., Ray N., and Sterry M. edd. (2019) *Burials, Migration and Identity in the Ancient Sahara and Beyond* (Cambridge 2019).

Goodchild R. (1965) "The unfinished 'Imperial' Baths of Lepcis Magna", *Libya Antiqua* 2 (1965) 15–27.

Gsell S. (1893) *Recherches archéologiques en Algérie* (Paris 1893).

Gsell S. (1898) "Le mausolée de Blad-Guitoun (fouilles de M. Viré)", *CRAI* 42 (1898) 481–99.

Gsell S. (1901) *Les monuments antiques de l'Algérie, Tome 1 & 2* (Paris 1901).

Hitchner R. B. (1995) "The culture of death and the invention of culture in Roman Africa", *JRA* 8 (1995) 493–98.

Kadra F. (1983) *Les Djedars. Monuments funéraires Berbères de la région de Frenda* (Algiers 1983).

Kalinowski A. (2017) "A mosaic of Daniel in the lions' den from Borj el Youdi (Furnos Minus) Tunisia: the iconography of martyrdom and the arena in Roman North Africa", *Antiquités Africaines* 53 (2017) 115–28.

Kenrick P. M. (2009) *Libya Archaeological Guides. Tripolitania* (London 2009).

Laporte J-P. (1980) "Un mausolea du IVe siecle: La Ghorfa des ouled Selama, pres d'Auzia", *Bulletin d'Archéologie algérienne* 7 (1980) 55–59.

Laporte J-P. (2005) "Les djedars, monuments funéraires berbères de la region de Frenda et Tiaret", in *Identités et culture dans l'Algérie Antique*, ed. C. Briand-Ponsart (Rouen 2005) 321–406.

Laporte J-P. (2009a) "Une maison-forte du IVe siècle: le Ksar El-Kaoua (Ammi-Moussa, Algérie)", in *Centres de pouvoir et organisation de l'espace*, ed. C. Briand-Ponsart (Caen, 2009) 467–508.

Laporte J-P. (2009b) "Une contribution méconnue du monde amazigh à l'architecture mondiale: les grands mausolées d'Afrique du Nord", *Actes du colloque l'apport des Amazighs à la civilisation universelle* (2009) 137–54.

Laporte J-P. (2013) "Le mausolée de Blad Guitoun", *Ikosim* 2 (2013) 91–108.

Largeau V. (1881) *Le Sahara Algerien. Les deserts de l'Erg*. (Paris 1881).

Le Glay M. (1966) *Saturne Africain histoire* (Bibliothèque d'écoles françaises d'Athènes et de Rome, fasc. 205) (Paris 1966).

Mattingly D. J. (1983) "The Laguatan: a Libyan tribal confederation in the Late Roman Empire", *Libyan Studies* 14 (1983) 96–108.

Mattingly D. J. (1995) *Tripolitania* (London 1995).

Mattingly D. J. ed. (1996) *Farming the Desert. The UNESCO Libyan Valleys Archaeological Survey. Volume 2: Gazetteer and Pottery* (London 1996).

Mattingly D. J. with Flower C. (1996) "Roman-Libyan settlement. Site distributions and trends", in *Farming the Desert. The UNESCO Libyan Valleys Archaeological Survey. Volume 1: Synthesis*, ed. G. Barker (London 1996) 320–42.

Mattingly D. J. ed. (2003) *The Archaeology of Fazzan. Volume 1: Synthesis* (London 2003).

Mattingly D. J. ed. (2007a) *The Archaeology of Fazzan. Volume 2: Site Gazetteer, Pottery and Other Finds* (London 2007).

Mattingly D. J. (2007b) "The African way of death: burial rituals beyond the Roman Empire", in *Mortuary Landscapes of North Africa*, edd. D. L. Stone and L. Stirling (London 2007) 138–63.

Mattingly D. J. and Sterry M. (2010) *Ghadames Archaeological Survey, Phase 1* (Unpublished Desktop Report) (Leicester 2010).

Mattingly D. J. (2011) *Imperialism, Power, and Identity. Experiencing the Roman Empire* (Princeton 2011).

Matoug J. M. (1998) "Wadi al-Fani (Khoms): mausoleum with subterranean tomb", *Libya Antiqua* n.s. 4 (1998) 274–76.

Merrills A. H. (2004) "Vandals, Romans and Berbers: understanding Late Antique North Africa", in *Vandals, Romans and Berbers: New Perspectives on Late Antique North Africa*, ed. A. H. Merrills (Aldershot 2004) 3–29.

Merrills A. H. (2016) "African geography in the triumph of Cornelius Balbus", in *de Africa Romaque, Merging Cultures across North Africa*, edd. N. Mugnai, J. Nikolaus, and N. Ray (London 2016) 121–30.

Merrills A. H. (2018a) "Invisible men: mobility and political change on the frontier of late Roman Africa", *Early Medieval Europe* 26 (2018) 355–90.

Merrills A. H. (2018b) "The Moorish kingdoms and the Written Word: three "textual communities" in fifth- and sixth-century Mauretania", in *Writing the Early Medieval West. Studies in Honour of Rosamond McKitterick*, edd. E. Screen and C. West (Cambridge 2018) 201–220.

Moore J. P. (2007) "The mausoleum culture of Africa Proconsularis", in *Mortuary Landscapes of North Africa*, edd. D. L. Stone and L. M. Stirling (Toronto 2007) 75–109.

Munzi M., Felici F., Cifani G., Cirelli E., Gaudiosi E., Lucarini G., and Matug J. (2004) "A topographic research sample in the territory of Lepcis Magna: Silin", *Libyan Studies* 35 (2004) 11–66.

Munzi M., Felici D., Matoug J., Sjöström I., and Zocchi A. (2016) "The Lepcitanian landscape across the ages: the survey between Ras el-Mergheb and Ras el-Hammam (2007, 2009, 2013)" *Libyan Studies* 47 (2016) 67–116.

Musso L., Baldoni D., Bianchi B., Cilla M., Di Vita-Evrard G., Felici F., Fontana S., Mallegni F., Masturzo N., Munzi M., and Usai L. (1998) "Missione Archeologica dell'Università Roma Tre a Leptis Magna, 1997", *Libya Antiqua* (New Series) 4 (1998) 187.

Nikolaus J. (2016) "Beyond Ghirza, Roman -period mausolea in Tripolitania", in *de Africa Romaque, Merging Cultures across North Africa*, edd. N. Mugnai, J. Nikolaus, and N. Ray (London 2016) 199–214.

Nikolaus J. (2017) *Roman Funerary Reliefs and North African Identity: A Contextual Investigation of Tripolitanian Mausolea and their Iconography* (Ph.D. diss., Univ. of Leicester 2017).

Norman N. and Haeckl A. (1993) "The Yasmina necropolis at Carthage, 1992", *JRA* 6 (1993) 238–50.

Pillinger E. (2013) "Inuenta est blandae rationis imago: visualizing the Mausoleum of the Flavii", *TAPA* 143 (2013) 171–211.

Poinssot C. and Salomonson J-W. (1959) "Le mausolée libyco-punique de Dougga et les papiers du comte Borgia", *CRAI* 102–103 (1959) 141–49.

Quinn J. C. (2013) "Monumental power: Numidian Royal Architecture in context", in *The Hellenistic West. Rethinking the Ancient Mediterranean*, edd. J. R. W. Prag and J. C. Quinn (Cambridge 2013) 179–215.

Rakob F. (1979) "Numidische Königsarchitektur in Nordafrika", in *Die Numider: Reiter und Könige nördlich der Sahara*, edd. H. G. Horn and C. B. Ruger (Cologne 1979) 119–71.

Rebillard E. (2009) *The Care of the Dead in Late Antiquity* (Cornell 2009).

Rebillard E. (2012) *Christians and their Many Identities in Late Antiquity, North Africa, 200–450 CE* (Cornell 2012).

Rebuffat R. (1975) "Trois nouvelles campagnes dans le sud de la Tripolitaine", *CRAI* 119 (1975) 495–505.

Richardson J. (1848) *Travels in the Great Desert of Sahara in 1845–46* (London 1848).

Riedlberger P. (2010) *Philologischer, historischer und liturgischer Kommentar zum 8. Buch der Johannis des Goripp nebst kritischer Edition und Übersetzung* (Groningen 2010).

Rizzo M. A. (2015) "L'area sacro-funeraria di Sidret el-Balik e le tombe dipinte", in *Archeologia ed epigrafia a Macerata: cinquant'anni di ricerche in Ateneo*, ed S. Cingolani (Macerata 2015) 86–87.

Rushworth A. (1999) "From periphery to core in Late Antique Mauretania", in *TRAC 99, Proceedings of the Ninth Annual Theoretical Roman Archaeology Conference, Durham 1999*, edd. G. Fincham, G. Harrison, R. Holland, and L. Revell (Oxford 2000) 90–103.

Rushworth A. (2004) "From Arzuges to Rustamids: state formation and regional identity in the Pre-Sahara zone", in *Vandals, Romans and Berbers: New Perspectives on Late Antique North Africa,* ed. A. H. Merrills (Aldershot 2004) 77–98.

Schäfer T. (1989) "Imperii Insignia, sella curulis und fasces. Zur Repräsentation römischer Magistrate", *AM* 29 (Mainz 1989).

Salmonson J. W. (1956) *Chair, Sceptre and Wreath: Historical Aspects of their Representation on some Roman Sepulchral Monuments* (Groningen 1956).

Sheldrick N. (2021) *Building the Countryside: Rural Architecture and Settlement in Tripolitania during the Roman and Late Antique Periods* (London 2021).

Sears G. M. (2007) *Late Roman African Urbanism: Continuity and Transformation in the City* (Oxford 2007).

Sears G.M. (2011) *The Cities of Roman Africa* (Stroud 2011).

Smith D. J. (1985) "Ghirza", in *Town and Country in Tripolitania*, edd. D. J. Buck and D. J. Mattingly (Oxford 1985) 227–39.

Sroumsa G. G. (2008) "Tertullian and the limits of tolerance", in *Tolerance and Intolerance in Early Judaism and Christianity*, ed. G. Stanton (Cambridge 2008) 173–84.

Stevens S. T. (2008) "Commemorating the dead in the communal cemeteries of Carthage", in *Commemorating the Dead: Texts and Artefacts in Context. Studies of Roman, Jewish, and Christian Burials*, edd. L. Brink and D. Green (Berlin 2008).

Stone D. L. and Stirling L. M. (2007) "Funerary monuments and mortuary practices in the landscapes of North Africa", in *Mortuary Landscapes of North Africa*, edd. D. L. Stone and L. M. Stirling (Toronto 2007) 3–31.

Stucchi S. (1987) "L'architettura funeraria suburbana cirenaica in rapporto a quella della chora viciniore e a quella della Lybia Ulteriore, con special riguardo all'età ellenistica: L'architectura suburbana Cyrenaica", *Quaderni di Archaeologia della Libia* 12 (1987) 249–377.

Tantillo I. (2010) "Introduzione storica: la città di Leptis Magna tra la metà del III e l'inizio del V secolo", in *Leptis Magna una città e le sue iscrizioni in epoca tardoromana*, edd. I. Tantillo and F. Bigi (Cassino 2010) 1–39.

Thomas E. (2007) *Monumentality and the Roman Empire: Architecture in the Antonine Age* (Oxford 2007).

Toynbee J. M. C. (1971) *Death and Burial in the Roman World* (Baltimore 1971).

Von Hesberg H. (1992) *Römische Grabbauten* (Darmstadt 1992).

Ward Perkins J. and Goodchild R. (1953) "The Christian antiquities of Tripolitania", *Archaeologia* 95 (1953) 1–82.

Yasin A. M. (2005) "Funerary monuments and Collective Identity: From Roman Family to Christian Community", *ArtB* 87 (2005) 433–57.

Funerary Landscapes

∴

Funerary Landscapes in Catalonia (3rd–6th c. AD)

Judit Ciurana Prast

Abstract

This article explores the funerary landscapes of present-day Catalonia (north-eastern region of Spain) from the late 3rd c. to the beginning of the 6th c. AD. It examines late antique burials within different landscape contexts and considers the placing of tombs and their spatial relationships with cities, rural settlements, suburban churches, roads and watercourses. It also introduces some reflections on how changes in the placement of burials within the landscape can be related to a shift in funerary practices and social attitudes towards the deceased.

Introduction

This paper examines funerary landscapes in both rural and urban contexts of late antique Catalonia between the 3rd and the 6th c. AD. The timespan broadly covers the last centuries during which this intensely Romanised territory (part of the Tarraconensis province) remained under Roman rule until the arrival of the Visigoths in the 5th c. AD. From an archaeological perspective, these centuries are characterized by deep transformations both in the morphology of cities and in countryside settlements.[1] In the Catalan area, research interests have favoured the segregated analysis of rural and urban funerary evidence. This has been influenced by several factors. Firstly, it is essential to stress the imbalance of the archaeological data available. While urban rescue excavations have unearthed extensive necropolis in towns, in the countryside researchers have to face more fragmentary archaeological knowledge. Secondly, archaeological evidence has been used and filtered depending on scholarly interests. For instance, suburban cemeteries have been examined in complement to topographical studies and often researchers have not considered funerary areas valuable by themselves. In such context, suburban churches and their funerary areas have been regarded as a single entity and tombs have received little attention beyond being quantified and classified according to their typology. In rural burial sites, the main issue is the lack of chronological markers to determine their age. The absence of grave goods or other furnishings has left tomb typologies as the sole dating reference, which is very limiting. Fortunately, studies on grave type are increasingly using radiocarbon dating, allowing great advancements to be made in these analyses.[2]

It has been a rooted interest of funerary archaeology to point out the necessity of contextualizing archaeological data in a broader sense and giving it a social dimension. However, in our area of study this has been a priority concern only quite recently.[3] Studying the number and distribution of cemeteries in a given period and/or landscape can constitute the basis of higher-level analyses of changes in social structure and religious beliefs. However, we should also take into account that burial is not exclusively related to religion or ideology. It has very practical implications since it affects issues of landownership and land-use (who owns the land and where the cemetery is), status and social relations (who is buried in the cemetery) and may also reflect attitudes related to belonging and communal identity. Thus, the location of the burials is the result of meaningful choices.

This article does not pretend to be a detailed catalogue of funerary sites in Catalonia.[4] Here, I present a selection of the most representative and relevant ones, dividing them into categories according to the type of site to which they are related. The intention is to encompass town and country and contextualise burial in order to highlight similarities and differences.

Urban Cemeteries

In this section we evaluate the evidence from suburban and urban cemeteries of Tarraco, Barcino and Emporiae. These sites have been selected because they have been intensely excavated and studied, offering an excellent opportunity for developing a better understanding of the cities and their necropolises. The large cemeteries attached to major Roman towns are the most intensively studied class of burials in the Catalan area. At some sites like Tarraco (present-day Tarragona) or Barcino

1 For regional focused studies in town and country, see Chavarría (1996) and Folch (2005). A *status questionis* for Tarraco and Barcino, see Macias (2000) and Beltrán de Heredia (2008).
2 Roig and Coll (2012).
3 Ripoll and Molist (2014) and Bolós (2012).
4 A regional study has not been attempted yet. However, several articles propose sub-regional or local catalogues. For the Tarragona area see López and Piñol (1993) and Menchón (2012). For the Gerunda-Girona area see Nolla and Sureda (1999). For the town of Dertosa-Tortosa see Navarro (2016). For the town of Iesso-Guissona see Pera and Guitart (2012).

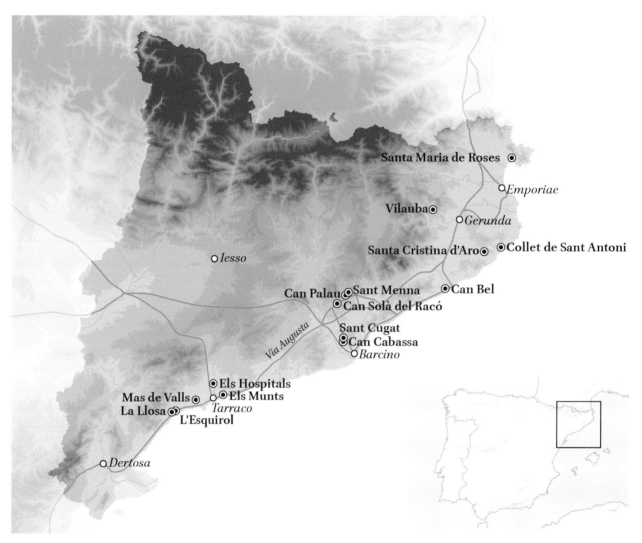

FIGURE 1 Burial sites cited in the article.

(present-day Barcelona), the combination of emergency archaeology with antiquarian records allows to draw a general framework of the location and evolution of necropolises. In overall terms, during the Late Roman period, a dramatic change in the mortuary landscape took place. Firstly, it has been demonstrated that suburban sanctuaries, erected during this period, had a capital role in the Christianisation of urban topography.[5] Suburban churches devoted to the cult of the martyrs acted as a magnet for funerary areas and became highly attractive burial sites for the Christian community. Secondly, burial spaces not only changed their location but transformed their appearance and internal organization.

The Roman city of Tarraco offers an exceptional prospect to examine funerary landscapes because of the abundance of archaeological data. During the Early Imperial era, Tarraco presented the typical image of monumentalized burial areas outside the city walls and attached to the main road, the *Via Augusta*. This major traffic route became the main axis of alignment for the burial plots that were largely organized in walled enclosures. Inside them, excavations have unearthed mausolea of varied typologies and monumental altars in coexistence with modest tombs built with recycled materials. These extra-urban funerary contexts display a compact image and are always restricted to the sides of the road.[6] Between the second half of the 2nd c. and the 3rd c. AD archaeology detects the first changes in the funerary landscape. The traditional Early Imperial enclosures and mausolea located in the eastern and western suburbs were progressively abandoned. At the beginning of the 3rd c. AD, a new form of placing the dead began to take shape: extensive cemeteries organized in rows that covered great areas.[7] These new cemeteries grew considerably during the 4th and 5th c. AD and occupied large

5 Godoy (1995).

6 Ciurana (2011b) 689–96.
7 Ciurana (2011b) 696–99.

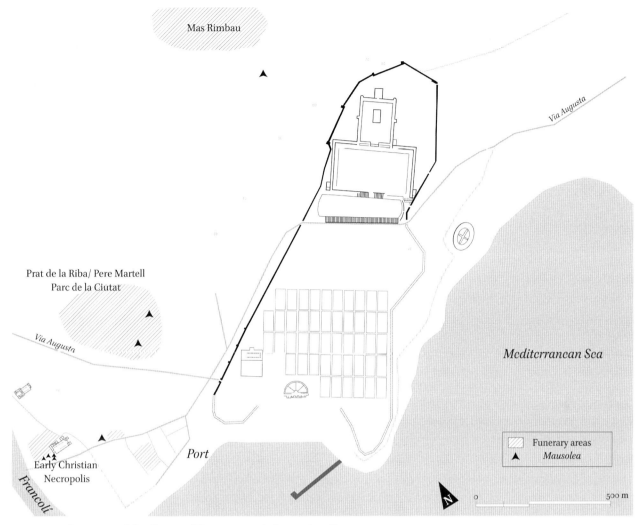

FIGURE 2 Location and distribution of funerary areas in late antique Tarraco.

portions of the western and northern suburbs of Tarraco (Fig. 2). Other extra-mural spaces, in particular those in the vicinity of the port area, were also used as burial grounds. These small cemeteries, composed of a maximum of 20 tombs, were inserted into the back of plots that fronted onto main streets, behind domus and bath complexes occupying the road frontage.[8] Evidence for Late Roman burials are also detected in disused spaces like quarries and ruined buildings.[9] These tombs were not on public display but in some way they did form part of the day-to-day experience of the living. The placing of more scattered and individual burials does seem to symbolise a different attitude to the significance of the dead, with them integrated into other land-uses. It is also probable that this was an alternative way to dispose of the dead for communities that were excluded from the traditional walled enclosures managed by the privileged class.

When referring to late antique funerary landscape in Tarraco, it is essential to mention the so-called early Christian necropolis. This extensive archaeological site was discovered during the construction of a tobacco factory in 1923 and excavated by Monsignor Serra Vilaró from 1926 to 1933.[10] During the course of the excavation, over 2,000 tombs and the remains of a basilica and a baptistery were discovered. This cult complex was erected to commemorate the martyrdom of Fructuosus, Augurius and Eulogius, who were burnt in the amphitheatre of Tarraco in 259 AD and likely buried in this suburban area. The presence of the martyrs' tombs converted this spot into the most desirable burial place for the Christian community. This densely occupied cemetery covered a vast area of 8,000 square m. The wealth and variety in typology and furnishings of the tombs demonstrates the privileged status of the place amid more affluent Christians.

8 Adserias, Pociña and Remolà (2000).
9 Remolà and Vilaseca (2000).
10 Serra (1929).

Although the genesis and growth of the cemetery is associated with the beginnings of Christianity in Tarraco, the early Christian necropolis initially developed in a suburban sector traditionally used for disposing the dead outside the city walls. Tombs, mausolea and monumental enclosures already occupied this peripheral space between the Francolí River and the port suburb of Tarraco in the Early Imperial period.[11] These funerary areas were located near the 'camí de la Fonteta' road and date back to the period between the end of 1st c. and the 2nd c. Some scattered burials were present on the area were the early Christian Necropolis later developed near the 'camí de la Fonteta'. This funerary space – that could be regarded as secondary in relation to the topography of the Early Imperial city – would greatly develop from the 3rd c. onwards. The cemetery would reach its peak of activity between the second half of the 4th and the first half of the 5th c.[12] Although its final moment appears to have been around the mid-5th c. AD, some funerary practices continued to take place inside the basilica during the 6th c.[13]

The high number of burials placed one over another hinders the analysis of its inner organization. The cemetery had its boundaries well delimited by a wall and two roads which connected it with the city and the *Via Augusta*. It seems that its inner development was rather chaotic but, when explored in more detail, we can verify the existence of an area without graves that divided the burial plot into two parts leading to the south-western façade of the martyrial basilica. Another archaeological feature documented by Serra related to the spatial organization of the necropolis is the central dumping site. According to his description, the pit measured 4.8 m long, 2 m wide, and 2 m deep and was filled with ceramic and glass sherds, ashes and animal bones.[14] This "gravedigger hut", as Serra defined it, has recently been identified as a rubbish tip used to discard the waste from funerary banquets.[15] Other archaeological evidence related to the ritual practice of the *refrigeria* is the typology of grave markers in the form of *mensa* and *triclinia*.[16] The custom of holding a banquet or a picnic by early Christians carried on with the practice of the Roman funerary and memorial meals, joining together the rituals of both Roman and Christian traditions.[17]

The construction of a basilica and adjoining cult buildings at the beginning of the 5th c. AD marked the period of the cemetery's maximum splendour. Encircled by thousands of tombs, the church had also an evident funerary function. Burials were placed underneath its *opus signinum* pavement and were marked with mosaic and marble slabs with inscriptions. 7 mausolea consisting of large chambers and crypts provided privileged burial spaces for groups of high social position and status. These monumental constructions were annexed to the northern nave and apse,[18] and all had their entrance facing into the interior of the basilica. Its privileged situation is not only inferred by its physical contact with the holy site, but also by its permanent connection with the prayers of the faithful and the Eucharistic liturgy. Of all these privileged funerary locations, the so-called 'mausoleum 17' stands out among them and is identified as a counter-apse.[19] At the time of its construction, the basilica incorporated a rectangular chamber to its western end which contained a large masonry tomb with two skeletons inside. The tomb was covered with stone slabs and slightly protruded from the original pavement of the chamber. Another outstanding feature was the presence of a base column in the south-western point of the tomb, which could have been the only vestige remaining from a baldachin covering it.

A second funerary basilica stood not far from the early Christian necropolis, located 250 m west of the complex and connected via a secondary road. In 1994, a rescue archaeological excavation recovered the plan of a three-nave basilica, rectangular in plan and with a quadrangular apse on its eastern side. Attached to the basilica was an *atrium* consisting of an open courtyard surrounded by a corridor giving access to several chambers. Excavations turned up some evidence of a previous necropolis dating back between the end of the 2nd c. and the 3rd c.,[20] a characteristic already detected in the early Christian necropolis. Another parallel was the discovery of a quadrangular counter-apse next to the foot of the central nave. Built alongside the nave and the *atrium*, it contained a privileged tomb placed in an axial position.

When unearthed, the building was in a very poor state of preservation. Whilst the majority of the foundations had survived, neither the walls nor the original floor were found *in situ*. According to the pottery recovered from scattered fragments of the *opus signinum* floor, the

11 On the typology of the tombs and organization of the funerary spaces in 'camí de la Fonteta', see Ciurana (2011b) 399–406.
12 López (2006) 225.
13 López (2006) 219.
14 Serra (1929) 62.
15 López (2006) 225.
16 Del Amo (1979) 143–50.
17 MacMullen (2009) 75–80.

18 Two of these mausolea flanked the apse, four were attached to the northern side of the basilica, and 1 on the western side: López (2006) 209–212.
19 López (2006) 213.
20 López (2006) 62–67.

basilica was built at the very beginning of the 5th c. and was in use for 50 years.[21] There was no doubt about its funerary function as burials filled up the *atrium* and the basilica. Originally, the *signinum* floor of the church had covered 152 sepulchres, neatly ordered and mainly oriented along an east-west axis. Some of the tombs were marked with inscriptions.[22] 90% of them were individual tombs, while the remaining 10% were double and triple tombs. This suggests the reuse of tombs for several depositions (probably within a family/kin group) and also the existence of a control and management process of the burial practices. It was possible to identify the sex of 44% of the recovered skeletons. Of these, 64% were men and 36% were women. Anthropological analysis pointed out that the interred people were part of a well-nourished and aged population, suffering from degenerative diseases and obesity.[23] Although the situation of the tombs offered a general image of homogeneity, there were some privileged burial locations inside the building. One of them was the counter-apse mentioned above. Another privileged location was the sanctuary, where 7 tombs were brought to light during the excavations. The demographic profile of the skeletons – men of old age – and the recovery of a fragmentary inscription alluding to a presbyter indicate the existence of a burial sector reserved for members of the ecclesiastical hierarchy.

Outside the early Christian complex near the Francolí River, other burial grounds covered significant parts of the western suburb. In these cases, there is no clear archaeological confirmation of the existence of an associated chapel or church. To the north of the *Via Augusta* existed a large 'funerary ring' formed by the necropolises of Carrer Pere Martell,[24] Avinguda Prat de la Riba[25] and Parc de la Ciutat,[26] with approximately 500 inhumations. All these cemeteries share identical features: horizontal growth with no superimposition or intercutting, internal organization in rows and low walls marking their limits. Even though there seems to be a lack of individual identification of the graves, if we explore them in more detail, we may detect tomb groups, likely to be related to a household or family. In the Parc de la Ciutat necropolis, the existence of circular pits containing disconnected skeleton remains near to some of these tomb clusters has been attested.[27] This may be an indication of tombs being reused over time and disarticulated human skeletal remains of former occupants being placed in ossuaries. Despite the uniformity of grave typologies, a small number of monumental constructions stood inside these cemeteries like mausolea and walled enclosures, showing the existence of richer tombs in this rather monotonous funerary landscape. It is noteworthy that this extensive funerary area was well connected with the city through the *Via Augusta*, and was not distant from the early Christian basilica of St. Fructuosus.

To the north-west of the acropolis of Tarraco, another extensive cemetery was in use from the end of the 3rd c. AD to the first half of the 6th c. AD. The Mas Rimbau necropolis was explored during the construction of new housing in the area between 1995 and 2000. As a result, we have a rather fragmented vision of the cemetery and, to this date, comprehensive study is lacking.[28] One of the most striking features is its location, which is not related to any former Early Imperial burial site or main road. The necropolis was laid on the southern part of a gentle slope ('turó de l'Oliva') that offered a clear view of the walled city of Tarraco. Up to 600 tombs have been excavated, belonging to various types of inhumation graves, from stone cists and inhumations inside amphora, to simple pits lined with *tegula* or covered with stone slabs. One discovery which took place in the Mas Rimbau necropolis gives us a glimpse into the presence of other religious groups (besides Christians) in Tarraco. The 1997 excavations unearthed 70 graves organized in rows dating from the second half of the 5th c.[29] One of the recorded cist graves was covered with several stone slabs, one of which bore a carved 7-armed *menorah* with a tripod base. There is no sufficient archaeological evidence to indicate that the Mas Rimbau necropolis was a Jewish burial ground. When inscriptions and symbols are lacking, it is extremely difficult to identify tombs as Jewish. Some researchers have pointed out that Jews interacted with their pagan and Christian neighbours, even making use of the same cemetery.[30] Many funerary symbols have been uncovered in *hypogea* and graves located in communal Jewish/Christian/pagan cemeteries. It is clear that the Mas Rimbau cemetery developed simultaneously to the early Christian basilicas and the

21 López (2006) 109–161.
22 Very few inscriptions were recovered during the excavation. It stands out the slab containing the epitaph of Thecla, consecrated virgin, deceased at the age of 77: López (2006) 145–46.
23 López (2006) 203–204.
24 Del Amo (1971–1972); Cortés (1981).
25 Foguet and Vilaseca (1994).
26 Ted'a (1987).
27 Ted'a (1987) 125.
28 The available publications cover some of the excavated areas: Macias and Remolà (1995); Bea and Vilaseca (2000).
29 Three of the burials presented grave goods (three glass *unguentaria* and a hen's egg) and one of the cist tombs was occupied by a canine burial; Bea and Vilaseca (2000) 158.
30 Rutgers (1992) 109–115; Rebillard (2003) 65–67.

'funerary ring' close to them. Its distant placement from the suburban Christian holy places would suggest that Mas Rimbau was a burial area in which a broader concept of collective or civic identity prevailed over religious beliefs.

Moving to the north, the city of Barcino offers an interesting parallel to Tarraco. Like in the capital of Tarraconensis, the birth of a Christianized suburban landscape is directly connected to the emergence of new funerary areas.[31] Mainly, cemeteries were located north-east and south-west of Barcino near the *Via Augusta*. Unlike the ones in Tarraco, the excavations in Barcelona have not been carried out in extensive lots, so the number of unearthed graves is limited, with many suffering considerable disturbance from modern construction. In several suburban areas, it has been noted that burial plots frequently occupied residential and productive buildings that had ceased their activity a few centuries prior. For example, in the Mercat de Santa Caterina necropolis, a pottery production site that was in use during the 1st c. AD, was covered at the end of that century with soil and dedicated to farming.[32] Approximately three centuries later, at the beginning of the 4th c. AD, this extra-urban area was used for burial. By contrast, in other parts of the western suburb of Barcino, it is possible to detect a certain degree of continuity between Early Imperial contexts and late antique funerary activity. A very interesting example of this circumstance is the site of the medieval church and monastery of Sant Pau del Camp.[33] In this area, archaeologists discovered several structures of the *pars rustica* of a villa that was active during the 1st and 2nd c. AD. However, it seems that parts of it were abandoned in the mid-2nd c. AD. Close to the villa (that was connected to Barcino by a road documented in Carrer Hospitals) stood a mausoleum consisting of a rectangular structure built in *opus caementicium*, housing two tombs in its interior. A striking aspect of this construction is its long survival: built in the 1st c. AD, it was not dismantled until the 5th AD. This coincides with the period of utilisation of the villa that appears to have been functioning up to the 5th c. A necropolis containing 99 tombs surrounded the villa and the mausoleum and developed from the 4th c. to the second half of the 7th c. These inhumation graves were built with *tegulae* and, in some cases, they presented a layer of *signinum* as a grave mark. The orientation of the tombs corresponded to that of the walls of the villa and were organized in rows. The Christianization process would have been completed with the construction of a church between the 6th and 7th c. AD.[34] Some structural remains including a horseshoe apsis were brought to light beneath the Romanesque church of Sant Pau del Camp and were identified with this cult building.

In the eastern and northern suburbs of the Roman city, several late antique cemeteries and mausolea have also been recorded. In Antoni Maura Square, a villa was partially excavated in 1945. This consisted of a rectangular building with several rooms opening to a central *atrium*.[35] From the documentation (despite many omissions and limitations), it is possible to infer the existence of a group of tombs of various typologies (*tegula* and amphora graves, cists, *formae*). This cemetery was located to the south-east of the Early Imperial villa that underwent a profound modification in the 4th or the 5th c. AD. A rectangular funerary building with a semi-circular apse was built in the space once used as a *triclinium*. Inside the rectangular chamber, 12 graves were discovered, including 6 double *formae* tombs. Among them stood a grave covered with a mosaic slab showing a *Chrismon* dated to the 5th c., which has been traditionally associated with the final resting place of Pacian, bishop of Barcino during the 4th c. Although the identity of the occupant of this privileged tomb remains unknown, it is very likely that he was a prominent member of the Christian community of the city. In the vicinity of Antoni Maura Square, other burial areas have been detected that attest the presence of an extensive late antique cemetery covering this extra-urban sector. For example, in Avinguda Francesc Cambó, the excavations detected more than 250 burials and a rectangular mausoleum. Burials presented a predominant NE-SO orientation and were arranged in rows, with no intercutting or superimposition documented. The results of the study of funerary amphora established a period of use for the cemetery between the end of the 3rd c. and the 5th c. AD.[36]

To the north of the city and close to one of the main gates related to the *cardo maximus* is located the necropolis of Mercat de Santa Caterina. Between 1999 and 2003, an excavation took place in the lot once occupied by the market of Santa Caterina. The result was the documentation of a late antique cemetery composed of 103 tombs and 11 funerary monuments.[37] Its development dated back to the 4th, 5th, and 6th c. AD and there was a clear division of the funerary space (Fig. 3).[38]

31 A *status questionis* is provided by López (2012) and Beltrán de Heredia (2010).
32 Huertas and Aguelo (2006) 73–74.
33 Beltrán de Heredia (2010) 378–82.
34 Beltrán de Heredia (2010) 381–82.
35 Travesset (1993).
36 Beltrán de Heredia (2010) 387.
37 Huertas and Aguelo (2006).
38 Huertas and Aguelo (2006) 94–201.

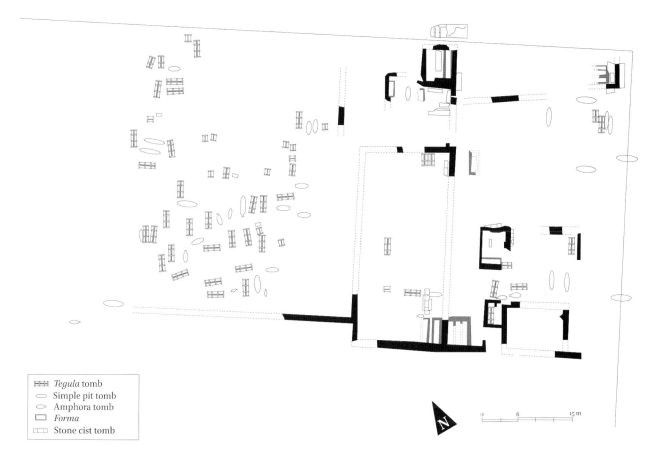

FIGURE 3 Mercat de Santa Caterina funerary area.
AFTER HUERTAS AND AGUELO (2006)

The northern band of the cemetery was covered by 69 tombs with different orientations. These were very simple graves, built with *tegula* and other recycled building materials. To the south, a second funerary aggregation was detected, bounded by two walls. Inside this plot, 30 more inhumation graves were excavated, along with the remains of 7 rectangular constructions that were apparently inside *areae* or walled enclosures. One of these rectangular *areae* presented considerable dimensions (18 m long × 8 m wide) and several *tegulae* and *formae* tombs were detected in its interior. Regarding the mausolea, they contained *formae* structures covered with *opus signinum* surfaces and walls decorated with paintings. Archaeological data manages to draw a rather complete image of this highly structured funerary landscape, organized in walled enclosures linked to the local elites.

Finally, another interesting aspect in late antique Barcino is the probable existence of a suburban sanctuary devoted to the cult of the martyr St. Eulalia. It has been proposed that this building was located at the spot presently occupied by the medieval church of Santa Maria del Mar.[39] Even though archaeologists have thus far been unable to unearth definite material evidence, the existence of a large cemetery documented below the Gothic church and in its surroundings would strengthen this hypothesis. In 1966, an archaeological excavation was carried out in the interior of the current church, which unearthed a burial area with 108 inhumations dated between the end of the 4th c. and the 7th c. AD. The cemetery displayed very distinct features. Firstly, tombs were not arranged in rows but gathered in clusters and presented different orientations. Secondly, two levels of tombs that overlapped were detected. The first level was covered with several strata of dirt, stone blocks and pottery sherds. Then, over this new circulation floor, a second level of tombs developed.

The territory of the city of Emporiae presents a rather different picture because of its particular topographic evolution. The Greek and Roman urban areas of Emporiae were abandoned from the 3rd c. AD onwards, with only the site of Sant Martí d'Empúries remaining populated, precisely the first spot occupied by the Phocaeans in the 6th c. BC. Throughout Late Antiquity, this urban settlement was the see of a bishopric, so the Christianization of the extra-urban area was very intense, judging by the presence of several suburban churches with its related

39 Beltrán de Heredia (2010) 392.

cemeteries. The ruins of the Greek Neapolis were occupied by an extensive late antique necropolis, not far from Sant Martí d'Empúries.[40] The main funerary area is composed of 501 inhumations mainly oriented east-west. Archaeological evidence points to burial activity in the 3rd c. AD up to the 7th c. AD. The cemetery was organized and limited by walls and its southern band was arranged around a building identified as a *cella memoria*.[41] This building was erected in the 4th c. AD, taking advantage of the *caldarium* of an Early Imperial bath complex. It consisted of a small building, rectangular in plan with a semi-circular apse at its eastern side and a rectangular, auxiliary chamber attached to it. At the centre of the rectangular room, a grave identified as a privileged tomb was placed. The structure was greatly modified during the second half of the 6th c. AD. In this second phase, the building was enlarged, creating a long rectangular space. A rectangular funerary chapel, which communicated directly with the church, was annexed to the north. This room was paved with an *opus signinum* floor and contained 4 stone sarcophagi with lids decorated with *acroteria*. On the other hand, access to the new building was also altered and monumentalised. The main entrance was situated in the western side of the complex through a ramp. From the 6th c. onwards, several *areae* or walled enclosures with stone sarcophagi were built in the immediate proximity of the church's apse. The funerary function of this Christian monument lasted up to the first quarter of the 7th c. AD. In the same extra-urban area, to the west of the funerary basilica, other small cemeteries have been discovered. For example, in 2009, a small group of 14 tombs and a funerary construction were unearthed near the Museum of Empúries. This rectangular mausoleum housed two stone sarcophagi and a *forma*, sealed with a *signinum* floors. Not far from this point, in the so-called Necròpolis Martí, an excavation was carried out in 1944. This area had been used as a funerary plot for cremations during the Greek period, from the 5th to the 3rd c. BC. In the Early Imperial period, this area was occupied by structures of the Roman city that were later abandoned in the 3rd c. AD. During Late Antiquity, the space was covered with 44 inhumations, east-west orientated and arranged in rows. Three grave typologies were documented: *tegula* tombs, amphora containers and simple pits (Fig. 4).

On the outskirts of Sant Martí d'Empúries, there is a group of medieval churches in which subsequent excavations have revealed that the medieval buildings were preceded by late antique funerary activity, a rather frequent circumstance underlined by other researchers.[42] These are the rural churches of Santa Margarida and Santa Magdalena.[43] It is complex to establish if these cemeteries centres were more related to the urban environment of Sant Martí d'Empúries or its activity was oriented to the rural areas. When the Pre-Romanesque church of Santa Margarida was excavated in 1957, the oldest archaeological features detected were several rock-cut tombs dated between the 3rd c. and the 4th c. AD. In the beginning of the 5th c. and during the following century, several structures related to the celebration of Christian liturgy were built. Amongst them stands out the baptistery with a rectangular central pool, which was the focus of various interventions and alterations. In an uncertain moment in the 5th c. AD, a burial was introduced inside the building and located in a preferential spot, just in front of the entrance. This has to be considered a privileged tomb, maybe occupied by a member of the local Christian elite. The wealth of this individual was displayed by the mosaic slab that covered the tomb and showed his name. Unfortunately, the line that contained it was affected by later alterations, although it has been hypothesized that the deceased could be identified as an *episcopus*. Progressively, during the 6th c. AD, more burials were brought inside the baptistery, to the point that the capacity of the baptismal pool was drastically reduced.

The study of Santa Margarida's archaeological remains has recently benefited from the application of geophysical methods. In 2015 and 2016, two campaigns of geophysical and magnetic surveys were carried out in the fields surrounding the church.[44] The results revealed a considerable number of anomalies interpreted as various buildings grouped in 4 complexes or clusters. A main road crossing the settlement and two secondary paths outlining its reticular structure were also identifiable from the resulting image. In order to verify the discoveries, a small area within one of the clusters was excavated and remnants of a construction dating from the 6th c. to the beginning of the 7th c appeared. The outcome of this archaeological exploration has strengthened the hypothesis that the late antique *episcopium* of Empúries was located there.[45]

The church of Santa Magdalena is located only 200 m to the south-east of the former church of Santa Margarida. It also stands on high ground and adjacent to the road

40 For an overview of the Neapolis necropolis, see Nolla and Sagrera (1995).
41 Tremoleda, Castanyer and Santos (2012) 337–39.
42 Chavarría (2007) 136.
43 Tremoleda, Castanyer and Santos (2012) 342–48.
44 Castanyer, Santos, Tremoleda, Sala, Ortiz, Julià and Riera (2019) 149–50.
45 Castanyer, Santos, Tremoleda, Sala, Ortiz, Julià and Riera (2019) 153.

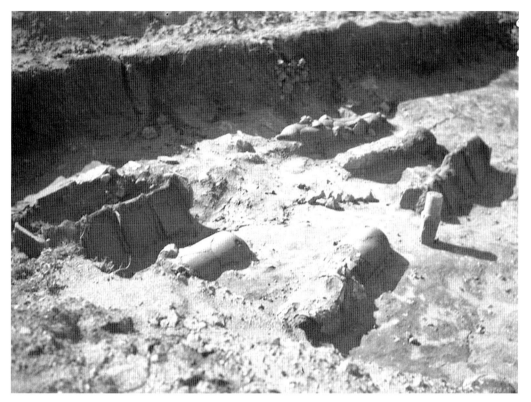

FIGURE 4 Late antique tombs discovered in Necròpolis Martí in 1944.
MUSEU D'ARQUEOLOGIA DE CATALUNYA

that connects this area with Sant Martí d'Empúries. In light of recent archaeological investigations, several chronological phases have been distinguished.[46] Between the end of the 4th c. and the first half of the 5th c. AD, a walled rectangular enclosure with a mausoleum attached to its eastern wall was erected. By then, the nearby Christian complex of Santa Margarida was probably already built, as the proximity of the mausoleum with the funerary area surrounding the baptistery seems to indicate. The monument presented an octagonal plan and its interior space was covered with a cupola. The octagonal room was flanked by two rectangular spaces possibly related to the celebration of commemorative rituals. During a second phase, likely in the 6th c., the building was torn down and a church with rectangular apse was built on the opposite corner of the original rectangular enclosure. The new church contained several privileged tombs located inside a funerary chamber that connected with the presbytery. Throughout the 6th and 7th c., the interior of the temple underwent several alterations: a new apse was constructed and another funerary chamber was annexed, as a result a Latin cross ground plan was created. Despite all the changes, the building always retained its funerary function. The cult and funerary use of the church extended until the 8th c.

Funerary activity was also registered outside: the church was encircled by a cemetery of 73 individual tombs arranged into 2 separate groups.

Rural Cemeteries

In the late antique period, rural habitat was mainly organized in residential and productive villas, farms and other sorts of settlements (*vici, castella*). The analysis of some rural settlements located in Tarraconensis shows that most establishments lost their original residential function and their spaces were reused for agricultural activities between the second half of the 4th and the 6th c.[47] Principally, our knowledge about rural sites has been provided by emergency archaeology initiated by the terms of infrastructure construction projects. Therefore, a large number of these villas and farms have not been fully excavated. At the same time, archaeological interest has been focused on the main domestic buildings, such as bath complexes and residential structures. Even though many rural cemeteries have been excavated and records have been published according to modern standards, funerary archaeology at rural sites has not developed as much as at large town cemeteries.

46 Aquilué and Nolla (2003) 8–11.

47 Chavarría (2001) 64–66.

To sum up, it is difficult to build up a map of rural settlements and its funerary areas due to fragmentary data.

Generally, the study of burial locations in the countryside has tended to highlight the association of burials with settlements. This exercise can be problematic, especially when a social interpretation is attempted. Although rural necropolises have been traditionally connected to the workers that made use of the territory on which the villa was located, we frequently ignore where this population lived. Material evidence suggests that, in some cases, the peasants lived in the same villa, but it is also possible that they lived nearby, in domestic buildings made of wood, adobe and other materials that have not been detected by archaeologists. The result of this is that, in many cases, we have evidence of scattered burials that cannot be connected to a settlement or vice versa. Notwithstanding these limitations, when looking at the archaeological evidence, rural burials can be grouped in different categories according to their relationship to settlements, religious buildings or mausolea.

The villa of Els Hospitals (El Morell) is located near the city of Tarraco, close to the Roman road that connected the Catalan coast with the inner Ebro valley.[48] The main building was erected in the mid or latter part of the 3rd c. AD. It has a rectangular plan with 4 facing cubicula, paved with *opus signinum* and mosaic floors and walls decorated with frescoes. During the 4th c. AD, archaeological evidence attests that some extensions to this residential building were built on its southern side, including a bath complex, a *culina* and a *latrina*. One century later, a new bath complex built in the south-west replaced the original one. Also in the 5th c., several rooms paved with *opus signinum* floors were incorporated to the eastern side of the new *balneus*. Between 350 and 450 AD, a number of abandoned spaces of the villa, especially on its eastern sector, were used as a burial ground for 9 tombs that contained 14 individuals (9 adults, 1 juvenile and 4 infants). Samples of two skeletons were submitted for radiocarbon analysis and it was concluded a dating to 380 AD, with an accuracy of ±45 years. This group of tombs were built with reused materials and were cut through the abandonment levels. Not only were they not located randomly, but were in rows following the east-west orientation of the walls of the abandoned rooms they occupied. Another striking aspect of this burial site is its proximity to the bath complex, which was at that time in use (Fig. 5a). This evidence of building vitality in the Els Hospitals villa during the 4th and 5th c. AD goes along with the disposal of the dead very close to the living, something that blurs the expected distinctions characteristic of the Classical period, which saw the separation of the domains of the living and the dead and the prevention of physical and spiritual pollution.

A very similar situation is attested in the villa of Mas de Valls (Reus), located also in the *ager* Tarraconensis. This rural settlement was partially explored in 1934–1935. During the excavations, two *hypocausta*, several tanks paved in *signinum*, a monolithic sarcophagus and a funerary inscription dated to the Early Empire were unearthed.[49] Other archaeological evidence related to the disposal of the dead consisted of 7 tombs made of *tegula* and lids of stone. This necropolis was located about 25 m north from the two *hypocausta* and was organized in two parallel rows, with one isolated burial. The graves were organized in the same orientation as the walls of the *hypocausta*. The human remains of 3 adults and 3 infants were recovered. Inside one of the infant burials, a *terra sigillata Hispanica* bowl was found placed near the head of the deceased. Although the available data is fragmentary, a sketch of the site drawn in 1945 shows a wall flanking the necropolis (which is referred to as an ancient wall). The existence of a ravine beyond this wall reinforces the image of these burials occupying a liminal space. Being set in a peripheral area does not mean the dead were hidden from the gaze of the living. One of the tombs was marked with a *mensa* structure made of masonry, while a stone sarcophagus was also noted. Thus, some monumentality and external markings made evident the existence of the dead in the landscape.

In the territory of the city of Barcino, there are several sites where the correlation between villa and cemetery can also be demonstrated. One of them is Can Solà del Racó (Matadepera). The main building of the villa has not been completely excavated, but its plan is known to be rather complex; a standout feature is a bathhouse composed of two *exedrae*. To the south of the residential area, 6 pottery kilns, several silos and a warehouse were discovered. The final period of use of the building dates back to the end of the 5th c. AD. About 50 m away from the main building, a burial ground of 20 tombs (with 23 individuals) developed during the 4th c. and 5th c. AD (Fig. 5b).[50] As in Mas de Valls, the small cemetery occupies a peripheral area, close to a ravine that could mark one of the boundaries of the villa estate.

Excavations at Collet in Sant Antoni de Calonge have identified a similar context. The small necropolis is located 200 m south-west of the villa and it is likely linked to it. From the end of the 2nd to the mid-5th c.

48 Macias and Menchón (2007).

49 Massó (2007).
50 Barrasetas and Vila (2004).

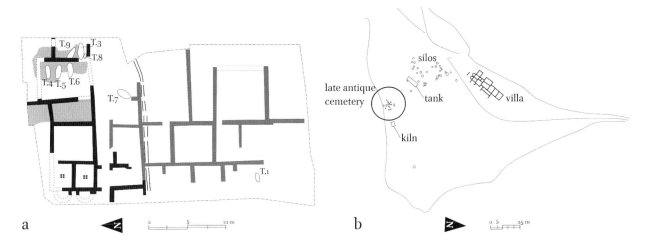

FIGURE 5 (a) The distribution of burials in the villa of Els Hospitals (after Macias and Menchón (2007)), (b) Burials at Can Solà del Racó (after Barrasetas and Vila (2004)).

AD,[51] 34 burials were inserted in a space in which a *figlina* and two pottery kilns formerly stood. When the cemetery was active, these Late Republican structures were not visible; therefore, the tomb pits were excavated in the abandonment strata, affecting some of the walls, which were out of view. In this small necropolis of at least 30 adults, 2 juveniles and 5 children, it is possible to identify two separate groups of burials that present different orientations.

Perhaps the most complete and clear example of the association between rural settlements and contemporary cemeteries is Can Cabassa (Sant Cugat del Vallès), an agricultural and stock exploitation centre with two associated cemeteries.[52] The origins of the settlement date back to the 2nd c. BC and this was renovated and enlarged during the 3rd and the 4th c. AD. The finished building was organized around a courtyard where several working spaces (storehouses, presses) were built. Surrounding the main building, in an open area, there were other productive structures such as 8 pottery kilns, 20 metallurgy kilns and a warehouse that would have stored 120 *dolia*. In the course of the first half of the 5th c. AD, a recession was evidenced by the abandonment of many working spaces and the change in function of some structures. During the second half of the same century, there was a partial recuperation until the cessation of activity at the settlement in the 6th c. AD.

Nevertheless, the archaeological investigation at Can Cabassa points to a later Visigothic reoccupation of the area in the 7th and 8th c. AD, attested by 200 pits for grain storage. Regarding the funerary uses of the Can Cabassa population, two cemeteries related to this farmstead were revealed during the excavations. Both date to the 4th and the 5th c.; however, it seems that the second cemetery began to be used shortly after the first in the second half of the 4th c. The first cemetery, composed of 26 tombs, is located in the south-west of the main building. Within its interior, it is possible to distinguish two groups of burials based on their different orientation (north-west/south-east and north-east/south-west). The second cemetery lies to the south-west and has yielded 62 burials oriented east-west. In these graves, the inhumations are contained in simple pits protected by *tegula*, and in pits covered with stone slabs or masonry walls. Also, there is a large group of burials in which amphora containers were used. Along with the conventional disposal of human corpses in these two cemeteries, up to 11 inhumations inside silos were discovered at Can Cabassa. These excavated pits, once used for the storage of grain, were reused during the 5th c. AD as a dump for household refuse. The forced anatomical position of the skeletons suggests that these were thrown inside the silo and covered with debris, animal corpses and pottery sherds. It has been proposed that this non-normative funerary practice could be related to the marginal or slave status of these individuals within the community.[53]

In some other cases these villa cemeteries are also associated to mausolea. These funerary monuments, likely connected to the owners of the villas, have a central disposition and are surrounded by other tombs. The archaeological site of Can Palau (Sentmenat) is a rural settlement partially excavated. Only some structures of the *pars rustica* are known to us. Close by, a small necropolis of 5 tombs and the inhumation of a dog, organized around a mausoleum, octagonal in plan with two *formae*

51 Nolla, Casas, Santamaria and Oliart (2005).
52 Artigues (2010–2011).
53 Roig and Coll (2012). On this type of deviant burial practice in the Barcino territory, see Roig (2015).

in its interior and probably covered with a mosaic slab.[54] Another monumental structure associated with villas and burials is known in Pla de l'Horta (Sarrià de Ter). In this site, close to the *Via Augusta*, the remains of an extensive Roman villa organized around two courtyards, with rooms decorated with mosaics, were discovered in 1970.[55] Three decades later, to the north of the villa, a necropolis of 28 tombs was unearthed. The cemetery was in use from the 3rd to the 6th c. AD. The graves were close to a rectangular structure, a possible enclosure. Inside, attached to one of the enclosure walls, there was a masonry tomb with multiple burials inside and three other burial pits at the centre of the precinct.

Although there is lack of material evidence, the existence of a central mausoleum in the villa of El Munts in Altafulla has been conjectured. The villa is an impressive aristocratic residential complex occupying an elevation facing the seashore, built at the beginning of the 2nd c. AD. At the end of the 3rd c. AD, an important part of the villa was destroyed by a fire, contributing to its abandonment. At the turn of the 4th c. AD, uniform accumulations of soil were used to cover the ruins of the building and some new structures were erected with very poor materials.[56] In that same phase, a cemetery began to develop within 100 m of the new constructions, over a disused agricultural warehouse. The result was an extensive cemetery of 169 tombs containing 186 individuals, ranging in date from the 5th to the 7th c.[57] According to its excavators, the radial organization of the necropolis would indicate the existence of a central building or main tomb.[58] One striking feature of this necropolis is the large number of burials compared to other rural settlements. This may indicate two different possibilities: either the late antique settlement of Els Munts was more extensive than originally thought or that this cemetery was used by multiple households and communities of the surrounding area.

Some of the burials related to mausolea span from the Late Roman to Early Medieval period. In Catalonia, there are a number of examples of private funerary monuments providing the basis for medieval Christian churches. One fine example is that offered by the site of the Església Vella in Santa Cristina d'Aro, where a funerary building identified as a *cella memoria* was discovered in 1962–1966.[59] This structure, dated to the 4th–5th c. AD, was composed of two attached rectangular rooms, housing two tombs: one laid there prior to the construction of the *cella* and another that was introduced afterwards. At the north of the building was located a small burial plot with several graves of uncertain chronology. In a later phase, between the 7th and the 9th c., a Pre-Romanesque church with a rectangular apse was erected on this spot, incorporating the old mausoleum inside, within the apse area (Fig. 6a). This church established a new burial ground, located behind its apse and in use up to the 10th c. AD. An analogous situation was recorded inside the south-eastern apse of the Romanesque church of Santa Maria (Roses), which integrated a mausoleum into its structure, rectangular in plan and with a semi-circular apse.[60] Inside this building, two tombs were placed within the apse, while the adjacent area was also used as a cemetery. In both cases, it is difficult to trace a thread of continuity between the private, late antique mausoleum, related to the *possessor* of a villa, and the medieval churches. Also, it is unclear if the specific social or ecclesiastic role of the deceased (or the altered remembrance of it) had some influence in the consecutive construction of a church.

Of specific relevance in the late antique period are the groups of burials placed inside disused buildings. This phenomenon has been traditionally presented as a sign of marginalization; a funerary occupation carried out by squatters. Yet, we must recall that these were not forgotten or abandoned locations. They were still within an exploited and managed farming environment. Therefore, the ruins of the villa remained evident, frequented and also owned. Furthermore, it is difficult to know how the nearby population perceived these ruins. It is evident that these former sites were convenient to the families that reused them as a burial place. Firstly, there was plenty of material on site for building the tombs (*tegulae*, stone slabs). Secondly, judging by the orientation of the graves, which follow the walls of the buildings they occupy, the surviving structures of these abandoned villas and farms could provide walled enclosures for the disposal of the dead. This phenomenon can also be traced in suburban funerary contexts.[61]

54 Coll (2001).
55 Llinàs, Montalbán, Frigola and Merino (2005); Palahí and Vivó (2015).
56 Tarrats, Remolà and Sánchez (2007).
57 Garcia, Macias and Teixell (1999).
58 Garcia, Macias and Teixell (1999).
59 Aicart, Nolla and Palahí (2008) 13–24.

60 Llinàs, Agustí, Frigola and Montalbán (2012) 303–304; Nolla (1997).
61 Tombs placed inside abandoned suburban buildings, such as baths and craft structures, were common in the western suburbs of Tarraco during the 3rd and 4th c. AD. The graves were laid in parallel to the walls that were partially preserved. Consequently, these walls were part of the funerary landscape of small and poor necropolises and they possibly functioned as elements of their interior spatial organization: Ciurana (2011b) 696–97.

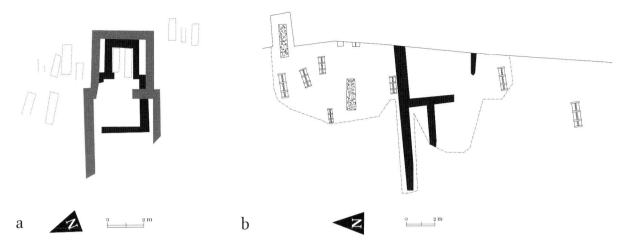

FIGURE 6 (a) Mausoleum and Pre-Romanesque church in Santa Cristina d'Aro (after Aicart, Nolla and Palahí (2008)), (b) Burials in Can Bel (after Burch and Nolla (2005)).

This reusing situation has been noted at sites such as Can Bel (Pineda de Mar).[62] Archaeologists discovered the remains of a building partially paved in *opus signinum* and with two *dolia in situ*. Stratigraphic evidence pointed out that it was built during the first half of the 1st c. BC and became derelict at the beginning of the 1st c. AD. Approximately 100 years later, the interior of the ruined building housed a small cemetery composed of 11 *tegula* graves, 9 of which were excavated. The human remains of 1 infant, 2 juveniles and 6 adults were recovered during the excavation. The last publication of results indicates that the burial ground was formed during a broad chronological span, between the 2nd c. and the 5th c. AD.[63] It is unclear which rural settlement the necropolis belonged to. Another Early Imperial villa (Can Roig) is presumed to exist 0.5 km away, but it has not been excavated and, therefore, it is uncertain whether it is contemporary to the necropolis or not. All the graves discovered in Can Bel were oriented east-west, as were the vestiges of the walls that encircled them (Fig. 6b). Two of the tombs were externally marked with rectangular masonry structures, which reveal the intention of underlining the physical presence of the final resting place. In the case of Can Bel, archaeology did not detect any evidence of material related to rubble from the former building. This means the area was cleared of debris before being used as a burial plot. A somewhat similar situation can be seen in the villa of Vilauba (Camús), where several spaces belonging to a residential villa abandoned in the 4th c. AD were later occupied by three burial inhumations, 2 infants inside amphora and an adult in a *tegula* tomb.[64] We know of other cases with scattered burials inside villas such as the Late Roman inhumations located in the villa of La Llosa (Cambrils), dated to the end of the 5th c. AD.[65] and the isolated burial excavated in the villa of L'Esquirol (Cambrils).[66]

Finally, the last category includes late antique burial sites related to Christian churches and monasteries, which are a late phenomenon in Tarraconensis. The known examples mainly date back from the 5th to the 8th c. AD and are rather scarce.[67] In the Barcino and Egara territory, the example of the church of Sant Menna (Sentmenat) stands out. The complete excavations at Sant Menna yielded 58 tombs located inside and outside the church, spanning from the mid-5th to the 8th c. AD.[68] In other cases, such as San Cugat del Vallès,[69] the funerary function of these churches is quite obvious as some burials are placed inside the church or within adjacent spaces.

Conclusions

The intention of this article is to provide an overview of how population in late antique Catalonia disposed of their dead. My approach has been limited because I have focused on a small number of urban and rural sites. Nevertheless, I have intended to present a varied tapestry of archaeological sites that can be representative and useful in introducing avenues for research. Obviously, further local and regional investigation will be required to produce a complete and integrated image of late antique funerary practices.

62 Cela and Subirats (1997).
63 Burch and Nolla (2005).
64 Castanyer and Tremoleda (1995).
65 Ramón (2007) 159.
66 López and Piñol (1993) 75.
67 For an overview see, Roig and Coll (2012) 377–80.
68 Roig, Coll and Molina (1995).
69 Artigues, Blasco, Riu-Barrera and Sardà (1997).

The analysis of the placement of the dead in the physical landscape allows us to draw conclusions about their role and that of funerary commemoration in a wider social dimension. It is clear from the archaeological evidence that from the 3rd c. AD onwards new forms of placing the dead in the landscape appeared in urban and rural contexts. The factors and processes that shaped this funerary change are closely related to the far-reaching transformations that defined the post-Classical world. By the late 3rd c., not only family but religious affiliation began to matter when it came to the dead and their remembrance. Thus, the care for the dead was essential in forming collective Christian identity.[70] This had an impact not only in the sacred and ritual sphere but also in terms of spatial organization of the cities and their areas of influence.

Suburban archaeological contexts are by far those that better reflect these transformations. For example, the city of Tarraco offers an exceptional opportunity to examine funerary data because of its abundance and richness in a wide range of funerary contexts. Prior to the 3rd c., the suburbia of the city was well organized by function. The main axis was the *Via Augusta*, while a system of secondary roads connected the city with its extra-mural territory. Residential areas and production structures were preferentially located near walls and roads.[71] Late Republican and Early Imperial tombs were placed adjoining the main road (the *Via Augusta* in the eastern suburb) and a secondary road that connected the city with the Francolí River ('camí de la Fonteta') in the western suburb. They consisted of family plots, often composed of wall enclosures with central mausolea and surrounding simpler tombs. Epigraphic materials associated with these funerary areas highlight the degree of relation of the deceased to others and their position inside the extended family hierarchy (parents and children, but also *clientes*, *liberti* or *patrones*).[72] These funerary spaces not only provided the scenery for the private cult and commemoration of the dead, but also a sort of archive for family memory.[73]

On one hand, during the 3rd c. (though the first symptoms can be traced since the mid-2nd c.), there is a notable decrease in funerary activity within the burial plots. On the other hand, during the 3rd and the 4th c., a new type of funerary landscape developed outside the customary Early Imperial burial sites, principally in the eastern suburb of Tarraco. Small concentrations of a maximum of 20 tombs are found inside or in close proximity to ruined suburban buildings abandoned during the second half of the 2nd c. These funerary spaces were located in peripheral spaces and distant from the main roads. These necropolises were short-lived and did not operate beyond the 4th c. At that same time, other necropolises began to form and grow on the edge of the suburbs, located far from the city walls but beside the *Via Augusta* (necropolis of Carrer Pere Martell, Avinguda Prat de la Riba and Parc de la Ciutat) and possibly secondary roads too (Mas Rimbau). During the 4th and the 5th c., these necropolises that could be identified with *cimiteria christianorum* developed in an unprecedented fashion. Their spatial organization reflected a growing sense of community. Tombs were arranged in parallel rows flanked by corridors that would allow circulation inside the cemetery. This reveals a centralised management of these mortuary spaces. Many questions remain open: who took care of and maintained order inside these large cemeteries? Was it the local Church authorities who decided who could or could not be buried there?

The tombs were very simple and made of reused materials (amphora, *tegulae*). There is no material evidence of grave markers, although this could be explained by the use of perishable materials like wooden steles. In these collective cemeteries there is a remarkable lack of features (such as mosaic slabs, sarcophagi or funerary inscriptions), denoting a lower social status of the deceased. Despite the prevailing poverty of the tombs, wealthy families also built their mausolea within the perimeter of these extensive burial sites (Parc de la Ciutat, Pere Martell), fitting their individual commemoration within the group identity.

The city of Barcino also presents archaeological contexts related to the emergence of late antique suburban cemeteries during the 4th and the 5th c. AD. On one hand, based on the archaeological evidence unearthed from the necropolis located at Avinguda Francesc Cambó, it is possible to trace the origins of funerary occupation as far back as the end of the 3rd c., which coincides with the initial phase of the extensive cemeteries in Tarraco. On the other hand, the first inhumations in the Mercat de Santa Caterina cemetery date to the beginning of the 4th c. The collective cemeteries are organized in rows of simple graves that coexist with wall enclosures and mausolea used by the upper classes. This phenomenon is documented in the cemetery of Mercat de Santa Caterina, where social differences are made explicit by the use of walls separating the different *areae*.

70 Chavarría (2015) 13.
71 For a diachronic study on the Tarraco suburbs, see Ciurana and Macias (2010).
72 Ciurana (2011b) 301–304, 463–67.
73 Ciurana (2011a) 342–44.

From the archaeological data, it is clear that cemeteries were a preeminent feature of suburban landscape in Tarraco, Barcino and Emporiae. In this last case, the ruins of the Greek Neapolis were occupied by an extensive late antique necropolis of more than 500 tombs. In the cases of Tarraco and Barcino, the large extensions of land dedicated specifically to burials is surprising. The tombs covered large surfaces, possibly in relatively under-developed rural landscapes. This could have been the case of the early Christian necropolis in Tarraco, where evidence of regular and recurring flooding of the Francolí River was detected by archaeologists.[74]

The conspicuous presence of the dead in the suburban landscape seems to have been a key element in the construction of the Christian group identity in late antique cities. For Christians, cemeteries were regarded as public spaces for commemorative gatherings. The whole congregation had an active role in funeral celebrations, participating in the rites.[75] This represented a considerable break from the Roman convention: the forum, where civic and communal values were promoted, was replaced by the cemetery. Closely linked to the commemoration of the dead was martyr veneration, which has a prominent position in the early Christian complex of Tarraco. The presence of the martyrs' sepulchre was the main factor that explains the incredible growth of the cemetery near the Francolí River. The desire of being buried *ad sanctos* impelled the Christian community, mainly the most privileged of their number, to establish their burials near the holy bodies. The most ancient material evidence of Christianity in Tarraco comes from the Francolí complex: the presence of Christians is attested by 22 funerary inscriptions dated to the middle of the 4th c. AD.

The erection of a basilica, a baptistery and other structures at the beginning of the 5th c. increased the presence of the organized community and the ecclesiastic hierarchy. The basilica was filled with underground burials and its counter-apse hosted a privileged tomb, which probably belonged to the promoter of the construction. A roughly contemporaneous second basilica was built 200 m to the north, housing hundreds of tombs in its interior. In these funerary basilicas, the holy space and the graves were joined. Public worship in proximity of decaying bodies (something that would have been profoundly disturbing centuries earlier) underscored the connection of the living and the dead in a sacred gathering place.[76] Churches were used for worship, but also as monuments that commemorated the community. Obviously, not everyone could be buried inside the basilica: being interred in the church building was already a significant mark of status. The pavements were breached in order to bury the bodies and the elites could signal their status through a relative degree of luxury on their tomb markers. Despite the lack of undisputed epigraphic evidence, it is likely that the clergy who held prominent positions within the Christian community located their tombs in such privileged areas as the apse or inside the baptistery. This can be seen in the northern basilica of the early Christian complex of Tarraco and inside the baptistery of Santa Margarida d'Empúries. In those funerary basilicas, the privileged class also displayed its social influence with their mausolea often built as church annexes (Santa Magdalena d'Empúries, *cella memoria* of Neapolis in Emporiae).

Our knowledge of late antique rural necropolis and burial practices is restricted due to the lesser amount of archaeological data available. Cemeteries associated with rural settlements were often very simple and poor, and for this reason, difficult to date with precision. As stated above, the rural population can often be traced through burials, sometimes in scattered settings such as in and around ruined villas, or near rural settlements still in use. Occasionally, we can identify burial groups in the landscape, but without a secure pinpointing of the living and working communities linked to them. It is often assumed that a site must be associated with these cemeteries; however, we should point out that a burial ground could be a focal point for scattered, small-scale habitats (such as in Els Munts). As noted above with urban sites, human remains were not necessarily disposed of in discrete areas. Sometimes, the dead were deposited nearby, visible from the habitation, like in Can Cabassa and Els Hospitals. Some cemeteries were placed near productive structures or bath complexes, keeping them visible and part of the daily experience. This is an ideological change that emerges also in urban contexts: the dead were not excluded and marginalised from the world of the living. To the contrary, they were included and brought together with the living. In other cases, burials were located on borders of various types, like property boundaries, roads or natural limits like ravines. Another aspect of rural burials is the small size of the cemeteries, rarely exceeding 20 tombs. This may indicate that these spaces were not used by multiple households, but more likely that they were managed by a single household, where each farm had its own cemetery.

74 This has been proposed as one of the factors that would have contributed to the abandonment of the northern basilica after 50 years of use: López (2006) 275, 277.
75 Yasin (2005) 448–49.

76 Yasin (2005) 441–42.

Between rural and urban cemeteries, it is possible to detect a number of recurrent patterns. If compared to previous centuries, both rural and suburban cemeteries register an important growth in quantitative terms. Suburban contexts provide forceful evidence of the increase in the number of registered tombs.[77] This could be related to a consistent population growth during the late antique period; however, other cultural and social factors might also have been involved. Throughout the 3rd c. archaeological evidence attests new burial patterns that seem to 'democratize' the burial practices. During the Early Imperial period, funerary commemoration appeared to be restricted to the sphere of the wealthy *familiae*. It is possible that poorer relations within the complex patronage system could have benefited from that and enjoyed a humble spot inside the family plot. Since the turn of the 2nd to the 3rd c., funerary activity was detected outside the customary burial plots monopolized by urban elites. Peripheral suburban areas were occupied by collective Christian cemeteries that would reach their number of burials between the 4th and 5th c. The spatial organization of these new funerary spaces reflected a new approach to the care of the dead: Christians were expressing religious communality and solidarity beyond family boundaries. These practices led to the development of a Christian type of funeral and corresponding commemoration of the dead. Inside these open-air cemeteries it was easier to assemble larger crowds during the funerals and the commemorative festivities. It is clear that martyr devotion and the frequenting of their tombs contributed to the expansion of some of these communal cemeteries. The erection of martyrial basilicas corroborates the entwinement of dead commemoration and the creation of a shared identity within the Christian community.

In the Tarraconensis countryside, articulated cemeteries organized in rows do not appear in the archaeological record until as late as the 3rd c. AD. Until that moment, the only forms of funerary occupation that archaeological evidence has registered consist of funerary monuments built by Early Imperial landowners within the limits of their *praedia*. While it is apparent that Christianization was the main driving force for the transformation in the suburbs, there is a lack of these certainties for the rural contexts. To some minor extent, it is possible to suspect a break from the previous Roman tradition with the emergence of small communal cemeteries that share some physical characteristics with the suburban ones: row organization and limits defined with wall enclosures. Some of these small rural cemeteries often occupied the ground of settlements long abandoned and, in many cases, they made use of its architectural vestiges. In these instances, graves showed perfectly oriented alignments following the orientation of the architectural structures. The reinforcement of the cemetery boundaries with walls seems to indicate also that the land was physically and ritually set apart. Despite the scarcity of information in rural context, when analysing a funerary space its social dimension has to be considered. Rural necropolises, regardless of the poverty of their materials, were managed spaces possibly used by a small household. A burial area was much more than an accumulation of tombs: it provided the venue for the inhumation, which was part of a funeral that consisted of a set of rituals and specific actions. Besides, the cemeteries were spaces of remembrance visited during the festivals that honoured the dead. These tombs did not belong to unwanted bodies, discharged in marginal and abandoned spots.

As noted in late antique burial sites in town and countryside, funerary occupation of the landscape gained visibility and cemeteries became a constant hallmark in the daily scenery of the living. This was especially noticeable in the cities, where an articulated network of suburban cemeteries ringed the habitat. The dead, portrayed as a community, became permanently visible and were used to shape new identity values.

Acknowledgments

I would like to express my gratitude to Sheila Coyle and Oriol Ciurana for their valuable language assistance and generous availability. I am also grateful to the anonymous external reviewers who provided extremely useful suggestions and constructive criticisms that helped reshaping and improving this article.

Bibliography

Adserias M., Pociña C. A., and Remolà J. A. (2000) "L'hàbitat suburbà portuari de l'antiga Tàrraco. Excavacions al sector afectat pel PERI 2 (Jaume I-Tabacalera)", in *Tàrraco 99. Arqueologia d'una capital provincial romana*, ed. J. Ruiz de Arbulo (Tarragona 2000) 137–54.

Aicart F., Nolla J. M., and Palahí Ll. (2008) *L'Església Vella de Santa Cristina d'Aro. Del monument tardoantic a l'església medieval* (Santa Cristina d'Aro 2008).

[77] In the case of Tarraco, we have recorded 321 tombs that date back to the Late Republican and Early Imperial period (from the 1st c. BC to the 2nd c. AD): Ciurana (2011b). Only taking into account the 'funerary ring' located on the western suburb of the city, up to 486 graves dated between the 3rd and the 5th c. AD have been unearthed.

Aquilué X. and Nolla J. M. (2003) *Memòria de les excavacions arqueològiques efectuades l'any 2003 a les Esglésies de Santa Margarida i Santa Magdalena d'Empúries* (Barcelona 2003).

Artigues P. Ll. (2010–2011) "La vil·la de Can Cabassa en els segles IV al VII", *Arqueologia Medieval* 6–7 (2010–2011) 8–23.

Artigues P. Ll., Blasco M., Riu-Barrera E., and Sardà M. (1997) "Les excavacions arqueològiques al monestir de Sant Cugat del Vallès o d'Octavià (1993–1994)", *Gausac* 10 (1997) 15–76.

Barrasetas E. and Vila G. (2004) "Les necròpolis de Can Solà del Racó", in *Actes de les Jornades d'Arqueologia i Paleontologia*, ed. M. Genera (Barcelona 2004) 778–90.

Bea D. and Vilaseca A. (2000) "Dues necròpolis del segle v d. n. E. a Tarragona: excavacions al carrer de Prat de la Riba i al Mas Rimbau", in *Tàrraco 99. Arqueologia d'una capital provincial romana*, ed. J. Ruiz de Arbulo (Tarragona 2000) 155–64.

Beltrán de Heredia J. (2008) "Barcino durante la antigüedad tardía", in *Recópolis y la ciudad en época visigótica* (Zona Arqueológica 9), ed. L. Olmo (2008) 274–91.

Beltrán de Heredia J. (2010) "La cristianización del suburbium de Barcino", in *Las áreas suburbanas en la Ciudad Histórica* (Monografías de Arqueología Cordobesa 18), ed. D. Vaquerizo (Córdoba 2010) 363–95.

Beltrán de Heredia J. (2011) "Santa Maria del Mar: un enclave cultual de la Antigüedad Tardía en el suburbium de Barcino", *Quadern d'Arqueologia i Història de la Ciutat de Barcelona* 7 (2011) 103–143.

Bolós J. (2012) "L'estudi de les necròpolis medievals catalanes, entre l'arqueologia i la història", in *Arqueologia funerària al nord-est peninsular (segles VI–XII)*, edd. N. Molist and G. Ripoll (Barcelona 2012) 71–85.

Burch J. and Nolla J. M. (2005) "Can Bel (Pineda de Mar, el Maresme)", in *In suo fundo. Els cementiris rurals de les antigues civitates d'Emporiae, Gerunda i Aquae Calidae* (Estudi General 25), edd. J. M. Nolla, J. Casas, and P. Santamaria (Girona 2005) 107–115.

Castanyer P. and Tremoleda J. (1995) "Vilauba (Camós, Pla de l'Estany)", in *In suo fundo. Els cementiris rurals de les antigues civitates d'Emporiae, Gerunda i Aquae Calidae* (Estudi General 25), edd. J. M. Nolla, J. Casas, and P. Santamaria (Girona 2005) 169–73.

Castanyer P., Santos M., Tremoleda J., Sala R., Ortiz H., Julià R., and Riera S. (2019) "El nucli de poblament tardoantic de Santa Margarida en el context del primer cristianisme emporità", in *Tarraco Biennal. Actes del 4t Congrés Internacional d'Arqueologia i Món Antic. VII Reunió d'Arqueologia Cristiana (Tarragona, 21–24 novembre 2018)*, ed. J. López (Tarragona 2019) 147–54.

Cela X. and Subirats I. (1997) *Memòria de l'excavació arqueològica d'urgència realitzada al jaciment de Can Bel (Pineda de Mar)* (Barcelona 1997).

Ciurana J. (2011a) "Prácticas y rituales en las áreas funerarias del suburbio oriental de *Tarraco*", in *Mors omnibus instat: aspectos de la muerte en el occidente romano*, edd. J. Andreu, D. Espinosa, and S. Pastor (Madrid 2011) 331–50.

Ciurana J. (2011b) *Pràctiques i rituals funeraris a Tarraco i el seu ager (segles II aC–III/IV dC)* (Ph.D. diss., Univ. of Tarragona 2011).

Ciurana J. and Macias, J. M. (2010) "La ciudad extensa: usos y paisajes suburbanos de Tarraco", in *Las áreas suburbanas en la ciudad histórica. Topografía, usos y función* (Monografías de Arqueología Cordobesa 18), ed. D. Vaquerizo (Córdoba 2010) 309–334.

Chavarría A. (1996) "Transformaciones arquitectónicas de los establecimientos rurales en el nordeste de la Tarraconensis durante la antigüedad tardía", *Butlletí de la Reial Acadèmia Catalana de Belles Arts de Sant Jordi* 10 (1996) 165–202.

Chavarría A. (2001) "Poblamiento rural en el territorium de Tarraco durante la antigüedad tardía", *Arqueología y territorio medieval* 8 (2001) 55–76.

Chavarría A. (2007) "Splendida sepulcra ut posteri audiant. Aristocrazie, mausolei e chiese funerarie nelle campagne tardoantiche", in *Archeologia e società tra tardo antico e alto Medioevo, XII Seminario sul tardoantico e l'altomedioevo (Padova, 29 settembre–1 ottobre 2005)*, edd. G. P. Brogiolo and A. Chavarría (Mantova 2007) 127–46.

Chavarría A. (2015) "Tumbas e iglesias en la Hispania Tardoantigua", *Arqueologia Medieval. Els espais sagrats* 7 (Lleida 2015) 13–45.

Coll J. M. (2001) *Can Palau (Sentmenat, Vallès Occidental). Memòria de la intervenció arqueològica d'urgència efectuada els mesos d'octubre i novembre de 1999–abril 2000* (Barcelona 2001).

Cortés R. (1981) "Excavacions al carrer de Pere Martell", *Butlletí Arqueològic de la Reial Societat Arqueològica Tarraconense* 3 (1982) 126–39.

Del Amo M. D. (1971–1972) "La necrópolis de Pere Martell", *Butlletí Arqueològic de la Reial Societat Arqueològica Tarraconense* (1971–1972) 103–171.

Del Amo M. D. (1979) *Estudio crítico de la Necrópolis Paleocristiana de Tarragona* (Tarragona 1979).

Foguet G. and Vilaseca A. (1994) *Memòria d'excavació Prat de la Riba- Ramon i Cajal* (Tarragona 1994).

Folch C. (2005) "El poblament al nord-est de Catalunya durant la transició a l'edat mitjana (segles V–XI dC)", *Annals de l'Institut d'Estudis Gironins* 46 (2005) 37–68.

Garcia M., Macias J. M., and Teixell I. (1999) "Necròpoli de la vil·la dels Munts", in *Del romà al romànic, història, art i cultura de la Tarraconense mediterrània entre els segles IV i X*, edd. P. Palol and A. Pladevall (Barcelona 1999) 278–79.

Godoy C. (1995) *Arqueología y litúrgia. Iglesias hispánicas (siglos IV al VIII)* (Barcelona 1995).

Huertas J. and Aguelo J. (2006) *Memòria de la intervenció arqueològica al solar del Mercat de Santa Caterina, Ciutat Vella (1999–2004)* (Barcelona 2006).

Llinàs J., Agustí B., Frigola J., and Montalbán C. (2012) "Necròpolis, hàbitats i llocs de culte a les comarques de Girona (segles V–XII dC)", in *Arqueologia funerària al nord-est peninsular (segles VI–XII)*, edd. Molist N. and Ripoll G. (Barcelona 2012) 301–316.

Llinàs J., Montalbán C., Frigola J., and Merino J. (2005) "La necròpoli del Pla de l'Horta (Sarrià de Ter, Gironès)", in *In suo fundo. Els cementiris rurals de les antigues civitates d'Emporiae, Gerunda i Aquae Calidae* (Estudi General 25), edd. J. M. Nolla, J. Casas, and P. Santamaria (Girona 2005) 195–210.

López A. (2012) "El suburbi funerari de Barcino a l'Antiguitat Tardana", in *Arqueologia funerària al nord-est peninsular (segles VI–XII)*, edd. N. Molist and G. Ripoll (Barcelona 2012) 431–56.

López J. (2006) *Les basíliques paleocristianes del suburbi occidental de Tarraco. El temple septentrional i el complex martirial de Sant Fructuós* (Tarragona 2006).

López J. and Piñol Ll. (1993) "El món funerari en època tardana al Camp de Tarragona", *Butlletí de la Reial Societat Arqueològica Tarraconense* 17 (1993) 65–121.

MacMullen R. (2009) *The Second Church. Popular Christianity A.D. 200–400* (Atlanta 2009).

Macias J. M. (2000) "Tarraco en la Antigüedad Tardía: un proceso simultáneo de transformación urbana e ideológica", in *Los orígenes del Cristianismo en Valencia y su entorno*, ed. A. Ribera (Valencia 2000) 259–71.

Macias J. M. and Remolà J. A. (2005) "El port de Tarraco a l'Antiguitat Tardana", in *VI Reunió d'Arqueologia Cristiana Hispànica. Les ciutats tardoantigues d'Hispania: cristianització i topografia*, edd. J. M. Gurt and A. Ribera (Barcelona 2005) 175–87.

Macias J. M. and Remolà, J. A. (1995) "L'àrea funerària baix-imperial i tardo-romana de Mas Rimbau (Tarragona)", *Citerior. Revista d'Arqueologia i Ciències de l'Antiguitat* 1 (Tarragona 1995) 189–201.

Macias J. M. and Menchón J. J. (2007) *La vil·la romana dels Hospitals. El Morell, Tarragona, Hic et nunc* 1 (Tarragona 2007).

Massó J. (2007) *Les excavacions inèdites del Museu de Reus a Porpres i a Parets – Delgades (1934–1936)*, Biblioteca Tarraco d'Arqueologia 3 (Tarragona 2007).

Menchón J. J. (2012) "Necròpolis de l'Antiguitat Tardana i Alta Edat Mitjana a les comarques del Camp de Tarragona, Conca de Barberà i Priorat", in *Arqueologia funerària al nord-est peninsular (segles VI–XII)*, edd. N. Molist and G. Ripoll (Barcelona 2012) 125–54.

Navarro S. (2016) *Funus Dertosanorum. El món funerari de la ciutat de Dertosa* (Tortosa 2016).

Nolla J. M. (1997) "Roses a l'Antiguitat Tardana. El cementiri de Santa Maria", *Annals de l'Institut d'Estudis Empordanesos* 30 (1997) 107–146.

Nolla J. M. and Sureda M. (1999) "El món funerari antic, tardoantic i altomedieval a la ciutat de Girona. Un estat de la qüestió", *Annals de l'Institut d'Estudis Gironins* 40 (1999) 13–66.

Nolla J. M., Casas J., Santamaria P., and Oliart C. (2005) "La necròpoli oriental de la villa romana del Collet de Sant Antoni", in *In suo fundo. Els cementiris rurals de les antigues civitates d'Emporiae, Gerunda i Aquae Calidae*, Estudi General 25, edd. J. M. Nolla, J. Casas, and P. Santamaria (Girona 2005) 11–103.

Nolla J. M. and Sagrera J. (1995) *Civitatis Impuritanae coementeria. Les necròpolis tardanes de la Neàpoli* (Estudi General 15) (Girona 1995).

Palahí Ll. and Vivó D. (2015) "Les necròpolis rurals de l'àrea suburbana de Gerunda", in *Necropolis and Funerary World in Rural Areas* (Studies in the Rural World for the Roman Period 9), ed. J. Tremoleda (Banyoles 2015) 87–116.

Pera J. and Guitart J. M. (2010) "Necròpolis tardanes a la ciutat romana de Iesso. Un problema a resoldre", in *Arqueologia funerària al nord-est peninsular (segles VI–XII)*, edd. N. Molist and G. Ripoll (Barcelona 2012) 161–73.

Ramón E. (2007) "La vil·la romana de la Llosa", in *El territori de Tarraco: vil·les romanes del Camp de Tarragona* (Forum 13), ed. J. A. Remolà (Tarragona 2007) 153–70.

Rebillard É. (2003) "Conversion and burial in the Late Roman Empire", in *Conversion in Late Antiquity and Early Middle Ages: Seeing and Believing*, edd. K. Mills and A. Grafton (Rochester 2003) 61–83.

Remolà J. A. and Vilaseca, A. (2000) "Intervencions arqueològiques al PERI-2, sector Tabacalera Tarragona", *Tribuna d'Arqueologia 1997–1998* (2000) 77–95.

Ripoll G. and Molist N. (2014) "Cura mortuorum en el nordeste de la Península Ibérica", *Territorio, Sociedad y Poder* 9 (2014) 5–66.

Roig J. (2015) "Necròpolis, aixovars i dipòsits humans anòmals en estructures no funeràries als territoria de Barcino (Barcelona) i Egara (Terrassa) entre el Baix Imperi romà i l'època visigòtica", in *Necropolis and Funerary World in Rural Areas* (Studies in the Rural World for the Roman Period 9), ed. J. Tremoleda (Banyoles 2015) 33–38.

Roig J. and Coll J. M. (2012) "El món funerari dels territoria de Barcino i Egara entre l'Antiguitat Tardana i l'època altmedieval (segles V al XII)", in *Arqueologia funerària al nord-est peninsular (segles VI–XII)*, edd. N. Molist and G. Ripoll (Barcelona 2012) 373–401.

Roig J., Coll J. M., and Molina J. A. (1995) *L'església vella de Sant Menna (Sentmenat)* (Sentmenat 1995).

Rutgers L. V. (1992) "Archaeological evidence of the interaction of Jews and non-Jews in Late Antiquity", *AJA* 96 (1992) 101–118.

Tarrats F., Remolà J. A., and Sánchez J. (2007) "La villa romana dels Munts (Altafulla, Tarragonès) i Tarraco", *Tribuna d'Arqueologia* 2006 (2007) 213–28.

Travesset M. (1993) "Una necròpolis paleocristiana a la Barcelona de l'època del bisbe Pacià (Segle IV dC)", *Finestrelles* 5 (1993) 71–140.

Serra J. (1929) *Excavaciones en la necrópolis romano-cristiana de Tarragona* (Madrid 1929).

Ted'a (1987) *Els enterraments del Parc de la Ciutat i la problemàtica funerària de Tàrraco* (Memòries d'Excavació 1) (Tarragona 1987).

Tremoleda J., Castanyer P., and Santos M. (2012) "Les necròpolis tardoantigues i altmedievals d'Empúries (l'Escala, Alt Empordà)", in *Arqueologia funerària al nord-est peninsular (segles VI–XII)*, edd. N. Molist and G. Ripoll (Barcelona 2012) 331–57.

Yasin A. M. (2005) "Funerary monuments and collective identity: from Roman family to Christian community", *ArtB* 87 (2005) 433–57.

The Late Antique Funerary Landscape of Rome: 3rd to 4th c. AD

Barbara E. Borg

Abstract

This chapter provides an overview of key aspects of the late antique funerary landscape and culture. It discusses elements of continuation such as necropoleis of simple shaft graves and the continued use of earlier mausolea as well as hypogea and catacombs, new monumental tomb types and cemeterial basilicas, with a special focus on innovative features, ideological and religious messages and patronage. It argues that changing funerary habits reflect a widening socio-economic gap in society, and that the most innovative structures and impressive building types, whether Christian or non-Christian, were most likely not initiated by the emperors or members of their family, but by prominent, wealthy private individuals.

Introduction

The funerary landscape of the capital of the Roman Empire was ever-changing and has always attracted much academic attention.[1] Funerary monuments and customs reflect the value systems, social hierarchies and often religious beliefs of any given society. They are therefore a prime source of socio-historical information, confirming, supplementing and sometimes contradicting and challenging the literary sources. For late antique Rome, interest has focused on the establishment of Christian practices and beliefs, with special attention to the catacombs and the circiform cemeterial basilicas that are specific to this city and widely believed to be Christian inventions. Other features have attracted less attention. Except for imperial mausolea, the large mausolea on their patrons' villa estates or clustered around the most important Christian basilicas are still significantly understudied. Even less research has been done on the continued use of older tombs and on the inconspicuous cemeterial areas of *fossa* graves (shafts) with no or very few modest grave goods and no (surviving) grave markers.[2] Moreover, all of these structures are typically discussed in isolation rather than as part of a complex funerary landscape.

In this chapter, I bring these elements together and provide an overview of the main features of the 3rd and 4th c. Roman funerary landscape. I focus on the architecture of funerary structures and mention interior decoration only in passing, since the latter raises so many additional questions that its inclusion would exceed the current scope.[3] Starting with a summary of features that essentially continue traditions of the High Imperial age, i.e. *fossa* graves and the continued use of earlier mausolea, I address hypogea and catacombs, monumental mausolea and cemeterial basilicas in turn. I pay special attention to the traditions on which they build, to their innovative aspects and to the messages contained in these architectural forms, before I conclude with some general trends such as the widening socio-economic gap and the impact of Christianity over these two centuries of dramatic change.

(In)conspicuous Continuations

Fossa graves and cemeteries are a ubiquitous feature of almost any funerary landscape, albeit a particularly inconspicuous one – at least to the eye of the modern archaeologist. This very fact, but also difficulties in dating them and their apparent lesser historical value compared with built structures and epitaphs in places such as Rome, has resulted in their neglect until very recently.[4] That this has started to change is due to at least two major factors. First, a change in research culture has led to more comprehensive and inclusive documentation and study of features that are less visually spectacular. Secondly, advances in scientific analyses, their increased affordability and their application to funerary remains from areas and time periods that also feature more conspicuous archaeological remains have increased enormously the potential to generate important, even exciting information not otherwise attainable. Not only can such clusters of *fossa* graves point to now-lost suburban villages or villas; in contrast to more visible tombs, these graves also normally still contain

1 Overviews include Hesberg (1992); Fiocchi Nicolai, Bisconti and Mazzoleni (1999); Johnson (2009); Hope (2009); Borg (2013); Borbonus (2014); Borg (2019).
2 The phenomenon of burial inside the city walls largely falls outside the timeframe of this chapter and will not be address here. For now, see Meneghini and Santangeli Valenzani (2000), with previous bibliography.
3 I shall also limit bibliographical references to the most essential and/or most recent publications that contain further bibliographies.
4 Graham (2015).

their skeletons, which in turn allow for scientific analysis. Through osteological examination, it is possible to identify the sex and age of the deceased, but also their history of diseases and health status at death, and the kind of labour they carried out, which has often left its mark on the bones. Occasionally, this allows for distinguishing between different status groups such as labourers (slaves?) and their masters. Analysis of strontium isotopes in teeth points to the deceased's diet, which helps assess the percentage of foreigners within the relevant group.[5] Most recently, a group of scientists has carried out the first ancient DNA tests on Roman skeletons, which even suggest *where* people originated.[6] Such simple graves covered vast areas and were interspersed between more visible tombs as well as domestic buildings, and it also seems that the spread of such cemeterial areas accelerated in Late Antiquity. Yet, there are no maps indicating their distribution and extension; because of the paucity of grave goods, dating these graves is difficult even under the best of circumstances and mostly impossible in retrospect, where excavators have only recorded their existence.

The continuing use and re-use of Roman tombs are still seriously under-researched and under-estimated.[7] Excavations mostly focused on a tomb's original features, while the effects of continued and repeated use were largely ignored and left undocumented. In view of epitaphs warning against tomb violation and of relevant legislation as collected in the *Digests*, later features were often thought to indicate illegitimate usurpation of a tomb. I have argued elsewhere that this is not necessarily justified. Tombs with sufficient epigraphic material rather suggest that long-term use was normally intended. Tombs were mostly founded for many generations of a family and served as monuments celebrating longevity.[8] Mausolea of the Early and Mid-Imperial period were often used throughout the 3rd c. and sometimes later, among both the élite and sub-élite. The former celebrated their family clan (*gens*) in and through their mausolea, frequently placing them close to the entrances to their estates. A striking example is a poorly preserved but richly decorated temple tomb with Ionic marble front porch and marble roof tiles erected at the 4th mile of the *Via Labicana* next to the entrance of an impressive villa ('*ad duas lauros*').[9] The villa was enlarged and embellished around the turn of the 2nd and 3rd c. and the tomb was probably erected at the same time or shortly thereafter, most likely by a wealthy *hominus novus*. When the villa was thoroughly renovated at the end of the 3rd or beginning of the 4th c., the tomb was newly decorated as well, receiving *opus sectile* floors and marble wall incrustation. Moreover, it was surrounded by a wall with niches and a rich entrance gate, a statement equal in ambition to the precinct surrounding Maxentius' mausoleum on the *Via Appia* (Fig. 1; cf. Fig. 3). The villa continued to be refurbished in the costliest manner into the 5th c. The continuous occupation and embellishment of the villa and treatment of the tomb suggest that both belonged for over two centuries to the same family, who employed it as a memorial to its founder and statement of its longevity.

Like the élite, the sub-élite aspired to establish a family line to preserve their name, even though periodically they had to resort to freedmen heirs to achieve this.[10] And even when a tomb was re-used after a hiatus, later depositions and structural changes usually respected the earlier burials. Niches with *ollae* (terracotta urns) may be plastered over. Bench graves and sarcophagi may obscure or even build over earlier depositions. Yet, care is taken not to disturb the burials as such. For instance, when, in the second half of the 3rd c., the *collegium* of the Pancratii started to use a tomb at the 3rd mile of the *Via Latina* some 40 years after the last burials had taken place, they moved the existing sarcophagi into the main burial chamber and set up their own caskets in the vestibule. If the situation the excavators found reflects the treatment of previous users' caskets, no effort was made to place them in an orderly fashion. Yet, that the Pancratii moved them into the neighbouring chamber in the first place and restricted their own depositions to the antechamber (and a newly excavated underground gallery) demonstrates some respect for previous occupants.[11] Conversely, prominent and conspicuous locations or evidence for natural disasters suggest that tomb destruction was sometimes officially sanctioned rather than a private act of violation.[12] It has often been observed – although rarely documented in detail – that late occupation of High Imperial tombs destroyed their original design and could look rather messy. Yet, we must be wary of imposing our own tastes and acknowledge the challenge in accommodating additional burials after the

5 Killgrove (2010); Killgrove (2019), for excellent overviews. For cemeterial precincts above Christian catacombs, see Fiocchi Nicolai (2016) 625.
6 Antonio *et al.* (2019).
7 But see Borg (2013) 123–60; Borg (2019) 123–90; Vella (2016).
8 Borg (2019) 123–90.
9 Armellin (2007) 85–95; Borg (2013) 36–37, 130–31.

10 Borg (2019) 151–90.
11 Borg (2013) 149–50. Given the prominent location and the wealth of the *collegium* who set up their own marble sarcophagi, I find it hard to believe that they simply usurped the monument.
12 Borg (2013) 155, 158.

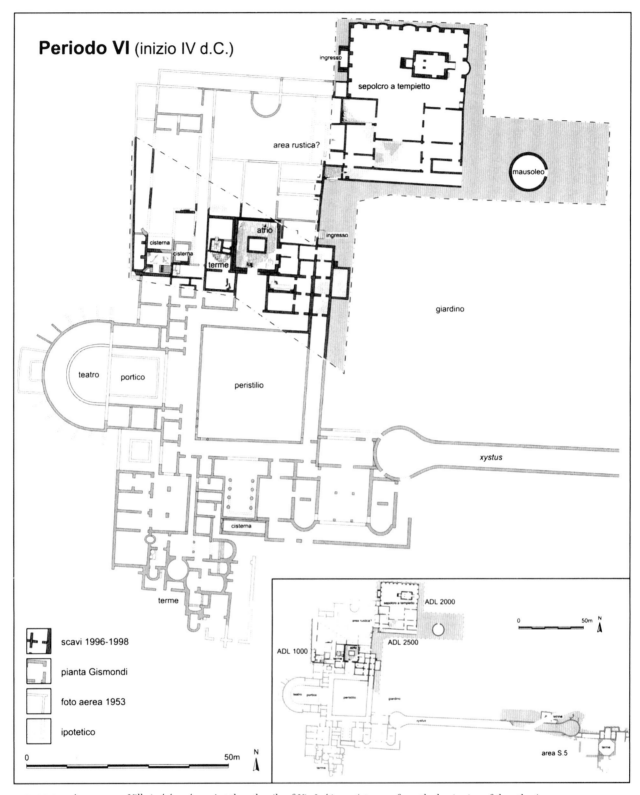

FIGURE 1 Anonymous Villa 'ad duas lauros' at the 4th mile of *Via Labicana* (stage VI from the beginning of the 4th c.).
COURTESY TO R. VOLPE, SOVRAINTENDENZA COMUNALE AI BENI CULTURALI MONUMENTI ANTICHI ED AREE ARCHEOLOGICHE DEL SUBURBIO, DRAWING BY JIM MANNING

originally planned graves had been filled. Family lines sometimes continued for much longer than a tomb's first patron had envisaged. To what extent use of existing tombs accounted for burial numbers overall, and how long the habit lasted, is currently impossible to tell.

This is not to deny that usurpation did occur, just to indicate that more research is needed to establish how such illegal violation can be distinguished from permitted continued use or re-use of a tomb or burial plot. Burials inside derelict non-funerary buildings

demonstrate most clearly an opportunistic use of space for burial.[13] At Ostia, we can see that epitaphs, sarcophagi and statues were taken from the necropoleis to be re-used for the adornment of the city, possibly as early as the turn of the 3rd and 4th c.,[14] and the re-use of sarcophagi seems to become more frequent from the last third of the 3rd c. onwards.[15] Obviously, at that time the mausolea they originated from were no longer in use and deemed dispensable. How long did it take for tombs to crumble and become a source for building materials and decorative items after they fell out of use? When this happened at a larger scale, the impact on the funerary landscape must have been substantial.

Hypogea and Catacombs

From the turn of the 2nd and 3rd c. onward, a marked change in the funerary landscape – albeit one less visible to passers by – was systematic and large-scale exploitation of the soft tuff rock around Rome for burial purposes. Underground burial chambers existed before, with both the large Late Republican to Early Imperial columbaria and smaller family tombs often featuring underground or semi-interred chambers. Yet, from then on, family mausolea were far more frequently excavated either into natural or artificial rock faces, or as burial chambers entirely set below the surface with little evidence of any major buildings or monuments above ground.[16] More importantly, underground tunnels became a new way of organising burial space and accommodating additional graves. Even though rock-cut hypogea comprising longish galleries existed elsewhere, there is no need to assume any foreign inspiration. A considerable number of early galleries in Rome re-used abandoned pozzolana mines and water tunnels. To my knowledge, the earliest datable re-use of this kind occurred in the galleries of a mine underneath the present church of S. Sebastiano on the *Via Appia*. Epitaphs and the relative chronology of the site suggest a date in the early 2nd c. at the very latest.[17] It is possible, indeed likely, that occasional re-use of such galleries also occurred elsewhere.[18]

What changed around AD 200, however, is that such tunnels were exploited systematically and at an unprecedented scale and that new galleries were excavated for burial as their primary purpose. Given that both decoration and epitaphs were initially very rare, dating is notoriously difficult, yet the general developments are clear.[19] At first, galleries were limited in size with lengths of only a few 10s of metres, consisting of one branch or very few side branches and accommodating limited numbers of burials. Even shorter galleries increased burial space in pre-existing mausolea.[20] Many of these original hypogea were later extended systematically, and eventually merged in the 4th c. to form the still-existing large catacombs of Rome.[21] The tunnels feature a range of different grave types and levels of decoration. The vast majority of graves were simple shafts cut horizontally into gallery walls (*loculi*), closed with tiles and sealed with plaster. A minority bore inscriptions, either painted or scratched into the still-wet plaster, and some featured items such as coins, little figurines or glass affixed to the plaster. An even smaller minority of loculi were closed off with marble slabs, sometimes inscribed and/or marked with simple decorative features, often conveying their patron's Christian or Jewish affiliation.[22] More elaborate niches and arcosolia as well as burial chambers marking certain groups within the collective increased in number, size and decorative effort from the early 4th c. onwards.[23]

The most hotly debated question around these gallery systems concerns their patronage.[24] It is generally

13 Meneghini and Santangeli Valenzani (2000), for buildings inside the walls; Di Gennaro and Griesbach (2003), for the suburbium.
14 Murer (2016); Murer (2019) 119–21 (but note that her claim that Isola Sacra tombs were destroyed already in the early 3rd c. (n. 41) is a misunderstanding).
15 It is not always clear whether a sarcophagus has in fact been used before or just been stored, but the re-working of portraits or erasure of inscriptions are clear signs.
16 Borg (2013) 59–72.
17 Tolotti (1953) 73–74.
18 An early date for the 'Jewish' Monteverde catacomb was proposed by Rutgers (2009) 21–22, but the evidence is weak: Vismara (2013) 1862.
19 Overviews in Fiocchi Nicolai, Bisconti and Mazzoleni (1999); Fiocchi Nicolai (2019).
20 Borg (2013) 143–46; see also here at n. 9.
21 It is impossible to draw a sharp terminological line between structures called 'hypogeum' and 'catacomb', and any definition must retain an element of arbitrariness. I am using 'hypogeum' to designate any more limited underground burial chamber or gallery system and restrict 'catacomb' to the very extensive systems that often united several pre-existing hypogea of different shapes and sizes. The term catacomb in the modern sense is not attested before the late 10th c. and derives from the ancient toponym '*ad catacumbas*' designating a burial area at the third mile of the *Via Appia* underneath and around the church now called S. Sebastiano: Bodel (2008) 238–39; Fiocchi Nicolai (2014) 273.
22 Fiocchi Nicolai, Bisconti and Mazzoleni (1999) ch. 3 (D. Mazzoleni); Borg (2013) 260–63.
23 For a typology of graves, see Nuzzo (2000).
24 Extended discussion in Borg (2013) 72–121.

agreed that some hypogea later integrated into the catacombs originally belonged to non-Christians, while many consider the larger gallery systems to have been established by Christian communities or Church authorities for exclusively Christian use.[25] Yet, Johnson pointed to features that would be difficult to reconcile with Christian faith, while Bodel rejected the idea on statistical grounds, and Rebillard even challenged the assumption that the Church had an emphatic interest in the care and commemoration of its dead, suggesting these largely remained a social rather than religious concern.[26] The attribution of any given gallery system to pagan, Christian or mixed user groups – ignoring for the sake of argument difficulties in using such binary terms – is often impossible given that figural decoration is very rare and a Christian epigraphic habit only developed over the course of the later 3rd and 4th c. Yet, certain cemeteries were regarded by patrons and users as Christian and designated 'ours',[27] and it is widely accepted that some cemeteries were founded by Christians for Christians. The least controversial example is 'Area I' of the later Callixtus catacomb.[28] Established on a plot of land ca. 30 × 75 m between the *Via Appia* and *Via Ardeatina*, it originally consisted of two separate galleries with some 180 burials. Subsequent extensions always remained within these confines, and it is normally assumed that a double cubiculum was used for the burial of the bishops of Rome from Pontianus (†235) to Eutychianus (†283). It is almost certain this is the funerary establishment initiated by Pope Zephyrinus (199–217) on his own property and overseen by his deacon and successor Callixtus.[29]

Similarly, it is generally agreed (although far from well-supported by evidence) that several hypogea and catacombs with evidence for Jewish burials were founded and used by Jews. The three largest yielded substantial numbers of epitaphs with Jewish epigraphic formulae and depictions of cult symbols. Their beginnings also seem to go back to the turn of the 2nd and 3rd c., confirming a parallel development to Christian catacombs.[30] It is controversial, though, whether either was used exclusively by what seems to be the majority faith group, and whether any similar hypogea or catacombs existed for pagans. The argument is highly complex, due to the limited quantity and inconclusive nature of the evidence, and the lack of clear boundaries between faith groups.

The exclusivity of Christian (and Jewish) cemeteries and catacombs has largely been argued with reference to literary sources. While the bulk of sources attesting to hostility between the groups pertain to the 4th c. and later, there is early evidence demonstrating uneasy relationships that occasionally resulted in persecution, prosecution and even revolt in some parts of the empire. The church fathers in particular warned about mingling with those who did not share Christian values and beliefs. Yet, evidence shows they did mingle, including in funerary contexts. The oft-cited episode around Spanish Bishop Martial, reprimanded by Cyprian for attending banquets of a pagan association, for admitting his sons into the same *collegium*, and for agreeing to their burial among these 'strangers', confirms both the concern such open-mindedness or leniency raised and that even senior members of the clergy happily buried their relatives with their social peers instead of fellow Christians. That Cyprian's rival Stephanus (254–257) reinstated Martial to his see further confirms that Cyprian's was a partisan rather than a majority view.[31]

Accordingly, we should also not be surprised if likeminded Christians admitted non-Christians into cemeteries established by and primarily for Christians when circumstances (such as social obligations) suggested this. After all, even within nuclear families, not everyone necessarily adopted the new religion, and the same goes for the extended *familia* about whose burial patrons had to care. And how clear would it have been to everyone who belonged to the in-group and who did not? We can only speculate how burial space was allocated in cemeteries such as Area 1. Its egalitarian outlook has suggested either the material poverty of the interred or an ideological stance of equality before Christ, or both. Yet, whether all graves in early Christian hypogea were offered to the faithful for free, or whether burial places were (also) sold as was usually the case in other communal cemeteries or tombs as well as in the 4th c. catacombs, is impossible to know. The latter possibility would suggest that non-Christian relatives of a patron likely found their way in as well – as was the case in Roman *collegia*. Traditionally, religion mattered little in the funerary realm. Unfortunately, we are lacking unambiguous

25 Summary of traditional views: Fiocchi Nicolai in Fiocchi Nicolai, Bisconti and Mazzoleni (1999) 13–36.
26 Johnson (1997); Bodel (2008); Rebillard (2009).
27 Fiocchi Nicolai (2014) 274–77, who also cites some early sources.
28 Fiocchi Nicolai and Guyon (2006); Borg (2013) 75–76.
29 Further candidates of (largely) Christian hypogea: Borg (2013) 76–79.
30 Summary in Borg (2020).

31 On Cyprian, *Ep.* 67.6.2: Johnson (1997) 45–46; Rebillard (2009) 28–29, 50–51; Bodel (2008) 182–83; Borg (2013) 73. For the argument more generally, see also Rebillard (2012).

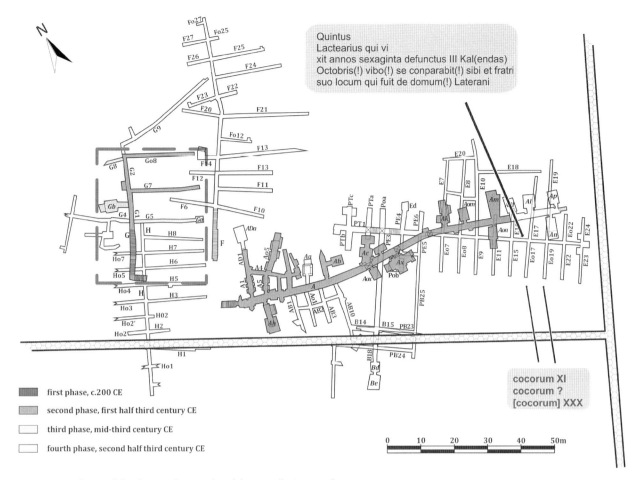

FIGURE 2 Phases of the three earliest nuclei of the Priscilla Catacomb.
© B. E. BORG

literary sources as well as systematic study and publication of full evidence from relevant parts of the catacombs, and dating is an additional challenge. But what are we to make of items affixed to the sealing mortar of *loculi* such as coins with the portraits of emperors persecuting Christians facing the viewer, magic gems showing Egyptian deities, figurines of pagan deities or heroes, or gold glass with Jewish ritual paraphernalia?[32]

In addition, topographical and organisational arguments suggest that many nuclei of the largest catacombs were established for a mixed user group. Three aspects are particularly noteworthy.[33] First, some of the largest catacombs were located on imperial or public property: Domitilla in the *praedium Domitillae* confiscated by Domitian; Pietro e Marcellino on the imperial estate '*inter duas lauros*'; the catacomb underneath S. Sebastiano on the *Via Appia* in an abandoned pozzolana mine with significant evidence for the burial of imperial slaves and freedmen as well as members of élite military corps; Praetextatus in an area of similar character.[34] To my knowledge, no advocate of exclusively Christian patronage of these catacombs has explained this circumstance.

Secondly, separate gallery systems often existed on one property. Assuming that the point of these new structures was shared and exclusive burial space for Christians, why were these gallery systems, close to each other and sometimes intertwined, kept separate over up to 100 years until the beginning of the 4th c.? Thirdly, there is at least some evidence suggesting allocation of burial space in these 3rd c. galleries in very similar ways as in *sub divo* cemeteries and tombs, here especially including the vast numbers of staff and dependants of the imperial household (Fig. 2).[35] At least initially, no special significance was attached to burial in the

32 Felle, Del Moro and Nuzzo (1994). For Jewish gold glass from the 'Christian' catacombs, see Noy (1995) 469–85; 471–72 no. 588 is from ss. Marcellino e Pietro.
33 Borg (2013) 72–121.
34 Borg (2013) 79–80, for a summary.
35 For the full argument, see Borg (2013) 91–96, 119–20.

extended underground galleries.[36] They mainly served less wealthy members of society who, during the 3rd c., increasingly lost the economic power to erect family tombs above ground. They may well have organised their burial in very similar ways as in the first centuries BC and AD, for which we have much richer epigraphic evidence demonstrating patterns of space acquisition within the then-popular columbaria, which served a similar range of collectives.[37]

Major changes only occurred from the late 3rd and beginning of the 4th c. onwards, when both the number and extent of gallery systems increased exponentially; when, in the early 4th c., many previously independent systems were merged; and when, as Rebillard argues, the emperor put the Church in charge of burial of the poor.[38] The organisation of burial within the catacombs is still little understood, but inscribed door lintels and decorative themes attest to cubicula or gallery parts reserved for families and/or *familiae* as well as *collegia* of various kinds, with others possibly reserved for members of a certain origin or nationality.[39] Surely, management by the Church would not have turned the catacombs into exclusively Christian cemeteries overnight. Yet, a growing number of Christians now become clearly visible through an unambiguously Christian epigraphic habit and a significant increase in biblical images.[40] Moreover, the growing number of relatively large, decorated cubicula demonstrates that the catacombs were no longer cemeteries of the poor alone, and the presence of more affluent patrons, even members of the senatorial class, suggests their attraction was the vicinity to a sacred Christian site such as a martyr's grave.[41]

Similar developments can be seen in the Jewish catacombs, where a decidedly Jewish epigraphic habit and use of imagery equally emerge only towards the end of the 3rd/beginning of the 4th c.[42] The chronological coincidence cannot be accidental. It rather supports a 4th c. date for the 'parting of the ways' (i.e. of Jews and Christians, but one could add 'pagans' here), probably accelerated rather than initiated by the boost Christianity received from Constantine's support, also visible in the simultaneous development of architecturally distinctive churches and synagogues.[43]

Monumental Tombs

Tomb building for families or small collectives continued for some time into the 3rd c., but eventually ceased around mid-century. In contrast, starting in the Severan period, some extraordinary mausolea emerge in new shapes and sizes, anticipating many forms that became more popular in the late 3rd and 4th c. Except for some imperial mausolea from the Tetrarchic period onwards, most of these mausolea are poorly studied. Two main questions have guided previous research: patronage and the ideologies and religious concerns they reflect. In fact, these two questions cannot be separated, and in order not to prejudice any results, I have organised this section according to the most common building types. I shall briefly discuss the last monumental tumulus; then three types of temple tombs inspired by temples for traditional gods and imperial *divi*; and finally new types that replaced them in the 4th c.

The Last Tumulus

The first mausoleum is not the beginning but the end of a tradition, a unique example of a tumulus tomb, the so-called Monte del Grano at the 3rd mile of *Via Latina*.[44]

36 It is sometimes objected that, while there is evidence, however sparse, in these gallery systems of Christian patronage in the form of biblical imagery, there is no indication of traditional Roman ('pagan') religion. This objection needs more extensive discussion, but two main problems are (a) the difficulty in establishing what should count as an indication of pagan religion, and (b) the absence of any religious elements in the narrow sense of the word from non-Christian tombs. Mythological imagery, for instance, is not just very rare indeed in all tombs at all times (for an overview, see Feraudi-Gruénais (2001)), but was largely abandoned from funerary representation after the Severan period. It was also not necessarily religious, which is why it was used by Christians too.

37 Schrumpf (2006); Borbonus (2014).

38 Rebillard (1999); Rebillard (2009) 120–21.

39 For the branch of the Domitilla catacomb reserved for the *mensores frumentaii*, slaves (*servi publici*) involved in Rome's grain supply and reporting to the *praefectus annonae*: Pergola (1990); for the catacomb of the Jordanians: LTURS 3 (2005) 89–93 s.v. Iordanorum coemeterium (P. De Santis); Borg (2013) 111–12; for strong evidence that the western part of the Marcellino e Pietro catacomb was used by members of the imperial court or military who came to Rome with Constantine (or Helena) from the Trier area, see Ingle (2019). Cf. Borg (2013) 93–94, for further collectives.

40 Epigraphy: Carletti (2008b); Dresken-Weiland, Angerstorfer and Merkt (2012). Paintings: Zimmermann (2015); Bisconti (2019).

41 The argument over the beginnings of burial *ad sanctos* is complicated and hampered by lack of (published) contextual evidence. Wiśniewski (2019) 83–100, for a recent discussion.

42 Borg (2020) 417–21; Rossi and Di Mento (2013) 328–40, 346–50, for Monteverde dates. Already Rutgers (1992) had argued for non-exclusive usage of the 'Jewish' catacombs.

43 The bibliography on this is vast but see esp. Schwartz (2001); Boyarin (2004); Carleton Paget (2004); Levine (2006); Boyarin (2008); Boyarin (2009). Cf. Borg (2020) 423–29, and Boin (2013) 124–64 for Ostia.

44 LTURS 1 (2001) 193 s.v. M. Aurelii severi Alexandri Sepulcrum (Z. Mari); Johnson (2009) 52 figs. 29–31.

The tumulus has lost its original, travertine-covered retaining wall, resulting in estimates of its original diameter between ca. 45 and 53 m. Differently from the tumuli of Augustus and Hadrian, which it 'cites', it featured an inner circular, domed chamber with two storeys, the lower 10 m in diameter. Its attribution to Alexander Severus initially rested on the male portrait of a kline sarcophagus found in the upper chamber. Yet, the portrait does not show the emperor, and our sole source on the emperor's burial place, the *Historia Augusta* (*Alex*. 63.3), only states that Alexander was buried in a *sepulchrum amplissimum*. This may suggest he was buried neither in the Mausoleum of Hadrian with his predecessors nor in the Severan family mausoleum on the *Via Appia*, since both were known to the author of the *vita*. Moreover, while the tumulus is smaller than the other two imperial ones, it is still enormous and exceeds by far private tumuli of any type or date.[45] More importantly, the tumulus type itself was utterly anachronistic by that time,[46] and had become the imperial tomb type *par excellence*. It has been suggested that Augustus' mausoleum was actually modelled on that of Alexander the Great, also Severus Alexander's ideological model. Such legitimacy claims would make most sense for the mausoleum of an emperor.[47]

Rectangular Temple Tombs

Most other large mausolea of the 3rd c. are temple tombs in that they imitate temples to the traditional Roman gods. Temple tombs were already the most popular type of freestanding mausoleum for the senatorial class as well as the wealthiest freedmen from around the turn of the 1st and 2nd c. The majority were modelled on rectangular podium temples with a freestanding front porch, likely inspired by the Templum Gentis Flaviae and temples for imperial cult.[48] Like other divine associations in the funerary realm imitating imperial visual language, temple tombs allowed patrons to deliberately straddle the borderline between claims to actual divinity and metaphorical expressions of honour and praise. Both readings were possible since divinity was in the eye of the beholder rather than an ontological category, an ambiguity that allowed for maximalist interpretations without challenging the emperor outright.

According to archaeological evidence and inscribed epistyle blocks, temple tombs continued to be used by the social élite throughout the 3rd c.,[49] although they became much more varied with time. The first well-dated example with a cruciform floor plan is Mausoleum XII on *Via Labicana*, next to the cemetery of the *equites singulares*.[50] The building had an impressive overall size of 17 × 11 m and its interior niches corresponded to 4 rectangular protrusions on the outside. Stairs provided access to the upper storey with its colonnaded porch. The high travertine podium contained the semi-interred, round burial chamber with deep niches for sarcophagi, which was adorned with a black-and-white mosaic floor showing vegetal scrolls, flowers and birds as well as a head in the centre. The walls were plastered and decorated with imitation marble incrustation, and small images of flowers and tendrils floating within the fields. The decorative elements date the building to the early 3rd c. The tomb owner is unknown, but its location within the imperial *praedia* suggests a person or family close to the imperial court.

Three further cruciform mausolea normally dated to the 4th c. may equally have been built during the 3rd. One is a temple tomb at the 4th mile of the *Via Appia* belonging to a villa nearby, which may have been owned by the family of the consul Iasdius Domitianus, who probably died as a member of the emperor's entourage in 235.[51] A similar but even larger building inside a porticus featured just opposite this tomb, but can no longer be examined without excavation.[52] A third cruciform temple tomb, this time without a lower storey, is still partly preserved at the second mile of the *Via Appia* in what was a necropolis on imperial or public property. According to a 15th c. sketch, it was part of a larger now invisible ensemble that is still poorly understood. Again, the building technique may suggest a date much earlier than the early 5th c. proposed by Windfeld-Hansen, and it could in fact have housed some of the hugely impressive 3rd c. sarcophagi found in pieces in the nearby Praetextatus catacomb, to which they clearly did not belong.[53]

45 Schwarz (2002).
46 Most scholars date it to the Severan period based on building technique; unconvincing is Pisani Sartorio (1979) 66 suggesting a 2nd c. date. It is the last tumulus built in Italy in antiquity.
47 For further arguments, see Freestone, Gudenrath, Painter and Whitehouse (1990); cf. Coarelli (1986) 35–37, 39, 56–58 for a tentative argument on location.
48 Borg (2019) 239–90.
49 For traditional rectangular temple tombs, see Borg (2013) 36–38.
50 Guyon (1987) 21–29 figs. 17–27, 29; Rausa (1997) 111–13 no. 24 figs. 24.1–4.
51 Windfeld-Hansen (2003b); Windfeld-Hansen (2003b); Borg (2013) 50–53 for the tentative attribution.
52 Borg (2013) 53.
53 Windfeld-Hansen (1969) 74–77 pls. 1a, 3c–d, 10, 11; Spera (2004) 267–68; Borg (2013) 53–55.

Circular Temple Tombs with Front Porch

Circular temple tombs were much rarer during the High Empire, but they probably included the cenotaph for Annia Regilla, wife of the powerful Herodes Atticus who accidentally killed her in AD 160. He opted for a shape likely modelled on the Pantheon, which is agreed to have been connected with the imperial cult no matter what other purpose(s) it may have served.[54] A further inspiration may have been the small rotunda on Hadrian's mausoleum, which lacked, however, a pedimented porch.[55]

S. Andrea

The only 3rd c. temple tomb of this kind I am aware of is the rotunda in the Vatican that was later transformed into the church of S. Andrea. Built over the spina of the Neronian circus at the foot of *mons Vaticanus* right next to the famous obelisk, it dates to the first third of the 3rd c.[56] With an original diameter of ca. 30 m, the *opus latericium* building was monumental compared to the 2nd c. tombs in the nearby necropolis. The rotunda featured a very low podium and probably a pedimented front and dome, as well as alternating rectangular and semi-circular niches inside, which became a standard feature of all circular tombs here discussed. The brick face was likely covered in stucco imitating ashlar masonry. Biering and von Hesberg's identification as the Phrygianum (temple of Cybele) known from written sources has not been accepted.[57] Given the structure partly built over a smaller tomb, it must have been another mausoleum.[58] Its location amidst a necropolis of mostly imperial slaves and freedmen would be odd for a member of the imperial family, and it is hard to see any candidates. Given also that the area formed part of the former imperial gardens and must still have been imperial or public property, a favourite of the imperial court is the most likely patron of this remarkable tomb.

Tor de'Schiavi

Chronologically the next mausolea of this kind are the so-called Tor de'Schiavi on *Via Praenestina* and Maxentius' mausoleum on the *Via Appia*, which closely resemble each other in their main features of a high, domed rotunda on a podium with separate entrance from the rear and a tetrastyle, double front porch with pediment and flight of stairs.[59] Exceptionally, in the Tor de'Schiavi, traces of interior decoration of marble veneer, mosaic and paintings in the cupola have been recorded by earlier visitors and are still partly visible. To some, the allegedly imperial building type and the mausoleum's proximity to the so-called Villa of Gordian suggest imperial patronage. Yet, the identification of the villa, based entirely on a vague note in the notorious *Historia Augusta* (*Gord.* 32), is doubtful,[60] and several features of the mausoleum equally point to private ownership. The exterior was covered not in travertine or marble, but in stucco imitation. At 19.2 m diameter, the building is smaller than S. Andrea and considerably smaller than the mausoleum of Maxentius (Fig. 3) and other 4th c. imperial mausolea at Rome, but roughly the same as the private circular Mausoleum III at S. Sebastiano (Fig. 5a).[61] Differently from other imperial mausolea, the tomb was erected *behind* a row of monuments that bordered the road, leaving them undisturbed. Considering the smaller Tetrarchs' mausolea outside of Rome,[62] Johnson suggested a lesser member of the imperial family such as an uncle or brother of Constantine. In any case, the mausoleum was used over several generations, which would be hard to explain had it been erected by a more prominent member of a Tetrarch's family.

Maxentius's Mausoleum

The only uncontroversial imperial circular temple tomb in Rome is the mausoleum erected by Maxentius on the *Via Appia* close to his suburban villa.[63] Within a large quadriporticus that directly bordered the road and built over earlier tombs, the mausoleum was a rotunda of 33 m diameter with a deep, hexastyle front porch. Its lower, partly interred burial chamber with its separate entrance from the rear features wide, deep niches along the walls of its circular corridor, intended for multiple burials in monumental sarcophagi. It demonstrates

54 Apart from the Cenotaph of Annia Regilla (Borg (2019) 19–20 fig. 1.10), a possible further example is the domed mausoleum at the Villa of Casal Bruciato: Calci and Messineo (1987/1988); Borg (2013) 21–22.

55 Borg (2019) 288; for the Mausoleum of Hadrian: Vitti (2013). Coarelli (2016) rejects the connection with the Pantheon and sees the Templum Gentis Flaviae as the model. Yet it is doubtful, in my view, that the Templum was a circular building: see here n. 146.

56 Biering and Hesberg (1987); Rasch (1990); Liverani (1999) 131–34 n. 58.

57 Biering and Hesberg (1987) 162–67; cf. the convincing discussion of the Phrygianum in Liverani (1999) 28–32.

58 Liverani (1999) 131 no. 57.

59 On the Tor de'Schiavi: Rasch (1993); Johnson (2009) 93–103; Blanco, Nepi and Vella (2013); Palombi (2019) 49–95 (C. di Fazio). Rasch's precise dating to the years 305–309 has drawn well-founded criticism for its methodology, but his argument that the Tor de'Schiavi features many elements that still feel experimental while they are fully developed in Maxentius' mausoleum is worth serious consideration (Rasch (1993) 92–94).

60 Palombi (2019) esp. 27–48 (D. Palombi).

61 Cf. n. 88.

62 Discussed below at n. 75–78.

63 Rasch (1984); Johnson (2009) 86–93.

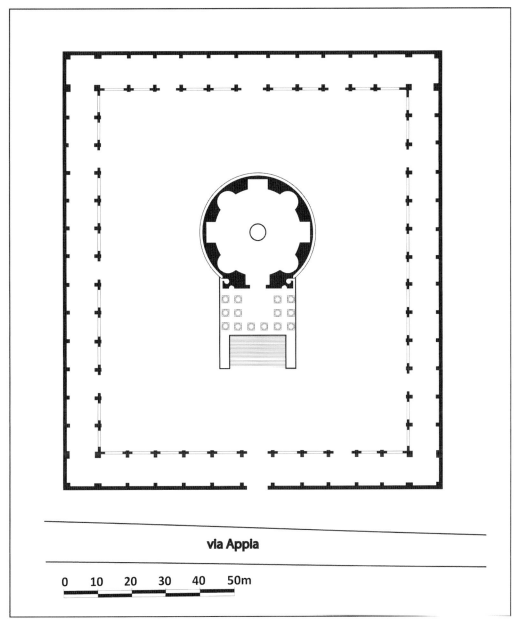

FIGURE 3 Mausoleum of Maxentius at the 3rd mile of *Via Appia*, beginning of 4th c.
DRAWING B. E. BORG AFTER RASCH (1984) PLS. 79B AND 81A

Maxentius' dynastic ambition and departure from his predecessors' habit of building individual tombs far from Rome.[64]

Circular Temple Tombs with Peristasis
A new type of temple tomb is first attested in the early 3rd c., distinguished from those just discussed by its outer peristasis of columns.

Temple of Portunus
The so-called Temple of Portunus at Portus is a Severan domed tholos with exterior peristasis of 24(?) columns sitting on a podium and semi-interred lower storey (Fig. 4).[65] The entrance into the upper chamber is unclear, although it seems there was no front porch. The podium was accessible via a system of vaulted corridors with rectangular niches or arcosolia large enough to allow for deposition of sarcophagi. The building's impressive ca. 28 m diameter exceeds that of the mausoleum of Gallienus. Size and location – remarkably, the building was included in Portus' later city walls – have suggested it was a temple (albeit not of Portunus). Given the shape of the crypt with its niches and the lack of any evidence for a temple at this site, it is far more likely

64 Rasch (1984) 78.

65 Lugli and Filibeck (1935) 93–94 figs. 60–61; Rasch (1993) 82, 84; Johnson (2009) 55–56 figs. 34–35.

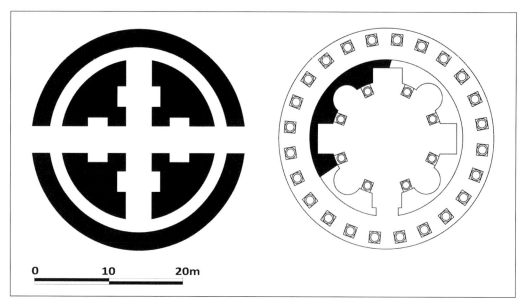

FIGURE 4 Temple tomb near Portus ('Temple of Portunus'), early 3rd c. (drawing B. E. Borg after Lugli G. and Filibeck G. (1935) *Il porto di Roma imperiale e l'agro portuense* (Rome 1935) fig. 61.

the building was a mausoleum,[66] which raises, however, the question of its patronage. Some have suspected an imperial patron while others have pointed out the lack of a suitable candidate. There can be no doubt its patron must have been an extraordinary individual, possibly with a special function in or relationship with the imperial port.

Mausoleum of Gallienus
Apart from the Monte del Grano, the only other possibly imperial mausoleum of 3rd c. Rome is the equally controversial, poorly preserved mausoleum attributed to Gallienus, which remains essentially unpublished despite its importance.[67] Its upper storey of 14.5 m diameter featured 6 semi-circular statue niches on the outside. Its semi-interred podium was originally much wider (ca. 18–19 m diameter),[68] suggesting it supported a peristasis like the 'Portunus Temple'. Inside, an annular corridor with arcosolia surrounded an inner core and 4 wide, deep niches flanked a vaulted corridor dissecting the podium. If the tomb's *opus latericium* work was covered in marble, none of this has survived, but many marble architectural and statue fragments were still visible on site in the mid-19th c. In essence, Bartoli's reconstruction has therefore been confirmed (although there is no evidence yet for a front porch).[69]

According to Aurelius Victor (*de Caes.* 69) and the anonymous *Epit. de Caes.* (40.3), Gallienus was buried at the 9th mile of the *Via Appia* and no remains of any serious contender for his tomb have been found.[70] If a fragment of porphyry from a statue or sarcophagus was in fact found on site, it would further confirm an imperial tomb.[71] Mari observes the mausoleum must have existed already when Gallienus was killed and assumes it had belonged to his family for at least several decades.[72] A brick stamp of AD 193–198 only provides a *terminus post quem*, but the lack of noticeable quantities of re-used materials supports a date not too late in the 3rd c. Had either Valerian or his son planned an *imperial* mausoleum, they would surely have chosen a less remote setting. The mausoleum's location on private land and at a distance from the city where funerary ostentation was less restricted is best explained by its construction as a family tomb by Valerian, whose career reaches back to the earlier 3rd c., before he became emperor.[73]

66 Rasch (1993) 85 with n. 601, and Brenk (2002) 60 with n. 2, have rightly noted that temples also sometimes have subterranean crypts, but no known example remotely resembles the case under discussion.
67 De Rossi (1979) 246–50 figs. 403–410, and 250–58 figs. 411–19 on the villa; Rasch (1984) 79; LTURS 3 (2005) 15–16 s.v. Gallieni monumentum, sepulcrum (Z. Mari); Johnson (2009) 42–47 figs. 19–24 reports limited excavations in 2003, which do not seem to have been published yet.
68 Thus the calculation of Johnson (2009) 46, supported by the 2003 excavations.
69 Johnson (2009) 46–47 with n. 131 and fig. 24.
70 *Anon. Vales.* (4.10) reports that Gallienus' mausoleum was at the 8th mile of the *Via Appia*, yet technically speaking, the mausoleum in question is located just before the ninth milestone and thus within the 8th mile: Mari, here n. 67, 15.
71 Johnson (2009) 42, unfortunately without a source for the information.
72 At n. 67, p. 15.
73 Given that Gallienus suffered a partial *damnatio memoriae* (before being deified by Claudius Gothicus), it is likely anyway that he was buried in his family's tomb.

'Berretta del Prete'

The anonymous, so-called Berretta del Prete at the 8th mile of the *Via Appia* is another circular, originally marble-clad tomb with a lower diameter ca. 16.5 m.[74] Its podium supported a peristasis of columns and featured a circular vaulted corridor inside. At a later stage, it was integrated into a larger building complex forming part of the villa. It is clearly later than the mausoleum of Gallienus as it was erected in *opus vittatum* with re-used bricks, although it may well date to the late 3rd c. rather than the 4th.

The general idea of a domed mausoleum surrounded by a peristasis of columns clearly resonated with the Tetrarchs. For his mausoleum in his palace at Split, Diocletian opted for an octagonal outer shape with columns on a podium (ca. 26.8 m diameter) surrounding a much taller cella, and a front porch. If the unadorned space in the podium was used for burial, the sarcophagus had to be brought in before building completion. Yet, the emperor's porphyry sarcophagus could have been displayed in the upper chamber.[75] The mausolea at Romuliana-Gamzigrad commonly attributed to Galerius and his mother are situated ca. 1 km outside the palace.[76] Mausoleum I consisted of a rectangular, inaccessible podium of 9.54 × 9.54 m containing the burial, and an octagonal upper storey. Mausoleum II featured a dodecagonal, equally inaccessible podium of 11 m diameter and a cylindrical cella surrounded by a lower peristasis of columns. Neither featured a front porch, so the entrance situation remains unclear. If they were in fact the imperial mausolea, they were considerably smaller than any known metropolitan imperial tomb.[77] The same goes for a tomb at Šarkamen just 35 km from Gamzigrad, similar in shape to and just 1 m wider than Mausoleum I. The foundations and fragments of the seated porphyry statue of an emperor right next to the building clearly mark it as imperial, and it has been tentatively but with good reasons attributed to Maximin Daia's mother, who was also Galerius' sister.[78]

4th c. Circular Mausolea

Both types of circular mausolea, those with front porch and those with peristasis, derive their design from pagan temples, and it has long been suspected it is the connotations of pagan cult that spelt the end of these building types under the Christian emperors. While circular structures continued to attract, they now consistently lacked podia and basements and featured clerestories and narthexes, sometimes opening onto Christian basilicas.

Mausoleum of Helena

The mausoleum of Helena at the 3rd mile of *Via Labicana* continued the tradition of domed rotundas without peristasis (Fig. 5b). The rotunda, dated to ca. 315–327 and 27.74 m in diameter, consisted of a lower, wider tier and an upper tier of considerably reduced diameter pierced by large windows.[79] The *opus latericium* construction was covered by imitation-ashlar stucco. The interior chamber was filled with light from the clerestory. It featured a marble floor, marble incrustation up to the dome, and mosaics in the vaults of the niches and likely the dome. The famous porphyry sarcophagus now in the Vatican probably stood in the rear, slightly wider niche. The front segment of the rotunda was cut off to allow a rectangular, wide porch to be added, which in turn opened onto the short side of a circiform basilica. The building thus lacked a proper façade, the most impressive element of all previous mausolea.

Many have deemed the sarcophagus decoration with cavalrymen unsuitable for a woman and assumed the mausoleum was planned for Constantine himself before he changed plans and moved to Constantinople. However, Johnson has argued that Constantine was not residing in Rome while Helena was, and that the estate was hers. The sarcophagus could have been planned for another member of the imperial family, even for Maxentius. Despite the uncertainties surrounding Helena's death and burial, and given that other women from the Constantinian dynasty were buried in Rome rather than Constantinople, it is most likely that Helena was buried in the mausoleum named after her.

Mausoleum of Constantina

The mausoleum of Constantine's daughter Constantina (†354), in which his sister Constantia (†350) and daughter Helena (†360) were also buried, was attached to the basilica of St. Agnes, albeit to its long side near the entrance (Fig. 5e).[80] It replaced a much smaller triconch

74 De Rossi (1979) 232–34 figs. 372, 376–83; Pagliardi (1985); Gai (1986) esp. 372–74; LTURS 3 (2005) 16 s.v. Gallieni monumentum, sepulcrum (Z. Mari).

75 Brenk (2002) 66–70; Johnson (2009) 59–70. A decision seems impossible right now: the following Tetrarchic mausolea featured inaccessible burial chambers, and even adorned sarcophagi were often deposited underground. On the other hand, in private mausolea, sarcophagi were frequently displayed in the upper (or only) chamber of a tomb.

76 Srejović and Vasić (1994) 130–35; Brenk (2002) 77–79; Johnson (2009) 76–82.

77 I am still not entirely convinced that the smaller rectangular temple inside the palace complex, which contained a crypt in its podium, must be discounted as the imperial mausoleum.

78 Johnson (2009) 82–86.

79 Rasch (1998); Johnson (2009) 110–118.

80 For the following, see esp. Rasch and Arbeiter (2007); Johnson (2009) 139–56, with some noteworthy corrections.

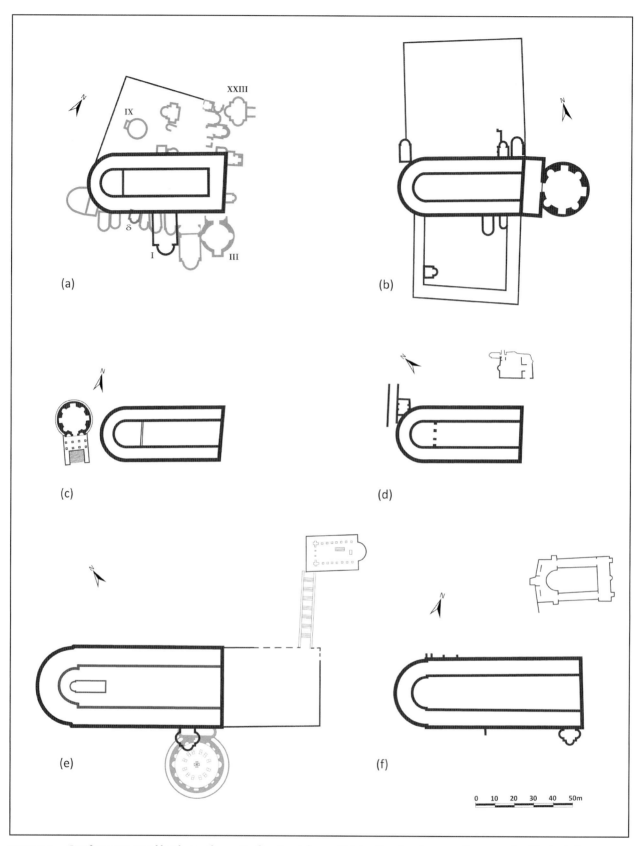

FIGURE 5 Circiform cemeterial basilicas, 4th c.: a. Basilica Apostolorum (S. Sebastiano) and surrounding mausolea, *Via Appia*; b. ss. Marcellino e Pietro and mausoleum of Helena, *Via Labicana*; c. anonymous basilica and mausoleum on *Via Praenestina*; d. basilica of Pope Marcus(?) on via Ardeatina; e. Agnese and mausoleum of Constantina, *Via Nomentana*; f. S. Lorenzo, *Via Tiburtina*.
DRAWINGS B. E. BORG

(discussed below). The *Liber Pontificalis* (180.11.12) mentions the basilica as built by Constantine on behalf of his daughter but no mausoleum, which raises the question of whether her burial there was intended from the start. It is possible Constantina was first buried in the triconch, which was later replaced. Yet, the triconch may never have been used and either she or someone after her death abroad (her brother Constantius II?) may have replaced it by the present building when the basilica was chosen for imperial burial.[81] The mausoleum itself measured an imposing 34.3 m in diameter, including a surrounding portico of columns supporting the roof of the rotunda's lower tier. The plan continued the tradition of circular mausolea with peristasis, but changed their outlook radically by attaching the tomb to the basilica via a narthex. Inside, semi-circular and rectangular niches alternated along the walls and 12 pairs of columns supported the central dome and clerestory. The vertical walls featured marble revetments while the niches, vault and dome were covered in mosaic, some with biblical scenes, others with traditional *felicitas temporum* imagery such as vintaging putti, which also decorated the porphyry sarcophagus in the central niche.

Mausoleum of Honorius

Towards the end of the 4th c., the last imperial mausoleum of Rome was attached to the southern transept of Old St. Peter's in the Vatican.[82] Due to its destruction by the Renaissance church and a lack of excavations, its reconstruction relies on early 16th c. and earlier notes and drawings. Even the outer diameter of the rotunda is debated, but given by one manuscript as 23.84 m. The mausoleum was attached to St. Peter's by a double-apsed vestibule and 7 niches featured inside. Everything else is conjecture, but it seems the mausoleum closely resembled the neighbouring rotunda of S. Andrea described above, which was substantially remodelled around the same time to feature a lower, wider storey and an upper section with windows.[83] The two buildings were even connected via their vestibules. Beneath the floor in the niches, vaulted brick chambers contained burials, including the imperial sarcophagi, although this may not have been their original place of deposition.[84] The first recorded imperial burial was that of Honorius' wife Maria, who died before 408, but her premature death may only have initiated the building. The mausoleum is best known for Renaissance descriptions of the imperial graves, which allow rare insights into imperial burial practices at the time. Maria's remains, possibly with those of her sister and second wife of Honorius, Thermantia, were found in a red granite sarcophagus with extraordinarily rich grave goods, two bearing her name. Another marble sarcophagus contained an adult and a child's wooden and silver-clad casket, likely belonging to Galla Placidia and her son Theodosius, both wrapped in heavy gold fabric. Further burials were treated similarly but remain anonymous and impossible to date. They may be imperial as well, but the translation of St. Petronilla's remains into the building that later adopted her name opens the possibility that some burials were in fact much later.

Private Mausolea

In the 4th c. as before, circular mausolea were no imperial prerequisite but also erected by private individuals, even though they constituted a minority. In the impressive villa 'ad duas lauros' (Fig. 1), in the late 3rd c., before the older rectangular temple tomb was substantially renovated and surrounded with its impressive quadriporticus,[85] a domed opus *latericium* mausoleum of 9 m diameter was erected at the eastern borders of the estate.[86] It featured a white marble floor and multi-coloured marble wall revetments. The entrance situation is unclear. When, in the 5th c., the villa was renovated a final time, the mausoleum was equipped with a water basin with mosaic floor, and another round building of just 5.3 m diameter was erected nearby, which may also have been a mausoleum.[87]

While the continued use of their ancestral temple tomb and burial on their estate suggest a non-Christian owner of the 'ad duas lauros' mausolea, circular structures occasionally occur around Christian basilicas. The best-documented cases are two rich but anonymous mausolea at the Basilica Apostolorum (Fig. 5a). Mausoleum III (17 m diameter) was connected with the southern aisle of the basilica via an apsed narthex and featured a protruding rectangular niche at its rear.[88] The narthex and niche walls were covered in marble, while the rest of the building was plastered and painted. Mausoleum XI (11.4 m diameter) was situated 8 m north of the basilica, with its (unexcavated) entrance towards an eastern secondary road.[89] Floor and walls were covered in coloured marble. A deep rectangular niche

81 Johnson (2009) 141–43 discusses various proposals.
82 Biering and Hesberg (1987) 168–72; Johnson (2009) 167–74.
83 Biering and Hesberg (1987).
84 Johnson (2009) 170.
85 Above at n. 10; Armellin (2007) 106–117.
86 Armellin (2007) 72–75.
87 Armellin (2007) 79–81.
88 Nieddu (2009) 156–68. The mausoleum's exact date is unclear, but it was the third added to the basilica's south wall shortly after its completion.
89 Nieddu (2009) 285–90.

extended from its western end, under which the famous monumental sarcophagus 'of Lot', with a couple in the central shell surrounded by biblical scenes and two burials inside, was found *in situ*. A bronze libation tube connected the lid with the mausoleum floor, under which further sarcophagi were deposited. The Lot sarcophagus dates the mausoleum to around the mid-4th c.

Structures with Apses and Multiple Conchs
Apsidal tombs became the most popular design choice of Late Antiquity, although again they have predecessors going back to the Severan period. At Ostia, Mausoleum B22[90] was a remarkable building complex of irregular shape, consisting of an apsidal building, an L-shaped annex (portico?) for multiple burials in *fossae* and arcosolia, and an open courtyard. The apsidal building's massive concrete foundations suggest it was a shrine-like structure on a podium with an entrance from the east.

Another 3rd c. example was part of the so-called Triclia complex *ad catacumbas* on the *Via Appia* (Fig. 5a).[91] Mausoleum δ was a rectangular chamber with a large protruding apse and a wide opening, with two columns *in antis* at the front. It has a mid-3rd c. *terminus post quem* by the construction of the piazza onto which it opened, and a *terminus ante quem* in the early 4th c. Basilica Apostolorum that destroyed its entrance. It is often assumed the structure was built at the same time as the other buildings around the courtyard. Yet, this date is at odds with the 5 or 6 decorated sarcophagi found in the mausoleum's floor and apse, all dating to the relatively short period between about 290 and 310. One depicts Ganymede, Eros and Psyche, and Narcissus, subjects perhaps more suitable for a pagan owner. Instead, the inscription on a Hunting sarcophagus re-used for a certain Bera includes her date of burial, an epigraphic feature usually regarded as typically Christian. Either the building was re-used in the Tetrarchic period, or it is a later addition to the Triclia complex and contemporary with the sarcophagi.

From the beginning of the 4th c., apsidal mausolea became the most popular architectural form in all cemeterial areas of the Roman suburbium, occurring as isolated buildings, parts of a row of tombs and attached to basilicas. Even though there are some relatively large examples, only the mausoleum attributed to the founder of the Basilica Apostolorum can so far be attributed to a high-status owner.[92]

Triconchs
During the 4th c., a more elaborate variant with multiple apses became popular both as entrance halls to villa buildings and as mausolea. The latter now often took the shape of a triconch, with three apses and a rectangular protruding entrance side. Such buildings could be either free standing or attached to basilicas.

S. Agnese and S. Lorenzo
Two examples of the type were attached to circiform cemeterial basilicas. The first formed part of the original plan of the basilica of St. Agnes at the 3rd mile of *Via Nomentana*,[93] but was soon replaced by the still-existing mausoleum of Constantine's daughter Constantina (now Santa Costanza; Fig. 5e).[94] As the basilica was built by (or on behalf of) Constantina, the triconch may have been intended as her tomb. Yet, no tomb of hers is mentioned in the *Lib. Pont.*, possibly supporting the view that the triconch was intended for a notable private individual or group.[95] Similarly, a triconch of ca. 11 m diameter opened onto the circiform basilica of S. Lorenzo on *Via Tiburtina*, in roughly the same place as the mausoleum at S. Agnese (Fig. 5f).[96] The triconch has traditionally been identified as a basilica for St. Stephen, but Serra has recently shown this is highly unlikely.[97] According to the *Lib. Pont.* (181), Constantine founded the basilica on imperial property as a dedication to the 3rd c. martyr who was buried in the nearby underground galleries, not in any of the mausolea attached to its outer walls. It is unclear whether the triconch was contemporary with the basilica or added later. In any case, it was certainly not an imperial mausoleum.[98]

An even larger triconch of ca. 15 m width dated to the mid-4th c. was situated north of (but detached from) the Basilica Apostolorum (Mausoleum XXIII; Fig. 5a). A small hypogeum was accessible from inside and featured an image of Hermes Psychopompos as well as an orans, while a large sarcophagus from the mausoleum depicted a noble couple between two 'Good Shepherds'.[99] Probably somewhat earlier and of similarly

90 Heinzelmann (2000) 196–97.
91 Tolotti (1953) 193–221; Jastrzebowska (1981) 73–75, with important corrections to the chronological development of the area; Nieddu (2009) 9.
92 Nieddu (2009) 137–40.
93 Stanley (1994); Magnani Cianetti (2004) 95–96 (F. Argenterò). It measured ca. 10.2 m diam.
94 Above nn. 80–81.
95 For this possibility, see C. Pavolini in: Magnani Cianetti (2004) 134–35, who also refutes the assumption by Stanley (1994) (ditto Hellström (2015) 297) that Constantina and her aunt were buried in a large apsed structure in the westernmost part of the basilica.
96 Serra (2002) 678–81.
97 Serra (2002).
98 Serra (2016) 1495–99, tentatively attributes an architrave with the single name IOHANNES (ICUR 7.17670B) to the triconch.
99 Nieddu (2009) 322–27 figs. 383–86. For a list of comparanda on which I draw here, see here n. 1420.

impressive size are two triconchs in the *sub divo* cemetery of Callixtus.[100] Two further triconchs of ca. 11 m diameter, dating to the first half of or mid-4th c., feature *sub divo* Domitilla.[101] Of these mausolea, only the western triconch may perhaps have been a martyrium.[102] All other triconchs lack any signs of veneration, and since none was certainly imperial, they must be regarded as private mausolea.

The Hexaconch in the Praetextatus Cemetery
Another extraordinary mausoleum that took the idea of apsed designs to the next level was situated some 20 m distance from the cruciform tomb in the Praetextatus cemetery discussed above.[103] The round cella was surrounded by 6 semi-circular niches protruding from the outside of the building, which had an outer diameter of 16–17 m. The niches as well as the building as a whole were covered by (semi-)domes. A vestibule or rectangular entrance porch opened to the south with two columns *in antis*. Windfeld-Hansen dated the building to the second half of the 4th or early 5th c. and it does indeed have close typological parallels in that period. Yet, it formed part of a larger, unique accumulation of buildings that appear to be funerary and follow High Imperial designs, suggesting an earlier date is also possible.[104]

Some Conclusions
Temple tombs loomed large in the 3rd and early 4th c., but there is increasingly less desire than before to copy any temple plan closely. The main bodies of a building could now be cruciform, hexagonal, octagonal or even multi-conch. Surrounding colonnades often did not reach the top of the roof – now domed – as in traditional tholoi, but looked more like porticoes turned inside-out, over-towered by the cylindrical core building. Many new shapes were not specific to tombs either and even those lending themselves to Christian interpretations (such as the cruciform ones or the triconchs) feature in baths and domestic architecture, where they marked the most representative rooms and served as reception halls and dining rooms. The shift away from close copies of traditional temples towards structures oozing social status thus started long before Christian patrons eventually dispensed of the last remains of pagan temple designs, pedimented fronts. Given that traditional temple tombs imitated the temples of the *divi* and alluded to divine cult, one wonders whether the decline of imperial cult – the last temple for a *divus* was that for Antoninus Pius and Faustina Maior[105] – perhaps rendered such ambition less meaningful.

Against this background, the choice of grand round temple tombs for Maxentius and the anonymous patron of the Tor de'Schiavi is remarkable. The two mausolea have often been hailed as the first tombs to imitate the Pantheon as a site of imperial cult, a Tetrarchic innovation intended to visualise a new emphasis on the emperor's divinity. Several scholars have concluded that adoption of this building type by the Tetrarchic emperor(s) indicates a merger of funerary and imperial cult.[106] But as we have seen, the key element of using a rotunda with pronaos for burial purposes is attested much earlier, even if on a lesser scale, and temple tombs had long been chosen for their associations with divine cult. Moreover, deified emperors did not receive any cult for the dead but imperial cult as *divi* instead, which is why their temples were unconnected with their burial sites.[107] As long as there is no further evidence for other than funerary cult in imperial tombs, there is no reason to assume that divine cult was intended there, especially since drawing attention to the emperor's mortality risked undermining his claim to divinity.[108] It may therefore be no coincidence that Maxentius' mausoleum is the only Roman temple tomb that can be identified as imperial. With little chance of actually receiving cult and a proper temple after his son's and his own (expected) *consecratio*, the idea of a temple tomb modelled on the Pantheon may have appealed to him for precisely the same reasons temple tombs had appealed to private patrons, while the other Tetrarchs went along with the fashion of the rest of the élite.

The members of the new Christian dynasties continued to prefer central-plan mausolea of impressive sizes and similar principal shapes, such as domed buildings with/without peristasis (and even octagons outside Rome).[109] But not only did they reject those architectural elements most clearly connected with pagan temples, the most dramatic difference was that mausolea

100 Fasola (1980) 255–78; Spera (1999) 113–15 UTT 175 and 177.
101 Ferrua (1960) 202–204.
102 Fasola (here n. 96) and others identified what they believe was a venerated grave.
103 Windfeld-Hansen (1969); Windfeld-Hansen (2003a) esp. 61–73 pls. 1b, 2–9; Spera (1999) 191 UT 323 figs. 136; 272; Spera (2004) 268–72. Cf. here at n. 53.
104 Borg (2013) 56.

105 Gorski and Packer (2015) 67–81.
106 E.g. Johnson (2009) 107–109, 180–85, 188.
107 Scheid (1993). The only exception is the Templum Gentis Flaviae: Borg (2019) 244–50.
108 The term 'heroön', mainly used for Christian imperial mausolea (Johnson (2009) 186–87), is problematic in any explanation of Roman mausolea, since there was no equivalent in Rome (and Latin) for the Greek concept and word 'heros' (a difficulty that also La Rocca (2002) overlooks).
109 If S. Aquilino in Milan was in fact an imperial mausoleum (Johnson (2009) 156–267).

now lacked a façade. Attached to cemeterial basilicas (see below), they no longer faced any major road and were literally overshadowed by a much larger structure. These spaces' splendour was largely limited to their light-filled interiors and only visible to those who viewed or entered them through these basilicas. Both purpose and audience had changed. Where we can tell, their entrances faced the main (frequently movable) altar of the basilica, where the eucharist and often the martyrs were celebrated.[110] Since, according to Christian belief, the emperor could not receive cult himself, the closest he could get to deification was admission to the heavens straight after death, his closeness to God and the privilege of sharing the honours martyrs enjoyed. As Eusebius confirms, proximity to their cult place was therefore perceived as a particular distinction.[111] One wonders to what extent again a pagan building may have served as model for expressing this architecturally. The structure now called 'Round Building' (previously known as 'Pantheon') at Ostia was a domed rotunda of ca. 22 m diameter attached to the back of a raised porticus at the short side of a forum-like piazza close to the harbour.[112] While the piazza, in contrast to the basilicas, was open to the sky, the rotunda did not have its own façade and was hard to appreciate from the streets at the rear. Multiple imperial portraits suggest imperial cult took place there, even though the structure was not a temple but a multi-purpose building (an audience hall for the Prefect of the Grain?).

Cemeterial Basilicas

By far the most visible and imposing funerary structures of Late Antiquity were the cemeterial basilicas. To be sure, there were graves in and around pretty much any church building of the city and its suburbium at some stage, yet, intramural burial started, from the second half of the 5th c., in a rather haphazard manner across the contracting city, often within large derelict buildings but not especially related to churches.[113] In contrast, burials marked the sites of all extramural basilicas, albeit with changing intensity. Among these, and apart from the basilicas for Peter and Paul on *Via Ostiense* and in the Vatican, the circiform basilicas are a particularly striking, innovative and enigmatic feature, on which I want to focus here.[114] They derive their name from their floor plans, which resemble circuses in featuring one rounded and one straight end, the latter at an oblique angle to the long walls. Inside, arcades or columns, which in turn supported a clerestory, set off an ambulatory that followed the outer walls except for the entrance side. Their lengths range from 65 to 98 m; they were situated on consular roads at about their third milestones; several of them were erected on uneven terrain requiring extensive terracing. Their patrons were wealthy and powerful and included emperors. Still, they appear to have been rather austere buildings, the only exterior decorative part being the entrance side in some cases. The interior decoration is largely unknown, and it has been suggested there may never have been any.

Yet, there are indications of a mosaic and marble sectile floor in S. Agnese,[115] and of plaster and paintings on the walls of the Labicana basilica.[116] Marble slabs covered an increasing number of graves in their floors. The lists of imperial donations in the *Lib. Pont.* attest to precious movable furniture such as gold and silver candelabras and altars. Six circiform basilicas are currently known: S. Agnese on *Via Nomentana*, S. Lorenzo on *Via Tiburtina*, an anonymous one on *Via Praenestina*, ss. Pietro e Marcellino on *Via Labicana*, S. Sebastiano on *Via Appia*, and S. Marco(?) on *Via Ardeatina* (Fig. 5). Almost no aspect of these structures is not debated in at least some quarters. It is generally agreed that they were a feature of the 4th c. only, but disputed whether the first examples were erected under Constantine or (at least started) before his reign, whether any were built after this emperor's dynasty came to an end, and who exactly were their patrons. Even their Christian purpose is questioned.

Dates

Three rather different criteria are used for dating these buildings, which are often hard to reconcile: the *Lib. Pont.* accounts of patronage; their size and design; and their building technique.[117] The basilicas on *Via Labicana*, *Tiburtina*, *Nomentana* and probably *Ardeatina* are mentioned in the *Lib. Pont.*, which also suggests Constantine's involvement. The *Labicana* basilica was erected on, or right next to, a large imperial estate and built over a cemetery of the *equites singulares*, an élite corps dissolved

110 See below at n. 149.
111 Fiocchi Nicolai (2016) 635–37; cf. Eusebius, *vc* 4.60.2.
112 Rieger (2004) 173–214, 301–12 with ill.; Boin (2013) 90–97. The building is dated to the Severan period.
113 Meneghini and Santangeli Valenzani (2000); Kneafsey (2018) ch. 4.
114 Overview: Fiocchi Nicolai (2001) 49–62; extensive discussion: Guidobaldi and Guidobaldi (2002); recent English summary: Hellström (2015).
115 Rasch and Arbeiter (2007) 19 with n. 173; 67.
116 Rasch (1998) 15.
117 La Rocca (2002) 1114–15. For a summary of the debate, see Fiocchi Nicolai (2002) 1193–95 with n. 34.

by Constantine after 312.[118] According to the *Lib. Pont.*, it was dedicated to the martyrs Marcellinus and Petrus and generously funded by Constantine. After its completion, the mausoleum discussed above was attached to it and ready for Helena's burial when she died in the late 320s.[119] The *Tiburtina* and *Nomentana* basilicas were larger and are generally dated later. According to the *Lib. Pont.* (180.11.12), S. Agnese was built by Constantine at the request of his daughter Constantina, who was buried in the attached mausoleum, although a now-lost mosaic inscription only names her as patron.[120] It is located near a *villa suburbana* used by Constantina (Ammianus Marcellinus 21.1.5), and the mausoleum built over Early Imperial structures of the productive sector of a villa that may have belonged to her estate.[121] It was the largest circiform basilica in Rome and the first featuring a gallery, which suggests to most scholars an error in the *Lib. Pont.* and a date during Constantina's presence in Rome from 337 to 351.

S. Lorenzo is equally large and featured columns instead of piers and arches. The *Lib. Pont.* (181.5–8) mentions a basilica erected by Constantine on *Via Tiburtina* at the Ager Veranus. The majority of manuscripts specify it was situated *supra arenarium cryptae* (i.e. of St. Laurence), which the circiform basilica is not. Yet, the first shrine above the martyr's grave dates to the late 6th c. and there is no other Constantinian basilica nearby. Serra has recently drawn new attention to the fact that several manuscripts of the *Lib. Pont.*, regarded by both Duchesne and Mommsen as generally more reliable, actually read *sub arenarium cryptae* instead of *supra*, which would describe the location adequately, as the basilica stands at the foot of the hill into which the catacomb with the martyr's grave extends.[122]

If the *Ardeatina* basilica is indeed that founded by Pope Marcus (AD 336), it was equally funded by Constantine,[123] but would call into question a linear development of basilica designs, since it resembles the early SS Marcellino e Pietro and Basilica Apostolorum rather than S. Agnese and S. Lorenzo. No source mentions patronage of the Basilica Apostolorum on the *Via Appia* (later dedicated to St. Sebastian). Its building technique is exceptionally similar to that of Maxentius' villa on the other side of the road, suggesting to some that the same crew of workers constructed it.[124] Moreover, no Chi-Rho signs were found among the graffiti of the *memoria* for the apostles that the basilica destroyed. The sarcophagi in Mausoleum δ, which was shut by the basilica walls, date to the Tetrarchic period, and two sarcophagi found *in situ* in the basilica date to *ca.* 300–320. Accordingly, there is agreement that the basilica is either the earliest of its kind or immediately follows the *Labicana* one.[125] A large mausoleum opening onto the basilica's southern aisle was destroyed soon after completion and replaced by two smaller tombs, possibly suggesting a *damnatio memoriae*.[126] Yet, it is unlikely its patron was Maxentius himself or a close family member, since Maxentius' mausoleum was clearly designed as a dynastic monument. Thus, the anonymous mausoleum was built either by one of his close allies or after his death. A growing number of scholars now believe in at least a Maxentian start date for the basilica (facing the issues just discussed), but a Constantinian date is still proposed by many, whose main challenge is to explain the silence of the written sources. Even if the mausoleum was intended for Constantine's mother Helena or his wife Fausta and abandoned because of a change of heart or fall from grace, respectively, it is hard to understand why the basilica, which enjoyed so much favour with the élite, did not remain connected with its funder/founder Constantine's name.[127] In my view, the most likely patron is a once-powerful but swiftly disgraced member of an emperor's inner circle, be this Maxentius or Constantine.

The case of the basilica near the mausoleum of Tor de'Schiavi on *Via Praenestina* discussed above is even

118 Guyon (1987) 30–33.
119 Guyon (1987); cf. *Lib. Pont.* 182.11–13. Helena's death is variously dated between 327 and 329; on her burial: Johnson (1992) 147–50. There is no evidence supporting Hellström (2015) 295 that the basilica may be pre-Constantinian.
120 Magnani Cianetti (2004) and above at nn. 80–81.
121 Magnani Cianetti (2004) 117–18 (P. Palazzo) 126–27 (C. Pavolini).
122 Serra (2015) esp. 42; Serra (2016) 1489–92. Neither Duchesne nor Mommsen, the authoritative original editors of the *Lib. Pont.*, knew of the basilica and could make sense of *sub*. For previous arguments, see e.g. Geertman (2002), whose 5th c. date for the circiform basilica remains unconvincing.
123 *Lib. Pont.* 202.3–4, 18–19; Fiocchi Nicolai and Vella (2016–2017).
124 On the basilica: Nieddu (2009).
125 Discussion in Nieddu (2009) 140–48, who settles on Constantinian patronage. For an early date, now also Hellström (2015) 296. Sarcophagi: Nieddu (2009) 132–33; mausoleum δ: above n. 91. I am not convinced that the re-worked portrait on the lion-hunt sarcophagus can be dated to the Constantinian period with sufficient certainty to date the entire basilica.
126 Nieddu (2009) 137–40 discusses suggestions.
127 One of the first and strongest promoters of a Maxentian date is Jastzebowska (most recently Jastrzebowska (2002)); for a Constantinian date, see Nieddu (2009) 139, who considers structural problems could have led to the mausoleum's destruction. This is possible but fails to explain why the building was not replaced by a single mausoleum. Her explanation for the silence of sources (lack of information or failure to fall into a category that the *Lib. Pont.* would have considered for inclusion) is not impossible but unlikely.

less clear.[128] While detached from the mausoleum and facing east, its proximity and a western door opening towards the mausoleum suggest the buildings were deliberately related to each other. Yet, while the mausoleum continued in use over several generations, the basilica was abandoned after 47 unsystematic burials had taken place. This is hard to explain, especially since recent fieldwork seems to confirm a date roughly contemporary to the mausoleum.[129] The fact it was never handed over to the Church (which in turn probably further discounts imperial patronage) certainly played a part,[130] and if the building type of the Tor de'Schiavi indicates a non-Christian patron, perhaps the basilica was added by a Christian family member who remained, however, an exception in this family?

Purpose and Patronage

The next debate revolves around the purpose and occupancy of the circiform basilicas. It is uncontroversial that they were primarily used for burial, that they were, in essence, huge, covered cemeteries (*coemeteria subteglatae*), since their floors were occupied entirely by *fossa* graves, often several layers deep, providing space for up to 2,500 burials. It used to be taken for granted that the main idea behind these buildings was to provide dedicated burial space for Christian communities, and to do so as close as possible to the graves of venerated martyrs from whose protection the deceased hoped to benefit. Yet, the explanation does not work equally in all places. Guyon pointed out early on that Peter and Marcellinus, after whom the *Labicana* basilica was named, are missing from the *Chronography of 354* and *Depositio Martyrum*, and that it was the basilica that promoted the martyrs, not the other way round.[131]

Based on her observations that none of the basilicas originally *incorporated* any martyr graves, that the *Via Praenestina* basilica may have been built by a non-Christian patron, and that patrons are imperial or at least high status, Hellström has suggested that the basilicas were the late antique equivalent to the large columbaria of the Julio-Claudian era.[132] They provided burial space for dependants while showing off patrons' huge households and generosity. It may also not be mere coincidence that several of them were patronaged by female members of the imperial house. The key idea is convincing: these patrons splashed out on these imposing buildings, putting their own munificence and benevolence on display. That the recipients of these benefactions were members of their households is possible in some cases, especially considering that certain sectors of the catacombs were often used and organised by members of imperial and other élite *familiae*.[133] Yet, the basilicas are too poorly preserved and documented for us to be sure about the nature of a clientele of modest means and status in their initial phase. Moreover, the explanation does not work for the *Ardeatina* basilica if indeed it is the one built by Pope Marcus, unless we assume the pope intended to bury mainly imperial staff there.

At the same time, the importance of Christian cult for these buildings is attested by the Constantinian donations of liturgical objects. Moreover, as I intend to demonstrate elsewhere, the Appian basilica was erected not just over a *memoria* for apostles Peter and Paul, but also over, and with great concern for, their presumed original grave(s).[134] The *formae* in the basilica floor also contained costly marble sarcophagi, and epitaphs attest to a larger number of members of the first two orders than from any other 4th c. basilica.[135] Clearly, in this case anyway, the attraction of the site hinged on the apostles' cult from the start. The mausolea attached to or surrounding the basilicas (bar the anonymous one on *Via Praenestina*) are mostly secondary additions and their state of preservation and documentation only rarely allow for more precise dating. Yet, they increased in number from the second quarter of the 4th c. onwards, and their very existence suggests that the martyrs the churches commemorated were the real attraction, even if not everywhere from the beginning.[136] The importance of martyrs from the 3rd c. onwards is demonstrated by the graffiti for Peter and Paul at the *memoria* the Basilica Apostolorum replaced,[137] from further graf-

128 Cf. at n. 59 above. For the basilica, see esp. Blanco, Nepi and Vella (2013) 286.
129 Blanco, Nepi and Vella (2013) 286.
130 M. Maiuro in LTURS 3 (2005) 37 s.v. Gordianorum villa.
131 Guyon (1987) 261–63.
132 Hellström (2015) 303–310.
133 Borg (2013) 91–93, 119–20; Maiuro (here n. 45, pp. 37–38) convincingly suggests that the very poor burials inside the basilica on *Via Praenestina* belonged to servile dependants of the owner.
134 For now, see Borg (2022). Already Guyon (1987) 262 noted that only the basilicas for the apostles were erected over their graves in the earlier 4th c.
135 Nieddu (2009) esp. 136–37, 366–68.
136 Whether that makes them *martyria* is debated and depends on the definition. It also does not necessarily imply burial of Christians only, even though one may expect only rare exceptions if any. Hellström's suggestion that it was imperial patrons that attracted other tombs (Hellström (2015) 310) is unconvincing for these élite mausolea.
137 ICUR 5.12907–13096; Diefenbach (2007) 43–55, for an overview and discussion, and now esp. Felle (2012).

fiti near martyr graves,[138] from epitaphs,[139] from literary sources detailing the benefits of participating in prayers for martyrs, and not least from Constantine's choices for his own burial.[140]

A further issue is the meaning of the basilicas' unusual form, especially whether the oblique angle at which the straight short side of the building is set bears any symbolic significance. Those who find this aspect negligible have suggested the circiform gardens of élite villas as models and symbols of paradise (Krautheimer), or the palatial aulas (Hellström). It is true that the experience of space in basilicas differed greatly from that in circuses, and there are marked differences in detail even in their floor plans. Yet, the oblique angle asks for an explanation, since it is clearly not accidental. Brandenburg observed that such oblique angles also occur in other types of basilicas (albeit later ones!), and suggested that the façades' angle towards the south was intended to maximise illumination.[141] However, the façades of the *Nomentana* and *Tiburtina* basilicas are angled north. Aulas may well have been an inspiration for the interior space, but La Rocca rightly noted that the symbolic power of architectural elements does not necessarily depend on 1:1 replication.[142] They could work more like a quotation in a text. Torelli's suggestion that the cosmic connotations of circuses explained the shape[143] raises the difficulty that the basilicas lack precisely those elements most strongly associated with cosmology, such as the spina.

I tend to prefer La Rocca's line of thought. Pointing out the key character of circuses as venues for competition and victory, and drawing on ecclesiastical sources comparing the struggle of martyrs with athletic (and gladiatorial) *agones* and a martyr's death with victory therein, he proposed that this is the most likely meaning of the form.[144] *If* the Basilica Apostolorum was the first circiform basilica, and if it was believed at the time that Peter (and Paul?) was martyred in the Circus of Nero, there may even have been a more specific connotation of the building's shape, which was, however, easily expandable to other Christians in the way La Rocca explains. If this is correct, the later basilicas did in fact imitate the Basilica Apostolorum as the first ever building dedicated to the apostles. Its significance is often underestimated, even though no other basilica attracted so many élite burials as this one – despite an anonymous patron. Considering Constantine's obvious favour of the apostles (he built 4 churches to them in Italy and famously the Apostoleion for his own burial in Constantinople), it would be in character if he had built his basilica on *Via Labicana*, which was only later associated with the martyrs in the adjacent catacomb, in imitation of a cemeterial building commemorating the apostles.

Finally, it is debated whether these basilicas served as covered cemeteries only, where all ritual activities were related to funerary commemoration, or the eucharist was celebrated there as well, at least occasionally.[145] It is generally agreed that the basilicas served commemorative activities and *refrigeria* (possibly in the form of *stibadium* meals in the curved ends of the buildings), and growing numbers of scholars now think that, initially, the basilicas saw celebrations of the Eucharist occasionally, and more regularly only at a late stage. The lack of any remains of altars is surely the weakest argument against the Eucharist, as no 4th c. church preserves such traces from its initial phase and altars were not structurally integrated into the buildings but movable.[146] Moreover, all Constantinian donations included altars. Similarly, it is unclear if none of the basilicas did indeed have a baptistery, as claimed. After all, the *Lib. Pont.* mentions a baptistery in the context of S. Agnese, and I shall argue elsewhere that the so-called well with its surrounding Constantinian graffiti underneath the Basilica Apostolorum *may* have been a baptistery too.[147] A stronger argument is the absence of clergy assigned to these basilicas, and the description of several celebrations of the Eucharist as exceptional.[148] Yet, Fiocchi Nicolai has discussed a range of sources clearly attesting to the importance of the Eucharist at martyr feast days, which were celebrated in cemeterial basilicas.[149] Considering further that the extramural basilicas of St. Paul's on *Via Ostiense* and St. Peter's in the Vatican were designed from the start for congregations and the celebration of the Eucharist while being

138 Carletti (2008a); Yasin (2015).
139 ILCV 1.2126–2187.
140 Fiocchi Nicolai (2001) 635–38; Johnson (2009) 119–29.
141 Brandenburg and Vescovo (2004) 95.
142 La Rocca (2002) 1125–27.
143 Torelli (1992), tentatively followed by Johnson (2009) 182–83, who rightly points to the likely cosmic connotations of domed rotundas.
144 La Rocca (2002) 1125–40. For this argument, it does not matter that arenas were more directly linked with martyrdom: this is about the language of competition and victory. For a number of reasons that I cannot explain here in detail, I disagree with La Rocca's further suggestion that the arrangements of Maxentius' villa on the *Via Appia* served as model for the basilicas with their founders' tombs, which, like the emperor's mausoleum, imitated the 'heroa' of Hercules. Cf. n. 108 above.

145 See the debate in Guidobaldi and Guidobaldi (2002) 1255–62.
146 De Blaauw (2001) esp. 971. But note the possible exception of the Basilica Apostolorum: Nieddu (2009) 91–95.
147 Borg, monograph in prep.
148 Sources in Krautheimer (1960) 26–28.
149 Fiocchi Nicolai (2016) 630–38.

erected over a century-old necropoleis and being used for burial already during the 4th c., I wonder whether we are trying to draw distinctions that did not occur to early Christians.

Conclusions

This overview of key features of the funerary landscape from the 3rd to 4th c., incomplete as it necessarily is,[150] has demonstrated its richness and diversity. It raises an array of questions about their historical, sociological and theological interpretation, only some of which can be addressed here. Others are better qualified to comment on the multitude of theological and liturgical issues the Christian basilicas and tombs raise. I would like to conclude with some general observations that link with socio-historical implications of the evidence. It is striking how much the Severan period was one of innovation and change. The extraordinary mausolea with new designs and/or sizes not seen since the Late Republic first appeared in the early 3rd c., when also smallish family mausolea experienced a final boom. Yet, the course was now set for widening the socio-economic gap over the course of a turbulent century that led to the discontinuation of middling classes' and freedmen's funerary habits – for economic or social reasons, or both. While a few prominent, rich private individuals and families promoted themselves through ambitious monuments in the wider surroundings of Rome, the rest of the population returned to collective burial forms, increasingly in underground hypogea and catacombs, which were not only more affordable and closer to the city but also provided a sense of community and identity.

By proxy, we associate the level of funerary ostentation with economic power and social status. Surely we are often right and there is no doubt that many of the simplest graves, whether in *sub divo* cemeteries or underground galleries, belonged to people with little means and low status. Yet, from the 4th c. onwards, we also find members of the senatorial class, who could have afforded their own tomb, buried in the floors of Christian basilicas or inconspicuous graves in the catacombs. On the other hand, the new large mausolea were only affordable to the wealthy and may have been limited to the top echelons of society.[151] Still, there is an acute danger of circular reasoning when many of the monumental tombs discussed above are attributed to imperial patrons based on building type, size or location alone. We also need to bear in mind that, due to the re-usability of their building materials, the most splendid mausolea were most prone to destruction, so that these tombs are considerably under-represented in our records. In previous centuries, no tomb type was exclusive to the emperor. The necessary distinction between him and the rest of the élite was established through smaller tombs and/or distance from the centre: the further away from the city, the more daring a patron could be. Distance from Rome could therefore explain private patronage of tombs such as S. Andrea, the 'Temple of Portunus' or the 'Berretta del Prete', suggesting that the Mausoleum of Gallienus was indeed his family tomb erected far outside Rome near the family villa before his father became emperor – and so in fact a private mausoleum. Reduced size, stucco ashlar imitation on the rotunda, and respect for pre-existing graves and tombs, relegating it to the second line, suggest that the Tor de'Schiavi may also have been non-imperial, despite being located closer to Rome.

Tituli from now-lost mausolea give us some idea of the kind of persons we are looking at and demonstrate that the senatorial élite retained their taste for temple tombs.[152] The titulus for Pomponius Bassus Terentianus from the 2nd mile of *Via Latina* was an extraordinary 7 m long with letters 21 cm high. It must have belonged to a mausoleum easily matching in size those discussed above.[153] Bassus was *consul suffectus* in 193(?), *amicus* of Septimius Severus and father of the homonymous *consul ordinarius* of 211 who married Marcus Aurelius' great-granddaughter. All preserved epistyles are straight, suggesting rectangular temple tombs or circular ones with front porch. For patronage of round temple tombs with peristasis, we have only the mausoleum of Gallienus to go by. If erected by his father as suggested, it belonged to a senator of the highest esteem and influence, who played an instrumental role in convincing the Senate to accept Gordian I as emperor and was put in charge of Rome during his predecessor's absence. Of course, the possibility remains that some tombs belonged to lesser members of the wider imperial family. Yet, would such a person have possessed a greater right to an ostentatious mausoleum than one of the emperor's powerful supporters in his administration or military? Moreover, who would count as such? How far removed can someone

150 The most obvious lacuna is arguably a consideration of non-Christian (and non-Jewish) 4th c. burial customs, a subject that is seriously under-researched. For now, see the excellent and rich survey by Vella (2016).
151 Powerful imperial freedmen like Claudius' Pallas or Domitian's Abascanthus who could outdo in funerary ostentation even the social élite (Borg (2019) 7–8) no longer existed in Late Antiquity.
152 Borg (2013) 32–35.
153 *CIL* 6.41195.

be from the emperor to still be called a member of his family?

Little changed in this regard in the 4th c. Private individuals did erect richly decorated circular mausolea, although smaller than the imperial ones. Patronage of late antique mausolea is best researched for the area around the Basilica Apostolorum, where patrons included a prefect of the city and a burial club.[154] The triconchs of S. Agnese and S. Lorenzo occupied prominent positions and were (both?) part of the original basilica plan, but it is highly unlikely the latter belonged to a member of the imperial family, and possible that neither did. Similarly, imperial patronage is attested for only 3 of the 6 known circiform *basilicae subteglatae*. It did not affect his status as patron that Pope Marcus received the funds for his basilica from the emperor. The patron of the *Praenestina* basilica, who would hardly have needed funds from elsewhere, is therefore no more likely to have been imperial than that of the Tor de'Schiavi. We have further seen how hard it is to argue for an imperial patron for the Basilica Apostolorum. The main difference to the *Praenestina* basilica is its erection on public or imperial property and, more importantly, the fact that its patron was permitted to erase and build over an existing, working necropolis, which needed permission from the emperor. Yet, how certain can we be that such permission was not granted to someone close to him? Does it matter that its founder's mausoleum was apsidal given that, with *very* few exceptions, the emperors since Augustus whose final resting place we know, and all emperors since the Tetrarchy, opted for central-plan tombs? While it is tempting to attribute major changes and innovations related to the new Christian faith to Constantine, evidence is growing that we should be more cautious.

The late antique funerary landscape did not change rapidly or radically. The most dramatic change was the erection of the Aurelianic Wall in the 270s, which introduced a monumental borderline where previously there was a gradual transition from intensely inhabited to more rural areas.[155] Outside the walls, change was slow. Previously built tombs continued to line all major roads, often forming cemeterial areas transected by secondary roads. Poor documentation of later phases and repairs prevents us from quantifying their continued use or re-use, which is, however, frequently attested until at least the 4th c. and sometimes later. *Fossa* graves, hypogea and catacombs, while catering for the majority of the population, were barely visible to passers-by. In turn, buildings without any funerary function – from baths, taverns and guest houses to production sites and villas of varying shapes and sizes – continued to mark the suburban landscape.[156] Yet, with time, the new mausolea of the élite, experimenting with innovative designs, matched in size only by the Late Republican tumuli and unprecedented in splendour, must have stood out and visualised the socio-economic gap as well as the élite's ambition to a degree not seen since the Late Republic. They were surpassed in size albeit not in architectural luxuriance only by the 4th c. cemeterial basilicas that dominated the roadsides and, over the course of the 4th c., accumulated mausolea around them that formed proper cemeteries. While patrons previously did their best to direct their mausoleum façades with their inscriptions towards major and minor roads, in these cemeteries, mausolea, including those of their founders, frequently opened onto the naves of the basilicas, turning their mostly austere backs towards passers-by. Other mausolea clustered around the basilicas and lined attached enclosures. Over time, these clusters around prominent basilicas must have increasingly marked the suburban landscape, although the decay of Early and High Imperial tombs and decline of non-funerary activities probably only started in the period considered here.

Acknowledgements

I would like to thank the editors for inviting me to participate in this volume, and for their patience and kindness during a difficult process of researching this chapter during the pandemic. I am also most grateful to the readers for their very helpful suggestions. Obviously, all remaining errors remain my own. Great thanks go also to Sally Osborne for her expert editing and linguistic corrections. I would finally like to thank Rita Volpe for kindly granting me permission to use her drawing of the Villa '*ad duas lauros*' in Fig. 1.

Bibliography

Primary Sources

Anon. Vales. = J. C. Rolfe ed. and transl., *Ammianus Marcellinus. History, Volume III, Excerpta Valesiana* (Loeb Classical Library 331) (Cambridge Mass. 1939).

Cyprian, *Ep.* = *CSEL* 3.465–842.

Lib. Pont. = R. Davis ed. and transl. *Book of the Pontiffs* (*Liber Pontificalis*) (Translated Texts for Historians 6) (2009).

154 Nieddu (2009) 351–75.
155 Dey (2011).
156 Against the reduction of the suburban landscape to its funerary function, see now Emmerson (2020).

Secondary Sources

Antonio M. L., Gao Z., Moots H. M. *et al.* (2019) "Ancient Rome: a genetic crossroads of Europe and the Mediterranean", *Science* 366 (2019) 708–714.

Armellin P. ed. (2007) *Centocelle II* (Soveria Mannelli 2007).

Becker A. H. and Yoshiko Reed A. (2004) (ed.) *The Ways That Never Parted. Jews and Christians in Late Antiquity and the Early Middle Ages* (Tübingen 2003).

Biering R. and Hesberg H. v. (1987) "Zur Bau- und Kultgeschichte von St. Andreas apud S. Petrum. Vom Phrygianum zum Kenotaph Theodosius d.Gr.?", *RömQSchr* 82 (1987) 145–82.

Bisconti F. (2019) "The art of the Catacombs", in *The Oxford Handbook of Early Christian Archaeology*, edd. W. R. Caraher, T. W. Davis, and D. K. Pettegrew (New York 2019) 209–20.

Blanco A., Nepi D., and Vella A. (2013) "Il mausoleo e la basilica circiforme della cd. Villa dei Gordiani sulla via Prenestina: tecnica e strategia die rilievo", *BullCom* 114 (2013) 285–94.

Bodel J. (2008) "From columbaria to catacombs: collective burial in pagan and Christian Rome", in *Commemorating the Dead: Texts and Artefacts in Context: Studies of Roman, Jewish, and Christian Burials*, edd. L. Brink L. and D. Green (Berlin 2008) 177–242.

Boin D. (2013) *Ostia in Late Antiquity* (Cambridge 2013).

Borbonus D. (2014) *Columbarium Tombs and Collective Identity in Augustan Rome* (New York, NY 2014).

Borg B. E. (2013) *Crisis and Ambition: Tombs and Burial Customs in Third-Century AD Rome* (Oxford 2013).

Borg B. E. (2019) *Roman Tombs and the Art of Commemoration: Contextual Approaches to Funerary Customs in the Second Century CE* (Cambridge 2019).

Borg B. E. (2020) "Does religion matter? Life, death, and interaction in the Roman Suburbium", in *Lived Religion in the Ancient Mediterranean World: Approaching Religious Transformations from Archaeology, History and Classics*, edd. V. Gasparini, M. Patzelt, R. Raja, A.-K. Rieger, J. Rüpke, and E. Urciuoli (Berlin 2020) 405–434.

Borg B. E. (2022) "Peter and Paul Ad Catacumbas: a pozzolana mine reconsidered", in *The Economy of Death: New Research on Collective Burial Spaces in Rome from the Late Republican to the Late Roman Period. Proceedings of the 19th International Congress of Classical Archaeology, Cologne/Bonn 2018*, edd. T. Fröhlich and N. Zimmermann (Heidelberg 2022) 45–58.

Boyarin D. (2004) *Border Lines: The Partition of Judaeo-Christianity* (Philadelphia 2004).

Boyarin D. (2008) "The Christian invention of Judaism. The Theodosian Empire and the Rabbinic refusal of religion", in *Religion: Beyond a Concept*, ed. H. de Vries (New York 2008) 150–77.

Boyarin D. (2009) "Rethinking Jewish Christianity: an argument for dismantling a dubious category (to which is appended correction of my *Border Lined*)", *JQR* 99 (2009) 7–36.

Brandenburg H. and Vescovo A. (2004) (ed.) *Die frühchristlichen Kirchen Roms vom 4. bis zum 7. Jahrhundert: der Beginn der abendländischen Kirchenbaukunst* (Regensburg 2004).

Brenk B. (2002) "Zum Problem der Krypta unter spätantiken Rundbauten", in *Centcelles: el monumento Tardorromano iconografía y arquitectura*, ed. J. Arce (Rome 2002) 59–81.

Calci C. and Messineo G. (1987–1988) "Via Tiburtina: Casal Bruciato (circ. V)", *BullCom* 92 (1987–1988) 437–47.

Carletti C. (2008a) "Nuovi graffiti devozionali nell'area cimiteriale di S. Sebastiano a Roma", in *Unexpected Voices: The Graffiti in the Cryptoporticus of the Horti Sallustiani and Papers from a Conference on Graffiti at the Swedish Institute in Rome, 7 March 2003*, ed. O. Brandt (Stockholm 2008a) 137–47.

Carletti C. (2008b) *Epigrafia dei cristiani in occidente dal III al VII secolo: ideologia e prassi* (Bari 2008b).

Coarelli F. (1986) "L'urbs e il suburbio", in *Roma: politica economia paesaggio urbano*, ed. A. Giardina (Rome 1986) 1–57.

Coarelli F. (2016) "Mausolei imperiali tardoantichi: le origini di un tipo architettonico", in *Costantino e i costantinidi – l'innovazione costantiniana, le sue radici e i suoi sviluppi: Acta XVI Congressus Internationalis Archaeologiae Christianae, Romae (22–28.9.2013)*, edd. O. Brandt, G. Castiglia, and V. Fiocchi Nicolai (Vatican City 2016) 493–508.

de Blaauw S. (2001) "L'altare nelle chiese di Roma e la committenza papale", in *Roma nell'alto medioevo: 27 aprile–1 maggio 2000* (Spoleto 2001) 969–90.

De Rossi G. M. (1979) *Bovillae* (Florence 1979).

Dey H. W. (2011) *The Aurelian Wall and the Refashioning of Imperial Rome, AD 271–855* (Cambridge 2011).

Di Gennaro F. and Griesbach J. (2003) "Le sepolture all'interno delle ville con particolare referimento al territorio di Roma", in *Suburbium. Il suburbio di Roma dalla crisi del sistema delle ville a Gregorio Magno*, edd. P. Pergola, R. Santangeli Valenzani, and R. Volpe (Rome 2003) 123–66.

Diefenbach S. (2007) *Römische Erinnerungsräume: Heiligenmemoria und kollektive Identitäten im Rom des 3. bis 5. Jahrhunderts n. Chr.* (Berlin 2007).

Dresken-Weiland J., Angerstorfer A., and Merkt A. edd. (2012) *Himmel, Paradies, Schalom: Tod und Jenseits in christlichen und jüdischen Grabinschriften der Antike* (Regensburg 2012).

Emmerson A. L. C. (2020) *Life and Death in the Roman Suburb* (Oxford 2020).

Fasola U. M. (1980) "Indagini nel sopratterra della catacomba di S. Callisto", *RACrist* 56 (1980) 221–78.

Felle A. E. (2012) "Alle origini del fenomeno devozionale cristiano in Occidente. Le *inscriptiones parietariae ad memoriam Apostolorum*", in *Martiri, santi, patroni: per una archeologia della devozione. Atti X Congresso Nazionale di Archeologia Cristiana*, edd. A. Coscarella and P. De Santis (Arcavacata di Rende 2012) 477–502.

Felle A. E., Del Moro M. P., and Nuzzo D. (1994) "Elementi di corredo-arredo delle tombe del cimitero di S. Ippolito sulla Via Tiburtina", *RACrist* 70 (1994) 89–158.

Feraudi-Gruénais F. (2001) *Ubi diutius nobis habitandum est: die Innendekoration der kaiserzeitlichen Gräber Roms* (Wiesbaden 2001).

Ferrua A. (1960) "Il cimitero sopra la catacomba di Domitilla", *RACrist* 36 (1960) 173–210.

Fiocchi Nicolai V. (2001) *Strutture funerarie ed edifici di culto paleocristiani di Roma dal IV al VI secolo* (Vatican City 2001).

Fiocchi Nicolai V. (2002) "Basilica Marci, Coemeterium Marci, Basilica Coemeterii Balbinae. A proposito della nuova basilica circiforme della via Ardeatina e della funzione funeraria delle chiese 'a deambulatorio' del suburbio romana", in *Ecclesiae urbis, vol. 2*, edd. F. Guidobaldi and A. G. Guidobaldi (Vatican City 2002) 1175–1201.

Fiocchi Nicolai V. (2014) "Le catacombe romane", in *Lezioni di archeologia cristiana*, edd. F. Bisconti and O. Brandt (Vatican City 2014) 273–360.

Fiocchi Nicolai V. (2016) "Le aree funerarie cristiane di età costantiniana e la nascita delle chiese con funzione sepolcrale", in *Costantino e i costantinidi – l'innovazione costantiniana, le sue radici e i suoi sviluppi: Acta XVI Congressus Internationalis Archaeologiae Christianae, Romae (22–28.9.2013)*, edd. O. Brandt, G. Castiglia, and V. Fiocchi Nicolai (Vatican City 2016) 619–70.

Fiocchi Nicolai V. (2019) "The Catacombs", in *The Oxford Handbook of Early Christian Archaeology*, edd. W. R. Caraher, T. W. Davis and D. K. Pettegrew (New York 2019) 67–88.

Fiocchi Nicolai V. and Guyon J. (2006) "Relire Styger: Les origines de l'Area I du cimetière de Calliste", in *Origine delle catacombe romane*, edd. V. Fiocchi Nicolai and J. Guyon (Vatican City 2006) 121–61.

Fiocchi Nicolai V. and Vella A. (2016–17) "Nuove ricerche nella basilica di Papa Marco sulla via Ardeatina: la tomba "dei gioielli" e il riuso di un acquedotto romano", *RendPontAcc* 89 (2016–17) 299–366.

Fiocchi Nicolai V., Bisconti F., and Mazzoleni D. (1999) *The Christian Catacombs of Rome: History, Decoration, Inscriptions* (Regensburg 1999).

Freestone I. C., Gudenrath W., Painter K., and Whitehouse D. (1990) "Recent research on the Portland Vase", *JGS* 32 (1990) 85–102.

Gai S. (1986) "La "Berretta del Prete" sulla Via Appia antica. Indagini preliminari sull'insediamento medievale 1984", *Archeologia medievale* 13 (1986) 365–404.

Geertman H. (2002) "La Basilica Maior di San Lorenzo f.l.m.", in *Ecclesiae urbis, vol. 2* edd. F. Guidobaldi and A. G. Guidobaldi (Vatican City 2002) 1225–47.

Gorski G. J. and Packer J. E. (2015) *The Roman Forum: A Reconstruction and Architectural Guide* (Cambridge 2015).

Graham E.-J. (2015) "Corporeal concerns: the role of the body in the transformation of Roman mortuary practices", in *Death Embodied: Archaeological Approaches to the Treatment of the Corpse*, edd. Z. Devlin and E.-J. Graham (Oxford 2015) 41–62.

Guidobaldi F. and Guidobaldi A. G. edd. (2002) *Ecclesiae urbis, vol. 2* (Vatican City 2002).

Guyon J. (1987) *Le cimetière aux deux lauriers: recherches sur les catacombes romaines* (Rome 1987).

Heinzelmann M. (2000) *Die Nekropolen von Ostia. Untersuchungen zu den Gräberstraßen vor der Porta Romana und an der Via Laurentina* (Munich 2000).

Hellström M. (2015) "On the form and function of Constantine's circiform funerary basilicas in Rome", in *Pagans and Christians in Late Antique Rome: Conflict, Competition, and Coexistence in the Fourth Century*, edd. M. R. Salzman, M. Sághy, and R. Lizzi Testa (Cambridge 2015) 273–90.

Hesberg H. v. (1992) *Römische Grabbauten* (Darmstadt 1992).

Hope V. M. (2009) *Roman Death: Dying and the Dead in Ancient Rome* (London 2009).

Ingle G. (2019) "A fourth century tomb of the followers of Mithras from the Catacomb of Ss. Peter and Parcellinus in Rome", *Studies in ancient art and civilisation* 23 (2019) 227–39.

Jastrzebowska E. (1981) *Untersuchungen zum christlichen Totenmahl aufgrund der Monumente des 3. und 4. Jahrhunderts unter der Basilika des Hl. Sebastian in Rom* (Frankfurt 1981).

Johnson M. J. (1992) "Where were Constantius I and Helena buried?", *Latomus* 51 (1992) 145–50.

Johnson M. J. (1997) "Pagan-Christian burial practices of the fourth century: shared tombs?", *JECS* 5 (1997) 37–59.

Johnson M. J. (2009) *The Roman Imperial Mausoleum in Late Antiquity* (Cambridge 2009).

Killgrove K. (2010) *Migration and Mobility in Imperial Rome* (Ph.D. diss., Univ. of North Carolina at Chapel Hill).

Killgrove K. (2019) "Using skeletal remains as a proxy for Roman lifestyles: the potential and problems with osteological reconstructions of health, diet, and stature in Imperial Rome", in *Routledge Handbook of Diet and Nutrition in the Roman World*, edd. P. Erdkamp and C. Holleran (London 2019) 245–58.

Kneafsey M. A. (2018) *The City Boundary in Late Antique Rome* (Ph.D. diss., Univ. of Exeter 2018).

Krautheimer R. (1960) "Mensa, coemeterium, martyrium", *CahArch* 11 (1960) 15–40.

La Rocca E. (2002) "Le basiliche cristiane "a deambulatorio" e la sopravvivenza del culto eroico", in *Ecclesiae urbis, vol. 2* ed. F. Guidobaldi and A. G. Guidobaldi (Vatican City 2002) 1109–40.

Levine L. (2006) "Jewish archaeology in Late Antiquity: art, architecture, and inscriptions", in *The Cambridge History of Judaism: Volume 4: The Late Roman-Rabbinic Period*, edd. S. T. Katz (Cambridge 2006) 519–55.

Liverani P. (1999) *La topografia antica del Vaticano* (Vatican City 1999).

Lugli G. and Filibeck G. (1935) *Il Porto di Roma imperiale e l'Agro Portuense* (Rome 1935).

Magnani Cianetti M. ed. (2004) *La Basilica costantiniana di Sant'Agnese : lavori archeologici e di restauro* (Milan 2004).

Meneghini R. and Santangeli Valenzani R. (2000) "Intra-mural burials at Rome betwen the fifth and seventh centuries AD", in *Burial, Society and Context in the Roman World*, edd. J. Pearce, M. Millett and M. Struck (Oxford 2000) 263–69.

Murer C. (2016) "The reuse of funerary statues in late antique prestige buildings at Ostia", in *The Afterlife of Greek and Roman Sculpture: Late Antique Responses and Practices*, edd. T. M. Kristensen and L. M. Stirling (Ann Arbor 2016) 177–96.

Murer C. (2019) "From the tombs into the city: grave robbing and the reuse of funerary spolia in late antique Italy", *ActaAArtHist* 30 (2019) 115–37.

Nieddu A. M. (2009) *La Basilica Apostolorum sulla Via Appia e l'area cimiteriale circostante* (Vatican City 2009).

Noy D. (1995) *Jewish Inscriptions of Western Europe, vol. 2 The City of Rome* (Cambridge 1995).

Nuzzo D. (2000) *Tipologia sepolcrale delle catacombe romane: i cimiteri ipogei delle vie Ostiense, Ardeatina e Appia* (Oxford 2000).

Pagliardi N. (1985) "Sepolcro c.d. Berretta del Prete (circ. XI)", *BullCom* 90 (1985) 100–101.

Palombi D. (2019) *La "villa dei Gordiani" al III miglio della via Prenestina : la memoria e il contesto* (Monte Compatri 2019).

Pergola P. (1990) "Mensores frumentarii christiani et annone à la fin de l'antiquité. Relecture d'un cycle de peintures", *RACrist* 66 (1990) 167–84.

Pisani Sartorio G. (1979) "Tomba detta di Alessandro Severo a Monte del Grano", in *Piranesi nei luoghi di Piranes*, ed. M. Alfieri (Rome 1979) 65–71.

Rasch J. J. (1984) *Das Maxentius-Mausoleum an der Via Appia in Rom* (Mainz 1984).

Rasch J. J. (1990) "Zur Rekonstruktion der Andreasrotunde an Alt-St.Peter", *RömQSchr* 85 (1990) 1–18.

Rasch J. J. (1993) *Das Mausoleum bei Tor de' Schiavi in Rom* (Mainz 1993).

Rasch J. J. (1998) *Das Mausoleum der Kaiserin Helena in Rom und der "Tempio della Tosse" in Tivoli* (Mainz 1998).

Rasch J. J. and Arbeiter A. (2007) *Das Mausoleum der Constantina in Rom* (Mainz 2007).

Rausa F. (1997) *Pirro Ligorio, tombe e mausolei dei romani* (Rome 1997).

Rebillard É. (1999) "Les formes de l'assistance funéraire dans l'empire romain et leur évolution dans l'Antiquité tardive", *Antiquité Tardive* 7 (1999) 269–82.

Rebillard É. (2009) *The Care of the Dead in Late Antiquity* (Ithaca 2009).

Rebillard É. (2012) *Christians and Their Many Identities in Late Antiquity, North Africa, 200–450 Ce* (Ithaca 2012).

Rieger A.-K. (2004) *Heiligtümer in Ostia* (Munich 2004).

Rossi D. and Di Mento M. edd. (2013) *La catacomba ebraica di Monteverde: vecchi dati e nuove scoperte* (Rome 2013).

Rutgers L. V. (1992) "Archaeological evidence for the Interaction of Jews and Non-Jews in Late Antiquity", *AJA* 96 (1992) 101–118.

Rutgers L. V. (2009) "Neue Recherchen in den jüdischen und frühchristlichen Katakomben Roms: Methode, Deutungsprobleme und historische Implikationen einer Datierung mittels Radiokarbon" *Mitteilungen zur Christlichen Archäolgie* 15 (2009) 9–24.

Scheid J. (1993) "Die Parentalien für die verstorbenen Caesaren als Modell für den römischen Totenkult", *Klio* 75 (1993) 188–201.

Schrumpf S. (2006) *Bestattung und Bestattungswesen im Römischen Reich: Ablauf, soziale Dimension und ökonomische Bedeutung der Totenfürsorge im lateinischen Westen* (Göttingen 2006).

Schwartz S. (2001) *Imperialism and Jewish Society: 200 B.C.E. To 640 C.E.* (Princeton 2001).

Schwarz M. (2002) *Tumulat Italia tellus: Gestaltung, Chronologie und Bedeutung der römischen Rundgräber in Italien* (Rahden 2002).

Serra S. (2002) "La basilica di S. Stefano all'agro Verano. Nuove considerazioni", in *Ecclesiae urbis, vol. 1*, edd. F. Guidobaldi and A. G. Guidobaldi (Vatican City 2002) 677–89.

Serra S. (2015) "Le fonti e l'archeologia. Alle origini del culto di San Lorenzo a Roma", in *Il culto di San Lorenzo tra Roma e Milano*, ed. R. Passarella (Milan 2015) 29–53.

Serra S. (2016) "*Fecit basilicam sub arenario cryptae*. La basilica Maior di S. Lorenzo fuori le mura: nuove considerazioni sulla cronologia e l'architettura", in *Acta XVI congressus internationalis archaeologiae christianae (Romae 22–28.9.2013): Costantino e i Costantinidi: l'innovazione costantiniana, le sue radici e i suoi sviluppi, vol. 2*, edd. O. Brandt, V. N. Fiocchi, and G. Castiglia (Vatican City 2016) 1489–1504.

Spera L. (1999) *Il paesaggio suburbano di Roma dall'antichità al medioevo: il comprensorio tra le vie Latina e Ardeatina dalle Mura Aureliane al III miglio* (Rome 1999).

Spera L. (2004) *Il complesso di Pretestato sulla Via Appia: storia topografica e monumentale di un insediamento funerario paleocristiano nel suburbio di Roma* (Vatican City 2004).

Srejović D. and Vasić Č. (1994) "Emperor Galerius's buildings in Romuliana (Gamzigrad, Eastern Serbia)", *Antiquité Tardive* 2 (1994) 123–41.

Stanley D. J. (1994) "New discoveries at Santa Costanza", *DOP* 48 (1994) 257–61.

Tolotti F. (1953) *Memorie degli apostoli in catacumbas: rilievo critico della memoria e della basilica apostolorum al III miglio della via Appia* (Vatican City 1953).

Torelli M. (1992) "Le basiliche circiformi di Roma. Iconografia, funzione, simbolo", in *Milano capitale dell'impero romano. Felix temporis reparatio. Atti del convegno archeologico internazionale, Milano 8–11 marzo 1990*, edd. G. Sena Chiesa G. and E. A. Arslan (Milan 1992) 203–217.

Vella A. (2016) "Le sepulture dei 'non cristiani' nel suburbio di Roma", in *Costantino e i costantinidi – l'innovazione costantiniana, le sue radici e i suoi sviluppi: Acta XVI Congressus Internationalis Archaeologiae Christianae, Romae (22–28.9.2013)*, edd. O. Brandt, G. Castiglia and V. Fiocchi Nicolai (Vatican City 2016) 681–709.

Vismara C. (2013) "Le catacombe ebraiche di Roma venticinque anni dopo. Palinodie, revisioni, nuove linee di ricerca", in *Per Gabriella: studi in ricordo di Gabriella Braga*, edd. M. Palma and C. Vismara (Cassino 2013) 1843–92.

Vitti P. (2013) "Il Mausoleo di Adriano, costruzione e architettura", in *Apoteosi da uomini a dei: il Mausoleo di Adriano*, ed. L. Abbondanza (Rome 2013) 244–67.

Windfeld-Hansen H. (1969) "L'hexaconque funéraire de l'area sub divo du cimetrière de Prétextat à Rome", *ActaAArtHist* 4 (1969) 61–93.

Windfeld-Hansen H. (2003a) "Le Cimetière de Prétextat. Edifice funéraire à plan cruciforme de l'area sub divo", in *Suburbium. Il suburbio di Roma dalla crisi del sistema delle ville a Gregorio*, edd. P. Pergola, R. Santangeli Valenzani, and R. Volpe (Rome 2003a) 727–34.

Windfeld-Hansen H. (2003b) "Via Appia, edificio funerario al IV miglio (Proprietà Lugari)", in *Suburbium. Il suburbio di Roma dalla crisi del sistema delle ville a Gregorio Magno* edd. P. Pergola, R. Santangeli Valenzani, and R. Volpe (Rome 2003b) 735–46.

Wiśniewski R. (2019) *The Beginnings of the Cult of Relics* (Oxford 2019).

Yasin A. M. (2015) "Prayers on site: the materiality of devotional graffiti and the production of Early Christian sacred space", in *Viewing Inscriptions in the Late Antique and Medieval World*, ed. A. Eastmond (Cambridge 2015) 36–60.

Zimmermann N. (2015) "Catacombs and the beginnings of Christian tomb decoration", in *The Blackwell Companion to Roman Art*, ed. B. E. Borg (Malden 2015) 452–70.

Burying the Saints Next to the Common Dead: the Burial Habits of the Christian Elite in the 4th c. and the First Translations of Relics

Efthymios Rizos

Abstract

This paper explores the connection between the burial habits of the Christian lay elite and the origins of the use of partitioned and transferred relics of saints. On the basis of textual and archaeological evidence, it is argued that the mobility of relics was linked to the desire of powerful Christians to have their dead buried near the saints (*ad sanctos*). Perhaps emulating the model of the mausoleum of Constantine the Great, the earliest known translations of relics were conducted for the consecration of private funerary shrines in 4th c. Anatolia and Constantinople. Privately sponsored by lay aristocrats in collaboration with bishops and monks, these early translations were opposed by imperial legislation and parts of the Christian community, but they gradually contributed to normalising this controversial practice, until it became an established aspect of public religion by the 5th c.

Introduction

Reverence for the remains of the holy dead was a central aspect of the Christian cult of saints from its earliest steps, such as in saint-related texts like the 2nd c. *Martyrdom of Saint Polycarp of Smyrna*.[1] A systematic categorisation of the diverse practices and beliefs of the Early Christian world with regard to relics is the subject of a recent monograph by Robert Wiśniewski. Among them, the transition from the veneration of intact bodies and undisturbed tombs to the use of exhumed and partitioned relics was the most distinctive cultural development, because of its sharp contrast with the long-established norms of the ancient world. It has therefore attracted the greatest interest amongst scholars. The great historian of the cult of the saints, Hippolyte Delehaye, could not hide his disapproval for this custom which, in his view, cost the cult of the martyrs its original dignified simplicity.[2] Delehaye believed that it started in the Greek East, where the laxity of local civic legislation presumably failed to protect the inviolability of tombs and bodies.

Most students of the cult of relics so far, notably Delehaye, Mango, and Wiśniewski, tend to frame its origins at the level of public religion and official regulation. This methodological starting point is justified, inasmuch as it follows the character of our written sources, most of which concern the discovery of saintly remains or the consecration of churches by bishops or other clerics. Yet, by focusing our enquiry on the attitudes of the clerical leadership, we leave two gaps in the narrative, one societal and one chronological: first, we fail to take account of the role played by sources of Christian power other than the clergy; second, we are left with a silence in testimonies between the first known translations of relics in the Constantinian period and their proliferation under the Theodosian emperors. The chronological gap has been noted by all scholars so far, and has been taken to mean that divisions and transfers of relics were not really practiced in this early period – Wiśniewski indeed argues that they remained very marginal until the 6th c.[3] By contrast, the societal gap has escaped attention and was never really discussed. In this study, we shall attempt to show that these two gaps are interrelated, by directing our enquiry to the domain of private Christianity which, as Kim Bowes has shown, played a paramount role in shaping religious practices and attitudes, including the cult of relics, during the 4th and early 5th c.[4] Our analysis will focus on a particular field of private religiosity, the construction of funerary shrines and tombs by landed families, aiming to shed light on a thus far overlooked link between the use of transferred relics and the custom of burying the dead near the resting places of saints (burials *ad sanctos*).

The Precedent of Constantine's Mausoleum

The first known long-distance translation of relics to a shrine away from their original resting place is that of the remains of the Apostles Andrew, Timothy, and Luke to the imperial mausoleum of Constantine in Constantinople. Although it is debated whether this happened in 336 or in the 350s, its motivation clearly lies with the concept of Constantine's funerary monument which was arguably the most impactful of the first Christian emperor's building projects for the

1 *The Martyrdom of Saint Polycarp of Smyrna* 18.
2 Delehaye (1933) 51; Wiśniewski (2019); Mango (1990) 51.
3 Wiśniewski (2019) 173.
4 Bowes (2008).

development of the Christian cult of saints.[5] Up to the times of Constantine, there is no evidence to suggest that Christians dedicated buildings or indeed anything to their saints, except for revering their resting places. The Apostoleion is the first building dedicated to a particular group of Christian holy figures on a site which was completely unrelated to them. It thus signals the introduction of votive practices of traditional religion to Christianity, or rather establishes a Christian version of votive religion, focused on the saints.

Constantine's burial scheme was innovative in many ways. Unlike his predecessors who were buried outside the city walls, he prepared his resting place on an intramural site.[6] Intramural burial was exceptionally reserved to civic heroes and founders (oikists), and Constantine could rightfully claim to be the founder of Constantinople.[7] Not only was he aware of the posthumous cult prescribed to him as a deified emperor, but he also pursued the additional honours of a civic founder. The pitfalls of this veneration for the religious reform he had introduced, however, were manifest. A Christian emperor had to receive a Christian burial and therefore traditional cremation was given up in favour of inhumation. As for the posthumous veneration of the dead emperor, a solution was found in the Christian devotion to the tombs of martyrs and apostles, which was introduced into the imperial mausoleum in a novel and completely unprecedented form. The imperial sarcophagus was surrounded by 12 *thēkai* (sarcophagi/cenotaphs) serving as *stēlai hierai* (sacred monuments) of the Apostles, and the circular hall containing them was equipped with an altar, in order to host Christian services. Eusebius' description indicates that the monument presented the emperor's body as an object of veneration alongside the Apostles. It seems that Constantine envisioned his commemoration as a Christian holy figure of sorts, perhaps a 13th apostle or *isapostolos*, as later tradition would call him.[8] Eusebius, however, is evidently uncomfortable with this idea and seeks to convince us that the emperor's intention was that '(...) after death his body should partake in the veneration of the Apostles, (...) trusting that he would make of the celebration of their memory a beneficial gain for his own soul.'[9] In other words, Eusebius claims that the emperor was so enthusiastic about Christian worship that he wished to attend its services even from his tomb.

The author is very careful and vague in his phrasing, presenting the concept as a personal view of the emperor, resulting from his piety. This not very convincing reading and Eusebius' insistence on the piety of Constantine's project probably targets Christian scepticism or embarrassment about innovations like the church/mausoleum and the veneration of lapidary monuments dedicated to the Apostles.

In his effort to justify the emperor's funerary display, Eusebius talks for the first time in Christian literature about spiritual benefits from burial at a place where the saints would be invoked. By having his body buried where the Christians would honour the Apostles, Constantine supposedly hoped to help his departed soul. Apparently, he was not the only member of his family to seek burial in the vicinity of the saints. The imperial mausolea of Constantina and Helena in Rome also reflect a similar motivation, choosing sites near catacombs which were known to contain tombs of martyrs.[10] Yet, Constantine's burial stands out by reflecting the view that it is not necessary to have oneself buried near the pre-existing tomb of a saint, but it is possible to turn one's own tomb into a shrine of the saints by having their remains brought and deposited in it. This may have caused dismay among some Christians, but it also set an important model of burial arrangements for the emerging Christian elite.

As Christian families were rising to pre-eminence and pagan ones were converting to the new religion, Christianity started to affect the traditional forms of monumental family burial. The tombs of the rich and the great now sought to reflect the Christian teachings of salvation and eternal life no less than the high social status of their owners. The ideology of the burial *ad sanctos* acquired great prominence, since power and prestige could secure burial near the special dead who were supposed to be influential in heaven. To be found next to a saint on the Day of Resurrection and Judgement was thought to secure protection and support for a less than saintly soul. In 420/421, the efficacy and necessity of such burials were refuted by Augustine in his treatise *De cura pro mortuis gerenda*, but by that point they were widely practiced in East and West alike.[11] It is not clear when exactly this belief first appeared, but, as we said above, it is first recorded in association with the mausoleum of Constantine, the very monument which motivated the first long-distance translation of relics. The link between the wish to be buried near the saints and the acquisition of exhumed relics can be followed throughout the 4th c.

5 Mango (1990) 53–54.
6 Johnson (2009) 1–57.
7 Bardill (2012) 372.
8 Dagron (2003) 138–43 (with a survey of earlier bibliography); cf. Bardill (2012) 375–76.
9 Euseb. *Vit. Const.* 4. 60.
10 Johnson (2009) 110–18, 139–56.
11 Wiśniewski (2019) 83–100; Duval (1988).

Turning a Tomb into a Martyrium in Cappadocia

In the mid-4th c., the necropolises of the Roman Empire seem to have been busy places. The Theodosian Code includes 5 rescripts of Constantius II and Julian, which address the offence of destroying sepulchral monuments and reusing or selling their building material.[12] The same situation is echoed in some epigrams by Gregory of Nazianzus, writing in Cappadocia between the 360s and 380s, who additionally reports that material from old tombs was used for the construction of new funerary monuments including shrines dedicated to martyrs. Gregory calls the latter *bemata*/βήματα and it appears that they were cemeterial oratories of sorts, which could contain burials of martyrs.

> Τιμὴ μάρτυσίν ἐστιν ἀεὶ θνήσκειν βιότητι,
> αἵματος οὐρανίου μνωομένους μεγάλου,
> τύμβοι δὲ φθιμένοις· ὃς βήματα δ᾽ ἡμῖν ἐγείρει
> ἀλλοτρίοισι λίθοις, μηδὲ τάφοιο τύχοι.

> 'To honour the martyrs means to be constantly dying in this life,
> Winning a greater life in heaven.
> Tombs belong to the dead. Let him who erects shrines to us (the martyrs)
> Out of stones belonging to others himself lack a tomb.'[13]

The construction of shrines with looted stones was not the only embarrassment. In some cases, the martyrs' shrines were so densely surrounded by tombs that it was difficult to discern where the saints were actually resting.[14] Moreover, it appears that some people treated these burial complexes as family mausolea, in which they buried their non-Christian relatives as well. Gregory fulminates against those who 'laid beside the martyrs the bodies of impure men, and now some tombs have their own priest' (πρῶτον μὲν ἐμίξατε σώματ᾽ ἀνάγνων ἀθλοφόροις, τύμβοι δὲ θυηπόλον ἀμφὶς ἔχουσι),[15] protesting against treating a martyr's shrine as a common burial site. In Gregory's view, the shrines were sites of Christian worship and therefore burials on their premises had to be strictly controlled.

Many aspects of the nature and appearance of these shrines remain unspecified. Did they contain undisturbed tombs of martyrs, or were they just shrines or cenotaphs dedicated to them? Did they house transferred relics? Some light on these questions is shed by Gregory's *Epigram* 118 which describes the family tomb of his friend and relative Amphilochos of Diocaesarea:

> Εἰς Λιβίαν τὴν γαμετὴν Ἀμφιλόχου
>
> Εἷς δόμος, ἀλλ᾽ ὑπένερθε τάφος, καθύπερθε δὲ σηκός·
> τύμβος δειμαμένοις, σηκὸς ἀεθλοφόροις·
> καί ῥ᾽ οἱ μὲν γλυκερὴν ἤδη κόνιν ἀμφεβάλοντο
> ὡς σὺ μάκαιρα δάμαρ Ἀμφιλόχου, Λιβίη,
> κάλλιμέ θ᾽ υἱήων, Εὐφήμιε· τούσδ᾽ ὑπόδεχθε,
> μάρτυρες ἀτρεκίης, τοὺς ἔτι λειπομένους.

> 'For Livia, wife of Amphilochos
> One house, but beneath is a grave, above a temple.
> A tomb for its builders, a temple for the triumphant victors (i.e. the martyrs).
> Some of the builders have already put on sweet dust,
> Like you, Livia, blessed wife of Amphilochos,
> And you, Euphemios, best of sons. Martyrs of Truth,
> Welcome the rest of them!'[16]

Apparently, this was a mausoleum consisting of a burial chamber at the lower level and a chapel of martyrs above. The epigram provides little detail about the precise form of the building, but a two-storey structure like this suggests that the mausoleum of Amphilochos' family followed the basic two-storey form of family tombs known from several parts of the Roman Empire. The Roman mausoleum was a versatile architectural type, taking various forms like that of a house, temple, rotunda, or tower. Whatever its outer appearance was, however, it normally consisted of two separate sections, one of which housed the burials and one which received the funerary rites performed in honour and memory of the dead. The mausoleum of Amphilochos of Diocaesarea probably followed this basic scheme, but, innovatively, it turned the ritual chamber of a traditional family mausoleum into a chapel dedicated to martyrs. By analogy to the mausoleum of Constantine, it seems that the cult of the martyrs here substituted for the pagan cult of the ancestors in a family tomb. Since the chapel is described as the upper storey, it cannot have contained an undisturbed burial of saints. It will have been either a dedicated shrine without relics or it will have contained relics brought from elsewhere.

12 *Cod. Theod.* 9.17.1–5.
13 *Anth. Pal.* 8.173.
14 *Anth. Pal.* 8.170, 172–74; Duval (1988) 69–70.
15 *Anth. Pal.* 8.170.
16 *Anth. Pal.* 8.118; Duval (1988) 70–73.

We are better informed about a mausoleum containing relics of the Forty Martyrs of Sebaste, which was built in ca. 357 by the family of Basil of Caesarea and Gregory of Nyssa on their estate of Anisa near Ibora in Pontus. Gregory of Nyssa mentions it in his *Second Homily on the Forty Martyrs of Sebaste* and in the *Life of Macrina*.[17] Apparently, the structure contained a sarcophagus with the bodies of Gregory's parents and sister, and a shrine with a quantity of relics of the Forty Martyrs. Gregory remembers the festive reception of the reliquary, which was organised by his mother, Emelia, when he was very young and still a layman. He states that he buried his parents by the relics, in order to secure the martyrs' influential intercession on the Day of Judgement, presenting the act as a normal burial *ad sanctos*. Yet, this is partly inaccurate, because, when the relics arrived in Anisa, Gregory's father, Basil the Elder, was already dead. In all likelihood, the shrine was created at Basil's pre-existing tomb, which means that this was a deposition of relics of saints at a dead person's tomb (one might call it a burial of the saints *ad mortuos*) rather than the burial of a dead person *ad sanctos* properly speaking. It seems that Emelia turned the resting place of her husband into the religious centre of the estate, and it indeed started to attract worshippers and developed a reputation for miracles. Yet, it did not cease to be used as a mausoleum, since both Emelia and her daughter, Macrina, were later laid to rest there. The precise form of the building remains unknown. It is tempting, however, to believe that this was the very shrine which Gregory of Nyssa undertook to rebuild in the form of an octagonal church in the 380s.[18]

Both of the chapels discussed in this section were private foundations on estates of Christian landowners of Cappadocia, which functioned at the same time as family tombs and shrines of martyrs, and housed relics brought from elsewhere.

Mausoleum or Martyrium? Archaeological Evidence from the West

To my knowledge, there are no archaeologically documented mausolea from 4th c. Anatolia, which could be associated with the descriptions of the Cappadocian Fathers. However, one can find several illustrative parallels in the 4th c. West, in Spain, Gaul, and Illyricum, which can be directly related to aspects of the textually attested mausolea of Cappadocia – especially their association with elite families and their estates, and their gradual evolution into cult sites.[19] Such are the mausolea/martyria excavated at the sites of Alberca (Murcia, Spain, Fig. 1),[20] Chur (Switzerland, Fig. 2),[21] Salona (Fig. 3),[22] Sopianae (Pécs, Hungary, Fig. 4),[23] Naissus (Niš, Serbia),[24] Diocletianopolis (the site of Paravela near Argos Orestikon, Greece, Fig. 5),[25] and Serdica (at the suburb of Lozenets in today's Sofia, Fig. 6),[26] all of which are 4th c. funerary buildings consisting of a burial crypt at the lower level and an upper floor, recalling the description of the mausoleum of Amphilochos of Diocaesarea. Most of them feature strong walls and buttresses, suggesting relatively tall structures. Some were found within urban necropolises (Salona, Sopianae, Naissus), others within villas (Alberca), and others at suburban locations (Diocletianopolis, Serdica-Lozenets). Some of them produced evidence for distinguished burials, possibly including families: the mausoleum of St. Stephen Square in Pécs (Sopianae), dating from the 350s, housed three sarcophagi with the remains of 14 individuals of various ages, mostly male, while the mausoleum of Jagodin Mala in Naissus contained several burials of the 4th–5th c., some of which were remarkably rich, including remains of precious clothing. In Spain and Gaul, mausolea are frequently found in the outskirts of villas, demonstrating continuity from the Early Roman tradition of burying the dead of landed families on their estates. Burial and ritual structures appear at prominent locations, marking the landscape through the cult of the dead of the seigniorial families. Very often, the architectural evolution of these buildings indicates that they developed into religious centres of their estates. At the villas of Pueblanueva near Toledo, Vandoeuvres in Gaul, and Muline in Dalmatia, mausolea and churches coexist, while the abundance of votive lamps at a mausoleum on the Dalmatian isle of Majsan also indicates the development of a cult.[27] The mausoleum/martyrium of Lozenets near Serdica was formed through the extension of a 3rd c. mausoleum which acquired two spacious antechambers and seems to have been transformed into a Christian shrine in the course of the 4th c. (Fig. 6). In the later 4th–5th c., Christian basilicas were adjoined

17 Greg. Nyss. *mart.* 2, 166–68; Greg. Nyss. *V. Macr.* 34–36; Duval (1988) 66–68.
18 Greg. Nyss. *Ep.* 22.
19 Bowes (2008) 135–46.
20 De Palol (1967) 106–116.
21 Sulser and Classen (1978).
22 Egger and Dyggve (1939).
23 Hudak and Nagy (2005) 17–25.
24 Milošević (2006) 173–86, esp. 176; Popović (2014).
25 Papazotos (1988) 195–218.
26 Boyadjiev (2006) 129–40.
27 Bowes (2008) 142–46 (with references to original excavation reports).

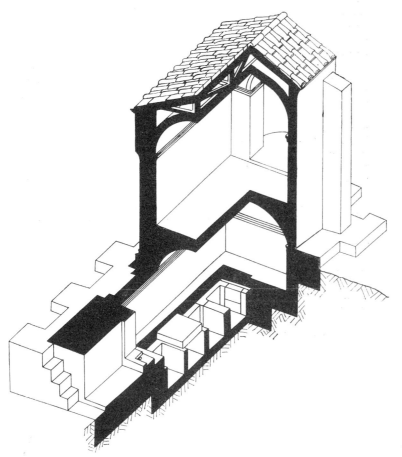

FIGURE 1
La Alberca (Murcia, Spain).
Mausoleum/martyrium
AFTER DE PALOL (1967)

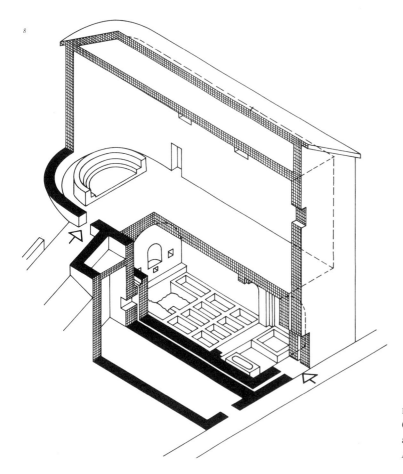

FIGURE 2
Chur (Switzerland). 4th c. burial chamber and church at Sankt Stephan.
AFTER SULSER AND CLASSEN (1978)

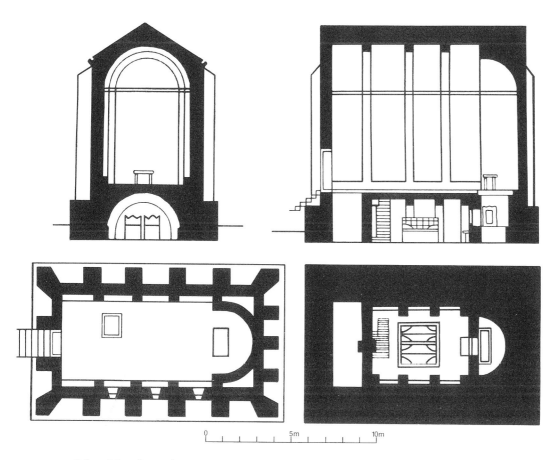

FIGURE 3 Salona. Mausoleum of St. Anastasius in Marusinac.
AFTER EGGER AND DYGGVE (1939)

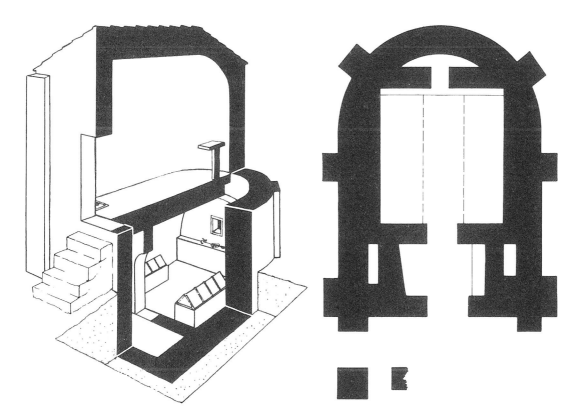

FIGURE 4 Sopianae (Pécs, Hungary). Mausoleum I
AFTER SULSER AND CLASSEN (1978)

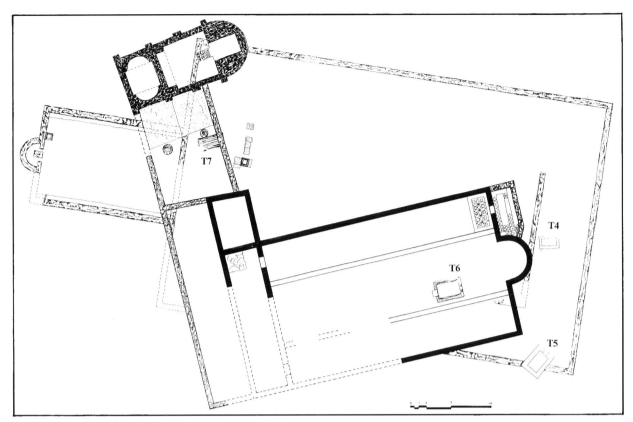

FIGURE 5 Diocletianopolis (Argos Orestikon, Greece). 4th c. mausoleum and later basilica at the site of Paravela.
AFTER PAPAZOTOS (1988)

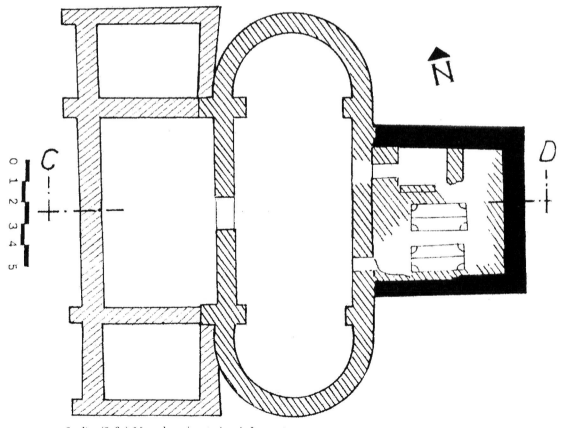

FIGURE 6 Serdica (Sofia). Mausoleum/martyrium in Lozenets
AFTER BOYADJIEV (2006)

to the 4th c. mausolea of Salona (Fig. 3), Naissus, and Diocletianopolis (Argos Orestikon) (Fig. 5).

Perhaps the best known of these examples is the mausoleum of Marusinac in Salona (Fig. 3), which became the core of a monumental Christian complex, in all likelihood dedicated to the local martyr Anastasius. Rudolf Egger associated the building with the martyrdom account of St. Anastasius of Salona (BHL 414, 415), according to which the saint's body was retrieved from the sea by a local wealthy lady called Asclepia who had it buried on her estate. Egger believed that the buttressed mausoleum of Marusinac housed the tomb of Asclepia and the sarcophagus of Anastasius.[28] This interpretation was based on an uncritical reading of a frequently occurring hagiographical *topos*: the wealthy matron who buries a martyr, often next to the tomb of herself or her relatives, is one of the commonest types of foundation narrative for shrines, occurring in several hagiographies in both the Greek and Latin traditions. Besides the story of Anastasius of Salona, it appears also in the Martyrdoms of Cyprian and Justina (BHG 455), Theodore of Euchaita (BHG 1761, 1762, 1762c, 1762d), Julian of Cilicia (BHG 966), Florus and Laurus (BHG 660–664), Athenogenes of Pedachthoe (BHG 197b), Processus and Martinianus (BHL 6947), Maximilian of Thebessa (BHL 5813), Juliana of Nicomedia/Pozzuoli (BHL 4522, 4523), Stephen the First Martyr (BHG 1650), and many others. Yet, even if we recognise this as a standard literary motif, it is also hard to deny that aspects of this narrative agree to some extent with what archaeology tells us about Marusinac: unlike the other martyria of Salona, this was a cult institution which emerged from a distinguished private mausoleum and also appears to have kept a tighter control of the burials that took place on its premises. This points to a rigidly organised religious establishment in a very selective relationship with the privileged parts of society. In other words, Marusinac was an elite shrine from its origins and throughout its development.[29]

Private Mausolea/Martyria in Constantinople

The hagiographic *topos* of private aristocratic sponsorship of the martyrs' burials by women may indeed echo some of the historical reality of the early cult of saints and relics. The role of female aristocrats must have been prominent in it and it indeed attracted some ironic mentions from pagans like Julian the Apostate.[30] Women are specifically mentioned as collectors of relics in certain martyrdom accounts. In the Greek legend of St. Julian of Cilicia, the persecutor warns the martyr as follows: 'You should not think that poor women will collect your bones and keep them in their bosom as of a righteous man.'[31] St. Alexander of Thrace (BHG 48–49) is threatened by his persecutor in similar terms: 'I shall disperse your fleshes and your bones in every land I shall pass through, so that no women will find pieces of your flesh or bones, nor will they perfume them and venerate you as one of the saints.'[32] The earlier discussed case of Emelia's chapel in Pontus provides a historically reliable attestation for a wealthy woman who, like Asclepia in the legend of St. Anastasius of Salona, buried relics of martyrs on her private estate. Another example, in the twilight between hagiographic legend and history, is the account of the ecclesiastical historian Sozomen about Eusebia, an aristocratic lady who brought relics of the Forty Martyrs of Sebaste to Constantinople. Like Emelia, she was also a female Christian landowner of the mid-4th c., who turned her villa into a monastery and buried relics of the Forty Martyrs in her mausoleum.

According to Sozomen's account, Eusebia was the owner of a suburban estate by the main gate of the Constantinian Walls of Constantinople, and she was apparently a well-connected person – she was a close friend with the wife of Flavius Caesarius, the consul of AD 397. Reportedly, she was a Macedonianist – a semi-Arian community loyal to the bishop of Constantinople Macedonius I (deposed in AD 360) – and, when she died, probably between 360 and 400, she bequeathed her villa to a monastic community of her creed and was buried on its grounds. Eusebia possessed a quantity of relics of the Forty Martyrs of Sebaste and wished to have them buried next to her body in her sarcophagus but demanded that their existence be kept secret. The monks complied, but they presumably celebrated secret services at her tomb, in honour of the martyrs. Some years later, consul Caesarius seized the estate and demolished the monastery. Eusebia's mausoleum with the relics of the martyrs was buried under a new basilica and forgotten. The presence of the relics, however, was miraculously revealed in dream visions to the Empress Pulcheria in the late 430s or 440s. After investigations which ascertained the details of Eusebia's burial, an excavation was conducted and uncovered her tomb.

28 Egger and Dyggve (1939) 131–48.
29 Egger and Dyggve (1939) 105–106.
30 Julian, *Mis*. 10.10–19, 39.
31 *Passio S. Iuliani Anazarbeni* (BHG 966) § 10.
32 *Passio S. Alexandri Romani* (BHG 48) § 29.

The excavated structure is described with the accuracy of a modern archaeological report by Sozomen who explains that the monks had ...

> created a subterranean oratory containing her tomb, and a building visible on the surface above, with its floor paved with baked bricks, and a secret descent leading thence to the martyrs. Pulcheria's excavation revealed the remains of (...) a pavement of baked bricks and a marble slab of the same size as their perimeter, under which the coffin of Eusebia came to light and the oratory containing it, wonderfully clad with purple-white marble. The lid of the sarcophagus was shaped like a sacred table and, on the side where the martyrs rested, there appeared a small hole. A man from the imperial household, who was present, inserted through that hole a fine rod which he happened to be holding. Drawing it out, he held it to his nose and smelled a sweet fragrance. This encouraged both the workmen and their supervisors, who hastened to uncover the coffin and found the remains of Eusebia. The projecting part of the sarcophagus on the side of her head was carved in the form of a chest, and was closed with a separate lid from inside. It was fastened with an iron fixing cast with lead, which was applied on its edges. In its middle, the same hole appeared again, indicating in an even clearer way that it contained the martyrs. As soon as these things were announced, both the empress and the bishop hastened to the shrine. The iron bonds were removed by experts, and the lid was easily lifted. Underneath it, plenty of fragrant matter was found and, within it, two silver containers, in which lay the holy relics.[33]

It is clear that Pulcheria's excavation revealed a vaulted tomb of a rather common type known from several archaeologically studied 4th and 5th c. examples, including at least two from Constantinople itself. The hypogaeum of Şehremini, discovered by Nezih Fıratlı in 1961, consisted of a vaulted chamber with 5 tombs, accessible through openings with stone slabs on its floor (Figs. 7, 8). It was found in the central part of the area between the Theodosian and Constantinian fortifications, not far from the reported location of Eusebia's tomb. It is likely to date from the mid- to late 4th c. (a mid-4th c. bronze coin was found in it), which means that it was roughly contemporary with the story of Eusebia.[34] Another

FIGURE 7 Istanbul, the hypogeum of Şehremini. Ground plan
AFTER FIRATLI (1966)

example is the early 5th c. mausoleum which stands by the Silivrikapı gate of the Theodosian walls. This is an above-ground vaulted chamber, which houses 5 sarcophagi of an evidently prominent Christian official and his family (Fig. 9). One of them is smaller and distinguished from the rest by its elevated position and fine material – Proconnesian marble instead of limestone. Its lid also included an opening, which has been interpreted as a kind of *fenestella confessionis*. All these features indicate that this elevated casket was a reliquary where relics of saints were kept and venerated beside the sarcophagi of the founder and his relatives. The cultic importance of the building is also suggested by its exceptional position between the main wall and the *proteichisma* of the Theodosian fortification.[35] These two tombs – a tiny sample from the hundreds that will have existed in the necropolises of Constantinople – indicate that neither the architecture of Eusebia's mausoleum nor her wish to have relics of saints buried by her sarcophagus were unusual.

Indirect evidence for the use of relics in private mausolea can be deduced from a decree issued by Theodosius I (AD 379–395) in AD 381 and addressed to the Urban Prefect of Constantinople. The subject is the removal of illicit burials from the intramural area of the city, under the threat of heavy fines and exile:

33 Sozom. *Hist. eccl.* 9.2. 13–16; Cronnier (2015) 152–156.
34 Fıratlı (1966) 131–139; Müller-Wiener (1997) 219–222.

35 Deckers and Serdaroğlu (1993) 140–163; Foletti and Monney (2013) 178–182.

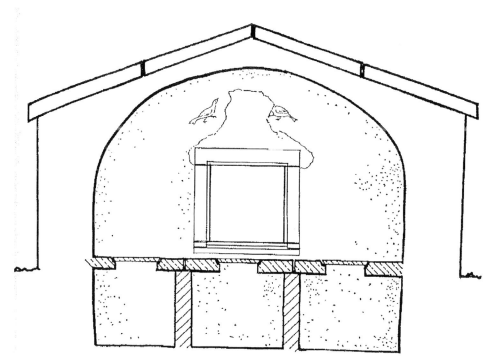

FIGURE 8 Istanbul, the hypogeum of Şehremini. Cross section
AFTER FIRATLI (1966)

All the corpses which are contained in urns or sarcophagi above ground must be taken and placed outside the city (...) And let no one, in their false and cunning shrewdness, exempt themselves from the purpose of this ruling, and suppose that shrines of apostles or martyrs are authorised for the burial of corpses. Let them know and understand that also they will have to be removed from there, just as from the rest of the city.[36]

The term used for the shrines of the apostles and martyrs (*sedes apostolorum vel martyrum*) is unattested elsewhere and may correspond to the Greek *bema* (βῆμα) of the epigrams of Gregory of Nazianzus. How should we understand these intramural shrines? Due to its exceptional urban development, Constantinople had within its walls the shrine of St. Akakios, which included tombs of the first bishops of Constantinople, and the shrine of the Holy Apostles with the imperial mausoleum. These sanctuaries, however, must have been under the strict control of the ecclesiastical and civil authorities, and it seems unlikely that illicit burials would have taken place on their premises. Still, though, their existence must have given the impression that burials were permitted within the spacious intramural area of the still young East Roman capital. This is especially true of the early years of Constantinople's development, when the city will have included extensive free spaces and large properties resembling country villas with open grounds. Much like the Christian landowners of Cappadocia and Sozomen's Eusebia, rich Christians in Constantinople will have built chapels for martyrs on their urban properties, which they will have used as mausolea. These shrines were apparently used as an excuse for maintaining tombs inside the walls against the established traditions of the ancient world.

The existence of Early Byzantine elite tombs within the Constantinian Walls is archaeologically documented. Although the old necropolises of Byzantium fell out of use within the Constantinian fortified area, sporadic discoveries of Early Byzantine hypogaea suggest that wealthy people continued to bury their dead in the city. The fact that the law of 381 limited its prohibition to monuments above ground may have encouraged the construction of subterranean vaulted tombs such as those found at Çemberlitaş, Beyazit, and near the Murat Paşa Mosque.[37] Besides, one can also mention polygonal vaulted halls which are assumed to belong to Early Byzantine mausolea/martyria and tend to concentrate in the area framed by the Third and Fourth Hills and the Xerolophos. These comprise the now lost Balaban Ağa Mescidi in Laleli, the still extant Şeyh Süleyman Mescidi in Zeyrek, and the large vaulted chamber in the basement of the building of Kırazlı Mescit Sk. Nr. 29 in

36 *Cod. Theod.* 9.17.6.

37 Müller-Wiener (1997) 219–222.

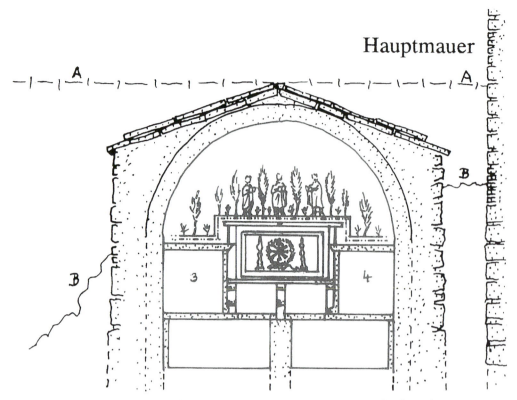

FIGURE 9 Istanbul, the mausoleum of the Silivrikapı gate. Cross section, showing the elevated sarcophagus/reliquary.
AFTER DECKERS AND SERDAROĞLU (1993)

FIGURE 10 Istanbul, the building of Kırazlı Mescit Sk. in Vefa.
AUTHOR 2013

Vefa (Fig. 10).[38] The date and use of these structures are uncertain. If they were mausolea/martyria, they could be convincingly associated with the Theodosian legislation concerning intramural burials in the capital.

Since Constantinople had very few local martyrs, it follows that the private shrines mentioned by the law of AD 381 were consecrated with relics brought from elsewhere. How did their owners acquire them? The answer probably comes from a decree promulgated by the same Theodosius I in 386, which prohibits the partition and purchase of relics: 'Let no one transfer a buried body to another place. Let no one dismember or trade in a martyr.'[39] Addressed to Cynegius, Praetorian Prefect of the East, this decree authorises the building of shrines (martyria) over pre-existing tombs of martyrs, but forbids the exhumation, division, transfer and circulation/trade of human remains as relics. The three illicit practices are explicitly named by the legislator who finds it necessary to add a clear definition of what an authorised martyrium is: 'Yet, if one of the saints is buried somewhere, let people have the possibility to add any structure they like for his veneration, which is to be called a martyrium'. By aligning himself with the view that a martyr's shrine is a building containing an undisturbed tomb, the legislator apparently targets the practice of creating martyria with transferred relics.

This law is often invoked, in order to argue that the transfer of relics was prohibited or strongly opposed until the late 4th c.[40] At the same time, however, it also shows that, despite opposition, translations of relics were widely practiced in an unregulated manner. It is a clear testimony of the early steps of the cult of dismembered and transferred relics at the level of private initiatives, very probably driven by a demand among members of the Christian elite to create private martyria/mausolea. It is probably no coincidence that the law of 381, concerning intramural mausolea and shrines, is addressed to the Urban Prefect of Constantinople, whereas the 386 ban on the exhumation, division, and circulation of relics is addressed to the Praetorian Prefect of the East. The former evidently targets the clientele of the relics trade in the capital, whilst the latter seeks its sources in the provinces.

The law of 386 belongs to a chapter of the Theodosian Code, which addresses offences related to the cemeteries and the honour of the dead. All the decrees preceding it prescribe heavy penalties, but the prohibition on the removal of relics from the tombs surprisingly says nothing about punishment, as if being an advisory directive rather than a law concerning a major offense. It is, of course, possible that it originally included penalties which may have been edited out during its recording in the Theodosian Code in the 430s. Be that as it may, this law, promulgated by Theodosius I and reaffirmed under Theodosius II, apparently preserved its actuality throughout the 70-year period of the Theodosian dynasty. How can this be reconciled with the fact that this was also the time when translations of relics reached their full development, in many cases with the endorsement of Theodosius I and his successors?[41] This contradiction perhaps reveals the real intentions of the law of 386. The emperors did not denounce the transfer of relics of saints altogether, but rather wished to remove it from the realm of private initiatives. The exponential proliferation of evidence for translations in the 5th c. is probably due to the fact that the practice was now placed under the full and perhaps exclusive control of the higher clergy and the imperial authorities, while private lay initiative subsided.

This brings us back to Sozomen's account of Eusebia, which is a retrospective assessment of 4th c. attitudes to the use of relics from the viewpoint of established mid-5th c. practice. In the 4th c., Eusebia kept a quantity of relics as a private possession and demanded from her inheritor monks to bury them in her tomb and keep their existence secret. The latter respected her wish, to which they were bound by an oath, but at the same time felt the duty to honour the martyrs in a proper liturgical manner. They therefore celebrated private services at her tomb, turning Eusebia's sarcophagus into an altar, and using her mausoleum as a chapel. When they left the place and the tomb was buried and forgotten, the saints appeared to the Empress Pulcheria and demanded that the relics be removed from the tomb and displayed for public veneration. This happened in the 430s or 440s, roughly when the decree against the exhumations of relics was republished in the Theodosian Code. The concluding message of Sozomen's account (written in the 440s) was that the place for relics was a church and public worship, not the privacy of a tomb or personal ownership.

38 Balaban Ağa Mescidi in Laleli and Şeyh Süleyman Mescidi: Müller-Wiener (1997) 98–99, 203; Dark (2013) 51–52. Vefa building: Özgümüş (2006) 529.
39 Cod. Theod. 9.17.7.
40 Mango (1990) 52; Cronnier (2015) 12; Wiśniewski (2019) 161–162.
41 Mango (1990) 60.

Eustathius of Sebaste, the Relics of the Forty Martyrs, and a Debate on Relics in the 370s

Two of the cases discussed here, the stories of Emelia of Cappadocia and Eusebia of Constantinople, involve relics of the Forty Martyrs of Sebaste, a cult which seems to have played an important role in normalising the practice of transferring and partitioning relics in Anatolia.[42] According to their legend, they were a group of Christian soldiers from Cappadocia, who suffered martyrdom near Sebaste of Armenia under Licinius. Their mode of execution was to be left outside during a very cold night, after which their bodies were burned in a furnace, and their ashes were thrown into a river. The Greek *Martyrdom of the Forty Martyrs of Sebaste* (BHG 1201) reports that their relics were miraculously preserved in the water, till the bishop of Sebaste collected them after a revelatory dream. Thus, the presumed relics of the Forty Martyrs were a large quantity of ashes and burned remains in the possession of the Church of Sebaste. The attitude of this ecclesiastical authority with regard to the ownership of these ashes is indicated by a phrase in the *Martyrdom* where we read that, after burning the remains, the persecutors discussed with one another and said: 'If we leave these relics like this, the Christians will collect them and will fill the whole world.'[43] This was precisely what happened. The Church of Sebaste acted not only as the custodian of these relics, but also as a steward who distributed them widely.

In 357, the controversial leader of a radical ascetic movement, Eustathius, was elected bishop of Sebaste. In the same year, his young protégé and later bishop of Caesarea, Basil, organised an ascetic community on the estate which he had inherited from his father in Pontus.[44] The project had the approval of his mother, Emelia, who, as we saw earlier, acquired relics of the Forty Martyrs and deposited them by the tomb of her husband. Gregory of Nyssa's account of the event does not tell how the relics had been acquired, but it has been convincingly suggested by Pierre Maraval that they were a gift from Eustathius.[45] By the 370s, relics of the Forty Martyrs were also acquired by shrines at Basil's see in Caesarea and at several villages of Cappadocia. Basil affirms that the Forty 'have surrounded our land like a continuous row of towers, proffering security against attack by the enemies, not confining themselves to one place, but being hosted by many villages, and having honoured many lands.'[46] The dates of these transfers are unknown, but they are likely to have taken place during the episcopate of Eustathius (357–ca. 379) and with his approval.

Shortly after his election to the episcopate in 370, Basil of Caesarea clashed with Eustathius over the theology of the Holy Spirit. Both of them died shortly before the First Council of Constantinople (381), after which Basil was remembered as a Father of the Church and Eustathius as a heretic.[47] This conflict explains Basil's silence about the bishop of Sebaste in his *Homily on the Forty Martyrs* (CPG 2863, BHG 1205), which was delivered in Caesarea in the early 370s,[48] and also the fact that Gregory of Nyssa, writing in the 380s, never mentions the close connection between his brother and Eustathius.

Eustathius of Sebaste, the spiritual leader of the first major monastic movement of Asia Minor, was an ally of the semi-Arian bishop of Constantinople Macedonius I (AD 342–346, 351–360). The doctrine and community represented by them were known, after the latter, as Macedonianists, and its members included the first generation of monks in the East Roman capital. The incipient phase of Constantinopolitan monasticism is thought to have been under the spiritual influence of Eustathius of Sebaste who remained on his throne for almost 20 years after the deposition of Macedonius in 360 and is likely to have retained his influence in the monasteries of Constantinople.[49] As we saw above, Sozomen reports that Eusebia of Constantinople and her inheritor monks were Macedonianists. This statement has been interpreted as criticism for Eusebia's acts – private ownership and burial of relics – in the negative light of heresy. This, however, is doubtful, both because Sozomen does not openly express such a view and because his references to the monastic communities of the Macedonianists are consistently respectful and positive, despite their heterodoxy.[50] Elsewhere, the author acknowledges the role of Macedonianist monks in bringing the head of John the Baptist to Constantinople, and extols their high ascetic traditions.[51] Sozomen's reference to the Macedonianist identity of Eusebia's community should rather be understood as a matter-of-factly historical comment, placing the event within a community which represented the prevalent doctrine of the imperial Church in the mid-4th c. Eusebia was loyal

42 Wiśniewski (2019) 169.
43 *Martyrdom of the Forty Martyrs of Sebaste* 13.
44 Silvas (2008) 32–38; McGuckin (2001) 88–97; Rousseau (1994) 73–76.
45 Maraval (1999) 197, 198; Silvas (2008) 33.
46 Basil, *Hom.* 19.8.
47 McGuckin (2001) 90–93; Rousseau (1994) 239–45, 313–14.
48 Bernardi (1968) 82–84.
49 Hatlie (2007) 62–65; Dagron (1974) 439–40, 513–14.
50 Duval (1998) 112–18; cf. Wiśniewski (2019) 94.
51 Sozom. *Hist. eccl.* 7.21.

to Macedonius of Constantinople and a sponsor of the monastic movement which he introduced to the capital under the spiritual guidance of Eustathius of Sebaste. Chances are that she was yet another contact in Eustathius' network of influence and that she acquired the relics of the Forty Martyrs as a gift from him.[52]

Whether the connection with the Macedonianist community and Eustathius was important or not, the broad dissemination of the relics of the Forty Martyrs was a development which triggered discussions about the nature of their cult in Asia Minor. The acquisition of relics by several villages led to a multiplication of their cult centres, generated different variants of the cult, and soon created competitions about legitimacy and primacy among the shrines. Where and how should the martyrs be venerated? How could one know which relic belonged to whom? Sebaste was the place of their martyrdom, but their homes and remains were spread all over Cappadocia. Several villages which possessed relics claimed to be also birthplaces of various members of the group, implying a closer personal connection with them. Basil of Caesarea makes it clear that these local connections are of no importance for the veneration of the martyrs who should be honoured as a group:

> The saints did not have only one home, because each one of them hailed from a different place. What then? Shall we call them men of no city or rather citizens of the entire world? For just like contributions in collections, which, although offered by different individuals, become a shared possession of their contributors, similarly, for these blessed men, the home city of each is common to all. And all of them, from all places, share with one another the homes which produced them. But, more importantly, why should we seek their homes which lie down here, when we can contemplate their current city?[53]

The saints are no more inhabitants of the earthly villages and towns of Cappadocia, but of heavenly Jerusalem where they live eternally united, and united should they be venerated.

The most ambitious of the rural cult centres of the Forty Martyrs was Sareim, a village in the territory of Zela in Pontus, which attempted to legitimize its presumably exceptional relationship with the martyrs by producing a pseudepigraphal *Testament of the Forty Martyrs* (BHG 1203).[54] Purporting to be an autograph testament composed by the martyrs from gaol, this document finishes with a long paragraph of greetings addressed by them to their friends and relatives in 5 villages of Cappadocia and Armenia, thus expressing the personal connections, of which these communities will have been very proud. The *Testament* agrees with Basil of Caesarea and the *Martyrdom* that the Forty should be venerated as a group, but it links the idea of cult unity to the unity of their relics. Since the saints were united by God in martyrdom, their relics had to be kept together as well, and their division was a sin which earned doom rather than grace. The martyrs warn the reader:

> But if anyone opposes our will, let this man be aloof from divine reward, let him face judgement for all his disobedience, for he overturns justice by mere whim, forcing us, as far as it is in his power, to be separated from one another – us whom our Holy Saviour has united in the faith, by His grace and providence![55]

According to the *Testament*, the saints bequeathed their relics exclusively to the village of Sareim, and wished that they be venerated only there:

> (…) once we accomplish the contest (…) we then wish that (…) our relics (…) be deposited at the village of Sareim in the district of Zela. For, although we all happen to come from various villages, yet we have chosen one and the same place of deposition for our repose. (…) no one should keep for himself any of our relics removed from the furnace, but he should take care that they be gathered together, and hand them over to the aforementioned people (…).[56]

Sareim attempted to delegitimise every other shrine of the Forty Martyrs, including the city of Sebaste itself, and it seems that Basil of Caesarea was addressing this polemic when he voiced, for the first time in Christian literature, the idea that the saints' grace was not affected by the partition of their relics, but remained fully present even in their smallest particle:

> And the amazing thing is that they do not visit those who receive them separated one by one, but they appear united as a chorus. What a miracle! They neither come short in number, nor do they

52 Maraval (1999) 202.
53 Basil, *Hom.* 19.2. For a translation of the whole text and commentary, see: Allen in Leemans *et al.* (2003) 67–77; Girardi (1990) 121–36.
54 Full text, translation, and bibliography: E. Rizos, CSLA-E00255.
55 *Testament of the Forty Martyrs of Sebaste* 1.4.
56 *Testament of the Forty Martyrs of Sebaste* 1.1.

admit of excess. If you divide them into one hundred, they do not exceed their own number; if you subsume them into one, they still remain forty all the same (…) the Forty are both altogether and, at the same time, in the company of each one of their group individually.[57]

In other words, the partition of the physical remains of the saints does not cause their division as an invisible group in heaven nor does it decrease their power. The proof is that the Forty always appear as a group to people who invoke them, regardless of where this prayer is offered.

In conclusion, the hagiographical dossier of the Forty Martyrs of Sebaste includes the literary voices of three institutions involved in the cult of their relics, which express two different stances towards it. On the one hand, the Church of Sebaste, talking to us through the text of the *Martyrdom*, and the Church of Caesarea, represented through Basil's *Homily*, are openly favourable to the idea of diffusion and see no contradiction between the division of the relics and the unity of the saints' cult. On the other hand, the village shrine of Sareim, represented by the *Testament*, opposes division and links the unity of the relics to the validity and efficacy of the cult. The only one of these texts which can be dated with confidence is the homily of Basil of Caesarea, preached in the 370s.[58] The fact that the *Martyrdom* and the *Testament* are similarly concerned with the question of relics and cult unity indicates that they could date from the same period, and certainly speak to the same debate. The discussion very probably resulted from the liberal policy adopted by Eustathius of Sebaste.

Conclusion

The reading of the evidence proposed in this paper allows a fresh answer to the question of how the use of transferred relics of saints evolved during the 4th c. The textual and archaeological testimonies create a picture of irregular private initiatives linked to the burial habits of the lay Christian elite. The first known shrines to be consecrated with transferred relics were private funerary sanctuaries built by Christian aristocrats, starting with the most illustrious Christian convert of the 4th c., the Emperor Constantine. His burial project set a major precedent and introduced the idea that vicinity to the saints' bodies was prestigious and beneficial, but it could be achieved by moving the remains of the saints to the tombs of the common dead rather than vice versa. The meteoric rise of a new Christian aristocracy with monastic interests in Constantinople and Anatolia, under the shadow, as it were, of Constantine and his tomb, alongside the liberal attitude of churchmen like Eustathius of Sebaste, resulted in a circulation of relics in private hands. Most of these privately-owned relics in the mid to late 4th c. were used for the consecration of shrines serving as family mausolea. Female aristocrats, monks, and some politically apt bishops seem to have been the main players in this dynamic process, which probably left its traces in the hagiographic *topos* of the matron who founds a martyr's shrine. Initially met with resistance from parts of the Christian community in Anatolia and by the imperial legislator himself, the cult of divided and transferred relics was gradually accepted and placed under the control of the church hierarchy and public worship by the mid-5th c.

Abbreviations

BHG *Bibliotheca Hagiographica Graeca*
BHL *Bibliotheca Hagiographica Latina*
CPG *Clavis Patrum Graecorum*
CSLA *The Cult of Saints in Late Antiquity*. Online database: http://csla.history.ox.ac.uk/

Bibliography

Primary Sources

Anth. Pal. = W. R. Paton. Revised by Michael A. Tueller ed. and transl., *Greek Anthology*, 5 volumes (Loeb Classical Library 67, 68, 84, 85, 86) (Cambridge Mass. 1916–1918 (rev. 2014)).

Basil, *Hom.* 19 = J.-P. Migne ed. *Basil of Caesarea, Homily 19, On the Holy Forty Martyrs. Patrologiae cursus completus: series graeca* 31 (Paris 1857) 489–508 (Text). P. Allen, "Basil of Caesarea," in *'Let us die that we may live': Greek Homilies on Christian Martyrs from Asia Minor, Palestine and Syria (c. AD 350–AD 450)*, edd. J. Leemans *et al.* (London 2003) 67–77 (English translation).

Cod. Theod. = T. Mommsen and P. M. Meyer edd. *Theodosiani Libri XVI cum Constitutionibus Sirmondianis et leges Novellae ad Theodosianum pertinentes*. 3 vols. (Berlin 1905); (Text). C. Pharr, T. Sherrer Davidson, M. Brown, C. Dickerman Williams, *The Theodosian Code and Novels, and the Sirmondian Constitutions* (New York 1952, 1969) (English translation).

Euseb. *Vit. Const.* = F. Winkelmann ed. *Eusebius Werke, Band 1, Teil 1: Über das Leben des Kaisers Konstantin* (Die griechischen christlichen Schriftsteller der ersten Jahrhunderte;

57 Basil, *Hom.* 19.8.
58 Bernardi (1968) 82–84.

2nd rev. edn. (Berlin and New York 2008) (Text). Cameron A., and Hall S. G., *Eusebius, Life of Constantine* (Clarendon Ancient History Series; Oxford 1999) (English translation).

Greg. Nyss. *Mart. 2* = O. Lendle ed., *Gregory of Nyssa, On the Forty Martyrs II.* in Heil G., J. P. Cavarnos, and O. Lendle, *Gregorii Nysseni Opera X.1: Gregorii Nysseni Sermones II.* (Leiden 1990) 137–56 (text).

Greg. Nyss. *V. Macr.* = P. Maraval ed., *Gregory of Nyssa, Life of Macrina. Grégoire de Nysse, Vie de Sainte Macrine.* (Sources chrétiennes) (Paris 1971) (text). Silvas, A. *Macrina the Younger, Philosopher of God.* (Turnhout 2008) (English translation).

Greg. Nyss. *Ep.* = P. Maraval ed., *Gregory of Nyssa, Letters.* ed. Maraval P., *Grégoire de Nysse, Lettres ; introduction, texte critique, traduction, notes et index* (Sources chrétiennes 363) (Paris 1990) (text and French translation). Silvas A. M. *Gregory of Nyssa. The Letters: Introduction, Translation and Commentary* (Supplements to Vigiliae Christianae 83) (Leiden and Boston 2007) (English translation).

Julian, *Mis.* = W. C. Wright ed. and transl., *The Works of the Emperor Julian*, vol. 3, Loeb Classical Library (London and New York 1913–1923) (listed as *Letter* 19) (text and English translation).

Martyrdom of the Forty Martyrs of Sebaste = O. L. Von Gebhardt ed., *Acta martyrum selecta. Ausgewählte Märtyrerakten und andere Urkunden aus der Verfolgungszeit* (Berlin 1902).

The Martyrdom of Saint Polycarp of Smyrna = Rebillard E. *Greek and Latin Narratives About the Ancient Martyrs* (Oxford Early Christian Texts) (Oxford 2017) 90–105 (text and translation).

Passio S. Alexandri Romani = Dimitrov D. (1935) "Пътуването на св. Александра Римски през Тракия", Известия на Българския Археологически Институт 8 (1935) 116–61 (Text).

Passio S. Iuliani Anazarbeni = Rizos E. (2021) "Saint Julian of Cilicia: Cult and Hagiography. Including the edition and English translation of the Greek *Passio S. Iuliani Anazarbeni* (BHG 966) and its *Epitome* (BHG 967d)", *Analecta Bollandiana* 139.1, 106–155.

Sozom. *Hist. eccl.* = J. Bidez and G. C. Hansen edd., *Sozomenus, Kirchengeschichte.* 2nd rev. edn., Die griechischen christlichen Schriftsteller der ersten Jahrhunderten, Neue Folge 4 (Berlin 1995) (Text). C. D. Hartranft "The Ecclesiastical History of Sozomen, comprising a history of the Church from AD 323 to AD 425" in *A Select Library of Nicene and Post-Nicene Fathers of the Christian Church: Second Series*, edd. P. Schaff and H. Wace (New York 1890) 179–427 (English translation).

Testament of the Forty Martyrs of Sebaste. Musurillo H., *The Acts of the Christian Martyrs* (Oxford Early Christian Texts) (Oxford 1972) xlix–l; 354–61 (text and English translation).

Seeliger H. R. and Wischmeyer W. *Märtyrerliteratur. Herausgegeben, übersetzt, kommentiert* (Texte und Untersuchungen yur Geschichte der altchristlichen Literatur vol. 172.) (Berlin, Munich and Boston 2015) 291–305 (text and German translation).

Secondary Sources

Bardill J. (2012) *Constantine, Divine Emperor of the Christian Golden Age* (Cambridge 2012).

Bernardi J. (1968) *La prédication des pères cappadociens : le prédicateur et son auditoire* (Paris 1968).

Bowes K. (2008) *Private Worship, Public Values, and Religious Change in Late Antiquity* (Cambridge 2008).

Boyadjiev S. (2006) "L'architecture du mausolée de Lozenetz et sa correlation avec ceux de la Moesie et de la Thrace", in *Early Christian Martyrs and Relics and their Veneration in East and West* (Acta Musei Vernaensis 4), ed. A. Minchev (Varna 2006) 129–40.

Cronnier E. (2015) *Les inventions de reliques dans l'Empire romain d'Orient* (Hagiologia 11) (Turnhout 2015).

Dagron G. (1974) *Naissance d'une capitale. Constantinople et ses institutions de 330 à 451* (Bibliothèque Byzantine: Etudes 7) (Paris, 1974).

Dagron G. (2003) *Emperor and Priest: The Imperial Office in Byzantium* (Cambridge 2003) (English translation by J. Birrell of Dagron, G. *Empereur et prêtre : étude sur le "césaropapisme" byzantin* (Paris 1996)).

Dark K. (2013) *Constantinople. Archaeology of a Byzantine Megapolis* (Oxford 2013).

De Palol P. (1967) *Arqueologia Cristiana de la España romana. Siglos IV–VI* (Madrid and Valladolid 1967).

Deckers J. and Serdaroğlu Ü. (1993) "Das Hypogäum beim Silivri-Kapı in Istanbul", *JAC* 36 (1993) 140–63.

Duval Y. (1988) *Auprès des saints corps et âme* (Paris 1988).

Egger R. and Dyggve E. (1939) *Forschungen in Salona III: der altchristliche Friedhof Marusinac* (Vienna 1939).

Fıratlı N. (1966) "Notes sur quelques hypogées paléo-chrétiens de Constantinople", in *Tortulae. Studien zu altchristlichen und byzantinischen Monumenten*, ed. W. N. Schumacher (Freiburg 1966) 131–39.

Foletti I. and Monney G. (2013) "Of holes and a holy man: new discoveries in the Silivri-Kapi mausoleum in Istanbul", *Kunstchronik* 66 (2013) 178–82.

Girardi M. (1990) *Basilio di Cesarea e il culto dei martiri nel IV secolo. Scrittura e tradizione* (Bari 1990).

Hatlie P. (2007) *The Monks and Monasteries of Constantinople, ca. 350–850* (Cambridge 2007).

Hudak K. and Nagy L. (2005) *A Fine and Private Place. Discovering the Early Christian Cemetery of Sopianae/Pecs.* (English translation by M. Saghy) (Pecs 2005).

Johnson M. J. (2009) *The Roman Imperial Mausoleum in Late Antiquity* (Cambridge 2009).

Leemans J., Mayer W., Allen P., and Dehandschutter B. (2003) *'Let us die that we may live': Greek Homilies on Christian Martyrs from Asia Minor, Palestine and Syria (c. AD 350–AD 450)* (London 2003).

Mango C. (1990) "Constantine's Mausoleum and the Translation of Relics", *ByzZeit* 83 (1990) 51–61.

Maraval P. (1999) "Les premiers développements du culte des XL Martyrs de Sébastée dans l'Orient byzantin et en Occident", *Vetera Christianorum* 36 (1999) 193–211.

McGuckin J. A. (2001) *St. Gregory of Nazianzus: An Intellectual Biography* (New York 2001)

Milošević G. (2006) "Late Roman martyrium and basilica at the Necropolis of Nis (Naissus)", in *Early Christian Martyrs and Relics and their Veneration in East and West* (Acta Musei Vernaensis 4), ed. A. Minchev (Varna 2006) 173–86.

Müller-Wiener W. (1997) *Bildlexikon zur Topographie Istanbuls* (Tübingen 1997).

Özgümüş F. (2006) "2005 yıllı İstanbul çalışmaları bilimsel raporu", *Araştırma Sonuçları Toplantısı* 24 (2006) 525–38.

Papazotos Th. (1988) "Ανασκαφή Διοκλητιανουπόλεως. Οι πρώτες εκτιμήσεις", *ArchDelt* 43.A (1988) 195–218.

Popović S. ed. (2014) *Late Antique Necropolis Jagodin Mala* (Niš 2014).

Rousseau P. (1994) *Basil of Caesarea* (Berkeley and Oxford 1994).

Silvas A. (2008) *Macrina the Younger. Philosopher of God* (Medieval Women: Texts and Contexts) (Turnhout 2008).

Sulser W. and Classen H. (1978) *Sankt Stephan in Chur. Frühchristliche Grabkammer und Friedhofskirche* (Zürich 1978).

Wiśniewski R. (2019) *The Beginnings of the Cult of Relics* (Oxford 2019).

Topography and Ideology: Contested Episcopal Elections and Suburban Cemeteries in Late Antique Rome

Samuel Cohen

Abstract

This chapter considers the perception of the suburban cemetery in the late antique Roman imagination. More specifically, it investigates how the cemetery was mobilised in Roman polemical texts to legitimise the memory of both the winners and losers of late antique papal schisms. Rome's extra-mural cemetery spaces were simultaneously associated with the city's saints and martyrs and linked with foreigners, heretics, and schismatics, and other outsiders. It was precisely this ambiguity that made the cemetery an ideal space for partisan polemicists to reimagine the recent history of Rome's factionalism. The conflicting portrayals of cemeteries in our sources reflect the battle to control them, both in reality and in Roman memory.

Introduction

Damasus' pontificate (366–384) began in contestation. In September 366, competing factions within the church had separately selected two men, Damasus and his rival Ursinus, to succeed Liberius (352–366) as bishop of Rome. The resulting schism was bitter and often violent, but by 368, Damasus was on the brink of victory.[1] According to the admittedly hostile *Gesta inter Liberium et Felicem episcopos* (hereafter, *Gesta*), an anti-Damasene polemical history of the schism written shortly after its conclusion, Ursinus and his supporters had been driven from the city.[2] Yet, they refused to be intimidated. Defiantly, they continued to conduct "services throughout the cemeteries of the martyrs (*coemeteria martyrum*)."[3] But the final battle was approaching. When the *fideles* of Ursinus gathered at the basilica complex surrounding the tomb of St. Agnes on the *Via Nomentana*, they were set upon by Damasus and his followers. The result was a massacre.[4] Damasus took control of the tomb of St. Agnes and Ursinus' supporters were dealt a bloody setback from which they would not recover.

That the final clash in a struggle to control the Roman church took place in a suburban martyrial basilica may at first seem strange. Indeed, as we shall see, the protagonists in this and other late antique papal schisms such as that between Boniface (418–422) and Eulalius, typically attempted to control the important churches within the city rather than the marginal areas near and just beyond the walls. However, as I will suggest in this essay, the subsequent battle to control how these conflicts were remembered took place in the city's suburban cemeteries, the burial place of Rome's martyrs, whose monuments – from small chapels and shrines to large imperially-sponsored basilicas – ringed the city.[5] It was here, "peripheral to the world of the living,"[6] in the words of Peter Brown, that the community of faithful – rich and poor, city dwellers, suburban villagers, and foreigners – could come together to celebrate the cults

1 An overview of the events described below can be found in Pietri (1976) 407–423; Pietri (1997); McLynn (1992); Curran (2000) 137–42; Lizzi Testa (2004) 129–70; Reutter (2009) 31–55; Trout (2015) 3–10. See also the extensive bibliography in Raimondi (2009) 169–70, n. 1.

2 *Gesta inter Liberium et Felicem episcopos* (hereafter *Gesta*) = *Collectio Avellana* (hereafter *Coll. Avell.*) ep. 1, ed. Otto Günther, *Epistolae Imperatorum Pontifi cum Aliorum Inde ab a.* CCCLXVII *usque* DLIII *Datae Avellana Quae Dicitur Collectio* (CSEL 35) (Vienna 1895). This text is titled *Quae gesta sunt inter Liberium et Felicem episcopos* but is commonly referred to in secondary literature as either the *Praefatio* (that is, it is the introduction to the second letter in the collection, the *Liber Praecum*), or the *Gesta Liberii*. Both titles are confusing given that the principal concern of the text is the schism between Damasus and Ursinus, which the author(s) understood as a continuation of the schism between Liberius and Felix. The *Gesta Liberii* is also the title of another late antique propagandistic text composed in the context of the Symmachian/Laurentian Schism and is discussed below. On this text, see Wirbelauer (1994) 134–38; Blair-Dixon (2007) 70–71. On the anti-Damasene perspective of the *Gesta* and its intended audience, see Lizzi Testa (2004) 131–32, 153–54; Torres (2019) 31–32.

3 *Gesta* 12: '*per coemeteria martyrum stationes sine clericis celebrabat*'. Note that *coemeterium* typically designates the tombs of martyrs and their churches rather than a communal cemetery; Rebillard (2003) 12–17.

4 *Gesta* 12: '*unde cum ad sanctam Agnem multi fidelium conuenissent, armatus cum satellitibus suis Damasus irruit et plurimos uastationis suae strage deiecit*' – 'When, therefore, many of the faithful had met at St. Agnes, Damasus with his creatures fell upon them and cut down many in their savage onslaught'.

5 Reekmans (1989) 861. Only rarely before the 9th c. (and then only in very peculiar or urgent circumstances) were corporeal relics (as opposed to contact relics) translated into the city's intra-mural churches; see Costambeys (2001) 171–72; Goodson (2008); (2010) 198–99.

6 Brown (1981) 42–43, quoted at 42.

of Rome's saints and through the saints, Christianity's sacred history. But despite their obviously positive associations, the cemetery remained an ambivalent space in the late antique imagination, simultaneously part of the Roman church and beyond it. The appeal to the cemetery in controversial literature could, on the one hand, legitimise claimants to the see of St. Peter and reinforce episcopal authority. But as an ideological counterpoint to traditional urban power structures, the cemetery also had the potential to challenge that authority and flatten social hierarchies. Cemeteries were obviously associated with saints, but also with heretics, schismatics, and recalcitrant clerics. In short, late ancient cemeteries and their associated cults were potent yet ambiguous symbols of Roman collective identity.[7] As such, they were not only sites of physical confrontation, as in the case of Damasus and Ursinus, but also of rhetorical contestation, where polemicists mobilised the memory of Rome's saints and through them the discourse of exile and martyrdom in order to reimagine the recent history of the Roman church and the men who competed to control it.

Focusing on the schisms between Damasus and Ursinus (during the 360s), and Boniface and Eulalius (during the later 410s), the following essay examines the rhetoric and the reality of the suburban cemeteries and the ideological role they played – both positive and negative – in the fight to control the late antique Roman church. I begin with a brief overview of the controversies. A topographical analysis, especially of the Damasus/Ursinus schism, suggests that in the battles to control the Roman church, suburban cemeteries were far less important than the major intra-mural basilicas. Indeed, as I discuss in Part II, from the perspective of those in power in the city centre, the areas around and beyond the walls including the city's cemeteries were potentially dangerous places associated with socially marginal and theologically problematic groups – a view that reflects the bishop's lack of administrative control in this area of the city. In contrast, Part III considers how Ursinus and to a lesser extent Boniface, having been relegated to the *suburbium*, appealed to the legitimising discourse of exile and their association with the city's saints and martyrs buried beyond the walls. But as I hope to demonstrate, the fullest reimagining of Roman cemeteries and the role they played in papal schisms took place in the 6th c. This was a period marked by crises for the Roman church, including the Acacian Schism (484–519) between Rome and Constantinople,[8] the Symmachian/Laurentian Schism, which was yet another controversy resulting from a contested episcopal election that divided the Roman church from 498 until 506/507,[9] the Three Chapters Controversy, which in 553 rekindled tensions between Rome and Constantinople and prompted a schism between the papacy and several northern Italian episcopal sees that lasted for generations,[10] and the Gothic War (535–554), which devastated much of Italy.[11] A plethora of documents and compilations were produced in response to these crises,[12] including the *Documenta Symmachiana* and *Laurentiana* – two dossiers of propagandistic pamphlets composed by the partisans of Symmachus and Laurentius,[13] the *Collectio Avellana*, a mid-6th c. collection of almost 250 documents from the 4th, 5th, and 6th c., including the *Gesta*,[14] and the collection of papal biographies known as the *Liber Pontificalis*, which was first compiled shortly after 535 or 536, with subsequent sections added in the 7th and early 8th c.[15] Each

7 Cooper (1999) 298; Härke (2001) 9–15; Yasin (2009) 46–47.
8 Deliyannis (2014). On the Acacian Schism, see Kötter (2013).
9 On the Laurentian Schism, see esp. Wirbelauer (1993); Sardella (1996); Sessa (2012) 208–246; Cohen (2015) 198ff.
10 On the Three Chapters, see, for example, Sotinel (2007).
11 See Kouroumali (2013) and Heydemann (2016) 36–40, on the Gothic War.
12 McKitterick (2020) 28–29, noting that many of the texts produced in this period were collections of historical material, has aptly described Rome and its environs as a "culture of compilation," characterized by "the assembly of an arsenal of the past."
13 These texts are referred to as the "Symmachian Forgeries" or the "Symmachian Apocrypha" in older scholarship. On the modern nomenclature, see Wirbelauer (1993) 99–110, and in general see also Sessa (2007) *passim* but esp. 85–88, Sessa (2012) 235–39. The *Documenta* are edited (with a German translation) in Wirbelauer (1993) 227–342.
14 Edited by Günther, cited above, n. 2. For an overview of the *Collectio Avellana*, see now Lizzi Testa (2019). The *Coll. Avell.* preserves documents related to schism and the authority of the bishops of Rome; its compiler(s) were clearly implicated in the factional politics of the period, especially the controversy surrounding Vigilius (537–555) and the condemnation of the Three Chapters, although scholars continue to debate the precise motives for its compilation. Compare Wirbelauer (1993) 134–38, Blair-Dixon (2007) 61–65; and Lizzi Testa (2019) xiv–xix.
15 For the dating of the *Lib. Pont.* and the subtly different reconstructions of its compilation, see Duchesne (1886–1892) 1: xxxiii–xlviii and xlix–lxvii; Vogel (1975) *passim* but esp. 101–108, 111–14; Noble (1985) 348–50; Capo (2009) 1–22; Davis (2010) xii–xvi; Blaudeau (2012) 21–23; Verardi (2013) 8–11; Verardi (2016); Geertman (2009); Cohen (2015) 200–201; and now McKitterick (2020) esp. 12–15, 25–35. A very useful overview of the various debates related to the text can be found in Moreau (2010). Blair-Dixon (2007) 65–66 provides a summary of Duchesne's dating of the *Lib. Pont.* and its epitomes, but now see also McKitterick (2020) 195–206. In addition to Duchesne's frequently cited edition, the *Lib. Pont.* was also edited by Mommsen, *Liber Pontificalis, Pars Prior* (to 715) (MGH *Gestorum Pontificum Romanorum* 1). Mommsen (xvii–xviii) argues that the *Lib. Pont.* was first compiled after the death

TOPOGRAPHY AND IDEOLOGY

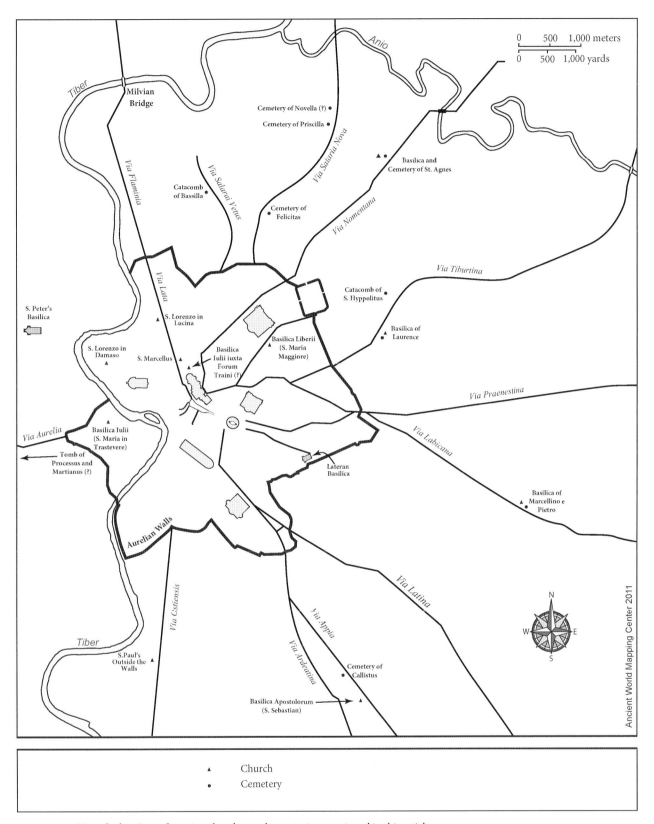

FIGURE 1 Map of 4th c. Rome featuring churches and cemeteries mentioned in this article.
ANCIENT WORLD MAPPING CENTER 2011

of these texts, in different ways and for different reasons, debated, repurposed, and sometimes outright fabricated the recent history of the Roman church to make ideological claims about its present and future. This is especially clear in the texts associated with the bitter fight between Symmachus and Laurentius, in which the extra-mural cemetery emerged as an essential theme in the retelling of the history of previous schisms. I conclude with a brief examination of the distinctive causes and features of Roman schisms in comparison to the other great cities in the empire, especially in relation to topography, and consider the evolving ideological significance of the cemetery in the late antique Roman imagination.

The Schisms of Damasus/Ursinus and Boniface/Eulalius: Topography and Contestation

To understand the use of the cemetery in the literature associated with contested papal elections, we must begin by returning to the conflict between Damasus and Ursinus. When Damasus' predecessor Liberius died, the Roman church was deeply divided. A decade earlier, Liberius had been banished to Thrace by Emperor Constantius II for refusing to agree to the condemnation of Athanasius at the Council of Milan in 355.[16] While in exile, a priest named Felix acted as bishop in Liberius' place.[17] After two years, Liberius capitulated to the emperor and was permitted to return to Rome.[18] Felix, however, was not willing to yield the city.[19] Liberius ultimately emerged victorious in the schism that followed and during the final years of his pontificate, he worked diligently to reconcile elements within the church which had supported his rival. But factionalism festered under the veil of unity. As a deacon, Damasus may have initially accompanied Liberius into exile but quickly turned back to Rome. Some within the church viewed this as a betrayal of Liberius, and Damasus was later accused of supporting Felix.[20] Shortly after Liberius' death, a faction hostile to Damasus gathered at the *basilica Iulii* and chose the deacon Ursinus as pope. A second group met at the basilica *in Lucinis* and selected Damasus.[21]

Waves of violence swept across the city. The contemporary anti-Damasene *Gesta* claims that Damasus suborned charioteers (*quadrigarii*) and a gang of ignorant rabble (*imperita multitudo*) who attacked and ultimately massacred the supporters of Ursinus at the *basilica Iulii*.[22] Damasus then seized the Lateran and was ordained bishop of Rome. Soon after, Ursinus and two of his deacons were exiled from the city by the urban prefect Viventius and the *praefectus annonae* Julianus.[23] But Ursinus still had supporters scattered throughout the city, some of whom had taken control of the *basilica Liberii* (St. Maria Maggiore). Approximately a month after the attack at the *basilica Iulii*, Damasus once again mobilised his supporters, this time including gladiators (*arenarii*), *quadrigarii*, and grave diggers (*fossores*). Wielding swords and clubs, they besieged (*obsidere*) the church. Again, according to the polemical *Gesta*, the supporters of Ursinus defended themselves, but ultimately, they were overwhelmed. Damasus' followers broke down doors, and in the resulting struggle, 160 Ursinians were killed and the church was left in ruins.[24] Ammianus Marcellinus' description of the schism confirms the violence reported in the *Gesta*. The historian characterizes the conflict as a vicious struggle that resulted in injuries and deaths (*mors vulneraque*). He also states that that in a single day 137 bodies were found at the *basilica Sicinini*, which may be another name for the *basilica Liberii*, although it is also possible that Ammianus is describing a separate incident.[25] At least

of Gregory I, but this proposal has largely been rejected. An overview of the Duchesne and Mommsen editions and their respective chronologies can be found in Wirbelauer (2014) 2–5. Duchesne was complementary to Mommsen's edition. See Duchesne (1898) 382.

16 See Liberius' letter *quamuis sub imagine* (JK 216 = CSEL 65, 164–66) written to Lucifer of Cagliari, Eusebius of Vercelli, and Dionysius of Milan; cf. Sulp. Sev., *Chron.* 2.39.

17 *Lib. Pont.* 37: '*Et congregans sacerdotes cum consilio eorum Liberius ordinauit in locum eius Felicem presbiterum episcopum, uenerabilem uirum*' – 'Gathering *sacerdotes* together, with their consent Liberius ordained the priest Felix, a revered man, as bishop in his place'; on Felix's 'election', see Ath., *Hist. Ar.* 75; Socrates, *Hist. eccl.* 2.37.

18 Liberius, *epistola. pro deifico* (JK 217 = CSEL 65, pp. 168f.): '*Itaque amoto Athanasio a communione omnium nostrum ... dominus et frater meus communis Demofilus (...)*' – 'And so I removed Athanasius from the fellowship of all of us ... my lord and common brother Demophilus'; Demophilus was the future Homoian Patriarch of Constantinople.

19 Theod. *Hist. eccl.* 2.14. claims that the emperor ordered that Felix and Liberius jointly administer the Roman church. But this was firmly rejected by the Roman people who responded by chanting 'One God, one Christ, one bishop'. See also Sozom. *Hist. eccl.* 4.15.

20 This episode is described, for instance, in Curran (2000) 137–38; Reutter (2009) 31–56. See also Wirbelauer (1994) 407–410.

21 These events are generally referred to as elections, however they might more accurately be described as nominations. See Ghilardi (2010) 174, n. 195 and De Spirito (1994) 266. The identities and locations of these buildings is discussed below.

22 On the definition of *multitudo*, see Slootjes (2016) 179–80, 190–91. On the identity and location of this and other churches involved in this schism, see below.

23 *Gesta* 5. Viventius is called *iudex Urbis*.

24 *Gesta* 7.

25 Amm. Marc. 27.3.12–13; '*Damasus et Ursinus supra humanum modum ad rapiendam episcopalem sedem ardentes,*

one more act of violence followed. As I described at the beginning of this chapter, Damasus and his supporters murdered many of the remaining Roman supporters of Ursinus at the cemetery of St. Agnes. Ammianus, who suggests that both sides were responsible for the violence, pithily claims that Damasus emerged victorious thanks to the efforts of his supporters.[26] Eventually, imperial rescripts banished Ursinians and other schismatics from the city and the *suburbium*.[27]

Fifty years later, Rome again experienced a contested episcopal election.[28] On 26 December 418, the ineffectual and unpopular Zosimus died. Zosimus had badly mishandled the Pelagian controversy, which had caused growing dissent within the Roman church – dissent about which Zosimus himself complained during his final years as bishop.[29] Upon his death, the archdeacon Eulalius was elected at the Constantinian Basilica (the Lateran). Shortly after and in opposition to Eulalius, a second faction elected Boniface in the church of Theodore. The next day, both candidates were consecrated, Eulalius at the Lateran, Boniface at the church of Marcellus, after which he went to St. Peter's.[30] Secular authorities in Rome and Ravenna must have feared renewed violence of the type that had characterized the Damasus/Ursinus affair, and the *praefectus urbi* Aurelius Anicius Symmachus moved quickly to preserve the *quies urbis*. On 29 December, he dispatched a letter to the emperor detailing the situation.[31] Less than a week later, Honorius replied in support of Eulalius, and Boniface was ejected from Rome.[32] In triumph, Eulalius celebrated the Feast of Epiphany at St. Peter's, while Boniface and some supporters occupied St. Paul's outside the walls.[33] Soon afterwards, supporters of Boniface wrote to the emperor and managed to convince him to reconsider his original ruling.[34] Honorius agreed and ordered both parties to appear in Ravenna before a synod of bishops (and the emperor) to plead their cases.[35]

The synod, however, was unable to reach a consensus and with Easter approaching, Achilleus of Spoleto was appointed to oversee Paschal services at Rome. Eulalius and Boniface were both barred from the city until a larger synod, scheduled to meet at Spoleto in early June, could convene to resolve the dispute.[36] It was at this point, according to the later tradition preserved in the *Liber Pontificalis*, that Boniface "lived in the cemetery of the holy martyr Felicitas, on the *Via Salaria*."[37] As it happened, the synod at Spoleto was not to be. In March,

scissis studiis asperrime conflictabantur ad usque mortis vulnerumque discrimina adiumentis utriusque progressis ... Et in concertatione superaverat Damasus, parte, quae ei favebat, instante. Constatque in basilica Sicinini, ubi ritus Christiani est conventiculum, uno die centum triginta septem reperta cadavera peremptorum, efferatamque diu plebem aegre postea delenitam' – 'Damasus and Ursinus, burning with a superhuman desire of seizing the bishopric, engaged in bitter strife because of their opposing interests; and the supporters of both parties went even so far as conflicts ending in bloodshed and death ... And in the struggle Damasus was victorious through the efforts of the party which favoured him. It is a well-known fact that in the basilica of Sicininus, where the assembly of the Christian sect is held, in a single day a hundred and thirty-seven corpses of the slain were found, and that it was only with difficulty that the long-continued frenzy of the people was afterwards quieted.' It is commonly assumed that the *basilica Liberii* and the *basilica Sicinini* represent the same church. But Ammianus may be describing a different event. For a summary of the scholarly positions taken about the identity of this building and the events associated with it, see esp. Boeft *et al*. (2009) 69–71. The identification of the *basilica Liberii*/St. Maria Maggiore with the *basilica Sicinini* is also discussed in Krautheimer (1937–1980) 3.55. Note that *basilica Sicinini* was eventually returned to Damasus by an imperial rescript sent by Valentinian I to Praetextatus, the *praefectus urbi*. See *Coll. Avell. Ep*. 6.

26 Amm. Marc. 27.3.13: '*Et in concertatione superaverat Damasus, parte, quae ei favebat, instante*' – 'And in the struggle Damasus was victorious through the efforts of the party which favoured him'.

27 *Coll. Avell. Ep*. 7 exiled the supporters of Ursinius from the city; *Ep*. 8, 9 demanded that schismatics be forced at least 20 miles from Rome.

28 Accounts of the schism can be found in Cristo (1977); Wirbelauer (1994) 410–15; Norton (2007) 65; Dunn (2015a). See also Duchesne's *notes explicatives* in *Lib. Pont*. 44.

29 Cristo (1977) 163, places the blame for the Boniface-Eulalius schism squarely on Zosimus. However, the degree to which he was responsible, or whether Eulalius was a partisan of Zosimus, is not clear.

30 *Coll. Avell. Ep*. 14. Note that the *Lib. Pont*. (ed. Duchesne, p. 227) states that Boniface's ordination occurred in the *basilica Iuliae*, [sic., the *basilica Iulii*?]. Duchesne (n. 4, p. 228) argues that Boniface was neither elected nor ordained at either a *basilica Iuliae or Iulii*, but rather that this tradition represents an interpolation from the *vita* of Boniface II. However, cf. the arguments of Geertman, Blaauw, and Laan (2004) 30. In an earlier essay, (2015a) 2, he argued that Boniface was ordained at San Lorenzo in Lucina. He now believes this church was San Marcello al Coroso. See Dunn (2015b) 148 and n. 40. On this church, see also Brandenburg (2005) 164–65.

31 *Coll. Avell. Ep*. 14: '... *ne quis quietem urbis uestrae perturbare temptaret*' – 'lest anyone try to disturb the peace of your city'.

32 *Coll. Avell. Ep*. 15: '*Bonifatium interdicta confestim urbe prohiberi ...*' – 'Boniface forthwith should be debarred from the city.'

33 As reported in another letter from Symmachus to Honorius, preserved as *Coll. Avell. Ep*. 16.

34 *Coll. Avell. Ep*. 17: '*exemplum precum presbyterorum pro Bonifatio*' – 'the example of the presbyters for Boniface'.

35 *Coll. Avell. Ep*. 18. Honorius' instructions to the synod are preserved as *Coll. Avell. Ep*. 20.

36 Reconstructed from *Coll. Avell. Ep*. 21–28.

37 *Lib. Pont*. 44: '... *habitauit Bonifatius in cymiterio sanctae Felicitatis martyris, uia Salaria*' – 'He was buried on the *Via Salaria* ⟨in the cemetery⟩ close to the body of the martyr St. Felicity'. On the *Liber Pontificalis*, see below. The Cemetery of Felicitas is also known as the catacomb of Maximus.

Eulalius re-entered Rome without imperial sanction and celebrated Easter at the Lateran, which included the traditional baptism of converts. In response, again according to the *Lib. Pont.*, Boniface celebrated "the Easter baptisms according to custom at the basilica of the blessed martyr Agnes."[38] While Boniface had remained outside the walls, Eulalius' entry into the city provoked a spasm of violence.[39] This, in turn, prompted immediate action from Ravenna. Eulalius ignored repeated commands to leave and ultimately had to be forcibly evicted from the Lateran.[40] Boniface returned to Rome and was officially recognised as bishop by the emperor.[41]

Several aspects of these schisms are worth highlighting. Most obviously, they are examples of the violent factionalism that at times characterized Roman ecclesiastical politics in Late Antiquity. And while the exact motives and composition of the parties involved are not easily recoverable, this factionalism manifested itself in the struggle to control specific buildings, especially the large intra-mural basilicas.[42] For instance, a topographical analysis of the Damasus/Ursinus schism reveals that Damasus' support was initially concentrated in the north-western part of the city around the Campus Martius. Here, we find the basilica *in Lucinis* where Damasus had initially been put forward as a candidate for the pontificate, likely the forerunner to St. Lorenzo in Lucina on the *Via Lata*.[43] A little to the south and west of the basilica *in Lucinis* was the *titulus Damasi* (St. Lorenzo in Damaso), which was founded by Damasus near the Theatre of Pompeii, likely on the site of his family *domus*.[44] The *Gesta* also notes that in addition to charioteers and grave diggers, Damasus recruited supporters from his extended household (*familiaris* and *satellites*), who were presumably also concentrated in this area of the city.[45] Striking out from his stronghold in the Campus Martius, Damasus first violently evicted his opponents from the *basilica Iulii*, the location of Ursinus' election. This is likely a reference to the *basilica Iulii iuxta Forum Traini* in *Regio* VII near the city centre, although the *basilica Iulii trans Tiberim*, today St. Maria in Trastevere, is also possible.[46] Damasus then took con-

38 *Lib. Pont.* 44: 'Bonifatius uero, sicut consuetudo erat, celebrauit baptismum Paschae in basilica beatae martyris Agnae' – 'Boniface celebrated the Easter baptism in the normal way at the basilica of the martyr St. Agnes'.

39 The violence is described in a letter of Symmachus to the *comes* Constantius (the future emperor Constantius III), *Coll. Avell. Ep.* 29.

40 *Coll. Avell. Ep.* 32.

41 *Coll. Avell. Ep.* 33. See also *Coll. Avell. Ep.* 34–37 on the end of the schism.

42 In a slightly different context, see McLynn (1992) 16–19; Latham (2012) 312.

43 The *Via Lata* is the name given to the intra-mural portion of the *Via Flaminia*, today Via Del Corso. On the identification of this building see Diefenbach (2007) 225 and n. 35, Brandt (2012a) 148–51, Mulryan (2014) 53–56. See also Ehrenheim (2012) 154–55; Curran (2000) 144; Trout (2015) 6, 188–89; LTUR 3.192–93. *Pace*, Cracco Ruggini (2003) 373, who states that this church is in Trastevere. As suggested by A. Ferrua, the term *in Lucinis* is likely a defective Greek genitive, which would render the phrase *in <?> Lucinae*. Most agree that the missing word must be *basilica*, not *titulus*, which in any case is anachronistic to the mid-4th c. Krautheimer (1937–1980) 2.182–84 found that the masonry excavated under the modern San Lorenzo in Lucina dates to the first part of the 5th c. This, together with the literary evidence, suggests that the early basilica on this site was constructed during the pontificate of Sixtus III (432–440), although Krautheimer was equally convinced that the building in which Damasus was elected also existed on or near this site in 366. Blair-Dixon (2007) 71–72, also identifies the precursor of San Lorenzo in Lucina as a building of Sixtus III, noting that excavations have shown that this site was likely a public or commercial zone in the 4th c., with a second Christian phase evident only from the early 5th c. onwards., Lizzi Testa (2004) 146–47, has suggested that the *basilica* (or *titulus*) *in Lucinis* was in fact the same church as the *titulus Marcelli*, which is under the modern St. Marcello al Corso and is quite near San Lorenzo in Lucina. On this building, see Krautheimer (1937–1980) 2.211–12, LTUR 3.211–12. More recently, however, scholars have reassessed the archeological evidence. Although there is not yet a consensus, most reject the connection between *in Lucinis* and the *titulus Marcelli* and several recent studies have concluded that the earliest phase of this site may indeed be connected to Damasus rather than Sixtus. See, for instance, Brandt (2012a) 105, (2012b) 28. According to Ehrenheim (2012) 159 and Brandt (2012a) 150–51, Damasus' 'basilica' *in Lucina* may refer to a church, or possibly a large hall where a congregation met before it was formally associated with a particular building. Mulryan (2014) 55 and n. 59, interprets the site as containing a mid-4th c. Christian structure, perhaps a small apsed hall, which was then largely demolished to make way for the 5th c. church built by Sixtus. While certainty is not possible given the state of our evidence, at a minimum we can say with confidence that the basilica *in Lucinis* referred to in the *Gesta* was in the northern part of the Campus Martius, and likely under San Lorenzo in Lucina. Even if we identify *in Lucinis* with the nearby *titulus Marcelli*, which is only approximately 650 m south of San Lorenzo in Lucina, we are left with the same conclusion: Damasus was selected as bishop by his supporters in this part of the city.

44 The *Lib. Pont.* states that Damasus built a church dedicated to Laurence *iuxta theatrum*, i.e. the Theatre of Pompeii, although there is some evidence to suggest that he may have substantially renovated an existing structure. The ancient building was destroyed in the 15th c. to make way for the Palazzo della Cancelleria; the modern San Lorenzo in Damaso was constructed to the north of the original site. See Krautheimer (1937–1980) 2.145–51, LTUR 3.179–82; Blair-Dixon (2002) 331–37; Mulryan (2014) 86–89; on Damasus' family connections to this area and early career, see Löx (2013) 26–27.

45 *Gesta* (*Coll. Avell. Ep.* 1.7 and 1.12, p. 2).

46 As the name of these churches suggest, both are attributed to Julius I (337–352). They are mentioned in Liberian Catalogue (Duchesne, *Lib. Pont.* 1.9) and in the *vita* of Julius in the *Liber Pontificalis*, which simply states '*Fecit basilicas* II, *una in urbe Roma iuxta forum et altera trans Tiberim*' – 'He built two

trol of the Lateran. This was followed by the massacre at the *basilica Liberii* on the Esquiline.[47] After this, Ursinus and his partisans struggled to maintain their foothold in the city centre and were eventually forced into the *suburbium*. Finally, and only after securing control of the intra-mural churches, Damasus extirpated the last vestiges of Ursinian support, which had coalesced around the extra-mural martyrial complex of St. Agnes.

While our surviving sources for the Eulalius/Boniface schism are not as rich in topographical detail, it appears that Eulalius, like Damasus, focused his efforts on securing control of the churches in the city centre. He quickly took control of the Lateran, where he was elected and ordained. Boniface, on the other hand, was elected at the now unidentifiable church of St. Theodore[48] and was ordained at St. Marcellus, today San Marcello al Corso to the south of St. Lorenzo in Lucina on the *Via Lata*.[49] Following his ejection from the city in the early phase of the schism, Boniface occupied St. Paul's Outside the Walls. Then, according to the *Lib. Pont.*, when both men had been exiled by the emperor, Eulalius and Boniface took up residence in martyrial cemeteries, Boniface at the cemetery of Felicitas, identified by De Rossi as a catacomb complex outside the Porta Salaria, about a mile from the city,[50] and then at St. Agnes, while Eulalius is said to have lived at St. Hermes at Antium (Anzio), although this likely refers to the *Basillae coemetrium* (Catacomba di Sant'Ermete/Catacombe di Bassilla) just north of the city where Hermes was thought to have been buried.[51] When Eulalius grew overconfident or impatient and returned to the city without permission, he again seized the Lateran. If he had hoped this act would make his episcopacy a *fait accompli*, it backfired spectacularly and Eulalius lost whatever support he still had at court.

The focus on intra-mural churches, especially during the early phases of these controversies, makes sense in light of the accepted model of episcopal oversight and community leadership in the later 4th c., which, as Steffen Diefenbach has described, expected Roman bishops to be able administrators, spiritual leaders for the Christian community, and importantly a visible presence within the city.[52] In both schisms, the main prize was the Lateran, the principal symbol of papal authority and the location from which Rome's bishops

basilicas, one in Rome close to the Forum, the other across the Tiber'. The *basilica Iulii iuxta Forum Traini* was identified by Duchesne (*Lib. Pont.* 1.205, n. 4) as a precursor of ss Apostoli; this proposal has received a mixed reception. See Krautheimer (1937–1980) 1.77–181 and LTUR 4.85. While its exact location and identity are uncertain, judging by its name, we can safely conclude that this church was near the forum of Trajan. The *basilica Iulii trans Tiberim* was also known as the *titulus Callisti* and finally as St. Maria in Trastevere. See Krautheimer (1937–1980) 3.65–71, LTUR 3.219–20. Pietri (1997) 33; Curran (2000) 138; Löx (2013) 27; Trout (2015) 6, prefer St. Maria in Trastevere as the location of Ursinus' election and the subsequent confrontation with Damasus' supporters, while Künzle (1961); De Spirito (1994) 267; Cracco Ruggini (1997) 170, n. 42, Latham (2012) 310–11; and Diefenbach (2007) 224–26, argue for the church in *Regio* VII near the city centre. Curran cogently argues that the *Gesta inter Liberium et Felicem episcopus*, the document, which contains this information, mentions the *basilica Iuli in Trastevere* 10 lines before it discusses the church in which Ursinus was elected. It would thus be strangely obscure if the second, less precise, reference referred to a different church, especially in a document in which precision regarding geographic locations was important. A slightly different reading suggests the opposite conclusion. The text is careful to distinguish between the two churches. Liberius' adversary Felix is described as having occupied the ⟨basilica⟩ Iuli trans Tiberim (*Coll. Avell. Ep.* 1.3) – clearly the future St. Maria in Trastevere, whereas Ursinus' election took place in a building called the *basilica Iuli* (*Coll. Avell. Ep.* 1.5). Curran's reading is certainly possible, but the fact that the author refers to this church differently may suggest that he intended a different *basilica Iuli*, which can only mean the building near the forum of Trajan. I believe the preponderance of evidence suggests this latter explication; however, our evidence is simply not sufficient to definitively prove the point either way. An overview of the debate can be found in Ghilardi (2010) 183–185.

47 Krautheimer (1937–1980) 3.1–60, esp. 54–55.
48 A church dedicated to Theodore at the foot of the Palatine is not documented before the 8th c. See Krautheimer (1937–1980) 4.279–88.
49 In an earlier essay, Dunn (2015a) 2, argued that Boniface was ordained at San Lorenzo in Lucina. He now believes this church was San Marcello al Corso. See Dunn (2015b) 148 and n. 40. On this church, see Krautheimer (1937–1980) 2.205–15; Brandenburg (2005) 164–65.
50 De Rossi (1864) 176–77, noted by Duchesne in *Lib. Pont.* 1, 229 n. 13. See also now LTURS 2.245–47. The 6th c. pilgrims' guide known as the *Itinerarium Salisburgense* notes that the church of St. Felicitas, next to the *Via Salaria*, contained the body of the saint. See *Itinerarium Salisburgense*. St. Marcellus is described in Krautheimer (1937–1980) 2.205–15.
51 The *Depositio Martirum* (*Lib. Pont.* 1.12) states that the martyr Hermes buried is 'in Basillae Salaria vetere.' This site refers to the *Basillae coemetrium*. It lies less than 2 km north of the Porta Pinciana along the *Via Salaria Vetus* – that is, in the opposite direction of Anzio – over which the Basilica of Basilissa, another Roman martyr thought to be buried in this location, was built. See LTURS 1.211–16; LTURS 3.61–65; Barbini (1998) 115–19, esp. 117; Löx (2013) 213–14. Damasus intervened in this location and may have initiated the early phase of the church's construction; he also composed *elogia* for several martyrs buried at this site, including for Hermes. These are translated in Trout (2015) 170–72. Given its proximity to Rome and its association with Damasus, Eulalius likely stayed in this location during his exile. Anzio, in contrast, is almost 60 km from Rome.
52 Diefenbach (2007) 231–32.

traditionally presided. It was also closely associated with Constantine and the imperial family.[53] The two *basilicae Iulii*, and the *basilica Liberii*, obviously connected to Damasus' immediate predecessors Julius I and Liberius, together with the other intra-mural churches, were the symbolic and bureaucratic heart of the Roman church and the buildings from which popes traditionally exercised their authority and interacted directly with the community as the leader of the *plebs sancta*. In contrast, the churches beyond the walls were peripheral to the administration and the identity of the Roman church.[54] Even the cult sites related to Peter and Paul at the Vatican and south of the city along the *Via Ostiensis* respectively appear to have had little power to legitimise those who controlled them.[55] And from a practical standpoint, while the Aurelian Wall was hardly an impenetrable barrier in peacetime – it regulated rather than prevented movement altogether – it could nevertheless disrupt contact between the *suburbium* and the urban population, a potential obstacle for an aspiring bishop of Rome.[56]

Marginal People and Spaces within and beyond the Walls

If this analysis is correct, the ideological significance of the martyrial shrines and cemeteries outside the city for the protagonists in these schisms was far less important than controlling the mechanisms of power and symbols of authority within the city. Indeed and somewhat surprisingly, although Rome's extra-mural cemetery spaces were closely connected with Rome's saints and martyrs – a feature I will consider in more detail below – they were also foreboding, marginal places. Jerome, who had been Damasus' secretary and advisor in the early 380s, remembered exploring the cramped and claustrophobic crypts of the apostles and martyrs as a schoolboy.[57] Bodies were buried in the walls on both sides of a narrow passage dug so deep into the earth that only rarely did daylight "temper the horror of the shadows." As Jerome tells it, his visits to the catacombs were comparable to Virgil's descent into the underworld: "horror ubique animos, simul ipsa silentia terrent."[58] But it was more than darkness that worried some Romans about the city's cemeteries and the zones near and beyond the walls.

As we have seen, the topographical details in the *Gesta* suggest that Damasus' core supporters were based in the Campus Martius and it was from here that he recruited an *imperita multitudo* of charioteers, gladiators, and *fossores*. Importantly, this area, as well as the extra-mural regions adjacent to XIV *Regio* (*Transtiberim*, modern Trastevere) and IX *Regio*, such as the *Ager Vaticanus/Vaticanum* and the zone around the Janiculum, had mixed reputations in antiquity. For one, this entire area was prone to destructive flooding, a fact which explains why aristocratic *domus* tended to be situated on the city's hills.[59] *Transtiberim*, which had been incorporated within Aurelian's walls at the end of the 3rd c., was also home to various noxious or otherwise dangerous activities such as tanning, which processed leather using urine and feces, and other cottage industries, which had the effect of increasing the risk of fire. It was also associated with migrants and other *peregrini*, especially newcomers from the East, although our evidence for this is admittedly circumstantial.[60] It is, however, likely that the combination of poverty and danger suppressed rents in *Transtiberim* relative to other areas of the city.[61] Similar trends can also be detected in the Campus Martius. For instance, a law of 397 forbad the constructions of "huts and hovels" (*casas seu tuguria*) in the Campus Martius, where private buildings of poor quality were encroaching on what had traditionally been public space.[62] The occupants of this shantytown were presumably newly arrived migrants to the city, as well as Romans who had been made homeless through fire, flood, or eviction. The association between Damasus and the *imperita multitudo* including *fossores* and members of the *factiones* reported in the *Gesta* may represent a generalized anxiety felt by some at the prospect of the development of novel ties of patronage with these unfortunate Romans, as well as with foreigners and marginal workers who lived in these areas and the zones immediately outside the walls. It may also reflect the traditional aristocratic chauvinism against those on the lower end of the social spectrum who were themselves, as we have seen, connected to the margins of

53 The Lateran as "the prize", McLynn (1992) 16. As Curran (2000) 139 noted, "The prize in the dispute of autumn 366 was the *episcopium* itself on the Lateran, but the *choice* of Damasus and Ursinus took place elsewhere".

54 Shepardson (2014) 22–23 has noted a similar pattern in 4th c. Antiochene ecclesiastical politics, where control of the Great Church was key to episcopal authority in the city.

55 Diefenbach (2007) 239–41.

56 Dunn (2015b) 153. On the symbolic importance of the wall, see Dey (2011) 116–23. On the other hand, the extra-mural cemeteries were as close to the city as one could be while still technically being outside it.

57 On Jerome's relationship with Damasus, see, for instance, Rebenich (2002) 31–40.

58 Jer., *Comm. in Ezech* 12. See also Grig (2012) 133–34.

59 Aldrete (2007) 33–50, 213–15.

60 Noy (2000) 150–51.

61 Abrecht (2019) 4–6.

62 *Cod. Theod.* 14.14.1 (397). See also Lippolis (2007) 201.

the city and the *suburbium*. This would make especially good sense if Ursinus' backers were drawn from some of Rome's wealthiest families, as has been suggested by Rita Lizzi Testa, although Damasus too had his share of aristocratic support.[63]

In addition to the poor and foreigners, this area was also home to both the entertainment and funerary industries.[64] The Circus Maximus was the most important venue for racing. But Rome had additional circuses and informal spaces for racing concentrated in the Campus Martius, as well as outside the walls.[65] The city's circus factions were also based in the Campus Martius, especially between the modern Palazzo della Cancelleria and Palazzo Farnese – that is to say, in and around the *titulus Damasi*.[66] Tellingly, the *titulus Damasi* was also known in antiquity as *in prasino* after the stables of the Green *factio*.[67] This further suggests that Damasus' family, which likely owned the property before it became a church, may have had a relationship with the Greens, which Damasus was able to exploit after his election to recruit *quadrigarii* and the other members of his *imperita multitudo*.[68] Drawn from the margins, gladiators and charioteers were largely slaves (although they could be quite famous and even rich), and they were closely associated with violence, both as individuals and as part of the *factiones* whose supporters occasionally engaged in destructive rioting in the city.[69] The thuggish reputation of charioteers was further degraded by their association with magic.[70]

Damasus' funeral workers were also likely recruited nearby, presumably from the cemeteries beyond the walls to the north and west of the Campus Martius. The identity and makeup of the *fossores* are disputed, but it appears that they were independent from the church.[71] Christian funerary workers were certainly viewed with less opprobrium than their stigmatized predecessors, but like charioteers and gladiators, the *fossores* had a reputation for violence, in Rome and elsewhere. Sarah Bond has noted that Alexandrian bishops relied on funerary workers (the *parabolani*) as personal enforcers during disputes, most notoriously Dioscorus' suppression of his opponents at the second ('Robber') council of Ephesus in 449.[72] That Damasus and his backers were able to recruit a small private army is also indicative of a wider trend, as some members of Rome's leading aristocratic families, many of whom lived in suburban villas beyond the Tiber, may have begun to form links of *clientela* not only with the traditional Roman *plebs*, but also with precisely the *peregrini*, *fossores*, *arenarii*, and *quadrigarii* associated with Rome's funerary and entertainment spaces.[73]

Aside from these socially marginal individuals, the zone beyond the walls was associated with unofficial Christian sects who were thought to gather in these spaces. In the second half of the 4th c., imperial concern for religious orthodoxy prompted increasingly punitive laws directed against groups declared to be heretical. While later legislation would banish heretics from the empire entirely, in the 4th c., it was good enough, at least in the short term, to expel them from the cities.[74] Reflecting the urban perspective of the legislators, the aim of these laws was to drive heretics from urban centres, especially Rome and Constantinople. The fact that the surrounding countryside would as a result be flooded with heretics and sectarians was at best a secondary consideration.[75] Thus, imperial legislation may well have caused the 'problem' of heretical gatherings

63 Both Damasus and Ursinus had some level of aristocratic support, but Ursinians may have enjoyed the backing of particularly high-status nobles. See Lizzi Testa (2004) 237. But cf. Löx (2013) 28–30.

64 Cracco Ruggini (2003) 374–75. On the status of *peregrini* in Late Antiquity, see Mathisen (2006).

65 The Circus Flaminius was located in the southern Campus Martius, although it appears to have been used infrequently and later, was also employed as a marketplace. The most important informal location for chariot and horse races and training was the so called Trigarium, an open space west of the stables of the factions also in the Campus Martius. Several additional circuses can be found beyond the Aurelian Wall. To the north, *Circus Gaii et Neronis* in the Ager Vaticanus was a substantial complex but was likely been returned to the people by Vespasian after Nero's downfall and may have been transformed into a public garden. What remained of its superstructure was demolished to make way for St. Peter's; nearby was the *Naumachia Traini* (or the *Circus Hadriani*) and an unnamed second Naumachia in XIV *Regio*. The Circus Varianus was built in the east during the reigns of Caracalla (198–217) and Heliogabalus (218–222). It was truncated by the construction of the Aurelian Wall in the 270s but appears to have remained in use afterwards. To the south along the *Via Appia*, Maxentius constructed his circus in the early fourth century. See LTUR 3.338–39; Richardson (1992) 266; Humphrey (1986) 540–60.

66 LTUR 4.339–40; Richardson (1992) 366; Pentiricci (2009) 291–312.

67 Krautheimer (1937–1980) 2.145–46; Blair-Dixon (2002) 338; Reutter (2009) 100–101. On the Green circus faction stables (*stabulum factionis praesinae*), see Mulryan (2014) 86–87, with nn. 4–6 on the archaeology of this site.

68 Trout (2015) 189; Cracco Ruggini (2003) 373–74, and n. 44.

69 Amm. Marc. 15.7.2; 28.4.29–31. In general, see Cameron (1976).

70 Lee-Stecum (2006) 225.

71 Guyon (1974) 574–80.

72 Bond (2013) 137, 138–43.

73 Cracco Ruggini (2003) 376.

74 Humfress (2008) 133. For example, *Cod. Theod.* 16.5.14, 18 and 34.

75 Hillner (2015) 214–15.

beyond the city walls. Non-conforming Christians simply had nowhere else to go.

Several examples of this can be detected in our Roman sources. For instance, the African bishop Optatus of Milevis described the Donatist congregation in Rome in the 360s, which consisted of an autonomous church with a succession of bishops who served a *paucus erraticus* – a small handful of transients who refused to be in communion with the official church.[76] Barred from meeting in any of the city's basilicas, Optatus claims, the Donatist schismatics were forced to meet in a decorated *spelunca foris a civitate*, with *spelunca* here almost certainly referring to a catacomb cemetery.[77] Interestingly, Optatus also highlighted the importance of the extra-mural shrines (*memoriae*) of Peter and Paul and claims that the Donatists failed to recognize them – a fact which highlighted their otherness, placing them outside the body of the legitimate church. Optatus' mobilisation of both the positive cemetery (home of the saints and their shrines) and the negative (dark *speluncae* of schismatics) demonstrates the rhetorical flexibility of these spaces, a feature which will be taken up by subsequent authors, as we shall see.

Similar associations between non-conforming Christian sects and the cemetery can be found in the work known as the *Praedestinatus*. Written in Italy between 432 and 440, the *Praedestinatus* contains a catalogue of heresies, which includes a curious entry about Tertullianists (*Tertullianistae*, i.e. Montanists) at Rome. The text claims that North African aristocrats named Octaviana and her husband Hesperius, who were supported by the powerful patrons Emperor Magnus Maximus (d. 388) and *magister militum* Arbogastes (d. 394), received permission to build a *collegium extra muros Urbis* for their Tertullianist minister.[78] They then seized a "place of our saints" (*sanctorum nostrorum locus*) – a reference to the tombs of the Roman martyrs Processus and Martianus on the *Via Aurelia*.[79] The phrase 'our saints' conceals the fact that the Montanists claimed Processus and Martianus every bit as much as the Catholics did. Jerome's opponent Jovinian was likewise associated with the suburbs of Rome. A law of 398 (?), preserved in the Theodosian Code, states that Jovinian was holding sacrilegious meetings "outside the walls of the most sacred City," although the reference here is likely to aristocratic villas rather than cemeteries. The law goes on to command that Jovinian be arrested, beaten, and forced into exile.[80] And finally, in the 370s, Damasus promoted the cult of Hippolytus on the *Via Tiburtina*, likely as an orthodox counterpoint to the nearby tomb of Novatian, around which supporters of Lucifer of Cagliari and possibly also of Ursinus were known to gather.[81]

These examples suggest that in the later 4th c., there was a very real conflict over the control of Rome's extra-mural cemeteries. This reflects the jurisdictional reality that in this period, Roman bishops had little authority in the *suburbium*. The city's intra-mural basilicas and titular churches were technically under the authority of Rome's bishops, although the *tituli* appear to have administered their patrimonies independently.[82] By the end of the 5th c., Rome's bishops celebrated stational liturgies in *tituli* and other minor non-titular basilicas, creating a "network of holy places administered by ecclesiastically sanctioned officials," in the analysis of Harry Maier.[83] But beyond this network, Rome also had a secret heterodox topography, focused on private, often domestic, space beyond the walls and supported by patronage from suburban elites.[84] Even Rome's extra-mural churches remained liturgically disconnected from the urban church well into the 5th c. and beyond. The most tangible manifestation of this division was the *fermentum*, a host consecrated by the bishop of Rome for use in the Mass celebrated in the churches *intra urbem*. Crucially, the *fermentum* was not sent to the suburban *parochiae* and *coemeteria*.[85] A letter of Innocent I (401–417) to Decentius, bishop of Eugubium (Gubbio) in Umbria, which describes the *fermentum*, suggests that during Innocent's pontificate there were two separate areas of ecclesiastical authority: the urban churches under the jurisdiction of the bishop of Rome and the suburban churches beyond the walls.[86]

76 Opt. 2.4 (SC 412, p. 246). As Optatus tells it, a small community of Donatists had established themselves at Rome, and subsequently asked that a bishop be sent from Africa to minister to them. This began the Donatist church in the city. On Optatus and his polemic against Donatism, see esp. Merdinger (1997) 50–60.

77 Opt. 2.4; on *spelunca* as cemetery, see Maier (1995) 246.

78 The text emphasizes the relationship between the Montanists and Magnus Maximus, the usurper who had overthrown Gratian, and Arbogastes, who, after promoting the ill-fated Eugenius was to die at the Battle of the Fridigus, in order to damage the Donatists' reputation.

79 *Praedestinatorum Haeresis* 86. See also Bowes (2008) 102.

80 *Cod. Theod.* 16.5.53.

81 Sághy (1998) 260–61; (2000) 283–86; Trout (2015) 11.

82 Hillner (2007) 231–37.

83 Maier (1995) 232. On the development of the stational liturgy, see Baldovin (1987) 150–53. The *Gesta* states that Ursinus' supporters '*per coemeteria martyrum stationes sine clericis celebrabat*' – 'held services without clergy in the cemeteries of the martyrs'.

84 Maier (1995) 235ff.

85 Cabié (1973) 26–29. On this letter and the *fermentum*, see Saxer (1989) 924–30.

86 Hillner (2006) 61; Dey (2011) 217–18; Saxer (1989) 925.

The most important and impressive of these churches, such as St. Agnes, were imperial foundations which had no initial relationship with the city's bishops.[87]

Saints and Martyrs beyond the Walls: Losers' Histories and the Reimagining of Cemetery Exile in the 4th and 6th c.

The negative view of the areas around and beyond the walls was a matter of perspective. For candidates in control of the administrative heart of the church such as Damasus and Eulalius (only temporarily, in Eulalius' case), the periphery of the city including the suburban cemeteries must have appeared as potentially dangerous space at the edge of their control. And it did not help that their adversaries had taken refuge precisely in this area. But things looked quite different from the viewpoint of Ursinus and Boniface. Unable to access the traditional loci of papal power inside the city, Ursinian propagandists turned this disadvantage into a virtue by inverting Rome's traditional sacred topography in order to make the area outside the walls a legitimate site for a Roman bishop. They did this by appealing to the discourse of persecution, exile, and martyrdom, viewed through the lens of the extra-mural cemeteries and martyrial churches. The *Gesta* claims that Damasus oppressed (*perurguere*) the Roman people, while the venerable Ursinus was sent *in exilium*.[88] No longer the loser in the fight to control the See of St. Peter, the *Gesta* depicts Ursinus as a heroic defender of the faith. Damasus, in contrast, is recast as an imperial persecutor who oppressed the Roman people, or as a *traditor* who had betrayed the church during times of persecution. The description of the violence is also evocative of *passiones*. Again, Damasus' partisans play the role of imperial persecutors who attacked and murdered the largely passive Ursinians. Like a martyr, Ursinus, a *uir sanctus et sine crimine* according to the text, gave himself over into the hands of his enemies.[89] With their leader exiled from the city and despite being harassed by many Damasean persecutions (*multis persecutionibus fatigatus*), the supporters of Ursinus fearlessly conducted religious services in the suburban cemeteries including that of St. Agnes, where many of them were martyred.[90] The polemical nature of the source makes it difficult to know whether the details of the Ursinian occupation of the cemeteries are accurate, or whether this is a literary conceit. But this appeal to spiritually meritorious exile and ultimately death for the 'true faith' may well have appealed to some of Ursinus' radical supporters.[91] The association between the Ursinians and the cemetery of St. Agnes may also reflect an effort to associate Ursinus with St. Agnes and Liberius. The admittedly later *Liber Pontificalis*, which I will discuss in greater detail in a moment, claims that Liberius decorated (*ornare*) the tomb of St. Agnes.[92] Liberius was also supposedly buried close to St. Agnes at the cemetery of Priscilla on the *Via Salaria*, a further connection between the bishop and the saint.[93] Considering the author of the *Gesta* viewed the schism as a conflict between those who had remained loyal to Liberius during his exile (e.g. Ursinus) and those who had betrayed him and become supporters of Liberius' opponent Felix (Damasus), the emphasis on the massacre at the cemetery complex of St. Agnes in the *Gesta* could be understood as an attempt to further link Ursinus with Liberius.[94] Or perhaps this event occurred in roughly the way it is described. Whatever the case, the cemetery is represented in the *Gesta* as a place where persecuted leaders of the church endured exile, and in doing so, lived in emulation of the martyrs.

Boniface's biographers in the *Lib. Pont.* also emphasized his connection with Rome's martyrial cemeteries, specifically the cemetery of Felicitas, where he was said to have lived, and the nearby cemetery basilica of St. Agnes, on the *Via Nomentana*, where he supposedly celebrated Easter and baptized catechumens. But unlike the *Gesta*, which although a piece of pro-Ursinus propaganda is at least roughly contemporary to the events it depicts, Boniface's cemetery exile is described only in the *Lib. Pont.*, which as I noted in the introduction, is a problematic source. The immediate local context for its compilation is generally thought to have been

87 Curran (2000) 128.
88 *Gesta* 2; 6; cf. Raimondi (2009) 171–72.
89 *Gesta* 11: '*Ursinus episcopus uir sanctus et sine crimine consulens plebi tradidit se manibus iniquorum et sexto decimo Kal. Decembr. iussione imperatoris ad exilium sponte properauit*' – 'Bishop Ursinus, a holy man and having committed no crime, out of regard for the people gave himself into the hands of wicked men, and on the 16th day before the Kalends of December, by order of the emperor, hurried into exile of his own accord'.
90 *Gesta* 12.
91 Ursinus' supporters are sometimes associated with Lucifer of Caligari. Mommsen (1898) 175, refers to the Ursinians as intransigent zealots (*intransigenten Eiferern*).
92 *Lib. Pont.* 36: '*Hic Liberius ornauit de platomis marmoreis sepulchrum sanctae Agnae martyris*' – 'Liberius decorated the tomb of the martyr St Agnes with marble tablets'.
93 *Lib. Pont.* 36: '*Qui etiam sepultus est uia Salaria, in cymiterio Priscillae*' – 'He was buried on the *Via Salaria* in the cemetery of Priscilla'. On this location and its association with St. Agnes, see Curran (2000) 135f.
94 If this is true, it is noteworthy that the memory of Liberius, which is controversial in later sources such as the *Liber Pontificalis*, was in the 4th c. thought of as legitimising.

the Symmachian/Laurentian Schism, which lasted from 498 until 506/507.[95] The apologetic tone of the *vita* of Symmachus in the *Lib. Pont.* has prompted scholars including myself to view the *Lib. Pont.* as a Symmachian production created in part to support his claim over and against Laurentius, although as I have also noted, it is significant that Laurentius is not harshly criticized.[96] In her new study, McKitterick has sensibly argued the *Lib. Pont.* is best understood as part of a generalized response to the various crises then engulfing Italy rather than a specific reaction to the Symmachian/Laurentian Schism.[97] In any case, it is clear that the *Lib. Pont.* took particular interest in the history of Roman schisms, the interpretation of which had a direct bearing on the legitimacy of Symmachus or perhaps of the early 6th c. Roman church more generally.[98] Indeed, the compilers of the *Lib. Pont.* appear to present earlier papal schisms, especially that of Boniface and Eulalius, as cyphers for that of Symmachus and Laurentius. Both Boniface and Symmachus faced a contested papal election; neither initially controlled the traditional and symbolic centre of papal power at the Lateran and both men were relegated to extra-mural martyrial basilicas, Boniface at St. Paul's, Symmachus at St. Peter's.[99] Additional details from Boniface's *vita* also echo those of Symmachus. It is striking, for instance, that the *Lib. Pont.* associates Boniface with the cemetery of Felicitas, where he was said to have lived while exiled from the city, and the martyrial complex of St. Agnes, where he conducted Easter baptisms.[100] Boniface is later reported to have constructed an oratory *in cymiterio sanctae Felicitatis* and decorated her tomb.[101] These same structures were later patronized by Symmachus, who is said in the *Lib. Pont.* to have "repaired the basilica of S. Felicitas" and to have "renewed the apse of [the church of] S. Agnes," both of which are said to have fallen into disrepair.[102] Similar resonances, especially the shared connection to Agnes, can be detected in the *Lib. Pont.*'s *vita* of Liberius. In his own time, Liberius had been a divisive figure thanks to his capitulation to the 'Arianising' emperor, Constantius II. For his part, Symmachus had been accused of various improprieties including sexual misconduct, mismanaging church property, and celebrating Easter on the wrong date.[103] Both men faced serious challengers who controlled the city; Symmachus was relegated to St. Peter's during much of his conflict with Laurentius, while Liberius, at least according to the *Lib. Pont.*, lived 'at the cemetery (*in cymiterio*) of St. Agnes with the emperor's sister Constantia [*sic*, Constantina]' upon his return from exile.[104]

Despite the suspicious similarities between Boniface and Symmachus in the *Lib. Pont.*, it is at least possible that Boniface's connection to St. Felicitas and St. Agnes reflects historical reality. Dunn, for instance, accepts the story of Boniface living in the cemetery of Felicitas at face value.[105] After all, he had to live *somewhere* while the emperor decided between himself and Eulalius. And like Ursinus, banned from the city and unable to access Rome's traditional power centres, Boniface (or perhaps the author(s) of his *vita*) later appealed to the sanctity of the cemetery to legitimise his claim to the episcopacy. His subsequent patronage of St. Felicitas and St. Agnes

95 On the Laurentian Schism, see esp. Wirbelauer (1993); Sardella (1996); Sessa (2012) 208–246; Cohen (2015) 198ff.

96 This is especially true when contrasted to an unabashedly pro-Laurentian document known as the *Laurentian Fragment*, which is edited by Duchesne in his edition of the *Liber Pontificalis* (1886–1892) 1: 44–46.
 Schism as context for the creation of the *Lib. Pont.*, see Wirbelauer (1993); Blair-Dixon (2007); Cohen (2015) esp. 200–202.

97 McKitterick (2020) 32. Verardi (2019) 371 makes a similar observation.

98 Blair-Dixon (2007) 66; Cohen (2015) 201–202.

99 It was during his time at the Vatican that Symmachus engaged in a program of renovation of St. Peter's, which for the first time made it a suitable administrative alternative to the Lateran. See Thacker (2013) 152. It is also noteworthy that the *Lib. Pont.* claims that Cornelius (251–253) was responsible for translating the relics of St. Peter to the Vatican. As Cooper (1999) 309 notes, this story, which explained how the relics of Peter were in fact at the Vatican and not at the basilica *ad catacumbas* (San Sebastiano fuori le mura) where Peter and Paul had been jointly venerated since the 3rd c., likely reflects the Symmachian attempt to enhance St. Peter's in both ideological and architectural terms.

100 Assuming that Boniface did indeed spend time in these cemeteries while his dispute with Eulalius was resolved, we need not imagine that he dwelt underground. It is much more likely, as Geoffrey Dunn has suggested, that he lived in a multi-purpose hall above the cemetery of Felicitas, chosen both because it was a convenient location near but still outside the city, but also amongst the saints, which perhaps added an aura of sanctity to Boniface. Dunn (2015b) 137–38.

101 *Lib. Pont.* 44.

102 *Lib. Pont.* 53: '*Hic reparauit basilicam sanctae Felicitatis, quae in ruinam inminebat. Hic absidam beatae Agnae quae in ruinam inminebat et omnem basilicam renouauit*' – 'He repaired the basilica of St Felicity, which was liable to collapse. He renewed the apse of St. Agnes' which was liable to collapse, and the whole basilica'.

103 On the accusations against Symmachus, see Sardella (1996) 26–29; Sessa (2012) 212–46; Cohen (2015) 198–200, and n. 7.

104 *Lib. Pont.* 37: '*Rediens autem Liberius de exilio, habitauit in cymiterio (…)*'. The text here must refer to Constantina, the daughter of Constantine who lived at Rome between 337 and 350 and not the emperor's sister Constantia, who died in 328. Constantine's similarly named granddaughter was born in 362. See Duchesne (1886) 208f, as well as Krautheimer (1937–1980) 1.34. and PLRE 1, 'Constantina' 2.

105 Dunn (2015b).

served much the same purpose. Symmachus' renovation of these same spaces in the 6th c. may represent his attempt to evoke the memory of Boniface. It is also conceivable that Boniface's relationship with these cemeteries was an agglomeration of invented details, which coalesced around a core of historical information over decades; or perhaps it was a 6th c. fabrication intended to stress Boniface as an antecedent of Symmachus. The *Lib. Pont.* was certainly not above manipulating evidence in order to present a particular narrative of the Roman church and to provide historical examples for later innovations.[106] As with the *Gesta*, what is important here is the emphasis the *Lib. Pont.* places on Boniface's association with cemetery spaces, whatever its historicity. To a 6th c. audience, the analogy between Boniface and Symmachus would have been clear. In particular, the story of Boniface's Easter baptisms outside the walls at St. Agnes provided an important precedent for Symmachus to do likewise when Laurentius controlled the Lateran.

Liberius' connection to St. Agnes is less convincing historically. The *vita Liberii* preserved in the *Lib. Pont.* is clearly garbled.[107] For one, it confuses Constantia for Constantina, who in any case had died 3,000 km away several years before Liberius became bishop.[108] There is, however, some albeit problematic evidence to support Liberius' decoration of the tomb of St. Agnes. A lengthy inscription in praise of the saint, preserved in the 8th/9th c. *Sylloge Centulensis*, could belong to Liberius, although this is by no means certain.[109] There is no firm archaeological evidence to support Liberius' intervention at St. Agnes; however, the chronology of the site at least makes it a possibility.[110] In fact, his act of memorialization may lie at the core of the tradition linking Liberius and Agnes, to which the story of the cemetery exile was later appended.[111] And while the similarities between Liberius and Symmachus in the *Lib. Pont.* are perhaps not as striking as those linking Boniface and Symmachus, they were obvious enough that Symmachian propagandists composed the *Gesta Liberii*, a forgery, which presents a thoroughly pro-Liberian (and thus pro-Symmachian) history of Liberius' pontificate that also happens to respond to specific accusations made by Symmachus' opponents. In the *Gesta Liberii*, we learn that the emperor Constantius II (referred to as Constans throughout) forced Liberius to live "as an exile in the cemetery of Novella on the *Via Salaria* three miles from the city of Rome."[112] Banished from the city, Liberius consulted the future popes Damasus and Siricius, and decided to baptize 4,012 new Christians at the nearby Ostian cemetery in emulation of the Apostle Peter, who had allegedly also performed baptisms at this same location. Here again, we are presented with the now familiar themes of cemetery exile and extra-mural Easter baptisms. The *Gesta Liberii* adds the additional element of Liberius' consultation with Damasus and Siricius and his emulation of St. Peter, all of which were intended to emphasize Liberius' (and thereby Symmachus') legitimacy as the bishop of Rome. And again, the cemetery is the focus of this legitimacy.

The supporters of Symmachus' rival Laurentius also understood the importance of the Liberius/Felix schism. Laurentian propaganda depicted Liberius, standing in for Symmachus, as a puppet of the emperor and a traitor to the faith.[113] The partisans of Felix, in contrast were reimagined as staunch defenders of orthodoxy and ultimately, as martyrs. And in the Laurentian texts, the cemetery once again plays an important role. For instance, much of the drama of the (entirely fictional) *passio* of Eusebius the Priest, a document produced by partisans of Laurentius, revolves around the attempt to recover and bury the body of the martyr. Upon Liberius' return from exile, Eusebius denounced the pope and the emperor as heretics. As a result, he was martyred, dying after several months locked in a cupboard. Two priests named Gregory and Orosius recovered Eusebius' body and buried it near 'the martyr and bishop Sixtus, in the cemetery of Callistus on the *Via Appia*.'[114] When the emperor found out that Eusebius' body had been buried, he ordered that Gregory be buried alive in Eusebius'

106 Curran (2000) 94. For instance, Boniface's *vita* predictably omits any mention of the court's initial support of Eulalius, which is evident from the *praefectus urbi* Symmachus' surviving correspondence.

107 I discuss the *vita* of Liberius and the later Symmachian mobilisation of the memory of Liberius in Cohen (2018).

108 Amm. Marc. 14.11.6. On Constantia/Constantina, see Jones (2007).

109 Preserved in two variants: ICUR II, 83 and 85. This inscription is accepted by De Rossi and Duchesne (*Lib. Pont.* 1.209, n. 19) as belonging to Liberius; Mommsen (1898) 176–78 suggests Felix II.

110 Krautheimer (1937–1980) 2.34–35; LTURS 1.34.

111 See *Lib. Pont.* 37. See also Diefenbach (2007) 449, n. 164. That nothing remains of the Liberian decorations need not suggest that they did not take place. See, *contra* Diefenbach, the comments in Wirbelauer (2014) n. 33.

112 *Gesta* 3 248–60. On the cemetery of Novella, see Wirbelauer (2014).

113 That Symmachus was ultimately confirmed as bishop thanks to the support of the Ostrogothic King, Theoderic – who, like Constantius, was not an orthodox Christian – made this depiction particularly biting.

114 *De sancto Eusebio presbyero: 'sepelierunt in crypta juxta corpus beati Sixti martyris et episcopi via Appia in coemeterio Calisiti*', As Lapidge notes (n. 23), the Eusebius referred to here is Pope Eusebius (d. 308).

tomb. He was also eventually buried by Orosius beside Eusebius. A bloody persecution of Christians then followed. In addition to the *passio* of Eusebius, a more direct intervention in the history of Liberius and Felix can be found in another Laurentian forgery, the *passio* of Liberius' opponent Felix. This text recounts roughly the same story of Liberius' stay in the cemetery of St. Agnes with Constantia Augusta, the sister of Constantius contained in the *Lib. Pont.*[115] But unlike *Lib. Pont.*'s account, the *Passio Felicis* claims that Constantia, a "pious adherent of the Lord Jesus Christ,"[116] refused to help Liberius. Felix was nevertheless expelled from Rome and eventually martyred. Here, Laurentius' propagandists attempted to create a counter-narrative, which denies Liberius (and thus, Symmachus) his connection with Agnes and her orthodox imperial patron, Constantia.

The different portrayals of Liberius preserved in texts composed almost 150 years after his pontificate ended are a clear illustration that the history of Roman schisms became a discursive battleground on which early 6th c. authors debated episcopal legitimacy. Indeed, according to the accounts preserved in the documents considered in this essay including the *Lib. Pont.*, the *Collectio Avellana*, and the various forgeries associated with Laurentius and Symmachus, every papal schism after Constantine resulted in at least one of the protagonists spending time in a Roman cemetery: Liberius at the cemetery of St. Agnes, Ursinus at St. Agnes' and other "cemeteries of the martyrs;" Boniface at the cemeteries of St. Felicitas, St. Agnes, and St. Paul's outside the Walls; Eulalius at the shrine of St. Hermes at the *coemetrium* of Basilla; and Symmachus at St. Peter's. For the candidates who failed to gain control of the Roman church – whether it was a temporary setback, as it was for Liberius, Boniface, and Symmachus, or a permanent defeat, as in the case of Ursinus – the cemetery was a potent contrast to the traditional centres of episcopal power within the city and a legitimising symbol of sanctity for controversial bishops.

Conclusions: Cemeteries and Schisms in Late Antique Rome

The schisms discussed in this chapter were the result of factionalism and the lack of agreed upon procedures for episcopal elections. The large size of the Roman church and its growing wealth and influence also encouraged divisiveness. And there was growing scope for violence in this period. Constantine's suppression of the *equites singulares* and the subsequent disappearance of the urban cohorts and the *vigiles* meant that when violence did break out, officials such as the urban prefect Symmachus, who had to preserve the peace during the Boniface/Eulalius schism, had few coercive options available.[117] The centrality of Symmachus in the surviving sources – he dispatched and received multiple letters to and from Ravenna – hints at a second important development: after the 3rd c., the emperor was rarely resident at Rome. Thus, unlike at Constantinople, Christian emperors were not in the habit of deposing Roman bishops or otherwise interfering in the ecclesiastical politics of the city. Indeed, Constantius II's exile of Liberius in 355 is the only example of its kind until the Ostrogothic king Theoderic supposedly imprisoned John I in 526 upon his return from an embassy to Constantinople,[118] and more firmly, Belisarius' deposition and exile of Silverius in 537.[119] This is not a coincidence. The deposition of Silverius corresponds to the reimposition of (eastern) imperial authority over Rome. Until this time, however, the lack of an imperial court in the city meant that the emperor (and his soldiers) were relatively slow to respond to contested episcopal elections and the attendant outbreaks of violence. Moreover, riots at Rome were not a threat to the position of the emperor. The situation was very different at Constantinople, where the proximity of the emperor and his court meant that public disorder, whatever its cause, was closely linked to political unrest.

The importance of controlling specific church buildings and cemeteries is another distinctive feature of Roman schisms. Topographical contestation was, of course, not unique to Rome. As recent studies by Shira Lander, Christine Shepardson, and Christopher Hass have amply demonstrated, Christians (and non-Christians) fought to control contested sacred places including

115 Duchesne (1886) 120–25. Verrando (1981) 117–18. The *Lib. Pont.* also preserves a version of the *passio Felicis* as the *vita* of Pope Felix II. This is both chronologically impossible and textually inconsistent. On the confusion over Felix's identity, see Curran (2000) 132–35; Cohen (2018) 148.

116 *Passio Sancti Felicis Papae* 306. See also *Lib. Pont.* 1.207. The Latin edition consulted for this chapter was that of Verrando but see the cautionary note of Lapidge (2018) 305. There is no modern critical edition of this text.

117 On the different categories of soldiers or paramilitary forces, which could typically be found in Rome between Augustus and Constantine, see Fuhrmann (2012) 124–30, 151–58.

118 John is presented as a martyr in the *Lib. Pont.* 55. But as Sessa (2016) 442–43, argues, it is highly unlikely that the king had anything to do with John's death.

119 See, for example, Sotinel (2010).

churches and cemeteries as part of controversies in North Africa, Antioch, and Alexandria, respectively.[120] But unlike Rome, these fights were generally not schisms within the official church, but rather conflicts between the official church and dissident Christians such as Homoians ("Arians"), Donatists, and Miaphysites, or else non-Christians like Jews and Greco-Roman polytheists. In contrast, there appears to have been almost no theological content to the conflicts at Rome discussed in this chapter, with the partial exception of Symmachus, who was accused of celebrating Easter on the incorrect date.

While topographical contestation was an important feature of internal Roman ecclesiastical politics, especially in the controversies that arose in the aftermath of contested episcopal elections, it can be difficult to parse 6th c. rhetoric from 4th c. reality. Did, for instance, Liberius *really* spend time in the cemetery of St. Agnes? Did the *Gesta* fabricate Ursinius' association with the cemeteries outside the walls? There is good reason to be skeptical of these and the other stories examined in this essay, especially when we are forced to depend solely on accounts preserved in the *Lib. Pont.* However, the better documented example of Boniface, which is the subject of several letters preserved in the *Collectio Avellana* between the *praefectus urbi* Symmachus and the emperor in Ravenna, suggests that at least in this case, extra-mural banishment of one or both candidates in a contested election was a practical way for Roman civic officials to maintain peace in the city until the schism could be formally resolved. For his part, dwelling in extra-mural martyrial *basilicae* was a practical choice, which allowed Boniface to adhere to imperial commands by technically leaving the city while simultaneously remaining nearby. The same may have also been the case in the other schisms discussed in this essay. Ursinus' connection to St. Agnes' also makes sense in this context, given that he had also been barred from the city. Thus, it may well be the case that some if not all of these cemetery exiles may in fact represent authentic historical traditions, even if they have been garbled by later polemicists.

The positive connotations of the city's cemeteries that we have seen, especially in the later texts, reflect the slow but insistent transformation of the religious topography of the city of Rome. The Lateran, the *Basilica Liberii* and the church built by Julius I near Trajan's forum colonized the heart of Rome by the mid-4th c. However, the growing popularity of martyr cults was simultaneously shifting attention towards the suburban cemeteries where the corporeal remains of saints were venerated.[121] At first, small catacomb shrines marked their location. Then, at roughly the same time as Liberius and Julius were building relatively modest churches inside the walls, Rome saw substantial imperially-sponsored interventions in the *suburbium*, including the construction of at least 7 churches such as St. Peter's on the Vatican and St. Paul's on the *Via Ostiensis*, as well as funerary basilicas like the complex constructed near the tomb of St. Agnes. These buildings dwarfed most intra-mural constructions.[122] As a result, while the practical locus of papal power remained inside the city, Christian sanctity could increasingly be found beyond the walls.[123] Writing to the daughter-in-law of his famous patron Paula in 403, Jerome claimed that people hurried past the "half-ruined [pagan] shrines" towards the tombs of the Christian saints in the suburbs.[124] For thinkers like Jerome, Rome's cemeteries were dark, potentially scary places; but the saints they contained were also the city's patrons, and their places of burial functioned as a sacred cordon encompassing and protecting the city and its inhabitants. Indeed, in his study of Prudentius' *Liber Peristephanon*, Michael Roberts points to the central role played by both time and space in the representation of Rome's martyr cults. Their tombs were part of the city's sacred landscape and set apart from it. Moreover, martyrial cemeteries and their shrines were frequently compared with, or described as, walls or other defensive works, protecting the city.[125] The burial places of Rome's martyrs and the impressive churches that serviced their cults made them uniquely suited to this role. St. Agnes, in the north-eastern part of the city, St. Felicitas nearby to the north on the *Via Salaria*, St. Peter to the west, ss Sebastian and Paul on the *Via Appia* and the *Via Ostiensis* to the south, together with Laurence on the *Via Tiburtina* in the east, Marcellus and Peter in the south-east on

120 Lander (2016); Shepardson (2014); Haas (1997).

121 Only rarely before the 9th c. were corporeal relics (as opposed to contact relics) translated into the city's intra-mural churches, and it seems likely that this process occurred once the non-saintly dead were increasingly more commonly buried inside the walls in the 6th c. See Costambeys (2001) 171–72; Goodson (2008); (2010) 198–99.

122 Reekmans (1989) 861; Curran (2000) 128; Brandenburg (2005) 16ff. The 7 imperial extra-mural churches are St. Peter's, St. Paul's (flm), the *basilica Apostolorum* on the *Via Appia* (*ad catacumbas* = St. Sebastian), a lost church in the cemetery near the *Via Praenestina*, ss Marcellino e Pietro (*ad duas lauros*) on the *Via Labicana*, St. Lorenzo at a cemetery on the *Via Tiburtina*, and St. Agnes on the *Via Nomentana*. A potential 8th church has recently been discovered on the *Via Adreatina*, although whether or not it was imperially sponsored is unknown. For this list, see Trout (2015) 4, n. 14.

123 Goodson (2010) 198–99.

124 Jer. *Ep.* 107.1.

125 Roberts (1993) 189–90.

the *Via Labicana*, and many smaller shrines, created a protective wall of martyrs – a spiritual analogue to the Aurelian walls which defended the city.[126]

Damasus recognized the power of this narrative. Having defeated Ursinus, he initiated an ambitious program to monumentalize the suburban burial places of the city's martyrs.[127] He certainly wished to increase the accessibility of these spaces for pilgrims visiting the city. But Damasus' interventions were also intended to establish his authority – and that of the Roman church – over spaces which hitherto were more typically associated with the aristocracy and the imperial family.[128] One way he accomplished this was to install substantial marble plaques inscribed with *elogia* celebrating the martyrs at many suburban churches.[129] And like certain prominent business and political leaders, Damasus' own name features prominently in the inscriptions marking these locations.[130] At the tomb of St. Agnes – the site of the Ursinian massacre, if we believe the *Gesta* – he placed a large marble slab, which included a plea that the saint look with favour upon Damasus' prayers.[131]

The other bishops considered in this essay were also interested in more fully establishing their authority beyond the walls through building and decorative programs. As we have seen, Liberius – at least according to the *Lib. Pont.* – decorated the tomb of Agnes, and Boniface is said to have constructed an oratory at the cemetery of St. Felicitas, decorated her tomb, and was buried near the saint. For his part, Symmachus, confined at St. Peter's and its environs for much of the period of his schism with Laurentius, sponsored an ambitious building program in the *suburbium*, which, in addition to the repairs to the basilicas of St. Felicitas and St. Agnes discussed above, included several new constructions clustered around St. Peter's such as a basilica dedicated to St. Agatha *in fundum Lardarium* to the west of the Vatican along the *Via Aurelia*,[132] and the basilica of St. Pancras (San Pancrazio) over the supposed tomb of the saint outside the Porta Aurelia on the Janiculum.[133] He also sponsored renovations of St. Paul's and especially St. Peter's, which for the first time firmly linked it to the institution of the papacy and enabled the Vatican to function as an alternative to the traditional papal base at the Lateran.[134] These interventions blurred the distinction between city and suburb and affirmed the Roman identity of the martyrs buried just beyond the walls who, under the authority of the bishop, protected the community.[135] They can also be understood as an appeal for unity after a period of bitter division.[136]

Like these building projects, the texts examined in this chapter attempted to impose a narrative upon these spaces as they re-imagined the recent history of the Roman church and the controversies that divided it. The participants in these schisms and the later polemicists who described them were engaged in an imaginative process of thinking *with* cemeteries, using them to debate issues of legitimacy and authority in the late antique Roman church.[137] Unable to appeal to the symbolic centres of papal power within the city, propagandists such as the author of the *Gesta* sought legitimisation from the ideological power of the cult of saints and their sites of memorialization, and through the saints, the memory of persecution and martyrdom. The peripheral nature of the cemetery also provided a rhetorical contrast with the city centre. The official church at the Lateran could be seen as imperial, pagan, corrupt, and disconnected from the sanctity of the *suburbium*. From this perspective, a bishop exiled to Rome's cemeteries was transformed

126 Dey (2011) 224.
127 For an overview of church building in the *suburbium*, see Reekmans (1989) 904–906.
128 Pietri (1976) 603–617; Trout (2015) 11–12. See also the important works of Sághy (1998) and (2000). Damasus attempted in particular to bring the cults of Peter and Paul under the control of the Roman church. See Curran (2000) 148–57. On Damasus' choices, see Sághy (2000) 276–77. For an overview of Damasus' building projects at Rome and in the *suburbium*, see esp. Löx (2013) 43–88.
129 Of the Damasean inscriptions, only one is known from an intra-mural church, unsurprisingly St. Lorenzo in Damaso.
130 According to Trout (2015) 54, Damasus' own name appears at least 37 times in these inscriptions, as well as in his non-epigraphic verse.
131 Damasus' epigraphic poetry is translated by Trout (2015). The *elogium* of Agnes can be found at p. 150.
132 *Lib. Pont.* 53: 'Hic fecit basilicam sanctae martyris Agathae, uia Aurelia, in fundum Lardarium: a fundamento cum fonte construxit, ubi posuit arcos argenteos II' – 'He built the basilica of St Agatha the martyr on the *Via Aurelia* at the farm Lardarius; he constructed it from the ground up, with a font, where he placed 2 silver arches'. This church was abandoned and fell into ruin by the mid-12th c. See LTURS 1.30–31.
133 *Lib. Pont.* 53: 'Eodem tempore fecit basilicam sancti Pancrati, ubi et fecit arcum argenteum, pens. lib. XV; fecit autem in eodem loco balneum' – 'Then he built the basilica of St Pancras; he provided a silver arch weighing 15 lb and there he also built a bath'. See LTURS 4.163–65.
134 Thacker (2013) 152; Reekmans (1989) 910–12.
135 Brown (2012) 252–53.
136 In the context of Damasus' interventions in the *suburbium*, see Curran (2000) 153–55. In the words of Charles Pietri (1997) 49, "la topographie romaine donnerait un témoignage complémentaire sur l'oeuvre du pape [Damasus] qui organise systématiquement la conquête de l'espace urbain et suburbain" – "Roman topography would give additional testimony to the work of the pope [Damasus] who systematically organized the conquest of urban and suburban space."
137 On this idea in an early modern context, see Ditchfield (2009).

from a rival candidate in a disputed episcopal election to a righteous and persecuted outsider who, surrounded by Rome's very special dead, refused to compromise the true faith. Indeed, the image of the bishop in the cemetery, cut off yet accessible, echoed that of the martyr, who was simultaneously part of this world and beyond it. Later texts such as the *Liber Pontificalis* and the *documenta Symmachiana* and *Laurentiana* also linked the cemetery with episcopal legitimacy and reimagined earlier schisms, including that of Damasus and Ursinus, as well as Liberius and his opponent Felix, through this lens. In short, Roman polemical texts used the cemetery to legitimise the memory of both the winners and losers of late antique papal schisms, and the conflicting portrayals of cemeteries in our sources reflect the battle to control them, both in reality and in Roman memory, and to deny their power to opponents.

However, whereas Ursinus' propagandists and 6th c. authors celebrated the cemetery as a place of pious resistance to illegitimate authority in emulation of the martyrs, Optatus, the *Praedestinatus*, Roman law, and Damasus himself portrayed these same spaces as a sanctuary for dissident clerics, heretics, and schismatics. Indeed, Liberius, Ursinus, Boniface, and Symmachus *were* schismatics from the perspectives of Felix, Damasus, Eulalius, and Laurentius respectively, who used the cemetery and its association with the cult of Rome's saints to undermine the authority of the urban church and its leaders. For those in control of the centre of episcopal power, the shadowy figures gathered in cemeteries were enacting a sinister inversion of the public worship of the official church.

Acknowledgements

This article was completed during my time as a research fellow at the DFG-Kollegforschergruppe, *Migration und Mobilität in Spätantike und Frühmittelalter* at Eberhard Karls Universität Tübingen. I would like to thank the DFG, as well as Mischa Meier, Steffen Patzold, and Sebastian Schmidt-Hofner for inviting me to participate, in addition to Fabian Völzing and the other fellows for their friendship and advice. This article benefitted greatly from the feedback and advice of Ray Van Dam, Michele Salzman, Julie Anderson, the two anonymous reviewers, as well as the editor, Luke Lavan. Finally, I first presented the research that ultimately became this article at the 53rd International Congress on Medieval Studies, Western Michigan University at a session organized by Jonathan J. Arnold. I would like to thank Jon for inviting me to participate, as well as the audience for their valuable feedback.

Bibliography

Primary Sources

Amm. Marc. = J. C. Rolfe ed. and transl., *Ammianus Marcellinus. History*, 3 volumes (Loeb Classical Library 300, 315, 331) (Cambridge Mass. 1939–1950).

Ath., *Hist. Ar.* = M. Atkinson and A Robertson transl. *Athanasius, History of the Arians Nicene and Post-Nicene Fathers* 4 (Buffalo 1892).

Coll. Avell. = O. Günther, ed., *Epistulae imperatorum pontificum aliorum inde ab a. CCCLXVII usque ad a. DLIII datae Avellana quae dicitur collectio* (CSCL 35) (Vienna 1895).

Cod. Theod. = T. Mommsen and E. Meyer, edd., *Theodosiani libri XVI cum constitutionibus Sirmondianis et leges novellae ad Thoodosium pertinentes* (Berlin 1905). C. Pharr transl., *The Theodosian Code and Novels, and the Sirmondian constitutions* (New York 1952).

De sancto Eusebio presbyero = *Acta Sanctorum quotquot orbe coluntur, Augusti III* (vol. 37 166–167) (1867). M. Lapidge transl., *The Roman Martyrs: Introduction, Translations, and Commentary* (Oxford 2018) 300–302.

Gesta Liberii = E. Wirbelauer, ed. *Zwei Päpste in Rom: der Konflikt zwischen Laurentius und Symmachus (498–514)* (Munich 1993) 248–60.

Itinerarium Salisburgense = F. Glorie, ed. *De locis Sanctis Martyrum quae Sunt Foris Civitatis Romae Ecclesiae quae Intus Romae Habentur* (CCSL 175, pp. 315–322). M. Lapidge transl., *The Roman Martyrs: Introduction, Translations, and Commentary* (Oxford 2018) 662–66.

Jer., *Comm. in Ezech* = F. Glorie, ed. *Commentariorum in Hiezechielem libri XIV* (CCSL 75) (Turnhout 1964).

Jer. *Ep.* = F. A. Wright ed. and transl., *Jerome. Select Letters* (Loeb Classical Library 262) (Cambridge Mass. 1933).

Lib. Pont. = L. Duchesne, ed., *Le Liber pontificalis; texte, introduction et commentaire.* 2 Vols. (Paris 1886).

Liberius, quamuis sub imagine = Alfred Feder, ed., *Tractatus mysteriorum, Fragmenta, Ad Constantium Imperatorem, Hymni* (Corpus Scriptorum Ecclesiasticorum Latinorum 65, pp. 164–166) (Vienna 1916). R. Flower transl., *Emperors and Bishops in Late Roman Invective* (Cambridge 2013) 238–39.

Opt. = Optatus of Milevis, *de schismate Donatistarum* = M. Labrousse, ed. and French translation, *Traité contre les donatistes* (SC 412, 413) (Paris 1995).

Passio Sancti Felicis Papae = G. N. Verrando ed. "Liberio-Felice. Osservazioni e rettifiche di carattere storico-agiografico", *Rivista di Storia della Chiesa in Italia Roma* 35.1 (1981) 122–123. M. Lapidge transl., *The Roman Martyrs: Introduction, Translations, and Commentary* (Oxford 2018) 305–306.

Praedestinatorum Haeresis = Migne, ed., *Praedestinatus, sive Praedestinatorum Haeresis* (PL 53, col. 587–622) (1865).

Socrates, *Hist. eccl.* = PG 67. 30–842.

Sozom. *Hist. eccl.* = PG 67. 843–1130.

Sulp. Sev., *Chron.* = A. Roberts transl. *Sulpicius Severus, Chronica* (1894); PL 20. 95–248.

Theod., *Hist. eccl.* = PG 82. 879–1278.

Secondary Sources

Abrecht R. R. (2019) "An immigrant neighbourhood in Ancient Rome", *Urban History* 47.1 (2019) 2–22.

Aldrete G. S. (2007) *Floods of the Tiber in Ancient Rome* (Baltimore 2007).

Baldovin J. F. (1987) *The Urban Character of Christian Worship. The Origins, Development, and Meaning of Stational Liturgy* (Rome 1987).

Barbini P. M. (1998) "Catalogo ragionato di ipogei e catacombe romane (entro il VI miglio)", in *Le catacombe romane: storia e topografia*, ed. P. Pergola (Rome 1998) 107–243.

Blair-Dixon K. (2002) "Damasus and the fiction of unity: the urban shrine of Saint Laurence", in *Ecclesiae Urbis. Atti del congresso internazionale di studi sulle chiese di Roma (IV–X secolo). Roma 4–10 Settembre 2000.*, edd. F. Guidobaldi and A. G. Guidobaldi (Vatican City 2002) 331–52.

Blair-Dixon K. (2007) "Memory and authority in sixth-century Rome: the *Liber Pontificalis* and the *Collectio Avellana*", in *Religion, Dynasty and Patronage in Early Christian Rome, 300–900*, edd. K. Cooper and J. Hillner (Cambridge 2007) 59–76.

Boeft J. d, Drijvers J. W., Hengst D. d, and Teitler H. C. (2009) *Philological and Historical Commentary on Ammianus Marcellinus XXVII* (Leiden 2009).

Bond S. E. (2013) "Mortuary workers, the church, and the funeral trade in Late Antiquity", *JLA* 6.1 (2013) 135–51.

Bowes K. D. (2008) *Private Worship, Public Values, and Religious Change in Late Antiquity* (Cambridge 2008).

Brandenburg H. (2005) *Ancient Churches of Rome from the Fourth to the Seventh Century: The Dawn of Christian Architecture in the West* (Turnhout 2005).

Brandt O. (2012a) "The early Christian basilica of San Lorenzo in Lucina", in *San Lorenzo in Lucina – The Transformations of a Roman Quarter (Skrifter utgivna av Svenska Institutet i Rom, 40, 61)*, ed. O. Brandt (Stockholm 2012) 123–54.

Brandt O. (2012b) "La chiesa di San Lorenzo in Lucina e il quartiere preesistente: nuove osservazioni." *Scavi e scoperte recenti nelle chiese di Roma.* (2012) 11 31.

Brown P. (1981) *The Cult of the Saints: Its Rise and Function in Latin Christianity* (Chicago 1981).

Brown P. (2012) *Through the Eye of a Needle: Wealth, the Fall of Rome, and the Making of Christianity in the West, 350–550 AD* (Princeton 2012).

Cabié R. (1973) *La lettre du pape Innocent I à Decentius de Gubbio* (Louvain 1973).

Cameron A. (1976) *Circus Factions: Blues and Greens at Rome and Byzantium* (Oxford 1976).

Cohen S. (2015) "Schism and the polemic of heresy: Manichaeism and the representation of papal authority in the *Liber Pontificalis*", *JLA* 8.1 (2015) 195–230.

Cohen S. (2018) "Liberius and the cemetery as a space of exile in late antique Rome", in *Mobility and Exile at the End of Antiquity*, edd. D. Rohmann, J. Ulrich, and M. Vallejo Girvés (Frankfurt 2018) 141–60.

Cooper K. (1999) "The martyr, the matrona and the bishop: the matron Lucina and the politics of martyr cult in fifth- and sixth-century Rome", *Early Medieval Europe* 8.3 (1999) 297–317.

Costambeys M. (2001) "Burial topography and the power of the Church in fifth- and sixth-century Rome", *PBSR* 69 (2001) 169–89.

Cracco Ruggini L. (1997) "Spazi urbani clientelari e caritativi", in *La Rome impériale. Démographie et logistique. Actes de la table ronde de Rome, 25 mars 1994* (Rome 1997) 157–91.

Cracco Ruggini L. (2003) "Rome in Late Antiquity: clientship, urban topography, and prosopography", *CP* 98. 4 (2003) 366–82.

Cristo S. (1977) "Some notes on the Bonifacian-Eulalian schism", *Aevum* 51. 1/2 (1977) 163–67.

Curran J. (2000) *Pagan City and Christian Capital: Rome in the Fourth Century* (Oxford 2000).

De Rossi G. B. (1864) *La Roma sotterranea cristiana Vol. 1* (1864).

De Spirito G. (1994) "Ursino e Damaso – una nota", in *Peregrina curiositas: Eine Reise durch den orbis antiquus*, edd. D. Van Damme, A. Kessler, T. Ricklin, and G. Wurst (Freiburg 1994) 263–74.

Dey H. W. (2011) *The Aurelian Wall and the Refashioning of Imperial Rome, A.D. 271–855* (Cambridge 2011).

Diefenbach S. (2007) *Römische Erinnerungsräume: Heiligenmemoria und Kollektive Identitäten im Rom des 3. bis 5. Jahrhunderts n. Chr* (Berlin 2007).

Ditchfield S. (2009) "Thinking with saints: sanctity and society in the Early Modern world", *Critical Inquiry* 35.3 (2009) 552–84.

Dunn G. D. (2015a) "Imperial intervention in the disputed Roman episcopal election of 418/419" *Journal of Religious History* 39.1 (2015a) 1–13.

Dunn G. D. (2015b) "Life in the cemetery: Boniface I and the catacomb of Maximus", *Augustinianum* 55.1 (2015b) 137–57.

Ehrenheim H. v. (2012) "The titulus Lucinae and the saint Lucina", in *San Lorenzo in Lucina – The Transformations of a Roman Quarter*, ed. O. Brandt (Stockholm 2012) 155–72.

Fuhrmann C. J. (2012) *Policing the Roman Empire: Soldiers, Administration, and Public Order* (Oxford 2012).

Geertman H, Blaauw S. d, and Laan C. E. v. d. (2004) *Hic fecit basilicam : studi sul Liber pontificalis e gli edifici ecclesiastici di Roma da Silvestro a Silverio* (Leuven and Dudley MA 2004).

Goodson C. (2008) "Building for bodies: the architecture of saint veneration in early medieval Rome", in *Felix Roma: The Production, Experience and Reflection of Medieval Rome*, edd. É. Ó Carragain and C. Neuman de Vegvar (2008) 51–80.

Goodson C. (2010) *The Rome of Pope Paschal I: Papal Power, Urban Renovation, Church Rebuilding and Relic Translation, 817–824* (Cambridge 2010).

Grig L. (2012) "Deconstructing the symbolic city: Jerome as guide to late antique Rome", *PBSR* 80 (2012) 125–43.

Guyon J. (1974) "La vente des tombes à travers l'épigraphie de la Rome chrétienne (IIIe, VIIe siècles): le rôle des fossores, mansionarii, praepositi et prêtres", *MÉFRA* (1974) 549–96.

Haas C. (1997) *Alexandria in Late Antiquity: Topography and Social Conflict* (Baltimore 1997).

Härke H. (2001) "Cemeteries as places of power", in *Topographies of Power in the Early Middle Ages*, edd. M. de Jong, F. Theuws, and C. Van Rhijn (Leiden 2001) 9–30.

Heydemann G. (2016) "The Ostrogothic Kingdom: ideologies and transitions", in *A Companion to Ostrogothic Italy*, edd. J. J. Arnold, K. Sessa, and M. S. Bjornlie (Leiden 2016) 17–46.

Hillner J. (2006) "Clerics, property and patronage: the case of the Roman titular churches", *Antiquité Tardive* 14.1 (2006) 59–68.

Hillner J. (2007) "Families, patronage, and the titular churches", in *Religion, Dynasty and Patronage in Early Christian Rome, 300–900*, edd. K. Cooper and J. Hillner (Cambridge 2007) 225–61.

Hillner J. (2015) *Prison, Punishment and Penance in Late Antiquity* (Cambridge 2015).

Humfress C. (2008) "Citizens and heretics: Late Roman lawyers on Christian heresy", in *Heresy and Identity in Late Antiquity*, edd. E. Iricinschi and H. M. Zellentin (Tubingen 2008) 128–42.

Humphrey J. H. (1986) *Roman Circuses: Arenas for Chariot Racing* (Berkeley 1986).

Kötter J-M. (2013) *Zwischen Kaisern und Aposteln: das Akakianisches Schisma (484–519) als kirchlicher Ordnungskonflikt der Spätantike* (Stuttgart 2013).

Kouroumali M. (2013) "The Justinianic Reconquest of Italy: imperial campaigns and local responses", *LAA* 8.2 (2013) 969–99.

Krautheimer R. (1937–1980) *Corpus basilicarum Christianarum Romae. The Early Christian Basilicas of Rome (IV–IX cent.)* (Vatican City 1937–1980).

Künzle P. (1961) "Zur basilica Liberiana: basilica Sicinini= basilica Liberii", *RömQSchr* 56 (1961) 1–61.

Lander S. L. (2016) *Ritual Sites and Religious Rivalries in Late Roman North Africa* (Cambridge 2016).

Latham J. A. (2012) "From literal to spiritual soldiers of Christ: disputed episcopal elections and the advent of Christian processions in late antique Rome", *Church History* 81.2 (2012) 298–327.

Lee-Stecum P. (2006) "Dangerous reputations: charioteers and magic in fourth-century Rome", *GaR* 53.2 (2006) 224–34.

Lippolis I. B. (2007) "Private space in late antique cities: laws and building procedures", *LAA* 2.3 (2007) 195–237.

Lizzi Testa R. (2004) *Senatori, popolo, papi: il governo di Roma al tempo dei Valentiniani* (Bari 2004).

Löx M. (2013) *Monumenta sanctorum. Rom und Mailand als Zentren des frühen Christentums: Märtyrerkult und Kirchenbau unter den Bischöfen Damasus und Ambrosius* (Wiesbaden 2013).

Maier H. O. (1995) "The topography of heresy and dissent in late-fourth-century Rome", *Historia* 44.2 (1995) 232–49.

Mathisen R. W. (2006) "*Peregrini, barbari*, and *cives Romani*: concepts of citizenship and the legal identity of barbarians in the Later Roman Empire", *AHR* 111. 4 (2006) 1011–40.

McKitterick R. (2020) *Rome and the Invention of the Papacy: The Liber Pontificalis* (Cambridge 2020).

McLynn N. (1992) "Christian controversy and violence in the fourth century", *Kodai* 3 (1992) 15–44.

Merdinger J. E. (1997) *Rome and the African church in the time of Augustine* (New Haven 1997).

Mommsen T. (1898) "Die römischen Bischöfe Liberius und Felix II", *Deutsche Zeitschrift für Geschichtswissenschaft* NS 1 (1898) 167–79.

Norton P. (2007) *Episcopal Elections, 250–600 Hierarchy and Popular Will in Late Antiquity* (Oxford 2007).

Noy D. (2000) *Foreigners at Rome: Citizens and Strangers* (London 2000).

Pietri C. (1976) *Roma Christiana: Recherches sur l'Église de Rome, son organisation, sa politique, son idéologie de Miltiade à Sixte III (311–440)* (Rome 1976).

Pietri C. (1997) "Damase évêque de Rome", in *Christiana respublica. Éléments d'une enquête sur le christianisme antique* (Rome 1997) 49–76.

Raimondi M. (2009) "Elezione 'iudicio dei' e 'turpe convicium': Damaso e Ursino tra storia ecclesiastica e amministrazione romana", *Aevum* 83. (2009) 169–208.

Rebenich S. (2002) *Jerome* (London 2002).

Rebillard É. (2003) *Religion et Sépulture: L'église, les vivants et les morts dans l'antiquité tardive* (Paris 2003).

Reekmans L. (1989) "L'implantation monumentale chrétienne dans le paysage urbain de Rome de 300 à 850", *Publications de l'École française de Rome* 123.1 (1989) 861–916.

Reutter U. (2009) *Damasus, Bischof von Rom (366–384): Leben und Werk* 2009).

Richardson L. (1992) *A New Topographical Dictionary of Ancient Rome* (Baltimore 1992).

Roberts M. J. (1993) *Poetry and the Cult of the Martyrs: the Liber Peristephanon of Prudentius* (Ann Arbor 1993).

Sághy M. (1998) "*Renovatio memoriae*: Pope Damasus and the martyrs of Rome", in *Rom in der Spätantike. Porträt einer Epoche*, ed. M. Fuhrmann (1998) 247–61.

Sághy M. (2000) "Scinditur in partes populus: Pope Damasus and the martyrs of Rome." *Early Medieval Europe* 9.3 (2000) 273–87.

Sardella T. (1996) *Società chiesa e stato nell'età di Teoderico: papa Simmaco e lo scisma laurenziano* (Soveria Mannelli 1996).

Saxer V. (1989) "L'utilisation par la liturgie de l'espace urbain et suburbain: l'exemple de Rome dans l'Antiquité et le Haut Moyen Âge", in *Actes du XIe congrès international d'archéologie chrétienne: Lyon, Vienne, Grenoble, Genève, et Aoste, 21–28 septembre 1986* (Rome 1989) 917–1033.

Sessa K. (2012) *The Formation of Papal Authority in Late Antique Italy: Roman Bishops and the Domestic Sphere* (New York 2012).

Sessa K. (2016) "The Roman Church and its bishops", in *A Companion to Ostrogothic Italy*, edd. J. J. Arnold, K. Sessa, and M. S. Bjornlie (Leiden 2016) 425–50.

Shepardson C. (2014) *Controlling Contested Places: Late Antique Antioch and the Spatial Politics of Religious Controversy* (Berkeley 2014).

Slootjes D. (2016) "Crowd behavior in late antique Rome", in *Pagans and Christians in Late Antique Rome: Conflict, Competition, and Coexistence in the Fourth Century*, edd. M. R. Salzman, M. Sághy, and R. Lizzi Testa (New York 2016) 178–94.

Sotinel C. (2007) "The Three Chapters and the transformation of Italy", in *The Crisis of the Oikoumene: The Three Chapters and the Failed Quest for Unity in the Sixth-Century Mediterranean*, edd. C. Chazelle and C. Cubitt (Turnhout 2007) 85–120.

Sotinel C. (2010) "Vigilius in the *Liber Pontificalis*: a memory lost, or manipulated?", in *Church and Society in Late Antique Italy and Beyond,* ed. C. Sotinel (London 2010) 1–21.

Thacker A. (2013) "Popes, emperors and clergy at Old St Peter's from the fourth to the eighth century", in *Old Saint Peter's, Rome*, edd. R. McKitterick, J. Osborne, C. M. Richardson, and S. Story (2013) 137–56.

Thompson G. L. (2015) "The *Pax Constantiniana* and the Roman episcopate", in *The Bishop of Rome in Late Antiquity*, ed. G. D. Dunn (Farnham 2015) 17–36.

Trout D. E. (2015) *Damasus of Rome: The Epigraphic Poetry. Introduction, Texts, Translations, and Commentary* (Oxford 2015).

Verardi A. A. (2013) "La genesi del Liber Pontificalis alla luce delle vicende della città di Roma tra la fine del V e gli inizi del VI secolo. Una proposta", *Rivista di Storia del Cristianesimo* 1 (2013) 7–28.

Verardi A. A. (2016) *La memoria legittimante: il Liber pontificalis e la Chiesa di Roma del secolo VI* (Roma 2016).

Verardi A. A. (2019) "Between law and literature: The *Liber Pontificalis* and canonical collections in Late Antiquity and the Early Middle Ages", in *The Collectio Avellana and its Rivals*, edd. R. Lizzi Testa and G. Marconi (Newcastle 2019) 370–87.

Verrando G. N. (1981) "Liberio-Felice. Osservazioni e rettifiche di carattere storico-agiografico", *Rivista di Storia della Chiesa in Italia Roma* 35.1 (1981) 91–125.

Wirbelauer E. (1993) *Zwei Päpste in Rom: der Konflikt zwischen Laurentius und Symmachus (498–514)* (Munich 1993).

Wirbelauer E. (1994) "Der Nachfolgerbestimmung im römischen Bistum (3–6. Jh). Doppelwahlen und Absetzungen in ihrer herrschaftssoziologischen Bedeutung", *Klio* 76 (1994) 388–437.

Wirbelauer E. (2014) "Agnès et les évêques de Rome jusqu'au VIIe siècle: un plaidoyer pour une relecture historico-critique du Liber pontificalis", *MÉFRM* 126.1 (2014).

Yasin A. M. (2009) *Saints and Church Spaces in the Late Antique Mediterranean: Architecture, Cult, and Community* (Cambridge 2009).

Other Memorials: Statue Monuments

∴

The Archaeology of Late Antique Statue Monuments

Luke Lavan

Abstract

Honorific statues did not only exist at the time of their dedication, as conceived by sculptors and letter-cutters. Rather, they were also moved, repaired, modified, neglected, and destroyed. This happened during what might be called their 'statue life', in which they went from being objects of memorial to artefacts of oblivion, in the same way as mausolea. The processes involved can be reconstructed from the archaeological study of statue monuments, especially the investigation of their context. This can also reveal a great deal more on the intentions of those who dedicated a statue, beyond what art history and epigraphy can demonstrate. In this paper, I set out the potential of a fully archaeological approach to these monuments, building on the strengths of the *Oxford Last Statues of Antiquity* project. In so doing, I give an additional perspective on the archaeology of memory in Late Antiquity, to that provided by the study of funerary monuments and their spoliation. I suggest that effort should be invested not just in studying the erection and removal of extant monuments but also those which we can surmise once existed. Thus, I seek to shift the study of public statuary away from describing the relics which survive, towards a historical consideration of how all such monuments were displayed and treated in Late Antiquity.

Introduction

This paper represents my methodological thoughts on late antique statue monuments, by which I mean the architectural supports on which sculpture was displayed. These survive, of course, far better than the statues themselves. Both have come to prominence recently, as a result of the Oxford Project *The Last Statues of Antiquity* (henceforth LSA).[1] In this paper, I confine myself to those monuments erected in the public space of streets and squares, rather than those set up within baths or private gardens. Such statues are mainly honorific dedications to individuals but do include a few religious images or 'works of art'. Specifically, I look at what context tells us and how it changes our appreciation of such monuments. The art-historical study of late sculpture, championed by Smith at Aphrodisias, is of course highly developed.[2] Much of it can be considered archaeological, as in the study of workmanship, including recutting or statue reuse.[3] We even see some scholars working on the detection and reconstruction of colour on late antique statues, as studies advance in this area.[4] Furthermore, the careful work of Ignazio Tantillo and Francesca Bigi, on the statue bases of Lepcis Magna, is developing an archaeology of epigraphic reuse.[5] I will not address these topics. Rather, in this paper, I look mainly at statue emplacement, spoliation, repurposing, and display, extending issues of context which Smith has moved to address at Aphrodisias, but which did not feature prominently in the wider LSA project.[6]

I first began to consider such issues whilst working at Sagalassos, from 2004–2006, where I realised that late antique statue monuments must be studied as archaeological artefacts to fully grasp their history and significance.[7] My research on statues began a little before the *Last Statues* project. Nonetheless, what follows here is now firmly based on the foundations they have laid down. In particular, their impressive database allows me to move around sites in unfamiliar regions with ease. I am most grateful to Bryan Ward-Perkins for encouragement to rework their data, to which I add some materials I have collected. My paper could be taken as a comment on LSA, as this was largely an epigraphic and art historical project, in which archaeology played a more limited role. Such commentary is inevitable as the ambition of LSA was so great and its impact has been to re-found the field: everything that comes after will

1 Oxford *Last Statues*: Smith and Ward-Perkins (2016). This paper reworks information presented in Lavan (2020) but presents the observations here in methodological terms, for a wider audience.

2 Art history, summary: Bergmann and Kovacs (2016). Aphrodisias: Smith (1999a), (1999b), (2001), (2002), (2007).
3 Statue recutting: Lenaghan (2016b).
4 Statue colour: Liverani (2014).
5 Base reuse at Lepcis Magna: Tantillo and Bigi (2010).
6 Many of the perspectives suggested in this article would not have occurred to anyone without the high standard of recent statuary publications coming out of Aphrodisias led by Smith, who adopted an explicitly contextual approach in his study of the statuary of the Theatre Baths: Smith (2007) with excellent statuary maps. See also efforts underway from LSA scholars to offer a more archaeological perspective on statues: e.g. Lenaghan (2022) and Lenaghan (2019), relating to Aphrodisias.
7 Blank statue bases at Sagalassos: Lavan (2006) 29–34; Lavan (2013) 289–353. I gave a paper in Oxford in 2006, prior to the LSA project being undertaken, which reviewed the significance of blank bases reused at Sagalassos. I have also managed to take this work further, thanks to grants from Leverhulme and Marie Curie, so that I have now studied the topic across the whole empire, as part of the monograph Lavan (2020).

now refer to it. However, this paper is rather intended a systematic reflection on how archaeology can revise historical methodology. This is something the *Late Antique Archaeology* series encourages as a whole and which I have pursued in my own work. My remarks are also pertinent to civic epigraphy in earlier periods, particularly the question of how statue bases should be recorded when first discovered.

Statue Monuments as Archaeology

We can note that very few late statue bases have come from well-recorded archaeological contexts. By this I mean that only a handful have been excavated carefully with their surrounding soil layers, from which dated artefacts could be retrieved. Maps of bases can be constructed at a small number of sites, such as Cuicul in Tunisia and Sagalassos in Turkey. Here, we have a reasonable chance of finding bases *in situ*, either where they were erected or where they were moved to in Antiquity. There are rather more bases with a generally provable architectural context. These too are often rather poorly recorded, either within space or in terms of the soil layers around them. The best-preserved of these sites were clearance excavated long ago, when scant regard was paid to the nature of surrounding stratigraphy. Thus, we often talk about bases being approximately *in situ*, relying on old reports or grainy photographs to suggest where bases might come from. In other cases, statue monuments come from late walls around plazas or streets, where material had been grabbed together unceremoniously from sources immediately to hand. Small fragments of statues, or uninscribed statue bases of uncertain date, were sometimes discarded and so do not enter into our considerations. Amidst such confusion, we might be tempted only to look at newly dedicated bases and sculpture from Late Antiquity, without worrying about what information was lost in early clearance excavations. Yet it is perhaps a little too easy to do this, unless the choice is made from some understanding of what one might been leaving out. In this paper, I will examine what archaeology can reveal about the topics of statue clearance, of statue display, and of statue treatment. But I will begin by making a few remarks on statue distribution, building firmly on the foundations laid by LSA.

Regional Statue Populations: What Sources, What Impressions?

The regional distribution of the late antique statue population has been reconstructed in an impressive manner from different types of evidence. This is a topic on which I have comparative and explanatory points to make, using some sources known to LSA, others not. The LSA distribution maps, based on attestations in texts, inscribed bases, and finds of statues, suggest a strong concentration in Africa, Italy, Greece, and Asia Minor, with some regions not participating in the 'statue habit' to the same degree, notably in the Levant. These patterns described by LSA seem very reasonable. I have myself found similar regional patterns in secular construction work: new market buildings or cellular shops are favoured over civil basilicas in one region or another, whilst late nymphaea are concentrated in one district and not elsewhere.[8] Nonetheless, the rarity of the monuments recorded by LSA in the Near East is unsettling. Here, statues feature a good deal in the literature of Malalas, Pseudo-Joshua Stylites, and ecclesiastical writers. In their anecdotes, statues are sometimes presented as holding special powers or have great significance. Indeed, there seem to be many more mentions of statues in literary sources for this region than for Asia Minor.[9]

What explains the low number of finds in Oriens? Is it later Muslim iconoclasm, or some deep-seated local habit? My own feeling is that the relatively low level of statue bases in the Levant does in part does reflect a regional tradition with different ways of honouring individuals. Libanius talks of the portraits of wood and colour, erected to himself and his ancestors, in the bouleuterion of Antioch.[10] Libanius also mentions images of Ellebichus, the general who presided over the Statues Trial, set up around the city after clemency was proclaimed: they attracted gazes, on account of his unusual hair, eyes, cheeks, and colouring. One wonders if perhaps his eyes were painted blue and the hair and beard painted blonde for a general of Germanic origin?[11] We are familiar also with the painted *imagines* of the Rossano Gospels, in the scenes of Christ before Pilate. If this image does indeed reflect the court of the 6th c. proconsul of Palestine, then we might again see here a Levantine use of painted boards. This perhaps compensated for a lesser number of statues. However, a dump of

8 Regional variation in monument popularity: see Lavan (2020) 428–30 for a summary, with distribution maps on 506–523.

9 Stories about statues in the north-east and Alexandria: Antioch: Saliou (2006) on Malalas; Lib. *Or.* 19.30 (AD 387) (of equestrian imperial, attacked); Edessa: Josh. Styl. 27 (AD 495/496) (of Constantine, with levitating cross); Lib. *Or.* 19.48 (of Constantius II, dragged and whipped); Dara: Malalas 16.10 (of Anastasius); Caesarea Philippi: Sozom. *Hist. eccl.* 5.21 (of Christ, dragged and mutilated); Alexandria: Theoph. Sim. 8.7.7–11, 8.13.11–15 (on tychaion, moving).

10 Images of Libanius and his ancestors, Antioch: Lib. *Or.* 2.10 (generic ref, not in bouleuterion), 42.43 (portraits are made of 'wood and color' (σανίς τε καὶ χρώματα)).

11 Portraits of Ellebichus, Antioch: Lib. *Or.* 22.39.

FIGURE 1 New base revealed by ground-level archaeology: Trier, Karl-Marx Str., Augustinerhof (Redrawn by L. Bosworth after Dehn et al. (1949) 300–301, with 300 fig. 17).

statues at Caesarea Palestinae, blocking an exit from the theatre, reminds us that the transition to Islamic rule might well have seen statue removals in some places, that have distorted the overall picture.[12]

In other regions, archaeological excavation can extend, if not overturn, the regional patterns suggested by LSA. If we look to Germany, we find an undocumented late statue monument set in a prominent urban setting. It stands at a crossroads in Trier, set within the final, late imperial, road surface, of ca. 269–395 (Fig. 1). Here was found a large base, 4 × 4.5 m.[13] In Britain, at Gloucester in the last phase of the forum, which is of mid-3rd to 4th c. date, a large monument base on the north-east side of the plaza was repaired, using reused material (Fig. 2). From the demolition debris above, fragments of a bronze statue were recovered, unspecified in type, which almost certainly came from the same monument (Fig. 3).[14] Whilst this might not seem like much, one should not underestimate the impact of a single (likely imperial) statue on rustic visitors to this western outpost of Roman urban civilisation. Would it not have made an impression on cattle-drovers coming down from Wales into the plaza? Perhaps it was their most vivid experience of *romanitas*. In both cases, a substantial monument had been set up or re-erected in urban public space, within our period. Two is not a lot of statues to add to the 7 examples known to LSA, for provinces north of the Alps (29%), although it be a reasonable estimate of the proportion of cases that archaeology can add elsewhere. Yet, the examples from Trier and Gloucester were both set up in highly impactful places: in a forum and at a street crossing. Perhaps, if used in the right place, only a few images were needed to make a city feel that

12 Statue dumps, Caesarea Palestinae: Peleg and Reich (1992); Caesarea Philippi (3rd–4th c. dump) see: Rieger (2018).

13 Statue base at crossroads, Trier: Dehn et al. (1949) 300–301, with 300 fig. 17.

14 Statue base on forum, Gloucester: Hurst (1972) 57 with 56 fig. 17.

FIGURE 2 Statue base repair revealed by ground-level archaeology: Gloucester, spolia repair in phase 2, set within the last surface of the forum.
REDRAWN BY L. BOSWORTH, AFTER HURST (1972) 57 WITH 56 FIG. 17

FIGURE 3 Bronze statue fragments from around late base at Gloucester.
REDRAWN BY L. BOSWORTH, AFTER HURST (1972) (24–69) 57 WITH 56 FIG. 17

it belonged to the world of classical portrait sculpture, a theme to which I will return later.

Even within areas richly adorned with late antique statues, we can use archaeology to increase the number of monuments known. In some cases, ground-level archaeology does the job for us. At Nora in Sardinia, a group of foundations for lost statue monuments are visible on the forum (Fig. 4). A large socle incorporating reused materials is oddly stuck onto one side of an arch. There are also a series of gaps in the republican paving,

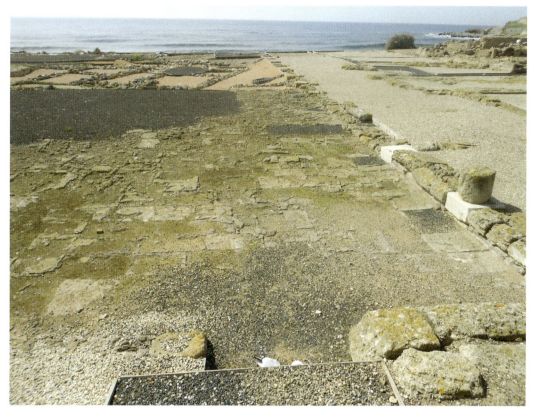

FIGURE 4 Late bases revealed by ground-level archaeology: paving gaps in front of column emplacements at Nora in Sardinia.
PHOTO: L. LAVAN 2017

for bases of both equestrian and pedestrian size. They are of irregular sizes and set in an irregular position, in front of columns of the forum portico. The only surviving statue here is Early Imperial (prior to 200), but the setting of the statues is unlikely to have been an original feature. The placing of statue bases touching portico columns is an aesthetic disjuncture which we know is typical of after the mid-3rd c.[15] It is difficult to be sure when these statues were removed. Clearly many other civic squares have lost their statues. We need to hunt for traces of their presence, which we might be able to classify as late antique. Elsewhere, we can identify the reuse of uninscribed/blank statue monuments, such as those noted in my study of late display arrangements at Sagalassos (Fig. 5).[16] Early imperial bases are sometimes modified in an unconventional manner and so reveal late use, as in the Forum of Caesar. Here, in AD 399–400, 22 uninscribed bases were redeployed as part of a late 4th c. restoration, alongside 3 inscribed bases. All arrived in the plaza together, at the same moment in time. They can be associated based on shared characteristics, being not only reused but bearing *urceus* and *patera* symbols that were cut away. The last trait indicates that they came from funerary or religious contexts. The bases also share unconventional modifications, with parts cut out to allow them to sit on steps or to rest against columns, revealing how they fronted the porticoes of the plaza.[17]

There are of course many other examples of early bases in public space where no such modifications have been

15 Base scars, Nora: I consider that the position of the scars, immediately in front of and touching the columns of the forum portico is suspicious. Ghiotto (2009) 349–51 with fig. 90, considers that the foundations / foundation gaps on the west portico date before 200, noting on 323–33 fig. 56, the Early Imperial example of F. Vera which appears to have been found *in situ* (p. 319 fig. 55 for map). However, nearby holes for bases XIII and XI seem to be irregularly set within the paving whilst those of the east portico are set in two cases covering over slabs. Thus, some could have been set up in 200–400. The irregularity of the different base sizes is also suggestive of a late date. Honorific inscriptions found out of context in the city extend until the 4th c. (of anonymous individuals, of no closer dating than this, on Ghiotto (2009) 349 with references), plus L. Lavan site observations April 2013, regarding the scars indicating the presence of other monument bases, now robbed. I thank I. Ghiotto for discussion on this, though opinions are my own.

16 Blank bases, Sagalassos: For find-spot maps based on excavation records, with a photo of the reconstructed statue monument, see Lavan (2013) 309–13 with fig. 6a (reconstructed example) and fig. 6b (map).

17 Blank bases, Rome (Forum of Caesar): These seem to relate to a further phase of monumental renovation: Corsaro *et al.* (2013) 123 with n. 2. For further discussion see, Lavan (2020) appendix K2a and K9.

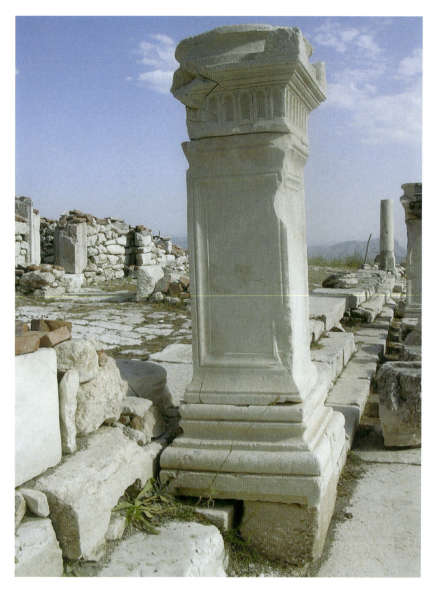

FIGURE 5
Late bases, revealed by their association *in situ*: Sagalassos, Lower Agora, composite statue monument of reused blocks.
PHOTO: L. LAVAN 2004

detected: normal statue bases with normal inscriptions, from earlier centuries. But we cannot be certain that an older base always displayed its original dedication in Late Antiquity. There may have been some cases where a late inscription was painted onto one side of a base, that otherwise carried a Republican or Early Imperial dedication, which is now lost. Painted inscriptions, written on otherwise uncut surfaces, have turned up on statue bases at Rome in the Ludus Magnus.[18] The use of applied marble plaques to make new dedications can give us some basis to detect secondary use when they are placed over existing inscriptions. This practice can be indicated by dowel holes or metal tabs cut into the inscribed faces of bases.[19] At Pheradi Maius, in Tunisia, there is an example of a statue base, visibly part of a late group, recovered alongside a togate statue, which had been coated in stucco, to cover over the initial dedication, as reported by Poinsott in 1926. Such subtleties, of replastering and repainting, are easily lost, even with well-controlled excavation.[20] This does introduce some doubt on the level of late antique statue dedications. Early inscribed bases, as well as uninscribed bases, could have been reused in Late Antiquity, to make new dedications, without their early texts being removed.

However, we need not despair. The use of stucco and of marble plaques as inscribed veneers for bases is a distinctly regional habit. It is prevalent in parts of Africa and is known for an inscribed base at Pompeii, undoubtedly

18 Painted inscriptions: Rome (Ludus Magnus): Corsaro *et al.* (2013) 478–79.
19 Metal tabs or dowel holes: Sala (iron and bronze tabs): Boube (1959–60) 143 nos. 2–3 with commentary on wider group in Lavan (2020) 700–701; Sagalassos (dowel hole in inscribed face): Lavan (2008) 203 n. 23 for P. A. Tibya =. Lanckoronski (1892) 226 no. 197.
20 Stuccoed bases, Pheradi Maius: Poinssot (1927) 55–56.

done when available stone did not cut sharply.[21] We can see this at Sabratha, where a very well-preserved dump of statue-base waste has been recovered, relating to the forum that was cleaned out in the mid-4th c. (see appendix 2). This deposit includes a few bases and pieces of monumental inscription, but the vast majority of its inscriptions are plaques from statue monuments. The level of preservation is very high, as a number of the inscriptions still have red paint in their letters (IRT 41, 50, 84). There is also a base (IRT 3) and a monumental inscription in stucco (IRT 14). Critically, these both cover over sandstone and are both late 1st c BC to 1st c AD. Later dedications are all marble, though not bases but plaques to cover more modest materials. Two dedications have been recut by turning the plaque round, presumably on the same base, as not all bases are the same width. Yet, no inscriptions on marble show signs of being stuccoed. Thus, it seems probable that here and at Pheradi Maius we have a regional habit, perhaps initially conceived to cope with local stone. This can be late, as Pheradi Maius shows us, but is likely to have been used more frequently in early centuries, before marble veneers became prevalent. In truth, rededication is only marginally visible at Sabratha, where preservation is good. Elsewhere, the practice is likely to have been far more limited, where good stone was available, though plastering could have happened. I suggest that it might be detected via careful observation of statue groups. The practice perhaps explains a few 'odd' survivals on some eastern agorai, where little known early civic figures jar with wider groups. This we might suspect for a re-erected statue of Ias at Sagalassos, set amongst dedications of around AD 400.[22] In contrast, where dedication groups seem coherent in date or theme, it is fair to assume that the original dedications remained visible, as with the statues of Dometeinos and Tatiana outside the bouleuterion of Aphrodisias.[23] Thus, the real level of new statue dedication is best revealed by the careful study of context. It is this theme that I will develop for the rest of this article.

Statue Clearance

We do have some well-preserved display contexts from Late Antiquity. Admittedly, almost all have been excavated through clearance excavation, with little regard for soil layers set around bases. We have fora, as at Cuicul, Thamugadi, Rome (the Forum Romanum), and Aquileia, or agorai, as at Aphrodisias and Sagalassos.[24] We also have streets, as at Ephesus, Sagalassos, and Tripolis ad Meandrum.[25] There are other sites, such as Uchi Maius or Lepcis, where we also know something of the decay of well-preserved monumental settings and the place of statue monuments within them.[26] To find statues together with their bases is of course very rare. This usually occurs as the result of earthquake collapse. Sculpture sometimes survives inside the basins of nymphaea, and, very rarely, on streets and in squares. Yet, my primary reflex, as an archaeologist, when looking at well-preserved 'statue landscapes' is not to map what is there, but rather to think what is absent. The statue base assemblages recovered from some sites provide impressive testimonies to the longevity and continuity of the statue habit in Late Antiquity. They also demonstrate the respect of city dwellers for images that were centuries old, no more so than in Africa, at Thamugadi, Cuicul, and Lepcis. Here, images of the Principate, of civic figures, emperors, and gods, coexisted with those of 4th c. rulers. Some changes to older monuments did take place, before the end of occupation. For example, imperial *quadrigae* were selectively removed from one part of the forum at Thamugadi (Fig. 6), although here free space was created by monument removal without being filled: perhaps to accommodate market stalls on the forum.[27] One can also document the rapid reuse of late dedications at Cirta, Lepcis, Thubursicu Numidarum, and Rome. We even find the bases of popular late antique emperors being reused, in not much more than a generation.[28]

21 Stuccoed bases, Pompeii: a base with an Oscan text honouring the consul Mummius, from the 140s BC is of tufa covered in stucco: Ball and Dobbins (2013) 487–90.
22 Odd survivals: Sagalassos, Upper Agora for Ias, daughter of Krateros son of Neon: Vanderhulst 6 Lanck 218 = Eck and Eich no. 68, see discussion and map in Lavan (2013) 325 plus 319 fig. 10a and 321 fig. 10b, with placement on south edge with Late Roman emperors. One could argue that some early statues were retained as being exceptional works of art, but I have not seen evidence that could support this outside of the capitals.
23 Coherent survivals: Aphrodisias, North Agora, portico, outside bouleuterion entrance for Dometeinos and Tatiana: Reynolds, Roueché, and Bodard (2007) nos 213a and 2.17; Inan and Alfoldi-Rosenbaum (1979) vol. 2 186–87; Smith. (1998) 66–69; Smith (2006) ca. 75 (not seen).
24 Well-preserved display contexts, fora: See Lavan (2020) appendix K9, plus 300–305 fig. E7a–g for maps.
25 Well-preserved display contexts, streets: Ephesus: see Lavan (2020) appendix H7 plus 306 fig. E7h; Sagalassos: Lavan (2020) appendices H7 and F7b; Tripolis ad Meandrum: Lavan (2020) appendices H7 and C4.
26 Record of decay: Uchi Maius: Ibba (2005) 171–73, 173–75, no. 55; G. De Bruyn (2014) 945 = Gavini *et al.* (2012) 2819–23 no. 2 with 2820 figs. 6–7 (photo and drawing) = no. 54. Lepcis: see, Lavan (2020) appendix K9 and V4b with references.
27 Statue editing, Pompeii (forum): Zanker (1998) 102–103 with fig. 51.
28 Rapid reuse of late antique statue bases, Cirta (LSA 2327), Thubursicu (LSA 2482), and Rome (LSA 1372): Lavan (2020) 295 with appendix K9. On Lepcis (6 examples), see especially the paper by Tantillo and Bigi (2010), translated in this volume.

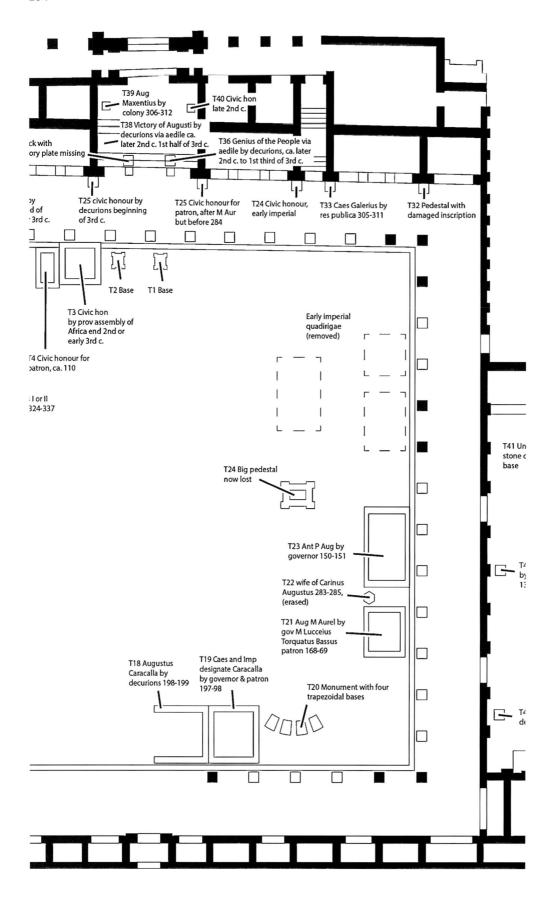

FIGURE 6 Statue removal: Thamugadi *quadrigae*.
REDRAWN BY L. BOSWORTH, AFTER ZIMMER AND WESCH-KLEIN (1989) 39 FIG. 16

FIGURE 7
Statue removal: Argos, statue plinths in a late antique portico stylobate on the forum.
PHOTO: L. LAVAN 2007

As we will see, there are a few massive ruptures visible within African sites, where a decision had been taken to clear out all or almost all of the monuments of a street or plaza. Such 'statue clearances' can be seen from archaeology widely across other parts of the empire. Sometimes, there is direct evidence of monument removal, such as a row of statue bases built into a wall adjacent to an agora, as happened at both Sagalassos and Ephesus in the 6th c.[29] In other places, datable traces are left on pavements, as at Sagalassos, or there are 'patches' of new slabs, as in Rome, within the Severan paving of the Forum Romanum. Scars left by former monuments were disguised (Fig. 8), like that marking the emplacement of the massive horse of Severus himself. At Rome, a 'great removal' occurred when the plaza was systematically emptied of old statues under the Tetrarchs, after the fire under Carinus in 283–285.[30] Art works from before this time, such as the statue of Marysas, clearly visible on the 2nd c. forum image of the *Plutei Trajani*, have vanished without a trace. In contrast, the Forum of Augustus was untouched. Within this plaza, 17 out of 28 of Augustus' statue monuments for *summi viri* were recovered by excavators and epigraphers. Others were found immediately close by during excavation (see appendix 1). This suggests that the plaza retained a good number of the original statues throughout Late Antiquity, as implied by the late 4th c. *Historia Augusta*.[31] Similarly, Trajan's equestrian statue was standing in the middle of his forum in the mid-4th c., whilst the Forum Pacis still had statues by Pheidas in the mid-6th c., as Ammianus and Procopius tell us.[32] This reinforces the feeling that the Forum Romanum really was cleared of its early statue assemblage under Diocletian.

However, outside of Rome, one can feel that the early imperial period is somehow strangely absent from the listings of inscribed bases found in fora/agorai. This is particularly true in much of Greece. Anyone hoping to use Pausanias' 2nd c. guidebook runs into difficulty when confronted by statue landscapes that have been modified, even removed, during the late 3rd or 4th c. We can sometimes find the socles of monuments he described, as at Argos, where an adjacent late portico uses statue plinths to form its stylobate (Fig. 7).[33] Statue base assemblages from places like Corinth, Tegea, or

29 Monument removal, with bases found, Sagalassos: Lavan (2013) 313, 315–20, 324–26; see also Lavan (2020) appendix S11. Ephesus: L. Lavan site observation 2005, which is part of a mid-6th c. phase of the baths connected to the building of the Curetes Stoa, which incorporated spolia from the Upper Agora (see Lavan (2020) appendix C4). Bases were also found stored in the Lower Agora that may come from the 6th c. clearance of the Upper or Lower Agorai.

30 Monument removal, traces only: Sagalassos: Lavan (2013) 309–313; Lavan (2020) appendix K9. Rome (Forum Romanum): Giuliani and Verduchi (1987) 117–18 (no. 16). On the fire, see the *Chronicle of A.D. 354*.

31 Preservation of early statues: Rome (Forum of Augustus): SHA, *Alex. Sev.* 28.6. See the catalogue and epigraphic references in Johnson (2001) 87–115 available at https://macsphere.mcmaster.ca/bitstream/11375/11826/1/fulltext.pdf (last accessed April 2021). For the arrangement of statues as planned by Augustus, see most recently Shaya (2013).

32 Preservation of early statues: Rome (Forum of Trajan): Amm. Marc. 16.10.15. Rome, Forum Pacis: Procop. *Goth.* 4.21.11–14.

33 Clearance of early statues: Argos: A rectangular temple, suspected of being 4th c. in date, has been excavated at the central area of the agora, constructed on top of a large, monumental base, for a statue group that is possibly mentioned by Pausanias: Piérart et al. (1980) 694–96; Piérart (1981) 906. On

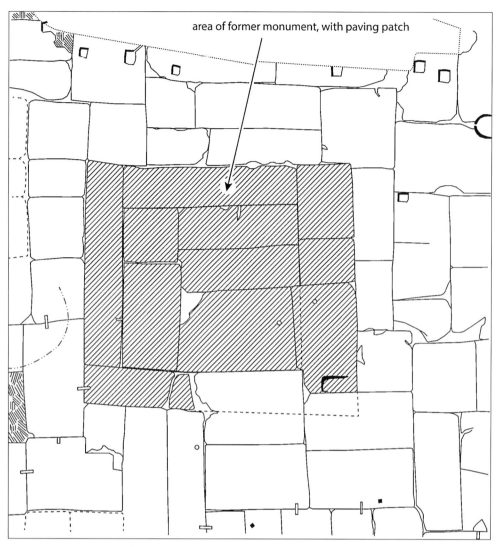

FIGURE 8 Statue removal: Rome, post-Severan paving patches over the site of a former monument (Giuliani and Verduchi (1987) 147–48 no. 22 with fig. 203).

Athens (Roman Agora), give the impression that there has been a clear-out of older dedications, sometime in the late 3rd or early 4th c., leaving only statues of the Tetrarchs and of later dynasties of 4th c. emperors. These clearances seem to have especially affected the plazas of Italy, Spain, and Greece, at different times in the late 3rd to 4th c., and a little later also in Asia Minor and Constantinople.[34] This horizon of destruction is too frequently encountered to relate to earthquake damage. It was nothing to do with Christianisation, as its early chronology demonstrates. But the phenomenon was not new: we hear of it in Early Imperial Rome.[35] Although largely revealed by negative evidence, such removals are worth studying as a facet of late antique statue culture.

Much of this early destruction leaves no trace. In the late 3rd to early 4th c., statue bases were still being reused, with recutting removing older dedications. But opportunities to document such 'statue clearances' do come from 4th to 6th c. walls that reuse them, particularly either side of the Aegean, but also in outlying sites from the West, as at Barcelona.[36] In these cases, large numbers of bases were either built into walls, without being recut, or inscribed plaques stripped from bases were reused as veneers by turning over the inscribed face.

the statue group that Pausanias is believed to have seen, see Piérart *et al.* (1980) 696.

34 Dominance of late 3rd to early 4th c. statues: see Lavan (2020) appendix K9 and related epigraphic reports cited with them.

35 Statue clearance, Early Imperial Rome: we have actions by Augustus and Caligula on the Capitol and in the Campus Martius: Suet. *Calig.* 34. Cass. Dio. 60.5.5 (Claudius wanted to and probably did remove statues of himself from temples and public buildings), 60.6.8 (Caligula moved statues of Gallic cities to Rome and Claudius sent them back).

36 Statue clearance, late antique, Barcelona: Beltrán de Heredia Bercero (2009) 144 with further references in Diarte-Blasco (2012) 71; Sparta: Frey (2016) 91; Philippi: Sève (2003); Ephesus: Lavan (2020) vol. 2 743–44 with vol. 2 209–212 and 823–24, relying on Aurenhammer and Sokolicek (2011) 60–66. See also below for Ostia, Aphrodisias, Sagalassos, and Sabratha.

At different moments, decisions were made to divest cities of a large part of their statuary. Sometimes, it seems that this was a response to the needs of a major building project, such as the city wall of the 360s at Aphrodisias. Alternatively, it was the result of a political decision. Thus, we hear of an urban prefect at Constantinople who melted down all the Greek bronzes of the Mese, to make a colossus of Anastasius.[37] But on other occasions, statue clearance looks likely to be a simple response to catastrophic damage. It can become visible if one has a reasonably good control over the stratigraphic dating of surrounding buildings. Something like this seems to have happened to the forum at Ostia, where all honorific statuary dates from after 310, whilst surrounding spolia contexts, both public and private, have revealed dedications from shortly before this time. This suggests that ruined material became available on a large scale in a haphazard manner in the early 4th c.[38]

Catastrophic damage is nowhere clearer than at Sabratha in Tripolitania. Here, damage to the forum statues is reflected in the aforementioned dump, found in the capitolium, and in slabs of epigraphic veneers found in the floor of the forum portico, relaid as part of late 4th to early 5th c. building works around the plaza. This floor of epigraphic fragments is a 'spolia context': that is, a discrete association of dated artefacts sealed in a single archaeological layer. The fact that it can be matched, in its nature, to the dump in the adjacent temple is significant. Furthermore, bits of inscription IRT 95 are notably found in both contexts. It is almost certain that this dump, alongside that which found its way into the portico, was created by the tidying up of the remains of statue monuments from the damaged forum. It had been decided that old statues were too broken to repair and had to be replaced. We find that the 19 identifiable dedications recorded, all for emperors, run from the time of Trajan up to the time of Constantine, [either Constantine I or II (IRT 54)]. The assemblage of fragments gives us a contextual date of 312–337 or 337–362 for the destruction. Under the dating rules I use, the date range should be the 25-year period after the start date of the last find. This fits well the wider chronology of rebuilding in the plaza. The lists of damaged inscriptions provide us with a record of statue clearance. Yet, this act of removal was also one of preparation, if we care to consider the new statue monuments subsequently erected on the same site. These date from the time of Valens and Valentinian (364–367). They mark a renewal of the city, expressed in statuary.[39]

Selective spoliation during *damnatio* will not be considered here, except to note that the concordance of epigraphy and archaeology is not direct. Indeed, this is only part of the story of late antique statue editing. Rather, one sees a wider process in which bases were moved around within Late Antiquity, as at Sagalassos, or were removed selectively over time, as at Philippi.[40] At Sagalassos, the group organisation of early statues on the Upper Agora seems to be too thematic to be original. In particular, one civic family (the Neons) is privileged for preservation, being placed in the Antonine nymphaeum, to which their bases do not belong (Fig. 9). At Philippi, we can note a gradual thinning of statues on the agora, until all that remained were images of the priestesses of Livia, retained until 536–616. It is likely that a monument mentioning this well-known empress was appreciated even in the 6th c., in what had been a Roman colony. Yet, despite the great interest of these sites to the topic of memorial, there are simply too few where selective editing can be traced at present. I would, however, plead with scholars to focus on sites where we do have a firm *terminus ante quem* (TAQ) for statue life at different periods. This might be some sort of dated deposit sealing the statue bases on a street or plaza, free from later interference. Such a sealing event occurred at Lepcis Magna in the Severan Forum at some time in the 5th c., with a great accumulation of silt, after which the Byzantine constructions above covered over the statue-base assemblage (Fig. 10). This gives us an area untouched by later spoliation, a process which greatly affected the Old Forum of the same city in the 6th c., to

37 Statue clearance, late antique: Constantinople (Mese): Malalas 16.13; Marcell. com. AD 505–506 (506). Aphrodisias: the vast majority of honorific statue bases of Aphrodisias were put into the city wall of the 360s according to R. R. R. Smith pers. comm. and De Staebler (2008a and 2008b), with Smith (2007) 209–10, who notes 80 statue bases identified in the wall. The dating of the city wall depends on ALA 22 of 365–70 and related gate inscriptions, though recently a longer chronology of 350s to 360s has been proposed, the dating basis of which is not yet published, leading me to accept a tighter chronology of the 360s around the existing published inscriptions: see Lavan (2020) appendix C5.

38 Ostia: for statue bases of 285–306 (LSA 1661), 380–89 (LSA 2582), and 389–410 (LSA 329): see Lavan (2020) appendix K9; for statue bases and inscribed veneers from later 3rd to early 4th c. spolia contexts close to the forum, which may or may not have come from it, see: Lavan (2020) appendices H2 (Nymphaeum on decumanus, 268–389), A3 (thermopolium, 250–450), W1 (*Foro della Statua Eroica* phase 1b, 350–375). It is possible none of these texts were displayed on the forum.

39 Sabratha: the north portico of the forum was given a paving of a "patchwork of broken stones and marble": Kenrick (1986) 30, 33–34. For the rebuilding of the plaza see, Lavan (2020) appendices K2a and K4b. For the dump of inscribed marble fragments found in the capitolium see, Lavan (2020) appendix Q1.

40 Statue editing, Sagalassos: Lavan (2013) 313, 326. Philippi: Sève (2003).

FIGURE 9 Statue movement: Sagalassos, Antonine Nymphaeum, non-matching bases, too small for the niches, likely inserted after a rebuilding of the monument in the earlier 6th c.
PHOTO: INGO MEHLING CCBYSA3.0 LICENCE

the detriment of its monuments.[41] Sites comparable to the Severan Forum are rare and tend to be abandoned in 5th c. for Africa, and in the 7th c. for Asia Minor. Many, as at Philippi and Ephesus, reveal agorai in their very final denuded condition. Others are well-preserved, providing us with snapshots to set against much rarer earlier statue landscapes. The only comparable sites I know of are the forum of Sarmizgetusa (3rd c.) in Dacia (Fig. 11) and the denuded forum of Pompeii (1st c. AD). The latter was a building site when covered by Vesuvius but is also known from a fresco for its statue details.[42]

But what can we learn from these snapshots in time, about statue wastage or statue movement? At Pompeii in AD 62, when an earthquake halted monumental investment, the forum appears to have civic notables being replaced by emperors. A row of statues of local magistrates, set against the east portico, gives us a flavour of honours past, but the southern side of the forum was then seeing equestrian statues replaced by outsize marble-clad bases that seem likely to have been reserved for princes.[43] Yet not all movement was about deleting images: bases erected inside a temple precinct on the

41 Sites with good TAQ, Lepcis Magna: There was then a build-up of silt, probably after the last late antique repairs to civic monuments and certainly before the Byzantine reoccupation, as the area had been covered by 0.5 m of flood sand by the latter time: Ward-Perkins (1952) 111 (not seen). This reference was derived from Pentricci (2010) 152. A *terminus post quem* (TPQ) for the beginning of decay in the forum can be derived from the last honorific statue base known from the forum. This is (from in front of the east portico) a reused base for a statue of PLRE 2.813 Fl. Ortygius, *comes* and *dux* of Tripolitania by *ordo* and *populus*: Tantillo / Bigi no. 31 = LSA 2177. Dated to AD 408–423, based on years of joint reign of Augusti Honorius and Theodosius II. A TAQ for the raising of the forum level seems to be the construction of the city wall, dated to 533 to 543 based on texts, see Lavan (2020) appendix V4c. Aphrodisias: see dismantling levels from the temenos around the Temple of Aphrodite: Lenaghan (2021) 209–29.

42 Sarmizegetusa: see overview of forum in Étienne, Piso, and Diaconescu (1990) and now Piso (2006) Pompeii: Laurence (2007) 20–37. Pompeii, forum fresco from Insula of Julia Felix: Ling (1991) 163–64 with Accademia Ercolanese (1762) plates 42–43.

43 Pompeii forum, local magistrates, east portico (C. Cuspius Pansa, Q Sallustius, M. Lucretius Decidianus Rufus, all *duumviri* and *quinquennales*): Laurence (2007) 33 with fig. 2.3; equestrian bases replaced, south portico: Zanker (1998) 102–103 with fig. 51.

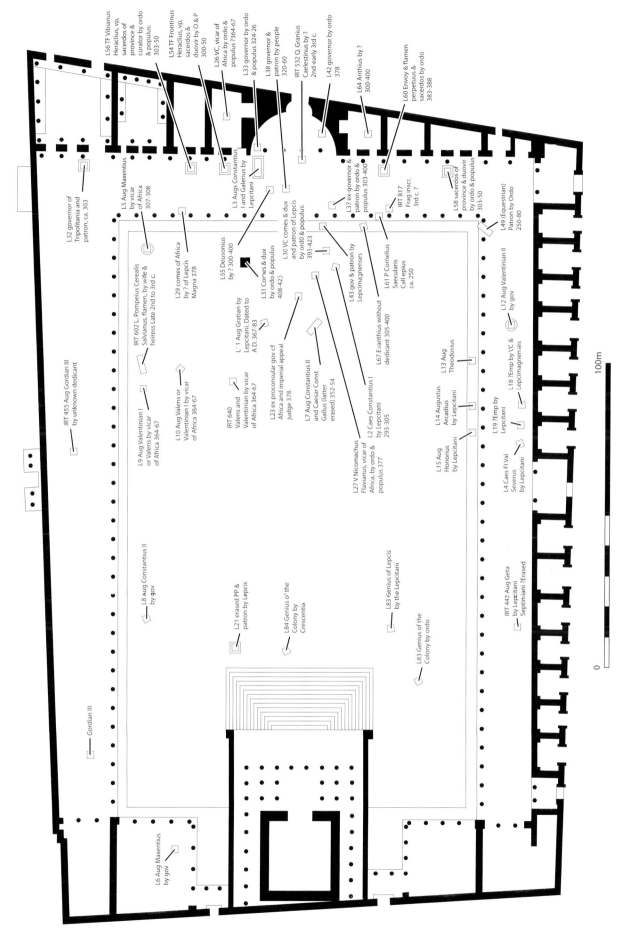

FIGURE 10 Passive accumulation seen in a well-preserved statue landscape, frozen in the early 5th c.: Lepcis Magna, Severan Forum (Redrawn by L. Bosworth after Tantillo and Bigi (2010) table 1).

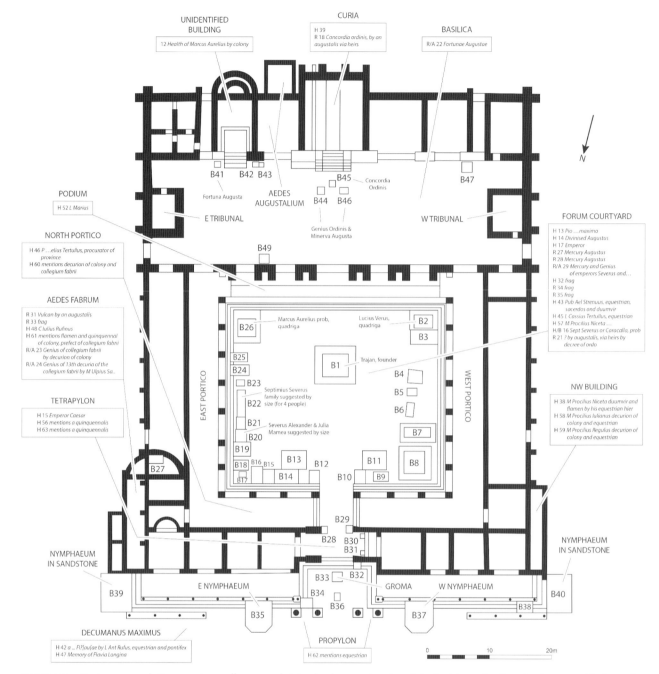

FIGURE 11 Passive accumulation seen in a well-preserved statue landscape, abandoned in the later 3rd c.: Sarmizgetusa map (Redrawn by L. Bosworth after Piso (2006) fold-out (*dépliant*) figure 1; Etienne, Piso, and Diaconescu (2006) 202–207, and Piso (2006) 211–314).

forum, including a dedication to the consul Mummius of the 140s BC, show back scars that reveal they were here in secondary use. It is quite likely they had been moved here from the forum.[44] At Sarmizgetusa in Dacia, abandoned around AD 275, we see a mature imperial landscape, similar to those in Africa, where the main forum is crowded with emperors, alongside a few deities and personified concepts, whilst provincial priests occupy a separate forum, and municipal magistrates occupy its portico. One suspects here that this arrangement, of

44 Pompeii forum, precinct of Temple of Apollo: Ball and Dobbins (2013) 487–90.

what is phase 3 of the forum, reflects the end of the process begun at Pompeii, whereby civic magistrates were being squeezed out the main plaza which was becoming the domain of emperors and high ideals.

When we come to the forum of Sabratha in the mid-4th c., the snapshot we have is less detailed: it is reasonable to think that all the inscriptions from the dump or portico floor relate to the forum even if we do not know where they stood (see appendix). What is striking is the degree to which 2nd–3rd c. municipal magistrates, though present, are so few in number compared to emperors. Yet the only positive evidence of reuse we

have is of imperial statues recycled for other emperors in the 3rd c. This suggests either that civic honours had been moved out or, more likely, that they always been few and had been swamped by emperors since the 1st c. AD. At neighbouring Lepcis, where the statue landscape was covered over by silt in the mid-5th c., we have a similar impression. Civic magistrates are again insignificant amongst emperors, governors and provincial priests. Only one civic honorand has been recycled, against three governors and one emperor. The fora of Cuicul and Thamugadi, likely fossilised at similar times [last dedications here are of 361–363 at both sites, C24 and T16], tell us a broadly comparable story, of imperial dominance, although there are higher numbers for civic honorands, some very old. It is also striking how statues of deities and personified concepts survived well in all four of these African sites, into the 4th–5th c.[45]

The evidence as we have it contradicts what we might expect. Rather than being gradually 'wasted', with lesser men forgotten, statues seem to have passively accumulated at Sabratha over the first three centuries, with emperors who should have been damned, like Commodus and Philip, escaping notice. At Lepcis, more recent imperial causalities, Severus II and Maxentius, escaped censure, whilst damned emperors sometimes had only their names erased, not their bases removed, as in the case of Geta.[46] After changes at the end of the Republic, seen at Pompeii, the Roman statue landscape looks remarkably stable. But this did not last for ever. The next comparable sites, where large numbers of bases survive, are Sagalassos and Aphrodisias. Both have an abandonment date in the early 7th c., which is thus the date of their final statue landscape. Here, substantial alterations are detectable. Sagalassos witnessed the removal of two religious images, *ca.* 400, whilst a partial statue clearance is visible in walls around the Upper Agora, *ca.* 500 At Aphrodisias, statues and bases accumulated in the Hadrianic Baths and its portico onto the South Agora, as if it had become a retirement home for material once displayed on the adjacent plaza, which now had relatively few such monuments.[47] At Sagalassos, several 1st and 2nd c. images of emperors still stood on its Upper Agora. Furthermore, a few early civic statues do survive at both sites. Yet the agorai have been reshaped. Pride of place is given to late emperors' images, whilst governors are also prominent at Aphrodisias, a provincial capital, as are late civic notables. Although it is harder to prove at the latter site, the agorai do not appear to hold simple accumulations of statues, but rather look to be places where the late antique monuments are particularly well set, as if some earlier statues had been pushed aside.[48]

Thus, the plazas of Sagalassos and Aphrodisias appear to represent a more conservative version of what we see on sites from Greece to Spain, which saw the wholesale removal of statue monuments except those of 4th c. emperors. But the overall picture is uneven. At Sagalassos, in contrast to the Upper Agora, the Lower Agora seems to have had nearly all of its statues replaced in two events, in the 4th c., and the early 6th c. Nonetheless, in the streets of this same city we have some coherent early statue fields that survive unscathed until the end of the site in the early 7th c., with groups of dedications to emperors and agonistic victors. A similar impression comes from Ephesus. Here, the agorai have been cleaned of statue monuments around 500 or a little later, whilst the main street enjoys rich preservation of a display of early 5th c. date.[49] There are obviously some trends here, but not a single coherent process.

45 Thamugadi: Zimmer and Wesch-Klein (1989) 39 fig. 16; Cuicul: Zimmer and Wesch-Klein (1989) 18 fig. 5; Lepcis Magna: Tantillo and Bigi (2010) table 1. All of these maps have numbers referring to gazetteer entries in their main text.

46 Emperor damned but not moved from forum, Lepcis Magna, Geta: IRT 42, see map in Tantillo and Bigi (2010) table 1.

47 Substantial alterations, Sagalassos: a Tyche statue was removed in the later 4th c, after 382: Lavan (2013) 315–16 with LSA 2531 and M. Waelkens, *Sagalassos – Jaarboek 2008. Het kristallen jubileum van twintig jaar opgravingen* (Leuven 2009) 206–208, figs. 152 a, b = LSA 2530; statue clearance into wall on the Upper Agora, *ca.* 500: Lavan (2013) 329, 320, fig. 10b with 294; at Aphrodisias Hadrianic Baths: Smith (2007) 209–210 with figs. 39–41 for maps, noting how some of the statues seem to have come from the temenos of the temple of Aphrodite, whilst others are too old to be original to the baths. Part of three statues kept in the Hadrianic Baths and the adjacent west portico ended up in the plaza's central pool, rather than parts of statues known to have stood on the rest of the plaza, suggesting that the latter was comparatively empty of statues when such rough spoliation took place: Smith (2007) 219. However, note that one late statue, well-set at the centre of the south side of the entrance courtyard, mentions the baths as its place of erection, as the honorand Hermias had given money to the baths: ALA 74. The frequency of honorific dedications in the Baths and the South Agora can also be compared using the list in https://insaph.kcl.ac.uk/insaph/iaph2007/inscriptions/toc/location.html (last accessed Feb 2022).

48 Late emperors prominent, Sagalassos: Lavan (2013) 325–26 plus map on 319 fig. 10a; Provincial governors and notables, Aphrodisias: ALA *passim*, plus Smith (1999a) (1999b) and Lenaghan (2019).

49 Large scale removal, Sagalassos (Lower Agora): Lavan (2013) 311–12 (row of anepigraphic bases established, likely in time of Julian); 313 (in wall of 475–525) date discussed in Lavan (2020) 462 as 'south wall'; Ephesus: Lavan (2020) vol. 2 655–59 (appendix K4b) and 823–24 (S3) (ii) plus H7 comments. Preservation, coherent statue groups on streets, Sagalassos: Lavan (2008) 203–204 (bases for Hadrian, Trajan, Gallienus, and family of Septimius Severus on colonnaded street; agonistic bases on road leaving Lower Agora from north); Ephesus: see Lavan (2020) appendix H7 plus 306 fig. E7h.

In different parts of the empire, it seems that the middle imperial centuries saw a time of accumulation not wastage. Many statues were probably never moved and left in peace, especially away from main plazas, where statue replacement was perhaps most likely. Yet from the 4th c., the systematic replacement of statue landscapes became common, either after trauma or as a political act. A few cities also practiced selective recycling. In earlier centuries, I suspect that most unpopular public statues were simply moved, but by the 5th c., old civic honorands on fora/agorai had become vulnerable to scrapping. By the 6th c., some of these places were still 'cemeteries to memory', where a city's story could be told, but squares with monuments going back 6 centuries, like Sagalassos, were increasingly rare, as disaster, disinterest, or practical needs broke traditions of monument preservation in many places.

Statue Display: in Groups, by Temples, on Porticoes, in Plaza Centres

In Groups

A more familiar theme, to which archaeological context has much to contribute, is statue display. It would be interesting to describe the intentional zoning of statues by dedication or dedicant, clearly visible in places as far apart as Pheradi Maius, Lepcis, Rome, Aphrodisias, and Sagalassos. This I attempt in my book on *Public Space*. In this article, I will rather talk about the general architectural arrangement of displays, and how they changed. The extent to which this topic has been neglected can be seen by looking at the agora of Tegea in the Peloponnese. Here, the reports of Vsem from *BCH* (1893) add valuable details of context, which epigraphers combing reports for the LSA did not exploit. There are three statue bases recognised in LSA, to Diocletian (LSA 569,) to Caesar Constantius I Chlorus (LSA 355), and to Caesar Constantine I (LSA 356).[50] All of these bases were reused, from odd bits of columns and blocks. But what has been missed is that they occurred in part of a wider group. Between 5 to 7 further illegible reused bases were found together with the inscribed blocks, here on the agora of Tegea, 4 m under the modern ground level. The bases of this group were apparently found *in situ*, as the excavator noticed that 4 of the bases were placed upside down. These odd bases are all likely to be of the same period.

Vsem notes that their faces carry two or three erased inscriptions, with some bases being modified in shape to permit a new wider surface, and so more inscriptions.[51] They can be considered at least a loose group, based on their common setting and shared characteristics of reuse. We can note the earliest start date for the group (284) from a late antique dedication recovered here. The latest end date is 337, although it can be stretched to 350, if we include another for Augustus Constans, reused in the adjacent church, that probably came from the plaza. All of the extant honorands are emperors who escaped *damnatio*. The erased examples presumably relate to those who did not. The long period of time between the start and end of the dedications suggests that we have here the remains of a display point for imperial portraits serving all members of the Tetrarchic and Constantinian dynasties. Editing took place as emperors rose and fell, but the accumulation of statues, rather than their expedient replacement, was the dominant tendency.[52]

Another important site is Sala, in Mauretania Tingitana. Here, two bases to Augustus Constantine I (LSA 2559) [titled *Maximus* and *Invictus*, so 312–324] and an unnamed Caesar (LSA 2560) were dedicated by the *res publica Salensium*. The letters R.P.SALENSIUM, which appear on both inscriptions, seem to be almost identical. They are irregularly cut, sometimes going out of the field reserved for the inscription, into the moulding.[53] However, if one reads the *BCTH* report of Boubé, it tells us that these two blocks were found in a line of 5 reused bases (including reused altars) in front of a 5-*cella* temple in the forum, an arrangement that still survives on site (Fig. 12a). The inscriptions of the other 3 bases had plaques on their surfaces (for inscriptions) that are now missing. The reuse of the altars, and the association of all three pedestals in the line of 5, echoing the temple, suggests that they constitute a single tight statue group, erected at the same time, and that we could expect the missing text to have been dedicated to other imperial colleagues during the reign of Constantine I. If this happened at the same moment as the two statues above, it must be in the period 317–324. During these years,

50 Statues in groups, Tegea: LSA 569, LSA 355, and LSA 356: their find-spot on the agora is based on the first report by Vsem (1893) 6, 9–11.

51 Redadications: Vsem (1893) 9–10.

52 See Lavan (2020) appendix K9.

53 Sala: Euzennat *et al.* (1982) 185–87, no. 304b = LSA 2559 (which has a drawing); see Boube (1959–60) 143–44 no. 1 (with find-spot in a line of 5 bases parallel to the retaining wall of the plaza on p. 143) = AE (1963) 66. Boube (1959–60) 143–44 no. 4 (with find-spot in a line of 5 bases parallel to the retaining wall of the plaza on p. 143 and detail of the plinth on p. 144) = AE 1963 65= LSA 2560 (that has a drawing, which shows that the base is broken off in the upper part so we cannot know if it was damned or not).

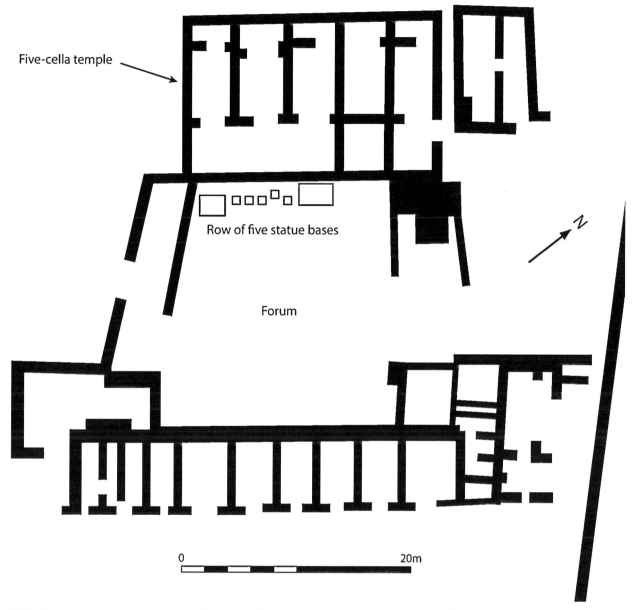

FIGURE 12A Late statue groups on fora: Sala, group of five reused bases including a dedication to Constantine as Caesar, with the other dedications lost or removed.
REDRAWN BY L. BOSWORTH FROM GOOGLE EARTH, A PHOTO OF I. TANTILLO (WITH THANKS), AND TOURIST PLANS

Crispus and Constantine II were Caesars to Augustus Constantine I, and Licinius II was Caesar to Augustus Licinius I in the East. This solution would suit the 5-base group well, as we have three missing dedications here which could be explained by the *damnatio* of Crispus, Licinius I, and Licinius II, to complete this statue group. The collection was likely conceived at a single moment when all of them were in office together. The dedication was perhaps associated with imperial cult activities in the temple behind, with each *cella* of 5 linked to one member of the imperial college of the period 317–324. This is suggestive evidence but it can be given greater confidence when we look at other sites. We find a similar row of 4 blank bases built into a common kerb on the forum at Ureu (Fig. 12b), alongside a dedication of Augustus Constantius I, and a group of at least two aniepigraphic but distinctive hemispherical bases, set on socles, on the forum at Hippo Regius, where bases for Valens and for a 4th c. proconsul were found.[54]

54 Ureu: AE (1974) 692 = LSA 1953 = Beschaouch (1974) 219–34, fig. 3 (photo of text) = Lep. 238. See, Lavan (2020) appendix K9 for remarks. Hippo Regius: anepigraphic / blank statue bases ('socles') on the forum, some of a hemispherical form, are mentioned by Marec (1954) 372. See Lavan (2020) vol. 2 720–21 for the rest.

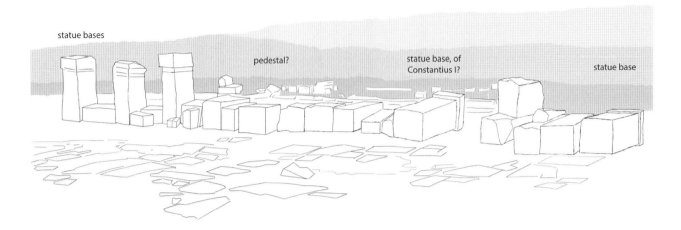

FIGURE 12B Late statue groups on fora: Ureu, group of bases incorporated into a kerb, including a dedication to Constantius I as Augustus, the others being blank.
REDRAWN BY L. BOSWORTH AFTER BESCHAOUCH (1974) 219–234, FIG. 2

By Temples

We could imagine that honours, at least of incense, were offered at such groups of statues, located on one side of a forum, under the Tetrarchy, where Christians might be asked to sacrifice to test their allegiance. More modest honours were perhaps also offered under Constantine. We can suspect a political function for the Tetrarchic to Constantinian statue groups commonly found on fora in the West and on the agorai of Greece. They can also be found associated with nymphaea, in Asia Minor, but these are best left aside here. In the West, the association is not just with fora but also sometimes also with temples on fora, as we have seen at Sala.

This association is most obvious at Saepinum, in Samnium, where outside the presumed Temple of Jupiter, were set two funerary *cippi*, re-inscribed as statue bases, to honour Constantine (LSA 2576) and Helena (not in LSA). Neither texts have previously been precisely located in urban space, in literature I have seen. Both were placed, in an ungainly manner, on the step infront of the sanctuary, for which they were a little too big (Fig. 13a). This temple is adjacent to a second building where a separate honorific plaque to Helena has been found (LSA 1751), alongside an actual statue of the empress, of which no image is available.[55] It is worth looking at the first two inscriptions in their archaeological context. Both seem to be *in situ*, both have the same style of base, and both are set on a socle. They flank a larger socle, placed at the centre of the group, and were accompanied by two further bases of a different style, set on the outside, within a line of 5 statue monuments. One of the two outer bases is now represented only as a recess, cut into the step it stood on. Thus, we originally had a group of 5, set in front of the temple (Fig. 13b).

In her dedication, Helena is described as 'the grandmother of two Caesars', as 'the wife of the divine Constantius', and as 'mother of the Augustus'. Constantine is described by the unusual formula '*di(i)s genito*' 'begotten of the gods'. This is only used elsewhere to honour Constantius I (at Colossae). Undoubtedly, the 'two Caesars', Constantine II and Constantius, the grandchildren of the Augusta, were honoured on the outside bases of this group, and at its centre would have stood the divine honorand, Constantius II. The group suggests a rededication of the building behind as a *Templum Flaviae Gentis*, of the kind known from Hispellum in 337. The dedication date is to the period 326–330, based on the titles of Helena. She is listed as '*Augusta*', which she had been since 325, and 'grandmother of two Caesars', which must be a time after the death of Crispus in 326,

[55] Statues by temples, Saepinum: Constantine: http://edh-www.adw.uni-heidelberg.de/edh/foto/F002464.JPG (last accessed June 2016), which is Gaggiotti (1979) 28 = AE (1984) 367 = EDR 079507 = LSA 2576 (which does not know its exact find-spot). Helena: EDR 134304 = M. Buonocore, "Roma antica e le iscrizioni imperiali. In margine al primo fascicolo del nuovo supplemento al volume VI del Corpus Inscriptionum Latinarum", BollArch 28–30 (1994) 27 (first publication), re-read by M. Buonocore in 2013 for the EDR entry. Not in LSA. Second Helena: CIL 9.2446 (with no find-spot details, other than saying found in the forum) = LSA 1751 = EDR 132921 (which says it is a tabula alt.: 86.00 lat.: 61.00 Crass. / Diam.: 26.00). See also Ruggiero and Vaglieri (1904) 3682; Gaggiotti (1979) 36 (not seen). See Lavan (2020) appendix K9 791–93 with further discussion.

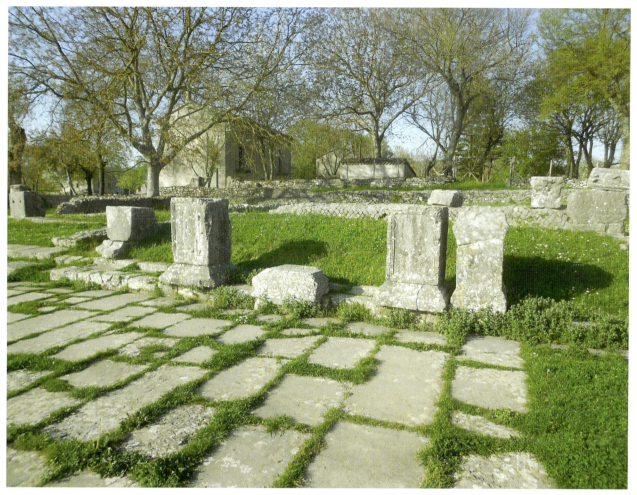

FIGURE 13A Late statue groups by temples: Saepinum, reused bases, an empty plinth, and a statue emplacement, in front of the 'Temple of Jupiter', hanging ungainly over the last step.
PHOTO: L. LAVAN 2016

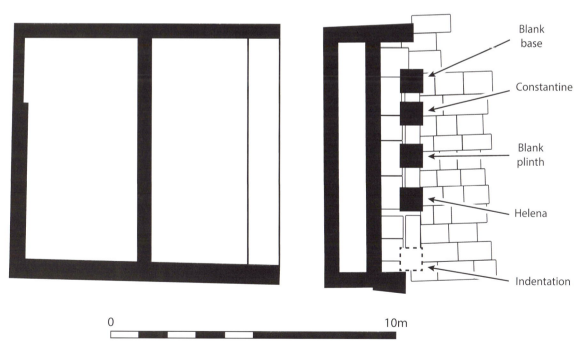

FIGURE 13B Statue groups by temples: Saepinum, reused bases, an empty plinth, and a statue emplacement, in front of the 'Temple of Jupiter', in plan.
REDRAWN BY L. BOSWORTH FROM SCOCCA (2015) 78–79 FIG. 94

even though Constantine is given still as *victor*, a title dropped in 324. This makes the group a very late statement of Constantinian tolerance of the imperial cult. The bases are also an exceptionally strong evocation of the unity of the core imperial family, after the killing of Crispus and Fausta in 326. All that is missing here is an altar, of which there is no sign, and which likely never existed.

In thinking of further temple associations, we might consider the statues of the sons of Constantine set outside the Capitolium/Philadelphion at Constantinople.[56] We might also think of the temple of Hadrian at Ephesus with its Tetrarchic group. But here, the statues may not have been set in front of the temple until the last decade of the 4th c., perhaps slightly later, drawing on structural details relating to a later statue, which implies a rebuilding of the structure.[57] Settings for imperial statues generally changed radically after Constantine, with canopies/ciboria used at Mactaris (x2) and Sagalassos, as they had been used by Constantine for tychaia at Constantinople, and within Tetrarchic tetrakionia.[58] Other small sacella persisted but temples were no longer a focus. Honorific columns took over as settings for imperial statues, as did advantageous placements at the centre of one side of a plaza or outside the entrance of a major public building.

On Porticoes

What other settings were used for displaying statuary? A major type, popular from around the 360s, was the setting of statues, usually of governors or of desacralised mythological subjects, in rows attached to the porticoes of streets or squares. By 'attached', I do not mean that bases stood on the pavement in front of a portico, at the bottom of its steps. This was a standard position for statues in the Early Imperial period, beyond any portico steps or eaves drains, with perhaps a foot of clearance beyond them. In contrast, a typical late antique base position is actually on the steps, often supported by an extra stone, placed underneath the socle. Statue bases invariably touch the columns and may even by attached to them with metal clamps. We can see a group of at least 9 blank bases balanced on portico steps at Sagalassos, forming a symmetrical arrangement on different levels. This group I would date to the time of Julian, as it uses the same spolia as a nearby statue monument inscribed with a text honouring this emperor. Its dedication was recently dated by Eck, Eich, and Eich to the 6th c., based on its odd letters, but regional parallels for these same letters now show it is 4th c.[59] An engaged row of bases on a street portico can also be seen at Gortyn, providing the primary display context for the inscriptions now set within the Heraclian 'basilica'. Two square bases survive *in situ*, one inscribed to Clodius Felix Saturninus. This was apparently part of the same group dedicated in 381–382, in conjunction with the establishment of the new praetorium at this time.[60]

Similar emplacements for rows of statues exist as markings at Ephesus on the Upper Agora east portico (Fig. 14a). The arrangement can be seen twice on the porticoes of the Embolos, where statues of governors decorate the Alytarch Stoa (14b), of which they were built as an integral structural element in the period 410–430.[61] A row is also known at Tripolis ad Meandrum, where the bases are uninscribed but the statues survive.[62] They likely were also so arranged at Rome, in front of the Basilica Julia, where, in 377, the Urban Prefect Probianus decorated the structure with at least seven unspecified statues, likely of mythological images. A line of statue bases was probably also established at Cuicul, where, on one side of the forum, set on

56 Constantinople (Philadelphion): The statues (likely the Vienna Tetrarchs) of Constantine's sons: *Parastaseis* 70, *Patria* 2.50, with Bauer (1996) 228–33 and Berger (1988) 322–67.

57 Ephesus (Temple of Hadrian): All the inscriptions are in Latin: Roueché (2009) (155–70) 155–61 = IvE 2.308, 309, 305.1–3, 306 (Stichel no. 78, LSA 718–21). See Lavan (2020) appendix H7 for details.

58 Under canopies, Mactaris: For reports on the temple, see: Chatelain (1911) 507–508; Lezine and Herranz (1951–52) 203 = Lep. 292–93; Picard (1957) 49–54 (for a description of the monument). For discussion see, Lavan (2020) appendix P1. Sagalassos: Talloen (2003) vol. 1. 69–70, vol. 2. 103, no. 573, fig. 220; Constantinople (Tychaia): Socrates, *Hist. eccl.* 3.11; Zos. 2.31.2; Hesychius (of Miletus) 41–42; Dagron (1974) 373–74; Bauer (1996) 219; Cameron (1976); see also Lavan (2020) appendix Q1 with further references for all these sites except Perge.

59 Statues on porticoes, Sagalassos: For find-spot maps based on excavation records, with a photo of the reconstructed statue monument, see Lavan (2013) (289–353) 309–313 with fig. 6a (reconstructed example) and fig. 6b (map). My date represents something of a risk, but it is the strongest reasoning currently available. It represents a refinement of my original date in Lavan (2013) 312. See Lavan (2020) appendices K9 and H7 for dating arguments.

60 Gortyn: The excavators believe that the group might have originated on the colonnaded street, noting that many togate and pallium statues were found here: Baldini *et al.* (2005) 284–88. A subsequent report gives more detail: Lippolis *et al.* (2010) 511–37 with stone plan that depicts shading for this phase on p. 536 fig. 18 and axonometric reconstruction on p. 537 fig. 19. See Lavan (2020) appendix C4 for more details. Saturninus is apparently also discussed in the major study of Tantillo and Bigi (2020) 10 (not seen), which appeared too late to include here.

61 Ephesus (Upper Agora): see Lavan (2020) appendices K4b and K9; Ephesus (Alytarch Stoa): see Lavan (2020) appendices H7 and F7a.

62 Tripolis ad Meandrum: see above n. 21.

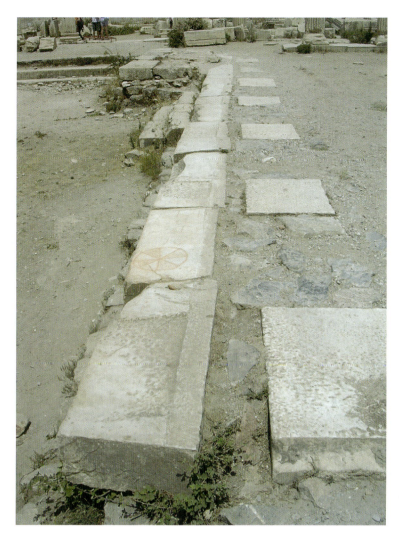

FIGURE 14A
Late statue groups on porticoes: Ephesus, Upper Agora, East portico, showing marks of statue emplacements on portico steps.
PHOTO: L. LAVAN 2005

the portico steps, a mixed group of civic, imperial, and religious images was probably assembled sometime in the later 3rd to 4th c. The blank statue bases brought into the Forum of Caesar were also arranged in the same manner, in 399–400, with cylindrical hollows cut out to fit them closely to the portico behind, just as a base in Ostia's forum was cut to sit on a step.[63] The origin of the practice of placing statues actually touching columns, in groups, obviously fashionable between the 360s and the 430s, was perhaps Constantinopolitan, given its spread to more than one region and to Rome. Did Constantine's architects arrange statues taken from Greek sanctuaries along the Mese in this manner, as drawings (Fig. 14c) of the Column of Theodosius suggest? In this setting statues were presented as a group assemblage, designed to provide a decorative addition to colonnades rather than to be admired individually. Imperial statues were not displayed in this manner, except in one case at Ephesus, where the display has been modified secondarily. This is, of course, a different way of presenting images than that which we saw for Tetrarchs and Constantinian emperors. It is perhaps suitable for a scenographic treatment, or a display of subordinate collegiality, as amongst governors.

In Plaza Centres

We see the statue habit drop away drastically over the entire Mediterranean, in the second quarter of the 5th c., after which statues became much rarer. This has been well-documented by the graphs of LSA and earlier by Stichel. Dedications only continue strongly

63 Cuicul: Lavan (2020) appendix K9; Rome (Forum, outside Basilica Julia): Gabinius Vettius Probianus, urban prefect, dated to AD 377 or 416 (*PLRE* 1.734 Probianus or *PLRE* 2.908 Probianus 1 erected 7 bases, of which known finds spots suggest an ornamentation of the façade: Lavan (2020) vol. 2 926–27, treating CIL 6.1658b–d and 37105 (LSA 1277, 1341–42, 1362), alongside CIL 6.10040–42 (not in LSA); Rome (Forum of Caesar): Lavan (2020) appendices K2a and K9. Ostia: Statue with bottom cut out: statue reerected by Ragonius Vincentius Celsus, prefect of the Annona: AE (1928) 131 = CIL 14.4717 = EDR 073107 = LSA 2582, of which its form is commented by Lavan (2020) vol. 2 appendix K9 p. 705.

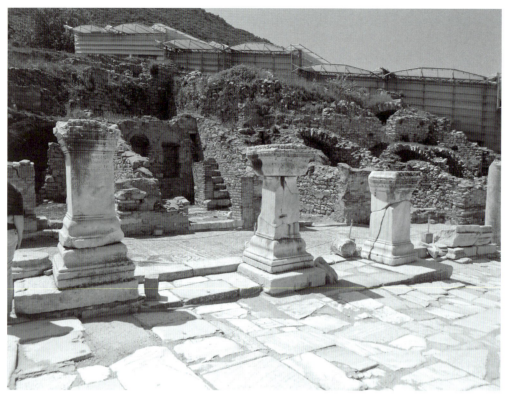

FIGURE 14B Late statue groups on porticoes: Ephesus, Embolos, Alytarch Stoa.
PHOTO: L. LAVAN 2013

FIGURE 14C Statue groups on porticoes: Constantinople, the Embolos or other Triumphal Way, from the Column of Theodosius I (after 16th c. drawings by F. Battista, Musée du Louvre, inv. 4951; Photos: (C) RMN-Grand Palais (Musée du Louvre)/Jean-Gilles Berizzi).

at Constantinople, and then not for very long.[64] Nonetheless, a final, and striking manner of displaying an image survives into the later 5th and 6th c. It is to display a statue, always imperial, in the centre of a plaza, on an honorific column. Here, the drop in statue dedications is arguably off-set by a much more dramatic setting, meaning that statues continued as visible elements of urban landscapes into the 6th c. This combination was of course inaugurated by Constantine in the

64 Statue dedications over time: Ward-Perkins (2016) 6–9 with figs 1.6 and 1.7 and Stichel (1982). Fall off for Constantinople: Gehn and Ward-Perkins (2016) 143–44.

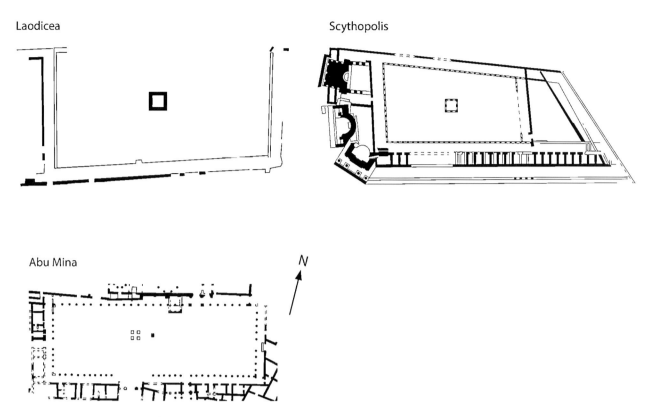

FIGURE 15A Late statues in plaza centres: Plans of Laodicea, Abu Mina, Scythopolis, column in forum. Laodicea: Şimşek (2013) 276 fig. 371. Abu Mina: Grossmann *et al*. (1995) 391 fig. 1. Scythopolis: Tsafrir and Foerster (1997) 122–23 with fig. D.

Eastern capital, but only became standard practice there from the later 4th onwards, after a pause under his sons. It continued into the early 7th c. The precise archaeological context of these monuments can be instructive for what it tells us about the prominence of a relatively small number of statues. It can be reconstructed in a few places. At Laodicea, Side, Abu Mina, and Scythopolis, we have the foundations for four honorific columns, of 5th–6th c. date. These are all set directly at the centre of their rectangular plazas (Fig. 15a). We also have the socle for a likely column from the round plaza of Justiniana Prima.[65] Statues, not crosses, likely topped all of these columnar monuments, when they were first set up: in no case can we attest to a cross being set up on an honorific column as its primary dedication in Late Antiquity: it was always secondary where we can confirm it. However, in all cases except Justiniana Prima, we miss the statue itself, any attachment for it, or a dedicatory inscription. This comes to us only from the Athenian Agora, where an honorific column has been recovered, not far from a dedicatory inscription to the empress Eudocia, native of the city (LSA 139). The monument was set roughly at the centre of the reduced agora of the early 5th c.[66]

65 Statues in plaza centres, Laodicea: In the centre of the agora was a Roman monument that was apparently converted into an honorific column. This is a square structure, visible on the plan and on photos of Şimşek (2010) 10 where it is clearly a monumental structure in ashlar blocks; see Lavan (2020) appendices F10 and S1. Side: Lavan (2020) appendix F9 and Mansel (1978) 169. Abu Mina: The remains of a possible honorific column were found in the Pilgrim's Court. A few steps west of the fountain, in the exact middle of the Pilgrim's Court, was a circular foundation that may have been the foundation for an honorific column. In the rubble here was found (by a previous expedition) a very large capital and an outsize base, which cannot be related to the adjacent church, although they were placed in the north wing of the Great Basilica by H. Schläger: Grossmann *et al*. (1982) 141. I have not been able to obtain further details of this capital. The date of the column is likely to coincide with the construction of the Pilgrim's Court, which is dated to after 475 and before 532, on the basis of contextual ceramics, not all of which are fully published, on which see Lavan (2020) appendix S1. Scythopolis: This monument is part of the Byzantine Agora described in Tsafrir and Foerster (1997) 122–23 with map on fig. D. Important details may be contained in Tsafrir (1994) 130–31 (not seen). Justiniana Prima: A stone 'column-support' ("support de colonne") stood at the centre of the plaza, which may have held the bronze statue (for an emperor given the military dress) of which two fragments were found nearby: Kondić and Popović (1977) 322 and p. 33 fig. 33. No direct indication is given of this being an honorific column rather than a columnar statue base, so I prefer not to assume we are dealing with an honorific column here.

66 Athens: A large square foundation was found west of the Athenian Agora. It was probably for a statue monument such as an honorific column. See Frantz (1988) 60–62 and 109 with

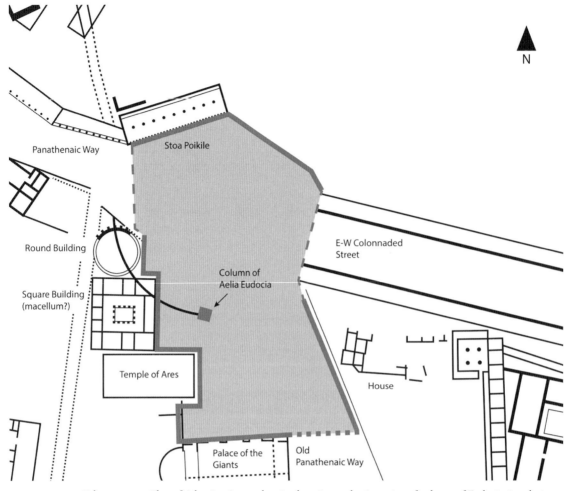

FIGURE 15B Urban context: Plan of Athenian Agora, showing location and orientation of column of Eudocia, in relation to surviving agora (shaded) and new E-W colonnaded street, of mid to later 5th c. date.
REDRAWN BY L. BOSWORTH FROM FRANTZ (1988) PLATE 6

Urban Context

The position of the column base at Athens for Eudocia (Fig. 15b) tells us about more than just its architectural setting. Whilst the base occurs roughly at the centre of the reduced agora, it is not aligned with it. Rather, it is aligned so as to be appreciated from the new east/west colonnaded street that passes off to the north side of the Library of Hadrian, which moves the route of the Panathenaic Way away from the Acropolis towards the interior of the city. Whilst the column should date from 421–450, based on its dedicant Theodosius II, the east/west street dates from the 3rd quarter of the 5th c. However, the latter date is not strong, relying as it does on unspecified pottery of the middle or third quarter of the 5th c. This comes from destruction levels of a basilica removed to make way for the street. It is therefore possible that column and street were built at the same time. We should not worry too much that the street is dated late in Eudocia's long life, if its ceramic date is accurate. Even when she was estranged from her husband, she was still active, and this was her home city. The initiative to honour her might well have been local, with the emperor conceding a favour to Athens.[67]

Surprisingly, her column was not visible along the new avenue. Rather it was set to the side of the street, within the small plaza that marked all that was left of the Athenian Agora. Indeed, the old plaza might now be

plate 46d and Baldini Lippolis (2003) 17. Baldini Lippolis associates it with a fragmentary epigram for a statue to the (empress – βασιληίδος) (Aelia) Eudocia put up by the emperor Theodosius (II) (Θεοδό σι[ος βασιλε]ύς), cut onto a marble column reused as a statue base. This column was found north of the Palace of the Giants in the area of the stoa of Attalus, in two fragments, which might well have stood on the square: Sironen (1994) 52–54.

67 Athens (east / west colonnaded street): The robbing layers over a basilica, destroyed to make space for the street, produced "pottery, of which the latest could be dated in the middle years of the 5th century after Christ". For all these details, see Shear (1971) 264–65 with plate 46 (plan) and 52a (photo showing extent of excavation). Frantz (1988) 15 and 79, where she describes the pottery as dating from the middle or third quarter of the 5th c., without giving further details of the ceramics.

considered almost like a way station, in terms of the new urban artery. Such a situation is paralleled elsewhere, at Laodicea, where the plaza and its column are also set off the main street. At Abu Mina, the column is set to be central in the main plaza but does not actually face down the site's major avenue, which leads into it. The opportunity to do this is missed by a few metres, with a fountain taking up the spot to which the street view leads. The same arrangement is found at Constantinople, for the column of Phocas. It too was set within a side plaza, at the Church of the Forty Martyrs, located thanks to the cistern which the plaza's paving covered. It is also true of the column of Constantine, which was not set to face down the line of the Mese. Rather, the column was set off to one side, just as it is today. This detail, so often misunderstood in reconstructions, can be seen from the map compiled by Mamboury that is preserved in the German Institute. On this survey, the route of the Mese is indicated by the sewer line and by an overlooked sidewalk set by the gate on the east side.[68] Thus, in Late Antiquity, there was no wider urban connectivity, via aligned columns visible down colonnaded streets, as envisaged by Bauer.[69] The one example which suggests otherwise is the Column of Phocas in the Roman Forum, which is aligned with a major street leading into the Subura. But this monument was initially dedicated in the mid-3rd c., probably to the Genius of the Roman People by Aurelian.[70] In contrast, late antique monuments, whether honorific columns or nymphaea, were set within plazas, not to serve the spaces beyond them.

Statue Treatment

Statue Curation
A final archaeological contribution to the history of late antique statue monuments can take us beyond the study of new dedications, which are rarely found after the second decade of the 5th c. By studying statue curation, we can move into the 6th c., to understand a bit the atmosphere in which the late honorific dedications in the *Palatine Anthology* were compiled, around the epigrams of Agathias. At Sagalassos, I explored evidence for the movement and re-erection of honorific statues on the upper agora in the years around AD 500. More recently, I have become aware of evidence from Ephesus, from the Embolos, which points to very late repair and redisplay of statue moments, at or after the time when the two agorai of the city were being cleared of their own honorific statues.[71] On this street, the two main statue groups have been repaired and extensively modified: one in front of the Alytarch Stoa, the other before a portico north-east of the Gate of Hercules.

The Alytarch Stoa group (Fig. 14b) is a coherent set of well-cut bases within similar tripartite statue monuments. They survive in their primary setting or close enough to be considered almost *in situ*. The bases are dedicated to a series of proconsuls of 410–436, in office around the time when the portico was erected. Yet, the series includes one stone statue sat on a base with mismatching attachments for a bronze statue. Furthermore, the same monument carried a head cut in the 6th c., not the earlier 5th c. The second group of bases, by the Gate of Hercules, for a collection of victories set around the empress Augusta Aelia Flacilla, is far more problematic. This heterogenous group (Fig. 16a) stands on bases crudely ripped from other structures, where the victories originally stood. The row also contains an odd dedication to a doctor Alexander. Most alarmingly, a bronze victory statue (Fig. 16b) has been converted in its upper parts into a togate honorific statue, by adding a band of 'cloth'.[72] In fact, of the 12 statue monuments in this row, all except two have been reset, away from their primary emplacements, within a sort of chaotic low kerb. This retains a new higher level of portico paving, in roughly-laid reused slabs, heterogenous and undisguised in nature.[73]

A similar rough kerb is seen in front of porticoes on other streets in Ephesus. But the kerb holding the victories can be associated with raising of the thresholds of the shops behind the portico, whose higher level it matches. The colonnade itself was rebuilt with unsorted reused material, producing a far uglier aspect than the Alytarch stoa, which kept its early 5th c. form. Recent excavations in the shops, alongside other phasing observations around the city, have suggested to me that this phase, and the statue kerb that goes with it represents a general rebuilding dating sometime between 576 and 614. I especially draw on sealed pottery and coins found in the sondages of the Upper Embolos shops here,

68 Constantinople (Column of Constantine): see Lavan (2020) appendix F9 with full references.
69 Sightlines and column monuments: Bauer (1996) 365.
70 Rome (Column of Phocas): see Lavan (2020) appendix F9 with full references.
71 Statue curation at Sagalassos: Lavan (2013) 324–26. See also Lavan (2020) appendix S11.
72 Ephesus (Alytarch Stoa): The stone statue (a togate marble torso) and the head have both been stylistically dated to the 6th c.: Auinger (2009) 33–36. For a full discussion on the first statue group see Lavan (2020) appendix C3. On the second statue group Lavan (2020) appendix H7.
73 Ephesus (Upper Embolos, east portico): statue group documented by Roueché (2002) 527–46, nos. 2–3 and 5–12, with a map on p. 529 fig. 2, plus L. Lavan site observations 2013.

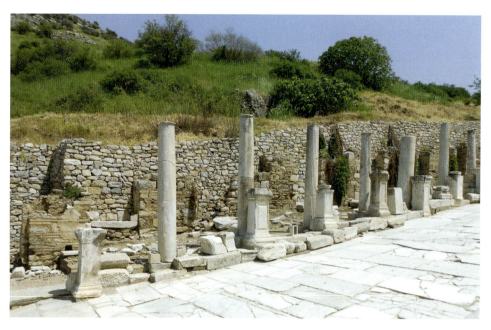

FIGURE 16A Statue re-erection: Upper Embolos east stoa with later 6th c. to early 7th c. kerb, into which most of the bases, set here in the earlier 5th c., have been reset.
PHOTO: L. LAVAN 2013

FIGURE 16B Statue re-erection: Lower torso of a bronze female statue (a victory) repurposed with a togate band above, to turn it into a portrait statue.
©AUSTRIAN ARCHAEOLOGICAL INSTITUTE, ARCHIVE NO. AF15_24, WITH THANKS

that date this reconstruction. Finds from the east portico reach as far as a coin of 576–577 of Justin II plus a coin of Totila/Justinian of between 542 and 565, whilst finds in the west portico extend to LRC Hayes 10 (ca. 570–660+ in LRP). Thus, we have a phase of 'statue care' contemporary with the time of Agathias, in a major city of the East. Here, city fathers took the time to re-erect monuments set up in centuries past, without seeking to rededicate them.[74]

Statue Modification

This late 6th c. rebuilding of the Embolos, effecting shops, porticoes, and statuary, can be paralleled elsewhere in Ephesus. It is visible on the Clivus Sacer, the Marble Street, the Arcadiane and the Plateia in Coressus. On the latter street, the colonnades and much of the street paving seem to date from this latest period.[75] The extent of the rebuilding raises questions as to the date of the final arrangement of well-preserved statue assemblages found in the nymphaea along the Upper Embolos and its extension, which were at the very least kept in place at this time, sometimes brought in from elsewhere. A universal feature of these statues, which are heavily

[74] For recent excavations see, Iro *et al.* (2009) 53–87. For dating arguments, see Lavan (2020) appendices C3 and H7.
[75] Rebuilding of streets of Ephesus: see Lavan (2020) appendices C3, Y4 and K9 for discussion with full references.

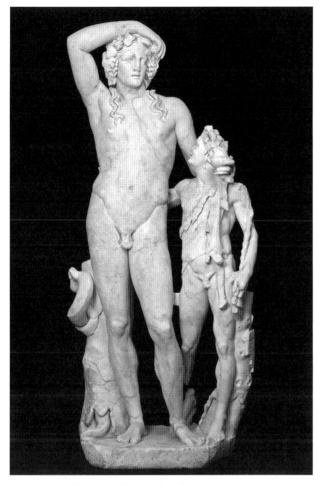

FIGURE 17 Statue modification: Sagalassos, Upper Agora Nymphaeum, Dionysos statue with penis removed prior to the walling of the niches.
WITH THANKS, © SAGALASSOS ARCHAEOLOGICAL PROJECT

slanted towards mythology, is the systematic removal of male genitals, at some point in their late antique history: not exposed breasts, nor buttocks, but just penises. This is true of the Nymphaeum of C. Laecanius Bassus (statues of mythological water-beings and satyrs, all cut), the nymphaeum of Domitian (head of Zeus and two river gods, latter both cut), the Apsidal Fountain (Polyphemus, Odysseus and his crew, in secondary use, all cut), and the Nymphaeum of Trajan (Dionysus statues, a satyr, a youth with a hound, perhaps Androklos, founder of Ephesus, other mythological figures and a colossal statue of Trajan, two naked men cut). It can be paralleled at nymphaea in Miletus and Side and at Sagalassos in the Antonine nymphaeum.[76] In the last case, statues of Dionysus (e.g. Fig. 17) must have been redisplayed without their male genitalia for some length of time, after the early 6th c. rebuilding of the fountain but before the same statues were covered with mortar and walled up. Otherwise, it is not easy to understand why the genitalia were cut off, in the absence of any other form of statue iconoclasm: it makes no sense to remove the genitals from a statue just as one is preparing to hide it.[77]

Dating the phenomenon of genital removal is not easy: in the 4th c., church authorities at Aquileia were happy to show male genitalia in mosaics set in their cathedral nave, whilst in the 7th–8th c., Levantine churches were decorated with scenes of classical mythology where neither the genitals of male gods nor the breasts of Aphrodite were covered. I would suggest that such editing, which looks to have been a regional phenomenon, probably occurred during the later 5th to 6th c. At this time, bishops were formally responsible for the leadership of the council of the notables, and so had some influence over the maintenance of secular public monuments. This was not a radical Christianisation but a subtle one, that sought to keep as much of the classical heritage as possible.

Statue Protection

Other minor forms of statue Christianisation can be seen in the form of inscribed crosses, which seem to date from 400 onwards in public space. We have very few examples of crosses carved into the heads and bodies of statues. Those documented by Christensen should not be taken as representative, nor always as indicating aggression. The examples in his catalogues have featured in eye-catching images for books and articles on religious change in Late Antiquity, especially book covers. Yet only 9 out the 58 examples he has collected are convincingly associated with iconoclasm. Now, in 2021 he has begun to recognise, following the research of LSA, that some of the crosses are on statues of Christians and that these crosses were hidden from view, just as some symbols of the religion were hidden in sculpted hair, as with a cross hidden in LSA 252 at Side (Fig. 18a).[78] Similarly problematic are crosses carved on statue torsos, without obviously damaging the object: one from the baths in Thubursicum Numidarum (Fig. 18b) has a cross on its chest but almost like a medallion. I would

76 Removal of genitals, at Ephesus (Embolos): Auinger and Rathmayr (2007) 250–53. Miletus and Side: full references in Lavan (2020) vol. 2 appendix H3 530–33.

77 Removal of genitals, at Sagalassos: Upper Agora Nymphaeum: see Waelkens *et al.* (1997) 156–62; Moens *et al.* (1997) 367–83, with figures, neither of which notice the removal of the genitals. See Lavan (2020) appendices H2, H3 and S7a.

78 Crosses on statuary: Kristensen (2021) his main catalogue: heads: nos 10, 11, ?15, 17, 18 (4 of 5 out of 24), torso 4, 13, 18, ?24 (3 or 4 of out of 26). Addenda (of 2021) 5 and 6 (2 out of 8) (both heads). Crosses in hair: LSA 252 (from Side). MXG ('Christ, Mary-born') markings in hair: LSA 150, 176 (both from Aphrodisias), 318 (from Sardis). See Lenaghan (2016a) 100–102.

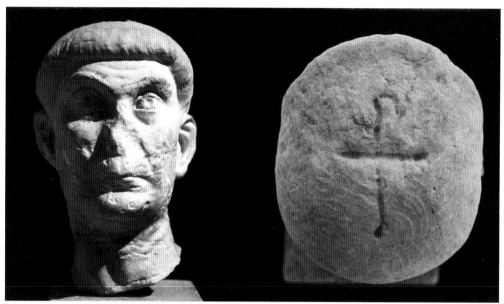

FIGURE 18A Statue protection? a cross in the hair of a new-cut late honorific statue, Side, LSA 252, later 4th c. Side Museum inv. no. 116 (photo: LSA, with thanks). Closest parallel for the head is one dated to 388–92 (LSA 163).

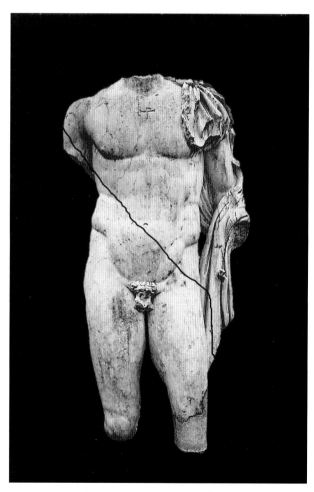

FIGURE 18B Statue protection?: cross on the torso of a statue from Thubursicum Numidarum: from F.-G. de Pachtère, *Description de l'Afrique du Nord, musées et collections archéologiques de l'Algérie et de la Tunisie. 14, Musée de Guelma* (Paris 1909) pl. 4.

also point to single crosses carved centrally onto the front of statue bases, as at Tripolis ad Meandrum and Thessalonica, or on socles, as at Sagalassos (Fig. 18c). Here, two nymphaea also have this treatment, again with crosses very carefully placed, not cut wildly or destructively.[79] Crosses equally occur on gates and arches in many places, as single well-cut symbols.[80] This practice looks neither like iconoclasm nor exorcism, but rather like atropaism, in which crosses were used to protect against earthquakes, a use that is well-attested in literary sources.[81] Such protections might of course also qualify a building or art work for maintenance from a city council led by a bishop. In this case, it is not only context that has produced an alternative interpretation but rather comparative reasoning, by looking at varied signs in different of urban settings. This suggests that a cross on a statue can be a mark attesting to statue care and longevity, rather than any desire to break with the

79 Crosses on statue bases at Thessalonica: L. Lavan site observations; at Tripolis ad Meandrum: Duman and Baysal (2016) 578–80 fig. 5; at Sagalassos: Lavan (2013) 319 fig. 10a and Lavan (2020) appendix S11.

80 Crosses on gate / arch lintels at Messene: L. Lavan site observation 2017; at Aphrodisias on City Gate: this cannot be dated except that it is later than the inscriptions of the 360s which they cut through: ALA 22 and 42; at Ephesus (on statue base likely from Gate of Hadrian): IvE 4.1351; at Constantinople (Golden Gate): Meyer (1938) 87–99 with 90 fig. 13; at Constantinople (Arch of Theodosius): Naumann (1976) 128 fig. 6.

81 On apotropaic crosses see Ćurčić (1992) (focusing on protection against earthquakes) with Crow (2008); Morony (2003) and Walter (1997).

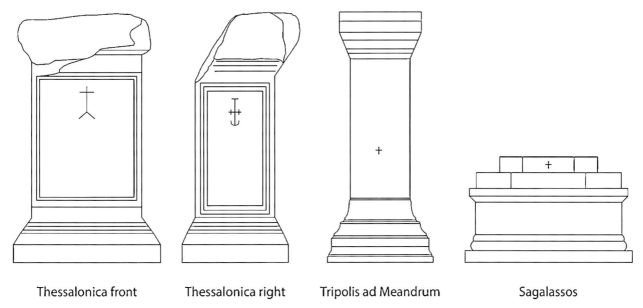

FIGURE 18C Statue protection?: crosses and an anchor on statue bases: Thessalonica (Roman Agora), Tripolis ad Meandrum (Colonnaded Street), and Sagalassos (Upper Agora).
DRAWN BY L. BOSWORTH FROM PHOTOS, NOT TO SCALE

classical past or smash up its artwork. Contextual study of such signs will produce other credible interpretations, especially when drawing on the established habits seen in earlier period. Yet, such is the modern appetite for finding Christian iconoclasm, especially supposed attacks on high culture, that such 'crosses killing statues' will continue to appear on the dust jackets of books that evoke rupture and regression in late antique culture.

Conclusions

In conclusion, I would say that archaeology reveals that late antique statue culture was somewhat stronger than even the LSA project suggests, and that statues were appreciated for longer into the 6th c. than one might imagine, when looking at new dedications alone. There are also missing episodes earlier, such as the 3rd and 4th c. statue clearances. These were systematic breaks with the past which need to be considered, to produce a rounded appreciation of statue history in the late period. We need to look more carefully at our statue monuments for their stratigraphic and architectural context. Archaeology does have a primary role to play in writing their story. We must go beyond the traditional formulation of literary texts, epigraphy, and art historical observation of sculpture, to provide a broader account of statue history. Furthermore, there is much to be gained from reading reports of the finds of statue bases for their contextual details, as well as for their epigraphic texts. These reports often contain physical details which have a strong bearing on how statues were displayed, and on how many statues were present in different late groups. Finally, we must scrutinise well-preserved sites to develop methodology which might take the study of ancient statuary towards areas only little unexplored, away from the study of statue dedication and towards the study of statue life and so to the study of memory, a critical component of the late antique psyche.

Of course, none of this would be worthwhile without the great database and synthesis that has been produced by the Oxford *Last Statues* project. Archaeology can never replace or realistically displace the epigraphic and art-historical study of statue monuments. The LSA has, of course, often taken on approaches that can be recognised as fully archaeological, without any help from the likes of me. Future progress lies in the combination of physical context revealed by excavation with that of the specific cultural meanings and representative forms identified from inscriptions and sculpture. But one might now consider broadening the LSA database, at the suggestion of Julia Lenaghan, one of its principal authors, to cover the following topics: 1. indications of missing objects (holes in the pavement, cutting on steps), 2. expanded group logic (covering uninscribed bases that relate physically to dated bases or patterns in specific locales), 3. materiality (technical details of paint, stucco, multiple cuttings, and cuttings for placement against columns or fences), and 4. historical movement moments in particular cities. Even so, the widest story of late statue history, of the maintenance and removal of older monuments, perhaps escapes the scope of the

LSA database for now. Really it requires a new research project. This would perhaps belong alongside a study of other forms of monument spoliation, a more fully archaeological topic than statue erection itself. Perhaps inevitably, the study of short-term memory will remain led by epigraphers, whereas that of long-term memory may be done more comfortably in a framework that is primarily archaeological.

Acknowledgements

I am grateful to the two referees for their comments on this paper, of which Julia Lenaghan declared herself, and for editorial assistance from Solinda Kamani.

Bibliography

Abbreviations

AE = *L'Année épigraphique*.

ALA = Rouéché C. (1989) *Aphrodisias in Late Antiquity: The Late Roman and Byzantine Inscriptions including Texts from the Excavations at Aphrodisias Conducted by Kenan T. Erim* (London 1989). Now available as a website: C. Rouéché, *Aphrodisias in Late Antiquity: The Late Roman and Byzantine Inscriptions*, revised 2nd edition, 2004, <http://insaph.kcl.ac.uk/ala2004>

CIL = *Corpus Inscriptionum Latinarum*.

EDR = *Epigraphic Database Roma* www.edr-edr.it

IRT = Reynolds J. M. and Ward-Perkins J. B. edd. (1952) *Inscriptions of Roman Tripolitania* (Rome 1952).

IvE = AA.VV., *Die Inschriften von Ephesos*, 8 vols. (Bonn 1979–1984).

PLRE = Jones A. H. M. (1971–1992) *The Prosopography of the Later Roman Empire, 3 vols* (Cambridge 1971–1992).

Primary Sources

Amm. Marc. = J. C. Rolfe transl., *Ammianus Marcellinus*, 3 vols. (Loeb Classical Library) (London and Cambridge, Mass. 1935–1939).

Cass. Dio = E. Cary transl. Cassius Dio, *Historia Romana* (Loeb Classical Library) (London and Cambridge Mass. 1914–1927)

Chronicle of A.D. 354 = T. Mommsen ed., *Chronica Minora* (MGH AA 9) (Berlin 1892) 143–48.

Hesychius (of Miltetus) = T. Preger ed., *Scriptores Originum Constantinopolitarum*, vol. 1 (Leipzig 1901–1907) 1–18.

Josh. Styl. = W. Wright ed. and transl., *The Chronicle of Joshua the Stylite* (Cambridge 1882); A. Luther transl. *Die syrische Chronik des Josua Stylites* (Berlin 1997) (with Syriac text).

Lib. Or. = R. Foerster ed. *Libanii Opera*, 12 vols. (Leipzig 1903–1927). A. F. Norman transl. *Libanius. Selected Works*, 2 vols (London 1969–1977); A. F. Norman transl., *Libanius. Autobiography and Selected Letters* (London 1992). A. F. Norman transl., *Antioch as a Centre of Hellenic Culture as Observed by Libanius* (Translated Texts for Historians 34) (Liverpool 2000). J. Martin ed. and transl., *Libanios, Discours II–X* (Paris 1988). See also M. J. B. Wright "Appendix: Libanios, Oration IX: On the Kalends", *Archiv für Religionsgeschichte* 13.1 (2012) 205–212. For a full concordance list see https://www.academia.edu/3612083/Libanius_Discourses_translations (last accessed March 2014).

Malalas = J. Thurn ed., *Ioannis Malalae Chronographia* (Corpus Fontium Historiae Byzantinae 35) (Berlin-New York 2000); E. Jeffreys, M. Jeffreys and R. Scott transl., *The Chronicle of John Malalas* (Melbourne 1986), which has important critical notes.

Marcell. com. = T. Mommsen ed., *Marcellinus Comes, Chronicon* (MGH AA 9) (Berlin 1894) 39–101; B. Croke transl., *Marcellinus Comes. The Chronicle of Marcellinus, a Translation and Commentary* (Byzantina Australiensia 7) (Sydney 1995).

Parastaseis = Av. Cameron and J. Herrin edd., transl. and comm., *Constantinople in the Early Eighth Century: The Parastaseis Syntomoi Chronikai* (Columbia Studies in the Classical Tradition 10) (Leiden 1984).

Patria = T. Preger ed., *Scriptores originum Constantinopolitanarum*, vol.2 (Leipzig 1907) 135–283.

Procop. Goth. = H. Dewing ed. and transl., *Procopius. History of the Wars, Books V–VIII* (Loeb Classical Library) (London and Cambridge Mass. 1916).

SHA, Alex. Sev = D. Magie transl. *Historia Augusta, Volume II: Caracalla. Geta. Opellius Macrinus. Diadumenianus. Elagabalus. Severus Alexander. The Two Maximini. The Three Gordians. Maximus and Balbinus* (Loeb Classical Library 140) (London and Cambridge Mass. 1924).

Socrates, Hist. eccl. = G. C. Hansen ed., *Socrates Scholasticus Historia Ecclesiastica* (GCS new series 1) (Berlin 1995).

Sozom. Hist. eccl. = J. Bidez and G. C. Hansen edd., *Sozomenus. Kirchengeschichte* (GCS 50) (Berlin 1960).

Suet. Calig. = J. C. Rolfe transl. *Suetonius*, vol. 1 (Cambridge and London 1920) 3–119.

Theoph. Sim. = C. de Boor and P. Wirth edd., *Theophylactus Simocattes. Historiae* (Leipzig 1972); Mi. and Ma. Whitby transl., *The History of Theophylact Simocatta: an English Translation with Introduction* (Oxford 1986).

Zos. = F. Paschoud ed. with French transl. and comm., *Zosime Histoire Nouvelle*, vols. 1–3.2 (Paris 1971–1989); English transl. in R. T. Ridley, *Zosimus, New History* (Byzantina Australiensia 2) (Canberra 1982).

Secondary Sources

Auinger J. (2009) "Zum Umgang mit Statuen hoher Würdentr.ger in spätantiker und nachantiker Zeit entlang der Kuretenstraße in Ephesos", in *Neue Forschungen zur Kuretenstra.e von Ephesos. Akten des Symposiums für Hilke*

Thür vom 13. Dezember 2006 an der Österreichischen Akademie der Wissenschaften (DenkschrWien 382. AF 15), edd. S. Ladstätter *et al.* (Vienna 2009) 29–52.

Auinger J. and Rathmayr E. "Zur spätantiken Statuenausstattung der Thermen und Nymphäen in Ephesos", in *Statuen in der Spätantike*, edd. F. A. Bauer and C. Witschel (Wiesbaden 2007) (237–69) 250–53

Accademia Ercolanese (1762) *Le Antichità di Ercolano Esposte* vol. 3 (Naples 1762).

Aurenhammer M. and Sokolicek A., "The remains of the centuries. Sculptures and statue bases in late antique Ephesus: the evidence of the Upper Agora", in *Archaeology and the Cities of Asia Minor in Late Antiquity* (Kelsey Museum Publication 6), edd. O. Dally and C. Ratté (Michigan 2011) 43–66.

Baldini Lippolis I. (2003) "Sistema palaziale ed edifici amministrativi in età protobizantina: il settore settentrionale dell'Agorà di Atene", *Ocnus* 11 (2003) 9–23.

Baldini I., Lippolis E., Livadiotti M. and Rocco G. (2005) "Gortyna. Il tempio del Caput Aquae e il tessuto urbano circostante: campagna di scavo 2005", *ASAA* 83 (2005) 271–95.

Ball L. F. and Dobbins J. J. (2013) "Pompeii Forum Project: current thinking on the Pompeii forum", *AJA* 117.3 (2013) 461–92.

Bauer F. A. (1996) *Stadt, Platz und Denkmal in der Spätantike. Untersuchungen zur Ausstattung des öffentlichen Raums in den spätantiken Städten Rom, Konstantinopel und Ephesos* (Mainz 1996).

Beltrán de Heredia Bercero J. (2009) "Arquitectura y sistemas de construcción en 'Barcino' durante la Antigüedad tardía. Materiales, técnicas y morteros: un fósil director del yacimiento de la Plaza del Rey", *Quaderns d'Arqueologia i Història de la Ciutat de Barcelona* 5 (2009) 142–69.

Berger A. (1988) *Untersuchungen zu den Patria Konstantinupoleos* (Ποικίλα Βυζαντινά 8) (Bonn 1988).

Bergmann M. and Kovacs M. (2016) "Portrait styles", in *The Last Statues of Antiquity*, edd. R. R. R. Smith and B. Ward-Perkins (Oxford 2016) 280–94.

Beschaouch A. (1974) "La découverte de trois cités en Afrique proconsulaire (Tunisie): Alma, Vrev et Asadi. Une contribution à l'étude de la politique municipal de l'Empire romain", *CRAI* (1974) 219–34.

Bigi F. (2020) *Senatori romani nel Pretorio di Gortina : le statue di Asclepiodotus e la politica di Graziano dopo Adrianopoli* (Studi 49), edd. F. Bigi and I. Tantillo (Pisa 2020).

Boube J. (1959–1960) "Séance de la Commission de l'Afrique du Nord", *BCTH* (1959–1960) 141–45.

Cameron Al. (1976) "Theodorus τρισέπαρχος", *GRBS* 17 (1976) 269–80.

Chatelain L. (1911) "Rapport sur une mission archéologique à Mactar (Tunisie)", *CRAI* 55.6 (1911) 505–513.

Corsaro A., Delfino A., de Luca I., and Meneghini R. (2013) "Nuovi dati archeologici per la storia del Foro di Cesare tra la fine del IV e la metà del V secolo", in *The Sack of Rome in 410 AD. The Event, its Context and its Impact. Proceedings of the Conference held at the German Archaeological Institute at Rome, 04–06 November 2010*, edd. J. Lipps, C. Machado, and P. von Rummel (Wiesbaden 2013) 123–36.

Crow J., Bardill J., and Bayliss R. (2008) *The Water Supply of Byzantine Constantinople* (JRS Monograph 11) (London 2008).

Ćurčić S. (1992) "Design and structural innovation in Byzantine architecture before Hagia Sophia", in *Hagia Sophia*, edd. R. Mark and A. S. Çakmak (New York 1992) 16–38.

Dagron G. (1974) *Constantinople. Naissance d'une capitale* (Paris 1974).

De Bruyn G. (2014) *Imago principum, imago deorum. Recherches sur les statues impériales et divines dans les cités d'Afrique (Ier – Ve siècles ap. J.-C.)* (Ph.D. diss., Univ. Caen Basse-Normandie) (Caen 2014).

Dehn W., Kempf T. K., von Massow W., Reusch W., and Steinhausen J. (1946) "Jahresbericht des Rheinischen Landesmuseums Trier für 1941 bis 1944", *TrZ* 18 (1949) 269–334.

De Ruggiero E. and Vaglieri D. (1904) *Sylloge epigraphica orbis Romani* 2.1 (Rome 1904).

De Staebler P. D. (2008a) "The city wall and the making of a late antique provincial capital", in *Aphrodisias Papers 4: New Research on the City and its Monuments* (JRA Supplementary Series 70), edd. C. Ratté and R. R. R. Smith (Portsmouth 2008) 284–318.

De Staebler P. D. (2008b) "Re-use of carved marble in the city wall," in *Roman Portraits from Aphrodisias*, edd. R. R. R. Smith and J. Lenaghan (Istanbul 2008) 184–99.

Duman B. and Baysal H. H. (2016) "Tripolis ad Maeandrum 2014 Yılı Kazı, Onarım ve Koruma Çalışmaları", *Kazı Sonuçları Toplantısı* 37.1 (2016) 563–84.

Étienne R., Piso I., and Diaconescu A. (1990) "Les deux forums de la colonia Ulpia Traiana Augusta Dacica Sarmizegetusa", *REA* 92 (1990) 273–96.

Euzennat, M. Gascou J., and Marion J. (1982) *Inscriptions antiques du Maroc vol. 2, Inscriptions latines* (Paris 1982).

Frantz A. (1988) *The Athenian Agora, xxiv: Late Antiquity A.D. 267–700* (Princeton 1988).

Frey J. M. (2016) *Spolia in Fortifications and the Common Builder in Late Antiquity* (Boston 2016).

Gaggiotti M. (1979) *Sepino: archeologia e continuità* (Campobasso 1979).

Gavini A., Khanoussi M., and Mastino A. (2012) "Epigrafia e archeologia a Uchi Maius tra restauro e nuove scoperte", *L'Africa Romana* 19.3 (Rome 2012).

Gehn U. and Ward-Perkins B. (2016) "Constantinople" in *The Last Statues of Antiquity*, edd. R. R. R. Smith and B. Ward-Perkins (Oxford 2016) 136–44.

Ghiotto A. R. (2009) "Il complesso monumentale del Foro", in *Nora. Il foro romano. Storia di un'area urbana dall'età*

fenicia alla tarda antichità (1997–2006) Vol. 1. *Lo scavo*, ed. J. Bonetto (Padua 2009) 245–373.

Giuliani C. F. and Verduchi P. (1987) *L'area centrale del Foro romano* (Florence 1987).

Grossmann P. *et al.* (1982) "Abū Mīna Zehnter vorläufiger Bericht. Kampagnen 1980 and 1981", *MDIK* 38 (1982) 131–54.

Hurst H. R. (1972) "Excavations at Gloucester 1968–71", *AntJ* 52 (1972) 24–69.

Inan J and Alfoldi-Rosenbaum E. (1979) *Römische und frühbyzantinische Porträtplastik aus der Türkei: Neue Funde* (Mainz 1979) vol.2.

Ibba A. (2005) *Uchi Maius 2. Le iscrizioni* (Sassari 2005).

Iro D., Schwaiger H., and Waldner A. (2009) "Die Grabungen des Jahres 2005 in der Süd- und Nordhalle der Kuretenstraße. Ausgewählte Befunde und Funde", in *Neue Forschungen zur Kuretenstraße von Ephesos. Akten des Symposiums für Hilke Thür vom 13. Dezember 2006 an der Österreichischen Akademie der Wissenschaften* (DenkschrWien 382. AF 15) (Vienna 2009) 53–87.

Johnson B. (2001) *Elogia of the Augustan Forum* (MA diss. McMaster University 2001)

Kenrick P. M. (1987) *Excavations at Sabratha 1948–1951* (JRS monograph 2) (London 1986).

Kondić V. and Popović V. (1988) *Caričin Grad: Utvrđeno naselje u vizantijskom Iliriku* (Belgrade 1977).

Kristensen T. M. (2012) "Miraculous bodies: Christian viewers and the transformation of 'pagan' sculpture in Late Antiquity" in *Patrons and Viewers in Late Antiquity* (Aarhus Studies in Mediterranean Antiquity 10), edd. S. Birk and B. Poulsen (Aarhus 2012) 31–66.

Kristensen T. M. (2021) *Addenda to T.M. Kristensen, 'Miraculous Bodies', 2012, with Some New Comments (version 1.3b, first drafted April 2017, revised February 2021)* available at https://www.academia.edu/45051520/ (last accessed April 2021).

Lanckoronski K. G. ed. (1892) *Städte Pamphyliens und Pisidiens*, vol. 2 *Pisidien* (Vienna 1892).

Laurence R. (2007) *Roman Pompeii. Space and Society*, revised edn. (New York 2007).

Lavan L. (2006) "Surface archaeology", in *2006 Yılı Sagalassos Kazı ve Restorasyon Çalışmaları*, ed. M. Waelkens, part 2 (Leuven 2006) 29–34.

Lavan L. (2008) "The streets of Sagalassos in Late Antiquity: an interpretive study", in *La rue dans l'Antiquité. Définition, aménagement, devenir. Actes du colloque de Poitiers (7–9 Septembre 2006)*, edd. P. Ballet, N. Dieudonné-Glad, and C. Saliou (Rennes 2008) 201–214.

Lavan L. (2013) "The agorai of Sagalassos in Late Antiquity. An interpretive study", in *Field Methods and Post-Excavation Techniques in Late Antique Archaeology* (Late Antique Archaeology 9), edd. L. Lavan and M. Mulryan (Leiden 2013) 289–353.

Lavan L. (2020) *Public Space in the Late Antique City*, vol. 2 (Late Antique Archaeology Supplementary Series 5) (Leiden 2021).

Lenaghan J. (2016a) "Asia Minor", in *The Last Statues of Antiquity*, edd. R. R. R. Smith and B. Ward-Perkins (Oxford 2016) 98–108.

Lenaghan J. (2016b) "Reuse in fourth-century portrait statues", in *The Last Statues of Antiquity*, edd. R. R. R. Smith and B. Ward-Perkins (Oxford 2016) 267–79.

Lenaghan J. (2019) "Another statue in context: Rhodopaios at Aphrodisias" in *Visual Histories of the Classical World: Essays in Honour of R. R. R. Smith*, ed. R. Raja (Turnhout 2019) 502–518.

Lenaghan J. (2022) "The Monument for Menandros (ALA 24)", in *Iscrizioni metriche nel tardo impero romano: società, politica e cultura fra Oriente e Occidente. Settant'anni dopo Louis Robert, Hellenica IV 1948*, edd. G. Agosti and I. Tantillo (Rome 2022).

Lenaghan J. (2021) "Models and adaptations; six statues of Aphrodite from Aphrodisias" in *Appropriation Processes of Statue Schemata in the Roman Provinces/Aneignungsprozesse antiker Statuenschemata in den römischen Provinzen*, edd. J. Lipps, M. Dorka Moreno, and J. Griesbach (Wiesbaden 2021) 209–229.

Lezine A. and M. Herranz M. (1951–1952) "Séance de la Commission de l'Afrique du Nord: Mactar", *BCTH* (1951–1952) 195–203.

Ling R. (1991) *Roman Painting* (Cambridge 1991).

Lippolis E., Livadiotti M., Rocco G., Baldini I., and Vallarino G. (2010) "Gortyna. il tempio del Caput Aquae e Il tessuto urbano circostante: campagna di scavo 2007", *ASAA* 88 (2010) 511–37.

Liverani P. (2014) "Late Antiquity 300–500 CE" in *Transformation. Classical Sculpture in Colour*, edd. J. S. Østergaard and A. M. Nielsen (Copenhagen 2014) 272–83.

Mansel A. M. (1978) *Side. 1947–1966 Yılları Kazıları ve Araştırmalarının Sonuçları* (Türk Tarih Kurumu Yayınları v.33) (Ankara 1978).

Marec E. (1954) "Le forum d'Hippone", *Libyca* 2 (1954) 363–416.

Meyer B. (1938) "Das Goldene Tor in Konstantinopel", in *Mnemosynon Theodor Wiegand* (Munich 1938) 87–99.

Moens L. *et al.* (1997) "An archeometric study of the provenance of white marble sculptures from an Augustan heroon and a middle Antonine nymphaeum at Sagalassos", in: "The 1994 and 1995 excavation seasons at Sagalassos", in *Sagalassos IV. Report on the Survey and Excavation Campaigns of 1994 and 1995* (Acta Archaeologica Lovaniensia Monographiae 9), edd. M. Waelkens and J. Poblome (Leuven 1997) 367–83.

Morony M. G. (2003) "Magic and society in Late Sassanian Iraq", in *Prayer, Magic and the Stars in the Ancient and*

Late Antique World, edd. S. B. Noegel, J. T. Walker, and B. M. Wheeler (University Park, Penn. 2003) 83–107.

Naumann R. (1976) "Neue Beobachtungen am Theodosiusbogen und Forum Tauri in Istanbul", *IstMitt* 26 (1976) 117–41.

Peleg M. and Reich R. (1992) "Excavations of a Segment of the Byzantine City Wall of Caesarea Maritima," *'Atiqot* 21 (1992) 137–70.

Pentricci M. (2010) "L'attività edilizia a Lepcis Magna tra l'età tetrarchica e il V secolo: una messa a punto", in *Leptis Magna. Una città e le sue inscrizioni in epoca tardoromana* ed. I. Tantillo and F. Bigi (Cassino 2010) 97–171.

Picard G. (1957) *Civitas Mactaritana* (Karthago 8) (1957).

Piérart M. *et al.* (1980) "Rapport sur les travaux de l'École française en Grèce en 1979: Argos", *BCH* 104 (1980) 689–99.

Piérart M. (1981) "Rapport sur les travaux de l'École française en Grèce en 1980: Argos", *BCH* 105 (1981) 891–912.

Piso I. (2006) *Le Forum Vetus de Sarmizegetusa I* (Colonia Dacica Sarmizegetusa I) (Paris and Bucharest 2006).

Poinssot L. (1927) "Inscriptions de Pheradi Maius", *BCTH* (1927) 53–60.

Rieger A.-K. (2018) "Imagining the absent and perceiving the present. An interpretation of material remains of divinities from the Rock Sanctuary at Caesarea Philippi (Gaulanitis)", in *Seeing the God. Image, Space, Performance, and Vision in the Religion of the Roman Empire*, edd. M. Arnhold, H. O. Maier, and J. Rüpke (Tübingen 2018) 27–58.

Reynolds J., Roueché C., and Bodard G. (2007) *Inscriptions of Aphrodisias* (2007), available online http://insaph.kcl.ac.uk/iaph2007.

Roueché C. (2002) "The image of Victory: new evidence from Ephesus", in *Mélanges Gilbert Dagron* (Travaux et Mémoires 14) (Paris 2002) 527–46.

Roueché C. (2009) "The Kuretenstrasse: the imperial presence in Late Antiquity", in *Neue Forschungen zur Kuretenstrasse von Ephesos: Akten des Symposiums für Hilke Thür vom 13. Dezember 2006 an der Österreichischen Akademie der Wissenschaften* (AF 15), ed. S. Ladstätter (Vienna 2009) 155–70.

Şahin S. (2015) "Spätrömisch-frühbyzantinische Inschriften aus Perge in Pamphylien" in *Inscriptions in Byzantium and Beyond: Methods – Projects – Case Studies*, ed. A. Rhoby (Vienna 2015) 177–85.

Saliou C. (2006) "Statues d'Antioche de Syrie dans la Chronographie de Malalas", in *Recherches sur la Chronique de Jean Malalas II* (Actes du colloque 'Malalas et l'Histoire', Aix-en-Provence, *21–22 octobre 2005*), edd. S. Agusta-Boularot, J. Beaucamp, A.-M. Bernardi, and E. Caire (Paris 2006) 69–95.

Scocca V. "Saepinum (Altilia)", in *Fana, templa, delubra. Corpus dei luoghi di culto dell'italia antica (FTD) 3 Regio IV Alife, Bojano, Sepino*, edd. S. Capini, P. Curci, and M. R. Picuti online edition http://books.openedition.org/cdf/3716 (Paris 2015).

Sève M. (2003) "Le forum de Philippes": http://users.otnet.gr/~provost/Forum/Forum.html (last accessed 01/03/2003, no longer exists).

Shaya J. (2013) "The public life of monuments: the summi viri of the Forum of Augustus", *AJA* 117.1 (2013) 83–110.

Shear Jr. T. L. (1971) "The Athenian agora: excavations of 1970", *Hesperia* 40 (1971) 241–79.

Şimşek C. (2010) *The Ancient City of Laodicea* (Denizli 2010).

Şimşek C. (2013) *Laodikeia (Laodicea ad Lycum)* (Laodikeia Çalışmaları 2) (Istanbul 2013).

Sironen E. (1994) "Life and administration of Late Roman Attica", in *Post-Herulian Athens: Aspects of Life and Culture in Athens, AD 267–529*, ed. P. Castrén (Helsinki 1994) 15–62.

Smith. R. R. R. (1998) "Cultural choice and political identity in honorific portrait statues in the Greek East in the second century A.D.", *JRS* 88 (1998) 56–93.

Smith R. R. R. (1999a) "Late antique portraits in a public context: honorific statuary at Aphrodisias in Caria, AD 300–600," *JRS* 99 (1999) 155–89.

Smith R. R. R. (1999b) "A late Roman portrait and a himation statue from Aphrodisias," in *100 Jahre österreichische Forschungen in Ephesos: Akten des Symposions Wien 1995*, edd. H. Friesinger *et al.* (Vienna 1999) 713–19.

Smith R. R. R. (2001) "A portrait monument for Julian and Theodosius at Aphrodisias", in *Griechenland in der Kaiserzeit : neue Funde und Forschungen zu Skulptur, Architektur und Topographie ; Kolloquium zum 60. Geburtstag von Prof. Dietrich Willers, Bern, 12.–13. Juni 1998*, ed. C. Reusser (Zürich 2001) 125–36.

Smith R. R. R. (2002) "The statue monument of Oecumenius: a new portrait of a late antique governor from Aphrodisias", *JRS* 92 (2002) 134–56.

Smith R. R. R. (2006) *Aphrodisias II: Roman Portrait Statuary from Aphrodisias* (Mainz 2006).

Smith R. R. R. (2007) "Statue life in the Hadrianic Baths at Aphrodisias, AD 100–600: local context and historical meaning", in *Statuen in der Spätantike*, edd. F. A. Bauer and C. Witschel (Wiesbaden 2007) 203–235.

Smith R. R. R. and Ward-Perkins B. edd. (2016) *The Last Statues of Antiquity* (Oxford 2016).

Stichel R. H. W. (1982) *Die römische Kaiserstatue am Ausgang der Antike. Untersuchungen zum plastischen Kaiserporträt seit Valentinian I. (364–375 n. Chr.)* (Rome 1982).

Talloen P. (2003) *Cult in Pisidia. Religious Practice in Southwestern Asia Minor from the Hellenistic to the Early Byzantine Period* (Ph.D. diss., Univ. of Leuven 2003).

Tantillo and F. Bigi edd. (2010) *Leptis Magna. Una città e le sue iscrizioni in epoca tardoromana* (Cassino 2010).

Tsafrir Y. and Foerster G. (1997) "Urbanism at Scythopolis – Bet Shean in the fourth to seventh centuries", *DOP* 51 (1997) 85–146.

Tsafrir Y. (1994) "Scythopolis capital of Palestine secunda", *Qadmoniot* 107–108 (1994) 117–31.

Vsem V. B. (1893) "Tégée et la Tégéatide", *BCH* 17.1 (1893) 1–24.

Ward-Perkins B. (2016) "Statues at the end of Antiquity. The evidence of the inscribed bases", in *The Last Statues of Antiquity*, edd. R. R. R. Smith and B. Ward-Perkins (Oxford 2016) 28–40.

Ward-Perkins J. B. (1952) "Excavations in the Severan Basilica at Lepcis Magna, 1951", *PBSR* 20 (1952) 111–21.

Waelkens M. et al. (1997) "The 1994 and 1995 excavation seasons at Sagalassos", in *Sagalassos IV. Report on the Survey and Excavation Campaigns of 1994 and 1995* (Acta Archaeologica Lovaniensia Monographiae 9), edd. M. Waelkens and J. Poblome (Leuven 1997) 103–216.

Walter C. (1997) "IC XC NI KA: the apotropaic function of the victorious cross", *REByz* 55 (1997) 193–220.

Zanker P. (1988) *Pompeji: Stadtbilder als Spiegel von Gesellschaft und Herrschaftsform* (Mainz 1988) translated as Zanker P. (1998) *Pompeii: Public and Private Life* (Revealing Antiquity 11) (Cambridge Mass. and London 1998).

Zimmer G. and Wesch-Klein G. (1989) *Locus datus decreto decurionum: zur Statuenaufstellung zweier Forumsanlagen im römischen Afrika* (Munich 1989).

Appendix 1. Statue Preservation: Rome, Forum of Augustus. List of inscribed bases found in the Forum of Augustus, dedicated together as a coherent group, under Augustus, which survived here beyond the end of Antiquity

Source: Johnson B. (2001) *Elogia of the Augustan Forum* (MA Diss. McMaster University 2001) 86–116, who provides further references to other editions of these inscriptions and details of their findspots.

	Honorand	FA	Findspot	Editions
Kings of Alba Longa	5 extant out of 16 or 17 originals			
	E1 Aeneas	1	FA	*Ins. Ital.* 13.3, p. 9 no. 1
	E2 Silvius Aeneas	0	Lavinium	*CIL* 1.21; *CIL* 1.2.3; *ILS* 62a.
	E3 Aeneas Silvius	1	FA	*Ins. Ital.* 13.3.2.
	E4 Alba Silvius	1	FA	*Ins. Ital.* 13.3.3.
	E5 (incertus) Silvius	1	FA	*Ins. Ital.* 13.3.4
	E6 Proca Silvius	1	FA	*Ins. Ital.* 13.3.5.
	E7 Romulus	0	PompeiiF	*Ins. Ital.* 13.3.86; *CIL* 1.22; *CIL* 1.2.4; *CIL* 10.809; *ILS* 64.
Heroes of the Republic	7 extant in FA, 4 extant in FR, of which 3 in BAemilia			
	E8 A. Postumius Regillensis (*dict.* 499 or 496, cos. 496)	1	FA	*Ins. Ital.* 13.3.10; *CIL* 1.2.22.3; *CIL* 6.31623.
	E9 M. Valerius Maximus (*dict.* 494)	x	FR	*Ins. Ital.* 13.3.60.
	E10 M. Furius Camillus (*dict.* 396, 390, 389, 368, 367)	0	RIncertum	*Ins. Ital.* 13.3.61; *CIL* 1.25; *CIL* 1.2.7; *CIL* 6.1308; *ILS* 52.
	E11 L. Albinius (*tr. mil.* 379?)	0	RPantheon	*Ins. Ital.* 13.3.11; *CIL* 1.24; *CIL*1.2.6; *CIL* 6.1272; *ILS* 51.
	E12 L. Papirius Cursor (*dict.* 325, 324, 310, 309, cos. 326, 320, 319, 315, 313)	0	RIncertum	*Ins. Ital.* 13.3.62; *CIL* 1.27; *CIL* 1.2.8; *CIL* 6.1318; *ILS* 53.
	E13 Appius Claudius Caecus (*cos.* 307, 296)	1	FA	*Ins. Ital.* 13.3.12; *CIL* 12.9; *CIL* 6, 31606.
	E14 C. Fabricius Luscinus (*cos.* 282, 278)	x	FR BAemilia	*Ins. Ital.* 13.3.63; *CIL* 6.37048.

(cont.)

	Honorand	FA	Findspot	Editions
	E15 C. Duilius (*cos.* 260)	1	FA	*Ins. Ital.* 13.3.13; *CIL* 1.2.11; *CIL* 6.31611; *ILS* 55.
	E16 Q. Fabius Maximus (*dict.* 221, 217, *cos.* 233, 228, 215, 214, 209)	1	FA	*Ins. Ital.* 13.3.14; *CIL* 1.2.12.
	E17 C. Cornelius Cethegus (*cos.* 197)	x	FR BAemilia	*Ins. Ital.* 13.3.64; *CIL* 1.2 p. 341; *CIL* 6.31630.
	E18 L. Cornelius Scipio Asiaticus (*cos.* 190)	1	FA	*Ins. Ital.* 13.3.15; *CIL* 1.2.14; *CIL* 6.31607.
	E19 L. Aemilius Paullus (*cos.* 182, 168)	x	FR BAemilia	*Ins. Ital.* 13.3.65; *CIL* 1.2 p. 341; *CIL* 6.31629.
	E20 Ti. Sempronius Gracchus (*cos.* 177, 163)	0	Arretium	*Ins. Ital.* 13.3.82; *CIL* 1.31; *CIL* 1.2.16; *CIL* 11.1830; *ILS* 58.
	E21 Q. Caecilius Metellus Numidicus (*cos.* 109)	1	FA	Fragment (a): *Ins. Ital.* 13.3.16; *CIL* 1.2.19; *CIL* 6.31604. Fragment (b): *Ins. Ital.* 13.3.16; *CIL* 12.19; *CIL* 6.31604.
	E22 C. Marius (*cos.* 107, 104–100, 86)	1	FA	*Ins. Ital.* 13.3.17; *CIL* 1.32; *CIL* 12.17; *CIL* 6.1315; *CIL* 6.31598.

Iulii

	E23 Gaius Iulius Caesar (*dictatoris pater*, pr. *ca.* 92)	1	FA	*Ins. Ital.* 13.3.7.
	E24 C. Iulius Caesar Strabo (*aed. cur.* 90)	1	FA	*Ins. Ital.* 13.3.6; *CIL* 1.4; *CIL* 1.2.27; *CIL* 6.1310; *ILS* 48.

More Heroes of the Republic

	E25 L. Cornelius Sulla Felix (*dict.* 82–79, *cos.* 88, 80)	1	FA	*Ins. Ital.* 13.3.18; *CIL* 1.2.20; *CIL* 6.31609.
	E26 L. Licinius Lucullus (*cos.* 74)	0	Arretium	*Ins.Ital.* 13.3.84; *CIL* 1.34; *CIL* 1.2.21; *CIL* 11.1832; *ILS* 60.
	E27 M. Claudius Marcellus (*aed. cur.* 23)	1	FA	*Ins. Ital.* 13.3.8.
	E28 Nero Claudius Drusus (*cos.* 9)	1	FA	*Ins. Ital.* 13.3.9.
	Total surviving in Forum of Augustus	16		
	Total surviving in Forum Romanum	4		

Abbreviations

FA = Forum of Augustus
FR = Forum Romanum
RPantheon = Pantheon in Rome
RIncertum = uncertain findspot in Rome

Appendix 2. Catastrophe: Sabratha, a lost statue landscape of the mid-4th c.: statue dedications from a spolia context and a dump relating to the destruction of the forum

Dedications from J. M. Reynolds and J. B. Ward-Perkins edd., *Inscriptions of Roman Tripolitania* (Rome 1952), taken from https://inslib.kcl.ac.uk/irt2009/

North Forum Portico, reused in the late pavement

23.	Dedication to Emp Marcus Aurelius, marble panel, AD 175–180 (date based on titulature), mid-point 177.5.
27.	Dedication to Emp Commodus, marble panel, AD 183–184 (titulature), mid-point 183.5.
41.	Dedication to the Indulgentia of Emp Severus Alexander, marble panel, AD 226–227 (titulature), mid-point 226.5. Traces of red paint in letters.
43.	Dedication to Emp Severus Alexander by Aemilianus, in response to latter's appointment to augurate, after paying city councillors 10,000 sesterces and food boxes on the occasion of the dedication, marble panel, AD 230–231 (titulature), mid-point 230.5.
95.	Honours for Gaius Anicius Fronto by citizens, carried out by Quintus Flavius Hicetas, grey marble panel, late 2nd to 3rd c. (lettering), range 187.5–300, mid-point 243.75. Pieces also present in the dump in the capitolium vaults.

Capitolium, dump in the vaults

1.	Reference to Apollo (?), white marble panel, 2nd to 3rd c. (lettering), mid-point 200.
3.	Title for image of Concordia, stuccoed sandstone convex base, 1st c. AD (lettering), mid-point 50.
4.	Dedication to Concordia by 'Africanus' (Two words: *Concordiae Africanus*), marble base, 2nd c. AD (lettering), mid-point 150.
9.	Dedication to Jupiter by 'Africanus' (Two words: *Ioui Africanus*), marble base, 2nd c. AD (lettering), mid-point 150.
10.	Dedications to Jupiter by Aemilius Aristides, 2 identical marble stellae, 2nd to early 3rd c. (lettering), range 100–212.5 mid-point 156.25.
11.	Dedication to Mithras (?), marble panel, 3rd c. (lettering), mid-point 250.
14.	Dedication to Augustus (?) monumental inscription on stuccoed sandstone, 23–25 BC (titulature), mid-point 24 BC
17.	Dedication to Divus Traianus, cream marble panel, 2nd c. (lettering, after deification of AD 117), range 117–200, mid-point 158.5.
19.	Dedication to Augusta Faustina, marble panel, AD 138–141 (career dates), mid-point 139.5.
20.	Dedication to deified Faustina, marble panel, *ca.* AD 141 (deification date).
24.	Dedication to Emp Marcus Aurelius, marble panel, AD 178 (titulature).
25a–c.	Dedications to Annius Verus, Commodus, and Lucilla, 3 marble panels, AD 164–166 (titulature), mid-point 165.
26a–c.	Dedications to daughters of Aug Marcus Aurelius, 3 marble panels, AD 164–166 (titulature and comparison to 25a–c), mid-point 165.
28.	Dedication to Emp Commodus, marble panel, AD 185 (titulature).
30.	Dedication to ?Emp Commodus, marble panel, AD 178–192 (reign), mid-point 185.
32.	Dedication to Emp Marcus Aurelius or Commodus, marble panel, AD 175 or AD 186 (titulature), mid-point 180.5.
34.	Dedication to ?Septimius Severus, marble panel, AD 193–211(reign), mid-point 202.
38.	Dedication to Emp Caracalla, marble panel, AD 210–211 (titulature), mid-point 210.5.
39.	Dedication to ?Septimius Severus, marble panel, AD 198–211 (titulature), mid-point 204.5.
42.	Dedication to Emp Severus Alexander, marble panel, AD 230 or AD 235 (titulature), mid-point 232.5.
44.	Dedication to Emp Severus Alexander and his mother Julia Mamaea by *Sabrathenses*, marble panel, AD 222–235 (reign), mid-point 228.5.
48.	Dedication to Caesar Philip son of Emp Philip by *Sabrathenses*, marble panel, AD 247–249 (reign), mid-point 248.
50.	Dedication to Emp Gallienus and Cornelia Salonina Augusta by *Sabrathenses*, marble panel, AD 265–266 (titulature), midpoint 265.5. Traces of red paint in letters.
51.	Dedication to Emp Claudius Gothicus or Probus, marble panel, AD 268–270 or AD 276–282 (probably based on title *Gothico* and use of name Marcus Aurelius), midpoint 275. Reused from 62 (2nd c. AD). Suggests the same monument was used, as removal would have created a monument to be used of exactly the right dimensions for the plaque.

(cont.)

Capitolium, dump in the vaults

52.	Dedication to Emp Aurelian, marble panel, AD 270–275 (reign), mid-point 272.5.
54.	Dedication to Augustus Constantine I or II, marble panel, AD 306–337 or AD 337–340 (reign), mid-point 323.
62.	Dedication to an anonymous emperor, marble panel, 2nd c. AD (lettering), range 100–200, mid-point 150.
64.	Dedication to the wife of an anonymous emperor, marble panel, 2nd c. AD (lettering), range 100–200, mid-point 150.
65.	Dedication to an ?Antonine emperor, marble panel, 2nd to early 3rd c. (lettering), range 100–212.5, mid-point 156.25.
66.	Fragment from imperial titulature, white marble panel, 2nd to early 3rd c. (lettering), range 100–200, mid-point 150.
67.	Fragments from imperial titulature, fragments of white marble panel, 2nd to early 3rd c. (lettering).
70.	Dedication to an anonymous emperor, marble panel, 2nd to early 3rd c. (lettering), range 100–212.5, mid-point 156.25.
71.	Dedication to an anonymous emperor, marble panel, 2nd to early 3rd c. (lettering), range 100–212.5, midpoint 156.25.
73.	Dedication to the wife of a 2nd/3rd c. emperor, marble panel, 2nd to early 3rd c. (lettering), range 100–212.5, midpoint 156.25.
75.	Dedication to third c. emperor, marble panel, 3rd c. (lettering), range 200–300, mid-point 250.
76.	Dedication to a third c. emperor, marble panel, 3rd c. (lettering and titulature), range 200–300, mid-point 250.
77.	Dedication to a third c. emperor, marble panel, 3rd c. (lettering), range 200–300, mid-point 250.
82.	Erased dedication to a third c. emperor, marble panel, 3rd c. (lettering), range 200–300, mid-point 250. Reused after *damnatio* of 147.
84.	Dedication to third c. emperor(s), marble panel, 3rd c. (lettering), range 200–300, mid-point 250. Traces of red paint in letters.
87.	Dedication to late 3rd/4th c. emperor, marble panel, late 3rd to 4th c. (lettering), range 275–400, mid-point 362.5.
88.	Fragment mentioning a legate, white marble panel, 2nd to 3rd c. (lettering), range 100–300, mid-point 200.
92.	Fragmentary honours for an anonymous, monumental building inscription, white marble architrave panel, 2nd to 3rd c. (lettering), range 100–300, mid-point 200.
95.	Honours for Gaius Anicius Fronto by citizens, carried out by Quintus Flavius Hicetas, grey marble panel, late 2nd to 3rd c. (lettering), range 187.5–300, mid-point 243.75. One piece also found in the late pavement of the North Portico of the Forum.
96.	Honours for Avitius Rufus, military tribune and duovir, by decree of curia, erected and paid for by his father, marble panel, 2nd c. (lettering), range 100–200, mid-point 250.
97.	Honours for an imperial procurator, marble panel, 3rd c. AD (lettering), range 200–300, mid-point 250. Reused for 149 in 4th c.
99.	Fragmentary honours, marble panel, unknown date.
113.	Honours for Numerius Avitus, *senator* and *curator*, by *Sabrathenses*, marble panel, late 2nd to 3rd c. AD (lettering), range 187.5–300, mid-point 243.75.
115.	Fragmentary honours mentioning *aediles*, marble panel, 2nd to 3rd c. AD (lettering), range 100–300, mid-point 200.
116.	Fragmentary honours, marble panel, not before 2nd c. AD (lettering in IRT, and also I take the TAQ as the fall of Carthage in AD 439, after which such honours are not known in epigraphy, range 100–439, midpoint 269.5.
117.	Quadriga for C. Flavius Pudens, *flamen, flamen perpetuus*, and *duovir*, by ordo and populus, erected and paid for by the honorand, marble panel, 2nd to 3rd c. AD (lettering), range 100–300, mid-point 200.
128.	Fragmentary honours for *flamen perpetuus* and *duovir quinquennalis*, marble panel, 2nd c. (lettering), range 100–200, mid-point 150.
131.	Fragmentary honours, marble panel, 3rd c. AD (lettering), range 200–300, mid-point 250.
133.	Fragmentary honours, marble panel, date unknown.
137.	Fragmentary honours, marble panel, date unknown.
139.	Quadriga given in fragmentary honours, marble panel, 2nd to 3rd c. (lettering), 100–300, mid-point 200.
140.	Biga given in fragmentary honours, marble panel, 2nd to 3rd c. (lettering), range 100–300, mid-point 200.
141.	Fragmentary honours, marble panel, 3rd c. (lettering), range 200–300, mid-point 250.
143.	Fragmentary honours, marble panel, 2nd to early 3rd c. (based on information shared with 117 which is dated by lettering, though not clear why it is dated to no late than early 3rd c.), range 200–312.5, mid-point 256.25.
147.	Fragmentary honours by *Sabrathenses*, marble panel, 3rd c. (lettering), reused from 82, range 200–300, mid-point 250.

(*cont.*)

Capitolium, dump in the vaults

149.	Fragmentary honours by *Sabrathenses*, marble panel, 4th c. AD (lettering), range 300–400, mid-point 350, reused from 97.
156.	Fragment, white marble panel, 3rd c. AD (lettering), range 200–300, mid-point 250.
160.	Fragment, marble panel, 2nd to 3rd c. AD (lettering), range 100–300, mid-point 200.
167.	Fragment, white marble panel, 3rd c. AD (lettering), range 200–300, mid-point 250.
168.	Fragment, marble panel, 2nd to 3rd c. AD (lettering), range 100–300, mid-point 200.
172.	Fragments, mentioning a contribution to the basilica, white marble panel, 3rd c. AD (lettering), range 200–300, mid-point 250.
175.	Fragment, marble panel, mentioning construction, 2nd c. AD (lettering), range 100–200, mid-point 150.
190.	Fragment, marble panel, 2nd to 3rd c. AD (lettering), range 100–300, mid-point 200.

The Many Lives of the Statue Bases of Lepcis Magna

Francesca Bigi and Ignazio Tantillo

Abstract

The city of Lepcis Magna is remarkable not only for the survival of a large number of late antique statue dedications *in situ*, but also for evidence of the extensive reuse of their epigraphic supports. This can be understood against a background of architectural reuse beginning in the 2nd c., that was particularly intense around the time of the construction of the Severan Forum, due to an oversupply of materials. This could lead to suitable architectural elements being reused as statue supports. Nevertheless, several different kinds of epigraphic reuse are identified, whereby inscribed supports were reemployed. This might involve loss of function or a renewal of function. Renewal can involve the inscribing of a new text on an older statue with minimal changes to it and can occur multiple times. A total study of epigraphic reuse against evidence of primary dedication reveals that, although still alive, the statue habit was in decline in the 3rd–4th c., and that reuse of honorific statues was common.

Introduction to the Problem

Starting from the second half of the 3rd c., in all areas of the empire where the custom of entrusting messages of various kinds to stone was preserved, a considerable proportion of inscriptions were engraved on previously used supports, variously adapted.[1] In Lepcis, this phenomenon reaches surprising levels, due to its pervasiveness and the wide range of procedures implemented. It is much more extensive than what has been revealed by the authors of the *Inscriptions of Roman Tripolitania*, notwithstanding their admirable and unusual sensitivity towards the non-textual aspects of inscriptions. The marked propensity to reuse seen at Lepcis undoubtedly has a background in local custom; however, it would be imprudent to claim that it is exceptional, given the still scant knowledge we have of this practice across the Roman world.

By way of introduction to this problem, it is useful to make a brief overview of the situation that is found in the capital of Tripolitania. In Lepcis, occasional reuse of inscribed stones can be encountered as early as the 1st c. AD. However, in general, in the first two and a half centuries of the city's epigraphic history, it remained the custom to engrave texts on supports/stones specially created for the purpose. Even recourse to collected material of other origins (architectural pieces), converted as far as possible to accommodate writing, appears sporadic: it is encountered in the Early Severan Age, just prior to the arrival of large quantities of marble intended for the grandiose building projects carried out by Septimius Severus and his son, Caracalla. With the end of this phase, the custom of converting architectural elements (pedestals) into epigraphic supports became more common. This was due to the wide availability of construction leftovers which could be purchased by private individuals after the conclusion of the works, although we do not know through which channels.[2] The Severan Age also sees the proliferation of statue bases made from scratch. Nonetheless, the production of new bases drastically declined from the mid-3rd c.[3] From this point on, the erection of new honorific monuments saw the reuse of pre-existing statue bases of statues and, occasionally, the deployment of unused architectural pedestals which had been stored in warehouses.[4] The second half of the 3rd c. also saw the explosion of another type of reuse in which numerous inscribed stones were reused together with disparate material. Between the end of the 3rd and 4th c., at least 55 epigraphic supports were reused as building material in new factories and in the restoration of existing buildings.[5] Among them, tripartite type

[1] This is a translation of an original paper by F. Bigi and I. Tantillo (2010) "Il reimpiego: le molte vite delle pietre di Leptis", in *Leptis Magna. Una città e le sue iscrizioni in epoca tardoromana* (Edizioni dell'Università degli Studi di Cassino), edd. I. Tantillo and F. Bigi (Cassino 2010) 253–302. Bibliographical references have not been updated. *Late Antique Archaeology* would like to thank the authors and the Centro Editoriale di Ateneo dell'Università di Cassino for their granting of permission to publish this piece.

[2] The awarders of IRT 401 and IRT 606 (on which below 'Statue Bases Made From Architectural Pedestals') were private. Since the material was imperial property, this is quite surprising: it is possible that the emperor or the superintendent of the works had granted the surplus to the city, and that the authorities of the latter had sold it.

[3] See Bigi (2010) 222–25; it is conceivable – even if unverifiable (see Tantillo (2010) 199–200) – that a similar reduction also extended to the production of new statuary.

[4] The case of Tantillo/Bigi nos. 21, 39, and 71 shows that some of these pedestals remained unused well into the 4th c.

[5] On the phenomenon, specifically in relation to Roman honorific monuments, Coates-Stephens (2002) underlines how in many centres the need to erect walls quickly gave rise to the spread of this practice; see also Coates-Stephens (2007) 176–77. The reuse in the walls of late Lepcis – never investigated systematically – is

limestone bases and blocks belonging to monumental dedications, usually used as simple ashlars, predominate; however, there are also moulded, marble monolithic bases converted into supports for ideal sculpture, slabs used to cover walls or floors, and supports of various types transformed into elements of architectural decoration.[6]

The purpose of this analysis is to show that the phenomenon of the reuse of inscriptions – the habit, for example, of reusing the same statue base – occasionally studied in isolation, cannot be removed from the transformation and recycling process that affects the stone heritage of a city. A global approach to the problem – which is not limited to examining inscriptions transformed into other inscriptions but attempts to follow the story of all stones that were made for or were at a certain point used for inscriptions – can provide an understanding of the evolution of the epigraphic and monumental landscape of a city, as well as the practices of which the inscriptions are only indirect evidence.

Let us return to our overview of reuse at Lepcis. We can distinguish three different procedures involved in the reuse of inscribed stones. The first consists in transforming pieces of various origin, initially made to fulfil another function, into supports for monumental inscriptions. The second consists of recycling stones already bearing writing, usually of a similar type, such as the reuse of a statue base. The third consists of the removal and rearrangement of stones bearing inscriptions for reuse for another purpose, such as *spolia*.[7] The first and third procedures imply a defunctionalisation for the original support. For example, a scroll frieze is reversed and inscribed on the back, becoming a slab with which to line a statue support. Alternatively, a stone bearing an inscription is reused as an architectural element or building block. However, the second procedure mostly translates into what we could call a renewal of function, e.g. a base being reused as another base, retaining its initial purpose.

Care must be taken with such categorisations as they can be said to overlap. Any medium on which writing is replaced with different writing undergoes a renewal of function to some extent. Correspondingly, a base created to support an honorary statue being reused to support the statue of the *Genius* of the *colonia*, while easily listed as experiencing a renewal of function, also on some level, undergoes a change of function. For convenience, and to avoid misunderstandings, we will refer to the category of inscriptions reused to exhibit other inscriptions as epigraphic reuse. We will talk about 'defunctionalising' reuses in the other cases.

A similar subdivision of three different types of the use and reuse of stones, however approximate and schematic,[8] can be valuable in highlighting some trends in the evolution of epigraphic heritage. Indeed, if, within a given context, we consider the testimonies – writings on new supports, writings on reused supports – in a diachronic perspective, it is possible to connect the prevalence of a certain type of reuse at different developmental stages. That is, if the predominance of the first type of reuse is noted in a certain period (along with low incidences of the other two types), it is conceivable that we find ourselves in a phase of growth of inscriptions and related practices, with demand exceeding supply for purpose-cut epigraphic supports. If the second type prevails, it may highlight a phase of stagnation or decline in production, but also of substantial continuity in the practices to which writing is connected, with statues being more expendable, but within an enduring 'statue habit'. Finally, if the third type predominates, we are possibly in a phase of cultural impoverishment, epigraphic decline, and the associated deterioration/extinction of epigraphic practices.

While we must be very careful in the generalisations involved in such a categorisation,[9] it can be extremely useful. In this regard, a clarification is essential, especially with regards to the examination of inscriptions transformed into *spolia*. It is one thing to reuse writing and the monument it accompanies when the practice of engraving inscriptions and creating that type of monument is still 'alive'; it is another to do it when the meaning of those writings and monuments has now been lost. In other words, recycling a statue in the 4th c., eliminating an honorand and replacing him with another, was very different from reusing a statue base when no more statues were being raised and the city

appreciable only to a small extent (see below 'Epigraphic Supports Used as Building Material').

6 However, there does not seem to be much evidence for the use of statues in foundations, a practice which in Rome began at the end of the 3rd c. (Coates-Stephens (2001); (2007); Varner (2004) 5); see, however, Di Vita and Livadiotti (2005) 53.

7 For an attempt to define *spolia*, the applicability of the term to reused statues, the different methods of 'recycling', see the stimulating observations of Kinney (1997) 118–19 and 122.

8 No formula can account for the variety of reuse procedures. Consider, for example, the difficulty of defining the case of Tantillo/Bigi nos. 88–89, created as statue bases, then converted into fountains, then re-inscribed and used to support ideal sculpture, and finally reused as building material in the Byzantine period. A brilliant attempt to conceptualise various types of reuse (in the textual field) can be found in Eco (1999), from which we have drawn some suggestions.

9 Suffice it to say that, in Lepcis, the second and third types of reuse overlap: nevertheless, while the reuse of the second type ends in the 5th c., that of the third type continues.

TABLE 1 Recycled elements used as epigraphic supports (funerary inscriptions from the Vandal-Byzantine period are excluded).

Type of element	Original date of the element	Transformed into	Date of reuse
Statue base	Second half of 2nd c.	Statue base: IRT 410	198–210
Statue base	Second half of 2nd c.	Statue base: IRT 415	198–210
Blocks of cornice	2nd c.	Statue base: IRT 393	201–202
Blocks of frieze-architrave	2nd c.	Statue base: IRT 423/no. 82	201–202 (then second half of 2nd c.)
Pedestal colonnaded street (Fig. 6, type 4.1b)	Severan	Statue base: IRT 401	After 211
Pedestal large nymphaeum (Fig. 6, type 4.1a)	Severan	Statue base: IRT 606	211–217
Pedestal small nymphaeum (Fig. 6, type 4.2a)	Severan	Statue base: nn. ?/22/36/13	ca. first half of 3rd c., erased text (then 290–294; then in the 4th c.; last in 379–395)
Pedestal small nymphaeum (Fig. 6, type 4.2a)	Severan	Statue base: Tantillo/Bigi no. 53	End of the 3rd-beginning of the 4th c.
Pedestal large nymphaeum Fig. 6 (type 4.1a)	Severan	Statue base: no. 71	324–326
Oversized pedestal	Severan	Statue base: Tantillo/Bigi no. 21	330–400
Pedestal small nymphaeum (Fig. 6, type 4.2a)	Severan	Statue base: ?/unpublished Gallienus	? Erased text (then in 267–268)
Pedestal small nymphaeum (Fig. 6, type 4.2a)	Severan	Statue base: Tantillo/Bigi nos. ?/27/40	? Erased text (then in 355–361; last ca. 378)
Pedestal small nymphaeum (Fig. 6, type 4.2a)	Severan	Statue base: ? = B.T.S. 4	? Erased text
Pilaster capital	2nd–beginning of the 3rd c.	Slab with public inscription: IRT 573	3rd c.
Fluted pilaster	2nd c.	Slab with public inscription: IRT 425	198–211
Fluted pilaster	2nd c.	Slab with public inscription: IRT 551	2nd–3rd c. (palaeography and content)
Fluted pilaster	2nd c.?	Slab with inscription: IRT 797	End of the 3rd c. (palaeography)
Fluted pilaster	2nd–beginning of the 3rd c.	Slab with inscription relating to restoration?: Tantillo/Bigi no. 78	4th c.
Slab with bas-relief	2nd c.?	Slab with imperial name: IRT 509	3rd c. (palaeography)
Slab with mouldings	2nd c.?	Slab with honorary inscription: IRT 787	3rd c.
Slab with mouldings	2nd c.?	Slab with inscription: IRT 809	3rd c.
Slab with mouldings	2nd c.?	Slab with funerary inscription: IRT 761	3rd–4th c.
Slab with mouldings, perhaps architrave	2nd c.?	Slab with inscription with imperial title: IRT 386	End of the 2nd–beginning of the 3rd c.
Element of *opus-sectile* paving	2nd–3rd c.?	Slab with funerary inscription: IRT 733	3rd–4th c.
Limestone half-column	1st c.?	Domed tomb cover: IRT 695	3rd or 4th c.
Limestone column drum	1st c.?	Punic-Libyan funerary text?: IRT 827	3rd or 4th c.
Series of fragments of fluted pilasters; slabs with mouldings or vegetal decoration	?	Slabs with inscriptions. Unpublished	?

was increasingly in ruins, as in the 6th c. The first case presupposes awareness of the act, and that decision was constrained by precise criteria or rules; the second does not. For this reason, in our analysis, we will start from the most ancient examples and stop at the Byzantine age, with a brief discussion of the methods of reuse of the 5th and 6th c., sufficient to show that in this era the perception of the value and meaning of inscriptions was now irreparably compromised and that inscribed stones were now reused freely, having become *spolia* to all intents and purposes, and selected on purely utilitarian criteria.[10] The stones reused in later ages, under the Arab period and the years of the Italian occupation are not discussed.[11]

The remainder of the contribution is divided into two separate but complementary parts. In the first, an in-depth examination of the material will be carried out, divided according to 'Types of Reuse'.[12] In the second part, we will try to interpret some characteristics of this phenomenon: in particular, we will try to expound the possible criteria which determined the choice of artefacts to be reused in late antique Lepcis. Finally, there will be a discussion on the causes and consequences of this phenomenon. We will try, as far as possible, to compare our data with the literary, epigraphic, and archaeological evidence of other parts of the empire. We also hope that, beyond their value for understanding the context in question, these considerations may also prove useful for the analysis of other contexts.[13]

10 See below 'Inscriptions Reused in the Byzantine Period'; for a brief discussion of reuse at Lepcis in the Byzantine period, see Deichmann (1975) 64.
11 This is the case of IRT 264; 304; 314; 315a; 481; 483; 572; 674; 675; 780; to which must be added IRT 387 and 452, inserted into a building that leaned against the Byzantine walls: Masturzo (2005) 52–53.
12 The order in which the three categories will be examined follows a broadly diachronic principle; that is, we will start from the first forms of reuse, which concern the transformation of heterogeneous materials into epigraphic supports, then moving on to the examination of the various epigraphic uses known by the inscribed supports, ending with the inscriptions that become *spolia*. Obviously, these phenomena do not necessarily arrange themselves in this sequence.
13 Two last preliminary clarifications: to avoid confusion in the case of supports that have been used more than twice and to fully account for the consistency of the phenomenon, we will avoid speaking generically of 'reused' stone, but we will differentiate the acts of reuse. In order not to burden the discussion with frequent references, for the descriptions and history of the buildings, reference to Pentricci (2010) 97–171 is implied; for a detailed analysis of the supports, refer to Bigi (2010) 219–50 and to the specific entries of the Tantillo and Bigi (2010) catalogue.

Types of Reuse

Epigraphic Supports Made Out of Recycled Elements

In the large sample available from Lepcis, there are inscriptions that are distinguished by being engraved not on a support made for that purpose but on a pre-existing element originally conceived for another use (Table 1). Although not particularly consistent from a quantitative point of view in Lepcis, this form of reuse, nonetheless, is found across a broad chronological span – ranging from the end of the 2nd c. to the beginning of the 5th. It incorporates disparate types of artefact, resulting in multiple forms of reuse. In fact, as in the case of bases formed by cornice blocks, the conversion of an object into an epigraphic support can lead to a substantial change of its original structure, to the point of being almost unrecognizable. Otherwise, as with architectural pedestals, the artefact can be exploited precisely because of its architectural form, in which case modifications appear non-existent or extremely limited.

Statue Bases Made from Heterogeneous Elements

In AD 202, a statue was dedicated to Septimius Severus and placed in the centre of the *frigidarium* of the Hadrianic Baths (IRT 393). The pedestal on which the statue sat has a rather anomalous form: it is made up of two rectangular marble blocks, placed side by side and held together by means of metal clamps (Fig. 1). These are not two elements expressly worked for the monument, but two reused architectural cornices, as can be seen from a surviving section of a decoration carved with dentils (Fig. 2). When converting them into a statuary support, care was taken to carve a moulded socle in the lower part of each stone, so as to make the whole appear like a common statue base.

A similar support also hosted a statue in honour of Caracalla dedicated in the same year (IRT 423), later transported to the Severan Forum and reused there for a new inscription to the *Genius* of the *colonia* (Tantillo/Bigi no. 82, Fig. 10.96). Also in this case, the base is formed by two blocks placed side by side, held together by a pair of clamps and likewise carved with a moulded socle (Tantillo/Bigi pl. XXI). Unlike the base of Septimius Severus, in this example, the reused members correspond to two blocks of architrave frieze, with the soffit carved with a guilloche lacuna. It is highly probable, given the presence of the moulded plinth, that both bases were surmounted by a third shaped element, used to crown the base and support the statue. Our knowledge of the upper parts of building elevations in Lepcis is not complete enough to identify from which original context came the architectural elements reused for the

FIGURE 1
Hadrianic Baths, right side of the base of IRT 393 with the junction of the two blocks.

FIGURE 2
Hadrianic Baths, back of the base of IRT 393 with the remains of the notched decoration.

two bases. Nevertheless, given the chronology of the two dedications, it is highly improbable that they were taken from ruined monuments, and it appears more plausible that they were left over from another building project.

The case represented by two statue bases in honour of ladies of the Severan imperial family, Paccia Marciana and Fulvia Pia[14] (respectively IRT 410 and 415) is also quite peculiar. Apparently, when viewed from the front, the two inscriptions appear to be engraved on a pair of twin-moulded monolithic bases worked in Pentelic marble. In reality, a more careful observation reveals that the two supports were obtained from a single, pre-existing base cut in two lengthwise (Fig. 3). Indicators of this are their anomalous thickness, their perfectly smooth back, and, above all, the presence on the sides[15] of traces of

14 On these two dedications, see also Aurigemma (1950) 70–71; table XIXa-b.

15 Having been cut in two, the original front of the base is now on the left side of IRT 410 and the right side of IRT 415.

FIGURE 3
Old Forum, front of IRT 410 and right side of IRT 415.

the obliteration of the original text and of the frame within which it was written (Fig. 4).[16]

That the bases obtained using collected material all belong to the Early Severan Age is a fact that might surprise one, above all, because it is dissonant with the widespread opinion that similar expedients are the prerogative of a later antique period, as they are connected with the difficulty of finding raw material. In fact, the peculiar form of these bases is due precisely to a real shortage of valuable raw materials, but this did not affect the city in Late Antiquity, but instead in the Early Severan period, before the opening of the large construction sites. The recourse to reused elements demonstrates that the decorative public works in marble of the 2nd c. must have put considerable strain on available architectural resources and had, consequently, left very little raw marble to be worked with in the following decades. It would only be with the huge influx of marble for the various Severan complexes in Lepcis that large reserves of valuable raw materials would be built up.

Although numerically limited, these examples also appear significant for another reason: they constitute the first sign of the change in taste that the reigns of Septimius Severus and particularly Caracalla brought. While in the 1st and 2nd c., honorific epigraphy in Lepcis used almost only bases carved in the local limestones, the Severan era saw a rejection of local stones and an extensive use of marble, which now represents the quality standard and the material *par excellence* for inscriptions (chap. 7.2.1–2). It is, therefore, on the basis of this new aesthetic that recovered marble elements were used to celebrate members of the reigning imperial college, if being aware that reuse would affect the form of the final product.

A similar base to those of Paccia Marciana and Fulvia Pia seems to have been used for two twin bases celebrating the construction of an aqueduct at the expense of

16 This is an emblematic example of the difficulty of pigeonholing the material within rigid categories of types of reuse.

FIGURE 4
Old Forum, back and left side of the base of IRT 410, with traces of the obliteration of the previous inscription and of the relative framing.

Servilius Candidus (IRT 358). Since it was not possible to carry out a first-hand examination of the stones in question, the utmost caution will be exercised in discussing them. Both texts, with identical wording, were engraved on the smooth back of a moulded base of the oldest type (see chap. 7.2.1), that is, one characterised by a greater width and by very simplified mouldings (Fig. 5). In reality, the comparison between the thickness of the bases of Candidus and that of the other stones of this typology seems to indicate that came from a single, pre-existing base cut in half and then reused. The IRT publishers do not mention any traces of writing on what must have been the original front. It is, therefore, not clear whether an unused epigraphic support was used, or if an original inscription in paint was lost, or whether instead a pair of stones was reused which, despite having the typical shape of statue bases, had originally been made for another purpose.

Statue Bases Made from Architectural Pedestals

If the period prior to the opening of the great Severan construction sites had been characterised by the difficulty in finding marble for the bases of statues, the situation was reversed with the building and completion of the sumptuous complexes of the Severan Forum, the Basilica and the Nymphaeum. The original project, which envisaged the duplication of the forum,[17] was reduced in extent during construction, thus making a considerable number of complete or almost complete marble architectural members superfluous.

17 Di Vita (1982).

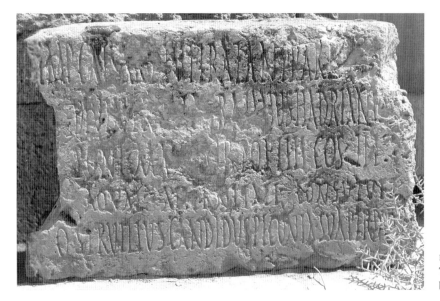

FIGURE 5
Theatre, IRT 358 engraved on a 1st c. molded base cut in two.

It is precisely this nucleus of materials that was used, over a span of two centuries, to erect a series of honorific monuments, the bases of which were obtained by reusing architectural column pedestals. There are a total of 9 specimens that belong to 5 generically homogeneous types, differing only in size and mouldings (Fig. 6).[18] Four bases are of the 'small nymphaeum' type (Fig. 7),[19] one of the 'small forum' type,[20] two of the 'large nymphaeum/temple' type (Fig. 9),[21] one of the 'Via Colonnata' type (Fig. 8),[22] and one is an oversized unique specimen (Tantillo/Bigi no. 21, Figs. 7.28; 10.25; pl. VII).

The structure of these column pedestals – consisting of a moulded socle and crowning, interspersed with a cubic or parallelepiped body – is in fact the same as that of any moulded monolithic statue base. This strong formal affinity not only allowed these pedestals to be recycled directly without intervening in any way on its structure, but above all allowed for a 'mimetic' reuse, which only the eye of an attentive observer could have detected. In transforming it into an epigraphic support, the only adaptation, in fact inessential, to which these artefacts could be subjected, was the sculpting of a moulded frame to hold the inscription, so as to further increase their similarity with other stones normally manufactured for this purpose.[23]

But the most significant aspect of the reuse of pedestals as statue bases lies in its connection with the building history of Lepcis. Since these elements were originally produced to serve in an architectural context, they could be considered proof of the destruction of the city's monumental heritage; that is, one could assert that if an element belonging to a building was reused, the latter must by now have lain in ruins. In reality, this is not the case: our analysis of the material shows without doubt that none of the pedestals reused as statue bases had ever been used for their original purpose. No collapse made these stones available; no ruined building was looted to make a quarry from which they were taken.

Firstly, all the pedestals used as pedestals in the Severan building complexes bear traces of a common fastening technique on their upper face, consisting of a dowel hole placed in the exact centre of the surface, connected with a drainage channel.[24] On the other hand, very different traces can be observed on those pedestals reused as bases for statues, such as an off-centre quadrangular hole (Tantillo/Bigi nos. 27/40, pl. IX), four holes arranged approximately near the four corners (Tantillo/Bigi nos. 27/40, pl. IX; no. 53), and a series of cuttings set around a pair of footprints

18 For a detailed analysis of the mouldings and the consequent typological subdivision, see Bigi (2010) 246–50 and Tantillo/Bigi Figs. 7.24–28.
19 Fig. 6, type 4.2a: Tantillo/Bigi nos. 13/22/36 on a single stone (Tantillo/Bigi Figs. 10.14; 10.26; 10.41; pl. VI); Tantillo/Bigi nos. 27/40 (Figs. 10.30; 10.48; pl. IX; no. 53; unpublished base by Gallienus at the Late Baths.
20 Fig. 6, type 4.2b: Tantillo/Bigi base with missing text no. 5, pl. XXVI.
21 Fig. 6, type 4.1a: Tantillo/Bigi no. 71, Fig. 10.81; pl. XX; IRT 606.
22 Fig. 6, type 4.1b: IRT 401.

23 In Lepcis, most of the statue bases created as such are characterised by the presence of a moulded frame. Among the bases made from reused pedestals, this framing was sculpted for IRT 606; on the Tantillo/Bigi base with lost text no. 5; for Tantillo/Bigi no. 13 and for the text subsequently erased, together with said frame, to make way for Tantillo/Bigi no. 40.
24 Ward-Perkins (1993) 96–97; pl. 46–47.

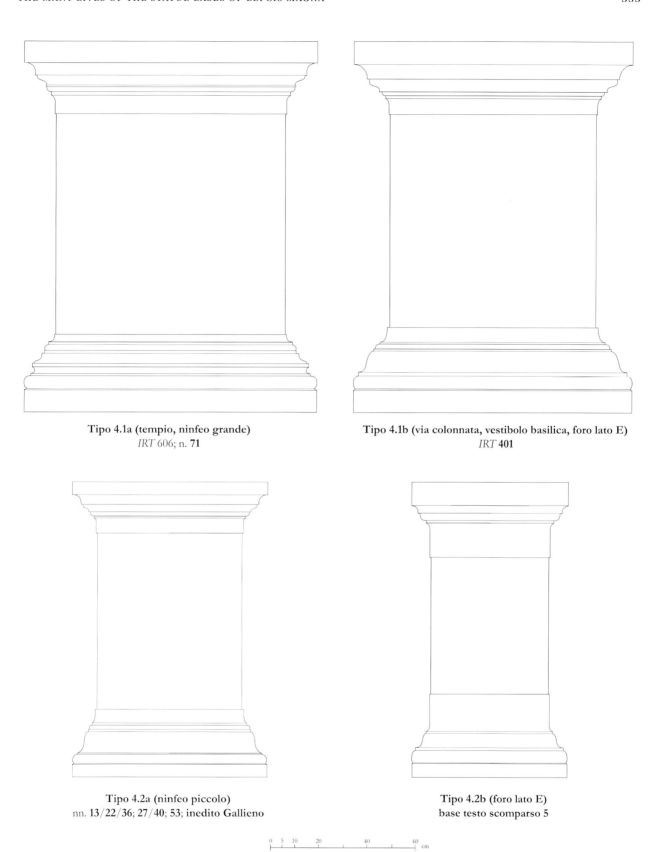

FIGURE 6 Typological subdivision of the architectural pedestals reused as statue bases (dis. F. Bigi).

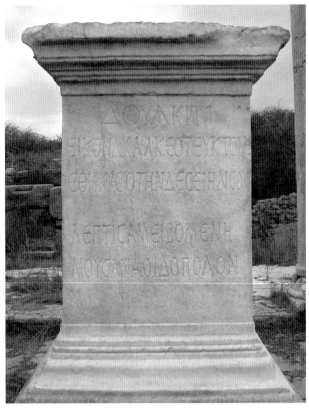

FIGURE 7 Temple of Serapis, pedestal of the genus 'small nymphaeum' reused for Tantillo/Bigi no. 53.

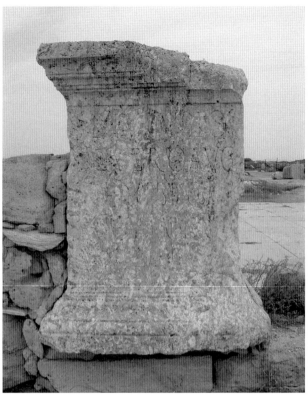

FIGURE 8 Old Forum, pedestal of the 'Via Colonnata' type reused for IRT 401.

(Tantillo/Bigi base with missing text no. 5, pl. XXVI). These are undoubtedly the traces of the fastening of statues and not of column bases. Furthermore, as in the case of the bases dedicated to the Divine Severus (IRT 401) and to Constantine (Tantillo/Bigi no. 71), the upper surface can also be perfectly smooth. Secondly, all the specimens are in a good, even excellent, state of preservation, with almost all the edges intact or affected by minimal chipping. This would not have been possible if they had been part of a ruined building or edifice.[25]

But it is the inscriptions they house that show in an incontrovertible way that at least two, if not five, of these pedestals were used from the outset as bases for statues. In fact, a dedication to *Divus Severus* (IRT 401, Fig. 8), presumably placed shortly after 211, was engraved on the limestone pedestal of a 'Via Colonnata' type, while a pedestal of the 'temple' type became the support of a dedication to Septimius Aurelius Agrippa, freedman of Caracalla (IRT 606, Fig. 9). Given the chronology of these

FIGURE 9 Theatre, pedestal of the 'temple' type reused for IRT 606

25 The rear part of the crowning of Tantillo/Bigi no. 53 appears to have been repaired in Antiquity but the perfect state of conservation of the rest of the stone leads us to exclude that it may have fallen from the upper structures of a ruined building. The substantial chipping visible on IRT 401 is attributable to the reuse of the stone in the Byzantine age as building material in the baptistery of the Old Forum.

two honorary monuments, it is impossible to believe that their supports came from any ruined Severan complexes, so soon after their dedication or even before they were completed.

The unpublished dedication of Gallienus from the Late Baths, carved on a 'small nymphaeum' type pedestal, is carved over a previous erased text, while the inscription in honour of Aristobulus (Tantillo/Bigi no. 22), dated to 290–294, engraved on a pedestal of the same type, had already been used for a text, the writing style of which places it no later than the first half of the 3rd c. (cf. Tantillo/Bigi no. 13). In both cases, therefore, the stones housed inscriptions dating from as early as the decades immediately following the completion of the Severan building projects. This group of testimonies could also include the pedestal that housed a dedication to the poet Serenus (Tantillo/Bigi no. 53, Fig. 7) decreed in the late 3rd/early 4th c., although, in this case, the time elapsed makes for a less decisive testimony.

These last three stones also provide further evidence that the architectural pedestals were never used as such. They are identical to those supporting the columns of the first order of the Severan Nymphaeum. If these pedestals had been used in the Nymphaeum and from there taken to be used as epigraphic supports, it would mean that the building was in a ruinous state already in the first half of the 3rd c. We would have to attribute such sudden destruction not to the ravages of time but to a major cataclysm. Since it is known that the Nymphaeum was destroyed by the overflowing of the wadi Lebda, we would consequently be forced to change the chronology of this flooding event too. If such a chain of events appears absurd in itself, the archaeological data also invalidates this reconstruction: it demonstrates that the Nymphaeum was still fully functional in Late Antiquity, when it was modified by adding a basin along its entire front (Tantillo/Bigi chap. 4.4.9).

At this point it is worth discussing the hypothesis of S. Ensoli Vittozzi,[26] who invoked the testimony of some inscriptions of the Severan Forum, which she believed were engraved on an architectural pedestals, to establish a *terminus ante quem* of the destruction of this monument. The thesis of this scholar has the advantage of having detected the first use of an architectural pedestal as a base for a statue but suffers from a hasty evaluation of the documentation which, if not corrected, risks further contaminating a tradition of studies already characterised by many misunderstandings. Ensoli mentions the "reuse of some column pedestals as bases for statues"[27] without specifying which pedestals or what the inscriptions are. If, as it seems, this reference is to the pedestals of the supposed second order, the annotation turns out to be completely wrong. The pedestals in question differ substantially from those actually reused as epigraphic supports. In addition to having smaller dimensions and simplified sequences of mouldings, the pedestals of the second order are distinguished by being carved together with a column imoscape (lowest part of a column) and simple column base (Fig. 10), elements absent on all other pedestals used for writing.[28] In essence, therefore, none of the elements of the hypothetical second order was ever reused as an epigraphic support.

Once it has been established that these stones are not materials derived from ruined contexts, it becomes clear that the pedestals that have become bases for statues are actually surplus pieces from construction sites. As such, they can, nonetheless, provide valuable information not only on the organization of work within Severan buildings, but also on the ways in which epigraphic supports were supplied. As far as the first question is concerned, the fact that four of the five types of pedestals are attested by a single, reused artefact could mean that it was customary to work a limited number of extra pieces, so as to have a replacement element ready if the one got damaged during construction. If this circumstance did not occur, the excess members could be put to another use.

There is also the possibility that some of the pedestals were initially sculpted for a sector of the complex that was never built; instead of being recycled in other parts of the building as was the case for a large number of other members,[29] they were set aside and then made available for a different use. In fact, a change of project during construction seems to be indicated not only by the existence of as many as four pedestals of the 'small

26 Ensoli Vittozzi (1994) 725.
27 Ibid.
28 Three limestone statue bases present a sort of cylindrical plinth carved in the same block (IRT 405; 637 and Tantillo/Bigi no. 67), but these materials are not comparable with those of the Severan structures.
29 After the abandonment of the project to duplicate the forum, the most valuable members found a new location in the Severan complexes, such as the winged griffins placed, as false ornaments, at the foot of the temple steps: Apollonj (1936) pl. XXIX; XXXI; Ward-Perkins (1993) 33; pl. 23c, and above all those elements that had already arrived in Lepcis in large quantities, such as the cipollino column shafts, which were repositioned in the vestibule of the Basilica and literally crammed in the two so-called 'halls of the 10 and 13 columns': Di Vita (1982) 87; Ward-Perkins (1993) 22–25. The hypothesis has been put forward that the colonnaded street is also the result of "an afterthought"; that it was designed at a later time precisely to exploit the large number of existing shafts: Parisi Presicce (1994) esp. 716. The problems related to the redesign of the Severan works are currently being studied by G. Ponti.

FIGURE 10 Severan Forum, pedestal of the supposed second order.
DRAWING BY F. BIGI

FIGURE 11 Fragments of fluted pilaster on the back of which is engraved Tantillo/Bigi no. 78.

nymphaeum' type which became bases for statues, but also by the anomalous usages of all the 'large nymphaeum' type pedestals. Of the latter, those found in the Nymphaeum itself do not have any supporting architectural function and are not integrated in a coherent way with other structural or decorative parts: indeed, they seem to have been placed there at a later time.[30] Another, however, must have remained unused until the time of its use as a statue base (Tantillo/Bigi no. 71). The case of these pedestals suggests that, once the initial project was abandoned, some of them were set aside in a makeshift location, while others found their way into a deposit of materials from which they could be sourced for other projects in the succeeding decades. The fact that such a warehouse could still provide high quality artefacts a century after the closure of the Severan building programme provides us with a significant indicator of the scale of the resources lavished on the city by imperial evergetism.

Inscriptions on Reused Slabs

Inscriptions could also be cut into reused veneers or applied decorative elements.[31] In this case, the writing obviously occurs on the back of the artefact, which in most cases turns out to be a piece of architectural decoration. In total, there are 11 inscriptions engraved on salvaged artefacts: four on the back of sections of fluted pilasters in white marble, almost always Pentelic (Fig. 11);[32] four on the back of slabs with mouldings of various types (IRT 386; 761; 787; 809); one on the back of a bas-relief with plant motifs (IRT 509); one on the reverse of a pilaster capital (IRT 573) and one on a hexagonal panel from an *opus sectile* floor revetment (IRT 733). To these texts must be added a series of minute unpublished fragments, stored in the museum; they bear the remains of letters attributable paleographically to the second half of the 3rd and 4th c. Among these are six fragments of revetment panels, five in white marble of various qualities and one in greco scritto marble;

30 The reconstruction advanced in Ward-Perkins (1993) fig. 43, where the pedestals are placed above the attic, is incompatible with their state of preservation; in other words, if they had collapsed from such a height, these pieces would have shattered.

31 Neither opisthographic slabs [with writing on both sides], which belong to another category of reuse, nor quarry marks, are considered here.

32 IRT 425; 551; 797 (unlike the publishers of IRTs, we do not consider IRT 797 a quarry mark); Tantillo/Bigi no. 78.

three fragments with vegetal decorations and two fragments of fluted pilasters.

For none of the elements mentioned are we able to precisely specify their architectural provenance; moreover, in the case of the slabs with portions of shaped frames, it is possible that they initially served both as a wall veneer or as a revetment for statue bases of the assembled type. It should be noted that these latter artefacts never present articulated sequences of shapes, and their decoration is often reduced to a simple cyma moulding or even a pair of rough parallel incisions that imitate a framing. As regards the slabs with vegetal decorations, the extremely fragmentary state does not even allow the reconstruction of the articulation of the decoration.

Epigraphic Reuse
The category of epigraphic reuse includes all those cases in which an inscription is engraved on a support that has previously hosted one or more texts. Although there are some examples of opisthographic slabs (with writing on both sides), this form of reuse essentially concerns statue bases, with a sample of over 50 artefacts that have held more than one inscription (Table 2). In fact, of all the late antique epigraphic texts of Lepcis, the only examples set on previously unused supports are the dedication to Archontius Nilus in the Old Forum[33] (Tantillo/Bigi no. 39) and that to a certain Evanthius in the Severan Forum (Tantillo/Bigi no. 67).

A notable absence is of those bases – so frequent in the late antique East[34] – made up of a series of salvaged elements stacked one on top of the other to create a composite support. At Lepcis, when a statue base is reused to engrave another text, it usually retains its tectonics and original form. The few exceptions are: (i) a dedication to the *Genius* of the *colonia* (Tantillo/Bigi no. 83, Figs. 10.97–98; pl. XXI), engraved on the side of a tripartite base rotated by 90° and placed on the back, and (ii) two equestrian bases adapted to serve as a twin support for a pair of standing effigies (Fig. 13; Tantillo/Bigi nos. 3 and 7; fig. 10.4; 10.9; pl. IV). In the latter case, the relative titulus is no longer placed on one of the short sides, but on one of the long sides. A variation of the initial set-up also occurs if the base is turned upside down, causing the socle to take the place of the crowning and *vice versa*. In only one case is it conceivable that this became necessary following damage to the original lower part (Tantillo/Bigi no. 35, pl. XII), while for the other two examples the reason behind such an intervention remains obscure (Tantillo/Bigi nos. 19 and 23, Figs 10.22; 10.27; pl. VII). Finally, the only examples of re-sizing of supports linked to epigraphic reuse, and not to a 'change of function' of the inscribed stone, are represented by a base in honour of C. Valerius Vibianus (Tantillo/Bigi no. 32; pl. XI) and by another dedicated to Laenatius Romulus (Tantillo/Bigi no. 33, Fig. 10.38; pl. XI). Only the socle was removed from the first, while the second was deprived of most of its crowning and socle in order to reduce its height, perhaps to place it in a setting where space was limited.

If we look at the distribution of the bases located in the Severan Forum (Tantillo/Bigi pl. I), we immediately realise that there was no single way of inscribing new texts onto a stone which already held another: the inscriptions can be found on the opposite faces, on adjacent faces, or stratified one on top of the other on the same side. A preference seems to have been accorded to engraving the second inscription on the opposite side to the original, as is shown by those bases which have all four sides finished and not, as often happened, with the back only roughly finished.[35]

This made it possible to exploit any decoration present on the sides,[36] but above all ensured a reduced visibility for the first text,[37] minimizing the visible reuse or even, if the base was placed against a wall, hiding it completely from view. A particular case consists of a tripartite marble base, where each of the four sides was used for an inscription (Tantillo/Bigi Figs. 10.29; 10.59; pl. VIII).[38] The tripartite marble bases,[39] which normally have all sides decorated with a frame,[40] could in fact be rotated more easily, thus offering a virgin surface each time; however, as proof of the fact that there was no rule for reuse, we should note that the tripartite base on which

33 The architectural pedestals, re-adapted to serve as bases for statues, discussed in the previous paragraph are not considered here. As for the base of Nilus, there is the possibility that it constitutes a discarded element due to the poor quality of the stone; it is probable that the lost dedication to Valentinian II (Tantillo/Bigi no. 12) was also inscribed above an erased text.
34 See, for example, the bases of Aphrodisias: Smith (1999) esp. figs. 2; 5–6; 8–9; Smith (2002) pl. XI.3.
35 In all five cases, in addition to those cited, there is also Tantillo/Bigi no. 12 on the rear of Tantillo/Bigi no. 55; 27 on the rear of 40 and no. 49 on the opposite face of an equestrian base initially used for IRT 426.
36 Tantillo/Bigi no. 34 on the opposite side of IRT 518 with *urceus* and *patera*, as Tantillo/Bigi no. 84 on the back of no. 46 and the tripartite type base of IRT 706, engraved on the back of an erased inscription. However, the figurative decoration can also be sacrificed, as happens for Tantillo/Bigi no. 60.
37 Always erased, except in one case (IRT 706).
38 Tantillo/Bigi nos. 26 and 52 and two other illegible texts.
39 In addition to IRT 706, this type of marble base also includes Tantillo/Bigi no. 61, IRT 817 and 640; see Bigi (2010) 223–25.
40 Unlike the bases of the same type carved in local stones, where the frame is present only on the front.

TABLE 2 Epigraphic reuses. The original dating of the supports is obtained from the formal analysis of the same and must therefore be understood as a general indication.

a. Secured reused

Biblio. Ref.	Support type	Material	Support's date	I Use	II Use	III Use	IV Use	Note
Tantillo/Bigi no. 28	Statue base	Limestone	First half–mid-2nd c.	First half/mid-2nd c.	4th–5th c., perhaps ca. 402 (no. 28)			
Tantillo/Bigi no. 9	Statue base	Marble	Second half of 2nd c.	Second half of 2nd c.	End of 3rd c.	364–367 (Tantillo/Bigi no. 9)		
IRT 630/ Tantillo/Bigi no. 57	Statue base	Marble	Second half of 2nd c.	Second half of 2nd c. (IRT 630)	Late Constantinian (Tantillo/Bigi no. 57)			
Tantillo/Bigi nos. 46/84	Statue base	Marble	Second half of 2nd c.	Second half of 2nd c.	ca. 300 (Tantillo/Bigi no. 46)	4th c. (Tantillo/Bigi no. 84)		
Tantillo/Bigi no. 10	Statue base	Marble	End of 2nd–beginning of 3rd c.	End of 2nd–beginning of 3rd c.	Beginning of 4th c.?	364–367 (Tantillo/Bigi no. 10)		
Tantillo/Bigi no. 56	Statue base	Marble	End of 2nd–beginning of 3rd c.	End of 2nd–beginning of 3rd c.	Late Constantinian (Tantillo/Bigi no. 56)			
Tantillo/Bigi no. 58	Statue base	Marble	End of 2nd–beginning of 3rd c.	End of 2nd–beginning of 3rd c.	Late Constantinian (Tantillo/Bigi no. 58)			
Tantillo/Bigi no. 59	Statue base	Marble	End of 2nd–beginning of 3rd c.	End of 2nd–beginning of 3rd c.?	Probably 324–326 (Tantillo/Bigi no. 59)			
IRT 423/ Tantillo/Bigi no. 82	Statue base	Marble	202	202 (IRT 423)	ca. mid-3rd c. (Tantillo/Bigi no. 82)			
Tantillo/Bigi no. 8	Statue base	Marble	Severan	Severan	352–361 (Tantillo/Bigi no. 8)			
Tantillo/Bigi no. 54	Statue base	Marble	Severan	Severan	?	Late Constantinian (no. 54)		
Tantillo/Bigi nos. 66/30	Statue base	Marble	Severan	Severan	?	4th c. (Tantillo/Bigi no. 66)	End of 4th–beginning of 5th c. (Tantillo/Bigi no. 30)	
Tantillo/Bigi nos. 22/36/13	Statue base	Marble	After 216	After 216	290–294 (Tantillo/Bigi no. 22)	ca. 320–360	379–395 (Tantillo/Bigi no. 13)	
Tantillo/Bigi nos. 40/27	Statue base	Marble	After 216	After 216	355–361 (Tantillo/Bigi no. 40)	ca. 378 (Tantillo/Bigi no. 27)		
Unpublished	Statue base	Marble	After 216	After 216	267–268			

TABLE 2 Epigraphic reuses. The original dating of the supports is obtained from the formal analysis of the same (*cont.*)

Biblio. Ref.	Support type	Material	Support's date	I Use	II Use	III Use	IV Use	Note
Tantillo/Bigi no. 31	Statue base	Limestone	Late Severan	Late Severan	408–423 (Tantillo/Bigi no. 31)			
IRT 542	Statue base	Limestone	2nd–first half of 3rd c.	2nd–first half of 3rd c.	*ca.* mid-3rd c. (IRT 542)			
IRT 644/ Tantillo/Bigi no. 83	Statue base	Limestone	2nd–first half of 3rd c.	2nd–first half of 3rd c.	After 260			
Tantillo/Bigi no. 37	Statue base	Marble	Beginning of 3rd c.	Beginning of 3rd c.	3rd c.	*ca.* mid-4th c. (Tantillo/Bigi no. 37)		
Tantillo/Bigi nos. 45/60	Statue base	Marble	Beginning of 3rd c.	Beginning of 3rd c.	End of 3rd– beginning of 4th c. (Tantillo/Bigi no. 45)	383–388 (Tantillo/Bigi no. 60)		
Tantillo/Bigi nos. 52/26	Statue base	Marble	Beginning of 3rd c.	Beginning of 3rd c.	?	End of 3rd c.–beginning of 4th c. (Tantillo/Bigi no. 52)	364–367	
Unpublished	Statue base	Limestone	Beginning of 3rd c.	Beginning of 3rd c.	3rd c. (dedicated to *Genius* of the *colonia*)			
Tantillo/Bigi no. 19	Statue base	Limestone	Beginning of 3rd c.	Beginning of 3rd c.	Second half/end 3rd c.	First half of 4th c. (Tantillo/Bigi no. 19)		
IRT 454/ Tantillo/Bigi no. 4	Statue base	Limestone	Beginning of 3rd c.	Beginning of 3rd c.	238 (IRT 454)	305–306 (Tantillo/Bigi no. 4)	[?]	
Tantillo/Bigi no. 24	Statue base	Marble	Beginning of 3rd c.	Beginning of 3rd c.	290–294 (Tantillo/Bigi no. 24)			
Tantillo/Bigi no. 2	Statue base	Limestone	Beginning of 3rd c.?	Beginning of 3rd c.?	293–305 (Tantillo/Bigi no. 2)	[?]		
Tantillo/Bigi no. 15	Statue base	Marble	Beginning of 3rd c.?	Beginning of 3rd c.?	?	?	394, 396 or 402 (Tantillo/Bigi no. 15)	Second or third use is in end of 3rd c.
Tantillo/Bigi no. 32	Statue base	Marble	Beginning– first half of 3rd c.	Beginning– first half of 3rd c.	*ca.* 303 (Tantillo/Bigi no. 32)			
Tantillo/Bigi no. 33	Statue base	Marble	Beginning– first half of 3rd c.	Beginning– first half of 3rd c.	324–326 (Tantillo/Bigi no. 33)			
Tantillo/Bigi no. 35	Statue base	Marble	Beginning– first half of 3rd c.	Beginning– first half of 3rd c.	340–350 (Tantillo/Bigi no. 35)			

TABLE 2 Epigraphic reuses. The original dating of the supports is obtained from the formal analysis of the same (*cont.*)

Biblio. Ref.	Support type	Material	Support's date	I Use	II Use	III Use	IV Use	Note
Tantillo/Bigi no. 41	Statue base	Marble	Beginning–first half of 3rd c.	Beginning–first half of 3rd c.	3rd c.?	350–360 (Tantillo/Bigi no. 41)		
Tantillo/Bigi no. 42	Statue base	Marble	Beginning–first half of 3rd c.	Beginning–first half of 3rd c.	378 (Tantillo/Bigi no. 42)			
Tantillo/Bigi no. 65	Statue base	Marble	Beginning–first half of 3rd c.	Beginning–first half of 3rd c.	[?]	4th c. (Tantillo/Bigi no. 65)		
Tantillo/Bigi no. 29	Statue base	Limestone	First half of 3rd c.	First half of 3rd c.?	*ca.* 378 (Tantillo/Bigi no. 29)			
Tantillo/Bigi no. 43	Statue base	Limestone	First half of 3rd c.?	First half of 3rd c.	4th c. (no. 43)			
Tantillo/Bigi no. 18	Statue base	Limestone	Second half of 3rd c.	Second half of 3rd c.	End of 3rd–beginnig of 4th c. (Tantillo/Bigi no. 18)			
Tantillo/Bigi no. 88	Statue base	Limestone	Second half of 3rd c.?	Second half of 3rd c.?	340–400 (Tantillo/Bigi no. 88)			Between the first and second use used as a fountain
Tantillo/Bigi no. 89	Statue base	Limestone	Second half of 3rd c.?	Second half of 3rd c.?	340–400 (Tantillo/Bigi no. 89)			Between the first and second use used as a fountain
Tantillo/Bigi no. 38	Statue base	Marble	Second half of 3rd c.	Second half of 3rd c.	mid-4th c. (Tantillo/Bigi no. 38)			
Tantillo/Bigi no. 14	Statue base	Marble	Second half of 3rd c.	Second half of 3rd c.	[?]	*ca.* 378 (Tantillo/Bigi no. 23)		
Tantillo/Bigi no. 11	Statue base	Marble	3rd c.	3rd c.	367–383 (Tantillo/Bigi no. 11)			
IRT 706	Statue base	Marble	3rd c.	3rd c. (IRT 706)	?			The erased text on reverse should be later
Tantillo/Bigi no. 63	Statue base	Marble	3rd c.	3rd c.	4th c. (no. 63)			
Tantillo/Bigi nos. 55/12	Statue base	Marble	?	Late Constantinian (no. 55)	*ca.* 378 (no. 12)			
Tantillo/Bigi no. 72	Statue base	Marble	?	?	324–326 (no. 72)			
IRT 457/ Tantillo/Bigi no. 7	Equestrian statue base	Limestone	Early Severan	Early Severan	266–267 (IRT 457)	352–354 (Tantillo/Bigi no. 7)		

TABLE 2 Epigraphic reuses. The original dating of the supports is obtained from the formal analysis of the same (*cont.*)

Biblio. Ref.	Support type	Material	Support's date	I Use	II Use	III Use	IV Use	Note
Tantillo/Bigi no. 3	Equestrian statue base	Limestone	Early Severan	Early Severan	3rd c.– before 305–306	305–306 (no. 3)		
Unpublished	Equestrian statue base	Marble	Severan	Severan	Second half of 3rd c. (dedicates to Aradius Rufinus)			
Tantillo/Bigi no. 50	Tetrapylon	Limestone	End of 2nd–beginning of 3rd c.?	2nd–beginning of 3rd c.?	?	Second half of 3rd c. (Tantillo/Bigi no. 50)		
IRT 346/625	Block	Limestone	First half of 1st c.	First half of 1st c. (IRT 625)	82–83 (IRT 346)			
IRT 777/790	Slab	Marble	?	2nd–3rd c. (IRT 777)	3rd c. (IRT 790)			
Tantillo/Bigi no. 79	Slab	Marble	?	?	4th c. (Tantillo/Bigi no. 79)			
IRT 809	Slab	Marble	?	?	3rd–4th c. (IRT 809)			
Tantillo/Bigi no. 44	Slab	Marble	?	?	4th c. (Tantillo/Bigi no. 44)			
IRT 618	Slab	Marble	?	2nd c. (IRT 618)	?			
IRT 671	Slab	Marble	?	?	?			
IRT 386	Slab	Marble	End of 2nd–beginning of 3rd c.	End of 2nd–beginning of 3rd c. (IRT 386)	?			
3 unpublished frags.	Slab	Marble	?	?	?			

b. Uncertain reuse

Biblio. Ref.	Support type	Material	Date of support	I use	II use	III use	IV use	Notes
Tantillo/Bigi no. 5	Statue base	Limestone	2nd–3rd c.?	[?]	307–308 (Tantillo/Bigi no. 5)			
Tantillo/Bigi no. 6	Statue base	Limestone	?	[?]	307–308 (Tantillo/Bigi no. 6)			
Tantillo/Bigi no. 90	Statue base	Limestone	?	[?]	340–400 (Tantillo/Bigi no. 90)			
Tantillo/Bigi no. 21	Statue base	Marble	Severan	[?]	4th c. (Tantillo/Bigi no. 21)			

FIGURE 12 Tantillo/Bigi no. 10, example of a base from whose front at least two inscriptions have been engraved and erased.

FIGURE 13 Original front of the equestrian base then used for Tantillo/Bigi no. 3, where you can see the recess for inserting the marble slab and the four fixing holes.

there is a dedication to T. Fl. Vibianus (Tantillo/Bigi no. 56) had previously been used only once.

The most attested practice instead consists in rewriting on the same face, sometimes even up to three times.[41] In most cases, the intervention is limited to erasing the older text and then writing the new one; however, there are examples of more invasive rearrangements of the epigraphic field, the frame of which can be reduced in thickness or even completely suppressed in order to expand, sometimes greatly, the available writing space[42] (Fig. 12). This practice must evidently be connected with the character of many late honorary dedications, much more verbose than those for which their epigraph supports were originally created.

If, following the elimination of several inscriptions from the same face, the epigraphic field was too low to allow easy preparation of the surface, the new text could be engraved on a separate support, which was then affixed to the body of the base. Judging by the thickness of the surviving recess, a metal plate had been affixed on the tetrapylon-shaped monument later rededicated to Porfyrius (Tantillo/Bigi no. 50, Fig. 10.57; pl. XVII) and, perhaps, on the left side of a base in honour of Constantius I (Tantillo/Bigi no. 2; pl. IV).[43] The original front of the equestrian base later dedicated to

41 Three unpublished dedications to Gallienus, Q. Aradius Rufinus, and the Genius of the colonia are engraved above a previous text. IRT 542 and Tantillo/Bigi nos. 8; 11; 14; 18; 24; 25; 28; 29; 32; 33; 35; 38; 42; 43; 58; 59; 63; 66; 72; 82 (on a still partially legible dedication to Caracalla); 88; 89; uncertain are the cases of nos. 5; 6; 21 and 90. Above two texts are engraved Tantillo/Bigi nos. 9; 19; 30 (this effaces no. 66, in turn on another inscription); no. 50 (on a tetrapylon-shaped monument) and perhaps also nos. 10; 23; 65. This list contains only the inscriptions engraved on bases used only on the same face; the texts engraved above previous texts on bases also used on other sides are listed in n. 45.

42 The frame of the epigraphic field has been eliminated in Tantillo/Bigi nos. 9; 10; 26; 30; 35; 40; and only resized in the case of Tantillo/Bigi nos. 19; 23; 38.

43 This expedient could be used even if the grain of the stone was not compact enough to be inscribed: see Tantillo/Bigi no. 67 and Bigi (2010) 227–28.

Constantius and Galerius (Tantillo/Bigi no. 3; Fig. 13), the base Tantillo/Bigi no. 65 (pl. XIX), perhaps Tantillo/Bigi no. 19 (pl. VII) and the left side of Tantillo/Bigi no. 4 (pl. IV) must instead have housed a marble slab.

A third possibility consisted in exploiting, in addition to the front face, the other two visible finished sides of the base. There are three stones that have only two texts carved on as many faces: that is to say the first inscription, erased, arranged on the front and the second on a side.[44] Small as it is, this sample nevertheless turns out to be highly significant: it suggests that the original inscription was not subjected to erasure only if another was to be engraved over it, but was rather obliterated at the moment when another face received a new text and the entire monument was thus dedicated to a different honorand. Except for one case,[45] in practice, there are no inscriptions wholly preserved on two contiguous sides: a base of the Macellum bears part of the original text (IRT 630; Tantillo/Bigi pl. XXIV), but care was taken to eliminate the name of the first honorand.

These three examples also seem to constitute, together with a base dedicated to Fl. Nepotianus (Tantillo/Bigi no. 41), an intermediate stage in a more articulated process of reuse. That is, they could represent the antecedent stage of those bases which show a text on one or both sides and two overlapped texts on the front. In fact, the principle that we have explained for supports with only two inscriptions proves to be valid in the majority of cases of bases that had three or four uses: at the time of carving the third inscription, the second was erased even if this did not occupy the space destined to the new dedication. Exemplary in this regard is the case of the base lastly dedicated to Fl. Nepotianus: the front was erased when the left side was used, which in turn was erased at the time of its last use, i.e. that of the dedication for the *praes* (Tantillo/Bigi no. 41; pl. XIV). If it had been decided to use the stone a fourth time, the eulogy of Nepotianus would have been removed and, in all likelihood, a new inscription would have been engraved on the front.

In fact, the analysis of the bases that have a text on one or two sides and two texts on the front[46] reveals a particularly significant aspect: it is only after having used the sides that one returns to writing on the front, meaning that it is nearly always the latest inscription to be engraved above the earliest one. Thus, a dedication to Honorius (Tantillo/Bigi no. 15) is engraved over the original one on the front side of a base that had previously housed two other texts on the sides. Likewise, an inscription for Theodosius (Tantillo/Bigi no. 13) was added to another with two inscriptions carved on either side[47] (Tantillo/Bigi nos. 22 and 36). This last example is particularly instructive because it provides a certain chronological sequence of the various re-uses, a sequence which elsewhere can only be inferred. The only two exceptions to this practice are represented by a dedication in honour of L. Aemilius Quintus (Tantillo/Bigi no. 60) and by another for the Emperor Fla. Valerius Severus (Tantillo/Bigi no. 4). A confirmation of what has been said also seems to come from the fact that we never find two superimposed inscriptions on both front and side.

A final consideration on this form of reuse concerns the acts of erasure and rewriting. The obliteration of the initial text was carried out with a flat chisel, with a point chisel or with a claw chisel on the letters of the text that one wanted to remove. It is necessary to underline that, through appropriate processing, marble could guarantee a perfectly polished writing surface even after the erasure of several texts. However, this prerogative seems to have been fully exploited only once (Tantillo/Bigi no. 54, Fig. 10.61), whilst, on the rest of the bases examined, the intervention remains always visible, testified to by an uneven epigraphic field, scratches, and several remainders of the letters belonging to the previous inscription. Not concealing[48] the traces of previous erased texts poses not only the problem of the legibility of the new inscription but also that of the attitude of the ancient spectator to such obvious reuse. The colouring of letters in red could partially remedy these problems,[49] but they could not have solved them completely.

We have therefore outlined, schematically, three ways of using the same support to engrave new texts. Since we are dealing with supports for statues, it is necessary to compare what we have identified so far with the data at our disposal regarding statuary. A fundamental premise for this operation is that the documentation relating to the statues is highly incomplete. It being impossible to connect the statues to their bases, we must address

44 Tantillo/Bigi nos. 31, 56, 57 on the side of IRT 630.
45 The base on which Tantillo/Bigi nos. 13, 22 and 36, discussed later. This does not apply to the equestrian bases already mentioned which, when they were reused to house groups of statues, underwent a substantial change in orientation.
46 Inscriptions engraved on the front face of a base, above a previous text: Tantillo/Bigi nos. 2, 13, 15, 37, 45, and 54. Inscriptions engraved on the front above two previous texts: IRT 454 and Tantillo/Bigi no. 30; for the texts on the sides of each base, see the individual catalogue entries in Tantillo and Bigi (2010) for more detail.
47 The same also applies to Tantillo/Bigi nos. 2, 37, 30, 54.
48 The fact that the marble surface bears the new incision excludes the presence of a mimetic plastering, which can only be hypothesised for surfaces not affected by further writing.
49 Especially in the case of the limestone bases, reading is made very difficult by the overlapping of the strokes of the letters with the marks left by the tools.

the question indirectly, exploiting the rare explanations on the nature of the image present in the text and analysing the fastening traces visible on the upper surfaces of the bases. However, it should be noted that the latter tool is not always effective. Not only because of the difficulty of interpreting the surviving traces,[50] but also because in bases characterised by a complex sequence of reuse, it is not easy to establish which of the different effigies should be connected to these traces. For example, when faced with the presence of clamp holes for bronze statues, we can only limit ourselves to noting that such stone was used at least once to support a metal statue. Furthermore, the examination of other evidence reveals that these indications are sometimes misleading: the cuttings visible on Tantillo/Bigi no. 32 (pl. XI), dedicated to the governor C. Valerius Vibianus, would suggest a bronze statue, but archival photos record a marble toga statue.[51] This same statue is among the very few published: connected to it is a reworked portrait head, whose physiognomy has been assigned to the late 3rd c.,[52] a dating compatible with that of the career of the governor. It is important to underline that if the base-statue assemblage really did correspond to the conditions of the find and, not to an arbitrary arrangement of the excavators, the monument dedicated to Vibianus would be the only one whose original, integral composition can be restored.

Of the bases with inscriptions overlapped on the front face alone, 11 have an upper surface still in good condition.[53] Seven of these show traces that the statue was not replaced,[54] which in only two cases seems to have been in bronze (Tantillo/Bigi nos. 18 and 24; pl. VIII); the only base with two sets of cuttings, and thus two different statuary groups, is the equestrian base lastly dedicated to Aradius Rufinus (Tantillo/Bigi pl. XXVIII). From this data, we could assume that the reuse of the same face was often consequential to the possibility of keeping the statue above unchanged. Applying this principle to the rest of the material, we could infer that at least most of the bases re-inscribed on the front side supported the same image, which could be adapted by replacing the head (Fig. 14), by modifying the features of the existing head,[55] or through other media.[56] Recarving portraits is a well-known feature, amply attested by a number of specimens that far exceeds that of the statues produced *ex novo* in Late Antiquity. Given the large number of bases that fall into this group, the Lepcis data, therefore, appears fully in line with what happened in the rest of the Roman world.

The material with which the statue was made and the possibility of using it again could be decisive when a base was rededicated to an office holder. In fact, if it is true, as is generally maintained,[57] that in the 4th c. marble statues were the only ones office holders could aspire to (the honour of a bronze statue was instead subordinated to the granting of an imperial dispensation), we should imagine a preference in reusing bases that already bore a marble image. Conversely, we should suppose the replacement of the statue when the dedication is carved onto a base that bears the fixings for a metal statue.

In the case of the dedications to the office holders of Tantillo/Bigi nos. 32, 33, 37 and perhaps Tantillo/Bigi no. 38, it would seem that the marble statue already present on each base was re-purposed for a new use.[58] The substitution of a statue can be recognised in the traces visible on the upper surface of the base dedicated to the *vicarius* Elpidius (Tantillo/Bigi no. 28; pl. IX), while, in the case of those bases which show exclusively cuttings for bronze statues, this substitution can only be supposed and no trace of it is preserved.[59] Also in this respect, the already-mentioned base in honour of Nepotianus (Tantillo/Bigi no. 41; pl. XIV) proves to be

50 For the recognising cuttings related to metal statues, see Willer (1996).
51 The statue placed above the base features prominently in CDRAAS 37/3; see also fig. 15.
52 Bianchi (2005) no. 6, 278–79; 297–98; figs. 13–16: the body is an early 2nd c. togate, while the features of the face recall the iconography of Diocletian or Probus.
53 Tantillo/Bigi nos. 8, 14, 32, 38, 58.
54 For prudence, we have excluded: Tantillo/Bigi base no. 33, which was resized and on which the traces refer only to the second use; base Tantillo/Bigi no. 28, which bears dubious traces, attributable to either a single statue or two; pedestal Tantillo/Bigi no. 65, which seems to have supported a single bronze effigy, and yet has a series of other holes which in principle refer to a second statue.

55 Blanck (1969) 19: it is the procedure that Cass. Dio 59, 28 calls *metarrhythmizein*. For some reworked portraits from Lepcis, see Bianchi (2005) esp. 297 fol., who points how even in Lepcis the heads with traces of successive adjustments numerically prevail over those produced *ex novo*. For the loricate statue of the Antonine age, with a readjusted head (here Fig. 14), see Bianchi (2005) 295 with n. 35 (with prev. bib.) and 299; Bergmann (1977) 154–56; pl. 46.5 who attributes the statue to a Constantinian prince.
56 On a base by Aquinum, dedicated to a late patron, and which reuses the support of a monument dedicated to an older *patronus*, we read of a 'statua perpetuabilis cum pictura similitudinis eius' – ' a permanent statue with a picture of his likeness' (CIL 10.5426); the language suggests that *statua* and *pictura* are not different objects (a statue and a painted effigy), but a statue in which the physiognomic features of the honorand were rendered with colour; it is likely that the statue of the first patron had simply been updated with painted stucco.
57 On the basis of Feissel (1984) 548–50.
58 It is difficult to interpretate the traces visible on the upper surface of the base dedicated to the *comes* Ortygius (Tantillo/Bigi no. 31), on that of Archontius Nilus (Tantillo/Bigi no. 39) and on that used for Tantillo/Bigi nos. 27 and 40.
59 See Tantillo/Bigi nos. 24, 34, 41, 43, and 45.

FIGURE 14 Tripoli, Museum, from the Severan Forum of Lepcis Magna. Example of readjustment of an imperial statue.

a particularly instructive example. Although it has been used three times, the only cuttings which remain on the upper surface are those relating to a bronze statue aligned with the front side, and thus related to the first dedication. We could deduce that the bronze statue had already been replaced with a marble one at the time of its first reuse, but we cannot know if the marble image explicitly mentioned in the dedication to Nepotianus was the same statue recycled, or a new one. In any case, it is important to note that the bronze statue and the marble example were both accompanied by the epigraphic use of at least two different sides of the base.

Without jumping to conclusions on the basis of this example, one could suppose that the decision to engrave a new text on one side of the base was linked to the difficulty of modifying the statue: normally, if one could remove the statue, one could turn the base or at least change the orientation of the composition, engraving the new text on a blank face of the support. Few are the bases that still have the upper surface allowing us to verify the validity or otherwise of this hypothesis. Three bases,[60] curiously all in limestone, bear numerous cuttings which, although not always easily interpreted, testify to a succession of statues, perhaps metallic. Four other stones have cuttings which instead seem to refer to a single image: bronze in the case of Tantillo/Bigi nos. 45 and 60 (pl. XVI) and marble in that of Tantillo/Bigi no. 37 and 56 (pls. XII; XVIII). We will notice that, judging from the archive records, a marble togate statue seems to have been found next to this last base (Fig. 15). It is conceivable that carving the inscription on one of the lateral sides went together with rotating the state above. However, we should not exclude the possibility, however strange this may seem, that a new text was engraved on the side of a base that retained its statue turned towards the front. The use of such a solution cannot be ruled out, for example in the case of Tantillo/Bigi no. 60.

Unfortunately, the upper surface of the base which held, in addition to the original text, three other engraved dedications (Tantillo/Bigi nos. 13, 22, 36), is not preserved. Here, each new titulus would theoretically have involved the alternation of three different statues: a toga for the proconsul, a chlamydate for the *praeses* and some other effigy for the emperor.[61] Even if it is legitimate to doubt that the entire image was replaced each time, it is extremely probable that each of the reuses involved at least some consistent adaptations to the details of the garments and the face, which, in any case, would have made the disassembly of the statue from the pedestal necessary.

Even the arrangement of the statues on bases with two used sides does not seem to follow a coherent and unambiguous logic. Only three still retain the upper surface: in one case, this has a single hole apparently related to a marble statue (Tantillo/Bigi no. 27 on the back of no. 40; pl. IX), in another, a pair of cuttings related to a bronze statue facing the front side of the base (Tantillo/Bigi Tantillo/Bigi no. 34 on the back of IRT 518; pl. XI). Only the stone that housed a dedication to Volusius Bassus Caerealis (Tantillo/Bigi no. 46),

60 Those engraved with dedications: Tantillo/Bigi no. 2 (pl. IV); no. 31 (pl. X); IRT 454 and no. 4 (pl. IV), the latter on the same stone.

61 On the problem, Smith (1999) 176–78.

FIGURE 15 Severan Forum, view of the north-western side at the time of the excavation. In the foreground the base of n. 56 and, in the background, that of Tantillo/Bigi no. 32, both flanked by a statue in a toga (CDRAAS 36/61).

engraved on the opposite side of that to the *Genius* of the *colonia* (Tantillo/Bigi no. 84), shows traces of two different images (Tantillo/Bigi pl. XXII); but here, it could not be otherwise, given the incompatibility of the two iconographic types.

In conclusion, the reasons why sometimes a base is re-inscribed over and over on the same face, ignoring the other sides equally furnished with an elegant frame, while other secondary sides of the base were used even if these were devoid of any ornament, seem to lie in a general evaluation of the monument which was to be reused, in which the form of the base could play a primary or secondary role with respect to the statue it supported.

Inscriptions as 'Defunctionalised' Spolia

Sporadic examples of inscriptions reused as building material can be found as early as the 5th c. BC[62] but it is not until Late Antiquity that the large-scale diffusion of this practice can be seen. This is not the place to deal with a detailed analysis of this category of evidence; however, it must be emphasised how few studies are still specifically devoted to epigraphic *spolia*,[63] compared with a vast literature on the reuse of figurative art or architectural elements.[64] This most likely derives from the fact that the reuse of inscriptions lends itself much less well than the reuse of decorative elements to being investigated from a perspective that seeks to identify 'meanings' in the use of *spolia* and, more generally, the ideological implications of reuse in Late Antiquity. Furthermore, except in exceptional cases, for the reuse of an inscription to be associated with certain meanings, it is necessary that between the original era of the stone and that of its reuse, there is a chronological gap, so to give the inscribed testimony a new value, perhaps as a reference to an *aura aetas*.[65] Such a gap does not exist at Lepcis. Here, most of the late antique examples are acts that reduce the inscribed stones to mere building material, devoid of any aesthetic or ideological value.[66] These are real *spolia* in the Renaissance sense of the term.[67] But this does not mean that the reused stones of Lepcis are meaningless evidence for us. On the contrary, the analysis of the genres of texts and of the types of supports sacrificed in Lepcis during the 3rd and 4th c. proves to be a valuable tool for understanding the multiple reasons that governed the practice of reuse (Table 3).

62 See the discussion on the oldest examples of the reuse of inscribed stones recorded in Coates-Stephens (2002).
63 The only works devoted solely to epigraphic *spolia* are those by Coates-Stephens (2002) and (2003).
64 For the extensive bibliography on the subject, see Kinney (1997) esp. 122–29 and Pensabene and Panella (1993–1994).
65 See the cases cited by Coates-Stephens (2002) 282–83 and 291.
66 Coates-Stephens (2002) 283 and 287 underlines how, alongside the cases of reused inscriptions with a particular meaning, there are many others in which the stones "were selected and laid in position [...] with no particular thought to their content or significance. In short, no conceptual consideration seems to have been made of the inscriptions' content or significance in either their original, nor their new, context".
67 That is, 'decontextualised' remains of ancient buildings and monuments; for the history of the term *spolia*, see Alchermes (1994) 167–68 and Kinney (1997) 119–20.

TABLE 3 Defunctionalising reuses of inscriptions.

Biblio. Ref.	Type of support	Original dating of support	Reused as	Date of reuse
IRT 628	Marble statue base	2nd c.	Base for ideal sculpture, *frigidarium* of Hadrianic Baths	3rd or 4th c.
IRT 629	Marble statue base	2nd c.	Base for ideal sculpture, *frigidarium* of Hadrianic Baths	3rd or 4th c.
Unpublished. Tantillo/Bigi base with lost text no. 5	Marble statue base	After 216	Base for ideal sculpture, *frigidarium* of Hadrianic Baths	3rd or 4th c.
Unpublished. Tantillo/Bigi base with lost text no. 6	Marble statue base	Beginning–first half of 3rd c.	Base for ideal sculpture, *frigidarium* of Hadrianic Baths	3rd or 4th c.
Unpublished. Tantillo/Bigi base with lost text no. 7	Limestone statue base	First half of 3rd c.?	Base for ideal sculpture, *frigidarium* of Hadrianic Baths	3rd or 4th c.
Unpublished. Tantillo/Bigi base with lost text no. 8	Limestone statue base	First half of 3rd c.?	Base for ideal sculpture, *frigidarium* of Hadrianic Baths	3rd or 4th c.
IRT 288	Marble statue-altar base	2nd c.	Base for ideal sculpture, palaestra of Hadrianic Baths	3rd or 4th c.
IRT 297	Marble statue-altar base	2nd c.	Base for ideal sculpture, palaestra of Hadrianic Baths	3rd or 4th c.
Tantillo/Bigi no. 88	Limestone statue base	*ca.* 250–300	Fountain and then as (inscribed) base for ideal sculpture	? and in 340–400
Tantillo/Bigi no. 89	Limestone statue base	*ca.* 250–300	Fountain and then as (inscribed) base for ideal sculpture	? and in 340–400
Unpublished. Tantillo/Bigi base with lost text no. 1	Marble statue base	Severan	Pier of the SE tetrapylon in the Macellum	3rd or 4th c.
Unpublished. Tantillo/Bigi base with lost text no. 2	Marble statue base	Second half / end of 3rd c.	Pier of the SE tetrapylon in the Macellum	3rd or 4th c.
Unpublished. Tantillo/Bigi base with lost text no. 3	Marble statue base	Severan	Pier of the SE tetrapylon in the Macellum	3rd or 4th c.
Unpublished. Tantillo/Bigi base with lost text no. 4	Limestone statue base	3rd c.?	Pier of the SW tetrapylon in the Macellum	3rd or 4th c.
IRT 545	Limestone blocks	After 139	Building material: ashlars in a vault of the Hadrianic Baths	2nd–4th c.
IRT 286	Marble slab	179–184	Building material: paving of the Hadrianic Baths	3rd or 4th c.
Tantillo/Bigi no. 70	Marble slab	305–306	Building material: coating in the Hadrianic Baths	4th c.
IRT 726	Limestone block	1st–2nd c. (palaeography)	Probably building material: ashlar in the west side of the theatre	End of 3rd or 4th c.
IRT 643	Limestone block	2nd c. (palaeography)	Probably building material: ashlar in the west side of the theatre	End of 3rd or 4th c.

TABLE 3 Defunctionalising reuses of inscriptions (*cont.*)

Biblio. Ref.	Type of support	Original dating of support	Reused as	Date of reuse
IRT 613	Limestone block	2nd–3rd c. (palaeography)	Probably building material: ashlar in the west side of the theatre	End o 3rd or 4th c.
IRT 594	Limestone block	2nd–3rd c. (palaeography)	Probably building material: ashlar in the west side of the theatre	End of 3rd or 4th c.
IRT 270	Limestone statue base	2nd–3rd c. (palaeography)	Probably building material: ashlar in the west side of the theatre	End of 3rd or 4th c.
IRT 276	Limestone statue base	2nd–3rd c. (palaeography)	Probably building material: ashlar in the west side of the theatre	End of 3rd or 4th c.
IRT 277	Limestone statue base	2nd–3rd c. (palaeography)	Probably building material: ashlar in the west side of the theatre	End of 3rd or 4th c.
IRT 459	Limestone statue base	260–268	Probably building material: ashlar in the west side of the theatre	End of 3rd or 4th c.
IRT 358 (a)	Limestone statue base	120	Probably building material: ashlar in the west side of the theatre	End of 3rd or 4th c.
IRT 358 (b)	Limestone statue base	120	Probably building material: ashlar in the west side of the theatre	End of 3rd or 4th c.
Unpublished	Limestone blocks with monumental inscriptions	1st–2nd c.	Building material: ashlars in room A of Late Baths	End of 3rd or 4th c.
IRT 298	Limestone statue base	2nd–3rd c. (palaeography)	Building material: ashlar in room A of Late Baths	End of 3rd or 4th c.
Unpublished. Dedicated to Divus Severus	Limestone statue base	2nd–3rd c.	Building material: ashlar in pilasters of room C of Late Baths	End of 3rd or 4th c.
Unpublished. Dedicated to Caracalla	Limestone statue base	2nd–3rd c.	Building material: ashlar in pilasters of room C of Late Baths	End of 3rd or 4th c.
Unpublished	Limestone statue base	2nd–3rd c.	Building material: ashlar in pilasters of room C of Late Baths	End of 3rd or 4th c.
Unpublished	Limestone statue base	2nd–3rd c.	Building material: ashlar in pilasters of room C of Late Baths	End of 3rd or 4th c.
Unpublished	Limestone statue base	2nd–3rd c.	Building material: ashlar in pilasters of room C of Late Baths	End of 3rd or 4th c.
Unpublished	Limestone statue base	2nd–3rd c.	Building material: ashlar in pilasters of room C of Late Baths	End of 3rd or 4th c.
Unpublished	Limestone statue base	2nd–3rd c.	Building material: ashlar in pilasters of room C of Late Baths	End of 3rd or 4th c.
Unpublished	Limestone statue base	2nd–3rd c.	Building material: ashlar in pilasters of room C of Late Baths	End of 3rd or 4th c.
Unpublished	Limestone statue base	2nd–3rd c.	Building material: ashlar in pilasters of room C of Late Baths	
Unpublished	Limestone statue base	2nd–3rd c.	Building material: ashlar in pilasters of room C of Late Baths	End of 3rd or 4th c.
Unpublished	Limestone statue base	2nd–3rd c.	Building material: ashlar in pilasters of room C of Late Baths	End of 3rd or 4th c.
Unpublished	Limestone statue base	2nd–3rd c.	Building material: ashlar in pilasters of room C of Late Baths	End of 3rd or 4th c.

TABLE 3 Defunctionalising reuses of inscriptions (*cont.*)

Biblio. Ref.	Type of support	Original dating of support	Reused as	Date of reuse
Unpublished. Dedicated to *Genius* of the *colonia*	Limestone statue base	2nd–3rd c.	Undefined building material in Late Baths	End of 3rd or 4th c.
AE (1959) 271	Limestone statue base	267–268	Undefined building material in Late Baths	End of 3rd or 4th c.
Unpublished, Dedicated to Q. Roscius Aradius	Marble equestrian base	3rd c.	Building material: corbel in the *frigidarium* of Late Baths	End of 3rd or 4th c.
Unpublished. Dedicated to C. and L. Cesari	Limestone statue base	Before the 2nd c.	Building material: pedestal in the *frigidarium* of Late Baths	End of 3rd or 4th c.
IRT 692	Limestone blocks	2nd–3rd c.	Building material: ashlar in Late Roman walls	End of 3rd or 4th c.
IRT 343	Limestone blocks	69–98	Building material: ashlar in late walls of Oea Gate	End of 3rd or 4th c.
IRT 482	Limestone blocks	15–16	Building material: ashlar in late walls of Oea Gate	End of 3rd or 4th c.
IRT 332	Limestone blocks	31	Building material: paving of Macellum	324–326
IRT 344	Limestone blocks	72–81?	Building material: balustrades of Curia	2nd–4th c.
IRT 814	Limestone block	1st–2nd c.	Building material: moulded element perhaps in Curia	2nd–4th c.
Unpublished. Dedicated to Flavia Pia	Limestone equestrian base?	2nd c.	Building material: ashlar in the enclosure of the Temple of Magna Mater	4th c.? Late antique
IRT 719	Marble stele	2nd–3rd c.?	Building material: indefinite in Vila del Nilo	4th c.? Late antique
IRT 436	Limestone statue base	198–212	Building material: corbel in *Porticus post scaenam*	4th c.? Late antique
IRT 604	Limestone block	1st–2nd c.	Building material: moulded element	2nd–4th c.
IRT 433	Limestone statue base	199–200	Building material: ashlar in North Temple	4th–6th c.
IRT 435	Limestone statue base	198–212	Building material: ashlar in North Temple	4th–6th c.
IRT 437	Limestone statue base	198–212	Building material: ashlar in North Temple	4th–6th c.
IRT 438	Limestone statue base	198–212	Building material: ashlar in North Temple	4th–6th c.
IRT 439	Limestone statue base	198–212	Building material: ashlar in North Temple	4th–6th c.
IRT 440	Limestone statue base	198–212	Building material: ashlar in North Temple	4th–6th c.
IRT 443	Limestone statue base	209	Building material: ashlar in North Temple	4th–6th c.
IRT 444	Limestone statue base	209	Building material: ashlar in North Temple	4th–6th c.

TABLE 3 Defunctionalising reuses of inscriptions (*cont.*)

Biblio. Ref.	Type of support	Original dating of support	Reused as	Date of reuse
IRT 592	Limestone statue base	2nd–3rd c.	Building material: ashlar in wall North of *Porticus post scaenam*	?
IRT 534	Marble architrave blocks	157	Building material: stairs in *cavea* of the theatre	?
IRT 323	Limestone architrave	AD 1–2	Building material in the portico behind the Calcidico	?
IRT 685	Limestone block	1st–2nd c.	Building material: ashlar in a house (R.V. *ins.* 2)	?
IRT 717	Marble block	2nd–3rd c.	Building material: ashlar in a *taberna*	?
IRT 649	Limestone statue base	2nd–3rd c.	Building material: ashlar in an infill of an entrance of palaestra of Hadrianic Baths	?
IRT 775	Limestone block	2nd c.	Building material: ashlar in an infill of an entrance of palaestra of Hadrianic Baths	?
IRT 441	Marble slab	209	Indefinite building material	?
IRT 516	Limestone block	1st c.	Building material: threshold in the pier east of Porto	?
IRT 720	Block?	1st–3rd c.	Building material: ashlar "hors de la ville ... dans une muraille"	?
IRT 342	Limestone block	77–78	Building material: ashlar in the Byzantine Gate	6th c.
IRT 350	Limestone blocks	81–96?	Building material: ashlar in the Byzantine Gate	6th c.
IRT 587	Limestone statue base	2nd–3rd c.	Building material: ashlar in the Byzantine Gate	6th c.
IRT 593	Limestone statue base	3rd c.	Building material: ashlar in the Byzantine Gate	6th c.
IRT 488	Limestone block	1st–2nd c.	Building material: ashlar in the Byzantine walls	6th c.
IRT 489	Limestone block	1st–2nd c.	Building material: ashlar in the Byzantine walls	6th c.
IRT 612	Limestone block	1st–3rd c.	Building material: ashlar in the Byzantine walls	6th c.
IRT 770	Limestone block	1st–3rd c.	Building material: ashlar in the Byzantine walls	6th c.
Tantillo/Bigi no. 90	Limestone statue base	340–400	Building material: ashlar in one of the towers of the Byzantine walls	6th c.
IRT 642	Limestone statue base	3rd c.	Building material: ashlar in the Byzantine walls	6th c.
IRT 819	Limestone block	Beginning of 2nd c.??	Building material: ashlar in one of the towers perhaps of the Byzantine walls	End of 3rd–4th c. or 6th c.
IRT 825	Limestone block	?	Building material: ashlar in one of the towers perhaps of the Byzantine walls	End of 3rd–4th c. or 6th c.

TABLE 3 Defunctionalising reuses of inscriptions (*cont.*)

Biblio. Ref.	Type of support	Original dating of support	Reused as	Date of reuse
IRT 365	Limestone block	98–138	Building material: ashlar in the church at the Old Forum	5th–6th c.
IRT 553	Limestone block	1st–2nd c.	Building material: ashlar in the church at the Old Forum	5th–6th c.
Tantillo/Bigi no. 39	Marble statue base	355–361	Building material in the church at the Old Forum	5th–6th c.
IRT 698	Marble architrave block	2nd–3rd c.	Building material: paving in the church at the Old Forum	5th–6th c.
Tantillo/Bigi no. 71	Marble statue base	324–326	Building material: ambo in the church at the Old Forum	6th c.
IRT 401	Limestone statue base	After 211	Building material: ashlar in the baptistery at the Old Forum	6th c.
IRT 400	Marble statue base	216	Building material: stair of the south apse of the Severan Basilica	6th c.
IRT 429	Marble statue base	216	Building material: stair of the south apse of the Severan Basilica	6th c.
Tantillo/Bigi no. 63	Marble statue base	mid-4th c.	Building material: stair of the south apse of the Severan Basilica	6th c.

As regards the forms of this kind of reuse in Lepcis, it must be noted that, since we are dealing with supports born to host a text, their reuse never takes the form of direct reinstallation,[68] but always involves some kind of metamorphosis of the original appearance. In the case of monolithic bases transformed into supports for ideal sculpture or tetrapylon-shaped monuments, minimal reworkings, such as the erasure of the text, may suffice. On the contrary, when the inscription becomes building material, it always undergoes a resizing, which can go from the simple elimination of the moulded elements up to the mutilation of large portions, passing through the dismemberment of the sequence, in the case of a monumental inscription engraved on several blocks.

Another aspect to note is that inscriptions inserted into walls with the inscribed face facing outwards, never see the complete obliteration of the text. However, these writings were not meant to be seen. In at least two known cases – but we can assume that the practice was more widespread – we have the certainty that the structure built by assembling recycled materials was covered with a suitable coating,[69] which masked differences in the materials and the presence of old inscribed texts.[70]

In principle, the erasure of the inscription should instead have been a fundamental requirement when transforming statue bases into supports of another type, given that the presence of the older honorary inscription under the statue of a deity or on a pier of a tetrapylon dedicated to a new honorand would have constituted not only an absurd inconsistency but also a disturbance in the reading of the monument by the ancient viewer. However, there are examples of bases transformed into pedestals for ideal sculpture from which the original text has been subjected to only partial or rather summary erasure, so that much of its content is still decipherable. Should we consider these cases as exceptional, or should we assume that the texts were always obliterated by applying a layer of stucco? Unfortunately for this class of artefacts, the question seems to be destined to remain unresolved.

68 See the appropriate distinction of "multiple forms of recycling, ranging from metamorphosis or consumption to intact reinstallation" made by Kinney (1997) 122.

69 As can be seen in room C of the Late Baths and in the western dressing room of the theatre.

70 A particular case is constituted by the dedicatory inscription of the Temple of Ceres *in summa cavea*, obliterated by a mosaic decoration, perhaps in the 4th c. (Di Vita (1990) 137).

Honorific Bases Used as Supports for Ideal Sculpture

Not infrequently, both monolithic and tripartite inscribed bases are found used as supports for ideal statues, without them undergoing traumatic modifications, but with the sole erasure of the text. This is the kind of reuse that least distorts the epigraphic support: the base of a statue continues to be a base of a statue, and from an aesthetic point of view the monument formed by the whole support-sculpture remained unchanged. However, a substantial change occurs at the semantic level: one thing is an ideal sculpture placed above an un-inscribed base, whose function is to contribute to the ornament of the city or of one of its buildings, another thing is an honorific portrait statue, which has a strong political significance. Therefore, precisely because of this shift in meaning, but above all because of the inevitable obliteration of the text for which the base was originally created, it is also necessary to label this reuse as a 'defunctionalising' one.

Judging by the surviving evidence, a constant feature seems to be the presence of selective criteria that govern the choice of one particular stone over another. In the first place, the bases reused as supports for ideal sculpture bear the traces of the elimination of only one text; that is, there are no cases of supports for ideal sculpture inscribed on several faces or several times on the same face. This is undoubtedly connected with the fact that the choice of bases with minimal epigraphic life would have guaranteed a more aesthetically satisfying result.[71] But the aesthetic criterion seems to be expressed above all, in the preference given to twin supports and those that looked homogeneous, according to a logic that did not spare even a pair of decorative altar-bases dedicated to the Polyad divinities (IRT 288 and 297). This demonstrates, together with the breadth and coherence of the interventions for which the bases were destined, that these interventions were not due to private initiative, but were planned by the authorities who could dispose of the city's statutory heritage, within the framework of the reorganization of a particular building or part of it.

The reuse of four, or perhaps six, statue bases transported to the *frigidarium* of the Hadrianic Baths[72] (Fig. 16) testifies to similar and substantial rearrangement work. On each of the long sides of the room, in correspondence with the gigantic columns, two moulded monolithic bases carved in Proconnesian marble were placed.[73] The pair set on the southern side of the room consists of two twin bases (IRT 628 and 629), originally part of a cycle formed by four honorific monuments dedicated by a local aristocratic lady to her family members in the Antonine Age.[74] The texts engraved on the front of these two supports were subjected to a superficial erasure, unlike those carved on the two stones of the opposite northern side, which were completely obliterated. Among the bases on the latter side, which are not identical but similar in size, the eastern one belongs to the group of architectural pedestals created for the Severan complexes but never put into place and, therefore, used as epigraphic supports (Tantillo/Bigi base with lost text no. 5, Fig. 6; pl. XXVI).[75] The other base, perhaps also previously used as a fountain, is distinguished by the anomalous appearance of the surface of the epigraphic frame, the roughness of which could be the result of the decay of a stucco coating, or a deterioration following an erasure process (Tantillo/Bigi base with lost text no. 6, pl. XXVI 26). On the other hand, it is not clear if the pair of bases[76] located on the short western side of the room, opposite the large masonry pedestals placed on the sides of the access to the basins, served as a support for statues, perhaps of smaller dimensions.[77]

Overall, the placement of these bases appears to be the result of a coherent arrangement, one which takes into account the architectural articulation of the room resulting from the great refurbishments of the age of Commodus. In this arrangement, a precise aesthetic purpose is clearly revealed, which is expressed in placing the twin or similar supports along the same side. Although there are no elements that allow the rearrangement of the frigidarium to be placed in a well-defined chronological horizon, the presence of the base of the

71 An active selection of similar bases might also mean – but it is difficult to ascertain – that, at the time of selection, the number of stones with a single epigraphic use was far greater than those with multiple uses, suggesting a generic element of chronology for the reuse.

72 It is not possible to connect the supports to the relative statues, since, of the more than 40 sculptures unearthed in the complex, only very few provide indications about their exact findspot.

73 Bartoccini (1929) 93; figs. 45–48 considered them only honorific bases.

74 The cycle is discussed in Bigi (2010) 242–42; see also Tantillo/Bigi nos. 9, 57.

75 Base of the 'small nymphaeum' type, discussed above 'Statue Bases Made from Architectural Pedestals' and below 'Statue Bases Used as Fountains'. Despite the thoroughness with which the text was erased, its spread over 10 lines can still be identified.

76 Tantillo/Bigi bases with lost text, nos. 7–8: in both of these tripartite types, only the central body is preserved, decorated with a simple cyma framing; see also Bartoccini (1929) fig. 85.

77 On the short sides, the statues were certainly placed on the four large masonry pedestals (as confirmed by the discovery of a statue of Asclepius *in situ*: Bartoccini (1929) 48; figs. 47; 55), but since the two bases do not seem to have been reused as building material, it is conceivable that they served in some way as a complementary support.

FIGURE 16 Plan of the frigidarium of the Hadrianic Baths with the location of the statue bases transformed into ideal sculpture supports. The question mark indicates erased text.

'small nymphaeum' type accompanied by an erased inscription, nonetheless, provides a *terminus post quem* for the intervention itself.[78] Since it is surplus piece from a Severan construction site, the base cannot be dated before around 210. Furthermore, at least one generation must have elapsed between its use as an epigraphic support and its use in the Baths (see below 'The Amount of Reuse and the 'Mortality Rate' of Enrolments' and 'Conclusions: The Reuse and Transformation of the Monumental Landscape of the City'). Therefore, it seems plausible to imagine that the reorganization of the room took place no earlier than the 240s or 250s.

A further but more limited relocation of the statuary furniture seems to have also affected the gymnasium of the same complex.[79] Here, at each end of the long southern side, a Pentelic statue base is preserved. Once again, we are dealing with a pair of twin bases – or altars[80] – which originally housed a dedication to Liber Pater (IRT 297) and one to Hercules (IRT 288), each erased in a rather accurate manner. Both stones are distinguished by the presence on their sides of representations without comparison in Lepcis: the base of Liber is decorated with a pair of crossed thyrsi (staff), while that of Hercules with a cyathus covered with acanthus leaves. It is possible that the choice fell on this pair of supports due to the desire to exploit their peculiar decorative features.[81]

Also, in the north-western corner of the Baths gymnasium, there is a column in Breccia di Sciro – of the same type as those arranged around the pool and in the lateral rooms – from which a statue base was obtained (Fig. 17). Honorific bases in polychrome marble are extremely rare; in Lepcis, there are none: this leads us to believe that such a support was intended to hold up ideal statuary. It is not possible to determine if this base was part of the same arrangement of the sculptural furnishings to which the two stones discussed above belong.

The case of the four statue bases found in the immediate vicinity of the Severan Forum and dedicated by the *praeses* Florentinus Rusticus (Tantillo/Bigi nos. 88–91) is different. Here, we have not only the certainty that they served as a support for ideal sculpture, but also the chronological horizon of the intervention.[82] We are, however, unable to analyse the articulation of the intervention itself and the place where it was carried out, since the group was dismembered and variously reused in the Byzantine era.[83] As regards the form of the statuary

78 Impossible to say whether this rearrangement also involved the six benches with neo-Punic inscriptions located inside the same *frigidarium*: Bartoccini (1929) 78; 182) believed, on the basis of the identification of Candidus who appears there with the builder of the Hadrianic aqueduct, that these elements were already part of the original equipment of the building and had been moved here and "reused" at the time of the rearrangement.

79 The bases, to which Bartoccini erroneously attributes a cultic function, were found *in situ* and as such inserted in the plan of the complex: see Bartoccini (1929) 30–31; fig. 34 and tables I and X.

80 This is how they are defined by the authors of the IRT; see, however, the problem of the distinction between bases and altars discussed in Bigi (2010) 221–33.

81 Note that the base dedicated to Hercules has its left half missing: this could perhaps mean that the selection was made when the support was already irreparably compromised.

82 The use of the verb *conlocare* almost certainly refers to this type of intervention: see Tantillo/Bigi no. 88, comment on line 6. The dedication of the bases is probably to be placed in the years 355–360 or 364–367.

83 Of the four bases, only the twin Tantillo/Bigi nos. 88–89, for whose location – which seems to be the result of a Byzantine arrangement – see comment to Tantillo/Bigi no. 88 and below 'Inscriptions Reused in the Byzantine Period'. Tantillo/Bigi no. 90, now lost, was reused as a block in a defensive tower,

FIGURE 17 Gymnasium of the Hadrianic Baths, breccia column reworked into the shape of a statue base.

rearrangement sponsored by Florentinus Rusticus, we will, therefore, limit ourselves only to pointing out once again the choice of a pair of twin supports[84] (Tantillo/Bigi nos. 88–89, Figs. 10.104–105; pl. XXIII). However, it is flanked by a third base, perhaps also reused, different from the others in that it was worked in three separate blocks[85] (Tantillo/Bigi no. 90, Figs. 10.106–107).

There are also four bases of dubious function, which could perhaps figure in this category of redeployments. Two come from the monumental nymphaeum erected at the beginning of the *Via Colonnata* and are both of the tripartite type and made of Proconnesian marble. From the first, consisting of a parallelepiped body of considerable size, a text of at least 60 lines has been deleted.[86] Currently, the base is placed on its side within the basin which was installed in the front part of the nymphaeum at a later date: this could perhaps be the indication of its later use as a support for an ideal statue. The second base, similar in size and ornamentation to the one on which IRT 706 is engraved in the same Nymphaeum, instead lies on its front, which prevents us from ascertaining the presence of any text or its erasure and, consequently, to evaluate whether or not the support has been subject to reuse.

The other two bases of dubious function are found in the Macellum: one is of a type similar to the base just mentioned in the Severan Nymphaeum (Tantillo/Bigi base with lost text no. 21). It is made up of a parallelepiped body in Proconnesian marble, decorated on the sides with an urceus and a patera (Tantillo/Bigi pl. XXVII); the other is formed by a block wider than it is tall, provided at the top and bottom with a simple cyma moulding (Tantillo/Bigi base with lost text no. 22), according to a morphology typical of the bases of 1st c. statues (Tantillo/Bigi chap. 7.2.1). Both stones are devoid of any trace of text. One could imagine that in this case, the inscription had been painted, or that the bases were intended from the start to serve as a support for something other than an honorific statue, something that did not in any case require an inscription.

Statue Bases Used as Supports for Tetrapylon-Shaped Monuments
Peculiar of Lepcis is the case of statue bases transformed into pillars of honorific monuments taking the form of a tetrapylon (Tantillo/Bigi chap. 7.2.8). Here, the epigraphic support becomes a constituent part of *another* epigraphic support. Therefore, from a strictly typological point of view, we would still be dealing with an honorific monument. Yet, depriving the base of its text and of the statue it supported is an operation which, as stressed previously, annihilates the initial meaning of the monument and reduces the base to a simple moulded stone.

Here too, the formal characteristics were decisive in the selection of which stones were to be destined for new assemblies: in fact, these are moulded monolithic bases which, by virtue of their form, lend themselves better to becoming vertical supports, being already furnished with moulded ends. So far, at Lepcis, monuments

while for Tantillo/Bigi no. 91, also lost, the first editor does not provide precise information regarding findspot.

84 The two specimens were created to be bases for honorific statues and were, therefore, accompanied by a text that was subsequently erased; they were later used as fountains and finally as supports for ideal sculpture: see Tantillo/Bigi nos. 88–89 and below 'Statue Bases Used as Fountains'.

85 Obviously, the aesthetic difference of the base was reduced once it was accompanied by a moulded socle and crowning element.

86 Tantillo/Bigi base with lost text no. 16.

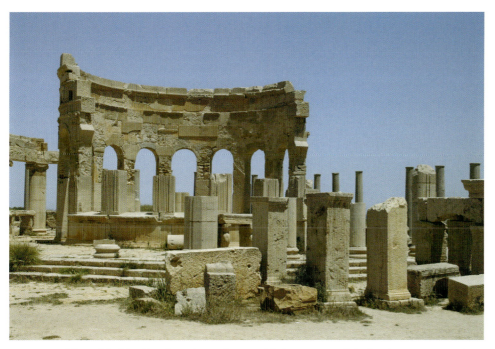

FIGURE 18 View of the Macellum from the south-west with the sequence of the four honorary tetrapylons.

in the form of small tetrapylons have been found exclusively at the Macellum, where, in front of the western *tholos*, four of them can be recognised side by side[87] (Fig. 18; Table 2). The westernmost monument, i.e. the one positioned close to the colonnade, is made entirely of recycled materials – sculpted in various qualities of local stones – among which are socle and crowning elements (perhaps already belonging to tripartite bases), and a moulded monolithic base from which the original text was removed (Tantillo/Bigi base with lost text no. 4).

The other three bases that fall into this class of reuse were all redeployed as part of the northernmost tetrapyon. Two are carved in Proconnesian marble (Tantillo/Bigi bases with lost text nos. 2–3, pl. XXVI) and one in Pentelic (Tantillo/Bigi base with lost text no. 1, pl. XXVI); all show clear traces of the erasure of texts originally engraved within the epigraphic field, and all housed a single text, i.e. they have not been subjected to repeated epigraphic uses.[88] One aspect to underline, beyond the usual formal homogeneity between the three supports, is represented by the almost absolute coincidence of their dimension and especially of the height of the individual stones,[89] which would have ensured minimal adjustments to overall dimensions, when assembling the structure.[90]

Statue Bases Used as Fountains

Two of the aforementioned bases which, in the second half of the 4th c. at the time of the reorganization sponsored by the *praeses* Florentinus Rusticus, were turned into supports for ideal sculpture had also previously been used as fountains, converting a pair of supports originally created for this use as honorific bases (Tantillo/Bigi nos. 88–89, figs. 10.104–105; pl. XXIII). The transformation into fountains, which involved, among other things, the clearing of the original text, took place through the installation of a spout on the front of each base, to which a pipe placed inside a carved cavity was connected, in the rear face. The flow of water has left unequivocal traces on the surfaces of both stones, which are in fact heavily eroded.

There is a third base that could fall into this category of redeployments. This is the aforementioned Tantillo/Bigi base with lost text no. 6 (pl. XXVI),[91] which has the back

87 In the tradition of studies and in the plans of the building, only three appear, since the northernmost tetrapylon seems to have always been ignored; on its belonging to the series, see below n. 89.

88 In this regard, see the observations on the bases reused in the *frigidarium* of the Baths, which likewise present only one erased text.

89 Tantillo/Bigi base with lost text no. 1: 150 cm; no. 2: 150 cm; no. 3: 151 cm.

90 This detail confirms that these elements belong to a tetrapylon, added to the fact that, of the three bases, two are placed side by side a short distance from each other and placed in line with the tetrapylon dedicated to Porfyrius (Tantillo/Bigi no. 50).

91 It too later became an ideal sculpture support at the time of the rearrangement of the *frigidarium* of the Hadrianic Baths.

and upper face cut by a deep recess that comes to an end on the front face of the stone. This recess could form the setting for a pipe; however, it should be noted that the stone bears no trace of the erosive action of the water. If the base had actually been transformed into a fountain, it could be hypothesised that the spout was placed in such a forward position, so as to allow the water to flow out, without touching the surface of the stone.[92]

In any case, whether they are certain or doubtful, the conversions of epigraphic supports into fountains are all works that are not particularly late in date: for the first two bases, their subsequent transformation into a support for ideal sculpture offers a *terminus ante quem* in the second half of the 4th c., while the use of the base of the baths as a fountain could be placed in the first half of the 3rd c.

Epigraphic Supports Used as Building Material

Most non-epigraphic reuses belong to this category, which we have chosen to illustrate following primarily chronological criteria, distinguishing late antique reuses from those of the Byzantine age, whilst also considering all the evidence present in specific buildings. Works of a limited extent or of a sporadic nature (levelling, repairs, etc.), or cases with an uncertain dating, are grouped together and discussed in the same paragraph.

The Hadrianic Baths

In addition to the bases transformed into supports for sculptures, other inscribed stones were reused in the various late antique restorations of the Hadrianic Baths. In a repair of the floor covering of the *caldarium*, the right side of a marble slab was reused, originally part of a dedication to Hercules (IRT 286).[93] The slab is lost and only an imprint of the inscription in the bedding mortar remains. Even the large Tetrarchic inscription which celebrated a restoration of the bath complex (Tantillo/Bigi no. 70, Figs. 10.79–80) had to be reused in a repair of some revetment not long after its erection. Five limestone blocks belonging to another monumental inscription (IRT 545), of considerable length, were also found in the *caldarium*. The blocks were found scattered on the ground but according to Bartoccini they had been "reused in the construction of an arch for which they were recarved like ashlars".[94] The number and size of the stones reused[95] indicate that the intervention must have affected a relatively large part of the roof of the room. This intervention did not belong to the initial construction of the baths, but took place after 139, and very probably also after 193.[96]

The West Dressing Room of the Theatre

In an unspecified period, but after the second half of the 3rd c. (Tantillo/Bigi chap. 4.2), the west dressing room of the theatre was reinforced with the construction of five large pillars, erected with extensive use of recycled materials taken from other buildings and honorific monuments dating between the 1st and the 3rd c.[97] Two large limestone blocks from honorific monuments have IRT 594 and 643[98] engraved on them (Fig. 19), whilst a third limestone base of the tripartite type bears a dedication perhaps in honour of Salonina (IRT 459). This inscription is not mentioned by Caputo, but was rightly pointed out by Di Vita,[99] as a possible *terminus post quem* for the rearrangement of the hall. The other two blocks reused in the pillars belong to the monumental inscriptions IRT 613[100] and 726. In particular, IRT 726 and the two anepigraphic blocks that lie next to it bear a cornice with a large sima carved with a cyma reversa

92 A long groove also cuts the upper surface of the base dedicated to the *praeses* Obsequius into two (Tantillo/Bigi no. 32: pl. XI), but in this case the hypothesis of a reuse of the stone as a fountain can almost certainly be rejected.

93 Romanelli (1925) 118 with n. 1 and p. 126 reports, without further specification, the presence of "some inscribed slabs" in the restoration of the marble veneer and the discovery of the imprint of a slab "with an inscription, apparently to Septimius Severus, in the floor of the *tepidarium* hall", perhaps to be identified with the inscription in question, which, however, is from the age of Commodus. Bartoccini (1929) 92 believed that the reuse of the slab happened shortly after the emperor's *damnatio memoriae*.

94 Bartoccini (1929) 91.

95 The longest of the five blocks measures 110 cm, and the other four make up a total length of 297 cm.

96 The inscription bears the *cursus honorum* of a person identified with C. Bruttius Praesens L. Fulvius Rusticus, consul for the second time in 139 (for the various stages of Praesens' career, see Syme (1985)); the partial erasure of the *cursus* visible on the stones would be due, according to the authors of the IRT, to the *damnatio memoriae* suffered, in 193, by his niece Crispina Augusta. If this interpretation were correct, we could place the repair of the vault in a phase subsequent to the great renovations of the Commodian age.

97 And not funerary as supposed by Caputo (1987) 126, who only notes the presence of some of these inscriptions without discussing them; for the description of the room: ibid., pp. 47–51. As elsewhere, other inscribed blocks are likely to be found in these structures as well.

98 Caputo (1987) pl. 44.4; IRT 643 was identified, on the basis of the measurements, as a chariot support by Zelazowski (1999) 886–87.

99 Di Vita (1990b) 137.

100 Caputo (1987) pl. 44.2; the authors of the IRT hypothesise that it belonged to an architrave; in reality, the block does not have the characteristics to support this identification.

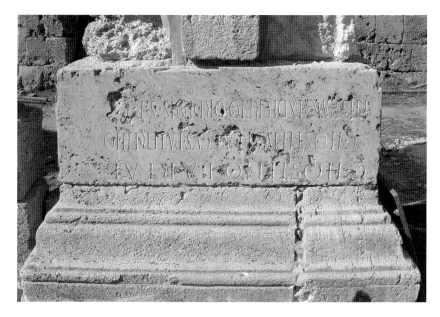

FIGURE 19
Western side of the theatre, base of IRT 643 and moulded plinths reused in one of the pillars.

FIGURE 20 Western side of the theatre, block with part of IRT 726 and other blocks with monumental cornices (from Caputo (1987)).

moulding[101] (Fig. 20). The three stones, therefore, seem to be the remnants of a structure of imposing dimensions, with the inscribed block bearing only the name of the individual involved in its erection being the sole remain of its dedicatory inscription.

The southern wall of the passage that leads from the hall to the *hyposcenium* is also characterised by the presence of inscribed bases, still of the tripartite type, re-used as ashlars. These are two dedications (IRT 276 and 277), to which we might add a third base (IRT 270), also tripartite and dedicated by the same person; although the latter now lies on the floor of the hall, it is probable that it too had been incorporated into some high row of blocks, in a wall or pillar, from which it later fell or was removed. Finally, in the corner between the dressing room and the western end of the stage, a pit was dug for the operator of the stagecraft system, in whose 'bottom floor' one of the two bases of Servilius Candidus[102] was found (IRT 358). This, like its twin, was adapted to serve as a support for the elevation poles of the stage, by carving a deep hole in one of its faces.

From the limited information that we have, it is not possible to establish whether the works just described were all contemporary. What is certain is that they were aimed at maintaining the stage system and the entire complex and must, therefore, not be overly late in date. Another element that suggests the same chronology, as it is incompatible with a carefully planned construction, can be seen in the precautions taken in the construction of the pillars of the dressing room. Here, the stones coming from honorific monuments are not only, as usual, all of the tripartite type, but also were selected – and arranged in the walls – on the basis of their size, which could even make up the entire thickness of a pillar (IRT 643; Fig. 19). Furthermore, the lower and upper part of each pillar was refined by inserting a moulded socle and crowning,[103] obtained from pre-existing shaped elements. Some of these originally belonged to tripartite bases, also of the equestrian type,[104] while others were

101 Caputo (1987) pl. 45.2: only a part of the name [*Ma*]*rcio Cre*[---] survives; in pl. 45.3 another block with similar mouldings is reproduced which could be part of the series.

102 The other, bearing the same number 358, was found in the *cavea*: Caputo (1987) 94, 98 and esp. 111; Di Vita (1990b) 137 also ascribes this reuse to the Constantinian age.

103 While the pillars do not have their relative crowning elements today, numerous shaped blocks lie in the room which were reused as crowning and which were later removed (IRT 726), although it is not clear if it was by the hand of the excavators: see Caputo (1987) 47 and esp. the caption to pl. 45.2; see also pl. 42.

104 See, for example, the block that today lies in front of the easternmost pillar: Caputo (1987) pl. 41.2.

architectural mouldings of the same kind as those still in place in many 1st and 2nd c. buildings.[105] Once covered with a layer of plaster,[106] the discrepancies between the moulded stones and all writing present on the blocks were completely obliterated.

The Unfinished Baths
The building most characterised by the use of recycled elements is undoubtedly the so-called Unfinished Baths. In the various rooms that make up the building, alongside numerous reused architectural elements,[107] there is a large number of inscriptions, variously reused as building material. Though of great interest, the building is still substantially unpublished,[108] as are the epigraphic testimonies reused here; we will therefore limit ourselves to a brief discussion, following the numbering and definition of the rooms adopted by Goodchild.[109]

In the walls of the hexagon-shaped room (A), there are at least a dozen grey limestone blocks, reused as ashlars, carrying parts of several monumental inscriptions written in lapidary capitals of the 1st–2nd c. Some of these stones are thought to be part of the same monumental inscription of which parts were reused in the West Gate.[110] In the external face of the southern wall, there is a statue base, of the tripartite type of which only the central body remains, dedicated to Liber Pater[111] (IRT 298; Fig. 21); a large block with a neo-Punic inscription and, walled up above one of the entrances, an arch-shaped horizontal element, which, although un-inscribed, seems to come from a monument in the form of a tetrapylon, of the same type still visible in the Macellum (Fig. 22; Tantillo/Bigi Fig. 10.57).[112]

The fate of 12 honorific bases[113] reused in the rectangular hall (C) was different: here, the inscribed supports were incorporated in the lower part of the pillars

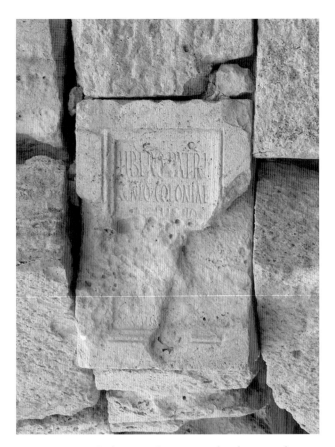

FIGURE 21 Late Baths, IRT 298 incorporated in the external masonry of room A.

corresponding to the columns placed in the centre of the room. These bases were of the tripartite type but, once again, only the body was re-used. The remains of marble wall revetment indicate that, once the room was finished, the inscribed blocks would no longer be visible. Among these stones, in addition to a dedication to Caracalla already surveyed by Goodchild,[114] we note one in honour of the Deified Severus and a series of honorific inscriptions for individuals of municipal rank.[115] Finally, in the basin immediately to the east, lies a monolithic moulded base in limestone bearing a dedication to the *Genius* of the *colonia*, for which it is not possible to determine the kind of reuse it was destined to.

In the room that was to be the frigidarium (D), we note again the presence, in the walls, of some limestone blocks with portions of texts in lapidary capitals of 1st–2nd c. date, which could be part of the same monuments reused in the walls of the hexagonal hall. Near the southern entrance, one of the pairs of twin columns rests on a long grey limestone base bearing an

105 E.g. in the podium of the Curia, in the building of the Old Forum transformed into a church, in the Arch of Trajan etc.
106 Traces of which are preserved on the walls of the same room: Caputo (1987) 49.
107 The ornament of the building, and in particular of the *frigidarium*, seems to have been made entirely of architectural elements taken from other monuments: see also for the construction history, Pentiricci (2010) 162–64.
108 Brief hints in Bianchi Bandinelli, Vergara Caffarelli and Caputo (1964); Goodchild (1965) is still the reference study.
109 Goodchild (1965) pl. VIII.
110 Goodchild (1965) 24–25 n. 20 reports an observation by Di Vita, according to whom some of these blocks would adjoin one another; repeated in Di Vita (1990) 446.
111 The stone reused here must be identified with IRT 298, erroneously believed lost by the IRT authors.
112 See Tantillo/Bigi no. 50 and Bigi (2010) 229–32.
113 Three others were perhaps walled up in the pillars on the western side, but the area is covered up by sands which makes a re-examination of the stones impossible.

114 Dated AD 215–216: Goodchild (1965) 23.
115 Whose names are listed by Torelli (1973).

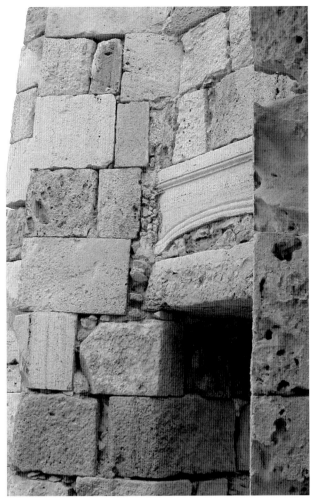

FIGURE 22 Late Baths, tetrapylon element reused in the external masonry of room A.

inscription in honour of Gaius and Lucius Caesar.[116] It was perhaps originally intended to support two statues and, like all the bases of the 1st c., it is distinguished by its very limited height and a correspondingly generous width.[117]

The western end of the hall housed two pools arranged around a central fountain, on the sides of which two niches for statues had been created.[118] The arched roofing of these niches is distinctive: for both, it was obtained by reusing an equestrian base in the lower part of which a curvilinear shape was carved (Fig. 23; Tantillo/Bigi pl. XXVII). That these are equestrian bases, and not elements derived from tetrapylons, is indicated not only by the perimeter moulding, which does not follow the arch shape and is instead cut by it, but especially by the presence, on the side of one of the bases,

116 Goodchild (1965) 21: "pairs of columns set on re-used limestone bases" (however, he does not mention the honorands).
117 The base is of a similar type to those of the two Julio-Claudian statue groups of the Old Forum: see Bigi (2010) 222–23.
118 Goodchild (1965) pl. VIIa.

of a deep rectangular recess for affixing an inscribed plate (Tantillo/Bigi pl. XXVII), according to a method frequently attested for equestrian statues.[119]

In front of the two pools lie the moulded socle and crowning elements of a tripartite equestrian base in Proconnesian marble, dedicated to Q. Aradius Roscius Rufinus Optatus.[120] The elements, probably abandoned before being put in place, were intended to act as a projecting entablature above one of the columns that adorn the corners of each basin. Still in the same room, but on the opposite wall, a moulded base in Proconnesian marble dedicated to Gallienus (Fig. 6) was found,[121] the intended re-use of which remains uncertain, as is that of a second base, this time in limestone, also in honour of the emperor.[122] Finally, we will note the presence in the *caldarium* (B) of numerous fragments of inscribed slabs, collected here to be evidently reused in the wall and floor revetment of the room.

In conclusion, as far as the complex of the Unfinished Baths is concerned, the logic of reuse appears here to be more than ever based on the criterion of form/utility, with epigraphic supports selected according to the use to which they were intended: the parallelepipeds blocks, whether they were parts of a monumental inscription or the body of a tripartite base, became ashlars; the equestrian bases or twin supports were exploited for their size and transformed into architectural members of various kinds; the slabs became part of wall or floor veneer.

The Late Roman Wall

Unlike the subsequent Byzantine walls, in the layout of the Late Roman Wall – dated between the end of the 3rd and the first half of the 4th c.[123] – a rather small number of inscriptions reused as building material has so far been found.[124] The route followed by the defensive walls

119 See Bigi (2010) 227–28 and, e.g. Tantillo/Bigi nos. 65 and 3 (equestrian bases).
120 The name of the honorand is engraved on the crowning block, the rest of the inscription was engraved on the missing central body, probably reused in some other sector of the complex; Tantillo/Bigi pl. XXVIII.
121 The dedication is engraved above an earlier erased text.
122 AE (1959) 271; we have not been able to view the base, of which we only know that "re-cutting was in progress": Goodchild (1965) 24. The two stones dedicated to Gallienus in AD 268 still provide the only *terminus post quem* for the chronology of the building: see Pentiricci (2010) 162–64.
123 The reference study is still Goodchild and Ward-Perkins (1953); for the discussion of the chronology, Tantillo/Bigi see no. 74, comment on line 4 and Pentiricci (2010) 164–67.
124 Obviously, this picture could change sensibly when the entire defensive route is freed from the sands that still mostly cover it. The western section is the best preserved, the southern one is almost entirely underground, while the eastern one is barely perceptible on the ground, as reduced to a few rows of blocks,

FIGURE 23
Late Baths, frigidarium, base of an equestrian statue reused as a niche cover.

crossed a peripheral area of the city, mostly necropolis, where the presence of public inscriptions was obviously limited.[125] A long block from a mausoleum, with a funerary inscription set within a *tabula ansata* (IRT 692), was found by G. Guidi in the inner face of the section of wall that leads from the coast to the West Gate.[126] Scattered near the latter lie six inscribed limestone blocks, which bear portions of texts in capitals from the 1st–2nd c., coming from still unidentified public buildings (IRT 343; 482).[127] For at least one of these blocks, IRT 343b,[128] we

are certain that it was reused as ashlar in the vault of the Gate, but it is almost certain that the other stones must also have been re-used in the fortifications.

The inscription in honour of Plautianus found in 1964[129] was certainly reused in the eastern section of the defensive circuit. In the same sector, IRT 460a, 460b and 633 were found, honorific inscriptions which appear wholly out of context: it is improbable that their original location would be in an area devoted exclusively to *necropoleis*.[130] The dedication in honour of Valerian Junior (IRT 460a) was, in fact, found, together with a fragment of a similar base (IRT 460b), in 1914 near Gasr Shaddad, a place from where it was then taken to perhaps be transported to the Italian *Forte Settimio Severo*.[131] IRT 633, a base for a chariot, was discovered, together with other material, near a tower of the walls.[132] Whether they have actually been reused or not, it should be noted that all the inscriptions mentioned are engraved on parallelepiped-shaped stones, which, as we have seen in the case of the other construction sites in the city, made them particularly suitable for being transformed into ashlars.

Diverse Masonry of Mixed Chronologies
There are numerous inscriptions found, in various buildings of the city, within walls generically defined as 'late'. The summary nature of the excavation reports, but above all the systematic disassembly of these walls, hinder – sometimes irreparably – the analysis of the methods of reuse and the identification of the chronological context in which they are inscribed. However, based on the

perhaps also as a consequence of looting that took place during the Italo-Turkish war.
125 Coates-Stephens (2007) 176 notes that the walls tend to use the material already available in the urban or suburban section they were going to cut. Indeed, in Lepcis, especially in the fortification segment immediately south of the West Gate, the wall is made up of numerous limestone architectural elements, pertaining to the elevation of mausoleums: Goodchild and Ward-Perkins (1953) 52; pl. XVIb.
126 At the level of the road, directed towards the city, which branches off from the Villa of the Mosaic of Orpheus: Goodchild and Ward-Perkins (1953) 49, n. 14.
127 Some of which were already reported by Romanelli (1925) 84; see the following note.
128 Goodchild and Ward-Perkins (1953) 70 and 71 reiterate the absence of public inscriptions reused in the walls, evidently ignoring or not considering valid the news reported by Romanelli (1925) 84: "among the ashlars that support it [the vault], one can note, on the north-east side, one with part of the inscription *TR PO*"; the slight discrepancies between the drawing reproduced in the 1925 study and the actual appearance of the block led the authors of the IRT not to consider the identification of this stone with frag. b of IRT 343, where it reads *PONT MAX TR PO*. If it is the same inscription, the discrepancies could be attributed to the fact that, at the time of the drawing, it was still incorporated in the masonry and, therefore, only partially visible; otherwise, if they were actually two distinct inscriptions, the number of reused blocks would rise to seven and this text should be considered unpublished. As for frag. a of IRT 343, in addition to the block reproduced in Romanelli (1925) ibid., the IRT inventories another one which adjoins to it.

129 AE (1967) 537 = (1973) 572; Di Vita (1966) 83–84.
130 See Tantillo/Bigi no. 74, comment on row 4.
131 So say, the authors of the IRT and Goodchild and Ward-Perkins (1953) 71; the base is untraceable today.
132 Goodchild and Ward-Perkins (1953) 53 and Zelazowski (2001) 81.

location of reused elements, it is sometimes possible to deduce a maintenance purpose and, therefore, bring the intervention back to a phase in which the building was still alive with its original function.

One of these cases is certainly the one represented by the reuse of IRT 332, a monumental dedication from the Tiberian age engraved on several blocks of a limestone architrave and generally considered to be the dedicatory inscription of the portico of the Macellum. Eleven blocks of the inscription were found, in the same Macellum, reused as paving stones in the stylobate, in the north-eastern portion of the portico. It is obvious that the reuse of such a large portion of the architrave presupposes the complete dismantling of the ancient portico of local stone and its replacement with one employing an extensive use of marble. The marbling of the colonnade seems to date back to the Antonine-Severan Age; however, traditionally, the renovation of the flooring with reused elements is connected to the general rearrangement of the building carried out in the Constantinian Age, when was *praeses* Laenatius Romulus.[133] The possible attribution of this reuse to the late period, an attribution by no means obvious, would lead us to imagine the presence of some depot used as a warehouse for abandoned architectural elements,[134] which could also act as a building material if needed.

In the Old Forum, in two of the four balustrades that divide the stairway of the podium of the Curia, two reused limestone blocks are found, coming from a monumental dedication, in which fragmentary letters of an imperial title can be discerned, perhaps attributable to Titus (IRT 344). The first block is inserted the second row of the balustrade, whilst the other fragment has been transformed into an element of architectural decoration – perhaps a crowning element – by carving a series of mouldings on both sides. The construction phases of the building are still waiting to be analysed;[135] however, it is possible to establish that the reconstruction of the podium dates back to a time prior to the middle of the 2nd c.[136] The reuse of the blocks of IRT 344 are likely to be connected to the rebuilding of the podium[137] rather than to any late antique repair – an eventuality that cannot be excluded anyway. If this hypothesis turns out to be correct, we would be dealing with one of the Lepcis' earliest cases of defunctionalising reuse. Also near the propylaea of the Curia, where it was possibly reused, we note the presence of another block, again with the remains of a monumental inscription from the 1st–2nd c. (IRT 814), which was recarved as a moulded crowning.

Another intervention that could perhaps represent a restoration prior to Late Antiquity, since it would presuppose the continuation of the cult, is the repair of the enclosure of the Temple of the Magna Mater in the same Old Forum. Here, in the sector facing the square, a large limestone base[138] was incorporated in which the name of Flavia Pia appears, most likely identifiable with the homonymous character honoured by a statue in the same temple.

Within rearrangements that we can only generically define as 'late antique' we can list the reuse of a marble stele (IRT 719) in the Villa del Nilo;[139] of a pair of unpublished tripartite bases in a vomitorium of the amphitheatre[140] and of a limestone base, originally dedicated to Geta (IRT 436), in the *porticus post scaenam* of the theatre. The function for which this last stone was intended is not clear: it was interpreted as a pillar cornice by Caputo[141] and as a bracket by the authors of the IRT. Whatever its use, traces of it still remain in the rectangular hole cut on the front, relating to the clamping of the stone to a contiguous element.

Finally, we note the presence, in the road that divides the theatre from the *Chalcidicum*, of an inscribed stone (IRT 604) which was subsequently transformed into an element of architectural decoration, carving a series of mouldings on the left side.

There are also a series of reuses of uncertain dating that could belong either to late antique phases, to

133 For the extent of this intervention, see Tantillo/Bigi no. 73 and Pentiricci (2010) 120–27.

134 In addition to the 'inscription depots' whose existence is discussed further on, in one of the secondary rooms of the *Chalcidicum*, there is a deposit of old architectural elements in local stone which made up the street front of the building and which were eliminated at the time of its restoration in marble.

135 The building is still substantially unpublished, with brief discussions found in Bartoccini (1950) 43–45; Balty (1991) 39–42 and Kleinwächter (2001) 234–36. Elements of the sandstone elevation reveal an initial phase attributable to the beginning of the 1st c. AD, as already noted in Floriani Squarciapino (1966) 86.

136 The frame of the northern balustrade is engraved with IRT 517; the inscription can be dated on a prosopographical basis to around AD 150 (the date of 185 was raised by Di Vita Évrard (1981) *passim*; see figs. 1–3; 6–7) and, therefore, provides a sure *terminus ante quem* for the rebuilding of the structure.

137 In fact, we note not only the care in arranging the reused inscribed stones, but also the homogeneity of these with the rest of the material and the shape of the mouldings carved on frag. b.

138 Unpublished inscription, found by F. Bigi in September 2005. On Flavia Pia, see also IRT 641.

139 Aurigemma (1928–1929) 259.

140 Di Vita (1990) fig. 17.

141 Caputo (1987) 133, who, however, does not specify which is the pillar in question.

Byzantine settlements, or to that period of deconstruction of the urban fabric, which saw squatters and very modest dwellings set inside the buildings. These were buildings which had lost their function, if they had not actually been reduced to ruins. Given the lack of chronological references, it did not seem prudent to exclude these instances of reuse from this study, although we will limit ourselves to listing them on purely topographical criteria.

Despite recent discussion,[142] the history of the eight statue bases dedicated to Geta[143] and found reused in the North Temple of the Old Forum remains clouded in uncertainty, both as regards their new function, and the date of their reuse, which has been connected to a supposed earthquake in 365, or ascribed to the Byzantine age, or to an even later period.[144] Our understanding of their reuse is also invalidated by the current arrangement of the bases, which perhaps does not correspond exactly with what was found by the archaeologists who first excavated the structure.[145] We will, therefore, limit ourselves to pointing out only one aspect. The eight bases are, as frequently in the Severan era, of the tripartite type, and only the central body was reused. In this case, the homogeneity of the supports does not derive so much from a choice aimed at the intended use – although the artefacts of this typology lent themselves well to being transformed into building material – but it derives from the fact that the bases had already been previously removed from the city's statuary heritage because they were dedicated to a condemned emperor. We will return to the question of the existence of a warehouse of statue bases in the second part of this contribution (below 'Inscription Depots?').

A base apparently of the most ancient type was found reused as building material in the northern wall of the *porticus post scaenam* of the theatre, IRT 592;[146] while in the same theatre, some marble blocks, originally part of the architrave of the scaena (IRT 534), were found reused in the steps of the *cavea*.[147]

IRT 323[148] was found in the granite portico that rises to the east of the theatre and in the rear of the *insula* of the *Chalcidicum*. The block on which the original dedication of the theatre was engraved was reused as a blocking wall of the largest intercolumniation of the portico, taking advantage of its large development in length (Fig. 24). Caputo attributes this action of "late inhabitants"; in reality, we can perceive a certain care in the arrangement of the large stone, which was surmounted by a plane of juxtaposed slabs, carved in the shape of a threshold, the thickness of which reaches the level of the plinth of the bases of the portico. More than an infill as the scholar believed, the intervention, therefore, seems to constitute a raising of the walking surface. Not far away, in a house that stood in the western corner of the *insula* to the north of *Chalcidicum*, a block belonging to IRT 685 was found embedded in masonry, a monumental inscription probably engraved on an architrave frieze block.[149]

In the south-western area of the city, in a taberna overlooking the road east of the Hadrianic Baths, a marble block bearing a possible funerary inscription (IRT 717) was reused. IRT 649 and 775[150] were incorporated into an infill of the western entrance to the gymnasium of the same baths: the first is a limestone base of the tripartite type, of which only the central body is reused; the second is a block that was originally part of a monumental inscription, probably belonging to the Hadrianic Baths themselves. Finally, near the eastern pier of the port, together with other material, two blocks of IRT 516 were found, one of which had been reused as a threshold; IRT 720, now untraceable, was seen "*hors de la ville ... dans une muraille*" – "out of town ... in a wall" but cannot be identified better.

Byzantine Period Contexts

In the Byzantine age, the reasons for the reuse of inscribed stones relates exclusively to a utilitarian logic, completely going beyond the set of rules, selection criteria, and meanings underlying reuse in previous eras. Unlike the older defensive walls, those erected in the Byzantine era are distinguished, especially in the section that encloses the Old Forum, by the presence of a high number of inscribed stones reused as ashlars. In fact, its layout cuts through the urban fabric and overlaps, sometimes even physically, the monumental remains of

142 Ricciardi (2005) 315, 332 with nn. 71–72.
143 IRT 433, 435, 437–40, 443, and 444. For the meaning and implications of the reuse of these bases, see below 'Selection Criteria'.
144 Ricciardi (2005) 330 with n. 69 and p. 332 n. 72.
145 Note the evident discrepancy between today's alignment of the bases and their position in an image from the time of the excavation: Ricciardi (2005) figs. 3.6 and 3.23.
146 See Bigi (2010) 222–23.
147 Caputo provides no indication of this reuse, reported only by the editors of the IRT; other blocks, obviously not considered here, were then used in the dwellings that were built in the theatre after the 5th c.: Caputo (1987) 132.

148 And not IRT 322 as in Caputo (1987) 114; pl. 146.1, corrected by Di Vita (1990b).
149 This seems to emerge from the description made in the IRT; there are no photographic reproductions of the two, now untraceable, blocks.
150 Bartoccini (1929) 93.

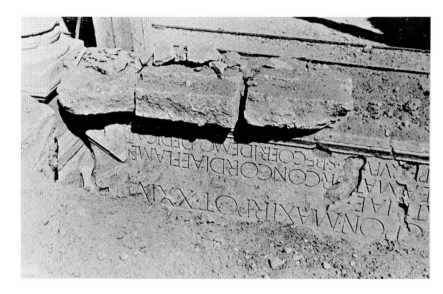

FIGURE 24
Portico behind the *Chalcidicum*, IRT 323 reused as a raised part of the pavement (from Caputo (1987)).

previous eras, which are, thus, transformed into quarries of materials that are easy-to-use.

Six limestone blocks found partly scattered around the Byzantine Gate and partly walled up in its upper tiers come from an arch in honour of Vespasian (IRT 342),[151] entirely dismantled. Four blocks pertaining to a monumental building perhaps dedicated under Domitian (IRT 350) were also incorporated into the walls of the same gate; a 2nd c. honorary base was incorporated into the topmost row of the structure (IRT 593);[152] IRT 587, used as ashlar in the vault but probably originally placed on the right balustrade of the Curia[153] and perhaps IRT 351.[154]

In the stretch of wall which reaches the sea, after having cut through the rear part of the two major temples,[155] two reused blocks of IRT 489[156] were found – parts of a monumental dedication using lapidary capitals. To these, we must add IRT 488, 612 and 770, all parts of monumental dedications now scattered near the 'Byzantine sea-wall' but which Romanelli describes as being incorporated into this stretch of wall.[157]

In the remaining part of the defensive layout, attestations of reused epigraphic material drastically decrease. To date, only Tantillo/Bigi no. 90, in a tower leaning against the western perimeter of the Severan Forum,[158] and IRT 642, reused in the stretch of wall that surrounds the eastern pier of the port have been found. To these, we can perhaps add IRT 819 and 825 – the first missing, the second transported to the museum – which Delaporte says he saw walled up in a late tower, east of the wadi Lebda. This vague indication could perhaps refer not to the 4th c. walls but to the Byzantine enclosure, since this sector was equipped with a series of towers.[159]

To a lesser extent, inscribed stones also appear as building material in the masonry of buildings converted into churches during the Byzantine era. Thus, when it was time to transform the building that stood on the south-west side of the Old Forum into a place of worship, steps were taken to equip it with an apse in whose external face were incorporated two blocks pertaining to two monumental inscriptions written in lapidary capitals (IRT 365; 553); its internal face had a Pentelic base dedicated to Archontius Nilus (Tantillo/Bigi no. 39).[160] IRT 698, now isolated within the structure, is reported

151 The monument, dedicated in AD 77–78, stood not far from the gate; Romanelli (1925) 86–87 reports that parts of this inscription and of IRT 350 were visible even before the excavation of the area.

152 On the inscriptions reused on the Byzantine Gate: Bartoccini (1925–1926) 69–70; Romanelli (1925) 86–87; Goodchild and Ward-Perkins (1953) 58.

153 The block has two pilasters framing the epigraphic field, exactly like IRT 517, *in situ* in the Curia: Di Vita-Evrard (1981) 192, fig. 4.

154 The inscription, lost, was seen in 1873 in an unspecified place, identified with the West Gate by Romanelli (1925) 85 or with the Byzantine Gate by the authors of IRT.

155 Referred to as C1 in Goodchild and Ward-Perkins (1953) 69.

156 The two blocks are reproduced in Romanelli (1925) 132; the second block was later published in Reynolds (1955) 130.

157 The indication provided by Romanelli (1925) 132–33 is not implemented by the publishers of IRT.

158 Tower B4, Goodchild and Ward-Perkins (1953) 60.

159 See the plan reproduced in Goodchild and Ward-Perkins (1953) fig. 4.

160 The reuse of stone is not recognised by Goodchild and Ward-Perkins (1953) 27, who simply describe it as "standing loose in the apse".

by Goodchild and Ward-Perkins[161] as walled up inside the raised platform where the altar was located. A large moulded base in Proconnesian marble (Tantillo/Bigi no. 71) was instead positioned in the centre of the nave facing the altar, a location indicative of the fact that the stone was entrusted with a specific function, almost certainly to be identified with that of an ambo.[162] The base was dedicated to Constantine in commemoration of the restoration of the *tripertita porticus*, and it is, therefore, probable that it was originally located in said building, only to be later moved to the place where it lies today.[163]

In connection with this church, a baptismal font was built in the centre of the square.[164] Here, in the western wall of the perimeter structure, a large, moulded limestone base dedicated to the Divus Severus[165] (IRT 401, Fig. 8) was used as a load-bearing element of the masonry. Given the size of the stone, it is probable that it was originally located in the immediate vicinity.

In the church installed in the grand Severan Basilica,[166] the presence of reused epigraphic material is limited to the southern apse only, where two polygonal bases dedicated to Septimius Severus and Caracalla were inserted in the steps of the raised platform (respectively IRT 400 and 429),[167] with a third base in honour of an anonymous 4th c. official (Tantillo/Bigi no. 63, Fig. 10.72). All three bases bear the marks of a resizing, which is becomes particularly obvious in the case of Tantillo/Bigi no. 63, shorn of half of its volume.

Finally, the fate of the two statue bases Tantillo/Bigi nos. 88–89 which we have seen first become a pair of fountains and then, in the second half of the 4th c., parts of a cycle of four inscribed bases for ideals statues. The group was dismembered in the Byzantine period – as evidenced by the reuse of no. 90 in a tower – and the two twin bases became, probably together with their related statues, the ornaments of a monumental entrance.[168] If, as seems to be likely from archival records,[169] this reconstruction was correct, we would have evidence of the only monumental decorative arrangement attributable to this phase of the city.

Reuse of Moulded Elements Belonging to Statue Bases
We have seen how one of the types of epigraphic supports that most suffered from reuse was that of composite statue bases made out of three separate blocks, of which the central element was often adapted to serve as an ashlar by virtue of its parallelepiped shape. However, the other two constituent elements of the base, namely the socle and the crowning element, once the whole was dismembered, could also be reused: the square plan form with projecting mouldings in fact allowed its easy transformation into decorative elements. There are numerous artefacts of this kind that are reused in the various buildings of the city. In addition to the already discussed examples of the west dressing room of the theatre (Fig. 19), the Unfinished Baths, and the addendum on the south-west side of the Macellum,[170] we must add the restoration of the western latrine of the Hadrianic Baths. Here, the four columns placed in the centre of the room were raised by means of a limestone block topped with a crowning element, made of a salvaged moulded socle (Fig. 25). Once masked by an appropriate coating, this architectural pastiche took the form of a real pedestal. With this form of reuse, we can now consider the equation of the statue base to the architectural pedestal to be complete. If initially, it was the pedestals that became statue bases, now it was the epigraphic supports which were transformed into architectural elements.[171] Reused socles and crowning elements also appear in the *frigidarium* of the same baths,[172] where they perhaps served as a statue support, and in the Macellum, in the

161 Goodchild and Ward-Perkins (1953) 27. It is a long marble block, decorated on the upper part with a cyma moulding, perhaps originally part of an architrave.
162 Goodchild and Ward-Perkins (1953) 27 do not assign any function to this stone, perhaps by virtue of the hypothesis that the church dated prior to the Byzantine period and that only the latter marked the diffusion of the ambos, identified only in churches 1 and 3 (p. 66); the acknowledgment of its use as a pulpit is instead due to Tantillo (2003) 989 with n. 5.
163 A further confirmation of this provenance is constituted by the fact that the architectural elements of the elevation of the *tripertita porticus* (bases, column shafts, and capitals) are reused in the church: Pentiricci (2010) 128–43.
164 Goodchild and Ward-Perkins (1953) 27–28, fig. 12 date the structure to the Justinian period due to the use of a distinctive type of mortar in its masonry.
165 The base belongs to the group of architectural materials reused as an epigraphic support: see above 'Statue Bases Made From Architectural Pedestals' and Bigi (2010) 246–50.
166 On this building, see Goodchild and Ward-Perkins (1953) 22, fig. 8.
167 It is possible that the third base of the series, IRT 404 dedicated to Julia Domna, which is now in the western nave, was also reused.

168 The entrance opens in the *insula* immediately to the south-west of the Severan Forum, the same in which a church is planted with an annexed cemetery area; although partially excavated, the area, nonetheless, shows traces of occupation in the Byzantine period, attested to (among other things) by an engraved cross above another entrance opening in the south-western corner of the same block. On this area: Goodchild and Ward-Perkins (1953) 29–31.
169 Bartoccini (1961) 111, figs. 12–13: in the images, we can recognise one of the two bases lying on the floor in front of the portal and the statue of a young athlete, also found lying down.
170 The first two cases have already been discussed in this contribution; for the third, see Pentiricci (2010) 120–27 with fig. 4.19.
171 See the considerations in Bigi (2010) 246–50.
172 Bartoccini (1929) fig. 64.

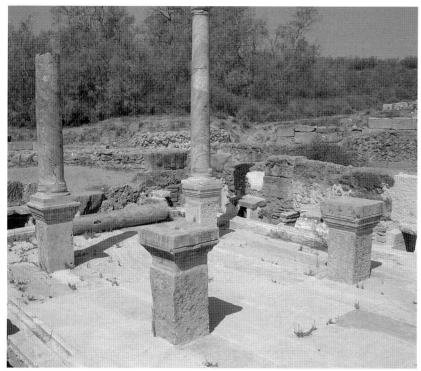

FIGURE 25 Hadrianic Baths, western latrine, moulded plinths and **crowning elements** reused to raise the columns.

piers of the western tetrapylon. Finally, there are at least another 30 such elements scattered as *disiecta membra* throughout the rest of the city which were apparently not reused.[173]

Meanings and Consequences of Reuse

The Amount of Reuse and the 'Mortality Rate' of Inscriptions

A quantitative analysis of the phenomenon as a whole is particularly instructive. We counted 61 stones, including the opisthographic slabs, which show signs of re-inscription. If we consider that many of these were used several times, the total number of reuses rises to at least 80. In other words, 80 texts were deleted or hidden (as when they survived on a side or on the back of the reused support) after a type of reuse that we can describe as 'epigraphic'. We should also look at inscriptions obliterated following their reuse as building material or otherwise experiencing a 'change of function' in the late period (excluding the Byzantine age). We have about 41 such inscribed stones used as building material in construction sites in the 3rd–4th c.[174] Yet it should be emphasised

that this estimate is only an approximation.[175] There are also 14 statue bases, almost all in marble, from which the text has been erased, mostly in order to make supports for ideal statuary (see 'Honorary Bases Used as Supports of Ideal Statues' and 'Statue Bases Used as Supports for Tetrapylons', above). Since it is absurd to imagine such an operation in Byzantine times, we would like to assign these interventions to the Roman or Late Roman period.[176] We can draw two initial conclusions from this: the first concerns our historical perception of the realities to which these inscriptions refer, the other concerns our ability to appreciate the monumental evolution of the city.

1) The data highlighted – the quantitative relevance of the phenomenon – can be combined with an analysis of the epigraphic supports. This makes it possible to establish, with a fair margin of approximation, the 'original' dating of the reused stones, obviously to be taken as a *terminus post quem* for the engraving of the oldest text documented on the support itself. From this, it emerges that, in the majority of cases, late inscriptions have

173 The count is based on a non-systematic survey of the excavated areas of the city carried out in 2003 and 2004.

174 Of which about 23 published; at least 18 other unpublished statue bases from the Late Baths and other places in the city.

175 Consider that many inscriptions relating to statues were found in places (streets, *insulae*) far from the most important public areas. Furthermore, a very large number of remains of honorific monuments of various types are found reused in restored structures.

176 On the other hand, the majority of them seem to have been reused in the framework of a coherent programme, such as the exhibition of ideal statuary in the baths, clearly referable to the needs of the 'Roman' city.

obliterated texts of the Severan period or later (Table 4). The possibility of indirectly returning many texts to the 'dark' decades of the Third Century Crisis pushes us to reconsider the value of statistics based on the mere counting of surviving inscriptions (Tantillo/Bigi chap. 5.3) and reveals how much our perception of the post-Severan age is distorted because of reuses that have compromised the preservation of the inscriptions which would have enlightened it.

2) If we add the inscribed stones (with unidentified texts) that became *spolia* to epigraphic reuses, we obtain a total number of inscriptions intentionally eliminated between the 3rd and 5th c.: at least 136 texts, which rises to 162 with those whose existence is deduced from the type of support (Tantillo/Bigi chap. 7, Appendix). This number, as mentioned above, is certainly approximate. If one then considers that known inscriptions produced in the same period do not exceed 100, one reaches the conclusion that in the Late Imperial Lepcis, more inscriptions were destroyed than were engraved. Approximately, for every new entry, two older texts were eliminated. With a 'death rate' nearly double the 'birth rate', the *colonia*'s epigraphic heritage was shrinking at a plague-like rate. This also invites us to reflect on the fact that many of the Early Imperial inscriptions, recovered by archaeologists from among the walls of the buildings, were no longer visible in the 4th c. The landscape that presented itself to a visitor in the mid-4th c. was very different from what we might imagine by scrolling through the pages of our bibliography.

TABLE 4 List of erased texts and relative chronology.

Lost text	Dating of lost text
Carved under Tantillo/Bigi no. 5	First half, mid-2nd c.
Carved under Tantillo/Bigi no. 9	Second half of 2nd c.
Left side of IRT 410 and right side of IRT 415	Second half of 2nd c.
Carved under Tantillo/Bigi no. 46	Second half of 2nd c.
Carved under Tantillo/Bigi no. 10	End of 2nd–beginning of 3rd c.
Right side of Tantillo/Bigi no. 56	End of 2nd–beginning of 3rd c.
Carved under Tantillo/Bigi no. 50	End of 2nd–beginning of 3rd c.
Carved under Tantillo/Bigi no. 59	End of 2nd–beginning of 3rd c.?
Carved under IRT 457 (see Tantillo/Bigi no. 7)	Early Severan
Right side of Tantillo/Bigi no. 3	Early Severan
Carved under Tantillo/Bigi no. 58	Early Severan

TABLE 4 List of erased texts and relative chronology (*cont.*)

Lost text	Dating of lost text
Carved under Tantillo/Bigi no. 66	Severan
Carved under the unpublished dedication to Arcadius Rufinus in Late Baths	Severan
Carved under Tantillo/Bigi no. 8	Severan
Carved under Tantillo/Bigi no. 54	Severan
Base with erased text Tantillo/Bigi no. 1	Severan
Base with erased text Tantillo/Bigi no. 3	Severan
Base with erased text Tantillo/Bigi no. 9	Severan
Base with erased text Tantillo/Bigi no. 10	Severan
Carved under Tantillo/Bigi no. 40	After 216
Carved under Tantillo/Bigi no. 13	After 216
Carved under the unpublished dedication to Gallienus in Late Baths	After 216
Base with erased text Tantillo/Bigi no. 5	After 216
Carved under Tantillo/Bigi no. 31	Late Severan
Carved under the unpublished dedication to Genius of Colonia in Late Baths	Beginning of 3rd c.
Carved under Tantillo/Bigi no. 24	Beginning of 3rd c.
Carved under Tantillo/Bigi no. 19	Beginning of 3rd c.
Carved under Tantillo/Bigi no. 37	Beginning of 3rd c.
Carved under Tantillo/Bigi no. 45	Beginning of 3rd c.
Right side of Tantillo/Bigi no. 52	Beginning of 3rd c.
Carved under IRT 454 (see Tantillo/Bigi no. 4)	Beginning of 3rd c.
Carved under Tantillo/Bigi no. 2	Beginning of 3rd c.
Carved under Tantillo/Bigi no. 15	Beginning of 3rd c.?
Right side of Tantillo/Bigi no. 3	3rd c.–before 305–306
Right side of Tantillo/Bigi no. 41	Beginning–first half of 3rd c.
Carved under Tantillo/Bigi no. 32	Beginning–first half of 3rd c.
Carved under Tantillo/Bigi no. 65	Beginning–first half of 3rd c.
Carved under Tantillo/Bigi no. 35	Beginning–first half of 3rd c.
Carved under Tantillo/Bigi no. 33	Beginning–first half of 3rd c.
Carved under Tantillo/Bigi no. 42	Beginning–first half of 3rd c.
Base with erased text Tantillo/Bigi no. 6	Beginning–first half of 3rd c.

TABLE 4 List of erased texts and relative chronology (*cont.*)

Lost text	Dating of lost text
Carved under Tantillo/Bigi no. 43	First half of 3rd c.
Carved under Tantillo/Bigi no. 29	First half of 3rd c.
Base with erased text Tantillo/Bigi no. 7	First half of 3rd c.?
Base with erased text Tantillo/Bigi no. 8	First half of 3rd c.?
Base with erased text Tantillo/Bigi no. 16	First half of 3rd c.?
Carved under Tantillo/Bigi no. 9	Second half of 3rd c.
Carved under Tantillo/Bigi no. 14	Second half of 3rd c.
Carved under Tantillo/Bigi no. 19	Second half of 3rd c.
Carved under Tantillo/Bigi no. 23	Second half of 3rd c.
Carved under Tantillo/Bigi no. 18	Second half of 3rd c.
Carved under Tantillo/Bigi no. 38	Second half of 3rd c.
Carved under Tantillo/Bigi no. 88	Second half of 3rd c.?
Carved under Tantillo/Bigi no. 89	Second half of 3rd c.?
Carved under no. Tantillo/Bigi 50	?–second half of 3rd c.
Tantillo/Bigi base with lost text no. 2	second half–end of 3rd c.
Right side of Tantillo/Bigi no. 15	Late 3rd c.
Carved under IRT 542	2nd–3rd c.?
Carved under Tantillo/Bigi no. 63	3rd c.
Carved under Tantillo/Bigi no. 11	3rd c.
Tantillo/Bigi base with lost text no. 4	3rd c.
Left side of Tantillo/Bigi no. 37	3rd?–before mid-4th c.
Left side of Tantillo/Bigi no. 52	?–before end of 3rd c. or beginning of 4th c.
Carved under Tantillo/Bigi no. 10	3rd–beginning of 4th c.?
Right side of Tantillo/Bigi no. 54	?–beginning of 4th c.
Opposite side of Tantillo/Bigi no. 41	?–before 350–360
Right side of Tantillo/Bigi no. 66	?–before the end of 4th c.
Left side of Tantillo/Bigi no. 15	?
Carved under Tantillo/Bigi no. 72	?
Carved under Tantillo/Bigi no. 25	?
Opposite face of IRT 706	?
On the back of Tantillo/Bigi no. 44 (slab)	?
On the back of Tantillo/Bigi no. 79 (slab)	?
On the back of IRT 809 (slab)	?
On the back of IRT 671 (slab)	?
On the back of IRT 386 (slab)	?
On the back of 3 unpublished frags. (slab)	?

TABLE 4 List of erased texts and relative chronology (*cont.*)

Uncertain Lost Texts

Carved under IRT 454 (see Tantillo/Bigi no. 4)
Carved under Tantillo/Bigi no. 5
Carved under Tantillo/Bigi no. 6
Left side of Tantillo/Bigi no. 2
Carved under Tantillo/Bigi no. 23
Carved under Tantillo/Bigi no. 21
Carved under Tantillo/Bigi no. 65
Carved under Tantillo/Bigi no. 90

Selection Criteria

The custom of reusing statues was extremely long-standing. Literary testimonies, from Cicero onwards, mostly describe the reuse of statues and not of their supports, a purely technical and marginal aspect.[177] The practice of rewriting a text on the support of the 'new' statue – which the Greeks perhaps indicated with the verbs *metepigraphein* or *metagraphein* – is illustrated by Dio Chrysostom in the famous speech to the Rhodians, our most important source on this phenomenon.[178] The authors' information can be integrated with that provided by some epigraphic documents which explain and specify the circumstances and methods of such interventions.[179] On the other hand, the sources are silent, or almost silent, on the destruction of the texts necessitated by their reuse as *spolia*. A full understanding of the Lepcis sample requires a comparison with the details that can be obtained from these testimonies, as well as with examples of reuse drawn from other regions of the empire.

Even just a quick glance at the plan of the bases of the Severan Forum (Tantillo/Bigi pl. 1) is sufficient to show how much the practice of reusing statues has shaped the evolution of the monumental landscape of this space. Not only do almost all of the stones show traces of reuse but supports used more than twice make up the majority: on some bases up to four different uses can be recognised, a record that does not seem to be equalled elsewhere.[180] The forum cannibalised itself for over a

177 Sources collected in Blanck (1969) 3–22; the famous passage of Cic. *Att.* 6.1.26 refers to Athens, and is confirmed by Plut. *Vit. Ant.* 60. See also Brandenburg (1989); Stewart (1999).
178 In particular Dio Chrys. *Or.* 31, 9; see Blanck (1969) 18–19.
179 See now especially Kajava (2003) on the Lindos decree of AD 22; the prohibition on reuse is sometimes expressly stated in the text of inscriptions, see Robert (1946) 109–111.
180 The only comparable case, to my knowledge, is constituted by RIT 171/89/94/95 (with the comment by Alföldy (1979)

century and a half, at surprising sometimes rates: in the only case in which it is possible to date two inscriptions following one another on the same support, we detect a distance of only 17/23 years between one use and the other, and a couple of other testimonies suggest that 25 or 30 years may have been a not infrequent interval.[181] Unfortunately, given the scarcity of information, it is difficult to compare this figure with that of other sites.[182]

How could all this happen? With what criteria were bases selected for reuse? Who made the decisions? It is worth emphasizing that since we are dealing with materials placed in public areas and reused for public works, all types of reuse were controlled by the civic authorities and were governed by specific legislation. This aspect should not be underestimated: in the cities there were official lists of the statuary heritage, which had to be periodically updated,[183] and imperial legislation remained very careful in regulating reuse until the 5th c.[184] In the 3rd and 4th c., the period that interests us, reuse operations therefore had to follow rigorous procedures. In Dio's discourse *To the People of Rhodes*, it is the *strategos* who indicates 'with a gesture of the index finger' – therefore with absolute discretion – which stones should be reused (Dio Chrys. *Or.* 31.9). In Lepcis and in other cities of the later empire, the person responsible for this choice could be the *curator*, a magistrate or the person to whom the operation was entrusted (the *curam agens*, in Greek *epimeletheis tês anastaseos*), even if the final responsibility fell on the whole *ordo*.[185] In a city that served as the seat of the provincial government, it is very likely that specific permissions, especially for the most important statues such as those of emperors and imperial family members, were given by the *praeses*, who was able to exert pressure on the council. Finally, it is possible – even probable in the case of honours for local notables – that the honouree who was preparing to take possession of an older statue could express a preference, and not only when he was granted the rare privilege of choosing the place where he would be honoured.[186] On what basis, therefore, did the responsible authorities designate which monument or monuments were to be reused? A series of possible factors are enumerated below – and not necessarily in order of relevance – which could obviously combine to determine the choice. We begin by considering two particular categories.

1) Elements made available following catastrophic events, collapses, demolitions. Contrary to what has been stated, none of the acts of reuse that we have considered – whether we are dealing with elements transformed into writing supports, recycled bases, or epigraphs reused as building material – can be connected with certainty to such circumstances; in other words, no reuse can be used as an argument for the ruin of individual buildings or generalised destruction caused by catastrophic events. This clearly emerges from the analysis of supports such as column pedestals later used as statue bases (above 'Statue Bases Made from Architectural Pedestals'). Obviously, we cannot exclude the possibility that some bases were reused following events that had caused the destruction of the monument of which they were part, such as statues that fell fortuitously, or were damaged by fires, etc.[187] Yet, this is never verifiable, and, crucially, it must certainly have concerned only a small portion of the total. The same applies to the reuse of blocks with monumental inscriptions from the 1st and 2nd c. If this were the cause of their reuse the number of inscriptions coming from

50 and 53); the list of reused bases in Blanck (1969) 61–92 is largely insufficient.

181 The base with a dedication to Nilus (Tantillo/Bigi no. 40) in office between 355 and 361, was reused in 378 for Nicomachus Flavianus (Tantillo/Bigi no. 27); the same support used for a statue to Aristobulus, from 290–294, was reused sometime later for a dedication to an anonymous *praeses*, before being dedicated again to Theodosius (379–395); not much more than a generation must have elapsed between the dedication to Cerealis (Tantillo/Bigi no. 46), *curator ca.* 300, and that to the *Genius* of the *colonia* engraved on the back of the same base (Tantillo/Bigi no. 84).

182 For some examples of close reuses see Horster (1998) 43 n. 29. Add a base of Gortyna dedicated first to Marcellinus (almost certainly the praetorian prefect of *ca.* 340), and then to Auchenius Bassus around 382: IC 4.323 and 314; in Tarraco we find a statue of Carus rededicated to Licinius: RIT 89 and 94. The inscriptions dedicated to individuals affected by *damnatio memoriae*, which could be immediately reused, must obviously be excluded: see Tac. *Ann.* 1.74; Suet. *Tib.* 58; *Calig.* 22.2; 57; Cass. Dio 59.28.2 ff.; see e.g. the aforementioned statue to Carus/Licinius at Tarraco, shortly after re-titled to Constantine (RIT no. 95); the bases for Diocletian reused for Constantius Chlorus by Thamugadi (CIL 8.17882 and 17883; with commentary by Lepelley (1981) 450).

183 Dio Chrys., *Or.* 31, 54. Similar registers could also be kept by individual temples, colleges, etc.: see e.g. ILAlg 2.1.483 = ILS 4921.

184 In this regard, Alchermes (1994) esp. 177–78; Anguissola (2004) 21 believes he can recognise a softening of the legislation only starting from the last decade of the 4th c. For the legislation relating to the protection of public works, Janvier (1969); Kunderewicz (1971).

185 Kajava (2003) 70. On the role of the *curia*, Lepelley (1979) 199–201.

186 As in IRT 601: '[bi]gam de publ(ico) ubi volet collocari' – 'a two-horse chariot at public expense where it wants to be placed'; on the high honour (as defined by Plin. *HN* 34.25) of designating the place where to set the statue, see also Kajava (2003) 71.

187 Or in particularly difficult circumstances: e.g. Hdn. 7.3 speaks of statues melted down by cities exhausted by Maximinus' tax demands.

monumental contexts reused in late building works would certainly be higher. Rather than envisaging a cataclysm, it seems more likely to connect the reuse of the inscriptions on blocks of architraves to the intentional dismantling of some buildings, perhaps following their restoration, their decoration in marble, or even their demolition.[188]

2) Statue bases reused as new bases or as building material, following the *damnatio memoriae* of the dedicatee.[189] Only a limited number of reuses can be attributed to this category. The most representative dossier consists of the statue bases for Geta, probably the emperor who underwent the most systematic application of *damnatio* in the history of Rome, and who we can assume was not treated more generously in his hometown.[190] None of these bases, except perhaps one (IRT 426, which could also be attributed to Caracalla, see Tantillo/Bigi no. 49) was reused for a new recipient. Eight of them were removed shortly after his death (below 'Inscription Depots?'). At least four others have been found in different parts of the city.[191] These supports were probably already removed and reused for other purposes in Antiquity, except in one case: we are almost certain that a beautiful marble base from the theatre, part of a cycle of four monuments dedicated there to the reigning family, has remained in its place. It was found by the excavators next to the other three, which suggests that the group was preserved intact until the end of use of the building in the 5th c.[192] This is not the place to address such an interesting and thorny topic as that of the possible permanence *in situ* of single bases with *abolitio nominis* in public spaces.[193] Specialists admit that reasons for such survivals could have been very different.[194] Might the identity of the original honorand somehow have been masked? This is what might have happened in the case of the two dedications to Maxentius in the Severan Forum, which show no trace of erasure of the name, but whose surface seems to have been prepared, through a methodical scratching, to apply a layer of stucco (Tantillo/Bigi nos. 5 and 6).[195] We do not feel like excluding a similar intervention in the case of the statue of Geta from the theatre, and of that for an anonymous praetorian prefect, whose name was erased from a large base but the base itself remained in place in the centre of the Severan Forum (Tantillo/Bigi no. 21).[196] One last observation in this regard: it has been said that of all the bases of Geta, only one was perhaps reused as a support for a new statue (IRT 426; to which that of the theatre could possibly be added). Now, all these supports, even those that were certainly removed, still have the *abolitio nominis*, which could mean that they had remained exposed for a certain period before being cleared or being subject to reuse by a 'change of

188 Perhaps resulting from a deterioration of the structures: whatever the cause, these would still be isolated cases.
189 The practice of the 'condemnation of memory' continued in the Late Empire in the same way as in the previous period. On the phenomenon, always useful Vittinghoff (1936); Pekáry (1985) 134–42; now Flower (2006). For the *damnatio* on portraits: see Jucker (1981); Bergmann and Zanker (1981); Stewart (1999) and above all Varner (2004). Finally, the essays collected in Benoist and Daguet-Gagey (2007) and (2008).
190 Only the image of Geta on the quadrifrontal Arch of the Severans was spared, probably due to its high location.
191 IRT 441, of AD 209, perhaps originally located in the Hadrianic Baths together with those of the father and brother of AD 202 (same form: see the observations of Barton (1977) 6), was found in the Severan Forum and **shows** unequivocal signs of reuse; from the same forum comes IRT 442, a marble base (with a curious form); two other dedications were found in the theatre: one of them was reused as a shelf (IRT 436), for the other (IRT 434), see the following note.
192 IRT 434, dedicated by Punicus together with the statues of Severus, Julia Domna, and Caracalla (IRT 392; 403; 422); Caputo (1987) 130 reports that the four bases were found "rather grouped". This argument adds to those made by Lefebvre (2007) 199 to state that the base remained visible. The elements of another cycle of monuments in honour of Severus, Julia Domna, and Caracalla, dedicated by D. Clodius Galba (IRT 395, 407, 424), were also found united. The cycle must have contained another base of Geta, lost and probably, therefore, already removed in Antiquity: unlike the previous group, formed by moulded marble bases, this nucleus is made up of limestone bases of the tripartite type, which lend themselves to reuse.
193 Benoist and Lefebvre (2007) 139; Lefebvre (2007). The mutilated statues were exhibited at least for a certain period: Varner (2004) 3. There are, in fact, other cases that suggest the permanence, at least of the support, in its original position: thus, the base of Maximian, from the front of the Temple of Hadrian in Ephesus, which was reused for Theodosius father of Theodosius I (IK Ephesos 306); see also, the case of the base in honour of Crispus, reused for Valens, from Cirta (ILAlg 2.535 and 594). Finally, in other cases, sometimes *damnatio* was limited to symbolic forms of condemnation, such as covering images with mud (SHA *Elag.* 13, 7),
194 A different case is that of monuments dedicated to several emperors, with a single inscription, where the erasure of the name of the *damnatus* could remain visible next to that of the colleagues not affected by condemnation: as in the case of the two groups to Constantius I and Galerius Augusti (n. 3) and to Constantius II and Gallus Caesar (n. 7). On cancellation as a 'sign' with a strong semantic and political significance, see Hedrick (2000) (esp. 117) and the various contributions in Benoist and Daguet-Gagey (2007) and (2008).
195 On the problem of stucco, see nn. 5–6.
196 In similar circumstances, considerations of a practical nature certainly intervened: the size and the considerable encumbrance of the two equestrian statues, as well as of the large monolith that supported the effigy of the prefect, were sufficient to dissuade any temptation to remove them.

function'.[197] If this were the case, it is possible that the overlying statues had also been mutilated or scarred, thus making a reuse of the monument as such impossible, or more problematic: this could help explain the prevalence of 'defunctionalising' reuses in the case of *damnatio memoriae*.

Reuse deriving from the two causes examined above, does not imply an authentic choice on the part of the person who carried it out: these pieces were offered for reuse by external circumstances. Instead, let us examine those factors that could also influence the active selection of undamaged material (exempting those made unusable by non-architectural circumstances, such as the statues of a condemned emperor), and those criteria that could be used to decree the 'sacrifice' of a still 'living' artefact. They can roughly be divided into two categories: criteria of a typological-utilitarian type, and criteria which take into account the historical significance of the monument. Once again, the subdivision of factors is only illustrative, the order of the causes being purely indicative.

3) Quality of the stone: in guiding the choice of base to be reused for a new inscription, the quality of the stone seems to have made up an important element. Marble bases appear the most attractive, due to the intrinsic value of the material,[198] but also due to the compactness of the grain, which better tolerates erasing/rewriting operations. Furthermore, very often, the bases were carved from the outset with frames also on the sides, thus offering a ready-made epigraphic base. However, this criterion was not systematically adopted: among the rededicated bases, we also find various limestone pieces, not always of the best quality.

4) Statue form: as it is usually impossible to connect statues to their respective bases, we must resign ourselves to examining the problem indirectly. There is little doubt that the quality of the artefact, the form of the statue, and, therefore, its adaptability to its new owner were taken into account when choosing the monument to be reused. It is presumable, as we have seen in detail, that often the statue was not replaced but only 'recycled' through the replacement of the head, the reworking of the features of existing statue, or by means of other expedients (above 'Epigraphic Reuse'). Reuse for the same category of honorands was undoubtedly easier and faster because it avoided replacing the body, which would have been indispensable in certain circumstances.

5) Location: assuming that, for convenience, it was preferred, where possible, not to move a monument and to limit the work of updating to the minimum, we can assume that location of the original monument played a role in its choice for reuse. This would help explain a phenomenon which has already been mentioned several times, namely the fact that some bases, regardless of their intrinsic value (size, quality of material and workmanship), have been reused up to four times, while others, despite presenting similar formal characteristics, experienced 'only' two uses or even just one. We know that even in Lepcis spatial hierarchies existed in public spaces (Tantillo/Bigi chap. 5.2.8) and we know that – the sources tend to record it – a further element of distinction was added to the honour of the statue if it was erected in a *locus celeber* or *celeberrimus*.[199] It is probable that there were some privileged and coveted places within the same forum or other public spaces.

6) Other utilitarian criteria: in the case of inscriptions transformed into *spolia*, it is not surprising to note the prevalence of purely utilitarian criteria. For example, as we have shown (above 'Honorific Bases used as Supports for Ideal Statues' and 'Statue Bases Used as Supports for Tetrapylons'), that bases transformed into supports for ideal statues or tetrapylon piers were selected on the basis of their formal homogeneity, in order to guarantee an aesthetically satisfying result. At other times, it is the structural form of the support that determined its use: thus, the bodies of the tripartite bases, with their parallelepiped shape, are transformed into ashlars for the wall textures. The same fate befell limestone blocks on which the monumental inscriptions of the 1st and 2nd c. buildings were engraved (above 'Epigraphic Supports Used as Building Material'). The inscriptions provided versatile, easily-reused material: the western dressing room of the theatre is an instructive example of how the structural potential of the various supports, and of other elements that belonged to inscribed monuments (*socles* and moulded crowns), could be exploited to the fullest.

Finally, we come to two of the most interesting aspects of the problem, which more specifically concern the subjects mentioned in the inscriptions.

7) Honorand: it was not just the statues of condemned individuals that were reused. The Rhodians accused by Dio Chrysostom defended themselves by stating that the statues they reused were not only broken, old or un-inscribed, but also belonged to persons

[197] As suggested by Lefebvre (2007) 201 for those of the North Temple.
[198] The predominance of marble in statue bases for late governors is noted by Horster (1998) 44, which, however, does not connect the phenomenon to selection deriving from reuse.
[199] Zimmer (1989) 31–32.

now unknown.[200] In Lepcis, as elsewhere, it is not usually possible to determine the original owner of a given statue base, because the first inscription is generally erased. From an examination of the cases in which we are able to read the original inscription, some interesting indications emerge. Excluding the emperors who suffered *damnatio memoriae*,[201] it seems possible to deduce, perhaps expectedly, that there were great reservations about reusing inscriptions linked to imperial monuments. In fact, there are also few examples belonging to this category that are reused as building materials.[202] At the limit, there are reuses for other emperors (a base of a statue of Gordian reused for Severus II Caesar: Tantillo/Bigi no. 4; the support of an equestrian statue of Gallienus, reused for a pair of statues of Constantius II and Gallus Caesar: Tantillo/Bigi no. 7). The only exception seems to be a base of Caracalla reused to support a statue of the *Genius* of the *colonia*.[203] On the other hand, examples of dedications to 'good' emperors being recycled for different recipients seem quite rare.[204] For the other categories, there is no real rule. We find a *curator*'s base reused for an effigy of the *Genius* (Tantillo/Bigi no. 46/84); bases of statues of notables reused for other notables (IRT 630/Tantillo/Bigi no. 57; no. 45/60), for officials (Tantillo/Bigi no. 52/26; IRT 518/Tantillo/Bigi no. 34), or for emperors (Tantillo/Bigi no. 55/12); bases of officials for other officials (Tantillo/Bigi no. 40/27). The most interesting case – to which we will return – consists of a base that first belonged to an anonymous person to whom a public statue had been decreed, then to a proconsul, then to a *praeses*, finally to the Emperor Theodosius I (Tantillo/Bigi no. 22/36/13). The only constant, according to these few testimonies, is that the base was not reused for 'lower' categories of honorands (for example, bases with dedications to proconsuls reused for simple local notables are not found).[205] But this is not a rule, but rather the result (and further confirmation) of the tendency to increasingly limit the *honor statuae* to representatives of imperial power, and towards the extinction of the statue habit among municipal aristocracies.

The choice of which honoured statue to sacrifice was a very delicate one. Dio accuses the Rhodians of opportunism in suppressing the ancient and venerable simulacra of the Macedonians or Spartans, and in sparing the Romans (Dio Chrys. *Or.* 31, 43). The imperial dedications were generally preserved, or reused for other emperors, because their reuse was prevented by considerations of a political, juridical, and religious nature; the imperial image was sacred, an object of worship and ritual practices, that could provide *asylum* (Tantillo/Bigi chap. 5.6.1). In other cases, from this point of view, the reasons for reuse were essentially opportunistic. It would be difficult to gain permission to reuse a statue of a still living notable or whose children and descendants still occupied a prominent position in the city; but it could be done if the family was extinct and the honoured person was now unknown even to his own descendants.[206] It was also improbable that a statue of an ex-governor or a powerful *patronus* still alive would be removed. However, it could have been done if the link between the family of the *patronus* and the city had been interrupted or not renewed. It is certain that the relations between the city and its ex-governors Aristobulus (proconsul of 290–294: Tantillo/Bigi no. 22) and Nilus (*praeses* of 355–361: Tantillo/Bigi nos. 39–40) had for some reason

200 Dio Chrys. *Or.* 31, 38; 72; 90; 141; uninscribed statues are also mentioned in the decree of Lindos: IK Lindos 419, rows 30–32; Kajava (2003) 74–75.

201 Among them we could, in a certain sense, also include Gallienus: while there is no example of the *abolitio* of his name in Lepcis, most of the monuments dedicated to him were reused in the following period (Tantilllo (2010) 13–16).

202 In the Unfinished Baths, there are dedications to Gaius and Lucius Caesar, *Divus Severus*, Caracalla, and two to Gallienus (all unpublished except for the last one: AE (1959) 271). A dedication to Salonina (?) was incorporated into a pillar of the theatre (IRT 459).

203 IRT 423 / Tantillo/Bigi no. 82. The erasure of Caracalla's name and the destruction of his portraits is only sporadic (Mastino (1981) 78–79; Varner (2004) 184; cf. Cass. Dio 79, 18, 1 with commentary by Scott (1931) 122); but the causes of the reuse of IRT 423 / Tantillo/Bigi no. 82 do not appear to be connected to a will of this kind, and seem rather opportunistic (as also, possibly, in the case of Tantillo/Bigi no. 49).

204 Horster (1998) 43 n. 31 cites some cases of imperial inscriptions reused for individuals of non-imperial rank: Hadrian was replaced by a governor (CIL 10.7202 and 7208); Sabina Augusta by a proconsul of 296–301 (CIL 8.12458 = ILTun 865; CIL 8.12459 = ILTun 866, Maxula; it is an opisthographic slab); Constantine by a governor of 343 (CIL 8.7008 = ILAlg 1.585; CIL 8.7013 = ILAlg 1.590, Cirta).

205 Nor are bases of **cult statues** reused for honorary monuments, in examples so far known; Dio Chrys. *Or.* 31, 11–12) evokes as an argument *per absurdum* on the possible reuse of statues to divinities. However, some of them were reused as *spolia*: IRT 288 and 297 were transformed into ideal statue bases; IRT 298 was walled, as was an unpublished base for the *Genius* of the *colonia* (Unfinished Baths). IRT 286 is a slab perhaps relating to a monument, reused in the flooring of the Hadrianic Baths. IRT 270, 276, 277 (walled in the western side of the theatre) are a hybrid between honorific and sacred dedications; see above 'Epigraphic Supports Used as Building Material'.

206 Dio Chrys. *Or.* 31, 72 imagines the objection of the Rhodians: "of many of these [the honorands of the statues] no longer remain relatives, and this thing [the reuse of the statues] is not done with any of those that are well known"; the orator replies by proposing the case of individuals whose descendants have lost the memory of their blood bond with the honoured one.

expired when the city of Lepcis proceeded to reuse the statues dedicated to them. It is probable that governors and officials from beyond the city were most exposed to the 'risk' of reuse, since they were distant characters, not in a position to defend their monuments.[207] It is worth insisting on this point: suppressing a statue, defrauding someone of a devoted honour, constitutes an act of hybris according to Dio Chrysostom (*Or.* 31, 42), or, more simply, it was an affront and a humiliation, as shown by the polite remonstrances of Favorinus or the vehement protests of Symmachus, who suffered this fate.[208] Therefore, it is certainly not a stretch to infer, from perhaps even the majority of reuses, an extinction of certain families, or that the certain patronal or friendly relationships had come to an end.

8) Dedicators: no less important than the honorands are the dedicators, as can be seen in the evolution of epigraphic practices (Tantillo/Bigi chap. 5.7). The value of the statues – but this also applies to other artefacts – was hierarchical not only on the basis of the identity and qualification of the person honoured and/or on the intrinsic value of the artefact, but also on the basis of who had erected and paid for them. In this regard, it should be noted that all the cases cited of bases that reuse older bases where it is possible to read the previous inscription constitute examples of public dedications that reuse public dedications.[209] Although this sample is numerically limited, this is perhaps not without importance. This conclusion is supported by the number of stones that underwent reuses of 'change of function' in Late Antiquity (therefore, before the Byzantine age). Of the 28 inscriptions relating to sacred dedications and honorific monuments, whose text is still legible and whose dedicatees can be identified, [excluding damned emperors], there is only one dedicated and publicly paid for.[210] The others are all stones placed and financed by private individuals or by individual magistrates (now only *permissu ordinis*, following a decree of the local senate).

The almost total absence of public dedications among the reused stones cannot be accidental.[211] Pliny recounts that, with an operation commissioned by the censors in 158 BC, all the statues were removed from the Roman Forum except those which 'were established by the vote of the Senate and People' (*populi aut senatus sententia statutae essent*'); similarly, the Emperor Claudius, after having removed many images that cluttered up the public areas of the city, placed future limitations on the dedication of statues by private citizens.[212] Publicly decreed statues were worth more and gave greater prestige than those placed by private individuals, according to a principle which is echoed for example in Cicero and Apuleius, and which is confirmed how rarely this honour was conferred on individuals of municipal rank.[213] It is logical to think that this principle was still valid in late Lepcis, and that it influenced the decision not only when it came to choosing individual statues to be reused, but also during the rearrangement of public areas, which forced a selection between statues (below 'Inscription Depots?').

There is another important theme that invites reflection: namely, the possibility that legal considerations also played a part in the choice of the statues to be reused. In effect, the city authorities had full authority over the monuments already dedicated by the citizenry. As they were publicly owned, they could dispose of them as they pleased (although Dio Chrysostom raises some objections in this regard).[214] The same power was also exercised over most of the statues placed at private expense in the *loca publica*[215] and which were generally donated to the community by the dedicatees; however, this right did not extend to any statues placed in private settings, to those belonging to the colleges, nor those of

207 It is plausible that a good part of the marble bases of the Severan Forum dedicated to late officials originally belonged to their 3rd c. predecessors; among the bases reused as building material, there is only one that belongs to an official, the equestrian base of Q. Aradius Rufinus in the Unfinished Baths (Tantilllo (2010) 14, n. 8, and above 'Epigraphic Supports Used as Building Material').

208 Favorinus, *Corinthian Oration* 33 *ss.* (Stewart (2003) 286–87); Symm., *Ep.* 9, 115. Dio Chrys. *Or.* 31, 86 compares, *per absurdum*, the erasure of the name that takes place following the condemnation of an individual to that which the honoured person undergoes when the decree in his honour is cancelled to make way for a new entry.

209 The only possible – and very dubious – exception is a *curator*'s base re-dedicated to the *Genius* of the *colonia* by a certain Crescentina (?): Tantillo/Bigi nos. 46/84.

210 Unpublished inscription in honour of Gallienus from the Unfinished Baths (Tantillo (2010) 15, n. 16).

211 The case of inscribed blocks from dismantled public buildings is obviously different (see 'Epigraphic Supports Used as Building Material' above).

212 Plin. *HN* 34, 30; for Claudius, Cass. Dio 60.25.2–3; Rollin (1979) 105–106; Lahusen (1983) 102–103.

213 Cic. *Verr.* 2, 4, 139; Apul. *Flor.* 16 with the comment of La Rocca (2005) 50–54. On the rarity of the honour of a public dedication to personalities who do not belong to the category of administrators, Alföldy (1979) 219–20.

214 In particular, the orator expressed doubts about the legitimacy of obliterating, with erasure, a public decree (Dio Chrys. *Or.* 31, 38).

215 Among the *loca publica*m there are also *loca sacra* (also placed under the control of the municipal authorities and treated as public places): for the definition of this juridical category, Thomas (2002); Dubouloz (2003); as regards specifically the inscriptions, Eck (1992). On the law relating to statues placed in public, Musumeci (1978); Rollin (1979); Lahusen (1983) 113–27; now Nista (1988) and Stewart (2003) 144–45.

statues, also *in publico positae*, over which the honorand and his heirs had been able to retain ownership.[216] The fact that we are unable to connect any reused stones to one of these latter categories does not mean we should underestimate the importance of legal constraints, which, here as elsewhere, could have played an important role.

Inscription Depots?

The transformation of inscribed stones, and particularly of foundations, into building material deserves further reflection. The selection of monuments to be spoliated could be spontaneous and might concern individual pieces, e.g. a statue forgotten in a dark corner of a dilapidated building. At other times, however, the city authorities worked on a larger scale and in a more systematic manner. We know that the most crowded public areas were subject to occasional 'thinning operations'. This is already attested in Republican and High Imperial Rome by authors who recall a series of interventions specifically aimed at reducing the number of statues.[217] In addition, it must be considered that the rearrangements of the same public areas, by restorations, extensions, or modifications, inevitably affected their statuary as well.[218] To limit ourselves to Africa, we are informed that at Thubursicu Numidarum, under the reign of Julian, great works were undertaken in the New Forum. Materials from various parts of the city were transferred to the renovated space. Selections were made from older material, whose inscriptions – engraved for the occasion and placed under the old statues – allow us to glimpse the mechanisms involved.[219]

It is legitimate to believe that something similar also happened in Lepcis in the 3rd or 4th c., on the occasion of the various rearrangements we know of, such as the restoration of the Basilica Ulpia (and its porticoes?) around AD 300, or of the Macellum and, above all, of the Old Forum, in the Constantinian age. In any case, relocations of statuary were found in the area of the theatre and its *porticus post scaenam* in the Late Imperial period.[220] All these interventions would have made a lot of material available, not all of which was not necessarily needed at that point. The example of the Unfinished Baths presupposes this: in its walls were found large quantities of reused pieces, of disparate typologies, provenance and chronology. Some stocks of spoliated material must have been maintained, unless we want to imagine an extremely degraded urban *decorum* already in the 4th c.

Such a conclusion is supported by the examination of a particularly interesting case. In the Northern Temple of the Old Forum, the excavators found eight limestone bases dedicated to Geta, all with his name erased, inserted in a structure which is now dated, not without uncertainties, "after 365 [with reference to the earthquake], perhaps in Byzantine age or after".[221] Comparison with the twin bases dedicated to Caracalla or Severus allows us to state with certainty that some of these bases were part of statue groups originally located in different sectors of the forum, and perhaps in other public areas of the *colonia*.[222] This means that, before being reused as building material, they had been sorted by type. This could not have happened until shortly after the *damnatio* of Severus' youngest son and the consequent removal of his effigies, which, as the accurate erasure of the name indicates, had only remained on display for a short time.[223]

What is most striking is the very existence of such planning. The case of the North Temple suggests that the stones removed following a public act of condemnation or for other reasons were kept under protection by the authorities and collected in warehouses, where they could remain for a very long time. A few metres away, two limestone bases dedicated to Maximinus

216 See especially Musumeci (1978) (whom we personally thank for his suggestions). In theory, at least some of the dedications placed by private individuals in Lepcis *ex testamento, permissu ordinis* could be ascribed to this category. Under normal circumstances, a private individual could not remove them, as the collective interest prevailed, i.e. the maintenance of the *ornatum*. The right of ownership, from a state of quiescence, was fully enforced again if the statue was razed to the ground, ceased to be part of the public *ornamentum*, and could, therefore, be recovered by the rightful owner. It is presumable that a possible reuse of these statues and their respective bases could have been carried out if the owners or their heirs granted the material to the city or if, once these had expired, it had been confiscated in the city's assets.

217 For the sources, see above n. 211 and Livy, *Epit.* 40, 51, 3; it is probable that in 4th and 5th c. Rome, it was the *curator statuarum* who dealt with it: Chastagnol (1960) 363–68.

218 As certainly happened in the Roman Forum itself with the rearrangement of the square under the Tetrarchy: Coarelli (1999) 27–33; Machado (2006).

219 Among these a colossal statue, probably imperial (ILAlg 1.1229), a statue of Trajan (ILAlg 1.1247 = ILS 9357), one of Constantine (ILAlg 1.1274): Lepelley (1981) 214.

220 Caputo (1987) 130.
221 Aurigemma (1940), 10; Ricciardi (2005) 332 and nn. 71–72 (fig. 3.23).
222 IRT 433 came from the *exedra*-shaped monument of the Old Forum (Lefebvre (2007) 197); IRT 438 and 439 also from the Old Forum (408 belongs to the same group), as well as 440 (twin of 388); IRT 435, 437, 443, 444 are instead of unknown origin. The limestone base with erased text lying in front of the Temple of Rome and Augustus (Tantillo/Bigi base with missing text no. 9) could also belong to the same series.
223 Lefebvre (2007) 201.

Thrax and his son Maximus were also found, with their names erased. All of these testimonies suggest a deposit of abandoned statues, probably housed in some room of the temple itself. This is not surprising: according to a definition reported by Aulus Gellius and dating back to Varro, the *favissae* of temples were the rooms used for the storage of various materials, including statues no longer in use.[224] It should be noted that a similar role seems to have been played in the 4th c. by the lower rooms of two other temples of Sabratha and Lepcis itself, where large quantities of marble slabs, both inscribed and blank, were found piled up.[225] The deposit of the North Temple seems instead to have specialised in bases, and possibly in statues (assuming that they too were stored together with their supports). It is probable that other warehouses of this kind existed, intended for pieces that had been removed for various reasons, in the vicinity of other public areas of the city; perhaps in particular for materials made available by the refurbishment and marbling of many public buildings in the 2nd and 3rd c.[226]

The Contribution of Lepcis to the Understanding of the Phenomenon of Reuse

The reasons why throughout the empire, starting from the 3rd c., earlier materials began to be readapted for the most diverse purposes, are the subject of discussion primarily in the field of archaeological studies. But the appreciation of the phenomenon also concerns other sectors of historical research and the periodization of Late Antiquity itself – which ushers in an era of reuse that continued into the Middle Ages – as well as the evaluation, not only in terms of continuity and discontinuity, of this historical era. From the early contempt of '*muri di bassa epoca*', seen as a manifestation of the decline of the times, more sophisticated explanations of the phenomenon have emerged: there has been talk of an 'aesthetic' of reuse, or rather there has been speculation on the possible ideological function of reuse of the ancient, as a desire to reconnect with the past to give *decus* to new monuments, to gain prestige, or to establish legitimacy.[227] Research on the reuse of statues and their supports, developed with a certain delay, concentrating on the traces of reworking of portraits. The problem of the causes of reuses was mostly tackled on the sidelines.[228] The transformation of the inscribed heritage of ancient cities into *spolia* has only recently been addressed.[229] It is obviously not our intention to re-discuss the question as a whole here; we will limit ourselves to elements that are inspired by the evidence from Lepcis, without claiming to give a solution to a phenomenon whose complexity cannot be reduced to univocal explanations.[230]

In the capital of Tripolitania, reuse does not appear to be attributable to generalised destruction.[231] Reuse cannot even be fully explained by the scarcity of material or by the difficulty of procuring suitable new blocks: still in the 4th c., the city's stone stores, overfilled by Severan construction sites, which remained partly unfinished, could supply marble blocks of high, finished quality. Furthermore, new materials seem to still have been imported in the Constantinian period. The practice of reuse followed another type of logic: this is shown by the fact that, while magnificent Proconnesian pedestals were destined for destruction, poor quality limestone bases could be written on three times. From a purely economic point of view, reuse appears to be connected to the desire not to spend money unnecessarily, rather than save it, in serving a reduced demand for new inscribed monuments.

The idea that the phenomenon is connected to problems of overcrowding in areas consecrated to the display of honorific monuments is also highly questionable. There was no shortage of space. Areas such as the *Via*

224 Aul. Gell. 2.10.3: '*cellas et cisternas, quae in area sub terra essent, ubi reponi solerent signa vetera, quae ex eo templo collapsa essent, et alia quaedam religiosa e donis consecratis*' – 'certain underground chambers and cisterns in the area, in which it was the custom to store ancient statues that had fallen from the temple, and some other consecrated objects from among the votive offerings'; Aulus Gellius/Varro alludes to statues that were part of the property of the temple, but this intended use could justify the storage of artefacts from other sources. See also the following footnote.

225 In Sabratha, in the rooms of the Capitolium: IRT p. 23 (the authors of the IRT thought of the consequences of the devastations of the Austoriani; Di Vita (1990) 457 of those of the earthquake of 365); in Lepcis, a similar warehouse has been identified in the Temple of Liber Pater: Masturzo (2005) 54–55. Two depots of inscriptions have been found in Ostia: Pensabene (2009) 188.

226 Similarly Kinney (1997) 124.

227 The point in Liverani (2004); for an overview of the problem, Giardina (1999); among the most relevant contributions to the analysis of reuse, Deichmann (1975) and Brenk (1987) and (1996).

228 The problem is systematically addressed by Blanck (1969) 95–96 and 105–106 (referred to by Pekáry (1985) 39–41) and by Niquet (2000) 87 ff.; see also, for the specific case of Side, Nollé (1993) 127 ff.

229 Coates-Stephens (2002).

230 On the complexity of the phenomenon and the difficulty of framing its origin with univocal explanatory models, see now Coates-Stephens (2002) 277; see also Ward-Perkins (1984) 213–17.

231 On the other hand, anyone wishing to link the phenomenon to destructive events of natural origin would have to explain why it appeared in practically all regions of the Roman Empire in the same period.

Colonnata or the gymnasium of the baths – which also would have lent themselves to this purpose – remained practically unused. And the inhabitants of Lepcis showed no reluctance to make room by getting rid of the superfluous statues when needs required it. Patterns of reuse do not even correspond with the need to build monuments in a hurry: this could at most be true in particular circumstances, for example when one was faced with the urgency of preparing the city's defensive walls. But this does not, as has been argued, apply to the reuse of the statues, since there is no reason to think that these were removed more quickly than in the past.[232]

As for the existence of possible ideological reasons for reuse, the picture outlined up to this point at least calls for prudence. A "certain reticence to speak of reuses" was noted throughout the 4th c. (and to a lesser extent for the 5th).[233] There are testimonies that show how a 'new' product was still considered preferable to one obtained from the reuse of the old, which involved the cannibalization of ancient artefacts.[234] When it comes to statues, the problem becomes even more delicate. It has been noted that no inscription ever mentions the fact that a new statue reused an older statue.[235] Indeed, we would be surprised if this were the case. Among the principles on which the very practice of erecting statues is based is that, still reaffirmed in the 4th and 5th c., of the perenniality of the monument (*ad sempiternam memoriam*), the idea is that the testimony of virtue represented by the image was destined for posterity, for eternity.[236] Apart from any legal problems (regulations aimed at the protection of monuments), the reuse of a statue must, therefore, have appeared far more difficult than that of an architectural fragment stolen from an old building. How was honorific statuary justified in a world where inscriptions and statues changed recipients with each generation? From this point of view, rather than looking for an ideology that justifies the practice of reuse, one should try to understand how one could live with such a form of schizophrenia.

Nonetheless, it is possible that, in a civilization in which the rededication of statues had become a daily habit, some form of ideology around this practice could have developed retrospectively. For example, it is perhaps ancient honorands realised the implications of the act of re-naming a particularly valuable or attractive monument (due to quality, location or perhaps because it already belonged to some prominent person), perhaps an old statue which had acquired a certain symbolic value, or had even become a point of reference in the urban topography.[237] This awareness could inspire the preferences of the honorands and the new honorand could also feel a certain satisfaction: the very fact of being judged worthy of appropriating that particular simulacrum, of usurping that particular place in the forum, constituted an index of his importance.[238] From this point of view, not moving the base, limiting oneself to replacing the head of the statue, leaving the rest intact, could have served a desire to mark a succession of honourees, and have driven a concern to maintain harmony and coherence between the different parts of the monument, or even to completely cancel the previous dedication.

In essence, to understand why the people of Lepcis, like probably many of their contemporaries, at some point began to reuse older artefacts, one must look elsewhere. The inscribed blocks reused in the new masonry came from old buildings that had been transformed or demolished in the meantime. For the statues, we have to consider changes in the needs of the social classes who had used this instrument in previous centuries to assert their supremacy; a change in celebratory habits that rendered obsolete many honorific monuments built to excess during an earlier phase of exuberant statue mania (Tantillo/Bigi chap. 5.6.3). The decline in artisan skills can also be attributed to the drop in commissions for 'new' products, to the possibility of reusing pieces that had already been worked, and, therefore, to the availability of ready-made artefacts which made it superfluous to waste resources that could have been better used elsewhere. In Lepcis, statues were reused because there were too many things that, for various

232 We know that many foundations for governors were erected even years after their departure and that the honours, certainly including the promise of a statue, were prepared in advance (with the granting of the patronage already before the end of the mandate); most of the imperial statues were probably erected no earlier than a few months after the elevation of their honorands as emperors (Tantillo (2010) 176 n. 33).
233 Liverani (2004) 430.
234 Coates-Stephens (2002) 280–281; see the famous inscription of Abella (CIL 10.1199 = ILS 5510) '*civitatem [A]bellam nuda ante soli deformitate sordentem silicibus e montibus excisis non e dirutis monuments advectis consternendam ornandamque curavit*' ('he took care that the city of Abella, which was squalid because of the deformity of its ground, was paved and adorned with stones quarried from the mountains and not taken from ruined monuments.') An emphasis on the value of novelty can be found in Tantillo/Bigi no. 71, row 5 (see no. 72). In particular for the statues, see the epigraphs of Madauros, which speak of purchased and imported statues (ILAlg 1.4011 and 4012; see Tantillo (2010) 199–200).
235 Kajava (2003) 72.
236 E.g. Greg. Naz., *Carm.* 2.2, 7, 15–17; some of the epigraphic formulations are collected by Horster (1998) 58; Slootjes (2006) 152.
237 Statues as topographical references: Roueché (2006) 240.
238 This could be another cause of the multiple reuses of the same support.

reasons, one no longer knew what to do with: artefacts that were no longer needed or materials that had accumulated over the centuries in stone storage depots. The number of new statues needed to honour the emperors and new patrons was decidedly lower than in the past, and the need to further enrich the *colonia*'s already conspicuous endowment with buildings was negligible: why then open new quarries, buy stones from outside, melt more bronze?

Conclusions: the Reuse and Transformation of the Monumental Landscape of the City

The places designated for the display of public monuments and where liturgies and political rituals take place are highly symbolic spaces, places of collective memory ("*lieux de memoire*").[239] A memory that is characterised above all, indeed defines itself, precisely because it is dynamic and manipulable. In the ancient city, the landscape of exposed texts, along with the monuments to which they were connected, appears to us as a reality in permanent movement, continuously reshaped through additions, modifications, and selections. It is above all the last aspect – the process of selection – that interests us in this research: the choice of what to keep and what to destroy seems to obey rules and was made after civic authorities had mediated between a series of needs, aesthetic practices, and policies.

We must not underestimate the consequences of this manipulation of the landscape. It is probably true that most of the statues were not worthy of a second glance, but it is also true that they made up an unconsciously recorded landscape.[240] Above all, a statue has meaning in the moment in which it is erected, and, unless it is made the object of recurring ritual practices (as could happen to imperial statues), it tends to be forgotten. The same could be true for a slab placed on a building, or for a dedication to a deity. When silent, however, these objects can suddenly attract attention once more if, for some reason, one decides to remove or suppress them.[241] Between 1941 and 1944, the Vichy regime had at least 1,700 bronze statues destroyed throughout France, sending them to arms factories in Germany: the operation, although conducted with caution in the awareness of the reactions it could provoke, aroused passionate popular protests.[242] Even in the contemporary world, and in the case of monuments now deemed politically unacceptable, the attitude towards their suppression is rarely neutral.[243] Even in the ancient city, reuse meant marking visually a detachment from the past, not necessarily in the sense of condemning it. Every change made to the monumental landscape was imprinted in the memory of citizens who, in noting these changes, emotionally participated in the transformations taking place in their own world. When the statue of Nilus was rededicated, perhaps not even 20 years later, to Nicomachus Flavianus, many would have able to remember the previous owner and to assign political value to that deed: an exhaustion of the relationship with the first, urgent need to honour the latter.

The lack of sensitivity sometimes shown by the city towards its own past, its glories, the glories of its old families, and its ancient and more recent benefactors may come as a surprise. How striking that the inhabitants of Madauros had the dedication to one of Constantine's sons engraved on the back of an inscription celebrating a *philosophus platonicus*, undoubtedly the renowned Apuleius (ILAlg 1.2115 = 4010): even if this statue was perhaps not the only monument erected by the *Madaurenses* to their illustrious fellow citizen, they still considered its preservation unnecessary or did not bother to restore it.

A visitor who had landed in the port of Lepcis under the reign of Constantius II, when Lepcis was still a *civitas muris et populo valida*, surrounded by a *suburbanum uberrimum*,[244] would not have been able to learn much about the illustrious past of the *colonia*. He could have

239 For a fitting definition, Nora (1984) esp. p. XIX: "La mémoire est la vie, toujours portée par des groupes vivants et à ce titre, elle est en évolution permanent, ouverte à la dialectique du souvenir et de l'amnésie, inconsciente de ses déformations successives, vulnérable à toutes les utilisations et manipulations, susceptible de longues latences et de soudaines revitalisations. [...] La mémoire est un phénomène toujours actuel, un lien vécu au présent éternel" – "Memory is life, always carried by living groups and as such, it is constantly evolving, open to the dialectic of memory and amnesia, unaware of its successive deformations, vulnerable to all uses and manipulations, susceptible to long latencies and sudden revitalizations. [...] Memory is an ever-present phenomenon, a lived link to the eternal present."

240 Zanker (2000) 223; Veyne (2002) 21.

241 Stewart (2003) 149.

242 Karlsgodt (2006). The final choice of the statues to be recycled was also based on the forecast of the impact that the destruction of one or another statue could have on the population (so in the same central directives by the Education Minister Abel Bonnard).

243 For an analysis on the fate of honorific monuments in modern societies and on the attitude towards forms of celebration perceived as politically inadmissible or simply out of fashion, see Levinson (1998). Think also of protests, not only by right-wing groups, at the removal of the Stele of Axum in Rome in 2005, a monument virtually ignored by the inhabitants for almost 70 years; or the very recent debate on the opportunity to destroy Franco's images and symbols in Spain.

244 Amm. Marc. 28.6.4.

deciphered the ancient inscriptions on the architraves of ancient buildings and read on their walls the memory of some recent restorations. And, certainly, he would have seen many statues. But these were not all of those whose dedication text we can now read in the *Inscriptions of Roman Tripolitania*. In the mid-4th c., in fact, the heritage of scripts on display included only a fraction of the inscriptions of various kinds produced in the first three centuries of the city's history. The old areas had been gradually robbed of their statue heritage; other monuments had been removed from places that people no longer frequented. Of the enormous quantity of statues and epigraphic writings generated in the Antonine and Severan age, a substantial nucleus certainly still survived, mostly concentrated in the theatre and in the Old Forum. This square was largely 'depoliticised': the arrival of the *praeses* had obscured the role of the *ordo decurionum* and had determined the shift of the centre of power from the *curia* to the area where the representative of the emperor worked (probably the Severan complex). When the old, large basilica on the southern side of the square collapsed, a portico was erected in its place: this act reflects the loss of importance of the Old Forum as a centre of political-judicial activity and its transformation into a representative space.

During the 4th c., as Christianization progressed, the temples on the opposite side were also gradually abandoned. Thus, the Old Forum ended up being transformed into a sort of museum. Without significant contributions of new images, which would have required a reuse of the old ones and would have upset the physiognomy of the statuary heritage, the Old Forum, although probably already partly looted, essentially appeared as the product of an accumulation of centuries. The same cannot be said for the beating heart of the late city, the Severan Forum, with its annexed Basilica. Here, in the mid-4th c., it would not have been possible to admire many older statues, excepting those of Severan emperors or of a few other individuals who for some reason survived the frenetic pace with which this space changed, together with the changing needs of celebration. These meagre testimonies of a radiant past were in effect submerged by the overwhelming quantity of recent portraits, those that glorified the new, more effective protectors of the late antique *colonia*. Updating the gallery of these characters was an essential operation; but this did not happen by adding something new, but by 're-semanticizing' the statue monuments. The evolution of the landscape did not proceed by accumulation, but by selection, an incessant and ruthless selection.

Bibliography

Abbreviations

CDRAAS *Centro di Documentazione e Ricerca sull'Archeologia dell'Africa Settentrionale.*

CIL *Corpus Inscriptionum Latinarum.* (1863-).

IC Guarducci M. ed. (1935–1950) *Inscriptiones Creticae*, 4 vols. (1935–1950).

IK *Inschriften griechischer Städte aus Kleinasien.* (1972-).

ILAlg Gsell S. ed. (1957) *Inscriptions latines de l'Algérie* 1. (1922); *Inscriptions latines de l'Algérie* 2, H.- G. Pflaum ed. (1957).

ILS Dessau H. (1892–1916) *Inscriptiones Latinae Selectae.* (1892–1916).

ILTun Merlin A. ed. (1944) *Inscriptions latines de la Tunisie.* (Paris 1944).

IRT Roueché C. M., Bodard G., and Vagionakis I. (2009) *Inscriptions of Roman Tripolitania* http://inslib.kcl.ac.uk/irt2009/; Reynolds J. M., Roueché C. M., Bodard G., Barron C. *et al.* (2021) *Inscriptions of Roman Tripolitania 2021* http://irt2021.inslib.kcl.ac.uk.

RIT Alföldy G. ed. (1975) *Die römischen Inschriften von Tarraco.* (Berlin 1975).

Tantillo/Bigi Tantillo I. and Bigi F. edd. (2010) *Leptis Magna. Una città e le sue iscrizioni in epoca tardoromana.* (Cassino 2010).

Primary Sources

Amm. Marc. = J. C. Rolfe, *Ammianus Marcellinus*. (Loeb Classical Library). (Cambridge Mass. 1939–1950).

Apul. *Flor.* = C. P. Jones ed. and transl. *Apuleius, Apologia, Florida, De Deo Socratis.* (Loeb Classical Library 534). (Cambridge Mass. 2017).

Aul. Gell. = J. C. Rolfe transl., *Aulus Gellius, Attic Nights*. (Loeb Classical Library 27). (Cambridge Mass. 1927).

Cass. Dio = E. Cary transl. *Cassius Dio, Historia Romana*. (Loeb Classical Library). (Cambridge Mass. 1914–1927).

Cic. *Att.* = D. R. Shackleton Bailey ed. and transl. *Cicero. Letters to Atticus, Volume I.* (Loeb Classical Library 7). (Cambridge Mass. 1999).

Cic. *Verr.* = L. H. G. Greenwood transl. *Cicero. The Verrine Orations Volume I: Against Caecilius. Against Verres, Part 1; Part 2, Books 1–2.* (Loeb Classical Library 221). (Cambridge Mass. 1928).

Dio Chrys. *Or.* = J. W. Cohoon and H. Lamar Crosby transl. *Dio Chrysostom. Discourses 31–36.* (Loeb Classical Library 358). (Cambridge Mass. 1940).

Favorinus, *Corinthian Oration* = Dio Chrys., *Or.* 37 = H. Lamar Crosby transl. *Dio Chrysostom. Discourses 37–60.* (Loeb Classical Library 376). (Cambridge Mass. 1946).

Hdn. = C. R. Whittaker transl. *Herodian, History of the Empire*. (Loeb Classical Library). (Cambridge Mass. 1969–1970).

Livy, *Epit.* = J. C. Yardley ed. and transl. *Livy. History of Rome, Volume XI: Books 38–40*. (Loeb Classical Library 313). (Cambridge Mass. 2018).

Plin. HN = H. Rackham transl. *Pliny. Natural History, Volume IX: Books 33–35*. (Loeb Classical Library 394). (Cambridge Mass. 1952).

Plut. *Vit. Ant.* = B. Perrin transl. *Plutarch, Lives*. (Loeb Classical Library). (Cambridge Mass. 1923).

SHA *Elag.* = D. Magie transl. *Scriptores Historiae Augustae*. (Loeb Classical Library). (Cambridge Mass. 1921–1932).

Suet. *Calig.* = J. C. Rolfe. transl. *Suetonius. Lives of the Caesars, Volume I: Julius. Augustus. Tiberius. Gaius. Caligula*. (Loeb Classical Library 31). (Cambridge Mass. 1914).

Suet. *Tib.* = J. C. Rolfe. transl. *Suetonius. Lives of the Caesars, Volume I: Julius. Augustus. Tiberius. Gaius. Caligula*. (Loeb Classical Library 31). (Cambridge Mass. 1914).

Symm. *Ep.* = O. Seeck edition, *Symmachus, Epistulae*. (1883).

Tac. *Ann.* = C. H. Moore and J. Jackson transl. *Tacitus. Histories: Books 4–5. Annals: Books 1–3*. (Loeb Classical Library 249). (Cambridge Mass. 1931).

Secondary Sources

Alchermes L. (1994) "*Spolia* in Roman cities in the Late Empire: legislative rationales and architectural reuse", DOP 48. (1994) 167–78.

Alföldy G. (1979) "Bildprogramme in den römischen Städten des Conventus Tarraconensis. Das Zeugnis der Statuenpostamente", in *Homenaje a García Bellido* 4. (Madrid 1979) 177–275.

Anguissola A. (2004) "Note alla legislazione su spoglio e reimpiego di materiali da costruzione ed arredi architettonici, I sec. a.C.-VI sec. d.C.", in *Senso delle rovine e riuso dell'antico*, ed. W. Cupperi. (Pisa 2004) 13–29.

Apollonj B. M. (1936) *Il foro e la basilica Severana di Lepcis Magna*. (Rome 1936).

Aurigemma S. (1928–1929) "Mosaici tra l'uadi Lebda e il circo", *AfrItal* 2. (1928–1929) 246–261.

Aurigemma S. (1940) "Sculture del foro vecchio di Lepcis Magna raffiguranti la dea Roma e principi della casa dei Giulio- Claudi. (pubblicazione provvisoria)", *AfrItal* 8. (1940) 1–94.

Aurigemma S. (1950) "L'avo paterno, una zia ed altri congiunti dell'imperatore Severo", *QAL* 1. (1950) 59–77.

Balty J.-Ch. (1991) *Curia ordinis. Recherches d'architecture et d'urbanisme antiques sur les curies provinçales du monde romain*. (Brussels 1991).

Bartoccini R. (1925–1926) "Il recinto giustiniano di Lepcis Magna", *Rivista della Tripolitania* 2. (1925–1926) 63–73.

Bartoccini R. (1929) *Le terme di Lepcis*. (*Lepcis Magna*). (Bergamo 1929).

Barton I. M. (1977) "The inscriptions of Septimius Severus and his family at Lepcis Magna", in *Mélanges offerts à L. Sédar Senghor*. (Dakar 1977) 3–12.

Benoist S. and Daguet-Gagey A. edd. (2007) *Mémoire et histoire: les procédures de condamnation dans l'Antiquité romaine*. (Metz 2007).

Benoist S. and Daguet-Gagey A. edd. (2008) *Un discours en images de la condamnation de mémoire*. (Metz 2008).

Benoist S. and Lefebvre S. (2007) "Les victimes de la damnatio memoriae: méthodologie et problematiques", in XII *Congressus internationalis epigraphiae Graecae et Latinae, Barcelona* 2002. (Barcelona 2007) 133–40.

Bergmann M. (1977) *Studien sur römischen Porträt des 3. Jahrhunderts n. Chr.* (Bonn 1977).

Bergmann M. and Zanker P. (1981) "Damnatio Memoriae: Umgearbeitete Nero- und Domitiansporträts. Zur Ikonographie der flavischen Kaiser und des Nerva", *Jahrbuch des Deutschen Archäologischen Instituts* 96. (1981) 317–412.

Bianchi Bandinelli R., Vergara Caffarelli E., and Caputo G. (1964) *Lepcis Magna*. (Milan 1964).

Bianchi F. (2005) "La decorazione architettonica in pietra locale a Lepcis Magna tra il I e il II sec. d.C. Maestranze e modelli decorativi nell'architettura pubblica", *ArchCl* 56. (2005) 189–223.

Bigi F. (2010) "I supporti epigrafici: tipi, decorazioni, cronologie", in *Lepcis Magna. Una città e le sue iscrizioni*, edd. Tantillo I. and Bigi F. (Cassino 2010) 219–50.

Blanck H. (1969) *Wiederverwendung alter Statuen als Ehrendenkmäler bei Griechen und Römern*. (Rome 1969).

Brandenburg H. (1989) "Die Umsetzung von Statuen in der Spätantike", in *Migratio et Commutatio. Studien zur alten Geschichte und deren Nachleben. Th. Pekáry zum 60. Geburstag*, edd. H.-J. Drexhage and J. Sünskes. (St. Katharinen 1989) 235–46.

Brenk B. (1987) "*Spolia* from Constantine to Charlemagne: aesthetics versus ideology", DOP 41. (1987) 103–109.

Brenk B. (1996) "Spolien und ihre Wirkung auf die Ästhetik der Varietas. Zum Problem alternierender Kapitelltypen", in *Antike Spolien in der Architektur des Mittelalters und der Renaissance*, ed. J. Poeschke. (Munich 1996) 49–92.

Caputo G. (1987) *Il teatro augusteo di Lepcis Magna. Scavo e Restauro. (1937–1951)*. (Rome 1987).

Chastagnol A. (1960) *La Préfecture urbaine à Rome sous le Bas-Empire*. (Paris 1960).

Coarelli F. (1999) "L'edilizia pubblica a Roma in età tetrarchica", in *The Transformations of Urbs Roma in Late Antiquity*, ed. W. V. Harris. (Portsmouth 1999) 23–33.

Coates-Stephens R. (2001) "Muri dei bassi secoli in Rome: observations on the re-use of statuary in walls found on the Esquiline and Caelian after 1870", *JRA* 14. (2001) 217–38.

Coates-Stephens R. (2002) "Epigraphy as *spolia*. The reuse of inscriptions in Early Medieval buildings", BSR 70. (2002) 275–96.

Coates-Stephens R. (2007) "The reuse of ancient statuary in late antique Rome and the end of the statue habit", in *Statuen in der Spätantike*. (Spätantike – Frühes Christentum – Byzanz B23), edd. C. Witschel and F. A. Bauer. (Wiesbaden 2007) 171–87.

Deichmann F. W. (1975) *Die Spolien in der spätantiken Architektur*. (Munich 1975).

Di Vita A. (1982) "Il progetto originario del « Forum novum Severanum » a Lepcis Magna", in *150-Jahr-Feier Deutsches Archäologisches Institut. Ansprachen und Vorträge. Rom 1979*. (Mainz 1982) 84–106.

Di Vita A. (1990) "Sismi, urbanistica e cronologia assoluta. Terremoti e urbanistica nelle città di Tripolitania fra il I secolo a.C. ed il IV d.C.", in *L'Afrique dans l'Occident Romain, Ier siècle av. J.-C.-IVe siècle ap. J.-C., Actes du Colloque, Rome 1987*. (Rome 1990) 425–94.

Di Vita A. and Livadiotti M. edd. (2005) *I tre templi del lato nord-ovest del Foro Vecchio a Lepcis Magna*. (Rome 2005).

Di Vita-Evrard G. (1981) "Le proconsul d'Afrique polyonyme IRT 517: une nouvelle tentative d'identification", MEFRA 93. (1981) 183–226.

Dubouloz J. (2003) "Formes et enjeux de la gestion quotidienne du territoire urbain dans la cité tardive", *Cahiers du Centre Gustave-Glotz. Revue reconnue par le CNRS* 14. (2003) 99–114.

Eck W. (1992) "Onori per persone di alto rango sociopolitico in ambito pubblico e privato", in Eck. (1996) 299–318. (=*Ehrungen für Personen hohen soziopolitischen Ranges im öffentlichen und privaten Bereich*, in *Die römische Stadt im 2 Jahrhundert n.Chr., Kolloquium Xanten 1990*, edd. H.-J. Schalles, H. Von Hesberg, and P. Zanker. (Cologne 1992) 359–76.

Eco U. (1999) "Riflessioni sulle tecniche di citazione nel medioevo", in *Ideologie e pratiche del reimpiego nell'alto medioevo. Settimane di Studi del Centro Italiano di Studi sull'Alto Medioevo* 46. (Spoleto 1999) 461–84.

Ensoli Vittozzi S. (1994) "*Forum novum Severanum* di Lepcis Magna: la ricostruzione dell'area porticata e i clipei con protomi di Gorgoni e 'Nereidi'", *L'Africa romana* 10. (1994) 719–52.

Feissel D. (1984) "Notes d'épigraphie chrétienne. (VII)", *Bulletin de correspondance hellénique* 108. (1984) 545–79.

Floriani Squarciapino M. (1966) *Lepcis Magna*. (Basel 1966).

Flower H. I. (2006) *The Art of Forgetting: Disgrace and Oblivion in Roman Political Culture*. (Chapel Hill 2006).

Giardina A. (1999) "Esplosione di tardoantico", *Studi storici* 40. (1999) 157–80.

Goodchild R. (1965) "The unfinished "Imperial" baths of Lepcis Magna", in *Libyan Studies. Select Papers of the Late R.G. Goodchild*, ed. J. Reynolds. (London 1976) 118–132. (=*LibAnt* 2. (1965) 15–27).

Hedrick Jr. C. W. (2000) *History and Silence. Purge and Rehabilitation of Memory in Late Antiquity*. (Austin 2000).

Horster M. (1998) "Ehrungen spätantiker Statthalter", *Antiquité tardive. Revue internationale d'histoire et d'archéologie* 6. (1998) 37–59.

Janvier Y. (1969) *La legislation du Bas-Empire romain sur les édifices publics*. (Aix-en Provence 1969).

Jucker H. (1981) "Iulisch-claudische Kaiser- und Prinzenporträts als 'Palimpseste'", *Jahrbuch des Deutschen Archäologischen Instituts* 96. (1981) 236–316.

Kajava M. (2003) "Inscriptions at auction", *Arctos* 37. (2003) 69–80.

Karlsgodt E. C. (2006) "Recycling French heroes: the destruction of bronze statues under the Vichy regime", *French Historical Studies* 29. (2006) 143–81.

Kinney D. (1997) "*Spolia*. Damnatio and renovatio memoriae", *MemAmAc* 42. (1997) 117–148.

Kleinwächter C. (2001) *Platzanlagen nordafrikanischer Städte. Untersuchungen zum sogenannten Polyzentrismus in der Urbanistik der römischen Kaiserzeit*. (Mainz 2001).

Kunderewicz C. (1971) "La protection des monuments d'architecture antique dans le Code Théodosien", in *Studi in onore di E. Volterra* IV. (Milan 1971) 137–53.

La Rocca A. (2005) *Il filosofo e la città. Commento storico ai Florida di Apuleio*. (Rome 2005).

Lahusen G. (1983) *Untersuchungen zur Ehrenstatue in Rom. Literarische und epigraphische Zeugnisse*. (Rome 1983).

Lefebvre S. (2007) "Condamnation de la mémoire et espace civique: pour une pédagogie du martelage en Afrique", in *Mémoire et histoire: les procédures de condamnation dans l'Antiquité romaine*, edd. S. Benoist and A. Daguet-Gagey. (Barcelona 2007) 195–213.

Lepelley C. (1979) *Les cités de l'Afrique romaine au Bas-Empire* I. (Paris 1979).

Lepelley C. (1981) *Les cités de l'Afrique romaine au Bas- Empire* II. (Paris 1981).

Levinson S. (1998) *Written in Stone: Public Monuments in Changing Societies*. (Durham 1998).

Liverani P. (2004) "Reimpiego senza ideologia. La lettura antica degli *spolia* dall'arco di Costantino all'età carolingia", RM 111. (2004) 383–433.

Machado C. (2006) "Building the past: monuments and memory in the Forum Romanum", in *Social and Political Life in Late Antiquity*, edd. W. Bowden, A. Gutteridge, and C. Machado. (Leiden and Boston 2006) 157–92.

Mastino A. (1981) *Le titolature di Caracalla e Geta attraverso le iscrizioni. (indici)*. (Bologna 1981).

Masturzo N. (2005) "Il tempio occidentale – il tempio di 'Liber Pater'", in *I tre templi del lato nord-ovest del Foro*

Vecchio a Lepcis Magna, edd. A. Di Vita and M. Livadiotti. (Rome 2005) 35–141.

Musumeci F. (1978) "Statuae in publico positae", *Studia et documenta historiae et iuris* 44. (1978) 191–203.

Niquet H. (2000) *Monumenta virtutum titulique. Senatorische Selbstdarstellung im spätantike Rom im Spiegel der epigraphischen Denkmäler*. (Stuttgart 2000).

Nista L. (1988) "*Ius imaginum* and Public Portraiture", in *Roman Portraits in Context: Imperial and Private Likenesses from the Museo Nazionale Romano*, edd. L. Nista and M. L. Anderson. (Rome 1988) 33–39.

Nollé J. (1993) *Side im Altertum: Geschichte und Zeugnisse* I. (Bonn 1993).

Nora P. (1984) "Entre mémoire et histoire", in *Les lieux de la mémoire* I, *La République*, ed. P. Nora. (Paris 1984) 7–49.

Parisi Presicce C. (1994) "L'architettura della via colonnata di Lepcis Magna", *L'Africa romana* 10. (1994) 703–718.

Pekáry Th. (1985) *Das römische Kaiserbildnis in Staat, Kult und Gesellschaft, dargestellt anhand der Schriftquellen*. (Berlin 1985).

Pentiricci M. (2010) "L'attività edilizia a Lepcis Magna tra l'età tetrarchica e il V secolo: una messa a punto", *Lepcis Magna. Una città e le sue iscrizioni*, edd. Tantillo I. and Bigi F. (Cassino 2010) 97–171.

Pernsabene P. and Panella C. (1993–1994) "Reimpiego e progettazione architettonica nei monumenti tardo- antichi di Roma", *RendPontAcc* 66. (1993–1994) 111–283.

Reynolds J. M. (1955) "Inscription of Roman Tripolitania: a supplement", *PBSR* 23. (1955) 124–47.

Ricciardi M. (2005) "Il tempio di Milk'Ashtart Ercole", in *I tre templi del lato nord-ovest del Foro Vecchio a Lepcis Magna*, edd. A. Di Vita and M. Livadiotti. (Rome 2005) 309–393.

Robert L. (1946) *Hellenica* II. (Paris 1946).

Rollin J. P. (1979) *Untersuchungen zu Rechtsfragen römischer Bildnisse*. (Bonn 1979).

Romanelli P. (1925) *Lepcis Magna*. (Rome 1925).

Roueché Ch. (2006) "Written display in the late antique and Byzantine city", in *Proceedings of the 21st International Congress of Byzantine Studies*, ed. E. Jeffreys. (Aldershot 2006) 235–54.

Scott K. (1931) "The significance of statues in precious metals in emperor worship", *TAPA* 62. (1931) 101–123.

Slootjes D. (2006) *The Governor and His Subjects in the Later Roman Empire*. (Leiden and Boston 2006).

Smith R. R. R. (1999) "Late antique portraits in a public context: honorific statuary at Aphrodisias in Caria, A.D. 300–600", *JRS* 89. (1999) 155–89.

Smith R. R. R. (2002) "The statue monument of Oecumenius: a new portrait of a late antique governor from Aphrodisias", *JRS* 92. (2002) 134–56.

Stewart P. (1999) "The destruction of statues in Late Antiquity", in *Constructing Identities in Late Antiquity*, ed. R. Miles. (London 1999) 159–89.

Stewart P. (2003) *Statues in Roman Society: Representation and Response*. (Oxford 2003).

Syme R. (1985) "Praesens the friend of Hadrian", *Roman Studies* V. (Oxford 1988) 563–78. (= *Studia in Honorem Iiro Kajanto*. (Helsinki 1985) 273–91).

Tantillo I. (2003) "L'impero della luce. Riflessioni su Costantino e il sole", *MEFRA* 115. (2003) 985–1048.

Tantillo I. (2010) "I costumi epigrafici. Scritture, monumenti, pratiche", in *Lepcis Magna. Una città e le sue iscrizioni*, edd. Tantillo I. and Bigi F. (Cassino 2010) 173–203.

Tantillo I. (2010) "Introduzione storica: la città di Lepcis Magna tra la metà del III e l'inizio del V secolo", in *Lepcis Magna. Una città e le sue iscrizioni*, edd. Tantillo I. and Bigi F. (Cassino 2010) 13–40.

Thomas Y. (20002) "La construction de l'unité civique. Choses publiques, choses communes, chose n'appartenant à personne et representation", *MEFRM* 114. (2002) 7–39.

Torelli M. (1973) "Per una storia della classe dirigente di Lepcis Magna", *Rendiconti dell'Accademia dei Lincei* 28. (1973) 377–410.

Varner E. R. (2004) *Mutilation and Transformation: Damnatio Memoriae and Roman Imperial Portraiture*. (Leiden 2004).

Veyne P. (2002) "Lisibilité des images, propagande et apparat monarchique dans l'Empire romain", *RHist* 304. (2002) 3–30.

Vittinghoff F. (1936) *Der Staatsfeind in der romischen Kaiserzeit: Untersuchungen zur Damnatio Memoriae*. (Berlin 1936).

Ward-Perkins J. B. (1993) *The Severan Buildings of Lepcis Magna. An Architectural Survey*. (London 1993).

Ward-Perkins J. B. and Goodchild R. G. (1953) "The Christian antiquities of Tripolitania", *Archaeologia* 95. (1953) 1–83.

Willer F. (1996) "Beobachtungen zur Sockelung von bronzenen Statuen und Statuetten", *BJb* 196. (1996) 337–70.

Zanker P. (2002) "Bild-Räume und Betrachter im kaiserzeitlichen Rom. Fragen und Anregungen für Interpreten", in *Klassische Archäologie. Eine Einführung*, edd. A.-H. Borbein, T. Hölscher, and P. Zanker. (Berlin 2000) 205–226. (Italian transl., *Spazi figurativi e forme di ricezione nella Roma imperiale. Questioni e suggerimenti per interpreti*, in *Un'arte per l'impero. Funzione e intenzione delle immagini nel mondo romano*, P. Zanker. (Milan 2002) 212–30).

Zelazowski J. (1999) "Honos bigae. Le statue onorarie romane su biga e le loro basi", in *XI Congresso internazionale di epigrafia greca e latina, Roma 1997*. (Rome 1999) 881–89.

Zimmer G. (1989) *Locus datus decreto decurionum. Zur Statuenaufstellung zweier Forumsanlagen im römischen Afrika*. (Munich 1989).

Tombs and Spolia in City Walls

∴

Memorial and Oblivion in Late Antiquity: the Testimony of *Spolia* in City Walls

Luke Lavan

Abstract

The life and fate of tombs is perhaps just as significant as their creation and primary use. Some are quickly destroyed, others last for centuries, either passively tolerated or venerated. Often, it seems that tombs and funerary monuments exist in an awkward intermediate position, where they have a degree of protection, but are not actively cared for. The timing of their destruction can be studied via many types of *spolia* context. The analysis of late city walls seems to be a good place to start, as these are massive, increasingly well-dated, and known to contain significant quantities of funerary *spolia*. In this paper, I outline the potential and difficulties of undertaking such a study, investigating the nature of tomb *spolia* in city walls in comparative perspective, by making contrasts between sites and between tomb material and other types of *spolia* reused at the same time. This work tries to reconstruct something of the history of late antique urban landscapes by documenting different snapshots of spoliation, offered by different *spolia* contexts. In this, the reuse of funerary monuments seems to represent an obvious indicator of cultural change, although reality is often more complex, as detailed descriptions of city walls demonstrate. Incidentally, new dates and field observations are proposed for a selection of 82 fortifications across the late antique world.

Remembering and Forgetting

Whilst this book has so far focused on burial, the funerary process is certainly not the only aspect of memorial worthy of study. The life of funerary monuments during and beyond the active memory of the deceased is also a significant area of interest. We can study this through advanced cemetery archaeology, which reveals memorial meals, silting, or non-funerary reuse of structures, as many of the authors of this volume have shown. In fact, the surfaces of cemeteries contain many interesting deposits which were missed by early rough excavations, as 'overburden' was removed by machine. But we can also try to study the fate of funerary monuments, grave stelae, and sarcophagi through the record of reuse off-site, in other monuments, where independent dating evidence may be available. In these contexts of reuse, often massive masonry layers, the story of funerary memorial or respect for the dead, is mixed up with other aspects of the evolution of a city. One might find pieces of temples, or of civic buildings, or of honorific statues, alongside those of mausolea and sarcophagi. Here, one has the chance to see the fate of tomb monuments in relative terms. It is possible to assess the importance of such monuments in relation to other structures, at the time a wall was constructed. It is easy to fall into exaggerated responses to seeing reused blocks, especially those carved to a high degree, set within the walls of seemingly functional late antique fortifications. Does the appearance of funerary monuments within a city wall show disregard for the memory of the dead or even Christianisation? Does the use of statue monuments in walls imply a decline in the appreciation of classical art? Does the use of temple *spolia* indicate religious iconoclasm? All these reactions are understandable, but we would do well to resist simplification and look more objectively at the testimony of *spolia* contexts, within and between different cities.

Spolia: an Introduction

There have been many articles exploring the definition of *spolia*, a term originally intended to describe spoils of war, which might in some (rare) cases have included architectural elements such as statues and perhaps veneers, taken from a defeated city, as if stripped from an enemy's corpse.[1] Now the word is commonly used to describe all reused architectural blocks, or those with some recognisable architectural decoration. Here, I distinguish decorated *spolia* within wider 'reused material', except when talking at generic level.[2] *Spolia* studies have often focused on supposedly meaningful reuse of specific blocks in new monuments (trampling on the memory of others, appropriating their treasures) or on the fate of individual buildings, which one can trace from distinctive decoration, or one hopes, by measuring

1 Articles exploring definitions of *spolia*: Uytterhoeven (2018) with further references. On the term *spolia* in literary sources: Coates-Stephens (2003) 314–37.
2 On the differences behind the two terms *spolia* and 'reused material', see Kinney (2011).

individual blocks to match them to their point of origin.³ Some have also studied the process of spoliation, as a series of technological or economic acts: via physical traces of dismantling, via the inscriptions of handlers found on columns or statues, via financial accounts left in papyri, or via the remains of marble dumps and workshops which specialised in cutting up blocks into thin veneers.⁴

However, archaeological traces of spoliation extend beyond the monuments themselves into the contextual analysis of the layers into which blocks were incorporated. Through these contexts, when combined with a study of what has not been spoliated, we can investigate the choice of monuments demolished for acts of construction and so obtain insights on the condition of urban landscapes as a whole. I have sought to outline this method elsewhere, but here I would, above all, stress its comparative, even quantitative, potential. This is especially true when we deal with massive *spolia* contexts, such as those found in some late antique city walls, where the construction of a fortification has been accompanied by very substantial acts of reuse and demolition, necessitating perhaps a rethinking of urban priorities as different parts of cities now either needed to be cleared to allow a new structure or were targeted because they were either damaged or no longer deemed relevant. As we seek to determine the afterlife of tombs, the testimony of city walls and other late *spolia* contexts is potentially of great importance. From them, we can determine whether funerary monuments were respected, honoured, or obliterated, at different dates within the history of the late antique and post-classical city.

Spolia in Context

One of the greatest benefits of studying *spolia* in context is that it allows one to develop insights on the phasing of large-scale building activities within cities. It allows different pieces of masonry with a similar profile of reuse (in terms of piece size, condition, reworking, decoration, sorting, or material) to be attributed to similar phases, in the same way that one might be tempted to do with areas of the same colour of mortar or form of bricks. However, in this paper, drawing on the work of Douglas Underwood and Nick Mishkovsky, I wish to do something rather less demanding: to simply build up a rough *spolia* profile for different city walls, looking at monuments incorporated indirectly (with demolition) or directly (without demolition), and obvious targets left untouched. From the selected sites, we considered the following factors: the kinds of monuments sourced for *spolia* (tombs, memorials, and monumental structures from the civic core); the state of the city's monuments and *necropoleis* (destroyed, partially dismantled, incorporated, or wholly preserved); and the treatment of spoliated material within the context of fortifications (modification, visibility, and decorative use). Additionally, we considered whether incorporated structures retained any of their original function when they became part of a fortification. The hope of all this was not only to investigate the condition of late antique urban landscapes, but to go further and attempt to recognise attitudes at work in the spoliation and preservation of different structures, especially monumental tombs.

Processes of spoliation can be described as either: i) symbolic (passive or active), ii) utilitarian (comprehensive or opportunistic), or iii) a mixture of some of the above. *Symbolic spoliation*, when active, can involve iconoclasm, the destruction of a monument or stripping of its ornaments, in an act of war or religious desecration. Such happenings are difficult to identify in the archaeological record, and must have been very rare, although they undoubtedly did occur. *Symbolic spoliation* of a passive nature concerns an area or building that was previous considered sacred or semi-sacred suddenly or progressively loses these attributes, such as a religious sanctuary or cemetery. *Utilitarian spoliation* elides somewhat awkwardly with the previous explanation but involves a type of spoliation in which destruction of monuments closely follows the needs of construction. When comprehensive, it does not seem to involve symbolic targeting, as when a new wall destroys and reuses all structures in its path, in a functional manner. When opportunistic, the reuse of materials occurs in a haphazard way after they become available, often because a building is damaged in an act of destruction, or because a field of ruins is now available in which any material to hand can be taken. In the two papers that follow, a great deal of the spoliation is of the utilitarian comprehensive kind, although there are still choices to be explained, as when buildings are left and others are taken down. The first of the explanations figures far less, whilst the last is chronologically circumscribed.

3 For a recent overview of *spolia* studies, Frey (2016) esp. 9–44.
4 Inscriptions of handlers of building materials: at Rome on column from Temple of Mars of Forum of Augustus, and also known from a pillar of the Colosseum: Meneghini and Santangeli Valenzani (2004) 70–71 (not seen). Inscriptions of handlers of statues: Barker (2020). Dumps of marble for reuse, Arles: Heijmans (1991) 196–97, with Latour (1953); Ostia: Gering (2018); Laodicea: Şimşek (2013) 98. Veneer cutting: Thasos: Marc (2010); Laodicea: Şimşek (2013) 295 fig. 403.

Nonetheless, a great deal of attention will inevitably focus on building spoliation still deemed to be symbolic. There are some categories of building where demolition or disfigurement will always be a subject of interest, as for temples, political buildings, statue monuments, and of course tombs. Here, one always hopes to detect symbolic spoliation of an active nature. It might be highly significant if an altar or cult statue was removed, but the architectural frame remained intact. Elsewhere, we might see veneers removed for financial reasons, even while buildings continued to be repaired or inhabited in a structured manner. This can be seen from around 400 in plaza porticoes at Ostia and Rome, and, to a lesser extent, Nora.[5] For statue bases, reuse often involved cutting away the old inscription or replacing a marble plaque so that the earlier identity of the honorand was entirely removed.[6] These nuances require a high degree of attention that may escape us, unless the surrounding archaeological layers leave us clues, as they only tend to do when urban occupation was messy at the time blocks were taken. It is far easier to spot less subtle processes. Earthquakes leave shattered pieces of stone, whilst fires leave traces of burning. Either might be a good reason to demolish a monument. Utilitarian spoliation may leave artefactual traces of dismantling or clues in the way the material is later reassembled, where no effort is made to hide or emphasise controversial features. We might also be able to make reasonable deductions, identifying this process and that of passive symbolic spoliation through other evidence contained in masonry contexts. It is that which we will attempt here.

Spolia in Perspective?

It is necessary to point out, despite all the academic discussion expended on *spolia*, that much late antique building work, indeed the vast majority in most regions, was carried out in new-cut materials or in indistinct mixed material where reuse is not clear. Late fortifications in the Balkans and in parts of Africa may have little or no reused material, being instead built in brick or with ashlars. The history of late antique building is emphatically not the history of building in reused materials. In some places, the employment of reused material is for the outer face of a structure, visible or not, perhaps its gates, or for the quoins of a wall.[7] Elsewhere, it might be confined to invisible foundations, where large stone blocks might play a particular structural role, covered by a mass of new-cut material above. Some regions see comparatively little reuse, such as Syria,[8] or a balance between select *spolia* and more new-cut material, as in Cilicia.[9] Others build in new bricks or use large quantities of rubble in masonry, perhaps derived from spoil heaps of quarries active earlier. The reused bricks of Rome represent an exception rather than the rule, making up the overwhelming majority of building materials used here from the 4th c.[10] Even in Asia Minor, where the presence of reused material is striking, we notice that it is confined to certain classes of building, being absent from some even as it is capable of making up 100% of some civic secular buildings in the 5th and 6th c.[11]

Thus, we are on the road to more nuanced interpretations of spoliation, just as earlier scholars sought to broaden interpretations of the meaning of reuse of specific blocks in new buildings. This is not to say that we will never identify instances of symbolic spoliation. I believe this can be assessed by the way blocks are placed, if they are undisguised, defaced, broken, or set into new sacral contexts, just as other forms of spoliation can be recognised by their own traits. What is essential here is that we consider a full range of possible motivations for spoliation practice and *spolia* construction, that put us as close as we can get to the immediate on-the-ground decisions of architects and builders, which is what the

5 Veneers etc. removed then buildings continued to be repaired or embellished: Ostia: Lavan (2020) with appendix V4b, citing Lavan (2018) (phase 7, reinforcement piers to combat earthquake of 443?, after stripping of veneer). Rome (Forum of Caesar): 5th late phase, stripping of the paving in two tabernae on the south-west side of the forum, before occupation by artisans in 400–425: Corsaro, Delfino, de Luca and Meneghini (2013) 127–31. Nora: Ghiotto (2009) 361–66 (Nora, where well-ordered room built in part of portico after stripping of paving in 5th c.).

6 On epigraphic reuse, in Italy: Machado (2017); in Lepcis Magna: Tantillo and Bigi (2010).

7 Reused material employed for outer face of walls: Aphrodisias: De Staebler (2008) 289–94 reused material laid as pseudo-isodomic masonry outside); Sagalassos (around north-west gate): L. Lavan site observation 2006 plus Loots, Waelkens and Depuydt (2000) 619–25 with esp. 617 figs. 21–22.

8 Building in new-cut material, for Syria, see e.g. Bostra seems to be new cut material in its late antique buildings, with some exceptions: Dentzer-Feydy, Vallerin and Fournet (2007) (exceptions: 34, 41, 44 in churches and shops). In new cut building material in the Syrian countryside: Tate (1992).

9 Building in new-cut material, for Cilicia, see Anazarbus which sees building featuring plenty of reused as well as new cut material, used carefully, some imitating *spolia* blocks. Neighbouring cities have similar building work: Posamentir (2011) 210–12. Alahan however, is overwhelmingly new cut material: Gough and Gough (1985).

10 Reused bricks of Rome: Heres (1982) 34, 128–29 (although the examples from Ostia are now uncertain in their chronology). Santangeli Valenzani (2007) 433–49, esp. 441, 444.

11 Asia Minor, uneven use of *spolia* in civic vs domestic buildings: e.g. Sagalassos: Lavan (2013a) 76.

recent case studies of Frey have invited us to do.[12] It is this perspective on reuse that is needed, rather than those held by writers of the late antique age, whose limited remarks on *spolia* might not be as significant in explaining change as we first thought they were. A good place to start is fortifications, as these often represent the largest '*spolia* contexts' known. Of course, there are plenty of limitations to understanding reuse from the primary evidence. Important structures that contain *spolia* may no longer exist and survive only on a few photos. Others are only investigated by survey, so that no-one knows about the *spolia* preserved in foundations, and only superficial impressions exist of what is contained within a wall. But despite all this, a preliminary study is useful to get a general grip on the subject before more detailed investigations.

Methodology

It is not easy to do a rigorous study of any cross-regional problem without falling into difficulties over permits. However, it is not currently illegal to think critically about the late antique city in any jurisdiction, so long as one confines one's access on sites to areas open to visitors, or to documentation that is already in the public domain. This is how all new primary observations on *spolia* have been made for this article: from tourist photographs without scales, taken by us in person or drawn from the internet, or from photos in formal publications. More detailed studies, of precise moulding measurements, epigraphic readings, and micro-stone analysis are to be commended. Nonetheless, wider patterns of spoliation can only be studied at some distance, obviating the permissions necessary for more detailed work. Our research, which also depends significantly on the publications of others, involved exploring a number of questions. We looked initially at the state of a city's *necropoleis* – to judge whether they were destroyed, partially dismantled, incorporated, or wholly preserved, when city walls arrived. This led us to ask, firstly: what funerary structures were incorporated wholesale, and if they lost or retained their original functionality. How did this compare to the fate of other structures set within fortifications? Secondly, the nature of spoliation was catalogued: the quantity and chronology of tombstones found in the wall, the presence or absence of sarcophagi, whether grave materials were used exclusively, or were there other types of *spolia* present as well, like statues, altars, or remains of civic buildings. Thirdly, a further set of questions were asked about the condition of the *spolia*: whether it was broken before going into the wall,

TABLE 1 Patterns of *spolia* incorporation, spoliation, and condition within 82 late antique city walls.

	Incorporation in walls	01 Mausolea	02 Temples	03 Arches	04 Baths	05 Aqueduct	06 Entertainment Buildings	06 Other large buildings	07 Defensive Circuits, Old	08 Major mons left outside	Spoliation by walls	01 Mausolea	02 Tombstones	03 Temples	04 Altars/Religious Dedications
Sites															
West	40	1	0	3	0	1	5	5	4	19		4	20	2	8
%		2.5		7.5		2.5	12.5	12.5	10	47.5		10	50	5	20
East	42	3	2	4	7	1	9	7	14	24		11	15	4	15
%		7.1	4.8	9.5	16.7	2.4	21.4	16.7	33.3	57.1		26.2	35.7	9.5	35.7
Total	82	6.5	2	14.5	7	4.5	26.5	24.5	28	90.5		25	85	11	43

12 On-the-ground decisions of architects and builders: Frey (2016) esp. 185–93.

or cut down, and how it was displayed – buried in the foundations, placed on the wall skin with face hidden, or fully displayed, potentially as decoration.

Results

The two papers that follow, by Underwood and Mishkovsky, and the gazeteers by Underwood and myself, present an overview of spoliation and preservation decisions involved in the construction of city walls, with a particular but not exclusive concentration on funerary monuments. The data is tabulated in summary in Table 1 and in detail in Table 2, at the end of this article. It is hoped that the broader focus on all monuments, spoliated or preserved, will generate something of a comparative perspective on the 'architectural victims' of such disruption. Of course, what is really needed is a parallel study of *spolia* contexts from civic buildings and from churches, so that we can also see city walls in comparative perspectives as 'agents' of disruption. But this cannot be achieved here, for various reasons. Firstly, the dating of late antique churches is notoriously poor in many regions. Secondly, churches and civic repairs involve a vast number of contexts whilst city walls included here represent very large contexts built at a single time of which we have a reasonably good chance of dating. The essential results of both studies are presented in the tables below. They do of course represent a crude record: an attempt to produce quantitative data from what is a selection of sites. The tables also record the simple incidence of preservation, *spolia*, or *spolia* treatment within a wall. They do not record the absolute quantity of materials from tombs and other sources in different walls, by number or by volume of stone. Despite all of this, some interesting patterns do emerge, that are worth commenting on, as preliminary reflections on what can now be known. These can be embroidered with some insights on reuse drawn from outside this study.

To start with the question of greatest interest: were funerary monuments considered more expendable than other structures when building late antique city walls? To this question we can give a resounding 'yes' for the West, where 47.5% of walls studied contain reused tombstones. In contrast, for the East, 28.6% of walls contain such material, or only 17.5% when Macedonia and the northern Balkans are excluded. The spoliation of mausolea/funerary buildings is rarer in the West, known in only 17.5% of cases. It seems not to be in the East, with 28.6% of cases, but this reflects an exceptional concentration in two areas: Pannonia and south-western Asia

05 Statuary/Honorific Monuments	06 Arches	07 Entertainment buildings	08 Unspecified Buildings	Condition within walls	Preservation – broken	Preservation – whole	Modification – chipped off	Modification – cut down	Vis: foundations/lower	Visibility: insidewallfacing	Visibility: outwallfacing	Visibility – plastered	Visibility – as decoration
5	3	2	29		5	3	0	13	12	19	8	0	2
12.5	7.5	5	72.5		12.5	7.5		32.5	30	47.5	20	0	5
16	1	10	27		9	16	1	1	6	10	23	1	10
38.1	2.4	23.8	64.3		21.4	38.1	2.4	2.4	14.3	23.8	54.7	2.4	23.8
33.5	11.5	17	128.5		26.5	26.5	1	46.5	48	76.5	51	3.4	17

TABLE 2 Patterns of *spolia* incorporation, spoliation, and condition within late antique city walls. Details by site of 82 urban fortifications.

	Incorporation in walls	01 Funerary Buildings	02 Temples	03 Arches	04 Baths	05 Aqueduct	06 Entertainment Buildings	06 Other large buildings	07 Defensive Circuits, Old	08 Major mons left outside	Spoliation by walls	01 Funerary Buildings	02 Tombstones	03 Temples	04 Altars/Religious Dedications
W	40	1	0	3	1	1	5	5	4	20		7	19	1	8
%	%	2.5		7.5		2.5	13	13	10	48		18	48	2.5	20
E	42	3	2	4	8	1	9	7	15	24		12	12	4	14
%		7.1	4.8	9.5	17	2.4	21	17	33	57		29	29	9.5	33
All	82	4	2	7	9	2	14	12	19	44		19	31	5	22

Minor. It is almost absent elsewhere, as in the southern Balkans. Rome stands out in the West as having spoliated funerary buildings, in both phases of its walls examined here. 'Other structures' supplied material more often into city walls (in 64.3% and 72.5% of cases) than tombstones, with honorific statues (40.5%), altars (33.3%), and parts of entertainment buildings (21.4%) being frequently used in the East. Here stadia fell victim: whole at Thessalonica and Sagalassos, in part at Aphrodisias. Theatres too, were occasionally used, as at Xanthos. At both Aphrodisias and Xanthos, the upper tiers of the building were decapitated, permitting the lower parts to continue. The pattern in the West is different: entertainment buildings were not spoliated in anything like these percentages. Rather, they were incorporated complete within city walls. This is surprising, given the vast amount of stone such structures can contribute to wall building. The habit is perhaps a function of date, reflecting continued use rather than a strategic choice (as 'bastions'): the preservation of these buildings in walls tends to be 3rd c. and spoliation of them later 4th c. and after. Entertainment buildings also contribute to other types of *spolia* building, with, for example, theatre seats forming part of churches and streets at Stobi, and of a gymnasium portico at Ankara.[13]

It is notable that temples were only rarely spoliated for city walls, although the practice can be detected on a low level, at 2.5% for the West and 9.5% for the East. Here, whatever our instincts, we need to sit down and describe what the archaeology is telling us about preferences not only for demolition but also for incorporation. For the latter process, we can note that in both eastern and western parts, entertainment buildings were the favourite, at 21.4% and 12.5%, followed by other large buildings, old fortifications, arches, then funerary buildings, the last of which are only used in only 7.1% (E) and 2.5% (W) of cases respectively. The case of altars is worth revisiting, having been glossed over above. The vast majority seem likely to have been funerary altars. Whilst some can be confirmed as coming from non-funerary contexts, as at Aquileia, where the dedications make this clear, most either occur with funerary *spolia* or can be identified epigraphically as such, with one group of

13 Entertainment buildings used in other *spolia* contexts: at Stobi: Kitzinger (1946) 89, 99, 101, 113, 116–17, 152–53 plus L. Lavan site

observation with *spolia* from the theatre in a range of late building contexts, including churches, the 'synagogue', the colonnaded street porticoes, a path, a sigma plaza; at Ankara: stadium seats also used in the gymnasium portico as well as in the Lower City Wall (see appendix to this article); at Xanthos, the theatre seats were used to convert the theatre into an theatre amphitheatre as well as in the adjacent late 6th to early 7th c. wall on the Lycian Acropolis, although this may have been two separate interventions, the result of removing two parts of the same structure: L. Lavan site observation 2005.

05 Statuary/Honorific Monuments	06 Arches	07 Entertainment buildings	08 Other/unspec buildings	Condition within walls	Preservation – broken	Preservation – whole	Modification- chipped off	Modification – cut down	Vis: foundations/lower	Visibility: in wall facing but facing insidewall	Visibility: in wall facing but facing outwards	Visibility – plastered	Visiblity – as decoration
6	1	2	29	4	4	0		13	11	18	8	0	2
15	2.5	5	73	13	13			33	28	45	20	0	5
17	2	9	27	10	18	1		3	8	12	24	1	12
41	4.8	21	64	24	43	2.4		7.1	19	29	57	2.4	29
23	3	11	56	14	22	1		16	19	30	32	1	14

inscribed gladiator *stellae* from Aphrodisias, found in the city wall, also being shaped in the form of altars.[14] It is possible that such blocks were removed for religious reasons or because they were exposed to easy removal, or they were taken as part of cemetery clearance. We can note that their spoliation in the East (in 33.3 % of cases) almost matches that of tombstones, although it trails them in the West, perhaps because they were somewhat less common here. In some cases, we cannot be sure if an altar was distinctively funerary, but we should not jump to firm conclusions about what its spoliation signifies in religious terms, as accompanying spolia often suggests a funerary origin.

In terms of specific attitudes to funerary monuments, we can prove an important negative. Evidence seems to show that spoliation of tombs cannot be related to Christianisation: its dating is too early in both the West and the northern Balkans. Some cities with multiple circuits, like Verona in Italy, and Amphipolis, Dion, and Athens, show that it occurs in the mid-3rd c. but not later.[15] Eastern evidence shows a more conservative attitude to tombs here in Late Antiquity than in the West. Where mausolea are spoliated, the evidence from Aphrodisias reveals that sarcophagi tended to be spared, where funerary monuments were not. The same appears to be true of Sagalassos.[16] This suggests an awareness of legal prohibitions or local traditions, alongside a pragmatic ability to bend the rules where possible. It is perhaps worth remarking that funerary material seems to be absent from reconquest fortifications of Africa in 6th c., except in one case considered, although it had been present in the 4th c. wall of Lepcis. Can we see here Eastern practices coming to the West with the Reconquest? Or do we have an African sensibility that was different to the rest of the West? More work is obviously needed, given the small number of case studies. The treatment of specific tombstones and mausolea does not support the existence of any radical attitudes to de-sacralising the dead. Tombs were neither defaced nor appropriated in late antique building work, being rarely used as any kind of decorative scheme. Positive examples of such modifications are very rare and alterations are normally very functional. The western preference for

14 Aphrodisias, gladiator *stellae*: Kontokosta (2008) 192.
15 For a view that tomb spoliation in Italy not religiously motivated, see also Murer (2018).

16 Mausolea spoliated but sarcophagi not: Aphrodisias (relatively few fragments of sarcophagi, many funerary monuments, with some sarcophagi left unspoliated in the cemetery): De Staebler (2008) 312–13. Sagalassos: L. Lavan site observation 2006 (two likely funerary monuments, a few statue bases, no small sarcophagi as in some late walls within the city).

cutting down *spolia* and reusing it inside walls is clear. In contrast, there is an eastern preference for preservation of *spolia* pieces whole, used in the outer wall facing. Yet rarely is this done with any decorative coherence, and where it is, as with weaponry friezes, it has little to do with tombs.

There are other results worth commenting on. A greater percentage of eastern walls (42.9%, with the West on 12.5%) seem to have built their walls using unbroken *spolia* blocks. Broken blocks are especially prevalent in 3rd c. walls in the Balkans (Macedonia and Athens) and in parts of western Asia Minor, in two waves. These may reflect real episodes of catastrophe, although the predominant *spolia* building technique appears to be unhurried, with careful sourcing of undamaged stone. The use of *spolia* for decoration seems to be confined to the Aegean region, reaching into the cites of western Asia Minor, probably again reflecting a conservative attitude to the preservation of memory and monuments associated with a Greek culture which late antique civic communities still identified with. This can also be seen in the decision to turn the inscribed or decorated side of reused blocks outward to face the viewer, in 57.1% of cases in the East as opposed to 20% of cases in the West. Here, they tended to be turned inward in 45% of cases or set in the foundations in 27.5% of cases, in contrast to the East where *spolia* in the foundations is only recorded in 19% of cases and turned inward in 28.6%. As Frey has noted at Aegina,[17] this might result in inscriptions being displayed upside down, but even so, such displays seem to have been meaningful in some way, when compared to habits elsewhere. Plastering of city walls to cover *spolia* is known, as at Sardis, where the walls are covered in grey stucco scored with lines to imitate ashlar masonry.[18] However, this is very rare, perhaps from preservation as much as choice. In future, we need to look more for *spolia* blocks being cut down to provide a smooth wall face, which would in most cases be necessary to prepare a plaster surface and so reveals some of the same attitudes at work. The very low level of such modification in the East (7.1% as against 32.5% in the West) suggest that here reused blocks were indeed meant to be seen.

Conclusions

The impact of late antique city walls on cemeteries is far less than one might imagine. Changes can be seen in the West, although funerary *spolia* was not the first choice of material to be reused. In the East, however, city walls had very little impact on such monuments. Cemetery structures were generally left alone. The date of changes, even in the West, suggests no ideological destruction, no intentional desacralisation. This is especially clear in the East, where, despite a few well-known cases, mausolea were not commonly destroyed by walls, when compared with other structures. Rather, local pragmatic decisions were taken about what to demolish close to the line of a wall: it is unsurprising to find cemeteries or entertainment buildings prominent as *spolia* targets, given their location on the edge of settlements where fortifications ran. They were the victims of *comprehensive utilitarian spoliation*. The nature of specific demolition choices varied greatly between cities, as did decisions as to whether to display, disguise, or hide re-used materials. However, there was not necessarily much chronological variability in these choices before the 7th c. After that time, spoliation often looks like a free-for-all, *opportunistic utilitarian spoliation*, carried out amidst a field of ruins, as for the inner circuits of Sardis, Aphrodisias, and Amorium.[19] This means that the future of *spolia* studies must lie in detailed reports, city by city. We should avoid generalisations based on superficial impressions or plausible ideas. It seems likely that not only mausolea but also temples were not particularly targeted in any type of late antique construction. Furthermore, the vast majority of tombstone *spolia* ended up disguised or hidden in wall cores, neither visibly defaced nor in decorative re-use, whilst the preservation of tombs within the line of walls was not typical, despite the example of Palmyra.[20] Thus, we cannot rely on rhetoric, ancient or modern, on this topic. So often, the studies presented

17 Aegina, visible *spolia* inscription placed upside down, Frey (2016) 75–79, esp. 77.
18 Sardis, walls covered in grey stucco scored with lines to imitate ashlar masonry: Van Zanten, Thomas and Hanfmann (1975) 35–52.
19 Spoliation as free-for-all: Aphrodisias: the inner wall is composed of a great variety of spoliated materials, including statue monuments and seats taken from the adjacent tetrastoon square: Erim (1986) 35, 53, 120 with Lavan (2020) 351–52 drawing on Smith (1999) 125–36, 161–62, 168–70 and Smith (2001) 125–26 discussing ALA 20, 21, 62, and 212. In contrast, the later 4th c. city wall does not use materials from inside the city, except those under repair: De Staebler (2008) 312, 314; for Sardis and Amorium see the appendix to this article; at Sagalassos late encroachment walls over the street contain a lot of mixed up broken materials: Lavan (2008) 206; Lavan (2013) 79.
20 Preservation of tombs within the line of walls: at Palmyra where access to tombs was still possible: Juchniewicz, As'ad and al Hariri (2010) 58.

here disprove or discard hypotheses rather than support evidence of strong attitudes.

Further studies of *spolia* contexts from churches and civic public building will undoubtedly shed light on these same themes. However, it is rather the study of differential spoliation which will give us insights into the demolition choices made in constructing of city walls: we must consider not only those walls where destruction of tombs and other buildings took place but those where walls seem to respect earlier structures by leaving them untouched and in continuous occupation. This is particularly pertinent at sites in Asia Minor: Ephesus, Sagalassos, Xanthos, Side, Miletus, and Patara. For these sites, a new analysis of dating, contained in this article's appendix, reveals the 6th c. as a common time of construction rather than dates during the crises of the 7th c., preferred by Philip Niewöhner and James Crow.[21] These were fortifications which coexisted with the secular public buildings left outside their circuits, which their limited and highly structured use of reused materials suggests.[22] When spoliation for wall construction is studied alongside the buildings left intact outside of late city walls, we can testify to a desire to maintain the classical monumental heritage, often for far longer than we expected. This is a part of regional trend which I have identified in relation to the repair of agorai in the Aegean into the 6th c. and which Niewöhner believes continued in the deliberate preservation offered to many structures in this area in the Middle Byzantine period, explaining a higher degree of survival.[23]

Yet, for a comprehensive picture of the late urban attitudes to older structures, we must extend and integrate differential spoliation into other methods, notably into studies of building repair. Individual repairs tell us little, but horizons of rebuilding, after disasters, give a sense of which structures were most essential and which less. Many years ago, Zanker suggested that the speed of repair to monuments might also give us a source of information on public priorities towards different types of structures, noting that in AD 79 the work to repair political buildings at Pompeii was far advanced in comparison to that of the temples, following the earthquake of AD 62.[24] This same information should be available from stratigraphic sequences from earthquake-prone sites in the East, where seismic damage has been convincingly identified. It is certainly available for Sagalassos, where the earthquake of *ca.* 500 saw extensive rebuilding of most, if not all, secular public buildings.[25] When repair horizons are taken together with *spolia* contexts, we can construct a much richer impression of late antique urban landscapes. In the East, it was often earthquakes which dealt the most dramatic changes, not episodes of fortification. Wall building events were not necessarily comprehensively destructive. We now can get beyond superficial impressions that walls either mark the abandonment of a city's suburbs or that they represent the degradation of its monuments, including its cemeteries. In many cases, walls simply represent new additions to cities which did neither of these things.

Acknowledgements

For the sake of external evaluation, my contribution to this section of related papers on *spolia* has been to assemble and analyse the dating evidence for the fortifications in Africa and the East, to rework the data on Italy, especially Milan and Aquileia, to frame the questions asked, rework the findings, and interpret the results. I am very grateful for the parallel work of Douglas Underwood and Nick Mishkovsky and their useful suggestions, and to Simon Barker for reading the text and for his friendly bibliographic hints.

Bibliography

Barker S. (2020) "Reuse of statuary and the recycling habit of Late Antiquity: an economic perspective", in *Recycling and the Ancient Economy*. (Oxford Studies on the Roman

21 Fortifications in Asia Minor relating to Islamic invasions: Niewöhner (2010) 57–58 and Crow (2017) 94–97.

22 Walls respecting earlier buildings: at Ephesus: has very little *spolia*, with buildings outside (e.g. Marble Street) intact, but is dated by me formally to 550–612 (although informally to the 570s–580s), when areas outside the circuit were still being repaired, in Lavan (2020) vol. 2 appendix C3 (on the Arcadiane); at Sagalassos: Lavan (2013a) 81; Xanthos: City wall of later 6th to early 7th c. date contains seat from upper part of theatre but not lower part nor tomb monuments on adjacent agora; Side: Inner city wall coexists with tetragonal agora and theatre, which it does not appear to spoliate: L. Lavan site observation 2004. See the *gazetteer* on the East.

23 Aegean, respect and repair of agorai in 4th–6th c.: Lavan (2020) vol. 1. 279, 425, 445, drawing on chapters on civic squares. Respect of classical structures in Mid-Byzantine period, western Asia Minor: Niehwohner (2019).

24 Repair around forum of Pompeii, after earthquake of 62: Zancker (1988) 124–31.

25 Repair at Sagalassos, after earthquake of *ca.* 500, though not as much building as excavators would suggest: Lavan (2020) vol. 2 appendix A4a (levelling by north-west gate), C3 (north-south colonnaded street rebuild), H6 (fountains), F6 (fountain house), F7b (Agora Gate, Arch leaving Upper Agora), H3 (2 nymphaea, possible), J2 (Agora Gate staircase), S4 (porticoes), S5a (Lower Agora paving), S10a (sundial), plus Lavan (2013b) 294–96.

Economy), edd. A. Wilson and C. Duckworth. (Oxford 2020) 105–90.

Coates-Stephens R. "Attitudes to *spolia* in some late antique texts", in *Theory and Practice in Late Antique Archaeology*. (Late Antique Archaeology 1), edd. L. Lavan and W. Bowden. (Leiden 2003) 314–37.

Corsaro A., Delfino A., de Luca I., and Meneghini R. (2013) "Nuovi dati archeologici per la storia del Foro di Cesare tra la fine del IV e la metà del V secolo", in *The Sack of Rome in 410 AD. The Event, its Context and its Impact. Proceedings of the Conference held at the German Archaeological Insitute at Rome, 04–06 November 2010*, edd. J. Lipps, C. Machado, and P. von Rummel. (Wiesbaden 2013) 123–36.

Crow J. G. (2017) "Fortifications" in *The Archaeology of Byzantine Anatolia: from the End of Late Antiquity until the Coming of the Turks*, ed. P. Niewöhner. (New York 2017) 90–108.

De Staebler P. (2008) "The city wall and the making of a late antique provincial capital," in *Aphrodisias Papers 4: New Research on the City and its Monuments*. (JRA Supplementary Series 70), edd. C. Ratté and R. R. R. Smith. (Portsmouth, RI 2008) 284–318.

Dentzer-Feydy J., Vallerin M., and Fournet M. edd. (2007) *Bosra aux portes de l'Arabie*. (Guides Archéologiques de l'institut Français du Proche-Orient 5). (Amman 2007).

Erim K. (1986) *Aphrodisias: City of Venus Aphrodite*. (New York 1986).

Frey J. M. (2016) *'Spolia' in Fortifications and the Common Builder in Late Antiquity*. (Mnemosyne, supplements. History and Archaeology of Classical Antiquity 389). (Leiden and Boston 2016).

Gering A. (2018) "Marble recycling-workshops nearby the Temple of Roma and Augustus: an interim report of the Ostia-Forum-Project's working campaigns in 2013 and 2014", in *Ostia Antica. Nouvelles études et recherches sur les quartiers occidentaux de la cité. Actes du colloque international. Roma-Ostia Antica 22–24 settembre 2014*, edd. C. de Ruyt, T. Morard, and F. van Haeperen. (Brussels and Rome 2018) 23–30.

Ghiotto A. R. (2009) "Il complesso monumentale del Foro", in *Nora. Il foro romano. Storia di un'area urbana dall'età fenicia alla tarda antichità. (1997–2006). Vol.1. Lo scavo*, ed. J. Bonetto. (Padua 2009) 245–373.

Gough M. and Gough M. *Alahan: An Early Christian Monastery in Southern Turkey. Based on the Work of Michael Gough.* (Toronto 1985).

Heijmans M. (1991) "Nouvelles recherches sur les cryptoportiques d'Arles et la topographie du centre de la colonie", *RANarb* 24. (1991) 161–200

Heres T. (1982) *Paries. A Proposal for a Dating System of Late-Antique Masonry Structures in Rome and Ostia, AD 235–600*. (Amsterdam 1982).

Juchniewicz K., As'ad K., and al Hariri K. (2010) "The defense wall in Palmyra after recent Syrian excavations", *Studia Palmyreńskie* 9. (2010) 55–73.

Kinney D. (2011) "Introduction", in *Reuse Value – Spolia and Appropriation in Art and Architecture from Constantine to Sherrie Levine*, edd. D. Kinney and R. Brilliant. (Farnham 2011) 1–9.

Kitzinger E. (1946) "A survey of the early Christian town of Stobi", *DOP* 3. (1946) 83–161.

Kontokosta H. (2008) "Gladiatorial reliefs and elite funerary monuments at Aphrodisias" in *Aphrodisias Papers 4. New Research on the City and its Monuments*. (JRA Supplement Series 70), edd. C. Ratté and R. R. R. Smith. (Portsmouth, RI 2008) 190–229.

Latour J. (1953) "Le sanctuaire d'Auguste et les cryptoportiques d'Arles", *RA* 42. (1953) 42–51.

Lavan L. (2020) *Public Space in the Late Antique City*. (Late Antique Archaeology Supplement 5.1) 2 vols (Leiden 2020).

Lavan L. (2013a) "Distinctive field methods for Late Antiquity", in *Field Methods and Post-Excavation Techniques in Late Antique Archaeology*, edd. L. Lavan and M. Mulryan. (Leiden 2013) 51–90.

Lavan L. (2013b) "The agorai of Sagalassos in Late Antiquity. An interpretive study", in *Field Methods and Post-Excavation Techniques in Late Antique Archaeology*, edd. L. Lavan and M. Mulryan. (Leiden 2013) 289–353.

Lavan L. (2018) "Chronology in Late Antiquity: lessons from the Palaestra", in *Seminario Ostiense 21–22 Ottobre 2015. (École française de Rome)*. (Rome 2018) https://books.openedition.org/efr/3814.

Loots L., Waelkens M., and Depuydt F. (2000) "The city fortifications of Sagalassos from the Hellenistic to the late Roman period" in *Sagalassos V*, edd. L. Loots and M. Waelkens. (Leuven 2000) 619–25, figs. 21–22.

Machado C. (2017) "Dedicated to eternity? The reuse of statue bases in late antique Italy," in *The Epigraphic Cultures of Late Antiquity*, edd. K. Bolle, C. Machado, and C. Witschel. (Stuttgart 2017) 323–61.

Marc J.-Y. (2010) "Chronique des fouilles en ligne: Thasos, Macellum 2010" http://chronique.efa.gr/index.php/fiches/voir/1951/. (last accessed September 2015).

Meneghini R. and Santangeli Valenzani R. (2004) *Roma nell'altomedioevo – Topografia e urbanistica della città dal V al X secolo*. (Palermo 2004).

Murer C. (2018) "From the tombs into the city: grave robbing and the re-use of funerary *spolia* in late antique Italy," *Acta ad archaeologiam et artium historiam pertinentia* 30. (2018) 115–37.

Niewöhner P. (2019) "Byzantine preservation of ancient monuments at Miletus in Caria. Christian antiquarianism in Western Asia Minor", in *Die Weltchronik des Johannes*

Malalas im Kontext spätantiker Memorialkultur edd. J. Borsch, O. Gengler, and M. Meier. (Stuttgart 2019) 191–215.

Niewöhner P. (2010) "Byzantinische Stadtmauern in Anatolien. Vom Statussymbol zum Bollwerk gegen die Araber", in *Aktuelle Forschungen zur Konstruktion, Funktion und Semantik antiker Stadtbefestigungen*. (Byzas 10), edd. J. Lorenzen and F. Pirson. (Istanbul 2010) 239–60.

Posamentir R. "Anazarbos in Late Antiquity", in *Archaeology and the Cities of Asia Minor in Late Antiquity*. (Kelsey Museum Publications 6), edd. O. Dally and C. Ratté. (Ann Arbor 2011) 205–224.

Santangeli Valenzani R. (2007) "Public and private building activity in late antique Rome", in *Technology in Transition. AD 300–650*. (Late Antique Archaeology 4), edd. L. Lavan, E. Zanini, and A. Sarantis. (Leiden 2007) 435–49.

Şimşek C. (2013) *Laodikeia. (Laodicea ad Lycum)*. (Laodikeia Çalişmalari 2). (Istanbul 2013).

Smith R. R. R. (1999) "Late antique portraits in a public context: honorific statuary at Aphrodisias in Caria, A.D. 300–600", *JRS* 89. (1999) 155–89.

Smith R. R. R. (2001) "A portrait monument for Julian and Theodosius at Aphrodisias", in *Griechenland in der Kaiserzeit: Neue Funde und Forschungen zu Skulptur, Architektur und Topographie*, ed. C. Reusser. (Bern 2001) 123–36.

Tantillo I. and Bigi F. (2010) "Il reimpiego: le molte vite delle pietre di Leptis" in *Leptis Magna. Una città e le sue iscrizioni in epoca tardoromana*, edd. I. Tantillo I. and F. Bigi. (Cassino 2010) 253–302.

Tate G. *Les campagnes de la Syrie du Nord, du IIe au VIIe siècle*. (Paris 1992).

Uytterhoeven I. (2018) "*Spolia, -iorum*, n.: from spoils of war to reused building materials: the history of a Latin term", in *Spolia Reincarnated. Afterlives of Objects, Materials, and Spaces in Anatolia from Antiquity to the Ottoman Era*, edd. I. Jevtić and S. Yalman. (Istanbul 2018) 25–50.

Van Zanten D., Thomas R. S., and Hanfmann G. M. A. (1975) "The city walls" in *A Survey of Sardis and the Major Monuments Outside the City Walls*, edd. G. M. A. Hanfmann and J. C. Waldbaum. (Cambridge Mass. 1975) 35–52.

Zanker P. (1988) *Pompeji: Stadtbilder als Spiegel von Gesellschaft und Herrschaftsform*. (Mainz 1988), read in translation as Zanker P. (1998) *Pompeii: Public and Private Life*. (Revealing Antiquity 11). (Cambridge Mass. and London 1998).

The Destruction, Preservation, and Adaptive Reuse of Funerary Monuments within Urban Fortifications in Late Antiquity: the West

Douglas Underwood

Abstract

The spoliation of Classical-era tombs became an increasingly widespread practice in Late Antiquity, and many newly-built monuments in late antique cities were constructed, in some part, with this *spolia*. However, little attention has been given to the intersection of *spolia* with the most substantial construction project in late antique cities, city walls. This paper puts forward a new approach to survey the quantity of reused sepulchral material incorporated in walls and how it was displayed in order to explore the impact wall construction had on cemeteries in Late Antiquity and the relationship of the late antique city to its ancient dead.

Introduction

In the 8th c., an uncertain author – possibly Paul the Deacon – composed a poem about the destruction of the city of Aquileia in the 5th c. by Attila the Hun. While the whole of the poem is important for what it shows about the Early Medieval view on the decline of Roman cities and catastrophes of the previous 300 years, one section stands out for its illumination of these points. Verses 14 to 19 lament the heights from which the city has fallen: "Beautiful, exalted, rich and eminent, you were once famous for your buildings, renowned for your walls, but more renowned for your countless throngs of citizens […] You are put up for sale everywhere throughout the world / nor is there rest even for those buried in you / soon their bodies are cast out of the tombs for the sake of their marble which is bartered."[1] Here the poet describes a scene in order to highlight the depths of indignities which the city has suffered – in an ultimate act of desecration, bodies were ejected from their tombs, which were despoiled and traded. The act of recovering, selling, and reusing the marble with which tombs were built indicates an utter dishonour for Aquileia, which had previously been outstanding, renowned for its city walls.

This passage thus draws together (albeit somewhat superficially) two key phenomena in the development of late antique urbanism, spoliation and city walls.[2] The practice of spoliation was not exclusive to Late Antiquity;[3] however, it did become considerably more common in frequency and pronounced in terms of the visibility of reused elements.[4] Similarly, urban fortifications are known from the Hellenistic and Classical eras; yet, in Late Antiquity walls became a critical defence in an increasingly troubled period. While both phenomena have been studied to some degree individually, considerably less attention has been given to their intersection, with the exception of two recent regional studies by Greenhalgh and Frey.[5] This is a missed opportunity, especially given that *spolia* compose a substantial part of the masonry of many (but not all) late antique fortifications.[6]

The following two papers seek to explore the intersection of these two important markers of late antique urban development, specifically through one subset of *spolia*, the use of which so incensed the 8th c. poet – grave materials. The two consecutive papers, one covering the western half of the Late Roman Empire and one covering the East, are the result of a preliminary research collaboration between the authors to explore the potential utility of documenting, categorising and analysing the intersection between tombs and city walls, as they were linked through the process of spoliation. By suggesting a new approach to study these two distinct, yet connected, monuments, they aim to shed light on both as well as the impact wall construction had on cemeteries in Late Antiquity. These papers are an initial application of that new framework, with an aim to further develop this project going forward, as there is great

1 Translated in Godman (1985) 107–11.

2 The literature on these topics is too vast to summarise here, but for walls, see Johnson (1983); Garmy and Maurin (1996); Christie (2001); Fernández-Ochoa and Morillo (2005); Dey (2010); for *spolia*: Krautheimer (1961); Deichmann (1975); Kinney (2006) 240ff; Brilliant and Kinney (2011); Coates-Stephens (2001) and (2002).

3 For a good example of an early example of a similar practice, see Frey (2015).

4 Underwood (2013) 405.

5 Frey (2016).

6 A limitation – one that will be encountered here, and certainly hinders the field broadly – is that it is often difficult to identify specific monuments from *spolia* fragments, thereby limiting what can be said about their origin and patterns of reuse, to say nothing about the more ubiquitous problems of survival, scientific excavation and published documentation.

FIGURE 1 Cities in the West with Early Imperial walls.
AUTHOR, WITH DATA FROM JOHNSON (1983)

potential here for novel conclusions about *spolia* and tombs in addition to memorialisation and cultural attitudes towards the dead in Late Antiquity. In the present paper, some introductory evidence for funerary monuments and sarcophagi in the West that were demolished to make way for walls will be explored and some trends in the ways in which they were incorporated into them laid out (the following paper by Nick Mishkovsky will largely explore the same topic, but focusing on the data from the East). It will start with a brief outline for the two monuments, walls and tombs, in the west separately, before looking at the legal context for both. It will then put forward a methodology for exploring the overlap between the two monuments, along with a broad overview of the data collected from around the West will be presented along with a handful of case studies in order to survey both the macro- and micro-patterns in the reuse of tombs in walls.

Walls in the Late Antique West

During the Early Roman Empire, city walls were built around a comparably small handful of cities in the west, particularly colonies and others with an elevated rank (Fig. 1).[7] Republican and Early Imperial city walls were essentially markers of status and of a new Roman urban form, and in many ways a projection of a new Roman hegemony.[8] They tended to be large in circumference, sometimes much larger than the new settlement, and imposing on the visual landscape.[9] However, they were, for the large part, not necessary for safety and security of the cities they surrounded especially as the strength of the Roman Empire gradually brought stability to the western Mediterranean over the 1st c. BC/AD.

In the 3rd c., however, significant challenges along the frontiers of the Roman Empire began to encourage a more localised response to threats. City walls began to be built around more cities with a wider range of statuses in Italy, Gaul and Spain from the later years of the century (Fig. 2). The earliest scholars of Late Roman fortifications, like Blanchet, argued that walls were put up in response to the various invasion of Germanic tribes into Roman territory in the 270s.[10] This chronological paradigm remained largely in place until recently, but better dating evidence is now being discovered for many late Roman fortifications; yet, it is still not perfect, indicated by a large number that remain 'undated late antique' (Fig. 3). The best evidence suggests that urban fortifications were built at different rates in each of the 3rd–6th

7 Hassall (1983).

8 Laurence *et al.* (2011) 148–49.
9 Johnson (1983) 13.
10 Blanchet (1907) 303–304.

FIGURE 2 Cities in the West with Late Antique walls.
AUTHOR, WITH DATA FROM JOHNSON (1983)

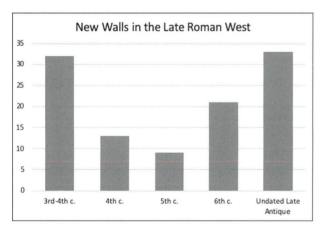

FIGURE 3 New walls in the Late Antique West by Century.
AUTHOR

c., possibly clustered in waves of building activity driven by particular historical incidents, and was overall more concentrated in the 3rd/4th and 6th c. A good portion of the 6th c. examples come from North Africa, where there had been very few city walls before the reconquest of the territory by the Byzantines under Belisarius, who fortified many settlements.[11]

Broadly, late antique walls across the West show considerable diversity in scale, design and appearance. The Early Roman walls of some cities were repaired or expanded, and elsewhere, new walls were built *ex novo*. Late antique circuits were generally thicker, had more towers, and often enclosed only a small, easily defendable area compared to earlier Roman city walls. This trend is particularly apparent in Gaul, where such walls are known as 'enceintes réduites'. For example, at Autun, the Augustan walls were refortified in 3rd c. with a small, 10 ha citadel (Fig. 4).[12] Such new design in fortifications impacted significantly on the urban topography, particularly on extra-mural cemeteries which grew more distant from the core of the city.[13] Moreover, as fortifications required an open area in front of the walls to repel attackers, buildings in that space had to be destroyed, some of which may have been graves, depending on

11 Sears (2007) 84.

12 Johnson (1983) 84.
13 Of course, distance alone is not a determining factor in usage, so there is no implication that these cemeteries went out of use because due to wall construction. Moreover, it is unclear in many instances how the inhabited area within a city related to the course of the wall; viz. whether any areas outside the (often reduced) walls were still inhabited, or whether the walls only enclosed the administrative elements of a city (Johnson (1983) 117; Goodman (2007) ch. 6).

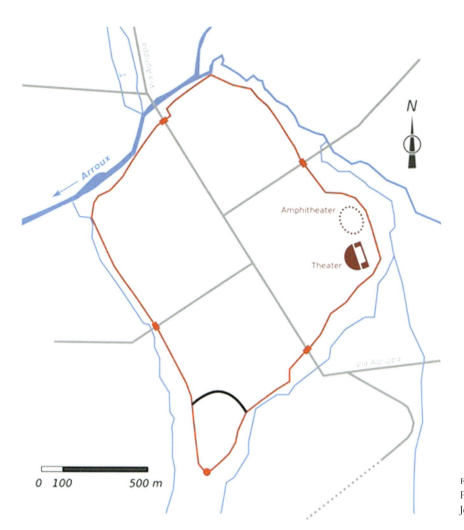

FIGURE 4
Plan of Autun (plan adapted from
Joël Thibault/Uiscefada CC BY-SA 4.0).

how 'reduced' the circuit was in relation to extra-urban cemeteries. These destructive processes, in addition to the general transformation of the urban layout which resulted in disused and ruinous buildings contributed to one of the most characteristic features of late antique city walls, the incorporation of *spolia*.

The use of *spolia* in late antique city walls varied substantially – the quality could range greatly, from re-cut stones to mis-matched pieces, and could be built into the foundations, the lowest footing courses, or even the superstructure, sometimes with its previous working hidden (i.e. turned inward) and sometimes clearly displayed.[14] Of course it is important to note here that there are many notable city walls that were built with little or no *spolia* in this period. While they seem to be the exception, the walls at St. Bertrand de Comminges, for example, or Ravenna, both of which are dated to the 5th c., were built with new material.[15] Or even slightly later, the city wall of Terracina, built in the Byzantine period, has little, if any, reused material.[16] In spite of this handful of outliers, the widespread use of *spolia* in most late antique walls is significant – enceintes were one of the largest construction projects in any town, in terms of sheer materials, and this is doubly true in Late Antiquity, when other large-scale civic construction slowed. Wall constructions required a massive amount of stone, for limestone mortar, concrete aggregate and facings.[17] The type, quantity and placement of *spolia* reused in these monuments, therefore, can provide insight into the priorities and values of the city-dwellers in the period of fortification, showing what was still being used, what was valued, what had some apotropaic significance and what was simply building materials. In this way, the exploration of grave structures incorporated into walls is valuable for our understanding of Late Roman attitudes toward the material remains of their ancestors and the changing attitudes towards death and burial.

14 As Frey (2016) shows in his case studies from a single region.
15 St Bertrand: Esmonde Cleary *et al.* (1996) 349; Ravenna: Christie and Gibson (1988) 182.
16 Christie and Rushworth (1988) 73–75.
17 Bachrach (2010) 57–59 has some estimates on the quantities required in one case, at Bordeaux.

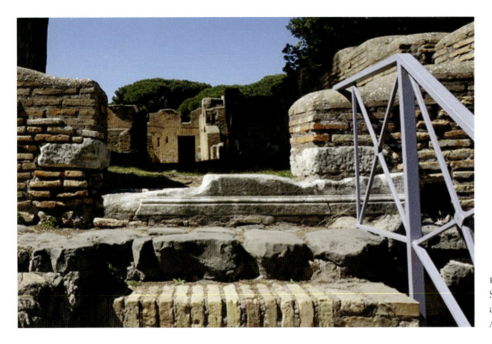

FIGURE 5
Sarcophagus reused as door sill at Ostia.
AUTHOR

Cemeteries in the Late Antique West

Cemeteries were universally situated outside of the *pomerium*, or legal boundary, of Roman cities across the west. The long-standing prohibition against the burial of the dead within the realm of the living meant that these spaces were placed at the edges of cities, often along major roads. Apart from their location, there is a wide range of variety in nearly every other characteristic, e.g. the layout of cemeteries, the kinds and scale of grave monuments within them, the presence of cremation vs inhumation, etc.[18]

The situation in Late Antiquity is even harder to summarise. Broadly speaking, many Roman era cemeteries continued to be used into Late Antiquity. However, there were several influencing factors on their evolution. Firstly, some cemeteries were damaged in the troubled 3rd c. and disused. For example, at Zaragoza, standing funerary markers were carried off, or at Mérida, mausolea were dismantled in the 3rd and 4th c., and the stones reused in 4th c. tombs.[19] In addition, as urban topography shifted – with the occupied area generally shrinking – some cemeteries were left further from the urban core, and thus went out of use. This can be seen at Amiens, where a 3rd c. wall, which enclosed a reduced area, was surrounded in the 4th c. by new cemeteries, built into the abandoned remains of the imperial city.[20] Demographically, most cities were less populated in by the 6th c. than they had been in the early 3rd, which meant that the kind of family continuity required for continued tomb maintenance would not have existed. Christianisation, in addition, disrupted the dynamics of the spaces of the living and the spaces of the dead, leading to more of an intermixing of the two, through the sacralisation of cemeteries that continued to be used, connected with the veneration of the holy dead.[21] Martyrial churches, built in the cemeteries that were burial sites during the period of Christian persecution, served as a locus for *ad sanctos* burial from the 4th c., thereby attracting further burials in Late Antiquity and beyond.[22] Finally, another major trend in late antique burial practice is the gradual spread of intra-urban burials from the 5th c.[23] While the prohibition against this practice was reiterated as late as 381,[24] burials within city boundaries became increasingly common into the Early Middle Ages. In short, some cemeteries went out of use and new ones were created as the physical form of cities changed, and others continued to be used, especially if connected to a sacred space. In the midst of all this, inhumation began to replace cremation from the 2nd c. in some parts of the empire, and spread gradually, becoming more common by the 4th c., if not earlier.[25] This was perhaps partially, though not fully, connected to the spread of Christianity, with its belief in the resurrection of the dead.

As Roman practices of burial, and indeed many cemeteries themselves, changed, the reuse of grave

18 Goodman (2007) 150–52 gives a brief overview of this variety for Gaul.
19 Kulikowski (2004) 106.
20 Goodman (2007) 212.
21 Esmonde Cleary (2013) 162–63.
22 As seen, for example, at Arles: Heijmans and Sintès (1994) 165.
23 Cantino Wataghin (1999).
24 *Cod. Theod.* 9.17.6.
25 Raynaud (2006); Cooke (1998).

FIGURE 6 Capitals embedded in foundations of Late Roman wall at Toulouse.
AUTHOR

material became increasingly common in Late Antiquity.[26] Elements of graves, most generally tombstones, which were generally fairly large and flat, but also sarcophagi, began to be reused in a number of different contexts.[27] At Ostia, for example, grave stones are reused as toilet seats, paving stones, in an aristocratic residence, and a sarcophagus (Fig. 5) was converted into a threshold.[28] Or at Arles, *spolia* from the adjacent cemetery was used to construct lean-to housing into the vaults of the circus at Arles in the 4th c. In these cases, the grave material was not used because of its original function. Rather, it was often disguised by hiding any previous markings and presenting a blank face. In some cases, sepulchral material was used in even more hidden ways, as at Toulouse, where several large tombs were demolished and used as aggregate in the foundations of the late antique riverfront wall (Fig. 6).[29]

Legal Context

From the middle of the 4th c., imperial edicts began to be issued to try to halt the destruction of tombs, which seems to have been a growing problem.[30] The broadest collection of such laws is in the Theodosian Code under title 9.17, *de sepulchris violatis*, which was repeated in large part in the Justinianic Code. Edict 9.17.1, issued in 340 by Constantius II, says "if any person should be apprehended in the act of demolishing a tomb, and if he should do this without the knowledge of his master, he shall be sentenced to the mines […] If by chance, anything taken from the tombs and carried to his house or villa should be discovered after the issuance of this law, the villa or house or any other building shall be vindicated to the account of the fisc."[31] Similarly, 9.17.2, from 349, prohibits "tak[ing] away columns or marble from monuments, or should throw down stones for the purpose of burning them into lime" with a fine of "a pound of gold for each tomb thus violated" unless they had "touch[ed] a tomb with the intent to harm it, he shall be compelled to pay twenty pounds of gold."[32] A penalty of ten pounds of gold was put forward in 356 for anyone who took material for the purposes of selling it, and in 363, Julian notes (and prohibits) that "some men even take away from the tombs ornaments for their dining rooms and porticoes.[33] Together these laws issued over a fairly brief period of just 23 years shed light on the range of grave spoliation that emperors wished to prevent. They try to stop tombs being taken apart (suggesting, seemingly, that such activities did occur – although the scale is impossible to determine) for decorating private houses by individuals, for burning into lime and for selling onward. It is interesting to note that the prohibitions here are noted in relation to the spoliation carried out by individuals. This is not referring to the sort of large-scale, systematic, spoliation that would be required to face a fortification wall that runs several kilometres in circumference.

Nearly a century later, in 447, laws were again passed to combat this (perceived? real?) problem. Title 23 of the Novels of Valentinian III is about the Violators of Tombs. It outlines that while previous emperors had attempted to stop tombs being violated, some mad individuals

26 Murer (2016) 195.
27 The reuse of grave material in Late Antiquity has not received the same level of study as its reuse in the Middle Ages, e.g. Greenhalgh (2012) ch. 5; Fabricius Hansen (2015).
28 Murer (2016) 195.
29 Baccrabère and Badie (1996) 127.

30 The following section (and indeed, the *de sepulchris violates*) exclusively deals with despoiling of graves for the purposes of taking marble and building materials. However, robbing graves for gold and other precious metals was also an issue as noted by Cassiod. *Var.* 4.18; 4.34 and in the 7th c. *Leges Visigothorum* (11.2.1–2).
31 *Cod. Theod.* 9.17.1.
32 *Cod. Theod.* 9.17.2.
33 *Cod. Theod.* 9.17.4; 5.

had "suppose[d] that they are not held subject to penalties previously established," and that "in light of day and openly tombs are being destroyed," and it was necessary for Valentinian III and Theodosius II to "renew [the] severity" of the earlier prohibitions.[34] This law takes particular aim at the clergy, whom it calls out as most responsible for this practice, although it does not give any indication of the motivations, financial or otherwise, of this group to behave in such a way. It sets as punishment for them the removal from the clergy and "perpetual deportation."[35] Valentinian and Theodosius also increase the penalties for destroying tombs or removing any marble or stone from them for everyone else – for slaves and the lower classes, death was prescribed and for the aristocracy, half their property and perpetual infamy was set as punishment. The law also brings in punishments for governors who fail to properly punish tomb violation, depriving them of their office and property if convicted. Valentinian and Theodosius' law was rescripted in the *Edictum Theoderici*, in the early 6th c. in quite blunt language: "qui sepulchrum destruxerit, occidatur."[36]

Clearly, there is a distinct push in the 4th and 5th c. to discourage the violation of tombs for the purposes of retrieving building material, with a reiteration of the same laws in the 6th c. as well. Of course, these laws tell us essentially nothing about the actual frequency or magnitude of this practice in Late Antiquity, nor if or how it evolved over that period. Still, the fact that law is generally reactive – that is to say, it responds to problems already arising, rather than forecasting future issues – suggests that some amount of grave robbing was happening or at least was perceived to have been happening. Moreover, this was either widespread enough, or offensive enough (or both) that the problem caught the eye of several emperors; in either case, their need to respond suggests that it was impacting a number of cemeteries around the empire or that it was a worrying crime.

Methodology

To examine the effects of late antique fortifications on the pre-existing urban and suburban landscape of monumental tombs and memorials, a methodology was developed in collaboration between the authors, under the guidance of Luke Lavan. The first step was to explore generally how the paths of late antique fortifications interacted with any monuments, large or small, that stood in their path, or if they went out of an expected shape to either include or exclude particular monuments. The full variety of structures spoliated or adapted for fortifications, including religious, civic, entertainment, or recreational structures, provide an important data-point to contrast against the treatment of memorials and tombs. With this data collected, it was immediately clear that a range of responses were possible, depending on the local conditions and needs of the wall-builders. For example, monuments could be left whole, and incorporated fully into the wall, as at the famous Pyramid of Cestius within the Aurelianic Walls in Rome, or the amphitheatre incorporated into the city wall of Perigueux. Or monuments could be left partially intact, or completely demolished, likely with some notable proportion of the materials going into the fortification as building material.

The next step was to look at tombs, specifically their demolition, incorporation, functional preservation, and decorative or non-decorative spoliation into city walls and to collect and categorise the evidence. A set of cities was established, where there was fairly good evidence for walls and cemeteries between the late 3rd and 7th c., and that had been fairly well recorded and published. This list was split into the eastern and western empires, with approximately half of the cities, and divided between the authors. A list of questions to ask about these cases was suggested by Luke Lavan, repeated here for convenience. We looked initially at the state of a city's necropoleis – to judge whether they were destroyed, partially dismantled, incorporated, or wholly preserved when city walls arrived. This led us to ask what funerary structures were incorporated wholesale, and if they lost or retained their original functionality. How did this compare to the fate of other structures set within fortifications? Secondly, the nature of spoliation was catalogued: the quantity and chronology of tombstones found in the wall, the presence or absence of sarcophagi, whether grave materials were used exclusively, or were there other types of *spolia* (like statues, altars or remains of civic buildings) present as well. Thirdly, a further set of questions were asked about the condition of the *spolia*: whether it was broken before going into the wall, or cut down and how it was displayed – buried in the foundations, placed on the wall skin with face hidden, or fully displayed, potentially as decoration.

These questions can be answered in a detailed site study and/or excavation by measuring and cataloguing every reused block – an approach that has worked well in the past for some cities, particularly Aphrodisias and Hierapolis (which will be discussed later) – but this requires a good deal of on-site exacting work and

34 *NMaj.* 23.1.
35 *NMaj.* 23.1.
36 *ET* 110; *Leges Visigothorum* 11.2.1–2.

a particularly well-preserved site for this to lead to any insights. Instead, our approach, where data was collected from published reports coupled with succinct site visits across a range of cities around the Mediterranean can still show a good deal about how walls employed *spolia*, whether casually or systematically and what patterns of reuse (especially chronological), if any, existed. While some larger regional trends may be observed, this methodology is best suited for studying the relationship between fortifications and monumental landscapes on a case by case basis. Each city was subject to its own local forces, and as we will see in the case studies, not every city built walls at the same time or in the same way. This certainly applies to the treatment of *spolia* and the incorporation of monuments into defensive circuits, and the preservation of the evidence in the present day. Strategic importance, civic wealth, and unique military and natural disaster-events all contributed to the ways in which cities fortified themselves in Late Antiquity.

However, this method is not without its difficulties. The preservation of fortifications as a result of prior excavations and modern urban expansion have had a variable effect on what can be determined about individual cities. The walls of Antioch on the Orontes, for example, were nearly completely demolished in the mid-19th c. Much of the *spolia* observed in the walls of Sparta was carried away by excavators in the early 20th c., more interested in the Classical inscriptions than recording the contexts of their finds. Patara, next to one of the widest sandy beaches in Turkey, was subjected to a number of arson attacks in the 1990s by locals who were opposed to restrictions on tourist development. For many reports on city walls, especially those done earlier in the 20th c., but even those of the last generation, the presence of *spolia* was rarely considered a feature to highlight, and it is often the case that 'reused' stones are noted, but without any specificity as to what kind of *spolia* was included, and often failing to record where it was situated and how it was displayed. Moreover, many decorative elements and inscriptions on spoliated ashlars will look largely the same whether they originate from a civic structure or monumental tomb. This necessitated gravitating towards certain well-documented and well-recorded sites, where some details about *spolia* with identifiable architectural features has been provided. The following selection of case studies attempts to include cities from across the spectrum of ancient and modern variables.

Walls and Tombs in the West

After exploring the selected cities and establishing a database of wall and *spolia* features, a few broad trends are apparent across Italy, Gaul, Spain and North Africa. It may be worth noting at the beginning that while the practice certainly pre-dated the Romans (e.g. the so-called 'Themistoclean wall" at Athens which incorporates material from buildings destroyed in the Persian invasion), there are exceedingly few, if any, Early Imperial urban fortifications which incorporate *spolia*, at least in any noticeable way.[37] The inclusion of *spolia* in walls is a predominantly late antique phenomenon. But once fortifications start being built around a wider number of cities from the second half of the 3rd c., the presence of tombstones, in addition to other reused stones, embedded in these walls becomes very common.[38] Chronologically, there is no apparent difference between the ways that 3rd–4th c. walls and those of the 6th c. employ *spolia*, except perhaps that its placement became more haphazard and less precise in some places, and there was a growing acceptance of showing the carved face of the reused stone.

Case Studies

Nevertheless, there is variety in how cities handled their reused material as it went into the wall. The following three case studies will demonstrate these differences and illustrate the range of approaches to reusing grave material. The wider results from other cities are subsumed within the table presented by Luke Lavan, which includes work by both Luke and Nick Mishkovsky, all tabulated together.

Lepcis

A defensive earthen bank surrounded Lepcis in the Early Empire, running 5.5 km and enclosing 425 ha (Fig. 7).[39] The city at its height never expanded to occupy the land anywhere near this defensive feature, and areas directly inside the bank were given over to cemeteries. This fact alone is interesting, as fortification walls are often considered to be synonymous with the *pomerium*, but here, burials within that boundary show that there was no such association at Lepcis.

37 It is impossible to rule out the inclusion of reused materials – brick or stone – as aggregate, or hidden in foundations, unless the wall is fully dismantled and recorded. There have been, to my knowledge, no indications of reused materials in Augustan-era walls discovered under those conditions.

38 Elements from tombs are often the most readily identified *spolia*, since they are more often used whole and marked with distinct inscriptions or funerary motifs. *Spolia* from other public buildings is generally difficult or impossible to identify without a clear inscription, due to its fragmentary nature and similar kinds of decoration employed by Roman masons.

39 Goodchild and Ward Perkins (1953) 47.

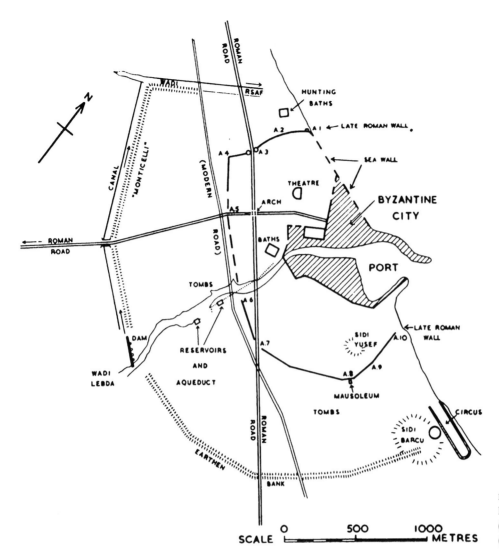

FIGURE 7
Plan of Lepcis Magna (Goodchild and Ward Perkins (1953) 46 Fig. 1).

The city's defences were strengthened with a stone-built circuit wall in the late antique period, likely in the early 4th c., running approximately 3 km and enclosing 130 ha. It was considerably smaller than the earlier earthen bank, running just inside the necropolis to the south of the city. While the wall has not been more precisely dated, it must have been built after the mid-2nd c., since it incorporates an arch from that period into a major gate.[40] An honorific inscription to Valerian from the 250s was found not far from the circuit, possibly indicating that it was used in or near the wall, thereby suggesting (although not proving) a *terminus post quem*.[41] On the other end, the wall was almost certainly built before 365 when the Austuriani besieged the city and Ammianus notes the city made strong by the *mur[us]*, or wall.[42]

This circuit was built in the common late antique method, with a mortar and rubble core faced on both sides by *grand appareil*. Beyond the above-noted 2nd c. arch, no further public monuments have been identified in the walls. An extremely large portion of the facing blocks (perhaps all, although the primary report is not specific on this point) came from grave monuments of one kind or another.[43] This is especially clear in the well-preserved section to the south of the west gateway. For example, incorporated in the wall are the tombstones of C. Avillius Marsus (*IRT* 633) and that of Q. Domitius Camillus Nysim, both dating to the 2nd to 3rd c.[44] It seems that the necropolis just beyond the wall was almost entirely denuded of tombstones to construct the wall; only a single mausoleum (of Gasr Shaddad)

40 Goodchild and Ward Perkins (1953) 49.
41 Goodchild and Ward Perkins (1953) 71.
42 Amm. Marc. 28.6.

43 Stones from other kinds of monuments (public or even private structures) have not been seen in the wall, but it is sometimes difficult to conclusively identify the original function of a stone that has been moved and cut down. There is a fragmented inscription (*IRT* 351) which seems to mention a censor and consul ordering works to be done, but it was not found *in situ* in the wall, nor is it fully clear what sort of dedication it comes from.
44 *IRT* 633; *IRT* 692.

FIGURE 8 Spolia in late antique wall at Lepcis Magna (Goodchild and Ward Perkins (1953) Plate XVIb).

still stands in this area, likely because it was used as a defensive tower.[45] What is clear about the *spolia* used in this circuit is that the facing stones have been cut down to size, and placed in the wall in fairly good coursing whichever way was most suitable – there was no attempt to hide their reuse, yet no attempt to display it either (Fig. 8).

The Late Roman circuit was largely destroyed in the mid-5th c. and new fortifications were built by the Byzantines after their conquest in the 530s. There were several quickly superseded phases to this wall, each slightly altering its outline (Fig. 9), suggesting a period of uncertainty, or changing circumstances. Throughout, however, it was 2.2 m thick at its base and 1.9 in superstructure and enclosed an area of 44 ha (later perhaps only 28 ha).[46] It was built slightly differently to other Byzantine walls in Africa as it did not have a concrete and rubble fill.[47] The blocks used in the wall were, similar to the earlier fortifications, almost completely reused. There seems to be a wider variety of deconstructed monuments whose stones were reused in this later circuit, including some columns. For example, in the so-called "Byzantine Gate", 6 blocks from a Flavian-era arch dedication (*IRT* 342) along with a statue base for M. Cornelius Capitolinus (*IRT* 593), and a section of the *curia* building taken from the Forum Vetus (*IRT* 587) are reused. While original location of the blocks from two former monuments are unknown, we can determine that the blocks from the Forum Vetus were reused very close (*c.*50 m) to their original site. In this case, reuse of these blocks seems to be driven primarily by location rather than any other factor.

Unlike the two earlier lunate circuits, the smaller Byzantine defenses have a more complicated layout, the result of interacting with more pre-existing buildings. This absorption is seen along the north edge of the Forum Vetus in the eastern part of the city. There the wall runs over the podia of the two temples of the forum, and nearby over portions of the Temple of Rome and Augustus.[48] Similarly, at the end of the Colonnaded street, the Byzantine wall runs over the paving and *exedra* of a Severan era piazza.[49] While the wall does not incorporate these structures in the same way as the Pyramid of Cestius in Rome, the wall did include the foundations of these older structures, and, with the Temple of Rome and Augustus, retained part of the still-standing western wall.[50] Moreover, it seems that the Severan forum was turned into a citadel around the same time as the construction of the walls. This was done partly through joining up this structure (Fig. 9) to the fortifications, but also through the walling up of doorways and the erection of other reinforcing walls.[51] In this way, the Byzantine fortifications at Lepcis interact with the pre-existing urban landscape, through both the incorporation of stones from a wider range of monuments or by building over the often ruinous remains of the Roman period.

Bordeaux

Bordeaux (Roman Burdigala), was an important city from the Early Imperial period when the native Celtic settlement was refounded as a Roman city. It sits at near the confluence of the Dordogne and Garonne rivers, making it a key entrepôt for goods moving to and from the Atlantic. Bordeaux reached a peak of prosperity in the late 2nd c., covering an area of around 180 ha.[52] Sometime in this booming period, likely before

45 Goodchild and Ward Perkins (1953) 53.
46 Goodchild and Ward Perkins (1953) 55.
47 Pringle (1981)1, 381.
48 Goodchild and Ward Perkins (1953) 59.
49 Goodchild and Ward Perkins (1953) 62.
50 Goodchild and Ward Perkins (1953) 59.
51 Goodchild and Ward Perkins (1953) 60.
52 Doulan (2013) 56.

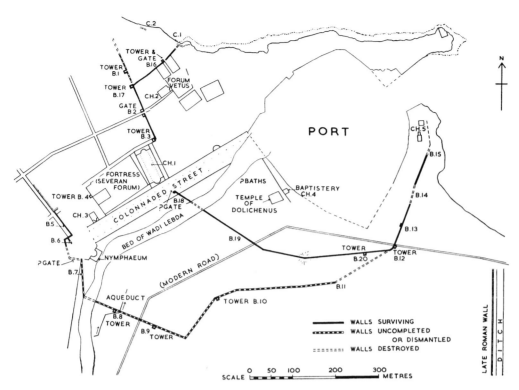

FIGURE 9 Plan of Byzantine fortifications at Lepcis Magna (from Goodchild and Ward Perkins (1953) 54 Fig. 4).

FIGURE 10 Plan of Bordeaux (from Jullian (1895) 87).

the Diocletianic reforms of the provinces, the city was made the capital of the province of Aquitania. However, a major change in the city's urban topography occurred in the second half of the 3rd c., when circuit walls running 2.35 km and enclosing only 32 ha were constructed (Fig. 10).[53] Dating evidence for construction includes from two coins uncovered in a thermal establishment destroyed to make a defendable area just outside the walls, which provide a *terminus post quem* of 274.[54] Ceramic evidence from the baths also reinforces a late 3rd to early 4th c. date.[55] More recently, excavations in 2001–2003 in the south-west corner of the fortifications, near the cathedral, uncovered a posthumous coin of Claudius II Gothicus, which has been dated to after 275, reinforcing the *terminus post quem*.[56] Further, material from a newly-built necropolis not far beyond the north face of the wall has been dated to no earlier than the early 4th c., providing a workable (if somewhat loose) *terminus ante quem*.[57] All together, these suggest a date around the end of the 3rd c.

The wall was constructed with a concrete and rubble core; the thickness of the wall at the base varies from 4 to 5 m, tapering to 2.5 m at the top, and overall height is unknown, but likely around 9 to 10 m.[58] The foundations of the wall varied considerably from location to location, depending on the natural conditions, and ranged in composition from levelled destruction layers to rubble and mortar or even large (reused) stones.[59] The lower courses of the wall – about 6 m or so in height – were faced in *opus quadratum* (*grand appareil*),

53 Barraud, Linères and Maurin (1996) 49.
54 Barraud, Linères and Maurin (1996) 75–76.
55 Barraud, Linères and Maurin (1996) 73.
56 Doulan (2013) 198.
57 Doulan (2013) 198.
58 Bachrach (2010) 44; Barraud, Linères and Maurin (1996) 66.
59 Doulan (2013) 198.

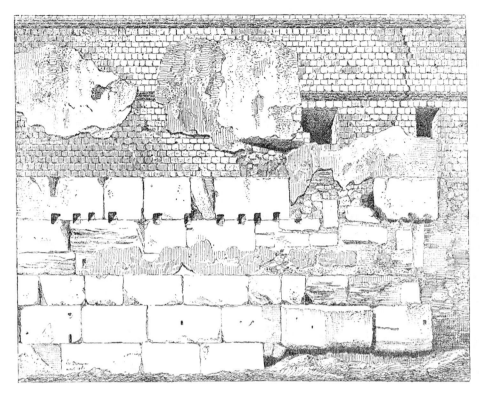

FIGURE 11 Drawing of Late Roman wall (from Jullian (1895) 46).

composed primarily – possibly exclusively – of reused blocks (Fig. 11). The wall was faced in the higher sections with small blockwork (*petit appareil*). These blocks, as far as their decoration gives any indication, were spoliated from a number of monuments; tombs, funerary monuments, an altar, and others of uncertain origin have been identified.[60] Friezes and cornices of a size appropriate to public buildings, parts of a fountain and the fragments of a grandiose monument decorated with marine motifs were discovered as well. The latest inscription that has been recorded from the wall *spolia* is an epitaph that notes the consulship of Postumus in 260.[61] The blocks were all cut down to fit the coursing of the wall. Blank reused blocks were chosen, if available, or they were placed with their blank side outward, or in some cases, roughly re-carved to remove any decoration. However, in the foundations, while courses were still partially respected, there was less concern with presenting a smooth outer surface, presumably because the stones would be hidden.

The construction of this wall circuit had a significant impact on the urban landscape of late antique Bordeaux. In part, this comes down to the quantity of reuse: it has been estimated that over 64,000 m³ of *spolia*, equalling something around 48,000 metric tons, were included in the lower courses of the wall, which is a sizeable portion of the estimated over 200,000 metric tons of stone that went into the wall overall.[62] Moreover, the construction of this fortification required 200 m³, or about 150 metric tons of limestone to make the mortar, and we might imagine that a good portion of that would have come from spoliated marble monuments. As clear from a few sections outside the walls like the baths at the Rue des Frères-Bonnes, there seems to have been clearances which likely extended around the entire circuit.[63] And this, coupled with the fact that the walls were much smaller than the maximum extent of the city, meant that there was a good deal of building material available to be reused, often in the direct vicinity of the circuit.[64] This was, except for the foundations, reworked and mostly faced inwards to hide its provenance in the new wall.

Finally, beyond what is included in the wall, what was excluded is also significant. Large portions of the imperial city's monumental core, like the forum, the amphitheatre and a monument called the Piliers de Tutelle were left outside the new fortified core of the city

60 Doulan (2013) 227.
61 *CIL* XIII.633.
62 Bachrach (2010) 49.
63 Barraud, Linères and Maurin (1996) 73.
64 Of course, beyond the buildings demolished, it is unclear how much of the city excluded from the new core was abandoned or still occupied. The new necropolis, just outside of the line of the fortification, suggests that the excluded portion was, conceptually at least, outside of the city. However, there is very little information about the actual state of habitation and use in the peripheral regions in the late 3rd and early 4th c.

and seemingly left standing – the latter monument, for example, survived in place until the 17th c. The amphitheatre, which was over 500 m from the enceinte, was damaged by fire, likely in the later 3rd c., but the builders of the enceinte decided not to incorporate the mass of masonry into their project as seen at other cities like Rome or Périgueux.[65] Instead, they strictly followed a quadrilateral plan, which, when considered with the care shown to the reused stone, suggests an uncompromising approach to this fortification project.

Barcelona

The colony of Barcino was established under Augustus, and commensurate with its status, a circuit wall was built shortly after its founding. Unfortunately, little is known about this early wall, which only survives in a few places. It was built in *opus vittatum* in the upper section with ashlar lower courses and enclosed an area of 10.4 ha.[66] Throughout the imperial period, the city was a prosperous and important port, although it was not a major administrative centre. It seems to never have grown significantly beyond its wall.

In Late Antiquity, the early Augustan wall was re-fortified on essentially the same line, with the addition of a new skin and added round or polygonal towers, along with an added extension to the south (Fig. 12). The wall incorporated no standing monuments (excepting, of course, the Augustan wall). In effect, the wall was made thicker and taller. The height of the curtain at present is around 9 m, topped by a string-course and parapet, although Férnandez Ochoa and Morillo suggest that it may have exceeded 10 m.[67] The evidence for dating the construction is less certain. The walls were originally thought, as were many fortifications across the West, to have been built around the time of the barbarian raids into Gaul and Spain in the 260s.[68] The *spolia* from the walls suggests that they were built after the mid-3rd c.[69] More critically, a coin of Claudius II Gothicus (*c*.268–70) was found in the infill of one of the round towers, and several 4th c. coins have recently been discovered from other towers, providing a *terminus post quem*.[70] Some scholars have recently suggested that the wall must have been constructed in the 5th c., and possibly even under the Visigoths.[71] However, this seems unlikely since by the 5th c. both usurpers and kings were selecting the city

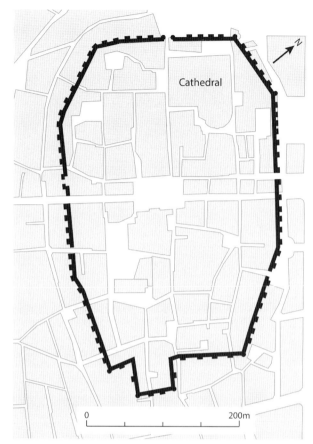

FIGURE 12 Plan of Barcelona (Redrawn by Lloyd Bosworth after Plànol de la ciutat de Barcelona amb el traçat de l'antiga muralla medieval (Segles XIII–XIV) https://commons.wikimedia.org/wiki/File:Planta_muralla_medieval_de_Barcelona.jpg).

precisely for its defensive circuit. It seems more likely that the circuit dates from the mid- to late 4th c., a date that has been reinforced by recent excavation data that suggests the construction took place after 360.[72]

The new skin added to the Augustan wall was constructed primarily in *opus quattratum*, largely composed of *spolia*. Some new stone seems to have been used on the towers. The reused stone employed elsewhere came from cemeteries and other extramural monuments. Cippi, altars, columns, friezes and sculptures have been found both within and used as facing for the wall (Fig. 13).[73] While at Bordeaux there is good evidence for a cleared area in front of the line of the wall, at Barcelona such a space can only be surmised by the presence of these extramural monuments reused in the fortification. This material has been cut down to fit in, or at least carefully set into regular courses. Carved or decorated faces have mostly been turned inward, or often (although not exclusively) had the decoration

65 Heijmans (2006) 39.
66 Gurt Esparraguera and Godoy Fernández (2000) 426.
67 Johnson (1983) 125; Férnandez Ochoa and Morillo (2005) 308.
68 E.g. Johnson (1983) 125.
69 Johnson (1983) 125.
70 Férnandez Ochoa and Morillo (2005) 318.
71 Puig and Rodá (2007) 627.

72 Puig and Rodá (2007) 628.
73 Puig and Rodá (2007) 628.

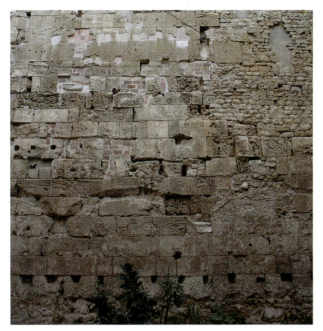

FIGURE 13 Late Roman wall at Barcelona (from Muralla romana. (Barcelona); https://commons.wikimedia.org/wiki/File:Muralla_romana_(Barcelona)_-_2.jpg).

carved off (Fig. 14).[74] In this way as well as in their interaction with the urban landscape and the incorporation of monuments, the use of *spolia* at Barcelona was much in line with that of Bordeaux, which may be a product of their relative proximity chronologically. At both cities, the material reused in walls was well sorted and heavily reworked, suggesting a careful and measured practice. Kulikowski sees this same practice at other building sites in 4th c. Barcelona, concluding that "pre-existing structures were carefully dismantled and their salvageable materials put into service in the new buildings."[75]

Conclusions

Altogether, both the broad observations across the data set and the specifics of the case studies suggest several trends in the intersection between *spolia* and graves in the late antique west. First, the reuse of grave material was not a rushed job, especially in the 4th and 5th c.; it was not the case that residents were collecting any stones fragments from destroyed tombs outside the city and throwing them into a fortification wall as the barbarians appeared on the horizon. Rather, the walls and the stones reused in them suggest a systematic, controlled spoliation of disused resources, primarily cemeteries, but also including other types of monuments. The earlier walls tended to rely more heavily on fairly

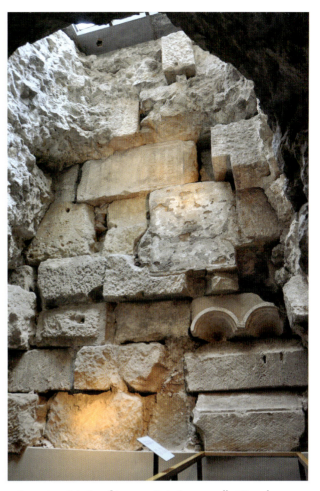

FIGURE 14 Interior of tower on Late Roman wall at Barcelona (MUHBA Barcelona archaeological underground inner part of a tower of the Roman wall; https://commons.wikimedia.org/wiki/File:MUHBA_subsol_interior_d%27una_torre_de_la_muralla_(2).JPG).

regularly-sized blocks that could be used in *opus quadratum* (except for foundation fills, where any material was thrown in as aggregate); later walls were more likely to incorporate column drums and other irregularly-sized pieces.

In large part, reused tombstones were cut down to size, seen beyond our case studies also at Narbonne (Fig. 15). As they would have been sources from a variety of individual structures, from gravestones to mausolea, but were being used in courses, resizing was a necessary element of the building process. The fact that the stones were cut down can partially obscure some of their history, specifically whether they were damaged either *in situ originali* or in the transport or handling between the original site and the workshop/site where they were sized; nevertheless, in walls of the west, especially those of an earlier date, reused tombstones were largely whole before they were altered for the fortifications, unless they were used as rubble for the concrete fill. Where they were placed after being resized depended primarily

74 Puig and Rodá (2007) 618.
75 Kulikowski (2004) 122.

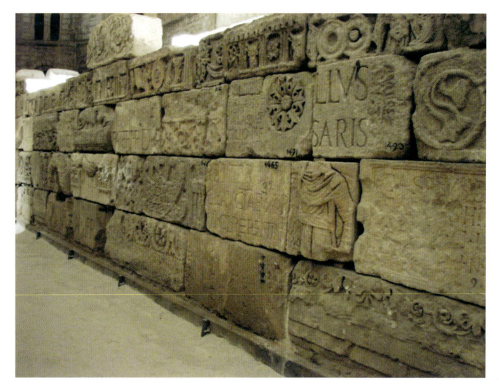

FIGURE 15
Spolia from Late Roman wall at Narbonne in the Musee Lapidaire.
AUTHOR

on what sort of masonry and construction method the wall employed. For the Gallic *petit appareil*, only a few strong courses were necessary for the foundation and footings (as the upper courses were composed of small, squared stones – which themselves may have been *spolia* but are generally so altered as to be beyond recognition), so *spolia* is restricted to the lower sections only. In other places, where *opus quadratum* was employed, *spolia* was placed at any height, with little apparent pattern on what kind of monument it came from. This suggests that reused stone was taken from its original context and cut down, transmuted into generic building material. Additionally, the general (although not exclusive) trends of turning decoration or inscriptions inward reinforces the idea that *spolia* in walls was not intended to present a message of any kind to those approaching the city. In those instances, as at Lepcis, where some decoration was displayed, it appears fairly haphazard. This preliminary study has not clearly identified whether certain kinds of decoration or inscriptions were more frequently turned outward or inward; further work on cataloguing specific instances will help clarify a conclusion on this important point. Anecdotally, the evidence gathered here does suggest, however, that there was no major prohibition on showing the epigraphic face, but given the option, a blank face was clearly preferred.

Finally, in the western empire, there are relatively few monuments, either whole or partially standing, that were amalgamated into walls. In some places, like Périgueux and Rome, well-built structures that were along or near enough to the course of the walls were added to them. However, this was not a common practice; most walls did not incorporate nearby monuments, except in the form of *spolia*. While in the east, the inclusion of standing grave monuments was not uncommon, in the west, no such spoliation has been recorded. The only real exception to this is when walls were built over, or integrating, an earlier circuit wall, as at Barcelona or Thugga. This shows that circuit walls in the late antique west were, for the most part, well-designed and well-structured. Builders did not take the shortcuts of building over nearby monuments or throwing any and all reused stone into the walls haphazardly. Instead, these fortifications were constructed along a sensible path, and the stone that went into them was mostly well-sorted and reworked to fit the needs of the coursing. These observations also speak to the way that late antique wall builders (and perhaps people more widely) viewed the cemeteries and graves outside their cities. Most walls in this period incorporate *spolia*, and the bulk of that *spolia* comes from grave monuments of one form or another.

This suggests that in late antique cities, practical need was a more important driving force compared to the respect for the dead or the prohibitions against the desecration of tombs. The scale of the practice also suggests that this was not carried out by individuals: to get the huge amounts of *spolia* – 64,000 m³ at Bordeaux, much of that from graves – widespread grave deconstruction must have been sanctioned by civic or higher

authorities. The construction of city walls was a public monument built with the impetus or control of the local council, provincial or imperial government (the institutional dynamics of carrying out such projects is uncertain); the collection of large amounts of tomb materials seems to only have been possible with the involvement of prominent authorities. That it was ending up in a civic monument being built for the defence of the city may have made this action a bit more acceptable, but it is impossible to know whether it was done grudgingly or with little care or consideration of the dead. While we can see that the reuse of grave material in the late antique west was common, with fortifications being one of the many destinations of this kind of *spolia* in this period, there is unfortunately little insight that can be gained into how the occupants of these cities felt about the process.

Acknowledgements

My greatest gratitude for assistance with this project goes to Luke Lavan, for suggesting the idea and spearheading the work, and Nick Mishkovsky for tackling half of a project too large for a single conference paper. My thanks go also to Dr Gill Clark at the British School at Rome for clearing some of the images used here and to the anonymous reviewers who suggested some helpful changes. Finally, thanks to Peter Crawford for the very thorough editing of my (rather sloppy) text. All errors remain my own.

Bibliography

Primary Sources

Amm. Marc. = J. C. Rolfe transl., *Ammianus Marcellinus*, 3 vols. (Loeb Classical Library). (London-Cambridge, Mass. 1935–39). (with Latin text).

Cassiod. *Var.* = Å. J. Fridh ed., *Magni Aurelii Cassiodori Variarum libri XII*. (Magni Aurelii Cassiodori Senatoris Opera 1). (CCSL 96). (Turnhout 1973). T. Hodgkin transl. *The Letters of Cassiodorus*. (London 1886). S. J. B. Barnish transl., *Cassiodorus: Variae*. (Translated Texts for Historians 12). (Liverpool 1992).

Cod. Iust. = P. Krüger ed., *Corpus Iuris Civilis* vol. 2: *Codex Iustinianus*. (Berlin 1887).

Cod. Theod. = T. Mommsen and P. Meyer *et al.* edd., *Theodosiani Libri XVI cum Constitutionibus Sirmondianis*, vol. 2: *Leges Novellae ad Theodosianum Pertinentes*. (Berlin 1905). C. Pharr transl., *The Theodosian Code and Novels: and the Sirmondian Constitutions*. (Princeton 1952).

NMaj. (Novels of Majorian) = T. Mommsen and P. Meyer edd., *Theodosiani Libri XVI cum Constitutionibus Sirmondianis*, vol. 2: *Leges Novellae ad Theodosianum Pertinentes*. (Berlin 1905) 179–96; C. Pharr transl., *The Theodosian Code and Novels: and the Sirmondian Constitutions*. (Princeton 1952).

Leges Visigothorum = Karl Zeumer ed., *Leges Visigothorum*. (MGH LL nat. Germ. 1). (Hannover/Leipzig 1902) 33–456; S. P. Scott transl., *The Visigothic Code*. (Boston 1910).

Secondary Sources

Baccrabère G. and Badie A. (1996) "L'enceinte du Bas-Empire à Toulouse", *Aquitania* 14. (1996) 125–29.

Bachrach B. S. (2010) "The fortification of Gaul and the economy of the third and fourth centuries", *JRA* 3. (2010) 38–64.

Barraud D., Linères J., and Maurin L. (1996) "Bordeaux", in *Enceintes romaines d'Aquitaine*, edd. P. Garmy and L. Maurin. (Paris 1996) 15–80.

Blanchet A. (1907) *Les enceintes romaines de la Gaule, étude sur l'origine d'un grand nombre de villes françaises*. (Paris 1907).

Brilliant R. and Kinney D. edd. (2011) *Reuse Value: Spolia and Appropriation in Art and Architecture, from Constantine to Sherrie Levine*. (Farnham 2011).

Cantino Wataghin G. (1999) "The ideology of urban burials" in *The Idea and Ideal of the Town between Late Antiquity and the Early Middle Ages*, edd. G. P. Brogiolo and B. Ward-Perkins. (Leiden 1999) 147–80.

Christie N. (2001) "War and order: urban remodelling and defensive strategy in Late Roman Italy", in *Recent Research in Late Antique Urbanism*. (JRA Supplementary Series 42), edd. L. Lavan and W. Bowden. (Portsmouth 2001) 106–122.

Christie N. and Gibson S. (1988) "The city walls of Ravenna", *PBSR* 56. (1988) 156–97.

Christie N. and Rushworth A. (1988). "Urban fortification and defensive strategy in fifth and sixth century Italy: the case of Terracina", *JRA* 1. (1988) 73–88.

Coates-Stephens R. (2001) "Muri dei bassi secoli in Rome: observations on the re-use of statuary in walls found on the Esquiline and Caelian after 1870", *JRA* 14. (2001) 217–38.

Coates-Stephens R. (2002) "Epigraphy as "spolia" - the reuse of inscriptions in early medieval buildings", *PBSR* 70. (2002) 275–96.

Cooke N. (1998) *The Definition and Interpretation of Late Roman Burial Sites in the Western Empire*. (Ph.D. thesis, Univ. of London 1998).

Deichmann F. W. (1975) *Die Spolien in der spätantiken Architektur*. (Munich 1975).

Dey H. (2010) "Art, ceremony, and city walls: the aesthetics of imperial resurgence in the Late Roman West", *JLA* 3. (2010) 3–37.

Doulan C. (2013) "Bordeaux", *Carte archeologique de la Gaule* 33.2. (Paris 2013).

Esmonde Cleary A. S. (2013) *The Roman West, AD 200–500: An Archaeological Study*. (Cambridge 2013).

Esmonde Cleary, A. S., Jones M., and Wood J. (1996) "The late Roman defences at Saint-Bertrand-de-Comminges. (Haute Garonne): interim report", *JRA* 11. (1996) 343–54.

Fabricius Hansen M. (2015) *The Spolia Churches of Rome: Recycling Antiquity in the Middle Ages*. (Aarhus 2015).

Fernandez Ochoa C. and Morillo A. (2005) "Walls in the urban landscape of Late Roman Spain: defense and imperial strategy", in *Hispania in Late Antiquity: Current Approaches*, edd. K. Bowes and M. Kulikowski. (Leiden 2005) 299–340.

Frey J. (2016) *Spolia in Fortifications and the Common Builder in Late Antiquity*. (Mnemosyne 389). (Leiden and Boston 2016).

Frey J. (2015) "The archaic colonnade at ancient Corinth: case of early Roman spolia", *AJA* 119. (2015) 147–75.

Garmy P. and Maurin L. edd. (1996) *Enceintes romaines d'Aquitaine*. (Paris 1996).

Godman P. (1985) *Poetry of the Carolingian Renaissance*. (London 1985).

Goodchild R. G. and Ward-Perkins J. B. (1953) "The Roman and Byzantine defences of Lepcis Magna", *PBSR* 21. (1953) 42–73.

Goodman P. (2007) *The Roman City and Its Periphery: From Rome to Gaul*. (London and New York 2007).

Greenhalgh M. (2012) *Constantinople to Cordoba: Dismantling Ancient Architecture in the East, North Africa and Islamic Spain*. (Leiden and Boston 2012).

Gurt Esparraguera J. M. and Godoy Fernández C. (2000) "Barcino, de sede imperial a urbs regia en época visigoda", in *Sedes regiae. (ann. 400–800)*, edd. G. Ripoll Lopez and J. M. Gurt Esparraguera. (Barcelona 2000) 425–66.

Hassall M. (1983) "The origins and character of Roman urban defences in the West", in *Roman Urban Defences in the West*. (CBA Report 51), edd. J. Maloney and J. Hobley. (Dorset 1983) 1–4.

Heijmans M. (2006) "La mise en défense de la Gaule méridionale aux IVe – VIes", *Gallia* 65. (2006) 59–74.

Heijmans M. and Sintes C. (1994) "L'evolution de la topographie de l'Arles antique: un etat de la question", *Gallia* 51. (1994) 135–70.

Johnson S. (1983) *Late Roman Fortifications*. (Totowa 1983).

Jullian C. (1895) *Histoire de Bordeaux depuis les origines jusqu'en 1895*. (Bordeaux 1895).

Kinney D. (2006) "The concept of spolia", in *A Companion to Medieval Art*, ed. C. Rudolph. (Malden 2006) 233–52.

Krautheimer R. (1961) "The architecture of Sixtus III. A fifth-century Renaissance?", in *De Artibus Opuscula 40: Essays in Honor of Erwin Panofsky*, ed. M. Meiss. (New York 1961) 291–302.

Kulikowski M. (2004) *Late Roman Spain and its Cities*. (Baltimore 2004).

Laurence R., Esmonde Cleary A., and Sears G. (2011) *The City in the Roman West, c. 250 B.C. - 250 A.D.* (Cambridge 2011).

Murer C. (2016) "The reuse of funerary statues in late antique prestige buildings at Ostia", in *The Afterlife of Greek and Roman Sculpture. Late Antique Responses and Practices*, edd. T. Myrup Kristensen and L. M. Stirling. (Ann Arbor 2016) 177–96.

Pringle D. *The Defence of Byzantine Africa from Justinian to the Arab Conquest*. (BAR-IS 99). (Oxford 1981).

Puig F. and Rodá I. (2007) "Las murallas de Barcino. Nuevas aportaciones al conocimiento de la evolución de sus sis-temas de fortificación", in *Murallas de ciudades romanas en el Occidentedel Imperio*, edd. A. R. Rodríguez and I. Rodá. (Lugo 2007) 597–630.

Raynaud C. (2006) "Le monde des morts", *Gallia* 63. (2006) 137–70.

Sears G. (2007) *Late Roman African Urbanism: Continuity and Transformation in the City*. (Oxford 2007).

Underwood D. (2013) "Reuse as archaeology in Ostia: a test case for late antique building chronologies in Ostia", in *Field Methods and Post-Excavation Techniques in Late Antique Archaeology*. (Late Antique Archaeology 9), edd. L. Lavan and M. Mulryan. (Leiden 2013) 383–409.

The Destruction, Preservation, and Adaptive Reuse of Funerary Monuments in Urban Fortifications in Late Antiquity: the East

Nick Mishkovsky

Abstract

The aim of this paper is to discuss the relationship between late antique city walls and the pre-existing urban landscape, particularly funerary monuments, as evidenced by the use of architectural *spolia*. To that end, I utilize a proposed methodology of systematic observation and research to examine how *spolia* is employed in unique local contexts. Out of a group of 20 surveyed cities across the eastern Mediterranean, I discuss Athens, Aphrodisias, Hierapolis, and Patara. By taking a qualitative approach to the examination of *spolia*, I find that late antique fortifications had a varied impact on the memorial landscape of cities, as a result of localized cultural shifts, violent destruction, or deliberate planning. Even within individual circuits, treatment of *spolia* can vary throughout, depending on location within the wall, decorative value, and the intent of the builders. Finally, I close with an account of my own experience applying this methodology in Rome.

Introduction: Fortifications and Urban Change in a Late Antique Context

Within the changing political, social, and environmental contexts of Late Antiquity, urban centres underwent a series of transformations. Whether it was the restructuring of provincial capitals, the reorientation of religious life under Christianity, or the violent upheavals of foreign invasion, urban landscapes were forced to adapt. The construction of city walls arguably left the greatest mark on these landscapes, due to their intrusive relationship to pre-existing monuments and the permanent divide they created between urban centres and the surrounding countryside, including a city's necropoleis. Reuse of architectural material, or *spolia*, from the pre-existing urban fabric is a common feature of many late antique urban fortifications, and one rooted in historical precedent. The Greek-founded cities of the Balkans and Asia Minor had a long-standing tradition of monumental stone fortifications and the associated use of *spolia*. The most widely cited example of this is the 5th c. BC Themistoclean circuit in Athens, built using large amounts of *spolia* from the Archaic city, including material from the monumental necropolis in the Kerameikos district.[1]

One of the major sources of architectural *spolia* were the large, suburban necropoleis that feature in nearly every Classical or Imperial city. In the case of the cities of Lycia, monumental tombs can be found within the urban core as well.[2] Relatively new centres of population, such as Constantinople, lacked these pre-existing "quarries" and as such, pre-4th c. funerary *spolia* is not found in such contexts. In the Classical and Imperial cities in the East, there are a variety of tomb types that can be found within the physical matrix of city walls, either incorporated *in situ* or dismantled as *spolia*. *Spolia* from a variety of regional tomb types can be observed in fortifications across the eastern provinces, i.e. tower tombs in Syria,[3] monumental temple tombs in Lycia,[4] and "false door" motif stelae in Phrygia, particularly in the city of Amorium.[5] Square house tombs, pedestal tombs, and altar tombs, found throughout the cities of Asia Minor, provided an equally attractive source of construction material. Stelae, however, are the most common form of grave marker reused in walls as they were plentiful, easy to transport, and required little to no modification to function as an ashlar block. In light of this regional variety, a more thorough examination of the use of funerary *spolia* was manifested in late antique fortifications in the Roman East, and what variables determine its presence or absence is necessary. The following study attempts to identify the unique contexts and methods of funerary spoliation and incorporation into city walls, via a methodology of standardized archaeological and literary survey.

Before proceeding, it is important to clarify that the spoliation and destruction of a tomb monument does not necessarily imply the same treatment of the sarcophagus and the body within. Cities had strict local laws forbidding the despoiling of sarcophagi, as can be

1 Theocharaki (2011) 104–105.
2 Keen (1992) 62 and Işık (2000) 92.
3 Intagliata (2017) 75.
4 Işık (2000) 27.
5 Lightfoot (2007) 40–41.

attested by the presence of numerous formulaic inscriptions found on the sarcophagi themselves. One such example from Aphrodisias reads:

> No one else shall have the authority to place another person in it or to remove any of the aforementioned persons from it, not even as a result of an act of the council or an intercession by a provincial governor, because he shall be impious and accursed and a grave-robber, and in addition to this he shall pay to the most sacred treasury 3,000 silver denarii, one third of which shall belong to the prosecutor.[6]

It continues that a copy of the inscription was deposited in the local registry office. Similar inscriptions can be found throughout the Roman East, including a well-documented example from the Marcia temple tomb in Patara.[7] Indeed, the results of this survey, outlined further below, suggest that *spolia* from sarcophagi are nearly entirely absent within the context of eastern late antique fortifications. As such, this discussion will focus entirely on the reuse of monumental tomb superstructures and stelae, rather than sarcophagi.

Methodology

To examine the effects of late antique fortifications on the pre-existing urban and suburban landscape of monumental tombs and memorials, a new methodology was developed in collaboration with Douglas Underwood, under the guidance of Luke Lavan.[8] Utilizing standard library research and walkover survey,[9] our aim was to identify regional trends in the sources and methods of spoliation across the Late Roman world. Twenty cities were surveyed in the eastern Mediterranean, chosen on the basis of preservation of late antique circuits, availability of published sources, and presence of spoliated materials. From the selected sites, I considered the following factors: the kinds of monuments sourced for *spolia* (tombs, memorials and monumental structures from the civic core); the state of the city's monuments and necropoleis (destroyed, partially dismantled, incorporated, or wholly preserved); and the treatment of spoliated material within the context of fortifications (modification, visibility, and decorative use). Additionally, I considered whether or not spoliated structures retained any of their original functionality, as in the case of the stadium at Aphrodisias, discussed further below.

The discussion of *spolia* within a circuit is largely limited to identifiable architectural features, decorative elements, or inscriptions, as spoliated ashlars will look largely the same whether they originate from a civic structure or monumental tomb. I will also consider incorporated buildings, as they fall under the category of 'adaptive reuse'. For the purposes of this survey, we chose to make note of the full variety of structures spoliated or adapted for fortifications, including religious, civic, entertainment, or recreational structures, as they provide further context for the treatment of memorials and tombs. As seen in the below case studies, certain cities exhibit a disproportionate amount of spoliation from suburban necropoleis, while others rely nearly entirely on monuments from the urban core, leaving the necropoleis intact. This could be indicative of differing local conditions or preferences that determined which structures were preserved and which were not, thus warranting inclusion and further investigation.

While some larger regional trends may be observed, this methodology is best suited for studying the relationship between fortifications and monumental landscapes on a case-by-case basis. Each city was subject to its own local forces, and as we will see in the case studies, not every city fortified itself at the same time or in the same way. This certainly applies to the treatment of *spolia* and the incorporation of monuments into defensive circuits, and the preservation of physical evidence in the present day. Strategic importance, civic wealth, and unique military or environmental events all contributed to the ways in which cities fortified themselves in Late Antiquity. Additionally, issues of site integrity, as a result of prior excavations and modern urban expansion, have had a variable effect on individual cities. For example, much of the *spolia* observed in the walls of Sparta was carried away by excavators in the early 20th c., who were more interested in the Classical inscriptions than recording the contexts of their finds.[10] Patara, next to one of the widest sandy beaches in Turkey, was subjected to a number of arson attacks in the 1990s by locals who were opposed to restrictions on tourism development.[11] The following selection of case studies represent the strongest physical and literary evidence available, and includes cities from across the spectrum of described variables.

6 Chaniontis (2004) 400–401.
7 Işık (2000) 45.
8 Lavan (2015) for an initial proposal for a standardized method for examining late antique urban topography.
9 Observations by the author in Thessaloniki, Philippi, Athens, and Isthmia (2017), Rome (2015), and by Lavan in Asia Minor (2006).
10 Frey (2016) 90–92.
11 Tanaka (2018) 84.

Case Studies

Athens

There are two 3rd c. fortification walls in Athens. The earlier of these, the Valerian wall, is dated to the mid-260s on the basis of numismatic evidence.[12] This wall largely follows the path of the Classical-era Themistoclean circuit, expanded to encompass the Roman city's growth to the East. Observation of the wall is hindered by Athens' modern day urban sprawl, and as such, much of its course lies out of view beneath the modern city. In the absence of visible remains, Theocharaki's 2011 survey of the wall serves as an excellent tool for describing the character of each section. Spoliated material is found throughout, concentrated particularly around the Sacred Gate, the Olympieion Precinct, and the area immediately south of the Acropolis, but is markedly absent from the eastern expansion.[13] Types of *spolia* include grave stelae, statuary, and architectural elements, as well as a number of incorporated pre-existing structures, such as the southern wall of the Olympieion Precinct. The concentration of funerary *spolia* around the Sacred Gate suggests a direct relation to the city's nearby major extramural necropolis, the Kerameikos. Numerous Late Roman pottery kilns in the district suggest the necropolis had ceased to function as a burial ground by the mid- to late 3rd c.[14] However, the area was not wholly spoliated for material, as many memorials and tomb structures survive to the present day.

The sack of the city by the Heruli in AD 267 precipitated the need for a second, inner defensive circuit. This Post-Herulian wall, built during the reign of Probus, follows an entirely new course encircling the area to the north of the Acropolis, skirting the eastern limit of the Classical agora and extending around and across the southern slope. While much of the civic core lay in ruins, evidence of repairs to the Valerian circuit suggest that the rest of the city was not abandoned at this point.[15] The wall itself is built as two parallel masonry faces, composed of carefully laid *spolia*, with a rubble core. The outermost face is composed of regular ashlar coursing reminiscent of Classical, pseudo-isodomic masonry, suggesting careful planning and sorting of the available pre-existing material (Fig. 1). The use of spoliation on the external face is apparent in the many outward facing entablature blocks, with little modification to their decorative elements. Conversely, the innermost face features more irregular pieces, including broken column shafts and drums, presented in cross-section. Fragmentary sculpture, column capitals, and other architectural embellishment have been discovered in the rubble core.[16]

There is a distinct lack of observable tomb spoliation in this secondary circuit, likely due to the absence of cemeteries in the immediate vicinity of its course and the wealth of readily available material from surrounding civic and memorial structures, damaged or destroyed in the Herulian raid. The Stoa of Attalos, for example, was wholly incorporated with limited modification. The outer colonnade and frontal retaining wall were removed, and the interior chambers and shops were likely converted into guards quarters or storage chambers.[17] Elsewhere, porous blocks from the Stoa of Eumenes were replaced with harder stones to increase the structure's defensive viability.[18] As with the rest of the newly built curtain wall, the methods of inclusion suggest an emphasis on structural unity and defensive utility, rather than showcasing the decorative qualities or preserving the function of the incorporated structures.

The treatment of *spolia* within the 4th c. Beulé Gate leading up to the Acropolis (Fig. 2)[19] is a different matter. The gate incorporates material from the Choregic Monument of Nikias, which appears to have been completely dismantled rather than destroyed. Many of its blocks, including its decorative Doric triglyph frieze and memorial inscription, are prominently and purposefully displayed. The aesthetic and memorial integrity of the monument is somewhat preserved, as the triglyphs and dedicatory inscription correspond to their original placement in an architectural scheme. In this example, the spoliation of a monument serves a dual purpose, providing an appropriately monumental entrance to the Acropolis, whilst perhaps inadvertently preserving the spirit of the original memorial. The same cannot be said of the restored Sacred Gate in the Valerian wall, where Theocharaki makes no note of reused material displayed, decoratively or otherwise, despite their close proximity to the extramural necropolis and the clear use of funerary *spolia* within the surrounding curtain walls.[20] This could be due to lack of preservation or visibility (in the case of material used as filling), or to a conscious decision by the builders of this circuit not to include spoliated material from tombs. One possible explanation could be that the earlier Classical gate may have already been in sufficient state of repair; as such,

12 Theocharaki (2011) 131.
13 Theocharaki (2011) 94–96, Table 2.
14 Gill and Hedgecock (1992) 420.
15 Theocharaki (2011) 135.
16 Travlos (1988) 126.
17 Travlos (1988) 132.
18 Theocharaki (2011) 132.
19 Camp (2001) 225.
20 Theocharaki (2011) 94–96, Table 2.

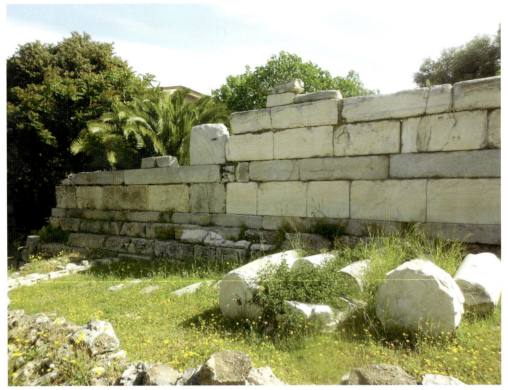

FIGURE 1 Athens, Post-Herulian Wall. Regular ashlar coursing reminiscent of Classical, pseudo-isodomic masonry, suggesting careful planning and sorting of the available pre-existing material.
PHOTO: LUKE LAVAN 2017

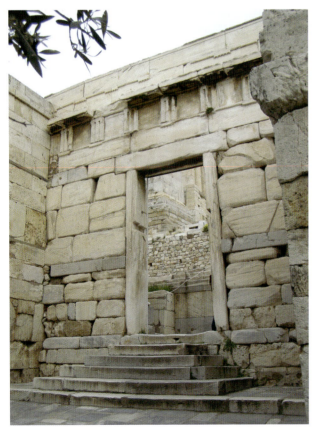

FIGURE 2 Athens, Beule Gate.
PHOTO: ANDRZEJ OTRĘBSKI CCAS 3.0 VIA WIKIMEDIA COMMONS

additional embellishment or pre-cut material would not have been necessary. The Beulé Gate, on the other hand, was an entirely new structure which would have benefitted from pre-existing structures nearby, many of which were already in a state of disrepair.

Aphrodisias

Any discussion about late antique fortifications in the East would be incomplete without mentioning the well-preserved walls of Aphrodisias. The wall is 3.5 km in length, encircles the entirety of the city, and features sections preserved up to 9 m in height. The wall and its associated monuments have been well studied and published, most notably by Peter De Staebler in *Aphrodisias Papers IV*. The site was largely abandoned following a 7th c. earthquake, and thus Aphrodisias presents a unique opportunity to study a well preserved late antique fortification without the intervention of later habitation. The city's elevated status as capital of the province of Caria-Phrygia (later solely Caria) directly resulted in the construction of the new wall, where none had existed before, and has been securely dated to the mid-4th c. AD on the basis of *in situ* dedicatory inscriptions.[21] Political power and status, rather than the threat of military

21 Ratté (2001) 125; De Staebler (2008) 287.

invasion, acted as the driving force behind the decision to build fortifications.

The wall features a large quantity of *spolia*, sourced primarily from the city's Classical and Imperial necropoleis. Much like the walls of Athens, the walls of Aphrodisias consist of two parallel faces of spoliated masonry with a rubble fill between. De Staebler estimates that 2,000 tombs would have supplied the 25,000 m² of stone needed to face the wall.[22] Based on these numbers and a survey of the surrounding necropoleis, one can assume that the entire suburban funerary landscape was co-opted for this purpose. As seen in the introductory example, even the local governor and city council were restricted in their ability to authorize the despoiling of tombs. As a result, few remains of sarcophagi are found in the walls themselves. Rather, stelae, tomb monuments, and large superstructures were dismantled and appropriated for the wall, leaving sarcophagi intact.[23] Certain sections feature high concentrations of *spolia* from single monuments, suggesting that material was gathered from local contexts, rather than transported over large distances. This also allows for visual reconstruction of individual tombs, appearing most commonly as square edifices with decorative mouldings or as pedestals which would have been surmounted by sarcophagi.

Commemorative stelae are abundant at Aphrodisias, including over 40 documented examples featuring gladiator reliefs, all found within secondary contexts associated with the wall. In 2001, 15 gladiator stelae were discovered *in situ* within a 100 m section of curtain wall, suggesting that most if not all came from a nearby monument.[24] Out of the 15, only two were found with their carved reliefs facing outwards. The rest were identifiable by dimensions, distinct profiles, and visible moulding around the edges.[25] While there is a lack of modification to the individual blocks, the fact that most are facing inwards suggests that decorative value was not taken into consideration. In fact, well preserved sections of wall facing display a relatively uniform pseudo-isodomic masonry pattern of headers and stretchers, like at Athens, that hearkens back to Classical and Hellenistic precedents.

Not all *spolia* was employed in a utilitarian fashion. The city's main gates prominently feature decorative *spolia* from both the necropoleis and select monuments from the urban core. The western gate reuses multiple elements from a pre-existing monumental arch, likely on or near the same spot of the later gate.[26] Voussoirs, spandrels with relief figures of Nike, and frieze panels are all employed with little modification, in a similar way to how they would have appeared in the earlier monument. De Staebler postulates that this arch must have been in a state of irreversible disrepair at the time of the wall's construction, otherwise it would likely have been wholly incorporated into the circuit.[27] The inner face of the south-east gate features a careful arrangement of twelve sculpted reliefs in two rows; three of these blocks include funerary inscriptions dedicated to members of the same family.[28] The blocks are purposefully arranged just above eye level to the right of the main portal, displayed in a similar fashion to how they would be were the original monument still standing.

There is little evidence of entire tombs being incorporated *in situ* into the wall, with the exception of a single tower in the southern section which may incorporate a monumental tomb at its core.[29] The city's stadium, stretching laterally across the northern edge of the site, was both incorporated and partially spoliated. The wall here cuts into the northern earthen embankment, while the eastern entrance was repurposed as a postern gate.[30] Blocks from the southern colonnade of the stadium are identifiable in the gates immediately to the east and west of the structure, while the upper rows of seating appear to have been removed for use as wall facing.[31] Despite these modifications, the stadium retained its function as an entertainment complex. Some time after the construction of the fortifications, a semicircular wall was added across the eastern end of the track to create an oval enclosure, and a monumental arcaded portico was built atop the wall (Fig. 3). This newly created amphitheatre was in use until at least the 6th c., as attested by inscriptions found on the seats.[32] In this case, the construction of the city wall acted as a catalyst for the renewal of a public monument, rather than its destruction and disuse. The destruction of the extramural necropoleis fed into this cycle of urban renewal as well, albeit in a way that largely sacrificed the memorial function of the tombs it spoliated. This is indicative of a clear sorting of priorities by the local authorities, where the functionality and integrity of the urban core was placed above the memorial significance of the suburban funerary landscape.

22 De Staebler (2008) 288.
23 De Staebler (2008) 312–13.
24 Kontokosta (2008) 192.
25 Kontokosta (2008) 199.
26 De Staebler (2008) 298–300.
27 De Staebler (2008) 299 n. 52.
28 De Staebler (2008) 300–301.
29 Ratté (2001) p. 126.
30 Welch (1998) 565.
31 De Staebler (2008) 288.
32 Welch (1998) 565–68.

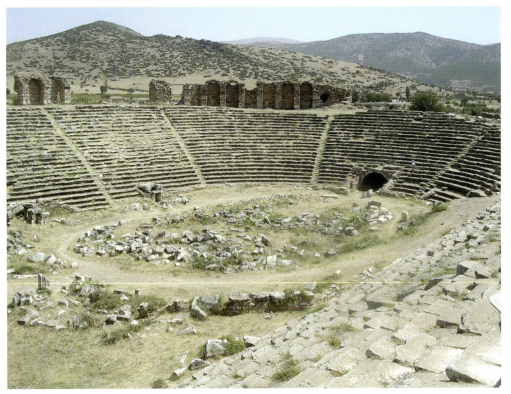

FIGURE 3 Aphrodisias. Sometime after the construction of the fortifications, a semicircular wall was added across the eastern end of the track to create an oval enclosure, and a monumental arcaded portico was built atop the wall, evoking an amphitheatre.
PHOTO: LUKE LAVAN 2010

Hierapolis

Hierapolis of Phrygia was a thriving urban centre throughout Late Antiquity, despite a devastating earthquake in the mid-4th c., which damaged much of the city's monumental infrastructure. The city recovered, albeit transformed by the subsequent rebuilding, evidenced by the conversion of the agora into a quarry and industrial yard, featuring multiple lime kilns.[33]

This was followed by a flurry of private, civic, and religious construction throughout the city; a large basilica was constructed in the city centre, followed by the establishment of the Martyrium of St. Philip in the eastern necropolis.[34] As part of this program of urban renewal and in accordance with the edicts of Theodosius I and Arcadius (AD 395–96), fortifications were constructed encircling nearly the entirety of the Roman city.[35] In their present form, the walls are over 2 km long, well-preserved primarily along the northern, eastern, and southern limits of the city.[36] As at Aphrodisias, medieval to modern habitation of the site was sparse, thus the integrity of the city and its fortifications survives relatively intact, though large swaths remain buried beneath calcinous and colluvial deposits, in some places up to 4 m deep.[37]

Hierapolis features vast and well preserved necropoleis with over 2,000 individual standing structures, ranging from Roman monumental sarcophagi and house tombs to more ancient Hellenistic tumuli (Fig. 4).[38] Despite these monuments' potential for spoliation, the majority of identifiable pre-cut material in the wall originates from large urban and suburban public structures, including the suburban theatre and the northern agora. A comprehensive 2010 survey of the city wall revealed that only 10% of the spoliated material could be securely attributed to the necropoleis, while over 28% could be attributed to the suburban theatre alone.[39] Many of the seats from the theatre can be observed along the eastern course of the wall, employed as facing in a similar fashion to the seats from the stadium at Aphrodisias. The entirety of the northern agora is left out of the new circuit, with the course of the wall running atop the stylobate of its southern portico. The presence of destroyed

33 D'Andria (2001) 111–12.
34 Arthur (2012) 278.
35 D'Andria (2003) 115.
36 Castrianni et al. (2010) 93.

37 D'Andria (2003) 106.
38 Equini (1972) 98.
39 Castrianni et al. (2010) 116.

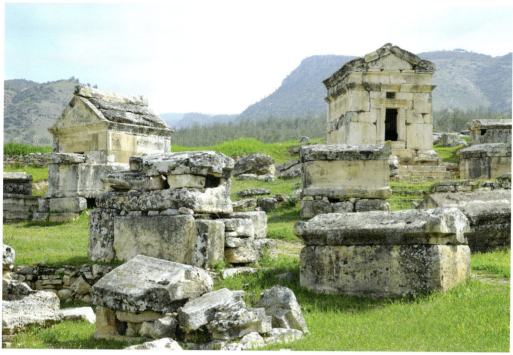

FIGURE 4 Hierapolis. The well-preserved necropolis features 2,000 individual standing structures, ranging from Roman monumental sarcophagi and house tombs to more ancient Hellenistic tumuli.
PHOTO: CAROLE RADDATO CC BY-SA 2.0 VIA WIKIMEDIA COMMONS

marble cornice blocks at the base of the wall confirms that the agora was ruined at the time of construction.[40]

Spolia is employed in a purposefully decorative fashion at the North Gate, which features 4 columns flanking the portal and sculpted lion and griffin head panels above.[41] The ashlars used in and around the gate are of higher quality than those found elsewhere in the circuit, with clear effort made to present a unified, monumental façade (Fig. 5). This was likely aided by the gate's proximity to the remains of the agora, from which the builders would have had a choice selection of pre-cut, monumental ashlars. This is not the case in the curtain wall, best observed along the eastern limits, where *spolia* exhibits a much wider range of shapes, materials, and damage. The wall incorporates standing structures as well, most notably the large, monumental Nymphaeum of the Tritons immediately south of the North Gate. This structure retained some of its aesthetic integrity, as marble embellishments can still be seen *in situ* and numerous sculptural decorations were found in the immediate vicinity.[42] While the monument continued to function in an aesthetic sense, it likely ceased to function as a fountain, as the water supply pipes were cut by the wall further along the course.[43]

The situation in Hierapolis appears to be the opposite of that in Aphrodisias, where the construction of the city walls was contemporaneous with the restructuring and renewal of the suburban funerary landscape, especially around the Martyrium of St. Phillip in the eastern necropolis. The construction of the martyrium brought a renewed importance to Hierapolis as a highly trafficked pilgrimage stop in Asia Minor, and specifically to the eastern necropolis as a place where individuals desired to be buried. Surveys conducted by the University of Oslo in the immediate area of the martyrium reveal a large Byzantine cemetery consisting of newly dug inhumation burials and reused imperial sarcophagi and house tombs.[44] This is not to say, however, that the necropoleis were entirely spared from spoliation for the purpose of the city wall. Tombs along the lower slope of the eastern necropolis, within the immediate vicinity of the wall are less well preserved than their counterparts further up the hill.[45] As claimed by Hill, certain elements of monumental house tombs can be observed within the context of the wall, though further walkover survey is required to determine the condition and visibility of this *spolia*. We do know, however, that the Imperial-era tombs in Hierapolis were constructed largely without the use of mortar and instead utilized

40 D'Andria (2003) 107.
41 Jacobs (2009) 202.
42 D'Andria (2003) 117–25.
43 D'Andria (2003) 116.

44 Ahrens and Brandt (2016) 395–96, 405.
45 Hill *et al.* (2016) 118.

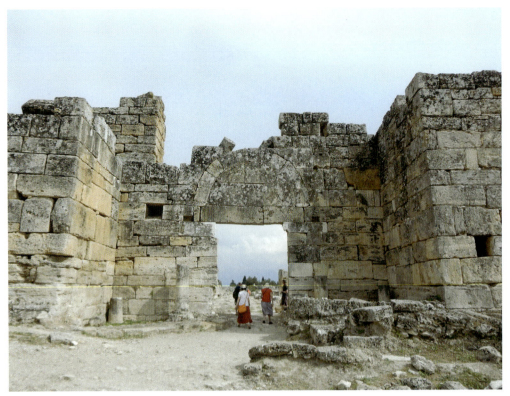

FIGURE 5 Hierapolis. Spolia employed in a decorative fashion at the North Gate, featuring 4 columns flanking the portal and sculpted lion and griffin head panels above. The ashlars in and around the gate are of higher quality than those found elsewhere in the circuit.
PHOTO: BETH M527 CC BY-NC 2.0 VIA WIKIMEDIA COMMONS

metal clamps.[46] These structures would have been relatively easy to disassemble in intact blocks, suggesting they might be found in good condition within the wall. Despite the intrusion of the wall, we can observe that the eastern necropolis as a whole continued to function as a funerary landscape, imbued with renewed importance thanks to the martyrium.

Patara

Patara was an important centre of trade in Late Antiquity, connected by a vast network of roads to the inland cities of Lycia and situated next to a deep, natural harbour. There was a pre-existing Hellenistic fortification, although this was rendered obsolete and largely dismantled during Imperial-era urban expansion.[47] There are a variety of tomb types present in Patara, including temple, rock-cut, and altar tombs, as well as Lycian style monumental sarcophagi.[48] These can be found in necropoleis on the northern, eastern, and southern edges of the city, as well as within the civic centre itself. The Early Byzantine walls cut a path through the centre of the urban core and are dated to the first half of the 5th c. on the basis of construction technique and relation to a large, contemporary basilica.[49] Both of the city's largest basilicas are located outside this defensive circuit, suggesting that the extramural area was not abandoned at this time.[50] In fact, the 5th c. was a time of relative peace for the region.[51] Regular coursing (though not pseudo-isodomic), tight seams, and a lack of broken material would imply that the wall was not built as a reaction to a destruction event. Rather, it can be seen as a carefully planned act of urban renewal and a status mark of its commercial and, in conjunction with the lavish new basilica, religious importance.

As in the above examples, the wall is constructed of two faces of spoliated masonry with a rubble core. Column drums are visible in profile, though not in large quantities or distributed in any way that would suggest a decorative or meaningful purpose (Fig. 6). Like at Aphrodisias, entire monuments, both funerary and civic, appear to have been dismantled and reassembled

46 Hill *et al.* (2016) 118.
47 Peschlow (2017) 281.
48 Işık (2000) 27.
49 Peschlow (2017) 285.
50 Ceylan and Erdoğan (2016) 176 assert that the primary extramural basilica was not martyrial in function, and was rather the seat of the bishop, further suggesting continued habitation of the area.
51 Foss (1994) 15.

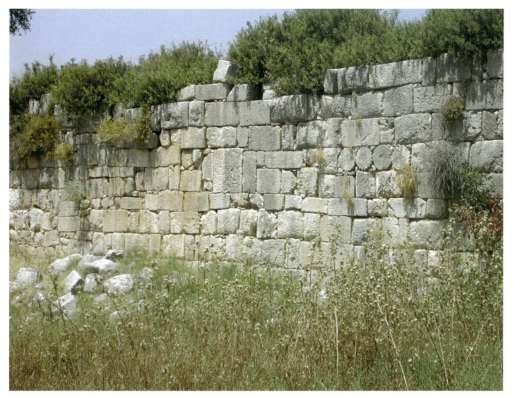

FIGURE 6 Patara. The wall is constructed of two faces of spoliated masonry with a rubble core. Column drums are visible in profile, although not in large quantities or distributed in any way that would suggest a decorative or meaningful purpose.
PHOTO: LUKE LAVAN 2003

in concentrated portions of the circuit. This is certainly the case with the so-called Marciana temple tomb, with distinctive *tropaion* reliefs and inscription prominently displayed within the same tower.[52] To the immediate north-west of the bouleuterion, a number of Imperial-era honorific statue bases were repurposed at the base of the curtain wall.[53] These include groups of blocks from single monuments, and are employed in a clearly decorative fashion, though are in many cases with the inscription inverted. Not all materials are given the same aesthetic consideration, however. A 1993 arson attack exposed blocks from the Claudian *Stadiasmus Patarensis* monument, repurposed as ashlars in the wall.[54] The blocks were found intact (aside from damage from the fire), implying that the monument was carefully dismantled, rather than destroyed in antiquity. However, little to no consideration was given to the aesthetic display of the blocks within the wall, as the inscribed faces were found upside-down, sideways, or facing inwards.[55] As with Marciana temple tomb and the statue bases by the bouleuterion, the blocks were found in close relation with each other. This would imply that this material was carefully sorted by the builders, and likely did not travel far from their original locations to their secondary context within the wall.

The wall incorporates a number of civic structures along its path through the city centre. The bouleuterion was converted into a corner bastion, with its openings blocked up and the interior filled in with rubble (Fig. 7).[56] Seats from the southern side of the cavea were removed and reused as facing in the wall, much the same way as the seats from the stadium at Aphrodisias.[57] Unfortunately, much of this modification is invisible today, due to a recent overzealous restoration of the building to its Imperial-era appearance. The Vespasianic bath was incorporated as a corner bastion as well, though Peschlow speculates that these could have remained in use post-incorporation. Visual inspection reveals a sturdy construction of ashlar masonry, with few external apertures or visible decoration. Whether decoration was purposefully removed or absent in the first place is unknown, as well as the post-incorporation status of the interior of the structure. Further study would be required to determine the full extent of modification,

52 Işık (2000) 105.
53 Lepke (2015) 135.
54 Onur (2016) 570–71.
55 Işık (2000) 93–99.
56 Peschlow (2017) 285.
57 Korkut (2006) 94.

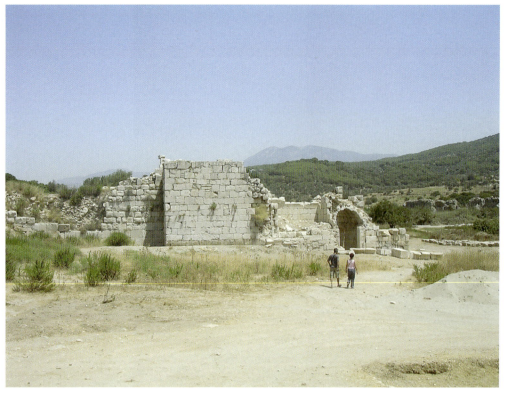

FIGURE 7 Patara. The wall incorporates a number of civic structures along its path through the city centre. The bouleuterion was converted into a corner bastion.
PHOTO: LUKE LAVAN 2006

and whether similar measures to fill and consolidate the baths, as with the bouleuterion, were taken.

The necropoleis at Patara, like at Hierapolis, appear to have been selectively spoliated for the purpose of inclusion in the wall. This is evident in the treatment of tombs in the nearby Tepecik necropolis, where certain monuments have been razed to their foundations, while others remain to this day in a near perfect state of preservation.[58] Within the wall itself, spoliated material from the necropolis appears to have been minimally altered, and is thus readily identifiable. This is particularly true for funerary altars and stelae, which can be identified by their distinctive shapes, as seen in Fig. 6, or the presence of inscriptions. As with the *Stadiasmus* monument, inscriptions can be found facing inwards or outwards, implying that little consideration was given to how they would be viewed by the passerby. While the form of these stelae have been minimally altered, their use in the wall implies no regard on the part of the builders and planners towards decorative or continued memorial function. This treatment varies throughout the wall, as seen in the decorative displays of *spolia* from the Marciana temple tomb and the bouleterion-adjacent statue bases.

Implications and Final Thoughts

Through this study, I have sought to highlight how a systematic examination of late antique city walls can inform us of the status of the pre-existing urban landscape, particularly funerary monuments and necropoleis. One of the early aims was to identify regional trends in the use of funerary *spolia*. The East contains far more visible reuse of *spolia* sourced from funerary contexts, as well as a greater variety of civic structures than in the West. The relationship between urban fortifications and monuments to the past, whether they be civic or funerary in nature, manifests itself in a unique fashion according to the political, social, and environmental contexts of each city, as illustrated by the above case studies. The destruction or continuity of necropoleis differs according to the specific contexts of each locality, ranging from total destruction and reuse in Aphrodisias, minimal interference at Athens, revitalization and continuity in Hierapolis, and selective spoliation at Patara.

58 Kocak (2016) 371 acknowledges that no direct connection can be made between the demolished tomb monument and the city wall, due to lack of comparable material left behind at the monument. However, he notes that inclusion seems likely, due to the presence of such material in the wall.

Where there is no evidence of destruction events, monuments are dismantled for the express purpose of inclusion in city walls, implying a selective and systematic program of planned spoliation. Such is the case in Aphrodisias, where the entirety of the suburban necropoleis was co-opted for this purpose, and at Patara, where select tombs and monuments (i.e. the Marciana temple tomb and the *Stadiasmus* monument) were carefully dismantled and recycled. Clear decorative embellishment of gates occurs at Aphrodisias, using *spolia* from tombs and civic structures. Similarly, *spolia* from statue bases and tomb reliefs adorns certain sections of curtain wall and towers at Patara. Both walls were built as part of a wider program of urban renewal; in Aphrodisias, they coincided with renovations to the theatre, Sebasteion, and stadium,[59] while in Patara, large extramural basilicae were constructed. The use of funerary monuments as building material is therefore a symptom of positive transformation, more so than the abandonment of heritage and memory. Such initiatives had to have come with explicit direction of provincial or Imperial authorities, though execution varied accordingly to date and other local factors. Thus we find a highly decorative 4th c. wall in Aphrodisias, encompassing the entirety of the urban core, and a utilitarian (though hardly rushed) 6th c. wall at Patara, cutting a path through the heart of the city and utilizing material from civic structures and funerary monuments in its immediate vicinity.

In cases where there is evidence of a destruction event, either the result of military invasion or natural disaster, we see two types of responses. At Athens, following the destruction of the Herulian raids, *spolia* closely mimics pseudo-isodomic masonry of the past. The external face of the wall displays a deliberate sorting of materials to achieve a unified, aesthetically pleasing result. This is taken a step further on the Acropolis with the reuse of the Choregic Monument of Nikias in the Beulé Gate. Conversely, the reuse of material from structures destroyed by an earthquake at Hierapolis displays less attention to regular coursing, sorting of materials, and decorative embellishment. Only the external face of the northern city gate exhibits any kind of uniformity, as well as the decorative use of sculptural *spolia*. One interpretation is that the builders of the city wall at Hierapolis wanted to present a suitably monumental entrance into the city, for the benefit of the external visitor (perhaps pilgrims to the Martyrium of St. Philip) and for the sake of civic pride. However, the limitations of the types of material available, heavily damaged by an earthquake and heterogeneous in nature, meant that same consideration could not be afforded for the rest of the circuit. In addition, the wealth of material from destroyed civic structures undercut the need to dismantle tombs in both these cities.

Structures are incorporated in all the above examples, adapted in ways that either transformed, destroyed, or preserved their original functionality. We see this best illustrated by the stadium of Aphrodisias and its conversion into an amphitheatre, a few decades later, whilst simultaneously serving as an integrated part of the fortifications. This positive application of spoliation and urban renewal can be compared to the treatment of the bouleuterion at Patara, for example, which was converted to a fortified bulwark. Tombs display even less potential for continued use after their incorporation, as they were either wholly adapted into defensive towers, or absorbed as structural fill. The sole exception to this may be at Palmyra, where a series of tower tombs incorporated into the late 3rd c. wall exhibit few internal or external structural changes, implying that they could have potentially continued to function as funerary spaces.[60] Not every tower tomb in the circuit received the same consideration, however, suggesting a selective choice to preserve certain monuments rather than an established standard. Likewise, monuments from the core of Patara were selectively spoliated and incorporated, though this likely had more to do with convenience than anything else (tombs closest to the circuit are dismantled for *spolia*).

The continuity of funerary landscapes varies in each of these sites. At Athens, the Valerian Wall employed only a fraction of material from the Kerameikos cemetery, despite its evident disuse at the time of the wall's construction. The later Post-Herulian wall, located in the urban core and far from the extramural necropoleis, utilized little to no funerary material. At Aphrodisias, there is a complete disconnect between the city and its memorial landscape, with the carefully planned demolition of the monumental necropoleis and masking of spoliated material within the city wall, with the exception of certain decorative displays around the city's main gates. Hierapolis presents clear, conclusive evidence for continual use of its eastern necropolis, which became an important pilgrimage site thanks to the Martyrium of St. Phillip. However, the necropolis appears to have been selectively demolished and spoliated based on proximity to the path of the wall, like at Patara. In all these cases, use of funerary *spolia* represents a series of localized choices; that of the city officials, who authorized the building of city walls and the demolition of

[59] De Staebler (2008) 289.

[60] Juchniewicz *et al.* (2008) 58.

monuments; of the planners, who plotted the course of the wall, determining which structures would be slated for demolition; and of the builders, who modified and placed this reused material in the wall, to be displayed and recognized or obscured and erased.

This is by no means meant to be a conclusive, definitive survey, but rather a stepping stone for further site-specific research. Studies can and should be written on the treatment of *spolia* in individual circuits and from specific monuments, as they seem to differ across the spectrum of various contexts. I argue that the material appearance of *spolia* as the result of destruction, preservation, or modification, has intrinsic value to understanding the function of a city wall within an urban and memorial landscape.

Appendix: Rome and Aurelian's Wall

The wall of Rome is famous for its length, its preserved state, and for the many monuments incorporated within its fabric. As such, it presents one of the best opportunities for the application of this proposed methodology, albeit with a greater focus on incorporated structures rather than spoliated material. As discussed in the above eastern case studies, however, principles of destruction, preservation, and modification can apply equally to a single architectural feature, such as an architrave or inscribed block, as it can to an entire monument. Extensive fieldwork on the Esquiline Hill was undertaken in 2015, centred on Porta Maggiore, for the express purpose of exploring the ways in which the wall interacts with these pre-existing structures; this will form the primary observational basis for this case study.

The wall was built during the reign of Aurelian from AD 271–75 and completed by his successor, Probus, as a response to the disastrous invasions of the Iuthugi and Macrommani tribes in the mid- to late 3rd c.[61] The wall is constructed primarily of regular brick course-work facing a concrete and rubble aggregate core. It is approximately 19 km in length, two-thirds of which are still visible and largely accessible today at least along the external face. The high degree of preservation is due largely to the continued use of the wall as a defensive barrier up until the reunification of Italy and the subsequent urban expansion of the city in the 19th c. This presents the challenge of sorting through 1,700 years worth of demolition and renovations, which often times included Imperial *spolia*. Ian Richmond's 1930 survey remains the best resource for understanding the original 3rd c. Aurelianic form of the wall, though more recent work on the subject by Robert Coates-Stephens and Hendrik Dey has led to a greater understanding of the precise dating of the late antique and Early Medieval phases. Using Richmond's account as a starting point, I was able to make observations on the use of *spolia* and the state of incorporated structures within the major late antique construction phases.

Along a tract of wall approximately 1.5 km in length, between the Amphitheatrum Castrense and Porta Tiburtina, the remains of at least 17 individual incorporated structures were observed. These include entertainment buildings, like the aforementioned amphitheatre, which was bricked-up and converted into a bastion (Figs. 8a–b), and the Circus Varianus, which was bisected by the wall. In both these cases, the incorporated structures were altered in such a way that they were no longer able to function as originally intended. The majority of incorporated structures were related to Rome's water supply, as the area around the Esquiline hill was the point of entry for the Aqua Claudia, Aqua Anio-Novus, Aqua Neroniana, and Aqua Marcia-Tepula-Julia. Two water *castelli* can be definitively observed, incorporated as towers or bastions, and two monumental arches which carried aqueducts over the major roads became city gates (the Claudian arch at Porta Maggiore and an Augustan arch at Porta Tiburtina). Textual and archaeological evidence of repairs to the Aqua Claudia and Aqua Marcia as late as the 7th and 8th c. suggest they continued to function well after the wall's construction.[62] Despite modification of the upper stories to include a parapet and arched windows, a lack of concrete or rubble fill in the *castellum* closest to Porta Tiburtina suggests it may have continued to function as well.[63]

The area around Porta Maggiore, where both the *Via Praenestina* and the *Via Labicana* entered the city, was the site of a major Republican and Imperial era necropolis, with the earliest tombs dated to the late 2nd c. BC.[64] The most visible extant monument is the Tomb of Eurysaces, which was incorporated into the central tower of the Aurelianic gate (Figs. 9a–b). Unlike the more famous Pyramid of Cestius, this tomb was partially demolished and completely obscured, only to be rediscovered when the gate was dismantled in 1838.[65] The tomb is well preserved in its southern, western, and northern faces, while the eastern face was shorn off at the time of its incorporation to follow the contour of the planned tower. The surrounding necropolis within the

61 Dey (2011) 13.
62 Coates-Stephens (1998) 171–72.
63 Volpe (1996) 54.
64 Coates-Stephens (2004) 11.
65 Peterson (2003) 232.

DESTRUCTION, PRESERVATION, AND ADAPTIVE REUSE OF FUNERARY MONUMENTS: THE EAST

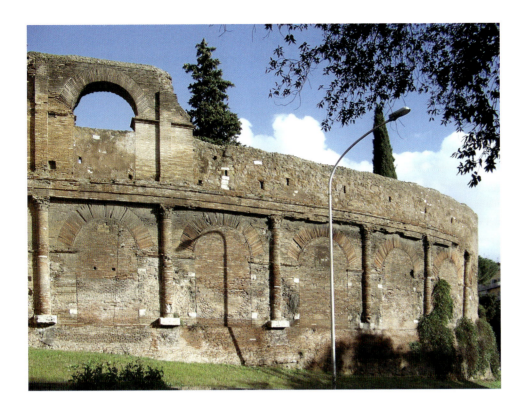

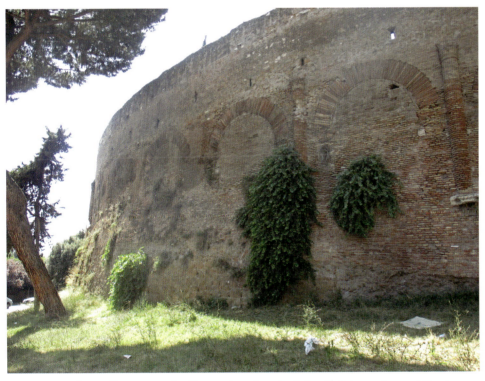

FIGURE 8 a. Rome. Along a tract of wall approximately 1.5 km in length, between the *amphitheatrum castrense* and *porta tiburtina*, the remains of at least 17 individual incorporated structures were observed. These include entertainment buildings, like the *amphitheatrum*, which was converted into a bastion.
PHOTO: CCCP, CC BY-SA 2.5 CA VIA WIKIMEDIA COMMONS); B. (PHOTO: NICHOLAS MISHKOVSKY 2015

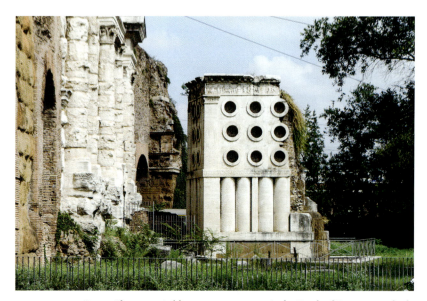 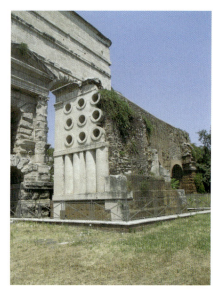

FIGURE 9 a. Rome. The most visible extant monument is the Tomb of Eurysaces, which was incorporated into the central tower of the Aurelianic gate, only to be rediscovered when the gate was dismantled in 1838 (photo: Byus71, CC BY-SA 4.0 via wikimedia commons); b. Angle showing the depth of the structure.
PHOTO: NICHOLAS MISHKOVSKY 2015

immediate vicinity of the gate was likely levelled at this time as well, as no monuments survive above the 3rd c. ground level.[66] Subterranean *colombaria*, however, display expansion and continued use for Christian burials at least until the 5th c.[67]

Spolia, rather than incorporated structures, is less obviously present in Aurelian's wall. A large portion of the brickwork was recycled from earlier Hadrianic structures, while the concrete aggregate utilized larger pieces of decorative masonry and sculpture.[68] The Honorian renovations in the early 5th c. embellished the gates with travertine facing, composed entirely of spoliated blocks, sourced at least in part from nearby tombs.[69] Porta Tiburtina, east of Porta Maggiore, preserves this Honorian curtain in its entirety (Figs. 10a–b). The blocks are clearly re-cut and fit together in a jigsaw-like fashion, with only cursory attention to regular coursing. At least one ashlar features a clear funerary inscription from the tomb of Ofillius, though this is fragmentary and upside-down. Traces of an earlier Honorian dedication inscriptions can be seen on a number of blocks, which were evidently dressed down prior to being re-inscribed, though not deep enough to completely erase the earlier lettering.[70]

In Rome, the treatment of pre-existing monuments and infrastructure seems to give little consideration to preservation of memory and original function, with the exception of maintaining the utilitarian functions of aqueducts and associated water *castelli*. As there was no destruction event prior to the construction of the wall, tombs are purposefully demolished or subsumed in a way that conceals their original features or negates their functionality. The levelling of the Porta Maggiore necropolis would have provided a wealth of statuary and decorative architectural elements, yet there is no evidence for the use of sculptural *spolia* in a decorative context. Instead, the wall is designed to be uniform and featureless throughout. This applies to the Honorian embellishment of the gates as well, though there is clearly some reused funerary material present, and decorative value was assigned to the travertine itself, rather than any artificially added features.

Further on-site survey and research is required to fully understand the methods of incorporation and the impact of Aurelian's wall on the city's funerary landscape. The conversion of the Mausoleum of Hadrian into a fortress, for example, is deserving of special consideration, due to its previous importance as a symbol of Imperial power and memory, and for its unique function and strategic significance as a fortified bridge-head thereafter. Conversely, in the case of Pyramid of Cestius, not included in this survey, no effort is made by the wall's architects to modify the structure or increase the defensive viability in any way. Instead, it sits astride the wall as a solid, unintegrated mass. This warrants further

66 Coates-Stephens (2004) 87.
67 Coates-Stephens (2004) 109.
68 Heres (1982) 20.
69 Richmond (1930) 259.
70 Richmond (1930) 32.

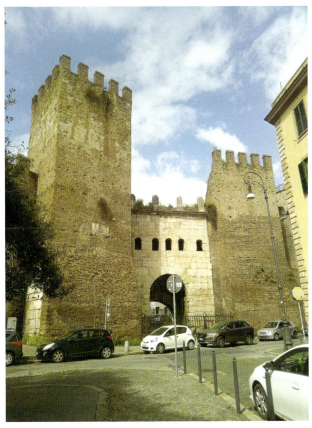 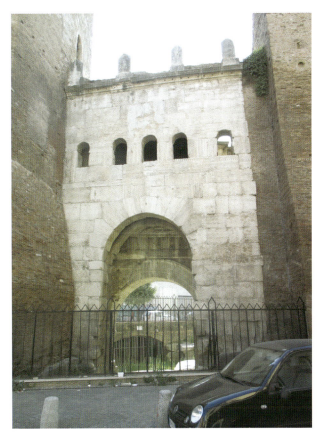

FIGURE 10 a. Rome. Porta Tiburtina, east of Porta Maggiore, preserves the Honorian curtain in its entirety (photo: Udine2812, CC BY-SA 4.0 via wikimedia commons); b. Closer up view of the Porta Tiburtina.
PHOTO: NICHOLAS MISHKOVSKY 2015

research into the motives and methods of this monument's inclusion. Rome itself is a microcosm of the Roman world; as seen from the above discussion, the treatment of individual monuments is context driven and varied according to a structure's strategic value, practical function, and material form. The contextual landscapes of memory, law, social practice, and natural environment shape the differences we see in urban fortifications in the East and West, between provinces, and between individual cities.

Bibliography

Ahrens S. and Brandt R. (2016) "Excavations in the north-east Necropolis of Hierapolis 2007–2011", in *Hierapolis Di Frigia VIII. (1): Le Attivita delle Campagne di Scavo Restauro 2007–2011*, edd. F. D'Andria, M. Pierra Caggia, and T. Ismaelli. (Istanbul 2016) 395–414.

Arthur P. (2012) "Hierapolis of Phrygia: the drawn-out demise of an Anatolian city", in *Vrbes Extinctae, Archaeologies of Abandoned Classical Towns*, edd. N. Christie and A. Augenti. (Farnham 2012) 275–305.

Camp J. M. (2001) *The Archaeology of Athens*. (New Haven 2001).

Castrianni L., Giacomo G. D., and Ditaranto I. (2010) "La cinta muraria di Hierapolis di Frigia: Il geodatabase dei materiali di reimpiego come strumento di ricerca e conoscenza del monumento e della città", *Archeologia e Calcolatori* 21. (2010) 93–126.

Chaniotis A. (2004) "New inscriptions from Aphrodisias. (1995–2001)", *AJA* 108. (2004) 377–416.

Coates-Stephens R. (1998) "The walls and aqueducts of Rome in the early Middle Ages, A.D. 500–1000", *JRS* 88. (1998) 166–78.

Coates-Stephens R. (2004) *Porta Maggiore: Monument and Landscape: Archaeology and topography of the southern Esquiline from the Late Republican period to the present.* (Rome 2004).

Ceylan B. and Erdoğan O. (2016) "The architecture and history of the city basilica of Patara: a preliminary report on four seasons of excavations", in *Lykiarkhissa: Festschrift Fur Havva Iskan*, ed. E. Yayınları. (Istanbul 2016) 173–92.

D'Andria F. (2001) "Hierapolis of Phrygia: its evolution in Hellenistic and Roman times", in *Urbanism in Western Asia Minor: New Studies on Aphrodisias, Ephesos, Hierapolis, Pergamon, Perge and Xanthos*, ed. D. Parrish. (Portsmouth 2001) 96–115.

D'Andria F. (2003) *Hierapolis of Phrygia. (Pamukkale): An Archaeological Guide*. (Istanbul 2003).

De Staebler P. (2008) "The city wall and the making of a late antique provincial capital", in *Aphrodisias Papers 4: New Research on the City and its Monuments*, edd. C. Ratté and R. R. R. Smith. (Portsmouth 2008) 284–318.

Dey H. W. (2011) *The Aurelian Wall and the Refashioning of Imperial Rome, AD 271–855*. (New York 2011).

Equini Schneider E. (1972) *La necropoli di Hierapolis di Frigia; contributi allo studio dell'architettura funeraria di età romana in Asia Minore*. (Rome 1972).

Frey J. M. (2016) *Spolia in Fortifications and the Common Builder in Late Antiquity*. (Boston 2016).

Foss C. (1994) "The Lycian coast in the Byzantine Age", *DOP* 48. (1994) 1–52.

Gill D. W. J. and Hedgecock D. (1992) "Debris from an Athenian lamp workshop of the Roman period", *BSA* 87. (1992) 411–21.

Heres T. L. (1982) *Paries: A Proposal for a Dating System of Late-Antique Masonry Structures in Rome and Ostia*. (Amsterdam 1982).

Hill D. J. A., Lieng Andreadakis L. T., and Ahrens S. (2016) "The North-East Necropolis survey 2007–2011: methods, preliminary results and representivity", in *Hierapolis Di Frigia VIII. (1): Le Attivita delle Campagne di Scavo Restauro 2007–2011*, edd. F. D'Andria, M. Pierra Caggia and T. Ismaelli. (Istanbul 2016) 109–20.

Intagliata E. E. (2017) "Palmyra and its ramparts during the Tetrarchy", in *New Cities in Late Antiquity: Documents and archaeology*, ed. E. Rizos. (Turnhout 2017) 71–83.

Işık F. (2000) *Patara: The History and Ruins of the Capital City of Lycian League*. (Antalya 2000).

Jacobs I. (2009) "Gates in Late Antiquity: the eastern Mediterranean", *Babesch* 84. (2009) 197–213.

Juchniewicz K., Ascad K. and al Hariri K. (2010) "The defence wall in Palmyra after recent Syrian excavations", *Studia Palmyreńskie* 9. (2010) 55–73.

Keen A. (1992) "The dynastic tombs of Xanthos: who was buried where?", *Anatolian Studies* 42. (1992) 53–63.

Kocak M. (2016) "Überlegungen zu einem Monumentalgrab aus der Tepecik-Nekropole von Patara", in *Patara VII. (1): From Sand Into a City: 25 Years of Patara Excavations. Proceedings of the International Symposium of 11–13 November 2013, Antalya*, edd. H. Işkan and F. Işık. (Istanbul 2015) 369–83.

Kontokosta A. H. (2008) "Gladiatorial reliefs and elite funerary monuments at Aphrodisias", in *Aphrodisias Papers 4: New Research on the City and its Monuments*, edd. C. Ratté and R.R.R. Smith. (Portsmouth 2008) 190–229.

Korkut T. (2006) "The parliament building of Patara", in *Proceedings of the XVIth International Congress of Classical Archaeology, Boston, August 23–26, 2003*, edd. C.C. Mattusch, A.A. Donohue, and A. Brauer. (Oxford 2006) 93–97.

Lavan L. (2015) "Distinctive field methods for Late Antiquity: some suggestions", in *Field Methods and Post-Excavation Techniques in Late Antique Archaeology*. (Late Antique Archaeology 9), edd. L. Lavan and M. Mulryan. (Boston 2015) 51–90.

Lepke A. (2015) "Neue agonistische Inschriften aus Patara", *ZPE* 194. (2015) 135–57.

Lightfoot C. and Lightfoot M. (2007) *Amorium: A Byzantine City in Anatolia*. (Istanbul 2007).

Onur F. (2016) "The Monument of Roads at Patara", in *From Lukka to Lycia, The Land of Sarpedon and St. Nicholas*, edd. H. Iskan and E. Dundar. (Istanbul 2016) 570–77.

Peschlow U. (2017) "Patara", in *The Archaeology of Byzantine Anatolia: From the End of Late Antiquity until the Coming of the Turks*, ed. P. Niewöhner. (New York 2017) 280–90.

Petersen, L. (2003) "The baker, his tomb, his wife, and her breadbasket: the Monument of Eurysaces in Rome", *ArtB* 85. (2003) 230–57.

Ratté C. (2001) "New research on the urban development of Aphrodisias in late antiquity", in *Urbanism in Western Asia Minor: New Studies on Aphrodisias, Ephesos, Hierapolis, Pergamon, Perge and Xanthos*, ed. D. Parrish. (Portsmouth 2001) 116–47.

Richmond I. A. (1930) *The City Wall of Imperial Rome: An Account of its Architectural Development from Aurelian to Narses*. (Oxford 1930).

Tanaka E. (2018) "Archaeology has transformed "stones" into "heritage": the production of a heritage site through interactions among archaeology, tourism, and local communities in Turkey", *História: Questões & Debates* 66. (2018) 71–94.

Theocharaki A. M. (2011) "The ancient circuit wall of Athens: its changing course and the phases of construction", *Hesperia* 80. (2011) 71–156.

Travlos J. (1988) "The post Herulian wall", in *Late Antiquity, A.D. 267–700*, ed. A. Frantz. (Princeton 1988) 125–41.

Volpe R. (1996) *Aqua Marcia: Lo scavo di un tratto urbano*. (Florence 1996).

Welch K. (1998) "The stadium at Aphrodisias", *AJA* 102. (1998) 547–69.

Spolia in Late Antique City Walls
Catalogue 1: Africa and the East

Luke Lavan

There now follows a listing of sites studied for this article, along with a review of the dating evidence. This is not a complete catalogue of major late fortifications, but rather of those which have significant accessible quantities of reused material fit for study, or which obviously incorporate earlier buildings. Sometimes, walls without *spolia* are included to differentiate them from other walls in the same city which do have reused materials. In other cases, post-antique fortifications are omitted, as their dating is too vague. A few sites have been cut simply because their reports have not been accessible or are not yet sufficiently detailed to use. The dating methodology followed here is that employed in Lavan L. (2020) *Public Space in the Late Antique City* (Late Antique Archaeology Supplement 5) (Leiden 2020) vol. 2 1–8. In Africa and a few other regions, we have coherent fortifications built in a single style to a coherent design, sometimes dated by one or several building inscriptions set above gates. Elsewhere, the primary phasing of fortifications is often simple, as there were obvious functional reasons for finishing circuits in a single programme of works: to protect a city the defenders needed to have a complete ring. This leads to a (usually justifiable) assumption that, until proven otherwise, they were of one phase in their primary construction.

However, the dating of fortifications can in other cases be subject to revision, especially in the first decades of their modern study. This is because of their size and complexity: occasionally, repairs were not fully taken into consideration when dates were first offered by scholars, which confuses results. As a result, a site with a number of widely separated sondages may initially produce some changes in dating, during the early years of expeditions, before the walls are properly surveyed for their own sake. It is also worth pointing out that the record we have of many fortifications is imperfect. Quite a few walls have been demolished since they were first noted by antiquaries, as in North Africa. Nonetheless, despite these limitations, it is still worth trying to produce an overview of where we currently are, even if some cases may change in their date, as it is already possible to rule in or out certain ideas. The degree of accuracy of our observations on specific types of reuse is not perfect. This is a preliminary study based largely on publications, of uneven levels of detail, and sometimes on brief visits to de-vegetated sections of walls with public access. Thus, it is to be expected that some finer details such as the re-cutting or display of blocks are often missed, as the information is not provided by reports. Furthermore, details of the contents of wall interiors and foundations can be obscured in the absence of excavation or wall decay.

Dating Classifications

Sub-Period Terminology

Time	Range	mid-point
Early/Beg.	0–12.5	6.25
First quarter	0–25	12.5
Second quarter	25–50	37.5
Third Quarter	50–75	62.5
Final quarter	75–100	87.5
Late/End	87.5–100	93.75
Earlier	0–50	25
Later	50–100	75

Dating Reliability

Cs10 Scientific (Radiocarbon, Archaeomagnetism, Thermoluminesence etc.)
Cs9 Contextual, ceramics
Cs8 Contextual, coins
Cs8x Contextual, other objects
Cs7 TPQ from ceramics/coins/inscription
Cs6 TAQ/Absolute from inscription *in situ* or almost *in situ*. For epigrams of statue bases, a text is *in situ* without wider context
Cs5 Catch-all masonry theory, e.g. mortar, use of specific *spolia*, lack of respect for aesthetics of design (giving date after 250)
Cs4 Re-used material, general presence (giving date after 250)
Cs3 Associative (finds, inscriptions, phase of development)
Cs2 Catch-all other (e.g. earthquake, water). I accept earthquakes only with clear seismic damage or counter-measures
Cs1 Architectural and artistic style, relying on well-dated parallels
0 No evidence cited

x Historical text/inscription not *in situ* (i.e. archaeological context not known at all)/depiction like Madaba map

z Background patterns, of regional development or site development

Publication Quality Score
0 No basis
1 Phases described
2 Dating basis alluded to: e.g. "5th c. pottery"
3 Dating basis described: e.g. ceramics/coins/scientific date/inscription

07AFR Ksar Belezma

Bibliography: Pringle D. (1981) *Defence of Byzantine Africa from Justinian to the Arab Conquest* (Oxford 1981).

Discussion of site: Pringle (1981) vol. 1 204–205, describing a square fort of coherent plan with a wall of a rubble core with ashlar [facing] containing reused architectural fragments and tombstones. For a plan and photos, see vol. 2 fig. 14 and pl. 12a. The fort is highly regular and neither it nor the photo gives the impression of buildings included or excluded. For the building inscription, with Solomon as Patrician: Pringle (1981) Gazetteer CB Inscr. 22.

Dating summary: range 536–544, midpoint 540, class Cs6 (absolute, inscription *in situ*), publication 3/3.

07AFR Thamugadi

Bibliography: Pringle D. (1981) *Defence of Byzantine Africa from Justinian to the Arab Conquest* (Oxford 1981).

Discussion of fort site (not an urban fortification): Pringle (1981) vol. 1 232–36, with unspecified reused material mentioned on p. 234. For a plan and photos, see vol. 2 fig. 2 with pl. 24a–42b. Building inscriptions of 539–540, found *in situ* over gates: Pringle (1981) Gazetteer CB Inscr. 25–27, 57. Also mentioned as fortified under Justinian in Procop. *Aed* 6.7.8. As an external fortification, it does not make sense to talk of buildings being excluded. It seems to incorporate an earlier piscina: Pringle (1981) 235.

Dating summary: range 539–540, midpoint 539.5, class Cs6 (absolute, inscription *in situ*), publication 3/3.

07AFR Bordj Hallal/Hellal

Bibliography: Pringle D. (1981) *Defence of Byzantine Africa from Justinian to the Arab Conquest* (Oxford 1981).

Discussion of site: Pringle (1981) vol. 1 185–87, describing a wall with rubble core faced with ashlar blocks including reused architectural fragments, columns, and tombstones. For a plan and photos, see vol. 2 fig. 22 and pl. 7a–8a, neither of which permit discussion of what buildings were included or excluded by the wall. For the building inscription of Solomon and Count Paul: see Pringle (1980) Gazetteer CB Inscr. 15–16.

Dating summary: range 536–544, midpoint 540, class Cs6 (absolute, inscription *in situ*), publication 3/3.

07AFR Bagai

Bibliography: Pringle D. (1981) *Defence of Byzantine Africa from Justinian to the Arab Conquest* (Oxford 1981).

Discussion of site: Pringle (1981) vol. 1 183–85, describing a coherent town wall circuit with reused material, incorporating Roman structures on its south side. For a plan and photos, see vol. 2 fig. 21 and pl. 6a–6b, neither of which permit discussion of what buildings were included or excluded by the wall, although in vol. 1 p. 184 it is noted that existing Roman buildings were incorporated in the wall's foundations. Dated by building inscription and a mention in Procop. *Aed*, 6.7.8. A redoubt was added in a second undated time, likely later during the East Roman occupation. For the inscription of Solomon: see Pringle (1981) Gazetteer CB Inscr. 14.

Dating summary: range 536–544, midpoint 540, class Cs6 (absolute, inscription *in situ*/in association), x (historical text), publication 3/3.

07AFR Calama

Bibliography: Pringle D. (1981) *Defence of Byzantine Africa from Justinian to the Arab Conquest* (Oxford 1981).

Discussion of site: Pringle (1981) vol. 1 188–91, describing two phases of wall, of which the first contained architectural fragments and cornices and the second contained architectural fragments and inscriptions. The second phase is dated by an inscription and a mention in Procop. *Aed.* 6.7.8. However, Pringle (1981) 189–90 notes, alongside less convincing arguments, that the towers have the same design in both phases, so preferring to place the first phase also within the main period of Byzantine wall building, with a temporary break in the works, creating two subphases. For a plan and photos, see vol. 2 fig. 24 and pl. 8b, neither of which permit discussion of what buildings were included or excluded by the wall. For the inscription of Solomon: see Pringle (1981) Gazetteer CB Inscr. 17–19. *op. cit.*

Dating summary: range 536–544, midpoint 540, class Cs6 (absolute, inscription almost *in situ*), x (historical text), publication 3/3.

07AFR Thugga

Bibliography: Pringle D. (1981) *Defence of Byzantine Africa from Justinian to the Arab Conquest* (Oxford 1981); Underwood D. (2019) *(Re)using Ruins: Public Building*

in the Cities of the Late Antique West, A.D. 300–600 (LAA Supplementary series 3) (Leiden 2019).

Discussion of site: Pringle (1981) vol. 1 244–46. For a plan and photos, see vol. 2 fig. 13 and pl. 51a–53b, 54b. Dating of 535–555 or later in East Roman period, based on close parallels to other forts especially to Diana (dated by *de Aed.* 6.7.8) and Madauros 1 (dated by Pringle (1981) CB Inscr. 5 under Justinian and Theodora) of comparable size, showing axial planning involving towers with lateral entrances. Of *spolia* (last minute details not incorporated into the catalogue), a photo in Underwood (2019) 166 fig. 157 shows a tower with large *spolia* blocks in the outer facing, unbroken, with some decorated faces turned outwards. Of incorporated buildings, the walls enclose the forum and *capitolium*: Pringle (1981) vol. 1 245. Other maps of the site show it excluded the Temple of Mercury, the plaza of the roses, a market building, and many other structures in the city centre.

Dating summary: range 535–555, midpoint 545, class Cs1 (architectural style), publication 3/3.

07AFR Sabratha

Bibliography: Pringle D. (1981) *Defence of Byzantine Africa from Justinian to the Arab Conquest* (Oxford 1981).

Discussion of site: Pringle (1981) vol. 1. 223–25, which describes a mostly homogeneous wall circuit rebuilding and replacing an earlier Roman circuit, with a secondary phase, still East Roman, around one gateway, which was strengthened. I have not found mentions of reused material. For a plan and photos, see vol. 2 fig. 28 and pl. 24b–27a. Other plans show that the theatre and some suburban quarters were left outside the walls, although the majority of public buildings were included inside. Mentioned as being walled by Justinian in Procop. *Aed.* 6.4.13.

Dating summary: range 535–555, midpoint 545, class x (historical text), publication 3/3.

07AFR Lepcis Magna (Wall 1)

Bibliography: Goodchild R. G. and Ward-Perkins J. B. (1953) "The Roman and Byzantine defences of Lepcis Magna", *PBSR* 21 (1953) 42–77. A comprehensive survey of the *spolia* will also soon be published by F. Bigi "Clusters of re-use: the Late Roman wall and the Unfinished Baths of Lepcis Magna", *Acta Norvegiae* 33 (forthcoming).

Discussion of site: The late Roman walls of Lepcis Magna are the largest of three circuits; the latter two date from the Reconquest and enclose a much smaller area; the first is more extensive.

Of incorporated buildings, I know only of the Arch of Antoninus Pius, that became part of the Porta Oea. The hippodrome and amphitheatre were excluded from the fortification.

Of *spolia*, the wall is constructed using a lot, possibly including a tombstone (IRT 633, 2nd to 3rd c. on lettering) and a block from a mausoleum with an inscribed *tabula ansata*: IRT 692 (2nd–3rd c. on lettering). In this volume, I. Tantillo and F. Bigi "The many lives of the statue bases of Lepcis Magna"" note the presence of an inscribed block from a mausoleum, inscribed blocks from a public building, and some statue bases that may have come out of the wall, including one dedicated to the Caesar Valerian Junior (AD 253–55, IRT 460a–b): Bigi's survey, which she kindly shared with me prior to publication, confirms the above results, providing on figs. 8–10 view and drawings of a section of unbroken architectural blocks including frieze blocks of triglyphs and metopes and of triglyphs and rosettes, reused in the facing of the wall with their faces turned outward. It was not clear whether this was the inside outer side of the wall. These are presumed by me to derive from funerary structures as no other spoliation candidates are mentioned, though Bigi suspects other monuments might have been used given the statue bases incorporated.

Of dating, the presence of the reused material suggests it so must post-date the Severan monumental apogee of the early 3rd c., normally coming after the mid-3rd c., and can be taken as coming after middle of the 3rd c., when visible reuse is common around the Mediterranean. No clear TAQ is available, though the contraction of the area of the city showing building work after the later 4th c., suggests a date before this time: Goodchild and Ward-Perkins (1953) 47–53, with 53 for tombstone IRT 633.

Dating summary: range 250–400, midpoint 325, class Cs4 (reused material, general presence), site development, publication 2/3.

07AFR Lepcis Magna (Wall 2 and 3)

Bibliography: Bandinelli R. B., Caffarelli E. V., Caputo G. and Clerici F. (1966) *The Buried City: Excavations at Leptis Magna* (New York 1966); Goodchild R. G. and Ward-Perkins J. B. (1953) "The Roman and Byzantine defences of Lepcis Magna", *PBSR* 21 (1953) 42–77; Pringle D. (1981) *Defence of Byzantine Africa from Justinian to the Arab Conquest* (Oxford 1981).

Discussion of site: There are two phases of reconquest wall in the city, both defending a small part of the site around the harbour, the third (incomplete) wall surprisingly enclosing a larger area than the second: Pringle (1981) 208–212; Goodchild and Ward-Perkins (1953) 47–53, 54 (general map), 56, 59. See Bandinelli,

Caffarelli, Caputo and Clerici (1966) 84 fig. 235 for a map of the line of the wall in the forum.

Of incorporated buildings, it includes the Severan Forum into wall line, using it as a fort. A great number of public buildings were excluded from the circuit, such as the Hadrianic Baths, theatre, macellum, chalcidicum, Severan Arch, nymphaeum, and much of the colonnaded street.

Of *spolia*, it reuses carefully chosen blocks but the presence of reused material is not easy to spot, so that no specific architectural elements are mentioned by Goodchild and Ward-Perkins (1953) 55–56. However, in this volume, F. Bigi and I. Tantillo "The many lives of the statue bases of Lepcis Magna", mention epigraphic spolia in the inner wall around the gate of the inner wall, and in the stretch of the same wall that leads from here to the sea, across the ruins of two temples. These include "six limestone blocks found partly scattered around the Byzantine Gate and partly walled up in its upper tiers come from an arch in honour of Vespasian (IRT 342) entirely dismantled. Four blocks pertaining to a monumental building perhaps dedicated under Domitian (IRT 350) were also incorporated into the walls of the same gate; a 2nd c. honorary base was incorporated into the topmost row of the structure (IRT 593); IRT 587 [hon. ded. on a block 2nd to early 3rd c. based on lettering], used as ashlar in the vault but probably originally placed on the right balustrade of the Curia and perhaps IRT 351 [frag.]. In the stretch of wall which reaches the sea … two reused blocks of IRT 489 were found – parts of a monumental dedication using lapidary capitals. To these, we must add IRT 488, 612 and 770 [all early. imp. frags]. In the remaining part of the defensive layout, attestations of reused epigraphic material drastically decrease. To date, only Tantillo/Bigi no. 90, in a tower leaning against the western perimeter of the Severan Forum, and IRT 642 [hon base of 2nd–3rd c. on letters], reused in the stretch of wall that surrounds the eastern pier of the port have been found. To these, we can perhaps add IRT 819 [frag 1st to 3rd c. lettering] and 825 [3rd–4th c. lettering] the first missing, the second transported to the museum – which Delaporte says he saw walled up in a late tower, east of the wadi Lebda. This vague indication could perhaps refer not to the 4th c. walls but to the Byzantine enclosure, since this sector was equipped with a series of towers.

Of dating, Pringle (1981) 211 considers that the initial fortification of the city was complete by 543, as this city seems to have been fortified in Procopius' account when the leaders of the Leuthae were slain at a banquet held by the *dux Tripolitianae* Sergius: Procop. *Vand*. 4.21.2–15. The initial fortification should thus probably date after the designation of the city as seat of the *dux* in 534: *Cod. Iust.* 1.27.2.1a (AD 534). However, the fortification that runs through the old forum, covering the site of two temples (already ruinous), is a later addition to the circuit, marking a reduction in the defended area. Yet, there is no reported difference in its construction technique, apart from the fact that it is less straight than the original fortification, according to Goodchild and Ward-Perkins (1953) 59. Thus, the inner fortification can be given the same date as the outer one, based on phase of development, because other changes in the circuit are reported, which show a strong similarity in construction technique: Goodchild and Ward-Perkins (1953) 72. One might like to credit this fortification redesign to after the events of 543, as this might provide a context for a replanning, but there is no argument under the rules of this study that can do this. Frankly, we do not have a rounded picture of the challenges facing the defenders of Lepcis in this period. Overall, I stick to a date range of 534–43 for both fortifications.

Dating summary (for both fortifications): range 534–543, midpoint 538.5, class x (historical texts), Cs3, z (associative, phase of development), publication 3/3.

08PAN Carnuntum (City wall)

Bibliography: Ertel C. (1999) *Spolien aus der westlichen Stadtmauer von Gorsium. Alba Regia* 28 (Székesfehérvár 1999); Schedivy E. (1985) "Notgrabung im Tiergarten des Schlosses Petronell", *Carnuntum-Jahrbuch* (1985) 60–101.

Of incorporated buildings, I know of none but have not seen detailed reports. The amphitheatre is left outside the walls.

Of *spolia*, there is a monumental inscription, a relief block (possibly from a grave monument): Ertel (1999) 42.

Of dating, the wall is given as late 3rd c., at earliest: Schedivy (1985) 100. However, it is not clear what this depends upon.

Dating summary: range 287.5–300, midpoint 293.75, class o, publication 1/3. Pending.

08PAN Aquincum (Legionary fortress)

Bibliography: Ertel C. (1999) *Spolien aus der westlichen Stadtmauer von Gorsium* (whole-volume issue of *Alba Regia* 28 (1999) (Székesfehérvár 1999); Parragi G. (1976) "Jelentés a Fényes Adolf utcában feltárt déli kaputorony ásatásáról", *Budapest Régiségei* 24 (1976) 137–44; Kérdö K. (1976) "Előzetes jelentés az aquincumi II–III. századi legios-tábor déli, valamint a IV. századi erőd nyugati frontján végzett kutatásokról," *Budapest Régiségei* 24 (1976) 71–75.

Of incorporated buildings, I know of none but have not seen detailed reports, though plans of the site

suggest the earlier fortress wall of the legionary base was used.

Of *spolia*, gravestones and grave altars are listed in Parragi (1976) 137–44. Ertel (1999) 42 notes that a subsequent tower contains gravestone and cornice fragments.

Of dating, the above-mentioned tower is, according to brick stamps, of the Valentianic period (AV VALENTINI/FRIGE/RIDVS VP DVX APVAL) given as of AD 369 (?)–373/374): Kérdö (1976) 72. However, this is an addition. Parragi (1976) 139/141 suggests a date for the primary wall of after the time of Constantine I because of fan shaped towers that are also found elsewhere on the Limes, but not here. He also points to the construction technique of the upper walls of the gate-tower, which is apparently identical with that of the Szentendre and Nagytétény camps. Whilst one does find campaigns of fortification in different frontiers, with similar features, I am not able to check the parallels here and I am not able to account for the direction of diffusion, as this is not always straightforward, when no high-status exemplar is identifiable. Therefore, I will take the mid-3rd c. as a TPQ on account of the use of reused material (although I do not know if it was hidden or in the wall face) and will use the brick stamp coming from the secondary tower as giving a TAQ for the first phase within the reign of the Valentinian, who died in 375.

Dating summary: range 250–375, midpoint 312.5, Cs4 (reused material, general presence), Cs6 (TAQ inscription) publication 3/3.

o8PAN Iovia (phase 2 of city wall)

Bibliography: Ertel C. (1999) *Spolien aus der westlichen Stadtmauer von Gorsium* (whole-volume issue of *Alba Regia* 28 (1999) (Székesfehérvár 1999), Soproni S. (1975) "Előzetes jelentés az alsóhetényi későrómai erőd feltárásáról", *Somogy Megyei Múzeumok Igazgatósága* 2 (1975) 173–182; Soproni S. (1978) *Der spätrömische Limes zwischen Esztergom und Szentendre* (Budapest 1978); Tóth E. (1988) "Az alsóhetényi 4. századi erőd és temető kutatása, 1981–1986. Eredmények és vitás kérdések", *Archaeologiai Értesítő* 114–115 (1988) 22–61

Of incorporated buildings, I know of none but have not seen detailed reports.

Of *spolia*, there were gravestones, fragments of likely grave monuments, and an imperial statue in phase 2 of the city wall: Ertel (1999) 42.

Of dating, the phase 2 is given as of after 374, see Tóth (1988) 28ff, which tries to date the second phase to after the Sarmatian-Quadi war of 374 based on the rebuilding of interior fort buildings where coins and skeletons have been found. This replaces Soproni (1978) 138ff (not in the bibliography of Etrel, from where I obtained this reference, but perhaps is Soproni (1978) or perhaps Soproni (1975) 179 (both not seen) horrea, relating to a coin of the 350s of Constantius II found in the second phase of the tower. My best guess at understanding the reports is that we have a TPQ of 350 from a coin of Constantius II, and a regional TAQ of *ca.* 433 for the end of large-scale investment in Roman frontier structure of fortifications and internal buildings of this kind, when Aetius ceded parts of Pannonia to the Huns. Although a tighter chronology might be suited from the evidence of destruction within the settlement, a range of 350–433 looks more reliable.

Dating summary: range 350–433, midpoint 391.5, class Cs7 (TPQ coin), z (regional development), publication 3/3.

o8PAN Gorsium

Bibliography: Ertel C. (1999) *Spolien aus der westlichen Stadtmauer von Gorsium* (whole-volume issue of *Alba Regia* 28 (1999) (Székesfehérvár 1999); Fitz J. (1972) "The excavations at Gorsium", *ActaArchHung* 24 (1972) 3–52; Fitz J. (1983) "Forschungen in Gorsium im Jahre 1980", *Alba Regia* 20 (1983) 201–204; Fitz J. (1985) "Forschungen in Gorsium in den Jahren 1981/82", *Alba Regia* 22 (1985) 110–13; Fitz J. (1987) "Forschungen in Gorsium im Jahre 1983–84", *Alba Regia* 23 (1987) 180–84; Fitz J. (1990) "Forschungen in Gorsium in den Jahren 1985/86", *Alba Regia* 24 (1990) 201–204; Fitz J. (1996) *Gorsium-Herculia* (Székesfehérvár 1996)

Discussion of site: The settlement was entirely replanned, with a new city wall at the beginning of Late Antiquity. The excavation of the wall has been reported as Fitz (1983) 201–204; Fitz (1985) 110–13; Fitz (1987) 180–84; Fitz (1990) 201–204. Also important is the general account of the site in Fitz (1972) 3–52.

Of incorporated buildings, there are none.

Of *spolia*, Fitz (1987) 180 points out reused material in the wall, notably an inscribed altar 'Cautop[a]tï'. However, the main report on *spolia* in the wall is Ertel (1999), who notes a large amount of reused material from grave monuments (podium structures going beyond a simple stele), some 72 % of the reused material in total (p. 43), as well as some altars (p. 35).

Of phasing and dating, Fitz entertains a general theory that the whole site was rebuilt after the Roxolani invasions of AD 260: Fitz (1996) 19f (not seen for this article, but seen previously). The phasing is reasonable based on the coherent plan of the site with its main streets and fortification and also a horizon of the use of *spolia* coming from the site's cemeteries, which is no longer present in subsequent building. The dating is however more uncertain. We have the following elements from inside

the city: (i) Fronting the Villa Amasia, on the north side of the street, there is a colonnade which has a TPQ provided only by 2nd c. finds (no later than 160s–70s). Coins of the 4th c. in layers above the villa foundation (pits, etc.) provide a contextual date, though it is difficult to be sure of their significance from the report, except that a coin of Valentinian was found in a well cutting the granary attached to the complex. He notes that "the age of the villa, on the basis of the 233 coins found on its floors and in the sewer of the bath, can be dated between the years 330 and 367." (ii) Opposite the Villa Amasia, outside the 'tabernae', on the south side of the street, there is a second colonnade which is thought to be 4th c. because it is at the same level as the '4th c.' street: Fitz (1972) 3–52, esp. 10 and 11, with appendix Y4 for details of their form and dimensions, and my important observation that in their first phase the 'tabernae' building seems to have been constructed as horrea. (iii) The 'Basilica Maior' dates to sometime after 244, due to a coin hoard of Philip Junior (made Caesar to his father Philip in 244, killed in 249), which was found in the building underneath the construction, from which early 3rd c. coins also come, providing a TPQ. The presence of a putative baptistery in the corner of this building, which does not face east, has been suggested as late 4th or 5th c. in dates based on regional parallels. Overall, there does not seem to be a good basis, on published evidence, for a Roxolani destruction in 260, as Fitz imagines. Rather, there is a TPQ of 244 for the construction of the Basilica Minor and there is an associative date, based on insufficiently published numismatic evidence, for the occupation of the Villa Amasia in the years 330–367, which presumably means its construction occurred in or before *ca.* 330.

More specific dating for the fortification comes from a dig on the wall from 1983/1984: Fitz (1987) 180, which describes coin finds from the eastern gate of the fortification. Here, in the passage next to the tower and outside the tower, were recovered 7 coins from Claudius II Gothicus (1 coin) and Diocletian (1 coin) to Gratian (2 coins), whilst around the tower, the coins were of the time of Constantine (3), his dynasty (2) to the dynasty of Valentinian (3), with 1 (likely outlying) coin of Marcus Aurelius. This seems to be associative dating evidence for the occupation of the site, which supports a return after the time of Claudius II Gothicus (268–70), perhaps under Diocletian. Although I do not know the precise context from which these coins come, they cause me to revise my date range given in Lavan *Public Space* vol. 2 172–73, but the disproportionate early group of CG coins causes me to suggest an associative TPQ for occupation of 268–70. Given the name of the place, suggesting a Tetrarchic renovation, it is perhaps reasonable to envisage a construction date in the 290s, as does Fitz. However, I am not currently aware of any dating evidence that will push the wall or the rebuilt city forward to this date. A construction date of the 25 year period after 268 seems justified based on the coin evidence, although this is not a regular contextual date by any means.

Dating summary: range 268–293, midpoint 280.5, class Cs3 (associative, finds), publication 3/3. Poor date.

10 MAC Philippi (Late repairs)

Bibliography: Provost S. (2001), "City wall and urban area in Philippi", in *Recent Research in Late Antique Urbanism* (*JRA* Supplementary Series 42) ed. L. Lavan (Portsmouth, Rhode Island 2001) (123–35) 132–34; Rizos E. (2011) "The late antique walls of Thessalonica and their place in the development of eastern military architecture", *JRA* 24 (2011) 450–468.

Discussion of site: This city saw its Hellenistic circuit reinforced in Late Antiquity, on more than one occasion, with the fortification by the theatre being repaired in the late 3rd–4th c., based on masonry styles: Provost (2001) 132–34. However, it is later repairs in *opus incertum* which concern us here.

Of incorporated buildings, I know of none, except for the earlier fortification. No major public buildings are left outside the city walls.

Of *spolia*, Hellenistic materials are reused, such as columns and sculpture fragments, and material from the Greek necropolis.

Of dating, these later repairs are given by Provost to the same time as the walls of nearby Thessalonica, based on the use of levelling courses of 5 bands of bricks. However, he admits this is a characteristic shared by the walls of Nicomedia, dated to the late 3rd or early 4th c., and the second city wall of Dion. Provost (2001) 133 invokes the dating of the walls of Thessalonica based on an inscription relating to a certain Hormisdas, who is describing building an unbreakable wall, in a tower on the eastern wall, which is discussed exhaustively by Rizos (2011) 455–56, who places notes parallels with mid-6th c. inscriptions and especially, in form and content, with a set of Latin inscriptions of 447 coming from the Theodosian Walls of Constantinople, which also praise the 'firm walls' erected. Rizos is not clear whether this inscription comes from phase C though he seems to be implying that it should be associated with this phase of work. However, Provost is not aware of the other arguments advanced by Rizos to date the wall to the period 440–475, extended by me (below) to 440–91. Given that these are pretty weak at Thessalonica, they must be regarded only as highly suggestive for Philippi, based

on architectural style, which it far from certain diffused from Thessalonica to Philippi.

Dating summary: range 440–491, midpoint 465.5, class Cs1 (architectural style, based on loosely-dated parallels), z (regional development), publication 3/3. Poor.

10MAC Amphipolis (Roman City Wall)

Bibliography: Lazaridis D. in *Prakt* 138 (1983) (not seen); Lazaridis D. (1997) *Amphipolis* (Athens 1997).

Discussion of site: A 'Roman' city wall has been excavated for a short stretch on the west side of the Acropolis.

Of incorporated buildings, I know of none. No major public buildings are left outside the city walls, as far as is known: E. Rizos pers. comm. 2022.

Of *spolia*, the wall is made of reused architectural fragments, such as column drums, capitals, triglyphs and metopes, statue fragments, and two pagan votive inscriptions (to Artemis Eilithyia and to the demon Babo). Some of the column drums are clearly visible in the wall face: Lazaridis (1997) 48–59 with fig. 57, resuming Lazaridis (1983) 37–38.

Of dating, no date is offered for the wall by Lazaridis. The wall is likely to date to after 250 on grounds of the visible use of *spolia* and is best related to the wider development of the city, which required a new wall sometime in the 5th to 6th c., as described below, likely after *ca.* 450.

Dating summary: range 250–450, midpoint 350, class Cs4 (reused material, general presence), z (site development), publication 3/3. Poor date.

10MAC Amphipolis (Late Acropolis Wall 1)

Bibliography: Bakirtzis Ch. (1996) "Ἀνασκαφή Χριστιανικής Ἀμφιπόλεως", *PraktAE* 151 (1996) 229–41; Hattersley-Smith K. M. (1996) *Byzantine Public Architecture between the Fourth and Early Eleventh Centuries AD, with Special Reference to the Towns of Byzantine Macedonia* (Thessalonica 1996).

Discussion of site: This wall (of three sides) is described in Bakirtzis (1996) 229–41.

Of incorporated buildings, there seem to be none. A great number of public buildings are excluded by the reduced circuit.

Of *spolia*, the wall includes Doric columns and architraves from temples, bases and capitals, columns drums, and triglyph and metope reliefs, some of which come from the nearby gymnasium (see pp. 229–231). Column drums are used decoratively in the wall face (fig. 96a).

Of phasing, the wall consists of a number of phases and repairs, but reuse of identifiable architectural materials, of which there is much marble, seems to be confined to its south and east sides, of which the south side looks most coherently like a late antique phase, which is what is described here. This is a wall with cut stone facings and a rubble core.

Of dating, the wall between towers E and F has produced a fragmentary inscription naming the emperors (p. 233) and tower F has produced a pagan votive dedicatory inscription (p. 233). A late antique monumental inscription found close to tower G invokes Christ as saviour and resurrection for the city, which Bakirtzis takes as a reference to saving the city from a destruction, which he believes is the plague/famine that struck the East in 542. He would like to give the same date to the wall. This is of course a major conjecture. It is more reasonable simply to relate the wall to the late antique churches it defends, likely later 5th–6th c. in date, based on admittedly weak regional chronological comparisons, after mid-5th c. urban rupture: see Hattersley-Smith (1996) 103–111 for references. But it should date before the decisive Slav invasions of 616 in this area, after which large scale occupation of these urban sites is not known outside of Thessalonica and a few major centres.

Dating summary: range 450–616, midpoint 533, class z (site development), z (regional development), publication 3/3. Poor date.

10MAC Amphipolis (Late Acropolis Wall 2)

Bibliography: Bakirtzis Ch. (1996) "Ἀνασκαφή Χριστιανικής Ἀμφιπόλεως", *PraktAE* 151 (1996) 229–41.

Discussion of site: At a later date, the western wall was rebuilt further back, cutting across basilica A (Bakirtzis 1996) 320 fig. 1), with a short section that included a pentagonal tower. Although likely to be 6th or early 7th c. in date, given regional circumstances, the wall must be given the same range as the previous Late Acropolis Wall, as no piece of evidence puts it firmly later. I have not yet been able to obtain any detail about its *spolia* content, though it does contain some reused material which is visible in its outer wall face: L. Lavan site observation 2003.

Dating summary: range 450–616, midpoint 533, class z (site development), z (regional development), publication 3/3. Poor date.

10MAC Cassandreia

Bibliography: Alexander J. (1963) *Potidaea. Its History and Remains* (Athens, Georgia 1963); Pazara Th. (1987) "To Diateixisma" ths Kassandreias", in *Praktika tou protou panelleniou symposiou istorias kai arxaiologias ths kalkidikhs. Polugyros 7–9 Dekenbriou 1984* (Thessalonica 1987).

Discussion of site: This wall has been studied by Pazara (1987) 157–92. See also Alexander (1963) (first plan of the wall, though probably outdated interpretation).

Of incorporated buildings, I know of none. I could not identify if any public buildings were left outside of the wall from the reports I could access.

Of *spolia* incorporated in the wall (Pazara (1987) 174–78), there are capitals, column sections, sculptures, column bases, a round altar with bucranion and garlands, headless sculpture of a male youth, funerary stellae (one in Latin, one in Greek), and a decree of the city. These are generally broken (Pazara (1987) 175–76, figs 21–25). Photos on p. 184 fig. 27 show columns visible in the wall face, as do photos on https://byzantine castle.blogspot.com/2014/06/blog-post_3662.html of a post/site observation of 2014 show reused blocks visible in the wall face, inside and outside. The condition of columns is hard to judge because they are laid across the wall, with only the short ends visible.

Of dating evidence, there are two bronze coins of the emperor Constantine I of ca. 313 and Manuel II Palaiologos (1391–1399), which are not very useful on their own without a precise stratigraphic description of their context. The city is recorded by Procopius as being devastated by the Huns, and then refortified by Justinian along with the wall across the isthmus into the peninsula of Pallene: Procop. *Aed.* 4.3.22. This Hunnic destruction was likely that of AD 539/540. However, it is far from certain that the sections of wall surveyed at Cassandreia are of the time of Justinian, especially as Procopius does not claim that Justinian built it anew. It seems likely that this circuit dates from sometimes after 250, on account of the presence of reused materials, but before 539/40, the date of the Hunnic attack. The lack of contextual detail for the coins is discouraging in using them as a TPQ, especially as one is post-antique, though a date in or after the time of Constantine is possible.

Dating summary: range 250–540, midpoint 395, class Cs4 (reused material, general presence), x (historical text), publication 3/3.

10MAC Thessalonica (phase A)

Bibliography: Adam-Veleni P. (2002) *Μακεδονικοί Βωμοί* (Athens 2002); Mallan C. and Davenport C. (2015) "Dexippus and the Gothic invasions: interpreting the new Vienna Fragment (Codex Vindobonensis *Hist. gr.* 73, ff. 192 v –193 r)", *JRS* 105 (2015) 203–226; Rizos E. (2011) "The late antique walls of Thessalonica and their place in the development of eastern military architecture", *JRA* 24 (2011) 450–68; Tzevreni S. (2019) "Τα τείχη της Θεσσαλονίκης / The Walls of Thessaloniki", in *Από τα Μακεδονικά στα Θεσσαλικά Τέμπη. Από τη Ρεντίνα στη Βελίκα / From Macedonian to Thessalian Tempi. From Rentina to Velika* (Thessalonica 2019); Velenis G. (1998) *Τα τείχη της Θεσσαλονίκης από τον Κάσσανδρο ως τον Ηράκλειο* (Thessalonica 1998); Vitti M. (1996) *Η πολεοδομική εξέλιξη της Θεσσαλονίκης. Από την ίδρυση της έως τον Γαλέριο* (Athens 1996).

Discussion of site: This was a stone wall, 1.65 m wide, of *opus quadratum* with square towers. A good review of this complex fortification of many phases, with references to earlier literature, is Rizos (2011) 450–68. See now also Tzevreni (2019) 49–59. For earlier surveys, see Velenis (1998) 43–63, especially 46 (not seen) and Vitti (1996) 124–25. I thank E. Rizos for this help in answering my queries on the walls of the city, of all periods examined here.

Of building technique (as described at the start of this notice): Velenis (1998) 56, 161.

Of incorporated buildings, I know of none, though the walls follow the route of a previous Hellenistic fortification in part. I do not think any major public buildings are left outside the walls.

Of *spolia*, phase A, includes a great quantity of reused material, especially in its towers in the lowland sections where they were built over part of the necropolis. It reuses funerary altars, funerary monuments, inscriptions, and other architectural blocks: E. Rizos pers, comm. 2022. For funerary altars see: Adam-Veleni (2002) (not seen).

Of dating, this phase is given a TAQ of 262 (previously ca. 254 in literature) because this is the date of a successful defence of Thessalonica against a Gothic attack in a fragment attributed to Dexippus, that seems to represent the 'Scythian invasion', now dated to this time: see most recently Mallan and Davenport (2015) 203–26. This only provides a TAQ for the construction of the wall, whilst the use of much reused material suggests a TPQ of 250, after which this practice becomes widespread. Vitti (1996) 125 with fig. 21 notes a coin of the city of Thessalonica showing a city gate from the time of Gallienus [reigned 260–268], which supports this dating hypothesis, even if we cannot be sure that it commemorates the building of the wall. Certainly, the wall must have been effective by the end of Gallienus' reign in 268, or the coin image would make no sense.

Dating summary: range 250–262, midpoint 256, class Cs4 (reused material, general presence), x (historical text).

10MAC Thessalonica (phase B)

Bibliography: Adam-Veleni P. (2002) *Μακεδονικοί Βωμοί* (Athens 2002); Barnes T. D. (1982) *The New Empire of Diocletian and Constantine* (Cambridge, Mass. and

London 1982); Leadbetter W. (2009) *Galerius and the Will of Diocletian* (London 2009); Mallan C. and Davenport C. (2015) "Dexippus and the Gothic invasions: interpreting the new Vienna Fragment (Codex Vindobonensis *Hist. gr.* 73, ff. 192 v –193 r)", *JRS* 105 (2015) 203–226; Rizos E. (2011) "The late antique walls of Thessalonica and their place in the development of eastern military architecture", *JRA* 24 (2011) 450–68; Tzevreni S. (2019) "Τα τείχη της Θεσσαλονίκης / The Walls of Thessaloniki", in *Από τα Μακεδονικά στα Θεσσαλικά Τέμπη. Από τη Ρεντίνα στη Βελίκα / From Macedonian to Thessalian Tempi. From Rentina to Velika* (Thessalonica 2019); Sutherland C. H. V. and Carson R. A. G. edd. (1967) *Roman Imperial Coinage vol. 6: From Diocletian's Reform (A.D. 294) to the Death of Maximinus (A.D. 313)* (London 1967); Velenis G. (1998) *Τα τείχη της Θεσσαλονίκης από τον Κάσσανδρο ως τον Ηράκλειο* (Thessalonica 1998); Vitti M. (1996) *Η πολεοδομική εξέλιξη της Θεσσαλονίκης. Από την ίδρυση της έως τον Γαλέριο* (Athens 1996).

Discussion of site: This phase involved the thickening of the wall on the inside face and the addition of some towers. It was of rubble masonry bonded by white mortar and broken tile. A good review of this complex fortification of many phases, with references to earlier literature, is Rizos (2011) 450–68. See now also Tzevreni (2019) 49–59 (from which I have lifted several references given here). For earlier surveys, see Velenis (1998) 43–63, especially 46 (not seen) and Vitti (1996) 105–106, 125–26 (which I read imperfectly).

Of building technique (as described at the start of this notice): Velenis (1998) 56, 161.n.

Of *spolia*, there were marble altars and tombstones from the 2nd–3rd c., according to Tzevreni (2019) 50. I have no information about their condition: Vitti (1996) 125 with note 250. See also Velenis (1998) 48 (not seen). For funerary altars see: Adam-Veleni (2002) (not seen). E. Rizos pers. comm. suggested to me that this should relate to reinforcements of the upland parts of the wall.

Of dating, we have a TPQ of 250, provided by the visible use of reused material. There is also the argument that after the end of the 3rd c. building work on walls was very different in character (Tzeverni (2019) 50) but I fail to see what walling has been dated to the 4th c. which might allow such a judgement. One can only say that the section of walling extended to protect the area of the 'Palace of Galerius' seems to be of phase C or D (following Rizos (2011) 453). This would be unlikely given the residence of Galerius in the city from 299 to 311. This gives us a very tentative TAQ of 311, as a date by which the palace site is likely to have been chosen. For the residence of Galerius, we can surmise that he moved his winter quarters to the city in 299 (a probable mint opened here in that year): Leadbetter (2009) for the campaign plus references; Sutherland and Carson (1967) 501–513, esp. 501–502 (mint of Thessalonica has coins which seem to inform types of Serdica of ca. 303/304 but lack the earliest Tetrarchic coins of the '4 at sacrifice' type). A TAQ of the last date at which the monument would have been erected is the end of the residence of Galerius I in Thessalonica in 311. We can assert this, as phase 2 on the south side of the monument does seem to be structurally contiguous with the vestibule of the palace, likely [although not certainly] built to serve Galerius, resident in the city from 299–311. See Barnes (1982) 62 for sources on his death in 311 in nearby Dardania (southern Serbia/Kosovo region).

Dating summary: range 250–311, midpoint 280.5, class Cs4 (reused material, general presence), x (historical text), publication 3/3.

10MAC Thessalonica (phase C)

Bibliography: Mango C. (1978) "The date of the Studius Basilica at Istanbul", *BMGS* 4 (1978) 115–22; Rizos E. (2011) "The late antique walls of Thessalonica and their place in the development of eastern military architecture", *JRA* 24 (2011) 450–68; Tzevreni S. (2019) "Τα τείχη της Θεσσαλονίκης / The Walls of Thessaloniki", in *Από τα Μακεδονικά στα Θεσσαλικά Τέμπη. Από τη Ρεντίνα στη Βελίκα / From Macedonian to Thessalian Tempi. From Rentina to Velika* (Thessalonica 2019) 49–61.

Discussion of site: A good review of this complex fortification of many phases, with references to earlier literature, is Rizos (2011) 450–68. See also Tzevreni (2019) 49–59. The most interesting phase for this exercise is perhaps phase C in which densely packed saw-shaped towers were added to the western side especially.

Of incorporated buildings, I know of none though the earlier fortification is incorporated. I do not think any major public buildings are left outside the walls.

Of *spolia*, there are seats taken either from a hippodrome or a stadium on the western side (Rizos (2011) 451–53 with figs. 5–6, 455). There are architrave blocks reused in the last saw-shaped tower on the W side, which backs onto a different phase of wall: L. Lavan site observation 2017. There were also a few funerary stelae in the NW parts of the circuit, which I did not see: E. Rizos pers. comm. 2021.

Of dating, this phase has been dated to 440–475 based on the general historical circumstances of resistance to the Huns after 440 and from a suggestive TPQ derived from the *proteichisma* which must date after phase C was complete. This contains brick stamps that are only so far found also in the church of Archeiropoietos, roughly ascribed to 450–475 inside the city. This church

is dated based on its similarities of plan and architectural sculpture to St. John Studios in Constantinople, assumed to be earlier, whilst a 9th c. text that claims Emperor Anastasius (reigned 491–519) gave a donation to the bishop after a miracle took place at the basilica of the virgin in Thessalonica, though there is no tradition that he built it (discussed on Rizos (2011) 457. St. John Studios in Constantinople can be taken as an exemplar given that it was a high-status building in the capital. This church was built by a consul in AD 462 (PLRE 2.1037 Studius 2) according to Theophanes A. M. 5955 (AD 462/463) (date in edn. Mango and Scott (1997)) and other authors, or perhaps just before his consulship of 454. This is suggested by verses once inscribed on the building (*Anth. Graec.* 1.4, as discussed by Mango (1978) 115–22 (not seen)). These verses give the Studios Basilica a date of *ca.* 450 for Mango. This is of course highly suggestive and quite weak dating evidence, though Rizos has done us all a great service by drawing together difficult evidence for the circuit and its phases. I will extend the date for the wall to 491, this being the accession date of Anastasius, which seems likely the latest date at which the Archeiropoietos church was built.

Dating summary: range 440–491, midpoint 465.5, class Cs 3 (associative, phase of development), Cs1 (architectural style, based on well-dated parallels), z (regional development), publication 3/3.

10MAC Dion (late antique 1)

Bibliography: Stefanidou-Tiveriou T. (1998) *Ανασκαφή Δίου, τόμος 1: Η οχύρωση* (Thessalonica 1998).

Discussion of site: The fortifications of Dion have been the subject of a monograph: Stefanidou-Tiveriou (1998), which K. Fragoulis has assisted me with by providing a summary of its contents. The first late wall was in part a large-scale repair of the original Early Hellenistic fortification, except on the E side which was completely new, following a zigzag course parallel to the Vaphyras river.

Of incorporated buildings, apart from the earlier fortification, the wall does not include any structure in its line. Major public buildings are excluded by the city wall, such as the theatres, stadium, and sanctuaries, although these had always been unprotected.

Of *spolia*, in some parts of the wall there is a dominance of funerary monuments, whereas architectural members from public buildings have mostly been used in others [p. 159]. A large part of the *spolia* integrated into the late Roman wall of Dion came from the city's cemeteries: funerary altars, stelae, sarcophagi, and architectural members from monumental tombs, like cornices, door frames, toichobate members etc. These *spolia* are mostly found on the northern and western sides of the wall. Other architectural members, including thresholds, architraves, and numerous stone blocks are found on all sides of the wall, always placed on the outer façade. It must also be noted that large marble blocks coming from monumental structures were incorporated into towers and the gates [pp. 164–66, figs. 117–21, dr. 51].

Of dating, according to Stefanidou-Tiveriou (1998) 197, the Late Roman wall of Dion was built in the middle or third quarter of the 3rd c. and was abandoned between the late 3rd and the third quarter of the 4th c. The chronology proposed by Tiveriou is based on coin finds from the wall (which should supply a TPQ, unless there are a lot of them in which case it could be a contextual date, which I have not been able to check) and on historical events, particularly the two sieges of Thessalonica by the Goths in 254 and 268. She suggests that Dion must have been fortified around the same period with Thessalonica to face these threats. See above revision of the date of the siege of Thessalonica to 262, described by Dexippus. The use of visible reused material independently suggests a date after 250, which is what I will use, as I wait for clarity on the context of the coins, giving us a range of 250–262.

Dating summary: range 250–262, midpoint 256, class Cs4 (reused material, general presence), Cs7 (TPQ coins) x (historical text).

10MAC Dion (late antique 2)

Bibliography: Stefanidou-Tiveriou T. (1998) *Ανασκαφή Δίου, τόμος 1: Η οχύρωση* (Thessalonica 1998).

Discussion of site: The fortifications of Dion have been the subject of a monograph: Stefanidou-Tiveriou (1998), which K. Fragoulis has assisted me with by providing a summary of their contents. The second late wall enclosed less than half of the Roman city, particularly its south-western sector. The entire south and most of the west side of these defences followed the course of the earlier Late Roman wall (only the upper parts of the superstructure must have been repaired in this phase), while the north and the east ones were completely new structures (what is more, the latter was founded parallel to the western kerb of the city's cardo maximus) [pp. 198–99].

Of incorporated buildings, the wall did not include any structure in its line apart from the earlier fortification. Buildings left outside the new walls, not previously excluded, seem to be largely private houses, from site plans and my site observation of 2017.

Of *spolia*, a large amount was used in the lower part of the masonry of the east and north sides of this wall, too: stone blocks (mostly fragmentary), column parts, small pedestals, parapets, funerary altars, and many

statue fragments. A significant number of (Doric) column drums [perhaps from temples?: LL] have been placed transversely into the eastern wall, along the cardo maximus, in a rather thorough and regular way, implying a decorative purpose [Stefanidou-Tiveriou (1998) 200–201, figs. 153–57]. There is again no attempt from Stefanidou-Tiveriou to identify the origin of these *spolia*. The condition of these blocks was varied. Sometimes they look complete, on other times there were damaged before entering into the wall: L. Lavan site observation 2017.

Of dating, Stefanidou-Tiveriou gives this 'early Christian' wall to the second half of the 4th c. [pp. 212–13], relying on a coin of Valentinian I to set a TPQ for the erection of the late wall to 364–367 [p. 208] and the dating of the majority of the coins retrieved from associated strata to set the date range of the main use phase of the walls between the late 4th and the early 5th c. Whilst the coin is not as good as having a number of clearly sealed finds from foundation, it is the strongest evidence at present, and the associated use finds are acceptable, even if we need to know the wider coins supply patterns across the whole site to be sure of this.

Dating summary: range 364–412.5, midpoint 388.25, Cs7 (TPQ coin), Cs3 (associative, finds), publication 3/3.

10MAC Athens (Valerian Wall)

Bibliography: Kroll J. and Walker A. S. (1993) *The Athenian Agora XXVI: The Greek Coins* (Athens 1993); Theocharaki A. M. (2011) "The ancient circuit wall of Athens: its changing course and the phases of construction", *Hesperia* 80 (2011) 71–156; Tselekas P. (2008) "Ταυτότητα και ιδεολογία στη ρωμαϊκή Αθήνα: Η νομισματική μαρτυρία", in *Η Αθήνα κατά τη ρωμαϊκή εποχή: Πρόσφατες ανακαλύψεις, νέες έρευνες / Athens during the Roman Period: Recent Discoveries, New Evidence* (Mouseio Benaki, Suppl. 4), ed. S. Vlizos (Athens 2008) 473–85.

Discussion of site: This wall includes nearly all the Roman city, following much of the Themistoclean circuit. It has recently been surveyed by Theocharaki (2011) 71–156.

Of incorporated buildings, the wall includes some pre-existing structures, such as the south wall of the Olympieion temenos. It did exclude the Panathenaic Stadium, but so had previous walled circuits of the city, so this did not represent a change.

Of *spolia*, there are grave stelae, statuary, and architectural elements.

Of dating, wall is based on it being logically prior to the 'post-Herulian' wall and on a peak in the numismatic evidence in the reign of Gallienus [reigned 260–268] who visited Athens in 264: Theocharaki (2011) 131 citing Kroll and Walker (1993) 117–18 (who believes the peak reflects the rebuilding, repair, and garrisoning of the walls) and Tselekas (2008) 476 (who thinks the money provided at this time was to protect the city, paying for the construction and repair of walls, the supply of foodstuffs and military equipment, and payment of defenders). I am very loath to accept such dating, as it constitutes a very loose associative dating, but the reused material does suggest a date of after 250, so I will accept a poor date here.

Dating summary: range 260–268, midpoint 264, class Cs5 (reused material, general presence), Cs3 (associative), publication 3/3. Poor date.

10MAC Athens (Post-Herulian Wall)

Bibliography: Baldini I. (2014) "Atene: la città Cristiana", in *Gli Ateniesi e il loro modello di città: Seminari di storia e archeologia greca 1: Roma, 25–26 giugno 2012* (Thiasos Monografie 5), edd. L. M. Caliò, E. Lippolis, and V. Parisi (Rome 2014) 309–321; Baldini I. and Bazzechi E. (2016) "About the meaning of fortifications in late antique cities", in *Focus on Fortifications. New Research on Fortifications in the Ancient Mediterranean and the Near East*, edd. R. Frederiksen, S. Muth, P. Schneider and M. Schnelle (Oxford 2016) 696–711; Baldini Lippolis I. (2003) "Sistema palaziale ed edifici amministrativi in età protobizantina: il settore settentrionale dell'Agorà di Atene", *Ocnus* 11 (2003) 9–23; Castrén P. (1994) "General aspects of life in post-Herulian Athens", in *Post-Herulian Athens. Aspects of Life and Culture in Athens*, ed. P. Castrén (Helsinki 1994) 1–14; Frantz A. (1988) *The Athenian Agora, XXIV: Late Antiquity A.D. 267–700* (Princeton 1988); Robinson H. S. (1959) *The Athenian Agora V: Pottery of the Roman Period* (Princeton 1959); Shear T. L. (1938) "The campaign of 1937", *Hesperia* 7 (1938) 312–62; Sironen E. (1997) *The Late Roman and Early Byzantine Inscriptions of Athens and Attica* (Helsinki 1997); Travlos J. (1988) "The post-Herulian wall", in *The Athenian Agora, vol. 24: Late Antiquity: AD 267–700* (Princeton 1988); Tsoniotis N. (2016) "The Benizeli mansion excavation: latest evidence on the Post-Herulian fortification wall in Athens", in *Focus on Fortifications. New Research on Fortifications in the Ancient Mediterranean and the Near East*, edd. R. Frederiksen, S. Muth, P. Schneider and M. Schnelle (Oxford 2016); Tzavella E. (2008) "Burial and urbanism in Early Byzantine and "Dark-Age" Athens (4th–9th c. AD)", *JRA* 21 (2008) 352–68.

Discussion of site: The wall received its main study in Travlos (1988) 125–41. Recent excavation of a section of wall has produced some stratigraphic data: Tsoniotis (2016) 712–24. It has also been the subject of important reflections by Baldini Lippolis, who is due to publish work from the Library of Hadrian pertinent to the

wall, of which the most important statements so far are Baldini (2014) 315–17 and Baldini and Bazzechi (2016) 696–711.

Of incorporated buildings, the wall includes the Stoa of Attalos, the Library of Hadrian, Theatre of Dionysius, and Odeion of Herodes Atticus. It excludes a large number of major public buildings from the city.

Of *spolia*, the wall contains large amounts, including entablature blocks, columns, column drums in the wall face, often in complete condition, and fragmentary capitals, sculpture, and architectural embellishments inside. It also includes a statue base dedicated by Herodes Atticus, an imperial letter of the first half of the 2nd c. (Shear (1938) 328), parts of the Alcibiades stellae, and elements from the Library of Pantainos, the Metroon, the Temple of Ares, the Odeion of Agrippa, the South-east Temple, and the South-west Temple (Travlos (1988) 130–31).

Of phasing, it is important to note that *spolia* from the Temple of Ares may have come into the wall from a repair. It may have lost a decorative bronze quadriga of elephants under Theodosius II (*Patria* 2.58), but it was respected in the construction of the Palace of the Giants and was not spoliated to build the post-Herulian fortification, as reused blocks from it come from repairs in the enceinte, not from within those parts related to its primary build: Baldini Lippolis (2003) 9–23 and by Frantz (1988) 58–61 12 with n. 34; Castrén (1994) 11.

Of dating, the wall has many sources, but remains controversial. It sported two building inscriptions (poetically worded), but the tightest dating evidence so far published has been numismatic: it has produced many later 3rd c. coins but no examples after the reign of Probus (272–76). On coins from Klypsedra area of walls see: Shear (1938) 16 coins from mortar layer by Klepseydra, immediately under the wall are from Aurelian to Probus (Shear (1938) 332–33). These coins, taken together, could give us a contextual date of 272–97, being the 25 year period after the start date of the last find: Frantz (1988) 5–11, esp. 6. Verse inscriptions relating to the wall name one Illyrius as builder, identified as proconsul Claudius Illyrius PIR 2nd edition C 892, published most fully in Sironen (1997) nos. 31–32. However, he is only known to have served under Probus (276–282) or later, but no later than 290, when L. Turranius Gratianus (PLRE 1 Gratianus 3) had ceased to be equestrian governor (*corrector*) of Achaea, under Diocletian. This chronology has been supported by recent excavations at the Benezeli mansion excavation, which have revealed two road surfaces running outside the wall, of which the lowest covers the foundation (*euthynteria*) of the fortifications. The lower street surface covers over an Athenian coin produced in the time of Gallienus of 264–267, which was found a few cm over the *euthyneria* of the wall, alongside pottery which supports a similar date, inside the road layer and in a layer beneath it: Tsoniotis (2016) 713, 720, 721 with figs. 9–10, dating to the middle of the 3rd c. (K5 and K13 in Robinson (1959) 60–61, pl. 68).

Of alternative dating hypotheses (listed in Tsoniotis (2016) 722 n. 33), Baldini Lippolis (2014) 315–17 has suggested the 6th c., noting that the late 4th to early 5th c. renewal of the Athenian Agora sought to repair rather than replace much of the main monumental structures of that area, that spoliation of funerary monuments and inscriptions, does not seem to really begin until the 5th c., probably later, and that finds in cemeteries set inside the city outside and around the post-Herulian walls date from the end of the 6th c., suggesting a major reorganisation of the area. This draws on the work of Tzavella (2008) 352–68, and on the dating of dress accessories found in graves, referred to by Baldini (2014) 317, n. 56. Baldini and her colleague have also pointed to the continued activity of the Athenian Agora in the 4th to 5th c., such as the dedication of honorific monuments, as an argument against the post-Herulian wall's logic: Baldini and Bazzechi (2016).

Overall, I find it impossible to agree with the recent revision of the walls' date based on the evidence so far published. The arguments of Baldini, whilst credible and well-informed, are associative, based on ideas of phase of development, whereas those of the coins and pottery depend on sealed contexts in clear stratigraphic relationships with the wall. They seem to fail to discount the possibility that the inner circuit could have coexisted with the wider city as a continuing monumental centre, as is the case at Ephesus and Side in Asia Minor. Thus, I continue to support the established dating, based on the coins and the inscriptions from the wall, which give a date range of 272–97. I do think it is possible however that the inner fortification became the main fortification of the city in the late 6th c., with the outer 'Valerian' wall being given up, and major urban changes occurring about this time.

Dating summary: range 272–297, midpoint 284.5, class Cs8 (contextual coins), publication 3/3.

10MAC Athens (Beulé Gate fortification on Acropolis)

Bibliography: Beulé E. (1862) *L'Acropole d'Athènes* (Paris 1862) 51–61; Dörpfeld W. (1885a) "Das choragische Monument des Nikias", AM 10 (1885a) 219–30; Dörpfeld W. (1885b) "Die Propyläen der Akropolis", AM (1885b) 38–56, 131–44; Sironen E. (1997) *The Late Roman and Early Byzantine Inscriptions of Athens and Attica* (Helsinki 1997); Svenshon H. O. (2001) *Studien zum*

hexastylen Prostylos archaischer und klassischer Zeit (Ph.D. diss., TU Darmstadt 2001).

Discussion of site: The short fortification which includes the gate across the west end of the Acropolis does not incorporate buildings but reuses a frieze of triglyphs and metopes. This was derived, along with other parts of the gate, from the Choragic Nikias monument (a memorial building): Beulé (1862) 51–61; Dörpfeld (1885a) 219–30; with excavation report of Dörpfeld (1885b) 38–56, 131–44, and summary plus illustrations in Svenshon (2001) 108–11, figs. 81–83, available at http://tuprints.ulb.tu-darmstadt.de/epda/000202/ (last accessed August 2013). The blocks are unbroken if worn and well-sorted, with wall faces of rows of pseudo-isodomic masonry, sometimes colour-matching. The gate displays the triglyphs and metope frieze as decoration. Other blocks have no inscribed elements facing outward nor are they reported as facing inwards. An inscription found nearby records the construction of the acropolis gate by Fl. Septimius Marcellinus, *vir clarissimus* and ex-agonothete, which is dated by onomastic criteria to the second quarter of the 4th c.: Sironen (1997) 104–106, no. 33. Sironen also thinks that the matter-of-fact prose commemorating a benefaction of a man of two ranks is typical of the early 4th c. onwards.

Dating summary: range 325–350, midpoint 337.5, class Cs4 (reused material), x (inscription not *in situ*), publication 3/3.

10MAC Aegina

Bibliography: Frey J. M. (2016) *Spolia in Fortifications and the Common Builder in Late Antiquity* (Boston 2016); Wurster W. W. (1975) "Architektur und Spolien", in *Alt-Agina 1.2: Die spätrömische Akropolismauer*, ed. H. Walter (Mainz am Rhein 1975) 9–38.

Discussion of site: The fortification has most recently been described by Frey (2016) 45–84. It has also been subject of a detailed monograph in German, which has seen description of the *spolia*: Wurster (1975) 9–38.

Of incorporated buildings, I know of none. I could not establish if it excluded major public buildings, though some demolition of an adjacent and external public building is shown on the site plans.

Of *spolia*, the walls contain a great deal of reused material, of complete blocks, possibly including elements taken from a dining hall, based on inscriptions (Frey (2016) 54). These inscriptions are used in the external wall facing, facing outwards, so as to create a completely inscribed surface over 30m or so, over the full height of the wall surface. There are also decorated architectural blocks that are turned inwards (Frey (2016) 76–77 fig. 3.19). These inscriptions can be considered as deliberate decoration in the *spolia* wall but they are not place in a way as to make whole texts legible, sometimes being placed upside down (pp. 76–77). Some of the blocks have been cut down a bit, as visible on Wurster (1975) 16 fig. 10, and the wall is generally very well constructed with blocks tightly fitted together, as Frey documents throughout his account.

Of dating, the wall is believed by Frey (2016) 54 to be later than AD 212 (the TPQ afforded by a name Aurelios, likely after the 212 *Constitutio Antoniniana*). This is because the buildings on site, from which the *spolia* was likely taken, were ruinous and covered by deposits, indicating that likely a lot of time had passed from the time of the inscriptions until now. He also points to "wheel-ridged pottery" in the spaces between ashlars in the wall, which I cannot credit as dating evidence as it is too imprecise. He also wishes to associate the wall with the invasion of Alaric of the late 4th c., but I do not credit this argument, giving only the end the late antique period as the decisive Slavic invasions of the Southern Balkans in 616.

Dating summary: range 212–616, midpoint 414, class Cs 7 (TPQ inscription), z (regional development), publication 3/3.

10MAC Isthmia

Bibliography: Beaton A. E. (1976) "The date of the destruction of the Sanctuary of Poseidon on the Isthmus of Corinth", *Hesperia* 45 (1976) 267–79; Frey J. M. (2016) *Spolia in Fortifications and the Common Builder in Late Antiquity* (Boston 2016); Gregory T. (1993) *Isthmia V: The Hexamilion and the Fortress* (Princeton 1993); Hayes J. W. (1975) *Roman and Pre-Roman Glass in the Royal Ontario Museum: A Catalogue* (Toronto 1975); Wohl B. L. (1981) "A deposit of lamps from the Roman Bath at Isthmia", *Hesperia* 50 (1981) 112–40.

Discussion of site: the Late Roman wall and connected Hexamilion fortress has most recently been described by Frey (2016) 128–75, with references to previous literature, the most important of which is Gregory (1993).

Of incorporated buildings, it includes a Roman Arch and a Roman Bath Building.

Of *spolia*, it reuses material from the Temple of Poseidon (Frey (2016) 136). This material comprised (p. 155) fluted and unfluted columns and entablature, including (p. 165) column drums. There are also parts of geison from a Doric order building (p. 165). Whilst many blocks are used within the wall facing, great efforts had been made to cut down, via systematic chiselling, or turn into the wall the original form of spoliated blocks, meaning that the architectural origin of the vast majority of pieces cannot be identified: Frey (2016) 153–55.

Mortar is used to hide undisguised blocks or such lack of disguise is in the lower courses/foundation, which either were not visible or were more heavily mortared (pp. 153–54). A tower built with rather less care for disguise has been given a full mortar covering layer to hide this fact (pp. 156–65 with pp. 162–63 with fig. 5.25), though bonding between walls and towers suggests this is the same period of construction (p. 166).

Of dating, the fortification is given as of the first decades of the 5th c. by Gregory (1993) who after reviewing earlier attempts to date the wall (p. 3), provides convincing excavated evidence. First there is coin of Arcadius of 402–408 from a fill laid down to support the foundations of the north-east gate of the Hexamilion. Second, graves around the gate are in two cases cut by the gate, grave 4 containing a glass vessel of the 3rd–4th c. (similar to Hayes (1975) nos. 340 [end 3rd to first half of 4th c.], 437, 438, [late 3rd to 4th c. date]), grave 3 a lamp of the 4th to first decades of the 5th c. (Athenian glazed lamp IPL 69-23) and a jar with later 4th to early 5th c. parallels. Grave 1, that post-dates the wall, contains coins of Marcian (450–457) and Leo (457–474) pp. 77–79. Thus, the coin from the foundation provides a TPQ for the gate of 402, supported by the material from graves 3 and 4, whilst grave 1 should give a TAQ for the gate of 482, as the grave itself can be given a range of 457+25 years based on the start date of the last coin. However, there are also fill deposits found piled up against the wall at the time of construction that regularly contain [as their latest material] Athenian pre-glaze lamps and pottery of the very late 4th and early 5th c.: p. 142, drawing on Wohl (1981) 112–40. Wohl describes lamps in layers dumped into the baths as part of works to build the wall, with the latest being pp. 135–36 nos. 44–46 of the first quarter and first half of the 5th c., based on local parallels which I am not going to scrutinise here. The same baths produced coins from floor levels or floor fill of 4th c. date, running up to an issue of 395–408. There is also a coin hoard of 97 coins from Isthmia with coins from Constans to Honorius, with the last coin being of 393–395: Beaton (1976) 267–79. This is thought to represent a disruption relating to the incursion of Alaric in 396.

Overall, the lamp deposit provides the latest contextual dating for the wall, of 400–425, based on 25 years after the start date of the last find whilst the coin of the foundation gives us a TPQ of 402. Therefore, I set the date as 402–425, discarding the significance of the hoard, which might mislead one into thinking the wall was built in anticipation of Alaric or just after, if taken alone as dating evidence.

Dating summary: range 402–425, midpoint 413.5, class Cs9 (contextual ceramics), Cs7 TPQ (coin) publication 3/3.

10MAC Corinth

Bibliography: Gregory T. (1979) "The late Roman wall at Corinth", *Hesperia* 48 (1979) 264–80.

Discussion of site: Corinth's inner fortification has been studied by Gregory (1979) 264–80.

Of incorporated buildings, I know of none. On excluded structures, see below.

Of *spolia*, it contains reused blocks, thought possibly to have come from the earlier city wall or from the amphitheatre, which was the only major structure left outside of it. Rubble fill in the wall contained marble slabs and a statue base, the latter of which had already been reused for a non-statue purpose p. 267.

Of dating, we have coins from sealed deposits (latest 364–375) and destruction deposits (latest 372–392) below the wall and also from, "broken material lamps and coins that go up to the very end of the 4th century", in dumped material that seems to be part of the wall's construction: Gregory (1979) 268–69. The best date is derived from the last coins which would give a contextual coin date of 25 years after the start date of 372, so 372 to 397. Gregory would like to place it after Alaric's invasion of 396, during which Zosimus 5.6.5 states that most of the cities of the Peloponnese were unwalled, but I prefer here to defer to the archaeological evidence, which is stronger, even if it does not rule out such a date.

Dating summary: range 372–397, midpoint 384.5, class Cs 9 (contextual, coins), publication 3/3.

10MAC Sparta

Bibliography: Frey J. M. (2016) *Spolia in Fortifications and the Common Builder in Late Antiquity* (Boston 2016); Waywell G. B. and Wilkes J. J. (1994) "Excavations at Sparta: the Roman Stoa 1988–1991. Part 2", *BSA* 89 (1994) 377–432.

Discussion of site: This wall has been studied by Frey (2016) 85–127.

Of incorporated buildings, the wall includes the theatre, building directly over its cavea seats (Frey (2016) 98–99), and the end of a stoa (p. 101). It excludes a large number of public buildings.

Of *spolia*, it reused Early Imperial statue bases (Frey (2016) 91), bucrania, garlands, circular bosses: (p. 97), architraves, frieze and cornice fragments of a building in the Corinthian order (p. 101), columns, inscriptions, part of a Doric frieze (p. 104), which is used turned outwards to decorate the wall face, within a pattern of different colour bands of reused blocks. Much of the material is in a damaged condition (broken, worn, chipped), damage that occurred prior to the stones being incorporated in the wall.

Of dating, the fortification is given as of the late 4th c., after 375 by Frey (2016) 92 citing ceramic evidence

of Waywell and Wilkes (1994) 423. This is phase V of trenches RSC 1, 2, 3, and the ceramics come from layers associated with the foundations of the Late Roman fortification. These contained little that was diagnostic (contexts 4159, 4158, 4155), though they are given as all likely to date to 4th c. except 4159 which could be very late 3rd c. A slightly higher layer in the same phase (4148), produced a fragment of ARS Hayes form 50, given as of late 4th–early 5th c., and a fragment of a Laconian copy of Athenian lamp Broneer type XXVII, given as 3rd or early 4th c. This suggested to the excavators a date for the fortification of late 4th–early 5th c., and then considered an association of the building works with the presence of Alaric and the Visigoths in 396 as being "most plausible". My own dating for ARS Hayes 50, listed in *Public Space* vol. 2 27 is 350–400 based on E. Vaccaro pers. comm. 2016. This would lead me to suggest the correct date for the wall under present evidence is 350–375, taking the start date of the latest sherd as providing a contextual ceramic date, that should be allowed to trump a date based on literary evidence, in order to maintain consistent dating principles.

Dating summary: range 350–400, midpoint 375, class Cs9 (contextual ceramics), publication 2/3.

11THR Philippopolis in Thrace (Post-Justinianic Wall)

Bibliography: Topalilov I. (2012) "Philippopolis. The city from the 1st to the beginning of the 7th c.", in *Roman Cities in Bulgaria*, vol. 1, ed. R. Ivanov (Sofia 2012) 363–437.

Discussion of site: This wall runs at the foot of the three hills, over the public baths.

Of incorporated buildings, I think there is only the theatre, from what I could see, though the whole circuit has not been excavated. It excludes a good number of public buildings from the defended circuit.

Of *spolia*, it seems to be entirely constructed of reused material. I saw a column, cornices, and architraves, visible in the outerface of the wall, of white marble, chipped or broken when they went in, where blocks were very poorly-coursed or uncoursed, in the presence of a mixture of grey stone ashlars, of diverse shapes, poorly jointed: L. Lavan site observation 2017. There is also sienite taken from street paving in this wall: Topalilov (2012) 13, 65–66.

Of dating, this wall can be considered post-Justinianic, as it is a contrast to the previous wall in *opus mixtum*, with pentagonal towers, which seems to reflect the circumstances of Justinian's reign. Procopius records building renewal under Justinian in the Balkans, including Philippopolis, in Procop. *Aed.* 4.1, and later 6th c. occupation is attested in buildings outside the Justinianic wall, running up to coins of Phocas (606–610), within monumental buildings, although they apparently meet their demise in the late 6th c.: Topalilov (2012). Thus, at this time we cannot think there was some kind of architectural free-for all, as represented by the post-Justinianic wall. It is likely to represent a development of the very last years of the city, which likely came to an end with the decisive Avar and Slav invasions of the region in 616. But as I do not have access to the data for the demise of intramural buildings in the city, I will set the TPQ as the end of the reign of Justinian. The latest repair to a building in the city (a monastery outside the reduced circuit) seals coins of Heraclius and Constantine of 613–17, but this does not oblige me to change the regional TAQ, or make the wall later than the Avar incursions, as Topalilov (2012) 66 suggests.

Dating summary: range 565–616, midpoint 590.5, class Cs4 (reused material), z (site development), z regional development, publication 3/3.

11THR Histria (Phase 2a)

Bibliography: Cârstoiu M. M. (2006) *Histria XII: Architecture grecque et romaine: membra disiecta. Geometrie et architecture* (Bucharest 2006); Demaneantu C. (1990) "Die spätrömische Festungsmauer von Histria", in *Histria. Eine Griechenstadt an der rumänischen Schwarzmeerküste*, edd. P. Alexandrescu and W. Schuller (Konstanz 1990) 265–83; Pippidi D. M. (1983) *Inscriptiones Scythiae Minoris graecae et latinae*. Vol. 1, *Inscriptiones Histriae et viciniae* (Bucharest 1983); Suceveanu A. (1990) "Das römische Histria" in *Histria. Eine Griechenstadt an der rumänischen Schwarzmeerküste*, edd. P. Alexandrescu and W. Schuller (Konstanz 1990) 233–64.

Discussion of site: This wall is described by Demaneantu (1990) 265–83. However, the dating evidence is provided by Suceveanu (1990) 233–64. There are many subsequent phases of wall on site but *spolia* is not mentioned in relation to them in these publications.

Of incorporated buildings, there appears to be a bath building, whose W wall is incorporated: V. Bottez pers. comm. 2022. The circuit does not appear to exclude any major buildings, but this may be due to lack of excavation.

Of *spolia*, there are theatre seats and columns, the latter of which are described as forming the west (outer) face of the foundation: Suceveanu (1990) 243. The theatre seats may be erroneous, see below. There are other architectural elements (including part of a 60m colonnade from a building dedicated under Antoninus Pius): V. Bottez pers. comm. 2022. Most of them are mentioned in Cârstoiu (2006) esp. ch. 13 "Spolia dans le mur d'enceinte" on pp. 362–82. Anthemion block of 5th

c. BC (pp. 64–65); pseudo-Corinthian capital (p. 244); pseudo-Corinthian pilaster capital (p. 245); Ionic architrave (epistyle) (pp. 272–74); Doric geison (p. 305); benches (p. 348 n. 958 with pl. 13.D); bases with socles (pp. 364–65); under-socles (p. 365); crowning block (p. 366); socles (p. 367); cornices (p. 368); benches, prob for *exedrae* as from a rectangular structure (pp. 368–69); cornices, architrave cornices (p. 369); column shafts (22 in total accessed), only one fluted (pp. 369–71); entablature elements (epistle block and 5 architraves in zone of the Great Gate) (pp. 371–73); entablature elements in section south of the Great Gate, which included inscription to Antoninus Pius (pp. 373–79, with length of colonnade on p. 378 and dedicatory inscription on p. 376 n. 1038 = Pippidi (1983) no. 151, pp. 289–90 (not seen)); blocks with traces of finishing or sealing (Cârstoiu (2006) 379–82). There are many types of inscriptions, from gravestones to honorary decrees, buildings dedications (as of a small building of the reign of Trajan), a dedication to IOM and Iunona Regina, alongside statue bases: V. Bottez pers. comm. 2022.

Of preservation or visibility, little is described in the report, other than that *spolia* is visible in the wall face and there is a prevalence for its use around the gate (Cârstoiu (2006) 262–63). Nevertheless, some observations can be made from looking at photos and figures of *spolia* in the wall. A row of columns is used at the base of the visible part of the wall (pl. 76 (103.F) and 110 (103.F, showing 22 columns, 1 of which damaged)). Pl.76–81 show photos of the (mainly external) wall face with unworked faces generally used on the outside, although there are a few moulded blocks visible and some with clamp marks. In the lower courses, the *spolia* seems to have been used in an aesthetic manner with alternating long and short blocks. They do not appear to be damaged prior to entering the wall and are carefully laid. The nature of the material suggests the well-ordered demolition of buildings to construct the wall rather than a random quarrying of a ruin field. There is no systematic description of what is found inside the wall and outside of it.

Of dating, we have, it seems, only a general coin profile of occupation for this site, which radically changes its occupied area over time. This suggests a major increase in occupation in the time of Claudius II Gothicus (big jump from 0.62% under Gallienus to 4% under Claudius II, then 3.4 under Aurelian), although Probus is preferred as constructor: Suceveanu (1990) 243. He does not explain why, but Demeaneantu (1990) 265 justifies this based on activity in the region under Probus in restoring walls. I will stick with the associative date suggested by the coin profile, of the reign of Claudius II Gothicus (268–270), although to be clearer one would have to compare the coin profile of the site to a profile of the overall regional coin supply.

Dating summary: range 268–70, midpoint 269, class Cs3 (Associative, finds), publication 3/3.

13ASI Sardis (Late Roman extensive wall)

Bibliography: Foss C. and Winfield D. (1986) *Byzantine Fortifications, an Introduction* (Pretoria 1986); Hanfmann G. M. A. (1983) *Sardis from Prehistoric to Roman Times. Results of the Archaeological Exploration of Sardis 1958–1975* (Cambridge Mass. and London 1983); Rautman M. (2011) "Sardis in Late Antiquity", in *Archaeology and the Cities of Asia Minor in Late Antiquity*, edd. O. Dally and C. Ratte (Ann Arbor 2011) 1–26; Van Zanten D., Thomas R. S., and Hanfmann G. M. A. (1975) "The city walls", in *A Survey of Sardis and the Major Monuments Outside the City Walls*, edd. G. M. A. Hanfmann and J. C. Waldbaum (Cambridge Mass. 1975) 35–52.

Discussion of site: The extensive city wall built at Sardis has been studied by: Van Zanten, Thomas and Hanfmann (1975) 35–52. The wall incorporates the western Bath-Gymnasium complex and follows the line of an Archaic fortification: Rautman (2011) 9. It contains reused architectural blocks in foundations and lower courses: p. 10. The inner and outer faces of these walls were covered in grey stucco and scored with lines in a vertical and horizontal manner to imitate ashlar masonry: Van Zanten *et al.* (1975) 35–52. Thus, *spolia* would be invisible. The majority of the facing is unfinished field stone: pp. 39–40.

Of directly incorporated buildings, there appear to be only the gymnasium, visible on the map provided in Van Zanten *et al.* (1975), and the Archaic fortification. This is also the case in a description of the wall given by Foss and Winfield (1986) 127–28. Of excluded buildings, there is Bath Building CG, and the temple of Artemis, but the latter does not really count as it was an extra-mural sanctuary, 1km or so south of the city.

Of *spolia*, some descriptions are given in Van Zanten *et al.* (1975): The South-west Gate contains, in a wall flanking the northern approach, a Hellenistic pediment with a shield-like device and other fine marble blocks of the same structure, a marble bench, other Hellenistic blocks, an acanthus-cavetto frieze of *ca.* 3rd c., of which a similar block appears in the adjacent Pactolus Bridge, a door frame of a type known from the Gymnasium (pp. 45–46). The Pactolus Bridge close to the route of the wall, sharing similar *spolia*, contained a gigantic block of 3rd c., perhaps from an anta, with cavetto, acanthus, and palmette (p. 48). Tower 4 includes material which seems to come from a building with an Ionic architrave,

pulvinated acanthus frieze, possibly Corinthian capitals and Ionic entablature with a false lion-head spout, alongside coloured column shafts, but this tower is different in size and plan from the other towers, and thus thought to be a 6th c. addition, contains *spolia* in its footing and facing (pp. 43–44).

Of dating, the wall has been suggested to be of 350–400 on account of, "coins and other material" found, "in the wall and against its foundation" for which see Hanfmann (1983) 143. However, Rautmann (2011) 10 regards the date as unsettled, pointing to some sections being associated with stratigraphy of the 3rd c., though apparently some parts "received attention" in the 4th c. and later, whatever that phrase means. He also notes that the western sections seem to have encouraged development in the early 5th c. by enclosing this area, providing a rough supplementary TAQ if one were needed.

Of real dating indicators, there are a few, mostly associative. The 3rd c. blocks from the SW Gate and associated bridge can provide a rough TPQ, but this is better given as the beginning of widespread use of reused material *ca.* 250. On the Pactolus Bridge, 4th c. coins came from above the wall or, in the latest case (Theodosius I, Arcadius, and Honorius of 383–95), from rubble on top of a marble block in the wall (p. 49). Pits dug near wall section 30 did not yield conclusive dating evidence, bar discovering Roman levels of 1st to 2nd c. under the wall, and a significant dump of material close to the fortification, where its latest coins were of late 4th to early 5th c. date including a coin of Theodosius II (reigned 408–450) (p. 44). The absence of material later than this here is suggestive that the wall was in place by this time, providing a weak TPQ of 450, using the full reign of Theodosius II rather than the 25 years after 408, under the rules of Lavan *Public Space* vol. 2.

Dating summary: range 250–450, midpoint 350, class Cs4 (Reused material, general presence), Cs3 (Associative, finds), publication 3/3.

16ASI Sardis (walls of acropolis)

Bibliography: Bates G. E. (1971) *Byzantine Coins* (Archaeological exploration of Sardis Monograph 1) (Cambridge, Mass. 1971); Butler H. C. (1922) *Sardis vol.1 The Excavations. Part 1, 1910–1914.* (Leiden 1922); Foss C. (1976) *Byzantine and Turkish Sardis* (Cambridge Mass. 1976); Hanfmann G. M. A. (1961) "The third campaign at Sardis (1960)", *BASOR* 162 (1961) 8–49; Hanfmann G. M. A. (1962) "The fourth campaign at Sardis (1961)", *BASOR* 166 (1962) 1–57; Hanfmann G. M. A. (1963) "The fifth campaign at Sardis (1962)", *BASOR* 170 (1963) 1–65.

Discussion of site: This wall which encircles the acropolis is described by Foss (1976) 57–59 and also by Butler (1922) 21–25. It is included here to provide a contrast with the Late Roman wall. The walls were built in a single impressive operation with levelling and foundations dug 1 m deep into the conglomerate bedrock. There are no obvious traces of later repair: Foss (1976) 58, drawing on Hanfmann (1961) 33.

Of directly incorporated buildings, there appear to be none. A great number of public buildings are excluded from the circuit.

Of *spolia*, the facing of the wall is composed of thousands of architectural fragments taken from the city, dating from the 5th c. BC to the 4th c. AD: Foss (1976) 58. This includes a large quantity of marble blocks, with many columns of coloured marble of modest width, often set in a row. There are larger column drums of white and coloured marbles, bases, capitals, architrave and cornice, egg and dart moulded blocks, plus some examples of 'late Byzantine' mouldings, all together in 'confusion', alongside inscriptions in Greek and Latin: Butler (1922) 23–24.

Of dating, a number of inscriptions were spoliated for the wall, the latest of which is an inscription of Justinian of after AD 539, thus providing a TPQ. Furthermore, the first phase of buildings inside the acropolis fortifications was destroyed by "violence and burning" and contain 5 coins ranging from 590–711 (Maurice to Justinian II). This suggests (if we apply a rough contextual coin date) that the destruction occurred in the 25 years or so after 705, the start date of the last coin, up to 730: Foss (1976) 58–59 making reference to the coin report of Bates (1971) 651, 1089, 1092 1099, 1103 (last coin of 705–711) and unpublished manuscripts on the dig. Hanfmann (1962) 37–39; Hanfmann (1963) 32 (suggesting a last coin of Constantine VII of 913–59 from a floor in the first phase, which was not used by Foss, for reasons unknown to me).

Dating summary: range 539–730, midpoint 634.5, class Cs7 (TPQ inscription), Cs8 (contextual, coins), publication 3/3.

13ASI Ephesus (City wall surrounding city centre, including theatre)

Bibliography: Foss C. (1979) *Ephesus after Antiquity* (Cambridge 1979); Foss C. and Winfield D. (1986) *Byzantine Fortifications, An Introduction* (Pretoria 1986); Heberdey R. (1907) "VIII Vorläufiger Bericht über die Grabungen in Ephesus 1905–06", *ÖJh* 10 (1907) 62–78; Müller-Wiener W. (1961) "Mittelalterliche Befestigungen im südlichen Ionien", *IstMitt* 11 (1961) 15–122; Roueché C. (1999) "Looking for late antique ceremonial: Ephesos and Aphrodisias", in *100 Jahre Österreichische Forschungen in Ephesos. Akten des Symposions Wien 1995*

(DenkschrWien 260. AF 1), edd. H. Friesinger and F. Krinzinger (Vienna 1999) 161–68; Scherrer P. (2006) "Die Agora: Vorläufiger Baugeschichte", in *Forschungen in Ephesos XIII.2 Die Tetragonos Agora in Ephesos*, edd. P. Scherrer and E. Trinkl (Vienna 2006) 49–54; Scherrer P. (2013) "The stratigraphy of the tetragonos agora", in *The Amphorae of Roman Ephesus* (Forschungen in Ephesos 15.1), ed. T. Bezeczky (Vienna 2013) 5–17.

Discussion of site: This wall has neither been fully described nor investigated seriously, although there are some comments in Foss and Winfield (1986) 132–33; Foss (1979) 111–12 and Müller-Wiener (1961) 86–88 What follows here is largely based on my own observations as a visiting tourist and reflection on the *spolia* of Ephesus.

Of incorporated buildings, it includes the Baths of Vedius, one side of the desacralised Temenos of the Temple of Hadrian (the southern portico of which contained the Church of St. Mary), some harbour structures, the theatre, and an unknown square building on the south side of the Arcadiane. The wall excludes a great number of major public buildings, especially to the south, although, as I will explain, these mostly continue to be occupied and not spoliated for the wall.

Of *spolia*, the city wall includes some obvious reused blocks around the gate by the theatre and the adjacent stretch of wall, unbroken, although I do not know of their origin. Here the decorated faces of blocks are not visible. So, they likely faced inside. Otherwise, the wall does not contain much notable reused material in the areas that I was able to examine: L. Lavan site observation 2013. Müller-Wiener (1961) 87 notes that in the entire course reused building blocks feature in inner and outer face, with a few worked stones and architectural fragments, which are sometimes found in broken condition inside the wall. Foss and Winfield (1976) 133 point out the re-use of blocks from the Hellenistic fortification in some places, particularly on the hill, after Müller-Wiener (1961) 88 points to the incorporation of blocks of the Hellenistic city wall on the Panayırı dağı. On the gate by the theatre, the large reused blocks are used in the inside and outside faces of the wall, as they are in the inside of the wall by the theatre. They do not look to have been damaged when included in the structure: L. Lavan site observation April 2013. The inside face of the city wall on the Arcadiane does not include obviously reused material.

Of phasing and dating, critical connections come from two gates in its length, close to the Theatre Square. (i) The first gate, which comes into Theatre Square from the tetragonal agora, serves a long-walled passage which exits into the tetragonal agora within the framework of the 6th c. rebuilding of the northern portico. Therefore, it is likely contemporary with the rebuilding of the portico and the major levelling works to raise up the 'police station area' to the west of the passage and north of the agora. Indeed, the gate passage's west wall retains earth from this late raised area on its eastern side (see Lavan *Public Space* vol. 2 appendix S4 and Scherrer (2013) 14). The agora work appears, from various dating indicators, to date to shortly after 550, as seen in Lavan *Public Space* vol. 2 655–59 (appendix K4b) and 823–24 (S3). (ii) The second gate in the city wall is set at the top of the Marble Street. It is inscribed with part of a set of acclamations found all along the Marble Street and Lower Embolos, honouring the families of Phocas, Heraclius, and the factions. Of these, the text on the gate honours the Christian emperors and the Greens, the faction which favoured Phocas. These unusual inscriptions seem to represent a coherent set of acclamations decorating the Marble Street, which were inaugurated in the time of Phocas, with modifications under Heraclius. Thus, the second gate, where the set of acclamations begins, should have been built during or prior to the reign of Phocas (602–610). The inscription on the second gate thus provides a TAQ for the city wall. In contrast, the 6th c. retaining walls associated with the first gate provide an absolute date for the wall, even if this is not more than a provisional one, through its connection to the later 6th c. phase of the tetragonal agora. For the acclamatory inscriptions, see Roueché (1999) 164 no. 1.1 = *IvE* 6.2090.

This means that I am proposing an earlier dating for the wall than has been suggested by most scholars. For example: (i) Scherrer thinks that the city wall dates to the '7th c.', due to the lack of coin finds in the city south of the fortification (of later than the second decade, or at the latest fourth decade, of the 7th c.), perhaps after the earthquake of AD 616 [not in Guidoboni Catalogo or Ambraseys Catalogue]: Scherrer (2006) 54 with n. 254 (for reports, and references to unpublished paper by H. Hellenkemper). (ii) Heberdey had also dated the fortification to the same time period as he regarded the presence of the acclamatory inscriptions of Phocas and Heraclius on the Marble Street, south of the wall, as implying that an unwalled classical city still functioned at that time [apparently he did not notice that the inscription on the gate was part of the same series]: Heberdey (1907) 73. However, I think that the relationship of the fortification to the Justinianic Arcadiane repairs and to the tetragonal agora suggests that it was part of the final phase of the late antique city. Thus, the new wall coexisted with the monumental repair and occupation of the Arcadiane, in the late 6th c. However, the wall was likely a little earlier than the inscriptions inscribed on the gate (probably written in 601–610), as

these acclamations ignore the Arcadiane which the wall sought to protect, privileging a north-south street route through the city. I would favour a date of around 580, based on the balance of evidence, although 570–590 might be more realistic. Nevertheless, here I keep a wider range of 550–610.

Dating summary: range 550–610, midpoint 580, class Cs3 (associative, phase of development across site), Cs6 (TAQ inscription), Cs5 (catch-all masonry, *spolia* use), publication 3/3.

13ASI Ephesus (Wall around hill of St. John)

Bibliography: Foss C. (1979) *Ephesus after Antiquity* (Cambridge 1979); Foss C. and Winfield D. (1986) *Byzantine Fortifications, An Introduction* (Pretoria 1986); Karwiese S. (1998) "Ephesos. Vorläufiger Grabungsbericht 1997: Stadion", *ÖJh* 67 (1998) 21–23; Müller-Wiener W. (1961) "Mittelalterliche Befestigungen im südlichen Ionien", *IstMitt* 11 (1961) 15–122.

Discussion of site: This sorely neglected fortification, of two main phases, has still not been properly studied. It has received a preliminary description by Foss and Winfield (1986) 132; Foss (1979) 106–107; Müller-Wiener (1961) 91–95 and 108f.

Of incorporated buildings, I know of none. The wall excludes the adjacent Temple of Artemis, although the settlement focus was established around the church at a time when this site was ruined.

Of *spolia*, the first phase has a tower of rubble with a facing of marble *spolia*, largely from the stadium and adjacent Temple of Artemis: Müller-Wiener (1961) 93 notes that the blocks from these monuments are inscribed, helping indicate their origin. The second phase reuses a Roman frieze: Foss and Winfield (1986) 132. It includes the decorative use of a row of columns in the outer facing of one of the towers flanking the gate of phase 1. Reused material can be seen on the rear facing of the gate and its flanking towers. Some of the columns in the 'row' of reused columns appear a bit chipped, but otherwise the material used in the wall does not look damaged or broken: L. Lavan observations by Google Images 2022.

Of phasing, the gates and the towers are of two phases, with the first phase having square towers connected to the side walls flanking the gate, the second by the current gate structure and a casing of the towers to make them pentagonal: Foss and Winfield (1986) 132. Müller-Wiener (1961) 108 identifies a part of the wall in blockwork a technique which he believes to be Justinianic or later 6th c., but this would not seem to be representative of the main first phase so will not be considered here. The hill surely had a number of retaining walls and perhaps even earlier fortifications corresponding with the building of the major Anastasian and Justinianic church here.

Of dating, a group of coins of Constans II (641–688) is associated with the fortifications, which Foss and Winfield (1976) 132 think provides a date. They also point to the time of Leo III (717–741, not Leo II as given in Foss and Winfield, which is a mistake) as being a possible time for the second phase of the fortifications, when Ephesus became a separate theme, with its capital here, as discussed in Foss (1979) 103–115 and 195f. I will not concern myself with the second phase, only the first one here. The coin evidence is presented in more detail in Foss (1979) 107 n. 12, plus p. 197 appendix 7, who describes 23 coins of Constans II found in Selçuk, the modern town built around the hill, without precise findspots. These coins, relatively common in Asia Minor, have not been found on the site in Ephesus according to Foss, making them highly significant as associative chronological indicators of a move of the settlement to the Hill of St. John. The Church of St. John was of course worth protecting earlier, so the wall could be earlier than this time. The coin evidence suggests strongly that the wall on this hill was not later than the end of the reign of Constans II, as it would be odd if the one known surviving medieval settlement core of Ephesus was not protected at the time the settlement shifted.

The spoliation of the stadium gives us a TPQ. This structure was converted into an amphitheatre, meaning that some of its structure might have been redundant and available for reuse before other sources. It was perhaps converted in the earlier 6th c., as the amphitheatre has coins which, after a slump in the 5th c., increase from the reign of Justinian onwards, with a peak (13) in the reigns of Justin II to Tiberius II (5), up to AD 578, though a small number are known after this (5 from Maurice-Phocas, 3 Heraclius, and 1 Constans II): Karwiese (1998) 21–23. However, so far, no such early spoliation of the stadium seats is known: only in the late city wall of 550–610. Thus it seems likely that it was only this latter construction, along the side of the stadium, which made its material available as a quarry. Indeed, the lack of reuse of the stadium blocks in the late city wall or prior to it (as far as I know), makes this very likely. Thus, I put the dating of the first phase of the wall around the hill of St. John at or after the same date range as the construction of the late inner wall of the city of Ephesus, so giving it a TPQ of 550, and a TAQ or the end of the reign of Constans II in 688.

Dating summary: range 550–688, midpoint 619, class z (site development), Cs3 (associative, coins), publication 3/3.

13ASI Miletus (Gothic Wall)

Bibliography: Foss C. and Winfield D. (1986) *Byzantine Fortifications, An Introduction* (Pretoria 1986); von Gerkan A. (1935) *Milet 2.3 : Die Stadtmauer* (Berlin 1935); Niewöhner P. (2008) "Sind die Mauern die Stadt?", *Arch Anz* (2008) 181–201.

Discussion of site: This simple circuit, 4 or 5 m high and 2.5–3 m thick has been studied by von Gerkan (1935) 81–84; Foss and Winfield (1986) 126; Niewöhner (2008) 181–86.

Of incorporated buildings, the wall followed the line of the ruined Hellenistic fortification: Foss and Winfield (1986) 137–38 and also the Baths of Capito: Niewöhner (2008) 185–86, who notes some entirely new sections that did not follow the Hellenistic wall on pp. 183–86 shown on map on p. 183 fig. 1. It did not exclude major monuments from beyond the city wall.

Of *spolia*, it was built of a foundation of column drums and faced with reused material that was also used in the wall core, with fig. 51 on p. 83 suggesting that its architectural elements were used to bind the wall faces inside the wall whereas flat stone plates were used on the face, suggesting an attempt to hide the decorated pieces. The *spolia* is mostly taken from grave monuments, whereas buildings tend not to be used to build the wall.

Of dating, it has been attributed to the time of Gallienus based on coins of this emperor found within the rubble core: Foss and Winfield (1986) 126 drawing on von Gerkan (1935) 83, who notes coins of Galerius to Constantine found outside the wall at a higher level pp. 80–87. As there are several coins (until I can know the latest issue, with Gallienus reigning from 260–68 in the East) we can suggest a contextual date of 260–285 for the wall, based on a 25 year range after the start date of the last find. I do not think we need to worry about the dating of Gothic invasions of the region in *ca.* 262 (*HA Gallienus* 5.2, 6.1), for which this wall might have been a later response as much as a preparation.

Dating summary: range 260–285, midpoint 272.5, Cs 9 (contextual coins), publication 3/3.

13ASI Miletus

Bibliography: Dessau H. and Hermann P. (1997) *Millet VI Inschriften von Milet*, vol. 1 (Berlin and New York 1997); Foss C. and Winfield D. (1986) *Byzantine Fortifications, An Introduction* (Pretoria 1986); Ladstätter S. (2008) "Roman, late antique and Byzantine ceramics", in *Das Vediusgymnasium in Ephesos* (Forschungen in Ephesos 14.1), edd. M. Steskal and M. La Torre (Vienna 2008) 97–198; Niewöhner P. (2008) "Sind die Mauern die Stadt?", *Arch Anz* (2008) 181–201; Niewöhner P. (2011) "The riddle of the Market Gate. Miletus and the character and date of the earlier Byzantine fortifications of Anatolia", in *Archaeology and the Cities of Asia Minor in Late Antiquity* (Kelsey Museum Publication 6), edd. O. Dally and C. Ratté (Ann Arbor 2011) 103–22; Niewöhner P. (2013) "Neue spät- und nachantike Monumente von Milet und der mittelbyzantinische Zerfall des anatolischen Städtewesens", *Arch Anz* (2013) 165–233; Niewöhner P. (2017) "Miletus", in *The Archaeology of Byzantine Anatolia: from the End of Late Antiquity until the Coming of the Turks*, ed. P. Niewöhner (New York 2017) 137–38; Turnovski P. (2005) "The morphological repertory of Late Roman/Early Byzantine coarse wares in Ephesos," in *LRCW I Late Roman Coarse Wares, Cooking Wares and Amphorae in the Mediterranean*, edd. J. M. Gurt i Esparraguera, J. Buxeda i Garrigós and M. A. Cau Ontiveros (BAR-IS 1340) (Oxford 2005) 635–46.

Discussion of site: This circuit is partially known, especially around the agora, and has been studied by Foss and Winfield (1986) 137–38; Niewöhner (2008) 184–86; Niewöhner (2017) 137–38; Niewöhner (2013) 165–233; Niewöhner (2011) esp. 107.

Of incorporated buildings, the wall took in parts of the Baths of Capito, as had the previous 'Gothic' wall, and also the Roman aqueduct and the Market Gate, which was converted into a gateway and tower, then the Baths of Faustina, and the Theatre: Foss and Winfield (1986) 137. Recent work has also identified that the porch of the Serapeion was also incorporated into the wall, framing a gate through the fortification: Niewöhner (2013) 184–86. The wall excluded major public buildings from its circuit.

Of *spolia*, the wall is faced with reused materials that are better chosen and laid than the earlier wall, consisting of architectural fragments and inscriptions, with broken statues also known from within the core: Foss and Winfield (1986) 137. From my site visit of 2003 I saw that the reused blocks were whole and were visible in the wall faces (both sides) but generally turned inward, though not uniformly so: L. Lavan site observation 2003.

Of dating, a Justinianic lintel from the Market Gate area has an inscription referring to the building of a gate in 538. This is normally assumed to date both the building of the city wall and the conversion of the Market Gate into a gate within it: Dessau and Hermann (1997) 35–36, 301 no. 206 (Justinianic gate inscription, with year calculated from consular and indiction dating given in the text). It has been suggested that this block may not be part of such a gate: the lintel is too short to bridge the gap, and has a cross inscribed on the back side of the block: see Niewöhner (2011) 103–107. In the rest of this article, Niewöhner also points out that there is evidence for considerable 6th c. vitality outside the city wall, as

an argument against the fortification's dating to the time of the inscription, with an extramural bath building (p. 108) thought to be active in the Justinianic period. In particular, Niewöhner feels that the wall might not date within Late Antiquity due to the persistence of an area of dense urban occupation recently excavated outside of the fortification, south of the west market, destroyed in the late 6th to mid-7th c., the ceramics of which will not go into here, but that with the latest start date seems to be an Early Byzantine lamp identified at Ephesus with *Palmettengriff*, dated to the outgoing 6th to middle of the 7th c.: Niewöhner (2013) 175–81. However, neither of these arguments are strong: (i) firstly, we simply cannot reconstruct the position of the inscription in the gate, and it remains likely that the inscription was associated with the gate, as it names a πόρτα, and was found in this place; (ii) secondly, other cities had active extramural areas in the 6th c. despite the installation of fortification walls, notably at Ephesus. Thus, the finding of an inscription of 538 relating to a gate should either indicate a restoration of the traditional Market Gate or its incorporation into the late fortification.

As a second dating strand, Niewöhner (2013) 187–89 describes a recent sondage against the wall by the baths which revealed a layer abutting the foundation of the wall, and stratigraphically contemporary with it (above a layer without any diagnostic finds). This abutting layer contained the following critical ceramics: a fragment of Late Roman C Ware plate of probably Hayes 3 [400–*ca.* 550 in LRP/SLRP], and a rim fragment of ARS form Hayes 67 [350–500 in LRP and Bonifay], coarse ware basins known in Ephesus [given as later 6th to first half of 7th c., but see below], an *ungentarium* of 5th to 7th c. date, and a lamp of Early Byzantine type with a round body, massive handle and vine tendrils on the shoulder ("massivem Griffzapfen und Weinranken auf der Schulter") dating from the 1st half of the 7th c. and probably the 2nd half of the 6th c.: [Ladstätter (2008) 119, which does give this date range, probably relating to Type 3 or a variant of Type 2]. For the coarse ware basins, see Turnovski (2005) 635–645, esp. 637 Fig. 3.6, who gives the coarse ware a 7th c. date, perhaps with production already in the 6th c., from a study of contexts that stop in the first half of the 7th c. These deposits give the wall a potentially earlier date than Niewoehner suggests, as its latest ceramics have start dates that begin in the late 6th c., rather than the 7th c.

Overall, the sondage is the most reliable way of dating the wall, although the inscription can be taken as providing a TPQ of 538, accepting that it is *spolia* rather than a part of the original gate. However, the sondage ceramics give us a contextual date of 550–75, based on the start date of the latest ceramic (the Early Byzantine lamp of ?Type 3, which is now known from the mid-6th c.), and we should not be at all surprised to find intensive occupation outside of the city wall once it was constructed. Thus, a date within the reign of Justinian is still possible, or shortly afterwards. No evidence so far published dates the wall to the time of the Persian wars of the early 7th c. or the attacks of the Islamic armies later in that century.

Dating summary: range 550–575, midpoint 562.5, class Cs 9 (contextual ceramics), Cs7 (TPQ, inscription), publication 3/3.

13ASI Aphrodisias (Late Roman fortification)

Bibliography: de Staebler P. (2008) "The city wall and the making of a late antique provincial capital", in *Aphrodisias Papers 4. New Research on the City and its Monuments* (JRA Supplementary Series 70), edd. C. Ratté and R. R. R. Smith (Portsmouth 2008) 284–318; Kontokosta H. (2008) "Gladiatorial reliefs and elite funerary monuments at Aphrodisias", in *Aphrodisias Papers 4. New Research on the City and its Monuments* (JRA Supplementary Series 70), edd. C. Ratté and R. R. R. Smith (Portsmouth 2008) 190–229.

Discussion of site: This wall has recently been studied by de Staebler (2008) 284–318.

Of incorporated buildings, it takes in the stadium, which it cuts one storey off. I do not know of major public buildings excluded by the circuit. Some mausolea served as the basis for towers.

Of *spolia*, it contains large amounts, including the remains of *ca.* 2,000 tomb monuments (though not their sarcophagi) (de Staebler (2008) 288, 312–13), a monumental arch (p. 299), blocks from the stadium and its colonnade (p. 288). There are also funerary stellae, such as a group of 15 altar shaped stellae for gladiators: Kontokosta (2008) 192. These reused blocks are generally in good condition, with decorated faces sometimes visible, though not always, and sometimes performing a decorative function.

Of dating of the city wall, the evidence is complex, although it does seem to be unified architectural conception. The only building inscription claiming to record the construction of the city wall is that on a lintel of the north-east gate, dating from *ca.* 365 to 370, based on letter style (comparable to a mid-4th c. inscription here) and the governor's titulature (a senatorial *praeses*) (see appendix G2 above for further details): ALA 22. See esp. commentary 3.10 and 3.16–19, noting that the gate is comparable to other gates in the wall, and thus seems to be a single phase, so dating the construction of the wall. However, a longer construction chronology, from the 350s, is confirmed by ALA 19 on the west gate, recording

the construction of the 'gate' [word restored] under Constantius II and a Caesar who appears to be Julian. Yet, a single primary construction programme has been recently reasserted, after a detailed study of the wall, so it does not seem reasonable to extend the start of the wall beyond 350 at present: de Staebler (2008) 285, 289. Of useful 'archaeological' material for close dating, from within the wall, only a block with an epigraphic text of the time of Diocletian has been revealed amongst the reused material employed to build it: ALA commentary 3.18. Overall, it seems fair to adopt a date for the city wall (and, by extension, for the portico rebuilding), which reaches across the full date range of the two inscriptions cut on the gates.

Dating summary: range 350–370, midpoint 360, Cs6 (absolute, inscription *in situ*) publication 3/3.

13ASI Sagalassos (main Late Roman fortification that includes NW gate)

Bibliography: Loots L., Waelkens M., and Depuydt F. (2000) "The city fortifications of Sagalassos from the Hellenistic to the late Roman period", in *Sagalassos V*, edd. L. Loots and M. Waelkens (Leuven 2000) 619–25; Poblome J. (1995) "Sherds and coins. A question of chronology", in *Sagalassos III* (Acta Archeologica Louvaniensia Monographiae 7), edd. M. Waelkens and J. Poblome (Leuven 1995) 185–205; Waelkens M. et al. (1997) "The 1994 and 1995 excavation seasons at Sagalassos", in *Sagalassos IV. Report on the Survey and Excavation Campaign of 1994 and 1995* (Acta Archaeologica Lovaniensia Monographiae 9), edd. M. Waelkens and J. Poblome (Leuven 1997) 103–216, 231–40.

Of incorporated buildings, it includes the Doric Temple (Loots, Waelkens and Depuydt (2000) 619–20), the NW Heroon (pp. 620–25), unspecified public buildings (p. 625), perhaps the Roman Bath building (p. 625) and the podium of a suspected temple (p. 616) [or perhaps funerary monument], and tower of the Hellenistic wall (p. 631). The fortification excludes the theatre, the gymnasium, the Doric fountain, and the Neon library.

Of *spolia*, it reuses blocks from the temenos of the Temple of Antoninus Pius, including temenos wall blocks (p. 626) and column drums, bases and a Corinthian capital (p. 631), unspecified ashlar building (p. 631), and a cornice and gable from a funerary monument (p. 619). Reused weaponry frieze blocks and relief fragments of an eagle and Ares and Athena were also found at the north-west city gate and probably came from above its lintel, originally coming from the bouleuterion façade: p. 620 with Waelkens M. et al. (1997) 231–40, esp. 231. I also saw on site many seats from the stadium reused in the section of wall (in the NW corner of the circuit) that runs over and adjacent to it and statue bases in debris likely from the wall on the slope west down from the Doric Temple. Blocks are reused in the wall facing, especially its external facing, without obvious damage. Some decorated blocks face outwards, but many reused blocks have no visible decorated face: L. Lavan site observation 2005.

Of dating, the city wall is given an associative contextual date from construction by coins of 383–392, from stratigraphy inside the adjacent Doric temple, relating to its conversion into a tower: Poblome (1995) 189–90. The city wall is given a supportive contextual *terminus ante quem* of the 6th c. by rubbish deposits piled up against the exterior of the wall, which seem to date from the early 6th c. based on pottery, though the last coin is of Theodosius II (425–450): Poblome (1999) 280, 317. I will accept here a contextual date for construction, based on the coins from the Doric Temple, of the 25 years after AD 383.

Dating summary: range 383–408, midpoint 395.5, class Cs8 (contextual coins), Cs3 (associative, phase of development), publication 3/3.

STOP PRESS: Recent excavations at Sagalassos have suggested that the wall is 6th c. in date. Publication of the evidence is in progress: P. Talloen pers. comm. 2021. My own 2023 fieldwork supports this new dating. However, for the moment I keep the chronology as above.

13ASI Hierapolis in Phrygia

Bibliography: Arthur P. (2006) *Byzantine and Turkish Hierapolis (Pamukkale)* (Istanbul 2006); de Bernardi Ferrero D. (1993) "Hierapolis", in *Arslantepe, Hierapolis, Iasos, Kyme: scavi archeologici italiani in Turchia*, ed. G. Pugliese Carratelli (Venice 1993) 105–187; de Bernardi Ferrero D. et al. (1987) *Hierapolis di Frigia, 1957–1987* (Milan 1987); Caggia M. P. (2008) "Agorà Nord – Stoà Sud", in *Hierapolis di Frigia II. Atlante di Hierapolis di Frigia*, edd. F. D'Andria, G. Scardozzi, and A. Spanò (Istanbul 2008) 87; Castrianni L., Ditaranto I., Di Giacomo G., Ditaranto I., and Scardozzi G. (2010) "La cinta muraria di Hierapolis di Frigia: il geodatabase dei materiali di reimpiego come strumento di ricerca e conoscenza del monumento e della città", *Archeologia e Calcolatori* 21 (2010) 93–126; D'Andria F. (2003) *Guida Archeologica. Hierapolis di Phryrgia (Pammukale)* (Istanbul 2003); D'Andria F. (2008) "Agorà Nord – Stoà Ouest", in *Hierapolis di Frigia II. Atlante di Hierapolis di Frigia*, edd. F. D'Andria, G. Scardozzi, and A. Spanò (Istanbul 2008) 86; D'Andria F. (2015) "Martyrion di San Filippo" and "Chiesa e Tomba di San Filippo", in *Nuovo Atlante di Hierapolis di Frigia. Cartografia archeologica della città e delle necropolis* (Hierapolis di Frigia 7),

ed. G. Scardozzi (Istanbul 2015); Guidoboni E. (1989) "Catalogo", in *Terremoti prima del Mille*, ed. E. Guidoboni (Bologna 1989) 574–739; Poblome J. (1999) *Sagalassos Red Slip Ware Typology and Chronology* (Studies in Eastern Mediterranean Archaeology 2) (Leuven 1999); Silvestrelli F. (2007) "Il Ninfeo dei Tritoni (Regio II): le fasi di età bizantina e postbizantina", in *Hierapolis di Frigia I: Le attività delle campagne di scavo e restauro*, edd. F. D'Andria and M. P. Caggia (Istanbul 2007) 333–58.

Of directly incorporated buildings, it is not clear if any joined the wall complete, but the above study records 'entire sections' of walls of pre-existing buildings on the north side, notably one of quadrangular shape, the stylobate of the S Stoa of the N Agora, and the back and side wall of the Nymphaeum of the Tritons (Castrianni *et al.* (2010) 103 with p. 102 fig. 4). Enough survives of the Nymphaeum of the Tritons for it to be considered as an incorporated building. The wall excludes a bath building, a theatre (though another is enclosed), the Roman agora, and the Martyrium of St. Philip (which was an extra-mural sanctuary).

Of *spolia*, the wall reuses material spoliated from the Roman Agora (also known as the North Agora), the Plateia, the Gymnasium, the Suburban (North) Theatre, and some funerary monuments, although the vast majority of the surrounding cemeteries were left intact (Castrianni *et al.* (2010) 116). It does not appear, from text or photos in article, like material is damaged, though there are mentions of fragments of a Doric frieze of the buildings around the Plateia. The above article doesn't provide much detail on condition or how blocks were built into the wall but on p. 101 fig. 3 a wall section of *spolia* has rusticated facings visible and redundant clamps but no inscribed or decorated surfaces visible, as far as I can see, which was also true of the North Gate when I visited it in 2010. However, the wall is considered by the surveyors to have been constructed in haste, diagnosed from the way it maximises the defensive capacity of the site, notably in its positioning of towers (p. 103). Of specific types of material, there are architectural elements (architraves, bases, capitals, columns, semi-columns, cornices, frontons of funerary monuments and seats, of which most are travertine (54%) and others are in white marble (42%) and reddish polychrome breccia (2%): pp. 115–16. Surprisingly, decorated architectural elements and marble and other precious materials are not used in wall sections close to the N and S gates, being otherwise used in both internal and external faces of the wall, being very frequent in the southern half of the East side and the South side, although the W half of the S side has been reconstructed by modern excavators without always taking account of the original position of the blocks: p. 116.

Of phasing and dating, the city wall is variously given as being later 4th to early 5th c., although the evidence for this is circumstantial, coming from destructions found in related areas. de Bernardi Ferrero (1993) 110, 157–58, notes that the Roman agora was heavily spoliated for the construction of the city wall which crosses this area, which he dates to the late 4th/early 5th c. The date given by de Bernardi Ferrero seems to be on account of the pottery workshop established in the adjacent spoliated Roman agora, which has been dated to the 5th–6th c., on the basis, probably, of the amphorae and open vases found there: de Bernardi Ferrero D. *et al.* (1987) 1, 34–37. The agora was destroyed in the second half of the 4th c. in an earthquake [no obvious candidates in Guidoboni (1989) 574–739]. It was then left outside the fortification that was built on the south side of the site: Caggia (2008) 87. The area of the agora became an industrial area, notably with kilns for producing tiles in its northern area, around the west stoa: D'Andria (2008) 86. There were also kilns for producing ceramics and rooms for different stages of ceramic production, in the northern area, around the east stoa: Caggia (2008) 87. Arthur (2006) 109–118, describes the development in a bit more detail, without further chronology, noting kilns built after the late 4th c. earthquake surviving to the 6th or even early 7th c., producing household ceramics, including mortars, basins, jugs, amphoras, and tiles (p. 109). There are large quantities of waste dumps around the former agora surface (p. 110). The recent survey on the fortification has claimed the earthquake that affected the agora area to be of the 3rd quarter of the 4th c., without substantiating this with evidence: Castrianni, Ditaranto, Di Giacomo, Ditaranto and Scardozzi (2010) 93–126. This same article gives a TAQ to the wall of the early 5th c., because of the way a road exiting from a gate in the wall seems to alter its direction to follow the route to the Martyrium of St. Philip of this date: p. 94. However, recent excavations have revealed another church, also at the top of this staircase, with a cult area incorporating the likely sarcophagus of St. Philip, which was venerated from at least the 4th c.: see D'Andria (2015) 135 and 136–37 for summaries of both, and bibliography. See also D'Andria (2003) 91–97 (not seen). I am left with little choice but to accept the dating range of all the articles suggested here, in the hope that in the near future the ceramic evidence behind the date will be published, as very likely the date depends upon this.

Support for a devastating earthquake of *ca.* 400 is also provided by deposits overlying the collapse of the Nymphaeum of Tritons (just south of the

Byzantine Gate) [not in Guidoboni *Catalogo*]. These post-earthquake deposits date to the 5th–6th c., as they contain the following ceramics: Red Slip pottery of the end of the 5th to 6th c. (p. 346 cat. 5–6 fig. 11, of form Attik 'Perge Late Roman A-B Ware' [not checked], Poblome Type 1B180 (Sagalassos Red Slip Ware) [part of phase SRSW 8 according to Poblome (1999) 306; SRSW phase 8 is 450/475–550/575]; a number of basins of a type produced in furnaces of the adjacent agora of 5th–6th c. date; fragments of an unguentarium given as attested from the 5th c. (with references to studies by Cottica), which peaks in the 6th–7th c. (p. 353 n. 26 fig. 14); a piece of African amphora given as datable to the 6th c. (p. 352 no. 22 fig. 14 Keay type 26 (*spatheion*)) [actually 387.5–700 Bon]: Silvestrelli (2007) 334–36. Although these deposits cannot directly date the earthquake they do not contain any sherds obviously confined to the 4th c., suggesting that the earthquake dating is correct. It remains a worry that fragments of broken blocks are not attested in the wall, if there really was such an earthquake, but this is a negative not a positive observation, and it may well be that the builders simply rejected such blocks or not much attention has been given to the condition of blocks by the recent surveyors, as seems to be the case in their article.

Dating summary: range 350–400, midpoint 375, class 0, publication 1/3. Poor.

13ASI Amorium (Lower City)

Bibliography: Belke K. and Restle M. (1984) *Tabula Imperii Byzantini IV, Galatien und Lykaonien* (Vienna 1984); Crow J. (2001) "Fortifications and urbanism in Late Antiquity: Thessaloniki and other eastern cities", in *Recent Research in Late-Antique Urbanism*, ed. L. Lavan (2001) 89–106; Harrison R. M. (1991) "Amorium excavations 1990: the third preliminary report", *AnatSt* 41 (1991) 215–29; Kuniholm P. I. (1995) "New tree-ring dates for Byzantine buildings", in *Twenty-First Annual Byzantine Studies Conference. Abstracts of Papers* (New York 1995) 35; Lightfoot C. (1998) "The survival of cities in Byzantine Anatolia: the case of Amorium", *Byzantion* 68 (1998) 56–71; Lightfoot C. and Ivison E. A. (2002) "Introduction," in *Amorium Reports 1. Finds: the Glass (1987–1997)* (BAR-IS 1020), ed. M. A. V. Gill (Oxford 2002); Lightfoot C. and Lightfoot M. (2007) *Amorium: A Byzantine City in Anatolia* (Istanbul 2007).

Discussion of site: Lightfoot and Lightfoot (2007) 104–117, and in several other syntheses, listed below.

Of incorporated buildings, it does not incorporate buildings in its length. It does not seem to exclude any major public buildings.

Of *spolia*, the wall does not include reused material, taking nothing from the city's cemeteries.

Of dating, it has been suggested as of the mid-5th to mid-6th c. based on its construction style [no specific dated parallels given] or from a large timber recovered from one the collapsed towers, which dendrochoronlogy shows was felled in 487 (Lightfoot and Lightfoot (2007) 107–108), or rather began growing in 362 and ended sometime after 487, being trimmed of its bark: Lightfoot (1998) 61. See the report of Kuniholm (1995) 35 (not seen). Finds from the tower were dated between the 5th and 7th c.: Harrison (1991) 220–22. This corresponds well with late literary evidence (George Kedrenos, *Georgios Cedrenus Compendium Historiarum*, ed. I. Bekker (Bonn 1838) 1.615) which claims that Zeno (474–491) 'built' the city (p. 46). More recently, it has been noticed that a Late Arab tradition also accredits Anastasius (491–518) with this act: Belke and Restle (1984) 123, and No. 9–11. Its design is discussed by Crow in relation to the walls of Thessalonica: Crow (2001) 99–100. But I will not use this argument here, as Thessalonica is not in the same region and the latter is not certain in its chronology, so dating by parallels is risky. On the excavation of the Triangular Tower, see now Lightfoot and Ivison (2002) 12–13 (not seen). Based on the other literature I have read, I suspect these finds have associative value relating to occupation. Here, I prefer the dendrodate of 487, although the timbers might have been used several years after, so I allow a 25 year period, which would put us in range for either Zeno or Anastasius.

Dating summary: range 487–512, midpoint 499.5, Cs10 (Scientific dating), Cs3 (Associative, finds), x (historical texts), publication 3/3.

13ASI Amorium (Upper City)

Bibliography: Ivision E. (2007) "Amorium in the Dark Ages (seventh to ninth centuries)", in *Post-Roman Towns, Trade and Settlement in Europe and Byzantium, vol. 2: Byzantium, Pliska and the Balkans*, ed. J. Henning (Berlin 2007) 25–60; Lightfoot C. (1998) "The survival of cities in Byzantine Anatolia: the case of Amorium", *Byzantion* 68 (1998) 56–71; Lightfoot C. S. and Ivison E. A. (2002) "Introduction", in *Amorium Reports 1. Finds: the Glass (1987–1997)* (BAR-IS 1070), edd. M. A. V. Gill with contributions by C. S. Lightfoot, E. A. Ivison, and M. T. Wypyski (Oxford 2002) 1–31; Lightfoot C. and Lightfoot M. (2007) *Amorium: A Byzantine City in Anatolia* (Istanbul 2007).

Discussion of site: This circuit is described by Lightfoot and Lightfoot (2007) 144–49 and also Lightfoot (1998) 56–71. More recent syntheses have also described the evidence, though without adding any new facts.

Of incorporated buildings, it does not directly incorporate buildings in its length. It excludes a church and a 'large building' in the lower town, but it seems to have

coexisted with the previous circuit which protected them.

Of *spolia*, there are Roman funerary stelae, seen in trenches L and ST, but also all around the edges of the mound where this wall once ran, of which only the foundations survive. No other details of condition or display setting of the *spolia* are known. Excavations in Trench L inside the acropolis revealed some structures associated with these *spolia* fortifications. A paved street has been assigned to the same period, alongside a pair of rooms either side of a passage leading to a courtyard. These structures made much use of *spolia* gravestones: Ivision (2007) 41.

Of phasing, the Upper City wall coexisted at some point with the Lower City circuit to which it is joined. However, it appears to be substantially later than the Lower City circuit, on account of its copious use of *spolia*: Lightfoot and Lightfoot (2007) 145.

Of dating, in terms of a TPQ, it is thought the walls might date from the use of the city as the headquarters of the *magister militum per Orientem* in the 640s, which is a rough but reasonable TPQ. However, 616 might be more reasonable as an outer TPQ, the date of decisive Persian invasions in Asia Minor: Lightfoot and Lightfoot (2007) 147–48. The destruction of the fortification was followed by a long period of desertion in which the tombstones from the wall were taken to use as building materials for houses in the immediate vicinity, suggesting a major loss of strategic control. This leads the excavators to consider that the wall shared in the major destruction of the town by the Arabs in AD 838, documented in literary sources, and visible in excavations of a tower in the Lower City circuit, where the latest coin of a group is of Theophilus (829/830) producing a contextual date of 25 years after the start date of the coin, so 829–54, supported by a radiocarbon date of *ca.* 800 from the ash in the upper layers of the collapse: Lightfoot and Lightfoot (2007) 110. For the evidence see: Lightfoot (1998) 62 and Lightfoot and Ivison (2002) 12–13 (not seen). This all supports a reasonable TAQ for the wall of the Upper City of 838. Furthermore, the stratigraphic level of the *spolia* fortification and the buildings in Trench L places these features well below the Middle Byzantine strata of the 10th and 11th c. that sealed its remains. Given this *terminus ante quem*: Lightfoot and Ivison (2002) 15–16 (not seen).

Dating summary: range 616–838, midpoint 727, Cs10 (scientific), Cs8 (Contextual coins), x (historical text).

13ASI Xanthos (repairs to outer rampart)

Bibliography: Cavalier L. (2005) *L'Architecture Romaine d'Asie Mineur: Les monuments de Xanthos et leur ornamentation* (Bordeaux 2005); des Courtils J., Cavalier L., and Lemaître S. (2015) "Le rempart de Xanthos: Recherches 1993–2010", in *Turm und Tor. Siedlungsstrukturen in Lykien und benachbarten Kulturlandschaften, Akten des Gedenkkolloquiums für Thomas Marksteiner in Wien, November 2012*, edd. B. Beck-Brandt, S. Ladstätter, and B. Yener-Marksteiner (Vienna 2015) 103–178.

Discussion of site: Entire sections of the outer wall were rebuilt (sections 1–4 and 21–33, whilst 5 and 20 were thickened), as described by des Courtils, Cavalier and Lemaître (2015) 130.

Of incorporated buildings, the wall followed an earlier route so does not directly incorporate any building except the previous city wall, as far as I am aware. The fortification does not seem to exclude any major public building.

Of *spolia*, the wall contained columns drums, entablature blocs, stelae and inscribed 'cippi': Courtils, Cavalier, and Lemaître (2015) 130. There were also Lycian blocks in section 1, Attic bases, and granite columns in section 2: p. 105. Section 5 has reused Roman blocks used as skin against the wall, though it is not clear if they are turned outwards (p. 106). Section 6 contains Lycian blocks (from funerary monuments) (p. 107). Section 10 contains 4 benches (p. 109). The E rampart contained two Lycian blocks from funerary monuments: (p. 110). Section 20 contained two bases or inscribed round altars (p. 114). Section 26–27 contained two Doric frieze blocks and an inscribed block. Section 28 contained trigliphs and an inscribed block (p. 117). Section 33 contained two inscribed blocks and an inscribed round altar (p. 118). There are also catalogue listings of the great quantity of Roman material found in the E rampart (p. 111) and W rampart (pp. 118–119), the former featuring grey granite or limestone columns, 2 types of Ionic frieze blocks, pedestals, benches, a voussoir, a cippus, and a circular altar, whilst the latter featured inscribed stelae (at least 15), marble and limestone columns, 2 Doric frieze blocks and 2 other types of frieze blocks, and many other architectural elements. The concentration of all the entablature blocks in section 24 and 32–33, whilst in 24 and 33 were blue-white marble columns and 2 distinct Corinthian capitals, not known elsewhere in Xanthos, all suggesting that *spolia* from demolished buildings was used here, likely demolished for the purpose.

The published thesis of Cavalier also informs us of the following errant blocks, definitely or likely reused within the fortification: Cavalier (2005). Of blocks deemed Hellenistic, there is an Ionic anthemion frieze (pp. 120–22). Of blocks deemed Roman, there is a limestone fluted column fragment (p. 132) in the N rampart, 50 granite columns or fragments in the E rampart (p. 133) and a blue marble column in the W rampart (p. 134), 2 composite capitals re-employed in the W rampart, 4 Ionic architraves in the N, E, and W ramparts (p. 145),

20 architraves of series 8 in the W rampart (p. 148), 2 architrave blocks of series 9 in the ?W rampart (p. 149), 2 architrave blocks of series 10 in the E rampart (p. 149), 2 architrave blocks of series 11 in the W rampart (p. 149), 2 blocs of architrave frieze of series 7 in the E rampart (p. 153), 25 Ionic frieze blocks in the W rampart (p. 514), 2 Doric frieze blocks in the W rampart (p. 516), 12 sima cornices of series 2, mostly in the 5 rampart section 24 (p. 162), and sima cornices without cyma of series 4 in the E rampart (p. 164).

Of condition, the reused blocks are in a good state. They are not generally broken, except in the NW section where some mouldings are cut off. The blocks are visible in the external and internal faces of the wall and in the interior. The decorations and inscribed faces of blocks are sometimes visible sometimes invisible without an obvious intention of decoration with the inscribed faces usually turned inside the wall: L. Cavalier pers. comm. 2022.

Of dating, the last surveyors of the fortification favour the last decades of the 3rd c. for the rebuilding [I take this as 270–300], based on unspecified inscriptions from the wall, the type of architectural blocks reused, and unspecified comparisons with other sites: des Courtils, Cavalier, and Lemaître (2015) 130. Of these, I take the inscriptions seriously as a dating indicator. P. Baker pers. comm 2022 tells me that few of these inscriptions are published, their date being of 2nd to 3rd c., being reused in all preserved sections of the wall. For example, there is TAM II, 1, 280 and 307, still in the north-west wall, that is dated to the first half of the 3rd c. If this is the latest dated inscription, the ensemble of inscribed texts would give us a contextual date of 200–250, of the full date range of the last inscription. As the reused material gives us a generic TPQ of after 250, I take the wall as dating from around this moment, rather than any later, until inscriptions from the wall that clearly date to the second half of the 4th c. are published. Given the dating of the 'Gothic' wall of Miletus, a dating in the third quarter of the 3rd c. is not impossible, rather than in the last quarter of the 3rd c.

Dating summary: *ca.* 250, class Cs 8x (contextual, other material), Cs4 (reused material, general presence), publication 2/3.

13ASI Xanthos (inner fortification enclosing Lycian Acropolis)

Bibliography: des Courtils J., Cavalier L. and Lemaître S. (2015) "Le rempart de Xanthos: Recherches 1993–2010", in *Turm und Tor. Siedlungsstrukturen in Lykien und benachbarten Kulturlandschaften, Akten des Gedenkkolloquiums für Thomas Marksteiner in Wien, November 2012*, edd. B. Beck-Brandt, S. Ladstätter and B. Yener-Marksteiner (Vienna 2015) 103–178; des Courtils J. and Laroche D. (1998) "Xanthos – Le Letoon. Rapport sur la campagne de 1997", *Anatolia Antiqua* 6 (1998) 457–77; des Courtils J. and Laroche D. *et al.* (1999) "Xanthos – Le Letoon. Rapport sur la campagne de 1998", *Anatolia Antiqua* 7 (1999) 367–99; des Courtils J. and Laroche D. *et al.* (2000) "Xanthos – Le Letoon. Rapport sur la campagne de 1999", *Anatolia Antiqua* 8 (2000) 399–83; Manière A.-M. (2002) "La maison de l'acropole lycienne à Xanthos", *Anatolia Antiqua* 10 (2002) 235–44; Manière A.-M. (2012) "Xanthos, Part 2. The West Area", in *Corpus of the Mosaics of Turkey* 1.2 (Istanbul 2012); Pellegrino E. (2002) "Le matériel céramique issu des fouilles menées en 1995 et 2000 sur l'acropole lycienne de Xanthos", *Anatolia Antiqua* 10 (2002) 245–60.

Discussion of site: The old *diateichisma* on the Lycian Acropolis is rebuilt with a wall using much *spolia* from the theatre, facing north into the interior of the city, with three pentagonal-shaped towers.

Of incorporated buildings, I can see only the fortification of the *diateichisma* and the theatre. It excludes most of the public buildings of the city, civic and ecclesiastical, including agorai, a civil basilica, churches, triumphal arch, colonnaded street, and theatre.

Of *spolia*, the *maenianum* of the theatre was demolished to provide building material, although the lower half of the theatre was apparently not touched. The reused material is visible in the external wall face, with theatre seats being visible and in good condition: L. Lavan site observation 2005.

Of dating, recent commentators have suggested this work dates to the 7th c. on account of its 'ship prow' pentagonal towers, comparable to the walls of Ankara. They also point to destructions to luxurious houses (on the Lycian acropolis) and to the cathedral in the 7th c. as evidence of urban change relating to this disjuncture: des Courtils, Cavalier and Lemaître (2015) 130–31. They cite a brief account of the end of the houses of the acropolis, without dating evidence, in Manière (2002) 235–44. I have not seen Manière (2012) which may contain more detail. However, the dating evidence of the destruction is given by Pellegrino (2002) 260 noting that in 2000 destruction level present in rooms 24E and 28E dated to the 6th to 7th c., on account of the presence of Cypriot Red Slip Ware (LRD to Anglo-Saxon readers) of Hayes 9b, which I take as being the ceramic with the latest start date in the assemblage. This ceramic type is given as 580–700 in *Atlante*, which I follow in Lavan *Public Space* vol. 2 51, and, if it is the find with the latest start date, it should give the destruction a contextual date of 580–605.

Overall, I am happy with this range in dating the fortification but would not put it later or consider that the destruction on the acropolis relates to anything more than a specific replanning. The wall does not seem to be part of a general ruin of the city, as it leaves a great part of the theatre still intact and functional, with no obvious sign of ruin in the spoliated blocks, which are well-constructed in the wall: L. Lavan site observation 2016. I think it could have coexisted with the theatre for some time in the 6th c., when pentagonal towers are attested in the Balkans. In doing so it would be similar to the nature of the late fortification of Ephesus, which I have re-dated to a similar time period. This was not an inner wall which drew widely on a field of ruins, as at Ankara, Amorium, or Aphrodisias, and seems to be more ordered in its use of *spolia* than the previous late 3rd c. fortification. Furthermore, whilst destruction evidence is known from the cathedral (not yet published), some other parts of the city centre do not show a single destructive event around this time, although the church of the agora was built and ruined in the late 6th to mid-7th c.: des Courtils and Laroche (1998) 463–68; des Courtils and Laroche et al. (1999) 372–76; des Courtils and Laroche et al. (2000) 344.

Dating summary: range 580–605, midpoint 592.5, class Cs 9 (contextual, ceramics), z (site development), publication 3/3.

13ASI Patara

Bibliography: Bruer G. and Kunze S. M. (2010) *Patara 1.1 – Der Stadtplan von Patara und Beobachtungen zu den Stadtmauern* (Istanbul 2010) 49–77; Crow J. G. (2017) "Fortifications", in *The Archaeology of Byzantine Anatolia: from the End of Late Antiquity until the Coming of the Turks*, ed. P. Niewöhner (New York 2017) 90–108; Helenkemper H. and Hild F. (2004) *Lykien und Pamphylien*, "Patara" *Tabula Imperii Byzantini 8: Lykien und Pamphylien* vol. 2 (Vienna 2004) 780–88; Işkan Işik H. (2010) "Patara 2009", *KST* 32.3 (2010) 1–21; Işkan Işik H. (2011) "Patara 2010 Yili Kazi ve Restorasyon Çalişmalari", *KST* 33.3 (2011) 15–39; Işik F. (1991) "Patara 1989", *KST* 12.2 (1991) 29–55; Işik F. (1993) "Patara 1993", *KST* 16 (1993) 253–281; Işik F. (1996) "Patara 1994", *KST* 17.2 (1996) 159–184; Işik F. (1997) "Patara 1995", *KST* 18.2 (1997) 191–218; Işik F. (1998) "Patara 1996", *KST* 19.2 (1998) 53–80; Işik F. (2000) *Patara: the History and Ruins of the Capital City of Lycian League* (Antalya 2000); Işik F. (2011) *Caput Gentis Lyciae. Patara – Capital of the Lycian League* (Antalya 2011); Işik F. (2011) *Caput Gentis Lyciae. Patara – Capital of the Lycian League* (Antalya 2011); Lepke A. (2015) "Neue agonistische Inschriften aus Patara", *ZPE* 194 (2015) 135–57; Michailidou M. (1991) "Rodos: Odós Panaitíou", *ArchDelt* 46 (1991) 498; Michailidou M. (2007) "City of Rhodes", in *Heaven and Earth. Countryside in Byzantine Greece*, edd. Drandaki, A. et al. (Athens 2007) 240–51; Onur F. (2016) "Patara Yol Anıtı / "*The Monument of Roads* at Patara", in *From Lukka to Lycia, The Land of Sarpedon and St. Nicholas* (Istanbul 2016); Peschlow U. (2017) "Patara", in *The Archaeology of Byzantine Anatolia: from the End of Late Antiquity until the Coming of the Turks*, ed. P. Niewöhner (New York 2017) 280–90; Ruggieri V. (2009) "Patara: due casi di architettura bizantina e la continuità urbana", *Orientalia Christiana* 75 (2009) 319–41

Discussion of site: This wall, which cut through the city centre, has been most recently described by Peschlow (2017) 285–86. Earlier syntheses add little more, with a recent contribution being Helenkemper and Hild (2004) 784–85. See also Bruer and Kunze (2010) 49–77; Işik (2011) 32–35, 62–65 (not seen).

Of incorporated buildings, the walls took in the bouleuterion (filling it in), a terrace wall, the Baths of Nero: Peschlow (2017) 285. It excluded several important public buildings from its circuit, such as a bath building, honorific arch, part of a colonnaded street, and a church, with a stadium and granaries being found on the other side of the harbour, apparently unprotected by a wall.

Of *spolia*, a list of material is provided by Bruer and Kunze (2010) 49–56, which includes stylobate blocks, columns, architrave blocks or friezes (p. 49), columns, architrave blocks, friezes or cornices, statue bases or pedestals of inscribed monuments, reliefs, altars (p. 58), and notably parts of grave monuments, with tropaia visibly reused in towers, with tower 2 reusing many elements from the Marcian monument, relief blocks, garland friezes and triglyph and metope blocks (p. 49). The walls specifically contained blocks of the Stadiasmus (or 'Road Guide Monument') and columns of a Roman stoa, invisible on the outside at the harbour: Peschlow (2017) 285. At the bouleuterion, inscriptions were reused upside down in a decorative effect: Peschlow (2017) 285. These included many agonistic statue bases for victors in sporting competitions, of which the latest was dated to 212–217: Lepke (2015) 135–57 esp. no. 6 (naming Caracalla and local personalities, with 13 inscriptions in total). For the Stadiasmus, see Onur (2016) 570–77. The *spolia* is found on the inside and outside face of the walls, as well as in the foundations, where granite columns are used (Bruer and Kunze (2010) 56–57), and weaponry reliefs are used decoratively in T2 (p. 49). The blocks look to have entered the whole wall from the images in Bruer and Kunze's report.

Of phasing, there has been debate about how the wall relates to the monuments of the city, especially one

church outside the walls, on which see below. See also Ruggieri (2009) 322–23 on arguments of this nature. However, I was struck on visiting the site in August 2005 to what extent the then newly excavated colonnaded city seemed to be unspoliated by the city wall, which crosses it via an earlier propylon incorporated into the fortification as a gate. To my eyes it seemed likely that the colonnaded street and fortification coexisted together in the same monumental landscape, so within the period of the intact monumental classical city.

Of dating, estimates have varied, as reviewed by Bruer and Kunze (2010) 74–75 (without reaching a definitive judgement). There appear to be two elements that can be used. The first is the similarity of masonry in a tower associated with the wall (and so contemporary or post-dating it) to an adjacent basilica church that has been dated to the first half of the 6th c. The church is reported as dating to the beginning of the 6th c., perhaps on the basis of a "capital of plaster" [mistranslation of pilaster capital?] made in the 6th c., in Işik (2000) 100–102 citing the following reports: Işik (1991) 37–38; Işik (1993) 257–58; Işik (1996) 170f.; Işik (1997) 200f., and especially Işik (1998) 65–69 with 77 fig. 15, reporting the work of E. Effenberger. The last report, which notes that the church has transepts, here suggests a date of the beginning of the 6th c. for the church, based on unspecified architectural ornament ("Bauplastik" – p. 65). See Bruer and Kunze (2010) 73f fig. 84 for the masonry shared with the tower (especially *spolia* from the tomb monument of Anassa). The second major dating element is the development of a cemetery outside of the walls NE of the bouleuterion which is likely to have developed after the wall was built [as this location was previously within the classical city]: Peschlow (2017) 285. The cemetery has produced ceramic and glass finds of 4th–5th c. date: Işkan Işik (2010) 12 and Işkan Işik (2011) 22–23. The cemetery finds suggest that the wall should have been in place no later than 25 years after the end of the 5th c., whereas the church suggests that the earliest date must be 500. Thus, although very crude, mixing different criteria, these two dating elements support a date range of 500–525, awaiting the publication of further evidence that will doubtless bring further precisions, on the specific finds and the architectural parallels being used. Comparisons with walls at Rhodes are persuasive (it has inner and outer walls with closely spaced rectangular towers like Patara) and Rhodes has produced coins of Constans II (641–688) and related ceramics from within the wall. However, under my dating system, I still privilege the stratigraphic evidence of sites related to the city wall above architectural parallels, so sticking with a date in the first quarter of the 6th c. For these arguments see Crow (2017) 96 citing Michailidou (2007) 245 fig. 212 (not seen) and Michailidou (1991) 498 (not seen). I thank J. Crow for these references.

Dating summary: range 500–525, midpoint 512.5, class Cs9 (contextual, ceramics), Cs8x (contextual, other objects), Cs1 (architectural style), publication 2/3.

13ASI Limyra

Bibliography: Borchhardt J. (2002) "Bericht der Grabungskampagne in Limyra 2001", *KST* 24.2 (2002) 303–314; Gassner V. (1997) *Das Südtor der Tetragonos-Agora. Keramik und Kleinfunde* (Forschungen in Ephesos 13.1.1) (Vienna 1997); Gerd R. *et al.* (2016) "The drowning of ancient Limyra (southwestern Turkey) by rising ground water during Late Antiquity to Byzantine times", *Austrian Journal of Earth Sciences* 109.2 (2016) 203–210; Marksteiner T. (2007) "Die spätantiken und byzantinischen Befestigungen von Limyra im Bereich des Ptolemaions," in *Studien in Lykien* (Ergänzungshefte zu den Jahresheften des ÖAI 8), ed. M. Seyer (Vienna 2007) 29–45; Marksteiner T. (2008) "Intraurbane Straßensysteme in Lykien", in *La rue dans l'Antiquité. Définition, aménagement, devenir. Actes du colloque de Poitiers (7–9 Septembre 2006)*, edd. P. Ballet, N. Dieudonné-Glad and C. Saliou (Rennes 2008) 223–30; Perlzweig J. (1961) *Lamps of the Roman Period*, Agora 7 (Princeton 1961); Piéri D. (2005) *Le commerce du vin à l'époque byzantine (V^e–VII^e siècles). Le témoignage des amphores en Gaule* (Bibliothèque archéologique et historique vol. 174) (Beiruit 2005); Pülz A. and Ruggendorfer P. (2004) "Kaiserzeitliche und frühbyzantinische Denkmäler in Limyra," *Mitteilungen zur Christlichen Archäologie* 10 (2004) 52–79; Marksteiner T., Lemaître S. and Yener-Marksteiner B. (2007) "Die Grabungen am Südtor von Limyra", *ÖJh* 76 (2007) 236–76; Robinson H.S. (1959) *The Athenian Agora V: Pottery of the Roman Period* (Princeton 1959).

Discussion of site: This circuit is divided into two enclosed areas, likely the consequence of a change in the water table: Gerd *et al.* (2016) 203–210. So far, work has mainly concentrated on the western of the two fortifications. There are two phases, only one of which can be dated to Late Antiquity.

Of buildings incorporated by the wall, there is the Ptolemaion in the West City, a massive honorific monument to Ptolemy II Philadelphos, and the baths in the East City. A number of public buildings are excluded by the walls, such as the theatre, a heroon, and a colonnaded street.

Of *spolia* used in the walls, Marksteiner (2007) 41 mentions altars and bases and Early Imperial architectural decoration in the first phase. He mentions elsewhere within the masonry of the first phase of the wall a reused

soffit (p. 35) and *spolia* without further precision (p. 38). I saw in the western walls in 2005 a lot of reused material in the wall faces, especially the external faces, but little of it was obvious architectural *spolia*, with the exception of three column drums (one Doric) in a gate blocking by the Ptolemaion and what looked like a statue base in the wall external facing by the Ptolemaion [so likely relating to phase 2]. I also saw a (fluted ?) column drum in the wall rear facing in the stretch of wall running south from this point: L. Lavan site observation 2005. This looks like very generic architectural reuse, selected carefully, with no obvious use of funerary monuments. It seems likely to relate to the second phase of the fortifications. Reused material is visible on both inside and outside faces of phase 1 walls by the Ptolemaion: see p. 34, figs. 5–6. I did not see any inscribed faces or decorated faces visible in the external face of the wall, beyond what is mentioned above.

Of phasing, Marksteiner detects two phases both of building in reused materials, though the latter is less careful and was built when the Ptolemaion was ruined, using its material, whilst in the first phase the building seems to have been intact and likely used as a tower: Marksteiner (2007).

Of dating, we have a number of indicators, for the first phase of the western fortification, especially described by Borchhardt (2002) 305–307. At the gate north of the Ptolemaion, in the foundation level for two street surfaces, the upper of which laps over the threshold, were recovered unspecified finds of the 4th to 5th c., whereas the street levels above contained ceramics from the 6th to 7th c. (p. 307). Furthermore, the construction of a church just south of the Ptolemaion is given as dating to the 6th c. based on architectural fragments such as liturgical furnishing, given as securely dated although no parallels are provided (p. 306). Marksteiner (2007) 43 dates the church to the first half of the 6th c., citing Pülz and Ruggendorfer (2004) 75, noting this dating depends particularly on the altar rails and the ambo, providing general references to works on churches in the region, but not specific dated parallels which might have been primary exemplars. The subsequent road paving laid in the area enclosed by the eastern fortification is 6th c., based on ceramics: Marksteiner (2008) 223–30.

However, more accurate dating is now available from Sondage 3b in the West City which found ceramics in the backfill of the foundation cut for the first phase of the late city wall, extending until the late 5th c. [actually to the early 6th c.]: Marksteiner (2007) 43. This evidence is described in detail, with a full ceramic report in Marksteiner, Lemaître and Yener-Marksteiner (2007) 236–76. The latest ceramics are as follows. Of fine ware (p. 206), the examples with the latest start dates are Cypriot Red Slip Ware (LRD) of Hayes form 2 [400–550 in LRP] imitating ARS Hayes form 83 [given as of the end of the 5th c., but 440–460 in Bon] and form 11 [given as a precious variant of a form dated from the second half of the 6th or beginning of the 7th c., form 11, being 550–650+ in LRP]. The latter was considered an intrusion from layers above. A bowl of light coloured fine fabric, of a simple form but close to bowls of similar form found in contexts of the end of the 5th c. or beginning of the 6th c. at Athens (Robinson (1959) 172ff and Gassner (1997) 208 pl. 67, 855 (not seen). Of lamps, there was a lamp similar in its oval form and triangular beak, to Attic and Asia Minor lamps of the 5th to 6th c. (p. 208) referring to Perlzweig (1961) 153 pl. 31, nos. 1817, nos. 1818 [but these are given by Perlzweig as first half of 3rd c. and first half of 4th c. respectively]. Of amphorae, there is a variant of amphora LRA1 B1 dated by Pieri to the beginning of the 6th c. (Piéri (2005) 221 (not seen). This is the latest dated ceramic from the backfill.

The building of the wall of phase 2 is given a TPQ of the 7th c. by coins and ceramic material coming from layers before the reordering of the site. Its levelling layer contains Early Medieval as well as late antique ceramics, studied by Joanita Vroom, that are not published yet: Marksteiner (2007) 44.

Overall, the ceramics from the backfill of the foundation trench in Sondage 3b give the best dating evidence for the phase 1 of the late wall. They give a contextual date of 500–525, being the 25 year period after the latest start date of ceramics in the fill. Not enough material is published yet to properly date the second phase.

Dating summary (late wall phase 1): range 500–525, midpoint 512.5, Cs9 (contextual, ceramics), Cs1 (architectural style) publication 2/3.

<u>13ASI Side (Inner Wall)</u>

Bibliography: Foss C. (1977) "Attius Philippus and the walls of Side", *ZPE* 26 (1977) 172–80; Foss C. (1996) "The cities of Pamphylia in the Byzantine age", in *Cities, Fortresses and Villages of Byzantine Asia Minor* (Collected Studies Series 538) (Aldershot 1996) 1–62; Gliwitzky C. (2005) "Die Kirche im sog. Bischofspalast zu Side", *IstMitt* 55 (2005) 337–409; Hellenkemper H. and Hild F. (2004) "Side" *Tabula Imperii Byzantini 8: Lykien und Pamphylien* vol. 2 (Vienna 2004); Lohner-Urban U. (2015) "Das Osttor von Side – Eine Sackgasse in der Spätantike", *Forum Archaeologiae* 77/12 (2015); Nollé J. (2001) *Side in Altertum: Geschichte und Zeugnisse* 2 (IK 44) (Bonn 2001); Peschlow U. (2010) "Mauerbau in krisenloser Zeit? Zu spätantiken Stadtbefestigungen im südlichen Kleinasien: der Fall Side", in *Krise und Kult. Vorderer Orient und*

Nordafrika von Aurelian bis Justinian (Millennium Studies 28), edd. D. Kreikenbom, K.-U. Mahler, P. Schollmeyer and T. M. Weber (Berlin 2010) 61–108; Piesker K. (2017a) "Side", in *The Archaeology of Byzantine Anatolia: From the End of Late Antiquity until the Coming of the Turks*, ed. P. Niewöhner (New York 2017a) 294–301; Piesker K. (2017b) "Stadtbauforschung an der sogenannten Attius Philippus-Mauer in Side (Pamphylien)", *Bericht über die 49. Tagung für Ausgrabungswissenschaft und Bauforschung: vom 4. bis 8. Mai 2016 in Innsbruck* (Dresden 2017b) 156–63.

Discussion of site: The wall is described by Piesker (2017a) 294–301 and Piesker (2017b) 156–63 (not seen). See also Peschlow (2010) 61–108. This work supersedes the detailed study of Hellenkemper and Hild (2004) 386–89 and Foss (1996) 43–44.

Of incorporated buildings, the wall took in cisterns, a monumental arch to use as a gate and the back wall of the theatre stage building, without damage to it or the adjacent agorai just outside the wall, which still retained its columns: L. Lavan site observation 1997, also noted by Peschlow (2010) 75, resuming 66–72, who sees other late antique monumental developments such as the re-erection of a nymphaeum were connected to the building of the wall. Another agora/Caesareum, honorific column, 4 nymphaea, two colonnaded streets, and an episcopal complex/large church were excluded by the walls. Cemetery monuments around the city also continued into existence.

Of *spolia*, the wall is built of ashlar blocks with perhaps some use of *spolia* decoratively, such as a row of marble columns/column sections laid flat, visible in the external wall face. These blocks do not seem to have been damaged before they entered the wall, though otherwise decorated blocks do not seem to have been made visible: L. Lavan site observation 1997. It is not known where these blocks come from.

Of phasing and dating, current survey work has identified three phases south of the theatre, the first for a Roman terrace wall pre-dating the theatre, the second the main late wall, and the third a topping of small *spolia* and tiles. The current surveyor suggests a construction of the walls after the 5th c. and perhaps during the period of invasions, in the 7th c., though the evidence on which this is based is not yet published: Piesker (2017a) and (2017b) (not seen). The dating of the wall has long been associated with an inscription relating to Attius Philippus a *comes primi ordinis* (an order set up by Constantine *ca*. 330, popular in the mid-4th c.). This was found in one of the towers but is considered by Foss as not mentioning a wall and being likely *spolia* as it is odd as the only building inscription from the wall in the position it was found in: Foss (1977) 177–78 with now Nollé (2001) no. 167. However, Hild and Hellenkemper (2004) 388 with notes still seek to use the inscription, as they regard it as very visible from the main entrance route.

Hild and Hellenkemper date the fortification to the mid-4th to 6th c. based on the good architectural survival of buildings outside the wall (pp. 388–98). This fact has raised concerns from other scholars: Gliwitzky (2005) 376–78. Furthermore, the discovery of late modifications to the older outer circuit wall, including a private occupation (but not destruction) of the East Gate dated by ceramics of the first half of the 6th c. [wares not specified], suggests the outer wall was still architecturally intact: Lohner-Urban (2015). N.B. I do not think that the weaponry friezes found on the East Gate of the previous outer fortification are necessarily a late antique embellishment: see Lavan *Public Space* vol. 2 501. Thus, the dating of the wall is currently uncertain.

Overall, if the inscription of Attius Philippus is accepted as non-*spolia*, *in situ*, then it dates the wall to the mid-4th c. However, if it is considered *spolia*, then the wall could well be later. As the current survey prefers a date using the inscription, we must wait further details before reaching a judgement. Nonetheless, the spatial connection of the wall to late antique building work, which seems to be built at the same time, and which the wall does not spoliate, strongly suggests a date of before the decisive Persian invasion of Asia Minor of 616, after which time secular civil building work is not known. It is surely further excavation which will provide a more precise range for the fortification, by relating the stratigraphy of the surrounding buildings to the wall. I will treat the inscription as providing a TPQ, even if we expect further publication on the site to produce a later start date.

Dating summary: range 350–616, midpoint 483, class Cs 7 (TPQ inscription), z (regional development), publication 1/3, Pending.

14PON Ankara (Lower City)

Bibliography: Akalın M. and Akalın A. (2008) "2007 Yılı Roma Hamamı Kutsal Yol Kazı ve Restorasyon Çalışmaları", *Müze Çalışmaları ve Kurtarma Kazıları Sempozyumu* 17 (2008) 131–50; Akok M. (1955) "Ankara Şehri İçinde Rastlanan İlkçağ Yerleşmesinden Bazı İzler ve Üç Araştırma Yeri", *Belleten* 19/75 (1955) 310–29; Bosch E. (1967) *Quellen zur Geschichte der Stadt Ankara im Altertum* (Ankara 1967); de Jerphanion G. (1928) *Mélanges d'archéologie anatolienne* (Mélanges de l'Université Saint-Joseph, Beyrouth, XIII) (Beirut 1928) 144–221; Görkay K. (2006) "Ancyra's unknown stadium", *IstMitt* 56 (2006) 247–71; Kadıoğlu M., Görkay K. and Mitchell S.

(2011) *Roman Ancyra* (Istanbul 2011); Peschlow U. (2015) *Ankara. Die bauarchäologischen Hinterlassenschaften aus römischer und byzantinischer Zeit* (Vienna 2015); Serin U. (2011) "Late antique and Byzantine Ankara: topography and architecture", in *Marmoribus Vestita. Miscellanea in onore di Federico Guidobaldi*, edd. O. Brandt and P. Pergola (Vatican 2011) 1257–80.

Discussion of site: The best studies of this wall, replacing earlier discussion are now Peschlow (2015) 105–15 figs. 187–97, and Kadıoğlu, Görkay and Mitchell (2011) 205–216, which assembles a lot of evidence including photos and verbatim translations of excavation reports that are difficult to access, and some notes of an unpublished excavation. The walls have only been revealed in a few places, though a coherent circuit of the lower city is emerging.

Of incorporated buildings, we hear of none. I have not been able to establish if the wall excluded a major public building.

Of *spolia*, we hear especially of andesite seats probably from a stadium: Akalın and Akalın (2008) 139f. fig. 9. 14 (mentioning sondages and andesite blocks) and Görkay (2006) 247, 248 n. 2. Their overall distribution of stadium seats in the wall is well-documented in Kadıoğlu, Görkay and Mitchell (2011) 209–217. There were also some decorated architectural blocks, although this seems to come from a section which has not been confidently ascribed to the same phase: Akok (1955) 316–17. In 1998 excavations, SW of the Roman Baths, revealed a section of wall that contained hard limestone blocks that (for a reason not explained) are believed to have come from an odeon or bouleuterion: Kadıoğlu, Görkay and Mitchell (2011) 216.

Of phasing, the wall is generally characterised by the use of reused material in facing with a mortared rubble core, being 2.8 m to 3.7 m thick: Kadıoğlu, Görkay and Mitchell (2011) 211–16. However, in one section around the Temple of Augustus the different system is used with irregular rubble below, *spolia* above, and brick levelling courses at intervals, whilst the wall is some 5 m thick: Serin (2011) 1275–78.

Of dating, the finding of stadium seats reused in the city wall as well as in the foundation of the portico around the palaestra has led to the works being associated with a lost inscription that records work done on both by a local benefactor, both on the city wall, against barbarians, and the gymnasium: Bosch (1967) 351 no. 289. This inscription is not dated but likely dates after the collapse of eastern security under Severus Alexander, beginning with the Persian invasion of AD 231. The generic use of reused material suggests a date of after 250, which I take as my TPQ. Another two inscriptions that mention the wall and governors associated with its building are p. 355 nos. 292–93, where one of the governors is a *clarissimus*. For a TAQ one could opt for 271, as do Kadıoğlu, Görkay and Mitchell (2011) 216, as this marks the invasion of Zenobia, which was the last 'barbarian' attack of the 3rd c., the city being brought back under Roman control in 272 by Aurelian: Zos. 50.1–2. Based on the inscription, when combined with the joint spread of *spolia* between the wall and gymnasium, this is a reasonable inference. However, it is just possible that the wall might have been related to the revolt of Tribigild in 399 in the interior of Asia Minor. Therefore, a weaker TAQ is the absence of a cross at the start of the inscription that might place it before AD 410 (see Lavan *Public Space* vol. 2 5 for dating of crosses). The wall was dismantled to use for a subsequent smaller fortress enceinte, which is dated to the 9th c. by inscriptions, meaning that it probably stood until the Arab sack of AD 838. The walls had previously been considered by de Jerphanion (1928) 144–221 and now Peschlow (2017) (page numbers missed). The fortress is dated by inscriptions to the reign of Michael III (842–867), with one specifically of AD 859, with earlier dating hypotheses now discarded: Peschlow (2017) 359.

Dating summary: range 250–410, midpoint 355, class Cs4 (reused material, general presence), Cs6 (inscription not *in situ*). Cs5 (catch-all masonry theory, use of specific spoils), publication 3/3.

15ORI Apamea

Bibliography: Balty J. Ch. (1988) "Apamea in Syria in the second and third centuries A.D.", *JRS* 78 (1988) 91–104; Balty J. C. and Van Rengen W. (1993) *Apamée de Syrie: quartiers d'hiver de la IIe légion parthique. Monuments funéraires de la nécropole militaire* (Brussels 1993).

Discussion of site: Balty and Van Rengen (1993) note the reuse of funerary stelae in a 3rd c. tower of the city wall. This tower is tower 15, on the eastern side, and is built on the site of a destroyed Hellenistic tower on this fortification circuit of the Hellenistic period.

Of incorporated buildings, there are none. This is just a tower in an earlier wall.

Of *spolia*, the tower is made of reused material, including many cippi and stelae, funerary altars (with holes at the top to allow libations), alongside column drums, column bases, and entablature elements of quadrangular and circular funerary monuments: pp. 9–10. No sarcophagi are recorded. There seems no reason to doubt the belief that the reused material here employed came from the adjacent cemetery (p. 9).

Of condition, there is no systematic description of the tower and its *spolia* but it seems that the inscriptions (130 in total p. 10) are partly known from the collapse of

the structure (p. 9) and a photo on p. 9 fig. 1 shows reused blocks used in the external wall face but not apparently turned towards decorated sides. Another photo shows in more detail that there are some moulded blocks turned outwards but no decoration nor inscriptions, in making up an ashlar block of well-sorted pieces: Balty (1988) 91–104, pl. 13.

Of dating, as far as I can see, the last inscription from the wall [and be advised that Balty includes some unspoliated monuments from the adjacent cemetery] seems to be a funerary stele for Felsonius Verus (p. 43 pl. 18) which is dated from the epithet *Gordiana* of the II legion's title in the years 242–44. This serves as a TPQ for the wall, and in the presence of so many inscriptions, it can also serve as the basis of a contextual epigraphic date, suggesting that the wall was constructed in the 25 year period after the start date of the last find: i.e. 242–267. However, there are 8 further stelae of soldiers of two cavalry regiments (pp. 46–53) which Balty (p. 14) informs us in three cases (not those shown in the collection, perhaps from elsewhere in the cemetery) can be shown to date to 252. This means that we are looking at a contextual epigraphic date of 252–77 for the construction of the towers. There is a risk that this reflects the dedications of the cemetery or the activity of the military units more than the construction of the wall, but in the absence of other evidence it must stand as a credible dating basis for the wall, particularly given the very large number of inscriptions recovered.

Dating summary: range 252–277, midpoint 264.5, class Cs 8x (contextual, other material), publication 3/3.

15 ORI Palmyra

Bibliography: As'ad K. and Yon J.-B., with Fournet T. (2001) *Inscriptions de Palmyre. Promenades épigraphiques dans la ville de Palmyre* (Guides archéologiques de l'IFAPO 3) (Beirut 2001); Juchniewicz K. (2013) "Late Roman fortifications in Palmyra", *Studia Palmyreńskie* 12 (2013) 193–202; Juchniewicz K., As'ad K. and al Hariri K. (2010) "The defense wall in Palmyra after recent Syrian excavations", *Studia Palmyreńskie* 9 (2010) 55–73; Michalowski K. (1962) *Palmyre II fouilles polonaises 1960 = Palmyra wykopaliska polskie 1960* (Warsaw 1962); Yon J.-B. (2012) *Palmyre* (Bibliothèque archéologique et historique 195) (Beirut 2012).

Of incorporated buildings, the wall includes tower tombs as towers, sometimes without modification to their function as tombs, and a potential *castellum aquae*: p. 56, 56–58. The city wall excluded a part of the earlier city and its public buildings, such as the Sanctuary of Arsu, as visible from site plans.

Of *spolia*, reused material is reported but I have not been able to identify it yet: Michalowski (1962) 52.

Of dating, it has been suggested to date to the Aurelianic period (272–275 in Palmyra). The wall likely dates after Aurelian's sack of the city in 272, as it involves such a radical replanning/exclusion of many areas of the city active until then. A TAQ of 303 may be derived from the fact that its secondary U-shaped towers share masonry types with the principia that bears the inscription of Diocletian's governor of 293–303 (see below): Juchniewicz (2013) 193–202. Earlier, scholars had favoured Diocletian for the wall: Juchniewicz, As'ad and al Hariri (2010) 55. But these structural details have led Juchniewicz to assume that the wall's primary phase is Aurelianic and the towers along with extant principia are perhaps Diocletianic. For the inscription see As'ad, Yon and Fournet (2001) 83 no. 26 = Yon (2012) (2012) 121, with PLRE 1.432 Sossianvs Hierocles 4.

Dating summary (cross-hall): range 272–303, midpoint 287.5, class Cs7 (TPQ coin), x (historical text), Cs6 (TAQ inscription *in situ*), Cs5 (catch-all masonry, general *spolia* use), Cs3 (associative, phase of development), publication 3/3.

Spolia in Late Antique City Walls
Catalogue 2: The West

Douglas Underwood and Luke Lavan

Part 1: Britain, Gaul and Spain

Douglas Underwood

A number of regional date ranges and TAQs are used in this section of the catalogue. They either describe the upper limit of known civic building work (Britain) or patterns of dated fortification as currently known, by archaeology or epigraphy (the latter in the case of Africa). This set of dates is drawn from the walls in this study (i.e. those with *spolia*, specifically funerary *spolia*). It should not necessarily be extended to other walls.

Africa	(for reconquest fortifications) 534–555
Britain	Before 400
Gaul	Before 425
Italy	3 waves ending by 310; 450; 565
Spain	Mostly before 350; one outlier: 486

Some ambiguity is present in our description of *spolia* in Gallic walls. The late riverside wall at Toulouse only contained *spolia* in the foundations, and at Dax, the *spolia* is not visible (only in the interior of the wall). At Poitiers and Angouleme, *spolia* seems to be restricted to the foundations. But at most other sites, there is *spolia* in wall foundations and also in their lowest courses. However, it is not always clear if this indicates visibility. It is possible that it relates to a construction technique whereby larger blocks provided stability at the base of a heavy construction. We might have excluded walls without visible *spolia* from this study of the late antique *spolia* habit, as these form a practice seen earlier, and there are perhaps other walls not detected by us which have significant *spolia* in foundations. However, as both the walls of Angouleme and Poitiers are dated by other means to after the mid-3rd c., and include funerary *spolia*, they are worth considering here.

Dating Classifications

Sub-Period Terminology

Time	Range	mid-point
Early/Beg.	0–12.5	6.25
First quarter	0–25	12.5
Second quarter	25–50	37.5
Third Quarter	50–75	62.5
Final quarter	75–100	87.5
Late/End	87.5–100	93.75
Earlier	0–50	25
Later	50–100	75

Dating Reliability

Cs10	Scientific (Radiocarbon, Archaeomagnetism, Thermoluminesence etc)
Cs9	Contextual, ceramics
Cs8	Contextual, coins
Cs8x	Contextual, other objects
Cs7	TPQ from ceramics/coins/inscription
Cs6	TAQ/Absolute from inscription *in situ* or almost *in situ*. For epigrams of statue bases, a text is *in situ* without wider context.
Cs5	Catch-all masonry theory, e.g. mortar, use of specific spolia, lack of respect for aesthetics of design (giving date after 250)
Cs4	Re-used material, general presence (giving date after 250)
Cs3	Associative (finds, inscriptions, phase of development)
Cs2	Catch-all other (e.g. earthquake, water). I accept earthquakes only with clear seismic damage or counter-measures.
Cs1	Architectural and artistic style, relying on well-dated parallels.
0	No evidence cited
x	Historical text/inscription not *in situ* (i.e. archaeological context not known at all)/depiction like Madaba map
z	Background patterns, of regional development or site development.

Publication Quality Score

0	No basis
1	Phases described
2	Dating basis alluded to: e.g. "5th c. pottery"
3	Dating basis described: e.g. ceramics/coins/scientific date/inscription.

01BRI Chester:

Bibliography: Wright R. P. and Richmond I. A. (1955) *Catalogue of the Roman Inscribed and Sculptured Stones in the Grosvenor Museum, Chester* (Chester 1955);

Blagg T. F. C. (1983) "The reuse of monumental masonry in late Roman defensive walls", in *Roman Urban Defences in the West* (CBA Report 51), edd. J. Maloney and B. Hobley (London 1983) 131.

Discussion of site: This is a large-scale repair of a single phase.

Of incorporated buildings, there are none reported.

Of *spolia*, over 100 funerary reliefs found. In fact, only a few small pieces pulled from the walls were not funerary.

Of preservation or visibility, Wright and Richmond (1955) note throughout that the reused blocks were placed on the inside of the walls, in its lower courses (pp. 6–7), with a facing of non-reused stones that is visible in plate 1, the frontispiece.

Of dating, the latest datable *spolia* element is an inscription from 213–22, but heavily weathered, suggesting that some time had passed between its first use and reuse. This gives us a contextual date of 213–38, given that this is not visible reuse in the wall facing, as we see after the mid-3rd c., after which time the practice becomes common. A regional TAQ for the end of investment in civic building works is *ca.* 400 in Britain.

Dating summary: range 213–238, midpoint 225.5, class Cs8x (contextual, other), Cs4 (reused material, general presence), z (regional development), publication 3/3. Generic late antique date.

01BRI London (Late Phase 1 and 2: Riverside Wall)

Bibliography: Blagg T. F. C. (1980) "The sculptured stones", in *The Roman Riverside Wall and Monumental Arch in London. Excavations at Baynards Castle, Upper Thames Street, London, 1974–76* (London and Middlesex Archaeological Society, Special Paper 3), edd. C. Hill, M. Millet and T. F. C. Blagg (London 1980) 124–193; Hassall M. W. C. (1980) "The inscribed altars", in *The Roman Riverside Wall and Monumental Arch in London. Excavations at Baynards Castle, Upper Thames Street, London, 1974–76* (London and Middlesex Archaeological Society, Special Paper 3), edd. C. Hill, M. Millet and T. F. C. Blagg (London 1980) 195–97; Morgan R. A. (1980) "The Carbon 14 and Dendrochronology", in *The Roman Riverside Wall and Monumental Arch in London. Excavations at Baynards Castle, Upper Thames Street, London, 1974–76* (London and Middlesex Archaeological Society, Special Paper 3), edd. C. Hill, M. Millet and T. F. C. Blagg (London 1980) 88–95; Sheldon H. and Tyers I. (1983) "Recent dendrochronological work in Southwark and its implications", *London Archaeologist* 4.13 (1983) 355–61; Parnell G. (1985) "The Roman and medieval defences and the later development of the inmost ward, Tower of London: excavations 1955–77", *Transactions of the London and Middlesex Archaeological Society* 36 (1985) 1–79; Barker S., Coombe P. and Perna S. (2018) "Re-use of Roman stone in London city walls", in *Roman Ornamental Stones in North-West Europe* (Etudes et Documents Archeologie 38), edd. C. Coquelet, G. Creemers, R. Dressen and E. Goemaere (Namur 2018) 327–42; Barker S., Coombe P. and Hayward K. (2021) "Londinium's landward wall: material acquisition, supply and construction", *Britannia* 52 (2021) 1–50.

Discussion of site: The wall is complex in its phasing, with at least two main phases and possibly some further later works. The riverside wall contained a considerably quantity of reused stone, unlike the landward wall. It was built around a concrete and rubble core, with ragstone facing and brick courses. It has been divided into an eastern wall that was set on foundations of timber piles beneath a chalk raft, over gravels, and a western wall built on ragstone dumped into clay. I am grateful to Simon Barker for help with this section.

Of incorporated buildings, there are none.

Of *spolia,* 52 sculpted blocks were found in the collapsed sections of the riverside wall, primarily from the monumental arch and the screen of the gods and goddesses, along with a few altars, and several blocks with an unclear, but probably funerary purpose. There would have been many more stones employed in the riverside wall overall that have not survived, presumably more funerary material would have been reused. None of the stones were from the sections of the wall with timber-piled foundations (Areas I and VI, per *The Roman Riverside Wall and Monumental Arch in London*). They were found in the western sections Areas II, V and VIII.

Of preservation or visibility, *spolia* was found in the rear (inside) face of the wall, mostly *ca.* 5 m up, but with some in the foundations (Area VIII). It is not impossible that reused stones were used in the outer (riverside) face of the wall, but little of this has survived. The use of these stones in foundations has parallels; their use in the other two sections, being used at an offset of the wall in a contiguous line, is less common and its purpose is not fully clear (perhaps structural? A parapet walk at this height seems unlikely). Nevertheless, appears that the reused nature of the blocks would not have been clear. In the foundation sections, there was no visibility.

Phasing and Dating Evidence: There appear to be two or more phases of construction of the Riverside wall (which is later than the landward wall built around 190), with slightly dates and dating evidence.

One portion of the Riverside wall (although originally thought to be 4th c.) has been dated to 255–275 – this range accounting for the lack of bark in the

timbers – based on dendrochronology (Sheldon and Tyers (1983) 358–60). The piles holding up the wall at the New Fresh Wharf waterfront site were matched with timber from the Baynard Castle piles, which were then matched with German and Ulster dendro-chronologies to provide a TPQ of 255 when the final ring of growth occurred on the Baynard Castle timbers. As noted, these piles had no bark, but some sapwood, so have been given a 20 year range by Sheldon and Tyers, which should give us a range of 255–275, with 275 being the TAQ for the placing of the piles in the ground. These piles were also subjected to C14 dating, which returned a date of AD 330–350 (Morgan (1980) 93), but the dendrodate is of higher degree of reliability.

The western portion of the Riverside wall (that with the *spolia*, so the only bit to concern us here) is later. There is an altar found within this section that offers a *terminus post quem* of the 3rd c., more specifically (but slightly more conjecturally) either AD 251–253 or 253–259, based on the inscription noting a governor Marcus Martiannus Pulcher and the mention of two emperors (Hassall (1980) 195–198). Barker *et al.* (2018) 332) have suggested a date of 350–375, based on how long the stones would have been in use before being recycled, making them therefore contemporary to the construction of the eastern-side 4th c. towers (see below, late phase 3). However, in the absence of later dated epigraphy, this argument must be regarded as speculative.

Overall, for the phase 2 of the wall, without the towers, the dendrodates provide the most convincing chronology of 255–75 as the date of construction. Of the phase 3 of the wall, it seems reasonable to take the radio carbon date as providing a range of 251 from the altar but otherwise a regional TAQ of 400 for investment in public building in Britain.

Dating summary (late phase 1, no *spolia*): range 255–275, midpoint 265, class Cs1 (Scientific), publication 3/3.

Dating summary (late phase 2): range 251–400, midpoint 325.5, class Cs1 (Scientific), z (regional development), publication 3/3.

01BRI London (Late Phase 3: Landward Walls, Towers)

Bibliography: Collingwood R. G. (1936) "Roman Britain in 1935: I. Sites explored: II. Inscriptions", *JRS* 26.2 (1936) 236–67; Maloney J. (1979a) "Excavations at Dukes Place: the Roman defences", *London Archaeologist*, 3/11 (1979) 292–97; Maloney J. (1979b) "Recent Work on London's Defences", in *Roman Urban Defences in the West* (CBA Report 51), edd. J. Maloney and B. Hobley (London 1979) 96–117.

Discussion of site: Towers were added secondarily to the landward walls, for which see the bibliography above.

Of *spolia*: most of the reused stone was recorded used in foundations. Lack of survival of remains above foundation level means it is now impossible to be sure about how blocks may have been used higher up or if recycled object were visibly displayed the facing of the bastions. The objects reused in the bastion foundations are generally large blocks that must have been deliberately selected to provide a substantial footing. This is clearly shown in the 1935 excavation of bastion 2 at Trinity Place. This excavation recovered inscribed blocks of the tomb monument of Julius Classicianus from the bastion (RIB 12, blocks), built into the foundation course, whilst funerary inscription RIB 29 came from the Castle Street bastion, and an unknown inscription came from the Camomile Street bastion RIB 31. For the Trinity Place Excavation, see Collingwood (1936) 254, 264–65 with pl. 29.

Of preservation or visibility: the above plate shows the Classicianus tomb block with its inscribed side facing outwards but in the foundation course, in a broken condition.

Phasing and dating: the addition of towers to the wall is confirmed by contextual dating at Duke's Place in 1971, where the V-shaped ditch of the landward wall was backfilled during the construction of tower 6; fill material there contained 1st and 2nd c. AD pottery, a barbarous radiate coin of the late 3rd c., and a coin of Constans dated to between AD 341 and 346: Maloney (1979a) 292–97; Maloney (1979b) 96–117. The latest generally given date for these towers is 375, but it is not clear what firm evidence that is based on. Overall, on present evidence, under the rules of this study, we have a contextual coin date of 25 years after the start date of the last coin, so 341–66. I thank Simon Barker for assistance in writing this section.

Dating summary: range 341–366, midpoint 353.5, class Cs9 (contextual, coins), publication 3/3.

01BRI Canterbury:

Bibliography: Frere S. S., Stow S., Bennett P. and Bowen J. A. (1982) *Excavations on the Roman and Medieval Defences of Canterbury* (The Archaeology of Canterbury 2) (Maidstone 1982); Barker S., Coombe P. and Perna S. (2018) "Re-use of Roman stone in London city walls", in *Roman Ornamental Stones in North-West Europe* (Etudes et Documents Archeologie 38), edd. C. Coquelet, G. Creemers, R. Dressen and E. Goemaere (Namur 2018) 327–42.

Discussion of site: The walls are a new construction of a single late antique phase, incorporating most of the Roman city.

Of incorporated buildings, there are none.

Of *spolia*, there is some in the walls, but it is not clear that any of it was funerary material. Reused stone found in the north side of Riding gate; Frere *et al.* (1982) 43 simply says "old building-stone"; this is unclear whether this is funerary at all. Part of the north wall nave at St. Mary Northgate (a medieval chapel built against the wall) may have had reused stones in the Roman wall face (although Frere *et al.* (1982) say nothing about it), according to Barker *et al.* (2018), suggesting that the wall was originally faced with this reused material. I haven't been able to track down much information about this section, and there is no indication that it was funerary material.

Of preservation or visibility, see above.

Of dating, a coin of Tetricus I (271–274) was found adjacent to the wall in a deposit at Burgate Lane. Frere *et al.* (1982) 36 argues that this layer, due to the size and angle, was not casual rubbish heap, but rather part of the wall construction. Moreover, it was sealed by another layer of clay and gravel that the excavators think is clearly part of the wall construction, leading them to believe that this layer is contemporaneous with the building of the walls. Secondly, in a bank that accumulated against the wall at the Burgate Lane site (that clearly postdates the wall, as it has at the bottom a seal layer that is the backfill of the construction trench), there was found a coin of Antoninus Pius, Antonine Samian wares (Dr 38, 33 and 37), and some coarse ware sherds that likely date from the 3rd c. (Frere *et al.* (1982) 35). A coin of Victorinus (268–270 or 269–271) was found under rubble under the partly robbed town wall at Dane John mound. Frere *et al.* (1982) 68 notes that it was sealed by a mortary rubble in the robbed foundation trench of the wall just east of the angle of the Dane John area, and is thought to have been sealed by the wall. Thirdly, a coin of Constantius II was found in the deposit that post-dated the fortification construction at Dane John, given as providing TAQ of *ca.* 380, although on its own, as a single find, it cannot do this.

Overall, the coins from the layers related to the construction of the walls can suggest a loose contextual date, of 25 years after the start of the last find, which is the coin of Tetricus, which gives us a range of 271–296.

Dating summary: range 271–296, midpoint 283.5, class Cs8 (contextual, coins), publication 3/3.

02HIS Lisbon

Bibliography: Leitão M., Fernandes L. and Filipe V. (2020) "*Felicitas Iulia Olisipo* e a reutilização de *Spolia* na antiguidade tardia: o exemplo do troço de muralha da casa dos bicos (Lisboa, Portugal)", in *Exemplum et Spolia. La reutilización arquitectónica en la transformación del paisaje urbano de las ciudades históricas* (Mytra 7), edd. P. Mateos Cruz and C. J. Morán Sánchez (Mérida 2020) 769–77.

Discussion of site: The walls are of a single phase, which was extensive but left part of the city outside, such as the baths repaired by the governor Numerius Albanus in AD 336 (CIL II 191).

Of incorporated buildings, there are none, with the theatre inside the walls and the circus outside.

Of *spolia*, most of the wall was constructed in *spolia*, and a good portion of that was funerary monuments (based on the form of an altar), so not simply grave stelae. Leitão *et al.* (2020) 772–73 give this report: "Para além deste aspecto, salienta-se o emprego de *spolia* como material construtivo dominante, constituido por silharia almofadada, blocos com entalhes vários e um conjunto de monumentos funerários, correspondentes a capeamentos de ara e uma estela […] São visíveis três exemplares distintos de monumentos funerários, concretamente capeamentos de ara ("coronamientos de ara con pulvini"), exentos e praticamente completos, além do fragmento de um outro exemplar."

Of preservation or visibility, there are a few visibly re-used stones in the lower courses of the wall. They have been cut down to fit the coursing. Many of the other blocks are likely reused (indicated by their irregular size/differing stone) but have been turned inward.

Of dating, in the single section of the late wall that has been explored, the only stratigraphic evidence comes from a pre-existing (non-fortification) wall, which the late fortification wall adjoined. The earlier wall has been dated to the second half of the 3rd c., but Leitão *et al.* (2020) 772 do not provide the rationale for this dating, and I have not seen the primary report. There is no good evidence for a TAQ, unless we take the general regional TAQ for building work on walls in Hispania of *ca.* 350 (ignoring the outlier of later works on Merida). This is a poor date.

Dating summary: range 300–350, midpoint 325, class 0, z (regional development), publication 2/3. Poor.

02HIS Lugo

Bibliography: Richmond I. A. (1931) "Five town-walls in Hispania Citerior", *JRS* 21 (1931) 86–100; Johnson S. (1983) *Late Roman Fortifications* (London 1983); González Fernández E. (2002) "Muralla romana de *Lucus Augusti*: nuevas aportaciones a su estudio y conocimiento", in *Arqueología militar Romana en Hispania* (Anejos del *Gladius* 5), ed. A. Morillo Cerdán (Madrid 2002) 591–608;

de Abel Vilela A., Alcorta E., Arias Vilas F., Carreño Gascón C. and Lopez de Rego J. I. (2004) *La muralla de Lugo. Patrimonio de la Humanidad* (Lugo 2004); Fernandez Ochoa C. and Morillo Cerdán A. (2020) "Late Roman city walls in *Hispania*: a reappraisal", in *City Walls in Late Antiquity: An Empire-Wide Perspective*, edd. E. Intaglia Courault, S. Barker and C. Courault (Oxford 2020) 11–20.

Discussion of site: These walls are of a single phase and an extensive circuit.

Of incorporated buildings, there are none, with no other major public monuments known.

Of *spolia*, there are tombstones and religious dedications.

Of preservation or visibility: Images from Richmond (who says nothing explicit on how *spolia* was placed) shows blank surfaces of differently sized and coursed *grand appareil*. González Fernández (2002) 593 notes that the wall was composed of slate slabs, rounded stones, ashlars and masonry and architectural elements reused from ruined buildings and epigraphs, all arranged in sections or layers throughout the wall. Some of the *spolia* was clearly reused as facing for the wall, but some was within the mass of the wall.

Of dating, Johnson (1983) notes reused material in the core and an 'overall style' that suggests post 250; Fernandez Ochoa and Morillo (2020) 14 say that they are late 3rd or 4th c. but provide no dating evidence. Richmond (1931) 90 says: "Twenty-seven [inscribed stones] are of use here, seventeen being tombstones, and the others religious dedications. Not one of the latter is so important as to suggest that a big building had been robbed. For the present purpose, it is still more important to note that no single inscription can be described as a late stone. Two tombstones (Eph. Ep. viii, 3 0; ix, 287) can be roughly dated. The lettering of one is said to be typical of the 3rd or 4th c.; the other, from Puerta Nueva, 3rd c. rather than 4th c. in style, mentions an Imperial *libertus*, named L. Septimius Hermeros, and this indicates a date not earlier than the 3rd c. for the erection of the walls. On the other side, the complete absence of 4th c. tombstones is particularly suggestive, since the stones under consideration come from the whole circuit and are the yield of many demolitions. The walls would thus appear to fall between AD 250 and AD 325, as outside limits. For its construction, the town robbed its grave-yards, as did many a town and fortress in time of need. It also robbed at least two shrines and one or two public buildings. But we do not get the impression that these public buildings were of great size or note." It is not clear if any inscriptions dating to 4th c. or later have been found since Richmond. González Fernández (2002) 602 notes that in the fosse/moat in front of the walls, coins of Claudius II (263–270) and Constantius II (360) were found along the bottom of the ditch, providing a contextual date of 360–385 for its fill, and so a somewhat loose TAQ of 385 or so for digging the ditch. An excavation at Praza del Campo Castelo found some coins of Gallienus and Claudius Gothicus [268–270] seemingly adjacent to, but not in the wall fabric, in stratified occupation layers, pointing to a TPQ of 268. González Fernández (2002) 604, however, is not particularly precise about the stratigraphy, noting the presence of: "los niveles de ocupación altoimperiales seccionados posteriormente por la misma, junto con niveles correspondientes a la etapa de construcción y posterior reocupación bajoimperial", and that the coins were found "a la altura de su cimentación" in that sector. Pottery in the layers immediately below the construction fills are dated to the late 3rd c. by González Fernández, who provides no further references or details on these excavations. Unless we are confused, the pottery he cites (TSH 15/17) does not check out as being correctly dated. Perhaps it is TS 15/17? Dragendorf of 1st/mid-2nd c. on http://ceres.mcu.es/, AD 40–90 on potsherd.net. Ritterling 8 is of AD 40–70 on potsherd.net. There is no TSHT.

Overall, the best dating evidence for the walls themselves would appear to be a TPQ of the mid-3rd c. for the use of visible reused material. The contextual epigraphic argument of Richmond noting the absence of reused material suggests that the walls did not extend into the 4th c., so should give us an upper end to the range of 325. The TPQ of 268 derived from coins within occupation layers brought to an end when the enceinte was constructed, is also suggestive, if of more associative value, but should be allowed to provide a later TPQ. Given the uncertainties surrounding the ceramic evidence I prefer not to use that.

Dating summary: range 268–325, midpoint 296.5, class Cs4 (reused materials, general presence), Cs8x (contextual, epigraphic), Cs (associative, phase of development), publication 3/3.

02HIS Leon

Bibliography: Richmond I. A. (1931) "Five town walls in Hispania Citerior", *JRS* 21 (1931) 86–100; García Marcos V. (2002) "Novedades acerca de los campamentos romanos de León", in *Arqueología militar Romana en Hispania*, ed. A. Morillo Cerdán (Cáceres 2002) 167–212; Morillo Cerdán A. and García Marcos V. (2006) "The defensive system of the legionary fortress of VI Victrix at León (Spain). The porta principalis sinistra", in *LIMES XIX: proceedings of the XIXth International Congress of Roman Frontier Studies held in Pécs, Hungary, September 2003*, ed Z. Visy (Pécs 2006) 569–83 (a summary); Garcia

Marcos V., Morillo Cerdán A. and Duran Cabello R. (2007) "La muralla tetraquica de legio: aproximación al conocimiento de su sistema constructive", in *Murallas de ciudades romanas en el occidente del imperio: lucus augusti como paradigma : actas del congreso internacional celebrado en Lugo (26–29. XI. 2005) en el V aniversario de la declaración, por la UNESCO, de la Muralla de Lugo como Patrimonio de la Humanidad*, edd. R. Colmenero, A. Rodà and I. Rodà (Lugo 2007) 381–400; Fernández Ochoa C., Morillo Cerdán A. and Salido Domínguez J. (2011) "Ciudades amuralladas y *annona militaris* durante el Bajo Imperio en Hispania: una cuestión a debate", in *Horrea Hispaniques. La question du stockage en Méditerranée romane* (Collection de la Casa de Velázquez 125), edd. J. Arce and B. Gonflaux (Madrid 2011) 265–285; Morillo Cerdán A. and Durán Cabello R. (2017) "La puerta meridional del recinto amurallado de la ciudad de León (siglos I–XIII). Análisis estratigráfico e interpretativo de una nueva evidencia constructiva", *Arqueología de la Arquitectura* 14 (2017) 1–26; Ranilla García M. ed. (2016) *Historia de una excavación horizontal. El hallazgo y la extracción de material lapidario de la muralla de León* (León 2016) (not seen).

Discussion of site: A skin was added to the front of a standing Flavian-era circuit, making the whole mass 5.25 m thick.

Of incorporated buildings, there are none.

Of *spolia*, there is a variety of reused blocks from paving stones, to voussoirs, and inscribed blocks, some from funerary monuments, including altars and numerous gravestones.

Of preservation or visibility, reused blocks seem to have been turned inward, but not necessarily cut down evenly, making reuse neither fully hidden nor fully visible. N.B. there is very little of the walls still *in situ*, so this observation, primarily drawn from the Torre de los Ponce, may not apply to the whole circuit. Further tombstones have been found in an emergency excavation from 2009–2010 (with detailed information about the tombstones published in Ranilla García (2016) (not seen).

Of dating, the second wall (i.e. the outer skin) is considered to be tetrarchic, based on stratigraphic evidence: e.g. coins of Maximian (RIC 76b, dated to 297–298) and Diocletian (dated to 286–305) excavated in the Puerta Obispo and militaria dated to the mid-3rd c. excavated at Santa Maria (Morillo *et al.* (2011) 271). Epigraphy from *spolia*: "Fourteen inscriptions provide evidence for the date of this wall. Five of them are altars, the rest gravestones. They belong mostly to the first or second century, but the dedication to the Nymphs by Pomponius Proculus Vitrasius Pollio should be placed in the middle of the second century, and the tombstone of L. Camplus Paternus in the third; while the lettering of six more is assigned by Don Angelo Nieto, Director of the Museum, to the third, rather than to the second century. The dating of letters is a difficult matter. Here, it can be left on one side, for it is evident that the group of stones, like those from Lugo and Astorga, extends into the third century, but not beyond its end." (Richmond (1931) 93). The epigraphic contextual date is then the second half of the 3rd c. or first quarter of the 4th, in line with the stratigraphic evidence, which gives a contextual coin date of 25 years after the start date of the last coin, so 297–322. This is to be preferred in accuracy to the contextual epigraphic date. Moreover, two necropoleis have been found outside the walls, both dating from the 4th c. onwards (García Marcos (2006) 203, who is not more specific on the chronology), which provide a supportive associative dating should it be needed.

Dating summary: range 297–322, midpoint 309.5, class Cs8 (contextual, coins), Cs8x (contextual, other), Cs3 (associative, phase of development) publication 3/3.

02HIS Mérida

Bibliography: Alba M. (1994) "Ocupación diacrónica del área arqueológica de Morería", *Memoria: Excavaciones Arqueológicas en Mérida* 1 (1994–1995) 285–316; Alba M. (2004) "Evolución y final de los espacios romanos a la luz de los datos arqueológicos (pautas de transformación de la ciudad tardoantigua y altomedieval)", *Augusta Emerita, Territorios, espacios, imágenes y gentes en Lusitania Romana* (Monografías Emeritenses 8), ed. T. Nogales Basarrate (Mérida 2004) 207–256; De Man A. (2009) *Defesas Urbanas Tardias da Lusitania* (Studia Lusitana 6) (Mérida 2009); Mateos Cruz P. and Pizzo A. (2020) "La reutilización de materiales en la muralla tardoantigua de *Augusta Emerita*", in *Exemplum et Spolia. La reutilización arquitectónica en la transformación del paisaje urbano de las ciudades históricas* (Mytra 7), edd. P. Mateos Cruz and C. J. Morán Sánchez (Mérida 2020) 55–63; Osland D. (2019) "Text and context: patronage in late antique Mérida", *Studies in Late Antiquity 3* (2019) 581–625.

Discussion of site: This is a Late Roman strengthening/thickening of an Augustan circuit.

Of incorporated buildings, there are none known.

Of *spolia*, the late addition was built largely from a wide variety of re-used Roman stones, including many ashlars reused from funerary monuments. Mateos Cruz and Pizzo (2020) 41 studied the reused elements and identified 41 pieces; in the Alcazaba area, all the reused stones, except for 2 pieces, were of 'funerary character'. Reused pieces in the Moréria area and the Alcazaba are

grave markers and cippus-type monuments. However, the Morería area has column drums and cornices from podium structures. The Alcazaba area has several stones with clamp marks and others have circular holes for lifting stones, both characteristics which suggest that funerary use is unlikely and monumental building more likely as an origin. There are a large number of undecorated reused stones that likely come from Roman monuments such as the theatre and amphitheatre: Dan Osland *pers. comm.* 2022.

Of preservation or visibility, *spolia* was mostly used as facing, with blocks turned inward and well-coursed. Some marks (i.e. clamp marks) are visible, but no obvious decoration or inscriptions, although a stone with a phallus is turned to face the outside of the external wall face in the Morérias section. There are a few reused elements in the core of the walls: Dan Osland *pers. comm.* 2022.

Of dating, evidence is fairly limited, unless De Man (2009) (not seen) has discussed new archaeological investigations, but I suspect not. Stratigraphically, excavations at the Morería (Alba (1994)) area show that the new wall section sits above a funerary area of the 3rd c. and cuts a dump from the 4th and 5th c. (Alba (2004) 228, with no details or references given). An inscription (CERV 363 = CICM 10) is known from a 9th c. manuscript, considered recently by Osland (2019) (not seen, but I thank the author for recommending it). This inscription notes that the Gothic diplomat Salla assisted the Bishop Zeno in rebuilding/repairing the walls in 483 (n.b. this is the only direct evidence of Visigothic wall work). Mateos Cruz and Pizzo (2020) 56 conclude that the addition is certainly 5th c. between the historical and archaeological evidence, but do not conclude a more specific date.

Overall, the finds from the dump should provide a contextual date for the walls. In their absence we are obliged to rest on the date of 483, from an out of context inscription, which is of course problematic. If any stratigraphic dating becomes available it should be allowed to trump the textual date.

Dating summary: 483, class x (inscription), publication 3/3.

02HIS Barcelona

Bibliography: Johnson S. (1983) *Late Roman Fortifications* (London 1983); Járrega Domínguez R. (1991) 'Consideraciones sobre la cronología de las murallas tardorromanas de Barcelona: ¿una fortificación del Siglo V?', *Archivo Español De Arqueología* 64 (1991) 326–35; Fernández Ochoa C. and Morillo Cerdán A. (2005) 'Walls in the urban landscape of late Roman Spain: defence and imperial strategy', in *Hispania in Late Antiquity: Current Perspectives*, edd. K. Bowes and M. Kulikowski (Leiden 2005) 299–340; Hernández-Gasch J. (2006) "The *castellum* of Barcino: from its Early Roman Empire origins as a monumental public place to the Late Antiquity fortress", QUARHIS *Quaderns d'Arqueologia i Historia de la Ciutat de Barcelona* 2 (2006) 75–91; Puig F. and Rodà I. (2007) "Las murallas de *Barcino*. Nuevas aportaciones al conocimiento de la evolución de sus sistemas de fortificación" *in Murallas de Ciudades Romanas in el Occidente del Imperio*, edd. A. Rodriguez Colmenero and I. Rodà (Lugo 2007) 595–632; Puig F. and Rodà I. (2010) *Las murallas de Barcino. Nuevas aportaciones al conocimiento de la evolución de sus sistemas de fortificación* (Barcelona 2010); Esmonde Cleary S. (2013) *The Roman West AD 200–500* (Oxford 2013) 130.

Discussion of site: The Late Roman walls at Barcelona followed nearly the same course as the early Augustan circuit. The early circuit enclosed 10.4 ha and ran 1.13 km. The early walls were faced in *opus quattratum*, were between 1.3 and 2 m thick, and may have been, according to one calculation, up to 9 m tall. Esmonde Cleary suggests that they were considerably shorter, perhaps half this height. A new skin was added to the Augustan enceinte in Late Antiquity, which made them thicker and taller. An extension was built from scratch in the south, making late antique walls slightly longer than the original at 1.31 km.

Of incorporated buildings, there are none.

Of *spolia,* the new skin of the walls (see below) was constructed primarily in *opus 'quattratum'* (*quadratum*), largely composed of *spolia*. The stone seems to have come largely from cemeteries, and other suburban monuments, indicated by the cippi, altars, columns, friezes, and sculptures many of which were found in the wall facing. These likely represent funerary buildings, but this is not certain from the reports.

Of preservation or visibility, generally, the *spolia* has been cut down, or at least carefully set into regular courses, and any carved or decorated faces have been turned inward.

Of dating, Johnson (1983) 125 claims this was built around the time of the barbarian raids into Gaul and Spain in the 260s; a coin of Claudius II Gothicus (268–270) was found in the infill of one of the round towers, and several 4th c. coins have recently been discovered from other towers (Férnandez Ochoa and Morillo (2005) 318). Járrgena Domínguez (1991) has argued that a coin of Maximus (the Spanish usurper) found in the mortar in a tower, and which dates to 409 must provide the date for the whole wall (Keay has suggested that this is a repair, not construction); Puig and Rodà (2007) 627) have followed this and put forward a

5th c. date. Some recent excavation work points to *ca.* 360 as a TAQ. Hernandez-Gasch (2006) 88–89 notes caution, saying that the evidence "come[s] from soundings which yielded few materials that were suitable for dating and, in some cases, were contaminated when part of the city wall was demolished in the 19th c. He notes that the materials of the soil located against F 34 (which was torn down by the construction of the city wall) provide a TAQ for the city wall itself. It is dated from the beginning of the 3rd century to the beginning of the 4th century. A TPQ is found in the level which leaned on the foundation of the wall and seems to have been formed sometime after the second half of the 4th century through the first quarter of the 5th century." Hernandez-Gasch seems to mix up his TAQ and TPQ here: this level gives a TAQ.

A real TPQ, which I will use here, seems to be provided from ceramics in a stratigraphic unit that was coequal with a section that was cut for wall construction. The pottery there is African Red Slip ware, type A/C (Lamboglia 40), which L. Lavan dates to 230/240–325 [following Atlante p. 65 which considers it to be equivalent to Hayes 50A of the same date range in LRP]. It is not clear from Hernández-Gasch if this is a single sherd or a group of vessels, so only provides a TPQ of 230 onwards for this layer that the wall seems to cut into. A real TAQ for the wall itself is provided by a level which was deposited over the wall foundation fill. The pottery there is TS African Red Slip ware, type A (Hayes 8B/Lamboglia 1C and Hayes 9B/Lamboglia 2B) and Hayes 23B, 19/194, 196, 19. The latest dates are from Ostia III/Atlante CVII, number 8, produced between 360 and 440 (Hernández-Gasch (2006) n. 40), and Lamb 9A/Atlante CVI, number 4, produced between 180 and 420 (Hernández-Gasch (2006) n. 40), of which the first is the latest ceramic which contextually dates the layer to 360–385, so giving a TAQ for the wall of 385.

Dating summary: range 230–385, midpoint 307.5, class Cs9 (contextual ceramics, for TAQ), Cs7 (TPQ pottery), publication 3/3.

03GAL Paris:

Bibliography: Johnson S. (1983) *Late Roman Fortifications* (London 1983); Duval P. M. (1989) "De Lutèce à Paris. 2. Lutèce gauloise et gallo-romaine", in *Travaux sur la Gaule (1946–1986)* (Publications de l'École française de Rome 116), ed. P. M. Duval (Rome 1989) 913–40; Trénard Y., Busson D. and Robin S. (1993) "Découvertes récentes dans l'Île de la Cité à Paris: élaboration d'une courbe dendrochronologique de référence pour la région Île-de-France et ses applications aux datations du Cardo et du rempart du Bas-Empire", *Actes des journées d'archéologie d'Ile-de-France: paléo-environnement et actualités, Meaux, 16 et 17 mars 1991* (Mémoires du groupement archéologique de Seine-et-Marne 1 1993) (Nemours 1993) 63–71, esp. 66; Busson D. (1998) *Paris (CAG 75)* (Paris 1998); Fourdrin J. P. and Bayard D. (2019) *Villes et fortifications de l'Antiquité tardive dans le nord de la Gaule* (Revue du Nord, Hors série Archéologie n° 26) (Villeneuve d'Ascq 2019); Esmonde Cleary S. (2020) "Urban defences in Late Roman Gaul: civic monuments or state installations", in *City Walls in Late Antiquity: An Empire-Wide Perspective*, edd. E. Intaglia Courault, S. Barker, and C. Courault (Oxford 2020) 27–50.

Discussion of site: This fortification is a single phase around the Île de la Cité, which left numerous monuments outside its circuit, most notably the forum, the theatre-amphitheatre, and the Baths of Cluny.

Of incorporated buildings, there are none.

Of *spolia*, there is varied material, from a wide range of monuments, and perhaps some funerary material reused in the construction of the walls. This comes principally (Duval (1989) 936) from the necropolis on the rue Pierre-Nicole. Some of this was inscribed on more than one face. However, Busson (1998) 401 argues that beyond a single decorated bas relief with a hare hunting scene which is thought, based on the imagery, to have come from a mausoleum, no other funerary inscriptions can definitively be said to have come from the walls. Many such inscriptions were found around the Île de la Cité, but their exact find in relation to the late antique walls is not especially clear. Instead, Busson (1998) 400 suggests that because of their similarity and the lack of obvious decoration for many (though not all) of the reused blocks, they came from a single monument, possibly the amphitheatre.

Of preservation or visibility: Inscriptions (not necessarily funerary) were visible in the walls, but they were in the mid-level courses (Busson (1998) 401). The highest courses were where the most disparate material, like decorative blocks, were found, some of which were cut down to fit the size of the courses.

Of dating, Lavan *Public Space* 149 on the fortification is dated to between AD 308 (the dendro-date of a major wooden bridge serving the north-south Cardo at Rue de la Cité) and 360 when Julian (*Misopogon* 340D) mentions the walls and wooden bridges: (the date of the building must be 308 as the date of cutting of the youngest wood recorded is winter 307 or the beginning of 308, and building would not take place for foundations in the winter). There are further connections to the other rebuilding/repaving of the Île.

Dating summary: range 308–360, midpoint 334, class Cs10 (scientific), x (historical text), Cs4 (reused building materials), Cs3 (associative, building phase), publication 3/3.

03GAL Le Mans

Bibliography: Guilleux J. (2000) *L'enceinte romaine du Mans* (Saint-Jean-d'Angély 2000); Dey H. (2010) "Art, ceremony, and city walls; the aesthetics of imperial resurgence in the Late Roman West", *JLA* 3 (2010) 3–37; Meunier H. and Augry S. (2019) "L'enceinte romaine du Mans et ses abords: première synthèse des interventions archéologiques récentes", in *Villes et fortifications de l'Antiquité tardive dans le nord de la Gaule* (Revue du Nord, Hors série, Collection Art et Archéologie, No 26), edd. D. Bayard and J.-P. Fourdrin (Lille 2019) 293–328.

Discussion of site: These walls are of a single phase, which left monuments outside the circuit, such as the theatre.

Of incorporated buildings, there are none.

Of *spolia*: "The lowest courses of the rising walls generally are composed of additional spoliated stone blocks, recut where necessary and carefully joined to form a sort of *opus quadratum* masonry" (Dey (2010) 11).

Of preservation or visibility, mostly blocks cut down and carefully coursed, thus hiding their reuse, for the foundations but a few sections are less-well disguised, including a very small number fragmentary, carved decorations. The differences between sections vis-à-vis visibility may be a result of different work gangs working to different standards, the availability of suitable material at hand or economic pressures.

Of dating, a bath (les thermes de l'ancienne école Claude-Chappe) was destroyed to make way for the walls. In the structure, 58 coins were found, all except 1 from the period of 260–275. The coins date up to at least 274 (Tetricus I) but end before the reform of coinage under Diocletian in 294; Guilleux (2000) 253 concludes that the destruction of the baths must have taken place in this window, giving a rough contextual coin date. A few later (4th c.) coins were found as well, but Guilleux argues that these were not in the stratigraphy of the baths in use and must come from after their abandonment and destruction. An archaeomagnetic examination of some bricks in a portion of the baths returned a date of 275, which is part of the latest building phase of the bath complex. Ceramics from a domestic site on the rue des Poules, also destroyed for the walls, include a Drag. 37, dated to the 3rd c. (the most closely dated of the pottery) [but given as 70–230 on potsherd.net], which supports the idea of use through much of the 3rd c., but not beyond. In the 1980s there was an archaeomagnetic investigation of 45 bricks from the walls themselves. The dates returned were 65, 200, 280 and 420. Guilleux (2000) 257 (and others) argue for a date around 280 for the manufacture of the bricks that go into the walls, taking this with the range of other evidence as well as similar walls with similar dates from Rennes, Nantes, and Tours. Meunier and Augry (2020) 311 cast some doubt on to these earlier researches, and are not fully convinced of the currently accepted date.

Overall, the coin evidence from the bath building is the strongest evidence, providing a contextual date of 274–299, supported by the archaeomagnetic date for its brick of 275. The bricks from the walls themselves, whilst centred in this date range, may include reused bricks and undetected repair phase so should not be relied on here, given the better-quality data we have. It is reasonable to shorten the date range to 294, given the number of the coins and the absence of those reflecting the monetary reforms of 294.

Dating summary: range 274–294, midpoint 284, class Cs9 (contextual, coins), publication 3/3.

03GAL Tours

Bibliography: Wood J. (1983) "Le castrum de Tours. Etude architecturale du ampart du Bas-Empire", in *Recueil d'études. Tours: Laboratoire d'archéologie urbaine*, edd. H. Galinié, C. Mabire La Caille, J. Motteau, B. Randoin and B. Watkinson (Tours 1983) 11–60; Seigne J. (2007) "La fortification de la ville au Bas Empire, de l'amphithéâtre-forteresse au castrum", in *Tours antique et médiéval: lieux de vie, temps de la ville: 40 ans d'archéologie urbaine*, edd. H. Galinié, T. Morin, and P. Audin (Tours 2007) 247–55; Esmonde Cleary S. (2020) "Urban defences in Late Roman Gaul: civic monuments or state installations", in *City Walls in Late Antiquity: An Empire-Wide Perspective,* edd. E. Intaglia Courault, S. Barker and C. Courault (Oxford 2020) 27–50.

Discussion of site: These walls are of a single phase, which left most of the former city outside the circuit.

Of incorporated buildings, there is a re-used amphitheatre, but no other monuments known.

Of *spolia*, like Bordeaux *et al.*, the lowest courses were constructed with reused material from a wide range of imperial monuments, and some funerary material (namely, a *cippus* and some funerary inscriptions, presumably tombstones. Wood (1983) 49–50 has a list of the recovered reused blocks). Upper courses were *petit appareil* and brick.

Of preservation or visibility, generally rectangular blocks are used in the foundations, with no obvious signs of reuse, nor of having been cut down. Many blocks have holes in them, which Wood argues came from either their first use or their reuse. A postern (called north-west) has a lintel with a frieze above the vault, visible on the exterior of the walls.

Of dating, Esmonde Cleary (2020) notes 330–350+ for the date but provides no further detail. Stratigraphic work at two sites along the walls have provided a mid- to

late-4th c. date. At one, a bath, the end of functioning is dated to 350–375, providing an associative TPQ. Seigne (2007) 255, unfortunately, does not give any details about what led to this chronology in his chapter on the walls. The second site is the defensive ditch at site 6. There, the end of maintenance of the ditch is associated with the conversion of the amphitheatre into a fortress (as the ditch was no longer necessary, from what I can understand). This is dated stratigraphically to the end of the 4th c. – again Seigne provides no specifics – and provides a TAQ of sorts for the walls being completed.

Dating summary: range 350–400, midpoint 375, class 0, publication 1/3.

04VIE Poitiers

Bibliography: Gauthier N. and Picard J.-Ch. (2014) edd. *Topographie Chrétienne des Cités de la Gaule, XVI, Quarante ans d'enquête (1972–2012)* (Paris 2014) 219–20 (not seen); Esmonde Cleary S. (2020) "Urban defences in Late Roman Gaul: civic monuments or state installations", in *City Walls in Late Antiquity: An Empire-Wide Perspective*, edd. E. Intaglia Courault, S. Barker and C. Courault (Oxford 2020) 27–50; Heijmans M. (2020) "The late Roman city walls in southern Gaul", in *City Walls in Late Antiquity: An Empire-Wide Perspective*, edd. E. Intaglia, S. Barker, and C. Courault (Oxford 2020) 51–62.

Discussion of site: These walls are of a single phase, which was fairly extensive but left the amphitheatre, a suburb, and a sanctuary outside the circuit.

Of incorporated buildings: There appear to be none.

Of *spolia*: Tombstones as well as blocks from other buildings. At the Rue Sainte-Catherine, a block was found in the wall fabric that was first a tombstone (CIL XIII 11078), then re-carved into a column base, before being reused for the third time in the foundations of the walls. A further funerary inscription: CIL XII 1131.

Of preservation or visibility, as far as I can tell (not being able to view the TCCG volume), the reused material was found exclusively in the foundations, and not in the walls proper.

Of dating, Esmonde Cleary (2020) notes first half of 4th c. without citing evidence, whilst Heijmans (2020) provides some detail: "the enclosure seems to have been built shortly after the fire of the Cordeliers district, so after AD 253, with the *terminus* provided by the latest coinage. This discovery thus seems to confirm the traditional dating of the end of the third century or the beginning of the fourth century attributed to this enclosure." Further detail on the precise relationship between the fire and construction may be available in the TCCG volume. Overall, we have a TPQ for the walls provided by the coinage. A regional TAQ can be evoked for Gaul of 425, after which major building works on walls are not known.

Dating summary: range 275–425, midpoint 350, class Cs 7 (TPQ coins), z (regional development), publication 3/3.

04VIE Saintes

Bibliography: *Inscriptions Latines d'Aquitaine* (ILA). *Santons* 45–51; 316–343; Johnson S. (1983) *Late Roman Fortifications* (London 1983); Maurin L. (1992) "Remparts et cités dans les trois provinces du Sud-Ouest de la Gaule au Bas-Empire (dernier quart du IIIe siècle–début du Ve siècle", in *Villes et agglomérations urbaines antiques du Sud-Ouest de la Gaule. Histoire et Archéologie. Deuxième colloque Aquitania: Bordeaux, 13–15 septembre 1990* (Aquitania, sixième supplément), ed. L. Maurin (Bordeaux 1992) 365–89; Maurin L., Thauré M. and Buisson J.-F. (1994) *Saintes Antique* (Paris 1994); Maurin L., Robin K. and Tranoy L. (2007) *Saintes* (CAG 17/2) (Paris 2007) 77 (not seen); Esmonde Cleary S. (2013) *The Roman West* (Oxford 2013); Esmonde Cleary S. (2020) "Urban defences in Late Roman Gaul: civic monuments or state installations", in *City Walls in Late Antiquity: An Empire-Wide Perspective*, edd. E. Intaglia Courault, S. Barker and C. Courault (Oxford 2020) 27–50.

Discussion of site: These walls are of a single phase, which left some monuments outside the circuit.

Of incorporated buildings, the amphitheatre is the only major monument close to the walls, but it is left outside the circuit.

Of *spolia*: Some of the stonework of the amphitheatre ends up in the walls but the building seems to continue in use: Esmonde Cleary (2013) 118). Johnson (1983) 106 notes walls were built on "large blocks of stone, mostly re-used from earlier buildings. Finds from the wall-core include statues of a first- or second-century date" and "One of the latest finds from the walls was a re-used inscription of an early third-century date." Maurin *et al.* (1994) 58 note the walls were made of spoliated "monuments publiques et funéraires". The *spolia* composed likely the whole edifice (evidence shows up to 5 m), not just foundations or lower courses.

Of preservation or visibility, *spolia* was turned inward: "Les parties lisses des pierres étaient soigneusement exposées en façade, les parties sculptées étaient cachées à l'intérieur du rampart" (https://mediolanum-santonum.fr/les-remparts-du-bas-empire.html – there are archival photos on this site, which show this very clearly).

Of dating, given as first half of 4th c. by Esmonde Cleary (2020) 39 and Johnson (1983) 106. A TPQ is reportedly provided from a re-used inscription of an early 3rd c. date, but I have not been able to verify any

details about this inscription, nor any other *spolia* found in the walls. Maurin (1992) 381 suggests that it dates from the reign of Diocletian, based on a necropolis just beyond the new walls dated to 275–285 (though does not give the presumably epigraphic information to substantiate this). This would give an associative TAQ for the walls. Thus, we have a possible date range of 200–285 based on published information.

Dating summary: range 200–285, midpoint 242.5, class Cs7 (TPQ inscription), Cs3 (associative, inscription), publication 2/3.

04VIE Angoulême

Bibliography: Maurin L. (1992) "Remparts et cités dans les trois provinces du Sud-Ouest de la Gaule au Bas-Empire (dernier quart du IIIe siècle–début du Ve siècle)", in *Villes et agglomérations urbaines antiques du sud-ouest de la Gaule*, ed L. Maurin (Bordeaux 1992) 365–89; Vernou, C. (1993) *La Charente* (CAG 16) (Paris 1993) 50–51; *Topographie Chrétienne des Cités de la Gaule, X, Province ecclésiastique de Bordeaux (Aquitania Secunda)* (Paris 1998) (not seen); Maurin, L. (2019) "Dans la Gaule du Sud-Ouest, l'enceinte et la ville dans l'Antiquité tardive", in *Villes et fortifications de l'Antiquité tardive dans le nord de la Gaule* (Revue du Nord, H.S. n° 26), edd. D. Bayard and J.-P. Fourdrin (Lille 2019) 41–56 (esp. 51–52).

Discussion of site: These walls are of a single phase, which was a reduced circuit, but we do not know yet which monuments, if any, it left outside. It seems to differ from some Gallic walls as it is less wide (only 2 m), there are no towers, and the elevation does not show tile courses, possibly making it a bit later. Otherwise, not much information has been uncovered or published about these walls.

Of incorporated buildings, there is none, with no other monuments known.

Of *spolia*, re-used blocks found in the single section of the walls discovered in 1991. Maurin (2019) 51 does not indicate what kind they were.

Of preservation or visibility, in foundations, so likely faced inward, like many other Gallic examples, but have no direct confirmation of this.

Of dating, mentioned by Gregory of Tours *HF* II, 37, which provides a TAQ of 591. No other especially clear direct evidence. A rescue excavation in 1991 uncovered a small stretch of the walls, but there were medieval ceramics mixed in; the excavators concluded that the walls were certainly post-4th c., and possibly post 7th, unless post-antique habitation near the walls caused the ceramics to get mixed (Maurin (2019) 51). It is not clear from this reference if the evidence for a 4th c. TPQ was ceramics or other artefacts – it's a footnote, so not overly detailed, but Maurin says the excavator based the date on ceramics. I will accept this with a 2/3 publication score, with the ceramics giving a TPQ of 300.

Dating summary: range 300–425, midpoint 362.5, class Cs4 (reused material, general presence), z (regional development), publication 2/3. Generic late antique date.

04VIE Périgueux

Bibliography: Maurin L. (1992) "Remparts et cités dans les trois provinces du Sud-Ouest de la Gaule au Bas-Empire (dernier quart du IIIe siècle–début du Ve siècle)", in *Villes et agglomérations urbaines antiques du sud-ouest de la Gaule*, ed. L. Maurin (Bordeaux 1992) 365–89; Garmy P. and Maurin L. (1996) edd. *Enceintes romaines d'Aquitaine. Bordeaux, Dax, Périgueux, Bazas* (Paris 1996); Girardy-Caillat C. (1996) "Périgueux", in *Enceintes romaines d'Aquitaine. Bordeaux, Dax, Périgueux, Bazas*, edd. P. Garmy and L. Maurin (Paris 1996) 127–54; Gaillard H. (2009) "La 'Porte de Mars' à Périgueux", *Aquitania* 25 (2009) 365–70; Girardy-Caillat C. (2013) *Périgueux, Carte archéologique de la Gaule 24/2* (Paris 2013) 68–69, 133–69; Maurin, L. (2019) "Dans la Gaule du Sud-Ouest, l'enceinte et la ville dans l'Antiquité tardive", in *Villes et fortifications de l'Antiquité tardive dans le nord de la Gaule* (Actes du colloque de Lille, janvier 2015, *Revue du Nord*, H.S. n° 26), edd. D. Bayard and J.-P. Fourdrin (Lille 2019) 41–56; Heijmans M. (2020) "The late Roman city walls in southern Gaul", in *City Walls in Late Antiquity: An Empire-Wide Perspective*, edd. E. Intagliata, S. Barker, and C. Courault (Oxford 2020) 51–62.

Discussion of site: These walls are of a single phase, which left numerous monuments outside the circuit.

Of incorporated buildings, an amphitheatre was included, while the sanctuary, forum, and baths were left outside.

Of *spolia*, a wide range of monuments were reused in the walls, funerary and otherwise. These have not been systematically studied, so there is no information about the variety and kinds of monuments they were derived from. In the absence of more detail, we assume the funerary material is tombstones, almost universal in Gaul.

Of preservation or visibility, Maurin (1992) 141 notes that funerary blocks and the upper parts of buildings (e.g. entablements and capitals) were mostly used in the lowest courses and foundation of the walls. Carved stones were mostly used in the interior of the walls, and large blocks for the exterior – many of these were recarved or cut down. This latter is evidenced from the off-centre lewis or grip holes on blocks from the Porte de Mars (Gaillard (2009) 2). Thus, a fairly blank, uniform face was given by the walls.

Of dating, Heijmans (2020) 54 says "Recent work on the 'porte de Mars' has given some indication for a construction date during the first half or perhaps even the middle of the fourth century" (CAG 24/2, 68–69; 133–169; TCCG XVI, 217). It thus confirms the chronology already proposed by Claudine Girardy-Caillat (1996) 153. Gaillard (2009) says at the Porte de Mars, the foundation trenches are after 274 and then the backfill material contains: "un *nummus* de Constance II, frappé vers 341–348 p.C., plusieurs fragments de bols ou de coupes (Isings 96, 106 ou 109 [from C. Isings *Roman glass from dated finds* Groningen 1957, which I was not able to check]) et d'un aryballe en verre, tous datés du IVe s. p.C., ainsi que plusieurs tessons d'amphores de type *spatheion*, diffusé en Gaule (Lyon, Marseille) à la fin du IVe s. ou au début du Ve [387.5–700 Bon]. Gailliard also notes about the paving: En revanche sur l'ouverture charretière, où un dallage de calcaire a été rencontré, établi de façon concomitante avec la base des tours encadrant le passage, les premiers niveaux de circulation conservés contiennent un mobilier du début du ve siècle (DSP languedocienne et imitation de nummus de Constantin de 336 p.C). Le dallage, probablement entretenu, a dû être utilisé en surface roulante dès le IVe siècle."

Gaillard's report, which is not a full archaeological report (but seems nevertheless to be well-informed), does not explain the date of 'after 274' for the foundation trenches. I cannot find any further reference to follow up for the archaeology of this date, although it presumably refers to the latest finds in the earlier stratigraphy which trench cuts. Gaillard dates the first rubble backfill covering the foundations to *ca.* 400; the earliest material was a coin of Constantius II (341–348) and the latest ceramics as *spatheion* (same as Keay 26?) amphora fragments which he – and others – date to late 4th to early 5th c. [387.5–700 Bon]. This suggests that the construction of the gate and walls possibly as late as later 4th c. if we look at the ceramics.

Overall, the *spatheion* from the construction levels is decisive in providing a contextual date of 387.5–412.5, for the construction of the walls, a date which is not contradicted by the date range of material in subsequent occupation layers connected with the use of the road.

Dating summary: range 387.5–412.5, midpoint 400, class Cs9 (contextual, ceramics), publication 3/3.

04VIE Bordeaux

Bibliography: Linères, J. and Maurin, L. (1992) "Bordeaux", in *Enceintes romaines d'Aquitaine: Bordeaux, Dax, Périgueux, Bazas*, edd. P. Garmy and L. Maruin (Paris 1992) 15–80, specifically 49; Maurin L. (1992) "Remparts et cités dans les trois provinces du Sud-Ouest de la Gaule au Bas-Empire (dernier quart du IIIe siècle–début du Ve siècle", in *Villes et agglomérations urbaines antiques du Sud-Ouest de la Gaule. Histoire et Archéologie. Deuxième colloque Aquitania: Bordeaux, 13–15 septembre 1990* (Aquitania, sixènne supplément), ed. L. Maurin (Bordeaux 1992), 365–89; Bachrach B. (2010) "The fortification of Gaul and the economy of the third and the fourth centuries", *JLA* 3 (2010) 38–64; Doulan C. (2013) *Bordeaux* (CAG 33.2) (Paris 2013), 198; Barraud D., Linères J. and Maurin L. (1996) "Bordeaux", in *Enceintes romaines d'Aquitaine*, edd. P. Garmy and L. Maurin (Paris 1996) 15–80; Hiernard J. (2003) "Des remplois singuliers : les spolia inclus dans les enceintes tardives des Trois Gaules", in *La Ville et ses déchets dans le monde romain. Rebuts et recyclages, Actes du colloque de Poitiers, 19–21 septembre 2002*, edd. P. Ballet, P. Cordier and N. Dieudonné-Glad (Montagnac 2003).

Discussion of site: These walls are a single phase and is a reduced circuit enclosing most of the major monuments of the city, though not all, as noted below.

Of incorporated buildings, there are none, with the amphitheatre and possible forum (Piliers de Tutelle) left outside the walls.

Of *spolia*, there are a variety of monuments, including much funerary material (referred to as 'débris funéraires' by Barraud *et al.* (1992), included in the foundations and lower courses of the walls. Barraud *et al.* (1996) 65 say "la plupart des temps (ou toujours) des matérial de remploi". I believe the 'débris funéraires' have been identified as such by inscriptions; decorated blocks have been discovered as well, but none identified definitely with a tomb. Much of the uncertainty about the blocks themselves comes from the very small sections that have survived to be documented, aggravated by much clearance work in the 1800s, with many blocks removed from context without adequate recording. It is thus unclear whether the funerary material was concentrated near necropoleis, or integrated throughout. Hiernard (2003) 266 has observed that the inscriptions re-used in the walls for the most part concern foreigners, so without family to keep their memory, and tomb, alive. Not having read this, I cannot comment on how convincing an argument it is.

Of dating, in a bath that seems to have been demolished to clear a space in front of the walls, coins from 261–266 and 274 were found in the backfill, giving a contextual date of 25 years after the start date of the last find for the construction of the walls in the 4th quarter of the 3rd c. In the walls, the latest reused datable epigraphic element notes the consulship of Postumus (260) and two coins noting Claudius Gothicus, dated to 270–273

and after 275, were found in the fabric of the walls. The last coin pushes the date range forward by one year by giving a TPQ of 275, though this does not change the end date of the contextual coin range.

Dating summary: range 275–299, midpoint 287, class Cs8 (contextual, coins), Cs7 (TPQ coin), Cs4 (reused material, general presence), publication 3/3.

04VIE Dax

Bibliography: Boyrie-Fénié B. (1994) *Les Landes* (CAG 40) (Paris 1994) 66–69; Maurin L. and Watier B. (1996) "Dax", in *Enceintes romaines d'Aquitaine*, edd P. Garmy and L. Maurin (Paris 1996) 81–125.

Discussion of site: These walls are of a single phase and are an extensive circuit.

Of incorporated buildings, there are none.

Of *spolia*, various inscribed blocks (altars): CIL XIII 410, 411, 414); some cippi (one anepigraphic, and CIL XIII 413, 415), a funerary Eros as well as some other statuary fragments; reused bricks, many with stamps (CIL XIII 12636, 12857, 12862); none of this material has been dated (it is unclear whether it is possible to date, but given that it has not been, likely not). Generally, it seems that there was not much reused material; however, the near complete demolition of the walls in the second half of the 19th c., means that this is difficult to know with any certainty.

Of preservation or visibility, not likely to be visible. It is not clearly stated where the *spolia* was found, except for one in the foundations, which points to the material not being visible; 8 funerary inscriptions were found in the height of the wall, which was constructed in *petit appareil* with brick bands, further suggesting it was in the fill.

Of dating, Maurin and Watier (1996) suggest second half of the 4th c., either during Constantius II or Valentinian's reign. Reused tombstones and other blocks (notably CIL XIII 8893, noting Victorinus in 269 or 271) suggest a TPQ of the late 3rd/early 4th c. A coin of Magnentius (350–353) found in the wall fabric, between bricks, can be taken, together with the epigraphy as a providing a contextual basis for construction date of 25 years after 350, the start date of this last find, which is what I adopt here.

Dating summary: range 350–375, midpoint 362.5, class Cs 8x (contextual, coins and inscriptions together) publication 3/3.

04VIE Toulouse

Bibliography: Baccrabère G. (1974) *Le rempart antique de l'Institut catholique de Toulouse* (Toulouse 1974) 19–20; Badie A. (2002) "Note à propos des matériaux utilizes pour la construction du rempart de l'Institut Catholique et nouvelles hypothèses pour sa dataion," in *Tolosa: Nouvelles recherches sur Toulouse et son territoire dans l'Antiquité*, ed. J-M. Pailler (Rome 2002) 564–68.

Discussion of site: There are two walls at Toulouse. The first, larger one, is certainly Early Imperial, likely Augustan. The second wall, built in a different style, closed off the riverfront and completed the earlier circuit.

Of incorporated buildings, there are none wholly incorporated, at least given current understanding/preservation of the walls. The theatre was inside the Augustan circuit, so no change when the late walls were built. No other major public monuments known from Toulouse, except an amphitheatre at Purpan, 3–4 km north of the city.

Of *spolia*: As the later, riverside wall was composed of brick, the only reused elements were in the foundations. Some of these are sculptural/figural and seem to come from grave monuments. None of this material has been precisely dated, but is generally 'high imperial' in style, suggesting that some period of time had passed before they were disused, taken apart and used for fill, leading to a 3rd or 4th c. date. Baccrabère (1974) 73–75 has proposed a reconstruction of a main funerary monument destroyed and reused in the foundations. He describes it as a 'type de tombeau tolousain' with a tall pyramidal roof and numerous sculpted elements. I would comfortably call this a mausoleum.

Of preservation or visibility, the riverside wall (at least from the sections that have survived) was made of brick, with *spolia* as aggregate in the concrete foundation. *Spolia* had been broken up before mixed into the foundations, so in no way visible.

Of dating, given as 3rd c. in literature. Poorly dated. Archaeomagnetic tests on some bricks in the riverside wall returned two dates, 190 and 275. The investigator noted a curious fact that both dates, and even a date between the two, are possibilities for when these bricks were made. More recently Badie has suggested, based on the same tests, that the bricks were more likely from the middle of the 1st c. He also argues that the bricks were cut down, thus implying they were reused from an original context, meaning that the production date of the bricks has little to do with the date of this fortification, which therefore remains undated (though widely assumed to be 3rd c.). Beyond the very loosely dated *spolia* elements in the wall, there is nothing that allows for more precise dating. The presence of reused brick suggests a generic date of after the middle of the 3rd c., whilst regional development for Gaul suggests a date before 425, after which independently dated building work on fortifications is not known.

Dating summary: range 250–425, midpoint 337.5, class Cs4 (reused material, general presence), z (regional development), publication 3/3.

04VIE Narbonne

Bibliography: Gayraud M. (1981) *Narbonne antique, des origines à la fin du III^e siècle* (Paris 1981) 284–86; Moulis D. (2002) "Le rempart de l'antiquité tardive", in *Narbonne et le Narbonnais*, ed. Éric Dellong (CAG 11.1) (Paris 2002) 140–47; Agusta-Boularot S., Ginouvez O., Lassalle A., Mathieu V. and Sanchez C. (2014) "Modalités du démantèlement des lieux de culte et politique de grands travaux de l'Antiquité tardive à *Narbo Martius*", *Gallia* 71 (2014) 65–77; Heijmans M. (2020) "The late Roman city walls in southern Gaul", in *City Walls in Late Antiquity: An Empire-Wide Perspective*, edd. E. Intaglia, S. Barker, and C. Courault (Oxford 2020) 51–62; Esmonde Cleary S. (2020) "Urban defences in Late Roman Gaul: civic monuments or state installations", in *City Walls in Late Antiquity: An Empire-Wide Perspective*, edd. E. Intaglia Courault, S. Barker, and C. Courault (Oxford 2020) 27–50; Heijmans M. (2004) *Arles durant l'Antiquité tardive. De la* Duplex Arelas *à l'*Urbs Genesii (Collection de l'École Française de Rome 324) (Rome 2004); Thiers F.-P. (1891) "Notes sur l'enceinte préwisigothique de Narbonne", *Bulletin de la commission archeologique du Narbonne* 1 (1891) 158–69.

Discussion of site: These walls are a reduced circuit of a single phase, which left numerous monuments outside its perimeter, such as the amphitheatre.

Of incorporated buildings, the walls ran around, and very near to, the capitolium, but it is unclear the exact integration between the two.

Of *spolia*, there are a variety of monuments, including many tombstones, included in the walls.

Of preservation or visibility, the *spolia* were cut down to a fairly uniform size and seem to be mostly turned inward (though most have been moved to the epigraphic museum and the exact position in the walls was not always thoroughly recorded).

Dating evidence: A bronze of Gallienus and a slightly larger bronze of Maximian found in the walls separately (although location and specifics of find have not been recorded) provides TPQs of 260 for the Gallienus coin and 288 for that of Maximian, though not a contextual date, as they were not found together. Additionally, a *spolia* block from the walls carried an inscription dedicated to Philip the Arab (244–249) from the residents of Beziers. The wall existed by the 5th c. when there is good attestation, like the mention of 'muris' in Sidonius' *Ordo* poem on Narbonne, which provides the TAQ of 394 when the poem was finished.

Incidentally, Heijmans (2020) 58 says "Recent research has shown that the temple known as the 'capitole', which formed the north-western corner of the city walls, was demolished at the end of the 4th or the beginning of the 5th c. (Agusta-Boularot et al. (2014)). This could provide another argument to date the walls to this period." Agusta-Boularot et al. (2014) highlight several places where architectural fragments were reused that are identified as coming from the capitol (although their identification is not definite – it is largely based on the scale of the decorative blocks. Dating for the destruction (and reuse) of the capitolium is based on the construction date (dated by inscription to 456) of the nearby palaeo-Christian church which used blocks identified by marble type as coming from the capitolium, as well as ceramics discovered in a boat that was sunk in a flood that caused damage to structures which required stone repairs (including some blocks identified by size and decoration as coming from the capitolium). Altogether, these point to the capitolium being demolished no later than the 5th c., as the walls follow the course of the capitolium platform, suggesting that the fortification incorporated the temple before it was demolished.

Overall, the TPQ of the coin of Maximian and the TAQ of the textual reference provides the strongest basis for a dating range so far.

Dating summary: range 288–394, midpoint 341, class Cs7 (TPQ, coin), Cs4 (reused materials, general presence), x (historical text), publication 3/3.

04VIE Nîmes

Bibliography: Manniez Y. and Pellé R. (2011) "Données nouvelles sur l'enceinte du *castrum* des Arènes de Nîmes", *Revue archéologique de Narbonnaise* 44 (2011) 125–44. Pellé R. (2015) "Note complémentaire sur l'enceinte du *castrum* des Arènes de Nîmes", *Revue archéologique de Narbonnaise* 48 (2015) 125–34; Heijmans M. (2020) "The late Roman city walls in southern Gaul", in *City Walls in Late Antiquity: An Empire-Wide Perspective*, edd. E. Intaglia Courault, S. Barker, and C. Courault (Oxford 2020) 51–62.

Discussion of site: There was an Early Imperial wall at Nîmes that covered a much larger area than the city ever occupied (paralleling Toulouse or Vienne). The late wall was smaller and marked by different construction techniques. It left numerous monuments outside its circuit, such as a temple and a theatre.

Of incorporated buildings, the relationship between the amphitheatre and wall is not fully established. In the best-understood section, they are apart at a distance of 55 m, with the wall following the curvature of the arena. However, in the extreme north, some early and

not particularly clear survey records suggest that the wall curved towards the area, possibly allowing us to conclude that they joined up, and the amphitheatre was integrated into the fortifications (for which, of course, there are numerous parallels). No other major public monuments known.

Of *spolia*, several points of the wall circuit have been discovered since the early 1800s, mostly when building work was carried out. There has been (to my knowledge) no broad synthesis reporting these finds. Yet at each, there have been some funerary inscriptions found, which Manniez and Pellé (2011) 127 note come from cippi (likely here used as funerary markers). For example, in an 1825 work on a prison discovered 20 such cippi were found. Pellé (2015) suggests that funerary inscriptions were a small portion of the reused blocks in the wall (which he thinks mostly came from a circus monument), but he does not try to quantify his claim.

Of preservation or visibility, at all currently-known sections, blocks were cut and/or turned inward, so as to disguise their reuse. They were found in foundations and further up the wall (Manniez and Pellé (2011) 126).

Of dating, Heijmans (2020) 58 notes "in Nîmes, the existence of a wall from Late Antiquity was revealed in 1975. It followed, at a distance of about 55 m, the curvature of the amphitheatre. Entirely built in *spolia*, much of which was inscribed, the wall was recognised over a length of more than 40 m, and must, on the south side, have stopped against the Augustan wall". Pellé (2015) has speculated that these blocks come from a single monument, perhaps a circus that was located directly south of the Augustan precinct. Recent observations seem to indicate that this section of late antique wall terminated at the amphitheatre, rather than running around it (Manniez and Pellé (2011)). However, the relationship between this section of wall and other sections – including the early imperial circuit, which was at least partly standing in late antiquity – is not fully clear, so no comprehensive picture of the late fortifications is currently possible. Nevertheless, the section discovered in 1975 might be identified with the wall mentioned by Julian of Toledo (*Historia Wambae regis*, 18) in his discussion of when the Visigoths tried in 673 to seize the amphitheatre, which was then surrounded by a powerful wall. I have proposed a date in the 5th c. for the construction of this stretch, at least, which seems to be confirmed by the discovery of a shard of DSP in a joint (Manniez and Pellé (2011) 139). Admittedly, this is only a *terminus post quem*, but for lack of other later elements, it must be taken into account. The sherd is a Rigoir type 1 (DSP dish 1 A to C from Lattara 6), with a datation of 400–500 [DCAMNO]. It was found wedged between two large blocks (S and T in Manniez and Pellé (2011)), more under one than the other. It was discovered in rescue excavations in 2009 beneath the Palais du Justice, north of the ancient amphitheatre. Regional development for Gaul suggests a date before 425, after which independently dated building work on fortifications is not known.

Dating summary: range 400–425, midpoint 412.5, class Cs7 (TPQ ceramics), z (regional development), publication 3/3.

Part 2: Italy

Douglas Underwood and Luke Lavan
05ITA Milan (phase 1)

Bibliography: Johnson S. (1983) *Late Roman Fortifications* (London 1983) 121; Humphrey J. (1986) *Roman Circuses: Arenas for Chariot Racing* (London 1986) 613–20; Bolla M. (1988) *Le necropoli romane di Milano* («RASMI», suppl. V) (Milan 1988); Ceresa Mori A. (1990) "Le mura", in *Milano capitale dell'imperio romano 286–402 d.c.*, ed. G. Sena Chiesa (Milan 1990), 98; Ceresa Mori A. (1993) "Le mura massimianee", in *Mura delle città romane in Lombardia*, Atti del Convegno (Como, 23–24 marzo 1990) (Como 1993) 13–36; Ceresa Mori A. and Sartori A. (1997) "Le mura e le terme", in *La città e la sua memoria*, edd. M. Rizzi, C. Pasini and M. P. Rossignani (Milan 1997) 28–32; David M. (2001) "Le difese di una 'capitale'. Lettura stratigrafica di un tratto della cerchia muraria milanese di età romana", in *Per Terram Modoëtae: Scritti offerti a Guiseppe Colombo*, ed. R. Cassanelli (Milan 2001); Ceresa Mori A. (2005) "Le mura romane: alcuni problem", in *Milano città fortificata, vent'anni dopo*, Atti del Convegno (Quaderni del Castello Sforzesco 5) (Milan 2005) 10–27 (not seen); Christie N. (2006) *From Constantine to Charlemagne: An Archaeology of Italy, AD 300–800* (Aldershot 2006) 321; Barnes T. D. (1982) *The New Empire of Diocletian and Constantine* (Cambridge Mass. 1982).

Discussion of site: These walls were very extensive, enclosing the full Early Imperial city. They are exceptionally difficult to study because of limited excavation and extensive rebuilding over the centuries which means that reused material cannot be confirmed as being *in situ* although its general location within or by the wall circuit is significant.

Of incorporated buildings, none are known in the first phase.

Of *spolia*, the skin of the wall was constructed primarily in *opus quadratum*, largely composed of *spolia*, although little of this has survived. The stone seems to have come largely from cemeteries and public

monuments, throughout its course: Ceresa Mori and Sartori (1997) 28–29. The facing and fill of the walls includes cippi, altars, columns, friezes, and sculptures. At least one necropolis has been identified as being likely dismantled during the construction of the walls, and some fragments of tombs [taken here to mean funerary buildings/mausolea] have been found (on the necropolis: Bolla (1988) 11–14). From via delle Ore was found a block of the amphitheatre that is believed to come from the walls: Ceresa Mori and Sartori (1997) 28–29. However, this is not very helpful without more description as the junction between the first and the second phase of the walls occurs at this point.

Of preservation or visibility, unknown, as no *spolia* has been found *in situ*.

Of phasing, the phasing of these walls is confused, with a second phase suggested for the circus and the area round the Herculean Baths, both of which break the area around the baths. See also below for this.

Of dating, Johnson says walls were in place before it was besieged in 268 [taken from Aurelius Victor *de Caesaribus* 33.2], and then rebuilt again under Diocletian, but provides no further evidence. Christie suggests they were built under Maximianus, but notes, citing Mori (1990), that archaeological evidence is awaited. The residence of Maximian from 293–305 (based on laws of the *Cod. Iust.* and other sources) provides a tempting context: Barnes (1982) 56–60. Dey (2011) 124 suggests the walls were built *ca.* 300 and supplemented and extended the earlier walls. David (2001) 23 thinks that there may be two phases – a tetrarchic phase and a slightly later (possibly Constantinian) one, distinguishable by different kinds of towers, square vs polygonal, on which see below. There have been no stratigraphic investigations to date either. Elsewhere, Ceresa Mori (1990) 29 notes that Aurelius Victor, *de Caesaribus* 39.45 says that Milan was given new walls in the time of Diocletian and Maximian; *Veterrimae religiones castissime curatae, ac mirum in modum novis adhuc cultisque pulchre moenibus Romana culmina et ceterae urbes ornatae, maxime Carthago, Mediolanum, Nicomedia*. However, this text does not tie city walls specifically to Milan. Finally, Ceresa Mori (1993) 23 states that reused materials in a tower at Via del Lauro 7 date from the Augustan to Severan period.

Overall, the dating evidence we have is quite weak, and the range of scholarly opinion reflects lack of access to high quality evidence. It is not clear how much if any *spolia* were found in the walls themselves, or whether it was visible, though until proved wrong we can assume that it was, providing a generic TPQ of 250. Sadly, at present the best evidence we have is the evidence of a siege in 268, which provides a suggestive TAQ. The wider speculation about the impact of Maximian is just that: speculation. It has to be ignored until further evidence is forthcoming.

Dating summary: range 250–268, midpoint 259, class Cs4 (reused material, general presence), x (historical text), publication 3/3. Poor.

05ITA Milan (phase 2)

Bibliography: David M. (2001) "Le difese di una 'capitale'. Lettura stratigrafica di un tratto della cerchia muraria milanese di età romana", in *Per Terram Modoëtae: Scritti offerti a Guiseppe Colombo*, ed. R. Cassanelli (Milan 2001); Ceresa Mori A. (2005) "Le mura romane: alcuni problem", in *Milano città fortificata, vent'anni dopo, Atti del Convegno* (Quaderni del Castello Sforzesco 5) (Milan 2005) 10–27 (not seen).

Discussion of site: The late wall trace seems, from its line, to be extended on the West to incorporate the circus and on the East to incorporate a new part of the city containing the Herculean Baths. It is possible that there were two separate phases, far removed in time, though the circumstances of early 4th c. imperial power, in which both of these two monuments were important, suggests that they were of the same phase. However, only the eastern extension, which is best dated, seems to include *spolia*.

Of incorporated buildings, the circus is taken in by the poorly dated western extension, whereas no buildings seem to be incorporated by the eastern extension.

Of *spolia*, the western extension does not seem to contain any *spolia*, at least as far as the photos and drawings in David (2001). The new skin of the eastern extension wall was constructed primarily in *opus quadratum*, largely composed of *spolia*.

Of phasing, David (2001) 23 with pers. comm. points out that the circus section contains polygonal towers whereas the excavations of Santa Maria Aurona, at the Monte di Pieta in the eastern extension found a square tower, along with much *spolia*.

Of dating: There is nothing to date the western section, other than it should be later than the first phase and that it might vaguely be related to the tetrarchic or late 4th c. use of the city as an imperial capital. The eastern section was built likely under the tetrarchy. Ausonius *Ordo urbium nobilium* 7 says the Herculean Baths gave their name to a *regio* of the city, writing in the time of Gratian (375–383). From Ausonius' description, a tetrarchic date is credible, as he selects this region of the city alone for mention, after describing a catalogue of prestigious imperial attributes, such as the

palace, the circus, and the mint. He is clearly describing a most favoured quarter of Milan, thus very likely one added or monumentalised recently, as a result of hosting the court, as in other expanding imperial capitals: Ravenna, Constantinople, and Antioch. Furthermore, in the eastern section, which David (2000) 23 thinks is Constantinian, a fragment of a tetrarchic monument was found reused in the walls. The statue base, for Maxmian as Augustus, is CIL V 5807/8 [LSA 1604], found in the excavation at Santa Maria d'Aurona, was reused in the walls. Ceresa Mori (1993) 23 notes that this base, found in 1868, was not particularly well-recorded and that it is not clear from the reports whether it was found in the walls or in a slightly later building adjacent to it. However, the simplest assumption in the absence of other evidence is that it is from the walls.

Overall, the wider association of these walls with the Herculean Baths, protecting a quarter specifically praised by Ausonius, suggest that it was indeed constructed after Maximian established his residence in the city as noted above, from AD 293. The fact that it was a prestigious quarter in the time of Gratian suggests that it was also protected with a wall sometime before 383. We can use the statue base as supportive evidence but do not need to rely on it. The statue base provides a reasonable supportive TPQ of 286, when Maximian became Augustus, if we needed it. We have no details on the distinct nature of this city wall section, in terms of its *spolia* use.

Dating summary: range 293–383, midpoint 338, class x (historical text), Cs7 (TPQ inscription), publication 3/3.

05ITA Verona (late antique phase 1)

Bibliography: Cavalieri Manasse G. and Hudson J. (1999) "Nuovi dati sulle fortificazioni di Verona (III–XI secolo)", in *Le fortificazioni del garda e I sistemi di difesa dell'Italia settentrionale tra tardo antico e alto medioevo*, ed. G. P. Brogiolo (Mantova 1999) 75–83; Christie N. (2006) *From Constantine to Charlemagne: An Archaeology of Italy, AD 300–800* (Aldershot 2006) 322.

Discussion of site: There are at least three phases of walls at Verona – a Republican-era fortification, which was altered and extended to include the amphitheatre in the 3rd c. (considered here); and a later wall (which is considered below).

Of incorporated buildings, there is an amphitheatre incorporated into the fortification, but a theatre on the far shore was left outside the walls.

Of *spolia*, this phase of the wall was composed mostly of *spolia*, from a variety of source material: "travertine blocks and architectural pieces including columns, occasional funerary epitaphs, and brick" (Christie (2006) 322).

Of preservation or visibility, reuse is visible from the mismatched blocks, as well as visible *spolia* in the walls: "Gallienus' wall comprises a visually haphazard and crude effort, incorporating much *spolia*" (Christie (2006) 322).

Of dating, the extension of the Republican wall is dated by an inscription on a gateway noting Gallienus: "*muri Veronensium fabricate iubente sanctissimo Gallieno*" (CIL V 3329).

Dating summary: range 253–268, midpoint 260.5, Cs6 (absolute, inscription), publication 3/3.

05ITA Verona (late antique phase 2)

Bibliography: Cavalieri Manasse G. (1993) "Le Mura Teodoriciane di Verona", in *Teodorico il Grande e i suoi Goti in Italia a. 454–526 d.C.*, ed. A. Giovanditto (Novara 1993) 633–51 (not seen); Cavalieri Manasse G. and Hudson J. (1999) "Nuovi dati sulle fortificazioni di Verona (III–XI secolo)", in *Le fortificazioni del garda e I sistemi di difesa dell'Italia settentrionale tra tardo antico e alto medioevo*, ed. G. P. Brogiolo (Mantova 1999), 75–83; Christie N. (2006) *From Constantine to Charlemagne: An Archaeology of Italy, AD 300–800* (Aldershot 2006).

Discussion of site: A new wall followed more-or-less the same course as the earlier one, but at a distance of about 10 m. It does not seem to have been built by Theodoric, as textual sources claim, but only a later now-lost phase or repair perhaps being that of Theodoric.

Of incorporated buildings, there are technically none, although the amphitheatre was incorporated into the 3rd c. walls.

Of *spolia*, there are architectural and inscribed blocks.

Of preservation or visibility, Cavalieri Manasse and Hudson (1999) 87 point out that the later walls were notable for the use of blocks mostly turned inward to hide their reuse.

Of dating, there were some works on the existing walls in the 5th c. (e.g. triangular tower projections and lesser gate blockings (Cavaliere Manasse (1993) 633–35). There is considerable *spolia* here, but it is unclear whether any of it can provide a TPQ. Dating for this work is literary: *Anon. Val.* 12.71, records Theoderic having built new walls: '*Muros alios novos circuit civitatem*.' Archaeologically, datable material in these walls is 4th–5th c. (Hayes 50 [350–400 E. Vaccaro pers. comm], 61B [400–500 Bon], Keay 25 [considered an error form by Bon p. 445 but with replacements in the range of 300–450 in Bon] and C variant amphora [considered an error form by Bon p. 445]) (Manasse and Hudson (1999) 80–81), or in a bath just west of the new wall, which had sealed construction deposits containing pottery: Hayes ARS 50 [350–400, as above], 52 [*ca.* 280–400 LRP], 53A

[*ca.* 350–430+ LRP], 58B [*ca.* 290/300–375 LRP], 73A [420–75 E. Vaccaro pers. comm.]. This latter deposit provides a contextual date for the construction of the walls, based on 25 years after the start date of the latest ceramic, so 420–45. The ceramics are a better criterion to rely on than the text, which might imply a repair that has been exaggerated by the literary sources. Thus, the date suggested by the ceramics should be followed in preference to a Theoderican date in the late 5th to early 6th c., which has to be disregarded as it gives a different range. Under the rules of this study the literary sources, popular as they may be, cannot be allowed to trump stratigraphic archaeology.

Dating summary: range 420–45, midpoint 432.5, class Cs9 (contextual, ceramics, for TAQ), Cs7 (TPQ pottery), publication 3/3. Exemplary.

05ITA Aquileia (wall M2)

Bibliography: Buora M. (1988) "Le mura medievali di Aquileia", *Antichità Altoadriatiche* (= *Aquileia e le Venezie nell'alto medioevo*), 32 (1988) 335–62; Christie N. (2006) *From Constantine to Charlemagne: An Archaeology of Italy, AD 300–800* (Aldershot 2006) 292. Bonetto J. (2005) "Difendere Aquileia, città di frontiera" in *Antichità Altoadriatiche* 59 (2004) (*Aquileia dalle origini alla costituzione del ducato longobardo. Topografia – Urbanistica – Edilizia pubblica*) (Trieste 2005) 151–96; Bonetto J. (2009) "Le mura", in *Moenibus et portu celeberrima. Aquileia: storia di una città*, edd. F. Ghedini, M. Novello and M. Bueno (Rome 2009) 83–92; Villa L. (2004) "Aquileia tra Goti, Bizantini e Longobardi: spunti per un'analisi delle trasformazioni urbane nella transizione fra Tarda Antichità e Alto Medioevo", in *Antichità Altoadriatiche* 59 (2004) (*Aquileia dalle origini alla costituzione del ducato longobardo. Topografia – Urbanistica – Edilizia pubblica*) 561–632; Maselli Scotti F. (2002a) "Riflessioni sull'urbanistica di Aquileia", in *Roma sul Danubio: da Aquileia a Carnuntum lungo la via dell'ambra* (Cataloghi e monografie archeologiche dei Civici musei di Udine 6) (2002a) 57–60; Maselli Scotti F. (2002b) "Notiziario archeologico. Aquileia, ampliamento del cimitero verso settentrione. Scavi 1999–2002", *Aquileia Nostra* 73 (2002b) 678–91; Brusin G. (1934) *Gli scavi di Aquileia un quadriennio di attività dell'Associazione Nazionale di Aquileia (1929–1933)* (Udine 1934) 83–84; Brusin G. (1943–1944) "Scavo di mura di difesa d'età imperial", *Aquileia Nostra* 14–15 (1943–1944) 7–40; Brusin G. (1957a) "Gli scavi archeologici di Aquileia nell'anno 1954", *Aquileia Nostra* 28 (1957a) 5–18; Brusin G. (1966) "Le difese della romana Aquileia e la loro cronologia", in *Corolla Memoriae Erich Swoboda dedicata* (Roemische Forschungen in Neideroesterreich 5) (Graz 1966) 84–94;

Barnes T. D. (1982) *The New Empire of Diocletian and Constantine* (Cambridge Mass. 1982); Nixon C. E. V., Rodgers B. S. and Mynors R. A. B. edd. and transl. (1994) *In Praise of Later Roman Emperors: The Panegyrici Latini: Introduction, Translation, and Historical Commentary* (Berkeley 1994); Villa L. and Tiussi C. (2017) "Aquileia in età tetrarchica e costantiniana. Trasformazioni urbanistiche e monumentali nel settore occidentale", *Aquileia Nostra* 88 (2017) 91–146.

Discussion of site: The phasing of fortifications at Aquileia is complex (3 phases, at a minimum, possibly as many as 5), and contested. In the first late antique phase (normally called M2), the circus wall was fortified with a few towers. This is assumed to be the same phase as that on the eastern side of the city, near the river and canals, which is also late. The first late antique wall has been recognised in three sections: by the fluvial port, by the amphitheatre, and in the NW corner/W side of the city beyond the circus.

Of building technique, discussions of the walls of Aquileia can sometimes merge together different wall sections, which is not helpful given the complexity of the phasing. The best description I have so far been able to access is that of Bonetto (2005) which distinguishes between the sections. It describes (pp. 183–84) the walling of the E side/fluvial port area which is describes as being set on piles or on the solid quay wall or on squared segmental foundation, with the re-use of architectural fragments, inscriptions, shaped bricks, brick decorations, and broken bricks, all derived from other contexts, with a difference in quality visible between the internal and external facings [quite what difference is not specified] which contain a core of stone flake, bricks, and fragments. It describes the section in the NW corner (p. 184) as being *opus mixtum* of bricks and small stones (facings?) covering a core of rectangular sesquipedalian bricks, for which no reused material is mentioned. The section by the amphitheatre (p. 184) is described as being a double-faced structure of small blocks of stone and terracotta [sounds like *opus mixtum*], with the frequent reuse of building materials and architectural blocks, [drawing on Maselli Scotti (2002a) 59–60 (not seen)]. The primary wall is throughout between 2.6 and 3.1 m in width.

Of incorporated buildings, a circus.

Of *spolia*, the walls near the river and canals features much reused material, including inscriptions and architectural features. L. Lavan saw one column laid flat on the inside face: L Lavan site observation 2001. The walls include a marble altar dedicated to Jupiter Heliopolitanus dated to the 3rd c., two dedications (bases in AE) to a personality of the Hadrianic period

(on the western stretch of the walls): Bonetto (2005) 187, citing Brusin (1943–44) 7–38; Brusin (1957a) 11 and Brusin (1966) 90. It also includes an altar dedicated to Jupiter Optimus Maximus and to the Divus Silvanus of the beginning of the 2nd c., and a limestone dado with an inscription of the 2nd c.: Brusin (1934) 83–84 = AE (1934) 235; Brusin (1934) 91 = AE (1934) 242, all taken from Bonetto (2005) 187. See also below for of AD 211–217 and 238 found near the port. Other epigraphic *spolia* listed in Brusin and AE does not necessarily come from this part of the walls. That in AE (1934) 230–45 also includes 7 further altars and a few other inscriptions.

Of preservation or visibility, on the riverside wall, large ashlar blocks were reused in the internal and external faces of the wall, though with no decorated faces visible as far as L. Lavan could tell: L. Lavan 2001.

Of phasing, the most comprehensive discussions so far is that of Villa (2004) which describes, in the NW corner and W side of the city: he describes phases of (i) a late sequence of a new curtain wall [which is what is described here], which is then (ii) reinforced by a thickening which contains pilasters facing outward, which are also a feature of (iii) a *proteischisma*, likely added at the same time, featuring within it semi-circular towers. This outer wall is then (iv) reinforced to become the main wall, replacing that at the rear, which is demolished. Then (v) polygonal towers are added. However, no dating evidence is available to place these phases between the 4th and 6th c.: Villa (2004) esp. 568–93, esp. 592. Based on building materials, it is not certain if the riverside wall is the same phase as the western wall, although it makes strategic sense that it is. However, the identification of the amphitheatre wall section, on the W but close to the river, with intermediate building materials of both *opus mixtum* and heavy use of architectural *spolia* suggests, like the wall width and strategic logic, that we are dealing with the same wall, gradually changing in its technique.

Of dating, the various phases of fortification at Aquileia are generally only dated in relation to each other, or sometimes based on specific historic events, as in Bonetto (2005), who explores the hypotheses in detail, noting recorded sieges in 238, 351 and 361. Bonetto notes inscriptions found in the walls provide a TPQ of the reign of Caracalla, from an altar found near the port: Brusin (1934) 46 and pp. 80–83 = AE (1934) 234 [given as AD 211–217 by AE], however there is also Brusin (1934) 73 with fig. 39 = AE (1934) 230 an altar dedicated to Jupiter Optimus Maximus of AD 238 [perhaps not in the same bit of wall?]. Very weak evidence is the associative argument that the first late antique wall was constructed when the palace was built in the western section of the city in the 290s, when Maximian was resident here (in 296, in *Frag. Vat.* 313 from Barnes (1982) 59 and sometime 293–296 when the betrothal of Fausta and Constantine takes place in the palace in the city, as implied by a painting seen in the palace there: *Pan. Lat.* 7 (6) 6.1–2 (oration 7 in edn and transl. of Nixon and Rodgers, with the Latin text of Mynors (1994) 198–99). The wall might have been built any time from 293 until the end of Maximian's reign in 305. Bonetto (2009) 89 asserts that recent excavations have shown this wall to date to the beginning of the 4th c., but does not tell us what evidence does this, citing (as far as my notes tell me) Maselli Scotti (2002a) 59–60, a reference which does not check out. It is not mentioned in Villa and Tiussi (2017) 91–146. It may concern Maselli Scotti (2002b) 678–91, but this does not contain explicit archaeological evidence that would help fix such a dating. Overall, the Maxentian date, though weak, is the best available, in the absence of stratigraphic data.

Dating summary: range 293–305, midpoint 299, x (historical text), Cs3 (associative, phase of development), publication 3/3. Poor.

05ITA Aquileia (wall M3, the *proteichisma* of wall M2)

Bibliography: Bonetto J. (2004) "Difendere Aquileia, città di frontiera", in *Antichità Altoadriatiche* 59 (2004) (*Aquileia ale origini alla costituzione del ducato longobardo. Topografia – Urbanistica – Edilizia pubblica*) (Trieste 2005) 151–9; Villa L. (2004) "Aquileia tra Goti, Bizantini e Longobardi: spunti per un'analisi delle trasformazioni urbane nella transizione fra Tarda Antichità e Alto Medioevo", in *Antichità Altoadriatiche* 59 (Aquileia ale origini alla costituzione del ducato longobardo. Topografia – Urbanistica – Edilizia pubblica) (Trieste 2004) 561–632; Bonetto J. (2009) "Le mura", in *Moenibus et portu celeberrima. Aquileia: storia di una città*, edd. F. Ghedini, M. Novello and M. Bueno (Rome 2009) 83–92; Maselli Scotti F., Mandruzzato L. and Mezzi M. R. (1995) "Foro Romano. Scavo 1995", *Aquileia Nostra* 66 (1995) 189–222; Maselli Scotti F. (1997) "Foro ovest. Scavi 1997", *Aquileia Nostra* 68 (1997) 361–62; Maselli Scotti F. (2001) "Aquileia, foro romano, zona occidentale. Indagini 2001", *Aquileia Nostra* 72 (2001) 487–93.

Discussion of site: It runs around the outside of M2 in the southern half of the city and has been studied in two sections, one in front of the W wall, described above, and the other in front of the riverside wall. The *proteichisma* definitely extends beyond the area later covered by the zig-zag wall (which cuts it), and its own *proteichisma*, set a few metres north of it, so should not be confused by it, as is visible in Villa (2004) 575 fig. 3 (west side), and also 594 fig. 9 (east side).

Of *spolia*: I have been able to recover no details of the *spolia* content of the W wall *proteichisma*, despite

wider masonry descriptions in this area, suggesting that it had none. However, on the riverside, the wall has been described by Villa (2004) who reproduces photos (p. 599 fig. 13.2) showing that it was composed of reused material, at least in its wall facing, though which side is not clear. Some of them look broken on this photo. Villa also notes that this was not the same type of large architectural blocks found in one section of the same wall, which is aligned differently to the rest and looks secondary (photos p. 599 fig. 13.1). This wall has marble architrave block fragments from the forum [although from its alignment this might be a slightly later phase]: Villa (2004) 601–602.

Of phasing, the *proteichisma* of the W side of the city clearly belongs with the secondary reinforcement of that wall, as both share pilasters, for which see above. Elsewhere, one can only note that it is likely to be later than M3 due to its functional and topographic dependence on it, especially given that it was a slighter construction.

Of dating, should be after the Maxentian walls, given it secondary relationship to and change of design from the first phase in the W side of the fortification. Further, the antemural reuses an architrave lintel inscription in honour of Valentinian II, Theodosius, and Arcadius of 382–392: Villa (2004) 601 citing Brusin (1934) 67 = AE (1934) no. 236. The marble architrave blocks in the structure extending the antemural are believed to have been spoliated from the forum in the last quarter of the 5th to 6th c. Similar blocks are found there with stone fragments that seem likely to relate to a spoliation event, covered by marshy deposits between the western staircase and the platea, laid down in a period between the last quarter of the 5th to 6th c. Villa (2004) 601–602 drawing on Maselli Scotti, Mandruzzato and Mezzi (1995) 189–90 (not seen); Maselli Scotti (1997) 361–62; Maselli Scotti (2001) 488–90 (not seen). This extension of the wall does not have to be the same phase as the wall of course – but it does seem to give a TAQ for the main phase of the *proteichisma*. I have not been able to discover what finds the date of the forum spoliation depends upon. However, if it is taken as provisional, overall, the date range can be set as 293–600, which is a generic late antique date. A better TAQ is the final recorded sack of the city in 590. The burning of Aquileia is treated in Gregory, *Ep.* 2.38 (to Bishop John) (ed. Norberg) or 2.45 (MGH Ep. Vol. 1 p. 145).

Dating summary: range 293–590, midpoint 441.5, class X (historical text), Cs0 (no evidence cited), publication 1/3 (pending). Generic late antique date.

05ITA Aquileia (Zig-zag wall)

Bibliography: Jäggi C. (1989) "S. Ilario in Aquileia: eine frühchristliche Memorie in ihrem stadtbaulichen Kontext", *Aquileia Nostra* 9 (1989) 298–306; Bertacchi L. (1995) "Il foro e la basilica forense di Aquileia. Gli scavi fino al 1989", in *Aquileia e nella Cisalpina romana: Atti della XXV Settimana di studi aquileiesi, aprile 1994*, ed. Mirabella Roberti (Udine 1995) 149–52 (not seen); Groh S. (2012) "Forschungen zur Urbanistik und spätantik-byzantinischen Fortifikation von Aquileia (Italien): Bericht über die geophysikalischen prospektionen 2011", *ÖJh* 81 (2012) 67–96; Buora M. (1988) "Le mura medievali di Aquileia", *Antichità Altoadriatiche* (= *Aquileia e le Venezie nell'alto medioevo*) 32 (1988) 335–62.

Discussion of site: This is the final late antique fortification, likely Justinianic, ran across the width of the city, essentially splitting it into fortified and un-fortified halves. It has a coherent 'zig-zag' or 'saw-tooth' design throughout its length, different to anything seen on site before.

Of incorporated buildings, this final phase was built directly on top of previous buildings (it is unclear whether they were intentionally levelled, or otherwise), possibly a theatre, incorporating them into the foundations.

Of *spolia*: There is no proper published record of the wall, but photos sent to me by Groh (2015), for which I thank him, suggest that there is some generic reused stone but that there are no obvious architectural blocks, at least in the wall face.

Of preservation or visibility, no obvious *spolia* is visible, from what I can see, within the wall face, only generic stone blocks of heterogenous types and thus likely in secondary use. This site is heavily over-grown and visibility is low, so this may be an over-simplification.

Of phasing, the wall facing is of fragments of bricks and small pieces of stone of varied dimensions which look like the result of recovered material from older walls organised in relatively homogenous and regular courses, using architectural *spolia* only around the site of the civil basilica: Villa (2004) 609.

Of dating, comparanda for the unusual design of the walls (zig-zag, or saw-tooth) suggest that it belongs to a later period, perhaps that of the Justinianic reconquest from 535 onwards, which is the date preferred by a recent comparative study: Groh (2012) 91–93. Parallels suggested for the saw-tooth wall include: Thessalonica, dated by brick stamps to the 5th c., before 491; Amorium, dated to sometime 487–512, based on dendrochronology (see gazetteer on the East). Buora (1988) 346 suggests it dates from the time of Narses, though we have no evidence for this. A TAQ is the final recorded sack of the city in 590. The burning of Aquileia is treated in Gregory, *Ep.* 2.38 (to Bishop John) (ed. Norberg) or 2.45 (MGH Ep. Vol. 1 p. 145).

Dating summary: range 535–590, midpoint 562.5, class Cs1 (architectural parallels), publication 3/3.

05ITA Aquileia (?*proteichisma* of Zig-zag wall)

Bibliography: Buora M. (1988) "Le mura medievali di Aquileia", *Antichità Altoadriatiche* (= *Aquileia e le Venezie nell'alto medioevo*) 32 (1988) 335–62; Jäggi C. (1989) "S. Ilario in Aquileia: eine frühchristliche Memorie in ihrem stadtbaulichen Kontext", *Aquileia Nostra* 9 (1989) 298–306; Christie N. (2006) *From Constantine to Charlemagne: An Archaeology of Italy, AD 300–800* (Aldershot 2006); Bonetto J. (2005) "Difendere Aquileia, città di frontiera", in *Antichità Altoadriatiche* 59 (2004) (*Aquileia dalle origini alla costituzione del ducato longobardo. Topografia – Urbanistica – Edilizia pubblica*) (Trieste 2005) 151–96; Groh S. (2012) "Forschungen zur Urbanistik und spätantik-byzantinischen Fortifikation von Aquileia (Italien): Bericht über die geophysikalischen prospektionen 2011", *ÖJh* 81 (2012) 67–96; Villa L. (2004) "Aquileia tra Goti, Bizantini e Longobardi: spunti per un'analisi delle trasformazioni urbane nella transizione fra Tarda Antichità e Alto Medioevo", in *Antichità Altoadriatiche* 59 (2004) (*Aquileia dalle origini alla costituzione del ducato longobardo. Topografia – Urbanistica – Edilizia pubblica*) (Trieste 2004) 561–632; Lopreato P. (1980) "Aquileia: lo scavo a S-O del foro romano. Gli ambienti tardo antichi e la basilica forense. Relazione delle campagne di scavo 1977–1979", *Aquileia Nostra* 51 (1980) 21–54; Brusin G. (1934) *Gli scavi di Aquileia un quadriennio di attività dell'Associazione Nazionale di Aquileia* (1929–1933) (Udine 1934); Bertacchi L. (2003) *Nuovo pianta archeologica di Aquileia* (Udine 2003); Giacca I. (1980) "Monete rinvenute nello scavo degli ambienti tardo-romani e della basilica forense a sudovest del foro romano di Aquileia", *Aquileia Nostra* 51 (1980) 153–68; Ward-Perkins B. (1984) *From Classical Antiquity to the Early Middle Ages. Urban Public Building in Northern and Central Italy AD 300–850* (Oxford 1984); Brusin J. B. (1991) *Inscriptiones Aquileiae*, vol. 1 (Udine 1991); Zaccaria C. (2017) "Il consularis Venetiae et Histriae Valerius Adelfius Bassus e il rinnovamento edilizio ad Aquileia in età teodosiana", in *Colonie e municipi nell'era digitale. Documentazione epigrafica per la conoscenza delle città antiche. Atti del Convegno di studi (Macerata, 10–12 dicembre 2015)*, edd. S. Antolini, S. M. Marengo and G. Paci (Rome 2017) 635–53; Bernier A. (2022) "PRRET 69", in *PPRET Inscriptions. Inscriptions pertaining to the Praetorian Prefects from 284 to 395 AD*, ed. P. Porena (2022) http://ppret-inscriptions.huma-num.fr/en/inscriptions/ppret69.html.

Discussion of site: This wall cuts across the middle of the city, in front of the zig-zag wall. It seems very likely to be part of the zig zag wall system but because of previous doubts about it, I am listing it separately here.

Of incorporated buildings, there are none.

Of *spolia*, Villa (2004) 607 notes that the wall (measuring 2.3 m wide) features *spolia* derived from the civil basilica where it crosses the ruined basilica and also in its eastern parts where reaches the port basin, drawing on Lopreato (1980) 50–52 (not seen). I know nothing of the visibility of this *spolia*.

Of phasing, Christie (2006) 292 describes the *spolia* from the river-side wall and the first (i.e. the straight) wall dividing the city in two, passing through the forum, as if the walls are of the same phase. However, the straight wall passing the forum edge is considered in other publications to be of a different phase, from its position being perfect for an antemural (*proteichisma*) of the zig zag wall below: Villa (2004) 566 fig. 1, 606–609, drawing on Brusin (1934) (not seen) and Bertacchi (2003) (not seen). Villa notes that this zig zag wall to the south only used architectural *spolia* when it crossed the area of the civil basilica, which suggests therefore that the two walls might have made use of a single *spolia* event, given the concentration here of *spolia* in the straight wall. He also notes that evidence for the 5th c. occupation of the area of the city beyond this wall does not suggest it was the boundary at this time, although this is a weak argument: Villa (2004) 607.

Of dating, the evidence is varied but not convincing. Firstly, this wall excludes the forum from the city, so we can use some of the dating summarised in Lavan *Public Space* vol. 2. p. 923. The forum was abandoned 379–404, according to the following evidence: (i) The fire destruction of the forum basilica produced burnt coins, including four of Valentinian II [375–392], one of Gratian [367–383], and one of 'Theodosius' [379–395 if this is Theodosius I, which is likely as Theodosius II was an eastern Augustus]: Giacca (1980) 164 and Lopreato (1980) 50 n. 14. N.B. the only later coin is of Valentinian III, but is from a post-destruction wall. This wall seems (from my reading of texts I could obtain) to be the city wall. It seems to come from a level associated with the reuse of architectural fragments within the wall but on its own can only provide a TPQ, following Villa (2004) 607.

Secondly, it has been suggested that a partial inscription found incorporated into a medieval bell tower might be related to the works. It records "a likely emperor (*Theodo* …) and praetorian prefect Hilarianus in charge of restoration of works and walls (*muros*) – probably the city walls (see Ward-Perkins (1984) 46, n. 39 on *muri* and *moenia*); the prefect is plausibly identified with Hesperius Hilarianus, son of the poet senator Ausonius

and in office in Gaul and Italy in the 380s, and so some scholars suggest the work was ordered by Theodosius the Great, perhaps in the wake of the defeat at Adrianople." (Christie (2006) 292). However, the inscription is out of context and could relate to a lost restoration of the circuit of the time of Maximian: Brusin (1991) 206, nr. 0451, photo 5 = EDR117562 listing other editions. See most recently the article of Zaccaria (2017) 647–50 and Bernier (2022) http://ppret-inscriptions.huma-num.fr/en/inscriptions/ppret69.html. It is dubious to associate the inscription with the wall, as it is not clearly recorded as being in a display context.

Overall, it seems that the wall is best associated with the zig-zag wall in a single development, on the grounds of position and of *spolia* use. The zig-zag wall would most likely have reused the line of this wall if it really was later than it, as a major construction would not normally chose to respect a minor structure in this way but would redefine the logic of the site by incorporating it or cutting across it. Therefore, the dating evidence of the zig zag wall, see above, is used to produce the date of this wall here, drawing on architectural parallels, placing it between the arrival of Justinian's armies in 535 and the sack of the city in 590. A detailed study of the *spolia* is obviously needed.

Dating summary: range 535–590, midpoint 562.5, class Cs1 (architectural parallels), publication 3/3.

06ITS Rome (late antique phase 1: Aurelian)

Bibliography: Richmond I. A. (1930) *The City Wall of Imperial Rome: An Account of its Architectural Development from Aurelian to Narses* (Oxford 1930), 11ff; Dey H. (2011) *The Aurelian Wall and the Fashioning of Imperial Rome* (Cambridge 2011), esp. 79; Heres T. L. (1982) *Paries. A Proposal for a Dating System of Late-Antique Masonry Structures in Rome and Ostia, A.D. 235–600* (Amsterdam 1982); Lanciani R. (1880) *Il sepolcro di C. Sulpicio Platorino. Estratto dalle Notizie degli scavi* (Rome 1880).

Discussion of site: These walls are an extensive circuit covering the vast majority of the Early Imperial city, excluding only monuments that were intentionally suburban. It has many phases but the primary build is what is described here.

Of incorporated buildings, there are two aqueducts, two arches, two *castella aquae*, amphitheatre, *castra praetoria* fort, tomb Pyramid of Cestius; Tomb of Eurysaces. Most major public monuments in Rome were situated closer to the centre, so few incorporated into the walls, beyond the Amphiteatrum Castrense, and possibly the nearby Circus Varianus. Mostly, the walls ran closer to the fringes of the city, so more funerary monuments incorporated: i.e. Pyramid of Cestius; Tomb of Eurysaces (well preserved in its southern, western, and northern faces, while the eastern face was completely shorn off at the time of its incorporation, to allow it to be contoured to the planned tower around Porta Maggiore, where both the *Via Praenestina* and the *Via Labicana* entered the city, which was the site of a major Republican and Imperial necropolis). Along a tract of wall approximately 1.5 km in length, between the Amphitheatrum Castrense and Porta Tiburtina, the remains of at least 17 individual incorporated structures were observed. These include entertainment buildings, like the aforementioned amphitheatre, which was bricked-up and converted into a bastion, and the Circus Varianus, which was bisected by the walls. In both these cases, the incorporated structures were altered in such a way that they were no longer able to function as they were originally intended. The majority of incorporated structures are related to Rome's water supply, as the area around the Esquiline Hill was the point of entry for the Aqua Claudia, Aqua Anio-Novus, Aqua Neroniana, and Aqua Marcia-Tepula-Julia. Two water *castelli* can be definitively observed, incorporated as towers or bastions, and two monumental arches which carried aqueducts over the major roads and became city gates (the Claudian arch at Porta Maggiore and an Augustan arch at Porta Tiburtina).

Of *spolia*, a large portion of the brickwork was recycled from earlier Hadrianic structures, while the concrete aggregate utilized larger pieces of decorative masonry and sculpture (Heres (1982) 20).

Of preservation or visibility, there is no visible *spolia* – excepting the incorporated buildings, some of which were quite visible, others (like the Tomb of Eurysaces), less so.

Of dating, <u>Literary</u>: Aurelius Victor, *De Caes*. 35.7: His tot tantisque prospere gestis fanum Romae Soli magnificum constituit donariis ornans opulentis, ac ne unquam, quae per Gallienum evenerant, acciderent, muris urbem quam validissimis laxiore ambitu circumsaepsit; *Epit. de Caes*. 35.6: Hic muris validioribus et laxioribus urbem saepsit; Chron. anno 354 (VZ 1, 278): Hic muro urbem cinxit, templum Solis et castra in campo Agrippae dedicavit; HA *Aur*. 21, 9: cum videret posse fieri, ut aliquid tale iterum, quale sub Gallieno evenerat, proveniret, adhibito consilio senatus muros urbis Romae dilatavit. Nec tamen pomerio addidit eo tempore sed postea; 39, 2: Muros urbis Romae sic ampliavit, ut quinquaginta prope milia murorum eius ambitus teneant. <u>Archaeological</u>: Lead pipes from first half of 3rd c. in Domus Lateranorum and the Sessorian Palace, which the walls go over, provide a TPQ. On the right bank of the river in Trastevere, the wall

bisected the *cellae vinariae nova et arruntiana*, a double portico erected at the beginning of the 2nd c., providing another TPQ. The remains on the inside of the walls were flattened and covered with new houses at the end of the 3rd c., while the section lying outside was apparently never again inhabited, providing an associative TAQ: Lanciani (1880) 127ff, esp. 128, a report which does not reveal what the basis of the dating of the houses is, although building style seems likely from the rest of the text; Richmond (1930) 17–18; Dey (2011) 173.

Overall, the Aurelian wall is primarily textually dated (Dey notes that all primary sources agree on a date under Aurelian) and archaeological sources support this dating, but provide no further precision or details.

Dating summary: range 271–282 (Aurelian), midpoint 276.5, class x (historical text), Cs3 (associative, building phase), publication 3/3.

06ITS Rome (late antique phase 3: Honorian)

Bibliography: Richmond I. A. (1930) *The City Wall of Imperial Rome: An Account of its Architectural Development from Aurelian to Narses* (Oxford 1930), 11ff; Dey H. (2011) *The Aurelian Wall and the Fashioning of Imperial Rome* (Cambridge 2011); Visconti C. L. and Vespignani V. (1880) "Delle scoperte avvenute per la demolizione delle torri della porta Flaminia", *Bullettino della Commissione Archeologica Comunale di Roma* (1880) 174–88.

Discussion of site: This is a heightening of the entire curtain (*ca.* 7 m above Aurelianic parapets), as well as the addition of a new storey on the towers and embellishing of the gates. The renovations covered the gates with travertine facing, composed entirely of spoliated block. Porta Tiburtina, east of Porta Maggiore, preserves this Honorian curtain in its entirety (Fig. 10).

Of preservation or visibility, blocks are clearly recut and fit together in a jigsaw-like fashion, with only cursory attention to regular coursing. At least one ashlar features a clear funerary inscription from the tomb of Ofillius, though this is fragmentary and upside-down. Traces of earlier inscriptions can be seen on a number of blocks of the Honorian dedication, which were evidently dressed down prior to being re-inscribed, though not deep enough to completely erase the earlier lettering. Overall conclusions are limited: much of this material was damaged when it was recovered from the walls or from the medieval tower of Sixtus IV, where a good amount of Roman stone was recovered.

Of *spolia*, tomb *spolia* can be seen in the marble facing of the Porta Tiburtina, embellished during the reign of Honorius. During the demolition of the Porta Flaminia, the blocks used in its facing (including architraves, cornices, friezes, bases) were found to come from funerary buildings [i.e. mausolea] of the Early Empire, which the few inscriptions recovered (parts of texts from monuments rather than stelae) also suggest; see Visconti and Vespignani (1880) 174–88, esp. 174; Quintus Haterius at the Porta Nomentana (curtain D1–2) and Sulpicius Maximus in the east tower of the Porta Salaria. Dey (2011) n. 55 suggests the blocks from the Porta Flaminia were used as facing; the *BullCom* report notes that some or most of the material was not *in situ*, so it is unclear how Dey has reached this conclusion. Nothing is stated in the report about whether the reused tomb material was faced inwards or outwards or reworked, other than the above-noted damage.

Of dating, at the Porta Portuensis, Porta Praenestina/Labicana, and Porta Tiburtina, statues (*simulcra*) of Arcadius and Honorius were erected by Urban Prefect Fl. Macrobius Longinianus (PLRE 2.686–687 Longinianus, in office AD 401–402), before Theodosius II was made Augustus in 402, according to the gate inscriptions: CIL 6.1188–1190 = CIL 6.31257 = ILS 797. Reference derived from Stichel no. 84; LSA 1306–1308, with further references. Although the project might have taken a number of years to complete, under the rules of this study the completion date is what is used for dating, so this is likely to been have marked by the statues, giving us a date of 401–402.

Dating summary: range 401–402, midpoint 401.5, class Cs 6 (Absolute date from inscription) publication 3/3.

Spolia and Civic Memory

∴

Urban Landscapes from Architectural Reuse: Spolia, Chronology and Civic Memory in Late Antique Ephesus

Luke Lavan

Abstract

For 120 years, Austrian fieldwork at Ephesus has given us one of the most-accessible and best-presented urban environments in which to experience Late Antiquity. Current excavations are providing us with stratigraphic dates for building work, in place of earlier chronologies based on architectural style. Despite this, much of the city remains a clearance-dug site, in which far from all masonry structures have been documented. In particular, the streets, in their paving and sidewalks, have not been fully examined, and neither have all their porticoes. This article presents an archaeological case study of the use of *spolia*, tied to excavation results, seeking to trace the ruin and renewal of one city during Late Antiquity. It offers insights into the macro-phasing of the city centre and the dates of many late building works within it, including its fortification. A series of distinct late landscapes emerge: a first of monumental splendour, a second of unconventional innovation, and a third of nostalgic memory: a 'last antique' city, ending with a hurrah, not a whimper. Yet, overall, it is the preservation of buildings, rather than their demolition, which comes out strongest from the study of *spolia* contexts, a testimony to the enduring value of civic memory in Greek cities of Asia Minor.

Clearance Excavation and the Late Antique City

Ephesus is rightly world-famous as a heritage site and tourist destination.[*] It is also one of the Mediterranean's best-preserved large cities (see map, Fig. 1).[1] As a major urban centre of Late Antiquity, it has naturally been the subject of a good deal of writing on urban life in the period. Some of this might even be termed 'classic work', if one considers the syntheses of Foss and Bauer. These are widely read, by both researchers and students.[2] Ephesus is a great place to introduce people to the late antique city, whether from its complex and varied buildings, from its epigraphy, or from traces of everyday life visible in gameboards, graffiti, and wheel ruts. In recent decades, Austrian archaeological reports emanating from the city have been full of observations and insights on late antique archaeology, with careful attention to stratigraphic sequences, which now produce contextual dates from finds, using internationally recognised ceramic forms and identifying new ones. As such, the site represents a vast testing ground for field methods in Late Antiquity. Nonetheless, those who work on Ephesus today are conscious that the city has not always been excavated to high stratigraphic standards. They have been left with a heritage of 'cleared' classical spaces, from the early British excavations of Wood in the 1860s, down to as late as the 1950s–1960s. Even then, reports often focused on inscriptions and architecture.[3] Earth covering over monumental buildings was quickly stripped from large areas, creating zones that current teams are now slowly making sense of, alongside their exemplary excavations of new areas. Yet, one should not see clearance excavation on older digs as reflecting ignorance. Rather, it represented as a specific habit of excavating classical buildings in the Mediterranean, quite different from that practised in Austria, where finer methods were used. Indeed, the situation at Ephesus parallels the treatment of medieval abbeys in the UK, before the 1960s, where stratigraphy was quickly removed to create sterile parks, as architecture was the focus, in stark contrast to the careful excavations of Roman and prehistoric sites at that time.

Yet, the fact that Ephesus was excavated extensively can provide us with advantages to compensate for the speed with which this was done. We can potentially address a wider range of questions than in a city that has only been lightly sampled, especially in relation to

[*] I dedicate this paper to Clive Foss, whose book of Ephesus was one of the first I read on the late antique city. This was a great inspiration, as his many other publications have been. Clive understood the late antique city when very few other people did and worked hard to build a story from excavation reports which other historians had neglected.

[1] All photographs are mine unless stated otherwise. They were taken as tourist photos at different times from 1998 to 2013 without a scale, in public areas of the site where photography is permitted.

[2] Classic work on Ephesus: Foss (1979); Bauer (1996) 269–99. See now the strongly archaeological syntheses of Ladstätter (2018) and (2019), where she sets out a new vision of the later city, well-founded in a great array of different field methods.

[3] Excavations, 1860s: Wood (1877). Austrian street excavations from 1899 to 1950s–1960s: see the listing of reports in Waldner (2020) 21–29 for the Embolos and adjacent streets. Auinger (2009) 36–38 also reviews on the documentation of statue monuments *in situ* / nearly *in situ* by the early excavations.

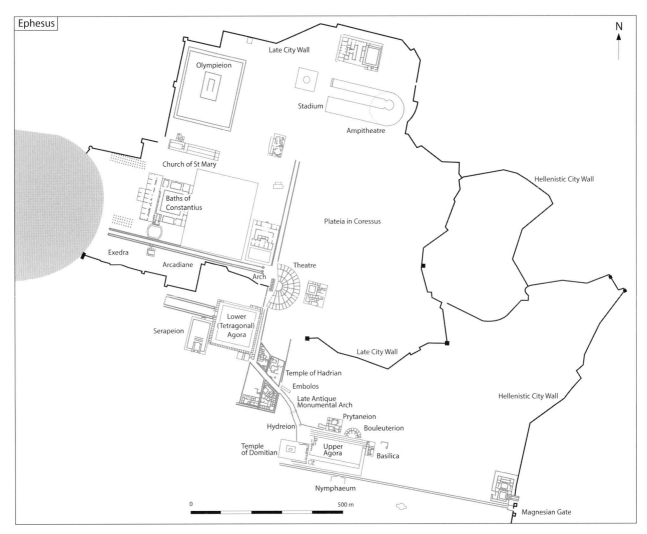

FIGURE 1 Map of Ephesus showing location of major streets and dated late building work mentioned in the text.
DRAWN BY LLOYD BOSWORTH

its public space. The presence of new excavations, often in the form of sondages, also makes it a suitable place to try methods designed to redress the damage caused by clearance excavation, such as I have attempted at Ostia. These techniques place particular emphasis on documenting fragile traces of late antique phases, often under threat from either low-resolution archaeology, modern conservation, or exposure to the elements. The work involves extensive cleaning, laser scanning, repair survey, masonry recording, and targeted excavation. It seeks to give a late history to 'secular' classical public monuments built in earlier times.[4] This is a type of field archaeology, where one does not actually dig very much. It is adapted to the professional constraints of our own times, which have seen a move away from excavation in British academia. It does, however, maintain a strong connection with stratigraphy, through targeted digs, as at Ostia, or by connecting observations to the trenches of others, as at Ephesus. This really is essential, if one is to obtain full benefit from any type of survey work. My thematic research on streets, recently published in the monograph on *Public Space in the Late Antique City*, has also drawn me to Ephesus, where this aspect of the city is well-preserved and is well-represented by a large amount of late construction activity. However, the infrastructure of the streets, of paving, porticoes, and sidewalks, have not yet been fully researched in terms of their late architectural development.[5] What I hope to demonstrate in this article is that this history

4 *Spolia* studies, Ostia: Lavan (2012); Underwood (2013); Sagalassos, Lavan (2013b).

5 For detailed discussion of all the phasing and dating suggested here, see Lavan (2020) vol. 2, with my dating methodology outlined in the introduction. This is where my main analysis of Ephesus is published, the detail of which I do not repeat here, as vol. 2 is now on open access, at https://brill.com/display/title/56088 (scroll down). I have made some revisions to take account of the monograph of Waldner (2020), from which new dating for the Lower Embolos has been important. This is summarised in an appendix to this article, along with some further observations I have made, as a result of the questions it has raised.

is accessible from a large-scale study of *spolia*, as one method to address the impact of clearance excavation on late antique sites.

The Ephesian Problem?

For some visitors, the site of Ephesus does not produce the same fascination that it does for me. Rather, it can produce as much disappointment as it does interest. There are of course highlights, such as the tetrastylon on 'the Arcadiane', or the churches of St. John and St. Mary. Yet, in comparison to Aphrodisias or Hierapolis, one can feel that something in the city is not quite right, at an aesthetic level. One crest-fallen Italian doctoral student said to me: "I didn't feel the emotion I was searching for". Indeed, looking down the Embolos, one may opine that such an important street ought really to be a little less messy.[6] The use of *spolia* is careless and ugly, to the extent that it represents almost an insult to the fine buildings from which it was taken. Late constructions, which inscriptions suggest are early 5th c. in date, are a disappointment. Here, Late Antiquity really does seem to be about decline. Students, interested in earlier periods, can be heard to mutter that "Christians ruined the classical city". It is claimed that religious fanatics, with their barbaric innovations, destroyed great temples to build miserable hovels out of *spolia*, reusing beautiful blocks in any ugly manner. Bishops and monks produced an archaeology of destruction of the memory of the classical world. To any late antique archaeologist, this is hard to stomach. "All this is unfair!", one might retort: "late antique building is just *different*!". Indeed, it is. Yet, one can lose such relativism with a visit to Bostra, Qalat Seman, or to a city in Cilicia. There, late antique architecture survives that stands aesthetic and technological comparison to the works of earlier times. Clearly, something is 'not quite right' about late antique Ephesus. But what is it, exactly?

For me, these feelings have long represented a puzzle. Did building in *spolia* represent an active assault on memory or an attempt to perpetuate it? More prosaically, how could late antique aesthetic disasters, such as the *Plateia in Coressus*, have coexisted with the mid-6th c. tetrastylon, or the 5th c. nymphaeum opposite the stadium, with its fine revetment and complex vaults? Do these differences represent a cultural choice, or a difference in status between buildings, or in the way in which they were financed? This article presents a possible solution, which focuses on understanding *spolia* archaeologically, from block to context to phase. Its primary concerns are with chronology and craft technique, rather than with modern aesthetic reactions or views suggested by ancient texts. My hypotheses are based especially on the observation of *spolia* use in the streets of the city, and in its late city wall. I must confess that I have only spent about 10 days total in Ephesus, from 1998 to 2016. Yet, in that time, I have been able to take many photos within public areas which have served as a basis for reflection when off site. Thus, I am an outsider, in that I have not so far had access to internal reports and archives. I long found the bibliography relatively difficult to access in the UK, largely because its works were kept in reference-only sections, where photocopying was limited. Only as I completed this article did open access, encouraged by OAI director Sabine Ladstätter, start to revolutionise access to Ephesian documentation. As a result, I must admit to being imperfectly informed. As such, I am happy for my argument to be levelled, demolished, and reconstructed, like a late antique *spolia* building. Therefore, I offer this text as an outline of method, which I hope might suggest future work on site.

History of Research on Buildings

The basic archaeological problem at Ephesus, as at so many clearance-excavated classical sites, is this: despite documentation of fine architecture, there has not yet been a systematic attempt to map and define less glamorous structural phases, in terms of 'buildings archaeology'. This is an English concept close to Germanic *Bauforschung* but which has grown up in the UK out of the practice of single context recording, best known from the Museum of London system.[7] It has moved from cataloguing soil layers to describing ugly and 'meaningless' lumps of masonry, using the contextual recording systems of urban archaeology. In contrast, architectural study (based often on logical systematic reasoning) is very well-advanced at Ephesus, especially for what might be termed period-architecture: the distinctive remains of Early Imperial temples or late antique churches with

6 I prefer to use the ancient name 'Embolos' for this street, suggested by an honorific inscription found on the street (LSA 726 by the lovers of the Embolos, of 5th–6th c. date). The Austrians often use *Kuretenstraße*, a name inspired by inscriptions found on reused columns of the Curetes Stoa. These columns originally came from the prytaneion, where they had been inscribed with the names of *curetes*.

7 *Archäologische Bauforschung*: https://koldewey-gesellschaft.de/bauforschung/ with some major examples published in their series. Single context recording: Roskams (2001); Museum of London (1994); Harris (1989). Applied to buildings: Hoggett (2000).

new-cut architectural elements. The architectural study of these remains is sometimes assumed to produce a building history, although, on stratigraphic inspection, things often turn out to be more complex, as they have in the Church of St. Mary.[8] Recent architectural research, especially as it has been developed by Hilke Thür and Ursula Quatember, has been very effective in picking up the traces of late antique modifications of earlier structures: for example, by detecting secondary or tertiary series of clamps.[9] But increasingly, sondages are providing the most valuable indications of chronology, on which I often rely here in suggesting the dates of phases. These have been published in stages, with the most recent coming in the detailed monograph of Alice Waldner, *Die Chronologie der Kuretenstraße* (Vienna 2020), which presents new sondages for the Curetes Stoa and part of the paving opposite.

Yet, there are large areas, especially of streets like the Arcadiane or Marble Street, where the recording of mundane masonry has not yet taken place. This includes elements which are obviously important for a 'buildings archaeologist', if less interesting for an architect. Even on the Embolos, where great progress has been made in analysing monuments, there remains a great deal to be done on the paving and porticoes. Recently, we saw the Alytarch Stoa receive a careful interdisciplinary study, complete with sondages, making it perhaps the best-published late portico in the Mediterranean.[10] But there are many other porticoes, even on this street, on which nothing has been published to date. Indeed, we might say that at Ephesus we still lack a set of arguments to build up phasing across the city on a large-scale: the site has been published as a series of monuments rather than as a city. The phasing of the streets, which might tie everything together, has been neglected, although a great deal of the history of Ephesus can be discovered within them. Along the Embolos, Waldner has tied different sondages together, to suggest an overall chronology for many aspects of the street. Nonetheless, it remains true that, even here, many late antique structures have not yet been placed in time.

Methodology: *Spolia* Analysis for Phasing

Across many sites, building phases dating from the 4th to 6th c. have not only been neglected but have also been over-simplified. Although we no longer destroy late antique buildings without record, as occurred in some places over part of the 20th c., we do tend to underestimate the complexity of the later phases of secular buildings: porticoes, street paving, shops, and so on. This typically gives us a foreshortened and wrong view of urban life in the period: we see cities through their final phases, of the late 6th or early 7th c., failing to appreciate that the late antique city had its own history, with very different subphases, with trajectories that do not all point in the same direction. The urban landscapes of the time of Julian and Theodosius were vastly different to those of Anastasius and Justinian, just as they were different to those of Tiberius II or Heraclius. In what follows here, I hope to outline a method for detecting some of this complexity, by identifying patterns of reuse, within the multi-layered archaeological sequence that the late antique remains of Ephesus present. I also suggest a provisional chronology for some undated building work at Ephesus, which, in turn permits a broad-based discussion of the urban character of the city at different moments within Late Antiquity, pertinent, in some ways, to an archaeological study of memory.

Spolia phase theories may be most useful in suggesting chronologies across sites where none exist, other than those dependent on invoking earthquakes. Of course, one should not dismiss earthquakes supported by diagnostic evidence of seismic damage and dated finds. But to invoke them more generally risks muddling chronology. This is an issue that Sabine Ladstätter has grappled with, debunking an early 7th c. seismic event, whilst identifying a late 3rd c. earthquake, from a re-evaluation of the Hanghäuser.[11] At first glance, '*spolia* phases' asserted across a city may look very similar to earthquake theories in their reasoning. They are only better in that they tie building works together with specific *spolia* characteristics, rather than setting works within a plausible site-wide sequence. The method outlined here does at least include some internal checks, derived from epigraphy and stratigraphic finds, in order to fix *spolia* theories in time, even if not every date that this article proposes is secure. The discussion that now follows is rather technical and requires some patience, being full of small structural details. However, what follows may be worth the effort, as it potentially redefines

[8] Architecture and stratigraphy, Church of St Mary: contrast the building description of Knoll (1932) with the stratigraphic analysis of Karwiese (1989) and the architectural re-analysis of Karydis (2019).

[9] Architectural studies (late repairs), Embolos: Thür (1989) and (1999b) 104–20; Quatember *et al.* (2009) 111–54; Quatember (2011); Quatember *et al.* (2017).

[10] Interdisciplinary study, Alytarch Stoa: Quatember *et al.* (2009) 111–54.

[11] Earthquakes at Ephesus, revisions: Ladstätter (2019) 15–16, 29. See also Schindel (2009) for arguments against an early 7th c. earthquake.

the chronology and nature of the public face of the one of the greatest cities of Late Antiquity.

The findings on the streets of Ephesus presented here are essentially a series of tentative structural theories based on the definition of phases, on a very large scale. These rely in part on conventional observations of context boundaries, put into a sequence of cuts and superpositions. They also rely on the study of reused building materials within such masonry contexts. As we all know, this reused material is sometimes called '*spolia*', although this Latin term, of Renaissance date, is perhaps better reserved for decorative architectural blocks, rather than ordinary stones in secondary use, which do not tell us as much. The word '*spolia*', does however, provide a more convenient term of art, so it is used here in general discussions of context rather than specific pieces. The '*spolia* observations' are quite simple and are of two kinds: (i) of how '*spolia* contexts' as a whole are constituted (i.e. what types of material occurs in different building projects), and (ii) of how builders dealt with the heterogeneity of reused material at a technological level (e.g. disguised/hidden or not; whole pieces or broken up; sorted by size or not; closely-jointed/levelled). Observations about the previous two factors are then used to make judgements on building phases, when joined to a more conventional study of context interfaces and comparative building heights. This can provide a basis for suggesting a chronology for much undated building work around the city.

In terms of definitions, a '*spolia* context' is simply any masonry context containing reused material. The study of the make-up of *spolia* contexts is little different to the study of mortar or brick in walls, except that the information is quicker to collect and can provide insights not only into chronology but also into a range of other topics, some of which I explored in a recent article.[12] The study of *spolia* contexts is especially important for secular public building work in Asia Minor, as architectural *spolia* is more frequent in these constructions in comparison to houses, almost certainly because spoliation and reuse were tightly controlled. Reference will also occasionally be made to specific *spolia* blocks that can be provenanced as coming from a particular building, which scientific analysis looks likely to improve. When this exists, it can give valuable dating evidence for both demolition and new construction in Late Antiquity. Yet, it is rare. This article mainly explores the nature of generic building in reused material, as a set of problems addressed by stone masons of the period. This is potentially an equally rich source on late antique urban development. The approach outlined here is admittedly only one of many which one can adopt in studying architectural reuse to reconstruct aspects of urban history. Some of these are explored further in this book, in relation to late fortifications, as others have done elsewhere.[13]

Dated Buildings and Reused Material in Late Antique Ephesus

Before launching into theories about *spolia* use and dating in late antique Ephesus, it is best to review well-dated late building work within the city, to see what form these constructions took. I will focus especially on secular public building, as here our documentation is best, and my suggested 'macro-phasing' relates to comparable structures. Thus, in looking at reuse, this study will work "from what we know, to what we don't know", to use a popular maxim often heard on archaeological excavations.

Fourth Century

For the 4th c., we have relatively few new structures from which we can study the building techniques that were being used.[14] Additions to the nymphaeum south of the Civic/Upper Agora are revealing. Here is a structure with repairs, associated with inscriptions of *ca.* 350. Reuse involves some recutting.[15] In this way, a statue base and a series of cornice blocks were incorporated into the renewed balustrade. These were disguised to a greater and a lesser extent. This reuse was not entirely hidden but is at least discrete. The front face of these blocks was recut to take the shape of the balustrade (Fig. 2a). Marked un-recut surfaces were confined to the rear (Fig. 2b). Other candidates for 4th c. building work at Ephesus include the rebuilding of the Temple of Hadrian, and the Exedra entrance court of the Baths of Constantius. At the Exedra, reused material is not obvious from visual inspection, although the structure does seem to be 4th c., and apparently includes some reused floor slabs.[16] The Baths themselves also have 4th c. work but again reuse is not obviously visible. Thus, in the 4th c. it seems, from the little that we know, that reuse in public monuments was tidy, with excellent sorting of reused material and/or limited disguise, where rebuilding took

12 *Spolia* methodology: Lavan (2013a).
13 *Spolia* and fortifications: Frey (2016); Lavan (forthcoming); Underwood (forthcoming); Mishkovsky (forthcoming).
14 This reflects a wider problem at Ephesus, where knowledge of the 4th c. is relatively poor, its levels being absent on many sites in the city, some of which were in ruins for a long time. On this see: Ladstaetter (2019).
15 Nymphaeum south of Upper Agora, restoration: IvE 4.1317; IvE 4.1316 = LSA 739. See also, Rouché (2009) 155–56.
16 Baths of Constantius, *exedra*: Scherrer (2000) 174–75.

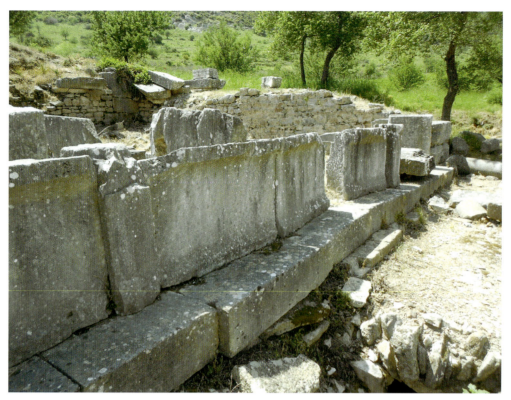

FIGURE 2A Disguise: Nymphaeum on street south of Civic Agora, new basin parapet made of re-cut reused blocks, likely mid-4th c. (front side, reuse invisible).

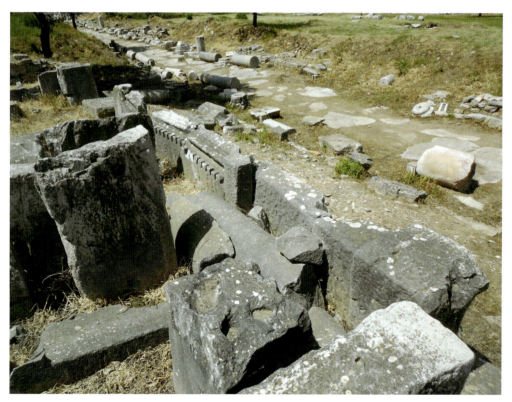

FIGURE 2B No disguise: Nymphaeum on street south of Civic Agora, new basin parapet made of re-cut reused blocks, likely mid-4th c. (back side, showing reused cornice).

place. As such, it reminds us of some 4th c. work from other regions of the Mediterranean. This has even confused Early Imperial archaeologists, causing them to attribute buildings to more 'respectable' periods, notably the first two centuries AD.

Comparanda from Elsewhere
From Africa, we have the three late fountains of Sufetula, impressive ashlar structures, of which the largest has a footprint of 12.6 × 4.6 m and an arcade height of 6.2 m. Here, there is some reuse but it is not immediately apparent. Indeed, there are many occasions where no reuse at all has been detected in 4th c. buildings in Africa.[17] Standards of civic building seem to have remained high, with new quarried material and well-disguised *spolia*, until the arrival of the Vandals, when civic building suddenly stopped rather than entering a long decline. Thus, it is often hard to separate late antique from earlier civic construction, a problem which has also been encountered in Greece. At Corinth, the triconch court of the Peirene Fountain, and its screen of columns, were long considered to be of 2nd c. date; but now they have been recognised as of the 4th or early 5th c., thanks to a close study of the masonry, which does include much reused material.[18]

Within Asia Minor, there are places where the identification of 4th c. secular building work has provoked disagreements, as at the Tetrastoon of Aphrodisias. Close observation now confirms that this whole structure dates from the 4th c.: not just its carefully reused colonnades but also its fine paving, which lacks any reused slabs,[19] Several 4th c. monuments in the Near East give the same impression. Here, a good number of 4th c. monuments have been missed, being mistakenly classified as 2nd c., as have some Umayyad secular structures, which are now starting to be dated correctly. Wolfgang Thiel credibly proposed that the tetrakionon and round plaza of Gerasa dated to the early 4th c., a hypothesis which has now been confirmed by stratigraphic excavation for an identical monument at nearby Bostra.[20] In so many places, the standard of 4th c. building looks to be amongst the highest done in Late Antiquity, being often easy to confuse with that of the Principate. Perhaps, therefore, some of the messiest colonnades found on streets and public squares of Ephesus are rather later than one might initially have supposed.

Fifth Century
Similar impressions form when we look at early 5th c. structures from Ephesus and other cities of western Asia Minor. The Stoa of the Alytarch (Fig. 3), on the Embolos, includes a lot of reused material. This is visible enough, in terms of stone colour or mismatching ornament, to remind one that one is not now in the High Empire. The stone is however usually well-sorted in terms of size and jointing. Its overall aesthetic is decidedly classical, if not in all aspects. The floor mosaic has a very diverse set of small carpets but set within a common border. Yet, there are plenty of parallels for this style, even some done at virtuoso level, in 4th c. fora/agorai, from Perge to Antioch and from Thessalonica to Cirencester, and later for streets in a few cases.[21] The standard of work is also high on adjacent early 5th c. fountains of the Embolos, as on the nymphaeum of the heroon and the nymphaeum opposite the stadium.[22] *Spolia* is used in places but so carefully as to be barely noticeable. There is also a lot of new-cut stonework, especially in decorative elements. We need not consider the 5th c. work on the Marble Street, dated by an inscription, or the Arcadiane, as here we have something very complex, as will become clear below. Thus, in the 5th c., we can talk of reused material being less well-sorted but still well-jointed, with less disguise than earlier. However, new-cut materials still occur, and the overall aesthetic effect feels very classical in its stylistic canons and proportions.

17 Sufetula, nymphaea: These buildings have been published with plans by Cèbe (1957) 163–206; Duval and Baratte (1973) 29–30 with figs. 14–15 (based on drawings in Cèbe (1972)), 74, 79–81 with figs. 49–50; Duval (1982) 612; Schmölder-Veit (2010) 118–19. For a detailed description see Lavan (2020) vol. 2 appendix H1 507–508.

18 Corinth, Peirene fountain: for a reanalysis of the late phases of this monument see, Robinson (2011) 252–65 with references to earlier literature.

19 Tetrastoon of Aphrodisias: see Lavan (2020) vol. 2 appendix K1a 612–16.

20 Tetrakionia, of Gerasa: Thiel (2002) 299–326; of Bostra: Dentzer, Dentzer-Feydy and Vallerin (2007) 265–66.

21 For the mosaic paving of the Stoa of the Alytarch see, Quatember et al. (2009) 116–18, 123–24; Miltner (1959) 282–83; Jobst (1977) 31 ff., Abb 38–50; Scherrer (2000) 122–23; Fildhuth (2010) 145–46.

22 Nymphaeum of the Heroon: Fildhuth (2010) (137–53) 141; Foss (1979) 69; Deichmann (1974) (549–70). On the dating see, Deichmann (1974) 555, 559; Thür (1999b) 118. Recent excavations around the monument have not produced stratigraphic information regarding the dating of the later phases: Waldner (2009) 283–315. See also Dorl-Klingenschmid (2001) 180–81 no. 17. Nymphaeum opposite the stadium: for reports see Vetters (1979) 127. The best account is Jobst (1986) 57–60. For a summary see Dorl-Klingenschmid (2001) 190–91 no. 28. On the dating Scherrer (2000) 118 assigns an early 5th c. date, although he gives no reasons for this. Jobst discusses his own dating of the first half of the 5th c. in detail, though there is very little to go on. Overall, the presence of the impost capitals seems to be the best grounds for dating the primary construction of the facade nymphaeum to the 5th c. onwards, plus the use of crosses as decorative motifs.

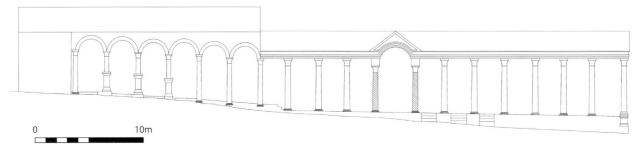

FIGURE 3 Well-sorted *spolia* columns: Alytarch Stoa, AD 410–436, on Lower Embolos.
COPYRIGHT AUSTRIAN ARCHAEOLOGICAL INSTITUTE, DIGITISED BY L. BOSWORTH

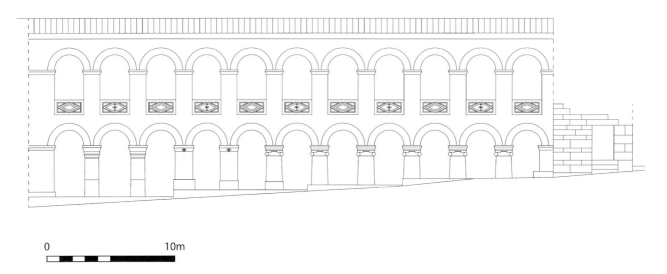

FIGURE 4 Mixed-sized *spolia* columns, well-set in an adventurous structure: Curetes Stoa, *ca.* AD 550, on Lower Embolos.
COPYRIGHT AUSTRIAN ARCHAEOLOGICAL INSTITUTE

Sixth Century

Moving forward slightly later in time, we have buildings like the Church of St. John, built around AD 500 under Anastasius and then adapted under Justinian, in the decades that followed. As late as 550, we see the Curetes Stoa on the Lower Embolos (Fig. 4) with stone elements of mainly new-cut material, alongside limited *spolia* use. One needs only to evoke the Tetrastylon on the Arcadiane (Fig. 5), dated equally to *ca.* 550, to realise the high quality of some building work done at this time.[23] Indeed, in many of the constructions from this moment, there is a surprising dip in *spolia* use and a preference for new brick in the body of buildings. New stone elements are cut for capitals and other decorative elements. Nonetheless, that reuse which does occur can be rather irregular. In the Curetes Stoa, the *spolia* is used in a way that produces some odd aesthetics in the colonnade, with columns of different width and height but within a structure that is quite pleasing and looks solidly built, in conjunction with its brick arcades, sitting on new impost capitals, carrying a great masonry superstructure above. Thus, in the first half of the 6th c., we see *spolia* use being controlled and limited but perhaps producing some non-classical features.

One must ask why so much other late public building work at Ephesus does not come close to this Justinianic standard. Why, for example, are there porticoes at on the Upper Embolos or on the *Plateia in Coressus* made entirely out of poorly matched and unrecut material, so irregular that one might imagine structural instability? Are these porticoes different to those elsewhere because they were paid with different funds? Or are they different because they are of a different date? The analysis of this article is focused on street architecture, partly

23 Curetes Stoa: Thür (1999a) 421–28; Thür (1999b) 104–20; Fildhuth (2010) 144–46; Miltner (1955) 34–44; Heberdey (1905) 76–77; Lavan (2020) vol. 2 appendix C4 294–95. On the monograms of *ca.* 550 inscribed on the Ionic capitals of the Stoa, see Thür (1999b) 112–13 with Abb. 1, 2, 14, 15, 16, 23, 24, Taf. 98, and plan 2; Fink (1981) 78. On the decree of the late 5th to 6th c. date, inscribed on one of its columns see, Feissel (1999a) 131, no. 13. Tetrastylon on the Arcadiane: Foss (1979) 57–58; Bauer (1996) 272–74; Wilberg and Heberdey (1906) 132–42; Lavan (2020) vol. 2 appendix F2 405–406. On the dating of its inscriptions, capitals, and relief carving, see below n. 56.

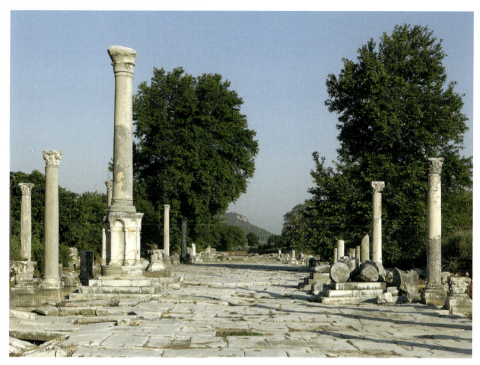

FIGURE 5 Building without *spolia*: Tetrastylon, *ca.* 550, on Arcadiane.
PHOTO: COPYRIGHT AUSTRIAN ARCHAEOLOGICAL INSTITUTE

because this is what most of my recent research has been about. However, streets provide a means of connecting phases between buildings in many districts of the city. This makes my attempts to date them of interest to the wider urban history of the metropolis.

State of the Evidence: Preservation, Restoration and Study

Before leaping into a site-wide analysis of *spolia* use, a few words of caution are needed, on the nature of the surviving evidence. The state of preservation and restoration does complicate what we can know. Late antique buildings here are already very complicated to study, with sequences of destruction and rebuilding. To that has been added the legacy of clearance excavation, which has removed soil layers and some wall phases. There is also anastylosis, which has tended to privilege the restoration of classical monuments, dating from before the 3rd c. AD. These issues might seem to represent a series of unsurmountable obstacles to scholars, especially as much early restoration is undocumented. Yet, this is not true everywhere. Some archive photos do exist of early excavations, showing the post-clearance state of the Arcadiane and the clearing of Embolos, from 1904–1905, 1954–58, and 1967 and of the post-excavation condition of the Marble Street and *Plateia in Coressus* (southern section), from 1906 and *ca.* 1906 respectively.[24] The photos, and the reports where detailed, reveal that the architectural elements of streets and porticoes were well-preserved.[25] Paving was largely found *in situ*, and columns and statue bases often lay where they fell. Some did not fall at all: those on the Marble Street and the Embolos (see Fig. 6a) were buried by a great depth of earth, the result of being at the bottom of a steep slope. Re-erection was done in a conservative manner, with odd *spolia* combinations generally being preserved as they

24 Archive photos of the Embolos are reproduced in Waldner (2020) 24–26 esp. 25 figs 3, 4a and 4b and 27 figs 5a and 5b, 145 fig. 11a, 129 fig. 29, 135 fig. 38, to which should be added archive photos A-W-OAI-N-III 0114, 0235; plus Auinger (2009) 52 fig. 24–25, and Quatember, Sokolicek and Scheibelreiter (2009) 137 figs 4, 6, 7 and 138 fig. 9. *Plateia in Coressus / Theatre Street*, southern end: A-W-OAI-N-III 0202 (date not recovered but likely first decade of 20th c., as on glass plate like photos of this date). For the Arcadiane, there are archive photos A-W-AOI-FON-00047, 00048, 00050, A-W-OAI-N-III 0088, 0095, 0230, 0231, 0241, 0242, 0243. For the Marble Street, there are archive photos A-W-OAI-N-II 0499, 0500, 0502, 0512. These archive photos are held by the Austrian Archaeological Institute, Vienna.

25 Embolos excavations: Waldner (2020) 21–29 gives a listing of all archaeological works and their excavation reports. Quatember (2005) gives an account of the excavation process, year by year, noting that the process was essentially one of 'freeing' buildings in a rapid excavation process, with quick restoration.

FIGURE 6A Architectural preservation: Upper Embolos under excavation, 1957.
COPYRIGHT AUSTRIAN ARCHAEOLOGICAL INSTITUTE, A-W-OAI-SWA-000922

were found, rather than matched with 'original' pieces. The wholesale return of spoliated columns from the 6th c. Curetes Stoa, on the Lower Embolos, to the Prytaneion on the Civic Agora, is something of an exception, not the rule. Archive photos reveal that the Arcadiane appears to have been excavated in a more ruinous state, with columns sometimes found pushed towards the centre of the street rather than sealed upright by earth, as on the Embolos. Nonetheless, the current re-erections of the colonnades here seem generally conservative and look coherent, with localised zones of *spolia* building contrasting with adjacent zones of Early Imperial survival.

For streets where photographic coverage is slim, we need not despair. Any tourist visiting Ephesus can make easy archaeological observations on what elements might be original and what is likely to be restoration. Admittedly, this is something which now comes more quickly to me than to others. At Ostia, I struggled for years with how to identify undocumented early 20th c. restoration. The pioneers of this site rebuilt walls using spare Roman bricks. This habit caused a great deal of confusion in my initial organisation of building phases, until I developed an eye for spotting this work.

At Ephesus, the most obvious way to detect original street material is to look for badly broken slabs, of many fragments, that have been left *in situ*. If these had been re-laid, the chances are that they would have been discarded or rather heavily mortared. Another trick is to look for tool marks left by early excavators, which provide a coherent 'net' over areas excavated by a single team. Thus, the south end of the Marble Street as paving is marked by a 'carpet' of tool strikes, running perpendicularly to the axis of the road. These look very much like the impacts of picks or mattocks used by early excavators to remove overburden.[26] Finally, one can look in the same manner at ancient occupation traces, like striations and wheel ruts, which link slabs together. Such traces, which cannot be fully considered in this article, are particularly visible on the Upper Embolos (Fig. 6b). I could go further, to suggest that we consider methods of structural analysis used at Ostia, to detect restoration mortar or unworn surfaces. However, there is enough extant evidence to suggest that the Arcadiane, Marble Street, Embolos, and adjacent roads do largely survive in the condition in which they were abandoned, during the first half of the 7th c.: in their paving, their statue bases, their colonnades, their major monuments, and their shops.

Of modern restorations, there are obvious areas of new pavement on the Clivus Sacer and on parts of the Embolos, between the Baths of Scholasticia and the statue base to Damocharis. Furthermore, the late basin façade of the Library of Celsus nymphaeum has also been taken away, to recover the reliefs that were set in it. Finally, a number of complex architectural structures

26 Tool strikes on paving, southern end of Marble Street: L. Lavan site observation April 2013.

FIGURE 6B Coherent preserved surfaces: Upper Embolos late paving (late rebuilding 1), section with ancient striations and shattered slabs, confirming that paving is at least partly *in situ*.

on the Embolos have been put back together from more dispersed fragments: such as the Gate of Hadrian and Arch of Heracles, and parts of the Nymphaeum of Trajan. Of ancient changes, most seriously, the Civic Agora saw spoliation and demolition of some parts of its surrounding buildings, from around 500, with its statue bases being entirely cleared out before the end of the 6th c. The latter process also seems to have affected the Tetragonal/Lower Agora but not the streets. Of medieval transformations, an area of rough late walls, containing statue fragments, was uncovered at the south end of the Marble Street. They were removed in the excavations of 1904–1907. These walls, which Auinger believes kept the street open after the collapse of the Hall of Nero, include material spoliated from the Hall, of which the last reused inscription dates from 585.[27] There was also some post-antique use of the routes of streets that I will deal with later, although this was slight and has not changed much of what we see today.

Overall, one can note that despite these processes of degradation, reoccupation, limited recording, and reconstruction, a good deal of late antique building, both messy and tidy, survives *in situ*. I can quite imagine that my summary approach might seem superficial to recent excavators who have uncovered and recorded the micro-history of individual buildings on the Embolos, with their sondages and exemplary publications. But macro-phasing of *spolia* can only be addressed across the city on a large scale. I am therefore presenting here, of necessity, only a preliminary analysis, to invite discussion, not a final report after detailed recording. As far as I can see, no restoration issues directly affect the argument I offer in this paper, although a detailed review of the subject by a site specialist is of course needed. Even so, it is unlikely that anyone will be able to afford sondages across the city to verify all the theories outlined here, so it is not worth waiting for this to happen before presenting some proposals.

Urban macro-phasing will always remain a topic of necessary speculation, not always as rooted in excavation as we might like. Of course, it would be a good thing to take XRF readings and record precise measurements of reused blocks. These can produce insights. However, colleagues working on *spolia* have noted to me that it is almost pointless to undertake this laborious work. What is needed is an overall characterisation of *spolia* styles and patterns by context, and this is best done as an overview rather than in great detail. This broad picture can be assembled within the bounds of tourist visits or even from one's own desk, from tourist photos published on Google. This is to simply to scrutinise evidence that is available to scholars and laymen alike, in public areas of an archaeological park where photography is permitted, in the accepted two-day maximum tourist stay at any one site in Turkey. This is a fair attitude not just for the study of *spolia* but also for causally inscribed behavioural texts, such as graffiti, and for surface markings,

27 *Spolia* walls at south end of the Marble Street: Auinger (2009) 36–37; Bauer (1996) 282; Feissel (1999a) 126–27, 131.

which occur in public areas of sites. Of the latter, until I began my work at Sagalassos, very few scholars took any notice of them, bar Charlotte Roueché and Angelos Chaniotis at Aphrodisias.[28]

Nonetheless, I am of course far from being the only scholar striving to understand the development of the streets of Ephesus. The Arcadiane has seen a number of introductory studies, whilst the Embolos has attracted a great deal of research. The excavations and surveys of Hilke Thür, Ursula Quatember, Alexander Sokolicek, Sabine Ladstätter, Daniel Iro, Helmut Schwaiger, Martin Steskal, Wolfgang Pietsch, Alice Waldner, and many others have contributed to the study of this important urban artery, connecting the Theatre Square with the Civic Agora. Pride of place must now go the monograph study of Waldner of 2020.[29] It was published after the completion of this article, which started life as a paper given in Vienna in 2016. At first glance, Alice and I might seem to be working at cross-purposes but I believe that our insights are entirely compatible, with Alice focusing on the results of sondages and myself focusing on wider masonry phasing. Alice has assembled in one place the excavation history of the street, references to reports and key studies, as well as bringing forward archive material not available outside of Vienna. The result is that I am here able to focus more directly on my own observations. These do not challenge the results of the sondages in any way, although they suggest a number of building phases that have not so far been identified. Ultimately, it will be for the sondage diggers of Ephesus to test all theories proposed here.

Phasing, *Spolia* and Late Antique Ephesus: an Analysis

Rebuilding 1: the Embolos:
Paving, Statues, Arch of Hercules, Porticoes
The best place to start to unravel the complex structural history of the late streets of Ephesus is the late paving found across most of the Embolos. This high-quality work is composed of mixed reused rectangular blocks, sorted into short rows that do not extend fully across the roadway, with odd corners being cut into the stones to permit a close fit. A distinguishing feature is the closeness of the joints and the good levelling of the blocks, which makes for a very even surface of this paving in the central section of the street. It is not quite as monumental as the earlier paving of the city found on the street south of the Civic Agora or on the upper Domitianstrasse: here, roughly quarried slabs or several metres in width are used, of a style also encountered at Gortyn.[30] Neither is the late paving quite as regular as the ordered grey limestone paving visible under middle sections of the Embolos, by the Damocharis base. This paving, likely of the 2nd c. AD, extends into connected side streets, where sidewalks and storm drainage are a key feature of what was a very sophisticated design. Nor is the late Embolos paving as glamorous as a section of multi-coloured alternating slabs visible on part of the Domitianstrasse, perhaps of 410–36 or earlier.

The secret to the chronology of the late paving of the Embolos lies in its relationship to statues decorating a closely related monument: the Alytarch Stoa. This street portico can be dated by a number of methods: stylistic for the mosaics, stratigraphic (via coins of around AD 400 from below the portico, the last being of Arcadius of 395–408), epigraphic (from the decree of ca. 439/42 carved secondarily onto one of its column), and so on.[31] The closest dating is provided by the portico's association with a series of statue monuments which were arranged in front of each column. Here we have a group of 8 (of which 3 have surviving inscriptions). These statue monuments, usually tripartite, composed of a crowning element, a base, and an isosceles triangle plinth, seem to be conceived in a similar style, as if they were erected as a group to decorate the portico when it was first built: they honour governors holding office within a short span of time, who may have had a hand in its building, which likely extended beyond one mandate. Some of these monuments are integrated into the portico stylobate itself and so are contemporary with it. One of the statue monuments, honouring the governor Stephanus, seems to date from ca. 410. Another, of a very similar style, stands immediately adjacent, dedicated to the Proconsul Isidore, which must date from sometime

28 Graffiti and surface markings: Lavan (2013a and b), Roueché (1999), and Chaniotis (2011), to cite just one highlight of the latter authors' works.

29 Works on streets, as selection: Arcadiane: Schneider (1999a) and (1999b). Embolos: Syntheses by Thür (1999a) and (1999b), Fildhuth J. (2010), Waldner (2020); collection of Ladstätter (2009) with recent excavations and specialist reports; architectural studies of Quatember (2008), (2011), (2017); Roueché (1999), (2002), (2009) and Feissel (1998) on epigraphy.

30 Middle Embolos, paving: L. Lavan site observation 2005. Paving on street south of Upper Agora: One might think these massive slabs Hellenistic, if Waldner had not encountered street levels of gravel and other mixed materials as late as the 1st c. BC on the Lower Embolos: Waldner (2020) 147–54.

31 Alytarch Stoa, stylistic dating of mosaics: see above Quatember *et al.* (2009) 123–24. Stratigraphic dating: Quatember *et al.* (2009) 123; Ladstätter and Steskal (2009) 90–91. See also Scherrer (2000) 122–23; Fildhuth (2010) 145–46. Epigraphic dating: IvE 1.44; Feissel (1999a) 131 no. 12.

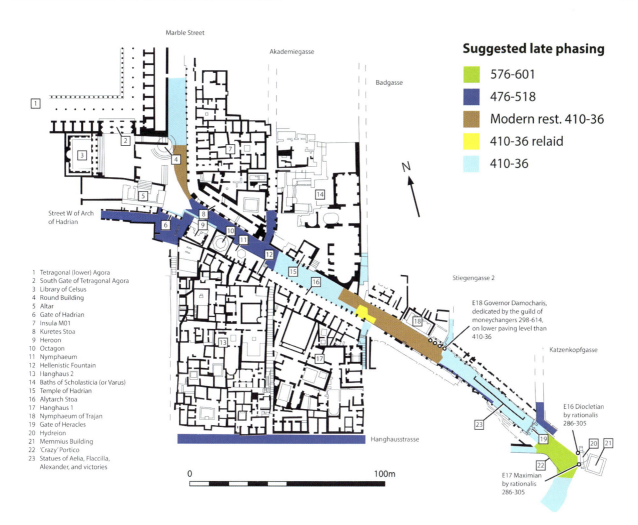

FIGURE 7 Map of paving sections on the Embolos, according to *spolia* characteristics. Also showing location of monuments in Embolos area. Rebuilding 1 is of 410–36, but its paving likely extended the full length of the street, into the Marble Street, including at least the Alytarch Stoa, the Gate of Heracles, and the two porticoes running north-west from it.
DRAWN BY LLOYD BOSWORTH

in 410–436, based on his prosopography.[32] The combination of archaeological and epigraphic evidence seems to suggest we are dealing with a 26-year period for the construction of the portico, of 410 to *ca.* 436, probably towards the beginning of this range, given the coin evidence.

Crucial for the argument here, the statue bases are not only bonded into the portico stylobate, via their supporting socles, but these socles stand on levelled stone blocks that are set within the sloping street slabs, as part of the same unit, height, and style of construction (Fig. 8). Thus, it appears that the street paving of the lower and central Embolos was laid at the same time as the Alytarch Stoa was constructed. Parallels for similar statue groups directly placed in front of portico columns tend to date from the later 4th c. to earlier 5th c. Such parallels come from Sagalassos (Lower Agora, east portico), Ephesus (Civic/Lower Agora, east portico), Tripolis ad Meandrum, Gortyn, and Rome (Basilica Julia). Given their date and wide distribution, they were perhaps inspired by a style established on the Mese of Constantinople.[33] The late paving of the Embolos and adjacent streets, is one that is visibly of reused blocks, mainly of marble, of slightly different colours. However, it is one that was laid with care: the slabs are of high quality, sorted into short rows (not always complete), and are cut to fit when odd angles prevent a join. Any

32 Alytarch Stoa, statue dedication dating: Feissel (1998) 91–104. See also Lavan (2020) vol. 2 appendix C4 pp. 95–96 appendix H7 pp. 555–56 but also wider statue environment described on pp. 550–569, with vol. 1. p. 306 fig. E7H.

33 Statues fronting porticoes, parallels: Sagalassos: Lavan (2013) 309–13 with fig. 6a and 6b. Ephesus: see Lavan (2020) vol. 2 appendix K4b pp. 679–80. Tripolis ad Meandrum: Duman and Baysal (2016) figs. 4–5 on p. 579, and fig. 6 on p. 580; see also Lavan (2020) vol. 2 appendix C4 pp. 296–98. Gortyn: see Lavan (2020) vol. 2 appendix C4 289–91. Rome (Basilica Julia): see Lavan (2020) vol. 2 appendix X1a pp. 925–27.

FIGURE 8 Alytarch Stoa, photo showing the bonding of statue emplacement blocks with the portico stylobate (esp. on the right) and their setting within the street paving.

inscribed faces are disguised by being set face down. As we will see, the late Embolos paving is still far better laid and more comfortable to use than the paving of the *Plateia in Coressus*, leading north of the Theatre. Indeed, the earlier 5th c. Embolos paving can be compared to that at Aphrodisias and Aizanoi, both known to be of a similar date.[34]

A quick look at monuments around the Embolos supports my suspicion that the street has been repaved at the date suggested by the Alytarch Stoa. Firstly, the late paving drowns the Nymphaeum of Trajan, in a manner that would not have been acceptable before the middle of the 3rd c. Secondly, the slabs are set above the level of statues erected by Diocletian and Maximian at the Hydreion, which used the previous street surface as their foundation.[35] Thirdly, a decree of Constantius II has been recovered from the paving by the so-called Temple of Hadrian, suggesting a *terminus post-quem* (*TPQ*) of 361.[36] However, we have here a much larger repaving project that goes beyond the Embolos itself, spreading into adjacent streets.[37] It is probable that many of the statues along the Lower Embolos, even those in front of the 'Temple of Hadrian', were rearranged as part of this earlier 5th c. rebuilding, given the similar style of the statue monuments which supported them, a tripartite arrangement, of crowning element, base and plinth of isosceles triangle shape.[38]

Most significant of all, there is a second spot on the Embolos, where a late portico was also provided with statue decoration, again placed on level blocks set within the paving. This is in the upper part of the street around the so-called Arch of Hercules. Immediately in front of the arch, before the street portico running north-east of it, is a row of statue bases. These statue

34 Street paving, parallels: Aizanoi: Lavan (2020) vol. 2 appendix C3 pp. 207–208. On its dating, Rheidt (1995) 712. Aphrodisias: Öğüş (2016) 50 with 48 fig. 3.1 and 3.3; Sokolicek (2016) 4 fig. 4.9, 70 fig. 4.17; Erim (1990) 11–13 with 12 fig. 4; Lavan (2020) vol. 2 appendix C3 pp. 237–43. On its dating: a summary of its phasing is provided by Sokolicek (2016) 75. I offer my own alternative phasing for the street, for which see Lavan (2020) vol. 2 appendix C3 pp. 240–43.

35 Hydreion inscriptions and slabs: IvE 2.308–309 and Roueché (2009) 157–58; Lavan (2020) appendices C3 216–17, H2 p. 523.

36 Embolos paving, *TAQ*: The inscription (IvE 1.41) was found in two pieces and is of the time of Constantius II. It relates to the rehabilitation of the praetorian prefect Philippus (PLRE 1.696–97 Flavius Philippus 7), dated to after 344 says Feissel (1999a) 130 no. 8. This must have been put in the road sometime after the death of Constantius II in 361: Miltner (1959) 283–86.

37 Side roads, stepped, leading off the Embolos: Lavan (2020) vol. 2 appendix J3 pp. 590–91.

38 Temple of Hadrian, bases: all the inscriptions of the Tetrarchic bases are in Latin: Roueché (2009) 155–61 = IvE 2.308, 309, 305.1–3, 306 (Stichel no. 78, LSA 718–21). For the bases see also, Lavan (2020) vol. 2 appendix H7 p. 557.

bases bore reused Victories and were set up around a statue of Aelia Flaccilla, Augusta of AD 379–386 (mother of Arcadius and grandmother of Theodosius II). Yet, Aelia Flaccilla is not left alone with her Victories. She is bizarrely also accompanied in this group by a doctor, Alexander. He seems (from the cross at the start of his inscription) to be no earlier than the first decade of the 5th c. Clearly, he does not belong in such illustrious company. Furthermore, one of the bronze statues recovered here seems to have been changed, with a Victory being converted into a portrait statue: the elegant feet of a fine female figure lead up into the folds of a toga. We know that the statues were brought from elsewhere, given their old dedications and mismatched bases, but does the primary arrangement date to the reign of Aelia Flaccilla (379–386) or to the a few decades later (410–436), as the street paving suggests?[39]

A clue to this puzzle lies in the contextual setting in which the statues are displayed. The statue monuments do not, for the most part, stand on the street paving, on matching plinths against the portico, as at the Alytarch stoa. Instead, we have a mixture of poorly matching plinths, set, in a very jumbled manner, within an ugly row of blocks, laid on or in front of the stylobate, which we might call a rough roadside kerb. This must be a secondary arrangement. If one looks carefully, one can see the remains of a very different and earlier system of statue supports preserved within the same group. The northernmost three statue monuments did not in fact stand on the ugly kerb of blocks just described. Rather, they were placed directly on the paving. The last one, which can only be traced now as an empty emplacement, stood on a levelled block, counteracting the slope of the roadway, yet set within its paving slabs. This is very similar to the arrangements supporting statue monuments in front of the Alytarch Stoa. Thus, it seems we have an earlier phase, in this row of bases, where there was the same conception of statue display and street ornament as in front of the Alytarch Stoa, of a portico ornamented by images. It too was set within a grand relaying of the street paving. The paving was of the same style, at both ends of this long street, of reused blocks well-sorted into short rows by size, with clamps disguised, though colours were mismatched. Likely, the arrangement here also dates to 410–436, even though it was later disturbed. Alexander surely arrived here as part of its rearrangement. Yet, Aelia Flaccilla and probably the victories are likely to have been here from phase 1. Flaccilla merited her place in 410–436 because she was the grandmother of the reigning emperor Theodosius II, not as empress in 379–386, although her more glorious title of *Augusta* is what is used on the dedication. Here, I am committing an epigraphic sin, in failing to recognise her title as dating the portico or initial statue group to 379–386. However, I have other reasons, beyond context, for doing this, as will become clear shortly.

When one takes an overall view of the development of the Embolos, it seems we have a major programme of works, from early in the reign of Theodosius. The Gate of Hadrian's southern pier has clearly been rebuilt as part of a very similar style of late road paving that flanks its eastern side (Fig. 9). This suggests that the primary rebuild of the monument was earlier 5th c., before any later works. Indeed, the water supply which the rebuilt pier sealed must have been part of a general replumbing of the wider street.[40] Quite how many monuments can be fixed to this great late phase of street paving is unclear. The conversion of the Library of Celsus façade into a monumental fountain/pool may be connected, especially given the naming of a Stephanus on its late building inscription. He is probably the same governor Stephanus as honoured in the statue base which decorates the Alytarch Stoa.[41] But we can clearly envisage a very large-scale urban renewal that coincides with the Arch of Hercules. Indeed, this monument masks the earlier Tetrarchic restoration of the Hydreion, which once looked down the Embolos from the top end.

The Arch of Hercules (Fig. 10a), which now dominates the Upper Embolos, is entirely set within this same late paving, in both its front staircase (of well-disguised *spolia*) and the paving of its podium, bonded into the street paving extending behind, south. This upper street paving is of a style identical to that below, which leads north down the Embolos. I do not want to speculate too much

39 Upper Embolos, Aelia Flaccilla base group: Roueché (2002) with 531 n. 4 for the empress (IvE 2.314 = LSA 723), with p. 529 fig. 2 providing a plan, with numbers for each statue. For Alexander the doctor: IvE 4.1320 = LSA 735–36 = Roueché (2002) 530 no. 1 with commentary on 538.

40 Gate of Hadrian, rebuilding of southern pier: Thür (1989) 122–28; Thür (1999b) 117, with L. Lavan site observations April 2013 on the reused material in the southern platform (under which a double water pipe was installed, though I saw three pipes on the west side). See also Lavan (2020) vol. 2 appendix F7b pp. 461–62.

41 Library of Celsus, inscription: IvE 7. 5115. Keil (1953) 80 dated the building work recorded in this inscription to after AD 400 as it began with a cross (otherwise suggesting a date from the 4th c. onwards from the letter style). Bauer (1996) 283 notes that the 'Stephanus' in the inscription could be the same as the Stephanus honoured in a statue further up the Embolos. Certainly a governor as dedicant is likely. Feissel has suggested that the language of the text, which notes that Ephesus decorated Stephanus just as he decorated the city, may refer to statues: Feissel (1998) 99. See this whole article for the new dating of the Stephanus base further up the Embolos.

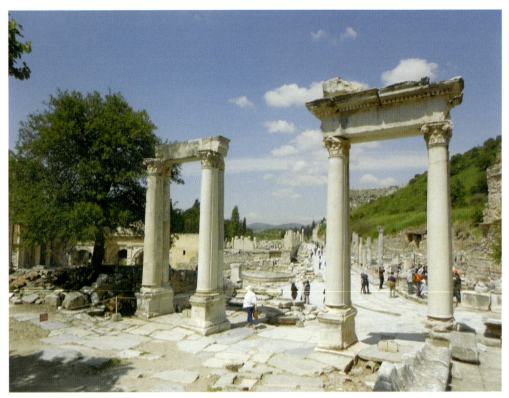

FIGURE 9 Gate of Hadrian, showing rebuilt pier on the right, set within paving comparable (on its far side) to that of 410–36, in contrast to original pier on the left, covered by paving of ?487.5–512.5.g.

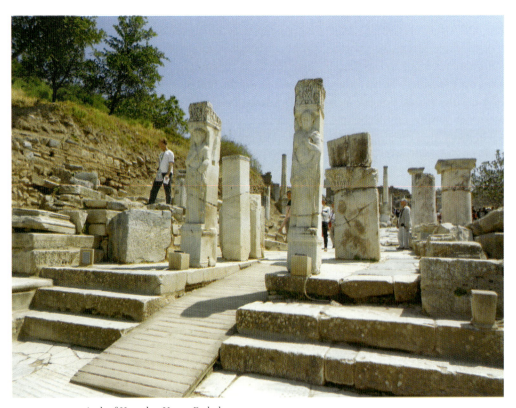

FIGURE 10A Arch of Heracles, Upper Embolos.

FIGURE 10B Arch of Heracles, Upper Embolos, showing structural relationship to paving and relationship to equestrian statue base pedestal (top left).

about the inscription of Flavius Constantius on the Arch itself nor on the sculptural style of the ornament, as these elements have not led us to a certain date. The study of the gate needs redoing, containing a significant error relating to the scale on its plan. Nonetheless, the report we have, by Bammer, does identify at least one phase of rebuilding within Late Antiquity, from already reused materials, thanks to his detection of a third series of clamp marks, beyond the second series established to reuse older blocks within the structure.[42] The equestrian statue base standing on the north-east side of the Arch, is also bonded into the same phase, the base covering over the lower late paving but being itself covered by the Arch, which has its top step built into the upper late paving (Fig. 10b).[43]

All of these works at the Arch of Hercules should be given the same date on account of their relationship to the Embolos paving, regardless of the vague inscription on the arch. The only remark worth making about the epigraphic text is that it starts with a cross (the ends of which are neither consistently straight nor splayed).

From my wider study of crosses as epigraphic signs, at the start of honorific and building inscriptions, we can say that it should date from sometime after the first decade of the 5th c.[44] In contrast, the Aelia Flaccilla base inscription from the east portico begins with the traditional formula of *agathe tyche* ('good fortune') and no cross. This gives us another indication that the Flaccilla text is probably now not in its original setting, likely having been brought from nearby. It should not be used to date the main rebuilding of the street. There certainly was activity on the street to honour the Theodosian dynasty: a statue base honouring the father of Theodosius was erected by a different proconsul but in 379–387, the same period as Flaccilla was Augusta (LSA 721, in Latin, without a cross but with *bona fortuna* as its opening). It was set in front of the Temple of Hadrian. Critically, this occurred at a time when the temple was rebuilt, as working on the rear of the base shows. Three tetrarchic bases found here, also decorating this façade, might well have been reset at a higher level at the same moment. Given that we have both Theodosius *pater* and Flaccilla *Augusta* on the same street, a dating of the roadway paving to the time of Theodosius I might seem possible. However, closer study suggests that the Alytarch Stoa provides the best quality dating that we have (inscriptions, coins, ceramics), and this is of 410–436, so in the reign of Theodosius II. In contrast, the statue bases dedicated to early members of the Theodosian dynasty can only provide associative evidence for activity on the street, due to their lack of direct primary connection with its paving. We must allow the Alytarch Stoa's rich chronological indicators to trump these ostensibly earlier bases. Further (see below), the Alytarch Stoa's dating of 410–36 for the road paving is supported associatively by the first late phase of the Curetes Stoa, at the bottom of the Embolos.

Given the secondary disturbance of bases of the Flaccilla group, it might seem difficult to date the porticoes leading down the Upper Embolos from the arch, although their stylobates do contain some reused material. Critically, they appear to be set at the same level as the late paving of the street and do actually stop at the arch, suggesting they were built with it. They recall a familiar urban association seen elsewhere. In other cities, there are a number of late antique constructions of 'porticoes with arch', as at Thibilis, Milan, Rome, Athens, and perhaps Constantinople.[45] Critically, these Upper

42 Arch of Hercules: studied by Bammer (1972–75) 117–22.
43 Equestrian statue base: Lavan (2020) vol. 2 appendix F7a pp. 450–51 and H7 p. 557.

44 Crosses discussion: see the dating foreword of Lavan (2020) vol. 2 5.
45 Arches built with porticoes leading to them: Lavan (2020) vol. 2 appendix F7a, with Milan on p. 428; Rome for Arch of Gratian, Valentinian II and Theodosius on pp. 433–34; Constantinople

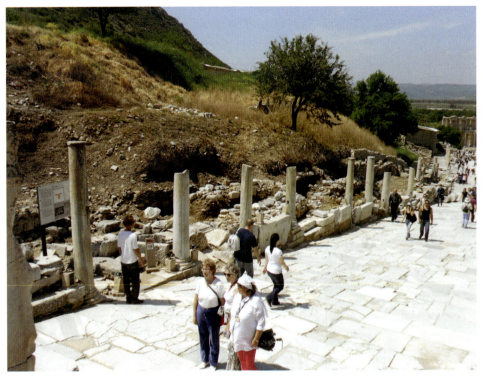

FIGURE 11 Upper Embolos, West Portico. Note the neat stylobate, good quality columns, and matching column bases, which have later been covered with more irregular walls, and in one case raised. The quality of the portico contrasts greatly to the present state of the East Portico. The neat stylobate of the first phase matches the height of the paving of 410–36 (Fig. 14a–b).

Embolos porticoes have at least two phases. The first phase (especially visible some distance away from the arch) is very neat. On the west side, it is composed of grey monolithic columns and Attic bases set on an ashlar limestone stylobate, of carefully reused blocks (Fig. 11). A neat stylobate of carefully chosen reused blocks is also perceptible on the east side. However, the second phase is decidedly messy. It included the rebuilding of the east portico, in very mixed-up *spolia*, especially near to the arch (see Fig. 14a–b). Here, the new portico is partially built on top of the portico of phase 1, reusing many of its bases, though sometimes there are now no bases at all. The phase 2 eastern portico also featured the raised 'kerb', mentioned above, of blocks laid in front of the stylobate, which retained a higher floor paving of jumbled reused blocks inside the structure. This two-phase story, with similar features, also seems to be visible on the western portico of the street as well, if in less radical form. Here a kerb was added but the portico was repaired, not rebuilt. The post-antique walling which covers the area should not distract us.

For the Upper Embolos, the following sequence can be suggested. In the first major phase, we have an early 5th c. portico on both sides of the road of grey columns, linked by an arch and by a new fine street paving. This 'unit' was built with accompanying shops, which can be traced on the west side of the street. The east portico was fronted by statues set on levelled blocks in the slanting paving[46] In the second major phase, the upper statue group reached its present form, including Alexander the doctor, whose base, unlike that for Flaccilla, does have a cross, at both the start and end of its dedicatory inscription. This second phase occurred when the shops were rebuilt, with their thresholds raised to their present height, as will be explored shortly.[47] For the Lower

for Constantinian Golden Gate and Troadesian porticoes on p. 445; with their porticoes also discussed in C2 and C3. See also appendix C3 for Thibilis on p. 186; Athens for street porticoes by Pompeion on p. 190.

46 Upper Embolos, portico shops: a shop floor with 4th c. material has been excavated on the west side (Sondage 2b 2005), with no recorded earlier layers, whilst on the east side earlier floors and related structures have been recovered under the shops rebuilt in the later 6th c. The west portico sondage 2b floor has as its find with the latest start date LRC Hayes 1–3 [which I take as meaning an unidentifiable form within the range of LRC Hayes 1 to LRC Hayes 3, which begins in 387.5 with Hayes 1a in LRP and ends in 600 with Hayes 3h in Atlante]: Iro *et al.* (2009) 59. For the east portico sondages see Iro *et al.* (2009) 61–63, 80.

47 The phases of the Upper Embolos (which early excavation photos show have not been greatly modified by restoration) seem largely unexamined by scholars, even in a recent colloquium volume on the street. This did, however, address the

Embolos, we have not just the Alytarch Stoa and its paving of 410–36, but a similar multi-phase sequence has now been published by A. Waldner, where sondages under the Curetes Hall have revealed an earlier row of shops, dating to the reign of Theodosius II (402–450). A coin of this emperor was recovered as the latest dating element in the finds relating to its construction, coming from the fill of a blocked drain. This work was done at this time when the alignment of the street was set to fit its present course.[48] But this row was later followed by a portico without shops on the present site. It was built within 500–525, based on the last find, although all other materials dating this phase have start dates in the late 4th to early 5th c. This structure was later replaced by the extant 2-storey brick portico of mid-6th c. date.

Rebuilding 1: the Marble Street and the Clivus Sacer

If we look elsewhere, in the adjacent streets, a two-phase rebuilding of the streets of Ephesus seems to be visible more widely. On both the adjacent Marble Street and the Clivus Sacer, we are confronted by late paving that is very similar to the Embolos, with well-chosen reused pieces, laid in short if not complete rows, without showing any inscribed faces, and with odd corners cut to fit. Again, marble dominates, although some other stone types are used.[49] The Clivus Sacer is paved in rather less well-sorted stone than the Embolos and may just possibly belong in the earlier 6th c., like the paving by the Curetes Stoa, discussed later. But on both streets, we again see porticoes of grey limestone columns on predominantly Attic bases, comparable to what is claimed above as the first phase of the Embolos porticoes around the Arch of Hercules. This suggests they were all built around the same time. Of distinct features, not seen on the Embolos, the porticoes of both streets are only built on one side of the roadway. However, the Marble Street also has fine sidewalks, set on each side of the road, mainly of dark grey limestone but containing lots of reused blocks, suggesting they are entirely late and date to the same time as the street slabs, with which they are well-integrated. Both streets have late shops behind their porticoes, of a similar style to those found on the Upper Embolos.[50]

On both streets, there is evidence of two phases. If one starts by looking at the opposite ends of the Marble Street, one sees that there are major differences in the quality of build. At the southern end (Fig. 12), the stylobate and steps are very finely laid without odd gaps, and the porticoes are made up of grey marble columns, whilst Attic bases predominate [of at least two types]. There are various stone types present in the closely-jointed stylobate and in the sidewalk, suggesting that both are late and likely contemporary with the neat but reused paving which they adjoin. At the northern end (Fig. 13), there is a neat sidewalk and paving but a rough stylobate, with a colonnade of badly sorted elements, and worse steps.

The Clivus Sacer portico seems also to have had two phases. The eastern end is well-ordered, with grey limestone columns and Ionic bases, with little heterogeneity. Yet, the western end is obviously rebuilt and a rough 'kerb' is set along the rest of the portico, either between the columns, or over the column bases, recalling the late rough kerb of the Upper Embolos. What was the function of the higher walking level (of gravel) retained by this ugly kerb in the portico? Did it reflect a higher street surface in beaten earth on the main roadway, recorded on some other sites, which has now disappeared? My guess is that the kerb still coexisted with the earlier 5th c. stone paving and that the higher portico floor helped keep shop-keepers dry in the event of flooding. It seems to have coincided, in at least one case, with a raising of shop thresholds.

Probably at this point it is best to 'stick my neck out' and suggest that the primary large-scale rebuilding programme, that we have seen on the Embolos, extended south into the Clivus Sacer and north into the Marble Street. This happened during the same time period, of the earlier 5th c., currently best-dated to between 410 and 436. The work was all done in fine good quality street paving of reused blocks, accompanied by homogeneous porticoes of grey limestone columns and Attic bases. It is likely the same programme of works as commemorated by an inscription on a console block on the south end of Marble Street, which supported a statue bust of the ?proconsul Eutropius (LSA 690), who 'adorned his fatherland with marble streets' οὕνεκα

latest use and medieval overbuilding of the street, and the phases within the shops here. For a summary of my own site observations and analyses made from photos taken as a tourist, in 2005 and 2013 see, Lavan (2020) vol. 2 appendix C3 pp. 215–25.

48 Curetes Stoa, excavations: see the appendix to this article, below. I calculate a contextual date of 402–50 under my rules, as this is the last dated coin, in a context of many finds. For consistency, I do not follow the dating here of the second half of the 5th c. used by Waldner.

49 Domitian Street: This street looks to have somewhat different paving, with patches of coloured paving, suggesting perhaps an earlier style of decorative Antonine or Severan date, although set within stretches of paving like the late Embolos paving: Lavan (2020) vol. 2 appendix C9a.

50 Clivus Sacer and Marble Street: Lavan (2020) vol. 2 appendices C3 (pp. 226–27 and pp. 213–15). My doubts about the paving of the Clivus Sacer is not expressed in that work, as I did not notice the distinctive nature of the paving by the Curetes Stoa.

FIGURE 12 Marble Street, south end: paving and portico, with well-sorted re-used elements, similar to the west portico of the Upper Embolos.

FIGURE 13 Marble Street, north end: paving and portico. Note badly-sorted re-used elements in the rebuilding of the stylobate and other colonnade parts, overlying a well-sorted sidewalk with associated street paving, comparable to the same elements at the south end of the street.

FIGURE 14A Upper Embolos, East Portico, south section, with statue bases: some set on paving, some set on/within kerb.

FIGURE 14B Upper Embolos, East Portico, north section, with statue bases: all set on paving, some enclosed by kerb. Note the northernmost missing statue emplacement (left side), a flat stone set within the late street paving, comparable to the arrangement seen at the Alytarch Stoa.

FIGURE 15 Rebuilding 2 of AD '410–436', on the Embolos and adjacent streets.
DRAWN BY LLOYD BOSWORTH

πάτρην/μαρμαρέαις κοσμήσας/ἐυστρώτοισιν ἀγυιαῖς.[51] This inscription dates to sometime in or after the early 5th c., as is indicated by a cross at the start of the inscription. For this massive building project, a great deal of stone was used and a vast supply of similar sized columns and bases became available from somewhere – perhaps from the Olympeion or another large temple complex?

One might counter that the Upper Embolos or Clivus Sacer porticoes look too neat in their stylobates to be late antique, even if we consider that the Attic bases and grey limestone columns they support are reused. But the relationship of the Upper Embolos porticoes to the Arch of Hercules and especially their height correspondence with the late paving makes it likely that these colonnades were indeed erected here in the earlier 5th c. We should remember that the Arch itself has new-cut material in places. As we have seen, there is also new-cut stone in many late civic building works around the same period.[52] Furthermore, very neat building work can be seen on almost identical porticoes of the southern end of the Marble Street. Here, the neat Ionic porticoes and their supporting steps and stylobate are visibly composed of well-jointed but clearly reused rectangular blocks of different colours. It is critical that epigraphic element which dates these porticoes to the 5th c. is a console block, tied in as a structural element, which supported a bust, not some statue base which might have been moved.

Thus, we can envisage a vast programme of high-quality urban renewal, extending all the way from the Theatre Square to the Civic Agora, and into many adjacent streets (Fig. 15). The dating might be a little wider

51 Inscription of Eutropius: The fact that it was set on a console block rather than a base means it was likely set into the adjacent portico: IvE 4.1304 (with find-spot from notebooks); LSA 611 suggests the limited size of the console means it supported a bust, which they would like to connect to an under-sized head found nearby, hollowed out behind, and so likely from a bust (LSA 690; Inan and Rosenbaum (1966) 151–53, no. 194, pl. 181.1–2.

52 Gate of Hercules: Lavan (2020) vol. 2 appendix F7a pp. 450–51.

in some areas than I suggest, with some slabs likely disturbed and re-laid towards the time of Justinian. Nonetheless, at a number of points (Arch of Hercules, Marble Street console, Alytarch Stoa) we can assert that renewal belongs after the first decade of the 5th c., and that some elements were complete by 436. There are currently no grounds to challenge the date provided for the Alytarch Stoa of 410–436, although one would naturally prefer more trenches to be dug in such a massive phase, to support this tentative hypothesis. The presence of honours for earlier figures, such as Theodosius' father or wife, may be best explained by their reuse here to reflect the propaganda of Theodosius II, rather than as a clear indication of the date of this phase. That is not to say that monuments to these earlier Theodosians did not already exist nearby when the works were done. Rather, the current form into which they are configured is that created in the earlier 5th c. Quite when the colonnaded porticoes of these streets were next rebuilt, in their present ugly form, will be explored later.

Rebuilding 2:
the Lower Embolos: Pavement Patches of the Early/Mid-6th c.

Let us look forward to some early to mid-6th c. work on streets which might give some further chronological markers (Fig. 15). These are now available for the first time thanks to the new monograph of Waldner, published since I submitted *Public Space*. They have been detected in a zone that significantly complicates the above theory. Waldner has conducted two sondages, under the paving of the Lower Embolos, adjacent to the Curetes Stoa and also opposite it, just south of the site of the Hexagon, by the modern entrance into the Hanghauser. The former trench has revealed fill under the slabs which contains, as its last finds, coarsewares of the end of the 5th to early 6th c., so giving a contextual date of 487.5–512.5.[53] The trench on the far side of the roadway has produced coins running up to 476–518, found under broken paving stones. This could be enough to disprove everything I have said above about the Embolos slabs, were it not for some minor differences in their arrangement: despite a similarity in conception, the paving in this part of the street appears more mixed in colour, less well-jointed, and less well-levelled (Fig. 16), than that on the middle and upper sections of the street or on the adjacent side roads (see Fig. 7, for the area concerned). It seems that in fact that the paving of the Embolos, from the Hanghauser entrance until the north end of the Curetes Stoa, is a local patch.

We can note that this area of repair extends more widely into surrounding streets. Paving of the same character can be seen in the adjacent side street leading north (Akademiegasse), in that of the avenue running west from the Gate of Hadrian.[54] However, the slabs immediately around the gate pier, on its east side, do look comparable to the Embolos paving of 410–436, being of generally grey-white blocks, closely jointed. For Hanghausstrasse, an older sondage, prior to the work of Waldner, has been published, where late paving like the Lower Embolos patch was laid. But here, the last dated deposit is deeply buried under the road construction, being dumped prior to the raising of the street. It is of 3rd c. date, with the road construction itself not given a contextual date, just this *TPQ*.[55] Around the Lower Embolos, it seems that we are in the presence of a significant late 5th to earlier 6th c. area of paving renewal, perhaps associated with works on water supply. The paving is so similar and so contiguous with that of '410–436' that it might well represent a relaying of it. However, wider structural arguments suggest that it dates slightly later, in its present form. Above all, the street paving by the Curetes Stoa should be contemporary with the third late phase of that structure, which it serves. The date of this third phase is 550, based on monograms on the building. I am not able to challenge that here. It may be that the monogram on the stoa, which does not name any dated individual, is dated too late, and the contextual dates suggested by ceramics and coins from the two street sondages of Waldner are correct. For the paving, the contextual dating should trump any associative date derived from the portico.

Rebuilding 3: the Arcadiane and the 'Byzantine' City Wall

Away from this renovation, the best dated piece of 6th c. street paving is that laid around the tetrastylon on the Arcadiane, a monument again dated to *ca.* 550, based on the letter style of its inscriptions and the architectural

53 Lower Embolos paving patch: This is a new observation not included in my *Public Space*. On the sondages under the street paving of see the appendix below, to this article.

54 Other 'patches': To this same late 5th to early 6th c. group can be added a thin strip along the west edge of the Upper Embolos, where a sewer might have been repaired or a sidewalk replaced. This strip of about 1 m / 1.2 m wide on the Upper Embolos, west side north of the Arch of Hercules, is built against a straight built edge of the paving of 410–36, suggesting that a gap had existed between the portico and the road paving, appropriate to a sidewalk or sewer capping. The street paving of the *Clivus Sacer* might also be included in the group although it is closer in style to the Upper Embolos paving and has seen considerable restoration, as suggested by some of the stone types.

55 Hanghausstrasse: Outschar (2000) esp 109 and 118.

FIGURE 16 Paving in front of Curetes Stoa, Lower Embolos, likely laid in 487.5–512.5.

style of its capitals and sculptural decoration.[56] Immediately around this monument, the street paving has been relaid, in fairly well-chosen slabs. Nonetheless, they have not been laid closely, with few corners cut out, and some are cracked. This area of paving (defined on Fig. 17), must be contemporary with the tetrastylon. It contrasts sharply to the surrounding sections with their homogenous rectangular slabs, arranged in rows that extended *all the way across the street*. This doubtless relates to the 2nd or 3rd c. phase of the street identified by Schneider, to which should belong the porticoes' beautiful homogenous pedestals, bases, and columns.[57] This is of course the finest piece of ancient street architecture in Ephesus, on a great avenue leading from the harbour to the theatre. It was doubtless the setting for many *adventus* of incoming proconsuls, who were obliged by law to visit Ephesus before any other city of the province of Asia.[58] Its sheer size has prevented a full study, especially of the surrounding monumental setting. Its Early Imperial features must have set the gold standard for the city. It was very well-constructed, with slabs laid in full rows of similar width, on roadways 21.37 m wide, flanked by porticoes of columns 3.5 m high, rather than the 3 m or so seen elsewhere in Ephesus. Indeed, the late

56 Tetrastylon: Lavan (2020) vol. 2 appendix F2 405–406. Dating: There are a number of criteria to use: (1) inscriptions: Heberdey in Wilberg and Heberdey (1906) (page no lost) noted that the characters are the same as those in securely dated Justinianic inscriptions on the site, such as a letter of bishop Hypatius (probably IvE 7.4135) (bishop during the 530s), though Heberdey did not provide any comparative details. (2) capitals: Wilberg, in the same article ((1906) 138–40), believed the capitals to date from the time of Justinian (527–65) based on the similarity in their acanthus leaves to those of San Vitale in Ravenna and a church in Parenzo (Poreč), whilst the pedestal form of semi-circular niches appears in Ravennate sarcophagi and on the Ambo of S. George's church in Thessalonica. The well-dated mid-6th c. nature of the first two of these inspires confidence. (3) relief carving: Deichmann (1974) (549–70) 568f. believed the style to be 6th c., based on various parallels, notably to a fountain in the 6th c. Church of St. John in the city. I do not wish to rely on this argument. (4) motif decoration: the presence of Latin crosses as part of the primary decoration makes a date before the 5th c. unlikely, given its limited appearance on imperial honorific monuments before this date.

57 Arcadiane, phasing: Schneider (1999a) esp. 474–5, describes the phasing of the Arcadiane colonnades, according to a basic architectural analysis. He sees three phases: one early 2nd c., the second 3rd c. (when Corinthian capitals were introduced alternating with the original composite capitals, supporting arcades), and a third late antique phase (on account of the use of much reused material in the colonnades). I think that Schneider's summary of the phasing is incomplete and incorrect for Late Antiquity, see Lavan (2020) vol. 2 appendix C3 pp. 211–214.

58 Proconsuls of Asia obliged to visit Ephesus before other cities in their province: Ulpian, *de officio proconsulis* book 1 in *Dig.*1.16.7.

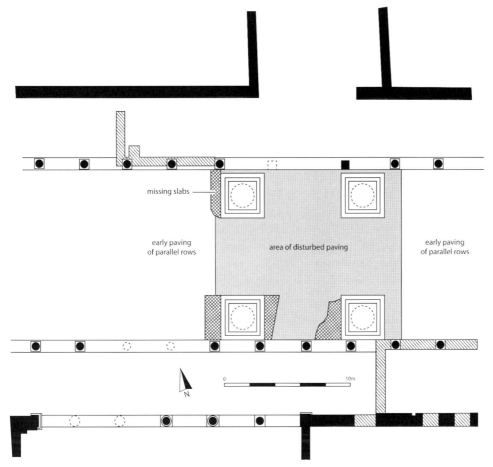

FIGURE 17 Arcadiane, paving reset around the Tetrastylon of *ca.* 550 (redrawn by Lloyd Bosworth), which dates the roughly-jointed paving found here, by association.

colonnades of the nearby *Plateia in Coressus* seem also to have been higher than others, so as to join easily into the adjacent Arcadiane.

Beyond the tetrastylon, the 'late' archaeology of the rest of this street is less well-dated. Quite how much of the later phasing dates from the time of Arcadius is unknown. Although the name 'Arcadiane' was used to describe the avenue in an inscription found along the street, it is very hard to be sure what this implies in structural terms. Does the inscription date from the time of Arcadius? Probably not, although it must date either from this time or sometime afterwards. Of late interventions, scholars have noted the mosaics in the porticoes, the rebuilding of section of the colonnades in reused materials, and the shops built alongside, using late masonry, of brick coursing and undiagnostic reused material and rubble. Schneider suggested that the Arcadian rebuilding might be responsible for most of the late construction, with some work on the porticoes dating from the time of the insertion of the tetrastylon. However, there is no evidence to support either view. The area affected by the tetrastylon is not the same as that where the rough colonnades were built. These colonnades are of a far inferior standard to the tetrastylon. The name of the road is the only element that suggests that there were works done here in the early 5th c.[59]

The arch at the Arcadiane's east end is not an arch of reused materials, as described by Foss. Rather, it is a conventional triple-portalled arch, with blocks in primary use.[60] However, it seems that someone at some stage removed the two southern piers of the arch, one

[59] Arcadiane dating: Schneider (1999a) 474–5 would like to associate the phase of late antique rebuilding with the inscription naming the street as the 'Arcadiane', thus indicating a restoration of Arcadius (395–408) (IvE 2.557; Feissel (1999b)). Schneider also suggests there might be an even later rebuilding of the street with *spolia* at the time of the insertion of the 4-column monument (mid-6th c.), or the city wall (thought to be 6th or early 7th c., see below). However, there is no archaeological evidence provided by Schneider to connect the *spolia*-built parts, nor any other part of the colonnades, with an 'Arcadian' dated rebuilding.

[60] Arch of reused materials west of Theatre Gymnasium: Foss (1979) 56. I have not located this on the ground, on any maps, or in any other publications. It seems to be a misunderstanding of the arch found here.

FIGURE 18 Arcadiane, showing short section of *spolia* colonnade on the south side of street, which is only present where the city wall behind serves as its back wall.

of which can still be seen, marked out on the stone. This permitted a ramp to be built which passed traffic through this spot from the Arcadiane, perhaps mules, as it is too narrow for most animals and wheel ruts are absent. One of the remaining inner piers [which is not just a statue base] is inscribed with a Latin text honouring a late emperor, possibly Arcadius, as a base for Honorius (LSA 711) was found nearby, in a similar style of lettering, in Latin (LSA 751). The arch might have been built in their honour or was at least rededicated to them, with the pier being removed somewhat later. We could perhaps suggest that the Arcadiane's shops and its portico mosaics (I have not seen the latter) date from the early 5th c., as they concern the whole street on both sides, which other building works do not.[61] Certainly, the shops are similar in construction to those on the Marble Street, Embolos and Clivus Sacer, which above are proposed as rebuilt in 410–436, although the masonry concerned is not a very distinctive construction type.

At this point, there is a very significant archaeological observation to make, which greatly affects our understanding of Ephesus after Justinian. This is an insight into horizontal rather than vertical stratigraphic relationships. It comes from noting where late *spolia* colonnades are located along the Arcadiane and observing what other building works coincide with them. Where these colonnades occur, they are made of very mixed-up reused blocks: of a variety of types of columns but also of pedestals, of different heights, and non-matching bases. Little care seems to have been taken in sourcing and sorting *spolia* or re-erecting it on site. There are three sections of rebuilt colonnade, with two on the north side but these are both very short. That on the south side is much longer, extending for perhaps 100 m. Critically, this long piece of rebuilt colonnade corresponds almost exactly with the presence of the late city wall, which serves as the rear wall of the colonnade (Fig. 18). This may house some beam holes for the portico roof, although I could not confirm this, as the walls were partly vegetated. In contrast, where the new fortification falls away from the line of the Arcadiane, there are shops but there are no *spolia* colonnades. Thus, the colonnades have likely been rebuilt along the street, to restore the monumentality of the Arcadiane, after the city wall was constructed.

This so-called 'Byzantine City Wall' (Fig. 19) was long thought to date from the early 7th c., its start date, suggested by Scherrer, being a now-debunked 'earthquake

61 Arcadiane: Shops: Lavan (2020) vol. 2 appendices C3 pp. 209–212 and Y4 p. 973. Portico mosaic: Heberdey (1900) 90; Idem (1902) 53 (with most detail). For overall context, see Schneider (1999a) 467–80. The fact that it was apparently present on both sides, rather than only on the area by the city wall, suggests that it does not belong to the last later 6th c. phase of the street, which had more localised renovations. Rather, it belongs sometime before, perhaps to the time of Arcadius or Justinian.

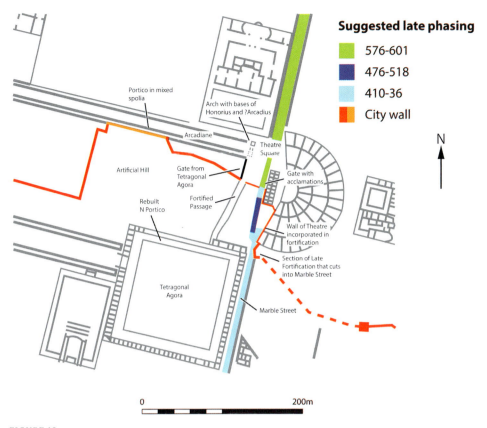

FIGURE 19
Rebuilding 3 of AD 550–610, detail of 'Byzantine City Wall'. Note its association with: (i) the *spolia* south portico of the Arcadiane; (ii) the late fortified passage, which is contiguous with the agora north portico; (iii) the late paving strip of columns along the west side of the theatre. Other paving segments relate to earlier or later phases (annotated by Lloyd Bosworth).

in AD 616'. An end date was once suggested on coin evidence: the area to the south of the wall ceased to have coins after the reign of Heraclius (610–641), with those of his successor Constans II absent, despite being relatively common in Asia Minor. So, it has been assumed that the zone south of the main city wall was abandoned, as a consequence of building it. In this logic, the coin finds date the city wall to sometime prior to 641. However, this arrangement can only have been short-lived: these same coins of Constans II are especially concentrated around the hill of St. John, 1.5 km outside the city, where a new fortified centre developed. Thus it seems likely that even the occupation of the old city must have soon have been given up, making the defence of the more extensive wall pointless.[62]

Alternative dating the 'Byzantine city wall' comes from a set of acclamations, as noted by Heberdey and Hellenkemper. These are inscribed on a gate set within the fortification, where it encounters the northern end of the Marble Street. They relate to the time of Phocas and Heraclius. However, these inscriptions should not be taken as providing a spot date. The texts are part of a wider ceremonial set, found both along the *Plateia in Corresus* inside the wall and on the Marble Street outside the wall. They honour the imperial families of each emperor, in conjunction with acclamations for the Blues and the Greens, perhaps marking the route of a procession. The southernmost acclamation comes from the Gate of Hadrian on the Embolos, far from the area enclosed by the fortification.[63] They should, therefore,

62 'Byzantine' City Wall, dating: Scherrer thinks that it dates to the '7th c.', due to the lack of coin finds in the city south of the fortification (later than the second decade, or at the latest fourth decade, of the 7th c.), perhaps after an earthquake of AD 616: Scherrer (2006) 54 with n. 254 (for reports, and references to unpublished paper by H. Hellenkemper). Heberdey had also dated the fortification to the same time period, as he regarded the presence of the acclamatory inscriptions of Phocas and Heraclius on the Marble Street south of the wall as implying that an unwalled classical city still functioned at that time [apparently, he did not notice that the inscription

on the gate was part of the same series]: Heberdey (1907) 73. See Lavan (2020) vol. 2 appendices C3 pp. 209–212, K2b pp. 655–59, and S3 pp. 823–24 for further dating arguments. On the concentration of coins of Constans II, see Foss (1979) 107 n. 12, plus p. 197 for his appendix 7, describing 23 coins of Constans II found in Selçuk, the modern town built around the hill, without precise findspots, and who sees this as a basis for dating the new fortification.

63 *Plateia in Corresus* and Marble Street, acclamations: see Lavan (2020) vol. 2 appendix H7 pp. 211–12, 212–13, 215; Thür (1999b) 109. Roueché suggests that these acclamations mark an area

be taken collectively to provide a *terminus ante quem* (TAQ) for the construction of the city wall, not a spot date. Our best TAQ for the fortification is in fact the reign of Phocas (so 602–610), not his successor Heraclius, as the specific acclamation on the fortification gate relates to the 'Christian emperors and the Greens', which was the favourite faction of Phocas.[64] Thus, it is a credible TPQ that we still need to find for the fortification.

Clearly, the wall was built at a time when the southern area of the city was still occupied. Both the acclamations and the condition of the monuments between the Theatre Square and the Upper Embolos confirm this. The absence, inside the wall, of distinctive *spolia* coming from the Embolos and Marble Street also suggests this. The fortification did have a little *spolia*, used decoratively at some points, but was not constructed from a landscape of ruins. Rather, the Embolos area was still monumental at the time and was not ruined to build the new wall that excluded it from protection.[65] A suggestive TPQ for the wall comes from the tetrastylon, of *ca.* 550, because it is of better quality than the colonnade on the Arcadiane that flanks the fortification.

A stronger date for the city wall can be obtained associatively, by looking at other structures which clearly coincide with the fortification. For these, developments in the adjacent Tetragonal Agora provide the most useful indications.[66] Here, we must deal with observations and claims that have not been fully published. The key to joining the late agora sequence to the city wall is a second gate through the fortification, 40 m west of that standing at the head of the Marble Street. This gate connects the Tetragonal Agora to the Theatre Square via a long deep passage. The walls of this deep passage seem likely to be connected to the defensive function of the city wall, with which they are contiguous: the walls are massive and there is no other obvious function for them other than as part of the fortification.

Indeed, since 2013, signposts at Ephesus say that the adjacent 'Police Station Hill', south of the Arcadiane where the fortification runs, was raised up with an artificial fill in the 6th c. The hill is defined on the south by the north portico of the agora, and on the east by a strong wall. This makes up one flank of the deep passage connecting the Tetragonal Agora to the Theatre Square. It is made of roughly the same technique as the back wall of the late north portico of the Tetragonal Agora, which forms the south side of the same hill, using large, reused ashlars and sometimes cut-down cornices. This portico back wall is distinctive in that it incorporates powerful buttresses, as if supporting a great weight behind. These two walls together retain a massive area of earth, thus creating the artificial hill along the south side of the Arcadiane. They seem, not only from their character but also from their connections, to be part of the same defensive building works as the city wall. The walls of the passage provided protection to the fortification gate leading from the agora, which the 'artificial hill' overlooks.[67] We appear to have a single large-scale urban project involving a new city wall built at the same time as a restoration of the adjacent civic plaza.

In the Tetragonal Agora, we are on safe chronological ground. There is a lot of evidence to suggest that the agora's northern portico, featuring impost capitals and mixed *spolia* use, is 6th c. in date. This odd three-storey portico, in which *spolia* use is relatively undisguised but still cut to fit, is an ambitious structure. It is built at a higher ground level, upon which a 6th c. coin-spread has been found. The level is 30 cm above the floor of the 4th c. rebuilding of the same agora. This earlier rebuilding was far more conservative, preserving the appearance of the original porticoes, even if the shops were largely rebuilt. It is important to point out that in this area some of the assumptions about *spolia*, made in older reports, need to be updated. From the way *spolia* was used around the agora, we can note that the east portico shops were also rebuilt, at the same time as the north portico. This is because both this east side of the agora

of civic ceremonial, perhaps for the reception of imperial portraits: Roueché (1999) 161–68. Gate of Hadrian, acclamations for the Blues and Greens (Gate of Hadrian): Thür (1989) 74–75 = IvE 4.1192(3).

64 For the acclamatory inscriptions, see Roueché (1999) with 164 no. 1.1 = IvE 6.2090.

65 See now the comments of Ladstaetter (2019) 39–40, who makes similar points about the city wall. On account of the absence of *spolia* from the Upper Agora in the city wall, which is present in late structures on the Embolos, Tetragonal Agora, Harbour district and Artemision, she favours an earlier date, perhaps in the Theodosian period. However, based on the relationship of the wall to dated works in the agora, and especially its relationship to areas of repair in very rough materials, I still favour a date in the later 6th c., as outlined in this article.

66 Tetragonal Agora, summary with full bibliography on the, see Aristodimou "Ephesus (antiquity), commercial agora (Tetragonos)", in *Encyclopaedia of the Hellenic World*, Asia Minor, URL:
 <http://www.ehw.gr/l.aspx?id=8214> (last accessed March 2016). The complex has only been published in preliminary form, especially for Late Antiquity, so what follows here can only be regarded as a very provisional summary, partly based on my site observations. The latest statement on the agora is Scherrer (2006) 48–51, replacing the first report of Wilberg and Keil (1923) but even the new report of Scherrer is by no means a thorough exploration of the phases and characteristics of the late buildings. For a plan see Scherrer (2006) 339 fig. 5.

67 Tetragonal agora, 6th c. rebuild: see Lavan (2020) vol. 2 appendices S3 pp. 823–24 and S4 p830–31.

and the buttressed back wall of the north portico, as well as the wall making up the west side of the passage to the aforementioned gate, all contain spoliated inscriptions taken from the prytaneion. Other parts of the same inscriptions and other prytaneion material have been identified in the Baths of Scholasticia. These come notably from contexts associated with the mid-6th c. Curetes Stoa and its overhead connection to the baths [but N.B doubt it might date 25–50 yrs earlier on p. 527–29]. None of the prytaneion *spolia* seems to be incorporated within the earlier rebuilding of the Tetragonal Agora in the 4th c. in the Tetragonal Agora.[68]

All this evidence seems to support a date in the mid- or later 6th c. for the rebuilding of the Tetragonal Agora and the contemporaneous construction of the 'Byzantine' City Wall, which coexisted with, rather than replaced, a fully monumental city. The great metropolis carried on developing both inside and outside of the new walls. The reduced circuit of the new fortifications did not equate with a contraction in the urban area, at the time it was built. As such, Ephesus was similar to other cities in Asia Minor with late antique walls, such as Sagalassos, which saw continued occupation outside of their new late walls, including of secular public buildings.[69] In contrast, the ruination/transformation of parts of the Civic Agora in the 6th c. is not in dispute. Bits of the civil basilica's dedicatory inscription even ended up in the 6th c. Church of St. John at Ayasuluk, although I do not know exactly what context they were reused in.[70] Further, a sondage of 2016 discovered a coin hoard deposited in the ruinous south stoa of the agora between 520–530, suggesting that degradation and demolition was well underway by then.[71] It is possible that honorific statue bases of the Civic Agora ended up in the building made out of statue bases on the Lower Embolos or supporting brick vaults between the Scholastica Baths and the Curetes Stoa. If so, we have a statue spoliation event that likely involved entirely clearing the Civic Agora.[72]

Rebuilding 4: the Plateia in Coressus

If we are to assert a later 6th c. date for the city wall, within the range 550–610, then a number of other dating hypotheses follow, based on the relationship of the wall to other structures. Firstly, at the north end of the Marble Street, an appallingly bad sidewalk has been installed, on the east side of the roadway. It leads beyond the end of the street portico to join the back wall of the theatre. This has been laid to cover a part of the late street paving that has been cut here by a short stretch of the 'Byzantine' City Wall, on the southern side of the theatre, which has been incorporated into the circuit (Fig. 20a). The bad sidewalk consists of a kerb retaining a new water pipe. The kerb partly covers intact slabs of 410–436 and partly covers over earth where the slabs have been crudely removed to provide the foundation trench for the fortification. In the new sidewalk, no effort has been made to sort or disguise reused elements. As a result, the jointing is extremely poor, with large gaps and some uneven surfaces (Fig. 20b). Secondly, there is an odd patch of rough street paving on the Marble Street, adjacent to where it is cut by the gate in the 'Byzantine' City Wall (Fig. 21). This must be contemporary with or a little later than the city wall. It has very different paving than the carefully reused slabs of the Marble Street to its south. It features broken columns used as paving slabs, which are not only a waste but also look terrible. They would have been very bumpy to ride over, for the carts which left their wheel ruts in them. No effort has been made to cut slabs to fit or disguise their origin, as it had been in the early 5th c. paving along the Marble Street. Nor indeed were efforts made equivalent to the late 5th to early 6th c. paving patch of the Lower Embolos,

68 *Spolia* used in Tetragonal agora: see Lavan (2020) vol. 2 appendix S3 pp. 823–24. For details on spoliated inscriptions see Lavan (2020) vol. 2 appendix K2b pp. 659–60, set within a wider discussion of the later 4th c. rebuild.

69 Occupation outside of late city walls, Sagalassos: Martens (2005); with Lavan (2020) vol. 2 appendix G3 p. 502 on the dating of the city wall to 383–408.

70 Alzinger (1972–75) 266, 299. Büyükkolancı and Knibbe (1989) 43–45 has no details on the find-spot / context of reuse. Whilst many parts of the basilica are reused, this piece has the earliest TAQ, others being known around *ca.* 550 from the Baths of Scholasticia and the Tetragonal Agora.

71 Civic Agora, south stoa: this coin hoard came from a level above the remains of the stoa, suggesting that ruin and spoliation was well-advanced at the time of its deposition: Schindel and Ladstätter (2016); Schindel (2016) 43. This detail is not in Lavan (2020).

72 D. Feissel kindly pointed out to me that the earliest legal epigraphy here, inscribed over the late chancels of the Hall of Nero and an adjacent pillar, is of 569: see Feissel (1999a) 131 no. 15. This suggests changes around that time, such as a move from the Civic Agora's basilica or perhaps simply a rebuild of the east portico of the Tetragonal Agora on which the Hall of Nero was set. Thus, it might be possible that the spatial organisation or reconstruction associated with this phase could have been completed by 569, giving an suggestive TAQ, so lower than 610. However, it probably should not coexist with the fine mid-6th c. monuments of the Curetes Stoa and the Tetrastylon of the Arcadiane. Although it is unrelated to these developments, one should also note that parts of a judicial inscriptions found here was also found reused around St. John, suggesting that there was a subsequent phase of spoliation of this area for St. John, after this street became ruined, or at least after the last dated inscription of 585 AD (no. 21) that came from the Hall.

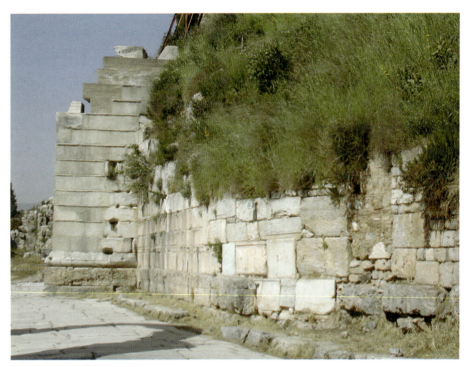

FIGURE 20A Section of late antique city wall, south of the theatre, which has here been incorporated into the circuit (of the left). The wall cuts through the road paving of the Marble Street, a detail hidden by a new sidewalk.

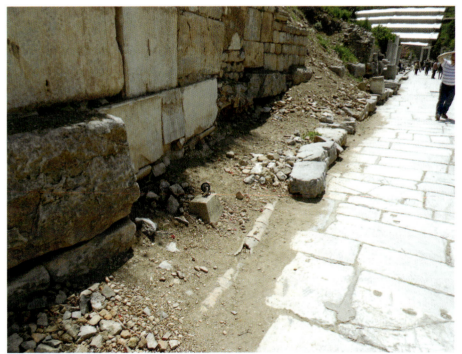

FIGURE 20B Rough sidewalk extension and paving north end of Marble Street. Note that the roadway paving of 410–436 was not built to a straight edge, so as to facilitate the sidewalk, as further south along the Marble Street. Rather, here, the paving has been displaced and the sidewalk is secondary. The paving was removed when the adjacent city wall cut into it. Subsequently, this scar was covered by the sidewalk and its piping, which also covered parts of the paving of 410–436 which had not been disturbed. Correct stratigraphic order: i) paving, ii) city wall foundation trench, iii) wall and trench fill, iv) water pipes and sidewalk.

FIGURE 21
Paving through gate in the 'Byzantine City Wall', on the Marble Street, showing a patch of street paving composed of split columns, subsequently marked by wheel ruts. Its position suggests that it was likely installed at the same time as the city wall, or certainly shortly after.

FIGURE 22
Plateia in Coressus, on the same line as Marble Street: an irregular unlevelled paving, including columns.

which was cut to fit and well-levelled, even if it is not closely joined.

Here, we can think of the terrible paving found further north, on this same route, on the *Plateia in Coressus*, leading from the Theatre towards the Stadium. This was also composed of split columns, or unlevelled paving slabs, that are often laid haphazardly, with no cutting to fit, producing bad joints (Fig. 22). The colonnades, on both sides of the road, are made of mixed-up columns, with odd pedestals and bases (Fig. 23). There is no attempt at unity, except in one section which may represent an earlier building façade. The heterogeneity of the columns recalls the latest colonnades of the Arcadiane. We need not envisage that this late colonnaded street was built to link to the city to the Anastasian-Justinianic Church of St. John, as if echoing the extra-mural Damianos Stoa, built to stop Artemis worshipers getting rained on, on their way to her Temple.[73] It could just have provided the newly fortified core of Ephesus with a major north/south colonnade, to match those areas outside, following as it does the larger column heights of the Arcadiane, rather than those of other streets. Indeed, an inscription, found along this street, taking the form of a block that may have served as a statue base, notes the paving, by a *curator* (*logistes*) and a *pater*, John and Leontius, of a *plateia* leading to the church of

73 Damianosstoa: Philostratos *VS* 2.23.

FIGURE 23 *Plateia in Coressus*, portico colonnade in mixed materials.

the Archangel Gabriel. It was not a street leading to St. John.[74] Although suggestive, this cannot give us as close a date for the works as can archaeology, the text being any time after 460. Rather, we should note the proximity of very mixed colonnades to areas affected by the new fortification, and also the alignment of the *Plateia in Coressus* with the Marble Street, where the road was patched with the same type of slabs – of split columns, just where it was cut by the new wall. Thus, the renovation of the *Plateia in Coressus* looks rather likely to date from the later 6th c. but evidently before the coherent set of acclamations to Phocas and Heraclius (mentioned above) were carved onto some of its columns.

Rebuilding 4: Upper Embolos

Having noticed the relationship of the rough late porticoes to the 'Byzantine' city wall we should now return to the Upper Embolos. Here, we again had a very rough east portico of unsorted materials, just north of the Arch of Hercules, fronted by the Aelia Flaccilla/Victories group. This was put together in a messy manner, without disguise (Figs. 14a–b). It had been constructed on the site of an earlier portico with an ashlar stylobate and Attic bases, that seemed in its primary phase to be the same date as the Arch of Hercules and the Embolos paving of ca. 410–436. Fortunately, here we now have some recent stratigraphic dating, from sondages undertaken within the north and south portico shops, from 2005. These excavations have detected a relaying of the shop interiors in the late 6th c., with coins and ceramics from shop floors/supporting deposits, on both sides of the road. In the east portico, the fill of a drain blocked to make a shop floor has yielded a lamp fragment dating of the second half of the 6th c. to first half of the 7th c., as its latest sherd. This was found alongside a coin either of Justinian (527–565) or Baduilla/Totila (541–552), struck sometime between 542 and 565. In the west portico, the substructure of a shop floor produced 12 coins of 4th–6th c. date, of which 10 were of the 6th c., the latest being a coin of Justin II of 576–577. Given the coherence of the works on both sides of the street, it is reasonable to take the evidence together as supporting a single phase of renewal. The finds indicate a contextual date, according to the rules I operate under, of the 25-year period from 576–601.[75]

The relationship of the new floor levels and thresholds with the masonry walls of the shops seems to indicate that the shop floors were not simply raised but that,

74 Inscription recording paving of *plateia*: IvE 8.124D, which suspected it might be in a secondary context, perhaps because *plateia* was interpreted as a plaza. I am grateful to Paweł Nowakowski for this reference. This base looked to me to be *in situ*: Lavan site observation 2013.

75 Upper Embolos, east portico, north of the Arch of Hercules, rebuilding: see Iro *et al*. (2009) with Lavan (2020) vol. 2 appendix C3 pp. 224–27.

FIGURE 24 Upper Embolos, East Portico, north of Arch of Hercules: portico pavement composed of heterogenous, reused, poorly sorted, undisguised, unlevelled slabs, without cutting to fit, bounded by 'kerb' on left, set in front of the portico columns.

on the east side, at least the shops were entirely rebuilt. This is particularly obvious in the section of sondage 4 of the east portico. The kerb between the columns, seen on both the Upper Embolos and the Clivus Sacer, likely dates from the same period as the shop rebuild. A very rough, uneven portico floor of undisguised and unsorted *spolia* blocks set in the Upper Embolos north-east portico (Fig. 24), sits behind the kerb, taking the same height. Critically, this floor serves the last threshold height of the east shops. This allows us to bring shop floors, portico floor, and kerb together into one building phase. It seems very likely that the portico's messy colonnade of unsorted mixed reused columns dates from the same period, even if it cannot be structurally proven. A final chronological indicator comes from a bar counter, inside the last surface of the east portico. This has produced a spread of coins dating from Anastasius to Heraclius (so 498 to 615), with no issues of Constans II, so documenting occupation in the 6th to earlier 7th c.[76]

The evidence from the Upper Embolos raises the possibility that the very similar shops on the Marble Street and on the Clivus Sacer were also entirely rebuilt at the same time, along with their porticoes. These were also reinstated secondarily in a messy manner. It seems that we have a massive and confident reinvestment in rows of cellular shops fronted by porticoes, on the major avenues of the city, even those left outside the new fortification. This is certainly a very intense period of artisanal occupation, which has produced evidence of water mills and some iron smelting, as if some of the restrictions on productive activity envisaged by Julian of Ascalon in his 6th c. manual might have been disregarded. This was possibly because a new city wall had been established, making this area suburban in the eyes of regulators. Or it is perhaps because there was just a slight relaxation of control over what was obviously still a very classical retail environment, of cellular shops and bar counters.[77]

76 Upper Embolos, east portico, shops, rebuilding: See Lavan (2020) vol. 2 appendix C3 pp. 223–24 for a detailed discussion, noting the sondage 4 section of Iro *et al.* (2009) on fig. 23 where the bottom of the shop walls corresponds with the height of the new threshold, above earlier structures destroyed on site. For the coins of Heraclius and Constans II at Ephesus, see Schindel (2009) 192–96 esp. fig. 24 and Scherrer (2006) 54.

77 Craft production along Embolos: Waldner (2020) 185, pointing to evidence of for metalworking from the Nymphaeum of Trajan, watermills, and a stone saw present in the Hanghaus 2. For the nymphaeum, where a melting-pot was found, see Quatember (2008) 280–89 and my appendix H2 of Lavan (2020) vol. 2 pp. 525–26. Note that I missed a lime pit (*Kalklöschgrube*) prior to the last water pipe of 400–450 (set in SE 12 burnt layer), the use layer of which includes ARS Hayes form 67 (350–500 in LRP Bon) plus an unspecified lamp fragment of late 4th to early 5th c. date (Kat. 39), whilst the fill of which includes LRC Hayes form 4 first group (*ca.* 360–420 in LRP). Behind the Octagon, a metal workshop, as revealed by an ash layer, bronze fragments and iron pieces was also revealed, dated by Thür to the late 6th to 7th c., on the basis

This was still a period for which there are traces of management of public space, notably in the organised tethering of animals, the markings of which can be seen on latest *spolia* porticoes in the Arcadiane but not along the Embolos. This extended to segregating pedestrians from traffic, and to maintaining the city's public supply of piped water.[78]

Rebuilding 5: the Embolos Summit and the 'Last Antique' City

The rebuild of 576–601 constituted a very substantial urban renewal, perhaps surpassing even that of 410–436, in extent (Fig. 25), if not in quality. To this period, we can perhaps date a further portico on the east side of the Upper Embolos south of the Arch of Hercules, at the very summit of the Embolos. This portico is very similar in character to those of rebuilding 4 north of the Arch, and a coin of Justin II (of 565–578) has recently been recovered from the mortar bedding of its floor, where a slab had been removed.[79] To a slightly later period, even more shambolic but before the road surface was given up (so 574–641), we could date a 'crazy' *spolia* portico, opposite. This is again south of the Arch of Hercules but on the west side of the street (Fig. 26). The structure, excavated in 1967 by G. Langmann, with little record, is made of reused columns of radically different widths, lengths, and colours, and other pieces of heterogenous spoliated material, with no thought for recutting. The colonnade was planted directly onto the street paving, without a stylobate. The sorting of materials by size is notably poorer than the rough porticoes found immediately to the north, or that facing it. The appearance of the ensemble is so odd as to make some suspect it is a modern stone store. However, a film of 1967 shows that the columns were already re-erected whilst more appealing column sections and capitals were stored opposite. In contrast, jumbled fragments were kept in the portico, as if fallen where they lay. Therefore, it is likely that this weirdest of porticoes is authentic.[80]

The 'crazy' portico is fronted by a very odd section of road paving, of irregular large slabs of black stone, well-polished. This 'odd section' covers the very top of the Embolos and rises uphill a considerable distance along the Domitian Street, if not for its full length. The same paving overlies the better portico opposite (of rebuilding 4), where the coin of Justin II was recovered from the mortar floor. Close by, between the Arch of Hercules and the same east portico, is an improvised sidewalk (Fig. 27) made entirely out of an inscribed monumental architrave, of blocks still joined by clamps, that leads up into a roughly paved and poorly levelled side street (*Katzenkopfgasse*). [This stepped route is itself structurally later than the adjacent shops north of the arch. Its paving style, of mixed reused blocks, with decorated faces turned over and joints cut to fit, is comparable to earlier 6th c. paving seen by the Curetes Stoa]. Whatever the date after 565 or 576 the crazy portico and architrave sidewalk were built, they represent the last attempt to reproduce a classical city of porticoes and street paving, before very different urban processes came into being.

We have some clues about what happened next to the streets of Ephesus, after this final monumental investment. Close by, along the Street of Domitian, is a row of shops first established within Late Antiquity. They had initially occupied the vaults of the 'Temple of Domitian' and then expanded a little onto the roadway, narrowing the street from 11.3 m to 8 m. Here, we can see that a final structural phase involved the blocking of doorways and raising of street and floor level by 1 m to 1.2 m, a development that coincided with the giving up of the cryptoporticus behind the vaults. The street at the time of the higher level was composed of various materials, which included broken architectural fragments from nearby buildings, such as the façade of the water tower of C. Laecanius Bassus.[81] This all likely happened before the reign of Constans II (begun 641), whose relatively common coins are absent from this area, unlike the coins of Heraclius his predecessor.[82]

of unspecified unpublished ceramics, which U. Outschar was then working on: Thür (1999) (104–20) esp. 118.

78 Tethering holes: L. Lavan site observation April 2013. Water supply: see above remarks about sidewalk extension of east side of Marble Street, where cut by the 'Byzantine' City Wall.

79 Upper Embolos, east portico, south of Arch of Hercules, excavated once roughly in the 1950s then carefully in 2015. The report of Ladstätter (2015) (14–16) gives a laser scan plan on p. 14 and a photo on p. 16. It produces some interesting dating evidence but the phasing is not developed fully. See Lavan (2020) vol. 2 appendix C3 pp. 223–25 for my own phasing.

80 Upper Embolos, west portico, south of Arch of Hercules: Lavan (2020) vol. 2 appendix C3 pp. 222–23. 'Crazy' portico film: Pathé Film 'Ephesus 1967' at 1:00 available at https://www.britishpathe.com/video/ephesus (last accessed April 2021). I was not

able to obtain Langmann G. (1967) *Tagebuch der Ausgrabungen in Ephesos 1967* (Archiv ÖAW-IKant) (not seen) held in Archiv des ÖAI Wien Inv. VII/267, which may provide more details.

81 Narrowing and raising of level of Street of Domitian: Vetters (1972–75) 311–30; Lavan (2020) vol. 2 appendix Y5 pp. 978–79.

82 Coins of Heraclius and Constans II across the city: see n. 76 above. The excavation of taberna II by the Hellenistic fountain house on the Lower Embolos has produced a large amount of material relating to the latest phases of occupation: Waldner (2020) 41–43. Waldner places the end of occupation in the mid-7th c. but I have not seen any finds from the inventory given by her that have a start date before the end of the 6th c., although there are several which have a range that extends into the 7th c. For this reason, I will retain the absence of coins

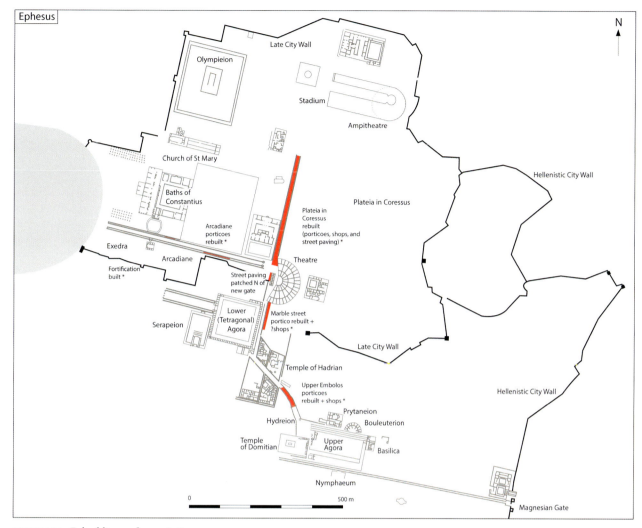

FIGURE 25 Rebuilding 4 of AD 576–601.
DRAWN BY LLOYD BOSWORTH

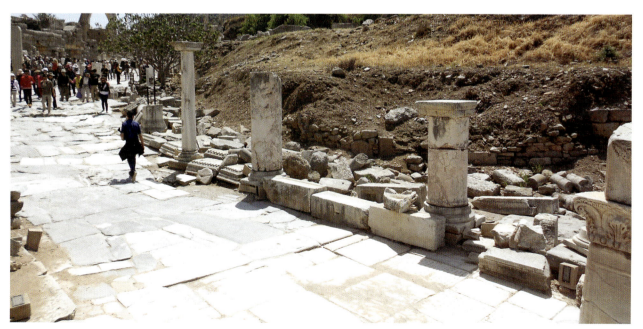

FIGURE 26 Upper Embolos, south of Arch of Hercules, west portico colonnade of heterogeneous materials.

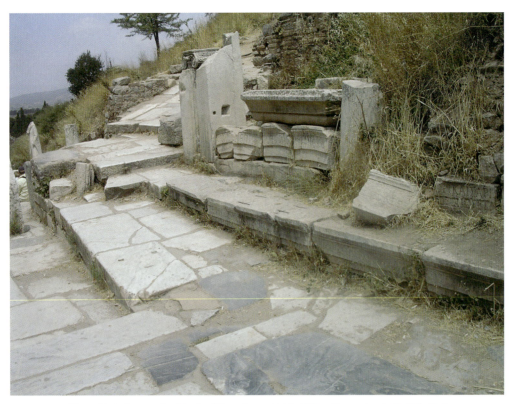

FIGURE 27 Upper Embolos, south of Arch of Hercules, east side. Sidewalk constructed of blocks from a re-used architrave, still joined by clamps.

Thus, we have a decay of the area during the reign of Heraclius. His time had begun with acclamations to the circus factions inscribed on monuments of the Embolos and Marble Street, as if these structures were still maintained and viable. But this did not last. At the top of the Embolos, a retaining wall 1.1 m thick was established on the south side of the street (SEM 1). This post-dates levelling layers dated to 570–595 [based on the start date of the last find]. The wall held back earth, keeping open the main roadway through here.[83] Walls composed of statues and other rubble, built at the bottom of the Embolos and along the Marble Street, suggest something similar, there narrowing but ultimately preserving this route.[84] Nonetheless, it does not seem likely that the ancient street surfaces were still in use, given the height of the earth fill encountered on the Street of Domitian. The Embolos and the other arteries of Ephesus were likely little more than tracks through fields of ruins, guiding pilgrims to places of memory that outlasted the population, which now moved to a new focus on the hill of St. John.

Exactly when the decisive change to the areas outside of the city walls occurred has been a subject of debate. A recent review of numismatic finds, in comparison to other sites and other regions, suggests to Schindel a clear break in 616 right across the city, after which coin finds are far fewer.[85] Schindel asserts a catastrophe in that year, likely a result of the major Persian invasion of that year, rather than an earthquake. But a new pattern of occupation, focusing mainly inside the 'Byzantine' city walls, only asserts itself in the reign of Constans II. Therefore, we can envisage a rupture in occupation in the city, based on dating precisions used by numismatists, though not used in my own standard dating calculations. It is possible that some of the very last functional repairs, such as the new higher surface on the Street of Domitian, might fit in the decades after this rupture. For more monumental repair, a regional *TAQ* of 614, the date of the decisive Persian invasion of Anatolia, seems still reasonable for the whole city. Quite what condition the street porticoes and shops were in, during the years following 616, is still to be fully explored. The final layers in many of the shops of the Upper Embolos

of Constans II on the Embolos as providing the best *TAQ* for the ancient occupation of the street.

83 Upper Embolos, Retaining walls,: Iro, Schwaiger and Waldner (2009) 47–50 with 48 for dating evidence. The find with the latest start date in the levelling layer built over by the wall is LRC Hayes 10 of *ca.* 570–660+ in LRP, amongst several late ceramic pieces.

84 Marble Street, walls with statue torso and rubble from Hall of Nero: Auinger (2009) 36–37, referencing Ephesus excavation diaries.

85 Coin finds from Embolos and other areas: Schindel (2009) esp. 194 fig 24 for the coins distribution.

involved destruction by fire, as did the peristyle court of Hanghaus 2.[86] There were doubtless other abandoned buildings, with decaying roofs, leading to wall collapse, and perhaps even failed barricades, now overrun with silt and vegetation. It was not very long before levelling works and retaining walls re-ordered the urban landscape, into something hardly urban at all.

Conclusion

The above analysis suggests a number of lines of conclusion: firstly, on method; secondly, on the nature of public building, especially its craft technique; thirdly, the history of public space; fourthly, on the persistence of cultural memory in Late Antiquity. On a methodological level, the study of *spolia* building in Asia Minor can be identified as a significant source of dating evidence in landscapes affected by clearance excavation, not simply in studying demolition but also in terms of new building. The observations presented here do have some parallels in other regions, where there has also been a habit of overlooking the complexity of Late Antiquity, to the detriment of its earlier phases. For the Levant, the unfinished habitation work of Wolfgang Thiel was well on its way to proving that many secular public late antique buildings were hidden within classes of monuments believed to be Early Imperial. As we have seen, Thiel's hunches about the tetrakionia at Gerasa and Bostra have now been proven through stratigraphic dating at the latter site. Such redating has also become an issue in terms of the Umayyad period constructions, which had also often been classified amongst classical buildings, to the extent that even William MacDonald thought that the tetrakionon of 'Anjar might be Early Imperial in date.[87] Ultimately, my hypotheses have to remain provisional, as large-scale cross-city phasing cannot be checked very often. Yet, perhaps *spolia* can reveal the nuances of late antique urban landscapes. Our understanding of what really happened in the late antique city, on many clearance-excavated Mediterranean sites, could be considerably improved by documenting the phasing revealed by reuse. In the absence of related stratigraphy, so often shovelled away, all tools are needed, whether precise or broad in application.

In terms of public building, late antique Ephesus is due a re-evaluation. Far from being an aesthetic mess, it seems that Ephesus was for most of its late history a very attractive city with beautiful porticoes and well-levelled paving, even if its building materials were reused. My Italian friend can take heart, as she only perceived the very last antique building work, which has been damaging the reputation of Ephesus as a late antique *metropolis*. The early 5th c. city was especially carefully built, of reused but well-sorted and well-jointed blocks. Craft techniques used can be easily related to those used in earlier centuries for building with new-cut stone. Any challenges presented by reuse were overcome, to minimise its visual impact. Even the city of Justinian seems to have been smart, with new buildings with experimental architectural forms, such as the Curetes Stoa and Tetrastylon. This work compensated for somewhat less careful use of *spolia*, which was now visible in porticoes etc., in a manner it had not previously been. Paving in reused slabs was now less well-sorted by colour and less well-fit. However, the fourth quarter of the 6th c., the time of Tiberius II Constantine and Maurice, seems to be a time when aesthetic standards of secular public architecture declined drastically, even if there was no let-up in the intensity of public building. The post-Justinianic but pre-Heraclian landscape saw some poor use of reused material. This extended beyond any alternative 'aesthetic' of *varietas* into the *bricolage* of using jarring blocks designed for other functions. Anyone who had to bump along in a cart over split columns, like those found along the *Plateia in Corresus*, would have been forced to agree. There had been a collapse of order in sorting and laying of reused stone, not just in paving (expressed in Fig. 28), but in highly visible locations, such as colonnades. This would have made a strong impact, as much on residents as on ancient visitors to the city.

Superficially, we might seem to have evidence of a later 6th c. trend towards of urban decline, long before the troubles seen under Heraclius. We might identify this in the shoddy porticoes on its streets, as much inside the city wall, as outside of them. Worrying developments are attested at a few other sites in Asia Minor. At Sagalassos, the Lower Agora shows signs of degradation at this time. Here, earlier 6th c. building programmes were not completed; porticoes rebuilt in the first part of the century were occupied by cellular shops; the Severan Nymphaeum was allowed to decay.[88] One might also mention Xanthos, where a church with a cemetery was built in the Lower Square.[89] However, the late 6th

86 Fire details: Schindel (2009) 192, 197.
87 Tetrakionion at 'Anjar: MacDonald (1988) front cover.
88 Sagalassos, degradation: Cellular rooms subdividing the portico: The most fulsome, clearest discussion to date is Putzeys (Ph.D. diss 2007) 240–53. See also, Lavan (2013) 301, 303–305 with fig. 4a; Lavan (2020) vol. 2 appendices S4 pp. 835–36, Y2–Y3 pp. 963–63. Severan Nymphaeum, Lower Agora, repairs and decay: see Lavan (2020) vol. 2 appendix S7a pp. 840–41; Lavan (2013b) 306–308.
89 Xanthos; des Courtils and Laroche (1998) 463–68; des Courtils and Laroche *et al.* (1999) (367–99) 372–76; des Courtils and

FIGURE 28 Schematic diagram of the evolution of paving types in Ephesus (drawn by Lloyd Bosworth), showing (top left to right, then bottom left to right), a development from: (i) equally spaced rows of identically-sized blocks; to (ii) parallel rows of unequal width of slabs sorted to fit; (iii) reused slabs sorted into rows; (iv) reused slabs cut to fit; (v) poorly sorted reused slabs with little effort to adapt slabs to join, with limited disguise; (vi) to reused slabs with little effort to sort, no adaption to join, with no disguise, nor levelling.

c. building work at Ephesus includes so much repair of existing structures that it demands a more nuanced interpretation. Straightforward continuity can be seen elsewhere in Asia Minor at this time: at Aphrodisias (agora) and at Sardis (shops) there is evidence of vitality and occupation into the early 7th c.[90] We are, therefore, obliged to take a more specific, local view, as Mark Whittow recognised some years ago, as a single trajectory of decline is unconvincing within the region.[91]

In terms of public space, the great rebuilding of streets at Ephesus under Theodosius II was very large-scale and perhaps reflective of the great investments made at Constantinople. I know of nothing discovered so far on this scale from late antique cities outside the capital, apart from the Justinianic Cardo at Jerusalem, although some other imperial cities probably did have them.[92] It was very likely an imperial project, given the attention paid to honouring deceased members of the dynasty of Theodosius II – his uncle, his grandmother, his great grandfather, and his father Arcadius, for whom the main street was renamed. A 'Theodosian Forum' recorded in an inscription (likely of 402–450 given the presence of an initial cross) may or may not be identical with the Tetragonal Agora which the Marble Street and Embolos passed (rebuilt 370–403 based on contextual coins and ceramics).[93] The street renewal might have begun earlier under Arcadius, around the avenue bearing his name but no dating evidence currently available allows us to do this, beyond two bases found here. Monuments honouring the Constantinian dynasty are notably absent from the renewed part of the city: one decree from that time having been confined to the road paving.[94] We seem to have a coherent large-scale urban project equivalent to

Laroche *et al.* (2000) 344. See also, Lavan (2020) vol. 2 appendix V3. Anemurium, decay of Baths: Russell (1995) 35–50; Lavan (2020) vol. 2 appendix Z2 p. 1000.

90 Aphrodisias (South Agora): see Lavan (2020) vol. 2 appendix S4 p31–34 with full bibliography and V5b p. 897. Sardis (shops on main east / west street): Crawford (1990); Harris (2004) 82–122. See also Lavan (2020) vol. 2 appendix Y4 pp. 970–73 for further discussion.
91 Interpretation of later 6th c. in cities of Asia Minor: Whittow (2001).
92 Justinianic Cardo at Jerusalem: see Lavan (2020) vol. 2 appendix C3 pp. 266–67 for details with further bibliography.
93 Tetragonal agora, rebuilding: see Lavan (2020) vol. 2 appendix K2b pp. 655–59 and Scherrer (2006) 48–51. For the inscription see *IvE* 5.1534 = Hicks (1890) 185 no. 184, with Bauer (1996) 292 noting that the findspot is not known, with further references.
94 Decree in road paving: see n. 36.

those we hear about from texts for Constantinople but which are now buried under modern Istanbul.

The later 6th c. rebuilding of the streets equally represents a massive secular civic public investment, though perhaps less likely to reflect an imperial donation, which was more likely focused on the new wall, built to somewhat higher standards. Ephesus was not going to go quietly. It was determined to remain classical until no available builder could remember how to put an Ionic portico together correctly. What events triggered these great building campaigns? Earthquakes are not a likely cause of the first great rebuilding, coming some 50 years after constitutions written by Valens and Valentinian on the subject of earthquake relief in Asia. But are they possible for the fourth rebuilding? There are, after all, 6th c. destruction deposits in shops on the Upper Embolos before their later 6th c. rebuilding. This question I will leave others to answer.[95] Regardless, the later 6th c. work is also part of a complete reshaping of city of Ephesus with its new fortification – a reshaping which extended both inside and beyond the walls.[96] Thus, we might also envisage here a great act of imperial patronage and 'urbanism', on a Constantinopolitan scale, in which civic display, amenity, and commercial dynamism remained important, as late as the 580s, including the re-erection of statue groups, many now almost 200 years old.

In terms of cultural memory, this final rebuilding of the civic fabric is worth considering, alongside our studies of tombs and honorific statue monuments. The very latest classical city of Ephesus was still trying to be Greco-Roman in so many ways – trying to reset monumental art and rebuild porticoes in a shabby manner – even after the *metropolis* was cut in two by the 'Byzantine' circuit wall – a fortification which did not spoliate arches, tetrastyla, statues, or nymphaea nearby. This is impressive continuity that we should not minimise, even if some of it looks ugly. At Ephesus, the city fathers maintained a classical face for the city right up to the end. The spolia contexts of the Embolos and Marble Street and Tetragonal Agora provide valuable testimony to the complexity of late urban life, even at this date. This was still a city with the theatre that St. Paul had known, with a great avenue leading to its harbour, with baths-gymnasia, and monumental reliefs or public statuary displaying its Hellenic foundation myths. Public inscriptions could be read going back to the early days of Empire. Neither notables, nor bishops, nor *vindices*, had killed off the classical city. Rather, something less tangible, like a specific technological rupture, had caused a loss of skills in specific areas, that made public construction look different. Yet, the cultural and political framework of the city remained intact.

To realise what a great effort went into the reconstruction of the porticoes, paving, and statuary of the streets of the city is moving. Here, we have a community deeply aware of its classical identity, wishing to keep up the appearance of their city, despite set back and disaster. The profile of its late secular monumental investment suits what we know about other cities in the Aegean region especially: that they continued to maintain an ethnically Greek emphasis on aspects of their urban tradition, seen in building work on propylaea and agora porticoes, or in the form of fortifications, and the preservation of older structures. Yet, the fact that the Ephesians could not successfully imitate the glories of the past in the 580s must have been painfully obvious to any early 7th c. visitor who walked through the well-preserved sections of the Arcadiane, into the jumble of the *Plateia in Coressus*, or up the Upper Embolos. Beyond the Arch of Hercules, they would have seen porticoes that were weird beyond imagination, irregular structures of *bricolage*, of poorly sorted materials that were badly erected and likely dangerous to inhabit. It was here that ancient urban civilisation finally fell apart, a transformation forced unwillingly onto the inhabitants of a great city with a thousand-year collective memory, who had kept their classical identity until the end. This article might not seem like a conventional contribution to the study of memory, reliant as it often is on texts, erasures, or defaced art. However, it is a first step to giving civic memory a bottom-up material dimension, a background of *spolia* use from which the significance of more dramatic evidence of monument destruction or preservation can be considered.

Reflections

The above conclusions are also perhaps not what one might expect to have extracted from a case study of contextual *spolia*. Earlier papers in this volume have examined reused material in walls, to examine which buildings were demolished at what period. We can of course do this for the Ephesian masonry contexts explored above: we can note the spoliation of the prytaneion columns to make the 'Curetes Stoa', or the architrave inscription of the Civic Basilica in the Baths of Scholasticia, both of around AD 550. This would give us an account of the ruin of monuments that is certainly

95 See above n. 76.
96 See above n. 62.

worth assembling, which can be cross-checked with excavations on the ground. But much of this, as on other sites, is ultimately less charged with ideology and active choice than we would like. For the Upper Agora, *spolia* contexts record the decay of a civic plaza and its political buildings but equally testify to the wasting of an entire urban quarter. More interesting is the specific robbing of columns of the Octagonal heroon, reused in a later 6th c./earlier 7th c. portico higher up the Embolos, using as it does material taken from within a densely occupied area. Also significant is the use of parts of the 'Parthian monument' to pave the exedra entrance of the Baths of Constantius or the transfer of columns from the 'Temple of Domitian' to the late 4th c. rebuild of the tetragonal agora. These last two cases suggest more active choices at work in demolition, as does the mid-6th c. wasting of many of statues bases for the construction of a wall in the Baths of Scholasticia, mentioned above.

Yet, neither of these types of *spolia* observations are new and would have not been worth an article. Rather, what the *spolia* contexts examined here show is the 'reverse imprint' of reuse, studied on a large scale: the intentional preservation of many highly expendable decorative buildings from along the Embolos, often centuries old. When new colonnades were rebuilt or added, these monuments generally remained untouched, even if now extramural. The *spolia* that was used rather came from elsewhere, likely from commercial or political handlers. These suppliers had brought stone from *spolia* yards, which drew on demolitions across the city and sorted it for reuse. Unstructured local scavenging was only likely after a devastating event. The low *spolia* content of the fortification is also revealing. Just as the final street colonnades in reused elements sought to imitate older models, the city wall itself, built around the same time, disdained to plunder the street monuments and porticoes that surrounded it. Its builders preferred to order new stone from local quarries. Of course, fashions for buildings did come and go. Some would slip away during the 5th c., the fruit of institutional or religious change. Yet, there remained a core of secular urban elements, the fabric of public space and its ornaments, that was going nowhere. These were architectural settings in which the civic efforts of centuries past could still be recognised, by any one prepared to read an inscription, and to be enjoyed by those who were not, for whom it was also maintained.

Thus, *spolia* contexts give us a practical testimony to respect for inherited secular monumentality, which might be considered memory, at a civic level. This comes not simply from their active treatment of blocks but also from what they do not include, something that is strongly apparent when *spolia* is studied contextually, as an archaeological material. These testimonies perhaps provide stronger evidence of prolonged remembrance, than that seen from the archaeology of tombs, despite all their hopes for eternal memorial. This was not individual memory but group memory, of the community as whole. In the fabric of their city, the people as whole could remember who it was: that they were Greeks, living in the Roman Empire, and that they were Ephesians. They did this not just from observing favourable imperial letters or from studying reliefs of the city's foundation by Androcles, displayed in its streets, but from the accretion and maintenance of old fountains and watchful statues which crowded them. This was no perfect memory. It was one in which the authentic inscriptions transcribed into the *Palatine Anthology* competed with folk legends about monuments, of the kind recorded by Malalas for Antioch.[97] Yet, it was a memory strong enough at Ephesus to ensure that venerable structures were untouched when a large-scale fortification looked to reuse stone only 30 years before the end of Antiquity, in a project which sought to reflect and reinforce the existing classical urban style, with mixed degrees of success.

Acknowledgements

I am grateful to Sabine Ladstätter for inviting me to Vienna to give this is paper to her team and for useful comments, which Alice Waldner also provided. Neither, however, should be seen as having any responsibility for the opinions expressed in this article, which I know are controversial. I am also grateful to Nikos Karydis for encouraging me to bring forward this research through his own work on phases (of churches) at Ephesus and for his friendship at Kent. I thank Lloyd Bosworth for his work on preparing the images.

97 Statues of Antioch: Saliou (2006).

TABLE 1 Ephesus, late street paving, summary of contextual spolia.

Ephesus, late street paving			Summary of contextual spolia observations					
Dating		Suggested group	Sorting		Disguise	Jointing	Levelling	Total of factors
			by size	by colour				
410–36	a	Domitianstrasse, Middle	5	4	2	4	5	20
410–36	a	Domitianstrasse, Lower	5	3	2	4	4	18
410–36	a	Upper Embolos, N of Arch	4	4	3	3	5	19
410–36	a	Middle Embolos, by Alytarch Stoa	4	4	3	4	4	19
410–36	a	Badgasse, closest to Embolos	4	4	2	3	3	16
410–36	a	Stiegengasse 2	5	4	2	3	4	18
410–36	a	Marble Street	5	4	2	4	5	20
476–518	b	Clivus Sacer	4	3	2	3	3	15
476–518	b	Upper Embolos, paving strip on W Side	2	2	2	1	2	9
476–518	b	Middle Embolos, E end of Alytarch Stoa	2	3	2	1	2	10
476–518	b	Akademiegasse	2	2	2	2	2	10
476–518	b	Hanghausstrasse	2	3	2	2	2	11
476–518	b	Katzenkopfgasse	2	2	2	3	2	11
476–518	b	Street west of Arch of Hadrian	2	2	2	3	2	11
550	b	Arcadiane patch by Tetrastylon	2	5	3	3	3	16
476–518	b	Lower Embolos	3	2	2	2	3	12
574–641	c	Upper Embolos, S of Arch	2	2	2	1	2	9
574–601	d	Marble Street patch by Byz City Wall Gate	2	2	1	1	1	7
574–601	d	Plateia in Coressus	2	2	2	1	1	8

Well-dated street sections are given date ranges without italics, whilst those which are dated by analogy are given italics.

Key		(Sorting and Levelling)		(Disguise)		(Jointing)	
		6	excellent	3	all	4	close, without cutting
		5	v good	2	clamps visible	3	cut to fit
		4	good	1	none	2	cut, but with gaps
		3	ok			1	not cut
		2	poor				
		1	v poor				

Appendix: New Late Antique Phasing, from the Lower *Embolos*

An excellent monograph on the Embolos is now A. Waldner *Die Chronologie der Kuretenstraße. Archäologische Evidenzen zur Baugeschichte des unteren Embolos in Ephesos von der lysimachischen Neugründung bis in die byzantinische Zeit* (Forschungen in Ephesos, Band: 11/4) (Vienna 2020). This appeared as my book on *Public Space* was in press. It contains a number of important observations on Ephesus which I do not include in the appendices of my volume 2. Therefore, here, I resume the phases and dating of excavations by W. Pietsch and A. Waldner, which are published in the latter's monograph. These relate to the Curetes Stoa at the north end of the Embolos, east side, and in adjacent areas of the street. Sometimes these involve references to the unpublished report of W. Pietsch, *Archäologische Untersuchungen an der Kuretenstraße* (Vienna 2001, unpubl.), Archiv Kuretenstraße (ÖAW-IKAnt) (not seen). The dating system used is that found in Lavan (2020) vol. 2 1–8, with my own dating decisions appearing here in square brackets. For ceramic abbreviations used here see Lavan (2020) vol. 2 16–8. The rigidity of this system is not to be taken too seriously. I do not think that dated based on ceramic coins can give precise year ranges as epigraphy might. However, they are given as such ranges because I aim for consistency in my dating assumptions. Anyone seeking to understand how I rank the relative quality of different sources of dating should consult my monograph, at the pages quoted above, on open access here: https://brill.com/view/title/56088. Read that before attempting to absorb what follows here.

<u>Late phase 1</u> (**Row of shops probably, if not certainly, fronted by a portico**): A structure was built in a new direction, that of the present street: Waldner (2020) pp. 137–38. It is mainly represented by wall D, divided by openings. This appears to be the front wall of shops, where shop doorways open out, perhaps fronted by a portico or being directly open to the street. Wall D cuts drain K3a of the 1st c. AD, establishing a new drain K3. Dating evidence recovered from the construction fill of this drain (on pp. 138–39) includes as the latest of many coins, issues of Theodosius II (reigned AD 402–450). Under the dating rules expressed in Lavan (2020), I take this as providing a contextual coin date of 402–450, based on the latest find. The dating range can be extended beyond the usual 25 years, as we do not know when, during the long reign of Theodosius II, the coin was struck. More dating comes from Wall E which is disturbed by the D2 part of wall D. This has produced evidence from a removal deposit/destruction layer, which is presented below, of which the latest find seems to be a sherd of LRC Hayes 3 [of 400–*ca.* 550 date, by my reckoning]. Thus, it does not give us a closer date for the building work of this 'late phase 1' than that of 402–450, given above. This phase likely goes with the general street renewal of 410–436 attested by the Alytarch Stoa, which stands almost opposite the Curetes Stoa. The phase does not have to be as late as the second half of the 5th c. as proposed on p. 143.

The details of finds relating to the destruction of Wall E are given on p. 139. They include two edge fragments of small variants of LRC plate shape Hayes 3F (K 1111. K 1112), which Waldner dates to the end of the 4th and first half of the 5th c. [LRC Hayes 3 is 400–*ca.* 550 LRP + SLRP but 3F is 500–600 Atlante]. This LRC 3F is a problem both for the dates of Waldner and myself. However, in the catalogue on p. 313 the sherd is labelled as LRC Hayes 3 not as 3F, suggesting a typo in the main text. A different (small) fragment is possibly Hayes 3 (K 1113) and there is also a plate of the form Hayes 1 (K 1114) 778 [387.5–475 LRP]. The amphora rim K 1115 of Kapitän II is given as dating to the late 2nd–4th c. [200–400 RADR], and K 1116 of an LRA 3 is given late antique–Early Byzantine [387.5–?600 RADR for two handled version]. Two coins of Arcadius [383–408] are also present.

Dating summary: range 402–50, midpoint 426, class Cs8 (contextual coins), Cs9 (contextual ceramics), publication (3/3).

<u>Late phase 2</u> (**Portico without shops**): Backwall C (of big *spolia* blocks), foundation B1 and stylobate wall B2 (of mortar with limestone rubble), belong together in the same phase on account of their common building height and also through the sequence of cuts visible in the section (pp. 139–40 with p. 133 Fig. 35). The building level of the structure produced a lot of finds, mainly of the Hellenistic period but with some late antique materials (5th c., with some being 5th to 6th c. date). There is also a mortar layer between old door wall D2 and B2 which contained a lot of finds, suggesting to Waldner use until at least the beginning of the 6th c. (p. 140).

The latest finds associated with the mortar building level of this structure are as follows (p. 140): LRC plates of form Hayes 2A (K 1118. K 1119) [370–460 in LRP] and Hayes 3–4 (K 1120) [3 is 400–*ca.* 550 in LRP + SLRP, 4 is 425–450 LRP] as well as an edge fragment of the LRC that relates to a buckled wall bowl or belonged to a lid (K 1121). For Waldner, these point to the 5th c., which is certainly supported by the Hayes LRC 3–4. Amphora fragments K 1122, K 1124 and K 1125, on the other hand, are assigned

to the local amphora type LRA 3 [387.5–?600 RADR for two handled version], which dominated Ephesus in the late antique–Early Byzantine period, with K 1122 given as probably of 6th c. date. To justify the dating of K1122, Waldner refers to Bezeczky (2005) citing 167–70 (Typ 55) 204 f [but note that in Bezeczky this is not Type 55 but Type 56 and another reference to pages 167–70 does not check out]. She also refers to Ladstätter (2008) 180–83. However, in the catalogue on p. 314, Waldner does not refer to Ephesus 56, just to Amphora LRA 3. In pers. comm. April 2021 she notes that it is indeed LRA 3 but of the 6th c., which I will accept based on deference as an unspecified variant identified at Ephesus.

Further dating evidence for late phase 2 comes from a second source: a lens of mortared rubble over foundation B2 which may be associated with same phase of construction. The most recent ceramic finds from it are given as late 4th to first half of the 5th c., especially two rims of LRC plates of form Hayes 1 (K 1126. K 1127) [387.5–475 LRP], as well as a pan with a button-like thickened rim (K 1128). W. Pietsch also quotes a coin from a construction pit of the same phase, which seemed to him to be a *nummus* of the 5th–6th c.

Overall, the mortar building level provides the strongest dating for this structure, given the doubt that surrounds the mortared rubble lense just described. Waldner believes that the mortar building level is likely to have originated at the beginning of the 6th c. or at least to have been used until this time. This is possibly based on the last ceramic (a type of LRA 3, mentioned above), although it is not clear from the rest of the material, which seems earlier. For myself, I will accept K 1122 as being 6th c. so giving us a contextual date of 500–525, based on it being the find with the latest start date.

Dating summary: range 500–525, midpoint 512.5, class Cs9 (contextual ceramics), Cs8 (contextual coins), publication (3/3).

Late phase 3 (Complete rebuilding of the portico without shops): Stylobate A was established over the previous stylobate B2, supporting an arcaded colonnade of reused columns that were brought from the Prytaneion: Waldner (2020) 133–34. The upper brick superstructure of the portico back wall and its vaulted chamber above are linked to this phase: A. Waldner pers. comm 2021. This portico is described in Lavan (2020) vol. 2 appendix C4 pp. 294–95 and in Thür (1999a) and (1999b). The stylobate is 50cm higher than the previous portico, with a related new higher street level (pp. 133–34) and new water supply pipes (WL1 and WL2).

The presence of monograms dated to *ca.* 550, on the Ionic capitals of this phase of the building, secure the dating of 550 as given in appendix C4 of Lavan (2020) vol. 2 294–95. This is supported by a governor's edict carved onto one of the columns (IvE 4.1352), which Feissel (1999a) 131 no. 13 dates to the 6th c., so providing a *TAQ*. This form of dating can compete with the contextual ceramics, as it is currently perceived as being more precisely dated and provides a spot date, rather than a range between a *TPQ* and a *TAQ*. However, such generic epigraphic dating, of a monogram involving no dated named individuals (referring to the Greens and Orthodoxy), can be subject to change, and it is thus very reassuring to have a contextual ceramic date with a range that is so close.

Dating summary (revised): 550, class Cs6 (absolute, inscription), Cs6 (*TAQ* inscription, from decree text), Cs9 (contextual ceramics), publication 3/3.

Late phase 4 (water pipe and floor): A third water pipe (WL3), coming from the direction of the Octagon under the road paving, cuts through walls A and B (the stylobate the previous phase) (pp. 133–34). This apparently contains later finds than layers relating to stylobates A and B but Waldner does not say what: Waldner (2020) pp. 134–35, citing (Pietsch 2001) (not seen) without page number.

The water pipe has dating evidence from the destruction levels (*Ausrisses*) of wall D, associated with its installation, of which the finds are listed on pp. 142–43 and p. 318 to 319 (K1159–1167). The most recent finds are three LRC plates of the form Hayes 1 (K 1159–1161) [dated to 387.5–475 in LRP] as well as a plate of the LRC form Hayes 3 with multi-row rouletting decoration on the bottom inside (K 1162) 809, which Waldner gives as the 5th or in the second half of the 5th c. [475–550 in LRP]. There are other finds of a lamp and glass fragments of bottle or jugs but none of the 4th to 5th c. and none have later start dates than LRC Hayes 3. Under the rules of Lavan (2020) this gives a contextual date of 475–500.

There are later finds from the fill of the trench cut for the water pipe, the finds for which are on pp. 141–43. The latest finds (p. 143) seems to be K1168 a ERSW imitation of LRC-plate form Hayes 3/10 of probably 6th c. date, alongside K1169 a plate of Hayes 67 [given as 5th c. but 350–500 on my list, as no variant is specified] and K1149 [not 1179 as in the text] an amphora of type Ephesus 56. The date given for Ephesus 56 by Bezeczky appears to be of 387.5–700 in a summary of amphorae at https://homepage.univie.ac.at/elisabeth .trinkl/forum/forum0312/62amphora.htm. However, Ladstätter (2008) 182 notes that type 56 is particularly found in advanced 6th c. contexts in the Vedius Gymnasium but not after. In my 2020 book *Public Space*,

I misunderstood the summary online, from an ambiguous remark of Bezeczky, so Ladstätter's observations take preference, meaning that I treat Ephesus 56 as dated to roughly 500–600. This error should affect my dating calculation for of the East side of the Upper Embolos in the 574–601 construction phase, proposed in Lavan (2020) but it does not change the actual date range.

A remnant floor deposit (of *spolia* layer BD1 and brick layer BD3) was found covering water pipes WL1, and WL2 and back wall foundation C2 (Waldner (2020) 135). These pipes might have been laid at the same time as WL3 but this is not clear from the text. The deposit they are laid within does not seem entirely understood from the section of Fig. 35, where WL1 is visibly later than WL2 but where other context boundaries for water pipe cuts have been lost. It is possible that the floor level belongs with phase 3 and was only disturbed for WL3. There appear to be no finds from this level.

This phase cannot be dated on presently published evidence, as the finds are too early for its position in the sequence. We can adopt a *TPQ* of phase 3 and a *TAQ* of the end of the reign of Heraclius in 641. This is possible as relatively common coins of Constans II are not known in this area, south of the 'Byzantine' city wall: Scherrer (2006) (49–54) 54 (citing coin lists in n. 264) and Schindel (2009) esp. 194 Fig. 24. One can also adopt an earlier *TAQ* of 614, being that of the decisive Persian invasion of Anatolia, after which secular civil public building seems to have come to a stop in the region.

Dating summary (revised): range 550–614, midpoint 582, class Cs6 (absolute, inscription, from monogram), Cs6 (*TAQ* inscription, from decree text), Cs9 (contextual ceramics), z (regional development), publication 3/3.

Late phase 5 (Subdivision of portico): A wall of *spolia* was seen blocking intercolumniations of the last portico: Waldner (2020) 135. However, in the early excavation photo of 1904 (Fig. 38) there seems to be a lateral secondary wall blocking the portico hallway itself. This phase cannot be dated apart from adopting the *TPQ* and the *TAQ* of the previous phase, for the same reasons.

Dating summary (revised): range 550–614, midpoint 582, class Cs6 (absolute, inscription, from monogram), Cs6 (*TAQ* inscription, from decree text), Cs9 (contextual ceramics), z (regional development), publication 3/3.

Street paving adjacent to *Curetes Stoa*: The street paving immediately adjacent to the Curetes Stoa is part of a wider repaving, which is described immediately after this entry ("Street paving from Hexagon/modern entrance Hanghauser to Curetes Stoa"). This can be dated by two sondages, the first considered here, adjacent to the Curetes Stoa. For reasons of continuity it is best to present this sondage now, with a full description of the paving reserved for the second entry here.

Of phasing, this paving postdates the last stoa building of phase 3, when the slabs of the street were raised up to match the height of the new portico stylobate. Fill from under paving slabs produced finds listed in Waldner (2020) 140–41.

Of dating, the last finds from this fill are given as dated to the end of (*augehende*) the 5th to early 6th c. These finds include LRC plate form Hayes 1 (K 1129) [387.5–475 LRP], LRC deep plate (K 1130) probably form Hayes 3 [400–*ca.* 550 LRP + SLRP but with many variants] given by Waldner as likely to date to the 5th c. Amphorae knobs seem on fabric to be LRA 3 [387.5–?600 RADR for two handled version] (K 1131–1135). The feet of the amphorae are almost closed, which encouraged W. to date them in the 5th c. There were also two cooking pot rims (K 1137. K 1138), which may be set in the late 5th and 6th c. AD. A comparative reference is made to Ladstätter (2008) (97–186), Abb. 31, 7. 9 but I was not able to identify this from the relevant volume. Three coins were found given as supporting a date of the 5th–6th c. (one of 355–361, one of 4th–5th c.; and a *minimus* of 5th–6th c. date).

Overall, Waldner takes this information as implying that the Kuretenstraße was relaid in the end of the 5th/beginning of the 6th c., at least in its northwest section. However, I can see only the cooking wares which could push the date into the late/end of the 5th c. Only these have a start date of this time. As the last dated items in the fill, they would rather give a contextual ceramic date of 487.5–512.5 for this phase, under the rules used in Lavan (2020) vol. 2. However, the position of this phasing in the wider history of the Curetes Stoa, being contemporary with the late phase 3 of the portico, means that I must adopt the monogram dating from that building, which obliges us to use a date of 550. I suspect that the monogram dating is too late but do not have the expertise to reopen its dating.

Dating summary (ceramics only): range 487.5–512.5, midpoint 500, class Cs9 (contextual ceramics), Cs8 (contextual coins), publication (3/3).

Dating summary (official): 550, midpoint 550, class Cs 6 (inscription, monogram), publication (3/3).

Street paving from Hexagon/modern entrance Hanghauser to Curetes Stoa: The paving outside the Curetes Stoa and adjacent monuments is laid differently to the rest of the Embolos and to the Marble Street. It has larger and more irregular gaps between slabs. The

reused slabs are also of more varied colours, and, in many places, they are less well-levelled. Thus, I think the section of paving from the north end of the Alytarch Stoa to the Curetes Stoa has been relaid, affecting the results across this area. Indeed, a rise in paving level can be noticed at the point where the Marble Street turns into the Embolos, where the north side of the Curetes Stoa begins. See map 28 for the location and boundaries of this paving area.

A second sondage of 2006, on the south side of the street was dug under broken paving slabs: "*einer kleinen Sondage am Südrand der Kuretenstraße, nordwestlich des modernen Aufgangs zur Wohneinheit 6 des Hanghauses 2 und östlich des Hexagons, gewonnen wurden*" with coins from Trajan to Anastasius I, with the last coin being of 476–518: Waldner (2020) p. 141. This excavation is marked as KUS06 on trench plan Fig. 1b on p. 15. This excavation does not seem to be published in full. It would give a contextual coin date of 476–518, under the rules of Lavan (2020) vol. 2, as the coin date range is longer than 25 years. Almost certainly, the paving is the same as that involving the Curetes Stoa above, as it is contiguous with it. This would give the paving a date of 550 based on the monogram of the Curetes Stoa. In my hierarchy of dating (Lavan (2020) vol. 2 p. 1, contextual ceramics take a higher factor. However, it would be foolish to try to make the two dates agree, as the monogram could have been inscribed onto the stoa later, and paving can well be disturbed and relaid in a manner that escapes the notice of archaeologists. Better, because of their different nature, to let the ceramics date the paving and the monogram date the portico. It is possible that either the monogram dating of phase 3 is 25 to 50 yrs too late. More excavation is needed.

Dating summary (ceramics, adopted): range 476–518, midpoint 497, class Cs9 (contextual ceramics), Cs8 (contextual coins), publication (3/3).

Other Details

<u>Street paving by Temple of Hadrian:</u> On trench plan Fig. 1b on p. 15 there is a 2006 excavation marked in front of the Temple of Hadrian. This looks like a pavement sondage. However, the results of this are not published in this volume of Waldner. The results will be important, because this sondage is an area where the paving which I ascribe to '410–436' is very well-preserved and coherent.

<u>Street paving and stylobate of Upper Embolos, east side, north end:</u> Pietsch (2001) (not seen) included a description of excavation SO 1/95, according to Waldner (2020) 182. This established that marble paving was established along the street with accompanying porticoes. Pietsch found that a sewer and a stylobate were established in the second half of the 1st c. AD, which Waldner connects to a Domitianic building programme. Perhaps on account of the fountain of Domitian, at the head of the street. The position of the sondage SO 1/95 is marked on trench plan Fig. 1b on p. 15, as being at the north end of the Upper Embolos East Portico, just before a side street joins the Embolos on the north side, just east of the Nymphaeum of Trajan. However, there is good reason to believe that the paving and portico stylobate referred to by Pietsch and Waldner, in relation to the sondage, are not the extant stylobates of the Upper Embolos, which lead up to the Arch of Hercules, at the same height.

From my site observations of 2005, 2013 (from photographs), and 2021 (from Google) I can note that, a lower level of paving is exposed here, in well-cut non-reused closely jointed marble or limestone slabs. On this lower paving stands a late antique but undated statue base to the governor Damocharis (LSA 2962). This paving is covered by the late paving that I attribute to the period 410–436, into which the Arch of Hercules is bonded, and at which height the extant porticoes run. The earlier paving is also covered by the late paving of a side street running into this junction. Nonetheless, there is another portico here, set at the level of the earlier paving, of which two pedestals survive, supporting white limestone Attic column bases. The right-hand pedestal of this 'portico' is butted against by the stylobate and last column base of the east portico of the Upper Embolos. This is clearly not the same phase of portico, coming at a different level. Its column base is set slightly above the top of the right-hand pedestal. I do not suggest any dating here, for what is likely to be a feature of the 2nd or early 3rd c. AD.

Bibliography

Abbreviations

IvE = AA. VV., *Die Inschriften von Ephesos*, 8 vols. (Bonn 1979–84).

LSA = *Oxford Last Statues of Antiquity Project Database* http://laststatues.classics.ox.ac.uk/

Primary Sources

Dig. = T. Mommsen ed., *Justinian Digesta seu Pandectae*. (Berlin 1870). A. Watson ed., *The Digest of Justinian* [revised English-language edn.]. (Philadelphia 1998), 2 vols. I have not used the translation corrections of http://iuscivile.com/materials/digest/received.shtml. (last accessed March 2014).

Philostratos vs = *Flavii Philostrati Opera* ed. C. L. Kayser. (Leipzig 1870–71) 2 vols.

Secondary Sources

Alzinger W. (1972–1975) "Das Regierungsviertel", *ÖJh* 50. (1972–1975) 229–300.

Aristodimou G. "Ephesus. (antiquity), commercial agora. (Tetragonos)", in *Encyclopaedia of the Hellenic World, Asia Minor* URL: <http://www.ehw.gr/l.aspx?id=8214>. (last accessed March 2016).

Auinger J. (2009) "Zum Umgang mit Statuen hoher Würdenträger in spätantiker und nachantiker Zeit entlang der Kuretenstraße in Ephesos", in *Neue Forschungen zur Kuretenstraße von Ephesos. Akten des Symposiums für Hilke Thür vom 13. Dezember 2006 an der Österreichischen Akademie der Wissenschaften*, edd. S. Ladstätter *et al.* (DenkschrWien 382. AF 15). (Vienna 2009) 29–52.

Bammer A. (1972–1975) "Ein spätantiker Torbau aus Ephesos", *ÖJh* 50. (1972–1975). (Beiblatt 93–126) 117–22.

Bauer F. A. (1996) *Stadt, Platz und Denkmal in der Spätantike. Untersuchungen zur Ausstattung des öffentlichen Raums in den spätantiken Städten Rom, Konstantinopel und Ephesos.* (Mainz 1996).

Bezeczky T. (2005) "Late Roman Amphorae from the Tetragonos-Agora in Ephesus", in *Spätantike und mittelalterliche Keramik aus Ephesos*, edd. F. Krinzinger and T. Bezeczky. (Vienna 2005) 203–30.

Bezeczky T. (2013) *The Amphorae of Roman Ephesus.* (Forschungen in Ephesos 15/1). (Vienna 2013).

Büyükkolancı M. and Knibbe D. (1989) "Zur Bauinschrift der Basilica auf dem sog. Staatsmarkt von Ephesos", *ÖJh* 59. (1989) 43–45.

Cèbe J.-P. (1957) "Une fontaine monumentale récemment découverte à Sufetula. (Byzacène)", *MEFRA* 69. (1957) 163–206.

Chaniotis A. (2011) "Graffiti in Aphrodisias: images – texts – contexts," in *Ancient Graffiti in Context*, edd. J. A. Baird and C. Taylor. (New York 2011) 190–243.

Crawford J. S. (1990) *The Byzantine Shops at Sardis.* (Archaeological Exploration of Sardis 9). (Cambridge Mass. 1990).

Deichmann F. W. (1974) "Zur Spätantike Bauplastik von Ephesos", in *Mansel'e Armağan, Mélanges Mansel*, vol. 1. (Ankara 1974) 549–70.

Dentzer J.-M., Dentzer-Feydy J. and Vallerin M. (2007) "Le tétrapyle et la place ronde", in *Bosra aux portes de l'Arabie*, edd. J. Dentzer-Feydy, M. Vallerin and M. Fournet. (Guides Archéologiques de l'institut Français du Proche-Orient 5). (Amman 2007) 265–66.

des Courtils J. and Laroche D. (1998) "Xanthos – Le Letoon. Rapport sur la campagne de 1997", *Anatolia Antiqua* 6. (1998) 457–77.

des Courtils J. and Laroche D. (1999) "Xanthos – Le Letoon. Rapport sur la campagne de 1998", *Anatolia Antiqua* 7. (1999) 367–99.

des Courtils J. and Laroche D. *et al.* (2000) "Xanthos – Le Letoon. Rapport sur la campagne de 1999", *Anatolia Antiqua* 8. (2000) 399–83.

Dorl-Klingenschmid C. (2001) *Prunkbrunnen in Kleinasiatischen Städte. Funktion im Kontext.* (Munich 2001).

Duman B. and Baysal H. H. (2016) "Tripolis Ad Maeandrum 2014 Yılı Kazı, Onarım ve Koruma Çalışmaları", *Kazı Sonuçları Toplantısı* 37.1. (2016) 563–84.

Duval N. (1982) "L'urbanisme de Sufetula – Sbeitla en Tunisie", *ANRW* 10.2. (1982) 596–632.

Duval N. and Baratte F. (1973) *Les ruines de Sufetula. Sbeitla.* (Tunis 1973).

Erim K. T. (1990) "Recent work at Aphrodisias 1986–1988," in *Aphrodisias Papers. Recent Work on Architecture and Sculpture*, edd. C. Roueché and K. T. Erim. (Ann Arbor 1990) 9–35.

Feissel D. (1998) "Vicaires et proconsuls d'Asie du IVe au VIe siècle. Remarques sur l'administration du diocèse asianique au Bas-Empire", *AnTard* 6. (1998) 91–104.

Feissel D. (1999a) "Épigraphie administrative et topographie urbaine: l'emplacement des actes inscrits dans l'Éphèse protobyzantine. (IVe – VIe s.)", in *Efeso paleocristiana e bizantina*, edd. R. Pillinger *et al.* (Vienna 1999) 121–32.

Feissel D. (1999b) "Öffentliche Strassenbeleuchtung im spätantiken Ephesos", in *Steine und Weg: Festschrift für Dieter Knibbe zum 65. Geburtstag*, edd. P. Scherrer, H. Taeuber and H. Thür. (Vienna 1999) 25–29.

Fildhuth J. (2010) "Die Kuretenstraße in Ephesos während die Spätantike", in *Die antike Stadt im Umbruch. Kolloquium in Darmstadt, 19. bis 20. Mai 2006*, edd. N. Burkhardt and R. H. W. Stichel. (Wiesbaden 2010) 137–53.

Fink W. (1981) "Das frühbyzantinische Monogramm", *Jahrbuch der Österreichischen Byzantinistik* 30. (1981).

Foss C. (1979) *Ephesus after Antiquity. A Late Antique, Byzantine and Turkish City.* (Cambridge 1979).

Frey J. M. (2016) *'Spolia' in Fortifications and the Common Builder in Late Antiquity.* (Mnemosyne, Supplements. History and Archaeology of Classical Antiquity 389). (Leiden and Boston 2016).

Harris A. (2004) "Shops, retailing and the local economy in the Early Byzantine world: the example of Sardis", in *Secular Buildings and the Archaeology of Everyday Life in the Byzantine Empire*, ed. K. Dark. (Oxford 2004) 82–122.

Harris E. C. (1989) *Principles of Archaeological Stratigraphy* 2nd edn. (London and New York 1989).

Heberdey R. (1900) "Vorläufiger Bericht über die Ausgrabungen in Ephesos IV", *ÖJh* 3. (1900) Beibl. 83–96.

Heberdey R. (1902) "Vorläufiger Bericht über die Ausgrabungen in Ephesos IV", *ÖJh* 4. (1902) Beibl. 53–66.

Heberdey R. (1905) "VII. Vorläufiger Bericht über die Ausgrabungen in Ephesos 1904", *ÖJh* 8. (1905) Beibl. 62–79.

Heberdey R. (1907) "VIII Vorläufiger Bericht über die Grabungen in Ephesus 1905–06", *ÖJh* 10. (1907) 62–78.

Hicks E. L. (1890) *The Collection of Ancient Greek Inscriptions in the British Museum: Part III. Priene, Iasos, and Ephesos.* (Oxford 1890).

Hoggett R. (2000) *Principles and Practice: The Application of the Harris Matrix to Standing Building Recording.* (University of Bristol, dissertation 2000).

Inan J. and Rosenbaum E. (1966) *Roman and Early Byzantine Portrait Sculpture in Asia Minor.* (Oxford 1966).

Iro D., Schwaiger H. and Waldner A. (2009) "Die Grabungen des Jahres 2005 in der Süd- und Nordhalle der Kuretenstraße. Ausgewählte Befunde und Funde", in *Neue Forschungen zur Kuretenstraße von Ephesos. Akten des Symposiums für Hilke Thür vom 13. Dezember 2006 an der Österreichischen Akademie der Wissenschaften.* (DenkschrWien 382. AF 15). (Vienna 2009) 53–87.

Jobst W. (1977) *Römische Mosaiken aus Ephesos I.* (Vienna 1977).

Jobst W. (1986) "Ein spätantike Straßenbrunnen in Ephesos", in *Studien zur spätantiken und byzantinischen Kunst. Festschrift für F.W. Deichmann*, edd. O. Feld and U. Peschlow. (Monographien des Römischgermanisches Zentralmuseum 10.1). (Bonn 1986) 47–62.

Karwiese S. (1989) *Erster vorläufiger Gesamtbericht über die Wiederaufnahme der archäologischen Untersuchung der Marienkirche in Ephesos.* (Denkschriften. Österreichische Akademie der Wissenschaften. Philosophisch-historische Klasse 200). (Vienna 1989).

Karydis N. (2019) "The development of the Church of St Mary at Ephesos from Late Antiquity to the Dark Ages", *AnatSt* 69. (2019) 175–94.

Keil J. (1923) *Ephesos III.1. Die Agora.* (Vienna 1923).

Knoll F. (1932) "Baubeschreibung", in *Die Marienkirche in Ephesos.* (Forschungen in Ephesos 4.1). (Vienna 1932) 13–78.

Ladstätter S. (2008) "Römische, spätantike und byzantinische Keramik aus Ephesos", in *Das Vediusgymnasium in Ephesos*, edd. M. Steskal and M. La Torre. (Forschungen in Ephesos 14.1). (Vienna 2008) 97–186.

Ladstätter S. (2009). (ed.) *Neue Forschungen zur Kuretenstrasse von Ephesos: Akten des Symposiums für Hilke Thür vom 13. Dezember 2006 an der Österreichischen Akademie der Wissenschaften*, ed. S. Ladstätter. (AF 15). (Vienna 2009).

Ladstätter S. (2015) "Forschungen in der Türkei: Ephesos: I.1.1.3 Kuretenstraße", *ÖJh.* (2015) 14–16.

Ladstätter S. (2018) "Eine Archäologie von Ephesos und Ayasoluk. Die Transformation einer antiken Großstadt während der byzantinischen Zeit. (6.-15. Jahrhundert)", *MiChA* 24. (2018) 80–105.

Ladstätter S. (2019) "Ephesos from Late Antiquity until the Late Middle Ages", in *Ephesos from Late Antiquity until the Middle Ages. Proceedings of the International Conference at the Research Center for Anatolian Civilizations, Koç University, Istanbul, 30th November - 2nd December.* (SoSchrÖAI 58). (Vienna 2019) 11–72.

Ladstätter S. and Sauer R. (2005) "Late Roman C Ware und lokale spätantike Feinware aus Ephesos", in *Spätantike und mittelalterliche Keramik aus Ephesos*, ed. F. Krinzinger. (Vienna 2005) 143–201.

Ladstätter S. and Steskal M. (2009) "Die Grabungen 1999 im bereich der Alytarchenstoa", in *Neue Forschungen zur Kuretenstraße von Ephesos. Akten des Symposiums für Hilke Thür vom 13. Dezember 2006 an der Österreichischen Akademie der Wissenschaften*, ed. S. Ladstätter. (DenkschrWien 382. AF 15). (Vienna 2009) 89–100.

Lavan L. (2012) "Public space in late antique Ostia: excavation and survey in 2008–2011", *AJA* 116. (2012) 649–91.

Lavan L. (2013a) "Distinctive field methods for Late Antiquity: some suggestions", in *Field Methods and Post-Excavation Techniques in Late Antique Archaeology*, edd. L. Lavan and M. Mulryan. (Late Antique Archaeology 9). (Leiden 2013) 51–90.

Lavan L. (2013b) "The agorai of Sagalassos in Late Antiquity. An interpretive study", in *Field Methods and Post-Excavation Techniques in Late Antique Archaeology*, edd. L. Lavan and M. Mulryan. (Late Antique Archaeology 9). (Leiden 2013) 289–353.

Lavan L. (2020) *Public Space in the Late Antique City.* (Late Antique Archaeology Supplementary Series 5). (Leiden 2021) vol. 2.

Lavan L. (forthcoming) "Memorial and oblivion in Late Antiquity: the testimony of spolia", in *Burial and Memorial in Late Antiquity. Vol.1: Thematic Perspectives.* (Late Antique Archaeology 13) ed. L. Lavan. (Leiden and Boston forthcoming).

MacDonald W. (1988) *The Architecture of Roman Empire. Vol. 2 An Urban Appraisal.* (Yale 1988).

Martens F. (2005) "The archaeological urban survey of Sagalassos. (south-west turkey): the possibilities and limitations of surveying a 'non-typical'classical site", *Oxford Journal of Archaeology* 24.3. (2005) 229–54.

Miltner F. (1959) "XXII Vorläufiger Bericht über die Ausgrabungen in Ephesos", *ÖJh* 44. (1959) 267–90.

Miltner F. (1955) "XX. Vorläufiger Bericht über die Ausgrabungen in Ephesos", *ÖJh* 42. (1955) Biebl. 23–59.

Mishkovsky N. (forthcoming) "The destruction, preservation, and adaptive reuse of funerary monuments in urban fortifications in Late Antiquity – The Eastern Mediterranean", in *Burial and Memorial in Late Antiquity. Vol.1: Thematic Perspectives.* (Late Antique Archaeology 13) ed. L. Lavan. (Leiden and Boston forthcoming).

Museum of London. (1994) *Archaeological Site Manual* 3rd edn. (London 1994).

Öğüş E. (2016) "Excavations on the Tetrapylon Street, 2010–11", in *Aphrodisias Papers 5: Excavation and Research at*

Aphrodisias 2006–2012. (*JRA* Supplement 103) edd. R. R. R. Smith, J. Lenaghan, A. Sokolicek and K. Welch. (Portsmouth, Rhode Island 2016) 48–57.

Outschar U. (2000) "Keramik macht Baugeschichte: die Begrenzung der Insula Hanghaus 2 in Ephesos: die Evidenz des keramischen Fundmaterials unter dem Pflaster der sog. Hanghausstraße", *Römische historische Mitteilungen* 42. (2000) 108–69.

Putzeys T. (2007) *Contextual Analysis at Sagalassos: Developing a Methodology for Classical Archaeology.* (Ph.D. diss., KULeuven 2007).

Quatember U. "Zur Grabungstätigkeit Franz Miltners an der Kuretenstraße", in B. Brandt, V. Gassner, S. Ladstätter. (edd.), *Synergia. Festschrift Friedrich Krinzinger* 1. (Wien 2005) 271–78.

Quatember U. (2011) *Das Nymphaeum Traiani in Ephesos.* (Forschungen in Ephesos 11.2). (Vienna 2011).

Quatember U. et al. (2008) "Die Grabung 2005 beim Nymphaeum Traiani in Ephesos", *ÖJh* 77. (2008) 265–334.

Quatember U. et al. (2017) *Der sogenannte Hadrianstempel an der Kuretenstrasse, Wien.* (Österreichische Akademie der Wissenschaften). (Forschungen in Ephesos XI.3). (Vienna 2017).

Quatember U., Sokolicek A. and Scheibelreiter V. (2009) "Die sogenannte Alytarchenstoa an der Kuretenstraße von Ephesos", in *Neue Forschungen zur Kuretenstra.e von Ephesos. Akten des Symposiums für Hilke Thür vom 13. Dezember 2006 an der Österreichischen Akademie der Wissenschaften*, ed. S. Ladstätter. (DenkschrWien 382. AF 15). (Vienna 2009) 111–54.

Rheidt K. (1995) "Bericht über die Ausgrabungen und Untersuchungen 1992 and 1993", *AA* 46.4. (1995) 693–718.

Robinson B. A. (2011) *Histories of Peirene. A Corinthian Fountain in Three Millennia.* (Ancient Art and Architecture in Context 2). (Princeton 2011).

Roskams S. (2001) *Excavation.* (Cambridge Manuals in Archaeology). (Cambridge 2001).

Roueché C. (1999) "Looking for late antique ceremonial: Ephesos and Aphrodisias", in *100 Jahre Österreichische Forschungen in Ephesos. Akten des Symposions Wien 1995*, edd. H. Friesinger and F. Krinzinger. (DenkschrWien 260. AF 1). (Vienna 1999) 161–68.

Roueché C. (2002) "The image of Victory: new evidence from Ephesus", in *Mélanges Gilbert Dagron.* (Travaux et Mémoires 14). (Paris 2002) 527–46.

Roueché C. (2009) "The Kuretenstrasse: the imperial presence in Late Antiquity", in *Neue Forschungen zur Kuretenstrasse von Ephesos: Akten des Symposiums für Hilke Thür vom 13. Dezember 2006 an der Österreichischen Akademie der Wissenschaften*, ed. S. Ladstätter. (AF 15). (Vienna 2009) 155–70.

Russell J. (1995) "The archaeological context of magic in the Early Byzantine period", in *Byzantine Magic*, ed. H. Maguire. (Washington, D.C. 1995) 35–50.

Saliou C. (2005) "Statues d'Antioche de Syrie dans la Chronographie de Malalas", in *Recherches sur la Chronique de Jean Malalas II. (actes du colloque «Malalas et l'Histoire», Aix-en-Provence, 21–22 octobre 2005)*, edd. S. Agusta-Boularot, J. Beaucamp, A.-M. Bernardi, and E. Caire. (Paris 2006) 69–95.

Scherrer P. (2000) *Ephesus. The New Guide.* (no place 2000).

Scherrer P. (2006) "Die Agora: Vorläufiger Baugeschichte", in *Forschungen in Ephesos XIII.2 Die Tetragonos Agora in Ephesos*, edd. P. Scherrer and E. Trinkl. (Vienna 2006) 49–54.

Schindel N. (2009) "Die Fundmünzen von der Kuretenstraße 2005 und 2006. Numismatische und historische Auswertung", in *Neue Forschungen zur Kuretenstraße von Ephesos. Akten des Symposiums für Hilke Thür vom 13. Dezember 2006 an der Österreichischen Akademie der Wissenschaften.* (DenkschrWien 332 = AForsch 15) ed. S. Ladstätter. (Vienna 2009) 171–245.

Schindel N. (2016) "OAI-Bericht 2016 Ephesos I.1.4.6 Numismatik", *Wissenschaftlicher Jahresbericht des Österreichischen Archäologischen Instituts.* (2016) 43.

Schindel N. and Ladstätter S. (2016) "Ephesus 2016", *Numismatic Chronicle* 176. (2016) 390–98.

Schmölder-Veit A. (2009) *Brunnen in den Städten des westlichen Römischen Reichs.* (Palilia 19). (Wiesbaden 2009)

Schmölder-Veit A. (2010) "Nymphäumsräume: Neue Treffpunkte in der spätantiken Stadt", in *Die antike Stadt im Umbruch. Kolloquium in Darmstadt, 19.bis 16. Mai 2006*, edd. N. Burkhardt and R. H. W. Stichel. (Wiesbaden 2010) 109–19.

Schneider P. (1999a) "Bauphasen der Arkadiane", in *100 Jahre österreichische Forschungen in Ephesos: Akten des Symposions Wien 1995*, edd. H. Friesinger and F. Krinzinger. (DenkschrWien 260. AF 1). (Vienna 1999) 467–78.

Schneider P. (1999b) "Die Arkadiane in Ephesos. Konzept einer Hallenstraße", in *Stadt und Umland. Neue Ergebnisse der archäologischen Bau und Siedlungsforschung. Bauforschungskolloquium in Berlin von 7 bis 10 Mai 1997.* (Mainz 1999) 120–23.

Sokolicek A. (2016) "Excavations on the Tetrapylon Street, 2012–14", in *Aphrodisias Papers 5: Excavation and Research at Aphrodisias 2006–2012.* (*JRA* Supplement 103) edd. R. R. R. Smith, J. Lenaghan, A. Sokolicek and K. Welch. (Portsmouth, Rhode Island 2016) 58–75.

Stichel R. H. W. (1982) *Die römische Kaiserstatue am Ausgang der Antike. Untersuchungen zum plastischen Kaiserporträt seit Valentinian I. (364–375 n. Chr.).* (Rome 1982).

Thiel W. (2002) "Tetrakionia. Überlegungen zu einem Denkmaltypus tetrarchischer Zeit im Osten des römischen Reiches", *AnTard* 10. (2002) 299–326.

Thür H. (1989) *Das Hadrianstor in Ephesos*. (Forschungen in Ephesos 11.1). (Vienna 1989) 122–28.

Thür H. (1999a) "Der Embolos. Innovation und Tradition anhand seines Erscheinungsbildes", in *100 Jahre Österreichische Forschungen in Ephesos: Akten des Symposions Wien 1995*, edd. H. Friesinger and F. Krinzinger. (Denkschr Wien 260. AF 1). (Vienna 1999a) 421–28.

Thür H. (1999b) "Die spätantike Bauphase der Kuretenstraße", in *Efeso paleocristiana e bizantina – Frühchristliches und byzantinisches Ephesos*, edd. R. Pillinger, O. Kresten, F. Krinzinger and E. Ruso. (DenkschrWien 282. AF 3). (Vienna 1999b) 104–120.

Underwood D. (2013) "Reuse as archaeology in Ostia: a test case for late antique building chronologies in Ostia" in *Field Methods and Post-Excavation Techniques in Late Antique Archaeology*, edd. L. Lavan and M. Mulryan. (Late Antique Archaeology 9). (Leiden 2013) 383–409.

Underwood D. (forthcoming) "The destruction, preservation, and adaptive reuse of funerary monuments within urban fortifications in Late Antiquity – The West", in *Burial and Memorial in Late Antiquity. Vol.1: Thematic Perspectives*. (Late Antique Archaeology 13) ed. L. Lavan. (Leiden and Boston forthcoming).

Vetters H. (1972–1975) "Domitianterrasse und Domitiangasse", *ÖJh* 50. (1972–75) 311–30.

Vetters H. (1979) "Ephesos Vorläufiger Grabungsbericht 1978", *AnzWien* 116. (1979) 123–144.

Waldner A. (2009) "Heroon und Oktagon. Zur Datierung zweier Ehrenbauten am unteren Embolos von Ephesos", in *Neue Forschungen zur Kuretenstraße von Ephesos. Akten des Symposiums für Hilke Thür vom 13. Dezember 2006 an der Österreichischen Akademie der Wissenschaften*, ed. S. Ladstätter. (DenkschrWien 382. AF 15). (Vienna 2009) 283–315.

Waldner A. (2020) *Die Chronologie der Kuretenstraße. Archäologische Evidenzen zur Baugeschichte des unteren Embolos von Ephesos von der lysimachischen Neugründung bis in die byzantinische Zeit*. (Forschungen in Ephesos 11.4). (Vienna 2020).

Whittow M. (2001) "Recent research on the late-antique city in Asia Minor", in *Recent Research in Late Antique Urbanism*. (JRA Supplementary Series 42). (Portsmouth RI 2001) 137–53.

Wilberg W. and Keil J. (1923) *Forschungen in Ephesos* 3. (Vienna 1923) 1–168.

Wilberg W. and Heberdey R. (1906) "Der Viersaulenbau auf der Arkadianestraße", in *Forschungen in Ephesos 1*, ed. O. Benndorf. (Vienna 1906) 132–42.

Wood J. T. (1877) *Discoveries at Ephesus: Including the Site and Remains of the Great Temple of Diana*. (London 1877).

Abstracts in French

Sépulture et Mémorial dans l'Antiquité tardive : perspectives et opportunités
Luke Lavan

Cet article propose un panorama de l'archéologie des coutumes funéraires et mémorielles ans l'Antiquité tardive, inscrivant les travaux présentés dans ce volume dans un contexte plus large. Il souligne l'importance de l'archéologie funéraire contemporaine au-delà du processus mortuaire, compte tenu de sa contribution aux études sur la structure sociale, l'identité culturelle, la démographie, la santé et l'habillement. En rapport direct avec le processus funéraire se trouve la composition des populations des cimetières, dans laquelle le traitement du nouveau-né, ou parfois de l'enfant à naître, est particulièrement significatif. Il existe également des tendances liées aux pratiques « d'inhumation déviantes ». La nature changeante des structures mémorielles, des stèles aux mausolées, est prise en compte. Les objets funéraires sont en déclin, tandis qu'on remarque une attention particulière pour les enfants et les jeunes adultes, avec la présence des objets significatifs (relayant l'attachement émotionnel) plutôt que de marqueurs de statut. La science contribue énormément à nos connaissances des rituels funéraires, de l'embaumement aux fleurs placées sur les tombes. Cependant, les textes nous livrent des aspects immatériels des rites funéraires et mémoriels, des processions aux repas caritatifs. Le traitement des sépultures au fil du temps révèle des cas de protection, de désacralisation, parfois plus précoces ou plus tardifs qu'on ne le pensait. Pourtant, la priorité donnée au mémorial comme objet funéraire semble avoir diminué. Malgré tout, les tombes n'étaient pas toujours spoliées lors des travaux de construction ; elles ont été conservées plus longtemps que prévu. La société de l'Antiquité tardive avait également d'autres débouchés pour la commémoration que l'inhumation, collectifs aussi bien qu'individuels.

Recherches bioarchéologiques récentes sur les cimetières du haut Moyen Âge en Italie
Alexandra Chavarría, Leonardo Lammana et Maurizio Marinato

Cet article présente un état des recherches impliquant des analyses bioarchéologiques disponibles pour quelques cimetières italiens datés entre le IVe et le VIIe s. Il s'intéresse à la manière dont ce type d'analyse spécialisée peut contribuer à répondre aux questions historiques actuelles (la fin des villas, l'utilisation des églises à des fins funéraires, l'immigration lombarde). Il souligne également la nécessité de prendre en compte la signification et le contexte social et économique des cimetières, un aspect d'une grande importance pour l'interprétation des résultats et leur contextualisation dans le cadre plus large de la période.

"Rendre visible l'invisible" : analyse des résidus organiques des dépôts funéraires romains tardifs
Rhea Brettell, Eline Schotsmans, William Martin, Ben Stern et Carl Heron

Le fait que des traces moléculaires invisibles, la 'saleté' souvent rejetée des conteneurs mortuaires substantiels, peuvent rester dans les dépôts funéraires, n'est pas suffisamment pris en compte. L'analyse de résidus organiques d'échantillons de sépultures romaines tardives (IIe–IVe siècle après J.-C.) en Grande-Bretagne a révélé leur potentiel de conservation de biomarqueurs diagnostiques. Parallèlement à l'analyse des résidus visibles de sépultures continentales similaires, ces résultats confirment que des substances résineuses étaient employées dans le traitement des morts dans tout l'Empire romain. Déposés au plus près du corps, elles masquaient la réalité de la déchéance, représentaient le statut du défunt et favorisaient la mémorialisation. Ces résultats, en conjonction avec l'approche et la méthodologie d'échantillonnage détaillées ici, ont une portée importante pour les futures recherches mortuaires dans la période de l'Antiquité tardive et au-delà.

La couleur de la mort : symbolisme des couleurs et sépulture dans la Grande-Bretagne romaine
Chloé Clark

L'objectif de cet article est d'étudier la couleur en tant qu'aspect peu étudié des rituels funéraires dans la Grande-Bretagne romaine tardive. La couleur est explorée à la fois comme un élément de présentation essentiel dans l'expérience vécue du rituel funéraire et comme un outil d'interprétation. Ces aspects entrelacés sont d'abord explorés avec une enquête sur les couleurs utilisées dans les traitements effectués sur et pour les morts. Suit une étude de cas sur les perles funéraires du cimetière oriental du Londres romain et du cimetière de Lankhills, qui explore le potentiel d'une approche symbolique des couleurs pour mieux comprendre les choix funéraires des personnes endeuillées.

Les cortège funéraires dans l'Antiquité tardive
Luke Lavan

Cet article présente une synthèse des données concernant les processions funéraires de l'Antiquité tardive. Elles proviennent exclusivement de textes, dont beaucoup sont hagiographiques, mais qui comptent également des histoires profanes, des lettres et certains textes de loi. L'objectif est de construire une évocation matérielle des processions funéraires qui contribuera à la visualisation d'une procession contemporaine de celle de Monique, mère d'Augustin, en 387 après JC. Des motifs communs émergent à travers le monde de l'Antiquité tardive, reflétant certaines coutumes romaines, telles que la libération des esclaves / captifs, comme on peut

s'y attendre à Constantinople et dans la Gaule mérovingienne au 6e s., où une procession d'investiture 'consulaire' subsiste uniquement pour les évêques, installés sur une chaise surélevée, même au-delà du 6ème siècle. Bien que les indices des processions funéraires soient largement confinés à l'élite, quelques éléments suggèrent que ces formes ont également influencé des processions funéraires plus modestes pour des individus plus pauvres.

Les mausolées romains tardifs en Hispanie
José Miguel Noguera Celdrán et Javier Arce

Cet article constitue une étude des différents types de monuments funéraires (*monumenta*, couramment appelés *mausolea*) utilisés dans la péninsule ibérique durant l'Antiquité tardive (IVe–Ve s.). Il établit leurs typologies, significations et fonctions individuelles, tout en soulignant que peu d'entre eux peuvent être identifiés comme des tombes chrétiennes. Au lieu de cela, la plupart sont associés à des villas romaines.

Les mausolées en Europe du Nord-Ouest : la transition de l'époque romaine à l'Antiquité tardive
Christopher Sparey-Green

Cet article résume l'état des connaissances concernant les principaux types des structures funéraires des provinces romaines du nord-ouest. À partir d'une définition du terme 'mausolée', les édifices de tradition classique sont brièvement décrits à l'aide d'exemples de la Gaule, de la Grande-Bretagne et de la frontière allemande, dans la période conduisant à la crise de la fin du IIIe s. Ensuite, l'évolution des traditions funéraires de l'Antiquité tardive est examinée dans le contexte des développements religieux, avec l'identification des types de bâtiments associés aux premiers lieux de sépulture et de culte chrétiens et honorant les personnalités majeures de l'Église primitive

Les mausolées romains tardifs en Pannonie
Zsolt Magyar

Cet article a pour objectif de présenter la chronologie, la typologie et la topographie des mausolées de l'époque romaine tardive en Pannonie d'un point de vue nouveau. Il contient des clarifications terminologiques et de nouveaux types de mausolées incluant des variantes locales. Il traite également de la question des constructeurs qui ont payé pour l'édification de telles structures funéraires.

Les mausolées dans l'Italie de l'Antiquité tardive
Mark Johnson

Dans l'Italie de l'Antiquité tardive, les mausolées reprennent de nombreuses pratiques de l'architecture funéraire romaine traditionnelle tant au niveau de leur emplacement que de leurs formes architecturales. Une nouvelle pratique a été introduite en conjonction avec le développement du christianisme : la construction de mausolées attenant à des églises. Le type dit de 'rotonde à dôme' a connu une utilisation accrue et des modifications variées pendant cette période, et a été utilisé pour la plupart des sépultures impériales. Les mausolées de l'Antiquité tardive étaient parfois construits comme des monuments à deux étages, incorporant à la fois une crypte et une chapelle funéraires.

L'évolution des paysages funéraires monumentaux dans l'Antiquité tardive : les mausolées de l'Afrique du Nord romaine tardive
Julia Nikolaus

Cet article examine les changements touchant les monuments funéraires des élites au cours de l'Antiquité tardive en Afrique du Nord à l'aide de sources archéologiques, d'inscriptions et de sources littéraires. Il met en évidence la nature complexe des pratiques funéraires en se concentrant principalement sur les mausolées de l'Antiquité tardive en Tripolitaine (Libye), et explore comment les élites locales utlisaient ces prestigieux monuments funéraires afin de mettre en évidence leur influence et leur statut, à une époque où le pouvoir est passé de l'autorité romaine centralisée à des souverains locaux (IVe et Ve s). L'article s'intéresse également aux mausolées en Tunisie et en Algérie, en particulier à la lumière de la montée du christianisme, et à la manière dont l'évolution des croyances religieuses peut avoir influencé la culture des mausolées dans cette région.

Paysages funéraires de Catalogne (IIIe–VIe s. apr. J.-C.)
Judit Ciurana Prast

Cet article explore les paysages funéraires de la Catalogne actuelle (région au nord-est de l'Espagne) de la fin du IIIe s. au début du VIe s. J.-C. Il examine les sépultures de l'Antiquité tardive dans différents contextes paysagers et considère le placement des tombes et leurs relations spatiales avec les villes, les établissements ruraux, les églises péri-urbaines, les routes et les cours d'eau. Il se penche également sur la façon dont les changements concernant l'emplacement des sépultures au sein du paysage peuvent être liés à une évolution des pratiques funéraires et des attitudes sociales envers le défunt.

Le paysage funéraire tardo-antique de Rome : IIIe–IVe s. apr. J.-C.
Barbara Borg

Ce article donne un aperçu des principaux aspects du paysage et de la culture funéraires tardo-antiques. Il discute des éléments de continuation tels que les nécropoles de tombes à puits simples et l'utilisation continue de mausolées antérieurs, ainsi que des hypogées et des catacombes, de nouveaux types de tombes monumentales et de basiliques funéraires. Il s'intéresse particulièrement aux innovations, aux messages idéologiques et religieux et au patronage. Il soutient que l'évolution des habitudes funéraires reflète un écart socio-économique grandissant dans la société, et que les structures les

plus innovantes et les types de construction les plus impressionnants, qu'ils soient chrétiens ou non, n'ont probablement pas été initiés par les empereurs ou les membres de leur famille, mais par de riches particuliers occupant une position éminente.

L'enterrement des saints à proximité des morts ordinaires : les habitudes funéraires de l'élite chrétienne au IVe s. et les premières translations de reliques
Efthymios Rizos

Cet article explore le lien entre les habitudes funéraires de l'élite laïque chrétienne et les origines de l'utilisation des reliques de saints. L'article s'appuie sur des sources textuelles et archéologiques pour montrer que la mobilité des reliques était liée au désir des chrétiens puissants de faire enterrer leurs morts près des saints (*ad sanctos*). Émulant peut-être le modèle du mausolée de Constantin le Grand, les premières translations de reliques connues ont été organisées pour la consécration de sanctuaires funéraires privés en Anatolie et à Constantinople au IVe s. Parrainées en privé par des aristocrates laïcs en collaboration avec des évêques et des moines, ces premières translations se sont heurtées à l'opposition de la législation impériale et de certaines parties de la communauté chrétienne, mais elles ont progressivement contribué à normaliser cette pratique controversée, jusqu'à ce qu'elle devienne un aspect établi de la religion publique au Ve s.

Topographie et idéologie – élections épiscopales contestées et cimetières péri-urbains dans la Rome de l'Antiquité tardive
Sam Cohen

Cet article étudie la perception du cimetière périurbain dans l'imaginaire romain tardif. Plus précisément, il examine la manière dont le cimetière a été utilisé dans les textes polémiques romains pour légitimer la mémoire des gagnants tout comme des perdants des schismes pontificaux de l'Antiquité tardive. Les espaces funéraires extra-muros de Rome étaient associés aux saints et aux martyrs de la ville, mais aussi aux étrangers, aux hérétiques, aux schismatiques. C'est précisément cette ambiguïté qui a fait du cimetière un espace idéal pour les polémistes partisans cherchant à réinventer l'histoire récente du factionnalisme de Rome. Les représentations contradictoires des cimetières dans nos sources reflètent une compétition pour les contrôler, à la fois dans la réalité et dans la mémoire romaine.

L'archéologie des monuments statuaires de l'Antiquité tardive
Luke Lavan

Les statues honorifiques n'existaient pas seulement au moment de leur dédicace, telles que les concevaient les sculpteurs et les tailleurs de lettres. Au contraire, elles ont été déplacées, réparées, modifiées, négligées et détruites, durant ce qu'on pourrait appeler leur 'vie de statue', au cours de laquelle elles se sont transformées d'objets de commémoration en artefacts livrés à l'oubli, au même titre que les mausolées. Les processus impliqués peuvent être reconstitués à partir de l'étude archéologique des monuments statuaires, en particulier par l'examen de leur contexte. Cet examen peut aussi nous informer sur les intentions de ceux qui ont dédié des statues, au-delà de ce que l'histoire de l'art et l'épigraphie peuvent démontrer. Dans cet article, j'expose le potentiel d'une approche entièrement archéologique de ces monuments, en m'appuyant sur les points forts du projet d'Oxford : *The Last Statues of Antiquity*. Ce faisant, je propose une perspective sur l'archéologie de la mémoire dans l'Antiquité tardive qui s'ajoute à celle apportée par l'étude des monuments funéraires et de leur spoliation. Je suggère que des efforts soient investis non seulement dans l'étude de l'érection et de l'enlèvement des monuments existants, mais aussi dans l'étude de ceux dont nous pouvons supposer l'existence. Ainsi, je cherche à déplacer l'étude de la statuaire publique de la description de ce qui subsiste vers une considération historique de la manière dont ces monuments étaient exposés et traités dans l'Antiquité tardive.

Les nombreuses vies des bases des statues à Lepcis Magna
Francesca Bigi et Ignazio Tantillo

La ville de Lepcis Magna est remarquable non seulement par la survivance d'un grand nombre de dédicaces de statues de l'Antiquité tardive *in situ*, mais aussi par une réutilisation extensive de leurs supports épigraphiques. Cela peut se comprendre dans le contexte d'une réutilisation architecturale qui a commencé au IIe s. et qui a été particulièrement intense à l'époque de la construction du Forum Sévérien, en raison d'une surabondance de matériaux. Cela a pu conduire à la réutilisation d'éléments architecturaux adéquats comme supports de statues. Néanmoins, plusieurs types de remplois épigraphiques différents sont identifiés, dans lesquels des supports portant des inscriptions ont été réemployés. Cela peut impliquer une perte ou un renouvellement de fonction. Le renouvellement peut se traduire par l'inscription d'un nouveau texte sur une statue plus ancienne, avec des modifications minimes, et peut se produire plusieurs fois. Une étude complète des remplois épigraphiques comparés aux dédicaces originelles révèle que, bien que toujours vivace, la statuaire était en déclin aux IIIe–IVe s., et que la réutilisation des statues honorifiques était courante.

Mémorial et oubli dans l'Antiquité tardive : le témoignage des remplois dans les murs de la ville
Luke Lavan

La vie et le destin des tombes sont peut-être tout aussi importants que leur création et leur utilisation originale. Certaines sont rapidement détruites, d'autres durent des

siècles, passivement tolérées ou vénérées. Souvent, il semble que les tombes et les monuments funéraires existent dans une position intermédiaire, où ils bénéficient d'un certain degré de protection mais ne sont pas activement entretenus. La chronologie de leur destruction peut être étudiée via de nombreux types de contexte de *spolia*. L'analyse des murs des villes tardo-antiques semble être un bon point de départ, car ceux-ci sont massifs, de mieux en mieux datés et connus pour contenir des quantités importantes de *spolia* funéraires. Dans cet article, j'expose le potentiel et les difficultés d'une telle étude, en examinant la nature des *spolia* funéraires compris dans les murs d'enceinte dans une perspective comparative, en contrastant différents sites et en comparant les matériaux utilisés dans les tombes à d'autres types de *spolia* réutilisés à la même époque. Ce travail tente de reconstituer une partie de l'histoire des paysages urbains de l'Antiquité tardive en documentant diverses occasions de spoliation, offerts par différents contextes de *spolia*. En cela, la réutilisation des monuments funéraires semble représenter un indicateur évident de changement culturel, bien que la réalité soit souvent plus complexe, comme le montrent les descriptions détaillées des murs d'enceinte. Par ailleurs, de nouvelles dates et observations de terrain sont proposées pour une sélection de 82 fortifications à travers le monde tardo-antique.

La destruction, la préservation et la réutilisation des monuments funéraires dans les fortifications urbaines de l'Antiquité tardive : l'Occident
Douglas Underwood

La spoliation des tombes de l'époque classique est devenue une pratique de plus en plus répandue dans l'Antiquité tardive, et de nombreux monuments nouvellement édifiés dans les villes tardo-antiques ont été construits, en partie, avec ces *spolia*. Cependant, peu d'attention a été accordée à l'intersection de *spolia* avec le projet de construction le plus important des villes tardo-antiques : les remparts. Cet article propose une nouvelle approche pour évaluer la quantité de matériaux venus de tombes réutilisés dans les fortifications et la manière dont ces matériaux étaient exposés, afin d'explorer l'impact de la construction des remparts sur les cimetières de l'Antiquité tardive et la relation de la ville tardo-antique à ses anciens morts.

La destruction, la conservation et la réutilisation des monuments funéraires dans les fortifications urbaines de l'Antiquité tardive : l'Orient
Nicolas Mishkovsky

Cet article examine la relation entre les remparts de la ville tardo-antique et le paysage urbain préexistant, en particulier les monuments funéraires, comme en témoigne l'utilisation de *spolia* architecturaux. À cette fin, je propose d'utiliser une méthodologie d'observation et de recherche systématiques pour examiner comment les *spolia* sont employés dans des contextes locaux uniques. Sur un groupe de 20 villes étudiées à travers la Méditerranée orientale, j'aborde les cas d'Athènes, d'Aphrodisias, de Hiérapolis et de Patara. En adoptant une approche qualitative de l'examen des *spolia*, je constate que les fortifications de l'Antiquité tardive ont eu un impact varié sur le paysage mémoriel des villes, en raison de changements culturels localisés, de destructions violentes ou d'une planification délibérée. Même au sein de circuits individuels, le traitement des *spolia* peut varier d'un bout à l'autre, en fonction de l'emplacement dans le mur, de la valeur décorative et de l'intention des constructeurs. Enfin, je termine en relatant ma propre expérience d'application de cette méthodologie à Rome.

Les remplois dans les enceintes urbaines tardoantiques : Catalogue 1 : l'Afrique et l'Orient
Luke Lavan

Les remplois dans les enceintes urbaines tardoantiques : Catalogue 2 : l'Occident
Douglas Underwood et Luke Lavan

Paysages urbains issus de la réutilisation architecturale : *Spolia*, chronologie et mémoire civique dans l'Éphèse de l'Antiquité tardive
Luke Lavan

Depuis 120 ans, les travaux menés sur le terrain par des équipes autrichiennes à Éphèse nous
ont livré l'un des environnements urbains les plus accessibles et les mieux présentés pour découvrir l'Antiquité tardive. Les fouilles actuelles nous fournissent des dates stratigraphiques pour les travaux de construction qui remplacent des chronologies antérieures basées sur le style architectural. Malgré cela, une grande partie de la ville demeure un site rapidement fouillé, dans lequel de nombreuses structures de maçonnerie n'ont pas encore été documentées. En particulier, les rues, leur pavage et leurs trottoirs n'ont pas été entièrement examinés, ni tous leurs portiques. Cet article présente une étude de cas archéologique de l'utilisation des *spolia* liée aux résultats des fouilles, cherchant à retracer le déclin et le renouveau d'une ville durant l'Antiquité tardive. Il explore les phases de construction du centre-ville et les dates de nombreux travaux de construction tardifs en son sein, y compris pour ses fortifications. Une série de paysages tardifs distincts émerge : un premier, de splendeur monumentale, un second, d'innovation originale, et un troisième de mémoire nostalgique : une ville de 'l'Antiquité terminale'. Pourtant, dans l'ensemble, c'est la préservation des bâtiments, plutôt que leur démolition, qui ressort le plus nettement de l'étude des contextes de *spolia*, témoignage de la valeur pérenne de la mémoire civique dans les villes grecques d'Asie Mineure.

LATE ANTIQUE ARCHAEOLOGY

Series Editor
LUKE LAVAN

Late Antique Archaeology is published annually by Brill, based on papers given at the conference series of the same title, which meets annually in London. Contributions generally aim to present broad syntheses on topics relating to the year's theme, discussions of key issues, or try to provide summaries of relevant new fieldwork. Although papers from the conference meetings form the core of each volume, relevant articles, especially syntheses, are welcome from other scholars. All papers are subject to satisfying the comments of two anonymous referees, managed by the discretion of the editors. The editorial committee includes Albrecht Berger, Will Bowden, Kimberly Bowes, Averil Cameron, Beatrice Caseau, James Crow, Jitse Dijkstra, Sauro Gelichi, Jean-Pierre Sodini, Bryan Ward-Perkins, Emanuele Vaccaro and Enrico Zanini. The next volume, based on papers given at meetings in 2018–2019, will concern *Imperial and Royal Archaeologies of Late Antiquity*. Journal abbreviations follow those used by the *American Journal of Archaeology*, whilst literary sources are abbreviated according to the *Oxford Classical Dictionary* (3rd edn. Oxford 1999) xxix–liv and when not given here, following A. H. M. Jones *The Later Roman Empire* (Oxford 1964) vol. 2, 1462–76, then G. W. H. Lampe *A Patristic Greek Lexicon* (Oxford 1961).

For programme information and notes for contributors, with contact details, visit:
www.lateantiquearchaeology.wordpress.com

For submissions and ordering information visit:
www.brill.com/publications/journals/late-antique-archaeology